PENGUIN REFERENCE

THE PENGUIN CONCISE
DICTIONARY OF ART HISTORY

Nancy Frazier, a former *Newsweek* reporter and magazine editor, holds an M.A. degree in art history. She has written widely on art, and worked with a distinguished panel of advisors for this dictionary. She is completing a Ph.D. degree in American Studies and lives in Amherst, Massachusetts.

The
PENGUIN
CONCISE
DICTIONARY
of
ART
HISTORY

NANCY FRAZIER

PENGUIN REFERENCE

PENGUIN BOOKS

Published by the Penguin Group
Penguin Putnam Inc., 375 Hudson Street,
New York, New York 10014, U.S.A.
Penguin Books Ltd, 80 Strand,
London WC2R 0RL, England
Penguin Books Australia Ltd, Ringwood,
Victoria, Australia
Penguin Books Canada Ltd, 10 Alcorn Avenue,
Toronto, Ontario, Canada M4V 3B2
Penguin Books (N.Z.) Ltd, 182–190 Wairau Road,
Auckland 10, New Zealand

Penguin Books Ltd, Registered Offices:
Harmondsworth, Middlesex, England

First published in the United States of America by Penguin Reference,
a member of Penguin Putnam Inc. 2000
Published in Penguin Books 2001

1 3 5 7 9 10 8 6 4 2

THE LIBRARY OF CONGRESS HAS CATALOGED
THE HARDCOVER EDITION AS FOLLOWS:
Frazier, Nancy.
The Penguin concise dictionary of art history / Nancy Frazier.
p. cm.
ISBN 0-670-10015-3 (hc.)
ISBN 0 14 05.1420 1 (pbk.)
I. Art—History—Dictionaries. I. Title.
N5300.F64 1999
709—DC21 98–56089

Printed in the United States of America
Set in Sabon
Designed by Joe Rutt

For Jack, Leslie, and David

PREFACE

Art history was challenged and defied during the early postmodern era, and it has flourished as a result. When the rumblings of deconstruction unsettled the ground beneath it, the discipline devoted to understanding artistic creativity shook, then realigned itself. As a result, the tired litany of style, influence, academic pedigree, and connoisseurship that used to drive art historical scholarship no longer satisfies. These discussions do not tell us what we really want to know: *Why?* Today we are inclined to go beyond the old formalism and "read" pictures contextually, looking for their interactions with the powers of culture, politics, philosophy, psychology, technology, and the economy. To accomplish this, our studies have become interdisciplinary, and are increasingly exciting.

My career in journalism had taught me to ask why things happen, and to tease out answers, so in beginning my studies of art history, I was enthusiastic about the widening horizon. When it came time to prepare for exams, however, I was dismayed because I could find no useful reference source that included the new perspectives. As there was none, I undertook to write one—for myself, for other students, and for all curious people who are interested in art. My goals have been to present information clearly and concisely, but not

dryly; and to use current scholarship and, sometimes, to cite controversial ideas, noting them as such, because the only thing we know to be true is that nothing is certain.

Even things that *should* be certain—dates and spellings, for example—are occasionally impossible to nail down. When there are contradictions, I use the most recent of the authoritative sources. Style is also slippery; neither logic nor hard-and-fast rules exist, so I have followed the most frequent American textbook conventions, alphabetizing Willem de Kooning under de Kooning, Theo van Doesburg under Doesburg, and Leonardo da Vinci under Leonardo, for example. Apart from magazine, newspaper, and scholarly journal articles, along with highly specialized books and monographs, my sources are listed in the bibliography.

Cross-references from one entry to another are indicated by CAPITAL LETTERS. But not *all* cross-references are always noted. There are extensive entries on COLOR, BRONZE, and EXHIBIT, for example, that delve into details that are entirely unnecessary when those words are used in passing and common knowledge is implied.

While I have discontinued the old-fashioned custom of listing locations for each work of art discussed in the text, I have retained the traditional

practice of locating artists according to the artistic movement of their time. Though recently contested, such periodization is still required knowledge for most students of art history. (I suggest readers consult the entry for periodization as well as that for each discrete period.)

Artists are often resolutely taciturn, especially when asked to explain themselves or particular works. But nothing is as enlightening as their own words when they do speak. Who but Francis Bacon might have said, "You can't be more horrific than life itself"? That thought echoes in his otherwise inexplicable paintings, as does Frida Khalo's comment "I paint my own reality." Such quotations, as well as clauses in the contracts they signed, their boasts and complaints, the assessments of their patrons, biographers, and contemporaries, as well as later critical judgments begin each biographical entry and, I believe, illuminate and enliven the individuals profiled. When the source of the quotation is other than the subject of the entry, a name and date are provided.

I was fortunate to be in the art history program at the University of Massachusetts at Amherst and study with talented and supportive teachers. I am indebted to Iris Cheney, whose untimely death took away a warmth and generosity that we all basked in. I am especially grateful to William Oedel, whose insights and intellectual challenges shaped the direction of my academic career: My interest in American art, history, and culture was sparked by his teaching. I am indebted to the acumen of Ann Mochon, for my understanding of contemporary art. In

addition to being a wonderful, stimulating teacher and a fine writer, Craig Harbison agreed to oversee a large portion of this book, as did Mark Roskill, whose own texts are foundational in the field of art history. Kim Southern, who earned the highest commendations from her professors, assisted me with fact-checking and the final organization of the book.

When the light I thought I was beginning to see at the end of an almost four-year-long tunnel seemed to vanish, Doris Troy brought it back into focus. Her friendship and humor are a beacon. Others have helped in many ways: Helen Searing, whom I have known and admired for many years, is a prominent architectural historian and specialist in eighteenth-century art, and was on the board of editors for this book; art historians Sonia Sofield and Charlene James generously shared their resources, as did the painter Edith Byron, and my friend John Bowman, an editor and writer on many subjects, especially Greece. Ed Knappman, at New England Publishing Associates, provided the expertise to turn an idea into a book, and Hugh Rawson at Penguin made the book come true. My husband, Jack, remains my anchor and moral support, as he has been for more than forty years.

It is unusual to find an index in a dictionary like this, but if you should wonder about Botticelli's varied influences, for example, or where, outside of Praxiteles' own entry, to find the numerous references to him, I think you will understand and appreciate this innovation.

Most reference books in this field, and of this scope, are compiled from the writings of numerous contributors. *The*

Penguin Concise Dictionary of Art History has a single author. If this text has but one voice, it benefits from the experience of several authorities. I am proud and honored to acknowledge the scholars who formed the Board of Editors and who agreed to read portions of the manuscript appropriate to their specialties.

Board of Editors

RICHARD BRILLIANT, formerly editor in chief of *The Art Bulletin,* is Garbedian Professor in the humanities, and Professor of Art History and Archaeology in the Department of Art History and Archaeology at Columbia University. He is the author of several books and many articles on ancient Greek and Roman art, and in 1992 published the groundbreaking study *Portraiture.*

CRAIG HARBISON is the author of *Jan Van Eyck: The Play of Realism* (1991) and *The Mirror of the Artist: Northern Renaissance Art in Its Historical Context* (1995), which has been adopted for courses in numerous colleges and universities around the United States and has appeared in several foreign languages, including French and German. Professor Harbison teaches art history in the Department of Art at the University of Massachusetts at Amherst.

MARK ROSKILL's most recent book is *The Languages of Landscape* (1997).

His contributions to scholarship in art history are vast. Best known are *What Is Art History?* (1976 and 1989) and *The Interpretation of Pictures* (1989), and texts devoted to nineteenth-century art—*Klee, Kandinsky, and the Thought of Their Time* (1992), for example. Professor Roskill teaches art history in the Department of Art at the University of Massachusetts at Amherst.

HELEN SEARING is Alice Pratt Brown Professor of Art at Smith College. She has curated, and written the catalogues for, three important architectural exhibitions: *Speaking a New Classicism: American Architecture Now* (1981), *New American Art Museums* (1982), and *Equal Partners: Men and Women Principals in Contemporary Architectural Practice* (1998). In 1982 she edited *In Search of Modern Architecture* for the Architectural History Foundation, in honor of Henry-Russell Hitchcock.

MARILYN STOKSTAD has served as president of the College Art Association and of the International Center of Medieval Art. She is Judith Harris Murphy Professor of Art at the University of Kansas, Lawrence, and Consultative Curator of Medieval Art at the Nelson-Atkins Museum of Art in Kansas City. Her book *Medieval Art* (1986) is a standard text, and her major new work, *Art History* (1995; rev. ed., 1998–99), for which she gathered a distinguished group of scholars, is an accessible, engaging, and beautiful survey text.

A

Aalto, Alvar (Hugo Henrik)

1898–1976 • Finnish • architect/
designer/sculptor • Modern

*I was nine years old when I first saw
the work of Eliel Saarinen [a picture
in a magazine]. . . . It was quite an
ordinary winter morning; I can
remember nothing else unusual about
it. But because of the impression made
upon me by those architectural
drawings I can say truly that another
architect was born.*

Majestically curving forms in nature
and the great forests of his native Fin-
land inspired the designs of Aalto. He
was also influenced by the work of his
compatriot Eliel SAARINEN, as ex-
pressed in the quotation above. Aalto
combined wood with modern building
techniques using iron and concrete. He
was fond of incorporating undulating
surfaces in his designs; a spectacular ex-
ample is the wood ceiling in the Viipuri
Library (1927, 1930–35), which the
historian GIEDION compares with "the
serpentine lines of a Miró painting."
Aalto was determined to free architec-
ture from the rigid straight lines and
right angles of De STIJL and the
BAUHAUS; he meant to socialize the ma-
chine aesthetic. If, besides their expres-
siveness, his ceiling curves can be
explained in terms of acoustical effi-
ciency, the curved brick facade of Baker
House (1947–49), a dormitory at the

Massachusetts Institute of Technology
in Cambridge, Massachusetts, might be
rationalized in terms of giving every in-
habitant a view of the Charles River. Its
effect, however, is to humanize the large
institutional building. One of Aalto's
important projects is the Town Hall
complex (c. 1949–52) at Säynätsalo, a
small island some 186 miles north of
Helsinki. The buildings have redbrick
exterior surfaces, and the compound is
constructed on two levels. It is domi-
nated by a Council Chamber with a
mono-pitched roof (one of Aalto's de-
sign signatures); the other roofs are flat.
Aalto's furniture design produced as el-
egant a chair as any made in the 20th
century; its curved plywood frame takes
advantage of the resilient strength of
laminated wood and the golden tones of
polished birch, a type of wood tradi-
tionally used for making skis. Aalto also
worked as a sculptor in bronze, marble,
and other mediums. In 1924 Aalto mar-
ried another architect, Ainu Marsio
(1894–1949), who became his profes-
sional as well as his domestic partner.

Abakanowicz, Magdalena

born 1930 • Polish • sculptor •
Modern

*They are mysterious. They are charged
with energy. . . . At the same time, they
are extremely powerful shapes.*

The works to which Abakanowicz refers in the comment above are what she called *Abakans,* strange, large objects usually between 10 and 13 feet tall and some 5 feet wide. Sometimes they hang from the ceiling as irregular shapes that may be walked around, even entered; many rise from the floor. First exhibited in the 1960s, the *Abakans* were boldly unlike anything seen before, and exerted a strong influence on contemporary artists. These and other of Abakanowicz's sculptures, like the burlap *Backs* begun in the 1970s—repetitive, headless curved forms seated in rows that might suggest prisoners to some and worshipers to others—have led to Abakanowicz's being called a fiber artist. But she also uses stone, and she works with huge trees found in the forest where they had been cut down but left because they were unsuitable for lumber. The trees are part of a sculpture series called *War Games*.

ABC

The term derives from an important essay by critic Barbara Rose entitled "ABC Art," published in the journal *Art in America* in 1965. In the essay Rose describes "an art whose blank, neutral, mechanical impersonality contrasts so violently with the romantic, biographical abstract expressionist style which preceded it that spectators are chilled by its apparent lack of feeling or content." The newly emerging approach Rose outlines came to be widely known as MINIMAL ART.

Abstract art

As a movement, Abstract art, like that of KANDINSKY, MALEVICH, and MONDRIAN, its pioneers (c. 1910), rejects reference to the visible world of objects and natural forms. Thus, the CUBIST experiments of BRAQUE and PICASSO, while abstract forms, are *not* purely Abstract, as they manipulate recognizable, perceived objects and the human figure. With a lowercase *a* abstract art is a synthesis, summarization, or concentration—works that make no effort to record specifically what the eye sees. In this sense, abstract art ranges from the ancient KOUROS to recent MINIMALIST painting and sculpture. Pure abstraction is NONOBJECTIVE. (See also CERCLE ET CARRÉ and ABSTRACTION-CRÉATION)

Abstract Expressionism (AE)

The first American-born art movement, Abstract Expressionism emerged after World War II in New York (it is also known as the New York School) and lasted into the late 1950s. In turning away from representation and the contemporary world, AE is said to have been a reaction to the horrors of the just-ended war. Several of its artists (e.g., Jackson POLLOCK and STILL), associating their state of mind, especially the fear of nuclear cataclysm, with the fear of the unknown experienced by prehistoric people, studied cave painting as well as American Indian art. Stream of consciousness and the subconscious, rather than theories about COLOR or composition, played a large role in AE discourse, as it had for the SURREALISTS before them, and by whom they were influenced. But where probing the subconscious was an individualized exploration for Surrealists, it was universalized among Abstract Expressionists. "Many Surrealists criticized contemporary Western bourgeois culture; Abstract Expressionism reca-

pitulated the history of man's inner life and his search for meaning, purpose, change and transformation. Surrealists sought the expression of the universal in the particular; the Abstract Expressionists found the personal in the universal," writes the historian Stephen Polcari. Subcategories of AE include COLOR FIELD painters such as REINHARDT, ROTHKO, and NEWMAN (and later POST-PAINTERLY ABSTRACTION—e.g., FRANKENTHALER, Frank STELLA, KELLY, LOUIS, and NOLAND) and ACTION PAINTING like that of Jackson Pollock, DE KOONING, and KLINE. The move, during the 1960s, from AE to POP ART paralleled the transition in critical theory from EXISTENTIALISM to STRUCTURALISM. This, in turn, reflected a change in focus from post–World War II alienation to a concern with consumerism. The European variant of Abstract Expressionism was named Art Informel and called TACHISME by the French critic Michel Tapié in his book *Un Art autre* (*Another Art;* 1952).

Abstraction-Création

Group organized in Paris in 1931 to succeed CERCLE ET CARRÉ, and with the same intentions: to combat SURREALISM and promote ABSTRACT art. The organizers were the Belgian sculptor/painter/architect Georges Vantongerloo (1886–1965) and the French painter Auguste Herbin (1882–1960). Through its exhibitions and publications, Abstraction-Création was an important influence. When GABO left Germany for Paris in 1932, he became active in the group.

Academic art/artists

This term refers to art produced according to the teachings of the ACADEMY.

Academic artists are conservative rather than avant-garde, traditional rather than experimental. They usually learned to draw from ANTIQUE casts before making studies from real people, and they chose themes according to the steadfast practices of the academy, giving priority to religious and HISTORY PAINTING over scenes of contemporary life. Challenges to academic training were formulated at the end of the 18th century with ROMANTICISM's insistence on giving emotion precedence over rules and regulations based primarily on the IDEAL. The academic system remained important despite successive attacks, and was taught by GÉRÔME, DELAROCHE, and GLEYRE, among others, even as anti-academicists promoted REALISM[2] and later 19th-century approaches.

Académie Julian

The most successful and important private art school in Paris, the Académie was founded by Rodolphe Julian (1839–1907). He had supported himself as a wrestler and circus manager while he studied art; one of his teachers was CABANEL. He established the Académie Julian in 1868 as a place where students could work from living models, especially in preparation for the ÉCOLE DES BEAUX-ARTS. In time Julian hired successful ACADEMIC painters, many of them winners of the PRIX DE ROME, to serve as critics. Women, unable to study at the École des Beaux-Arts, were admitted to the Académie Julian beginning in 1873; the AMERICAN IMPRESSIONIST Cecilia BEAUX was among the numerous Americans to enroll (DEWING and HENRI were others). At first women students

worked with men, but in 1877 a separate women's studio was opened. Women also paid more than male students (60 francs per month versus 25 for men), probably because Julian had to compete with the École des Beaux-Arts for men, but not for women. Julian did not provide classes in anatomy, perspective, art history, or aesthetics, as did the École des Beaux-Arts.

Academy

The first academy was so called because the land on which it arose, about a mile northwest of Athens, was reputedly once owned by a legendary hero named Academus. This plot was later walled in, landscaped with walks, groves, and fountains, and bequeathed to the public. It was here that, c. 400 BCE, PLATO, who had a small estate nearby, taught until his death (347 BCE). The "olive grove of Academe" flourished until it was closed in 529 CE by Justinian's decree outlawing pagan education. In 1462, during the ITALIAN RENAISSANCE, Marsilio FICINO revived the CLASSICAL idea with the Platonic Academy of Florence, under the patronage of the MEDICIS. Here scholars met informally for readings, lectures, and discussion of Greek letters. The teaching of art specifically was not institutionalized until 1563, when VASARI, supported by Cosimo I de' Medici, founded the Accademia del Disegno (the Latin de + signum means "representations by signs"). Laymen joined artists to study at Rome's Accademia de San Luca (Academy of Saint Luke), established in 1593 under Zuccaro and named for the patron saint of painters. A strong motivation of these schools was to separate the artist from the category of craftsman and to endow him (and later her) with higher social and intellectual status.

During the reign of Louis XIV, in 1648 the French Académie Royale de Peinture et de Sculpture was founded for the instruction of painters, sculptors, architects, engravers, and music composers. Here French CLASSICISM was launched, stressing the past for prototype and using plaster casts from the ANTIQUE for models. As ALBERTI had done during the 15th century, French Academicians established a subject hierarchy: At the bottom were STILL LIFE (e.g., shells, fruits, flowers); on ascending levels came LANDSCAPES, animals, GENRE scenes, PORTRAITS, HISTORY PAINTINGS; at the pinnacle were the Sacraments of the Roman Catholic Church. The authority of tradition, the "academic style" expressed by rationality of "line" (e.g., POUSSIN), was soon challenged by "moderns," whose concern was with color rather than line (see LINE VS. COLOR) and direct observation of life instead of ancient statues (e.g., RUBENS). The ÉCOLE DES BEAUX-ARTS succeeded the Académie Royale after the 1795 Revolution. Until 1848 SALON juries were government appointed; after that academy members made up the juries. Soon rival salons were held for rejected or dissenting artists. Women were admitted to study at the École in 1897. (See also PRIX DE ROME)

The Royal Academy of Arts in London was formed in 1768, with the American expatriate artist WEST among its founders. REYNOLDS was the first president. KAUFFMAN and Mary Moser were also founding members; however,

the records indicate no other women at the school until the 1860s, at which time they were admitted to study.

In the United States, the American Academy of Fine Arts in New York (1801–40) and the Pennsylvania Academy of the Fine Arts in Philadelphia (founded 1805) were organized, the former superseded in 1826 by the National Academy of Design, with MORSE as its first president. The first woman to enter the National Academy was Anne Hall, who became a full member, or Academician, in 1833, after six years as an Associate. CASSATT, though sometimes so listed, was never a member of the National Academy. Records that distinguish race were not and are not kept, but it is thought that TANNER was the first African-American member of the National Academy—he became an Associate in 1909 and an Academician in 1927.

Acconci, Vito
born 1940 • American • written/ body/performance artist • Conceptual

I think that when I started doing pieces, the initial attempts were very much oriented towards defining my body in a space. . . . Then there was a shift from me as say, margin, to me as center point, as focal point . . . but it seems that since then I am in a marginal situation again.

The CONCEPTUAL artist will not necessarily produce an object of any kind, and certainly not an object of art in conventional terms. The burden of any Conceptual work is the idea it communicates. One of the works Acconci refers to in the quotation above is *Fol-*

lowing Piece (1969), in which he kept a careful record of his activities of randomly choosing and then trailing an individual until he or she went into a private place. *Telling Secrets* (1971), an example of the second stage in the quotation, involved no written documentation; rather, it was more akin to PERFORMANCE ART: Acconci stood at the end of a pier in New York City between 1 and 2 A.M. telling people incriminating secrets about himself. In other experiments Acconci practiced self-mutilating BODY ART (e.g., *Trademarks,* 1970) by, as he explains, "Biting myself: biting as much of my body as I can reach. Applying printer's ink to the bites; stamping bite-prints on various surfaces." His seemingly outrageous and attention-getting acts are efforts to engage in psychological investigation of ideas about the relationship of an artist to an audience.

Acropolis
The Greek word *acropolis* means "high or upper city," often fortified, like the Acropolis of Athens. A limestone plateau that rises 230 feet above the city, the Athenian Acropolis was a natural fortress as early as MYCENAEAN times. According to legend, the founding king of Athens was Erechthonius, born of Mother Earth when she was fertilized by the scattered semen of Vulcan, who had tried to rape Minerva. As in other primitive fertility myths (see "CAPITOLINE" WOLF), the child was meant to be banished but was saved instead. The site on the Acropolis where the building called the Erechtheion (421–405 BCE) now stands is the most sacred: It was here that one of the

women to whom the baby was entrusted went mad and threw herself into the water when she saw that Erechthonius had snakes for legs. Here, also, the child god guarded the Acropolis in serpent form, and here Athena contested with Poseidon for control of Athens. On this spot the miraculous olive tree of Athena grew and the tombs of Athens' early kings were located. The Erechtheion was built after the death of PERICLES. It is a complex building, best known for its Porch of the Maidens (see CARYATID). Before going through the gate to the Acropolis—called the Propylaia (c. 437–432 BCE), designed by Mnesicles and fronted with six massive Doric columns—one climbs steps that pass by a small Temple to Athena Nike (427–424 BCE). Built under the direction of Callicrates (see ICTINOS), it is an entirely Ionic building (see COLUMN ORDERS). On the parapet built around that TEMPLE c. 410 BCE is the renowned stone RELIEF *Nike Fastening Her Sandal,* in which the fabric of Nike's robes is carved so expertly and elegantly as to make it look transparent, and to reveal sensuously the human form beneath. The PARTHENON is the signature monument of the Acropolis.

acrylic paint

Acrylic paints, made up of PIGMENT dissolved in a synthetic MEDIUM, were first developed during the 1880s to substitute for OIL PAINT. Acrylics, as they are known, have steadily improved since then and were introduced into general use during the 1950s. Their advantages are the relative speed with which they dry; ease of application; and the clarity, stability, and durability of color. Various synthetic mediums enable acrylic paint to take many forms, from transparent to opaque. FRANKENTHALER used greatly diluted acrylics for her "stain" paintings, at one end of the spectrum; HARD EDGE painters like Ellsworth KELLY and NOLAND, and PHOTOREALISTS such as ESTES and FLACK, achieve brilliant, unmodulated effects at the other.

Action painting

The critic Harold Rosenberg coined this term in 1952 to describe a form of ABSTRACT EXPRESSIONISM in which the artist's movement, touch, or process of making the work is integral to, and embodied in, the meaning of the work itself. Jackson POLLOCK's "drip" or "poured" paintings are material records of the physical motions, or actions, that created them, as are KLINE's forceful marks on canvas. (See also GESTURAL)

Adam, Robert

1728–1792 • British •
architect/designer • Neoclassicist

. . . to transfuse the beautiful spirit of antiquity with novelty and variety.

Adam was born in Scotland. After making the European GRAND TOUR, he settled in London, where his practice was a great success. His exposure to Roman ANTIQUITIES under PIRANESI's tutelage had the most enduring effect on his subsequent work in terms of composition and motifs, which he synthesized within a ROCOCO sensibility into "the Adam style." This style swept over England in the 1760s and spread to France and America. Adam's designs included interiors, furniture, metalwork, and carpets, as well as buildings. For Kenwood

House (1767–69) in London, his library has GROTESQUE decorations inspired by wall paintings that had come to light with the excavations of POMPEII and HERCULANEUM in the 1730s and 1740s. Adam designed a cylindrical tomb for a friend, the philosopher David Hume. Adam's buildings influenced the American BULFINCH, among other architects.

Aegean art

Art from areas around the Aegean Sea produced during the Bronze Age is studied under the umbrella term "Aegean." This includes CYCLADIC, MINOAN, and MYCENAEAN art.

Aertsen, Pieter

1507/8–1575 • Netherlandish • painter • Northern Renaissance

An example of how glossy fish, tin, and copper reflect each other is found in the paintings of [Aertsen]. This man admirably rendered stalks with color, and in this regard everything seemed alive, both the leaves and the fruits. . . . In sum, he was superior in the art of clever treatment of reflections; indeed, he was a great, able, and cunning deceiver of human eyes and a resourceful impostor. For one imagines seeing all sorts of things, yet it is nothing but color which he was able to mix in such a way as to make the plane seem round, the flat in relief, the mute eloquent, and the dead alive. (Carel van Mander, c. 1604)

Aertsen was active in bustling, cosmopolitan Antwerp before returning to Amsterdam, his birthplace, in the 1550s (for Antwerp, see PATINIR). A STILL LIFE painter, and the first to have created full-fledged still lifes since AN-CIENT times, he is best known for one of art history's most provocative works. *Meat Still Life* (1551), an oil about 6½ feet wide by 4 feet high, locates the viewer uncomfortably close to a meat stall. One of the larger objects on display is a cow's head, half-skinned, looking us directly in the eye. Meat, pretzels, sausages, pigs' feet, dead fowl, and other produce are for sale in this outdoor setting. Lest 16th-century viewers doubt (perhaps moralizing) references to excess, scattered shells of mussels and oysters, considered aphrodisiacs, could remind them. The multitude of allegorical signs (e.g., two dead fish lying in the form of a cross allude to Christ) is complemented by a small scene in the distant landscape, presumably Mary and Joseph on their flight to Egypt. (This kind of composition, with the biblical narrative in the background rather than the foreground, is known as an inversion; see also van LEYDEN.) It is significant that the painting is dated mid-March 1551, which is the period of Lent, when eating meat was traditionally prohibited among Catholics. Art historians offer nearly as many interpretations as the painting offers food. Does it downplay the biblical NARRATIVE in order to escape the iconoclasm of the period (see ICON)? Does it exemplify a convention of peasant satire? Does it invoke the idea of responsibility to the needy? Or does it speak plainly but vividly about the benefits of the material world to a wealthy consumer culture?

Aestheticism/Aesthetic movement

A movement evolved from the theory of art first formulated by KANT. Known by the phrase—or rallying cry—"art for

art's sake," Aestheticism disassociates art from the ideas and values of its time. It was advanced by a group of European Romantics that included Gustave Flaubert and BAUDELAIRE, and became an almost religious conviction in Britain during the 19th century. Aestheticism was championed by the critic PATER, who has been called "the high priest of Victorian aestheticism." Pater promoted the concept of art for art's sake to uphold the idea of art's purity, sanctity, and idealism and the artists' indifference to issues of truth to nature, accuracy of representation, and social consciousness. The argument reached the courts in the 1870s after WHISTLER had exhibited his work at the new Grosvenor Gallery in London, where the art-for-art's-sake position was promoted. RUSKIN wrote that the price tag on Whistler's painting *Nocturne in Black and Gold: The Falling Rocket* (1875) was "for flinging a pot of paint in the public's face." Whistler sued for libel and won in principle—the principle that the painter could alter objective truth to fit subjective aesthetic standards—if not in financial victory. In France, the writings of Mme. de Staël and the art of the SYMBOLISTS upheld the Aestheticist position.

aesthetics

The German philosopher Alexander Gottlieb Baumgarten (1714–1762) coined this term in *Meditationes* (1735); he also wrote *Aesthetica* in 1750-58. Baumgarten identified aesthetics—the theory of the beautiful—as an independent philosophical discipline. According to W. Eugene Kleinbauer, "The aesthetician tries to learn the nature of art, to evolve a (non-historical) theory of art, to define such terms as 'beauty,' 'aesthetic value,' 'truth,' and 'significance.'" While Kleinbauer correctly adds that "The modern art historian avoids all such metaphysical speculation," it is no longer true that "in much of the Western world . . . art history is non-philosophical." Baumgarten and WINCKELMANN, who combined the words "art" and "history" for the first time, were contemporaries. (See also ART HISTORY)

Agesander

1st century BCE–CE • Greek • sculptor • Hellenistic

Out of one block of marble did the illustrious artists Agesander, Polydoros, and Athenodoros of Rhodes, after taking counsel together, carve Laocoön, his children and the wondrous coils of the snakes. (Pliny the Elder, 1st century CE)

The LAOCOÖN in the Vatican Museum, long believed to be the original work of Agesander (also known as Hagesander), Polydoros, and Athenodoros, as described by PLINY the Elder above, is now considered a Roman copy (see ROMAN ART). However, the names of the same three artists are inscribed on sculpture fragments found in 1957 in a grotto near a Roman imperial villa of the 1st century CE. The grotto at Sperlonga was probably used for fanciful dinner parties, and the sculptures are thought to have shown scenes from Homer's *Odyssey:* A head identified as Odysseus bears a strong resemblance to the head of the suffering priest Laocoön.

AIDS

Throughout the 1980s and 1990s, the AIDS epidemic ravaged the population of artists, claiming countless lives (e.g., MAPPLETHORPE, HARING, and WOJNAROWICZ). The disease became the subject of much of the art of those decades, both by the artists it struck and by their friends. One of the first exhibitions devoted to art about AIDS was *Witnesses: Against Our Vanishing*, curated by the photographer Nan Golden and held in 1989 at the Artists' Space in New York City. In June 1987 a group in San Francisco gathered to found the Names Project AIDS Memorial Quilt. Each panel of the quilt has the name of someone who died of AIDS. In ten years, more than 41,000 individual 3-by-6-foot panels had been assembled from throughout the world, and the quilt, which is regularly on exhibit, has raised $1.7 million for AIDS service organizations; it is the largest example of a community art project in the world, and it has, in effect, redefined the tradition of quiltmaking. In December 1991, when a bell tolled every 10 minutes in art galleries and museums around the world to mark the rate at which people were dying of AIDS, a *Day Without Art* was initiated. It was just that: Galleries and museums were closed to the public during their ordinary hours, though often they sponsored events related to the AIDS epidemic.

airbrush

Initially used only commercially, the airbrush is a small machine that sprays paint to achieve a smooth, evenly shaded finish. The spray can be adjusted from pencil thin to a broad mist. The first noncommercial artist to use the airbrush was MAN RAY. He was followed by POP ARTISTS and PHOTOREALISTS.

Albani, Cardinal Alessandro
1692–1779 • Italian •
ecclesiastic/collector/patron

Cardinal Albani is in our days the restorer-in-chief of Antiquity. The most mutilated, disfigured, incurable pieces are, through him, given back the flower of their youth . . . ; the fragment of a bust which, even if it were whole, would have been una testa incognitissima *to all the antiquarians receives from him both a new life and a name which indelibly settles its destiny.* (Pierre-Jean Grosley, c. 1759)

From a family of churchmen and patrons, Cardinal Albani is renowned as the sponsor of WINCKELMANN, who lived, wrote, and served as librarian at the cardinal's home, and was also curator for the collection of ANTIQUITIES the cardinal assembled. Albani was responsible for the first careful excavations of the Palatine Hill in Rome. Sculptures of ANTINOUS found at Emperor Hadrian's villa at Tivoli were among the treasures collected with his support and exhibited at his Roman villa, in the gallery where MENGS later painted the ceiling FRESCO *Parnassus with Apollo and the Muses* (1760–61). This painting is an exemplar of the "noble simplicity and calm grandeur" identified by Winckelmann as the primary attributes of CLASSICAL art. In 1733, Pope Clement XII bought much of Albani's collection, including the statues of Antinous, and made it the core of a new museum on the Capitoline Hill. Albani's enthusiasm for art was not in doubt, but his profiteering

and scruples were, even in his own day, as the cynical quotation above suggests.

disciplines of science, but also in their quiet beauty.

Albers, Josef

1888–1976 • German/American • painter/designer • Concrete Art/Op Art

. . . how do we see the third dimension when created as an illusion by the artist in terms of lines, flat shapes and colors on a two-dimensional field?

Albers apprenticed in a STAINED GLASS workshop prior to joining the BAUHAUS in 1920, the year after it was founded. He was quickly advanced from student to teacher, heading the school's glass workshop there until 1933. After Johannes Itten left the Bauhaus in 1925, Albers shared responsibility with MOHOLY-NAGY for the school's foundational course. Albers immigrated to the United States in 1933, and taught at BLACK MOUNTAIN COLLEGE and major American universities. In 1950 he became head of the Department of Architecture and Design at Yale University, continuing his role as a powerful influence in training artists, architects, and designers. Early in his career, Albers made a series of glass pictures with bits of bottles and scraps salvaged from a town dump. Set above lighted boxes, these ABSTRACT designs glow, rich with varieties of color and texture. Albers's most renowned work is the series of paintings he began in 1950 entitled *Homage to the Square*. With seemingly infinite variation, he juxtaposed one square of color against the background of another. These studies of visual perception are extraordinary not only in their manifold contributions to several

Alberti, Leon Battista

1404–1472 • Italian • architect/sculptor/painter/writer • Renaissance

His genius was so very versatile that you might almost judge all the fine arts to be his.

The epitome of a "Renaissance man," Alberti played so many significant roles that any effort to describe his importance risks both under- and overstatement. The comment quoted above, which seems to represent the latter, was, in fact, written by Alberti himself; he used the third person without false modesty, for he made no bones about his quest for fame. The glory of fame was a forthright pursuit of the CLASSICAL revival, with its grounding in HUMANISM and its belief in the centrality of man and his ability to understand and even fashion his world. ITALIAN RENAISSANCE thinkers valued theory, and Alberti was a theoretician of the first order. It is he who codified and refined BRUNELLESCHI's description of PERSPECTIVE. The preface of Alberti's tract *On Painting* (*De pictura*, 1435) was dedicated to Brunelleschi, the book itself to Gianfrancesco GONZAGA, Marquis of Mantua. Alberti wrote the tract first in Latin, then translated it into Italian (*Della pittura*, 1436). The practice of architecture had not been his primary interest, but after Brunelleschi's death Alberti took it up seriously. His designs—for San Francesco at Rimini (c. 1450) and for Sant' Andrea, Mantua (c. 1470), for example—reveal that where

Brunelleschi adapted the Classical vocabulary piecemeal, Alberti had a much deeper, holistic understanding of it. Alberti's writings include literature and embrace architecture (on which his artistic reputation is based), sculpture, and even a moralistic dissertation, *The Family* (1433). Alberti was the illegitimate son of a merchant who was exiled from Florence, his mother died when he was two years old, and his father, who adopted him, died when he was 16. Deprived of his inheritance by relatives while he was at the universities of Bologna and Padua, he was poor and frequently ill. Alberti first went to Florence, the center of Italian Renaissance culture, in 1428. His given name, Battista, is that of the patron saint of Florence. He chose to adopt the name Leon, signifying lion and carrying the astrological sign of Leo, symbol of the sun. For his personal emblem he devised a winged eye, which he incorporated into a self-portrait plaque. The portrait, in profile, is of the Classical Roman type.

Alexandrian School
See PERGAMENE SCHOOL

Algardi, Alessandro
1598–1654 • Italian • sculptor/ architect • Baroque

[Pope Innocent] made him so many offers, so many promises, plied him with so much flattery and aroused in him so many hopes that they made him change his mind, and cancel all his contracts. (Giovanni Battista Passeri, 17th century)

Changes in the power structure of Rome had a profound effect on artists. The death of Pope Urban VII, and the (temporary) exile of his BARBERINI supporters, was bad for BERNINI but good for Algardi. When Innocent X became pope in September 1644, Algardi, who had been in Rome for some 20 years, was able to move from the shadow into the limelight, displacing Bernini as the most favored sculptor of the day. Algardi and Bernini both sculpted busts of Innocent; Algardi's (c. 1646) is more subdued and idealized than that of Bernini. Algardi was a member of the "classicist" group in Rome, seeking to portray the eternal and ideal rather than the transient and emotive, although he tended to combine the two in what the historian WITTKOWER calls "a compromise." This difference in approach had already been apparent when, following the idea but not the spirit of Bernini's *Tomb of Urban VIII* (1627–47), Algardi's *Tomb of Leo XI* (mid-1630s) rejected its drama. Algardi designed one of the most magnificent of all Roman villas for Prince Pamfili. When Cardinal Mazarin rose to power in France in the mid-17th century, he tried to lure Algardi to Paris. He was nearly successful in 1648, but as the quotation above from Algardi's friend Passeri indicates, the pope was even more persuasive.

Algarotti, Francesco
1712–1764 • Italian • patron/critic

I go again and again to look at the divine works of Palladio without ever growing tired of them.

In 1732 Algarotti wrote a letter to a friend from his student days about his

admiration for PALLADIO, an excerpt from which is quoted above. Born in VENICE and educated in Rome and Bologna, Algarotti influenced many leading artists, but especially the two with whom he had the closest contacts and who were the most important of their era, TIEPOLO and CANALETTO. Handsome and charming, Algarotti took advantage of both traits, enjoying the friendship of princes and philosophers, Frederick the Great and Voltaire among them. He wrote a series of books and articles, and though he championed Venetian artists, he spent little time at home in Venice. In commissioning works from painters, Algarotti followed the conventional practice of assigning them the subjects and details to be included as well as the literary connections. But he went beyond that in recognizing and making special accommodation to individual artists' styles and strengths. "Indeed, this openness to experience is one of his most attractive characteristics, but it makes it difficult to gauge the strength of his influence on individual painters," writes the historian Francis Haskell in a study of art and society of the BAROQUE period.

alla prima

From Italian, meaning "at first," alla prima refers to painting directly onto a surface without preliminary drawing or underpainting. Occasionally used (e.g., by HALS, CARAVAGGIO, and VELÁZQUEZ) before the 19th century, alla prima became popular then because of both technical advances in paint manufacture and the temperamental preferences of ROMANTIC artists (e.g., DELACROIX). Alla prima painting expresses fluent, spontaneous brushwork. It character-

izes the work of MANET and of van GOGH, as well as of the IMPRESSIONISTS.

Allston, Washington

1779–1843 • American • painter • Romantic

Trust your own genius, listen to the voice within you, and sooner or later she will make herself understood not only to you, but she will enable you to translate her language to the world, and this it is which forms the only merit of any work of art.

Allston introduced ROMANTICISM to America, though Americans at that time were still more interested in buying their own portraits rather than the expressive HISTORY PAINTINGS Allston wanted to sell. From a well-to-do South Carolina family, Allston first studied at Harvard College, then made his way to Europe. He learned the GRAND MANNER from WEST, then from 1803 to 1808 made the GRAND TOUR, with long stays in Paris and Rome. That he saw himself as a gentleman/intellectual/poet is clear from his Byronic *Self-Portrait* (1805). His dark curly hair and sensuous lips are set against an ambiguous architectural background evocative of both a dungeon and Roman ruins. *Elijah in the Desert* (1818), from the biblical story of the prophet who survived by being fed by ravens, is a SUBLIME landscape, with the very small figure of Elijah hardly noticeable. But the desolate terrain and tortuously gnarled tree against a turbulent sky communicate a sense of awe. Allston made another trip abroad in 1811 and returned to America in 1818, but did not flourish as he had hoped. A major project that he had started in London, *Belshazzar's Feast,* a visionary

prophecy of disaster, became his personal albatross, a project he could neither finish nor leave alone, much as the Ancient Mariner carried his wretchedness in Samuel Taylor Coleridge's poem. Coleridge was, as it happens, Allston's friend and constant companion while they were in Rome, exploring the COLOSSEUM by moonlight and contemplating the strange and supernatural. Allston called *Belshazzar's Feast* "the tormentor of my life." The voice of which he spoke, in his advice to another painter, quoted above, apparently would not allow him to finish translating his vision into paint.

Alma-Tadema, Sir Lawrence
1836–1912 • Dutch/English • painter • Academic

Who knows him well he best can tell /
That a stouter friend hath no man, /
Than this lusty knight who for our
delight hath painted Greek and
Roman. (Comyns Carr, 1899)

Alma-Tadema settled in London in 1870. Like his friend and contemporary LEIGHTON, Alma-Tadema created a hedonistic fantasy world of languorous, sensual women in luxuriant settings. These settings were likely to include fur rugs and marble fountains, benches, and columns, the latter archaeologically correct ANTIQUITIES—Alma-Tadema went to POMPEII to inspect the newly excavated ruins in 1863. If his paintings insulated their viewers from the problems of contemporary life, they also provided strong undercurrents of eroticism. *Under the Roof of Blue Ionian Weather* (1901) is an oblong canvas filled by a semicircular marble wall tiered with benches. Decorating the benches, besides the suggestion of bas-reliefs (see RELIEF), are beautiful women wearing filmy pastel dresses. The title may have been taken from a phrase in a letter Shelley wrote in 1820: "We watched the ocean and sky together, under the roof of blue Italian weather." Alma-Tadema was well rewarded for his work, and in 1899 was knighted. At the banquet celebrating the event, the art critic Comyns Carr wrote the doggerel quoted above, the chorus of a longer composition that was set to music. While Alma-Tadema, Leighton, and, in America, Thomas DEWING were creating their decorative, somnolent upper-class women, CÉZANNE painted lumpy, nude female bathers; GAUGUIN first painted Breton peasants in native costume, then Polynesian women in Tahiti; and TOULOUSE-LAUTREC documented women as performers in everything from the circus to the whorehouse.

altarpiece
The altarpiece first appeared during the early 13th century when Catholic priests began celebrating Mass with their backs to the congregation. Religious images placed on, above, or behind an altar were painted on one PANEL or several hinged panels: A diptych is two panels, triptych is three, and polyptych means "many panels." The outside panels, or wings, are opened or closed according to prescribed ritual. Small, supplementary paintings at the base of an altarpiece form the predella. While convention usually dictated the content and form of the main panel, at times an artist would use the predella for experimental or unconventional images. For *The Adoration of the Magi*

(1423), for example, GENTILE da Fabriano's predella picture *The Nativity* was an unusual night scene. Smaller altarpieces for private chapels were made for individual patrons, especially during the Late GOTHIC period as private devotion became increasingly mystical. Paintings of Christ and the saints both inspired visions and recorded them— portraits of PATRONS, presumably enjoying the mystic apparitions depicted in the painting, were often included in the altarpiece, usually on the side panels. Besides their primary liturgical intention, form, and content, as the art historian Michael Baxandall writes, altarpieces were also emblems of civic pride. They fulfilled the desire for pomp and splendor as well as "the propaganda endeavors of the urban religious orders, competition between patrons, and rivalry among artists."

Altdorfer, Albrecht

c. 1480–1538 • German • painter • Northern Renaissance

The need to reproduce [Altdorfer's image of the Schöne Maria] *popularly . . . could not be more apparent, and it seems a fairly compulsive need. The* Schöne Maria *becomes a momentary obsession . . . fetishized in its splendors and in its ordinariness (depending on which visual context one considers).* (David Freedberg, 1989)

Some of Altdorfer's paintings sweep a viewer into the forest or along a steep, descending road bordered by high trees and thick bushes. His landscapes are overpowering rather than friendly; his woods seem primeval. This may represent, in part, rejection of the excesses of luxury for which the Church was coming under attack, and it may also be a reaction to news that explorers of the New World were ruining the as yet "uncivilized" lands across the ocean. Working in a lush region surrounding the Danube River, Altdorfer seems to imagine a world of beginnings, of primitive, untamed forces, a pantheistic sort of religious experience. *Saint George Slaying the Dragon* (1510) is a small painting, less than a foot high, in which Saint George and his horse as well as the dragon are overwhelmed by dense, nearly anthropomorphic foliage. Simultaneously magnetic and frightening, such landscapes are powerfully mystical. Mysticism takes a different turn in connection with a subject Altdorfer began to paint about a decade later. Known as the *Schöne Maria* (c. 1520), this is a picture of the Virgin and Child based on a famous image from Santa Maria Maggiore in Rome. Altdorfer was commissioned to produce it for a church in Regensburg, Germany, which was erected on a site where, with anti-Semitic fervor, a synagogue and Jewish cemetery had been destroyed. The church became a Christian pilgrimage destination, and Altdorfer's painting gained renown for working miracles. He and his WORKSHOP made numerous copies of the Madonna, as did many other artists, leading the historian Freedberg, quoted above, to also write, ". . . every image became a vehicle for thanks, an intimate mediation with God, and the focus of the anxieties against which only the Virgin, acting through *and as* her representation as the *Schöne Maria* of Regensburg could protect." In another vein, Altdorfer's *Battle of Issus* (1529) is an imaginary, bird's-

eye view of Alexander the Great's triumph over Darius; we see the hero and his troops dwarfed like ants in a vast, spectacular Alpine vista.

American Impressionism

In the 1890s a group called Ten American Painters was formed by Americans working in an IMPRESSIONIST style. Among them were HASSAM, WEIR, TWACHTMAN, Frank Benson (1862–1951), Willard Metcalf (1853–1925), and Edmund Tarbell (1862–1938). Others who painted in an Impressionist style but were not members of the group were CHASE, CASSATT, Lilla Cabot Perry (1848–1933), BEAUX, and Theodore Robinson (1852–1896). Most of these artists had studied in Paris; in the hands of Americans, however, Impressionism was somewhat different. They seem less interested in, or less willing to dissolve, form as, for example, MONET did. The historian John Wilmerding writes, "American artists generally were too deeply ingrained with a national aesthetic tradition of realism and narrative to be able to perceive or accept fully the intellectual and formal implications of the French theories. . . . In sum, American artists on the whole gave priority to the substance of their subject matter, over its perception (retinally or optically), rather than the reverse." This unwillingness to abandon the real world is sometimes attributed to a pervasive, underlying materialism of Americans, especially during the period of unprecedented economic growth and capitalism.

American Renaissance

This term refers to the CLASSICAL eclecticism of American art and architecture from the 1880s through the 1920s. Charles MCKIM (of MCKIM, MEAD, and WHITE), Cass Gilbert (1859–1934), Daniel H. Burnham (1846–1912), Ernest Flagg (1857–1947), and John Russell Pope (1874–1937) are among American Renaissance architects.

American Scene

Whether American Scene painting was a subset of REGIONALISM or vice versa, both were Depression-era efforts to isolate, validate, and recognize that which was particularly American, from traditional values to the new cultures of office work, industrialization, and even unemployment. Among artists so categorized (although sometimes against their wishes) were BISHOP, MARSH, and HOPPER.

amphora

A Greek vase with two handles used for storing and shipping liquids such as wine, oil, and honey. (See also POTTERY)

Analytic Cubism

See CUBISM

anamorphosis

See PERSPECTIVE

Anastaise

See MINIATURE

ancient

In ART HISTORY this term, which has its roots in the Latin *ante* for "before," generally refers to the historical period that predates Christianity. "Ancient" is primarily used to modify GREEK and ROMAN art—that is the traditional implication of the phrase "ancient art"—

and secondarily Egyptian art, as well as that of the Ancient Near East. Increasingly the arts of African lands south of Egypt are studied under the heading of Ancient Africa, and the early arts of China, Japan, and Cambodia are also called "ancient," though the prefix "ante," in the Western time frame, obviously has no relevance.

Anderson, Laurie
born 1947 • American • performance • Contemporary

I dreamed I had to take a test in a Dairy Queen on another planet.

For a series of PERFORMANCES, Anderson recorded the phrase quoted above and attached the tape to the bow of a violin, an instrument she has played since childhood. By moving the bow across the head of her tape player, which was attached to the body of the violin, she manipulated the sound of the phrase. The sentence itself evokes a variety of images, from sleeping, to ice cream, to space travel, and just as many questions: "What kind of test?" "Why in a Dairy Queen?" for example. Such multiple layers and evocations characterize Anderson's work. Her four-part *United States,* of which the first part was performed in 1980, is a complex multimedia stage presentation recorded on videotape. In it her voice, and sometimes her persona, is oddly disguised and distorted. The "story" she tells is unconstrained by either chronology or coherence, but, again, it raises perplexing questions, as when a woman repeatedly asks, "Hello, excuse me, can you tell me where I am?" The repeated answer from a gas station attendant is "You can read the signs." An accretion of confusion, frustration, and impotence seems the inevitable consequence of such a work. Anderson has performed in places as diverse as the Whitney Museum of American Art and a BENEDICTINE convent in the Midwest in which 3,000 nuns reside.

Andokides Painter/Potter
active c. 525 BCE • Greek • Archaic

The painter of the red-figure pictures is known as the Andokides Painter because four [now some twenty] vases of the group bear the signature "Andokides epoisen," made by Andokides. (J. P. Beazley, 1928)

Andokides is the potter's name, and the anonymous painter identified with his production is named after him. Believed to be the inventor of the RED-FIGURE TECHNIQUE of painting POTTERY, the Andokides Painter first used the technique on "bilingual" pots, that is, those with the earlier BLACK-FIGURE pictures on one side and red-figure images on the other.

Andre, Carl
born 1935 • American • sculptor • Minimalist

I think art is expressive but it is expressive of that which can be expressed in no other way.

In addition to the comment above, from an interview in 1970, Andre said, "I am certainly no kind of conceptual artist because the physical existence of my work cannot be separated from the idea. . . . My art springs from my desire to have things in the world which

would otherwise never be there." Those things include eight lengths of square wood beams stacked two by two in alternate directions to form *Pyre* (*Element Series* constructed 1971 from a 1960 plan). This might seem to resemble one of LEWITT's CONCEPTUAL sculptures were it not for Andre's interest in details like the texture, grain, and design of the materials. *Stone Field Sculpture* (1977) is an assembly of 36 huge glacial boulders transported to a grassy site in front of a building in downtown Hartford, Connecticut, and lined up in an improbable regular, rational order.

Andrea del Castagno
before 1419–1457 • Italian • painter • Renaissance

Andrea del Castagno was a great disegnatore *and of great* rilievo; *he was a lover of the difficulties of the art and of foreshortenings, lively and very* prompto, *and very* facile *in working.* (Cristoforo Landino, 1480)

Despite the high opinion of him expressed by the Latin scholar and philosopher Landino, quoted above, Andrea's reputation suffered badly for 300 years on the basis of gossip spread by VASARI. The scandal Vasari perpetrated was that Andrea, a coarse and violent man, killed DOMENICO in a rage of jealousy over his rival's skill in painting with oil in the Venetian manner. The story was discounted in the 19th century when Andrea's records were discovered and showed that, in fact, he had died before Domenico. Moreover, OIL PAINTINGS were not widely produced in VENICE until 1475 (see ANTONELLO), after both protagonists were

dead. His infamy aside, Andrea was among the Florentine avant-garde, exploring PERSPECTIVE and creating characters with an intensity, if not a truculence, that he, personally, probably shared. His FRESCO *The Last Supper* (c. 1447) is painted on a wall of a convent's refectory, or dining hall. His *David* (c. 1449–50), painted on a leather shield, is a forceful, energetic rendering of the lithe young giant-slayer in motion. This style is less like MASACCIO's solid figures, and those of Andrea's own *The Last Supper*, and more in the animated, muscular style that characterizes the last half of the century.

Andrea del Sarto
1486–1530 • Italian • painter • Renaissance

But one day, as he was doing a St. Jerome in penitence for the king's mother, some letters arrived from his wife at Florence. . . . He asked the king's permission to go, saying that he would return when he had arranged some affairs, and that he would bring back his wife, to enable him to live there more comfortably, and that he would bring with him valuable paintings and sculptures. The king trusted him, and gave him money, while Andrea swore on the Gospels to return in a few months. . . . When the time for his return to France had passed . . . he had spent all his money and the king's also. But though he wished to return, the tears and entreaties of his wife prevailed more than his own needs and his promise to the king. [King] Francis became so angry at his faithlessness that he for a

18 ANGELICO, FRA (GUIDO DI PIERO)

long time looked askance at Florentine painters, and he swore that if Andrea ever fell into his hands he would have more pain than pleasure, in spite of all his ability. Thus Andrea remained in Florence, fallen very low from his high station, and maintaining himself as best he could. (Vasari, mid-16th century)

Andrea's paintings reflect substantial borrowing from and influence of others. He trained under PIERO di Cosimo, and came under the authority of LEONARDO, MICHELANGELO, RAPHAEL, and BARTOLOMMEO. He shared the artistic reins of Florence with Bartolommeo after Raphael left. Andrea was especially interested in enlivening Leonardo's PALETTE while still using his methods of MODELING, and was much admired for his coloring, which VASARI called "divine." However, as the excerpt quoted above shows, Vasari was also responsible for the gossip that Andrea's wife dominated him when he returned home from France, where he had been called to work for FRANCIS I (also a PATRON of Leonardo). Be that as it may, Andrea painted numerous beautiful Madonnas, especially the *Madonna of the Harpies* (1517), for which his wife was the model. What to Vasari was scandal was romanticized by Robert Browning in the 19th century, in a poem he entitled *Andrea del Sarto*. Browning constructed a lengthy monologue through which the artist, speaking to his wife, explains his renunciation of riches in favor of her love. He contrasts his role as husband with that of his three unmarried contemporaries, Leonardo, Raphael, and Michelangelo,

and rests content with his choice and his lot. PONTORMO, ROSSO, and Vasari himself were among Andrea's students.

Angelico, Fra (Guido di Piero)
c. 1395/1400–1455 • Italian • painter • Renaissance

[Fra Angelico] was a simple and most holy man . . . most gentle and temperate, living chastely, removed from the cares of the world . . . humble and modest in all his works. (Vasari, mid-16th century)

A Dominican monk and a painter for the order, Angelico created works that were conservative rather than experimental; his interest was in presenting Christian teachings, and not in trying new ideas. While he might incorporate linear PERSPECTIVE in his picture, he would not hesitate to place a figure in a space with a ceiling too low to stand up in, as is true of his well-known *Annunciation* FRESCO of c. 1440–45. Generally modest and direct in his compositions, Angelico was attentive to some decorative details, a patch of lawn covered with wildflowers, for example, and the angel's wings he painted in bands of mellow color. Rejecting the massive forms and expressiveness of MASACCIO, Angelico painted figures with serene, doll-like faces. His spare but still tangible and real-appearing frescoes for the Monastery of San Marco (where the *Annunciation* described above is located) were spiritual images that impressed van der WEYDEN, who stopped in Florence during his pilgrimage to Rome in 1450. Through van der Weyden, Angelico's ideas reinforced the NORTHERN RENAISSANCE

artists' interest in making images that are appropriate to their particular environment in both subject and style.

Anguissola, Sofonisba

1532–1625 • Italian • painter • Mannerist

If it were possible to demonstrate with a brush before the eyes of Your Holiness the beauty of the soul of this illustrious queen, Your Holiness could not see anything more wonderful. But with those aspects that art is able to render I have not neglected to the best of my ability to show Your Holiness the truth.

Besides living for 93 years, Anguissola challenged other 16th- and 17th-century norms as well as expectations of a woman: She was well educated, she studied under the artist Bernardino Campi in her hometown of Cremona, and she became so successful a painter that in 1559 she was called to the court of King Philip II in Madrid, where she painted for 20 years. A friend and painting instructor to Philip's third wife, Isabel of VALOIS, Anguissola wrote the comments quoted above to Pope Pius IV in a letter that accompanied her portrait of Isabel. Anguissola is the first known woman artist to achieve international fame. Little is certain about her career, though much is speculated: for example, that she knew MICHELANGELO and CARAVAGGIO and influenced van DYCK (who drew her when she was quite old), and that she influenced and encouraged other women artists. She was, however, unable to break one enduring tradition, the neglect of women artists in the discipline of ART HISTORY—at least until the 1970s. Since then examples of her work have slowly been coming to light. These are primarily portraits, some self-portraits, and many of her own family. As CASSATT would do some 300 years later, Anguissola reveals a sensitive understanding of women and children as people, not merely props, and paints the independence and dignity she finds in their character. One curious work of hers is a picture of a picture being painted; dated about 1550, it is entitled *Bernardino Campi Painting Sofonisba Anguissola.*

Animal style

Refers to the use of animals, birds, and fantastic beasts as the basis for usually intricate designs. Scythians—nomadic people from the steppes north of the Black Sea who made their way to Assyria at the end of the 7th century BCE—created some of the earliest Animal style designs and carried them west. Animal style was also used by the Germanic tribes that settled Western Europe (see MIGRATION). They created enameled and jeweled metalwork of extraordinary craftsmanship. By the 5th century CE, the Animal style was widespread, used sometimes in CLOISONNÉ, or in precious stones, and for objects like decorated fibulae (fasteners, usually for clothing) of bronze, silver, and gold. A purse cover from the *Sutton Hoo Ship Burial* (c. 655) has gold and enamel decorations that include animals and men as well as geometric patterns. From a Viking ship ritually buried (c. 825) in Oseberg, Norway, comes an intricately carved wooden post in the form of a snake or dragon head, decorated with

complex geometric and curvilinear INTERLACE designs. The Animal style even influenced the monastic SCRIPTORIUM; it appears, for example, in the *Lindesfarne Gospels* (c. 698) and the BOOK OF KELLS (early 9th century).

Anshutz, Thomas
1851–1912 • American • painter • Realist

. . . a truly admirable genre painting,
Steelworkers' Noontime by Thomas
Anshutz, may come on the market. I
recommended it years ago . . . to a
Detroit collector. . . . I hope that you
will think about it. . . . It is unique to
my knowledge, as an industrial subject
in American nineteenth-century genre.
(Edgar P. Richardson, 1965)

A student of EAKINS at the Pennsylvania Academy of the Fine Arts, Anshutz also taught there, and took over the directorship after Eakins was dismissed. Anshutz is best known for one painting, *Steelworkers—Noontime* (1880), a composition that appears to arrest the activity of workers at a factory during their lunch break, as in a snapshot. It is a strange work that also seems to capture an undercurrent of hostility and tension. A pioneering scholar in American art, Edgar P. Richardson (1902–1985) appreciated the merits of this painting and, in the 1965 letter quoted from above, recommended its purchase to John D. Rockefeller. The Rockefellers did not acquire it, however, until 1973. Retrospectively, John D. Rockefeller explained that he bought it, finally, because it "seemed to us to present an aspect of the American story through art that was intriguing and significant to have." In fact, it has become one of the signature works of the family's American art collection, and a key example of American REALISM. HENRI and SLOAN, who went on to form the ASHCAN SCHOOL, were two of Anshutz's students.

Antal, Frederick
1887–1954 • Hungarian • art historian

[Hogarth was] evoking sympathy for
the poor, unlicensed strolling
companies put out of business by the
Licensing Act.

Antal's studies of art were based on their social context, and he applied his philosophical commitment to MARXISM to understanding the works of artists of various periods. In *Florentine Painting and Its Social Background* (1948), Antal described GIOTTO's personification *Justice* (c. 1305–06) in the Arena Chapel of Padua as representing the bourgeois outlook of the time. Similarly, writing about an ENGRAVING by HOGARTH, *Strolling Actresses Dressing in a Barn* (1737–38), Antal gave his opinion of the artist's intention, as expressed in the passage quoted above. Antal's were the first major art historical writings with a theoretical basis in Marxism.

Anthemius of Tralles
6th century • Greek • mathematician/theorist

[Architecture is] the application of
geometry to solid matter.

The dates of his birth and death are uncertain, but it is known that Anthemius was a Greek mathematician whose specialty was geometry and optics. In 532

he and Isidorus of Miletus were selected by Emperor Justinian to design HAGIA SOPHIA. Isidorus was a professor of physics at universities in Alexandria and Constantinople, and his expertise was in mechanical engineering; he also wrote a scholarly treatise on vaulting. (See ARCH)

Antinous

About 123 CE, the Roman emperor Hadrian (ruled 117–138 CE) took a Greek boy named Antinous as his companion. Part of Hadrian's attraction to Antinous reflected his devotion to Greek culture—love between man and boy, called Greek love, characterized the civilization of ancient Greece. Antinous drowned in the Nile at the age of 19 and one speculation is that he took his own life as a ritual sacrifice on Hadrian's behalf. Early death also fulfilled the Greek ideal that it is better to die young, at the peak of one's power and beauty, than to suffer the inevitable reversals of age. After the boy's death, Hadrian deified Antinous and established cults devoted to the new god. These spread quickly and widely, reaching the farthest borders of the Greco-Roman world. More than 28 temples were dedicated to Antinous, although none remains. Multitudes of talismans, coins, and cult statues, monumental and miniature, of Antinous do survive of the thousands that must have been created. They have been found in places as distant from one another as the foothills of the Caucasus Mountains along the Black Sea, the western shores of the British Isles, the mouth of the Rhine, the North African coast, and even oases deep in the Sahara. Eugenie Strong wrote in *Roman Sculpture* (1907), "As the Antinous is the last of the great classic types given to the world by the antique, so also is it among the most powerful and majestic. . . . In Antinous all the cults of declining Paganism seem to meet." Ancient texts as well as images describe a beautiful, wistful youth with inward-looking eyes, thick brows, soft cheeks, full mouth, and straight nose; his face was probably as well if not better known than that of the emperor himself. As a god, Antinous was both Dionysian and Apollonian, and in statues he appears in the traditional poses of Apollo, Hermes, and Dionysus. He was believed to pronounce oracles, perform miracles, and heal the sick. Pilgrims journeyed to his shrines, and his PASSION was reenacted, as were those of Christ, Sebastian, and other saints years later. The Antinous type is believed to have influenced ITALIAN RENAISSANCE artists including DONATELLO and ANTONELLO. Later, BERNINI said he "turned to the Antinous as to the oracle."

antique/antiquity

Derived from the Latin *antiquus,* meaning "old," the term is loosely used to designate something old-fashioned, or that has value due to its age. IN ART HISTORY, "antique" refers primarily to objects, and fragments of objects, of ancient GREEK and ROMAN art, produced in periods referred to as antiquity. Romans themselves began the practice of copying Greek antique sculpture by reproducing it, which is why today, although we have few Greek originals, we know Greek statues largely through Roman copies. Romans also adapted Greek style to suit their own needs: For example, the *Augustus of Primaporta* (20 BCE) shows the

Roman emperor Augustus in a pose like POLYKLEITOS's *Doryphoros* (c. 450 BCE), but with adjustments—where the figure of Doryphoros is nude, the emperor is clothed, his right arm is raised as though to address his troops, and the mythological figures decorating his breastplate have contemporary, political significance. Of all Roman emperors, Hadrian (76–138 CE) was the most ardent Grecophile; when his companion, ANTINOUS, died and was deified, Hadrian commissioned cult images that imitated CLASSICAL Greek NUDES. By the beginning of the ITALIAN RENAISSANCE, both Greek and Roman antiquities were avidly pursued in archaeological campaigns, collected, studied, and copied, though for the most part Roman copies and Greek originals were undifferentiated. Sometimes Renaissance artists used textual descriptions of great works (e.g., see APELLES), but usually they drew from the antiquities themselves. The pattern of looking back to ancient Greece and Rome for exemplars continued, spawning many Classical revivals (see NEOCLASSICISM and WINCKELMANN), especially in the ACADEMY, where the phrase "drawing from the antique" refers to using plaster casts of antiquities as models. As was true of the Romans, every era that looks to antiquity for inspiration, including POSTMODERN America, adapts the Classical example for its own purpose. (See also CLASSICISM)

Antonello da Messina

c. 1430–1479 • Italian • painter • Renaissance

One of those extraordinary geniuses who turn up every now and then as if to refute theorists who like to relate history in terms of necessary developments from stage to stage. (Frederick Hartt, 1969)

Antonello lived in VENICE for only some 18 months, beginning in 1475, but he had a revolutionary effect on painting there: The unprecedented use of OIL PAINT to create atmosphere, light, and color was taken up in Italy after Antonello's example. He was not the first to use oils in Venice, but he was the most influential. Born in the Sicilian city of Messina, Antonello may have learned to paint in oils from NETHERLANDISH-trained Spanish masters who traveled through Sicily. One of Antonello's earliest and most elegant oil paintings, *Saint Jerome in His Study* (c. 1460–65), shows the Netherlandish influence: indoor setting, a meticulous attention to detail, rich color, and controlled illumination. The work of van EYCK is brought to mind. Still, *Saint Jerome* is quite Italian in its attention to PERSPECTIVE and the rolling hills beyond the window frames. Also one of the greatest portraitists in history, Antonello probed his subject's character and state of mind. *Portrait of a Man in a Red Cap* (c. 1473–74), a three-quarter head and shoulders against a dark background, is thought to be a self-portrait. The man's expression is questioning, both deferential and proud, and very intelligent. In c. 1478 Antonello painted *Saint Sebastian,* believed to be a wing of an ALTARPIECE commissioned for a church in Venice. Sebastian is one of the saints traditionally called upon for protection against the plague; between 1456 and 1528, a series of plagues killed one quarter of the population of

Venice. The sexual ambiguity of Antonello's *Sebastian*—the gentle contour of his body and the wistful, submissive expression on his face—is an affect repeated frequently during the ITALIAN RENAISSANCE. Little is known about Antonello personally. Among those he influenced is Giovanni BELLINI.

Apelles
active before 336–c. 300 BCE • Greek • painter • Late Classical

The painter who surpassed all those who were born before him and all those who came later was Apelles of Cos, who was active in the 112th Olympiad [332 BCE]. He alone contributed almost more to the art of painting than all other painters combined and also produced volumes, which contain his doctrine. (Pliny the Elder, 1st century CE)

The work of Apelles is known to us only by reputation, for neither painting nor writing by his hand survives. Using and blending only the four traditional colors—white, black, yellow, and red/ocher—he achieved the superlative effects extolled by PLINY the Elder in the quotation above. The most renowned Greek painter of his time, Apelles was the counterpart of his contemporary, the sculptor PRAXITELES; works of both artists were characterized by the sensuous, lithe grace (Greek: *xapis* or *charis*) of their slender, elegant figures. In his treatise on painting, Apelles is reported to have commented that his great success came from knowing when a work was finished. In his opinion, other artists lacked his restraint. Pliny speaks of the usefulness of Apelles as an exemplar, then goes on to note that in one area of his technique, nobody else could compete: ". . . he coated his finished works with a black varnish so thin that while it accentuated the reflection of the brightness of all the colors and protected the painting from dust and dirt, the varnish was visible only to one inspecting it close at hand; but this also involved considerable theoretical calculation, lest the brightness of the colors offend the eye, as in the case of those who look through a transparent colored stone, and also so that, from a distance, the same device might, though hidden, give somberness to the colors which were too bright." Apelles' *Aphrodite Anadyomene* (*Aphrodite Rising from the Sea*) became legendary. Perhaps BOTTICELLI had the idea, if not the form, of this precedent in mind when he worked on the *Birth of Venus* more than 1,000 years later; he was certainly thinking of Apelles when, in 1497, he followed the suggestion of ALBERTI that artists should re-create a vanished painting of Apelles as described by the Greek author Lucian. Botticelli's *Calumny of Apelles,* showing Hatred, Deceit, Fraud, Calumny, Penitence, and Truth, is as agitated and tormented a work as his *Birth of Venus* is serene.

Aphrodite (Venus) of Cnidos (Knidos)
PRAXITELES sculpted several nude figures of the goddess Aphrodite, but his c. 340 BCE statue, in beautiful Parian MARBLE, was the most renowned, influential, and notorious in ancient texts. This may be the first time the nude female body was portrayed sensuously, and as a figure to be seen and appreci-

ated equally from every angle. When Praxiteles finished this *Aphrodite,* he offered to sell it to the people of Cos, but they demurred in favor of a relatively discreet statue. The more venturesome Cnidians took it and stood it in a small sanctuary surrounded by columns. There, according to ancient accounts, it so aroused the lust of young men that they copulated with it. Later, as PLINY the Elder records, the Cnidians refused an offer from the king of Bithynia to absolve them of their debt in exchange for the statue, which had become a major tourist attraction for them. Nothing from Praxiteles' own hand survives, and the Roman copies we do have fall well short of fulfilling its literary reputation. As the apologia for Aphrodite's nudity, we are supposed to have surprised her as she bathed, and she has reacted with spontaneous modesty, bending forward and shielding her pubic area with her hand. In contrast to the frank nudity of Greek males, the implication is that the female body is still meant to be hidden (see NUDE). The *Cnidian Aphrodite* is Late CLASSICAL, and in the following, HELLENISTIC, era it and other versions of the goddess were frequently portrayed. During the ITALIAN RENAISSANCE (and subsequently the NORTHERN), her reputation, perhaps a few early reproductions, and succeeding *Aphrodite*s prompted numerous interpretations and copies in bronze, marble, and paint. None is more famous or exquisite than BOTTICELLI's *Birth of Venus*, albeit his is a free, almost airborne interpretation of the pose. (See also APELLES for Botticelli's literary inspiration.) The most notable American derivative is POWERS's *Greek Slave* (1843).

Aphrodite (Venus) of Melos (Milo)

Found by a peasant on the island of Melos in 1820, this larger-than-life (6' 10") Parian MARBLE sculpture, bought on the spot by the French ambassador, quickly made its way to France and the Louvre. In 1821 an influential French scholar, Antoine Quatremère de Quincy (1755–1849), wrote, "I feel that this statue can give us an idea of the art of the Greeks perhaps superior to that which previous statues of this nature have given us with respect to the type of ideal beauty belonging to the imitation of feminine." Yet he also recognized problems: "The question of originality (taking the word in an absolute sense) will probably long and perhaps forever remain unsolved with regard to the most beautiful art antiques." Quatremère's speculation was prophetic; currently the statue is thought to date from 150 to 100 BCE, and to be in a long line of replicas and versions of a 4th-century BCE type. Speaking for himself, Quatremère wrote, "I will limit myself to saying that . . . in relation to the qualities which artists usually define by the words GRANDEUR OF STYLE, AMPLITUDE OF FORM, IDEAL CHARACTERISTICS, PURITY OF DESIGN, ACCURACY, LIFE AND MOVEMENT, and also in respect to HANDSOME EXECUTION, I will not hesitate to give it the first place among all those [antique statues of Aphrodite] which I have seen." The statue's missing arms have never been restored, as their proper position has not been agreed upon. And despite the great fame that has always surrounded it, reviews of the statue itself have ranged from awe to ennui, the latter expressed by a 20th-century writer

who called it the "rather chill giantess in the Louvre."

Apollinaire, Guillaume
1880–1918 • French • poet/critic

The secret aim of the young painters of the extremist schools is to produce pure painting. Theirs is an entirely new plastic art. . . . A man like Picasso studies an object as a surgeon dissects a cadaver.

Apollinaire has been called the "literary apostle" of CUBISM. He lived in the famous tenement in Montmartre (the "laundry boat") with PICASSO and his circle. Apollinaire was well known among Symbolist poets, and his insights into contemporary painting are recorded in *The Cubist Painters* (1913), originally entitled *Aesthetic Meditations,* which became its subtitle instead. In it he spoke about the "New Painting" more often than about "Cubism" specifically. He made perceptive observations regarding the use of techniques like COLLAGE, painted letters, and found materials, and discussed artists' intentions, as quoted above. Apollinaire was also a great supporter of Henri ROUSSEAU, FUTURISTS, and the SURREALISTS.

Apollo Belvedere
During the 16th century, and long afterward, the most renowned statues from the ANCIENT world were the LAOCOÖN and the *Apollo Belvedere*. The *Apollo,* slim and lithe, is naked except for the cape draped over his outstretched arm and a diagonal shoulder strap that must have held his quiver. Belvedere means "beautiful view" in Italian, and although it was certainly that, the statue is actually named for the court in which both it and *Laocoön* stood—a walled garden with orange trees, fountains, and niches for sculpture, built as part of the pope's villa c. 1500. References to this *Apollo* occur in the 15th century, but the time and place of its discovery are a mystery. It was long believed to be a Greek original, and although today it is generally thought a copy, no one is sure if the original was a 4th-century BCE bronze by PRAXITELES or by LEOCHARES; a 1st-century BCE work; or a much altered Roman copy from Hadrian's time, that is, the 2nd century CE. Whatever its origin, this *Apollo* was extolled with hyperbolic appreciation, especially by WINCKELMANN and by GOETHE. They were hardly alone. When the 18th-century American painter WEST was taken to the Belvedere courtyard, he was carefully watched by his hosts, who were probably not disappointed: "My God! How like it is to a young Mohawk warrior," exclaimed the callow West, satisfying the Europeans' anticipation of his New World naiveté. Throughout history, from DÜRER's engraving *Adam* to STUART's portraits of George Washington, the pose of the *Apollo Belvedere* has been a model for artists.

Apollodoros
5th century BCE • Greek • painter • Late Classical

Apollodoros of Athens was the first to give his figures the appearance of reality. (Pliny the Elder, 1st century CE)

As none of his paintings survives, Apollodoros is known through literary works only. These tell us that he was the first to use shading or MODELING, thus

his reputation for inventing realistic or "illusionistic" (that is, the illusion of reality) painting. Whereas his predecessors had painted flat WASHES of COLOR inside their outlines, Apollodoros was known as *skiagraphos,* painter of shadow. PLINY the Elder, quoted above, also suggests that ZEUXIS followed in the footsteps of Apollodoros.

apotropaic/apotropaia

Apotropaic images were meant to ward off evil, to forewarn and frighten would-be wrongdoers. They are often attached to buildings (e.g., the *Medusa* sculpted for the west pediment of the Temple of Artemis at Corfu, or ancient Corcyra, c. 600–580 BCE), or to city gates (e.g., the Lion Gate at Mycenae, c. 1300–1250 BCE, which has two carved lions meant, perhaps, to invoke divine power in defense of the citadel beyond). Imaginary beasts like the griffin—a lion's body with the head and wings of an eagle—and Greek Gorgons—three monstrous sisters with glaring eyes and snakes for hair—are apotropaic. The Etruscan bronze *Chimera* of the 5th to 4th century BCE, which has a lion head, a snake tail, and a goat head on its back, is an example (see "CAPITOLINE" WOLF and ETRUSCAN ART). A wider application of the term includes images, amulets, and talismans believed to work magic spells or to protect the bearer, owner, or wearer (e.g., a mezuzah or a cross).

Appel, Karel
See COBRA

appropriation
In 20th-century art, appropriation refers to the reuse of an image or design, or some part of either, that has already appeared (usually) under the signature of another artist or in another context. The appropriated image may be used alone or as part of a COLLAGE. Whereas borrowing or copying in earlier times was mainly for the purpose of education and artistic or cultural association, appropriation in the POSTMODERN era is an end in itself, and has several implications. For one, it denies the exclusive "aura" of a work of art (see BENJAMIN) and the notion of the artistic genius of its creator. This kind of defiance characterizes the rephotographing by Sherrie Levine (born 1947) of photographs by WESTON. When a borrowed image is combined with other images, that appropriation also mocks the notion of artistic "integrity," whether of period, style, material, or whatever goes into the mix (see Michael GRAVES). Often there is irony and parody in appropriation, that is, showing up the preceding work for some conceptual flaw, or finding in it some matter for derision. Although chronologically MODERN rather than Postmodern, a prime example is DUCHAMP's *L.H.O.O.Q.* (1920), in which he drew a beard and mustache on a photograph of LEONARDO's *Mona Lisa* and added the acronym of the title. Phonetically, in French *L.H.O.O.Q.* is an obscenity. In sum, appropriation has become an act of defiance of the CANON and of rebellion in general.

aquarelle
See WATERCOLOR

aquatint
The term is used for both the PRINTING process and the end product, or PRINT.

Aquatints are TONAL rather than LINEAR, and their name, from the Latin *aqua,* for "water," is derived from their visual similarity to WATERCOLORS rather than from means of production. The method of producing aquatints was refined by Jean-Baptiste le Prince (1734–1781). A copper or zinc plate is coated with an acid-resistant rosin that is granulated so that the acid will penetrate its minute interstices, creating a grainy printed surface. Areas that are meant to remain white (or whatever color the paper is) are "stopped out" with an acid-resistant varnish. Traditional methods of ETCHING are used for objects, figures, and details. The aquatint may be colored after printing, with watercolor, for example, or during the printing process by superimposing one or more plates, each for a different colored ink, over the initial print. GOYA made numerous aquatints; one of his best known, a combination of etching and aquatint, is *The Sleep of Reason Produces Monsters* (plate 43 from the series *Los Caprichos,* 1799).

arabesque
Used in the belief that arabesque decoration originated with the Arabian people, the term describes intricate patterns of scrolls, interlacing foliage, and nonfigurative ornamental designs. Spectacular examples of arabesque, often based on geometry and related to calligraphy, are found in ISLAMIC ART. The influence of the arabesque on Western art extends to the designs of William MORRIS in the 19th century and Frank STELLA in the 20th.

Arbus, Diane
1923–1971 • American • photographer • Modern

Freaks were born with their trauma. They've already passed it. They're aristocrats.

After working in fashion photography, in the 1960s Arbus began taking pictures of people on the fringes of society. The comment quoted above was one she made to *Newsweek* magazine when she was interviewed in connection with an exhibition of her work at the Museum of Modern Art in New York, in 1967. The offensive connotations of the term "freaks" are obvious today, but it was not Arbus's wish to poke fun at or ridicule her subjects. Her pictures of dwarfs, female impersonators, and even children have an unsettling edge that both repels and fascinates a viewer. Arbus came from financially privileged circumstances, and she seemed determined to unburden herself of them. There has been much psycho/biographical speculation about her motives, especially because she committed suicide, but whatever her conscious or subconscious intentions, her photographs remain powerful, disturbing, and challenging.

Arcadia/Arcadian
Originally the place in the Peloponnese where Pan, god of woods, fields, flocks, and herds, was worshiped, Arcadia became synonymous with an idyllic, pastoral setting. The Arcadian theme, sometimes in the guise of Virgil's Golden Age and the Bible's Garden of Eden, has a rich history in poetry and art. A Roman wall painting of 70 CE

(possibly adapted from a PERGAMENE work of c. 200 BCE) personified Arcadia as a statuesque woman with a knobby staff in her hand and a leafy wreath on her head. However, most Roman pictures of Arcadia were pastoral landscapes, consistent with a city dweller's desire to escape to the country: In both city and suburban villas, well-to-do Romans had Arcadian scenes painted on their walls. Pan's association with Dionysus and his retinue of nymphs and shepherds as well as satyrs and maenads, and with music, introduces an undercurrent of romance, eroticism, and intoxication to much Arcadian imagery. That is evident in the ITALIAN RENAISSANCE, especially in Venetian paintings such as GIORGIONE's *Pastoral Symphony* (also known as *Fête Champêtre*, c. 1510), which includes two nude Greek Aphrodite figures of a type popularized by PRAXITELES in the 4th century BCE and reintroduced by Venetian painters. The lyric bent of Giorgione's art was developed in association with a group of poets of the "Arcadian movement." In 1690 an Academy of the Arcadians *(Accademia degli Arcadi)* was founded in Rome with princes, along with cardinals and other ecclesiastics, who came to its meetings dressed like Arcadian shepherds and masked in order to avoid disputes related to status. Explanation of Arcadian themes usually proves elusive, but never more so than in regard to POUSSIN's two versions of *The Arcadian Shepherds* (inspired by GUERCINO's painting of c. 1621–23, *Et in Arcadia ego*). They are discussed in a famous essay by PANOFSKY, *Et in Arcadia Ego: On the Conception of Transience in Poussin and Watteau* (1936). Panofsky sees "a basic change in interpretation" between Poussin's first and second renderings of c. 1628/29 and c. 1655. In the latter, "The Arcadians are not so much warned of an implacable future as they are immersed in mellow meditation on a beautiful past," Panofsky writes, and suggests that one historical explanation may be the relative calm after the "spasms of the Counter-Reformation." In the mid-19th century, American artists painted and photographed idealized Arcadian landscapes, and the first art journal in New York was named *The Arcadian* (1872–78). During the 1880s, EAKINS made photographs, oil paintings, and sculpture exploring the theme of Arcadia.

arch

An arch spans an opening, like a doorway, by distributing the thrust of its own weight laterally as well as vertically onto supporting piers. By way of contrast, in trabeated (or post-and-lintel) construction, a horizontal beam rests on COLUMNS or posts. Greek architecture was largely trabeated, whereas Roman builders, using concrete, made great advances by improving arcuate construction. The spanning members are made of wedge-shaped blocks—voussoirs—that hold each other in place. To increase load-bearing capacity, distance spanned, and height, Romans employed a series of arches—arcades. Other Roman elaborations on arches are barrel, groin, and sequential groin vaults—a vault being a construction where the top of the arch becomes a ceiling rather than just a passageway. A beautiful example of the structural

use of arches in Roman engineering is the Pont-du-Garde aqueduct at Nîmes (c. 16 BCE). Originally temporary constructions, probably of wood, triumphal arches were set up for celebrations of military heroes. By the end of the 1st century BCE, they became permanent propagandistic monuments, like the ARCH OF TITUS (c. 90 CE). The persistence of the arch form over time is accompanied by a multiplicity of shapes, from the round Roman to the lancelike GOTHIC to the multilobed and keyhole shapes of ISLAMIC architecture.

Arch of Titus

The triumphal ARCH became a staple of Roman propagandistic display, the symbol of an emperor's victorious return home from conquest abroad. Among those still standing is the Arch of Titus (c. 90 CE) commemorating Roman victory in the Jewish Wars (66–70 CE), ending with the sack of Jerusalem and the destruction of the Second TEMPLE. (It was actually constructed by the emperor Domitian after Titus died.) One image sculpted in high RELIEF inside the arch shows Titus in his chariot and a procession of Romans carrying off sacred artifacts from the Temple: a table of shewbread (12 loaves of blessed, unleavened bread that priests placed in the sanctuary), trumpets, censers, and the seven-branched candlestick. In the front of the procession are representations of Jewish prisoners who, as slave labor, were employed to build the Roman COLOSSEUM (c. 70–80 CE). The sculpture is renowned for its feeling of depth and movement, and for the way it endeavors to draw passersby into the parade.

Archaic

The root word is Greek for "beginning" and in general archaic refers to that which belongs to an earlier time. Specifically, Archaic designates a period in Greek art from roughly 650 to c. 480 BCE. This art was heavily influenced by 2,000-year-old Egyptian and Near Eastern prototypes that rely on geometric conventions for representing the human figure rather than on observation of the natural world. Archaic Greek statues were forward-facing (FRONTAL), rigid, symmetrical, and lifeless—more a symbol than a copy of the human body (see KOUROS/KORE). Archaic painting is known primarily from vases decorated first in BLACK- and later RED-FIGURE TECHNIQUES. Transition from the Archaic to the CLASSICAL period parallels the Athenian experience of political and social revolution. In 510 BCE the autocratic government that had controlled Athens for 50 years was overthrown, and a series of succeeding constitutional reforms led to the new, democratic system of government and, eventually, the CLASSICAL period.

archaic smile

See KOUROS

Archipenko, Alexander

1887–1964 • Russian/American • sculptor • Cubist

I did not take from Cubism, but added to it.

In close contact with CUBIST painters after he moved to Paris in 1908, Archipenko applied the principles of their approach to his sculptures. With *Walking Woman* (1912) he achieved the

effect of "reversing space": He created form through shaped, volumetric voids surrounded by bronze, as if the bronze were carved to shape the empty, open space. One of the founders of the SEC- TION D'OR, Archipenko extended his in- terest in balance and harmony of form to color, and he revived its use in sculp- ture. As he comments in the quotation above, Archipenko added greatly to Cubism with sculpture of light, space, and color. He moved to the United States in 1923, and five years later be- came an American citizen. He taught in the art departments of several American universities and opened a successful school in New York City in 1939.

Arcimboldo, Giuseppe

1527–1593 • Italian • painter • Mannerist

This extremely inventive painter knew not only how to find the relevant semitones, both small and large, in his colors, but also how to divide a tone into two equal parts; very gently and softly he would gradually turn white into black, increasing the amount of blackness, in the same way that one would start with a deep, heavy note and then ascend to the high and finally the very high ones. (Gregorio Comanni, late 16th century)

Arcimboldo is best known for his com- positions of STILL LIFE objects—meats, books, fruits and vegetables—with which he constructed portraits. The most renowned of those works is the portrait he painted of and for his PA- TRON, Emperor Rudolph II. This is an extraordinary example in which the emperor's nose is a pear, eyelids pea pods, and mustache hazelnut husks; it

was praised in a long poem by Arcim- boldo's contemporary Comanni, who is quoted above. Rudolph was well pleased, not only by the beauty and ingenuity of the picture, but also by the analogy: The portrait—*Vertumnus* (c. 1591)—is named after the ancient Roman god of vegetation, protector of gardens, orchards, and the ripening of fruit. Arcimboldo's visual puns in- cluded other fantasies: He imagined a Trojan horse formed of writhing sol- diers, their flaming torches becoming the horse's mane. The pun first deceives with the image of a horse, and then with the concept of the Trojan horse itself, one of history's great myths of decep- tion (containing inside its wooden structure a conquering army). Himself Milanese, Arcimboldo's inventions were admired by the HAPSBURGS, who made him court painter at Prague from 1562 to 1587. The eccentric Queen CHRISTINA of Sweden also bought his work. Though he left behind no docu- mentation, his friend Comanni de- scribed Arcimboldo's Pythagorean experiments with COLOR, praising his CLASSICAL and scientific knowledge. However, Arcimboldo was generally dismissed until the Surrealists found his work appealing (see SURREALISM). Recent assessments of Arcimboldo's accomplishments explore his experi- mentation with a form of color counter- point based on Pythagorean intervals of the musical scale (see PYTHAGORAS) and the notion that his paintings, long mis- understood as fantastic jokes, are actu- ally imperial allegories.

Arensberg Circle

From 1914 to 1921, Walter Conrad Arensberg, a Shakespearean scholar

and patron of the avant-garde, acted as host to numerous artists and writers, conducting a New York City version of Gertrude STEIN's Paris salon. He backed DUCHAMP, whose notorious 1912 *Nude Descending a Staircase* he bought, and welcomed Duchamp's life-long friend PICABIA, joining them, through his own writing, in their promotion of the DADA movement. He also supported American MODERNISTS including DEMUTH, SCHAMBERG, SHEELER, DOVE, and Joseph STELLA. Many of these artists were members of the STIEGLITZ Circle too, but where Stieglitz was the artistic majordomo, Arensberg was more self-effacing, providing food and conversation in a private rather than a public setting.

Arianism

A point of view expressed by the theologian Arius of Alexandria (c. 256–336). Arius argued against the doctrine of the Trinity and the idea that Christ could be equal with God and have eternal life. Rather, Arius and his followers, Arians, believed in the single, human nature of Christ, albeit the highest possible human nature. This doctrine was opposed by the bishop Athanasius (c. 296–373, also of Alexandria) and his followers, who insisted that Christ was fully God, and that Father, Son, and Holy Ghost were equal and composed of the same substance. Later, Arianism was also countered by Monophysitism, a doctrine that supported the entirely divine nature of Christ. Arianism was declared heretical at the Council of Nicaea in 325, though that decision was reversed 10 years later. The controversy continued. Germanic tribes entering and gaining

power in Rome's eastern territories, especially, adapted Arianism (see MIGRATION). For barbarians, the Arian point of view enabled an idea of Christ as a heroic, glorified chieftain. The ways in which these theological arguments were translated into artistic terms remain an interesting but unresolved discussion among art historians. "The fourth century ushered in a war of images," writes the historian Thomas Mathews. He adds, "The images of Christ determined what people were to think of him not only in the early centuries of the current era, but ever after." To Mathews, the luminous robes Christ wears are to be seen as anti-Arian propaganda, glorifying the divine nature of Christ rather than, as often proposed, his imperial stature.

Armory Show

A historic and notorious event of 1913, officially called the International Exhibition of Modern Art, became familiarly known as the Armory Show after the building in which it first opened—the Armory of the 69th National Guard Regiment on Lexington Avenue in New York City. Later, somewhat modified, the exhibition traveled to Chicago and Boston. It is estimated that as many as half a million visitors saw the show. There were approximately 1,600 works—paintings, sculptures, drawings, and PRINTS—and three quarters were by American artists. The 25-member planning committee, headed by DAVIES, was called the Association of American Painters and Sculptors. The intent was to exhibit "the best examples procurable of contemporary art, without relation to school, size, medium or nationality." There was some discord

before the grand opening on February 17 (e.g., Italian FUTURISTS wanted to be seen as a group and declined to participate at all when they were not able to do so), but it was minor compared to the uproar that accompanied the actual event, when dissenters from President Teddy Roosevelt to the artist COX discredited the show. The greatest rancor was directed at European MODERNISTS, particularly MATISSE (who was burned in effigy by art students in Chicago) and DUCHAMP, whose *Nude Descending a Staircase* became the subject of snide remarks, most famously that it looked like "an explosion in a shingle factory." Although its artists were called "cousins to the anarchists in politics" in the press, the new prevailed, winning converts and opening eyes to revolutionary ways of seeing and painting. The Armory Show is probably, to this day, the most influential exhibition ever to have been mounted in America.

Arneson, Robert

1930–1992 • American • potter • Modern

I really thought about the ultimate ceramics in western culture . . . so I made a toilet.

A student of the innovative potter Peter Voulkos (born 1924), who did much to break down distinctions between art and craft, Arneson produced work in POTTERY that is outrageous, funny, and often barbed. His series of toilets, like *John with Art* (1964), is a colorful reminder of DUCHAMP's porcelain plumbing fixture (*Fountain*, 1917), and a feat of one-upmanship as well: Arneson made his own glazed and painted ceramic toilet, while Duchamp simply took a manufactured item and put it on display. Arneson's toilet has an added commentary: Inside the bowl, as if written with excrement, is the word "art." Arneson said, "I had finally arrived at a piece of work that stood firmly on its ground. It was vulgar, I was vulgar." Arneson also ventured into political satire, and he made a series of ceramic TERRA-COTTA self-portrait CARICATURES, usually with his tongue sticking out of the side of his mouth.

Arp, Jean (Hans)

1886–1966 • German/French • painter/sculptor • Dada

Artists should not sign their works of Concrete art. These paintings, sculptures, objects should remain anonymous and form part of nature's great workshop as leaves do, and clouds, animals, and men.

Writing in 1942, Arp used the term CONCRETE ART (see the quote above), which had been proposed by van DOESBURG and KANDINSKY, as a substitute for ABSTRACT ART because, as Arp put it, ". . . nothing is less abstract than Abstract art." A founder of DADA, Arp moved his own work from painting to COLLAGE, to RELIEF, to freestanding sculpture, or "sculpture in the round." His Dada collages resulted, it was said, from his having torn up a drawing and dropped the pieces of paper on the floor, only to discover that their serendipitous arrangement pleased him, solving problems with which he had struggled (e.g., *Square Arranged According to the Laws of Chance*, 1916–17). Arp's system conforms to that of Dada poets who cut and scattered words from newspapers to compose

their poetry. Despite the supposed random spontaneity of Arp's art, it has certain recognizable traits or "figures"—for example, a viola-like form that might be "read" as a woman. When SURREALISM emerged in 1924, Arp participated in that movement, and contributed to the journal of De STIJL. With LISSITZKY, Arp edited *The Isms of Art* (1914–24), a survey of contemporary movements. During the last 30 years of his life, Arp experimented with BIOMORPHIC forms that may suggest things like gnomes, snakes, and clouds, and also allude to the process of metamorphosis. An example is *Aquatic* (1953), a 13-inch-high marble form that seems both a sea creature and a female torso. MIRÓ and CALDER are among later artists influenced by Arp.

art
Although from the Latin word meaning "skill," the term was originally applied very generally. Painting, drawing, engraving, and sculpture were not formally listed as arts until the late 17th century. During the late 18th century, distinction between artist and artisan gained currency. The artisan was one whose skills were manual, supposedly without intellectual, imaginative, or creative purpose. In the mid-19th century, a new distinction was allowed between "liberal" and "fine" arts, the latter routinely associated with creativity and imagination. In recent years, in recognition of the extent to which capitalism and value are intertwined, and of their influence on categorical separations, efforts are made to blur distinctions between, for example, machine-made, handmade, imaginative, reproduced, and original art. Such efforts also lead to reassessing POPULAR CULTURE, FOLK ART, CRAFTS, and other endeavors conventionally outside the FINE ART category, not only bringing them into the fold through cultural discourse, but also actually including them in new works of art through such means as ASSEMBLAGE and APPROPRIATION.

Art Brut
This term, used by DUBUFFET, translated from the French means "raw art." It refers to work that is unmediated by outside influences such as schooling and tradition, or by any confining rules and regulations regarding technique and STYLE. Dubuffet found images produced by children and mental patients particularly interesting. He left his collection of Art Brut to the city of Lausanne, where it may be visited by the public at the Château de Beaulieu.

Art Deco
Named after the Exposition Internationale des Arts Décoratifs et Industriels Modernes (International Exhibition of Modern Decorative and Industrial Arts) held in Paris in 1925, Art Deco is sometimes called Jazz Modern or *moderne*. Where its predecessor, ART NOUVEAU, was handcrafted, asymmetrical, and tended toward flowing, sinuous lines, Art Deco was either machine made or attuned to the machine aesthetic, balanced, with shapes, both geometric and natural, more massive and simplified. In architecture, the spire of the Chrysler Building in New York City (1928–30) by William Van Alen (1882–1954), with its tower of sunlike, semicircular forms decreasing in size as they come to a point, is a preeminent example of Art Deco design. The style was particularly

inventive in the field of DECORATIVE ARTS, from lamps to tea services, and in its use of wrought iron, stainless steel, and etched glass. Art Deco sculpture is often part of the architecture of a building.

art for art's sake
See AESTHETIC MOVEMENT

art history
The effort to record, identify, understand, and explain ART. Accounts of art and artists by PLINY the Elder in the 1st century CE are the earliest art historical records available, and our knowledge of GREEK ART is heavily dependent on him. Pliny mentions Xenokrates of Sikyon (3rd century BCE), both a sculptor and a writer, who may have been the first art historian. Pliny himself depended heavily on Xenokrates for information. PAUSANIAS, a 2nd-century CE Greek traveler, has left long and detailed descriptions of the paintings, sculptures, and architecture he saw on his trips through Greece and other countries. The effort to systematize a history of art grew during the RENAISSANCE, especially in the hands of VASARI and later van MANDER. To this point, art history was largely (often undocumented) biography and EKPHRASIS, that is, vividly (sometimes imaginatively) descriptive accounts of works of art. In the 18th century, WINCKELMANN redefined the history of art. He believed that art is the product of external forces, and that Greek art, which he valued above all, was the result of favorable geographic, climatic, and political circumstances. Not himself an artist, Winckelmann was important in promoting the NEOCLASSICAL movement.

During the 19th century, HEGEL directed thoughts about art history to the idea that each age had its own "geist," or spirit, and that the art of any period inevitably reflects that mood, tone, and energy. Also during the 19th century, CONNOISSEURSHIP—an ability to discern and distinguish quality—came to the forefront of art studies, especially as enthusiasm for COLLECTING grew. MORELLI, BERENSON and FRIEDLÄNDER are significant among connoisseurs. During the 20th century, the approach of WÖLFFLIN, who established criteria for seeing—as opposed to his predecessors' criteria for judging—gained ascendancy. Wölfflin was a FORMALIST in his approach, and he brought to his analysis an interest in the cultural and psychological factors that influence form. The focus of MÂLE and of WARBURG was on content, and led to studies in ICONOLOGY and ICONOGRAPHY by PANOFSKY. Panofsky opened a field rich in opportunities for the interpretation of images. Art historical studies have, since World War II, taken a multitude of approaches with ideologies (e.g., MARXISM) and trends that both complement and contest one another. Recent methodological approaches are based on philosophies and theories of, for example, FEMINIST studies, SEMIOTICS, and PSYCHOANALYSIS, and investigate concepts of ORIENTALISM, STRUCTURALISM, DECONSTRUCTION, HISTORICISM, and NEW HISTORICISM. These interests find voice in the NEW ART HISTORY. "One of the strongest determinants in art historical writing is the scholar's conception of history itself," writes W. Eugene Kleinbauer. He adds, "Art history is molded by a philosophy of history—by an understanding of the

general divisions of history, the nature of historical periods, and the causes of historical change."

Art Informel
See TACHISME and ABSTRACT EXPRESSIONISM

Art Nouveau
Beginning in the 1880s and at its peak in the 1890s, Art Nouveau was perhaps as purposefully "new" as any style in the DECORATIVE ARTS—as opposed to styles that referred to historic precedents. That said, there were still historic references and borrowings, from Japanese arts, for example, and from the ROCOCO style. Artists working in Art Nouveau include BEARDSLEY, the Belgian architect HORTA, and the Scottish architect MACKINTOSH. Among its signature stylistic details were limply sinuous tendrils, flowers, and leaves, and women with long, flowing hair. The name originated in a Parisian gallery called L'Art Nouveau, opened by S. Bing in 1895. In Scandinavia and Germany the style was named Jugendstil, from a magazine in which Art Nouveau was featured. In Spain it was Modernismo; in Italy, Floreale or Stile Liberty.

Art of This Century
See GUGGENHEIM

Art Workers' Coalition (AWC)
A group originally formed by TAKIS and some friends in protest against their exclusion from the Museum of Modern Art in New York. AWC's field of interest grew to include wider social and political demands. "[The] Museum's activities should be extended into the Black, Spanish and other communities. It should also encourage exhibits with which these groups can identify," the group proclaimed. On May 18, 1970, with Robert MORRIS leading and 2,000 participants joining in, they staged an Artists' Strike Against Racism, Sexism, Repression, and War after the invasion of Cambodia and the killing of four students at Kent State University. ANDRE was another active AWC member. The AWC brought important issues to public attention, not the least of which was, as the critic Hilton Kramer wrote, "the artist's moral and economic status vis-à-vis the institutions that now determine his place on the cultural scene, and indeed, his ability to function as a cultural force . . . a plea to liberate art from the entanglements of bureaucracy, commerce and vested critical interests— a plea to rescue the artistic vocation from the squalid politics of careerism, commercialism, and cultural mandarinism." CONCEPTUAL ART—giving precedence to ideas rather than objects—came to the foreground at this time. AWC activities declined after 1970.

Arte Povera
The Italian critic Germano Celant organized two exhibitions in 1967 and 1968 and published a book, *Arte Povera* (Italian for "poor" or "impoverished art"), about the movement he promoted. Celant wrote, "Arte Povera expresses an approach to art which is basically anti-commercial, precarious, banal and anti-formal, concerned mainly with the physical qualities of the medium and the mutability of the materials. Its importance lies in the artists' engagement with actual materials and with total re-

ality and their attempt to interpret that reality in a way which, although hard to understand, is subtle, cerebral, elusive, private, intense." Without using traditional forms, artists in this movement endeavor nevertheless to provoke spontaneous reactions to their work. A foremost Arte Povera artist is Mario Merz (born 1925), who uses a variety of materials to make "igloos." These suggest shelter and a humble, nomadic life. Merz incorporates stuffed iguanas and alligators and neon words or letters in the presentation of his ideas.

Arts and Crafts Movement

Inspired by the ideas of RUSKIN and PUGIN, the Arts and Crafts Exhibition Society was founded in England in 1888 and gave its name to the subsequent movement. Its reformist members protested against industrialization, which, they believed, led to the degradation of work, the working class, and the environment. Passionate in their commitment, they preached a return to handmade craft, which they considered an art form. They also advocated return to the MEDIEVAL system of WORKSHOPS, and sometimes promoted utopian communities that would help to realize their goals. William MORRIS was an influential leader of the movement in England; George Bernard Shaw wrote of the first Arts and Crafts exhibition in 1888, "Perhaps the beginning of the end of the easel-picture despotism is the appearance in the New Gallery of the handicraftsman with his pots and pans, textiles and 'fictiles' [pottery] and things in general that have some other use than to hang on a nail and collect bacteria." Nine years later the Boston Society of Arts and Crafts was founded, followed, within a decade, by hundreds of organizations devoted to supporting and selling handmade goods. Elbert Hubbard (1856–1915), writer and organizer of the Roycrofters community in East Aurora, New York, and the furniture maker, designer, and theorist Gustav Stickley (1857–1942) are two of the best-known promoters of Arts and Crafts in America.

Ashcan School

Members of the Ashcan School were American artists who attacked social injustice in the early 20th century, following the example of the documentary photographer RIIS and in tune with writers such as Stephen Crane and Upton Sinclair. They painted poverty, prostitution, and drunkenness, and illuminated the plight of society's castoffs in street scenes and in scenes of domestic debasement. Emblematic of their themes, and naming the movement, were cartoons like the one by SLOAN, depicting homeless men rummaging through garbage for a meal. Many contributed to a Socialist magazine, *The Masses*. Several of the members of The EIGHT were Ashcan artists, but not all. REALISM[2] was their style, but it had to do with the cold eye they cast on life more than with representational accuracy.

assemblage

The three-dimensional, sculptural counterpart of COLLAGE or MONTAGE, traced back to the PICASSO-BRAQUE collaborations of 1912 and to DUCHAMP's "ready-mades." Assemblages were so named by curators at the Museum of Modern Art in New York when they presented an exhibition entitled

The Art of Assemblage in 1961. Discarded "junk" and "found objects" are typically used for assemblages. Their variety ranges from large, nonrepresentational walls constructed by NEVELSON to the small, glass-fronted boxes of CORNELL. Assemblage plays an intriguing part in visionary constructions, as the huge, heroic work by James Hampton, made entirely of salvaged materials, testifies (see NAIVE ART).

atelier

Meaning "workshop," the term derives from French and Latin words having to do with wood, revealing its origin in carpentry. Its reference today is especially to an artist's studio. (See also WORKSHOP.)

Athenodoros

See AGESANDER

atlantid

See CARYATID

Attie, Dotty

born 1938 • American • painter/draftswoman • Feminist

I do personal work couched in impersonal terms. . . . When I started making small drawings an internal fantasy started coming out . . . a taboo erotic fantasy.

Attie was a founding member of the important, nonprofit A.I.R. (for artist in residence) Gallery in New York City, begun in 1972 to support women artists. (SPERO was also a member.) In 1970, after years of painting, Attie began to draw, telling stories in small boxes that contain oddly cropped images. *Adventure at Sea* (1977), a series

of 33 squares (3 across and 11 down), follows a character, Pierre, through an inexplicable sequence of visual clues—a hand grasping a door, the chest and part of the torso of a partially draped body, parts of faces—interspersed with squares containing equally inscrutable text. The only almost fully represented image is of a sailing ship. The effect of the story is unnerving—and sexually suggestive, as Attie notes in the quotation above—but it ultimately derives its impact from the utter indeterminacy of the narrative. While this mode emerged from CONCEPTUAL art, it bears much of the ambiguity of POSTMODERN thought, and might best be described as an antinarrative narrative style.

attribute

The object that serves to identify an individual, especially a mythical character or one of the saints: In Greek art, Gorgons are recognized by the snakes they have for hair and Hercules by his lion skin. In Christian art, arrows are the attribute of Saint Sebastian; Saint Catherine's attribute is her wheel. Sometimes an attribute substitutes for a person; for example, in certain contexts, the image of a lion takes the place of Saint Mark.

Audubon, John James

1785–1851 • American • painter/naturalist • Romantic

I know I am not a scholar, but meantime I am aware that no man living knows better than I do the habits of our birds.

Audubon was born in Haiti to a chambermaid who died a few months after his birth. His French father was a sea-

man, adventurer, and merchant whose commerce included slaves. The artist spent his early years in Brittany. He cites Jacques-Louis DAVID as his guide, but there is no record of his having studied in Paris. Audubon's monumental four-volume *The Birds of America*, the first folio of which appeared in 1828, was preceded by Alexander Wilson's folio *American Ornithology* (Vol. 1, 1808), which Audubon used for purposes of identification. He also referred to the pioneering work of the 18th-century French naturalist the comte de Buffon, whose 44-volume encyclopedia of natural history was issued over a span of more than 50 years (1749–1804). Buffon's nine volumes on birds were published between 1770 and 1783. Audubon tried his hand at several businesses, with little success. In 1819 his financial mishaps landed him in debtor's prison and he was forced to declare bankruptcy. Subsequently, he devoted himself to travel and research for the watercolors for *Birds of America* and the *Ornithological Biography*, a five-volume text to accompany his pictures. The detail, rich color, beauty, and fidelity of Audubon's paintings are remarkable. Even more significant, artistically and scientifically, is that his were the first illustrations of birds behaving in character and in their natural environment. Thus, his picture of two Chuck-will's-widows, "drawn from nature," and painted on May 7, 1822, shows a snake wrapped around a branch of a tree; below it is a female bird whose large, insect-catching beak is opened wide; and above it is the male, beak closed but patterned tail feathers splayed wide in agitation. The scene was one Audubon witnessed firsthand. For the most part, his pictures are of birds he shot—he killed thousands. He then positioned them by tying threads or wire to various of their body parts to achieve a natural-looking pose. His pictures surpassed by far earlier representations. To show variety in behavior and appearance, he frequently included several views of birds in one image. Nearly all the original illustrations were produced by Audubon and his assistants between 1812 and 1836. ENGRAVINGS were first made in London during the 1820s, and were published over a period of years. In 1831, when Audubon was 46 years old, the first volume of *Ornithological Biography* was issued. His progress was stymied by disasters, including a fire in 1836 that destroyed his drawing kits and guns. Audubon's concept of presenting an animal species in its natural environment was a great advance. His work preceded—and in ways foreshadowed—the observations and theories of Charles Darwin, whose major work on evolution, *The Origin of Species*, was not published until 1859. In 1853, when Commander Matthew Calbraith Perry sailed off to open Japan to the West, among his gifts for the emperor, in addition to a plow, scythe, grindstone, and small-scale steam engine, were editions of Audubon's *Birds of America* and *Quadrupeds of America*, which sold, at that time, for $1,000 apiece.

aureole
Refers to a radiance that emanates from a figure, often from the whole body, not just the head (see HALO).

autodestructive art

Sometimes a form of HAPPENING, works designed to self-destruct were especially popular during the 1960s and '70s: for example, TINGUELY's construction *Homage to New York* (1960), a work intended to disintegrate. There is playfulness, humor, and a certain cynicism in the creation of such works. Among the purposes of autodestructive art (along with much art of the later 20th century) is its defiance of COLLECTING. However, as a form of PERFORMANCE, it has an opportunity to earn money from an audience. Also, in an era of film and video, the activity of the art, if not its material presence, is recorded and preserved for posterity.

autograph work

A term used regarding a work of art entirely by a single artist's hand to distinguish it from either misattributed works or those to which other artists may have contributed.

Automatism/automatic writing

See SURREALISM

autoradiography (neutron autoradiography)

Bombarding a painting with neutrons and measuring their half-life enables an analysis of the chemical composition of PIGMENTS. It also shows the distribution of specific pigments. Autoradiography creates images on film based on successive exposures over a period of about a month. These photographs may allow researchers to see how an artist built up a painting from the first to the final image. The fifth autoradiograph of Rembrandt's *Self-Portrait* of 1660, for example, shows a previously invisible sketch executed rapidly in a dark color. It provides, in essence, another work of art by Rembrandt for scholars to study.

Avery, Milton

1885–1965 • American • painter • Modern

Why talk when you can paint?

Avery used clearly outlined forms filled with harmonious colors, usually soft and light: pale greens, pinks, and lemony yellows. The majority of his pictures were of landscapes and figures. *Mother and Child* (1944) is an example of his structural simplification. In 1926 Avery married Sally Michel, a painter, who took a job as an illustrator so that he could devote himself to painting. Their apartment became a meeting place for younger artists, including GOTTLIEB, ROTHKO, and NEWMAN. Avery's influence had more to do with example than with ideology, for as the quotation above suggests, Avery was not fond of proclamations and would rather paint than talk about it. He, himself, had found inspiration in PICASSO and MATISSE, whose simplified and flattened shapes he adopted. During the 1950s, the popularity of ABSTRACT EXPRESSIONISM deflected interest from Avery for a time, but the strength and subtlety of his paintings have reasserted his importance.

Avignon

Avignon is a city in southern France, the capital of the Provence region. It was a small papal territory in 1305, when the papacy was moved there from Rome,

subjecting it to French rule. PETRARCH called this period, which lasted until 1377, the "Babylonian Captivity." The papal palace was richly decorated with murals and tapestries in the Avignon style, one that combined the elegance of Parisian painting with English and Flemish "realism of particulars" (see NOMINALISM) and Italian HUMANISM. This art became known as the International Style (see GOTHIC). DUCCIO's pupil MARTINI moved from SIENA to Avignon c. 1335, as did a number of Northern European artists. Some scholars speculate that animosity between Italy and France during the Avignon papacy, later aggravated by the Great Schism of 1378 to 1417 (when three rivals claimed the papacy), may have encouraged Italians to look chauvinistically to their own CLASSICAL past for inspiration, leading, subsequently, to the ITALIAN RENAISSANCE. After the popes left, Avignon remained a cosmopolitan city with royal residences and a MEDICI bank. During the 15th century, a school of painting that combined both Italian and NORTHERN RENAISSANCE influences flourished. It was for the Carthusian monastery in Avignon that CHARONTON painted the *Coronation of the Virgin* (1453) and perhaps the *Avignon Pietà* (c. 1455).

Aycock, Alice

born 1946 • American • architectural sculptor • Neo-Expressionist

The spaces are psychophysical spaces. The works are set up as exploratory situations for the perceiver. They can be known only by moving one's body through them.

During the 1970s, Aycock built structures like *Maze* (1972) and *The Beginnings of a Complex* (1977), which are, as described above, constructions and situations in which the "viewer" must experience the work physically in order to truly understand it. *Complex* might seem to resemble a child's playground, with freestanding wood and concrete constructions linked by underground passages. But the ladder descending into the tunnel and those ascending the buildings evoke the terrors of vertigo and claustrophobia. About the *Maze* Aycock added that she had wished to create "a moment of pure panic." More recently, Aycock designed a painted steel, fiberglass, and wood construction 20 feet high entitled *Tree of Life Fantasy: Synopsis of the Book of Questions Concerning the World Order and/or the Order of the Worlds* (1990–92). Painted white, it resembles a roller coaster, a totem pole, a tree—it suggests multitudes of associations but is, itself, none of them. And in contrast to her early works, it inspires amusement rather than feelings of anxiety.

B

Bacon, Francis

1909–1992 • British • painter •
Expressionist

*You can't be more horrific than life
itself.*

Bacon painted inexplicable violence,
pain, and fear, usually on large can-
vases. The way he applied paint was
consistent with the anguish he ex-
pressed—sometimes in attenuated
patches, rough smudges, and vaporous
veils—yet his colors could be luminous.
To the extent that they are discernible,
Bacon's subjects, or forms, are con-
torted and sometimes amputated bod-
ies, bloody mouths emitting blurred
screams, often naked men in sado-
masochistic symbiosis. Paradoxically,
though not atypically, Bacon was long
acclaimed by writers who discussed his
work with barely a nod to either his bi-
ography or his homosexual preference,
both of which are as integral to the
paintings as is their pigment. Born of
English parents living in Ireland (his fa-
ther trained racehorses there), Francis
was whipped and sexually abused by
stable hands as a child, and later
thrown out of the house by his parents.
He went to London at 16 and showed
some of his early work in galleries five
years later. He had no formal training.
"He talks about sex and alcohol the
way most people discuss the weather,
but he also exudes a natural courtliness
and grace, as if he were a good boy try-
ing to be bad," writes the critic Michael
Kimmelman. Bacon's lover, and the
subject of several pictures, committed
suicide during the course of the artist's
long, sordid, alcoholic life. Bacon said
that PICASSO and DUCHAMP were the
only 20th-century artists he admired; he
acknowledged the importance of
VELÁZQUEZ in a series of paintings in-
spired by the 17th-century Spaniard's
Pope Innocent X. While Velázquez's
pope embodies power and appears ma-
lign and suspicious, Bacon's oddly
transparent figure in *Head: Study after
Velázquez's Pope Innocent X* (1948–49)
floats on his throne, imprisoned inside
indefinite railings, usually called a space
cage, his skirt cut off beneath the knees,
his gaping mouth uttering a terrible,
silent howl. (To some critics, the un-
identifiable anxiety of Bacon's pope
calls to mind MUNCH's *The Scream* of
1893, while others conclude that he is
not necessarily screaming but could be
yawning or roaring with laughter.) An
unusual acknowledgment of Bacon's in-
fluence appeared in a 1989 version of
the movie *Batman,* in which the villain
destroys every work of art in Gotham's
museum except for one he liked—a
painting by Francis Bacon.

Baglione, Giovanni

c. 1566–1643 • Italian •
painter/writer • Baroque

*I know nothing about there being any
painter who will praise Giovanni
Baglione as a good painter.*
(Caravaggio, 1603)

Baglione's mistake was to copy the
work of CARAVAGGIO so well that it was
mistaken for that of the great master.
Caravaggio publicly ridiculed Baglione,
who in turn took him to court; the
comment quoted above was made by
Caravaggio during the first trial for
slander—there was a second three years
later, in 1606. Baglione's flirtation with
Caravaggesque style was brief, and de-
spite the other's derision, Baglione's ca-
reer was successful. By the time he died,
in Rome (where he was born and prac-
ticed throughout his career), Baglione
had been knighted and served as presi-
dent of the Academy of Saint Luke, to
which Caravaggio did not belong.
Baglione also wrote books, including
one of artists' biographies. His entry on
Caravaggio is remarkably unbiased,
though he does comment that Caravag-
gio ."sometimes would speak badly of
the painters of the past, and also of the
present, no matter how distinguished
they were." (See also CARAVAGGISTI)

Bakst, Léon (Lev Rosenberg)

1866–1924 • Russian • painter/stage
designer • Symbolist

*Our friendly feelings for Levushka
Rosenberg were mixed with some
pity. . . . He had been left without any
means of subsistence after the sudden
death of his father, a well-to-do man (a
stockbroker, I believe). . . . Levushka
had been obliged to find the means to
keep not only himself but also his
mother, his grandmother, two sisters
and a very young brother.* (Alexandre
Benois, 1964)

Bakst was a member of the WORLD OF
ART and of Serge Diaghilev's Ballets
Russes, which, from 1909 to 1929,
showcased talents in the fine and the
performing arts. Bakst collaborated
with BENOIS, whose *Memoirs* are
quoted from above, and was foremost
among Ballets Russes set and costume
designers—others included BRAQUE
and de CHIRICO. Bakst used strong, rich
colors and fantastic designs, much in-
spired by BEARDSLEY, for ballet subjects
he usually took from Russian folklore
and Oriental tales. His designs for
Schéhérazade (1910) conjured up a
barbaric and voluptuous East and be-
came the most famous decor of the age.
The architecture on the backcloth was
vaguely related to the mosques and
pavilions of Shah Abbas at Isfahan,
with their blue-and-green-tiled walls
and painted ceilings. (Bakst's blue-
green combination inspired the jeweler
Cartier to set emeralds and sapphires
together for the first time.) Golden
lamps hung from an immense looped
curtain of apple green and sky blue,
spotted with pink roses and circles of
black and gold. A coral carpet had blue
and pink rugs and was piled with cush-
ions. *Schéhérazade* established Bakst's
reputation and had widespread in-
fluence—on fashionable clothes and
interior decorating as well as on jew-
elry—after taking its Parisian audience
by storm.

baldacchino/baldachin

From the Italian for "canopy," refers to a structure of COLUMNS supporting a cover that usually stands above an altar. Or, as in RAPHAEL's painting *Madonna del Baldacchino* (c. 1508), the canopy shelters the Virgin and Child. Some baldacchinos were portable and may have covered holy relics that were carried in a procession. The most renowned baldacchino is BERNINI's design in Saint Peter's, Rome (1623–34). This gigantic bronze work has spiral columns and stands nearly 100 feet high beneath the church's DOME and over the main altar. The bronze was supplied by the BARBERINI pope Urban VIII, who had it removed from the roof of the Roman PANTHEON portico. (As one observer remarked, "What the barbarians failed to do [during the sack of Rome in 1527], the Barberini did.")

Baldessari, John

born 1931 • American • mixed media • Conceptual

I will not make any more boring art.

Baldessari had studied painting and was teaching it at the California Institute of the Arts in 1968 when he changed the name of his course to Post-Studio Art. He used "studio" to mean all the standard trappings of art: paints, brushes, and so on. During 1971 he wrote and repeated again and again the statement quoted above, and reproduced it as a LITHOGRAPH. Thus, making no "art object," Baldessari proclaimed his anti-MINIMALISM and anti-MODERN (POST-MODERN) manifesto. In *Heel* (1986), most of the 11 photographic images he assembled relate to feet—a dog getting its nails clipped, a horse being shod, injured human feet—but the central picture of a crowd scene in a city is perplexing. An absence of continuity and rational explanation provokes a viewer to return to the images in search of and to invent meaning. For another of his "works," Baldessari sang LEWITT's *Sentences on Conceptual Art* to a medley of popular melodies. Interested in theory, Baldessari studied STRUCTURALISM. The art critic Corrine Robins writes, "Reading shapes his thinking, which shapes his art, which is all about thinking—in a visual context."

Baldung Grien, Hans

1484/5–1545 • German • painter/printmaker • Northern Renaissance

[In 1544] Baldung created his final and most monumental expression of the vanquished artistic self. Produced . . . the year before the artist's death, and subverting all those scenes of origin with which Albrecht Dürer prefaced his oeuvre, Baldung's Bewitched Stable Groom *woodcut stands as a fitting end page to the brief moment of self-portraiture in German Renaissance art.* (Joseph Koerner, 1993)

Baldung is believed to have entered DÜRER's Nuremberg WORKSHOP by 1503. After a few years he settled in Strasbourg, where he spent most of his life. He was interested in the occult, and there is a strong vein of perverse eroticism in much of his work. It has been suggested that Baldung's intention was to overthrow the ideas of Dürer. Bal-

dung's dark-toned woodcut (see WOOD-BLOCK) *Witches' Sabbath* (1510) is set in a forest where both trees and witches are bare, and one witch rides backward on a flying goat. She carries a long pole with a forked end that supports a cauldron of brew. This same pitchforklike instrument reappears in one of Baldung's last PRINTS, an inexplicable image called *The Bewitched Groom* (1544), about which the historian Koerner writes above. The groom—a stable hand rather than a bridegroom—is flat on his back, radically foreshortened, his feet at the bottom edge of the picture and his head at the threshold of a stall where a horse looks over its shoulder at him. The groom has fallen on top of the double-duty hay pitchfork/witch's broom. A cackling, grinning hag peers in through a window. As strange as any other part of the picture is the fact that Baldung's own coat of arms is on the wall, and the work is considered a self-portrait, as Koerner writes. The mystery of the image is tantalizing, but whatever hidden meaning it may have, it does reflect the fascination with the bizarre that permeated the era and was especially popular among Protestants as an alternative to conventional religious imagery.

Balla, Giacomo
1871–1958 • Italian • painter • Futurist

On the 8th of March, 1910, in the limelight of the Chiarella theater of Turin, we launched our first Manifesto to a public of three thousand people—artists, men of letters, students and others; it was a violent and cynical cry which displayed our sense of rebellion, *our deep-rooted disgust, our haughty contempt for vulgarity, for academic and pedantic mediocrity, for the fanatical worship of all that is old and worm-eaten.*

Balla joined the original FUTURISTs but worked in Rome rather than Milan, where they were located. He signed the commentary quoted from above in the movement's *Technical Manifesto* of April 1910. One of Balla's best-known paintings is an amusing picture called *Dynamism of a Dog on a Leash* (*Leash in Motion;* 1912). The movement of the little dog, its leash, and the feet of the human walking it are shown by multiplying them in comic-book fashion, a kind of pinwheel effect. "Dynamism" was a rallying cry of Futurists.

Balthus (Count Balthasar Klossowski de Rola)
born 1908 • French • painter • Modern

I wish to do surrealism after Courbet.

The comment above was made after Balthus saw the first exhibition of SURREALISTs in Paris. Though he was never a member of their group, and was a great admirer of COURBET, there are elements of surreal fantasy and dreaminess in his pictures. A recluse who lives in the South of France, Balthus was obsessed with eroticism and adolescent girls, which he made a recurrent theme. It is evident, for example, in *The Golden Days* (*Les Beaux Jours;* 1944–46): A child of perhaps 12 reclines on a chaise in a seductive pose, with her legs apart, looking in a mirror. Behind her is a fireplace with a roaring fire, and the cropped figure of a shirtless man appar-

ently adding wood to the blaze. An eerie, unsavory mood is created by juxtaposing ideas of innocence and transgression, just as the simple, neat room conflicts with the scene's implied, sordid meanings.

Bamboccianti

A group of painters who were both popular and controversial in Rome during the 17th century. They showed the everyday working and street life of ordinary people—bakers, peasants, blacksmiths—rather than the well born (see also GENRE). Although the Bamboccianti neither idealized nor romanticized their subjects, as POUSSIN did his shepherds, for example, they were not social revolutionaries. They were not interested in showing poor people exploited by the rich, or in unveiling the serious social unrest among the underclasses. Their movement, precipitated by the Dutch artist van LAER and given his nickname (which means "malformed doll or puppet"), successfully drew a clientele from the constantly changing and ever-widening new moneyed class. One of van Laer's associates, Michelangelo Cerquozzi (1602–1660), was so well received that he even attracted some wealthy PATRONS and managed to gain admittance into the high-minded artists' GUILD, the Academy of Saint Luke in Rome. The popularity of the mainly Northern Bamboccianti both surprised and enraged artists of the establishment, who deplored the success of these unconventional competitors. Hostility became fierce, and denouncement—by ROSA, SACCHI, and RENI, among others—impassioned. The success of the Bamboccianti peaked in the 1640s and '50s.

Barberini family

The beginning of the BAROQUE era in Italy and the name Barberini are synonymous. Born in Florence in 1568 to a wealthy family, Maffeo Barberini was just 55 and in excellent health when he was elected pope in 1623, to begin a 21-year reign as Pope Urban VIII. He had fits of temper and dabbled in astrology, but was also deeply religious, handsome, cultivated, friendly, fond of poetry, and himself a poet. A volume of his poems, *Poemata* (1631), was illustrated by BERNINI. Bernini was the chief artist and architect for Urban VIII, who immediately set about the completion of Saint Peter's in Rome. Besides his famous BALDACCHINO, Bernini was also commissioned to design the pope's most important monument to himself, his tomb in Saint Peter's. The Barberini palace, filled with art and other treasures, had a theater with seating for 3,000. (The first opera performed there was a story by Giulio Rospigliosi, later Pope Clement IX, who was a PATRON of POUSSIN). Bernini was in charge of stage sets. An account by one theatergoer describes the spectacle: "When the curtain rose a marvelous scene appeared showing the most distant buildings in perspective, above all St. Peter's . . . and many others well-known to those who live in Rome. . . . Nearer that part of the stage where the acting took place was real water held back by dikes which had been specially placed round the scene and you saw real men rowing people from one side to the other." (This account brings to mind the sea battles staged some 1,600 years earlier at the COLOSSEUM, the ruins of which were located nearby.) Among other artists favored by the Barberini circle of

relatives and friends were Pietro da CORTONA, SACCHI, CLAUDE LORRAIN, and CARAVAGGIO. In a collaborative effort, Cortona, along with Carlo Maderno (1556–1629), BORROMINI, and Bernini, designed the Barberini Palace (begun 1628), now a museum. It once held the BARBERINI FAUN (c. 220 BCE), but that sculpture is now at the Glyptothek in Munich.

Barberini Faun
(also known as **Bacchus, Drunken Faun, Sleeping Faun/Satyr**)
Believed to be a Roman copy of a HELLENISTIC original (c. 220 BCE), this is a marble sculpture of a naked man who is apparently sleeping in a stupor of satiation, sexual and/or alcoholic. Because his ears are slightly pointed and he seems to have a tail, the assumption is that he is a satyr, or Pan (Latin *Faunus*), Greek god of the woods, fields, flocks, and herds, a follower of Dionysus (Latin *Bacchus*). His muscular body, spread out on an animal skin, is highly erotic, intimating the vulnerability of a person who is watched without his knowing, a voyeurism often used in portrayals of women but rarely of men. The Barberini sculpture was thought to have been found at Hadrian's villa. According to one story, it was thrown at Goths during the siege of Rome in 537 CE. Its first recorded reemergence was in 1628, when it was in the possession of Cardinal Francesco BARBERINI and had probably been restored by BERNINI. The Marquis de Sade found it "sublime," and Crown Prince Ludwig of Bavaria was obsessed by it. After competition from others who wanted it and some who did not want it to leave Italy, Ludwig was finally able to own the work. It

was taken to Munich in October 1819 by a team of nine mules, and it is still there, on view at the Glyptothek museum.

Barbizon, School of
By the 1860s, more than two decades after a group of LANDSCAPE painters had begun to live and paint there, the tiny village of Barbizon and neighboring hamlets Chailly and Marlotte, in and around the forest of Fontainebleau (about 30 miles from Paris), had become the most famous art colony in France outside of the capital itself. Tourists as well as artists from the rest of Europe and America traveled to see firsthand the inns, views, and even individual boulders and trees made famous by COROT, MILLET, and the leader of the Barbizon colony, Théodore ROUSSEAU. To Rousseau it was ARCADIA, and he imagined that "Homer and Virgil would not have minded sitting there and contemplating their poetry," as he put it. Guidebooks were written, paths paved, and signs were placed for sightseers to take their bearings. If the original Barbizon School painters sought to establish their idyllic rural art colony as an antidote to creeping industrialization and urbanization, commercialization also exploited the undeveloped landscape in direct proportion to the esteem in which it was held. The GONCOURTs parodied the Barbizon aesthetic in *Manette Salomon* (1867), a novel in which their artist is seized by "an almost religious emotion . . . each time . . . he felt he was before one of the great majesties of nature." Aside from sentimentality and anthropomorphism—giving human characteristics to features of the scenery—the pioneering

Barbizon artists, by studying the landscape and painting outdoors before completing their pictures in the studio (see PLEIN AIR), opened the path for IMPRESSIONISTS like MONET, BAZILLE, SISLEY, and RENOIR (who made painting excursions to the region). Certainly Barbizon—ultimately more a generic than a regional designation—was a new approach to painting the landscape. But more than that it was a new way of *contemplating* the landscape. It was a reactionary mode: The original Barbizon artists glorified nature and peasant life. Their concepts carried the echo of Jean-Jacques Rousseau's social philosophy having to do with people acting in harmony with nature. Also of great significance, it was the artist's own sentiments and attitude—toward the landscape and toward life—rather than either an accurate or an idealized report of what was seen by the eye, that counted for Barbizon artists and changed the core of landscape painting.

Barlach, Ernst
1870–1938 • German • sculptor • Expressionist

My mother tongue is the human body or the milieu, the object, through which or in which man lives, suffers, enjoys himself, feels, thinks.

A sculptor who often worked in wood, Barlach sometimes created figures engulfed in wide, volumetric robes. Structural details of the bodies beneath them are not visible, but their intuited presence and mystical energy are. Barlach visited Russia in 1906 and was impressed by its FOLK ART. He was also inspired by MEDIEVAL German sculpture. His *War Monument* (1927) is a floating bronze figure suspended above a tomb: Emerging from a pyramid-shaped floating cloak is just a head with eyes closed and mouth at rest. This monument expresses deep spiritual peace. It is as though we are able to witness a soul departing its body in this unique interpretation of a WAR MEMORIAL.

Barnes, Albert C.
1872–1951 • American • drug manufacturer/collector

This mystic, whom we have treated as a vagrant, has proved his possession of a power to create, out of his own soul and our own America, moving beauty of an individual character whose existence we never knew.

After inventing the formula for a silver nitrate, Argyrol, to treat gonorrhea, cystitis, and other diseases, Barnes became a millionaire at the age of 35. With the help of his Philadelphia high school classmate GLACKENS, Barnes began collecting art. By the early 1920s he had the greatest privately formed collection of IMPRESSIONIST, POST-IMPRESSIONIST, and early MODERN paintings in America. He also bought African art. Barnes established an art school on his estate in Merion, Pennsylvania. Enthusiastic about a mural by DOUGLAS at the Club Ebony in Harlem, in 1928 Barnes awarded him a tuition-free scholarship at the school plus a stipend (see HARLEM RENAISSANCE). Another black artist who excited Barnes's interest was PIPPIN. The quotation above, from a publication called *The New Negro*, is an appreciation of African-American art. Though he collected little American art, he did buy the first painting SLOAN ever sold. Barnes

established a foundation for educational purposes, but his collection was not generally open to the public during his lifetime, and access was still very limited for three decades after his death. In the early 1990s, however, restrictions were eased, and the Barnes Foundation agreed to release 80 paintings for worldwide exhibit while the galleries were renovated, lighting was improved, and a climate-control system was installed. The exhibition tour to seven cities raised $17 million toward the renovations. However, the hours at the museum were kept relatively limited.

Barocci, Federico

c. 1535–1612 • Italian • painter • Mannerist/Baroque

When a painting by Barocci, who used bright colors and gave agreeable looks to his figures, is seen for the first time, even by a connoisseur, it will please him perhaps better than a painting by Michelangelo, which at first glance looks so rude and unpleasant that it makes you turn your eyes away from it. (Bernini, 1665)

The Counter-Reformation called a halt to the artificial coloring, as well as the often erotic overtone, of Mannerist painting (see MANNERISM). In the middle of the 16th century, the tendency was to darken pictures and give them a more somber mood. However, as BERNINI suggests in the quotation above, Barocci found a style that acknowledged but overcame the austerity demanded by the Church. His use of clear and luminous color was acceptable as exciting spiritual rather than erotic ardor, and his paintings have an optimism that was missing in the dark canvases of TINTORETTO and CARAVAGGIO. Barocci worked in Rome for a time, but became ill (from an attempted poisoning, he claimed) and returned home to Urbino. When he sent *The Visitation* to Rome c. 1583–86, the canvas was so admired that a continuous line of people waited to see it during the three days of its exhibition.

Baroque

Specific delimitations and definitions of the Baroque period are not agreed on. Its beginnings in the early 17th century overlap with MANNERISM, and its dissolution during the last decades of that century is interwoven with the emerging interest in ROCOCO (see PERIODIZATION). Equally uncertain is the origin of the term. It may derive from a Portuguese word for a pearl with an irregular surface. In 1855 BURCKHARDT first used "baroque" in reference to STYLE. (For a stylistic theory about Baroque, see WÖLFFLIN.) In reaction to the affectation, artificiality, and apparent emotional detachment of Mannerism, art of the Baroque era reported both the more natural look of the world and a sense of personal engagement. There is, however, wide variety in Baroque art, from the stillness and restraint of POUSSIN and VERMEER at one end of the spectrum to the intensity of CARAVAGGIO and the action-packed drama of RUBENS on the other. These polarities are sometimes contrasted as, respectively, "Classic Baroque" and "Romantic Baroque." They turn up in still another guise as the dispute of LINE VS. COLOR. REMBRANDT's paintings and BERNINI's sculpture express the Baroque artists' concern with psychological motivation and response. The

Counter-Reformation is important to some but certainly not to all Baroque art. It did influence commissions originating in Rome around 1600, where, according to principles laid down by the Council of Trent, the papacy patronized art on a large scale "for the greater glory of God and the Church." In the Spanish Netherlands, the Catholic Restoration of Antwerp in 1585 influenced the artists' intention to draw the audience to the heart of religious experience. In Protestant Holland, Baroque art also flourished. The historian John Martin writes, "The problem of the Baroque may be somewhat simplified, if not fully resolved, by viewing the lack of stylistic uniformity as the result not only of national differences, but of a process of evolution." Part of this evolution was inspired by the tremendous advances in astronomy, optics, and physics during this period, as well as by the philosophical writings of Descartes.

Barr, Alfred Hamilton
1902–1981 • American • art historian/museum director

. . . a battleground of trial and experiment.

The Museum of Modern Art was founded in New York City in 1929, and Alfred Barr, at the age of 27, became its first director (1929–1943). A Harvard-educated art historian, Barr first studied paleontology, which helps to explain the scrupulousness of his scholarship. "He brought to his job a Calvinist integrity . . . and a broadly imaginative understanding of modern art as architecture, design and films as well as painting and sculpture," wrote the journalist Aline Saarinen in 1958. Barr was responsible for the early purchases that shaped MOMA (as the museum is known). He was especially astute in advising the Rockefeller family in their acquisitions of MODERN art, which also formed the core of MOMA's collection. Barr's comment quoted above refers to PICASSO's notorious painting *Les Demoiselles d'Avignon* (1907), which the museum owns.

Bartholdi, Frédéric-Auguste
1834–1904 • French • sculptor • Academic

Colossal statuary does not consist simply in making an enormous statue. It ought to produce an emotion in the breast of the spectator, not because of its volume, but because its size is in keeping with the idea it interprets.

Bartholdi was born in Alsace-Lorraine, which Emperor Napoleon III lost to Germany during the Franco-Prussian War. The sculptor's memorial honoring defenders of the fallen Alsatian town of Belfort, *The Lion of Belfort* (1871–80), was designed with passionate devotion. From its position on a rock ledge high above the town, the 70-foot-long, 38-foot-high lion expresses the idea that while France may have lost the war, her courage remains intact. In contrast to THORVALDSEN's heroically dying *Lion of Lucerne,* sculpted some 60 years earlier into live rock, Bartholdi's is twice as large, freestanding, carved of red sandstone, and fiercely protective. In his best-known and most colossal work, the 151-foot-high *Statue of Liberty* (1875–84), Bartholdi looked to the heroic woman in DELACROIX's *Liberty Leading the People* (1830) for ICONOGRAPHY, substituting a torch for Dela-

croix's flag. Gustav Eiffel, engineer/designer of the Eiffel Tower (1889), collaborated with Bartholdi on the iron-and-steel skeleton beneath the statue's copper sheeting. The presentation of *Liberty* as a gift from the people of France to the people of America was promoted by French libertarians determined to link their country's Third Republic with the democratic United States of America in defiance of Napoleon III. In June 1871, Bartholdi sailed for America. As his ship entered New York Harbor, he saw Bedloe's Island and conceived of putting his great monument there—where it still stands.

Bartlett, Jennifer

born 1941 • American • painter • New Image

. . . a conversation, where you start with a thought, bring in another idea to explain it, then drop it.

With the comment quoted above, Bartlett describes her composition entitled *Rhapsody* (1975–76), made up of 987 painted metal plates. Bartlett's innovation was to fill the gallery wall with even rows of 1-foot-square steel plates that were commercially coated with white enamel before she painted them. Some of the squares were designed to represent recognizable forms when assembled—a house, a mountain—while others were geometric. Some tiles were part of a larger composition; some contained scenes on a single square. Bartlett worked both in freehand and with mechanical implements. *Falcon Avenue, Seaside Walk, Dwight Street, Jarvis Street, Greene Street* (1976) is named after five streets she had lived on. Installed, the work is a horizontal sequence of five discrete compositions containing four-over-four tiles; each of the five represents one of the places she lived in New York and California. Bartlett was among a group of painters whose works the 1978 show at the Whitney Museum of American Art in New York called *New Image Painting* (see NEW IMAGE). During the 1980s, Bartlett mixed painted scenes, such as a wall covered with a landscape, with constructed objects set in front of them, like a table and chair.

Bartolommeo, Fra (Baccio della Porta)

1472–1517 • Italian • painter • Renaissance

Baccio was loved in Florence for his ability; was an assiduous workman, quiet, good-natured, and God-fearing. He preferred a quiet life and avoided vicious pleasures, was very fond of sermons, and always sought the society of learned and staid people. It is rare when Nature creates a man of genius and a clever artist that she does not prove his worth. (Vasari, mid-16th century)

Spiritually shaken by the death of SAVONAROLA, Bartolommeo put aside painting for several years and entered a Dominican order. Then, in VENICE in 1508, he studied the work of Giovanni BELLINI. Bartolommeo's impressive *Mystic Marriage of Saint Catherine of Siena* (1511) was influenced by one of Bellini's ALTARPIECES. It is more than 8 feet high and as imposing in affect as it is in size, yet it seems stilted in expression. Working in Florence, Bartolom-

meo used the pyramidal compositions of LEONARDO and in turn influenced RAPHAEL, to an extent. After Leonardo, Raphael, and MICHELANGELO left Florence, Bartolommeo and ANDREA del Sarto inherited the mantle. Yet it must be confessed that Florentine painting remained unexciting under their leadership until the style of MANNERISM took hold.

Barye, Antoine-Louis
1796–1875 • French • sculptor • Romantic

Just look: here is a huge lion defending itself against a serpent. What strength and naturalness in the pose! How graceful and facile is the carving of the curve extending from the animal's head to its tail. The Expression of the head is simultaneously frightened and angry. (Jules G. Janin, 1833)

Emotional extremes, terror to ecstasy, were hallmarks of ROMANTICISM. In sculpture as in painting, animals served to express or provoke fear. Barye created a new category as "animalier," showing the unbridled ferocity, strength, musculature, and predatory behavior of animals. He studied animals at the zoo, the Jardin des Plantes in Paris. Titles of his bronzes—*Jaguar Devouring a Hare* (c. 1830) and *Tiger Devouring a Gavial* (1831), for example—describe his themes. They combined the era's fascination with people and animals from distant lands with its taste for violence. That may explain why some of Barye's sculptures were refused by SALON juries after the July 1830 Revolutionary outbreak. However, his entry in the 1833 Salon brought rave reviews from the critic Janin, who is quoted above. A bronze cast of *Lion Crushing a Serpent* (1832) was ordered for the Tuileries Gardens. It was understood as a metaphor for the July Revolution, with the lion (zodiacal sign for July) representing the power of the people and the snake serving as a symbol of the evil of the Bourbon dynasty.

bas-relief
See RELIEF

Baselitz, Georg (Hans Georg Korn)
born 1938 • German • painter • Neo-Expressionist

It was not a matter of taking a form from the man and sticking it on the canvas. It was a matter of inventing the man.

Baselitz changed his name from Korn, dropping Hans, when he was 23. Enrolled in the Academy of Arts and Crafts in East Berlin in 1956, before the Berlin Wall had been built, he was suspended for "social and political immaturity." Baselitz began showing his paintings in the early 1960s in West Berlin and by 1969 he had become known worldwide for very large pictures with their subject matter turned upside down. His intention is that viewers look first at the painted surface as such, then begin to consider the image. Black, blue, and flesh-colored paint is applied in thick lines and swirls in *Late Dinner in Dresden* (February 18, 1983), and the faces—once they materialize (one man has two heads)—evoke fear and horror. Citing the precedent of

PICASSO's *Ambroise Vollard* (1910), Baselitz said that the artist "established Vollard as a painting, and not vice versa." In that context he added the comment quoted above.

basilica

From the Greek *basilikos,* meaning "royal." In ROMAN architecture the term referred to the building's function—public halls that accommodated numerous businesses, the stock exchange, law courts, offices, and administrative (including civic) services—rather than its form. It was, however, often an oblong building with side and center aisles and clerestory windows (that is, windows above the roof that covers the side aisles, but below the roof over the center aisle). The form and term were adopted for the Early Christian churches. Old Saint Peter's in Rome (begun c. 319, no longer extant), which Emperor Constantine ordered constructed at the place where Christians believed Saint Peter to be buried, was a basilica.

Basquiat, Jean-Michel

1960–1988 • American • painter • Graffiti

Royalty, heroism, and the streets.

With the comment above, Basquiat described the subject matter of his art. The royalty and heroism to which he refers is that of his black heroes, like the jazz saxophonist Charlie Parker, who is celebrated in a work called *Charles the First* (1982). Basquiat also used a crown as one of his own "tags," or signatures. His style is primal, using stick figures such as children draw—disturbed children with nightmares of grinning skele-

tons and unfriendly dogs: *Boy and Dog in a Johnnypump* (1982) is an example. Catapulted to fame before his death at 27 from a drug overdose, Basquiat has been mythologized, especially in a movie about his life. Controversy surrounds him: One challenge is that he is not a true graffiti artist to the extent that graffiti is considered a vernacular expression with high standards of craftsmanship in its calligraphic interlacing of letters. Basquiat merely scribbled his personal signatures—the crown and SAMO—short for "same old shit"—on marketable canvases more than on walls. The most serious doubts have to do with the promoting and marketing of Basquiat, son of an upper-middle-class Haitian and Hispanic family (not impoverished, in other words, as most true graffiti artists are presumed to be). Once discovered, he was coddled, feted, and, it is said, fed cocaine. In another camp are critics who consider him a natural genius and believe that his paintings "poetically evoke the vicious greed, racism, and inhumanity of the society he was struggling to learn to live within," as the director of the Whitney Museum of American Art wrote in an exhibition CATALOGUE surveying Basquiat's work. Both camps find ways of charging the other with racism.

Bassano, Jacopo (dal Ponte)

c. 1510–1592 • Italian • painter • Italian Renaissance

You must know, Oh!, Domenico, that during my journey I saw a miracle—a piece of black drapery that looked like white. (Giovanni Battista Tiepolo)

Jacopo's father and brothers were also artists, but his work was the most inno-

vative and enduring. Named after the small town in which he was born and spent most of his life, Jacopo was trained in and kept current of styles and trends in nearby VENICE. In fact, a portrait of Jacopo in the role of musician appears in one of VERONESE's great Venetian feast paintings, *Marriage at Cana* (1563). However, Jacopo remained faithful to what is called his "rustic" manner, exemplified by his *Pastoral Landscape* of the 1560s, in which women and children are involved in farm duties—milking a cow and feeding sheep—while a man carries home a heavy load. The road he travels leads to a landscape of hills and trees, painted with an energetic brush, beneath a sky full of scudding clouds. For works like this, Jacopo is known as a developer of GENRE paintings. He was admired by TIEPOLO, who wrote the words quoted above in a letter to his son. The painting to which Tiepolo refers is *Saint Lucille Baptized by Saint Valentine*, one of Jacopo's finest works, in which the thin strokes of color on Saint Lucille's clothing look almost black close up, and at a distance become a shiny white.

Baudelaire, Charles
1821–1867 • French • poet/critic

Modernity is the transitive, the fugitive, the contingent.

In chronology and in preference, Baudelaire reached across the great revolutionary periods of French life and art, finding himself in tune with MANET as well as DELACROIX. His poetry inspired SYMBOLISTS; his discussions of art were important to practitioners as various as COURBET (who included Baudelaire in his autobiographical pic-

ture *The Painter's Studio,* 1854–55) and the sculptor Medardo ROSSO. In his SALON reviews Baudelaire formulated ideas that serve as signposts to the directions art would take. He was never reticent, believing that a critic should be "partial, passionate and political." A great promoter of urban life, in 1845 he directed artists toward the epic, heroic qualities of the present, a theme he would expand on in *The Painter of Modern Life* (1863). The man he named as most closely realizing his idea, Constantin Guys (1802–1892), now little studied, was a journalist-artist who had covered the Crimean War. Guys was adept at rapid sketches and watercolors of SECOND EMPIRE Paris, scenes that would soon interest MANET, DEGAS, and other IMPRESSIONISTS. Indeed, before Impressionism made its debut, Baudelaire defined its concerns—the transitive, fugitive, contingent—as quoted above. He also discussed a subject that absorbed the Italian MACCHIAIOLI as well as members of the BARBIZON SCHOOL, writing, "There is a great difference between a work that is *complete* [which may be left rough, spontaneous, and open-textured], and a work that is *finished* [that is, worked up in detail, smoothed out]; in general what is *complete* is not *finished,* and . . . a thing that is highly *finished* need not be *complete* at all." This important idea became fundamental to MODERNISM.

Bauhaus
Bauhaus means "house for building." The name was given to a school of design founded in Germany by the architect GROPIUS in 1919, and it refers to a new teaching method rather than to a

particular style. The school began in Weimar, where it first manifested a short-lived EXPRESSIONIST phase that was replaced in 1923 by a commitment to "functionalism," the idea of the primacy of purpose or function over all else. The Bauhaus moved to Dessau in 1924, and from there to Berlin in 1932, but it was closed by the Nazis in 1933. Its faculty wished to break down the barriers separating painters, sculptors, architects, craftspeople, and industrial designers. While the principles of craftsmanship and the moral responsibility of the designer were adapted from the ARTS AND CRAFTS MOVEMENT, Bauhaus teachers chose to embrace, rather than reject, possibilities offered by industrialization and technological advance. From ART NOUVEAU, Bauhaus theorists and designers took the idea of the organic development in design and the involvement of the artist in all fields of visual expression. The core of Bauhaus teaching was a foundation course developed by Swiss painter and theorist Johannes Itten (1888–1967). It was meant to free the student from past experiences and prejudices—initially the curriculum offered non-Western philosophies and mystical religions. Bauhaus teachers included KANDINSKY, ALBERS, KLEE, and FEININGER. The INTERNATIONAL STYLE of architecture evolved at the Bauhaus. MIES VAN DER ROHE said of the school 20 years after it had closed, "The Bauhaus was not an institution with a clear program—it was an idea."

Bayeaux tapestry

Produced c. 1070–80 to record, commemorate, and justify the victory of William the Conqueror and his claim to the throne, this 20-inch-high, almost-230-foot-long narrative is a pictorial record of William's conquest of England. It was commissioned by his half brother, Odo, bishop of Bayeaux. It is named a TAPESTRY incorrectly, as it is embroidered (not woven) in wool on linen. Besides its political intent, the tapestry provides us with a rich historical document of everything from arms, armor, matériel, and techniques of warfare, to castle design and contemporary costume. As a cultural record, the Bayeaux tapestry is comparable to the NARRATIVE in the COLUMN OF TRAJAN. Stylistically, some scenes show an influence of the new ROMANESQUE style, but for the most part, the quest to present information takes precedence over style.

Bazille, Frédéric
1841–1870 • French • painter • Impressionist circle

I am completely alone in the country. My cousins and my brother are at the resort; my father and mother are living in town. This solitude pleases me enormously; it makes me work a lot, and read a lot.

The comment above was written in a letter to a friend shortly before Bazille left to join a French infantry unit, the Third Regiment of Zouaves, on August 16, 1870. While enjoying his solitude at that time, he was by no means a solitary type. On the contrary, he was a great and generous friend of first MONET, then RENOIR, both of whom he helped with money and lodgings. Bazille studied medicine and art, and it was in his drawing class in Paris (under GLEYRE) that he met Monet. In 1864 he failed

to pass the medical examinations and devoted himself to painting. He not only shared his studio with his friends, but he also painted it, and them: *The Studio in the rue la Condamine* (1870). MANET, Renoir, SISLEY, and a figure who may be Monet are in the picture. Renoir, in turn, painted Bazille painting dead birds—*Le Héron* (1867). (Sisley painted the same dead birds in a STILL LIFE.) With a more conservative style than that of his friends, Bazille's range was wide, from great bowls of flowers to erotically charged scenes of men sporting around a pool of water, standing, reclining, and wrestling in dappled light: *Summer Scene, Bathers* (1869). He has captured the tension of how men interact without looking at one another, in the same terms, and resulting in the same mood, as Thomas EAKINS's famous *Swimming* (1885). When Bazille wrote the letter quoted from above, he was working on a large painting, more than 6½ feet long: *Landscape* (1870) is a picture of sparse trees and dry ground. There has been speculation that Bazille planned to fill this landscape with figures, yet that seems unlikely, for each tree is individualized, almost anthropomorphized, as if to take the roles played by the men in *Summer Scene*. Bazille's final intention in *Landscape* remains unknown; he died in combat in the Franco-Prussian War on November 28, 1870.

Baziotes, William

1912–1963 • American • painter • Abstract Expressionist

The subject matter in [an artist's] work can be the tremors of an unstable world.

Among the earliest ABSTRACT EXPRESSIONISTs, Baziotes was one of the first to absorb SURREALISM and its use of automatism and BIOMORPHISM, in the early 1940s. *Cyclops* (1947), with a large eye in its center, is such a biomorphic form, floating in an amorphous space. It was inspired by a rhinoceros Baziotes fed peanuts to at the zoo. "He was playful and cute and toy-like, but at the same time, he chilled me. He seemed prehistoric and his eyes were cold and deadly," Baziotes later wrote.

BCE

An alternative to BC for purposes of dating, BCE stands for "Before the Common Era." (See also CE)

Bearden, Romare

1912–1988 • American • painter • Modern

Of great importance has been the fact that the African would distort his figures if by doing so he could achieve a more expressive form. This is one of the cardinal principles of the modern artist.

Using techniques of MODERN art—COLLAGE and CUBISM—Bearden explored his African heritage as well as the contemporary life of his people. *She-Ba* (1970), for example, is a boldly colored collage with deep and lighter greens, bright red, yellow, and orange surrounding the figure of a woman cut from black paper. The title comes from the name of an ancient kingdom whose people settled Ethiopia. The woman holds a scepter of the kind made familiar in ancient Egyptian art. Bearden established certain recurrent symbols, like the train, to symbolize white civiliza-

tion and its encroachment on that of blacks. A photo image of a train appears in the collage *The Prevalence of Ritual: Baptism* (1964), along with faces provided by West African masks and other objects both painted and pasted on the paperboard surface. "I seek connections so that my paintings can't be only what they appear to represent," Bearden explained.

Beardsley, Aubrey

1872–1898 • English • illustrator • Art Nouveau/Symbolist

I seldom or never advise anyone to take up art as a profession, but in your case I can do nothing else. (Edward Burne-Jones, 1891)

Beardsley worked in an ART NOUVEAU style, but he epitomized the decadence of the SYMBOLIST era and the sexuality that so fascinated it—keep in mind that Richard von Krafft-Ebing's treatise, *Psychopathia Sexualis,* was published in 1886 and translated into English in 1892. BURNE-JONES, who appreciated Beardsley's talent, as the quotation above makes clear, introduced him to the playwright Oscar Wilde, and Beardsley did pen-and-ink illustrations for Wilde's drama *Salome* (1894). In the drawing *Salome with the Head of John the Baptist,* Beardsley embodies the eroticism that MOREAU only implied in his renderings of the theme. As Beardsley's demonic Salome holds John's severed head to kiss it, they gaze into each other's eyes. Her expression is predatory, his apprehensive. Tendrils, peacock feathers, and one lascivious flower heighten the tension. This moment is the climax of Wilde's play,

and it synthesizes both a fascination with and a fear of female sexuality. The FEMME FATALE, so popular among PRE-RAPHAELITE artists, was nowhere as destructive a figure as in the hands of Symbolists like Beardsley and Moreau. Beardsley's limply swaying, curving lines, flowers, leaves, and tendrils are allied to the Art Nouveau style that flourished in the DECORATIVE ARTS.

Beaux, Cecilia

1855–1942 • American • painter • American Impressionism

More than all, the knowledge to which I had been so accidentally admitted (or was it a momentary access of generosity from the stars?) accompanied all the years (and accounted for much) of my predilection for portraiture, and the manifestations of human individuality. I always saw the structure under the surface, and its capacities and proportions.

Beaux earned success as a portraitist whose clients included the French premier Georges Clemenceau and the wife and daughter of American president Theodore Roosevelt. (She also made a drawing of Roosevelt himself, who sat for about two hours "talking and reading Kipling, reciting the same, also Browning," as she reported.) Beaux began her studies of art in Philadelphia, and returned there to teach at the Pennsylvania Academy of the Fine Arts after attending the ACADÉMIE JULIAN and traveling in Europe from 1888 to 1890. When she was elected to be an associate of the National Academy of Design in May 1894, contingent on submission of

a self-portrait for the academy's permanent collection, she showed herself in a three-quarters view with an earnest, determined gaze. Her palette had lightened after her studies in France, and she painted with a looser, freer hand. Besides important men, Beaux portrayed women with sensitivity, showing their character and strengths, whether beautiful young women lost in their own world, such as in *The Dreamer* (1894), or a sketch of the writer and reformer Ida Tarbell, who was her friend. She also gave biweekly critiques, in New York, for a painting class organized by the feminist and social reformer Elizabeth Cady Stanton.

Beaux-Arts style

An eclectic style of the 19th and 20th centuries, Beaux-Arts borrows from the various earlier ACADEMIC styles practiced at the ÉCOLE DES BEAUX-ARTS. In architecture, Beaux-Arts style combines new industrial materials with the earlier design approaches, as in the Bibliothèque Sainte Geneviève in Paris (1838–1850) of LABROUSTE, and in San Francisco, the Palace of Fine Arts (1915), designed by Bernard Maybeck (1862–1957). In sculpture, CARPEAUX's work is an example.

Beazley, Sir John P.

1885–1970 • English • art historian

In trying to ascertain the authorship of the paintings *on vases, it was necessary, if one may so say, to keep* potter *at arm's length. . . . Now that the* painters *of nearly all important Attic vases, and most of the less important, have been determined, the*

whole material must be restudied from the point of view of the potters; *and this time we must be prepared to hold the* painters *at arm's length. . . . Then it will be possible not only to write the history of Attic vases from the point of view of the* potters, *but, in the long run, to shed fresh light on the* painters *with whom they collaborated.*

John Beazley, quoted above, was an early student of Greek vase painting. Using the same methodology as MORELLI—identifying idiosyncratic details like the treatment of anatomy and clothing—Beazley distinguished the work of one artist from that of another, and gave numerous anonymous Greek vase painters an identity and personality. The BERLIN PAINTER is one of the important talents Beazley singled out, studied, and named, in 1911. (See also POTTERY)

Beckmann, Max

1884–1950 • German • painter • New Objectivity

My heart beats more for a raw, average vulgar art which doesn't live between sleepy fairy-tale moods and poetry but rather concedes a direct entrance to the fearful, commonplace, splendid and the average grotesque banality of life.

Hemmed in between two world wars, Beckmann served as a German medical orderly in the first and was a refugee—in Holland and later in the United States—during the second. His work moves between those shocks to the system he describes above: fearful, commonplace, splendid, average, and grotesque banality. Like the scenes he

painted, each value individually seems bearable, but combined they are intolerable. In some images, such as *The Dream* (1921), Beckmann jams a perverse cast of unseeing, unfeeling characters into tight spaces, translating the MEDIEVAL crowded design, or HORROR VACUI, into 20th-century suffocation. Beckmann was dismissed by the Nazis from his teaching post in Frankfurt. During the last 20 years of his life, his years of exile, Beckmann often used the Medieval TRIPTYCH, a three-panel ALTARPIECE format, together with the heavy outlines and strong color of STAINED GLASS. A triptych he completed just before he left Germany in 1933, *Departure* (one of a series), has depictions of dreadful, inexplicable horror on the two outside wings, and in the center, an ambiguous scene in which people ride in a boat on an infinite expanse of ocean. Beckmann was high on the list of artists whose work was maligned as DEGENERATE ART by Hitler in 1937. In a lecture delivered in 1938, Beckmann spoke of art as "the quest of our self that drives us along the eternal and never-ending journey we must all make."

Bell, Clive
See FRY

Bellini, Gentile
c. 1429–1507 • Italian • painter • Renaissance

Gentile was safely taken in [Turkish] galleys to Constantinople ... he was received graciously and highly favoured as being something novel, especially as he presented the prince with a lovely picture, which he greatly admired, wondering how a mortal man could possibly possess such divine talent as to be able to express natural things so vividly. Gentile had not long been there before he painted the emperor himself so well that it was considered a miracle. (Vasari, mid-16th century)

According to VASARI, Gentile was sent to Turkey in about 1479 in place of his brother, Giovanni (see below), where he carried out several commissions. Most of that work is lost but two splendid marbles do survive, one a dignified but relaxed bust, *Sultan Mohammed II,* with his long, sharp, thin nose and white turban, the other a picture entitled *Turkish Boy* (c. 1479–80). The boy, dressed in the most exquisite and delicately embroidered robe, works intently on his writing tablet. One of the stories Gentile brought home to VENICE is about how the sultan, dismissing a European picture of John the Baptist's severed head, ordered his swordsmen to behead a slave in order to show how a fresh decapitation should look. The punch line of the story is that Gentile then decided it was time to leave for Italy. On his return he painted *Procession of the Relic of the True Cross* (1496), which depicts one of the many elaborate parades in Venice. The figures seem to line up along the grid formed by the stonework of the Piazza San Marco in this 14-foot-long painting, which is a splendid record of the pomp and ceremony of contemporary Venetian life. Gentile's reputation eclipsed that of his brother, Giovanni, in their day, but because he was more conventional in style and expression, that changed over time.

Bellini, Giovanni

c. 1431/36–1516 • Italian • painter
• Renaissance

. . . the Grand Turk happened to see some portraits brought by an ambassador, which filled him with wonder and amazement, and although paintings are prohibited by the Mahommedan laws he gladly accepted them, ceaselessly praising the artist and his work and, what is more, requesting that the master should be sent for. The [Venetian] senate, reflecting that Giovanni was of an age at which he could ill support hardships, and unwilling to deprive their city of such a great man, especially as he was at the time employed upon the hall of the great council, decided to send his brother Gentile, who would, they thought, do as well. (Vasari, mid-16th century)

VASARI's account, quoted from above, may reflect his personal preference for the work of Giovanni over that of Gentile more than that of the Venetians, who actually appreciated Gentile well enough. Giovanni's birth date, and the dates of most of his paintings, which went unsigned, as well as the scant knowledge of his biography, all make his life seem as mysterious as his pictures. Part of their uncertainty may be due to the hazy, cloudy atmosphere of VENICE. As shapes become softened in such an ambience, so does sensibility. *Agony in the Garden* (c. 1465) presents the dawning of the day on which Christ will be arrested, and he awaits the soldiers while his apostles sleep. Bellini isolates Christ visually by showing us only his back and spatially by contriving a mound, away from his companions, on

which to set him. The scene is desert-like, with ominous details like a broken fence of spiky wood, a reminder of the Crown of Thorns. Moreover, the landscape is carved up by curving topological details that make it even more unsettling. This subject was also treated by Giovanni's brother-in-law, MANTEGNA, at roughly the same time, both artists having taken it from their teacher, Giovanni's father, Jacopo BELLINI (see below). Mantegna's and Giovanni's paintings are often contrasted to reveal the hard rockiness of Mantegna, the sharpness of his focus, the solidity of his presentation, the distress of his figures, and the elaboration of the buildings in the background. Giovanni's subtlety and his sensitivity to climate and illumination gain prominence by the comparison. Giovanni pioneered in the exploration of light and its effect on the landscape during different seasons, atmospheric conditions, and times of day. The ability to do this on canvas owed much to his mastery of OIL PAINTING. Until recently it was believed that Giovanni learned the techniques of oil painting from ANTONELLO, but studies now indicate that painters in Venice, including Giovanni, were using oil before Antonello arrived. Yet Antonello did seem to influence Giovanni, who took up techniques similar to those of van EYCK, which Antonello had learned. Giovanni's *Saint Francis in Ecstasy* (c. 1485) is predominantly oil. His arms open wide, Francis faces the light, perhaps praying to the rising sun. This ecstatic scene, with a fertile valley and a castle beyond the cave in which Francis lives, is crowded with symbols (e.g., a grape arbor signifying Communion) and a close observation of nature: More

than 20 different species of plants and animals have been identified. In 1506, DÜRER wrote an interesting assessment of Giovanni and of other Italians: "Among the Italians I have many good friends who warn me not to eat and drink with their painters . . . they copy my work . . . and then they revile it and say that it was not in the antique manner and therefore not good. But Giovanni Bellini has highly praised me. . . . All men tell me what a God-fearing man he is. . . . He is very old, but is still the best painter of them all."

Bellini, Jacopo
c. 1400–1470/71 • Italian • painter
• Renaissance

. . . he became so excellent that he was the most famous in his profession. To preserve this renown in his house, and to augment it, he had two sons, devoted to the arts and possessing great ability, the one Giovanni, the other Gentile, named after Gentile da Fabriano, his dear master, who had been like a loving father to him.
(Vasari, mid-16th century)

Only some 50 of his paintings survive, but about 310 drawings by Jacopo remain, the largest collection of drawings by any ITALIAN RENAISSANCE artist. Colin Eisler's 1989 study of Jacopo's role in the dazzling world of 15th-century VENICE describes him as the founder of the early Venetian Renaissance and its most famous painter. This changes earlier assessments that spoke of him largely as the father-in-law of MANTEGNA and the father of Gentile and Giovanni BELLINI (see above). A number of the works Eisler discusses are newly attributed to Jacopo, having

earlier been assigned to PISANELLO, with whom Jacopo competed. Jacopo is believed to have been an assistant to GENTILE da Fabriano (for whom he may have named his son, as VASARI says above) in painting the *Strozzi Altarpiece* (1423). He was certainly an influence on his son-in-law, but in that case the influence worked both ways. The new information Eisler provides is controversial. While Jacopo's *Madonna and Child with Donor* (c. 1441) breaks no new ground, his lovely and ambitious landscape setting, with tiny farms, castles, no fewer than four cities, and a mountain range, reveals his knowledge of PERSPECTIVE and an interest in the unique atmospheric coloring of Venetian light. Jacopo's two books of drawings, one now at the Louvre and the other at the British Museum, are dated c. 1450. They contain a great variety of subjects, exquisitely drawn, and were used as models for many Venetian artists. One perspective study, *Flagellation*, is an elaborately detailed architectural rendering of a large palace. Only on looking very closely does one see the distant figure of Christ tied to a column in the long covered walkway.

Bellori, Gian Pietro
c. 1613–1696 • Italian • writer/artist

. . . some people . . . in their schools and their books teach that Raphael is dry and hard, that his manner is statue like, and claim that he has no fire or spirit.

Bellori became the most important critic and chronicler of BAROQUE art in Rome during the second half of the 17th century. The son of a poor farmer, he grew up among art and artists in the

home of Francesco Angeloni, a rich collector, antiquarian, and writer. Bellori took art lessons from DOMENICHINO. He studied the art of ANTIQUITY and prepared a catalogue of some leading Roman collections, as well as his book, *Lives of the Modern Artists* (first published in 1672). He broke with VASARI's tradition (subsequently followed by BAGLIONE), by skimming over gossip—and even thoroughness—in order to concentrate on what he considered most significant in contemporary art: the concept of the IDEAL. Bellori's heroes were Domenichino, POUSSIN (his friend), ALGARDI, and, above all, MARATTA. He worshiped at the "altar" of RAPHAEL, and in the commentary quoted from above disparaged those who diminished his hero's work. For him the enemies were primarily CARAVAGGIO, BERNINI (whom he barely mentioned), CORTONA, and BORROMINI. Bellori's influence was great. In 1671 he was named secretary of the association for artists in Rome, the Accademia de San Luca (see ACADEMY), and became librarian and antiquarian to Queen CHRISTINA of Sweden (who settled in Rome in 1655) in the 1680s. Bellori's creed—which favored the CLASSICAL influence—had effect over the next century.

Bellows, George Wesley
1882–1925 • American • painter • Realist

You can learn more in painting one street scene than in six months' work in an atelier.

Bellows was an athlete at Ohio State University before he went to New York City, where he studied art with HENRI.

Bellows assimilated stylistic characteristics of the MUNICH SCHOOL and of HALS—a dark PALETTE against which white becomes luminous, bold "slashing" brushstrokes, and a coarseness that both reflected and created the subjects he painted. Bellows joined the ASHCAN painters and shared their commitment to experiencing and recording the unvarnished urban scene. His painting of street life on the Lower East Side, *Cliff Dwellers* (1913), shows the crowded, buzzing energy of tenement life in summer, when everyone lives outdoors. An ENGRAVING of this picture, published in the Socialist journal *The Masses*, carried the ironic quip "Why Don't They All Go to the Country for Vacation?" As did EAKINS before him, Bellows painted boxing pictures, but Bellows makes his predecessor's toughminded pictures seem dainty by comparison. Yet using the same dark palette and bold stroke, Bellows could also sensitively portray his blond-haired daughter, as he did in *Anne in Black Velvet* (1917).

Ben Day (benday)
A pattern, most often dots, that first appeared in printing, usually in newspapers and comic books, benday serves as a simplified means of giving tone to portions of a picture. The process was invented by a New York printer, Benjamin Day (1838–1916), and was adopted in painting by LICHTENSTEIN.

Benedictine
A monastic community was founded in the 6th century by Benedict of Nursia (c. 480–543). His guidelines for monastic life became the standard for what is known as the Benedictine order. During

the 9th century, a functional plan for a Benedictine monastery was drawn up and widely adopted. The prototype is for the Abbey of Saint Gall (c. 817) in Switzerland, originally rendered in red ink on five pieces of PARCHMENT sewn together. The central building is the BASILICAn church, and in surrounding structures were the SCRIPTORIUM, refectory (dining hall), school, and hostel—Benedict required that hospitality be extended to all visitors.

Benjamin, Asher
1773–1845 • American • architect • Federal

Columns, when well disposed . . . are very ornamental, and in some cases, of real use; but care ought to be taken, that they be properly placed in such situations as they will appear to advantage; and in such numbers, and of such size, as will best suit the building on which they are placed.

A working carpenter, Benjamin published seven handbooks, or builder's guides, among them the first original architectural design book in America—*Country Builder's Assistant: Containing a Collection of New Designs of Carpentry and Architecture* (1797)—from which the quotation above is excerpted. (An earlier volume, published in Philadelphia in 1775, Abraham Swan's *British Architect: or the Builder's Treasury of Staircases,* was originally published in England.) Benjamin's *The American Builder's Companion* followed in 1806. With his publications, Benjamin spread the ideas introduced in New England by BULFINCH throughout the expanding nation. It is estimated that 35,000 copies of his books were sold. Originally from Connecticut, Benjamin moved his practice to Boston, where it flourished in the early 19th century.

Benjamin, Walter
1892–1940 • German • literary critic/essayist

. . . that which withers in the age of mechanical reproduction is the aura of the work of art. This is a symptomatic process whose significance points beyond the realm of art. One might generalize by saying: the technique of reproduction detaches the reproduced object from the domain of tradition.

The quotation above is from Benjamin's essay *The Work of Art in the Age of Mechanical Reproduction,* first published in 1936. It is "perhaps, the single most discussed and influential cultural essay of the century," writes the historian Michael Camille, an opinion so frequently repeated that "perhaps" ought by now to be deleted. The disintegrating "aura" of which Benjamin speaks above is the ineffable, the mystical, the spiritual, the transcendental in a work of art, and, concurrently, the genius and authority of the artist. Benjamin's discussion evolves from the presence of photography and film as mass media, but it reflects backward to PRINT and forward to television, and even to virtual reality. With his ideas in *Mechanical Reproduction,* Benjamin lays the groundwork for the POSTMODERN. He describes how photography has altered the elitist nature of art works by providing REPRODUCTIONS available to the middle and lower classes. This has important influence on "the reaction of the masses" to art, and

on the politics of artistic reproduction, reception, and perception. Benjamin effectively eliminates the authority of both the art object and its maker, and detaches the art image from its ritual function—"the location of its original use value." The relation of "original" to SIMULACRUM, and the notion that to be original something must be reproducible, adds to the widening discussions Benjamin sparked. Born a Jew in Germany, Benjamin was in France during World War II, awaiting notification that he would be able to leave, when he was mistakenly led to believe that his freedom would be denied, and he killed himself.

Benois, Alexandre

1870–1960 • Russian • painter/stage designer/art historian • Symbolist

It is impossible to describe the excitement which took possession of me. The performance I had intended and dreamed of was unfolding itself to the music which had, so to say, been made to order for it, and had been composed in accordance with my wishes and been actually sanctioned by me. . . . On this memorable day I experienced that very rare feeling—not unmixed, somehow, with pain—that occurs only when something long wished for has at last been accomplished.

The rehearsal Benois describes above was one for which the ballet master was Michel Fokine, with the young Nijinsky in the troupe. Benois was an entrepreneur, artist, theater designer, critic, scholar, and leader of the WORLD OF ART movement. Along with the great impresario Serge Diaghilev and the designer BAKST, he brought the Ballets Russes to life and took it to Paris. Benois wrote extensively, recording his memoirs as well as the two-volume *History of Russian Painting in the 19th Century* (1901–02). He and his compatriots were absorbed with Russian history and culture. After the Revolution of 1917, Benois became curator of paintings at the Hermitage in Saint Petersburg, Russia's great museum.

Benoist, Marie-Guillemine

1768–1826 • French • painter • Neoclassicist

Let's not talk about it again or the wound will open up once more.

The works of 30 women were exhibited at the Paris SALON of 1793, Benoist's among them. (Her full name was Marie-Guillemine Leroulx-Delaville, comtesse Benoist.) She had been a student of VIGÉE-LEBRUN and was then studying under Jacques-Louis DAVID. Her masterpiece, which brought her fame in the Salon of 1800, is *Portrait of a Negress*, a three-quarter portrayal of a seated woman whose head is wrapped in a turban. She sits with one breast bared and gazes directly out at the viewer, who is placed slightly below her. The woman has dignity and beauty, though her eyes are sad. The painting was made six years after the abolition of slavery in France, and might be considered a manifesto of emancipation of both women and slaves. Benoist received commissions from Napoleon and a stipend from the government. When the monarchy was restored, her husband, Count Benoist, was appointed to a position of state, which meant she could no longer ex-

hibit her work. Her distress over the prohibition prompted the words quoted above from a letter she wrote to her husband.

Benson, Frank
See AMERICAN IMPRESSIONISM

Benton, Thomas Hart
1889–1975 • American • painter • Regionalist

I wallowed in every cockeyed ism that came along and it took me ten years to get all that modernist dirt out of my system.

Born and raised in Missouri, Benton studied briefly at the Art Institute of Chicago. He was influenced by the CUBISM and SYNCHROMISM that were flourishing in Paris early in the 20th century, as well as by the international aestheticism of the STIEGLITZ Circle. Then, as the tirade above reveals, Benton rejected all that. He became the leader and spokesman for the American REGIONALISTS of the 1920s and 1930s. Known as hard-nosed, reactionary, and xenophobic, he also celebrated the heroic, busy, gritty life of the American working class. Benton traveled through the South and Midwest to absorb the mood and rhythms of the country. In murals like *America Today* (1930–31), Benton monumentalized the everyday—subway riders and moviegoers, for instance—while, in the late 1930s, he gave mythic stories like those he painted in *Susannah and the Elders* and *Persephone* an earthy, American flavor. Benton's figures seem to burst the seams of their clothing and his scenes explode with energy, yet with all the jingoism of

his intentions, his writhing style resembles nothing so much as a 20th-century El GRECO.

Bérard, Christian
See NEO-ROMANTICISM

Berenson, Bernard
1865–1959 • American • art historian

Whatever comes, I shall always worship you without exception as the most life-enhancing, the most utterly enviable person I have ever had the good fortune to know.

Born a Jew in Lithuania, his father an immigrant peddler, Berenson converted to the Episcopalian religion. He was sponsored by wealthy Bostonians who financed his education at Harvard and in Europe, where he studied under MORELLI. Berenson wrote the words quoted above to his first major client, Isabella Stewart Gardner, whose home is today a museum in Boston that still has the major paintings Berenson acquired for her. Foremost among them is TITIAN's *Rape of Europa* (1559), long considered one of the most excellent paintings (if not the most excellent) of the ITALIAN RENAISSANCE in America. Berenson was brilliant and charming and renowned as a CONNOISSEUR. In 1895 he discredited a painting attributed to GIORGIONE, *A Lady Professor of Bologna,* saying it was "neither a lady, nor a professor, not of Bologna, and least of all by Giorgione." Berenson teamed up with the art dealer DUVEEN, and ethical questions have been raised about their partnership. Their correspondence, embargoed until the year

2005, should shed new light on their dealings. Berenson bequeathed his villa near Florence, I Tatti, with its art and book collection, to Harvard University, and it is used as a study center for Italian art. (See also SASSETTA)

Berlage, H. P. (Hendrik Petrus)
1856–1934 • Dutch • architect • Modern

Imitation architecture is a lie. Lying is the rule, truth the exception. And thus in architecture, decoration and ornament are quite inessential while space-creation and the relationships of masses are its true essentials.

In 1929, HITCHCOCK wrote, ". . . in Holland, the New Tradition is almost entirely dependent upon [Berlage] and has brilliantly developed the many tendencies inherent in his personal manner into a general national style." That style, identified with Nieuwe Kunst, the sober Dutch version of ART NOUVEAU, was expressed by Berlage with smooth redbrick facades and simple detailing in light stone at rooflines and windows. He used a variety of materials, but each according to its own properties, not frivolously or as substitute for or pretense of something else. His comments quoted above state his philosophy, as does his 1906 competition entry for the Palace of Peace in The Hague, sponsored by the American industrialist Andrew Carnegie. Berlage's unadorned building with brick and stone walls lost to a heavily ornamented design with multiple towers and spires reminiscent of a high GOTHIC church. The words "sturdy," "rational," and "functional" describe Berlage's work, in contrast to

that of some of his contemporaries (e.g., Eduard Cuypers, 1859–1927), who stressed architecture as art and a means of self-expression. Among the prominent architects who formulated a MODERN architectural idiom, Berlage played an important role in implementing the Dutch Housing Act of 1901, the first municipal legislation to mandate that when a town reaches a population of 100,000, it must draw up a master plan for future development.

Berlin Painter
6th–5th century BCE • Greek • vase painter • Late Archaic

One of the best Greek vases we possess is the amphora No. 2160 in the Berlin Museum. There is something specially charming about these graceful woodland people. . . . The question, however, who painted the piece has been variously answered . . . the present writer . . . now proposes to examine the work of this anonymous painter, who may be called the Master of the Berlin Amphora. (J. P. Beazley, 1911)

BEAZLEY introduced the "Berlin Painter," and named him for an outstanding vase, owned by the Berlin Museum, on which are depicted Hermes and satyrs. This artist, who specialized in large vases, often with single figures, is now recognized as a preeminent painter in the early period of the RED-FIGURE TECHNIQUE. His specialty was a tall, elegant figure rather than a scene, set against a black background, and executed with precise detail and impressive drawing skill. That detail and skill were so pronounced, in fact, that

Beazley privately described the Berlin Master to a colleague as "a model of conciseness carried ad absurdum." (See also POTTERY)

Berlinghieri, Bonaventura
active c. 1228–1274 • Italian • painter • Late Gothic

If thou wilt be perfect, go sell what thou has and give to the poor.

Bonaventura Berlinghieri was from a family of painters who worked in Lucca, not far from Pisa. His father, Berlinghiero Berlinghieri (died before 1236), is one of the earliest Italian artists identified by name; other than that there is little information about Bonaventura. The words from the Gospel of Saint Matthew quoted above are on his work, the first known pictorial representation of the legend of Saint Francis. It was painted for an ALTARPIECE dated 1235, only nine years after Francis died. Francis holds a book in his left hand and his right palm is forward, showing his stigmata, but most of his body—so elongated that the ratio of his head to the rest of him is almost 1:10—is swallowed up in his long, dark robe. Such robes are worn by monks of the mendicant order he founded in 1209, the Franciscans. Stiff, forward-facing (FRONTAL), with sunken cheeks and piercing eyes, in Bonaventura's *Saint Francis* the saint is both powerful and ethereal—he seems to be floating on tiptoe. Themes taken from the story of his life surround him, and in one of them he preaches to the birds who perch, in rapt attention, on what looks like a hill of cascading cake frosting. These conical shapes are stylized MEDIEVAL mountains. Berlinghieri's painting is an example of the MANIERA GRECA.

Berman, Eugène, and Léonid Berman
See NEO-ROMANTICISM

Bernard, Émile
1868–1941 • French • painter/writer • Symbolist

Anything that overloads a spectacle [of nature] covers it with reality and occupies our eyes to the detriment of our minds. We must simplify in order to disclose its meaning.

Bernard and GAUGUIN together devised a new approach to painting that rejected the tenets of IMPRESSIONISM and sought a simplified, almost "naive" approach—they even talked of imitating the art of children. Between 1886 and 1887, with Louis Anquetin (1861–1932) and TOULOUSE-LAUTREC, Bernard developed the style of flattened, outlined figures called (in February 1888) CLOISONNISM because it was reminiscent of CLOISONNÉ. Bernard defined his style as "a simplified handwriting which endeavored to catch the symbolism inherent in nature." *Breton Women in the Fields* (1888), painted the same year as Gauguin's *The Vision After the Sermon (Jacob Wrestling with the Angel)*, is an example of the two artists' similar stylistic approach. They also used the term SYNTHETISM, introduced by Gauguin. There is little agreement about whether Gauguin was the leader or the follower in the stylistic breakthrough they achieved; however, it is certain that Bernard was the more intellectual of the two. A breach be-

tween them occurred when they exhibited with the Impressionist and Synthetist Group at the Café des Arts, outside the grounds of the Exposition Universelle, or World's Fair, of 1889. The eight artists who exhibited were selected by Gauguin, and the deference paid to Gauguin alienated Bernard. In 1891 Bernard published the first lengthy article about CÉZANNE, whom he had not yet met but whose work he greatly admired. Bernard spent several years in Cairo, and on his return visited Cézanne. Later they corresponded. It was to Bernard that Cézanne made his famous comment about treating nature "by the cylinder, the sphere, the cone." In his writings Bernard promoted the work of both Cézanne and REDON.

Bernini, Gian Lorenzo

1598–1680 • Italian •
sculptor/architect • Baroque

Better a poor Catholic than a good heretic.

In the period that followed the Counter-Reformation, Bernini avidly championed Catholicism. The son and student of a Florentine sculptor who moved to Rome, Bernini was a child prodigy. Cardinal BARBERINI warned the father that his son would soon outstrip him. The father replied, "It doesn't bother me, for as you know, in that case the loser wins." Cardinal Barberini became Pope Paul V, on whose payroll Bernini's father was listed. Gian Lorenzo reportedly spent every day, for three years of his youth, sketching ancient marble sculptures in the Vatican. He worked for eight popes and several monarchs, as well as an array of lesser prelates and nobles. His talents were prodigious, not only as a sculptor and architect, but as painter, playwright, and stage designer too. Bernini was a Barberini protégé under Urban VIII (for whom he designed the BALDACCHINO over the high altar of Saint Peter's). He was occasionally supplanted, as when Innocent X became pope and, as new administrators conventionally do, replaced his predecessor's favorites: Innocent gave pride of place to ALGARDI and BORROMINI. Still, Bernini's fame was so great that, despite papal disregard, he received major private commissions. Then, even Innocent, of whom Bernini made a portrait bust in marble, could not resist and called him back. When Bernini was to sculpt Saint Lawrence, according to one story he put his own leg into a fire in order to understand his subject's pain. This search for truth in expression echoes the quest of his BAROQUE contemporary CARAVAGGIO. There is little correspondence in their characters, however. Bernini was profoundly devout: During the last 40 years of his life, at least, he went to church every day and took Communion twice a week. His most renowned sculpture is based upon the life of Saint Teresa and her description of the extreme but sweet pain she experienced after an angel plunged an arrow of fire into her heart. Bernini's portrayal of this mystical experience, *The Ecstasy of Saint Teresa* (1645–52), is in the Cornaro Chapel of Santa Maria della Vittoria in Rome. An angel stands above Teresa, whose head is thrown back, mouth open, eyes closed in a trance of both spiritual and sexual transport. The figures are enclosed in an elaborate architectural structure. Light

from a window above them illuminates a shower of bronze rays, yet the radiance seems to pour down from the ceiling, high overhead, which is painted with angelic forms, clouds, and light. On either side of Teresa, as if they were in box seats at a theater, are sculpted portraits of the Cornaro family, who interact with each other. Are they creating the vision before them? Or are they playgoers watching it unfold? How does the audience fit into the scheme? The fervor of Bernini's figures vitalizes marble, whether it is a horse bearing the emperor—*Constantine* (1654–70)—or the bust of a king—*Louis XIV* (1665)—who bears only his massive curls, a lacy cravat, and extravagant drapery. Bernini transcends the constraints of stone, as he put it, "to render marble flexible, so to speak, and to know how to combine painting and sculpture." But there was humor in his repertoire, too, and that is expressed with a wonderful baby elephant, outfitted majestically, carrying an obelisk on its back (1666–67) on the Piazza Santa Maria sopra Minerva in Rome. As Bernini created an entire dramatic experience inside the Cornaro Chapel, he also shaped religious experience in his architectural designs. When his son came upon him in the small church of Sant' Andrea al Quirinale (1658–70) and asked what he was doing there, Bernini replied, "I feel a special satisfaction at the bottom of my heart for this one work of architecture, and I often come here as a relief from my duties to console myself with my work." Entirely different in scale, but similarly all embracing in its effect, is the vast Piazza of Saint Peter's begun in 1656. The main function of the space was to contain the crowds that assembled for the papal benediction on Easter Sunday, but Bernini's parade of COLUMNS, which he likened to outstretched arms, was designed to welcome the faithful.

Bernward, Archbishop of Hildesheim

appointed bishop 993, died 1022 • German • patron

In the year of our lord 1015 Bishop Bernward installed the doors.

During the 11th century, the city of Hildesheim was the art capital of Northern Europe, and Bernward, himself an accomplished goldsmith, was a foremost PATRON of the arts. Inspired by monuments he saw during time he spent in Rome with the emperor Otto III, Bernward returned to Germany and commissioned doors for the OTTONIAN church of Saint Michael in Hildesheim (built under Bernward's direction 1001–31). This bronze portal of 1015, 16½ feet high, is surmounted by a band containing the inscription quoted above. It was made by the lost wax casting process, and was the first truly monumental sculpture cast in the north (see BRONZE). The decorative program pairs scenes from Genesis with illustrations of the New Testament. "The intellectual content of the doors matches the audacity of their physical creation," Marilyn Stokstad writes. "St. Bernward [canonized in the 12th century] must have designed the iconographical program himself, for only a scholar thoroughly familiar with both art and theology would have conceived of combining this clear narrative history with such subtle interrelationships." Juxtapositions of Eve and the Virgin, known

as the New Eve, imply that through Mary paradise may be regained (see TYPOLOGY). While it is an intellectually sophisticated narrative, the scenes are expressed in simple, direct, and highly emotional style, with features in the background shown in low RELIEF and animated figures in high relief. Bernward was also responsible for a bronze column that was inspired by triumphal monuments like the COLUMN OF TRAJAN in Rome. Bernward's column narrates the life of Christ, and in this work the style is intense, compressed, even brutal. It is not known when, where, or to whom Bernward was born, and the tomb installed for him in Saint Michael's is empty.

bestiary

A book about animals, real and mythical, the bestiary goes back to prehistoric lore. Accounts of animal life were recorded by Herodotus (5th century BCE), Aristotle (6th century BCE), Plutarch (c. 46–120 CE), and the Roman author Aelian in his *De natura animalium* (*On the Nature of Animals;* c. 220 CE). Bestiaries in Latin became popular in MEDIEVAL art and flourished in England, especially during the 12th and 13th centuries. For example, an English manuscript in the Pierpont Morgan Library, perhaps made in Lincoln and given to Worksop Priory in 1187, has a page illustrated with a hunter who is taking aim at a mother monkey. She holds one infant in her arms while another clings to her back. According to the accompanying text, a mother monkey loves one baby and neglects the other. When hunted, she will carry her favorite in her arms, but when she tires she will drop it, and only the unloved

baby will survive. Bestiaries were often heavily infused with Christian symbolism and morality, and one of their functions may have been for spiritual instruction. The prototype was written by an anonymous author now called Physiologus, the name also given to his book of animal lore. The actual date and place of origin for the *Physiologus* are unknown, though 200 CE and Egypt (Alexandria) are strong candidates. Numerous bestiaries were compiled, transcribed, and illustrated, content was updated, new animals (real and imagined) added, emphasis changed, and although all sorts of beasts, birds, and fish were included, these books always began with the lion. (See also ILLUMINATED MANUSCRIPT)

Beuys, Joseph

1921–1986 • German • sculptor/activist/performer • Modern

We must continue along the road of interrelating socio-ecologically all the forces present in our society until we perform an intellectual action which extends to the fields of culture, economy, and democratic rights.

An almost mythic PERFORMANCE artist whose persona was indistinguishable from his work, Beuys was a distinctive figure in his fishing vest and soft-brim hat. Art and political activism were synonymous for Beuys. He was a co-founder and an unsuccessful political candidate of the German Green Party. In one of his political demonstrations, organized in 1971 to protest deforestation, Beuys staged *Overcome Party Dictatorship Now,* in which volunteers swept the forest floor and painted white crosses and rings on trees designated to

be harvested for lumber. He created the idea of "social sculpture," in which everyone involved is both artist and performer. During the 1980s, Beuys came to think and talk of art as a means of reconstructing the entire social organism. "Only from art can a new concept of economics be formed, in terms of human needs, not in the sense of waste and consumption," he said. He found support in the writings of the Austrian social philosopher Rudolf Steiner (1861–1925), especially *The Philosophy of Spiritual Activity*. Reaching back to premodern, pre-Socratic times, when science and art were unified, Beuys saw the making of art as a religious, transcendent activity connecting artist and community. He talked of restoring to his audience the lost "primitive wisdom of being." Dismissing clear, logical, linear thought, which alienates people from the entire natural environment, he substituted a consciously intuitive mode of thinking. Beuys used fat as a sculptural medium because it quickly and directly responds to heat and cold, analogous to spiritual warmth versus cool rationality. He used animals including a horse, stag, elk, fox, swan, goat, coyote, hare, and moose in his drawings, performances, and sculptures. In performance he made animal sounds to give voice to animals who could not speak for themselves. "I see it as a way of coming into contact with other forms of existence, beyond the human one," he explained. In *How to Explain Pictures to a Dead Hare* (1965), which he described as a complex tableau about problems of language, thought, and human and animal consciousness, he carried a dead hare around a picture gallery while he, face

covered with honey and gold leaf, spoke to it. In *Coyote* (1974), Beuys spent day and night during an entire week enclosed in a room of a New York City gallery with a coyote and a number of props that included a flashlight (representing energy) and *The Wall Street Journal* (representing capital and commerce). Beuys associated the coyote with Native American spirituality, and one motive of this "Action" was to point up the importance of that consciousness. Beuys's personal history was as memorable as his presence. He was a pilot in the German Luftwaffe during World War II; in 1943 his plane was shot down over the Crimea. He claimed to have been rescued by nomadic Tartars who saved his life and restored him to health by wrapping him in fat and felt, both materials that he later used frequently in his art. The idea of art's beneficent power is a thread and theme in all of Beuys's work.

Biedermeier

This style, used mainly for furniture, reflects the relatively unpretentious values of the German and Austrian bourgeoisie of the period 1815–48. The origin of Biedermeier furniture was aristocratic, but compared to furniture of the Directoire (c. 1793–1804) and Empire (c. 1800–15) periods, it was more comfortable and simpler. The term is applied to other DECORATIVE ARTS as well, and painting to a limited degree. For example, the painting entitled *First Outing of the Emperor [Franz I] and Empress after the Emperor's Serious Illness, 9th April 1826* (1828–32), by Johann Peter Krafft (1780–1856), is wrapped up in the lively middle-class crowd rather than in the royal subject

for whom the work is named. The term "Biedermeier" was based on a satirical, fictional character named Gottlieb Biedermeier who was meant to typify middle-class vulgarity. It was applied to the style in the 1850s, somewhat after the fact.

Bierstadt, Albert

1830–1902 • American • painter • Romantic

His style is demonstrative and infused with emotion . . . [Bierstadt] doubtless holds that art from beginning to end is nothing more nor less than imitation— imitation inspired (if not controlled) by veracity, refined by taste, and, we may add, assisted by artifice; he likes a subject that is noble in itself, and disdains to illumine common things. (G. W. Sheldon, 1881)

Brought from Germany to America when he was two years old, Bierstadt returned to DÜSSELDORF to study in 1853. He worked with WHITTREDGE there, and the two went to Rome before Bierstadt returned to the United States in 1855. Then, in 1859, Bierstadt went with Col. Frederick Lander's army expedition, on horseback, to explore the West. He photographed and painted sketches of scenery that no white people had ever seen. Back East in his studio he used large canvases to paint the magnificent views he had seen—the 6-foot-high by 10-foot-wide *Rocky Mountains, Lander's Peak* (1863), for example. This not only portrays the sweeping, majestic mountains but also carefully records a Native encampment. The people are going about their daily lives in this fascinating combination of grandiose landscape and GENRE scene.

With his great success, Bierstadt challenged the preeminence of CHURCH in the field of landscape painting. On his second trip West in 1863, Bierstadt went all the way to California, recording the Yosemite Valley and the Sierra Nevada. His ROMANTIC canvases, exaggerated for dramatic effect (as the contemporary commentator quoted above points out), were stirring. In addition to the gold rush and the idea of Manifest Destiny (see COLE), Bierstadt's paintings fanned the flames of westward migration. His patrons were the country's wealthy new industrialists who enjoyed the conspicuous consumption his large-scale pictures provided, as well as their image of America's seemingly limitless natural resources.

Bingham, George Caleb

1811–1879 • American • painter • Romantic/Genre

. . . in dress, habit, costume, association, mind, and every other particular, [the boatmen] are an anomaly. . . . Mr. Bingham has struck out for himself an entire new field of historic painting, if we may so term it. He has taken our western rivers, our boats and boatmen, and the banks of the streams for his subject. The field is as interesting as it is novel. (*Missouri Republican,* Nov. 27, 1847)

Twenty years before Mark Twain wrote his famous stories, Bingham chronicled life on the Mississippi and Missouri Rivers. In luminous color and lively scenes, Bingham portrayed the fur traders and bargemen who transported raw materials and produce to market. It was, as the reviewer quoted above remarked, a new subject. That was also

true of *The Country Election* (1851–52), a crowded scene of activity where men (there are no women, as they did not yet vote) jostle one another, drink alcohol, electioneer, and carry on as a cross section of the population is wont to do in a carnival-like atmosphere. Whether Bingham meant the painting as an accolade, a CARICATURE, or an objective look at democracy in operation is left to the viewer to decide.

biomorphic

Used to describe abstract forms that seem organic or protoplasmic rather than discrete or firm. Examples of biomorphic forms are found in the sculpture of ARP, MOORE, and HEPWORTH, and in TANGUY's, MIRÓ's, and GORKY's painting.

Bishop, Isabel

1902–1988 • American • painter/printmaker • American Scene

I try to limit content in order to get down to something in my work. . . . I want to show that these young women can move, not just physically, but also in their own lives.

Bishop was born in the Midwest and arrived in New York City at 16. She studied at the Art Students League, and was only 22 when she rented her first apartment/studio at Union Square and 14th Street, an area then thickly populated with artists. With colleague Kenneth Hayes Miller, who was also her teacher, and other artists, she went to Europe to study the RENAISSANCE and BAROQUE masters. Interested in contemporary urban culture, Bishop spent more than 50 years painting and making PRINTS of everyday people—shoppers, shop girls, shoeshine men, bums, and especially the new culture of women office workers in New York City (e.g., *Encounter,* a painting, 1940; and *Office Girls,* an ETCHING, 1938). Her unique style—with energetically moving figures and often highly contrasting lustrous light and vaporous shadow—sometimes included pencil drawing on top of the lightly painted surface. The author Helen Yglesias writes: "Motion, depth, possibility, dignity, communion and autonomy combine with superb technique in Bishop's paintings and etchings of women in pairs, freeing them from the stultifying confines of pictorial *object,* allowing them to transcend the boundaries of canvas and frame, and to emerge as total persons, the aim of all great art."

bistre

A French word for a transparent brown PIGMENT derived from burned wood. REMBRANDT used dilute bistre for many of his brush drawings.

bitumen

Bitumen is a substance widely known in ancient times; the word is the Roman name for the hydrocarbons that occur naturally or are distilled from coal, petroleum, and asphalt. Bitumen as a brown PIGMENT yields a glossy, dark medium. However, it never thoroughly dries, and it virtually self-destructs over time, as paintings by RYDER testify.

black-figure technique

A 7th- and 6th-century BCE style of ARCHAIC Greek POTTERY decoration, this technique developed in Corinth: Black silhouette designs were drawn against the natural, red-orange clay. The black

was not actually paint but, rather, a clay solution that turned black in a three-stage firing process. For emphasis, outlines and details were incised, and sometimes color (red, white, purple) was added. A Corinthian masterpiece is the *Chigi Vase* (mid-7th century), named for the 17th-century Italian family who owned it. It is also an important historic document in that it shows contemporary military practice: Troops assembled in tight formation, advancing to the notes of a musician playing a double flute, carry shields in their left hands and swords in their right—they are the mercenaries called hoplites. The FRANÇOIS VASE is an Athenian black-figure masterwork from c. 570 BCE. (See also RED-FIGURE TECHNIQUE)

Black Mountain College
A progressive school in western North Carolina where many avant-garde artists taught after World War II. These included the composer CAGE, the dancer Merce Cunningham, and the painters ALBERS, DE KOONING, MOTHERWELL, and RAUSCHENBERG.

Blackburn, Joseph
active mid-18th century • American • painter • Rococo

. . . the English Rococo portraitist Joseph Blackburn established himself in Boston and ruled the city's market in the late 1750s, in effect setting standards for taste and price . . . it became incumbent upon American artisans to meet the challenge he posed. Copley did this in the case of Blackburn, first by imitating him and then, by 1760, by surpassing him, so that there was no longer any need for the Englishman himself. (Paul Staiti, 1995)

Blackburn settled in Boston in 1755, bringing with him from England the new Georgian ROCOCO style and its pastel colors. He also introduced the English CONVERSATION PIECE. His most renowned picture is *Isaac Winslow and His Family* (1755), in which the high-fashion velvet, satin, and lace clothing of his sitters is rendered in luscious color. As is true of FEKE, SMIBERT, and his other predecessors in the colony, Blackburn shows little sense of character or personality. However, unlike the others, he shows the prosperous merchant and his wife with the hint of a smile, which is actually a real smile on the face of one of the children. Although the most advanced artist in New England at that time, Blackburn was soon overtaken by COPLEY, as the historian Staiti remarks in the comment quoted above. (See REYNOLDS for Blackburn's portrait of Sir Jeffery Amherst.)

Blake, William
1757–1827 • English • painter/printmaker • Romantic Classicist/Symbolist

The taste of English amateurs has been too much formed upon pictures imported from Flanders and Holland; consequently our countrymen are easily brow-beat on the subject of painting; and hence it is so common to hear a man say: "I am no judge of 'pictures.' " But O Englishmen! I know that every man is so who has not been connoisseured out of his senses.

Blake was a mystic, seer, poet, and painter. He came under FUSELI's influence and was in thrall to ROMANTICISM's Sturm und Drang—storm and stress—as Fuseli had been. Blake was energetic in his defense of Fuseli when the latter's work was demeaned, and was equally ardent in his attacks on REYNOLDS, whose ACADEMIC tradition he resented and on whose *Discourses* he wrote highly critical annotations. He began, "Having spent the Vigour of my Youth & Genius under the Oppression of Sir Joshua & his Gang of Cunning Hired Knaves Without Employment & as much as could possibly be Without Bread, the Reader must Expect to Read in all my Remarks . . . Nothing but Indignation & Resentment." Blake was not, in fact, recognized during his lifetime, nor for long afterward. He had begun to draw from casts of ANTIQUE sculpture at the age of 10, spent a brief, unsatisfactory period at the Royal ACADEMY, and with greater rewards studied PRINTS of MICHELANGELO's work. As a visionary he thought he spoke directly with God, and he expressed his personal, religious sentiments in books he wrote and illustrated using the LINEAR mode of NEOCLASSICISM, combined with the oddly elongated and muscular figures of Fuseli. Blake devised a complex technique of ETCHING in an effort to approximate the look of ILLUMINATED MANUSCRIPTS of the MEDIEVAL period. *The Ancient of Days,* frontispiece of *Europe: A Prophesy* (1794), is one of his best-known prints: The bearded, windswept old prophet leans out from a fiery orb, rays of light emanating from his hand. Blake believed that Nature's forms are symbols to be understood through divine inspiration. In contrast to the violence implicit in Fuseli's work, Blake's world of dreams and visions is mystically ecstatic instead of threatening.

Blakelock, Ralph

1847–1919 • American • painter • Visionary

For a long time I thought that he was merely worrying because he was so unfortunate. No one would buy his pictures and he was very downcast. I thought if fortune would only favor us he would be himself again, but at last we were obliged to have him taken away. (Marian Blakelock, 1908)

The commentary above by Blakelock's wife is even sharper with the knowledge that once her husband was institutionalized due to a mental breakdown, his paintings started selling for great sums of money. She was living in such dire poverty that she could not even afford to visit him. Blakelock and RYDER, another American visionary painter, are often associated with one another. Both painted moonlit scenes in thick paint, IMPASTO. Blakelock was largely self-taught, and he did not go abroad for his rite of passage, as most ambitious American artists did. Rather, he went West to Colorado, Wyoming, Utah, Nevada, and California. *Moonlight, Indian Encampment* (1885–89) has the mysterious mood that characterizes all of Blakelock's pictures.

Blaue Reiter, Der (The Blue Rider)

Both the movement and the "Almanac" in which its philosophy was expressed were named after a cover illustration of horse and rider by KANDINSKY. He,

MÜNTER, and MARC were founding members of Der Blaue Reiter, which held its inaugural exhibition in Munich in December 1911 and January 1912 (later traveling to Berlin, Cologne, Hagen, and Frankfurt). Besides Münter, Marc, Kandinsky, and August Macke (1887–1914), other painters included the French artists DELAUNAY and Henri ROUSSEAU. An offshoot of German EXPRESSIONISM, members of Der Blaue Reiter had no common style; they did share, though, a penchant for spirituality and expressive color. Kandinsky was the group's leading theorist and spokesman. Der Blaue Reiter did not survive the First World War (in which Marc and Macke died).

Bles, Herri met de
c. 1510–c. 1551 • Netherlands • painter • Northern Renaissance

. . . it has been suggested that Met de Bles later settled in Italy, where he was called Civetta, *or little owl, because it was said that he always hid an owl somewhere in his landscapes as a secret signature.* (James Snyder, 1985)

Antwerp was the home of Herri met de Bles (whose name refers to a forelock of white hair), probably for his entire career. (For Antwerp, see PATINIR.) Taking advantage of the appetite for landscape painting among the new merchant class, met de Bles made that his specialty, often, if not always, tucking an owl somewhere in the scene, as the historian James Snyder reports above. Where earlier artists concentrated their landscapes in small, incidental views seen, for example, through a window or in the background of a biblical scene, now the biblical aspect seems almost incidental and the scenery is given precedence—a compositional style called inversion. Thus, met de Bles's *Road to Calvary* (c. 1535) takes place on a hill outside the imagined city of Jerusalem, which provides a beautiful and inviting microcosmic panorama, wrapped in atmospheric PERSPECTIVE. This "normalization" of an incident from Christ's Passion, while reversing the emphasis previously on the story, may have other sources or references. It could, for example, represent one of the Passion plays that were popularly staged at that time. Nevertheless, the landscape was still his preoccupation, as his preliminary sketches, which leave out people entirely, demonstrate. Met de Bles was greatly influenced by his uncle, Joachim PATINIR.

Bleyl, Fritz
See Die BRÜCKE

Blunt, Anthony
1907–1983 • English • art historian

It is fair to conclude not only that [Poussin] was well versed in their ideas but that he regarded Stoicism as a guide to the conduct of his life.

A specialist in French art and the 17th century, Blunt ranked high in British cultural life: Director of the Courtauld Institute of Art (1947–74), Surveyor of the King's/Queen's Pictures (1945–72), he was knighted in 1956. Blunt's studies of POUSSIN are authoritative. Dismissing FRY's assessment that Poussin's compositions were cool, FORMALIST exercises, Blunt investigated their meaning. Through the artist's letters, in addition to the paintings themselves, Blunt focused on the role of Stoicism,

especially as it had been synthesized by early Christian theologians, both on Poussin's life, as in the comment quoted above, and on his paintings. Taking Blunt's approach a step further, the historian Mark Roskill uses it to demonstrate how Blunt's studies of Poussin may in turn mirror Blunt's own personal, moral, and philosophical preoccupations. That indifference and the "cool detachment" characteristic of Stoicism, and the use of allegory to mask events, are seen to parallel Blunt's own masquerade: During World War II Blunt, who had Communist sympathies and had studied with ANTAL, was a military informant for the Russians. While he carried on his official life, these facts were hidden from the public, similar to the artifice behind which Poussin hid his lack of sympathy for the Catholicism current in Rome.

Boccaccio, Giovanni
1313–1375 • Italian • writer

There is nothing which Giotto could not have portrayed in such a manner as to deceive the sense of sight.

Boccaccio wrote courtly romances, pastoral poems, and learned treatises, but he is most remembered for the *Decameron* (1348–51), the earliest important work of vernacular, colloquial literature ever written in narrative prose in Western Europe. The text is made up of 100 stories about love, sex, adventure, and trickery. The setting is a country villa outside Florence to which seven women and three men have gone to escape the bubonic plague (Black Death) of 1348. The literary NATURALISM with which Boccaccio treats his characters is

part of the nascent HUMANISM of the ITALIAN RENAISSANCE that would blossom over the next century. Boccaccio was a friend and follower of PETRARCH, and, as the quotation above suggests, an admirer of GIOTTO, whom he considered "the Petrarch of painting."

Boccioni, Umberto
1882–1916 • Italian • painter/sculptor • Futurist

In the monuments and exhibitions of every European city, sculpture offers a spectacle of such pitiable barbarism, clumsiness, and monotonous imitation, that my Futurist eye recoils from it with profound disgust!

Boccioni jointly signed the FUTURIST manifestos with his colleagues. He also wrote his own *Technical Manifesto of Futurist Sculpture* (1912), which begins with the comment quoted above. His paintings fully realize Futurist dynamism, which he also expressed in sculpted works. With the Futurist's disdain for the "boring" nude, and insisting on "absolute and complete abolition of definite lines and closed sculpture," Boccioni wrote, "We break open the figure and enclose it in environment." His best-known work, *Unique Forms of Continuity in Space* (1913), is a striding bronze figure whose clothing moves in energy-whipped, curving surfaces. It is interestingly compared with the NIKE OF SAMOTHRACE (c. 190 BCE), a statue whose robes and wings also define its movement. Both might be said to exemplify a figure enclosed in its environment, so to speak. Boccioni died in 1916 in a fall from a horse.

Bochner, Mel
born 1940 • American • installation • Conceptual

Everything that exists is three-dimensional and "takes up" space (space considered as the medium in which the observer lives and moves). Art objects are qualitatively different from natural life yet are co-extensive with it. This results in the unnaturalness of all art (a factor of its intrusion).

Bochner majored in philosophy at college, and in New York during the 1960s contributed important critical writings about MINIMAL and PROCESS art, and participated in the formulation of ideas concerning CONCEPTUAL art. He based his own work on mathematical theory —for example, *Three Ideas and Seven Procedures*, ostensibly concerned with describing seven methods, *beginning, adding, repeating, exhausting, reversing, canceling and stopping*, which was shown at the Museum of Modern Art in 1971. This INSTALLATION was, in part, written on a length of masking tape that connected spaces and was made up of counting sequences recorded in black and red, with a counter sequence in red.

Böcklin, Arnold
1827–1901 • Swiss/German • painter • Symbolist

Your remark that an easel picture should not be treated like a decoration, but carried out as the expression of a definite practical mood, precisely reflects my view concerning this picture. . . . Up to now I have kept the work carefully hidden, in order not to be led astray by premature comments. At a later stage, however, an expert opinion becomes indispensable, because the eye can grow accustomed even to mistakes.

Böcklin lived in Italy after mid-century, and the comments quoted above were written in Rome, in 1865, to a PATRON for whom he was painting a picture. Back in Basel, his birthplace, during the Franco-Prussian War of 1870–71, Böcklin contemplated human brutality as he heard and saw the fighting across the Swiss border. This he expressed in *The Battle of the Centaurs*, of which he painted different versions in 1872–73. As ancient Greeks had used conflict between those mythological half-human, half-horse creatures as metaphors for contemporary events, so too did Böcklin, who painted them throwing boulders and pulling hair. His centaurs struggle grotesquely on a perversely un-Greek, snow-covered landscape. *Centaurs* is Böcklin's most renowned work, but he also painted strange, moody landscapes like *Island of the Dead* (1880, first version). Synthetic, as SYMBOLIST art intended, *Island* draws together elements from different landscapes in an imaginary, subjective picture of a haunting, lonely place. The title was assigned later; Böcklin himself called the work "a picture for dreaming over." Böcklin inspired a series of German followers, and later was much admired by SURREALISTS, de CHIRICO especially. In his later years Böcklin was preoccupied with designs for an airplane.

body art

As CONCEPTUAL artists reject the goal of creating objects as the artist's goal, and as EARTH AND SITE artists change the landscape instead of painting it, a group of artists, during the late 1960s and early 1970s, began to use their own bodies as their "canvas" or sculptural medium. Body art sometimes involves self-mutilation, as when the American BURDEN dragged himself, bare-chested, through broken glass. Some body art is made not *in* public, but through documentation (e.g., photographs and film) is made *for* the public. A good deal of FEMINIST body art is confrontational, challenging beliefs about propriety: Annie Sprinkle sat naked onstage and offered viewers a speculum with which to examine what most had never seen: a female's internal organs. Embarrassment aside, at least some viewers must have questioned the cultural conventions that made such an act of seeing seem sinful.

Bol, Ferdinand

1616–1680 • Dutch • painter/etcher • Baroque

In the burgomasters' room, above the mantelpiece, towards their chamber, done by Ferdinand Bol, 1500 guilders. (Contract, 1655)

According to GUILD regulations, students were not permitted to sign their works as long as they worked for a master. Bol was a pupil of REMBRANDT, and there is a memo on the back of a drawing in which Rembrandt notes that he had sold two of Bol's paintings. This was a usual practice. Bol worked for Rembrandt during the 1630s, then went on to make up his own successful career; one of the first known paintings with his signature is c. 1635. A later work, *Jacob's Dream* (c. 1645), has some of the master's spirituality, but also an affectation of elegance not to be found in Rembrandt. While Bol's early paintings bear strong resemblance to Rembrandt's, they became more bland in time. In 1655, along with FLINCK and LIEVENS, Bol received a commission to paint the new town hall in Amsterdam—the contract is quoted from above. When he married a wealthy merchant's widow in 1669, Bol stopped painting.

Bondol, Jean

active c. 1368–81 • Flemish • painter • Late Gothic/International Style

In the year of the Lord 1371, this work was illuminated by order and in honor of the illustrious prince Charles, King of France, in the thirty-fifth year of his life and the eighth of his reign; and John of Bruges, painter of said King, has made this picture with his own hand.

The inscription quoted above emphasizes that the illustration next to it is by the hand of Jean of Bruges, as Bondol was known, and no one else. This information appeared in large gold letters in a Bible that was presented to Charles V, Bondol's PATRON and an ardent bibliophile. In fact, opposite the claim is a MINIATURE showing the presentation of the book to Charles by the courtier who

paid for it. As far as its placement, size, and content are concerned, the inscription was unprecedented. Bondol's paintings followed the path set earlier by PUCELLE, giving weight and substance to figures and placing them in defined spaces. In addition, Bondol was fascinated with repetitive decorative patterns, like the fleur-de-lis, which he used in the manner of all-over wallpaper design. His best-known work, the *Angers Apocalypse Tapestries* (c. 1373–82), was executed for Charles's brother, Duke Louis of Anjou. At that time the TAPESTRY was the most expensive art form. In Northern Europe it took the place of the FRESCO and additionally served for insulation, covering cold stone walls with blankets of woven plants and fantastic animals in rich colors. Bondol prepared CARTOONS for the tapestries that were executed under the supervision of Charles's weaver, Nicolas Bataille. Each of the six individual pieces was almost 15 feet high, and the suite was more than 470 feet long in total. Their source was the Book of Revelation, Saint John's vision of the end of the world. Of almost 90 original scenes, about 70 survive. PANOFSKY wrote of Bondol's work, "With honest, straightforward veracity biblical events, legends of the saints—or for that matter from Roman history—are staged in a bourgeois or rustic environment portrayed with a keen, observant eye for landscape features and such homely details as casually draped curtains, seats and couches with wooden overhangs shaped like diminutive barrel vaults, and crumpled bedspreads."

Bonheur, Rosa

1822–1899 • French • painter • Romantic

Why wouldn't I be proud of being a woman? My father, that enthusiastic apostle of humanity, repeated to me many times that woman's mission was to uplift the human race, that she was the Messiah of future centuries. I owe to his doctrines the great and proud ambition . . . for the sex . . . whose independence I will uphold until my last day. Moreover, I am persuaded that the future belongs to us.

Bonheur's father was associated with the Saint-Simonian Socialists whose programs included equality for women. Bonheur herself became internationally renowned as a painter of animals. She rejected the ferocious, exotic, and often bloody subjects of other ROMANTIC artists (e.g., DELACROIX and BARYE) to paint working animals like the oxen in *Plowing in the Nivernais* (1849). This painting may have been inspired by a passage about rural life in one of George Sand's novels. *Horse Fair* (1853) bursts with the energy of magnificent, barely restrainable horses. For 50 years it was among the most widely admired paintings in the West. For her research Bonheur went not just to country fairs, but also to slaughterhouses. For the latter, she had to get permission from the prefect of police to dress in the appropriate attire, which was men's clothing. She explains this in her *Reminiscences* (published posthumously, 1910), which is quoted from above. In 1894 Bonheur became the first woman officer of the French Legion of Honor.

Queen Victoria and Cornelius Vanderbilt were among her admirers and clients.

Bonnard, Pierre

1867–1947 • French • painter • Nabi

I am of no school. I am looking only to do something personal.

For several years Bonnard shared a studio with VUILLARD and DENIS. Like them, he was a member of the NABIS circle, and later of the FAUVES, and as his comment above hints, he tried and incorporated many stylistic approaches, including ART NOUVEAU. "Intimate" is the word used to describe the mood of both Bonnard's and Vuillard's small paintings of everyday, middle-class life. Bonnard is the more complacent of the two, with images like those of a girl at a writing desk and children leaving school. Even when he painted outdoor scenes, he gave them an indoors intimacy. An example is the small painting on wood, slightly more than a foot high and 10 inches wide, *Two Dogs on a Deserted Street* (c. 1894). Set on a city street, the space nevertheless feels private and confined, as there is no sky and the buildings press the animals toward the front of the PICTURE PLANE. Tacking his canvas on a wall rather than using an easel, Bonnard usually painted from memory and from quick sketches in pen and ink and in pencil. He worked in his dining room or in a hotel room, but rarely in a studio because he was so intent on preserving the immediacy and spontaneity of inspiration. It is Bonnard's later landscapes, interiors, and nude figures that represent his claim to being a MODERN artist. *Dining Room on the Garden* (c. 1933) is a scene in bright color that compresses the table and wall, trapping a female figure between them and isolating her, off to the side, from the window that looks outside to the garden. This picture contains echoes of MATISSE, especially a work like his *Red Room (Harmony in Red)*, of 1908–09, to which it is similar in subject and sensation though not in color, for Bonnard's PALETTE is luminous rather than bold. He used geometry inventively to structure and stabilize a canvas, and sometimes his complex, busy patterns hide figures that emerge only after concentrated study of the canvas, or else quite by surprise. In 1945 Bonnard commented, "There is a formula that perfectly fits painting: lots of little lies for the sake of one big truth."

Bonnat, Léon

1833–1922 • French • painter • Academic

I was brought up in the cult of Velázquez. As a youngster I was in Madrid. On the brilliant days that one sees only in Spain, my father sometimes brought me to the Prado where we lingered in the Spanish rooms. I always left with a feeling of profound admiration for Velázquez.

Born in France near the Spanish border, Bonnat was raised and studied art in Spain before he continued his schooling first in Paris and then Italy. He worked in the HISTORY PAINTING mode, as did his friend and traveling companion—to Egypt (for the opening of the Suez Canal), the Sinai, Palestine, Turkey,

and Greece—GÉRÔME. Bonnat's paintings, while also in the ACADEMIC mode, probe more deeply into emotional states than do those of Gérôme. *Job* (1880) shows with a disturbing degree of exactitude the emaciated body of an old man. For his painting *The Crucifixion* (1874), as a student (who bribed a guard to let him see the model) wrote home, ". . . standing up against the wall was the large cross with the subject [corpse] crucified on it, a horrid sight; but it shows how these French artists believe in truth." The student was WEIR, one of more than 60 Americans who studied with Bonnat. EAKINS was another, and it was probably Bonnat who encouraged Eakins to visit Spain. Bonnat was renowned for history and religious subjects, and as a portraitist. Though he first taught independently, he was later given a position at the ÉCOLE DES BEAUX-ARTS.

Book of Hours
A selection of psalms and prayers for daily use at the canonical hours. In the latter Middle Ages, Books of Hours were usually preceded by a calendar and specific prayers like the Penitential Psalms. Small, usually prettily illustrated, these Books of Hours were intended to be held and admired and to be used for private devotion. They reflected the increase and popularity of private piety during the late MEDIEVAL period, in part a rebellion against the financial excesses (the selling of indulgences, for example) and political upheaval (see AVIGNON) in the official church. Popular reform movements of the late 14th and 15th centuries stressed the power and importance of personal

piety. The most beautiful Books of Hours belonged to wealthy Medieval aristocrats, as indicated in this verse of Eustache Deschamps, written at the end of the 14th century: "A Book of Hours, too, must be mine / Where subtle workmanship will shine, / Of gold and azure, rich and smart / Arranged and painted with great art, / Covered with fine brocade of gold. . . ." Though Deschamps chides the social pretensions of wealthy buyers, thousands of plain versions were owned by ordinary people, and the Book of Hours is as much a part of POPULAR CULTURE as it is of HIGH ART. Although most books were made by monks before 1100 (see SCRIPTORIUM), after 1200 they were produced by professional scribes, often in commercial studios. The text, perhaps highlighted with initials of burnished gold, could take less than a week. MINIATURES could be painted at the rate of two or three per day, depending on size and complexity. While PAPER was used for some books, those that were meant to be luxurious and to last a long time, as were the Books of Hours, were on PARCHMENT. Paris was the great center for production during the 14th century, and it was there that the best-known, and to many the most beautiful, Book of Hours in the world was made: *Très Riches Heures,* painted by the LIMBOURG brothers (1413–16) for their patron, Duke Jean de Berry. (See also ILLUMINATED MANUSCRIPT)

Book of Kells
The largest (13 × 9½ inches) and richest ILLUMINATED MANUSCRIPT in Ireland, the *Book of Kells* is an early-9th-century gospel and was called the

"chief relic of the Western World" as early as the 11th century. It and the *Lindesfarne Gospels*, another HIBERNO SAXON manuscript, produced a century earlier, are two of the world's greatest works of art. Lavish, intricate, and extraordinary in its imaginative design, the *Book of Kells* is probably the manuscript described in the 12th century as "the work of angels." In fact, its date and place of origin are uncertain. The most famous page, densely decorated and known as a "carpet page" (a term coined because of a resemblance to Persian rugs), is that with Christ's monogram, the CHI RHO. Such gospel books were used by missionaries to show the word of God, and they were believed to embody—that is, to *be,* not merely to represent—that word.

Borch, Gerard ter

(also Terborch) 1617–1681 • Dutch • painter • Baroque

Terborch has prudence, worldly experience, taste and tact. Taste is nothing but tact in the realm of aesthetics. Max J. Friedländer, 1949

Distinguishing features of ter Borch's pictures, in addition to the qualities mentioned above by FRIEDLÄNDER, are the amazing texture of his fabrics, especially shiny satin, and his inclination to paint the backs of figures, using body language to express feeling. He does both in *The Parental Admonition* (c. 1654), in which the neck of the standing young woman, the set of her shoulders, and the tilt of her head seem to bespeak chastened modesty—thus, the title given in the 18th century. Writing about the picture, Goethe imagined that the man, seated, with one hand raised,

is lecturing his daughter. Later research concludes he is not her father at all but, rather, a client at a brothel with a coin in his fingers. Brothels were one of several popular GENRE scenes of 17th-century Dutch art. Whatever the cause of her distress, the expression of emotion and the contrast of light and shadow characterize it as BAROQUE art. More anachronistic, but, ironically absolutely timely, was ter Borch's *Swearing of the Oath of Ratification of the Treaty of Münster* (1648). This treaty ended the Eighty Years War between Holland and Spain and gave the Netherlands its independence. The picture renders a contemporary event almost as though it were a news photograph. In addition to recording portraits of more than 50 participants, ter Borch included his own self-portrait. Not only was such a documentary picture extremely unusual, but it was also apparently unpopular: The artist was unable to sell it—he could not get the reportedly very high price that he put on it.

Borghese family

Pope Paul V (elected 1605), formerly Camillo Borghese (1552–1621), preceded the reign of the BARBERINI pope (Urban VIII). Paul V spent lavishly on palaces, churches, chapels, fountains, and paintings. Though extravagant, he lacked the taste and style his successor would display. Paul's nephew, Cardinal Scipione Borghese (1576?–1633), was an avid collector and patron of art who bought works by CARAVAGGIO and RUBENS as well as old masters. Scipione was BERNINI's first important patron; Bernini sculpted *David* (1623) for him and it remains to this day at the Villa

Borghesè, now a museum. *David* was also the last work executed under Borghese patronage, for Urban VIII's reign soon began.

Borgianni, Orazio
1575–1616 • Italian • painter • Baroque

Borgianni came under the influence of CARAVAGGIO. BAGLIONE discusses in detail a *David and Goliath* (after 1604) painted by Borgianni, describing Goliath as "an enraged mastiff." (See also CARAVAGGISTI)

Borofsky, Jonathan
born 1942 • American • installation • New Image

The images I create . . . come from two sources: an inner world of dreams and other subconscious "scribbles" . . . and an outer world of newspaper photographs and intense visual moments remembered.

Larger than life, and distorted in one way or another, Borofsky's figures defy the constraints of ordinary gallery space. For example, *Installation,* of December 1980, included a drawing of a person that was continuous—from floor and side walls up to the ceiling. In another *Installation* (1984–85), the haunches of the figure, which is bent over double, reach nearly to the ceiling. Such gallery INSTALLATIONS usually contain a mix of drawing, painting, sculpture, written words, and audio, all in the service of a theme with political or social connotations: A Ping-Pong table has the national defense budgets of the United States and Soviet Union stenciled on different sides. While objects and figures are diverse, each is numbered sequentially as part of Borofsky's recording, or cataloguing, of his own work. This unifies what is often a chaotic environment.

Borromini, Francesco
1599–1667 • Italian • architect • Baroque

Meissonier had as a principle, he said, to create something new. Like Borromini, he enjoyed being singular in his compositions. (Jacques-François Blondel, 1772)

The son of a mason, born on the banks of Lake Lugarno, Borromini started out as a stonecutter and went to Rome at the age of 20. He worked under BERNINI, whom he grew to resent, especially because of Bernini's technical shortcomings. As did the painter ALGARDI, Borromini profited from Bernini's misfortune: When Pope Innocent X (1644–55) replaced his predecessor, Urban VIII (see BARBERINI FAMILY), Bernini's loss of status also benefited Borromini. Bernini's sculpture was pure BAROQUE, but his architecture was more restrained. Borromini, on the other hand, was adventurous, even revolutionary, in his architectural design. His walls curve as though sculpted or molded, and building facades are deeply concave and boldly convex. As Baroque artists of the other mediums used light to dramatic effect, so too did Borromini. His style reached its peak in the Chapel of Saint Ivo for the University of Rome (begun 1642). This is a spectacular, complex design with a floor plan that includes the shape of a six-pointed star, and an exterior facade that layers two concave stages below an undulating convex stage that is topped

by a high but narrow DOME. Borromini was the architectural genius of the Baroque era, but he was also a lonely, unhappy man who ended his life by suicide. Jacques-François Blondel (1705–1774), whose assessment is quoted above, was an architect, teacher, and prolific writer who linked the work of MEISSONIER and Borromini with some reservations about the innovations of both. Writers who disdained the Baroque, like the sculptor FALCONET, could take advantage of Borromini's sad end and equate his "disorders" with the style he practiced. Falconet wrote, "If through an error of judgment—of which, fortunately, there are but few instances—a sculptor were to mistake the irrational impetuousness which carried off Borromini . . . for the divine enthusiasm of genius, let him be convinced that . . . far from beautifying the objects they portray, [it] remove[s] them from the truth and only serve[s] to represent the disorders of the imagination."

Bosch, Hieronymus

c. 1450–1516 • Netherlandish •
painter • Northern Renaissance

The difference that, to my mind, exists between the pictures of this man and those of all others is that the others try to paint man as he appears on the outside, while [Bosch] alone had the audacity to paint him as he is on the inside. (Fray José de Sigüenza; 1544?–1606)

Sigüenza, quoted above, was librarian to the Spanish king Philip II (reigned 1556–98), who collected works by Bosch during the century after the artist's death. Sigüenza goes into elaborate detail describing Bosch's best-known work, called today (a modern invention) the *Garden of Earthly Delights* (c. 1504). Sigüenza believed that the "basic theme" is that man's evil ways are shown by "many allegories or metaphors that present them in the guise of tame, wild, fierce, lazy, sagacious, cruel, and bloodthirsty beasts of burden and riding animals." That is all certainly true, but still leaves unexplained how or why Bosch, who seems to have led a fairly conventional life as an upstanding citizen in the provincial town of 's-Hertogenbosch, came up with some of the most bizarre creatures of all times—ears that form the wheels of a cannon, a belly with a mouth in it— and mixed them up with pornographic exotica as well as imported animals such as a giraffe and an elephant. Some of his sources are derived from alchemy, and some of his motivation must certainly have been wrapped up in the apocalyptic turn-of-the-century mentality, increased by political and religious disorder of the kind that would, by 1517, lead to the Protestant Reformation. It is known that an early owner of the painting, if not the first, was also noble, so it was an important work from the outset. Historians believe that Bosch traveled to Italy around 1505, and his maniacal inventions found their way into the work of Italian as well as other Northern European artists. It should be noted that he was also a landscapist who could create vast, airy views of great beauty, and a caricaturist whose faces, though very occasionally beautiful and serene (e.g., the Virgin in *Adoration of the Magi*, c. 1510), were

as ugly, contorted, and expressive as any in history.

Bossche, Agnes van den
active late 15th century • Flemish • painter • Northern Renaissance

The flag is the only Netherlandish painting in any technique that can be assigned with assurance to a female painter. (Diane Wolfthal, 1985)

Van den Bossche is the first woman artist of the NORTHERN RENAISSANCE whose painting is securely documented. As works on CANVAS, flags held lower status than did PANEL paintings of the time, which probably explains why a woman received commissions to paint them. Her c. 1481–82 flag for the city of Ghent, a triangle some 9 feet long and 3½ feet high, is decorated with the Maid of Ghent, who has hip-length hair and a brocaded dress trimmed with ermine, and is accompanied by a heraldic lion. This lion, whose paws are larger than the woman's head, has an extravagant, ornamental tail that curls with flamelike tendrils. Wolfthal, who is quoted above, also reports that this is the only flag that can be assigned to the Early NETHERLANDISH school.

Botero, Fernando
born 1932 • Colombian • painter • New Realist

. . . exaltations of life communicated by the sensuality of form.

Botero has invented a cast of unique characters, "Boteromorphs," who look a lot like inflated balloons. He presents them with a mix of irony and affection. He painted numerous family groups of such obese individuals—*Portrait of a Family* (1974), for example, with mother, father, and two babies standing in front of an apple tree. On a ladder resting against the tree is one large leg, its foot at a level with the mother's head, the rest of the "body" invisible, presumably above the picture frame. Among his Boteromorphs are also Latin-American dictators, figures from old-master paintings, and NUDES picnicking on the grass. The sensuality of form, to which Botero refers in the quotation above, is shown in his careful attention to shapes and details, which he renders with rich color and meticulous detail.

bottega
See WORKSHOP

Botticelli, Sandro
c. 1444/5–1510 • Italian • painter • Renaissance

In these same days of Lorenzo de' Medici the Magnificent, which was a veritable golden age for men of genius, flourished Alessandro, called Sandro according to our custom, and di Botticelli, for reasons which I shall give presently. He was the son of Mariano Filipepi, a citizen of Florence, who brought him up with care, teaching him everything which children are usually set to learn. . . . Although Sandro quickly mastered anything that he liked, he was always restless and could not settle down at school to reading, writing and arithmetic. Accordingly his father, in despair at his waywardness, put him with a goldsmith who was known to

him called Botticelli, a very reputable master of the craft. Very close and friendly relations then existed between the goldsmiths and the painters, so that Sandro, who was an ingenious lad and devoted to drawing, became attracted to painting, and resolved to take it up. (Vasari, mid-16th century)

Botticelli rebelled against the doctrinaire intellectualism of ALBERTI and MASACCIO's Florentine followers, and he eschewed their MODELING techniques, atmospheric PERSPECTIVE, and deference to the supremacy of observation; instead he painted imaginary, often idealized people—NEOPLATONIC visions—and developed a LINEAR style resembling that of his teacher, LIPPI. But Botticelli endowed line—whether defining a figure or in billowing draperies—with incomparable beauty and delicacy of expression. He loved the rich surface patterning that characterized the International Style (see GOTHIC) and was reactionary enough to use gold on the robes of a Madonna, and even on Venus's hair in his best-known work, *Birth of Venus* (c. 1484). Such gilding had not been seen in several generations (see GOLDEN HOUSE OF NERO). Moreover, this painting had the first important nude woman, based on a Greek model, since ANTIQUITY. Botticelli also pioneered in the use of color, building up rich effects by coating a TEMPERA surface with layers of tinted oil glaze. In *Adoration of the Magi* (c. 1475–76) he achieved better than 20 reds or pinks, using only the standard three or four PIGMENTS, by manipulating underpaint and the sequence of layers. He did the same with blues and yellows. Botticelli's paintings of pagan myths, so favored by the Neoplatonist circle of Lorenzo de' MEDICI that VASARI mentions in the passage quoted above, are read as complex political allegories, and sometimes as personal, amorous allegories in the life of his Medici PATRON. Probably inspired by the fiery monk SAVONAROLA, who denounced the "pagan excess" of Florence and decreed the famous Bonfires of the Vanities, Botticelli's later works displayed a fervid emotionalism. It is thought that Botticelli even burned a number of his own "pagan" pictures (though, fortunately, not the masterworks *Birth of Venus* and *Primavera* (c. 1482). His moralistic fervor and high anxiety show in the *Calumny of Apelles* (1490s), which actually followed a recommendation of ALBERTI to re-create the work of the Greek artist APELLES from written descriptions, as none of the art itself survived. Botticelli also painted a scene that he himself called *Apocalypse, Mystical Nativity* (1501), but while its overwrought emotional content is clear, interpretation of it has never been successful. In the far right foreground of the earlier *Adoration,* Botticelli painted an ambiguous self-portrait: Wearing a gold cloak, he gazes out of the picture at its audience, his mouth soft and sensuous, but his large, heavy-lidded eyes are both challenging and questioning. According to an often repeated though undocumented story, Botticelli once woke up from a dream in which he was married, and then spent the night wandering Florence for fear that the dream would return were he to sleep again. Court records do document that he threatened his neighbor, a

weaver, with violence because the man made too much noise at his loom.

Boucher, François

1703–1770 • French • painter • Rococo

Boucher was earning 50,000 livres per year for his steady output of loves of the gods, amorous shepherds, and fantasy landscapes. (By comparison, an average comfortable bourgeois, living on revenues from bonds or real estate, earned 3,000–4,000 livres; the salary of a professor at the Sorbonne was about 1,900.) (Thomas Crow, 1985)

As a youth, Boucher worked on ENGRAVINGS for the *Recueil Julienne,* a compilation of WATTEAU's work assembled after Watteau died. Watteau had been an independent, private painter, but as his artistic heir, Boucher became court painter to Mme. de Pompadour (who commissioned from him at least eight portraits of her) and head of the French Academy in 1765. Boucher's masterpiece, the tapestry CARTOONS for *The Rising of the Sun* (he also painted *The Setting of the Sun;* both 1753), may symbolize the stable and enduring relationship of Louis XV with Pompadour, his lover. The subject is the god Apollo leaving Thetis at dawn to begin the day's labors. At dusk, Apollo returns to Thetis. In Boucher's hands the insinuated eroticism of Watteau's ARCADIAN outings become outspoken in the form of pink and plump nudes and cupids. Boucher's paintings were primarily decorative, graceful allegories filled with nymphs, shepherds, and goddesses in lush garden settings. DIDEROT, the great ENLIGHTENMENT intellectual, was disappointed with the painter he had earlier thought so promising. In 1765, the same year the artist became director of the academy, Diderot wrote about Boucher, "Depravity of morals has been followed step by step by the debasement of taste and the decline in color and composition as well as in the character and then expression, and finally by the deterioration of draftsmanship." Nevertheless, Boucher had great financial success, as described in the quotation above.

Boucicaut Master

active c. 1390–1430 • Flemish • painter • Late Gothic/International Style

With a little imagination one can visualize the bookseller's apprentice hurrying across the street with several gatherings [folded sections that will be bound together] for the Boucicaut Master to paint, and dropping off a few further up the road. (Christopher de Hamel, 1994)

In 1415 the English invaded and defeated the French in the Battle of Agincourt and took prisoner the reputedly chivalrous, heroic, kindly, and just Maréchal de Boucicaut. At that time Boucicaut owned one of the most magnificent of all BOOKS OF HOURS. The artist of this ILLUMINATED MANUSCRIPT is anonymous—work in the style of this book is thus attributed to the "Boucicaut Master"—but circumstantial evidence points to a man named Jacques Coëne. Coene is documented as an important illuminator of the time. He was a Flemish painter who lived in Paris in

1398, then went to Milan. Signs of the courtly International Style of GOTHIC art are apparent in the elegance of his work (for example, the illuminated page entitled *The Visitation*, c. 1410). But forward-looking in the Boucicaut/Coene style is an interest in panoramic landscapes and a certain lightness at the horizon suggesting atmospheric PERSPECTIVE (some 100 years before LEONARDO). A number of books dating from the early years of the 15th century are credited to the WORKSHOP of the Boucicaut Master, who may have overseen something like a production line for Books of Hours, as de Hamel, a paleographer, envisions him in the passage quoted above (see PALEOGRAPHY). The Boucicaut Master had many followers; his greatest rivals were the LIMBOURG brothers.

Boudin, (Louis-) Eugène
1824–1898 • French • painter • Naturalist

Your letter arrived at the moment when I was showing [three men] my little studies of fashionable beach resorts. These gentlemen congratulated me precisely for having dared to put into paint the things and people of our time.

With the beach scenes mentioned above, Boudin explored a new subject and carved out his niche in out-of-doors painting: modern life at the seashore. As the railroads expanded in the 1850s, beaches became increasingly popular middle-class resort destinations. During the 1860s, Boudin recorded scenes like that in *The Beach at Trouville* (1865), in which a line of fully dressed, windswept visitors to the seashore stand, their

backs to us, looking across the ocean. Above them large clouds move briskly, and along the shore workhorses wait, ready to haul off the two tall boxes in which people changed into their bathing costumes. Boudin's style seems as brisk and breezy as the wind that whisks clouds, skirts, scarves, and whitecaps into a froth. The recreational seashore became a popular theme, also painted by MONET, whom Boudin "discovered" and encouraged to paint seriously, and by the American HOMER, who visited France in 1866. The tradition of outdoor painting to which Boudin belongs is called Naturalism to distinguish it from the movement known as REALISM,[2] and sometimes "pre-Impressionism," as it preceded the true IMPRESSIONIST movement.

Bouguereau, William-Adolphe
1825–1905 • French • painter • Academic

As long as he was in the room, there was absolute silence. . . . It usually took three hours to criticize the entire class during which time the models shifted their positions only as the master moved from one student to another. . . . Endlessly, from one easel to another the little man shifted or glided and spoke words of criticism or praise. Always gentle, always fair, never saying things he did not really mean, it was a pleasure as well as a privilege to listen to him. (Edmund Wuerpel)

Bouguereau upheld the CLASSICAL tradition in the face of one avant-garde movement after another. His subjects were primarily women and children in a number of roles. When he painted peasant women, they were beautiful, bare-

foot, and nubile; his *Destitute Family* (1865) has the pyramidal composition of a RENAISSANCE picture. The underlying eroticism of his females becomes overpowering, literally, in his riotous picture *Nymphs and Satyr* (1873): Four voluptuous nudes dance around and tug at an inexplicably recalcitrant satyr in a lush green glade. The historian William Gerdts wrote about how this painting, transported from Paris, where it was a SALON picture, to America, where it became a saloon painting, was installed "next to a stag's head, no less," over the bar of a popular New York watering hole. A PRIX DE ROME winner, Bouguereau lived in Rome 1850–54, then returned to Paris and great success. From 1883 he was a teacher at the ACADÉMIE JULIAN—Edmund Wuerpel was an American student who recorded Bouguereau's studio practices, as quoted above. Bouguereau married one of his first students, Elizabeth Jane Gardner (1837–1922), also an American, and one of the first American women to pursue formal art classes in Paris. (Women were not allowed to study at the ÉCOLE DES BEAUX-ARTS, but were admitted at the Académie Julian and at independent studios run by artists like BONNAT.) Gardner always worked in the style of her teacher, but two of Bouguereau's other American students, BEAUX and HENRI, went in very different directions, not only from their teacher, but also from each other.

Boullée, Étienne-Louis

1728–1799 • French • architect • Neoclassicist

This is my belief. Our buildings—and our public buildings in particular—should be to some extent poems. . . . It is to you who cultivate the arts that I dedicate the fruits of my long vigils . . . we must not presume that all we have left is to imitate the ancients!

Boullée was an architect for whom symmetry was the "premier beauty" and the sphere was the most majestic and magnificent form, not only because of the grace of its outline, but also for the regularity of its shading from light to dark. He believed that the art of organizing masses, especially simple geometric forms of large dimensions, constituted the genius of architecture. Through such shapes and their arrangements, Boullée achieved what he called an "architecture of shadows," or shadings. The most renowned of Boullée's designs is the Project for a Memorial to Isaac Newton (1784)—the great ENLIGHTENMENT scientist and philosopher had died in 1727. The memorial is a gigantic sphere that alludes not only to the universe but also, perhaps, to the apple, thus symbolizing Newton's theories of gravity and of terrestrial mechanics. "The unique advantage of this form is that from whichever side we look at it (as in nature) we see only a continuous surface which has neither beginning nor end, and the more we look at it, the larger it appears," Boullée wrote. The interior of the hollow globe is occupied only by an empty sarcophagus, but the shell is pierced by small holes through which the light of day would shine like the planets and stars that, Boullée said, "decorate the vault of the sky." As did his contemporary LEDOUX, Boullée believed that architecture should express character—*architecture parlant* (architecture that speaks)—a point of view

that anticipates ROMANTICISM's emphasis on feeling over rationality.

Bourgeois, Louise
born 1911 • French/American •
sculptor • Modern

*It is a very murderous piece, an
impulse that comes when one is under
too much stress and one turns against
those one loves the most.*

The comment quoted above refers to a
work called *The Destruction of the Father* (1974), a group of lumpy, breast-like shapes inside a cave that are tinged
by red light. There is a table, and also
forms that seem to be animal limbs.
Bourgeois's sculptures, which resist
categorization either as FIGURATIVE,
ABSTRACT, or NONOBJECTIVE, are simultaneously all and none of the above.
They are, however, sexually suggestive
in their allusions, and the materials,
often latex over plaster, have a disagreeable, clammy effect. Male and female
organs—or shapes that bring them to
mind—are equally unpleasant.

Bouts, Dirc (Dieric)
c. 1415–1475 • Netherlandish •
painter • Northern Renaissance

*In one [painting by Bouts] the emperor
has judgment passed on a count, a
member of the court, because the
empress had accused him of having
made attempts on her honor; in the
other, the emperor sentences his
empress to be burnt, after the
aforementioned accusation has
been proved false. This was
estimated at 230 crowns of 72
placques each. (From Contract,
c. 1471)*

A painter in the city of Louvain, Bouts
may have been driven from his Haarlem
home by peasant wars that erupted
there around 1444. His series of four
pictures painted for the equivalent of a
courtroom in the Louvain town hall,
Justice of Emperor Otto III (c. 1471–
73), illustrates the meting out of sentences described in part by the quotation above, taken from a 17th-century
document based on the original contract. Contracted for by a group of men
who administered justice in the room
to be decorated, the cautionary, moralizing purpose of the Bouts commission
is certainly site-specific. Bouts's earlier
Holy Sacrament Altarpiece (1464–68,
for Saint Peter's Church at Louvain) is
the first known documented work of
importance in Early NETHERLANDISH
art. The contract includes stipulations
regarding subject matter and specific
details. The central PANEL of this ALTARPIECE, a *Last Supper,* is notable for
its use of PERSPECTIVE. Van MANDER
wrote that Albert van Outwater was cofounder with Bouts of the Haarlem
School. Only one of van Outwater's
works has been securely attributed, but
descriptions of his treatment of landscape have an affinity with those of
Bouts. Bouts's delicately rolling hills
and toylike towns, seen as backgrounds
and through windows, bring the paintings of van der WEYDEN (e.g., *Saint
Luke Portraying the Virgin,* c. 1435–40)
and van EYCK (e.g., *Virgin and Child
with Nicolas Rolin,* c. 1435) to mind,
although Bouts was more of a storyteller than they were.

bozzetto
Italian for "sketch," this term refers to
either a model for a sculpture or a

painted sketch. The EQUESTRIAN statue of Louis XIV that was never cast, for example, is known to us by the highly finished bozzetto BERNINI made of his design.

Brady, Mathew B.
c. 1823–1896 • American • photographer • Realist

Let him who wishes to know what war is, look at this series of illustrations. (Oliver Wendell Holmes, 1863)

Brady studied painting and then, at about 20, learned the daguerreotype process from MORSE. He became a successful portrait photographer; among his portraits are *Samuel F. B. Morse* (c. 1845) and *Abraham Lincoln* (c. 1863). He is best known for his Civil War photographs—he was one of 300 cameramen who had passes to enter the battlefields. Since photography was still in its early stages and exposure time relatively long, they could not shoot live skirmishes. The photographs that made Brady famous—*On the Antietam Battlefield* (1862), for example—show the terrible aftermath of battle, with only dead, twisted bodies strewn on the landscapes. It was about these pictures that Holmes made the comment quoted above.

Bragaglia, Antonio Giulio
See MUYBRIDGE

Bramante, Donato
1443/4–1514 • Italian • architect • Renaissance

I shall place the Pantheon on top of the Basilica of Constantine.

LEONARDO sketched his ideas of centrally planned, domed churches, and they were taken up by Bramante while he was in the Milanese court of Ludovico SFORZA. However, Bramante's first masterpiece was in Rome: a small, circular, two-tiered shrine surrounded by COLUMNs and capped by a DOME. The Tempietto (Little Temple, 1502), as it is known, was built on the site then believed to be where Saint Peter was martyred. It has been an extremely influential monument, and not just for succeeding architects: There is an allusion to it in the background of RAPHAEL's painting *Marriage of the Virgin* (1504). The papacy of Julius II, who was, like Bramante, from Urbino, brought about such a vast rebuilding program that, as Rome's foremost architect, Bramante was nicknamed "Ruinante." In a contemporary satire, Bramante is at the pearly gates outlining to Saint Peter his building program for heaven. It included replacement of the "straight and narrow path" with a "spacious spiral ramp staircase by which the souls of the old and weak could ascend on horseback." Bramante was called on to design a new Saint Peter's church; his ambitious plan for it, of 1506, is described in his comment quoted above. It is known to us from a medal commemorating the start of building: It shows a multitiered building with TEMPLE fronts and DOMEs flanked by high towers. He planned to revive the use of concrete, a familiar material in ancient Rome but used rarely since then. When Bramante died, the project had hardly progressed; Antonio da Sangallo the younger (see SANGALLO) became chief architect in 1520 and retained the position until his

death, at which time, in 1546, MICHEL-ANGELO took over and changed the design.

Brancusi, Constantin
1876–1957 • Romanian • sculptor • Modern

Don't look for mysteries. I give you pure joy. Look at the sculptures until you see them. Those nearest to God have seen them.

Brancusi's journey by foot from Romania to Paris is part of the legend that surrounds him. It is certain that he arrived in Paris in 1904. He worked for RODIN, whose studio he left saying, "Nothing grows under the shade of great trees." Moving away from the tree, but no doubt never quite out of its shadow, Brancusi developed his style as an antithesis of Rodin's. In answer to Rodin's sensuous, life-size couple in an erotic embrace, *The Kiss* (1886–98), Brancusi sculpted his own versions of the same subject. One, *The Kiss* (1912), is a not-quite-2-foot-high cube, a block of limestone. By comparison, Brancusi's couple is paradoxically both antierotic and doubly so: With its rough-textured, affectionate, naive simplicity, it seems more instinctual than Rodin's pair. Absorbed with themes of creation, birth, life, and death, Brancusi sometimes finished and polished his forms to a degree that gives the material—marble and metal—a mirrorlike surface. He often experimented with the egg shape, and an evolution can be traced from a head, *Sleep* (1908), embedded in rough-hewn marble (bringing to mind MICHEL-ANGELO's sculptures emerging from stone), to *Sleeping Muse* (1910), a

smooth, elegant, ovoid form with mere traces of features, like those on a CYCLADIC figure. *The Beginning of the World* (c. 1920), which he also called *Sculpture for the Blind,* has the same oval form in marble with a smooth, unmarked surface. It rests on a polished metal plate placed, in turn, on an unpolished stone stand. Thus, a trio of textures as well as a trio of forms are understood to make up the origin of life as we know it. The bases for his sculptures, which Brancusi constructed himself as an integral part of the work, are made sometimes with harmonizing materials, textures, and lines, and sometimes with contrasting: for example, a coarse base with a polished sculpture. By this means he creates a dichotomy or dialectic, complicating the meaning of each work. In one of his best-known sculptures, the bronze *Bird in Space* (1928), Brancusi epitomizes the ecstasy of soaring. It is the realization of a quest Brancusi himself described: "All my life I have sought the essence of flight."

Braque, Georges
1882–1963 • French • painter • Cubist

In art, progress does not consist in extension, but in the knowledge of limits. . . . The senses deform, the mind forms. Work to perfect the mind. There is no certitude but in what the mind conceives.

Braque was greatly influenced by the geometry of shapes in CÉZANNE's paintings, and that led him toward the planes of CUBISM, which he developed in 1908. He and PICASSO began work-

ing together in 1909, after Braque had seen Picasso's *Demoiselles d'Avignon* (1907), which, Braque said, made him feel "as if someone were drinking gasoline and spitting fire." Though for decades it has been a litany that Picasso and Braque developed Cubism together, more credit in pre-Cubist contributions, from 1906 to 1908, is now given to Braque. In late 1909 the two were exchanging ideas and techniques to the extent that, for certain periods, their work cannot be told apart; they were, Braque commented, like mountain climbers roped together. In 1910 *(Violin and Palette)* Braque introduced "writing" onto the canvas in the form of musical symbols on sheet music. Having taken that step, he would move on, in September 1912, to work in COLLAGE (papier collé) with *Fruit Dish and Glass.* The work is ironic as well as inventive; the paper pasted onto the canvas is wallpaper that was preprinted to simulate wood. At each step of Cubism's development, Braque and Picasso worked in tandem, pushing one another in new directions. The collaboration ended in 1914 with the outbreak of World War I. Braque went into the French army and was seriously wounded; a bullet lodged in his head, nearly blinding him. After the war he continued painting in a Cubist style, and then returned to FIGURE painting as well, becoming increasingly introspective. From 1947 until 1956, he painted a series of *Studio (Atelier)* pictures, the interior of his own working spaces, which are "like re-imagined encyclopedias in which one object swaps identities with another, visual plots are thickened, and front and back change places. Birds that have been laid down on individual canvases take off on their own. (One of them looks like an overweight goose)," the critic John Russell writes, adding, "These are huge, complex and difficult paintings."

Breton, André
See SURREALISM

Breton, Jules
1827–1906 • French • painter • Realist

Stop right there, imitators! Millet created masterpieces, even when interpreting humans brought down by deprivation to the bottom of their being; you have no right to deny his great, his divine beauty.

In 1853 Breton dedicated himself to depictions of peasant life. The historian Robert Rosenblum calls him "Millet's milder-mannered understudy who could present France's vast agricultural population not as an image of raw, threatening power, but as a simple society of archaic harmony dominated by the serene, recurrent rhythms of daily labor and church ritual." Where MILLET's "ragged scarecrows" bent over in the fields (e.g., *The Calling of the Gleaners,* 1857) were jeered at the SALON, Breton's colorful, attractive women ending their day's work with heads held high (e.g., *Recall of the Gleaners,* 1859) got rave reviews. Breton honored Millet, as the comment quoted above makes clear, but he differentiated his own peasants as biblical people compared to Millet's, who were from a "strange, almost prehistoric dream."

Breuer, Marcel

1902–1981 • Hungarian •
architect/designer •
Modern/International Style

*To build ... is not to play a role, not to take
a vote, not to give an opinion. It is a
passion, basic as the bread we eat.*

Born in Hungary, Breuer studied at the
BAUHAUS, where in 1928 he designed
the cantilever chair for which he is well
known. He used newly developed re-
silient steel tubing to support its seat
and back, which were of woven straw
caning framed by bentwood. "I consid-
ered such polished and curved lines
not only symbolic of our modern tech-
nology, but actually technology itself,"
Breuer commented. With GROPIUS,
Breuer fled Nazi Germany. He went
first to London and then the United
States, where, beginning in 1937, he
taught at Harvard and worked in part-
nership with Gropius. In 1963–66 he
designed the Whitney Museum of Amer-
ican Art with a facade of large, rough-
surfaced masonry blocks in overhanging
tiers and irregular, and irregularly
spaced, windows. About this contro-
versial building the critic Ada Louise
Huxtable wrote that appreciation had to
be acquired, as with "olives and warm
beer." Ultimately, she declared, "it re-
veals itself as a carefully calculated de-
sign that squeezes the most out of a
small, awkward corner lot with maxi-
mum artistry and almost hypnotic skill."

Broederlam, Melchior

c. 1355–c. 1411 • Flemish • painter
• Late Gothic

*... the greatest of all pre-Eyckian
panel painters insofar as their work
has been preserved—is Melchior
Broederlam of Ypres, mentioned in the
accounts of Philip the Bold as "peintre
monseigneur" from 1391 and as
"varlet de chambre" from 1387.*
(Erwin Panofsky, 1953)

Broederlam was in the VALOIS court of
Philip the Bold, where he was asked to
paint everything from banners to chairs
and even to prepare layouts for tiled
floors. Along with SLUTER, he designed
furnishings for the Chartreuse de
Champmol monastery complex in
Dijon, though he did not have to aban-
don his own WORKSHOP at Ypres to ful-
fill his commissions. Broederlam's
prestige was great, as the quotation
from PANOFSKY above suggests, and his
influence wide. Broederlam's most im-
portant surviving works are the painted
wings, or shutters, for a large carved AL-
TARPIECE (c. 1393–99). On each single
shutter Broederlam painted two sepa-
rate NARRATIVE scenes: the *Annuncia-
tion* and *Visitation* on one pair, the
Presentation and *Flight into Egypt* for
the other. While traits of Late GOTHIC
International Style predominate (e.g.,
cubical-like structures, swaying DRAP-
ERY, and gold background), Broeder-
lam's scenes show a sense of depth,
contrasting architecture and landscape.
His figures appear more natural than in
earlier paintings, and he envisions a sin-
gle light source for MODELING them,
which he does with soft coloring. He
continued the old practice of using a
gold backdrop for the "sky" and filled
it with supernatural beings, but Broed-
erlam also painted in a lifelike hawk
swooping down, a touch that insinuates
"real" sky. Thus did Broederlam bal-
ance MEDIEVAL idiosyncrasies with

steps toward the verisimilitude of the NORTHERN RENAISSANCE.

bronze

Most civilizations went through a period during which people discovered that when alloyed with tin, copper was more easily heated and shaped, and that the higher the percentage of tin, the harder (and grayer) the resulting bronze. (Brass, more yellow than bronze, combines copper and zinc.) Other metals might be added to copper alone, or to bronze, varying its properties. Dated between the Stone and Iron Ages, the Bronze Age may have begun in Mesopotamia as early as the 4th millennium BCE (opinions differ about this date). It was once thought that a statue's place of origin could be determined by the makeup of its alloy, and that Romans used lead but Greeks did not. It is now understood that both used lead. In fact, nearly every WORKSHOP of the ancient Greek and Roman periods used essentially the same processes. Bronze is worked by hammering sheets of it into a mold, repoussé; by nailing and shaping it onto a carved wooden foundation; or by casting. Small solid objects could be cast by pouring liquid bronze into molds. (Sometimes molds were made of sand.) Other objects, from small MINOAN figures of bulls to major CLASSICAL statues, were made by the *cire perdue,* or lost wax method of hollow casting. This involves several steps: First, roughly made of clay or plaster, the carved model is coated with wax. The wax is more finely sculpted with details, and that in turn is coated with clay. When the model is baked, the wax melts away through a hole left for that purpose. Molten bronze is then poured into the hollow spaces thus created. The technique was developed so that casts could be reused. The ancient Greeks excelled in bronze casting, and the legendary DAEDALUS was said to have made a large bronze statue. According to one tradition, two mid-7th-century BCE Greeks on the island of Samos, already a production center for bronze armor and kitchenware, invented the lost wax technique. However, there is evidence that the process was known to Sumerians a good deal earlier, and that in fact the Greeks learned it from the Egyptians. In any case, the technique enabled casting of life-size and larger statuary. Trunk, arms, legs, and head were cast separately, then fitted and finished so carefully that the joins were invisible. The process was almost an assembly line from the 7th century BCE on. Hair and beards were added to customize each statue; jewelry and clothing concealed seams, joins, and chaplet holes. Silver was used for eyes, fingernails, and teeth, though sometimes tin was substituted. Eyes of glass paste or colored stones were inserted into their empty sockets before the head was attached. The ancient bronze working procedure was illustrated on the RED-FIGURE *Foundry Vase* of c. 475 BCE.

Few original Greek sculptures, either of bronze or of marble, survive. Roman conquerors, 2nd century BCE, looted them for their palaces and villas. Roman artists made useful though less than satisfying marble copies (see POINTING), but as the imperial fortunes waned, the original bronzes were melted for weapons or to make household items. Bronze sculptures not lost to expediency were later destroyed by

Christian distaste for pagan Rome's luxury and "brazen images." However, some stunning bronze originals submerged in shipwrecks have been recovered from the sea and restored, notably the RIACE BRONZES of c. 460 BCE.

From the end of the Roman Empire to the beginning of the ITALIAN RENAISSANCE, freestanding monumental bronzes were no longer made, and the lost wax art of casting them was itself lost. (Lost wax casting of bronze doors did continue; see CAROLINGIAN and GHIBERTI.) Not until DONATELLO's early-15th-century *David* was monumental hollow casting of statuary revitalized. Bronze sculpture declined after BERNINI's death in 1680, and remained dormant until RODIN took it up at the end of the 19th century. Rodin reinvented bronze as an expressive material, a line of development taken in different directions by sculptors as diverse as DEGAS, BRANCUSI, GIACOMETTI, and MOORE.

Bronzino, Agnolo
1503–1572 • Italian • painter • Mannerist

In Florentine art among the first symptoms of response to the Counter-Reformation is Bronzino's replica of his Pietà . . . *to suppress the allusive sensuality of* bella maniera *in favor of direct declarative statement.* (Marcia Hall, 1992)

In *Allegory of Venus* (c. 1544–45), Bronzino paints a scene with many of the discomfiting irregularities that distinguish the work of his Mannerist teacher, PONTORMO: ambiguity of space, unnatural, even impossible human forms and postures, and disturbing color (see MANNERISM). In contrast to Pontormo's religious subjects, however, Bronzino's mythological allegory has a lascivious edge: With frowning intensity (and a muscular arm that calls MICHELANGELO to mind), Time personified pulls back a curtain to reveal Cupid, who twists sensually and incestuously around his mother, Venus, to kiss her mouth as he holds her breast. The scene is dense with both bodies and allegory. Its political context is a matter of conjecture, for it was commissioned by Cosimo I de' MEDICI as a gift to King FRANCIS I of France. Mannerists used masks to symbolize deceit (there are two in *Venus*). Cosimo also commissioned two PIETÀS from Bronzino, finished in 1545 and 1552. Although the same CARTOON was used for both, there is a great change in coloring— from bright and artificial to dark and somber—and in facial expressions, from benign to miserable. In short, there was a change of mood that matched a change that had taken place in the religious climate of the time: the Counter-Reformation. Marcia Hall's comment, quoted above, refers to that change in Bronzino's second *Pietà*.

Brouwer, Adriaen
1605/6–1638 • Flemish • painter • Baroque

He always scorned the world's vanity. / He was slow in painting and spent money generously. / With pipe in his mouth in foul taverns, / There he spent his youth, completely out of money / He lived the life he painted. (Cornelis de Bie, 1661)

Born in Flanders, Brouwer worked in Dutch Haarlem, where he probably

studied under HALS, as well as in Flemish Antwerp. He was the most influential painter of "low life" GENRE painting in the Netherlands of the 17th century, giving a new earthiness to the tradition BRUEGEL the Elder had pioneered a century earlier. His rude and bawdy peasants are presented with masterful, brisk brushstrokes. Brouwer's paintings have a sharp bite: *Fighting Card Players* (c. 1631–32), for example, is ugly and violent. In *Tavern Scene* (c. 1631–32), a drunk reaches under a woman's skirt while she tugs at his hair. RUBENS and REMBRANDT are among those who admired and collected his work. Brouwer influenced van OSTADE in Holland and TENIERS in Flanders. Whether Brouwer's themes had moralizing intent or were forthright observation, meant to be a "slice of life" and nothing more, is debated. So is the cause of his imprisonment in Antwerp in 1633 and that of his early death, which has been attributed both to dissolution and to the plague that swept through the city in 1638. The poem of the chronicler de Bie, quoted from above, suggests that Brouwer's paintings were true to his own lifestyle.

Brown, Ford Madox
1821–1893 • English • painter • Realist

This picture is in the strictest sense historical. It treats of the great emigration movement which attained its culminating point in 1852. The educated are bound to their country by quite other ties than the illiterate man, whose chief consideration is food and physical comfort. I have, therefore, in order to present the parting scene in its fullest tragic development, singled out a couple from the middle class.

The picture Brown describes, *The Last of England* (1852–55), is his masterpiece. It has the circular format of a TONDO, and the subject—a married couple with a baby—alludes to the Holy Family theme. But this is a political subject, not a biblical one, as Brown's commentary above explains. It concerns the economic necessity of leaving the homeland. Brown's wife modeled for the woman, he for the man; the child is all but hidden under the mother's cloak. They are on a departing boat; the husband holds an umbrella to shield his wife from the ocean spray. Behind them is "an honest family of the green-grocer kind," behind them a "reprobate" shaking his fist at the country he must abandon. Brown himself was in dire financial straits at the time he painted the picture, and was planning to leave for India, which he probably would have done had the painting not sold. (Despite Brown's comment, the rate of emigration greatly increased over the next decades.) Brown had traveled and studied widely before settling in London in 1844. Important influences on his style were works of HOLBEIN, which he saw in Basel, and the NAZARENES, whose work he saw in Rome. In 1848 ROSSETTI began to study with him, and they formed an enduring friendship. In Brown's largest, most complex and ambitious painting, *Chaucer* (1851), Rossetti was his model for Chaucer and various members of the PRE-RAPHAELITE BROTHERHOOD modeled for other characters. Brown was never a member of the Brotherhood, though he sympa-

thized with their ideas, acted as adviser, and adapted some of their subjects and techniques. One of those techniques was a meticulous finish, MILLAIS's "wet white" method of layering transparent colors bit by bit on a wet white GROUND. Brown also painted landscapes, which he did out-of-doors, looking at nature as RUSKIN and the Brotherhood urged.

Brücke, Die (The Bridge)

A group of German architectural students who wished to paint—KIRCHNER, together with Erich Heckel (1883–1970), Karl Schmidt-Rottluff (1884–1976), and Fritz Bleyl (1880–1966)—formed Die Brücke in Dresden in 1905/06. Their first exhibition, in 1906, which NOLDE was invited to join, marked the emergence of 20th-century German EXPRESSIONISM. One of their intentions was to revive woodcuts (see WOODBLOCK), which they honored as a uniquely German MEDIUM—they were nationalistic in spirit, and their name signifies their faith in the future, for which they intended to act as a "bridge." They were especially interested in MEDIEVAL art and the operations of the craftsmen's GUILDS. Proudly uninfluenced by the contemporary movements of CUBISM and FUTURISM, Die Brücke members did, however, find inspiration in African and Oceanic sculpture and ETRUSCAN ART.

Bruegel, Jan, the Elder

1568–1625 • Flemish • painter • Baroque

Under the flowers I have placed a jewel, with minted coins [and]

with rarities from the sea. Your excellency must judge for yourself if the flowers do not surpass gold and jewels.

The son of Pieter BRUEGEL, Jan the Elder did not follow the Bruegel industry of copying his father's work, as his older brother, Pieter the Younger, did. Instead, Jan the Elder developed into a highly original, very inventive painter, and became one of the leading Antwerp artists of his day. He often worked with other artists—paintings by three or more artists were not uncommon in the 17th century, and Flemish painters were especially good at teamwork. Jan the Elder collaborated several times with RUBENS. He popularized paintings of forest interiors filled with wild animals; busy ports, harbors, and river scenes; and especially pictures that allude to traveling. He also painted STILL LIFE, and his astonishing rendering of texture earned him the nickname "Velvet Bruegel." Meticulously detailed and richly colored, *Vase with Flowers* (1605) contains 58 species and 72 varieties of flowers, both spring and summer blossoms. He painted from live blooms (perhaps supplemented with a botanical drawing or two, and maybe an artificial flower), probably from the gardens of the archdukes in Brussels. While writers today mention the VANITAS aspect of such paintings, referring to the transience of life, Jan the Elder did not, nor did his client, Cardinal Borromeo. On the contrary, Borromeo wrote about how much, in the midst of winter, he enjoyed the sight and imagined scent of Jan the Elder's flowers. Jan's sons, Jan II (1601–1678) and Am-

brosius (1617–1675), continued their father's tradition.

Bruegel, Pieter, the Elder
c. 1525/30–1569 • Flemish • painter • Northern Renaissance

No one except through envy, jealousy or ignorance of that art will ever deny that Pieter Bruegel was the most perfect painter of his century. But whether his being snatched away from us in the flower of his age was due to Death's mistake in thinking him older than he was on account of his extraordinary skill in art, or rather to Nature's fear that his genius for imitation would bring her into contempt, I cannot say. (Abraham Ortelius, cartographer, 1574)

Little documentation about Pieter Bruegel the Elder survives, and the homage paid by his friend Ortelius, quoted above, is the only contemporary source about him. It is known that Bruegel was in the Antwerp GUILD in 1550, and that he traveled over the Alps and visited Italy in the following years. Like DÜRER, he made wonderful drawings along the way, but unlike Dürer and other Northern artists, he was not greatly influenced by the Italian masters. On the contrary, he remained resolutely interested in the landscape and lore of his own homeland, and represented both with gusto. He introduced the winter landscape as an independent category, and it was taken up by others, including his son Jan BRUEGEL and de MOMPER. If Pieter Bruegel looked to any authority, it was that of BOSCH, but only early in his life when Bosch's sense of irony and the bizarre appealed to

Bruegel. Comparing Bruegel's *Battle Between Carnival and Lent* (1559) with Bosch's *Garden of Earthly Delights* (c. 1504), one can almost imagine that Bruegel portrays the very scene Bosch had been looking at before closing his eyes and transforming it into a demonic nightmare. The elements of excess that concerned Bosch, from inebriation to fornication, are also present in Bruegel's rollicking scenario. Bruegel's *Battle* is seen from high overhead, a PERSPECTIVE he often employed to astounding effect. This is especially true in *Fall of Icarus* (c. 1553–60), a picture of the moment in Ovid's *Metamorphoses* when the wax that attached Icarus's wings melted and the boy plunged into the sea. The viewer is placed in the sky, where Icarus's father, DAEDALUS, who made the wings, might be—though his image was rubbed out in one version, he is present in another. A peasant is plowing beneath us, and then the land falls off to the sea far below where Icarus splashed down—only his feet are visible. W. H. Auden describes this painting in a poem entitled *Musée des Beaux Arts* (1938). He remarks on how insignificant this catastrophe is to the plowman, or to those on the ship who must have been amazed at what they saw: The tragedies of failure and death are personal to those who suffer them. For the rest of the world life goes on.

It is uncertain what effect the Protestant Reformation or the Counter-Reformation may have had on Bruegel, and whether his religious references are specifically directed to one or the other. Perhaps his cynical perspective was cast on religion in general. The intention of his peasant scenes is similarly conjec-

tural. Were they moralizing, or comic merely for the sake of comedy? Or perhaps they were meant to validate a Flemish national tradition in the face of oppressive Spanish rule. All that may be said with some certainty is that these pictures were not painted for the peasants themselves.

Brunelleschi, Filippo
1377–1446 • Italian • architect • Renaissance

[Members of the jury] were astonished at the difficulties he had set himself— the pose of Abraham, the placing of the finger under Isaac's chin, his prompt movement, and his drapery and manner, and the delicacy of the boy Isaac's body; and the manner and drapery of the Angel, and his action of seizing Abraham's hand. (Antonio Manetti, 15th century)

The judges were astonished by his work, as Brunelleschi's biographer, Manetti, remarks in the quotation above, but they denied him the prize in the competition to design bronze doors for the Florence Baptistery. GHIBERTI was the winner. It was a fortunate decision: If he had won, Brunelleschi probably would not have renounced sculpture to become an architect, and the style of ITALIAN RENAISSANCE architecture would not have developed in quite the way it did. Brunelleschi went to Rome with DONATELLO and studied the ancient buildings and monuments still standing, the PANTHEON and COLOSSEUM especially. For the Florence Cathedral, which had been under way since 1296, Brunelleschi designed a dome—no large-scale DOME had been built since the Pantheon, and, in the

West, the construction technique had been lost. Brunelleschi's style is characterized by clarity and ordered harmony, derived both from CLASSICAL examples and from the application of mathematical ratios. Santo Spirito (begun 1436), with a cruciform plan, approaches Classical ideals in its cool rationality and use of a ratio of 1:2 throughout the building. He used white stucco with elegant details of trim in gray limestone called *pietra serena*, or "serene stone." Brunelleschi's logic of design and crisp articulation are seen in the Pazzi Chapel (begun c. 1440), which approaches the central plan he later realized in Santa Maria degli Angeli (1434–37) in Florence. Equally, had he won the Baptistery doors commission, Brunelleschi might never have invented the scientific methodology for showing linear PERSPECTIVE. His famous demonstration of the accuracy of his perspective scheme was the "peepshow": Standing with his back to the Florence Cathedral, a viewer held, in one hand, a picture, painted in perspective, of that same cathedral. He stood in the very spot from which the picture had been painted, and as he looked through a "peephole" that was bored at the "vanishing point," he held in his other hand a mirror that reflected both the painting of the cathedral and the actual cathedral itself. In the mirror he ascertained that pictorial illusion matched visual reality. This experiment, performed in about 1413, confirmed Brunelleschi's system, on the basis of which artists like DONATELLO and MASACCIO began investigating the portrayal of distance. It remained for ALBERTI, later, to establish the geometric system that enabled artists to plot perspective graphically.

Brygos Painter

6th–5th century BCE • Greek • vase painter • Late Archaic

The cups decorated by the Brygos Painter were provided by the potter Brygos. Brygos also furnished the imitators of the Brygos Painter with many of their cups; others were furnished by imitators of the potter Brygos. (J. P. Beazley, 1944)

The perils inherent in distinguishing and identifying anonymous artists are revealed in the quotation from BEAZLEY, above. Named for the potter whose ceramics he decorated, as Beazley points out, the Brygos Painter was highly accomplished in the RED-FIGURE TECHNIQUE. He specialized in decorating the KYLIX, used as a wine goblet, with appropriate themes of revelers. This painter was the first to present persuasive images of striding figures, rendering them in profile, and showing CONTRAPPOSTO on vases some years before it appeared in sculpture. He also showed an odd sense of humor: Having drained the kylix of its contents, the unfortunate reveler drinking from one Brygos cup would come on a scene in which a man, who has similarly overindulged, is sick to his stomach.

Bryson, Norman

born 1949 • English • critical theorist • Postmodern

It is a sad fact: art history lags behind the study of the other arts. . . . What is certain is that while the last three or so decades have witnessed extraordinary and fertile change in the study of literature, of history, of anthropology, in the discipline of art history there has reigned a stagnant peace.

Bryson's words, quoted above, were written in 1983. They were recorded again by the art historian Donald Kuspit in the professional journal *Art Bulletin* in March 1987, introduced by the alarm "Art history is in crisis." Bryson was then director of English Studies at Kings College, Cambridge University, England, and thus an outsider to the discipline he critiqued. But his words had struck their mark, and by 1988 he was able to write, "There is little doubt: the discipline of art history, having for so long lagged behind, having been among the humanities perhaps the slowest to develop and the last to hear of changes as these took place among even its closest neighbors, is now unmistakably beginning to alter." Spurred on by Bryson's scrutiny, encouraged and engaged not only by his writings on art but also by essays he collected and edited, art historians have been applying new METHODOLOGIES of critical theory such as SEMIOTICS, POSTSTRUCTURALISM, FEMINISM, Post-Colonialism (see ORIENTALISM), and PSYCHOANALYTIC and GENDER STUDIES to study art. Bryson has unquestionably sparked self-examination, opened many doors, and energized the field of ART HISTORY. He also moved to the United States and took a teaching post at Harvard University.

Bulfinch, Charles

1763–1844 • American • architect • Federal/Neoclassicist

I enjoyed too the confidence and good will of my fellow townsmen, who

*chose me one of their Selectmen at the
early age of twenty-seven. The
occupation [of] this office and
superintending the building of the
State House after my plans afforded
me sufficient and agreeable
opportunity.*

Bulfinch had no formal architectural
training. Rather, born into a wealthy
family, he was a practitioner in the gen-
tleman-amateur tradition, self-taught
from books. He went on the European
GRAND TOUR in 1785. Among the many
buildings he designed were the Con-
necticut State House in Hartford (after
1785–prior to 1795) and the Massa-
chusetts State House in Boston (1795),
about which he reminisced in the quota-
tion above. Redbrick with marble trim,
its outstanding features are white
COLUMNS and a golden DOME topped
with a cupola that itself is topped by a
gilded pinecone. In 1818, appointed by
President James Monroe, Bulfinch went
to Washington, D.C., to succeed LA-
TROBE as architect of the Capitol.

Burchfield, Charles
1893–1967 • American • painter •
Modern

*[The painter should] paint directly the
emotion he feels, translating a given
object or scene without detours. . . .
The pulsating chorus of night insects
commences swelling louder and louder
until it.resembles the heart beat of the
interior of a black closet.*

Many of Burchfield's paintings are rec-
ollections from his childhood—emo-
tions of fear, excitement, loneliness. His
pictures have a wavering, supernatural
aura, a haunting mysteriousness. They

do not fit under any stylistic umbrella,
although they are EXPRESSIONIST in
some aspects, as well as idiosyncratic.
One of his personal touches comes from
his love of music: In trying to express
sound, he arrived at visual equivalents
in the form of short, expressive, often
parallel lines. His wish to represent sen-
sory experience in a visual language
places him among MODERNISTS like
DOVE, MUNCH, and KANDINSKY, in con-
trast to his frequent categorization as
an idiosyncratic, anachronistic artist.
Comments excerpted from his journals,
quoted above, describe some of his
concerns. Burchfield painted mainly in
WATERCOLOR (e.g., *The First Hepaticas*,
1917–18).

Burckhardt, Jacob
1818–1897 • Swiss • historian

*I want to get away from all of them,
from the radicals, the Communists, the
industrialists, the intellectuals . . . the
philosophers, the sophists, the state
fanatics, the idealists, from every kind
of "ist" and "ism."*

A cultural historian and the author of
*The Civilization of the Renaissance in
Italy* (1860), Burckhardt merits both
credit and blame for determining how
we have looked at and thought about
art of the ITALIAN RENAISSANCE, the pe-
riod that has, at least until recently,
dominated the study of ART HISTORY.
For Burckhardt, as for VASARI, on
whose writings he relied, the European
Renaissance meant Italy in general and
Florence in particular, and every revi-
sionist reassessment begins by paying
its dues to both writers. As the historian
Francis Haskell writes, ". . . it still re-
mains almost impossible for most of us

not to think of Italian painting, sculpture, and architecture as having been born in Florence and as having then 'progressed' in a direct line, so to speak, along the road which we will all have to follow: childhood, adolescence, maturity, and (by implication) decay and death." This "diachronic" (see SYN-CHRONIC) line of progression is a legacy of Burckhardt, who also looked for ideological consistency and identified the cult of the individual—which he did not always necessarily applaud—as characteristic of the Renaissance. BÖCK-LIN, a friend of his who went to live in Italy, was among the late-19th-century painters who took Burckhardt's escapist protests, such as that quoted above, and praise of Renaissance Italy to heart.

Burden, Chris
born 1946 • American •
Performance • Pluralism

At 6:00 p.m. three invited spectators came to my studio. . . . Wearing no clothes, I entered the space. . . . Two assistants lifted one end of a 6-foot sheet of plate glass onto each of my shoulders. The sheets sloped on the floor at right angles from my body. The assistants poured gasoline down the sheets of glass. Stepping back they threw matches and ignited the gasoline. After a few seconds, I jumped up sending the glass crashing to the floor.

The event he describes above is one Burden staged on April 13, 1973, on Oceanfront Walk in Venice, California. He named it *Icarus* after the mythical son of DAEDALUS whose wings melted away when he flew too close to the sun.

In his PERFORMANCEs Burden submits himself to danger and violence, which, he believes, are woven through contemporary culture. In another performance, *Shoot* (1971), a friend fired a rifle at his arm and wounded him. In part through the danger, surprise, and fear involved, Burden purposefully establishes a strong emotional connection between himself and his audience. He learns— and those present actually see—what it is like to experience and participate in destructive acts like those that are daily fare on television but foreign to the lives of most people.

Burgundy
See VALOIS

Burke, Edmund
See SUBLIME

Burne-Jones, Sir Edward Coley
1833–1898 • English • painter •
Pre-Raphaelite/Symbolist

The look of the pictures has done me good: I feel that I could paint so much better already.

Burne-Jones met his lifelong friend and collaborator, William MORRIS, at Exeter College of Oxford University in 1853. Both were inspired by reading RUSKIN. ROSSETTI gave Burne-Jones a few lessons, but his art was otherwise self-taught. Burne-Jones supplied Morris with designs for STAINED GLASS, tiles, and TAPESTRY. In 1862 he went to Paris and Italy with Ruskin, who had him copy GIOTTO and Venetian painters like TITIAN and TINTORETTO, artists whose qualities of "grace," "tranquility," and "repose" Ruskin valued. After Burne-Jones went on to VENICE

without Ruskin, he described his reactions to what he saw in the letter to Ruskin quoted from above. Eight pictures of his in the opening exhibition of the Grosvenor Gallery in London in 1877 brought Burne-Jones sudden fame and moved him to the forefront of AESTHETICISM. (Known as a shrine of artiness, the Grosvenor was lampooned in Gilbert and Sullivan's *Patience*, 1881.) The women Burne-Jones painted were beautiful and chaste, sensual and remote, dreamy and languorous, and the subjects in which they appeared were taken from MEDIEVAL legend or CLASSICAL mythology, although he also painted biblical and fanciful themes. (Chaste though the women may have been, his paintings of women proved irresistible to some men who bought them and could not refrain from planting kisses on the canvas.) Among "fanciful themes" is *The Golden Stairs* (1876–80). A procession of 17 women (all based on a single model) descends a spiral staircase "like spirits in an enchanted dream, each moving gracefully, freely, and in unison with her neighbors," as a contemporary reviewer wrote. "What is the place they have left, why they pass before us thus, whither they go, who they are, there is nothing to tell." Burne-Jones received letters from around the world asking for an explanation. His ambiguity was intentional, linking him to the SYMBOLIST movement, and to Stéphane Mallarmé's later (1891) pronouncement: "To *name* an object is to take away three-fourths of the pleasure given by a poem. This pleasure consists in guessing little by little: to *suggest* it, that is the ideal." The descent of Burne-Jones's reputation was swift, however. In his 1927 book *Landmarks in Nineteenth-Century Painting*, BELL reproduced *The Golden Stairs*, citing it as the epitome of Pre-Raphaelitism, a movement of "utter insignificance in the history of European culture."

burnish

In general, burnishing refers to polishing a surface, usually by rubbing it. More specifically, the term applies to laying down metal leaf—gold, silver, tin—on various surfaces such as wood and parchment. A burnishing tool both rubs the leaf onto the prepared surface and brings it to a shine. The MEDIEVAL monk THEOPHILUS describes a burnisher as "a tooth or a bloodstone that has been carefully cut and polished on a smooth, shining horn tablet." He also mentions using the teeth of beaver, bear, and boar.

Bush, Jack Hamilton
1909–1977 • Canadian • painter • Abstract Expressionist

. . . I did try what he suggested, which was to paint simpler, no hot licks to be up to date, no trying to be in style. To try and find out what Jack Bush was as an artist.

One of the group of Canadians known as Painters Eleven, based in Toronto, Bush was a colleague of Jock MACDONALD. Bush, too, was strongly influenced by the critic GREENBERG, about whom he speaks in the quotation above. Bush's interest in color is evident in works like *Painting With Red* (1957), with its contrasting, bold circular shapes against a light background. Later, with the series of *Sash* paintings, his shapes and colors are more con-

trolled. In *Sash on Red Ground* (1963), the sash is a vertical, columnar, hourglass form that holds bands of color. As Greenberg himself wrote about Bush, "he became a supreme colorist. When it comes to putting one color next to another, Noland and Bush are alone in this time, and maybe in any other." (See also NOLAND)

Byzantine

For several reasons, including the fact that paganism was strong among Rome's ruling aristocracy and the civil service, the emperor Constantine moved his center of activity east of Rome. In the year 330 he transferred the capital of the empire to the ancient Greek fortress town of Byzantium. It stood close to the main focus of the empire's trade, and was a strategic location for checking enemies from the East as well as migratory tribes from the steppes. Moreover, Christianity was growing ever stronger in the East. The new capital was called Constantinople; today we know it as Istanbul. However, it was Byzantium that lent its name to the civilization that lasted for 1,000 years. The shift eastward continued under Constantine's successors as Roman territory came increasingly under attack from northern and eastern Germanic tribes (see MIGRATION). An example of the transition to the Byzantine style is the cruciform-plan mausoleum of Galla Placidia (c. 425) in Ravenna, on the Italian Adriatic Sea. Its plain brick exterior belies its rich interior decoration—a distinction between outside and inside that is characteristic of EARLY CHRISTIAN buildings. The inside walls are adorned with colorful mosaics (MOSAIC art reached its zenith in the Byzantine era) that combine some vestiges of CLASSICAL observation of the natural world with rigidity and abstraction. Byzantine style emerges from a blend of Greek, ROMAN, and Near Eastern art. Its First Golden Age (526–726) is seen in the church of SAN VITALE (Ravenna; 526–47), a domed octagonal building with a central plan and mosaic images of the emperor Justinian and his wife, Theodora. In Constantinople itself Justinian built a palace church dedicated to HAGIA SOPHIA (Church of Holy Wisdom; 532–37), a masterpiece of Byzantine style. The apse mosaic at Sant' Apollinare (c. 549) in Classe (Ravenna's port) transmits an important political and theological message: Christ is not seen in person; rather, he is symbolized by a jeweled cross in a starry circle. Such decoration suggests the influence of the Monophysites (from the Greek meaning "one nature"), who maintained that Christ was only divine, not both human and divine. Their argument about Christ's nature fueled the growing rejection of Christian figurative imagery that culminated in iconoclasm: During the 8th century, Emperor Leo III ordered the destruction of all images that showed Christ, the Virgin Mary, saints, or angels in human form (see ICON). Besides the theological argument, this prohibition also pitted the power of the Eastern emperor (who appointed the patriarch of the Orthodox Church) against that of the Western pope. In 843 iconoclasm officially ended and art again began to flourish, leading to a Second Golden Age of Byzantine art. Exemplary of this period is the dome mosaic of the small monastery church in Daphne, near

Athens, an awe-inspiring head and shoulders called *Christ Pantocrater* (*Ruler of the Universe,* c. 1100). The final break between Catholicism in the West and Orthodoxy in the East came in 1054. In VENICE, long under Byzantine influence, the five-domed Saint Mark's church was begun in 1063 and given a remarkable biblical mosaic program. (Saint Mark's facade and outer domes date from later periods.) Around 988, according to legend, a Russian ruler named Vladimir learned from his envoys that only in Byzantine Christianity did God "dwell among men."

Vladimir himself accepted Christianity and introduced Orthodox Christianity to Russia, which became a cultural province of Byzantium. During the Fourth Crusade (1204), French knights captured Constantinople instead of proceeding to Jerusalem as originally intended, so in the 13th century the Byzantine Empire was ruled by Western nobles. In 1261 the Byzantines drove out the Westerners, and the final flowering of Byzantine art lasted from 1261 until the conquest of Constantinople by the Ottoman Turks in 1453.

C

Cabanel, Alexandre
1823–1889 • French • painter •
Academic

*M. Cabanel is not an artist; he is a
saint. He doesn't make art; he makes
perfection. He does not deserve
criticism; he deserves paradise.*
(Camille Lemonnier, 1870)

Once reputed to have more students
than any other living French master,
and more winners of the PRIX DE ROME,
Cabanel himself received most of the
honors that the French government be-
stowed on artists. His international rep-
utation was well deserved, judging by
the tone of Lemonnier's praise, quoted
above, from a SALON review. As did
GÉRÔME, Cabanel taught at the ÉCOLE
DES BEAUX-ARTS, and there was some-
thing of a rivalry between them. At the
Salon of 1886, at least 112 exhibitors
were Cabanel's students. His popularity
dwindled, however, and Gérôme took
the lead, especially among Americans.
Both were ACADEMIC painters who
favored exotic Middle Eastern sub-
jects. Cabanel's best known of that type
is *Cleopatra Testing Poisons on Con-
demned Prisoners* (1887), an erotic rep-
resentation of the popular Oriental
FEMME FATALE. Perhaps more alluring,
and certainly less threatening, is his ear-
lier and most famous work, *The Birth
of Venus* (1862). This voluptuous nude,
floating on ocean swells with cupids fly-
ing about her, is sleeping, and thus vul-
nerable rather than dangerous. She is
the opposite of MANET's bold and con-
frontational nude *Olympia,* which was
painted the following year.

Cage, John
1912–1992 • American • musician
• Modernism

*Where do we go from here? Towards
theater. That art more than music
resembles nature. We have eyes as well
as ears, and it is our business while we
are alive to use them.*

Cage studied with the musically revolu-
tionary composer Arnold Schönberg,
and himself became an iconoclast. His
performances and ideas—including in-
determinacy, randomness, and using
the *I Ching*—made Cage a motivating
influence outside music. Building on
ideas of DUCHAMP, Cage also removed
art from the realm of aesthetic purity.
Cage abandoned the effort of commu-
nicating through music as "art" and
strove instead to make the listener
conscious of what exists in the environ-
ment. The everyday world, then, be-
came the source and stage for art.
Unlike DADAists and SURREALists, Cage
did not employ psychological devices to
probe the individual's subconscious—
his goal was to avoid personal determi-

nation altogether. A performance at BLACK MOUNTAIN COLLEGE in 1952, often called simply "the Event," is historic: Beneath RAUSCHENBERG's *White* paintings, with Edith Piaf records playing in the background, Merce Cunningham (Cage's collaborator and companion) danced among members of the audience, pursued by a barking dog; simultaneously poets read poetry from ladders, four boys dressed in white served coffee, and Cage, sitting on a step ladder, occasionally read a lecture on the relation of music to Zen Buddhism. The Event is legendary as the first HAPPENING, on which the movement by that name was based. Cage also influenced FLUXUS and CONCEPTUAL ART.

Caillebotte, Gustave
1848–1894 • French • painter • Realist/Impressionist

I am always very happy to see you but I cannot say for sure that I won't be in the country shortly. Several times now I've come down to leave and the moment I reach the bottom of the stairs the rain begins again. This weather is really vile.

Caillebotte exhibited with the IMPRESSIONISTs, collected their works, and shared some of their interests—the wide boulevards of modern Paris, for example. *Paris Street: Rainy Weather* (1877) catches the sensations of an instant in which wet, gray cobblestones, sidewalk, and umbrellas reflect the ambient light, and fashionable people, singly and in couples, hurry along in their private, umbrella-sheltered worlds to wherever they may be going. Judging

from the excerpt of a letter he wrote to PISSARRO in 1879, quoted from above, one effect the rain had on Caillebotte was to make him long for the sunny countryside. Shared topics aside, Caillebotte's painting technique is more polished than that of other Impressionists. In *The Floorscrapers* (1875)—a subject that allies him with REALISM—Caillebotte has chosen an unusual theme: three men finishing the wood floors of what seems to be a chic Paris apartment (these may be Caillebotte's own rooms). He examines this labor-intensive scene from an odd angle that makes the parallel floorboards slant sharply, reminiscent of the Japanese prints that fascinated Impressionists (see UKIYO-E). This seems both an interest in the urbanization of labor—yet hardly industrialization—and a contemplation of human collaboration, as the men work in tandem. The historian Robert Rosenblum astutely links this scene with paintings EAKINS made of men rowing together (e.g., *The Biglen Brothers Turning at the Stake,* 1873). The two Caillebotte paintings discussed above secure the painter a place as an innovator in the 19th century. His own Impressionist art collection, bequeathed to the state and accepted only over the protest of most ÉCOLE DES BEAUX-ARTS teachers, cast him as provocateur, causing an uproar when it was exhibited in 1897.

Calder, Alexander
1898–1976 • American • sculptor • Abstract

My entrance into the field of abstract art came about as the result of a visit

to the studio of Piet Mondrian in Paris in 1930. I was particularly impressed by some rectangles of color he had tacked on his wall in a pattern after his nature. I told him I would like to make them oscillate—he objected. I went home and tried to paint abstractly—but in two weeks I was back among the plastic materials. I think that at that time and practically ever since, the underlying sense of form in my work has been the system of the universe, or part thereof. For that is a rather large model to work from.

The essence of Calder's MOBILES, as they were named by DUCHAMP, is captured in the passage quoted above wherein the sculptor describes his inspiration. The signature works by which he is known are standing or, usually, hanging mobiles set into motion by air currents. He used diverse materials for the free-form shapes he suspended in space from strings or wires, and they move fast or slowly depending on the force of the breeze and their own predisposition. After World War II, Calder began to work on a monumental scale, exemplified by the 42-foot-wide sheet metal *Mobile* (1959) designed for the Arrivals building at Kennedy Airport in New York. As much as the airplanes seen taking off and landing from the huge window that frames it, this work is the epitome of flight. In the 1960s Calder added stabiles to his oeuvre— equally monumental metal sculptures firmly planted on the ground. *Four Elements* (1962), located outside a museum in Stockholm, has four freestanding, whimsical, bright red, yellow, and green forms, and while grounded they do move, driven by motors.

Callicrates
See ICTINOS

Callot, Jacques
1592/93–1635 • French • printmaker • Mannerist

The "Grandes Misères" may . . . be regarded as a precipitation of his general feelings about war, brought to a head by the invasion of Lorraine. (Anthony Blunt, 1953)

Callot's interest in beggars and people with deformities often seems inspired by BOSCH and BRUEGEL, and in the sense that he exaggerated forms, his work is in accord with the Mannerist turn away from CLASSICAL beauty (see MANNERISM). He worked in Florence for the MEDICI court, often ENGRAVING images of the public festivities the Grand Duke staged to amuse Florentines. When the Grand Duke died in 1621, Callot returned home to Nancy. There his interests changed; he drew landscapes, sometimes giving them fantastic rock outcrops and ruined buildings, and religious themes inspired by the Counter-Reformation (e.g., *The Agony in the Garden*, 1625). In the 1630s, when Richelieu invaded Lorraine and captured Nancy, Callot did a series of ETCHINGS on the horrors of war, *Grandes Misères de la Guerre,* to which BLUNT refers in the quotation above. In one scene, *Hangman's Tree,* he shows only the thick trunk and lower branches of the huge tree from which bodies hang like strange, morbid fruits. A priest stands on the ladder halfway up the tree giving absolution to the next victim. This is a grisly scene, and it foreshadows images that will be produced in the next century (see GOYA). Some

historians believe Callot was not anti-war, but Blunt's analysis suggests otherwise: "The result is strangely grim, and gives the lie to those who maintain that Callot was a purely detached observer, recording the scene of hanging without emotion as if it had been the Fair of Gondreville."

camera obscura

Literally "dark chamber," from the Latin, the camera obscura was used to project images on a surface where they could be accurately traced. A precursor of photography, the camera obscura was originally a closed dark room with a tiny hole on the side facing the scene to be recorded. Light rays from that scene entered through the hole and projected it onto the opposite wall. Until corrected by a convex lens or mirror, the image projected was upside down. The color in these images was intense, for although the scene was reduced in size, the color remained the same. Not only artists but the general public as well was fascinated by the camera obscura during the 17th century, especially noting that it showed moving images. Most 16th- and 17th-century treatises recommended it for artists; HOOGSTRATEN described using one, and VERMEER probably employed a camera obscura for compositional purposes. By the 18th century a portable model became popular, and CANALETTO seems to have taken advantage of it for his panoramic paintings.

Cameron, Julia Margaret
1815–1879 • English • photographer • Pictorialist

My aspirations are to ennoble photography and to secure for it the character and uses of High Art by combining the real and Ideal and sacrificing nothing of Truth by all possible devotion to Poetry and Beauty.

Cameron received her first camera as a gift from her daughters when she was 48. She became known for her majestic photographic portraits of major figures in British intellectual society. Showing just his head, she captures the intensity of the British historian in her *Thomas Carlyle* (1863), for example. Cameron used suggestion and approximation rather than clarity and detail, and sometimes, as with *Carlyle,* harsh illumination from above to achieve a dramatic effect. She was one of the few early photographers who subscribed to AESTHETICISM, the concept of art for art's sake, an underpinning of PICTORIALISM. Cameron articulated her intention in the quotation above. She also said, "I longed to arrest all beauty that came before me, and at length the longing has been satisfied."

Campin, Robert
c. 1375/79–1444 • Netherlandish • painter • Northern Renaissance

What strikes a viewer, first and foremost, about [Campin's] Virgin and Child before a Firescreen is its insistent emphasis on the everyday world, materialistic, full of singular objects, adroitly chosen. (Craig Harbison, 1995)

Along with van EYCK, Campin was one of the founding artists of the NORTHERN RENAISSANCE. However, Campin's approach to the visual world was as different from that of his contemporary as

were their PATRONS: Campin's work went not to members of the peripatetic Burgundian court (see VALOIS), but primarily to members of the middle and upper-middle class in the prosperous city of Tournai (south of Bruges and Ghent, in modern Belgium). Campin seems to have spent most of his life in Tournai, where in 1428 he took part in a revolt against the government. In 1432 he was sentenced to undertake a pilgrimage to Provence as penance for adultery. His paintings reflect the status of his clients: In simple domestic settings they are proudly bourgeois. In *Virgin and Child before a Firescreen* (c. 1425), for example, Mary looks like a Flemish housewife nursing her infant in her own sitting room. A basket-weave firescreen behind her, with delicate tongues of flame only just visible above its rim, may symbolize the Virgin's HALO and the Pentecostal fire of the Holy Spirit, but as Harbison, quoted above, maintains, it is day-to-day bourgeois domesticity—not hidden symbols, class struggle, or noble pretension—that preoccupied the painter of this image. Indeed, the very ordinariness of the setting, along with certain stylistic analyses, actually raises doubts that this important work was, in fact, by the hand of Campin, who was the premier painter of Tournai with many important clients. Another questioned attribution is Campin's "masterpiece," an ALTARPIECE known as the *Merode Triptych,* usually dated c. 1425–28. (Analysis through DENDROCHRONOLOGY suggests that the wood PANELS date from the 1450s to the 1460s.) Its central panel, the *Annunciation,* again a domestic scene, is a wonderful catalogue of a contemporary interior in which the

Virgin sits at her kitchen table. The right wing of the TRIPTYCH has an image of Joseph at work; the product of his carpentry has been identified as a mousetrap and its meaning described as illustrating the story of Christ's mission to trap the devil. The left wing shows kneeling DONORS of the middle class. Campin's authorship of several works, besides those mentioned, is proposed rather than confirmed, as the pictures are unsigned and undated. Attributions aside, looking at these works through their own "visual language" and not with a particular set of expectations, we more fully understand them. As Harbison also writes, "Realism in the fifteenth century commented on, perhaps even derived from, its social setting."

Canaletto (Giovanni Antonio Canal)

1697–1768 • Italian • painter • Rococo

Mr. Smith engaged Canaletto to work for him for many years at a very low price and sold his works to the English at much higher rates. (Horace Walpole, 18th century)

Canaletto began his career in the studio of his father, a painter and designer of theatrical scenery, especially for the opera. He excelled in "vistas" or "views" (*veduta* in Italian), which he began painting in 1720. As WALPOLE observes in the quotation above, Canaletto worked for the British consul to Venice, Joseph Smith, and dedicated a set of 31 ETCHINGS, published between 1744 and 1746, to him. Smith acted as intermediary when Englishmen on the GRAND TOUR wanted to buy Canaletto's views of Venice and its great festivals.

During the War of the Austrian Succession (1740–48), when there were few tourists in Venice, Canaletto went to England. There he took the Thames River and British country houses for his subjects. He returned to Venice in 1755. Canaletto's pleasure in Venetian light, his care in representing the surfaces of Venetian buildings, the glowing animation of the skies, and the activity below them all contribute to the appeal of his paintings, especially to visitors who, having returned home, wished to recapture the atmosphere of their sojourn. To achieve his effect, Canaletto changed his viewpoints, moved closer and farther away, rotated some buildings, and changed some rooflines—in short, the views he painted accommodated his aesthetic taste as much as they imitated what he saw. It is thought that he used the CAMERA OBSCURA as a complement to other devices, from ruler and compass to CLAUDE GLASS, and to any available optical aids that he might have found compositionally useful. But while he benefited from such implements, he was not constrained by them. Canaletto's light, delicate atmospheres are consistent with the ROCOCO period, but his work is not completely coherent with that style.

Cano, Alonso

1601–1667 • Spanish •
painter/sculptor/architect • Baroque

[His] will, dictated on August 18 and August 25, 1667, as Cano lay ill in bed just ten days before his death, starts with a declaration of faith in the tenets of the Catholic Church. To the document he attached a list of debts, most of which were for clothing with the exception of one for paper and another for canvas. (Harold Wethey, 1955)

The 17th century is called Spain's "golden years": Although politically decadent under the last of the Hapsburg rulers, it was a brilliant period for Spanish literature (e.g., Cervantes, 1547–1616), and saw the rise of the Spanish school of painting. In this period Cano sculpted figures with grace and beauty. One of the most notable is a painted wooden carving, the *Immaculate Conception* (1655–56). In 1667, the year of his death, Cano designed the first masterpiece of Spanish BAROQUE art, the facade of the Granada Cathedral. Along with other examples of his work, the *Immaculate Conception* is on view inside the cathedral. The refinement of Cano's touch belies the violence of his temperament. Among his transgressions, he was suspected of murdering his wife. He had applied for and was accepted for a position at the Granada Cathedral in 1652, after her death. His designs included two magnificent silver altar lamps and he was engaged in painting seven large canvases—the *Life of the Virgin*—for the sanctuary. But his relations with the canons of the cathedral were strained; they denied him ordination as a priest, for which he had supposedly been studying. The bitterness of his relations with them is preserved in correspondences and the minutes of chapter meetings. His will, referred to in the quotation above, also stated that "because of his great poverty and numerous debts, he could not leave money for masses to be said for his soul."

canon

From its initial Greek definition as a pole, "canon" referred also to the rules that serve to keep things straight, upright, and in good order. The canon went on to include the rules themselves (e.g., the *Canon* of POLYKLEITOS) and, ultimately, those works in a given discipline that measure up to its most stringent rules or standards. Such standards are always somewhat in flux, and never more so than in recent years, when the choice of works considered foundational in the study of ART HISTORY has been vigorously criticized. This canon is contested for its aristocratic bias and an exclusive CHRISTIAN, white, male, CLASSICAL, and Eurocentric focus. (See also FEMINIST, POPULAR CULTURE, FOLK ART, and OUTSIDER ART)

Canova, Antonio

1757–1822 • Italian • sculptor • Neoclassicist

We began to talk . . . of the custom of clothing statues. Whereupon I protested that God Himself would be unable to do something fine if He tried to portray His Majesty dressed like that, in his French breeches and boots.

Canova's father died when he was four, his mother remarried, and Antonio was sent to live with his grandfather, who owned a quarry and was a stonemason. Soon after his 10th birthday he was apprenticed to a sculptor. With the money he earned from his first important work, *Daedalus and Icarus* (1778–79), Canova set off for Rome. He was in close contact with the cultivated society of intellectuals and PATRONS and much influenced by new research in ANTIQ-

UITY. Canova's purity and clarity of form, idealized beauty, and grace were part of the new NEOCLASSICAL wave. But his life and work not only straddled two centuries, it also reflected the dreadful period of Italian history when Rome was invaded by the French and the Republic of Venice dissolved. When Venice fell to the French, Canova almost fled to America but went instead to Possagno, his native village. He worked in Vienna, and also held the post of Inspector General of Antiquities at the Vatican, the position that RAPHAEL had inaugurated. Napoleon called him to Paris twice—one of the visits is referred to in the letter from Canova to Napoleon quoted from above. It should be added that Canova went on to say that the EQUESTRIAN statue he was modeling would be clothed "in the heroic style" because "it was not fitting that [Napoleon] should be represented in the nude while commanding his army." That became academic, however; after Napoleon's demise, a figure of Charles III of Naples by another sculptor was placed on the horse Canova had fashioned. In 1815, at the pope's behest, Canova went to France, where he recovered Italian works of art looted by Napoleon. In London he studied the ELGIN MARBLES, about which he wrote, "The works of Pheidias are truly flesh and blood, like beautiful nature itself." When Canova died, he was buried with full state honors.

canvas

A woven fabric, canvas may be made of materials that range from hemp to cotton and linen. In VENICE during the be-

ginning of the 16th century, canvas, like that used in sails, started to replace wood PANELS as the material of choice for OIL PAINTING. The logic of adopting canvas in that shipbuilding center seems obvious and especially advantageous, considering its relative ease of transportation through a city of narrow bridges. At first a smooth GROUND to paint on was created, as with panels, by preparing the canvas surface with GESSO, a plaster-based coating. Then, reducing the thickness of the gesso, painters began experimenting with the variety of textures that different weaves provided. Consistent with his bold, broad brush technique, TINTORETTO often used a coarse weave, especially for paintings that would be seen from a distance. Because untreated canvas absorbs liquid, artists have almost always treated canvases; however, FRANKEN-THALER chose to work on raw canvas when she developed her technique of staining rather than painting. Artists conventionally stretch their canvas over a wooden frame of whatever size they decide to work in. ABSTRACT EXPRES-SIONISTs, on the other hand, who wanted to interact with their materials in new ways, might, like KLINE, attach the canvas to a wall, thus creating a resistant surface to act against. Jackson POLLOCK placed his canvas on the floor so that he could walk around, reach over, and pour paint onto it. (See also SUPPORT)

"Capitoline" Wolf

Few canonical texts omit this bronze wolf, which exerts a powerful spell as much for its fiercely protective, maternal aura and the legend that surrounds it as for its artistry. Almost 3 feet high, it is believed to be an ETRUSCAN work of c. 500 BCE, and is celebrated as a representation of the animal that saved Romulus and Remus, legendary founders of Rome. According to the historian Levy (59 BCE–17 CE), the two were twins born to a Vestal Virgin who was ravished by Mars. Cast into the Tiber River, the infants were discovered by a wolf, who then nursed and cared for them. They later established Rome on the site of their rescue. The Wolf itself is of uncertain lineage. While it is known that a statue of a she-wolf was dedicated on the Capitoline Hill in Rome in 296 BCE, it is not known whether this is the original; it could even have been made in the Middle Ages, as some 19th-century scholars believed. Two suckling infants beneath the wolf were not added until the ITALIAN RENAISSANCE. Writers praise the alert guardianship of the animal, and it has been suggested that the Wolf may well have been the APOTRO-PAIC guardian of a tomb. As the representation of the surrogate mother of Rome, however, the work with totemic power finally brings most unbelievers to heel. Authentically Etruscan or not, this image served the propagandistic aims of Italian nationalism as late as the 20th century, when it was used to endorse the Fascist dictator Benito Mussolini. Another spectacular Etruscan bronze, the Chimera of the 5th to 4th century BCE, is less controversial and provides an intriguing contrast. Of about the same size as the Wolf, the Chimera, with a lion head, snake tail, and goat head on its back, is as supple as the Wolf is stiff, as active as she is still, as aggressively threatening as she is

wary. In the *Chimera* we see realized the potential for movement and life that the *Wolf* holds in abeyance.

Caracciolo, Giovanni Battista (called Battistello)

1578–1635 • Italian • painter • Baroque

Though he started as a Mannerist, Caracciolo came under the influence of CARAVAGGIO and was one of the most important of that artist's early followers. Caracciolo lived and worked in Naples (where Caravaggio had been twice, in 1607–08 and in 1609–10), and was instrumental in establishing the Neapolitan SCHOOL of painting. (See also MANNERISM and CARAVAGGISTI)

Caravaggio (Michelangelo Merisi)

1571–1610 • Italian • painter • Baroque

Has anyone else managed to paint as successfully as this evil genius, who worked naturally, almost without precepts, without doctrine, without study, but only with the strength of his talent, with nothing but nature before him, which he simply copied in his amazing way? (Vencincio Carducho, 1633)

In his own time, Caravaggio was compared to the Anti-Christ, whose "false miracles" would lead great numbers of people, deceived and moved by his paintings, straight to hell. POUSSIN, who hated him, said, "Caravaggio came into the world to be the ruin of painting." Caravaggio was transgressive and radical in his personal life as well as in his public art. His criminality

was heinous and cowardly—he attacked one of his victims with a sword, from behind—he was dangerous and unpredictable. He killed a man in a dispute over a wager on a tennis match and was himself murderously beaten. Little defense of his behavior is possible, though modern scholars have proposed alternative readings of the historical sources that discuss Caravaggio, and these range from blaming the prejudice of his contemporary biographers to the effort by later writers to mythologize his violence. "The miracle of Caravaggio is that a man personally so out of control ever mustered the discipline to make paintings, much less produce masterpieces," Elizabeth Cropper and Charles Dempsey wrote in 1987, an adequate summing up. Caravaggio's unprecedented "realism," or NATURALISM, was anti-IDEAL to begin with and adopted the everyday world of the lower classes as a conventional setting. In two versions of *Supper at Emmaus* (1601 and 1606), the news of Christ's resurrection is presented, and the reaction to it becomes, in the later work, increasingly subtle, personal, and complex. Caravaggio seems to be following an effort to popularize Counter-Reformation revivalism as it was promoted by Saint Philip Neri, founder of an order called the Oratorians. Caravaggio set ordinary people in unexceptional settings, and then he exploded the ordinary with the miraculous. Light was his means of exposing idea and feeling, and his dramatic use of it was unprecedented (see CHIAROSCURO). Little wonder his detractors worried about his power of persuasion. His contrast of light and shadow, bright and dark, is es-

pecially eerie in combination with the undercurrent of outrage in his works— the *Beheading of Saint John the Baptist* (1608) is an example: The man holding a knife behind his back stands astride the naked John, forcing his head against the ground. At the ready is the charger, or platter, on which the severed head will be given to Salome (as indeed it is in another of Caravaggio's paintings). Unsettled drama also permeates Caravaggio's blatantly confrontational homoerotic paintings, with their seductive, androgynous figures. His first major PATRON, Cardinal del Monte, was a man who lived a self-indulgent life, mainly in the company of young boys dressed up as girls. Caravaggio resided in Monte's household for a time and reflected his sponsor's taste in a series of images. In *Bacchus* (1597–98), the god offers the viewer a goblet of wine, lounges like a Roman sybarite, and has before him a luscious bowl of ripe fruit that is, on closer inspection, rotting. Beauty and decadence, light and dark, ordinary people and strong emotion are characteristics of Caravaggio's paintings. His devotion to naturalism was so pronounced in the *Death of the Virgin* (1605–06)—the Virgin so clearly looks like a corpse—that the fathers who commissioned it for a chapel in the Roman church of Santa Maria della Scala found the painting offensive and rejected it. (They were not the only people who refused a work after commissioning it from Caravaggio.) RUBENS, in Italy about that time, persuaded his own patron, the Duke of Mantua, to buy the *Death of the Virgin*. When the BAROQUE era is seen as an international wave with a number of national styles, it is clear that Caravaggio

precipitated the first, "Early Baroque," in Italy, and that his influence on artists of France, the Netherlands, and Spain, as well as of Italy, was decisive.

Caravaggisti

Painters who came under the influence of CARAVAGGIO and adopted his style of painting, even if only briefly (e.g., BAGLIONE).

caricature

Based on exaggeration or mockery of physical traits, the caricature is a comic portrait, or a scene for ridicule, satire, and burlesque. The decoration of the famous sound box of a Mesopotamian lyre of c. 2600 BCE, in which animals play the roles of people, may be among the earliest caricatures. Fragments of POTTERY from ancient Egypt dated c. 1295–1070 BCE have paintings in which cats and mice are dressed as humans in what seem to be parodies of the upper classes. Social satire inspires much caricature. Artists of ancient Greece and Rome practiced caricature, although it was their poets and dramatists who used it most effectively. MEDIEVAL images of Jews frequently took the form of wicked caricature, as did propagandistic PRINTS of the leaders of the Catholic and Protestant Churches during the 16th-century Reformation. The initiation of caricature as serious art is generally attributed to Annibale CARRACCI in the last decade of the 16th century. Caricature as political attack flourished in England during the 18th and 19th centuries, when artists often sold directly to the public, not to avoid editorial infringement on their point of view but, rather, to profit directly from the party or candidate offering the best

price (HOGARTH was an exception). Major caricaturists in England were James Gillray (1757–1815); Thomas Rowlandson (1756–1827); George Cruickshank (1792–1878); and TENNIEL. Their work was rarely credited as art, but the very people who denounced it (e.g., WALPOLE) also collected it. Somehow the work of the French caricaturist DAUMIER has fared better in entering the CANON, while for the most part, work of the English artists did not. The ephemeral nature of political satire—the fodder of caricature—is doubtless the cause of its short life and lack of appreciation, though the artist's drawing skill is frequently exceptional. The distinction between caricature and CARTOON (in the modern sense of the word) blurred during the 19th century, though "caricature" is the staple of political cartooning. Caricature remains fundamentally "purposeful deformation of the appearance of the original," as Richard Brilliant writes. And it presumes a shared culture, for, as he adds, "recognition of the person to be portrayed is essential. To be successful, hence recognized, the caricature depends on the viewer's prior knowledge of the original and on the deformation of those facial features thought to be most typical of the subject."

Carolingian art
c. 750–c. 900

Named for the Frankish king Charles the Great, known as Charlemagne in French (the word "Carolingian" comes from the Medieval Latin word *Carolus,* for "Charles"). The pope crowned Charlemagne emperor of Rome in 800 at Saint Peter's on Christmas Day. By this action the new emperor was legit-imized by the highest religious authority of Western Christendom (and the pope received the protection of Charlemagne). Western (or Roman) Catholicism remained officially independent of secular rulers; in the East, however, the Orthodox Church of the BYZANTINE empire did not separate spiritual and secular authority, but instead vested both in the emperor, who appointed the patriarch of the Church. Charlemagne's personal seal read *renovatio Romani imperii,* meaning "renewal of the Roman Empire"; the Carolingian period is known as a renaissance. Charlemagne declared himself Constantine's heir and looked back to Christian Rome for inspiration, although he established the center of his realm at a favorite residence in Aachen, Germany. It was a monumental palace complex with administrative offices, royal workshops, and the Palatine (Palace) Chapel (c. 792–805), chief architect of which may have been the bishop Odo of Metz. This large masonry and mosaic building has a central plan, its DOME rising over an octagonal base. Originally it had a walled forecourt from which crowds could see the emperor when he stood in a second-story window. Learning and the arts were promoted by Charlemagne and his scholarly protégé Alcuin of York, and thrived. As part of a program of educational reform, a new and simple script known as Carolingian minuscule was introduced, and manuscript illumination flourished; according to legend, Charlemagne's *Coronation Gospels* (c. 800–10) was buried with him. The so-called author portraits of ancient Roman manuscripts became models for representations of the evangelists in

Carolingian books. Charlemagne died in 814 but his influence continued in the work of his children and grandchildren. The *Utrecht Psalter* (c. 830), or psalm book, with its lively, vividly expressive pen-and-ink drawings, is probably the best-known book from the period. Carolingian books show a melding of HIBERNO SAXON and Mediterranean styles; important ILLUMINATED MANUSCRIPTs might be written in gold on purple vellum, imperial symbols. Covers of gold inset with precious gems (for example, on the *Lindau Gospels,* c. 870) protected the text and turned the book itself into an object of devotion.

Carolus-Duran (Charles-Émile-Auguste Durand)

1837–1917 • French • painter • Academic

When his money was exhausted [during his studies in Rome] he returned to Paris, there to begin the long struggle with poverty and disappointments which developed in him a strength to overcome difficulties and a desire to assist other poor young artists, which when rich and influential he never failed to do. (Anna Seaton-Schmidt, 1917)

Carolus-Duran established his reputation as a fashionable portraitist as well as a popular and successful teacher. He set up a small, independent studio that was distinguished by the number of English and American students he attracted. His teaching differed from that of the ÉCOLE DES BEAUX-ARTS in that he did not stress pencil drawing but, rather, had his students work directly on canvas with paint. He was also a strong advocate of the importance of color. Carolus-Duran's *The Woman with a Glove* (1869) is a graceful, full-length portrait of his wife dressed elegantly in black, with a yellow carnation in her hair. The painting shows the influence of VELÁZQUEZ, whose work was important to Carolus-Duran. It also makes allusions to TITIAN's *Man with the Glove* (c. 1523), and perhaps to society portraits by British painters of the previous century. Even more interesting is its connection to the works of Carolus-Duran's own American student, SARGENT, whose style was close to that of his teacher. In fact, Sargent's *Portrait of Carolus-Duran* (1879) marked the start of the American painter's professional career.

Carpaccio, Vittore

c. 1460/66–1525/26 • Italian • painter • Renaissance

Carpaccio's almost contemporary legend of Saint Ursula makes use of the long horizontal format . . . to represent ceremonial events: the dispatching and reception of ambassadors, processions. Several episodes may be combined in one canvas so figures may appear more than once within the same scene. Color helps the viewer recognize them and thus make sense of the narrative. (Marcia Hall, 1992)

In a fanciful and witty style, harmonized by a golden tonality, Carpaccio painted narrative scenes for a fraternal group, the Scuola di Sant' Orsola (Ursula)—*Scuole* (plural)—under the auspices of the church, who were dedicated to carrying out good works. Saint Ursula, whose legend Carpaccio illustrated in the 1490s, went to Rome

accompanied by 10 maids of honor and 11,000 virgins (see VORAGINE). On the return trip, Ursula and her court of virgins were all slaughtered by Huns. Carpaccio's characters are usually solemn-faced, with little expression, yet they seem portraitlike. Casual details— dogs, conversants, passersby, and architecture in the background—add anecdotal interest, and as Marcia Hall points out in the comment quoted above, he used color codes for NARRATIVE purposes. Gentile BELLINI seems to have had some influence on Carpaccio in that series, but there is no connection between the two in Carpaccio's *Meditation on the Passion* (probably c. 1510). Here the artist has invented two aged, emaciated saints with long white beards, seated on either side of a dead Christ, who, oddly enough, is similar to but more attractive than the figure CRIVELLI painted three decades earlier. There is a multitude of intriguing landscape details, but most significantly, half of the countryside is composed of verdant, rolling hills, and leafy trees, while the other half is rocky, with one bare, contorted tree scratching at the sky.

Carpeaux, Jean-Baptiste

1827–1875 • French • sculptor • Beaux-Arts

Immediately he seized a pen, a bit of paper and, in a second, traced a few marvelously intersecting lines, making with a few movements the best composition in the world; in short, five minutes afterward, he had arrived at his group! (Charles Garnier, 1880)

Carpeaux is one of the few sculptors who established themselves during France's SECOND EMPIRE. His masterpiece is *The Dance* (1866), a group of figures for the front of the Paris Opéra (1861–74). The building was designed by the architect Charles Garnier (1825–1898), whose recollection of Carpeaux's moment of inspiration is quoted above. The sculpture became scandalous, however, when complaints that the nude bacchantes were drunk, vulgar, and indecent were accompanied by demands that the work be removed. The outbreak of the Franco-Prussian War diverted attention from *The Dance,* and after the war it received praise instead of reproach. The next group of nudes Carpeaux made for public display was more restrained: *The Four Continents* (1867–72) are four women who include America wearing a feather headband and Africa with a chain around one leg. Carpeaux reproduced the head of Africa as a bust bound with ropes and inscribed "WHY WAS I BORN A SLAVE?" Carpeaux was favored at the court of Louis Napoleon (Napoleon III) and lost stature as well as his health with the Third Republic.

Carr, Emily

1871–1945 • Canadian • painter/writer • Expressionist

You must be absolutely honest in the depicting of a totem for meaning is attached to every line. You must be most particular about detail and proportion. I never use the camera nor work from photos; every pole in my collection has been studied from its own actual reality in its own original setting, and I have as you might term it, been personally acquainted with every pole here shown.

Carr single-mindedly combined a love for her native British Columbia with the pursuit of art. Many of her works focused on the life and lore of West Coast Native Americans whose totems, graveyards, and churches she studied. Her commitment to Indian art is expressed in the quotation above, from a lecture she gave in 1913. She added, "Indians I think express it well when they say to one another 'come and see the woman make pictures with her head and hands, not with a box.' " *Corner of Kitwancool Village* (c. 1930) shows a series of totem poles moving into the distance. The foremost totem seems alive: Its lowest figure has a large red mouth and wide-open eyes; it appears strangely beseeching as it gazes directly at the viewer. The top of the pole has an older, wiser face. Electric blue hills showered by supernatural light fill the background. Carr's works, including many composed of swirling brushstrokes and landscapes empty of people, are highly charged as if with spiritualism. Carr was neglected during her early career and had to run a boardinghouse and make souvenir pottery in order to survive. Finally, she found and was encouraged by painters in the GROUP OF SEVEN, and she has become one of Canada's most renowned artists. She also wrote several autobiographical books.

Carrà, Carlo
1881–1966 • Italian • painter • Futurist/Metaphysical School

Now it seems that my spirit is moving in an unknown matter or is lost in the whirlpools of sacred spasm. It is Knowledge! It is a sweet dreaming that dissolves all measure and broadens my individuality in relationship to things.

During the 1910s, Carrà signed the FUTURIST manifestos along with his colleagues BOCCIONI, Luigi Russolo (1885–1947), BALLA, and SEVERINI. About 1915 he began to turn his back on Futurism and studied the work of GIOTTO and the ITALIAN RENAISSANCE. The following year he met de CHIRICO and they began to paint in the style they named Scuola Metafisica, or the Metaphysical School. Its two main principles, formulated between 1917 and 1919, were to evoke those states of mind that question the existence of the ordinary, objective world, and to achieve this through solid, clearly defined forms that, paradoxically, look quite objective and ordinary. Scuola Metafisica lasted only a few years. Carrà and de Chirico quarreled over the authorship of the movement and diverged, but Scuola Metafisica bridged the gap between Futurism and SURREALISM. While de Chirico's enigmatic images are dark and threatening, Carrà's are more melancholy and less frightening. An example of his work is *Mother and Son* (1917), in which both figures are oversize, featureless dressmaker dummies, similar to those de Chirico used, in an almost empty but claustrophobic room. The commentary quoted above is from Carrà's essay "The Quadrant of the Spirit," written in 1919.

Carracci, Annibale
1560–1609 • Italian • painter • Baroque

Thus, when painting was drawing to its end, . . . it pleased God that in the

city of Bologna, the mistress of sciences and studies, a most noble mind was forged and through it the declining and extinguished art was reforged. He was that Annibale Carracci. (Giovanni Pietro Bellori, 1672)

Reaction against all that was artificial in MANNERISM found a powerful expression in the paintings of Annibale. His works are the epitome of NATURALISM, yet, if they look back to the ITALIAN RENAISSANCE for clarity and inspiration, they also look to contemporary life for the bluntness of truth. His *Butcher's Shop* (c. 1581–84) is an example of the best of GENRE painting. In addition, art historians think that it contains portraits of three of the Carracci: Ludovico (Annibale's cousin, an artist of high and original accomplishment, from whom Annibale learned painting); Agostino (Annibale's brother, who taught him ENGRAVING); and Annibale himself. In part because Ludovico, his teacher, was the son of a butcher, Annibale's painting is also thought to be an allegory of the academy that the Carracci founded in their hometown of Bologna. It was the first academy based on the premise that art can be taught by the study of ANTIQUE and Renaissance traditions, at the same time stressing the importance of drawing from life. However, genre scenes were by no means Annibale's main preoccupation. *The Dead Christ* (c. 1581–84) revisits the idea MANTEGNA had about 80 years earlier, of looking at the foreshortened body as though standing at its feet. Annibale's blunt confrontation with this corpse is equally disconcerting, and the wounds are bloodier, the body more twisted, and the moment of death somehow more recent. To the extent that BAROQUE artists meant to draw the audience into the religious experience, this was, and remains, an overwhelmingly effective work. Called to Rome in 1595 to paint in the Farnese Palace, Annibale decorated the Galleria Farnese (1597–1601), a room that measures some 68 by 21 feet and is some 32 feet high, with the *Loves of the Classical Gods*. In his biography of Annibale, quoted from above, Bellori also writes about the FRESCO: "And since the end of all irrational pleasures is sorrow and punishment . . . he painted Andromeda bound to the rock to be devoured by the sea monster, symbolizing that the soul bound to emotion becomes the food of vice if Perseus—that is to say, reason and the love of the worthy—does not come to his assistance." Carracci's scenes were divided by illusory frames and fictitious architecture. Even more than MICHELANGELO, who identified himself as a sculptor above being a painter, Carracci painted monochrome figures meant to look like sculptures. He went so far as to paint these figures as though some of their "marble" parts had broken off, that is, as if they were actual relics, but with lifelike details, such as eyes that look heavenward. Carracci's stay in Rome was fairly short: Suffering severe depression, in about 1605 he became incapacitated and gave up his studio. He died in 1609, not yet 50 years old.

Carracci family

Three outstanding members of this family of artists—Ludovico (1555–1619), Agostino (1557–1602), and An-

nibale (see above)—set a new course for Italian art at the end of the 16th century. The accomplishments of Annibale ultimately outdistanced those of the others, but the artistic reform they instituted together was realized initially through the academy that they opened in Bologna around 1582. The Accademia degli Desiderosi, started in Ludovico's studio, emphasized the study of nature and drawing from life, not only people but plants, animals, landscapes, and objects as well. They also formulated the CLASSICAL ideal in a period when discoveries from ANTIQUITY had persuasive influence. Their motivation was in large part a strong reaction against the artifice of MANNERISM and a direct appeal to the viewers' emotions. This is especially true of their religious paintings, which were inspired by the Counter-Reformation.

Carriera, Rosalba
1675–1757 • Italian •
painter/pastelist • Rococo

I have been unanimously admitted to the Académie. No vote was taken, as no one wanted to make use of the black ball.

Carriera was painting snuffboxes and MINIATURES on ivory in Venice when, the story goes, an Englishman persuaded her to take up PASTEL. But she was no "Little Match Girl"—Carriera had a good education in French, history, literature, and music. She was admitted to the Academy of Saint Luke in Rome in 1705 and earned several notable portrait commissions, including the kings of Denmark and Poland. She went to Paris in 1720 and met RIGAUD and WATTEAU as well as members of the French court, from whom she also received commissions. Her portraits show a deft hand at subtle flattery. The French academy welcomed her, and its artists followed her example of an elegant but intimate kind of portraiture. She started in the light and airy ROCOCO vein, with its superficial glamour, but her later pictures became more expressive. A *Self-Portrait* of c. 1744 looks at a woman nearing her 70s with gray hair and a thoughtful, though glazed, cast to her eyes. One cannot help but read dismay there, knowing that in two years Carriera would lose her sight.

cartoon
The Italian *cartone* means "cardboard." The term "cartoon" first referred to full-scale drawings for designs that would be applied to other surfaces: walls, wood PANELS, STAINED GLASS windows, rugs, TAPESTRIES, and CANVASES. Some cartoons were POUNCEd; that is, pinpricks along drawn lines allowed charcoal dust to filter through and transfer the picture to the desired surface. By MASACCIO's time (early 15th century), enough PAPER was available to be used for FRESCO cartoons. Cartoons by RAPHAEL and RUBENS for tapestries are among the world's most prized works of art. During the 19th century the word "cartoon" began to be used for humorous drawings, especially the political satires earlier known as CARICATURES. This occurred in 1843, after the popular English magazine *Punch* published a humorous cartoon that parodied serious cartoon submissions in a competition to design decorations for the Houses of Parliament.

During the 20th century, humor has became the main usage of the word, especially the cartoon strips of POPULAR CULTURE. Since the 1960s, however, new developments have redefined the term: Using cartooning techniques—black outline and dot screen—and comic books themselves as sources, LICHTENSTEIN made cartoon images into HIGH ART. In his groundbreaking book, *Maus* (1986), Art Spiegelman (born 1948) used the comic strip format to tell the story of his parents' deportation and concentration camp experiences during World War II. At the end of the 20th century, the comic strip is an increasingly serious medium for political and social satire.

caryatid

A sculpted female figure used in place of a COLUMN. Conflicting stories explain its origin, one being that caryatids represent the women who danced around a tree sacred to the goddess Artemis Karneia, or Caryatis. Another explanation is given by VITRUVIUS. He relates the caryatid to Greek women from the town of Carya who collaborated with the Persians when they invaded Greece. These women were later humiliated: Treated as slaves, they were forced to carry heavy burdens on their heads, as caryatid columns carry the weight of a building. The earliest examples of caryatids that survive are the elaborately dressed ARCHAIC columns standing guard at the Treasury of the Siphnians at the Sanctuary of Apollo at Delphi, c. 530 BCE. The CLASSICAL caryatids from the Porch of the Maidens, or south porch of the Erechtheion (421–405 BCE) on the Athenian ACROPOLIS, are even more renowned. The male version of a caryatid, of which surviving examples are rare, is an atlantid (*atlas* in Greek; plural *atlantes*). *Telamon* (pl. *Telamones*) is the Roman term.

Cassatt, Mary

1844–1926 • American • painter/printmaker • Impressionist

After all give me France. Women do not have to fight for recognition here if they do serious work.

Born in Philadelphia, Cassatt lived as an expatriate in Paris, where she was able to enjoy more freedom (as expressed in the comment above), and to work and exhibit with the great French IMPRESSIONISTS, DEGAS, RENOIR, and MONET. She, too, painted in bright colors, without shadows or particular attention to depth, but concentrated on the momentary effect of light, and she, too, was greatly influenced by Japanese prints (see UKIYO-E). Unlike her male counterparts, however, who usually painted women as ornaments or as sexual or social problems, Cassatt portrayed women as individuals in their own, independent, female worlds. She reveals their relationships to one another, to their children, and to the domestic and social lives of which they were the center. She also recorded their public personas: In *Woman in Black at the Opera* (1880), the subject, looking through her opera glasses, is both spectator and participant in the upper-class urban milieu that was frequently an Impressionist theme. The painting prompts contemplation about the act of seeing, and of being seen. Equality for women was important to Cassatt, but

there is great subtlety in her approach, and her paintings never made strident statements. Toward the end of her life she tried to help the women who worked at a factory near her own mansion. She is reported to have said, "If I weren't a weak old woman, I'd be a Socialist." In the early 1890s, Cassatt painted a mural—*Modern Woman,* now lost—for the Women's Building at the Columbian Exposition of 1893 in Chicago.

Castiglione, Baldassare
1478–1529 • Italian • author

I have made drawings of various types based on Your Lordship's suggestions, and unless everybody is flattering me, I have satisfied everybody; but I do not satisfy my own judgment, because I am afraid of not satisfying yours. (Raphael, in a letter to Castiglione, c. 1514)

In his book of dialogues, *The Courtier* (written 1508–18, published 1528), Castiglione formulated the standards for aristocratic behavior. These included disdain of materialism and ostentation, and esteem for elegance and restraint. In view of the excesses of turn-of-the-century Italy, the restoration of the MEDICIS to power in Florence in 1512, and the papacy of Leo X (which began in 1513), Castiglione's book seems politically as well as socially motivated. He may have helped his friend RAPHAEL compose a letter to the pope that resulted in Raphael's appointment as Superintendent of Antiquities. In *Castiglione* (c. 1514–15), Raphael's subject is soberly dressed in shades of black, gray, and white; the portrait is warm, softly lighted, and gentle in effect. As does the quotation from his letter, above, the painting articulates the artist's friendship and admiration for Castiglione. When the painting was auctioned off in the 17th century, REMBRANDT tried to buy it, but the bidding exceeded his resources. Nevertheless, it remained in his memory, and two of his own self-portraits used it as a point of reference.

catacombs
The underground cemeteries of ancient Rome, a network of corridors and burial chambers called cubicula (singular "cubiculum"), were sometimes on as many as five levels. Paintings on the walls of Christian cubicula in Rome are among the earliest examples of EARLY CHRISTIAN ART.

catalogue/catalog—collection
MUSEUMS document their collections of works of art in comprehensive catalogues.

catalogue/catalog—exhibition
In their earliest and simplest forms, exhibition catalogues did little more than identify the works of art presented. During the late decades of the 20th century, exhibition catalogues gained importance as documents of current scholarship. Detailing the theme of the exhibition, the catalogue contains essays by CURATORS and scholars who are specialists in the field. It may discuss the historical circumstances of the artist or artists presented, along with new information about the artists' PATRONS, associates, influences, and so on. Consequently, significant exhibition catalogues are reviewed as major new scholarly texts. (See also EXHIBITION)

catalogue/catalog—raisonné

Raisonné, French for "reasoned," refers to a catalogue devoted to the works of a single artist. The scholar producing it strives to describe all available pertinent, factual documentation including dates, biographical information about the artist, the PROVENANCE (i.e., sequence of ownership), attributions, and exhibition history of each work, whether ENGRAVINGS of the work were made, and all previous scholarship.

cathedral

The bishop's chair or throne (from the Latin *cathedra*)—originally placed in the apse, or niche, behind the high altar—gave its name to the church where the bishop officiated. A cathedral is an urban building.

Catlin, George

1796–1872 • American • painter • Romantic

I love a people who have always made me welcome to the best they had . . . who are honest without laws, who have no jails and no poorhouse . . . who never take the name of God in vain . . . who worship God without a Bible, and I believe that God loves them also . . . and oh! how I love a people who don't live for the love of money.

Between 1830 and 1836, Catlin explored the world of Native Americans in the vast and largely unvisited area from the upper Missouri River and the headwaters of the Mississippi to the Mexican Territory in the far Southwest. He produced written documentation as well as comprehensive pictorial records that included portraits of chieftains—

e.g., *Keokuk (The Watchful Fox), Chief of the Tribe,* 1832—warriors, and medicine men and women. He also portrayed ceremonies, dances, hunting, games, and warfare. On his own, with neither financial support nor official sanction, Catlin pursued his mission from tribe to tribe, making careful, accurate representations. These ultimately formed the basis for the Indian Gallery opened by the Smithsonian Institution in Washington, D.C. Catlin's feelings about his subject are expressed in the quotation above. Some of his contemporaries accused him of sentimentality, perhaps to avoid feeling guilty about claiming the territories Indians inhabited. Contemporary critics are more likely to challenge Catlin for exploiting Native Americans for his own artistic and economic interests than for romanticizing them.

Cavallini, Pietro

active c. 1273–1308 • Italian • painter/mosaicist • Late Gothic

I here commemorate Petrus de Cerronibus, whose life spanned a hundred years, who never covered his head even in the cold, and who was my father—[signed] Giovanni Cavallini, scriptor to His Holiness the Pope. (between 1230 and 1260)

The above acknowledgment of Pietro by his son is one of the very few written documents regarding Cavallini. (Of three others, one contains his signature as witness to a land transfer, and two concern the terms of his employment by the king.) Cavallini, located in Rome, worked in MOSAIC as well as paint, and in an interesting blend of styles. This composite is seen in the row of seated

apostles of his *Last Judgment* FRESCO (c. 1291). The figures have that stiff FRONTALITY of the contemporary BYZANTINE style, but they also have a CLASSICAL volume and solidity, and their forms are MODELED with light. This modeling suggests that Cavallini may have seen some ancient ROMAN wall paintings that are lost to us now but probably resembled those later found at HERCULANEUM. At any rate, Cavallini is appreciated for his influence on GIOTTO, whose own *Last Judgment,* in the Arena Chapel (1305–06), draws from Cavallini.

CE
An alternative to AD for purposes of dating, CE stands for Common Era. (See also BCE)

Cellini, Benvenuto
1500–1571 • Italian • sculptor • Mannerist

Sculpture is the mother of all the arts involving drawing. If a man is an able sculptor . . . he will easily be a good perspectivist and architect, and also a better painter. . . . A painting is nothing better than the image of a tree, man, or other object reflected in a fountain. The difference between painting and sculpture is as great as between a shadow and the object casting it.

Cellini was extravagant with both words and materials. He wrote two treatises on art, rhymes, letters, and an autobiography in which he described himself as a statesman, soldier, and lover, as well as an artist. He was a goldsmith above all, but MICHELAN-GELO's influence also led him to sculpture. Cellini's forms are curvaceous and highly decorative. A member of the FONTAINEBLEAU school for five years (1540–45), he created a gold saltcellar for the French king FRANCIS I that is ornamented with nude, elongated, reclining figures of Neptune and Earth. The virtuosity of its workmanship is as brilliant as the material from which it is made. Only his saltcellar and a RELIEF, *Nymph of Fontainebleau,* survive from that period. To heighten its dramatic effect, Cellini used the MANNERIST device of exhibiting his work by candlelight. He lost favor with Francis I as a result of palace intrigue and returned to Florence, where he achieved renown for *Perseus* (1545–54), a larger-than-life-size bronze sculpture commissioned by Cosimo de' MEDICI. Both its elaborate detail and its vitality established his reputation as a sculptor, and he vividly describes casting it in his well-known and lively autobiography. Cellini's devotion to art, and to his own self-fulfillment, was untempered by the politics or the religious strife of his era.

Celtic cross
A circle surrounds the juncture of its vertical post and horizontal arms in this cross. Such freestanding Celtic crosses, carved of stone and as high as 17 feet, were erected around monastic grounds in the Irish countryside from the 8th to the 10th century. Their designs have spirals and INTERLACE patterns and depict Christian themes with simplified but expressive figures. Some scholars see a relationship to COPTIC art. Primarily located in Ireland, Celtic crosses are

also found in Scotland and on the Isle of Man.

Cennini, Cennino

1370–1440 • Italian • artist/writer • proto-Renaissance

Here begins the craftsman's handbook, made and composed . . . in the reverence of God, and of The Virgin Mary, and of Saint Eustace . . . of all the Saints of God; and in the reverence of Giotto, of Taddeo and of Agnolo, Cennino's master; and for the use and good and profit of anyone who wants to enter this profession.

None of Cennini's own art survives, but his book, *Il libro dell'arte* (completed 1437, known in translation as *The Handbook of Crafts*), is extremely valuable as a compendium of early-15th-century Florentine artistic techniques. For example, after his description of the steps to be taken in applying nine layers of GESSO, and then sketching the composition to be painted with charcoal made from burned willow twigs, he writes, "When you have finished drawing your figure, especially if it is in a very valuable [altarpiece], so that you are counting on profit and reputation from it, leave it alone for a few days, going back to it now and then to look it over and improve it wherever it still needs something. . . ." Cennini equates painting with work, although all work was believed to be the result of sin and the loss of Paradise. However, Cennini sees art as a worthy project requiring imagination and invention to reveal the invisible. In that endeavor he links painting with poetry, as the poet, too, composes "strange fables." The value and dignity Cennini accords the artist binds him to the ITALIAN RENAISSANCE. As he describes in the quotation above, he was a student of Agnolo GADDI, son and pupil of Taddeo GADDI, who was the godson and student of GIOTTO. Cennini is thus believed to be an accurate source of information about the methods of Giotto and his followers.

ceramics
See POTTERY

Cercle et Carré (Circle and Square)

A group formed in Paris, in 1929, by the artist-critic Michel Seuphor (born 1901) and the Uruguayan painter Joaquín Torres-García (1874–1949). Its first exhibition, in April 1930, was on the ground floor of the building in which PICASSO lived. Cercle et Carré was a reaction against the figuration or residual representation of less rigidly nonobjective ABSTRACT artists. Included in Cercle et Carré were KANDINSKY, LE CORBUSIER, LÉGER, MONDRIAN, SCHWITTERS, Joseph STELLA, TAEUBER-ARP, and ARP, though he was both an Abstract and a SURREALIST artist. The Cercle et Carré group and its periodical by the same name were short lived, but they had considerable impact. Their activities and mailing list were taken over by the ABSTRACTION-CRÉATION group in 1931.

Cézanne, Paul

1839–1906 • French • painter • Post-Impressionist

But I always come back to this: the painter should devote himself entirely

to the study of nature and endeavor to produce pictures that are an education. Chatter about art is almost useless.

Throughout his lifetime, even while he was rejected by the press and public, other artists collected Cézanne's paintings: PISSARRO owned fourteen, DEGAS seven, RENOIR three, GAUGUIN five, and in 1899 MATISSE bought Cézanne's *Three Women Bathers* (1879–82) even though he, Matisse, was near financial ruin. Cézanne's first one-man exhibition was held by VOLLARD in 1895. FAUVE, CUBIST, German EXPRESSIONIST, Russian SUPREMATIST, and CONSTRUCTIVIST movements were all directly indebted to him. The vision his work inspired was powerful enough to penetrate four centuries of obscurity and revive the reputation of PIERO della Francesca: Both he and Cézanne represented figures and objects as geometric, volumetric forms. Cézanne's range was grand and diverse—portraits, FIGURES (notably bathers), landscapes (especially Mont-Sainte-Victoire in Provence), and STILL LIFES. In the latter category he is famous for his signature apples on a tipped surface, or plane. Using psychoanalytic theory, Meyer SCHAPIRO's influential 1968 essay considers that Cézanne's apples carry "a latent erotic sense" and show "an unconscious symbolizing of a repressed desire." Cézanne's often quoted intent may have been, as he told BERNARD, to "treat nature by the cylinder, the sphere, the cone," although its relevance to his own work is dubious, and it is suggested he may have been speaking primarily as a "teacher." Perhaps more important was his comment to the effect that he wanted to make something

solid and durable of IMPRESSIONISM, for Cézanne was concerned with solidity, volume, and form. His devotion to solid form was equaled by his commitment to color, which he used for MODELING, rather than using the age-old technique of shading, or tonal modeling with black and white. Of himself, and of his great series of male and female bathers, Cézanne wrote that he wished to do "Poussin over entirely from nature." Respectful of that great 17th-century French painter, Cézanne's comment is ambiguous but understandable. Like POUSSIN, Cézanne was interested in CLASSICAL authors, but unlike Poussin, whose scenes were idealized, Cézanne painted *as,* if not exactly *what,* he saw. Regarding the bathers, whom he painted in landscape settings, among the obvious problems he cited was "to gather together the necessary number of people . . . willing to undress and remain motionless in the poses I had determined." (He once shouted at a restless model, "Be an apple!") Of his contemporaries, he most admired "the humble and colossal Pissarro," nine years his senior, who became his painting companion. Cézanne was born in Aix-en-Provence. His father, a tyrant whom he feared, made hats—and enough money to buy the local bank. At the Collège Bourbon, Cézanne developed his love of classical literature—he held Virgil and Plato above all—and a friendship with Émile Zola. In many ways this friendship was the emotional center of Cézanne's life, and it became exceedingly painful. It ended when Zola published *L'Oeuvre* in 1886, and Cézanne saw a character in the novel as unkindly representing himself. A shy man, given to outbursts of rage,

Cézanne was both insecure and over-confident about his own art. Despite the esteem his work enjoyed, Cézanne was never quite satisfied with it, and the very year of his death he wrote, "Shall I ever reach the goal so eagerly sought and so long pursued? I hope so, but as long as it has not been attained a vague feeling of discomfort persists which will not disappear until I shall have gained the harbor."

Chagall, Marc
1887–1985 • Russian • painter • Expressionist/Cubist/Fauve

The fact that I made use of cows, milkmaids, roosters, and provincial Russian architecture as my source of forms is because they are part of the environment from which I spring and which undoubtedly left the deepest impression on my visual memory of any experiences I have known. Every painter is born somewhere.

Chagall went to study in Paris in 1910, and associated with APOLLINAIRE and painters of the new CUBISM, as well as the other Jewish artists MODIGLIANI, SOUTINE, and PASCIN (see also SCHOOL OF PARIS). Chagall was from a family of Hasidic Jews in Vitebsk, Russia. He returned home to Vitebsk after the Russian Revolution and set up the Free Academy there. He was ousted after just a year, in 1919, at the instigation of MALEVICH, who supported a more radical, avant-garde approach than that of Chagall. Many of Chagall's richly colored scenes that recollect his youth are steeped in both Jewish and Russian folklore. "By the time he left Russia for good, in 1922 ... integration of Russian Jewish life into the bloodstream of

modern art was complete," writes the critic John Russell. Art historians identify the offshoots of several movements in Chagall's paintings: EXPRESSIONIST emotion, FAUVE colors, CUBIST geometries, even de CHIRICO's Metaphysical painting, in addition to SURREALIST fantasy. His work does contain many of the irrational characteristics that are manifest in Surrealism, but while he was claimed by spokesmen of the movement, Chagall denied the affiliation, rejecting especially its interest in AUTOMATISM and PSYCHOANALYSIS: "For my part, I have slept well without Freud," he told an interviewer in 1944. Many of Chagall's images are romantic homages to his wife, Bella; he may, for instance, show himself floating above her to plant a kiss on her face (*Birthday*, 1915–23). But his work is not all light-hearted. *White Crucifixion* (1938) portrays Jesus as a crucified Jew, surrounded by symbols of Jewish worship and German persecution. In fact the original painting, later overpainted, had a Nazi swastika on a flag at the upper right. "Christ has always symbolized the true type of the Jewish martyr," Chagall once said. Among his important commissions was a series of STAINED GLASS windows he designed for the Synagogue of the Hadassah Medical Center in Jerusalem in 1962.

Champaigne, Philippe de
1602–1674 • Flemish • painter • Baroque

Philippe de Champaigne is important not only as an original artist but also as summing up one aspect of French art in the middle of the seventeenth century. His portraits and his later

religious works are as true a reflexion of the rationalism of French thought as the classical compositions of Poussin in the 1640s. One uses the formula of Roman republican virtue to express his beliefs, and the other that of Jansenism. (Anthony Blunt, 1953)

An accomplished, successful artist employed by Cardinal Richelieu early in his career, Champaigne did his best work after he became familiar with the doctrines of Jansenism, as BLUNT notes in the quotation above. A fervently emotional religious movement—the most puritanical wing of French Catholicism—Jansenism emerged in France in 1640 with the publication of Cornelis Jansen's *Augustinus*. It was in part a reaction to the abstract, mechanistic, scientific rationalism of the era's physicists and philosophers: The works of Galileo and Descartes were published during the same period. Champaigne's masterpiece, *Two Nuns of Port Royal* (full title: *Mother Catherine Agnes Arnauld and Sister Catherine de Sainte Suzanne, the Artist's Daughter. The Ex Voto of 1662*), was painted in gratitude for the cure of his daughter: A Jansenist nun, she had been paralyzed but then recovered—thanks to the prayers of the prioress, Champaigne believed. One of the bare gray walls of the background is inscribed with the story of her miraculous recovery. The older nun kneels in prayer, the afflicted woman is seated. Both have large red crosses on their white habits, both are serene, and a ray of light communicates the miracle that has occurred. Jansenism displeased both the Jesuits and the Crown, and the nuns of Port Royal were under threat of persecution. They were soon expelled and dispersed.

Chardin, Jean-Baptiste-Siméon

1699–1779 • French • painter • Rococo

Messieurs, messieurs, not quite so fast! Seek out the worst of all the pictures here, and think that two thousand unfortunates have broken their brushes between their teeth, in despair at ever doing anything as bad. . . . If you will hear me out, you will perhaps learn to be indulgent.

Chardin persisted in painting STILL LIFE compositions because he enjoyed them, despite their low status in the ACADEMIC hierarchy. With some exceptions, a vivid contrast of strawberries and white carnations, for instance, his arrangements are quiet juxtapositions of shapes and subtle plays of color. He also painted a series of meditations on the theme of mothers and children—for example, *Morning Toilette* (c. 1741). These may have to be taken with a grain of moralizing salt regarding female virtue. Consider a contemporary observer's words (linking the political term "Third Estate" to painting for what may be the first time): "Does a woman of the Third Estate ever pass by [the picture] without believing that here is an idea of her character . . . her domestic surroundings, her countenance, her frank manners, her daily occupations, her morality, the emotions of her children. . . . While her *Mother* adjusts her hair, this *little Girl* turns to look back at the *Mirror*. . . . In this . . . we read awakening vanity." Some historians read into Chardin's servant class an

oppressed proletariat prescient of the French Revolution. Whether or not that is true, he did ennoble ordinary people and simple things—pots, pitchers, eggs, meat—and he could hardly be farther from the effete fripperies of BOUCHER or the eroticism of FRAGONARD. Both were his contemporaries; in fact, Chardin was Fragonard's first teacher (Boucher was his second). DIDEROT, a great supporter of Chardin, wrote, "It is the business of art to touch and to move, and to do this by getting close to nature. Welcome back, great magician, with your mute compositions! How eloquently they speak to the artist! How much they tell him about the representations of Nature, the science of color and harmony! How freely the air flows around these objects!" Chardin was a modest artist whose speech to the jurors of the official SALON of 1765, quoted from above, ends "Adieu, messieurs; be lenient, messieurs, lenient!"

Charonton, Enguerrand (Quarton)

c. 1410–c. 1466 • French • painter • Late Gothic/Northern Renaissance

Item: In Paradise . . . should be all the estates of the world arranged by said Master Enguerrand . . . there should be the heavens in which will be the sun and the moon. . . . After the heavens, the world in which should be shown a part of the city of Rome. (contract, 1453)

Enguerrand Quarton, or Charonton, as he is called in English, painted the brilliant, intensely colored *Coronation of the Virgin* (1453) for the Carthusian monastery of Villeneuve-les-Avignon. A lengthy contract, quoted from above, designates the scenes that are to be in the *Coronation*. The program was quite specific, yet it also left certain details to the artist's discretion. In 1970 the historian Charles Sterling identified Charonton as also the painter of the famous *Avignon Pietà* (c. 1455), which had, in the past, been hung next to the *Coronation*. In this PIETÀ, the scourged body of Christ, contorted by rigor mortis, curves rigidly over his mother's lap; the heads of the three mourners repeat the arc of Christ's body, and at the left edge of the picture the man who commissioned the work, dressed in a white surplice, kneels in prayer. Sterling found stylistic elements that connected the two paintings, such as similarities in the treatment of fingers and of folds in the DRAPERY, as well as the shapes of nostrils, lips, and eyebrows. Moreover, the landscape in the *Pietà* is reminiscent of the hills in the background of the *Coronation*. These features, not specified by the contract, were apparently added by Charonton, who included a prominent local landmark, Mont-Sainte-Victoire, in his scene. (More than four centuries later, CÉZANNE depicted the same mountain more than 60 times.) Once the association between the two paintings and Charonton is made, it seems likely that the DONOR represented in the *Pietà*, a gaunt man with high cheekbones and furrowed brow, is the same Jean de Montagnac who signed the contract for the *Coronation*. As interesting as Sterling's *Pietà* attribution is, there is not universal agreement among art historians, some of whom find as many

differences as similarities between the two paintings.

Chartres Cathedral

Chartres is a town 55 miles southwest of Paris. It was the location of a pre-Christian goddess cult and then a church that burned down before the 11th century. The Cathedral of Nôtre Dame was founded in the 11th century where the church had been. The cathedral, now familiarly known as Chartres, itself burned twice in the 12th century: in 1134 and in 1194. Its rebuilding, which continued until 1260, was inspired by the philosophy of the abbot SUGER, and is the embodiment of GOTHIC ideas. The western portion of Chartres was roughly contemporary with, and is thought to resemble, Suger's (now lost) west side of the Abbey Church of Saint-Denis. Having survived the 1194 fire, it preserves our best examples of Early Gothic architecture and decoration. Its three entryways are called the Royal Portal because they include sculptures of biblical kings and queens. Their "jamb" or column statues are of a type first used at Suger's Saint Denis. In contrast to earlier RO-MANESQUE sculptures that are subordinated to the building's form, Gothic statues begin to show independence and integrity. When the Gothic era progresses—as it is seen to do on Chartres's later facades—architectural sculpture becomes increasingly naturalistic, individualized, and self-contained. Christ enthroned surmounts the central of the Royal Portals at Chartres. Where Romanesque sculptures, like those by GISLEBERTUS, emphasized the threat of damnation (e.g., *Last Judgments*), the Gothic spirit placed stronger emphasis on salvation. Above the Royal Portal are three lancet (acutely arched) STAINED GLASS windows, and above them is a large "rose window"—a circular stained-glass window articulated with stone "tracery," or ornamentation that gives a lacelike effect. Beyond its western facade, the balance of the cathedral, rebuilt after 1194, is the first masterpiece of mature, High Gothic style. Its nave rises over 300 feet. Chartres contains more than 8,000 images in various media, and has retained almost all of its original stained glass. Chartres's crypt contains the relic that made the cathedral one of the most important pilgrimage destinations of the MEDIEVAL period: remnants of silk from what is believed to be a robe worn by the Virgin Mary. The miraculous holiness of this relic (which survived both fires) contributed to the fervor with which an extraordinary cross section of the faithful sometimes dedicated themselves to the cathedral's rebuilding: "One might observe women as well as men dragging [wagons loaded with building supplies] through deep swamps on their knees," as a contemporary account described it. But because they resented the imposition of new taxes that rebuilding Chartres necessitated, it was not consistently supported by either nobles or the general population, and cathedral financing even provoked intermittent riots during the 13th century.

Chase, William Merritt

1849–1916 • American • painter • Impressionist

My God, I'd rather go to Europe than to heaven!

Chase played three important roles: As a tastemaker he introduced French IMPRESSIONISM to America, as a teacher he taught the leaders of American Modernism (SHEELER, DEMUTH, and O'KEEFFE), and as an artist he was among the best-selling AMERICAN IMPRESSIONISTS. He was from a modest Indiana background, but he took easily to the fashionable world of New York and profited from his trip to Europe, as the quotation above suggests. To an early acquaintance with the MUNICH SCHOOL, he added mastery of the PLEIN AIR landscape, and he evolved a personal, eclectic blend. Chase was less concerned with exploring the effects of light, which preoccupied many French Impressionists, than with developing his virtuosity and ability to use paint beautifully. He was also devoted to capturing the affect of those he loved. Whether painting his home, studio, or the sandy, sun-bleached coastline of Long Island where he spent summers, his own environment and family were frequently his subject matter. *The Fairy Tale* (1892), for example, is a sparkling, affectionate picture of his wife and one of his daughters seated among the dunes. There is a sense of pleasure and well-being about his pictures for which many critics dismiss him.

Chevreul, Michel Eugène
1786–1889 • French • chemist

Now what do we learn by the law of simultaneous contrast of colors? It is that when we regard attentively two colored objects at the same time, neither of them appears of the color peculiar to it, that is to say, such as it would appear if viewed separately, but of a tint resulting from the peculiar color and the complementary of the color of the other object. On the other hand, if the colors are not of the same tone, the lightest tone will be lowered, and the darkest tone will be heightened; in fact, they will appear by the juxtaposition different from what they really are.

Chevreul's researches on color began when he was a professor of chemistry, and continued during his employment at the Gobelins TAPESTRY works. In his book *On the Law of the Simultaneous Contrasting of Colors* (1839, quoted from above), he maintained, for example, that contrast harmony is increased by juxtaposition of complementary colors like yellow and violet. His influence on artists was vast, among them PISSARRO, SEURAT, the DELAUNAYS, MACDONALD-WRIGHT, and RUSSELL. Besides incorporating his ideas in their painting, with Chevreul's theories in mind artists also became conscious of the frames they used, and even expressed concern about the color of the walls on which their work was displayed. Seurat went a step further by extending the notion of complementary colors to his frames. Besides his interest in color, Chevreul is known for work defining the nature of animal fats and their effects on the manufacture of soap and candles, and for his moral rectitude: "Chevreul was a determined enemy of charlatanism in every form," insisted the author of a biographical entry about him in the *Encyclopaedia Britannica* of 1911.

Chi Rho (XP)

The first two letters of the Greek word for Christ, *Xpictoc,* are combined to make a cross. This monogram symbolized Christ's presence. Constantine's troops were ordered to place the XP monogram on their shields during the battle in which he defeated the army of Maxentius in 312. XP decorated sarcophagi and was the inspiration for intricate embellishment on ILLUMINATED MANUSCRIPTS, such as the BOOK OF KELLS.

chiaroscuro

This word combines the Italian *chiaro,* meaning "light," with *oscuro,* for "shade." Chiaroscuro in art refers to the contrast of strong shadows with bright highlights, usually with forms determined by the meeting of dark and light rather than by outlines. It is a technique that may achieve theatrical effect. ITALIAN RENAISSANCE artists who pioneered in and explored chiaroscuro were SEBASTIANO del Piombo, RAPHAEL, and GIULIO Romano. The use of chiaroscuro by CARAVAGGIO influenced many other artists. Chiaroscuro combined with SFUMATO is called the "dark manner." (See also TENEBRISM)

Chicago, Judy (Judy Cohen)

born 1939 • American •
teacher/painter/sculptor/mixed media
• Feminist

I believe in the power of art to change consciousness.

Born in Chicago, Judy Cohen changed her name to Judy Chicago. She was an educator, innovator, and organizer in the FEMINIST ART movement of the early 1970s. In addition to her mission of educating women artists, she was determined to educate the public about women. *The Dinner Party* (1979), an INSTALLATION, is her most renowned project and a tour de force that the critic LIPPARD has called "one of the most ambitious works of art made in the postwar period." The "dinner table" is an equilateral triangle 48 feet on each leg. Each of the 39 place settings is dedicated to an important woman, and each has a runner, chalice, and a plate designed to symbolize the woman honored. Table linens are made with traditional needlework techniques, including crochet and appliqué. Vaginal imagery is integral to the design. Among the "guests" are O'KEEFFE, Susan B. Anthony, and Sojourner Truth. The names of 999 additional "women of achievement" are inscribed on the tile floor. More than 100 women collaborated to bring *The Dinner Party* to completion, and it drew some 10,000 people to the San Francisco Museum of Modern Art, where it was first shown. Applauded for its effort to encourage social change by bringing to light the accomplishments of women, it was also attacked from various philosophical positions. To some the vaginal imagery was disconcerting, for example; others objected to the lack of nonwhite women artists. Chicago formed the nonprofit Through the Flower Corporation to oversee the exhibition of *The Dinner Party* across the United States.

chimera

Refers to a mythical, fire-breathing, part-lion monster, usually a female ani-

mal. For the most famous chimera, see
"CAPITOLINE" WOLF.

chinoiserie

China had a long tradition and sphere
of influence, from its white-glazed POT-
TERY that inspired 9th-century Islamic
potters to invent a tin-based GLAZE to
the Chinese silks that were imitated in
Italy in the 14th century. However, the
term "chinoiserie" refers particularly to
Western imitations or evocations of
Chinese art, made during the 17th and
18th centuries. These were more fanci-
ful than accurate, and were especially
prevalent in the ROCOCO-style DECORA-
TIVE ARTS, with designs on wallpaper,
silver, dinnerware, and furniture (e.g.,
Chinese Chippendale) as well as fabric.

Chirico, Giorgio de

1888–1978 • Greek/Italian • painter
• Metaphysical School

Et quid amabo nisi quod aenigma est?

"What shall I love if not the enigma?"
quoted above, was inscribed on de
Chirico's *Self-Portrait* of 1911. Some of
his enigmas are empty city streets seen
from disorienting PERSPECTIVES, some-
times with six vanishing points. Painted
predominantly in a mustard yellow,
brown, and blue, they are nightmarish
stage sets. De Chirico was a MODERN in
his disruption of believable space and in
the coalition of different points of view.
His notion of painting as symbolic,
metaphysical vision (see CARRÀ), and
his interest in Nietzsche, Schopenhauer,
Theosophy, and the subconscious—all
part of his era's currency—also fed his
work. But among all artists of his time,
he painted pictures that were distinctive

in their representation of fantasy. In
The Melancholy and Mystery of a Street
(1914), a child rolls a hoop down an
empty, arcaded street that, perversely,
widens in the distance and tilts toward
her. A shadow cast on the street is inex-
plicable, as are other details, and all are
ominous. De Chirico's premonition of
SURREALISM is clear, or at least it was to
the Surrealists who adopted his strate-
gies. However, de Chirico, who rarely
associated with the world outside his
own family and had an obsessive depen-
dence on his mother, was alienated by
the stridency of the Surrealist group.
There were recriminations on both
sides, and de Chirico broke resolutely
from them in 1933 by renouncing the
paintings of his early career, which were
those the Surrealists admired. "De
Chirico seemed hell-bent on self-
immolation," writes the critic Michael
Kimmelman about how the artist paro-
died, devalued, and discredited his ear-
lier accomplishments. "The paradox is
that his late works, in their extreme
campiness and nihilism, are much more
shocking than the classic de Chiricos,
with their melancholic views of antique
ruins." During the late 1990s, those re-
actionary works, with their references
to the past, disdain of MODERNISM, and
their parody and irony, seem purely
POSTMODERN long before the move-
ment had a name.

Christian art
See EARLY CHRISTIAN

Christina, Queen of Sweden
1626–1689 • Swedish • collector

*I have it in my thoughts and resolution
to quit the crown of Sweden and to re-*

tire myself unto a private life, as much more suitable to my contentment, than the great cares and troubles attending upon the government of my kingdom; and what think you of this resolution?

The Queen of Sweden posed this question to the startled English ambassador before she began secret preparations to flee her country in 1653. The palace apartments contained more than 800 paintings. "There is an infinite range of items," Christina said, "but apart from some thirty or forty Italian originals, I discount them all." After the crown was formally removed from Christina's head on June 6, 1654, she made her way to Italy, disguised as a nobleman, and her cherished works of Italian masters left the palace with her. There were several stops en route, including one in Innsbruck, where, in November 1655, she made public her conversion from Lutheranism to Roman Catholicism. Her entry into Rome, in a procession that included most of the College of Cardinals, proceeded to the papal apartments, where the pope received her. Christina appointed BELLORI to be her librarian and antiquarian, and in her palace she displayed those works she had kept from the great collection her father, Gustavus Adolfus, had looted from Prague: paintings by RAPHAEL, TITIAN, CORREGGIO, VERONESE, and RUBENS among them. While Christina was in Italy, France was gaining in prestige and art collections. Cardinal Richelieu's secretary and successor, Cardinal Mazarin, was an avid but greedy connoisseur who considered Christina his arch rival. He is reported to have told his business manager to "keep that crazy woman out of my cabinets . . . for one could so easily take some of my small paintings." Christina, herself erratic and volatile, died at the age of 62 after living more than half her life in Rome.

Christo (Christo Javacheff, born 1935 in Bulgaria) and **Jeanne Claude de Guillebon** (born 1935) Site/Process art

You like to see what is behind the package, as well as appreciating the new form that has been created, the new visual value . . . the most important thing is the passage from one form to another. Also the continuation, that the first form peeks through from behind. No, the thing that is behind is not so important either, only that motion, that passage is important.

Christo started by wrapping relatively small projects: *Package on a Wheelbarrow* (1963), for example. Over the decades, joined by his wife, Jeanne Claude, he has wrapped everything from bridges (*The Pont-Neuf, Paris, 1975–85,* 1985) to islands (*Surrounded Islands, Biscayne Bay, Greater Miami, Florida, 1980–83*). He installed an 18-foot-high, 24½-mile-long line of white fabric across the landscape north of San Francisco—*Running Fence, Sonoma and Marin Counties, California 1972–76,* and scattered 3,100 blue umbrellas in Japan and gold ones in California. All of these projects have an unexpected beauty that is altered and enhanced by changes in the light, the weather, and

other natural events. The involved negotiations and planning they require are part of the work in progress, and the excitement they generate is often irresistible. Writing in *The New York Times* about the wrapping of the Berlin Reichstag, which was completed in July 1995, Michael Kimmelman found himself swept into the spirit of the celebrated event as the final length of material was unrolled to finish covering the German parliament building. "The only thing missing was a bow on top," he began his report. It had taken 60.5 tons of silvery fabric that was held in place by 10 miles of bright blue rope. Kimmelman, a self-declared skeptic, was unable to resist enthusiasm and appreciation. Besides the beauty of the new form, which Christo refers to in the comment above, when an object becomes invisible, or accentuated by outline, what it is, what it stands for, and what it means become increasingly a matter for contemplation. In other words, when something is visually changed, or rendered "absent," its presence and significance are multiplied. Christo raises money and enlists public support, and sells his drawings to cover the cost of his projects; it is important to him that he make no profit from the completed work. Its only economic benefit is enjoyed by local merchants. Kimmelman's conclusion is as eloquent as his introduction—about topping the German parliament with a bow—is jesting: "The project was transient. But it left an afterimage of a kinder, gentler Reichstag. . . . So much so-called political art nowadays struggles to make an impact and fails. Without trying

'Wrapped Reichstag' may well have been the most effective example of political art in years."

Christus, Petrus
c. 1410–1475/76 • Netherlandish • painter • Northern Renaissance

In short, [Christus] transformed the language of his great predecessors [van Eyck and van der Weyden] into a homely idiom, plain to the point of artlessness and humbly human rather than heroic—a "basic Flemish" readily assimilable by those who, like himself, hailed from the less developed Northern districts of the Netherlands. (Erwin Panofsky, 1953)

PANOFSKY's assessment of Christus, highlighting the relative simplicity of his style, might seem to detract from the artist's status, yet it is just that quality that gave his work wide appeal, and he was, finally, more influential than his famous forerunners. Christus is documented as being in the busy mercantile city of Bruges soon after van EYCK died in 1441. Van Eyck's influence on Christus's work appears in the fine details of brocade, gems, and other particulars in a painting usually named *Saint Eloy in His Studio* (1449), though that identification is uncertain. It is a picture of a goldsmith and his clients (perhaps the first GENRE painting in NETHERLANDISH art), and might have been commissioned by the goldsmith's guild. Eloy was a 7th-century goldsmith who became a martyr and subsequently the trade's patron saint. The clients in the picture are apparently buying a wedding ring, but there is much uncertainty

and speculation regarding the implied message. Another of Christus's well-appreciated works is *Portrait of a Lady* (c. 1470). The "lady" really seems just a child. Her head is encased in a stiff black hat held on by a chin strap. Her hairline has been plucked to make her forehead higher, as was the fashion of the time. She seems impatient with having to sit for the artist and casts a sidewise glance at him.

chryselephantine

Uniting Greek words for "gold" *(chrysos)* and "ivory" *(elephantinos)*, the term refers to sculpture that combines those materials. Earlier cultures used chryselephantine—for example, an exquisite Phoenician ivory carving titled *Lion Mauling a Nubian* (c. 880 BCE), inlaid with jewels as well as gold—but the most celebrated chryselephantine works, both by PHEIDIAS (5th century BCE), are known only through literary sources: *Athena Parthenos,* standing 40 feet high in the PARTHENON, and a colossal seated *Zeus at Olympia,* named one of the SEVEN WONDERS OF THE WORLD. Both were described by PAUSANIAS in the 2nd century CE. The core of Pheidias' statues was wood, but he used gold veneer for the clothing and ivory veneer for the heads, hands, and feet. If those colossi are the most famous chryselephantine works, a group of small figurines might be the most infamous. Three small female carvings purporting to be MINOAN made their way to the United States in the early 20th century, the most renowned a "Snake Goddess" at the Museum of Fine Arts in Boston. But not only is their PROVENANCE now in question, so too is their authenticity.

Church, Frederic Edwin

1826–1900 • American • painter • Hudson River School

We were soon among the most terrible crags and yawning chasms I ever saw—jagged black rocks piled up in awful grandeur—we were lost in amazement. And yet as we progressed they became still more terrible.

A student and brilliant disciple of COLE, Church went with his mentor on sketching rambles in New York's Catskill Mountains, where Cole had his studio in the 1840s. Church responded to the spiritualism of the TRANSCENDENTALIST movement and to the prosperous PATRONS who wanted patriotic landscapes charged with the American doctrine of Manifest Destiny (see COLE). Many of them were financially as well as philosophically invested in the nation's march westward. Church painted landscapes with sunsets that fulfilled the most ardent cravings for the SUBLIME. With his "Great Pictures"—showing a single work for the price of admission—he enjoyed box-office success: The majestic *Niagara* (1857) earned him $4,500, a great sum for the time. Church traveled to the North Atlantic to paint *Icebergs* (1861); to South America to paint a volcano, *Cotopaxi* (1862); and to the Near East in 1867 to follow the path Jesus had trodden. "After years of seeking the wild, the new, and the virginal in South America and elsewhere, he was now plunging into the most aged, history-laden part of the world," the historian John Davis

writes. "His journey east was essentially a search for origins . . ." The search was propelled by Charles Darwin's *The Origin of the Species* (1859) and Church's need to reconcile his religious sentiments with post-Darwinian science, which removed God from the landscape. In the passage quoted above, from a letter to a friend, Church describes his approach to the El Khasné at Petra, which he painted in 1874, five years after his return home. He entered Petra via a narrow passage through cliffs that rose 300 feet on either side of him—thought to be the split left in the rock by the rod of Moses. The cliffs darkly framed his view of El Khasné ("the Treasury"), and this is the view that he painted. *El Khasné* is one of the paintings that convince Davis that Church did find the spiritual comfort he sought while on his quasi-scientific, archaeological expedition.

Cimabue (Cenni di Pepi)
c. 1240–1302 • Italian • painter • Late Gothic

Cimabue thought to hold the field in painting, and now Giotto has the cry, so that the fame of the other is obscured. (Dante, *Il Purgatorio*, c. 1317)

Cimabue, a nickname, means "dehorner of oxen" and may allude to Cenni being a violent man. Working in Florence, he was the last major practitioner in the MANIERA GRECA, and is best known for his large altar PANEL, the *Madonna Enthroned* (c. 1280–90): The Virgin, with the Christ Child on her lap, is seated in the upper portion of an elaborate architectural (but imaginary and unbuildable) throne.

Angels surround her and prophets peer through arches in the throne's base. The beginning of an interest in three-dimensionality is evident. In contrast to this formal, stolid, monumental presentation, Cimabue also painted *Crucifixion,* a FRESCO that is filled with agitation and emotion. Although Cimabue's fame was great, it was eclipsed by that of his successor GIOTTO, as the passage quoted from Dante makes clear.

cinquecento
The Italian for "five hundred," this term actually refers to the 1500s, or, more commonly in English, the 16th century.

Circle
Name of a nearly 300-page CONSTRUCTIVIST manifesto published in London in 1937 by HEPWORTH, NICHOLSON, and GABO. Included were drawings and commentaries by many major artists (e.g., MONDRIAN, whose important essay *Plastic Art and Pure Plastic Art* appeared there). Illustrations by both Constructivists and non-Constructivists were included.

Circle and Square
See CERCLE ET CARRÉ

cire perdue (lost wax process)
See BRONZE

Cistercian
Like the congregation at CLUNY, the Cistercians were a reformed order of BENEDICTINE monks that originated in Burgundy, France. However, they were founded, in 1098, as a reaction to the

elaborate art and liturgy of the Cluniac order. Cistercians lived an austere life. They established communities in the wilderness and worked there as laborers, clearing forests, draining swamps, and developing a wool trade. Led by Bernard of Clairvaux (abbot 1115–54), they practiced strict mental and physical discipline. Their order, of whom 50 percent were women, flourished and spread. Their buildings were as unadorned as their lives, and majestic in their simplicity: They valued perfect proportions and excellent masonry over sculpted decoration. The Abbey Church of Nôtre Dame (1139–47) in Fontenay has a simple geometric plan and plain walls, pointed barrel vaults, and ARCHes that may have been influenced by ISLAMIC architecture. Pointed arches later characterized GOTHIC buildings.

Clark, Lord Kenneth

1903–1983 • English • art historian

Above all I believe in the God-given genius of certain individuals, and I value a society that makes their existence possible.

The sentiment expressed above puts Clark in the camp of the AESTHETIC movement, an heir to the effusive PATER. It was expressed in Clark's book *Civilisation* (1969), which was composed from the scripts of a television series of the same name. The series made Clark a celebrity outside his own profession, where he was already renowned: He was the Keeper of Fine Art at the Ashmolean Museum in Oxford, then director of the National Gallery in London while serving as Surveyor of the King's Pictures, and held numerous ad-

ditional posts, including chairman of the Independent Television Authority. While *Civilisation* was a sweeping survey of Western art, Clark's other books focused on particular themes. Best known among them are *Landscape into Art* (1949) and *The Nude* (1956). Independently wealthy, Clark was also an art PATRON and collector.

Classical

Used almost off-handedly in reference to anything of high quality and enduring appeal, from hairstyles to automobiles, in art "Classical" particularly indicates the civilizations of Greece and Rome. The term derives from the Latin *classis*, which originally meant "mobilizing the army." Because the military was ranked according to social and financial status, the word came to mean that which is of the highest order, *classicus*, in contrast to a lower order, *proletarius*. During the Middle Ages, students—who were called *classici*—studied Greek and Roman authors, which is how their civilization began to be known as Classical. The most specific art historical meaning of Classical narrowed during the early 19th century, when it served to contrast emotional ROMANTICISM with the measured, restrained, balanced, and orderly quality of Greek art of the period between 480 and 323 BCE. Preceded by the ARCHAIC and followed by the HELLENISTIC, this Classical period is conventionally divided into three parts:

Early Classical, 480–450 BCE. The Classical era begins with the Greek victory over vastly superior forces in the Persian Wars (490–480 BCE). Success confirmed the Greek sense of moral and

political superiority, including the institution of democracy. It may also have inspired the relaxed, freestanding posture of painted and sculpted figures called CONTRAPPOSTO. But while experiencing liberation, Classical artists maintained sobriety and control, constraints that give the name *Severe Style* to the art of this early, transitional Classical period. Examples are the RIACE BRONZES (c. 460 BCE) and the DISCOBOLOS (450 BCE). Faces of these statues are less vacant than are those of ARCHAIC statues; they appear thoughtful and are on the verge of showing emotion. Whereas Archaic sculptures were stiff, these powerful, athletic bodies are represented in moments of arrested action.

High Classical, 450–c. 430/420 BCE. Also known as the Classical Moment, this period is usually characterized as one of a new, self-confident frame of mind. This is manifested in Athens' rise to power and epitomized by the building program that PERICLES launched on the Athenian ACROPOLIS. During the early years of this period, the sculptor POLYKLEITOS had translated Greek philosophical ideals into an artistic treatise known as the *Canon*. Celebrating values of order, measure, proportion, control, and harmony, Pericles enlisted the sculptor PHEIDIAS to oversee his project. Of this, and of the entire period, the PARTHENON is the High Classical exemplar. The period represented the first intellectual peak of HUMANIST optimism.

Late Classical, 420–323 BCE. After the terrible plague that struck Athens in the summer of 430 BCE (in which Pericles died) and following the Peloponnesian War (431–404 BCE), which

Athens ultimately lost to Sparta, Athens forfeited its political preeminence. His opponents blamed Pericles for having broken an earlier vow to leave the Acropolis in ruins as a reminder of Persian barbarianism. He was also condemned because, in order to finance the Acropolis development, he used tithes paid to Athens by independent states for the defense of Greece against the Persians. The mutual defense pact was known as the Delian League because the money was originally housed in the Treasury at Delos. There was a sense that Athenians were being punished for hubris (excessive pride), as the Persians had been 50 years earlier when they lost the war. Works of art began to show a turning inward, especially evident in numerous carved grave markers, the *Hegeso Grave Stele* (c. 410 BCE), for example. The strong, athletic figures of earlier periods became soft, sensuous, and languorous, and female NUDES became part of the artistic repertoire for the first time. But there also developed a somewhat paradoxical predilection, in the period 430–400 BCE, for the purely decorative look of DRAPERY. Deeply, elaborately carved drapery had already appeared (e.g., *Three Fates/Goddesses* on the Parthenon), but in Late Classical images, such as *Nike Adjusting Her Sandal* (c. 420 BCE), it might seem, as J. J. Pollitt writes, that "ornamental beauty has become an end in itself and to a great degree has usurped the role of meaning or 'content' in the specific narrative sense." Traditionally the Late Classical period ends with the death of Alexander the Great in 323 BCE and the beginning of the Hellenistic era. Some historians dispute that division based on

the belief that it recognizes a political change, not a stylistic one. As yet there is no consensus on establishing a new, or an intermediary, period.

classicism/classicist/classicizing

In ART HISTORY these terms suggest the adaptation of techniques, ideas, and attitudes of GREEK and ROMAN ART, especially those based on logical, rational principles and deliberate composition. In this context artists of the RENAISSANCE, and later artists like POUSSIN, were "classicists" in their acceptance of and building on CLASSICAL tradition. Distinctions are complicated, however, by the specifically NEOCLASSICAL movement that began in the 18th century. Needless to say, Neoclassical artists like Jacques-Louis DAVID were classicists, but classicists (or classicizing artists) were not all Neoclassical.

Claude glass

A small convex mirror backed with black or silver is called a Claude glass because the landscape it reflects resembles those painted by CLAUDE LORRAIN, and because he is thought to have used such an optical device. The Claude glass suppresses details and simplifies TONAL gradations of COLOR. The convex curve creates an indented foreground, called a *coulisse,* another characteristic of Claude's work. Numerous artists, from CANALETTO to COROT, are thought to have used a Claude glass.

Claude Lorrain (Claude Gellee)

1604/5?–1682 • French • painter • Baroque

Claude Lorrain is a painter who carried landscape to perfection, that is to human perfection. (John Constable, 1836)

Claude, who was born in France, went to Rome to become a pastry cook. He found work in the home of the painter Agostino Tassi, and the die was cast. By the 1630s he had established his own reputation as a landscapist. As did his friend and countryman POUSSIN, Claude remained an expatriate in Rome throughout his life. He was entranced by the countryside outside the city, the Roman *campagna.* In this environment he saw the poetry of light, a bucolic serenity, and the romance of Virgil's poetry. In contrast to Poussin, whose landscapes are formed according to rational geometric progression, those of Claude are atmospheric and airy, open and light. Where Poussin's landscapes were preferred by intellectuals, Claude's PATRONS were from the aristocracy. He invented a compositional technique of using trees or buildings or even ships to "frame" the outer edges of the picture, and a foreground *coulisse,* or space for the viewer to slip in to the picture, so to speak. In the middle ground there is likely to be a basinlike body of water, a horizon with hills, and heavy atmospheric PERSPECTIVE in the background. (See also REPOUSSOIR) Claude resolutely introduced asymmetry, which gave great weight to one side of the picture, but he carried off potential imbalance through a bowl of sky. He also reduced the human figure to almost insignificant dimensions. The pastoral mood of Claude's serene, ideal landscapes had great influence on late-18th- and early-19th-century European and American painters (see COLE) and came to epitomize the notion of

the PICTURESQUE. (See also CLAUDE GLASS)

Claudel, Camille
1864–1943 • French • sculptor • Modern

At last you were "yourself," totally free of Rodin's influence. (Eugène Blot, 1932)

At 17 Claudel moved to Paris with her mother and siblings expressly to study sculpture. Because women were not yet admitted to the ÉCOLE DES BEAUX-ARTS, she studied with private teachers in a studio she and others rented. RODIN came in as a substitute teacher, and they began a relationship, when he was 43 and she 19, that lasted 15 years. She was his collaborator and model as well as his lover (though not his only one). He would neither marry her nor treat her as a serious, independent sculptor, although her talent and skill were prodigious. She worked with him on the *Burghers of Calais* (1886) and *Gates of Hell* (1880–1900), and there was a similarity in their approaches until she left him as a declaration of autonomy. Claudel then changed her subject matter and style, fashioning small figures in everyday scenes. The odds were too much against her success, and sculpting was extremely difficult without major, state commissions. Her life veered into tragedy as she became paranoid about Rodin stealing her work, and her family became convinced that she should be committed to an asylum. They did so when she was 49, and she spent the final three decades of her life there. Blot, quoted above, was her friend and agent. He wrote to her at Montdevergues asy-lum hoping to help her out of her depression. The work to which he refers is *L'implorant,* first modeled in the mid-1890s and cast in bronze in 1900. It is a kneeling woman, precariously bent forward, whose arms reach up beseechingly.

Clemente, Francesco
born 1952 • Italian • painter • Neo-Expressionist

My overall strategy or view as an artist is to accept fragmentation and to see what comes of it—if anything. . . . Technically, this means I do not arrange the mediums and images I work with in any hierarchy of value. One is as good as another for me.

Clemente's images are ambiguous, overlaid with psychodrama, and widely diverse: In 1981 he painted two dozen 8¾-inch by 6-inch MINIATUREs in the delicate patterned style of Indian IL-LUMINATED MANUSCRIPTS *(Francesco Clemente Pinxit),* while in 1983 he painted a big, 6½-foot by 7¾-foot, distinctly indelicate head with small heads peering from its eyes, nostrils, mouth, and ear *(Untitled).* These choices reflect the openness he expresses in the quotation above. His influences and sources are similarly diverse, ranging from the political activist-artist BEUYS to the self-referential ABSTRACT EXPRESSIONIST artist TWOMBLY, from Christianity and the Tarot to Egyptian and SURREALIST art, and from the mystical writings of BLAKE to those of theorist Roland Barthes (see SEMIOTICS). Remaining consistent, however, are Clemente's insistent self-portrayals and his auto- or homoeroticism.

Clodion (Claude Michel)

1738–1814 • French • sculptor •
Rococo

*Sculptor of the Graces. (Mercure de
France, 1779)*

Clodion's not quite 2-foot-high *Satyr
and Bacchante* (c. 1780) is an example
of the frivolous, erotic, and sensuous in
ROCOCO style. It captures the high pitch
of the era's self-indulgence, even as it
was on the verge of change. Clodion
was influenced by BERNINI, whose
sculpture he studied during several
years spent in Rome. He was also af-
fected by the paintings of his French
contemporary FRAGONARD. Clodion
was a virtuoso modeler in both stone
and clay—it has been said that he could
shape marble as if it were malleable—
but he is best known for his small
TERRA-COTTA (baked clay) creations
that were usually displayed on table-
tops or shelves. The assessment of his
work quoted above is from a letter writ-
ten by an Italian visitor to a 1779 exhi-
bition in which Clodion's work was
shown. His style linked him with the
Ancien Régime, the monarchy, and
aristocracy, but despite being a monar-
chist he managed to adapt to the Revo-
lution and subsequently the Empire,
periods during which his work may
have prompted reveries of better times.

cloisonné

Cloison is French for "partition" or, in
anatomy and botany, "a dividing mem-
brane." Cloisonné is a technique that
uses wire or metal bands fused to a sur-
face—like a dividing membrane—to de-
fine forms or figures that are then filled
with enamel or inlaid with gemstones.
Turquoise, lapis lazuli, carnelian, ob-
sidian, and colored glass are some of the
inlays. Cloisonné designs were used to
form fantastically beautiful falcon,
eagle, vulture, and winged-scarab pen-
dants like those buried with the Egypt-
ian king Tutankhamen in about 1325
BCE. Germanic tribes also excelled in
the art of cloisonné (see ANIMAL STYLE).

Cloisonnism

The look of CLOISONNÉ led to the appli-
cation of the word "Cloisonnism" to
the 19th-century paintings of BERNARD,
GAUGUIN, van GOGH, and others. After
the IMPRESSIONISTS had so rigorously
banned the idea of outlining forms and
of drawing (from which outlines are de-
rived), those POST-IMPRESSIONISTS re-
stored it. "Outline expresses that which
is permanent, color that which is mo-
mentary," wrote Édouard Dujardin, the
critic who coined the term "Cloison-
nism." "The work of the painter will be
something like painting by compart-
ments, analogous to cloisonné." MOD-
ERNISM in painting owes a great deal to
the concept of Cloisonnism, which pre-
tends no approximation of the natural
world.

Close, Chuck

born 1940 • American • painter •
Photorealist

*. . . I just stopped. Made a clear break.
I decided I didn't want to make those
paintings anymore; I wanted to do
something different, to force myself to
make new solutions. So, I decided to
work from photographs, not because
that's what I wanted my art to be
about, but because no matter how
interesting a shape was, if it wasn't in
the photograph I couldn't use it.*

In the comment above, Close describes his switch to head and neck portraits, and to self-portraits, based on photographs in which the subject is looking straight at the camera. The scale is very large, about 9 feet high and 7 feet wide. At first Close painted in black and white, but he started to use color in 1970. Even with the switch to color he imposed severe limitations on himself—for example, the number of colors he would use—because he found those confinements creatively liberating. He roughed in his images with an AIR-BRUSH before meticulously finishing them. His *Self-Portrait* (1968) is an example of how his portraits bring viewers uncomfortably, even offensively, close to faces in which the stubble of beard is all too clear. In 1988 Close suffered a spinal blood clot that left him confined to a wheelchair and almost immobile. As he had earlier set formal restrictions for himself and triumphed, now his limitations were physical. Again he triumphed. Sometimes having to hold the brush in his teeth, he still painted enormous portraits based on Polaroids and carefully planned on a grid of small squares that are like a tile mosaic in grays and browns. "A ravaged artist had become, in a miracle, one of the great colorists and brush wielders of his time," wrote the critic Roger Angell about Close's 1996 exhibit.

closed form/open form

A term most often used for sculpture, this phrase may also be applied to painting and architecture. Forms that are "closed," like the Greek KOUROS and DONATELLO's *David* (c. 1435), are self-contained, seeming not to interact with or refer to the environment in which they exist. In contrast, sculpture such as NIKE OF SAMOTHRACE (c. 190 BCE) or BERNINI's *Ecstasy of Saint Teresa* (1645–52), both of which relate to, depend on, and interact with their surroundings, are open form. WÖLF-FLIN described closed form as characteristic of the RENAISSANCE (ITALIAN and NORTHERN), and open form of BAROQUE art.

Clouet, Jean (c. 1485–1541) and François (c. 1516–1572)
French • painters • Northern Renaissance

In those days there was Janet, who painted very good portraits; his portraits of François I and François II are at Fontainebleau. . . . He worked equally well in oils and in miniature. Ronsard spoke favorably of him in his poetry. (Félibien, 1679)

Jean Clouet was listed among the king's artists at FONTAINEBLEAU in 1516, and it is a c. 1525 portrait of FRANCIS I for which he is famous today. The largest part of this painting is taken up by Francis's elaborately decorated and embroidered, shimmering silk shirt with great puffed sleeves; Francis's head appears too small in proportion to his splendid bodice. This painting is frequently linked to contemporary works of HOL-BEIN, especially his similarly ostentatious portrait *Henry VIII* (1536). Jean's son, François, named perhaps in honor of the king, succeeded his father as a court painter to Francis I in 1540. No less attentive to luxuriant detail, François is best remembered for a perplexing picture called *Diane of Poitiers at Her Bath* (c. 1570). However, every-

thing but the name of the artist, who signed it, is now in question. If not Diane, who is the nude woman seated decorously in her tub? She may be Marie Touchet, the mistress of Charles IX. The mysterious figure is framed by drawn, bright red drapes; in the room behind her is a fireplace and one of her servants with a kettle of water. The other servant is nursing an infant while a child reaches to pluck a grape from the bowl of fruit on the tray that covers the tub. Whatever the symbolism and the lady's identity, the painting is full of engaging detail. Little is known about François Clouet, and attributions of his paintings and drawings are problematic. In fact, after both Jean and François died, they were thought to have been one and the same person, as recorded in the quotation above, and, moreover, regardless of their merit, French portraits from 1500 to 1620 were assigned to "Janet." It was not until the 19th century that the comte de Laborde, a historian of French art, rediscovered and distinguished between father and son.

Cluny

The Cluniac congregation was founded in 910 in Burgundy, France, and soon established the first great monastic reform movement during the ROMANESQUE period. Members of a branch of the BENEDICTINE order, Cluniac monks were known for using the arts to enhance the beauty of church services. (They, in turn, provoked the reformist, more ascetic CISTERCIANS.) The Cluniac reform spread to new and existing monasteries, and also grew by affiliation with or establishment of priories (religious houses), especially at loca-

tions along pilgrimage routes. The entire international congregation was ruled by a single abbot who was headquartered in Burgundy. Cluny III (1088–1130), as the building on the site, the Abbey Church of Cluny, is called, was the largest and most splendid church in Europe. According to legend, Saint Peter himself designed the church and presented it to a monk by the name of Gunzo, who was responsible for the project. It reflected developments of the first Romanesque architecture in France. All but the south TRANSEPT of Cluny III was destroyed after the French Revolution, in the early 1800s, and its style and grandeur are known mainly through its plan, archaeology, theoretical reconstruction, and churches such as the Cathedral at Autun (c. 1120–30) that were influenced by Cluny. Some sculpture remaining at Cluny III, such as carved capitals (the top, decorative portion of a COLUMN, pier, or pilaster), shows high accomplishment; GISLEBERTUS and possibly the anonymous Master of the Church of the Madeleine at Vézelay (1120–32) learned their craft at Cluny.

Cobra (CoBrA)

In 1948, reacting to the cold rationality and geometry of De STIJL and CONSTRUCTIVISM, artists in Copenhagen, Brussels, and Amsterdam united in a movement named for their cities: CoBrA. Allied in principle with American ABSTRACT EXPRESSIONISM as well as DUBUFFET and ART BRUT in France, they insisted on free expression and abstraction—sometimes figurative, sometimes entirely NONOBJECTIVE. They used thick paint and strong, at times even violent colors. Cobra painters in-

clude Karel Appel (born 1921), whose apparently nonrepresentative abstractions seem to coalesce into strange, animated FIGURES and faces.

codex, codici (pl.)

Codex refers to a book with bound pages, in contrast to a SCROLL, which is unrolled to be read. Most ANCIENT and EARLY MEDIEVAL literature was on papyrus scrolls. Papyrus came from Egyptian marshes and was becoming scarce as the Christian era opened. It was also less durable than PARCHMENT (treated animal skin). A form of pagan codex using animal skins has been found from as early as 1st-century CE Rome. A codex made from PAPER existed in the Christian community by the 2nd century. The first Christians preferred codici to scrolls and paper to parchment: Paper was inexpensive and unpretentious—compared to costly pages made of animal skins—and the early Church was poor and humble. Moreover, the codex form distinguished their texts from both pagan literature and the Jewish Torah, both of which were on scrolls. After Constantine institutionalized Christianity in the 4th century, the codex was standardized, but parchment became preferred. Besides its durability, this preference was possibly based on the very reasons parchment had earlier been rejected—expense and its connection to paganism: Wealthy, aristocratic pagans were prime candidates for conversion to Christianity, and religious texts were frequently used to proselytize. The process of copying texts from papyrus roll to parchment codex began under Constantine. Until recently, it was believed that codices with several columns

of text on a single page were the result of simpleminded imitation, as scrolls were composed of columnar text. Now such books with multiple columns, like the 4th-century *Codex Sinaiticus*—with four columns of text per page—and the three-column *Utrecht Psalter* of c. 830, are often interpreted as purposeful rather than naive efforts to imitate older (familiar) forms on the part of the scribes who copied them (see SCRIPTORIUM).

Coene, Jacques
See BOUCICAUT MASTER

Coeur, Jacques, House of
Jacques Coeur (c. 1400–1453) was the wealthiest man in France and financial minister to King Charles VIII. His house in the city of Bourges, France, is an intriguing example of domestic architecture and a key to understanding Northern European sensibility. In contrast to the highly symmetrical, logically organized architecture of Italy during the same period, Coeur's house, built between 1443 and 1451, has windows and rooms of different sizes and shapes appropriate to their functions rather than to any prerequisite for balance and harmony. Richly carved decoration and detailing sometimes plays on the owner's name, which translated from the French means "heart." There are numerous stairways, narrow halls with unexpected turns, and surprising effects of changing space and light. Marvelous illusions are created on the building's facade where what appear to be windows with figures leaning out of them are actually sculpted stone portraits—either of servants or of Coeur and his wife. Originally these were

painted to resemble reality even more closely. Coeur's brilliant career was as unpredictable as his house: He was falsely accused of poisoning the king's mistress and imprisoned. After his release he became a religious crusader, and died defending Constantinople against Turkish forces.

Cole, Thomas

1801–1848 • American • painter • Romantic/Hudson River School

I never succeed in painting scenes, however beautiful, immediately on returning from them. I must wait for time to draw a veil over the common details, the unessential parts which shall leave the great features, whether the beautiful or the sublime, dominant in the mind.

American landscape painting during the 19th century was inspired by conflicting drives. One was the doctrine of Manifest Destiny, which proclaimed the white American's divine mandate to claim the "wilderness" for "progress," whether or not it was already inhabited. The other looked at the land already claimed by industrialization with melancholic nostalgia. On each side of the dichotomy, attention was directed at what seemed unique, important, and "American" about the American landscape. Thomas Cole was not the first painter of the American land—he was preceded by, for example, Alvan Fisher (1792–1862) and Thomas Doughty (1793–1856)—but he was the most outstanding of its early interpreters. Born in England, Cole came to America with his parents in 1818. He found the drama of the Hudson River region, and especially the Catskill Mountains, to his taste. He located his studio there and immersed himself in and painted its spectacularly beautiful views, thus establishing what would be named the HUDSON RIVER SCHOOL. Nature was symbolic as well as inspiring for Cole: Details like the "blasted" tree (destroyed by natural causes such as lightning) could represent a life cut short; a sawed tree represented the incursion of civilization in the wilderness; and a gnarled tree or rock formation could be seen as one of America's natural antiquities. True to the ROMANTIC notion of inspired genius, he often painted in the landscape the small figure of a pensive poet. Cole was a close friend and hiking companion of William Cullen Bryant (1794–1878), America's leading nature poet, who wrote *Thanatopsis* (1817). Self-taught and an avid American patriot—there was new resistance to European influence—Cole nevertheless believed he must take the European GRAND TOUR, which he did in 1829. After three years he returned home even more persuaded of his adopted country's natural and moral superiority—didacticism infused his work. *The Course of Empire* (1836) is a sequence of five pictures that James Fenimore Cooper called "the work of the highest genius this country has ever produced." In this allegory for the cyclical stages through which a civilization passes, Cole painted *Savage, Pastoral,* the *Consummation of Empire, Destruction,* and *Desolation.* Whether a caveat to the new nation, documentation of the inevitable, or a political commentary on the Jacksonian era, the content of the message is debated by scholars. So are the scenes in a later, four-painting series, *The Voyage of Life* (1842). Here he

metaphorically follows the stages from joyful birth, to hopeful youth, to tormented manhood, to, finally, death and salvation. Cole's own "voyage" ended prematurely when he died of an "inflammation of the lungs" 10 days after his 47th birthday.

collage

From the French for "pasting or gluing," a collage is a composition made by affixing various materials to a flat surface. As a novel technique for studio art it was pioneered by PICASSO, BRAQUE, and GRIS, who began to make mixed-media collages in 1912. They combined pieces of newspaper and other preprinted patterns on their canvases to produce various textures, forms, and images. The idea evolved in several ways, from PHOTOMONTAGE to inventions in three-dimensional art, especially CONSTRUCTIONS and ASSEMBLAGES. These works boldly defied and ultimately revolutionized centuries-old conventions that defined ART.

collecting

Research on and documentation of collecting are increasingly important to studies of ART HISTORY. PATRONAGE and collecting constitute one approach, and the development of MUSEUMS is another. In ANCIENT times ETRUSCANS collected Greek vases (see POTTERY), and Romans both collected and copied Greek sculpture. Charlemagne preserved Latin poetry and prose (see CAROLINGIAN). The activities of collecting in any century determine what remains available to future generations. From the mid-1550s, princely collections developed in Europe with the fabled Kunst- und Wunderkammer—"chamber of art and marvels"—or, as commonly called in English, cabinet of curiosities. These contained a mix of knickknacks as well as CLASSICAL sculpture and treasures from nature (e.g., beautiful or unusual stones and shells). Means of collecting have ranged from looting and the spoils of war to buying the treasures of a deposed monarch: When Charles I was beheaded, in 1649, his collection of paintings was disposed of in what has been called the "Sale of the Century." TENIERS, court painter to Archduke Leopold Wilhelm, documented his patron's collection with a type of painting known as the cabinet picture: In *The Gallery of Archduke Leopold Wilhelm* (1651), one of 11 such representations, Teniers recorded the archduke's paintings in minute detail. Several had been bought from the estate of Charles I, mentioned above. Most museums state their goals in terms of "collecting, preserving, and educating," so that, even if they have space to show only a fraction of their holdings, they continue to collect. Selling works of art—deaccessioning—is problematic for museums, as the ethics of disposing of works of art are complex. Selling is usually allowed only in order to exchange one work for another that is more appropriate to the overall collection. Selling from the collection to raise money is frowned on. That the culture of collecting has its own history is recognized in a number of books on the subject. Francis Haskell has written on both patronage and collecting. *The Origins of Museums: The Cabinet of Curiosities in Sixteenth- and Seventeenth-Century Europe,* edited by O. Impey and A. MacGregor, 1985, is another source of

information. The *Journal of the History of Collections* keeps up-to-date with research on the subject.

Colonial Style

In American art history, this term broadly refers to style before the Revolutionary War (1776–83). It was generally eclectic and dependent on European precedents. Much of this art was anonymous, and in painting was almost exclusively made up of portraiture.

color

The eye's perception of color depends on the light emitted, or reflected, by an object. *Local color* refers to the actual, intrinsic color of something as it would be seen in daylight against a neutral background; that is, local color does not reflect ambient light or other colors. (For example, the local color of snow is white, although it may look pink at sunset.) In painting, PIGMENT is the insoluble substance, mixed with a binder, used to give the paint its color, or "hue." The variables of color are:

hue—This refers to the perceived color of an object—for example, red or yellow.

value—A relative term, value represents a position on the scale between white (the highest) and black (the lowest). A color such as tan, for example, has a higher or lighter value than a brown, which is darker and closer to black. When the average value in a painting is closest to white, its "key" is highest; moving closer to black, its key lowers.

intensity (also called *saturation* and *chroma*)—Also a relative term, intensity refers to the purity of a pigment, a measure of its visual strength, or brightness. *Chromatic* painting concerns the juxtaposition of intense colors.

While the application of color, or pigment, to works of art certainly depends on the medium, or binder, that carries it (from water to wax, oil to pixel), the choice of color, or artist's PALETTE, is usually characteristic of the historic period in which he or she paints. Color in MEDIEVAL art was of supreme importance, its jewel-like purity considered a reflection of Paradise. During the ITALIAN RENAISSANCE, the emphasis began to change and drawing came to be valued more highly than coloring—a judgment articulated in the mid-16th century by VASARI, who placed the art of Florence higher than that of its rival, VENICE, where the visual effects of color and light were strong. Vasari's point of view, though challenged, gained strength and prevailed. The battle was joined when the French Academy debated the issue in 1671, and though its official position was to give them equal weight, its unofficial position favored drawing. Backed up by Platonic theory, the academic position held that whereas color was mundane, relating to the world of emotion, drawing was spiritual and a skill of the intellect. Because to their respective admirers RUBENS represented the camp that favored color and POUSSIN that of line, the dispute was phrased as the Rubenistes vs. the Poussinistes, or, sometimes, the Moderns vs. the Ancients (see LINE VS. COLOR). This back and forth took a new turn during the 19th century, when IMPRESSIONISM and NEO-IMPRESSIONISM set to examining the properties of light and color and FAUVE painters broke all rules relating

to color. A multitude of theoretical explorations of color ranges from those of ARCIMBOLDO in the 16th century to those of ALBERS in the 20th.

Recently, the quarrel over "refreshing" Renaissance art, what the historian Marcia Hall calls the "Cleaning Controversy," prompted emotion almost as shrill as that piqued by Vasari. After centuries of believing that Italian Renaissance color in painting, especially that of MICHELANGELO, was restrained by discretion, washing the dirt off the walls of the Sistine Chapel revealed that it was, rather, submerged beneath centuries of accumulated grime. The sometimes boisterous colors of the great Italian masters were difficult for some art historians to accept. "Knowing little about Renaissance color technique and palette, and reared on images that were sedately obscured, they were suddenly confronted with a brilliance in the color, and what had been beloved and familiar images now seemed both strident and indecorous," writes Hall. While cleaning may restore some parts of old paintings to their original appearance, nothing can be done to reverse other ravages of time, such as the damage to top layers of paint on DUCCIO's *Maestà* (1308–11), which gives the flesh color a greenish tint, or the common occurrence of the darkening of color, especially the browning of green.

Color Field Painting

Initially part of ABSTRACT EXPRESSIONISM, Color Field painters covered a canvas to its edges with large fields of color, intimating that the painting would, or could, continue beyond the edges to infinity. Despite their large size, these works are meant to be experienced at close range so that they surround the viewer in a color environment. ROTHKO and NEWMAN are among the Color Field painters. Other Abstract Expressionists (e.g., Jackson POLLOCK and DE KOONING) similarly absorb the viewer's entire field of vision; however, their canvases are meant to convey the process of artistic creation (see ACTION PAINTING). Evidence of the artist's hand, or the process of making the art, is underplayed in Color Field Painting, and in works such as those of FRANKENTHALER and LOUIS, who stained their canvases instead of using a brush, the artist's touch is virtually removed. Later Color Field painters (e.g., Ellsworth KELLY) fit into the category of HARD EDGE PAINTING.

Colosseum

Nothing expresses the grandeur and ingenuity of ancient Rome as well as its public architecture, and nothing displays those qualities better than the Colosseum. If, as the saying proclaimed, "All roads lead to Rome," once there, the Colosseum was the embodiment of the Empire. It may have been named for a colossal bronze statue of the emperor Nero as god of the Sun that was removed under Hadrian's rule by 24 elephants, or for the size of the theater itself (some 615 feet long, 510 feet wide, and 160 feet high), or for both. The Colosseum was dedicated by Titus in 80 CE. Jewish prisoners of the Judean War had been employed for its construction (see ARCH OF TITUS). The exterior facade is notable for its use of the three Greek COLUMN ORDERS flanking rows of ARCHes: Doric on the ground floor, Ionic in the middle and Corinthian on top. The masonry blocks

were originally fastened together with iron tenons; these were torn out and used for making weapons during the MEDIEVAL period. Some 80 numbered entry arches led, through passages, into the oval amphitheater—so enormous that for opening celebrations it could be flooded to stage a full-fledged naval battle. Other lavish festivities included chariot races, gladiatorial battles, and Christian martyrdom. An estimated 50,000 spectators could be entertained. During the early 19th century, a British botanist noted curious and rare varieties of flora in the Colosseum ruins. He theorized that they grew from ancient seeds spread by feed that had been imported for the exotic animals brought in some 1,800 years earlier—ostriches, crocodiles, elephants, boars, bison, hippopotamuses, bears, leopards, tigers, and lions—all slaughtered at an unbelievable rate. (Titus had 5,000 animals killed in a single day.) Excavations begun in 1850 revealed a vast underground network of dens, passages, ramps, and even elevators to lift large animals into the arena, and showed that the botanist's conjectures were true.

column

A vertical pillar or shaft usually employed to support a horizontal element, but also purely decorative or commemorative (see COLUMN OF TRAJAN). A row of columns is a *colonnade; peristyle* indicates that the colonnade surrounds either a building or courtyard; *peripteral* describes a building surrounded by a colonnade. A decorative, shallow projection that resembles a column but is non-load-bearing is a *pilaster*. According to convention, the structural column derives from the trunk of a tree; however, the peripteral Greek TEMPLE has also been imagined by the architectural historian SCULLY as surrounded and supported by a procession of soldiers. Greek columns were usually built up in sections, called drums. These were fastened with metal pins soldered in place. ROMAN columns, in contrast, were usually monoliths, with separate capitals and bases. Column styles seem distinct according to time and place, yet are also interrelated. For example, the Greek Doric capital resembles those of MINOAN times. Capitals are the column's clearest identifying characteristic: Lotus-, papyrus-, and palm-like designs capped Egyptian columns; ancient Persian palaces had bull heads; sacred, freestanding columns erected by the 3rd-century BCE Indian emperor Asoka had four lions back-to-back. A BYZANTINE innovation was complexly ornamented carvings not only on capitals but also on impost blocks just below them. ROMANESQUE capitals often bore miniature monsters or NARRATIVE scenes (known as "historiated" capitals). Column shafts are equally inventive; some are clustered; some, usually less than the entire circumference of a pillar, are attached or engaged with the wall; and others—the most famous of which support the BALDACCHINO of Saint Peter's in Rome (designed by BERNINI)—are fashioned to appear twisted. Innovation included using KORE figures (CARYATIDS) as the column shaft. The ROMANESQUE trumeau, a columnlike support that divides two openings, usually of a cathedral portal, reached great complexity with writh-

ing, entwined figures. A building's stylistic allegiance is most often reflected in the type of column used.

column orders

Refers specifically to variations in Greek architecture related to a building's COLUMNS. The orders include the base, shaft, and capital of the column, along with the entablature it supports, consisting of architrave, frieze, and cornice. Of the five well-known examples, all but the Tuscan have fluted shafts. Each order has its distinctive capital. The Tuscan, with its Doric capital, is the simplest column and is said to be derived from the ETRUSCAN temple. Named for its origin on the Dorian mainland, the massive, severely simple Doric column was, according to VITRUVIUS, based on male proportions. Its entasis, a slight bulge along its shaft, was described as "muscular." Doric columns had plain capitals; their friezes, just under the pediment, were divided into alternating panels of triglyphs (*tri*, meaning "three"; *glyphs,* meaning "carved grooves") and metopes, which were usually bas-relief (see RELIEF) scenes from mythology. From Ionia, which also influenced the robes seen on ARCHAIC korai (see KORE), the Ionic column seemed relatively feminine: taller, slimmer, and more refined. The coil of its capital has been related alternately to a palm tree, a ram's horn, and fern fiddleheads. Above the Ionic capital is a running frieze that was often sculpted. ICTINOS was the first architect to combine the two orders, using the Ionic column and frieze for the interior of a Doric TEMPLE. He may also have been the first, in c. 450 BCE, to use a Corinthian column, initially for a temple interior. The acanthus leaves of the Corinthian capital are supposed to have been inspired by plants growing on the grave of a Corinthian maiden, an idea that also comes from Vitruvius. Corinthian columns were used with architectural detailing that generally accompanied the Ionic order.

Column of Trajan

The emperor Trajan ruled from 98 to 117 CE, during which time he built the last and greatest of the Roman forums. It was dominated by a huge BASILICA, at the back of which, between two library buildings (one for Greek books, the other for Latin), stood the commemorative marble column, 128 feet high, built in 113 CE, perhaps the work of Trajan's military engineer/architect Apollodoros of Damascus. The base served as the emperor's mausoleum and his statue originally stood on top (the statue was lost in the Middle Ages and replaced by one of Saint Peter in the 16th century). Inside the column is a staircase, lighted by 43 small windows. During Trajan's reign the empire reached its farthest boundaries, and the RELIEF carving encircling the column commemorates his two Dacian campaigns that expanded the empire into Hungary and Rumania. More than 2,500 figures populate some 155 episodes, presented chronologically in a NARRATIVE sequence that grows larger in width (but remains low in relief) to retain legibility as it mounts higher. The uppermost scenes were best appreciated from the tops of the no longer extant two-story libraries. This winding record of history emphasized Roman feats of

engineering and architecture as much as military prowess, consistent with imperial propagandistic braggadocio. The pictures were probably once painted, and certain details, such as armor, were enhanced by metal. Moreover, the orientation of figures—their gazes, gestures, movement, and actions—was consistent with the actual directions of places and events: Facing forward reflected going in the direction of Dacia, or downstream on the Danube. Generally accepted as the most extensive narrative work of art from the ANCIENT world, because of its upward spiraling, increasingly distant story line, and despite the sculptural adjustments mentioned above, the narrative's continuity is difficult for an individual to follow. But as Richard Brilliant has demonstrated, the artist "converted the narrative into a double system of sets, one proceeding along the helix, the other, as a paranarrative, set at vertical intervals in tableau form." These tableaux acted like chapter headings, repeating certain figures of Trajan, the protagonist, as both anchor and heroic icon. "The Column of Trajan," Brilliant writes, "can legitimately assert its claim as the classic example of Roman narrative art; incorporating elements of narration that offered immediate as well as extended gratification, it is coherent in detail and in its thematic formulations, all governed by a heroic central character who never disappears from view or from the consciousness of viewers." The Column of Trajan inspired many later monuments, among them the 11th-century bronze column commissioned by BERNWARD to narrate the life of Christ, and Napoleon's column in the Place Vendôme.

computer graphics
See PRINTING

Conceptual art
Conceptual art followed MINIMAL ART later in the 1960s. In making Conceptual art, the artist is concerned with an idea, not an object: "The world is full of objects, more or less interesting; I do not wish to add any more," commented the Conceptual artist Douglas Heubler in 1969. In one sense it is antimaterialist and anticonsumerism. From another point of view it is an entirely intellectual pursuit, disassociated from notions of craftsmanship. KOSUTH said, "The art I call conceptual is . . . based on . . . the understanding of the linguistic nature of all art propositions." Sol LEWITT, also working in the conceptual mode, often presents ideas for others to execute in what is designed to be a temporary mural, and ACCONCI explored his relationship with others as his conceptual endeavor.

Concrete art
In 1930 van DOESBURG proposed the term "concrete art" as a more accurate description for ABSTRACT or NONOBJECTIVE ART because, he pointed out, abstracting implies removing. "Concretion signifies the natural process of condensation, hardening, coagulating, thickening, growing together. . . . Concretion is something that has grown." ARP was among the few artists who adapted van Doesburg's term at the time. In 1947 it was revived in Paris and in the work of ALBERS, who had moved to the United States and exhibited regularly with the American Abstract Artists group as well as with ABSTRACTION-CRÉATION in Paris.

Condivi, Ascanio

1525–1574 • Italian •
painter/Michelangelo's biographer •
Renaissance

*From the hour in which the Lord
God by His singular beneficence
made me worthy not merely of the
presence (which I would hardly have
hoped to enter), but of the love,
the conversation, and the close
companionship of Michelangelo
Buonarroti, the unique sculptor and
painter, I . . . applied myself with all
attention and study to the observation
and collection not only of the precepts
he imparted to me about art, but of his
sayings, actions, and habits, together
with everything in his whole life which
seemed to me to warrant wonder or
imitation or praise.*

Condivi was a student of MICHEL-
ANGELO. Although his artistic achieve-
ments are negligible, his *Life of
Michelangelo* (1553), quoted from
above, was reputedly dictated to him by
the master himself in an effort to correct
errors in the first edition of VASARI's
Lives (1550). One example is Vasari's
statement that the slaves Michelangelo
carved for the tomb of Julius II repre-
sented the provinces captured by the
pope. Condivi called them the Liberal
Arts captive at the pope's death—a sig-
nificantly different metaphor. In his sec-
ond edition (1568) Vasari tried to meld
both ideas, but the importance derived
from the contrast throws light on
Michelangelo as the shaper of his own
image for posterity.

connoisseurship

A connoisseur, in its original French
meaning, is one who knows. However,
in 1892 the consummate connoisseur,
MORELLI, wrote, "It has been said, sar-
castically, that the art connoisseur is
distinguished from the art historian by
knowing something about the art of
the past. If he happens to be of the bet-
ter sort he abstains from writing on
the subject. On the other hand, the
art historian, although writing much
upon art, really knows nothing about
it; whilst the painters who boast of
their technical knowledge are neither
competent critics nor competent his-
torians." Connoisseurship's other re-
nowned practitioners, BERENSON and
DUVEEN, used their skills to authenti-
cate works of art, not only distinguish-
ing them from counterfeit, but also
establishing "authorship," period,
style, and those details that depend on
visual familiarity and depth of knowl-
edge. However, they also greatly dis-
credited esteem for connoisseurship by
combining it with commerce. While
pure connoisseurship is now down-
played in art historical studies, it still
has a significant role, especially in com-
bination with scientific methods of re-
search. The ongoing reattribution of
works by REMBRANDT is a foremost ex-
ample.

Constable, John

1776–1837 • English • painter •
Romantic

*Painting is a science and should be
pursued as an inquiry into the laws of
nature. Why, then, may not landscape
be considered as a branch of natural
philosophy, of which pictures are but
experiments?*

When he was 26 Constable made a mo-
mentous decision to devote himself to

painting. He wished to concentrate on what he called "natural painture," by which he meant the "pure and unaffected" portrayal of the English countryside. He worked outdoors, sketching in OIL, to capture the immediacy of a scene. *The Haywain* (1821), his famous rural idyll, exemplifies his desire to show both a distinctive place and a particular time; the title he originally gave the work was *Landscape: Noon.* "No two days are alike, not even two hours; neither were there ever any two leaves alike since the creation of the world," he said. His "scientific" observations included sketches of cloud formations, and he studied the effect of light and atmosphere on the sky as well as the countryside. After his wife died, in 1828, Constable's work became more turbulent. The oil sketch *Hadleigh Castle* (1828–29) is of a ruined castle by the sea; it expresses disaster and desolation in subject, mood, and technique. Constable used a palette knife to apply the paint, and the surface is flecked with white daubs, called "Constable's snow," that further agitate appearance and affect. Constable conceded both his own melancholy—"How for some wise purpose is every bit of sunshine clouded over in me"—and the consolation painting brought: "My canvas soothes me into forgetfulness of the scene of turmoil and folly and worse." Constable concentrated on rural scenes of farming during a period when the Industrial Revolution was actually wreaking havoc on the landscape and on the lives of country people. This was especially true in his native Suffolk. While he acknowledged those troubles in writing, no overt sign of them appears on the canvas—unless one reads them, by inference, into elements such as storms and ruins.

Constructivism

A revolutionary concept for sculptural forms, Constructivism intended to supplant the long tradition of works that were carved (subtractive), modeled (additive), and cast (see BRONZE) in favor of those that are constructed, as the word implies. Based on PICASSO's experiments, Constructivist ideas found a foothold in Russia, where the old RENAISSANCE traditions were less entrenched and the social revolution under way at the time mandated nonelitist forms. TATLIN is credited with designing the first totally ABSTRACT, nonrepresentative Constructivist sculpture. Constructivists split over their interpretations of the nature and purpose of art. Some, like Tatlin, POPOVA, and RODCHENKO, embraced the Russian Revolution's rejection of useless art in favor of practical, easily understood, socially useful "Productivist" works. Others (e.g., GABO) were interested in the principles of Constructivism but rejected its rigid utilitarian, antispiritual/intellectual mandate. Artists committed to the latter camp left Russia, for the most part. The pros and cons of the Constructivist factions were argued in numerous manifestos. (The labels "Constructivism" and SUPREMATISM were sometimes interchanged.) Outside of Russia, Constructivist ideas had enduring influence, and many permutations in Europe and America, especially through the BAUHAUS. In the 1980s, a group of avant-garde architects embraced the idea of combining Constructivism and DECONSTRUCTION in a movement they named Deconstruc-

tivism—based on the idea of disassembling MODERN architecture and then reassembling it in new ways. Rarely built, these experimental concepts are purposefully disorienting.

Conté crayon

Crayon is French for "pencil" and this type of "pencil" was named after a French painter who was an inventor of almost mythical genius, Nicolas-Jacques Conté (1755–1805). The Conté crayon, patented in 1795, was originally made from a mixture of graphite and clay. SEURAT used the Conté crayon along with chalk to achieve the gloomy mood of twilight on a snowy day in his black-and-white drawing *Place de la Concorde, Winter* (c. 1882–83). Today the term "Conté" is a trade name for synthetic chalks.

context (contextualization)

To study art "in context" is to examine its existence in relation to pertinent information outside the work of art itself. Where FORMALIST studies remove the work of art from external circumstances, contextual studies return it. Contextual approaches include examining the historic period in which it was created, the written text it may have illustrated or to which it refers, and artists on whom and works on which it depends for models or inspiration. MARXISM is a contextual approach from a socioeconomic point of view. Works that have been removed from their original locations were, in the past, studied without reference to their intended surroundings or environment. Contextual studies imaginatively, if not physically, "recontextualize" them. For example, GRÜNEWALD'S *Isenheim Altarpiece*

(1512/13–15), now in a museum, is hypothetically relocated in its original monastery, where victims of a skin disease were cared for, thus expanding the significance of Christ's ravaged flesh. In the words of the historian Brunilde Sismondo Ridgway, "An object out of its context can only be appreciated on aesthetic grounds, for its visual appearance, like someone beautiful whom we admire from a distance, without ever speaking to or getting to know. After a while the exercise seems futile and pleasure pales by comparison with intelligent and lively conversation with a less physically attractive but more articulate companion. Any artifact acquires beauty and importance as a representative of the culture that produced it." Literature, agricultural and/or technological developments, and psychology are some resources. Arnold Hauser's *Social History of Art* (1951) and, by way of contrast, Meyer SCHAPIRO's psychoanalytic *The Apples of Cézanne: An Essay on the Meaning of Still-Life* (1968) are each contextual but in very different ways. PATRONAGE is a contextual consideration in *The Taste of Angels* (1948) by Francis Henry Taylor, a past director of the Metropolitan Museum of Art. He examines the influence of patrons since the ancient Egyptians. Patronage is also the topic of Francis Haskell's *Patrons and Painters: Art and Society in Baroque Italy* (1980).

continuous narrative/continuous representation

Describes illustrations in which more than one episode in a story appear within a single image and with the same background. For example, on one page of the early-6th-century *Vienna Gene-*

sis, Rebecca is seen both en route to the well and, having drawn the water, giving it to Eliezer and his camels. Nearly 1,000 years later, continuous narrative is seen when Saint Peter appears three times in MASACCIO's *The Tribute Money* (c. 1427): In the center of Masaccio's picture, Christ tells Peter he will find a coin in a fish's mouth, at left Peter takes the coin from the fish, and at right Peter gives the coin to the tax collector. (See also NARRATIVE/NARRATOLOGY)

contrapposto

Refers to pivoting of the body, no matter how slight, around the central axis of the spine. In contrast to the rigid, stiff-legged FRONTALITY of ancient Egyptian and Mesopotamian stone figures and of the Greek KOUROS, 5th-century BCE Greece witnessed a stunning advance exemplified by *Kritios Boy* (480–470 BCE), our first historic example of contrapposto in sculpture. The subtle shift of weight to one leg, angle of the hips, turn of the head, and consequent relaxation reveal understanding of the muscular and skeletal form and a momentous new NATURALISM that has the effect of giving life to stone. With this understanding, the Greek sculptor could advance to showing the body in motion with anatomical fidelity. *Kritios Boy* is dated at the borderline dividing the ARCHAIC and CLASSICAL periods, the beginning of an era sometimes known as the Greek Miracle: after the birth of democracy in 510 BCE and subsequent Greek victories over the Persians. Thus, the unprecedented liberation embodied in the artistic realization of contrapposto may be linked to the unparalleled freedom implicit in the idea that the individual Greek male citizen could shape his own destiny and that of the state. During the ITALIAN RENAISSANCE, when the Classical world was enthusiastically rediscovered, artists took contrapposto to extravagant limits, as seen in the exaggerated torsion of MICHELANGELO's *Dying Slave* (1513–16).

conversation piece

This secular version of the popular RENAISSANCE type (SACRA CONVERSAZIONE), in which two or more people converse, in- or out-of-doors, was especially popular in Britain during the 18th century. GAINSBOROUGH is the best-known painter of conversation pieces.

Copley, John Singleton

1738–1815 • American • painter • Colonial

. . . the people generally regard [painting] no more than any other useful trade, as they sometimes term it, like that of a Carpenter tailor or shew [sic] maker, not as one of the most noble Arts in the World.

Copley's Irish parents immigrated to America in the mid-1730s, and he was born in Boston. His father died in the mid-1740s, and in 1748 his mother remarried. Copley's stepfather, Peter Pelham (1697–1751), was a skilled ENGRAVER who specialized in the difficult medium of the MEZZOTINT. Copley was instructed by Pelham until his stepfather died, in 1751. The rest of Copley's education in art came from studying the paintings of SMIBERT, FEKE, and BLACKBURN and from reading books on English, French, and Italian art. He became a successful portraitist among

Boston's merchant and professional elite: A portrait by Copley became an emblem and affirmation of an individual's success. The historian Paul Statie writes, "Copley's unmatched success as a producer in a culture of consumption was built upon his ability to sell dream material that told consumers in visual terms what it was possible for them to believe about themselves. . . . [He] helped the elite define who they were, for both themselves and others." Seemingly unable to paint the human form with any sense of true anatomy, Copley painted the stuff of the colonial American's material life—the silks and satins, brocades and laces, embroidery and gold braid—with a sheen, elegance, and opulence more dazzling than the real thing. He fashioned himself as an aristocrat, and at the same time saw his patrons as Philistines, as suggested by the quotation above from a letter he wrote in 1767. Nevertheless, Copley achieved great intimacy and direct rapport with his sitters. But he wished to acquire an English style, so he corresponded with artists in London and sent them his most highly accomplished work, *Boy with a Squirrel (Henry Pelham)* (1765). This is a picture of his half brother seated at a table with a tiny squirrel on a gold chain and a glass of water nearby. It is an extravagant show of texture and reflections, from polished wood and water to pink satin collar and light gold vest. The links in the chain, and even the hairs on the boy's head, might be counted one by one. Copley has also painted the fresh sweetness of youth and an appealing little flying squirrel. In return he received the now infamous opinion of REYNOLDS that he could become "one of the first Painters in the World" if he went to study in Europe "before [his] Manner and Taste were corrupted or fixed by working in [his] little way at Boston." Copley wrote to WEST in 1770, "I am desireous of avoideing every imputation of party spir[it], Political contests being neighther pleasing to an artist or advantageous to the art itself." Copley's wife was the daughter of a Tory merchant who was a principal agent for the British East India Company, and in 1774, an angry mob threatened Copley and his family for allegedly harboring a Tory. Copley left for England on the eve of the American Revolution. Two years earlier Copley had painted the revolutionary Samuel Adams (1770–72); the historian Carol Troyen writes, "For Copley . . . *Adams* was a stirring history painting in the guise of a portrait." Earlier still he had painted *Paul Revere* (1768). The circumstances of the *Revere* commission are unknown, but some scholars read a political statement in Copley's portrait of the thoughtful silversmith, especially considering Revere's participation in Revolutionary politics and the anti-British symbolism of the teapot that Revere holds in his hand: The despised British Townshend Acts of 1767 had imposed duties on certain English goods entering America, including the East India Company's tea. However veiled his politics, though, Copley's artistic ambition was clear—he sailed for England in June 1774. He continued to receive portrait commissions and painted several HISTORY PAINTINGS. His most notable work from England is *Watson and the Shark* (1778), an unusual scene documenting an actual accident off the coast of Cuba in which the young Watson's

leg was bitten off by a shark. The picture caused a popular sensation when it was exhibited in London. Copley never returned home.

Coptic art

"Coptic" means native of Egypt but in current usage it signifies Christian-Egyptian. As in other parts of the Roman Empire, Christianity was established in Egypt, and by 553 CE the last bastion of the ancient pagan faith, a temple to Isis on the island of Philae, was closed. Egypt came under BYZANTINE influence, but disputes with the Orthodox Church led to establishment of the independent national Coptic Church. Coptic art could be more decorative than illustrative; it was a distinctive blend, combining ancient local traditions of Egypt (e.g., FRONTALITY) with later Greco-Roman influences. It is characterized by an abstract, formal style with strong outline drawing and clear brilliant color. (See SUB-ANTIQUE)

Cornell, Joseph

1903–1972 • American • sculptor • Modern/Surrealist

I do not share in the subconscious and dream theories of the surrealists.

According to the comment quoted above, Cornell did not subscribe to the processes used by SURREALISTS, but his work was exhibited with theirs and clearly demonstrates their influence. Fitting small, found objects into shadow boxes, Cornell created strange, evocative circumstances—not scenes as such, but configurations that prompt stories in the mind of the viewer. His materials include souvenirs and discarded materials (such as SCHWITTERS used) in combinations that are inexplicable through any connection other than the imagination. *Untitled (The Hotel Eden)* (1945), for example, is an ASSEMBLAGE that contains a bird, tattered papers with writing, a coil, a ball, and other items inside a painted box some 15 by 15 inches square and almost 5 inches deep.

Cornish Art Colony

A group of more than 70 artists, playwrights, architects, landscape designers, writers, actors, and patrons of the arts who lived and worked in Cornish, New Hampshire, during the late 19th and early 20th centuries. Members included SAINT-GAUDENS, the DEWINGS, and COX in addition to playwrights such as Percy MacKaye and the performers Isadora Duncan and Ethel Barrymore. For three years Cornish even served as the site of Woodrow Wilson's summer White House.

Corot, Jean-Baptiste-Camille

1796–1875 • French • painter • Naturalist

Be guided by feeling alone. We are only simple mortals, subject to error; so listen to the advice of others, but follow only what you understand and can unite in your own feeling. Be firm, be meek, but follow your own convictions.

Corot was the central figure in the development of French 19th-century landscape painting. With Théodore ROUSSEAU, Corot came increasingly to be associated with outdoor or PLEIN AIR painting. Early in his career Corot traveled widely throughout Europe, includ-

ing three visits to Italy. He taught two generations of painters, lived to the age of 80, and was extremely prolific. His productivity plus his popularity led to a multitude of forgeries and the joke that Corot had painted 3,000 pictures, of which 6,000 were in America. He began to paint the landscape during a period when it was still ranked below HISTORY PAINTING in France (see ACADEMY). However, an interest in the countryside, weather, and other natural phenomena was consistent with the writings of Jean-Jacques Rousseau (1712–1778), who sought truth and saw morality in the "primitive," natural world. While the English landscape painter CONSTABLE preceded and perhaps influenced Corot, Constable's comment that "painting is a science," next to Corot's appeal to "feeling," highlights distinctions between them. Corot felt, and offered his audience, the beauty of the landscape: not morality or social commentary, but the pleasure of visual sensation. Perhaps there are allusions to music as well; it is suggested that Corot's favorite composers, Beethoven and Mozart, influenced the moods and rhythms of Corot's art. There is a soft focus, a sense of many semitransparent veils, and a gentle atmospheric ambience and subtlety in Corot's later landscapes. *Souvenir of Mortefontaine* (1864), for example, is two-thirds taken up with the feathery amplitude of the silvery green, leafy branches of a tree. Behind it the perfectly still, silvery water melds, on the horizon, into a soft sky of the same colors. It is an altogether harmonious picture.

corps exquis
See EXQUISITE CORPSE

Correggio (Antonio Allegri)
c. 1489–1534 • Italian • painter • late Renaissance/proto-Baroque

It is impossible to describe the delicate vivacity which characterizes the works of Antonio da Correggio. He depicted hair in a manner unknown before ... soft and downy, the separate hairs polished so that they seemed of gold and more beautiful than natural ones, which were surpassed by his coloring. (Vasari, mid-16th century)

Ecstatic bliss, spiritual and sexual, characterizes the works of Correggio. His ceiling paintings combine the illusionistic trickery of MANTEGNA's *Camera degli Sposi* (1465–74) with the energized, muscular figures of MICHELANGELO's Sistine Chapel ceiling (1508–12). The viewer feels swept up into a whorl of celestial activity. On the domes of a church and the Cathedral of Parma, the city where he spent most of his career, Correggio painted Christ in one and the Virgin in the other, each levitating directly overhead. The audacity of looking up into their swirling robes was at least as bold as Mantegna's eye-level view in the painting *Dead Christ,* in which Christ is seen feet first. Correggio's ceilings were prototypes for BAROQUE artists. The mythological FRESCOes he painted in Mantua, to satisfy Duke Federigo GONZAGA's appetite for unusual excitements, illustrated the extramarital affairs of the god Jupiter, legendary ancestor of the Gonzaga family. *Jupiter and Io* (c. 1532) portrays the lustful god as a huge smoky cloud, his grip on the naked, fleshy Io like a huge, dark paw, and just the shadow of his face kissing hers. This sexual rapture seems prescient

of BERNINI's *Ecstasy of Saint Teresa*, sculpted more than a century later.

Cortona, Pietro da (Pietro Berrettini)

1596–1669 • Italian • painter/architect • Baroque

Images of the nude are not per se obscene . . . [but] more often than not the painter of nude images designs them with some immodesty. Nor would a painter deserve praise who, in order to show off his skill, pictured and exhibited . . . the lawful embraces of a married couple in the nude, for not all that we are allowed to do in private are we allowed to represent in public.

Cortona's genius, the historian WITT-KOWER writes, "was second only to that of Bernini," and his achievements should be considered among the most outstanding of the 17th century. Curiously, Cortona refused to choose the subjects he painted but preferred instruction from his PATRON. Luckily, one of his greatest supporters was Marcello Sacchetti, a man of learning, steeped in CLASSICAL culture and a poet as well. Sacchetti discovered the young Pietro after admiring a copy he had made of RAPHAEL's *Galatea* (1512). Under the Sacchetti family wing, Cortona was given the important commission for decorating their country home, a project on which SACCHI also worked. Later, the so-called Academy of Saint Luke dispute between Cortona and Sacchi became famous (see ACADEMY). Both artists departed from the Classical belief that linked painting with poetry (see UT PICTURA POESIS), but where Sacchi insisted on a style consistent with

tragedy, calling for few figures in simple, unified compositions, Cortona argued on behalf of the great epic drama, a grandiose theme with many episodes. Sacchi's point of view reflects "Classic" BAROQUE; Cortona's, "High" Baroque. An example of Cortona's painting in this manner is his ceiling FRESCO for the BARBERINI palace in Rome, *Glorification of the Reign of Urban VIII* (1632–39). Cortona's ceiling, inspired by the illusionism of CORREGGIO (*Assumption of the Virgin*, c. 1530), is an exuberant, complex picture that overwhelms and transports a viewer into the light-filled "infinity" above. And despite the comment, quoted above, from Cortona's *Treatise on Painting and Sculpture* (1652), a number of nude forms do float overhead, seeming perilously close to the spectator's head.

Cotán, Juan Sánchez

1560–1627 • Spanish • painter • Baroque

The framing space, or window, in Sánchez Cotán's still lifes would probably have been recognized by contemporaries as a cantarero, *or primitive larder. The hanging of fruits and vegetables from strings attached somewhere above was an allusion to actual practice that helped to keep them from spoiling.* (Peter Cherry and William Jordan, 1995)

Cotán had a successful career as a painter of STILL LIFES before he joined the Carthusian order as a lay monk in 1603, at the age of 43. He painted vegetables and fruits—cabbage, leek, parsnip, lemon, apple—suspending some of them from strings. Sometimes he hung dead birds in his arrangements.

These compositions are eloquent in their parsimony, placed against a black background in what looks like a large shadow box but was a *cantarero,* as described by Cherry and Jordan above. They add, "None of the compositions suggests the random disorder of a larder shelf, however, so it would be a mistake to forget that these are artfully arranged." It is even proposed that Cotán's arrangements have a basis in mathematics. Among the most beautiful is *Still Life with Quince, Cabbage, Melon, and Cucumber* (1600). The objects look unreal, even surreal. They might emphasize asceticism, the absence of touch, and geometric organization rather than nourishment. The Carthusian order, which Cotán joined after painting most of the still lifes for which he is known, stresses solitude; the brothers took meals, studied, and prayed alone for most of their day. They ate no red meat and they fasted on Fridays, sustaining themselves on bread and water. In his later years, Cotán devoted most of his time to painting sacred subjects and to illustrating the history of his order, though he did continue painting still lifes from time to time.

Cotman, John Sell
See NORWICH SCHOOL

counterproof
See OFFSET

Courbet, Gustave
1819–1877 • French • painter • Realist

The title of "realist" has been imposed upon me, as the men of 1830 had imposed upon them the title of "romantics." Titles have never given a just idea of things; were it otherwise, the work would be superfluous.

Courbet was born in the rural town of Ornans, which he made both famous and infamous in his paintings, especially *Burial at Ornans* (1849). Because this picture raised the grim, everyday life of ordinary people in a harsh, provincial landscape to the level of HISTORY PAINTING, it created a scandal. *The Stone Breakers* (1849)—an old and a young man doing backbreaking work beside the road—was considered equally unseemly, and dangerous in addition. The revolutions of 1848 were still fresh, and the unrest of workers was a threatening specter. Courbet's friend Pierre-Joseph Proudhon, a Socialist, saw an indictment of capitalism in *The Stone Breakers,* which he compared to a biblical parable. (The painting was destroyed during World War II.) Courbet is called the father of the "Realist" movement, though he demurred, as in the quotation above (see REALISM[2]), that it was the labeling, not the intent he disputed. For he also wrote, "Realism is essentially the democratic art." He was adamant that painting could only represent things "both *real* and *existing.*" He insisted that "An abstract object, invisible or nonexistent, does not belong to the domain of painting." He was also firm in his ideas about education. In 1861 a group of students, dissatisfied with the state-run ÉCOLE DES BEAUX-ARTS, asked Courbet to direct an alternative school. Though he declined, saying, "I do not have, and I can not have, students," he agreed to work with them in a rented studio. The

model was usually a peasant with a farm animal. While the official 1855 Paris Exposition was in session, Courbet presented an *Exhibition of Forty Paintings* in a shed called the Pavilion of Realism. His "Manifesto of Realism" introduced the show's catalogue. The most important painting on exhibit was his own large and endlessly intriguing work, a scene set in his studio with himself at the easel painting a landscape, a nude model looking over his shoulder from behind. To the left of the painter are people from Ornans: hunter, peasant, worker, Jew, priest, a young mother with her baby. On the right side are portraits of people from Courbet's life in Paris: client, critic, and intellectuals, including his friend BAUDELAIRE. The title of the work is *Studio of a Painter: A Real Allegory Summarizing My Seven Years of Life as an Artist* (1854–55); the "seven years" are from 1848 to 1855. The only unequivocal statement that can be made about this painting is that it measures more than 19½ feet in length and is nearly 12 feet high.

Couture, Thomas
1815–1879 • French • painter/teacher • Academic/Eclectic

I have made a tour of painting as many make a tour of the world. I shall relate to you my voyages, my discoveries. They are not so numerous and I believe very simple. You will not have the difficulties I had, but will learn easily what it is necessary to know.

Among the lessons Couture taught was that, "Yes, the artist ought to submit himself to the taste and customs of his country, for his mission is to please and to charm." He accomplished that mission when he showed *Romans of the Decadence* at the SALON of 1847. It is a scene of ROMAN debauchery spread across a huge canvas, almost 26 feet in length, 15½ feet high. The implicit moral lesson about corruption and decline led to much speculation about the artist's points of reference. Was he alluding to contemporary excess? The painting was exhibited on the eve of the 1848 Revolution. After the Revolution, Couture concentrated on modern French history. *Decadence* became a symbol of tradition, though Couture was called a painter of *juste milieu,* that is, one who mediates between strict NEOCLASSICISM and ROMANTICISM. Couture placed strong emphasis on the importance of the rough sketch, or *ébauche,* which remains visible on the canvas despite application of thick paint and layers of GLAZE. Couture's students included those who rebelled against his teaching, like MANET, and those who supported it, like PUVIS DE CHAVANNES.

Cox, Kenyon
1856–1919 • American • painter/critic • Academic Classicist

The lack of discipline and the exaltation of the individual have been the destructive forces of modern art.

The ARMORY SHOW of 1913 was the subject of the essay in which Cox made the statement quoted above. "This thing," he also wrote about that exhibition, "is not amusing; it is heartrending and sickening." Besides being an impassioned critic of the new, Cox was a skilled painter in the old, ACADEMIC

manner that looked back not only to CLASSICAL style but to Classical subject matter as well. *An Eclogue* (1890) is a painting that plays with ANTIQUITY; it is likely that the title has a ROMAN source in Virgil's *Eclogues*—idyllic pastoral poems. One female figure is based on the APHRODITE OF MELOS. Cox studied in Paris and brought his academic training, especially the study of the NUDE, home with him. Yet the landscapes in which he placed his FIGURES could be quite free and impressionistic. During the 1880s and 1890s, MURAL painting was very popular in America, and Cox was especially successful as a muralist.

Coysevox, Antoine
1640–1720 • French • sculptor • Baroque

There is no direct evidence to show that he lost the favour of the King, but it is certain that by the 1690's the taste of the latter was moving away from the classical manner, of which Girardon was the distinguished exponent, and beginning to favor a more Baroque style. It is partly for this reason that the position of Girardon's rival, Coysevox, improved as that of Girardon became weaker. (Anthony Blunt, 1953)

In the quotation above, BLUNT describes Coysevox's rise to eminence as one of the major sculptors employed in the decoration of VERSAILLES. Coysevox also carved portrait busts that show he had looked carefully at those done by BERNINI. However, his TERRACOTTA bust of LE BRUN (1676) is more restrained and subtle than those he made of Louis XIV later. Later still, sculpting portraits of his friends, he shows a naturalism and freshness that will come to the fore in the ROCOCO of the next century.

Cozens, Alexander
1717–1786 • English • painter • Romantic

Too much time is spent in copying the works of others, which tends to weaken the powers of invention, and I scruple not to affirm, that too much time may be spent in copying the landscape of nature herself.

Cozens composed a treatise called *A New Method of Assisting the Invention in Drawing Original Compositions of Landscape* (1786), from which the comment above is taken. It is a curious remark in that not only do his own cloud studies look true to nature, besides being poetic, but they also were (Cozens's scruples notwithstanding) copied by none other than CONSTABLE, England's preeminent landscape painter and observer of clouds! Citing LEONARDO as a reference, Cozens suggested using ink blots as a prompt to the imagination when seeking ideas for landscape forms. Alexander Cozens's son, John Robert Cozens (1752–1798), was also a landscape painter.

Cranach, Lucas, the Elder
1472–1553 • German • painter/printmaker • Northern Renaissance

. . . without images we can neither think nor understand anything. (Martin Luther, 16th century)

Early in his career, paintings—e.g., *Crucifixion* (c. 1500)—and drawings by Lucas Cranach were highly charged, al-

most exploding with emotion. That changed with his embrace of the Protestant Reformation. Despite his disapproval of some religious imagery, such as crucifixes, Martin Luther, quoted above, was well aware of the persuasive value of art. Luther worked closely with Cranach, his friend and follower, in the development of numerous works. Cranach also painted Luther's portrait several times. In fact, the evangelical fervor of both Lucas the Elder and his son, Lucas the Younger, also an artist, was so great that they created the equivalent of a school of visual rhetoric on behalf of the Reformation that lasted some 50 years. Cranach's WOODBLOCK print *Allegory of Law and Grace* (c. 1529) is a clearly propagandistic image: With the writings of Luther as his source, Cranach used biblical imagery to distinguish the Protestant belief in salvation through faith from the Catholic stress on good works. Part of the new Protestant ethic was a more positive and encouraging attitude toward sexuality. This helps to explain Cranach's paintings of nude women, such as the three Graces in *The Judgment of Paris* (c. 1530). While the women wear only necklaces and transparent veils around their loins, Paris is outfitted as a German knight in a full suit of armor—somewhat inconvenient for romantic overtures, as is the advanced age of his companion. When he developed his nudes, Cranach's style became oddly stylized: His figures flattened, looking stilted or awkward. They seem retrospectively GOTHIC, decorative, and affected—anachronistic. Why he adopted this style is uncertain, but one speculation is that it was an easy model for the

members of his very large and successful WORKSHOP to copy.

Crawford, Thomas

1813–1857 • American • sculptor • Neoclassicist

. . . a new stereotype rose to replace the Demonic Indian: the Doomed Indian. . . . Probably the most vivid image of the Doomed Indian is the most official one, placed where few visitors notice it today—on the Senate pediment of the U.S. Capitol in Washington. (Robert Hughes, 1997)

A New Yorker who worked as a stonecutter and then studied at the National Academy of Design, Crawford went to Rome in 1835 and enrolled in THORVALDSEN's studio. Later, his own studio in Rome became one of the most active. As did his fellow Americans abroad, Crawford kept in touch with developments at home. When the United States moved into its era of large-scale patriotic sculpture programs—and congressmen decided that American artists should receive the commissions—Crawford's assignments included designs for bronze doors on the new wings of the Capitol and sculpture for the Senate's pediment. His instructions regarding the pediment were to provide an allegory of "the struggle between civilized man and the savage, between the cultivated and wild nature." *The Progress of Civilization* (1851–63) has figures on either side of America, who was personified as a woman (in ANCIENT dress) accompanied by an eagle. Pioneers, merchants, Native Americans, teachers, even industry, in the guise of a mechanic, and the "Doomed

Indian" Hughes writes about above are all part of Crawford's design. Crawford died suddenly, of a brain tumor, before he could finish the project, which was completed by others according to his plans.

Crivelli, Carlo
c. 1430–1495 • Italian • painter • Renaissance

. . . a formula that would, without distorting our entire view of Italian art in the fifteenth century, do full justice to such a painter as Carlo Crivelli, does not exist. He takes rank with the most genuine artists of all times and countries, and does not weary even when "great masters" grow tedious.
(Bernard Berenson, 1894)

He was born in VENICE, but little else of Crivelli's biography is known, although court records of 1457 find him guilty of keeping an absent sailor's wife captive and hidden for purposes of carnal knowledge. He spent six months in jail and subsequently left Venice. After three decades of productivity, what we see of Crivelli's oeuvre is inconsistent in terms of expression, and is sometimes exceptionally strange. His *Pietà* (c. 1470) is so disturbing a representation of Christ (flaccid body, pointed face, and open mouth) and two angels (whose grimaces resemble nausea more than grief) that it is difficult to look at. In contrast, *The Annunciation with Saint Emidius* (1486) is so intriguing that it is hard to stop looking at it. This is a flamboyant display of PERSPECTIVE and of exceedingly detailed architecture lavishly ornamented with GROTESQUES and textiles, especially Oriental rugs.

There are also elements to trick the eye—an oversized gourd and apple—and a multitude of other engaging details. For a church in Ascoli, this ALTARPIECE celebrates the pope's 1482 grant of limited self-government to the town. That happened on the Feast Day of the Annunciation; thus, two messages are commemorated here: one from the angel Gabriel, who brings the word of God to Mary, and the other from the pope. BERENSON's assessment of Crivelli, quoted above, acknowledges both how impossible it is to fit him into a category and how endlessly interesting his paintings are.

Crome, John
See NORWICH SCHOOL

Cropsey, Jasper Francis
1823–1900 • American • painter • Romantic/Hudson River School

I was so disposed to adorn my writing book, on the margin, wherever there was a blank space, with fancy letters, boats, houses, trees, etc., and paint, or color the picture in my books that I would undergo the reprimand of the teacher, rather than desist from it.

Cropsey worked in an architectural office before he took up painting, first in WATERCOLOR, then in OIL. Encouraged by established painters, he began showing his work, advocating truth to nature and expressing admiration for the work of COLE. In 1847 he made the GRAND TOUR of Europe. On returning home, he set himself to painting American scenery. His success enabled him to return to England, and he became active in the social and artistic circles there.

He painted some English scenery but continued to produce American landscapes, such as *Autumn—On the Hudson River* (1860), a sweeping vista with the unique colors of the season and carefully observed details of nature. Queen Victoria appointed Cropsey to the American Commission of the 1862 International Exposition in London, and he received a medal for his service. He returned to New York in 1863, taught, and produced architectural designs that included an elaborate mansion for himself that he named Aladdin. Financial reverses forced him to sell Aladdin, however. Cropsey wrote the words quoted above in 1846, to be included in a book about American artists.

Crucifixion

Crucifixion was a widespread form of execution in the ANCIENT world: Before the execution of Christ, 6,000 fugitive slaves, followers of Spartacus, were said to have been nailed to crosses along the road to Damascus, and there was a period during Roman rule when 500 Jews were crucified every day. Punishment by crucifixion continued until Constantine converted to Christianity, which in the 4th century became the state religion. Described in texts, crucifixions were, apparently, never visually represented—although a cross alone symbolized Christ during the early 4th century. Once Christianity was secure, Crucifixion images began to appear, but they showed Christ with his eyes open and without expression. Not until the dramatic GERO CRUCIFIX (c. 970) is his suffering conspicuous. A number of explanations for this new approach are proposed, among them the conjecture that as long as conversion to the faith was foremost, a suffering Christ would be disadvantageous imagery. Once the Church was secure, as it was by the 10th century, more dramatic renderings could serve other philosophical, theological, and political intentions. Points of view external to the event portrayed were argued out in images: The Eucharist, for example, was alluded to by paintings that included angels capturing the blood from Christ's wounds, and politics were sometimes coded into the entourage of witnesses surrounding the cross. Perhaps the most startling Crucifixion in history was that painted by GRÜNEWALD on the *Isenheim Altarpiece* (1512/13–15), in which Christ is shown with dreadfully lacerated and punctured flesh. Significantly, the *Isenheim Altarpiece* was made for a monastery where sufferers of ergotism, a skin disease, were cared for. In the 20th century, CHAGALL painted Crucifixions that included symbols of Judaism, such as a tallith and menorah, and scenes reminiscent of pogroms and Nazi destruction.

Cubism

Following FAUVISM, but remaining consistent with MODERNISM, Cubism abandoned perspective, disrupted traditional representations of space, and sacrificed the use of continuous contour and conventional MODELING. However, where previous Modernists asserted the flatness of the canvas, Cubists played with that concept by portraying different aspects and facets of geometrically shaped objects—the cylinder, sphere, and cone of which CÉZANNE had spoken—on a flat surface. It was BRAQUE who first painted in this man-

ner, and MATISSE, looking over entries to the 1908 SALON D'AUTOMNE, who said of him to the critic Louis Vauxcelles, "Braque has just sent a painting made up of small cubes." Braque was rejected at that Salon, but when Vauxcelles later saw Braque's work he coined the term "Cubism" to describe it. (Vauxcelles is also the man who first used the word "fauve" to describe the art so named.) Cubism soon became an art-world buzzword, though in truth the works in question contained far fewer cubes than other shapes. From 1908 to 1914, PICASSO and BRAQUE, working together, explored various possibilities of showing the faceted shapes of objects and people whose forms they broke apart and reassembled, so to speak. Picasso brought to Cubism his interest in African and Oceanic art, inspired by visits to the Ethnographic Museum in Paris, while Braque thought more about Cézanne's blocklike surfaces.

During its development, two distinct approaches characterize Cubism. The first, *Analytic Cubism,* involved the breakdown of a subject into component aspects and their rearrangement. Colors and contrasts are reduced to shades of brown and gray, black and white. The second is *Synthetic Cubism,* also called Collage Cubism. Here images were constructed from objects and shapes cut from paper and other materials. Synthetic Cubism was an artistic breakthrough that had the effect of liberating painting and sculpture from their traditional materials and techniques. (See also ASSEMBLAGE)

While Picasso and Braque worked together, other artists individually explored the Cubist approach. Two,

GLEIZES and Jean Metzinger (1883–1956), collaborated on the first important theoretical tract, *On Cubism* (1912). The so-called Salon Cubists showed their work together at the 1911 SALON DES INDÉPENDANTS. Others who joined the group include the sculptor ARCHIPENKO, the Italian painters who developed FUTURISM, and LAURENCIN, DUCHAMP, and GRIS.

Cubist Realism
See PRECISIONISM

cult of saints
The earliest Christian saints were individuals who were persecuted because of their faith. Once persecution ended, the Church beatified people for extraordinary acts of devotion. From c. 500 to 750, the Christian cult of saints gained popularity, probably because each saint might be appealed to for specific assistance: Saint Anthony took care of pigs, Saint Apollonia (whose teeth had been pulled) cured toothache, Saint Genevieve cured fever, and Saint Sebastian warded off plagues. Saints had symbolic ATTRIBUTES associated with their lives that identified them in a work of art: For example, Sebastian has one or more arrows in his body; Jerome is accompanied by a lion, his constant companion after he removed a thorn from its paw. The cult of saints inspired works of art and artists in many ways: Events in the life of a particular saint formed the decorative programs for FRESCOES and ALTARPIECES in churches where their relics were housed; hagiographies (saints' biographies) provided texts for ILLUMINATED MANUSCRIPTS. The container for relics of a saint, a RELIQUARY, might be as

elaborate as the bejeweled golden statue fashioned, probably during the 11th and 12th centuries, to hold the skull of the miracle-working Saint Foy. With their magical powers, the relics of saints drew pilgrims and patrons, and thefts of relics by churches and monasteries (including those of Saint Foy, and of Saint Mark by the city of VENICE) were frequent. Throughout the MEDIEVAL period and into the RENAISSANCE, while the cult of saints thrived, artisans and artists produced anything from modest pilgrimage souvenirs such as metal flasks decorated with biblical scenes, badges, and popular PRINTs to major altarpieces. An example of the latter is van EYCK's *Virgin in a Church* (c. 1440), which shows the most-hoped-for experience of pilgrims: a vision. Van Eyck's Virgin is thought to be the small statue in a pilgrim church that has come alive and moves forward in the picture, carrying the infant Christ in her arms.

curator

Although the director of a small MUSEUM may also be a curator, the distinction is that the former is the administrative head while the curator is in charge of all or part of the collection. A large museum has curators for specific subcategories of the collection, such as Ancient and American art, and for educational programs. A curator's job includes research, planning exhibitions, acquiring works, deciding if and how works will be shown (both borrowed and from the museum's own collection), and providing information for the public through such means as CATALOGUES, wall labels, and gallery tours. The choices a curator makes are increasingly recognized as providing social, historical, and political CONTEXT, and as having important financial repercussions regarding the value of works. The ethics of curating are an important contemporary concern.

Curry, John Steuart

1897–1946 • American • painter • Regionalist

I don't feel that I portray the class struggle, but I do try to depict the American farmer's incessant struggle against the forces of nature.

The least well known of the REGIONALIST triumvirate that included BENSON and WOOD, Curry was Kansas born. He studied at the Kansas City Art Institute before he went to the Art Institute of Chicago, and then, as had his colleagues, on to Paris and New York. The dynamic fervor of Curry's brushwork and figures is seen in pictures like *Tornado Over Kansas* (1929), in which a farm family rushes to their underground storm shelter as the threatening funnel approaches. The comment quoted above is pertinent to this work. Curry's murals are in Washington, D.C., and the Kansas state capitol, where he imagined abolitionist John Brown as a latter-day Moses.

Cuyp, Aelbert

1620–1691 • Dutch • painter • Baroque/Classical phase

Cattle and a shepherd, by Albert Cuyp, the best I ever saw of him; and the figure is likewise better than usual: but the employment which he has given the shepherd in his solitude is not very poetic: it must, however, be allowed to be truth and nature; he is catching

fleas or something worse. (Sir Joshua Reynolds, 1781)

Cuyp painted panoramic views of the Dutch countryside—he lived in Dordrecht. He may not have traveled to Italy, but he was influenced by the soft, golden light seen in paintings of the Roman *campagna,* or countryside (see ELSHEIMER). Besides sunlit landscapes populated by cows, sheep, and small figures of shepherds—disapproved of by Reynolds in the quotation above— Cuyp also painted atmospherically still and glistening river scenes, full of sailing craft both large and small, often around sunset (e.g., *The Maas at Dordrecht;* no date). They will be recollected in the United States some 200 years later, in the marine paintings of LANE.

Cycladic art

Art of c. 3000–2000 BCE (late Neolithic to early Bronze Age) from a cluster of islands in the Aegean Sea north of Crete, known as the Cyclades. White MARBLE was abundant, and most notable among Cycladic works are numerous marble female figurines. These are flat, schematic, and similar in design: arms folded across the chest, ovoid heads, and wedge-shaped noses. They were found in graves. Such highly abstracted forms reduce the figure to its essentials, as will later Greek art, especially during the GEOMETRIC and ARCHAIC periods. From presumption rather than knowledge, Cycladic statuettes have been called idols, but their purposes and meanings are not known.

D

Dada

This movement was begun in 1916 by a group of French and German artists and poets in Zurich, in reaction to the hysteria of World War I. Had they not gone to Switzerland, most would have been called to fight. Several explanations for the origin of the word include a claim that it came from opening a French-German dictionary and landing on *dada,* which is French for "hobbyhorse." The members rejected reason, logic, and FUTURISM, which they believed had led to the war. Dada, founded in particular by a German actor and playwright, Hugo Ball, embraced nonsense, political anarchy, the emotions, intuition, and irrationality. It was negative and pessimistic. Meetings were held in the music hall Ball ran, the Cabaret Voltaire. The major artist in the group was ARP. Dada spread rapidly through Europe after the war, affecting, albeit briefly, numerous artists (e.g., SCHWITTERS, MONDRIAN, LISSITZKY, van DOESBURG, and GROSZ). It also surfaced briefly in New York. A huge exhibition was held in Berlin in 1920, but Dada had run its course by 1921 (the last great Dada exhibition was in 1922), when it was displaced, in Paris, by SURREALISM.

Dadd, Richard

1817–1886 • English • painter • Fairy Painter

Splitting is either good or bad. For not so the same terms are had.

Dadd was a student at the Royal Academy when, lost in morbid thoughts about the devil, he murdered his father. He was institutionalized in Bethlem Hospital, familiarly known as Bedlam. During 43 years of confinement he continued to paint strange, fairy-tale scenarios; Fairy Paintings, as such fantasies were called, were popular in mid-19th century England. He recorded detail obsessively in his hallucinatory world, and worked on his masterpiece, *The Fairy Feller's Master Stroke,* for nine years, 1855–64. The creatures in this picture are gnomelike but of inconsistent scale; we look at them as if through blades of grass, but our point of view is confusing, and there is no horizon. A man with an ax, the "feller," seems poised to split a nut that is bigger than his own head, but he is too far away to reach it. And instead of looking at the nut, he looks straight ahead. A barely discernible figure facing the feller, a white-bearded man in a conical hat, seems to be a controlling appari-

tion. The perplexity, the extraordinary finesse of details that look real but are impossible, and an underlying feeling of malevolence make this image frightening. Dadd wrote a long explanation entitled *Elimination of a Picture & its subject—called The Feller's Master Stroke*. It is not a coherent narrative, as the quotation from it above demonstrates, but it provides glimmers of Dadd's intention. The lines about splitting have sinister echoes in that Dadd had attacked his father violently with a knife and razor. While Dadd's work escapes stylistic categories, it has visionary qualities.

Daedalus/Daedalic

The mythical first sculptor, Daedalus was celebrated by both Greek and Roman authors. Homer introduced him in the *Iliad* around the 8th century BCE and his persona developed over subsequent centuries in multitudes of texts. PLATO wrote that Daedalus's statues are like opinions: ". . . if they are not fastened up they play truant and run away." In fact, there are many literary references to the necessity of chaining a Daedalic statue to keep it in place; from the start, Daedalus was known as a sculptor who freed the limbs of statues from their torsos, opened their eyes, and gave them life. Whether a true historical sculptor preceded the legends of the fictional man is a topic of debate and research, and the great variety of roles he has assumed over time are accompanied by an equally rich professional vita that includes goldsmith, architect, inventor, and magician, as well as sculptor. One of his most notorious creations was the wooden cow in which King Minos's wife, Pasiphae, hid so that she could mate with a bull. Daedalus was also responsible for the labyrinth in which the half-man, half-bull Minotaur, Pasiphae's offspring, was hidden. And he made wings for himself and Icarus, his son. Icarus lost his wings when he flew too close to the sun and the wax that attached them to his body melted. In the 4th century BCE artists took the name of Daedalus. In terms of style, "Daedalic" refers to a type of sculpted figures in the Early ARCHAIC period. About one-third life-size, these flat, planklike sculptures, often marble and often women, are clothed, sometimes wear wide belts, are rigid, forward-facing (FRONTAL), and have hair reminiscent of the wigs on both Egyptian and Mesopotamian statues. A well-known example is the 7th-century BCE *Auxerre* statuette at the Louvre.

Daguerre, Louis-Jacques-Mandé

1789–1851 • French • painter/photographer • Realist

By this process, without any idea of how to draw, without any knowledge of chemistry and physics, it will be possible to take the most detailed views, the most picturesque scenery in a few minutes. . . . With the aid of the daguerreotype everyone will make a view of his castle or country-house . . . even portraits will be made.

A successful painter and entrepreneur who was able to create great effects with the DIORAMAS he painted and exhibited, Daguerre is credited with discovering the processes that produce positive exposures from the surface of a silvered plate that has been exposed to

light. He may have experimented with the camera with the intent of improving his dioramas. The process he patented is called the daguerreotype, and its use spread quickly. One of Daguerre's first successful daguerreotypes was modeled on the traditional STILL LIFE: *Still Life in Studio* (1837) demonstrates the detail and fine gradations in tone, from white to black, Daguerre could capture. Each exposure produced only one print. An Englishman, William Henry Fox Talbot (1800–1877), had also worked on a photographic process based on the light sensitivity of silver. His intention was to duplicate drawing, at which he was unskilled but which he wished to accomplish. Talbot's discoveries led to the modern negative print process and eventually evolved into the marketable film and photographic prints that replaced Daguerre's method.

Dalí, Salvador
1904–1989 • Spanish • painter •
Surrealist

I believe the moment is at hand when, by a paranoiac and active advance of the mind, it will be possible (simultaneously with automatism and other passive states) to systematize confusion and thus to help discredit completely the world of reality.

The last major artist to join the SURRE-ALIST group, Dalí is also one whose name is synonymous with the movement. Born near Barcelona—the Catalan environment of GAUDÍ, PICASSO, and MIRÓ—he was a highly emotional child given to hysterical outbursts, memories of which influence the irrationality and violence of his paintings.

He studied at Madrid's Academy of Fine Arts before he went to Paris (in 1928) and met the Surrealists. Three important influences on his work were de CHIRICO, Freud's writings on dreams and the subconscious, and the Spanish poet Federico García Lorca, whose dreams were expressed in drawings of refined romantic sensibility. However, Dalí's subjects and style were very different. He used the hard-edged TROMPE L'OEIL technique with luminous but unsettling colors that sometimes look like tinted photographs—he called them "handpainted dream photographs." His intentions are expressed in the quotation above from his book *La Femme Visible* (1930); he named his method "critical paranoia." His best-known work, *The Persistence of Memory* (1931), describes an interminable emptiness in which commonplace objects— three pocket watches—become bizarre, limp forms draped over a branch, the edge of a solid rectangle, and an ambiguous, inexplicable form. A fourth watch retains its shape, but has ants all over its surface. Dalí contributed to the first Surrealist motion picture, a landmark in experimental cinema, Luis Buñuel's *Un Chien Andalou* (1929). In 1938 Dalí met Freud, who told him, "What interests me in your art is not the unconscious but the conscious." Dalí was moving away from Surrealism (from which its dictatorial founder, André BRETON, who had previously embraced Dalí, expelled him in 1934, in part because Dalí supported Franco). Dalí's late paintings were devoted to the mystery of Christ and the Mass: *The Crucifixion* (1951), more than 6 feet high, locates the Cross as if it were

floating in a dark night, with daylight, clouds, and a landscape below. Most astonishing is the PERSPECTIVE—as though the artist were high above the CRUCIFIXION, looking down on Christ's bent head and at the shadow of his stretched-out arms on the cross. Dalí moved to the United States in 1940. He designed for the theater, magazines, and jewelry makers. He cultivated an outlandish appearance (e.g., waxed, handlebar mustache) and eccentric, exhibitionist behavior. In 1950 he returned to Spain and a reclusive life.

Dalou, Jules
1838–1902 • French • sculptor • Neo-Baroque/Romantic

I have made the resolution to undertake, without further delay, the monument about which I have dreamed since 1889, dedicated to the glorification of the workers. This project is in the air; it is of the times. . . . The future is there. It is the cult called to replace past mythologies.

The first 19th-century sculptor to profess admiration for BERNINI, Dalou was inspired by Bernini's BAROQUE style. A lifelong Socialist and French Commune supporter, Dalou felt compelled to flee France after the collapse of the brief revolutionary government and beginning of the Third Republic. He went to London, and there succeeded in gaining commissions from upper-class patrons, then returned to Paris after the general amnesty of 1879. He was chosen to design a grandiose bronze monument, *The Triumph of the Republic* (1879–99), for the Place de la Nation. In an over-life-size composition, the Republic

is a woman standing on a globe above a chariot drawn by two lions. She is accompanied by figures of Liberty (a nude youth with a torch), Industry, and Justice. Abundance follows behind. Thousands of Parisians took part in a festival to celebrate the unveiling of the final monument in 1899. Dalou's vivid and heroic public works contrast with his more personal sculptures. One is a commemorative marble bust executed 1888–90 of COURBET, a friend and fellow Socialist, and another expresses his support for Alfred Dreyfus. Dreyfus was a Jew victimized by prejudice and false accusations of treason; the "Dreyfus Affair" split the art community as well as all strata of French society. Dreyfus was sent into exile in 1895, the same year Dalou sculpted *Truth Denied*, a nude woman sitting on a rock with her head buried in her arms in a pose of utter dejection. During the 1890s, Dalou worked on TERRA-COTTA models for a "Monument to Workers," a glorification of labor, a project that he described in the words quoted above, but it was unfinished at his death.

Danube School
Rivers and forests had an especially powerful grip on German artists of the NORTHERN RENAISSANCE, and the Danube River had a particular lure for some, including ALTDORFER and CRANACH the Elder. Altdorfer's *Danube Landscape* (c. 1520–25), a romantic and mysterious scene, is an example of this interest: a castle tucked at the bottom of a winding path that runs through dense woods to the river below. There are no people in Altdorfer's painting, but Cranach includes the

Holy Family in the foreground of his wild Danube landscape of tall pines and birches, despite its distinctly non-Danube subject: *Rest on the Flight into Egypt* (1504). As is true of members of the HUDSON RIVER SCHOOL some three centuries later, the term "Danube" signifies an approach to and interest in landscape rather than an association of individual artists or a specific place.

Daubigny, Charles-François
1817–1878 • French • painter • Barbizon School

It seems as if the canvas exposed in front of the site had painted itself by some magic process and new invention. (Théophile Gautier, 1859)

Born into a family of artists, Daubigny decorated trinkets for a clockmaker and worked as a restorer of paintings at the Louvre. He studied with DELAROCHE and traveled to Rome. His success in the early 1850s was marred by complaints that his landscapes lacked finish. In 1859, the year he was named Chevalier of the Legion of Honor, a CARTOON appeared showing a man in his bathing trunks standing in front of a large painting. The caption read: "Effect produced on a visitor to the Salon by the water in the marvelous paintings of M. Daubigny." The name of the actual painting, which hung in that year's SALON, was *The Banks of the Oise*. The renowned photographer NADAR both bought the painting and printed the cartoon in a newspaper he published. Some critics, in fact, found a photographic quality in the painting—perhaps the magic new invention to which Gautier refers in his review quoted above. Daubigny worked on his famous studio-boat, the *Botin*, from which he painted his riverscapes.

Daumier, Honoré
1808–1879 • French • painter/printmaker • Realist

Il faut être de son temps.

"One must be contemporary," quoted in the original above, is one of the few authenticated statements made by Daumier, and a byword for REALISM[2]. Daumier was a social satirist in a time marked by social unrest rooted in the Industrial Revolution and the repressive activities of King Louis Philippe. In his CARICATURES, Daumier portrayed the king as Gargantua, the glutton invented by Rabelais. He also wittily turned the king, whose face was bottom heavy, into a pear; *poire*, French for "pear," also means "dunce" or "simpleton." Daumier was imprisoned for six months, in 1832, for such insults, but he remained relentless in his portrayal of injustice. *Rue Transnonain, April 15, 1834* (published in 1834) records an incident that followed a workers' demonstration during which a man, shooting on troops from a window at 12 rue Transnonain, killed an officer. Vengeful soldiers broke into the building and murdered eight men, a woman, and a child. Daumier's LITHOGRAPH shows four corpses, a man in his nightshirt, a child, and, barely visible, mother and grandparent. It is a bloody, grisly scene. As had Jacques-Louis DAVID, Daumier made analogies between the dead man's pose and conventional representations of the dead Christ. Daumier's translation of the sordid facts of contemporary life into art included humorous jibes at lawyers. His CARTOON *Nadar Elevating*

Photography to the Height of Art (1862) shows the famous photographer taking pictures from the basket of a hot-air balloon. We get the message that "elevation" refers only to Nadar's altitude, not to aesthetics. In his unfinished painting *The Third-Class Carriage* (c. 1862), Daumier considers the dislocations of progress: The first major French railway line was established in 1843. Daumier's scene is set inside a railway carriage and the figures who face us—an elderly woman with a basket, a young woman nursing her child, and a young boy—look like peasants from a painting by MILLET. But they seem to have been scooped up out of their natural environment and dropped into a world in which they lose not only their identity, but their dignity as well. His appeal to emotion makes Daumier a ROMANTIC, but his interest in social justice is that of a Realist.

David d'Angers, Pierre-Jean
1788–1856 • French • sculptor • Romantic

As for myself, I concede to no jury of artists the right to admit or to refuse the work of their colleagues. . . . I recognize but one judge for the artist—the public, which can and should pass sentence upon cliques and coteries.

An eloquent witness of the times in which he lived—the First Republic, the Empire of Napoleon I, the Restoration of Louis XVIII, Charles X, the July Monarchy of Louis Philippe, and the brief Second Republic—David d'Angers received a NEOCLASSICAL training and absorbed ROMANTIC ideas and attitudes. His head of Victor Hugo (c. 1827–30), encircled with a laurel wreath, has a ROMAN look, while his bronze medallion portrait *Théodore Géricault* (c. 1827–30) is appropriately Romantic (see GÉRICAULT). Among his best-known works is a 14-foot-high, dynamic figure, the *Grand Condé* commissioned in 1816, one of a dozen colossal marble statues erected on a bridge across the Seine. It represents a famous 17th-century general, a military hero at 22, as he is about to hurl his baton at the enemy during the 1644 Battle of Freiburg, which he won for France. The sculpture no longer exists, but is known from bronze casts of the MAQUETTE made in 1817. David d'Angers added his hometown of Angers to his name in order to avoid confusion with the painter Jacques-Louis DAVID, whom he greatly admired. David d'Angers was friends with the literary figures of his day, and Victor Hugo wrote *Ode to David* for him in 1828.

David, Gerard
c. 1460–1523 • Netherlandish • painter • Northern Renaissance

Gerard David's Baptism of Christ triptych is surely one of the masterpieces of the artist's career. . . . [His work] has been thought by some critics to be lacking in energy and conviction, yet careful analysis of David's Baptism shows it to be not only unusual but, I believe, of deep personal significance. (Craig Harbison, 1979)

When Archduke Maximilian was imprisoned in Bruges in 1488, the authorities called on David to decorate his quarters with pictures. David himself went to court, if not jail, for making off

with several boxes of "patterns," or a MODELBOOK. It was an act of retribution, as the man from whom he confiscated the patterns owed him a large debt. So perhaps David had better reason than either van der WEYDEN or BOUTS, both of whom had similar commissions, to be asked for murals on the subject of justice for the city hall of Bruges. David followed MEMLING as the city painter of Bruges. Among his most unusual works is an ALTARPIECE, *Triptych with the Nativity* (c. 1505–10). It has a full-blown landscape with great trees in full leaf, a stream, and oxen. The theme is biblical, and the landscape must be seen in that context; it comes close to being an independent, self-contained visual appreciation of nature. The *Baptism of Christ* (1502–07), mentioned in the quotation above, was concerned with contemporary questioning of that ritual, especially regarding the salvation of unbaptized infants, as Harbison goes on to demonstrate. In representing such theological questions several years before the Protestant Reformation, David effectively anticipated in paint what would later be discussed in print. As Harbison puts it, "Art would not serve as a precise record of developments in other spheres; rather than mirroring thought, art might provoke it." This is an important reversal of what is considered the standard procedure: art illustrating ideas that have already acquired currency by the written word. The same can be said of the secular world evoked in David's images of the Virgin feeding the child (e.g., *Virgin and Child with a Bowl of Porridge*, c. 1520), in which Mary is more like a contemporary mother than

the Queen of Heaven (see also CAMPIN). David shows a new maternal ideal that was just emerging in European society. His images were made in the midst of the Reformation, when pictures as ICONS were suspect; thus, his "normalizing" of Mary may have had additional impetus.

David, Jacques-Louis

1748–1825 • French • painter • Neoclassicist

The Academy is like a wigmaker's shop; you cannot get out of the door without getting its powder on your clothes. What time you will lose in forgetting those poses, those conventional movements, into which the professors force the model's torso, as if it were the carcass of a chicken. Even the latter . . . is not safe from their mannerisms.

David was admitted into the French Royal Academy in 1766, and after a series of unsuccessful efforts finally won its PRIX DE ROME in 1774. His great HISTORY PAINTINGS, such as *The Oath of the Horatii* (1784), fulfilled both the CLASSICAL ideals he absorbed in Rome (in fact, he returned to Rome to work on the painting) and the French taste for political metaphor: father and son pledging themselves to the honor of their country, women weeping as their husbands, brothers, and lovers go off to war—individual self-sacrifice for the greater good. The story looked back to Horace and forward to the Republic. Serious, sober, spartan, and manly, it was so well admired that people of the time began to talk of "David's revolution." The *Horatii* was followed by

Death of Socrates (1787), another heroic figure and moral message about a man maintaining dignity to the end. No less an authority than REYNOLDS proclaimed, "This picture is in every sense perfect." David's personal history followed the roller-coaster course of French politics. Early in the Revolution David supported Robespierre and the extreme wing of the Jacobins. After the Revolution, in 1790, he began his elaborate *Oath of the Tennis Court,* which commemorates the meeting, on June 20, 1789, at which the deputies of the Third Estate swore not to disband until they had given France its constitution. He showed a highly finished preparatory drawing of it at the first SALON of the Revolutionary period in 1791. This was a new kind of history painting, portraying current events rather than ancient or mythological ones. After the Revolution, David spearheaded the movement that led to replacing the academy with the short-lived Commune of the Arts. The comments quoted above were made in a speech to his students. With the downfall of Robespierre, David was imprisoned. Released, he unhesitatingly painted for Napoleon's Empire. When Napoleon returned from Elba, David declared his allegiance. With Napoleon's downfall, the aged David went into exile in Brussels, where he died. During the height of his power, David was as influential as LE BRUN had been a century earlier. Clear, solemn, heroic, powerfully dramatic yet simple in his composition, David was a NEOCLASSICAL painter. This is seen in *The Death of Marat* (1793). Marat was a hero of the Revolution murdered in his bath by Char-

lotte Corday. (Marat had a skin condition that necessitated soaking in the tub, so he adapted a tub for use as his desk and received visitors as if in his office.) David had called on Marat the day before the murder. In David's painting, Marat has a stab wound on his chest, his head has fallen back, and his arm hangs loose. Marat is in the familiar pose of the dead Christ of many PIETÀS; David based his rendering on paintings by RAPHAEL and by CARAVAGGIO.

Davies, Arthur B.
1862–1928 • American • painter • Visionary/Symbolist

. . . the great imaginator. (Robert Henri, 1910)

If his dreamlike paintings of unicorns and virginal maidens in mystical settings (e.g., *Unicorns,* 1906) make Davies seem an unlikely associate of the socially conscious members of The EIGHT with whom he exhibited, that is no more paradoxical than the double life he led as the head of two families. The escapist themes and muted TONAL harmony of his work (in paintings such as *The Dream,* c. 1908) aligned him with the French artist PUVIS DE CHAVANNES; their visionary aspect connected him with earlier Americans like RYDER, BLAKELOCK, and INNESS. Davies was a leading figure in New York's art world. He was able to bridge its fractious groups, and, as president of the Association of American Painters and Sculptors, was a prime mover of the 1913 ARMORY SHOW. The appreciation of Davies by HENRI quoted above is excerpted from Henri's review of the Ex-

hibition of Independent Artists in 1910, in which Davies showed his work.

Davis, Alexander Jackson

1803–1892 • American • architect • Romantic eclectic/Picturesque

The Greek temple form, perfect in itself, and well adapted as it is to public edifices, and even to town mansions, is inappropriate to country residences. The English collegiate style is for many reasons to be preferred. It admits of greater variety both of plan and outline . . . while its bay windows, oriels, turrets, and chimney shafts give a pictorial effect to the elevation.

In collaboration with his first associate, Ithiel Town (1784–1844), Davis designed several GREEK-REVIVAL state capitols (Indiana and North Carolina, 1831; Illinois, 1837; Ohio, 1839), and the United States Custom House in New York (1833–42). Davis also popularized the GOTHIC revival in the United States, especially in cottages such as the Henry Delamater Residence in Rhinebeck, New York (1844), with its steeply pitched roof and ornate carpentry details. His ideas found expression in the earliest suburban developments of the 1850s. Among Davis's most splendid houses is Lyndhurst, Tarrytown, New York (1838 and 1865–67). A great stone mansion based on the models of Cambridge and Oxford Universities, Lyndhurst represented a similar design in Davis's book *Rural Residences* (1837), and he called it English collegiate style, as in the excerpt from the book quoted above. With its STAINED GLASS windows, paneled rooms, carved, pointed ARCHES, and tracery, Lyndhurst, reminiscent of WALPOLE's Strawberry Hill, seems like a MEDIEVAL castle transplanted to America.

Davis, Stuart

1894–1964 • American • painter • Modernist/Abstraction

One day I set up an eggbeater in my studio and got so interested in it that I nailed it on the table and kept it there to paint.

Before they followed HENRI to New York City, the ASHCAN painters had worked for Davis's father at the *Philadelphia Press,* where he was art director. At the age of 16, Stuart Davis, too, went to New York to study with Henri. The ARMORY SHOW, and his subsequent interest in French CUBISM, changed his stylistic direction, but Davis kept the focus of his work largely on American themes. The eggbeater mentioned above, with other objects, was the subject of a yearlong process of disciplined research he pursued in an effort to flatten space and natural forms. "I felt that a subject had its emotional reality fundamentally through our awareness of . . . planes and their spatial relationships," he wrote. Words that appeared on signs, packaging, and in advertisements intrigued him and became part of his COLLAGE-like paintings. Some of his works are prescient of POP ART.

de Kooning, Willem

1904–1997 • Dutch/American • painter • Abstract Expressionist

One day, I'd like to get all the colors in the world into one single painting.

Born in Rotterdam, Netherlands, de Kooning moved to New York City when he was about 23 years old. In the early 1960s, he settled on Long Island, where he could be close to the sea. "There is something about being in touch with the sea that makes me feel good. That's where most of my paintings come from," he once told a friend. De Kooning worked in an ABSTRACT EXPRESSIONIST style, specifically ACTION or GESTURAL PAINTING, in which clear indications of how the work was made—the stroke of the brush or splash of the paint—are intact for the viewer's contemplation. When the viewer looks closely at one section of a painting, a sense of a figure will move into focus, then move out again. Contrasting colors are superimposed on one another, and it sometimes seems that the artist has achieved his goal, as expressed in the comment above. As for other painters of his period (e.g., GORKY and Jackson POLLOCK), for de Kooning painting was an EXISTENTIALIST experience, recording anguish, the meaninglessness of life, and the importance of action over understanding. De Kooning is notorious for his series of paintings of women, throughout the 1950s especially. They are fierce, angry, dismembered, and reassembled as the most horrendous kind of FEMME FATALE. These were not offhanded, spontaneous impressions; rather they were worked on, and revised, over long periods of time. (His reputation for being unable to finish a painting was widely known.) De Kooning read avidly in philosophy and literature. Perhaps more clearly than his contemporaries, de Kooning used painting to examine and try to understand the world around him. As he once remarked to the critic Harold Rosenberg, "There is no plot in painting. It is an occurrence which I discover by, and it has no message."

De Stijl
See STIJL, DE

dealer
An intermediary between buyer and seller. Before dealers came to represent artists, as they do today, MEDIEVAL artists found PATRONS through their participation in WORKSHOPS and GUILDS. Becoming more independent during the RENAISSANCE, artists were often contacted by patrons through intermediaries acting as "agents." With the growth of a mercantile class and private commissions, both fairs and shops could become an artist's outlet. During the 18th century, as the range of COLLECTING expanded, the role of dealers began to grow. In the 19th century, some dealers became important advocates for avant-garde art (e.g., see DURAND-RUEL, VOLLARD, and GOUPIL'S GALLERY). Still, there remained a core of dealers (e.g., DUVEEN and BERENSON) on whose CONNOISSEURSHIP of historic periods wealthy patrons depended. The importance of dealers today is reflected by the lavish advertisements they place in various art magazines. The power of the art dealer over an artist's ability to earn a living is inestimable. Artists in the 20th century have used many tactics that serve, at least in part, to bypass and sometimes short-circuit that power, from producing noncollectible art (e.g., PERFORMANCE and AUTO-DESTRUCTIVE ART) to selling their work in cooperatively run galleries.

decalcomania
See ERNST

Deconstruction
A term coined by Jacques Derrida, Deconstruction is an approach of POST-STRUCTURALISM. Belief in the instability of meaning is a foundation of this point of view. According to Derrida, all "texts" are subject to reconsideration and "deconstruction," and a work of visual art is considered as much a text to be "read" as is a written work. Via Deconstruction, questions about a work of art may multiply ad infinitum; "the last word" can never be written. While ideas of Derrida and other Poststructuralists are conveyed through writing (an irony not lost on those or other purveyors of words), they are also expressed in works of art. One way that this occurs is by the artist subverting, sabotaging, and generally defying interpretation.

Decorative art
In the mid-1970s the term "Decorative," or sometimes "pattern," art was employed to describe painting that was pleasing to the senses and focused on pattern and structure in overall design rather than representation. Influences to be found for this movement were MATISSE and ISLAMIC art as well as Oriental design. The political weight of Decorative art had to do with its affirmation of skills, such as quilting and textile and basket weaving, that were historically described, and usually discounted, as secondary crafts and women's work. Thus, Decorative art participates in the philosophy devoted to removing barriers between "high" and "low" and "art" and "craft."

Miriam SCHAPIRO, Joyce Kozloff (born 1942), and Robert Kushner (born 1949) are among artists working in Decorative art.

decorative arts
While paintings and sculpture serve a more singularly decorative purpose than, for example, a chair or a teapot, ironically the term "decorative arts" came to be used for such utilitarian objects. Ceramics (see POTTERY), textiles, and furnishings of all kinds fell into the decorative category. Paintings and sculpture were called FINE ART (beaux arts), implying a hierarchy as much as a distinction. Yet throughout most of history prior to the late 18th century, there were no such distinctions. Even during the RENAISSANCE, when artists secured higher social status than could craftspeople, there was an interdependence between a painting and its interior setting, whether it hung over a sideboard or next to a window, or was painted on the ceiling. The occasion for separating the decorative and fine arts was the French Revolution. As the philosopher/critic Arthur Danto writes: "It was Jacques-Louis David, functioning as artistic commissar, who decreed the division, classifying furniture making as an inferior art in contrast with the high arts of painting, sculpture and architecture." Jacques-Louis DAVID, a revolutionary, was motivated by wanting to discredit the values of the old aristocracy, who were patrons of fine furniture makers. He was also driven by his belief that painting and sculpture could serve the moral purpose of elevating the "masses." David's discriminatory classification has been challenged ever since it was made, most vehemently by the

ARTS AND CRAFTS movement, institutions like the BAUHAUS, and contemporary efforts to break down hierarchical barriers.

Degas, Edgar

1834–1917 • French •
painter/sculptor • Impressionist

A painting is a thing which requires as much trickery, malice, and vice as the perpetration of a crime; make counterfeits and add a touch of nature.

Degas met MANET at the Louvre, where Degas was copying a painting by VELÁZQUEZ. Subsequently Degas became a member of the avant-garde and was grouped with the IMPRESSIONISTS. He was sympathetic to their struggles and intentions, but their preoccupation with painting outdoors, and with light and fleeting perceptions, interested him less than the movements of human and animal forms. Drawing was far more important to Degas than it was to most Impressionists, who were likely to ignore outlines in favor of generalized shapes. Working frequently with PASTELS, Degas made many pictures of ballet dancers and racehorses. He also produced MONOTYPES of prostitutes and pastels of women bathing or getting into and out of tubs. Most of these women look cumbersome and are portrayed in unattractive poses. The bathers and prostitutes, especially, have prompted numerous books and articles positing the artist's misogyny, his impotence (now disputed), and speculation about whether the bathers are also prostitutes. Though the subject was treated in earlier art (see GENRE), with the growth of urbanization, prostitution became a socioeconomic and medical problem of greater consequence during the 19th century. Degas may have categorized prostitutes according to then current pseudoscientific studies that related physical types to moral and intellectual status. Degas was extremely interested in Japanese WOODBLOCK prints (see UKIYO-E). Many of his pictures show their radical cropping and dramatic use of empty space. *Viscount Lepic and His Daughters* (1873) is an example of Degas bringing three figures to the front of the PICTURE PLANE, then cutting off the girls at the waist and their father at his thighs. With the empty space behind the figures, and with the various directions in which the people—and even a dog and an umbrella—point, the whole composition is both disorienting and magnetic. Manet and Degas were *flaneurs,* a term that came to describe the artist who wandered the streets watching the bustle of daily activity and noting it in his sketchbooks. One of Degas's most perplexing works is, however, an indoor scene, *Intérieur (Interior;* c. 1868–70), often subtitled *Le Viol,* meaning "The Rape." Whether Degas called it that, or whether a rape has or will take place, is uncertain. In fact, everything about the painting has been unsettled since it was first shown to the public in the beginning of the 20th century, and a multitude of interpretations have been offered. Literary sources are postulated, especially a shocking novel by Zola, *Thérèse Raquin,* published in 1867. The painting's composition is, again, disorienting. A man stands by the door, casting a dark shadow; a seemingly dejected woman is at the other side of the room, and of the canvas, her back to him. The most highly illuminated object, directly

beneath a lamp on a table in the center of a room, is an open box with pink lining. There are objects of clothing scattered around the room. Whatever is the "meaning" of this awful moment must be left to the observer's imagination. Degas's notes about it tell us only that he meant to "greatly elaborate the effects of the evening—lamp, candle, etc. The intriguing thing is to show not the source of the light but the effect of the light." Degas also worked as a sculptor, MODELING horses and ballet dancers above all. His *Little Fourteen-year-old Dancer* (1880–81) was the only sculpture he exhibited during his lifetime. It was remarkable not only for the child's bold spirit, but also for the fact that he dressed the wax statuette in a real tutu and ballet shoes; the real hair on her head was tied in a ribbon. The statue was not cast in bronze until 1919, at which time more than 20 copies were made.

Degenerate Art (Entartete Kunst)

The name given by Nazis to works systematically confiscated by them from German museums and exhibited at the Galerie am Hofgarten in Munich in 1937. The scorned works were juxtaposed with the art of the insane and children, the "resemblances" highlighted by labels for purposes of demeaning the artists. For contrast, in a new gallery across the park from the Degenerate Art was an exhibit of traditional, representational art highly approved of by the National Socialists. Artists deemed "degenerate" included KANDINSKY, KLEE, CHAGALL, MATISSE, and PICASSO. For propaganda purposes, the exhibit of Degenerate Art toured

Germany. Meanwhile, exhibitions were mounted in Paris and London to offset the effects of the Nazi effort, and works of the same artists were shown as examples of "independent" international art.

Delacroix, Eugène

1798–1863 • French • painter • Romantic Baroque

O young artist, you search for a subject—everything is a subject. Your subject is yourself, your impressions, your emotions in the presence of nature.

With contemporaries Victor Hugo and Hector Berlioz, Delacroix completed the trinity of late-18th- and early-19th-century Romantics preeminent in French literature, music, and art. Delacroix had modeled for GÉRICAULT's *Raft of the Medusa,* and his own paintings similarly presented contemporary events with great drama on very large canvases—characteristics of ROMANTICISM. Delacroix wanted to thrill, to move, to motivate his viewers in the new French Republic. Himself an eyewitness to the popular July 1830 uprisings in Paris that reignited the spirit of revolution, Delacroix was excited by the battle for individual freedom—individualism was an important tenet of Romanticism. Delacroix's *Liberty Leading the People* (1830) became an archetype for the image of idealistic and heroic revolution. The figure of Liberty is a bare-breasted woman forging ahead, holding the Tricolor above her head as both emblem and weapon. Her dress billows as if she had created a wind by the force of her movement, bringing to mind the great HELLENISTIC

marble NIKE OF SAMOTHRACE (C. 190 BCE). But Delacroix's Liberty strides among fallen bodies with the smoke of burning Paris behind her. The picture combines journalistic reporting and mythic allegory. Delacroix used dramatic lighting, a rich PALETTE, and sweeping—and sometimes splashing—brushstrokes. In many of his pictures Delacroix applied paint with energy appropriate to their violence. He was fiercely anti-CLASSICAL, and his battle with INGRES became a cause célèbre. A standard comparison of their styles contrasts pictures that both artists made of Paganini: In Ingres's NEOCLASSICAL pencil drawing of 1819, Paganini is rendered in a formal manner with crisp, descriptive lines and elegant shading; cropped at the hips, he is not playing his violin, which is tucked beneath his arm, but he is composed, sophisticated, idealized. Delacroix's oil painting of 1832 shows Paganini playing his violin, his entire body curving as if with the resonance of his music. There are none of the careful specifics and objective details of Ingres; for Delacroix, art is subjective and intuitive. In 1831 Delacroix accompanied a French diplomatic mission to Morocco. A few paintings, such as *Women of Algiers* (1834) and *Jewish Wedding in Morocco* (1837/41), resulted from his trip, but the seven note/sketchbooks and some WATERCOLORS he brought home have greater spontaneity and enormous appeal. Influenced by the work of RUBENS and Géricault, Delacroix himself influenced numerous artists, including RENOIR and van GOGH. In his eulogy at the artist's death, BAUDELAIRE wrote, "What is this mysterious *je ne sais quoi* which Delacroix, to the glory of our century, has translated better than any other artist? It is the indivisible, the impalpable; it is the dream, the nerves, the soul. And he has done this . . . with no other means save contour and color."

Delaroche, Hippolyte-Paul

1797–1856 • French • painter • Neoclassicist/Romantic

The public readily admires Jane Grey's pose. It admires the cautiousness of the hands, the sickly whiteness of the shoulders; there is nothing that is not approved of by interested viewers, even down to the left knee, resting alone on the pillow. (Gustave Planche, 1834)

Delaroche endeavored to portray scenes from the past, from religion and literature—HISTORY PAINTING—with the veracity of today's sharp-focus photography. He presented themes as if they were from a stage play, tableaux frozen in time. *The Execution of Lady Jane Grey* (1834) is a prime example: Blindfolded, wearing a brilliant white silk dress, the young woman is about to be beheaded. She is watched by her executioner, whose red tights presage the blood soon to flow onto straw so carefully painted that individual stalks could be counted. The composition is clear and balanced, details of costume and style are exact and dispassionately recorded. Yet the picture is fraught with implied if not explicit emotion. Delaroche was an artist who found a path between the extremes of cool NEOCLASSICISM and passionate ROMANTICISM, a *juste milieu,* as it was called. The text quoted above is from a review of the

SALON of 1834 in which *Jane Grey* was shown. Delaroche has a reputation as a gifted teacher, with more than 355 recorded pupils, GÉRÔME and MILLET among them.

Delaunay, Robert

1885–1941 • French • painter • Orphist

Color alone is form and subject.

As he moved through CUBISM and FAUVISM, Delaunay created brightly colored *Eiffel Tower* paintings (c. 1909) that appealed to German EXPRESSIONISTS, who invited him to exhibit with the BLAUE REITER group. As his interests evolved, Delaunay's concentration on the effects of COLOR led him to refer back to the color studies of SIGNAC and to develop ideas for entirely NONOBJECTIVE paintings in a style APOLLINAIRE named ORPHISM. Important theoretical bases for Delaunay's work were the scientific writings of CHEVREUL on color harmonies as well as those of Charles Henry, who discussed color in terms of movement. Delaunay's brilliant circles and spheres, as in *Simultaneous Contrasts: Sun and Moon* (1913)—flaming reds, hot yellows, and golds embedded in dark and light greens and blues—were painted in a circular (TONDO) format. These "Disks," or "Cosmic Circular Forms," Delaunay himself referred to in terms of "Simultaneity." With the less celebrated paintings of a contemporary, the Czech-born Frantisek (Frank) Kupka (1871–1957), and those of the American SYNCHROMISTS, Delaunay's experiments with color were among the earliest examples of nonrepresentational, nonobjective ABSTRACT ART in Europe.

Delaunay-Terk, Sonia

1885–1979 • Russian • painter/designer • Orphist

Up to the present, painting has been nothing but photography in color, but the color was always used as a means of describing something. Abstract art is a beginning towards freeing the old pictorial formula. But the real new painting will begin when people understand that color has a life of its own, that the infinite combinations of color have a poetry and a language much more expressive than the old methods. It is a mysterious language in tune with the vibrations, the life itself, of color. In this area, there are new and infinite possibilities.

Sonia Terk, born in the Ukrainian town of Gradizhsk, settled in Paris in 1905 and spent most of her life there. With Robert DELAUNAY, whom she married in 1910, she believed in the primacy of COLOR and was a cofounder of ORPHISM. The Delaunays received a commission to decorate the Air and Railroad Pavilions for the Paris Exposition of 1937, and *Study for Portugal* is her GOUACHE design for that project: four scenes that brightly capture mood and movement with simplified figures, landscape, and architectural details. She had already expanded into fabric design after piecing together a quilt for her son in 1911. She worked also in COLLAGE, bookbinding, book illustration, and design, including costumes for a Diaghilev ballet. Her work in textiles led her into a collaboration with couturiers and great success in the world of fashion. An interest in merging the fields of commerce and art resulted in her publishing articles and delivering lectures on her

theories and work. In 1930 she returned to painting and joined the ABSTRAC-TION-CRÉATION group. She wrote the words quoted above in 1949.

Demuth, Charles
1883–1935 • American • painter • Precisionist

America doesn't really care—still, if one is really an artist and at the same time an American, just this not caring, even though it drives one mad, can be artistic material.

Demuth incorporated the slanted "lines of force" used by FUTURISTs in his landscapes with flatter, less aggressively fractured, and more carefully organized PRECISIONIST forms. His colors in these works—he often used pencil with WATERCOLOR washes—are relatively pale and subtle. Taking on the challenge of what he considered the national trait of passivity toward mechanization, as in the comment above from a letter he wrote to STIEGLITZ, around 1920 Demuth began to paint symbols of American industry: *My Egypt* (1927) is a view of an enormous grain elevator that looms as large as the great Pyramids. In *I Saw the Figure 5 in Gold* (1928), his carefully organized planes are brilliantly colored with fire engine red and brassy gold. Inspired by a poem by Demuth's friend William Carlos Williams, the painting vividly expresses the truck's clanging gong, howling siren, and rumbling wheels racing through the dark, rainy night.

dendrochronology
The science of measuring tree rings in a cross section of wood that enables an estimate of the year the tree was cut down. Dendrochronology is sometimes used to confirm an age provided by RADIO CARBON DATING. Since the 1960s, dendrochronology has been a useful means of determining the earliest possible year of a painting on a wood PANEL and of building timber. For example, it was used to establish that a painting entitled *Girl with a Flute*, assigned to VERMEER, was painted on wood from a tree felled in the early 1650s. (That does not prove that Vermeer was the artist, however, and its attribution, debated on the basis of STYLE, has recently been changed to "circle of" Vermeer—probably one of his children, as he is not known to have had students.)

Denis, Maurice
1870–1943 • French • painter/writer • Symbolist/Nabi

. . . it is well to remember that a picture—before being a battle horse, a nude woman, or some anecdote—is essentially a plane surface covered with colors assembled in a certain order.

The comment above, from Denis's essay "Definition of Neo-Traditionalism" (1890), is so frequently quoted that it has practically become the definition of MODERN art. Denis was 20 when he wrote the words that effectively turn attention from the historic subject of a work to its means and materials of production. It was the underpinning of SYNTHETISM and the development of ABSTRACTION and its multitude of variants, from CUBISM and ABSTRACT EXPRESSIONISM to MINIMALISM. Despite the significance of his proclamation, Denis's name, as well as his art, is relatively unknown, certainly in compari-

son to those about whom he wrote. Even in his most renowned painting, *Homage to Cézanne* (1900), he shows himself very much in the background while both of his idols, CÉZANNE and REDON, share the limelight. Curiously, in *Homage*, a copy of a STILL LIFE by Cézanne serves as stand-in for Cézanne himself.

Der Blaue Reiter
See BLAUE REITER, Der

Der Sturm
See STURM, Der

Derain, André
1880–1954 • French • painter • Fauve

... These strange African images made a powerful impression upon André Derain who, while regarding them with a great deal of fondness, admired the talent with which the sculptors from Guinea and the Congo had reproduced the human figure without utilizing any element taken from direct vision. (Guillaume Apollinaire, 1912)

Derain and VLAMINCK became friends in 1900, and it was Vlaminck, according to APOLLINAIRE, who showed Derain the African sculpture, masks, and fetishes he had discovered in antique stores. Apollinaire goes on to describe the chain of circumstances through which Derain eventually communicated his interest in African artifacts to PICASSO and BRAQUE, who later would use those artifacts for their experiments in CUBISM. Derain, who seems to have been an important link for many artists, had also met MATISSE in 1899, when he was 19 years old, and he intro-

duced Matisse to VLAMINCK at the large van GOGH retrospective of 1901. Van Gogh's bold use of color and paint inspired them, as did that of GAUGUIN. Derain was among the painters who exhibited at the famous 1905 SALON D'AUTOMNE, where the FAUVE movement was named. His spontaneity and inventiveness are evident in *London Bridge* (1906): The PERSPECTIVE is both arbitrary—as if one were suspended in midair above the bridge—and distorted. Bold primary colors are used, but the sky is flaming red, orange, and yellow, some buildings are blue, and the water is bright green with strokes of bright blue and high yellow. As the short-lived Fauve movement waned, Derain was attracted to Cubism. Derain's politics as well as his art have a smudged reputation: Accusations of Nazi collaboration are long-standing. Derain's defenders say he believed his trip to Germany would liberate 300 artists held captive there, and would affect the return of his house, which the Nazis had requisitioned. Though his reputation rivaled that of any other living painter in the 1920s, it has since declined.

Dervini Krater
Named for the area of Macedonia where it was found in 1962, this large, bronze, HELLENISTIC vase, more than 2 feet high, contained cremated remains believed, from an inscription, to be those of a nobleman. Variously dated from the 4th and 2nd centuries BCE, it is a masterpiece of metalwork, with applied silver details. REPOUSSÉ scenes show Dionysus and Ariadne and their attendants as well as a parade of animals that include a lion with its prey—a

goat—slung over its back. Separately cast and attached to the shoulder of the vase are four lovely, seated female figures. To the wonder of its exquisite detail and workmanship may be added the fascination of its decoration, which provides important information for the study of the Dionysian cult.

Desiderio da Settignano
1429/32–1464 • Italian • sculptor • Renaissance

Some say that he came from Settignano, a place two miles from Florence, others consider him a Florentine, but this is of little importance where the distance is so slight. He imitated the style of Donatello, being naturally endowed with gracefulness and lightness in the treatment of heads. His women and children possess a soft, delicate and charming manner, due as much to Nature as to art. (Vasari, mid-16th century)

Desiderio was born and trained in the stonecutting village of Settignano, where the ROSSELLINOS lived and where, later, Michelangelo became entranced with marble. Desiderio executed a monumental tomb for the Florentine HUMANIST Carlo Marsuppini (after 1453) that was set across from the earlier Bruni tomb by Bernardo Rossellino at Santa Croce, Florence. Desiderio was a student of DONATELLO and skilled at *rilievo schiacciato* (thin or shallow RELIEF), as evident in the marble panel *Madonna and Child* (c. 1460). This example, along with the several PUTTI on the Marsuppini tomb, show Desiderio's keen observation and obvious skill at sculpting children, al-

luded to in VASARI's comment quoted above.

Dewing, Maria Oakey
1845–1927 • American • painter • Naturalist

I must paint pictures or die.

Early in her career Maria Oakey was linked with CASSATT as one of the two most promising American women artists of their time. She had studied at Cooper Union School of Design for Women in New York, in Paris with COUTURE, and then with William Morris HUNT and LA FARGE. She was successful as a STILL LIFE and PORTRAIT painter, and her commitment to her work was strong enough to prompt the statement to Oscar Wilde quoted above. After she married Thomas Dewing (see below) and raised a family, Maria Dewing painted less, and her subjects changed from people to gardens. She was extraordinarily skilled at painting garden scenes: *Garden in May* (1895) is a floral masterpiece of pink and white blossoms in her extensive gardens. She took the unusual PERSPECTIVE of a gardener bending over to the level of the fragrant flowers. Later in her life, when Thomas was ill and no longer painting, Maria again took up the FIGURE. Her oeuvre is largely lost, but interest on the part of contemporary art historians is bringing her accomplishments to light, and from time to time some of her lost works are resurfacing.

Dewing, Thomas Wilmer
1851–1938 • American • painter • Aestheticism

Dewing is one of those figures who summarize an age, and in his art may

be seen an original distillation of many later nineteenth-century tastes and preoccupations: Victorian idealism and illusion, fin-de-siècle nostalgia and wistfulness, an aestheticism joined to poetic and musical sensibilities, and shapes of the real world treated as vehicles of either personal or universal meaning. (John Wilmerding, 1976)

Dewing, like RYDER, evades most categories. In fact, comparing him with Ryder yields an interesting juxtaposition. Where Ryder built up layer upon layer of thick dark paints to create strangely threatening, moonlit landscapes, Dewing lightly brushed his landscapes with pale, filmy vapors: greens, blues, pinks, pallid taupes. The black figures in Ryder's landscapes are almost grotesque, gesticulating silhouettes. Dewing's figures are equally anonymous, but they are graceful, elegant, ethereal women who float, dreamlike, in his misty landscapes (e.g., *Summer,* c. 1890). Dewing's paintings, like those of WHISTLER and INNESS, were impressionistic, but not in the studied sense of the IMPRESSIONIST movement. Dewing was interested in illusion and mood. The well-dressed, upper-class, idle women who populate his canvases, as they did many other contemporary pictures, were known as "decorative." The historian Wilmerding, quoted above, situates Dewing in time and place. His scenes should also be understood in the context of a period during which, in fact, many women were struggling for and insisting on an opportunity to do more than stand around looking like beautiful ornaments. Interestingly, Thomas Dewing married a painter, Maria Oakey (see Maria Oakey DEWING).

di sotto in sù
See PERSPECTIVE

Diachronic analysis
See SYNCHRONIC ANALYSIS

Diderot, Denis
1713–1784 • French • philosopher/ critic

Here, then is how I would have a school of drawing run. When the student knows how to draw easily from prints and busts, I keep him for two years before the academic model of man and woman. Then I expose to him children, adults, men in the prime of life, old men, subjects of all ages and sexes, taken from all walks of society, in a word all kinds of characters. . . . After the drawing hour an able anatomist will explain the skinned body to my student . . . and he will draw from the skinned body once a month at most.

Diderot is generally considered to be the founder of art criticism, which he launched in 1759 when he began to write regular reports on the SALONS in Paris. His opinions appeared in *Correspondance littéraire,* whose subscribers were a small number of the elect throughout Europe including princes, kings, and Catherine of Russia, from whom he accepted a pension. Despite his popularity and influence, both church and state in France continued to reject him. Diderot's strong opposition to practices at the ACADEMY, such as

drawing from plaster casts and from models posed as if they were CLASSICAL statues, is expressed in the quotation above. He promoted the notion of students studying human nature and interaction in the world around them. "To the works of nature the beholder must supply significance, feeling, thought, effect, emotional influence; in the work of art he expects to find all that, and it must be there," he also wrote in his "Essay on Painting" (1766). It was translated into German and also published by GOETHE. Diderot's *Philosophical Thoughts* (1746) was burned for its attack on Christian dogma and morals, and Diderot's continued defiance led to his imprisonment. While in prison he began the *Encyclopédie*, on the arts and sciences, which would occupy him for the next 20 years. Part of the ENLIGHTENMENT's great project of cultural education, assembled under Diderot's direction, it contains 17 volumes of text, with 72,000 articles, and 11 volumes of plates. Besides Diderot himself, its 140 contributors included the most prominent philosophers, Voltaire, Rousseau, and d'Alembert among them. The goal was to present in clear, accessible prose the fruits of accumulated knowledge and learning. Because of censorship, successive volumes appeared at an irregular pace. The first seven were issued, one per year, from 1751 to 1757. Distribution of the 10 remaining volumes took place in 1766. The volumes of plates, relatively unaffected by censorship, were released at the rate of roughly one per year from 1761 to 1772. In its original printing, about 4,000 copies were made.

Die Brücke
See BRÜCKE, Die

Diebenkorn, Richard
1922–1992 • American • painter/printmaker • Abstraction

I seem to have to do it elaborately wrong and with many conceits first. Then maybe I can attack and deflate my pomposity and arrive at something straight and simple.

Diebenkorn has moved between representational and nonrepresentational, ABSTRACT and FIGURATIVE art. He painted landscapes, nudes, and color studies, working in bright and luminous colors such as buttercup yellow, violet, and mellow turquoise. *Ocean Park*, named after the section of Santa Monica, California, where he lived, is an essentially abstract series from the 1970s. *Ocean Park N. 107* (1978), for example, nearly 8 feet high and some 6 feet wide, is composed of rectangles, wide and narrow, that capture the colors of Pacific air, a sliver of water, the green of, perhaps, a boat, the bright yellow sun. Diebenkorn is considered the dean of the California painters, a group that includes Elmer Bischoff and David Park, who was Diebenkorn's teacher at the California School of Fine Arts in San Francisco.

Dine, Jim
born 1935 • American • painter • Pop Art/New Realist

My paintings are involved with "objects." At a time when the consumption of same is so enormous I find the most effective picture of them to be not a transformation or romantic

distortion but a straight smack right there attitude. I am interested in their own presence.

Dine made ASSEMBLAGES, ENVIRON-MENTS, and HAPPENINGS before he started to create paintings of, and with, real things. One of his most vivid and impressive is *Five Feet of Colorful Tools* (1962). This assembles a collection of actual tools that he has painted in a kaleidoscope of colors, along with outline shapes painted on the large canvas, from the top of which these tools are hung. Dine also painted everyday items of clothing—ties, belts, hats, shoes, and in one instance, *Double Isometric Self-Portrait* (1964), two bathrobes side by side. "I came to make self-portraits when I felt I knew enough about myself to speak publicly and about that subject. I used an image of a bathrobe because I found a photo of one and after rendering it on canvas, it seemed to be my body inside," he commented.

diorama

The familiar diorama of today is found in natural history museums where three-dimensional models, often behind glass, reproduce particular scenes and natural habitats. However, the diorama was invented by DAGUERRE in 1822, before he worked on photography, which he probably investigated to enhance his dioramas. Such dioramas were large paintings with special lighting effects shining through the painted surface. The lighting mimicked various times of day (e.g., moonlight) and atmospheric conditions. Theatrical in effect, such paintings were often housed in a room that was itself often called a diorama.

Standing in the room, a viewer was meant to have the illusion of being present in the actual scene in which he or she was surrounded. The term "diorama" combines French words for "through" and PANORAMA.

diptych

Derived from ancient writing tablets with hinged leaves (*di* means "two"), a diptych is a pair of PANELS, either painted or carved, that are to be seen open or closed. (See also ALTARPIECE)

Discobolos

The *Discobolos* (460–450 BCE), or *Discus Thrower* (in a competition of both ancient and contemporary Olympic Games), was a bronze sculpture by MYRON. The original is missing, but it was copied several times in marble by Roman artisans and discussed by the ancient writers Lucian and Quintilian. In the figure of a NUDE young man, knees bent, right arm raised to launch the discus, the torsion of his body expresses collected energy and suspended animation. Once the problem of showing CONTRAPPOSTO in freestanding sculpture had been solved, a new world of possibilities opened up. Besides its exploration of movement, the self-control explicit in this work embodies the highest values of Greek CLASSICAL art and of Greek life as well. Buried at a villa on the Esquiline Hill in Rome, the first of several *Discobolos* replicas was discovered on March 14, 1781, and immediately became famous. In the 20th century, Adolf Hitler imagined the statue to represent the young manhood of what he considered the "master race" and moved to acquire it. It was

sold to him despite protests of the Italian High Commission for Science and Art; however, it was returned to Italy in 1953. In a scene of Leni Riefenstahl's documentary of the 1936 Berlin Olympics, a shot of *Discobolos* comes to life as a real athlete. Commissioned to record the games as an exaltation of Hitler's National Socialism, the film—perversely—used monuments associated with Greek democratic idealism to promote Nazi totalitarianism.

divisionism

The term used by NEO-IMPRESSIONIST painters themselves for what came to be known as POINTILLISM.

Dix, Otto

1891–1969 • German • painter • New Objectivity

Nothing superficial and unessential could have survived the intense heat of trial and persecution. At the same time the material and spiritual difficulties . . . left their mark.

In Germany, after World War I, there was a marked reaction against abstraction and a return to representative, FIGURATIVE, or "objective" art. This revealed itself in the biting commentaries of GROSZ, BECKMANN, and Dix, whose approach was called NEW OBJECTIVITY. There was exaggeration and confrontation in their works. Dix's *Dr. Mayer-Hermann* (1926) is a bizarre portrait of a rotund dentist whose equipment reflects and distorts surrounding reality and overpowers the bloated man, with his expressionless baby face. Dix did not leave Germany during the Nazi regime, though his

work was condemned and removed from public collections. He continued to portray Fascism with cynicism and disgust, but hid his criticism in traditional allegories like *The Seven Deadly Sins* (1933). At the age of 52 he was forced to join the Home Guard, was taken prisoner, and spent several months in a prisoner-of-war camp. After the war his work acquired a religious spirituality in an EXPRESSIONIST style. He linked his new work, and that of other German artists, to the years of suppression they had endured. He describes their feelings in the quotation above.

Dobell, Sir William

1899–1970 • Australian • painter • Modern

I am always worried whether I am doing my best work. I think I have been side-tracked a lot by trying to keep up to date with modernism. I am essentially a traditionalist and I think trying to be a modernist . . . I have failed to do my best work.

In 1929 Dobell won a scholarship that allowed him to study in London. Before returning home in 1938, he also visited France and Belgium. Among the artists whose work left a great impression on his was the highly expressive and distorted portraiture of SOUTINE. In 1944 Dobell won a prize for portraiture awarded by the Art Gallery of New South Wales. Two of the unsuccessful competitors challenged the award, claiming Dobell's painting was CARICATURE, not a portrait. Besides making Dobell a household name, the court case marked the conflict that MODERN art created in Australia. Another of his

works is *Dame Mary Gilmore* (1957), which shows a ramrod-straight, gray-haired aristocrat with lacy collar, shimmering gown, and white gloves. Her elongated neck and body give the painting a MANNERIST affect, but in her posture and face Dobell has captured an impressive statement of advancing age and unassailable dignity.

Doesburg, Theo van
1883–1931 • Dutch •
painter/architect • De Stijl

In the same way as man has ripened to be able to oppose the domination of the individual, arbitrariness, the artist, too, has ripened so as to be able to resist the domination of individuality in plastic arts.

As originator of De STIJL, van Doesburg claimed that the movement was founded in Dutch Protestant idealism, influential in Dutch culture since the Reformation. De Stijl was the purest and most idealistic of MODERN approaches, with its search for the perfect harmony its practitioners believed possible both for the individual and for society. Theirs was a spiritual/ethical mission. In their art they gave absolute primacy to the straight line and right angle. Inviting artists to contribute to their publication, van Doesburg wrote, "The quadrangle is the token of a new humanity. The square is to us what the cross was to the early Christians." He based two of his paintings, both entitled *Card Players* (c. 1916–17 and 1917), on CÉZANNE's *Card Players* of c. 1892. In the first version, van Doesburg systematized the people and objects of Cézanne's picture into flattened geometric shapes, including curves as well

as rectangles. Though abstracted, the scene is entirely recognizable. In the second work, van Doesburg used only straight lines, and the picture's relation to its subject is nearly indecipherable. Van Doesburg and MONDRIAN worked together closely until van Doesburg deserted the vertical/horizontal axis for diagonals in a variation he named Elementarism in 1924. Feeling betrayed, Mondrian left De Stijl.

dome
Domes vary widely in size and shape, from the spherical lid of the PANTHEON to the onion-shaped domes of Byzantium. Among the most adventurous experimenters was BORROMINI, who designed an oval dome for San Carlo alle Quattro Fontane (1638–41) in Rome and a complex "star hexagon" for Sant' Ivo della Sapienza (1642–50), also in Rome. For the most part domes are spherical vaults of even curvature built on a circular base. There are several means of constructing and supporting a dome, including the cylindrical drum, groin vaults (see ARCH), and adaptive permutations that enable a circular lid to be put on a square base. Derived from the Italian word *duomo,* meaning "cathedral," domes are actually among the earliest forms of overhead covering. Examples from ancient Europe are the conical "beehive" tombs at Mycenae of c. 1300 BCE (see MYCENAEAN). To Romans the dome represented heaven, and none is more celestial than that of the PANTHEON. The small, chapel-like rooms of Christian CATACOMBS in Rome had decorated domes. Once Christianity was authorized by Constantine, church buildings with a central plan, such as the Church

of Santa Costanza in Rome (c. 337–51), were covered by domes. Some historians suggest that Roman baths, associated with the idea of baptism, plus the Catacombs, where the promise of life after death was foremost, combined to promote building domes for Christian churches; however, that interpretation is controversial. Domed ceilings were often decorated with MOSAICS. The 6th-century HAGIA SOPHIA is a masterpiece of the BYZANTINE era with a central dome supported by pendentives—the triangular area joining arches that enclose or define the base of the dome.

Domenichino (Domenico Zampieri)

1581–1641 • Italian • painter • Baroque

Lanfranco's frescoes are very well displayed above Domenichino's Evangelist figures which, being more finished, more meticulously painted and closer to the eye, permit the vision of Glory to diffuse itself into the distance in a way better adapted to the whole. (Bellori, 1672)

The FRESCOES in Rome's San Andrea della Valle (1622–27), referred to by BELLORI, above, were the subject of fierce competition between LANFRANCO and Domenichino, who tried to claim the entire project for himself. It had been promised to Lanfranco, and was the largest commission ever awarded to an artist until—as the result of Domenichino pulling strings—the work was divided, to the fury of both. "But," as Bellori goes on to write, "this change did not bring such damage to art that it did not still remain glorious." Both artists had studied at the CARRACCI

FAMILY "academy" in Bologna and were masters of the fresco technique. Carracci students were known for their CLASSICIZING style, and Domenichino had been among the most ardent classicists. This is evident in his *Life of Saint Cecilia* (1613–14), frescoes at the church of San Luigi de' Francesci in Rome, where the figures are taken directly from ancient Classical statues and set among archaeologically correct furnishings. When he worked on San Andrea, his earlier restraint had a burst of energy that looked more like the influence of CORREGGIO, RAPHAEL, and MICHELANGELO than of ANTIQUITY. As the historian WITTKOWER writes, "It may be supposed that Domenichino wished to outshine his rival Lanfranco."

Domenico Veneziano

c. 1410–1461 • Italian • painter • Renaissance

The lighting is an important part of Domenico's innovation [in the St. Lucy Altarpiece], bathing in a credible atmosphere the architecture and figures within the perspective space. . . . [The picture's placement] in a loggia with open-air exedra behind— that unique kind of indoor-outdoor building so suitable to the central Italian climate—enabled him to provide outdoor lighting in an architectural (and therefore perspectival) framework. (Marcia Hall, 1992)

Domenico was a painter of the Florentine avant-garde that included UCCELLO, ANDREA Castagna, and PIERO della Francesca, all of whom were inspired by MASACCIO. He was born and

trained in VENICE, whence his name, but little else is known of his background. In Florence by the late 1430s, it may be that he brought with him a Venetian PALETTE of pinks and light greens offset by coral, white, blue, and other rich colors. This color scheme is notable in *Madonna and Child with Saints,* known as the *Saint Lucy Altarpiece,* painted c. 1445. Domenico also used strong natural light to illuminate his pictures, and was interested in exploring PERSPECTIVE, as described by Hall in the quotation above. Yet he remained somewhat retrospective in his tendency to line up his cast of characters in the front of the PICTURE PLANE, and to deny them the expression of emotion. Domenico did pioneer in important areas: He seems to have been the first to paint his figures in the kind of grouping called SACRA CONVERSAZIONE, or "sacred conversation"; he was also one of the first to paint a TONDO, or circular composition; and, although the mural has been lost, documents suggest that he was the first Italian artist to experiment with OIL PAINTING, perhaps in combination with the egg TEMPERA used in *buon* FRESCO.

Domus Aurea of Nero
See GOLDEN HOUSE OF NERO

Donatello
c. 1386–1466 • Italian • sculptor • Renaissance

Speak, damn you, speak!

During his early career in Florence, Donatello was in GHIBERTI'S WORKSHOP, and his own sculpture showed, for a time, the same sinuous curves his master had inherited from the International Style (see GOTHIC). But he was not yet technically in charge of the human figure: The eyes of his c. 1408 marble *David* are vacant and the legs unnatural. The eyes begin to focus with *Saint George* (c. 1414) but the legs, still problematic, are hidden behind a shield. An important step is that *Saint George,* although in a niche (on the same building, Orsanmichele, as NANNI'S *Quattro Santi Coronati*), is more believable, alert, confident, and individualized, and he stands at the very front of his niche looking as though he could step out on request. From this time forward Donatello's sculpture is known for its psychological depth and expressive power—Donatello himself is said (by VASARI) to have cursed at his statue known as the *Zuccone* ("Pumpkin Head"; c. 1415 to mid-1430s), as in the quotation above. His later bronze *David* of c. 1435, two-thirds life-size, was the first freestanding NUDE in about 1,000 years. It was also the first example of sensuality attached to the human form since ANTIQUITY. His helmetlike hat and high boots suggest this *David* may have been modeled on an antique image of Mercury. "Donatello's first innovation . . . followed repeatedly in the Italian Renaissance, was the transformation of the King of Israel into a young Greek god," wrote Kenneth CLARK, who also posits the likeness of ANTINOUS as a possible point of reference for Donatello's *David.* What seems certain is that while previous sculptors had based their work on the example of other statues, Donatello used a living boy for his model, and, moreover, represented him with an

aura of self-confidence and self-satisfaction. Donatello left Florence in the mid-1440s and went to Padua. His *Gattamelata* (1447–53) was the first monumental bronze EQUESTRIAN statue since antiquity and an homage to the *Marcus Aurelius* monument standing on the Capitoline Hill in Rome. Besides the freestanding sculpture discussed above, Donatello made images in RELIEF. His interest in linear PERSPECTIVE is apparent in his skillful use of very thin, shallow relief *(rilievo schiacciato)* to represent distance while raising the height of closer objects. An intriguing innovation in relief is the bronze floor for the tomb of Bishop Giovanni Pecci at Siena Cathedral. To a viewer standing at the foot of the tomb, it looks persuasively like the dead bishop, bronzed and laid to rest. The bishop's head faces the high altar (above which DUCCIO's *Maestà* stood in Donatello's time) and from this vantage point the deceased seems to receive blessings from the presiding cleric. "Donatello's ingenious solution in the Pecci tomb was to create metaphorically a cost-free perpetual Mass for the Bishop's soul that was activated every time a priest stood at the altar," writes the historian Geraldine Johnson. When he was in his late 60s, the expressive qualities in Donatello's sculpture evolved in a startling way with *Mary Magdalene* (1454–55): the emaciated, almost repellent appearance of the aged, repentant saint, once a beautiful woman. This is Donatello's personal statement about the relationship of body to soul. The power and influence of Donatello's innovative work affected both painting and sculpture for the greater part of the 15th century.

donor

In art a donor is usually the individual who commissions a work, perhaps on behalf of a church or museum, or gives it as a gift. Donors were frequently portrayed along with religious subjects in ALTARPIECES of the late MEDIEVAL and early NORTHERN RENAISSANCE periods. Accompanied by saints, such images were commissioned in thanks for benefits received, or in the hope that the saint will serve as a friendly intermediary before God on the donor's behalf. The donors of CAMPIN's *Merode Triptych* are an example. Sometimes the terms donor and PATRON are interchangeable, but subtle distinction may be drawn from the roots of each word: For donor the Latin origin is to give, whereas the root of patron is father.

Doré, Gustave

1832–1883 • French • illustrator/painter • Romantic/Realist

There is a saying by Gustave Doré which I have always admired: "I have the patience of an ox." I find in it a certain goodness, a certain resolute honesty—in short, that saying has a deep meaning, it is the word of a great artist. (Vincent van Gogh, 1883)

Van GOGH's admiration for Doré, quoted above, was expressed in a letter to his brother Theo written the same year Doré died. Doré had moved to Paris from his home in Strasbourg in 1848, and worked for three years on the *Journal pour rire*. He subsequently illustrated numerous books, including stories by Balzac (1855), Dante's *Inferno* (1861), Cervantes' *Don Quixote* (1863), the Bible (1866), and Milton's

Paradise Lost. There is often a highly emotional, dramatic flair to these illustrations that links Doré to the ROMANTIC sensibility. In the 1860s and 1870s, however, he was in England, where he captured the suffering and plight of the urban poor with both accuracy and pathos. It was these LITHOGRAPHS, in the mood of REALISM, that impressed van Gogh.

Dossi, Dosso (Giovanni de Lutero)
c. 1490–1541/42 • Italian • painter • Renaissance

The gentle manner of Dosso of Ferrara is esteemed in his proper works, but most of all in those which are called parerga *["accessories," or "background"]. For devoting himself with relish to the pleasant diversions of painting he used to depict jagged rocks, green groves, the firm banks of traversing rivers, the flourishing work of the countryside, the gay and hard toil of the peasants, and also the far distant prospects of land and sea, fleets, fowling, hunting, and all that genre so pleasing to the eyes in a lavish and festive style.* (Paolo Giovio, 16th century)

During the 15th century, a high level of skill was achieved by a group of painters established in Ferrara, where the ESTE dukes called a variety of artists from Northern Europe, as well as Italy, to their courts. In the 16th century, Dosso dominated the Ferraran school. The historian Frederick Hartt suggests that the flatness of the local landscape prompted these artists to flights of high imagination. Such elevation is appreciatively described by Dosso's contemporary Giovio, in the quotation above. Dosso's most characteristic works are mythological subjects, of which *Melissa* (1520s) is often named as his masterpiece. An enchantress, Melissa liberates humans whom the wicked witch has turned into animals and trees. In Dosso's painting, the fantasy landscape surrounding Melissa is in transition—men emerge from two tree trunks and are concealed in others—and a wistful dog contemplates a shiny suit of armor, awaiting his turn to be demetamorphosed into a knight. Dosso is both playful and sophisticated, and a rich colorist.

Dou, Gerrit
1613–1675 • Dutch • painter • Baroque

[Dou] filled his house in Amsterdam with almost countless distinguished children for instruction and learning. (Joachim von Sandrart, 1675)

As a boy of 14, Dou was REMBRANDT's first student in Leiden and probably stayed with him until Rembrandt left for Amsterdam. Then Dou started his own school in Leiden, and became a fashionable and highly successful artist. Later, he too left for Amsterdam, where he continued teaching, according to his contemporary SANDRART, quoted above. Dou was a painter of everyday, GENRE scenes, highly detailed and with an enamel-like finish. Some had moralizing themes, such as women's virtues or, as in the case of *The Evening School* (before 1665), a work he painted as a student of Rembrandt, an educational theme. Seated at a table with his pupils, the teacher sharpens his pen by candlelight—this allegorical picture is on the

subject of keeping one's skills honed. The candlelight symbolizes enlightenment in the education of children. Small, candlelit scenes became a specialty of Dou in his later years.

Douglas, Aaron
1899–1979 • American • painter • Modern

A great migration, away from the clutching hand of serfdom in the South to the urban and industrial life in America, began during the First World War. And with it there was born a new will to creative expression which quickly grew in the New Negro Movement of the twenties. At its peak, the Depression brought confusion, dejection and frustration.

The movement about which Douglas speaks in the quotation above is the HARLEM RENAISSANCE, of which he was a part. His words also describe one of the themes of a series of murals illustrating the lives of African-Americans, entitled *Aspects of Negro Life* (completed 1934), that he painted for the Countee Cullen Branch of the New York Public Library. These murals combine an intriguing illusion of lamination, as if each image was built up with layers of tissue paper rather than paint. Figures appear as shadows, or silhouettes, giving the flat forms a unique sense of depth. In four panels, the sequence moves from an African setting to historic images, from slavery to the Civil War, against an American background. The third panel, *An Idyll of the Deep South,* "portrays Negroes toiling in the fields, singing and dancing in a lighter mood, and mourning as they prepare to take away a man who has

been lynched," as Douglas described it. It is the fourth panel, *Song of the Towers,* that Douglas describes in the quotation excerpted above. In 1939 Douglas went to Fisk University, where he founded the school's art department.

Dove, Arthur
1880–1946 • American • painter • Modern

Why not make things look like nature? Because I do not consider that important and it is my nature to make them this way. To me it is perfectly natural. They exist in themselves, as an object does in nature.

One of the three painters STIEGLITZ championed most energetically (the others were MARIN and O'KEEFFE), Dove went to France for 18 months in 1908 and was drawn to the work of both CÉZANNE and MATISSE. In *The Lobster* (1908), a STILL LIFE that seems about to tumble out of its frame before us, the bright color and decorative pleasure of Matisse are combined with the structural building up and complexity of design found in Cézanne. Dove's treatment of subjects became more stylized, simplified, and finally abstracted, though never entirely NONOBJECTIVE. He once said, "There is no such thing as abstraction. It is extraction, gravitation toward a certain direction, and minding your own business."

Downing, Andrew Jackson
1815–1852 • American • architect (landscape and building)/author • Eclectic/Revival

With the Passion for novelty, and the feeling of independence that belongs to

this country, our people seem
determined to try everything.

The first landscape architect in America and father of the park movement, Downing wrote several influential books, among them *Cottage Residences* (1842) and *The Architecture of Country Houses* (1850), in which he describes Italian villas, Victorian mansions, and the very popular GOTHIC fantasies. His comment, quoted above, aptly explains the prevailing taste for "everything," Greek and Egyptian styles included, symptomatic of the era's revivalism. As Downing also wrote, "A blind partiality for any one style in building is detrimental to the progress of improvement."

draftsmanship/draughtsmanship
Refers to DRAWING ability.

drapery
In art, "drapery" refers to any fabric that falls in folds or pleats. The treatment of draperies, especially the method used for MODELING, often serves to define STYLE. The elaborately detailed and sensuous fall of fabric following contours of the body in the High CLASSICAL stone figures of the *Three Goddesses* (c. 438–432 BCE) and of *Nike Fastening Her Sandal* (c. 410 BCE) is known as the wet drapery style. In MEDIEVAL pictures, drapery tends to fall into schematic, decorative folds that have little reference to the weight and texture of the fabric or to the body beneath it, although in certain instances it does have great expressive content (e.g., EADWINE and STOSS). Even during the ITALIAN RENAISSANCE, the intrinsic qualities of fabric and its relation to the human form are treated only sporadically. Paintings of NORTHERN RENAISSANCE artists are more attentive to the texture and uniqueness of materials such as fur and brocade. Ultimately, the representation of drapery is generally consistent with the mood and meaning the artist has in mind, from the subtle infusion of light on the clothing and table covers in VERMEER's pictures to the once again schematic rendering of cloth in a painting such as Henri ROUSSEAU's *The Sleeping Gypsy* (1897).

drawing
Refers to images executed by means of lines, outlines, and shading, usually with pencil, or pen, or in charcoal, chalk, or some such graphic medium. The conventional meaning of drawing refers to what were often preparatory designs or studies for a work that would ultimately be painted or sculpted. These drawings became recognized and collected as works of art in their own right during the RENAISSANCE. (See also LINE VS. COLOR and GRAPHIC ART)

Drost, Willem
c. 1630?–after 1680? • Dutch • painter • Baroque

Although I have always resisted the re-attribution, I must admit that its very existence forces me to look at the painting more critically. One then discovers that features of the painting which were always considered marks of its greatness as long as it was a Rembrandt—a certain vagueness, a poetic suggestiveness, an ambiguity of meaning—turn into signs of inferior artistry when they are attributed to Drost. (Gary Schwartz, 1985)

Little is known about Drost or his work, but he was catapulted into the limelight in the late 1980s after a member of the Rembrandt Research Project (RRP) tentatively reattributed one of the best-known works by REMBRANDT —the *Polish Rider* (1655) at the Frick Museum in New York City—to him. Several works that appear to bear his mark have been found, including a self-portrait (1662), but there seems small likelihood that an undiscovered genius is being retrieved. After the question about the *Polish Rider* was raised, some commentary tended toward the opinion that it never was so magnificent as may previously have been thought, as the quotation above suggests. When he was asked about the de-attribution of the *Polish Rider,* Julius Held, a major Rembrandt scholar, dismissed the RRP as the "Amsterdam Mafia" and stood by the idea that Rembrandt himself painted what Held calls an "idealized portrait" of a youthful Polish national hero. Held's point of view was vindicated in October 1997 with word from the RRP that the authenticity of *Polish Rider* was confirmed as being by the master's hand—perhaps touched up a bit by another artist to make it more sellable after Rembrandt went bankrupt in 1656.

drypoint
See INTAGLIO

Drysdale, Sir George Russell
1912–1981 • English/Australian • painter • Realist

I don't know I've ever tried to analyze this question of painting aborigines.

Somebody once said to me: "You're doing something rather valuable, because this sort of thing will disappear one day and there won't be any records." Well, I hadn't even thought of it like that. . . . I think it is simply because somehow in a way these people, they not only have to me a peculiar dignity and grace, not the sort . . . one thinks of in the Apollo Belvedere, but the way in which a man comports himself in an environment which is his and has been his and his alone, he's at ease in it.

Born in England, in 1923 Drysdale went with his family to settle in Australia, where he studied art. He was commissioned by a newspaper to document the effects of drought in Western New South Wales in 1944, and became known for his brilliantly colored paintings that explore the hardships of rural, outback life. Exhibitions of his work in London sparked new interest in Australian art. Drysdale explored the plight of the Aborigines and their encounters with white settlers. The comment quoted above was in response to the author Geoffrey Dutton's question about his attachment to the Aborigines. Drysdale's pictures are generally sketchy, and show figures with the flat look of much FOLK ART. Still, they are strongly expressive, conveying loneliness and often a strange, puzzling discomfort. *The Rainmaker* (1958) has an especially unusual theme: The face of this Aboriginal religious man, whose presence is outlined in dark lines against an ocher and red background, is erased or dissolved, so that it has no features.

Dubuffet, Jean

1901–1985 • French • painter • Art
Brut

*It is the man in the street that I'm
after, whom I feel closest to, with
whom I want to make friends and
enter into confidence and connivance,
and he is the one I want to please and
enchant by means of my work.*

In his early 40s when he began paint-
ing seriously, Dubuffet created works
steeped in ideas of philosophy and psy-
chology. He studied the way an indi-
vidual perceives an object before
consciously focusing on it, and he was
intrigued by images unaffected by ACA-
DEMIC constraints, such as those made
by children and psychotics. He coined
the term ART BRUT to describe such art.
His own figures have the outline forms
with which children typically express
themselves, and his style consciously re-
jects signs of sophistication while, para-
doxically, it is purposefully learned and
cultivated. One example is *View of
Paris: The Life of Pleasure* (1944),
which has sticklike figures lined up
along the bottom of the picture in front
of a flat backdrop of brightly painted
doors, windows, and identifying words
(e.g., "modes," "pianos") representing
a city street. In the 1960s, Dubuffet
began, from a series of doodles, to de-
velop interlocking forms that look like
parts in a jigsaw puzzle and which he
called the "hourloupe" series. When
these free-form figures—sometimes
standing alone as sculpture—became
transformed into recognizable allusions
to real objects, he named them "simu-
lacres." *Group of Four Trees* (1972), a
fanciful construction of epoxy paint on
polyurethane over metal, standing 40

feet high, is an example of one of his
simulacres.

Duccio di Buoninsegna

active c. 1278–1318 • Italian •
painter • Late Gothic

*On the day that it was carried to the
Duomo the shops were shut, and the
bishop conducted a great and devout
company of priests and friars in
solemn procession, accompanied by
the nine signori, and all the officers of
the commune, and all the people, and
one after another the worthiest with
lighted candles in their hands took
places near the picture, and behind
came women and children with great
devotion.*

Duccio, who worked in SIENA, strad-
dled the MANIERA GRECA and the Inter-
national Style of French GOTHIC. The
grace and elegance of Duccio's figures
are often compared to the sturdier,
sculptural figures of GIOTTO in Flo-
rence. In contrast to the discretion of his
painted characters, Duccio himself
seems to have been quite unruly:
Records show that he was fined at least
nine times for various transgressions.
In 1308 Duccio was commissioned to
paint *Altarpiece of the Virgin* for the
Cathedral of Siena. In 1311 a cere-
monial procession escorted the ALTAR-
PIECE to the cathedral, or *duomo*, amid
the chiming of all the city's bells, the
flourish of trumpets, and the bellow of
bagpipes. As also described in the con-
temporary account quoted from above,
candles and torches lighted the way.
This, the *Maestà,* is Duccio's most
renowned work. In its central PANEL the
Virgin is surrounded by a multitude of
saints and angels, and each face, framed

by a HALO, is carefully individualized. Yet each is also characterized by a kind of ethereal wistfulness. Originally the altarpiece contained a large group of paintings, including a predella of 13 smaller subjects beneath the main panel and 16 subjects above it. The back was composed of 26 images relating to the story of the PASSION. All this was enclosed within an extraordinary, elaborately carved and gilded architectural frame. In 1506 it was removed from its original altar and subsequently sawed apart. The pieces were redistributed, some lost, some sold, so that it is now left to the imagination to reconstruct the overwhelming effect of the work, shimmering in candlelight, in the early 14th century. Duccio's influence was widespread: MARTINI and PUCELLE were among his followers. (See also MAESTÀ)

Duchamp, Marcel
1887–1968 • French •
painter/sculptor • Dada

My aim was a static representation of movement—a static composition of indications of various positions taken by a form in movement—with no attempt to give cinema effects through painting.

The comment quoted above, made by Duchamp in 1946, is from his explanation of how the infamous *Nude Descending a Staircase* (1912) came about. He was interested in breaking up forms, as CUBISTs had done, but "wanted to go further—much further—in fact in quite another direction altogether," he said. He denies that either FUTURISM, DELAUNAY's simultaneity, or the stop-action photography of MUYBRIDGE and Éti-

enne-Jules Marey prompted the work a critic called "an explosion in a shingle factory" when it appeared and created havoc in the ARMORY SHOW of 1913. His notoriety, after that show, made him an international figure, but his skepticism about the fundamental value of art and his hatred of its commercialization led to his invention of "ready-mades." They were exactly what he called them: manufactured items that he used for his own purpose. The first ready-made was *Égouttoir* (*Bottle Rack;* 1914), a galvanized-iron rack for drying bottles to which he merely added an inscription and his signature. His most notorious ready-made, *Fountain* (1917), was a urinal. Repercussions from his act of elevating ordinary objects to the status of art simply by insisting that they were art remain with us today. His painting on glass, *The Bride Stripped Bare by Her Bachelors, Even (The Large Glass)* (1915–23), also his last painting in any MEDIUM, is both the great centerpiece of his early career and as enigmatic as any painting in the history of art. In puzzling over it, scholars have used every possible approach, from whimsical to Freudian (which at times seem interchangeable). Duchamp himself stated that he wanted to "put painting once again at the service of the mind." CONCEPTUAL art, a movement that spread after the late 1960s, owes allegiance to Duchamp. The irony, doubt, *jouissance,* or sense of play, of POSTMODERNISM are also rooted in Duchamp. The critic Arthur Danto writes, "The story of the avant-garde in the twentieth century, whether in America or in Europe, seems largely to be the story of Duchamp." A frequent

visitor to New York, Duchamp moved permanently to the United States in 1942. He renounced art for two decades, as far as most people knew, and even his closest friends were shocked to learn, after his death in 1968, that he had been secretly occupied with a major project. *Étant Donnés: 1. la chute d'eau, 2. le gaz d'éclairage (Given: 1. The Waterfall, 2. The Illuminating Gas)* is an INSTALLATION at the Philadelphia Museum of Art. It may be seen only through two peepholes in an ancient wooden door. The "bride" returns, an oddly mutilated, naked form holding a lamp, lying in the foreground of an idyllic setting on a bed of twigs and dead leaves. JOHNS called it "the strangest work of art in any museum."

Dufy, Raoul

1877–1953 • French •
painter/illustrator/designer •
Expressionist

Unhappy the man who lives in a climate far from the sea, or unfed by the sparkling waters of a river!

Dufy worked his way through current styles, including IMPRESSIONIST and FAUVE, and after 1908 experimented with CUBISM before he developed his personal style. This is characterized by calligraphic lines and bright colors, characteristic also of the EXPRESSIONISTS. His subject matter—harbor and racetrack scenes—match his light touch. (He also worked in the DECORATIVE ARTS: TAPESTRY, POTTERY, textiles.) Dufy began painting regattas in 1907 and they remained a subject of interest to him, especially at Le Havre, where he was born; at Deauville between 1925 and 1930; and in England from 1930 to 1934. Against a rich blue background that unifies the sky and water is a jolly scene of multicolored and multi-shaped flags, a white boat, and the sketchy black outlines of the town in *The Harbor at Deauville* (c. 1928). Dufy's enjoyment of such scenes is expressed in his comment quoted above. Perhaps it is his apparent lack of deep conviction or angst that marginalizes Dufy's work for most art historians, though it equals that of a nearly exact contemporary, the more serious and highly esteemed ROUAULT, in individuality and invention.

dugento/duecento

Italian for "two hundred," this term actually refers to the 1200s, or, more commonly in English, the 13th century.

Duncanson, Robert S.

1817/22–1872 • American • painter • Romantic/Hudson River School

Every day that breaks, to my vision, sheds new light over my path. What was once dark and misty is gradually becoming brighter. My trip to Europe has to some extent enabled me to judge of my own talent. Of all the landscapes I saw in Europe (and I saw thousands) I did not feel discouraged.

Entirely self-taught, Duncanson was the first African-American artist to earn international fame, though he was virtually forgotten until the centenary of his death, when the Cincinnati Art Museum mounted a retrospective of his work. He spent eight months in Europe and, as the quotation above indicates, came home reassured. A skilled painter in the style of the HUDSON RIVER SCHOOL, he moved to Cincinnati in

...

about 1857 but had numerous commissions, some from Boston. Every detail is meticulously recorded in the idyllic *Blue Hole, Little Miami River* (1851); the scene is set near the junction of the Ohio and Little Miami Rivers, a favored escape route for fugitive slaves. Outside of the mainstream, Duncanson was long neglected and considered a secondary, derivative painter. Attention was drawn to his work during the 1990s, when the historian David Lubin, in his book *Picturing a Nation: Art and Social Change in 19th-Century America* (1993), looked for coded meanings in Duncanson's work. Reading between the brushstrokes, so to speak, Lubin and succeeding art historians find messages hidden in Duncanson's landscapes. For example, boats crossing water are metaphors for the flight to freedom, and Roman ruins represent the end to which slave-owning nations are destined. Duncanson's physical and mental health became increasingly troubled; he entered a mental hospital in September 1872 and died there that December. It is now believed that he probably had a brain tumor.

Duquesnoy, François
1597–1643 • Flemish • sculptor • Baroque

Duquesnoy was probably a greater artist than Algardi; in any case, he was less prepared to compromise. (Rudolf Wittkower, 1958)

A BAROQUE sculptor, Duquesnoy was a friend of POUSSIN, and their ideas about the importance of CLASSICAL references for art were in harmony. Born in Brussels, Duquesnoy moved to Rome in 1618 and was, according to WITT-KOWER, "so thoroughly acclimatized that even the discerning eye will hardly discover anything northern in his art." The compromise of ALGARDI that Duquesnoy rejected, to which Wittkower refers in the quotation above, was between BERNINI's Grand Manner Baroque and restrained Classicism. Duquesnoy lived in Rome until shortly before his premature death, at the age of 46. From 1627 to 1628 he worked for Bernini on the BALDACCHINO of Saint Peter's. In 1629 he received a commission for his most famous work, a marble, over-life-size *Saint Susanna* (1627–33)—BELLORI said that a more perfect synthesis of the study of nature and the ideas of antiquity could not be found. Her serene face gazed directly at the congregation; the martyr's palm in her right hand, she directed the worshiper's attention by gesturing toward the altar with her left. As the sculpture was so site-specific, the meaning of the posture and gesture was lost when it was moved from the niche in the church of Santa Maria di Loreto for which it was designed. Duquesnoy's clarity and restraint in the pull of gravity on the folds of the clothing contrast to works by Bernini, where DRAPERY seems to have a life of its own. Duquesnoy had special skill at imbuing his PUTTI with the affect of small children, and with both *Susanna* and putti he inaugurated a BAROQUE type that many followed.

Dura-Europos
The ANCIENT city on the Euphrates River called Dura-Europos was known only from literary sources until after World War I; in 1920, a British patrol stumbled on the site. Excavations,

under a Franco-American team, began in 1928. It is believed that Dura was founded by one of Alexander the Great's Macedonian successors, shortly after Alexander's death in 323 BCE. *Dura* is from the Greek word for "fortress," and *Europos* probably derives from the Macedonian city of its founder (Seleukos). Dura was under Roman rule when it was conquered and destroyed by the Sasanids (a dynasty of Persian kings) in 256 CE. One of the most remarkable discoveries during excavations is the great number of religions that were practiced there. Besides temples belonging to several pagan cults, there was a Jewish synagogue and a Christian church with a baptistery. Both synagogue and baptistery were in private houses, and both were preserved because they stood near the city wall and were filled with sand and rubble to shore up a defensive embankment when Dura was under siege. There are some paintings in the baptistery (of Adam and Eve and the Good Shepherd), but those in the synagogue are especially numerous and in an excellent state of preservation. They contain scenes from Jewish history and legend, such as *Finding of the Baby Moses*. Figures of people and animals on these murals make perfectly clear the flexibility with which prohibitions against art, as in the Second Commandment, were interpreted during certain periods of Jewish history as well as in early Christianity. Stylistically, paintings in the Dura synagogue show the figures flattened, forward-facing (FRONTAL), outlined, and their poses formulaic—simplified to quite geometric, abstract forms. There are only occasional lifelike details that seem to show the influence of ROMAN ART, such as the DRAPERY of a man's clothing (possibly Moses or Ezra) who is reading the Torah in the synagogue. For the most part, characteristics of Dura's Near Eastern heritage are evident: Faces are expressionless, there is little if any effort to show depth of field, and people are represented in a hieratic scale—the more important the individual, the larger he or she is drawn. Moreover, both Persian and Roman clothing styles are represented in the pictures. It is apparent that both JEWISH and EARLY CHRISTIAN ART of this period is drawn from the same pictorial repertoire as were the arts of competing cults such as Mithraism, Manichaeism, and Gnosticism. They all vied for followers, and so, one might speculate, in an eclectic set of illustrations, diverse individuals might find something personally meaningful.

Durand, Asher B.

1796–1886 • American • painter • Romantic/Hudson River School

In recommending you, in the beginning of your studies, directly to Nature, I would not deceive you with the expectation, that you will thus most speedily acquire the art of picture-making—that is much sooner acquired in the studio or the picture gallery. I refer you to Nature early, that you may receive your first impressions of beauty and sublimity.

Kindred Spirits (1849) is Durand's most celebrated painting and a paean both to COLE, who had died the year before, and to 19th-century American landscape painting of the HUDSON RIVER SCHOOL. It is a dramatic scene of a gorge, with the figures of Cole and his

close friend William Cullen Bryant standing on a ledge, talking. This is just the kind of landscape the two loved, and there is also a wealth of the kind of symbolism Cole loved to use, including a broken tree trunk to represent a life cut short, a bird flying into the hazy distance signifying Cole's departed soul, and a nearby bird that is surely Bryant's. The picture, commissioned by one of Durand's longtime patrons, was presented to Bryant (also a friend of Durand) in appreciation of his moving oration at Cole's funeral. Full of ROMANTIC sentimentality, glorification of nature, and spiritualism, *Kindred Spirits* also pays homage to the great American wilderness in which they all saw the nation's Manifest Destiny (see COLE). The comment made by Durand, quoted above, appeared in a periodical called the *Crayon,* published in America for writings about art.

Durand-Ruel, Paul

1831–1922 • French • art dealer

. . . without Durand-Ruel's stubborn advocacy and devoted and selfless support, Impressionism would not even have been in a position to attract the business of those who . . . were eager to cash in on its slow success. (John Rewald, 1956)

Durand-Ruel defended and championed the IMPRESSIONISTS during the 1870s despite the financial difficulties they caused him. His gallery was on la rue Lafitte in Paris, a street lively with art galleries and antique shops. Perennially short of cash, Durand-Ruel was forced to hold back payment to artists from time to time and lost some of the artists he represented to Theo van Gogh, Vincent's brother, who worked for GOUPIL'S GALLERY, and to Georges Petit, his most active competitor. Invited by an American dealer, Durand-Ruel visited the United States in his search for new outlets; trips to New York in 1886 and 1887 proved successful—his sales established some fine Impressionist collections in America, and he was encouraged to open a branch office. During his absence, however, several of his artists, Monet among them, took advantage of the other outlets. While one argument made was that Durand-Ruel was "pushing" Impressionists to reduce his own stock, that overlooks his importance, as the historian REWALD points out in the quotation above. Among all of Durand-Ruel's painters, RENOIR was the only one who remained faithful and never dealt with Theo Van Gogh. In the mid-1890s, Durand-Ruel's business was a financial disaster, though he continued to give important shows to contemporary painters.

Dürer, Albrecht

1471–1528 • German • printmaker/painter • Northern Renaissance

One may often search through two or three hundred men without finding amongst them more than one or two points of beauty which can be made use of. You therefore, if you desire to compose a fine figure, must take the head from some and the chest, arm, leg, hand, and foot from others.

Dürer broke through many barriers and trod much new ground, and did so with unsurpassable skill in drawing, watercolor and oil painting, and printmak-

ing. He also wrote treatises on art—the quotation above is from *The Book of Human Proportions,* written in 1513, and brings to mind the legend of the AN-CIENT Greek ZEUXIS (c. 450–390 BCE), who combined the traits of many women to create his sculpture of Helen of Troy. Among Dürer's earliest works, drawn in pen and ink before he was 13, are self-portraits of prodigious skill. Moreover, the artist portrayed himself as an individual, a personality—not only the practitioner of his craft, the usual rationale for a self-portrait. Dürer explored his inner life, which was frequently shrouded by depression. He depicted this allegorically in an EN-GRAVING titled *Melencolia 1* and dated 1514. In one of his most startling and controversial self-portraits (of 1500), Dürer presents his likeness in a way that calls to mind an ICON of Christ: nearly expressionless, with long hair, and with large, mesmerizing eyes gazing out at the viewer. His artistic and religious, or spiritual, intention in this self-portrait is one of the ongoing puzzles for art historians: Was he suggesting that the artist/creator is Godlike, or that the artist's inspiration comes from God? Was he illustrating an idea, related to the mystical doctrine professed by Saint Francis and popularized by Thomas à Kempis—*Imitatio Christi,* or Imitation of Christ—that to follow Christ is to become like him? Or was he mindful of theologian Nicholas of Cusa (1401–64), who proposed that looking at Christ's image and being looked at by it is reciprocity of love in which self-love becomes an act of devotion? Can Dürer, or should he, be absolved of accusations of blasphemy, or of narcissism? Dürer traveled widely from his home in Nuremberg. He went to Italy to see and learn, and recorded his journey with extremely beautiful WATERCOLOR impressions of the landscape. These reappear in the backgrounds of subsequent works. His effort to visit and perhaps study with SCHONGAUER was precluded by Schongauer's death. Still, Dürer became the most accomplished and renowned printmaker of his time, adept at both woodcut (see WOODBLOCK) and engraving. An example of the former is the action-packed *Four Horsemen of the Apocalypse* (1498). In contrast is his engraving *Knight, Death, and Devil* (1513), which, with untold numbers of fine lines, seems to hold the viewer, as well as the knight on his horse, in suspended animation. As was Schongauer's, Dürer's father was a goldsmith. Dürer had the additional benefit of a godfather who was a leading German printer. Dürer became a follower of Martin Luther, whose teaching influenced Dürer's work at the end of his life. This is visible in a 1523 woodcut, *The Last Supper,* in which the artist took a traditional subject and gave it new doctrinal meaning. For Luther the sacrament was a commemorative rather than a symbolic event, so in Dürer's image the platter that previously would have held the symbolic "sacrificial lamb" is significantly empty. Representing the Lutheran belief that bread and wine do not miraculously become Christ's flesh and blood, and that the laity, not just the priest, should partake of both, a basket of bread and a pitcher of wine sit unceremoniously on the floor, and a chalice is set on the table. The style Dürer used for this image is sophisticated in its lucidity, but distilled and direct compared to his earlier

woodcuts. That is also in step with the unadorned directness of Reformation thinking.

Duret, Théodore
1838–1927 • French • writer/collector

As soon as people looked at Japanese pictures, where the most glaring, piercing colors were placed side by side, they finally understood that there were new methods for reproducing certain effects of nature which had been neglected or considered impossible to render until then, and which it might be good to try.

Duret was an important supporter of the Impressionists, whose work he also explained to the public at large, especially in *The Impressionist Painters* (1878), from which the quotation above is taken. He endeavored to connect IMPRESSIONISM with the tradition of Western art, French painting in particular, and pointed to the convention of contemporaries laughing at artists who were later lionized. Duret was MANET's chief defender, and Manet painted his portrait in 1868. WHISTLER painted his portrait in 1882, as did VUILLARD in 1912.

Düsseldorf School
From the late 1840s to the early 1860s, several American painters studied in Düsseldorf under the leadership of LEUTZE. Included were WOODVILLE, BINGHAM, Eastman JOHNSON, and, among landscapists, BIERSTADT and WHITTREDGE. Characteristic of painting in Düsseldorf was a fixation on detail and sharp REALISM[1].

Duveen, Baron Joseph
1869–1939 • English • art dealer

You can get all the pictures you want at fifty thousand dollars apiece. That's easy. But to get pictures at a quarter of a million—that wants doing.

Joseph Duveen joined his father's business and built it into the world's largest dealership in art. He also formed some of the most important collections in the United States, selling to Henry Frick (1849–1919), Andrew Mellon (1855–1937), J. P. Morgan (1837–1913), and John D. Rockefeller (1839–1937). One of the stories told is that, when he was still green, Duveen tried to best Morgan, offering him a collection of 30 miniatures of which just 6 were great treasures. Morgan sharply selected and pocketed the six best, divided Duveen's figure by 30, multiplied by 6, and paid Duveen accordingly. Duveen's uncle, also in the business, and the one who usually dealt with Morgan, is quoted as saying, "You're only a boy, Joe. It takes a man to deal with Morgan." BERENSON worked for Duveen during a partnership of some 26 years, signing certificates that authenticated RENAISSANCE paintings especially. Duveen's influence was powerful; he persuaded his clients to ignore modern pictures in favor of the far older works he sold with characteristically flamboyant comments such as the one quoted above. REMBRANDT's *Aristotle Contemplating the Bust of Homer* (1653) is one of the famous pictures that passed through his hands. Though he and Berenson raised dealing to a fine art, their ethics have been questioned, most seriously in Colin Simpson's book *Artful Partners* (1986).

Duveneck, Frank

1848–1919 • American • painter •
Realist

American Velázquez. (Henry James,
1875)

Duveneck was born in Kentucky to
German immigrants. His father was a
shoemaker, and Duveneck worked as a
sign painter and as an assistant to an
itinerant church decorator. In 1870 he
went to Munich, to study at the Royal
Academy. On his return to the United
States, he taught in Cincinnati; COX and
TWACHTMAN were among his first
pupils. He returned to Munich, where
he started his own classes; several
Americans, known as the Duveneck
Boys, were enrolled. Duveneck had a
PAINTERLY style and, typical of the MU-
NICH SCHOOL, his early works were
dark, but his PALETTE brightened in the
1880s. *The Turkish Page* (1876) is both
vintage Munich (realistic depiction of
workers or peasants focusing on a cer-
tain picturesqueness of their clothes and
way of life) and Duveneck in top form.
The subject is a thin young boy, on a
shiny marble floor, with a copper bowl
on his lap. A white parrot, wings
spread, is perched on the edge of the
bowl. Henry James, quoted above,
agreed with "aesthetic Boston" that
Duveneck, then 26, was an American
painter of resounding significance.

Dyck, Sir Anthony van

1599–1641 • Flemish • painter •
Baroque

. . . the best of my pupils. (Rubens,
1618)

A child prodigy who studied painting at
the age of 10 and registered as a master
in the GUILD before his 19th birthday,
van Dyck was playing a major role
in the execution of RUBENS's designs at
21, the age at which he became court
painter to James I of England. His talent
and fame soared, as did his commis-
sions. The seventh child in a prosperous
merchant family, he seems to have been
a deeply religious Catholic, but his per-
sonality and philosophical point of
view are not reliably documented. Bio-
graphical hearsay suggests that he was
excessively fond of luxury, proud, am-
bitious, sensitive, excitable, and highly
competitive. If Rubens set the standard
for his century as both painter and gen-
tleman, van Dyck came as close as any-
one else to meeting it. To Rubens's
stylistic exemplar van Dyck added TIT-
IAN's Venetian coloring and atmos-
phere; on his travels throughout Italy he
filled his sketchbook with studies after
Titian (and may even have sparked
Rubens's interest in the Venetian's
work). Rubens and van Dyck together
changed the formal, standardized con-
cept of portraiture. In *Charles I, King of
England, Hunting* (c. 1635) van Dyck
portrayed the ill-fated king dismounted,
standing casually in front of his horse,
which seems to genuflect respectfully
(see EQUESTRIAN). In painting sinuously
elegant noblewomen, van Dyck in-
creased the length of their bodies to
nearly twice the norm, reminiscent of
the GOTHIC International Style's hyper-
elegance. His *Marchesa Elena Grimaldi
Cattaneo* (1623), in which a Genoese
noblewoman stands beneath a ruby red
umbrella held by an African page,
brings to mind that Genoa was a key
port in the slave trade of the 16th and
17th centuries. In that age of explo-
ration, painters of the BAROQUE were

fascinated by the foreign and exotic. Painter to royalty in the Netherlands and in England, in 1632 van Dyck was appointed "Principalle Paynter in Ordinary to their Majesties," knighted, and presented with a gold chain by Charles I. In 1635 a special road and dock were constructed to facilitate the king's visits to van Dyck's studio. Van Dyck died in 1641, however, only 42 years old. Rubens had died the previous year— and Charles would be beheaded in 1649.

Dying Gaul/Dying Gladiator

The status of the conqueror is aggrandized when the enemy is honorable and brave, as is this life-size marble figure, a Roman copy of a HELLENISTIC bronze original dated about 220 BCE. It was part of a larger group of sculptures that included *Gallic Chieftain Killing His Wife and Himself*. The figures are generally believed to represent victims in the war King Attalus I of Pergamon had just waged against Gallic invaders. In the *Dying Gaul*, as it is generally known, although PLINY the Elder called the work "Dying Gallic Trumpeter," the subject has a rope around his neck, and although clearly suffering from the bleeding wound in his side, he maintains a worthy dignity. Yet his pathos is undeniable, and especially interesting when compared with the late ARCHAIC types of fallen warrior figures, as on the Greek Temple of Aphaia at Aegina (c. 490–480 BCE), whose bearing shows no evidence of their lamentable circumstances. Lord Byron wrote an impassioned tribute to the wounded Gaul in *Childe Harold* (1818) that ends, "Shall he expire / And unavenged?—Arise! ye Goths, and glut your ire!"

E

Eadwine, the Scribe

active c. 1150 • Anglo-Saxon •
monk/scribe • Romanesque

Prince of Scribes

Covering a full page of the large-format
Canterbury Psalter, or psalm book (c.
1150), is a picture of a monk hard at
work. Bent over the book he is writing,
he has a pen in one hand and a knife—
for scraping over errors that need fix-
ing—in the other. The importance and
rigor of his task are expressed by the in-
tensity of his gaze, the containment of
his figure inside an architectural frame-
work, the tight swirls of the fabric of his
robes, and the inscription, quoted
above, that proclaims the elevated
stature of the writer. Although it was
long thought to be a self-portrait, more
recent opinion suggests this may be a
representation of a famous Canterbury
scribe of an earlier period.

Eakins, Thomas

1844–1916 • American •
painter/sculptor • Realist

*I was born in Philadelphia July 15th,
1844. I had many instructors, the
principal ones Gérôme, Dumont
(Sculptor), Bonnat. I taught in the
Academy from the opening of the
schools until I was turned out, a
period much longer than I should have
permitted myself to remain there. My
honors are misunderstanding,
persecution, & neglect, enhanced
because unsought.*

Born and raised in Philadelphia, Eakins
spent his life there, except for approxi-
mately four years of study in Europe
that began in 1866. In Paris he studied
under the artists he lists above, and
when he traveled to Spain he was
strongly affected by VELÁZQUEZ and
RIBERA, whose work he called "Big
Painting." There are two strains that
characterized his work when Eakins re-
turned home. One is a pervasive gloom:
His mother was mentally ill and con-
fined to the house for two years before
she died. Eakins helped care for her,
and the family's agony is evident in
paintings he made at the time of his sis-
ters (e.g., *Home Scene,* c. 1871). The
other characteristic of that era's work
was a seemingly compulsive study of
detail, especially seen in several pictures
of rowers (e.g., *Max Schmitt in a Single
Scull/The Champion Single Sculls,*
1871). Eakins measured, plotted grids,
took photographs, and even sculpted
figures that he then placed on the grids.
In one picture he graphed ripples in the
water, giving each ripple three surfaces,
and figured out how the light would be

reflected by each surface. He was meticulous in accuracy of PERSPECTIVE, light, and color. Truthfulness to nature was his creed. It also led to the "misunderstanding, persecution, & neglect" that he wore like a stigma. Insisting that artists need a thorough understanding of the human body, he studied anatomy, performed dissections at a medical school, and wanted his students to dissect also. He insisted that both male and female students paint nude models. His gesture of removing a model's loincloth to show a muscle, and numerous other indiscretions, led to his dismissal, in 1886, from the Pennsylvania Academy of the Fine Arts, where he had served as director. Ten years earlier he had suffered a blow when the painting that is now considered his masterpiece, *The Gross Clinic* (1875), was rejected for the Centennial Art Exhibition because of its harsh truth; the surgical procedure, and especially the bloody hand of the surgeon—heroicized as a Christ-like figure—was too much for the sensibility of the judges. The painting was hung in the medical exhibition instead. During his later years Eakins painted a series of portraits of people he knew—usually not commissioned—and they reveal a contemplative, disconsolate sadness.

Earl, Ralph

1751–1801 • American • painter • Colonial

... *When [Earl] wished to represent one of the Provincials as loading a gun, crouching behind a stone wall when firing on the enemy, he would require Mr. d. to put himself in such a position.* (Barber and Punderson, 1890)

There is no evidence that Earl had any formal instruction before he painted his first known pictures depicting scenes of the Battles of Lexington and Concord in 1775. The pursuit of veracity led him to the battlefields with his friend Amos Doolittle, as described in the quotation above. The result was four historical paintings that Doolittle, a novice at the skill, made into ENGRAVINGS. In 1778, during the Revolutionary War, of which he disapproved, Earl went to England and trained under WEST, but he returned home in 1785 and painted in the COLONIAL STYLE—portraits of stiff, forward-facing, grim-looking people whose clothing and surroundings signify their social rank—almost as if he had never left New England. In *Oliver Ellsworth and Abigail Wolcott Ellsworth* (1792), the sitters are placed on either side of a window that looks out on their estate. Oliver, who played an important role in the writing and ratification of the Constitution, holds a copy of that document in his hand; Abigail, dressed in a shimmering white gown that leaves barely any flesh exposed and a bonnet that is almost twice the size of her head, appears far older than her 36 years. Despite his emotional parsimony, Earl did display a decorative flair that often showed up in his careful rendering of richly patterned rugs, and he was skilled in painting landscapes, which he usually reduced to window views. Earl's death, according to the report of a minister in Connecticut, was the result of "intemperance."

Early Christian art

No Christian FIGURATIVE art has survived from the 1st and virtually all of the 2nd century. What has been found is symbolic rather than NARRATIVE: an anchor as a symbol of hope; and various devices to represent the cross, including an Egyptian ankh, a symbol of life. Use of the fish as a symbol was early (c. 160–230, used by the theologian Tertullian)—the Greek word for fish, *ichthus,* is a rebus for the phrase "Jesus Christ, Son of God, Savior." The fish stood for Christian baptism and for Christ himself. The CHI RHO (XP) appeared in the 4th century. Representation of Christ as a man and of scenes from the New Testament may have been avoided in deference to biblical prohibitions against images, and perhaps because complicity in the illegal cult could be dangerous. In addition, art was associated with pagan luxury. Such explanations, though, are only speculative. During the 3rd and early 4th centuries, before the emperor Constantine's 313 Edict of Milan recognized Christianity, some figurative images appear, like that in an early-3rd-century cubiculum (chamber, mortuary chapel) in the Roman CATACOMBS that shows Christ as the Good Shepherd. Surrounded by sheep, Christ carries a lamb on his shoulders. The shepherd image is traceable to ancient Egypt and Mesopotamia as well as pagan Greece (e.g., *The Calf-Bearer* of c. 560 BCE), but the meaning of this one differs in that the pagan figures carry a sacrificial offering to the god, while Christ, as shepherd, protects his flock. A vault MOSAIC from the Mausoleum of the Julii (Rome, 3rd century) shows Christ as the sun god (Helios, Apollo, or the Roman *Sol Invictus*/Victorious Sun) driving the horses of the sun chariot in a golden sky. The HALO, both pagan and Christian, derives from this association with the sun. Such adaptations, or fusions, of different ideas or images are referred to as "syncretistic." Before 330, Christ appeared as poor and humble, as were his followers, to whom he offered an afterlife more promising than their life on earth. Constantine changed the status of both the cult and its art, and in 380, under Theodosius, Christianity became the official religion of the Eastern Roman Empire. Formerly private and secret, Christian imagery now became public and official. But earlier styles prevailed. The Roman BASILICA, for example, was an important prototype for Old Saint Peter's in Rome (begun c. 320–27, no longer extant). Some scholars argue that traditional designs made the new religion seem more familiar and thus more palatable. When Christ acquired a regal posture, a throne, and royal robes— e.g., *Christ Enthroned in Majesty,* an apse mosaic in Santa Pudenziana, Rome (410)—the intention may have been to gain support for the emperor by association, according to some theories. Affiliation of Christ with imperial power is debated, however, as in the controversial thesis of Thomas F. Mathews, who finds images of Christ that are both anti-imperial and motivated, he believes, by theological disputes. Stories from the Hebrew Bible and the New Testament were told in church mosaics (e.g., Santa Maria Maggiore: *Parting of Lot and Abraham, The Stoning of Moses, Infancy of Christ,* Rome, c. 432–40), on the RELIEFS of sarcophagi (*Junius Bassus,* c. 359), and in ILLUMI-

NATED MANUSCRIPTS (*Vienna Genesis* and the *Rossano Gospels,* both early 6th century). As progression from papyrus SCROLL to CODEX came about, illustrations were derived from pagan examples and JEWISH ART found in libraries, like the famous one in Alexandria. The *Rossano Gospels* shows that by the early 6th century the CANON of Christian sacred texts and their cycles of illustration were established. (See also TYPOLOGY)

Early Classical
See CLASSICAL

Early Medieval (Late Antique)
3rd to 6th century • Classical
The style was spread by Alexander the Great in the 4th century BCE, and then by the expanding Roman Empire to places like DURA-EUROPOS and FAIYUM. It also influenced regions north of Rome to which Christianity later spread. But artists of these regions were not very interested in Classical descriptions of the outside world that endeavored to be true to what the eye saw. They remained strongly committed to their own local traditions, which included hieratic scale (formal and priestly rather than natural), FRONTALITY, rigid symmetry, space in registers, and intense gazes (see SUB-ANTIQUE). By the 3rd century such non-Classical conventions had evolved into a vernacular, popular style known as Late Antique (e.g., the *Tetrarchs,* 305 CE).

Earth and Site art
During the 1960s artists began to transform or work with the landscape. One of the best-known endeavors is SMITHSON's *Spiral Jetty* (1970), an artificial landscape he created in the Great Salt Lake in Utah. Walter De Maria's (born 1935) *Lightning Field* (1977) is a grid of 400 stainless-steel poles, each about 20 feet high, arranged in 16 rows and installed on a flat site in New Mexico. Their effect, when they attract bolts of lightning at night, is spectacular. Another pioneering artist is Michael Heizer (born 1944), who described his intrusions in the Nevada desert as "dirtwork" to the historian Jonathan Fineberg. His projects range from leaving traces of human transience in the form of his own motorcycle tracks, to removing 240,000 tons of material forming a 30-foot-wide, 50-foot-deep, and 1,500-foot-long canyon in Mormon Mesa, Overton, Nevada—*Double Negative* (1968–70). Earth art is related to MINIMALISM by its insistence on working with materials, not just ideas (as opposed to CONCEPTUALISM). Because only films or photographs of an earthwork are usually collected or exhibited, it defies art world commerce. All of these site-specific works move into and change the natural world in an "invasive" way that bears no relation to conventional landscape architecture. But each artist has created a unique experience for the spectator willing to make a pilgrimage to the site, an experience meant to link the human visitor to the earth, and to natural forces, in a new way, and with a sense of awe for the grandeur of the landscape itself.

École des Beaux-Arts
This is the government school in Paris that provided tuition-free instruction for an international student body as well as for French nationals. The institution evolved from the Académie

Royale de Peinture et de Sculpture founded by Louis XIV in 1648. Its name changed with the political winds: L'École royale . . . L'École impériale . . . L'École nationale, and so on. Competition and entrance examinations to study at the Beaux-Arts were rigorous. Students prepared for exams, and sometimes supplemented their course of study at Beaux-Arts by working with independent teachers and private schools such as the ACADÉMIE JULIAN. Women were denied access to Beaux-Arts until 1897. Studying nude models in the life class (to which women were not admitted until 1903) was the foundation of artistic training, though students usually had to prepare for it by drawing from casts of CLASSICAL or RENAISSANCE sculpture. There were also classes in anatomy, perspective, art history, and aesthetics. One of the chief advantages at the Beaux-Arts, available only to French students, was the opportunity to compete for the PRIX DE ROME. Winners attended the French Academy in Rome. The École des Beaux-Arts underwent many administrative and organizational changes during the course of the 19th century, but remained committed to traditional ACADEMIC training throughout.

Edmonds, Francis William
See MOUNT

egg tempera
See TEMPERA

Eight, The
Refers to artists who exhibited together in 1908 at New York's Macbeth Gallery: HENRI, SLOAN, GLACKENS, LAWSON, LUKS, SHINN, DAVIES, and PRENDERGAST. In style and subject matter their works were diverse, and they never again exhibited as a group; rather, they were united by their defiance of the standards, especially those of "beauty," upheld by the National Academy of Design, which had rejected work of their members. Henri was the magnet for this group, several of whom followed him from Philadelphia to New York. Hostile contemporary reviews poked fun at them, calling them "Apostles of Ugliness," an idea they cultivated with astute, self-promotional instincts. Some, but not all, of The Eight belonged to the ASHCAN SCHOOL. Most important about all of these artists was their determination, despite the European training many had, to base their subject matter resolutely at home, in the United States.

ekphrasis
Ekphrasis means "words about images." Ekphrastic text, or discourse, regarding an image is descriptive, frequently invented, and often so elaborately particular that a reader or listener might imagine the topic under discussion to be the primary source for the image rather than its representation. PLINY the Elder and PHILOSTRATUS were ekphrastic writers through whom we learn the content of ancient works of art that have been lost. Where 19th-century readers of these and other ancient writers concerned themselves with whether and where the paintings they discussed actually existed, theorists and historians today look into ekphrasis as an opportunity to find layered meanings, for both the original and contemporary readers.

Elementarism

See van DOESBURG

Elgin Marbles

The Turks were in control of Athens' when the British diplomat and art collector Thomas Bruce, seventh Earl of Elgin, a Scot, formed his purpose of removing from the ACROPOLIS what he said were "some stones with inscriptions and figures." With permission from the Turkish government, which tended to regard such CLASSICAL antiquities as the relics of infidels, he began doing so in 1801. Consequently, much of the north, south, and east friezes of the PARTHENON, many of the decorative panels (metopes), and nearly all the pedimental sculpture, as well as some other sculpture that was then on-site, including a CARYATID from the Erechtheion, were exported to England. While some praised Elgin for saving the sculpture from neglect and deterioration, others called him a vandal. According to legend, Lord Byron carved the words "What the Goths spared, the Scots have destroyed" into the stone of the Acropolis. Byron was the first to suggest the possibility that Elgin, who saw himself as a "patron saint" of ANTIQUITY, had instead robbed the Greeks of their historic heritage. Elgin's self-defense was an 1810 pamphlet, "Memorandum on the Subject of the Earl of Elgin's Pursuits in Greece." In 1816 the collection, known as the Elgin Marbles, was purchased for the British Museum for £36,000—£14,000 less than the expenses Elgin had incurred. Elgin himself suffered dire misfortune—imprisonment by Napoleon (who blamed him for French reverses in its relations with Constantinople), a disfiguring skin disease, disaffection and divorce from his wife, and the loss of his wealth. The conflicting attitudes toward Elgin's treasure are reflected in contrasting assessments of their aesthetic value, and in the heated controversy over returning them to Greece that continues to this day.

Elsheimer, Adam

1578–1610 • German • painter/engraver • Baroque

I have never felt my heart more profoundly pierced by grief than at this news [of Elsheimer's untimely death]. (Rubens, c. 1610)

Around 1600 Elsheimer settled in Rome, where he came under the influence of CARAVAGGIO's expression of mood through dramatic manipulation of light and shadow. Elsheimer became known for translating this effect in paintings on small copper plates. He had a strong, appealing personality that attracted a circle of artists—RUBENS, who is quoted above, was among his admirers—and his interest in the Roman *campagna,* or countryside, influenced Italian landscape painters, the French CLAUDE LORRAIN, and the Dutch landscapists. Those who did not see his paintings firsthand may have known them through ENGRAVINGS. Preferring a low point of view, Elsheimer poetically set dark trees against a bright sky, achieving a lyrical and delicate effect. But the sky is dark in one of his most wonderful paintings, a nighttime scene called *The Flight into Egypt* (1609) which is only 12 × 16 inches. The darkness is illuminated by a full moon reflected on the water, a lantern carried by Joseph, the shepherds' camp-

fire, and a star-filled sky. But his was not the routine casual sprinkling of stars. Elsheimer seems to have carefully observed the Milky Way, and even to have looked at it through a telescope. It was the era of Galileo, who was turning his "optic glass" to the skies, and who, in seven years, would be condemned by the Holy Office in Rome for proclaiming that the earth moves around the sun.

emblem book

An emblem is an image with a specific symbolic meaning. Artists seeking eternal truths in transient reality see the physical world as symbolic, allegorical, or emblematic of a higher, transcendental order. Correspondences between the natural and supernatural, the temporal and eternal, were found in "emblem books" such as Andrea Alciati's *Emblematum Liber* (1531) in which a motto, a picture, and an epigram serve for each emblem. Alcati's is the earliest known emblem book. One of the best-known English emblem books is Geoffrey Whitney's *A Choice of Emblemes* (1586). Cesare Ripa's *Iconologia* (1593), an alphabetized dictionary of symbols, attributes, and personifications, was a standard reference used by artists for two centuries. Today it serves as an interpretive key (see ICONOGRAPHY). BERNINI's *Time Revealing Truth* (1647–52) follows Ripa's definition of Truth as "a beautiful nude woman, holding in her right hand the Sun, at which she gazes, and under her foot is the globe of the world. She is pictured nude to show that simplicity is natural to her. She holds the sun to indicate that truth is the friend of light . . . and the world under her foot denotes that she is above all worldly things." Thinking of life allegorically was deeply ingrained in the 17th-century mind.

encaustic

From the Greek, meaning "to burn in," the encaustic process involves application of molten wax in which PIGMENT has been suspended. In ancient Greek art, encaustic painting may have been used on statues and murals, but although literary texts describe the technique, surviving samples are extremely rare. Some Pompeian wall paintings using encaustic, as well as encaustic portraits on mummy cases from FAIYUM, Egypt, c. 160–170 CE, suggest what earlier paintings may have looked like. Encaustic was generally abandoned in favor of TEMPERA and other techniques. In the 1950s JOHNS used encaustic, often in mixed MEDIUMS, especially for his target and flag paintings.

engraving

Strictly speaking, engraving refers to cutting into either a metal or a wood matrix with the engraver's tools—burins or gravers—for the purpose of PRINTING the image thus created. Line engraving was the earliest method of reproducing images. The engraving technique was developed in ancient times, as the engraved back of a round, bronze ETRUSCAN mirror of c. 400 BCE reveals. However, metal surfaces were not used to impress images until PAPER came into use in the West; the oldest known examples date from the early 1400s, and were made by goldsmiths. The term "engraving" is also widely used to describe a PRINT that is the end product of the process. (See also INTAGLIO and WOODBLOCK)

Enlightenment

From its development in Paris during the first decades of the 18th century, the Enlightenment spread throughout Europe and to the United States. It was characterized by belief in rational, empirical knowledge over religious faith or mysticism. The "philosophes" of the Enlightenment were intellectuals who launched a concerted effort, via the written word especially—witness DIDEROT's *Encyclopédie*—to educate the wider population about such concepts as liberty, happiness, nature, and natural law. Theirs was a campaign for the liberation of mankind (and occasionally women), including slaves, Protestants, and Jews. Besides Diderot's writings and those of Montesquieu (1689–1755) and Jean-Jacques Rousseau (1712–1778), the American Declaration of Independence and the French Declaration of the Rights of Man and of the Citizen are Enlightenment documents. The acknowledged beginning of modern political culture, the Enlightenment is a POSTMODERN bête noire, an excuse, according to its critics, to exercise imperialist power rather than true equality. Its demystification of religion led, they believe, to a mythologizing of science and technology. Jacques-Louis DAVID, Joseph WRIGHT of Derby, HOUDON, GOYA, and JEFFERSON, among others, have Enlightenment connections.

Ensor, James
1860–1949 • Belgian •
painter/printmaker •
Symbolist/Expressionist

My unceasing investigations, today crowned with glory, aroused the enmity of my snail-like followers, continually passed on the road. . . . Thirty years ago, long before Vuillard, Bonnard, van Gogh, and the luminists, I pointed the way to all the modern discoveries, all the influence of light and freeing of vision.

Ensor's family owned a souvenir shop in Ostend (where he was born, lived, and died), which supplied him with many of the ugly, strange carnival masks he used in his paintings. In his best-known image, *Christ's Entry into Brussels in 1889* (1888), a grotesque parody of the contemporary world, the masklike faces of the crowd run the gamut from grinning skull to monstrous clown. Christ, in the background, is barely visible behind the teeming masses of dreadful humanity. This major opus, more than 12 feet wide, is a bitter, depressing view of the human condition, predominantly in thickly encrusted brown, black, and white with some green. Among messages displayed are LONG LIVE JESUS, KING OF BRUSSELS and LONG LIVE THE SOCIALIST STATE. The painting is interpreted on many layers, some having to do with the painter's own life, others with the historical realities of contemporary Belgium, including labor unrest. As REDON had been, Ensor was inspired by the writing of Edgar Allan Poe. He was a member of Les VINGT, but largely unappreciated by his contemporaries for most of his bitter, reclusive life. His work was finally recognized (as the 1915 quotation from his writings, above, indicates) once Freud and the new SURREALIST movement provided grounds for understanding his expeditions into the depths of the human mind.

Epstein, Sir Jacob
1880–1959 • American/English •
sculptor • Modern

*I imagine that the feeling I have for
expressing a human point of view,
giving human rather than abstract
implications to my work, comes from
these early formative years.*

Born to a family of Polish Jewish immi-
grants on New York City's Lower East
Side, Epstein studied at the Art Students
League. With the money from his first
commission, illustrations for a book
about the city's Jewish quarter (*The
Spirit of the Ghetto,* 1902), Epstein
went to study in Paris before settling
permanently in London in 1905. He be-
came a controversial figure in 1908
when his sculptures (now destroyed)
for the facade of the British Medical As-
sociation headquarters shocked the
public because some figures were nude
and one was pregnant. Though his
ABSTRACT works were relatively few,
one of his best known is *The Rock Drill*
(1913–14), a VORTICIST concept that
seems to be the torso of a mechanical
monster. Most of his sculptures are
representational, and the *Tomb of
Oscar Wilde* (1912) in Paris calls to
mind ancient Assyrian winged bulls.
Epstein had a fine collection of ancient
Greek, African, Polynesian, and pre-
Columbian sculptures. After World
War I, he again aroused controversy by
his expressive distortions of form and
his deliberately crude and "primitive"
treatment of religious themes. Through-
out his life he cast portraits in bronze.
These are characterized by pitting and
furrowing of the surface that suggests
the clay from which they were cast. He
made portraits of Albert Einstein,
Chaim Weizmann, and Yehudi Menu-
hin, among others. In 1940 he pub-
lished his memoirs, *Let There Be
Sculpture,* from which the quotation
above is taken.

equestrian
Derived from the Latin *equus,* for
"horse," in art history "equestrian"
refers to the representation of a figure
on horseback. While such images pre-
date ROMAN ART, (e.g., the 7th-century
BCE horsemen on the RELIEFS of the
palace of King Assurbanipal and those
on the PARTHENON frieze), the bronze
statue *Marcus Aurelius,* in which the
emperor addresses his troops (c. 175
CE), is arguably the most important
statue to survive from Roman times.
This type of image, of the ruler on
horseback, was a Roman Imperial tra-
dition that looked all the way back to
Alexander the Great and, before Mar-
cus Aurelius, had been used to honor
Julius Caesar, Augustus, Domitian, and
Trajan. Such monumental bronzes were
placed on a significant site, perhaps
the town plaza or square, where they
were toppled as frequently as the men
they portrayed were discredited or
overthrown. Mistaken identity saved
Marcus Aurelius from destruction by
Christians who thought the sculpture
represented Constantine, the first
Christian emperor. Still unrecognized
during the 15th century, and still the
epitome of courage and leadership, this
larger-than-life-size bronze inspired
DONATELLO's *Gattamelata* (finished in
1453). Donatello's was not the first
equestrian representation since Roman
times—equestrian images were com-
mon on SEALS through the Middle Ages,
and the renowned 13th-century Ger-

man sculpture *Bamberg Rider* (c. 1230–37), at the Bamberg Cathedral, is also an example—but it was the first bronze equestrian since ANTIQUITY. It was a point of reference for VERROC-CHIO's c. 1479–92 *Bartolomeo Colleoni*, but where Donatello's grim rider sits rigidly on his stolid, massive steed, Verrocchio's fierce general swivels in his saddle and stands in his stirrups on an animated horse. (Verrocchio's *Colleoni* was, in turn, the model for a much replicated statue of Joan of Arc, c. 1874, by Emmanuel Fremiet.) Hubert Le Sueur's 1633 equestrian statue of Charles I, who was beheaded in 1649, narrowly missed being melted down after Cromwell's men found it and sold it by the pound at "the rate of old brass." The brazier who bought it made a fortune on fake relics, but kept the statue intact. Charles II rescued and installed it at Charing Cross overlooking the execution site, where, to this day, every January 30 the Royal Stuart Society holds a wreath-laying ceremony to commemorate Charles I's death. In 1654, BERNINI compensated for the mistaken identity of *Marcus Aurelius* with a marble statue, *Constantine*. Bernini sculpted an ecstatic, astonished rider, mounted on a high-spirited, rearing horse, who has just seen a vision of the Cross. The problem of a rearing horse and how to stabilize it had long tantalized sculptors. Bernini's marble horse was set in front of a wall and actually attached to it. (LEONARDO's earlier design of a rearing horse, for the SFORZA family, was never cast.) In the mid-17th century, the rearing-horse problem was finally resolved by a Florentine sculptor, Pietro Tacca (c. 1577–1640), who was working on a monumental bronze equestrian of and for Philip IV, based on a design by VELÁZQUEZ. Tacca wrote to GALILEO for advice. The solution: Use the horse's tail as a prop. On two legs and a tail, braced internally with iron supports and anchored to the ground, Philip remains dramatically poised to oversee the Plaza de Oriente in Madrid, where the statue was placed in 1844. Such equestrian longevity is an exception to the rule; the vandalism of the French Revolution, during which all equestrian monuments of royalty were destroyed, is more typical.

Equestrian figures rendered on canvas and paper drew on sculpted predecessors; one of the most spectacular equestrian images—though not of a ruler—is DÜRER's 1513 ENGRAVING known as *Knight, Death, and the Devil* (although Dürer called it simply *Rider*), which followed Donatello, Verrocchio, and other Italian precedents. In the 16th century, TITIAN observed this tradition with his portrayal of Emperor Charles V (1547) in full armor, lance in hand, horse prancing, as did RUBENS and most artists called on to elevate nobility. For his work at the Spanish court, Velázquez not only painted rulers and a very young prince on their horses, but he also made equestrian paintings of the royal ladies, whose brocaded skirts covered over more than two-thirds of the bodies of their mounts. Even more famous than the *Charles I* by Le Sueur are van DYCK's equestrian paintings of Charles I, especially *Charles I Dismounted* (c. 1635), which takes the equestrian honorific a step further: Charles now stands in front of his horse, which bows its head deferentially. While most equestrian images of

the 19th century followed earlier conventions, Jacques-Louis DAVID's painting of Napoleon crossing the Alps (*Napoleon at Saint Bernard*, 1800) takes on an extraordinary life of its own. Though the painting is basically the rearing-horse type, David fills the canvas with horse and gesturing commander. Napoleon's gold cape is whipped by his putative speed, the horse's mane and tail swirl in an extravaganza of heroic excess—a vibrantly painted quotation from Leonardo's and Bernini's equestrian ideas. David's *Napoleon* seems a melodramatic parody, but was not meant to be. The heroic equestrian convention is subverted, however, by the sculptor MARINI, whose naked horsemen on rudimentary steeds, pathetic and sometimes humorous, seem to skip backward from the mid-20th century over the entire history of art to restore the horses painted on the walls of prehistoric caves.

Ergotimos
See FRANÇOIS VASE

Ernst, Max
1891–1976 • German • painter/sculptor • Dada/Surrealist

A ready-made reality, whose naive destination has the air of having been fixed, once and for all (a canoe), finding itself in the presence of another hardly less absurd reality (a vacuum cleaner), in a place where both of them must feel displaced (a forest), will, by this very fact, escape to its naive destination and to its identity . . . : canoe and vacuum cleaner will make love.

Ernst launched the Cologne, Germany, DADA group using his name to call it Dadamax. He introduced COLLAGE and MONTAGE to the Dada vocabulary with an appropriately non sequitur rationale, as explained in the 1936 text quoted from above. By using a drawing of a beetle upside down to represent a boat in the collage *Here Everything Is Still Floating* (1920), Ernst plays with metamorphosis as well as nonsense. He moved on toward SURREALISM with the quizzical, inexplicable *The Elephant Celebes* (1921), a painting in which the elephant might seem to have the head of a bull on the end of its tail, if we could believe it was a tail and not a trunk, and an elephant, not a machine. It was inspired by a photograph of a Sudanese corn bin raised above the ground. A strong element of fear, reminiscent of de CHIRICO, is added to perplexity in Ernst's montage *Two Children Are Threatened by a Nightingale* (1924). The painted scene, in garish colors, is largely sky with a blast of yellow at the horizon, and small figures of a woman in distress and a man, poised on the roof of a shed, running with a child in his arms. Besides the heavy wood frame surrounding the picture, elements of the painting are constructed of wood, such as an open gate and the frame of the shed. In 1925 Ernst experimented with FROTTAGE. The idea came to him at a seaside inn as he studied the floorboards "upon which a thousand scrubbings had deepened the grooves." Placing a sheet of paper on the boards, he then rubbed black lead over them. "I was surprised by the sudden intensification of my visionary capacities and by the hallucinatory succession of contradictory images superimposed," he later

wrote. He equated the effect of contemplating frottage images to that liberation of the subconscious achieved by Surrealism's "automatic writing." Ernst also used photographs, as well as images from highly scientific texts, as resources, taking from them what and as he wished. Ernst was briefly interned by the Germans but escaped from France to the United States in 1941. *Europe After the Rain* (1940–42) expresses the post-Auschwitz, post–atomic bomb apocalypse. For it he used decalcomania, a Surrealist technique in which the artist briefly places a sheet of paper or glass on a newly painted surface. When the paper/glass is lifted, it leaves the painted surface textured in unpredictable ways. One of the most celebrated of Surrealist works, *Europe After the Rain* has been called "an altarpiece of the deluge."

Escher, Maurits Cornelius
1898–1972 • Dutch • graphic artist • Optical illusion

The border line between two adjacent shapes having a double function, the act of tracing such a line is a complicated business. On either side of it, simultaneously, a recognizability takes shape. But the human eye and mind cannot be busy with two things at the same moment, and so there must be a quick and continual jumping from one side to the other. . . . This difficulty is perhaps the very moving-spring of my perseverance.

Escher traveled frequently in Europe, especially Italy, drawing whatever caught his interest. But it was his trip to Spain in 1936, where he made detailed copies of Moorish MOSAICS in the Al-hambra and in the mosque La Mezquita at Córdoba, that he was inspired by the repetitive, overall designs of ISLAMIC ART. His own experiments with repetition used recognizable figures, such as birds and fish. These confound a viewer's distinction between background and foreground. Beyond investigating optical perception, Escher's work is concerned with mathematical, scientific, and often philosophical principles. His *Hand with Reflecting Globe* (1935), a LITHOGRAPH, is a self-portrait in which his hand, in the foreground, holds a reflecting sphere. He and the room in which he sits are reflected with the distortion of a convex surface. His face is locked in the exact center of the globe. Escher said of it, "No matter how he turns or twists himself, he cannot get away from that central point: the ego remains immovably the focus of his world." He also commented, "All my works are games. Serious games." Escher's prints are prized by mathematicians and scientists.

Escorial
Spanish power was at its zenith during the last half of the 16th century. Philip II (reigned 1556–98) made Madrid his capital and permanent residence and built the great monastery-palace complex known as El Escorial (1563–84). It is named for the village outside the city where it is located. Juan de Herrera (1530–1597) took over from the original architect, changing his BRAMANTE-inspired design for a more severe, granite structure; Philip had instructed him, "Above all, do not forget what I have told you—simplicity of form, severity in the whole, nobility without arrogance, majesty without ostenta-

tion." The rectangular compound, enclosing numerous governmental, religious, and other buildings, stresses its horizontality, is enormous in scale, and has exquisite granite stonework. Philip had VIGNOLA and PALLADIO consulted for the church, and Herrera carried out the design with their CLASSICAL recommendations in mind. Van der WEYDEN's *Deposition*, also known as the *Escorial Deposition* (c. 1435–42), is listed in the inventories of the Escorial in 1574, and Philip also owned paintings by BOSCH. Other major artists whose works were collected at Escorial over the centuries include VELÁZQUEZ, RIBERA, and El GRECO.

Este family

By the mid-13th century, Ferrara, a city in the lowlands of northern Italy near the Po River, was subject to the power of the Este family. It remained their stronghold until 1598. The Este dukes, especially Niccolo III (1383–1441) and Lionello (1407–1450), supported a cultivated court and many artists, including PISANELLO, Jacopo BELLINI, ALBERTI, PIERO della Francesca, and MANTEGNA. Even the NETHERLANDISH artist van der WEYDEN worked for them. A Ferranese school flourished under their patronage, though its artists are less well known than those listed above. The three most important are Cosimo Tura (c. 1430–1495), Francesco del Cossa (c. 1435–1476/77), and Ercole de' Roberti (c. 1455/56–1496). According to Frederick Hartt, "The utter flatness of Ferrara and its surroundings, the absence of anything that might be called landscape, the comparative dullness of the wide, straight streets and low houses, seem to have

had the effect of spurring the painters to great imaginative efforts." Of the Estes, the most imaginative, as far as patronage is concerned, was Isabella. She married Francesco GONZAGA and in Mantua, the Gonzaga domain, she had a "grotta," or cave, built—which was really a glorified study in which she kept her collections that ranged from CLASSICAL sculptures, gems, coins, and medals to manuscripts. She assigned pictures with mythological subjects to PERUGINO, CORREGGIO, BRONZINO, and Mantegna. Mantegna had earlier painted the illusionistic ceiling of the *Camera degli Sposi* for her Gonzaga grandfather-in-law. In one of Mantegna's paintings for Isabella, Mars embraces Venus while her husband gesticulates on the sidelines; historians discuss the significance of this portrayal in relation to Isabella's personal affairs. Rumor aside, she was a highly educated, interesting, and accomplished woman.

Estes, Richard

born 1936 • American • painter • Photorealist

I'm not trying to reproduce the photograph. I'm trying to use the photograph to do the painting.

Using a combination of oil and synthetic paints, along with photographs he has taken himself, Estes zeroes in on the commercial, urban scene in such pictures as *Candy Store* (1969). Every item in this storefront display—boxes of popping corn, trays of fudge and peanut brittle, cans of peanuts—is seen through sparkling clean plate glass. The glass even reflects people passing and cars parked across the street. The style,

called alternately PHOTOREALISM and New Realism, grows out of POP ART, but as Estes commented in the same interview in 1972 from which the excerpt quoted above is taken, "the trouble with pop was that it made too much comment. A very sophisticated intellectual game type thing." While perhaps not so politically suggestive, Estes's paintings are extremely sophisticated, FORMAL compositions in terms of his choice of viewpoint, detail, and colors. His selection of subjects is thought-provoking beyond the image presented: *Candy Store* is not merely an accurate depiction of a store front; it is a commentary on excess. In a sense his paintings are 20th-century TROMPE L'OEILS, but rather than fooling the eye to think it is looking at a real object, the painting deceives the viewer into thinking it is a photograph.

etching

This is a form of INTAGLIO printing in which the metal surface used to print is given an acid-resistant coating. Instead of cutting directly into the metal, the artist draws an image on the coating, thus exposing the metal beneath it to penetration by acid. This acid will "bite" the plate only where the lines of an image are wanted. Gradations in the depth of the etched lines are controlled by "stopping," taking the plate out of the acid at different times, and varnishing the lines that have reached the desired depth to prevent further biting when the plate is resubmerged. When the coating is entirely removed, the image etched onto the plate remains. In all intaglio printing the lines cut into the plate are filled with ink, which is then transferred, under pressure, onto paper.

In soft-ground etching, the artist draws on a sheet of paper that is placed over the coated plate. At the same time that the pressure of the pencil makes its impression, so too does the texture of the paper; thus, the mark on the ground, and consequently on the plate, and subsequently the print, depends on whether the paper was fine (giving a sharp, clean line) or rough (giving a thicker, grainy line).

Etruscan art

Prior to the rise of Rome, the cities of Etruria dominated a region of central Italy between Florence and Rome, named Tuscany after their inhabitants, the Etruscans. The ancient Greek historian Herodotus wrote that they migrated to Italy from Asia Minor, but scholars disagree about that. Etruscan civilization reached its peak in the 7th and 6th centuries BCE when, for a time, they challenged the power first of Greece, then of Rome. Never unified, the squabbling Etruscan cities fell to the Romans during the 5th and 4th centuries BCE. Greek art was admired and imported into Etruria (see FRANÇOIS VASE) and Greek influence is seen in Etruscan art. But it had its own integrity and character, recognized in objects like the "CAPITOLINE" WOLF and the *Chimera*. Etruscan funerary art and practices were especially impressive, both for reproducing underground pseudo-domestic architecture with carved replicas of household items and for decorating the walls of burial chambers with painted banquet scenes and animals. Until recently scholars were primarily concerned with uncovering what Etruscans derived from Greek works of art and artists, but current re-

search pays attention to ways in which Roman art followed Etruscan models.

Euphronios
late 6th century BCE • Greek • vase painter/potter • Late Archaic

We cannot know what led Euphronios to turn from decorating vases to shaping them. A mishap; change in eyesight—there were no spectacles to correct such changes; the legitimate desire for a still better living. He may have actually preferred shaping vases to decorating them. Like many other vase-painters he had been trained in both branches from a boy, was master of both crafts; and when the opportunity came, or the blow fell, he dropped the brush and devoted himself to the potter's art.
(J. P. Beazley, 1944)

BEAZLEY's commentary on, and speculation about, the artist who has been named Euphronios illuminates both the complicated process of identifying anonymous Greek vase painters and the historic prejudice, in Western culture at least, of giving precedence to painters over craftspeople. That was not necessarily the case in the 6th century BCE. As Beazley also comments, "That Euphronios the painter is the same as Euphronios the potter is not proved, but highly probable." Once ground had been broken by the ANDOKIDES PAINTER, Euphronios was among the pioneers of the RED-FIGURE TECHNIQUE. His great strides in the study of anatomy, musculature, and movement made him famous in his day. The scene on a KRATER, *Hercules Strangling Antaeus* (c. 510 BCE), is attributed to Euphronios. (See also POTTERY)

Euthymides
active c. 500 BCE • Greek • vase painter • Late Archaic

Euphronios never did anything like it.

The inscription above is on an AMPHORA decorated by Euthymides. It is usually interpreted as a boast and a challenge, a "cry of envy and hate wrung from a jealous and despairing rival," as BEAZLEY writes. However, Beazley himself demurs: "I take it rather to be the sort of good-humored vaunt that a young man gaily tosses to his friend; and I dare say I shall have the support of those who are young, or have not yet quite forgotten the insolence of their generous youth." Whatever the tone of the claim, it was made just before the end of the 6th century BCE when, like his rival EUPHRONIOS, Euthymides explored the RED-FIGURE TECHNIQUE and investigated human poses. On a vase named *Revelers* (c. 510–500 BCE), Euthymides painted a comic scene of drunken dancers, presenting them in motion, turning and twisting, and as seen from the side, front, and back. (See also POTTERY)

Evans, Walker
1903–1975 • American • photographer • Social Documentary

[I am] a penitent spy and an apologetic voyeur.

During the Great Depression, the photographer Evans and the writer James Agee were sent on assignment by *Fortune* magazine to Alabama, where the two lived with a poor farm family and documented the family's life in words and photographs. Their book, *Let Us Now Praise Famous Men,* was pub-

lished in 1941. Like LANGE, Evans took photographs both of people and of empty places that strongly characterize the people who are missing. *Washroom and Dining Area of Floyd Burroughs' Home, Hale County, Alabama* (1936) is an empty room. It is a sophisticated abstract composition as well as a scene evocative of the sharecropper's stark life. Evans's comment about himself, quoted above, was made in connection with a series of subway portraits he took surreptitiously, with hidden camera, in 1938 and 1941. He anticipates the accusations of exploitation and the questions of privacy contemporary scholars raise regarding photography with a purpose of social documentary.

ex voto

Refers to an offering donated to a shrine, usually of a saint, either in thanks for a favor done or in supplication for divine help. Artists such as CHAMPAIGNE and KAHLO have adopted the ex voto, a form of popular worship, for their personal expressions.

Exekias

active c. 550–525 BCE • Greek • potter/vase painter • Archaic

Even in the vase painting of Exekias, whose ability to convey dramatic tension sets him apart from most Archaic artists and links him to the Early Classical period, we do not so much see *the emotional experience of the figures represented as* intuit *it from the subtle brilliance of the composition.* (J. J. Pollitt, 1972)

Both potter and painter, Exekias is considered the greatest of the BLACK-FIGURE vase painters. His most impressive example, a KYLIX (drinking cup) decorated with a picture called *Dionysus in a Sailboat* (c. 540 BCE) on the inside surface, shows an important advance in concept: The white sail is painted as if it were actually billowing with the force of the wind. Thus, Exekias moved beyond rendering a flat, symbolic representation of a sail to showing a more naturalistic look of one. As the historian J. J. Pollitt remarks in the above quotation, such details are an advance from the rigidity of conventional ARCHAIC representations, adding expression to the scene. In this case, the picture seems to illustrate a line of Homer's poem describing a voyage of the god of wine, Dionysus: "But soon an offshore breeze blew to our liking—a canvas-bellying breeze. . . ." Also well known among Exekias's paintings is *Ajax and Achilles Playing a Board Game,* the scene on a vase now in the Vatican.

exhibit/exhibition

The Latin roots of the word "exhibit" mean "to hold" and "out"; in other words, "to show." Exhibits at a MUSEUM may draw entirely from the institution's own collections, or, using its own holdings as a basis, borrow complementary works from other museums. Some exhibitions open and close at a single museum; others travel, both nationally and internationally. The size and importance of exhibitions vary from a small show of a private collector's Japanese prints, for example, to a "blockbuster" such as the CÉZANNE exhibition of 1996 that traveled from Paris to London to Philadelphia. Exhibition themes may focus on a narrow time period, as did *The Search for*

Alexander of 1982–83, about Alexander the Great, or on a single artist, as did the Cézanne show and that of HOMER of 1995–96. Each such major exhibition takes years to organize and requires enormous skills of negotiation on the part of the borrowers (and often reciprocal lending or offers of restoration in exchange for the loan). Considering risks of loss and damage, and the fact that many visitors come specifically to see them, museums are reluctant to lend their most valuable and famous objects. However, a successful major exhibition, well conceived, organized, and arranged, with important research informing the catalogue reader as well as the visitor, is a once-in-a-lifetime occasion to see significantly related works that are usually hundreds of miles, if not continents, apart. The disadvantage is that mammoth exhibitions have become so popular, drawing such huge crowds (as did the 1996–97 VERMEER show in Washington, D.C.), that it becomes nearly impossible to see them with contemplative leisure and, considering Vermeer's small canvases, difficult to see them at all. (See also CURATOR and CATALOGUE) Unprecedented and promising during the last decade of the 20th century, "virtual" exhibitions have become available electronically. They have the advantage of making temporary exhibits more permanently available, and of bringing distant collections to one's own computer screen. (See also SALON, MUSEUM)

Existentialism

An ethical and philosophical point of view that is concerned with the individual's isolation in an irrational, unpredictable, and often hostile world. Existentialism, which influenced numerous artists during the 20th century, stresses the individual's responsibility for his or her choices and actions. Jean-Paul Sartre (1905–80) was a foremost Existentialist philosopher.

Expressionism

Among those terms (e.g., ROMANTICISM, IMPRESSIONISM, SYMBOLISM, and REALISM[2]) that have different significance depending on whether or not they are capitalized, expressionism (with a lowercase *e*) describes artistic work that is, indeed, emotionally expressive—GRÜNEWALD's horrifying *Isenheim Altarpiece* (1512/13–15) is a prime example. Modern Expressionism, as a self-conscious movement, is traced to the supreme individualism and self-expression of two contemporary, albeit very different, 19th-century artists—van GOGH and GAUGUIN. From the beginning of the 20th century, Expressionism is used most specifically to characterize the pre–Nazi era art of Germany and Austria. Writers important to the movement were RIEGL and Wilhelm Worringer, who incorporated Riegl's thoughts about subjective, spiritual intent with more psychologically based theories of empathy. Worringer became a great supporter of Expressionist painters. In Germany, Die BRÜCKE, Der BLAUE REITER, and NEW OBJECTIVITY fell under the umbrella of Expressionism. Since the intention, or essence, of Expressionism is to give external form to inner feeling, it follows that individual styles and techniques used for that visible form vary widely. In America, Expressionism came into its own as ABSTRACT EXPRESSIONISM.

Exquisite Corpse (*corps exquis*)

A process in which several people contribute to a common text or drawing without seeing what others have done. *Corps exquis* was a conceit of SURREALISM devised by André Breton, and named for an instance in which several people, unaware of the context to which they added words, ended with the phrase "the exquisite / corpse / shall drink / the bubbling / wine." In the realm of imagery, the practice produced unexpected poetic associations that could not have been obtained in any other way.

Eyck, Jan van

c. 1395–1441 • Netherlandish •
painter • Northern Renaissance

Als Ich Chan

Translated as "I can" or "to the best of my ability," the words above are van Eyck's personal motto. In the early 15th century, when van Eyck appeared on the scene, royal courts were still strong and still provided the main patronage of art in Northern Europe; but they were changing. In the retinue of Philip the Good, Duke of Burgundy (now Belgium), noble courtiers were being replaced by functionaries drawn from the generally rising middle classes. As these individuals gained their wealth and power, they enlarged and commemorated their prestige by supporting the arts. As a painter in the Burgundian court in Bruges, van Eyck was kept busy with all manner of assignments, from interior decoration to designing processional floats and food extravaganzas. Philip even used him as a special envoy to foreign countries. The first great work of art with van Eyck's name on it,

Altarpiece of the Lamb (c. 1423–32, and also known, from its location, as the *Ghent Altarpiece*), was not, however, for the court. It was begun by his brother, Hubert, who had died by 1426, and was finished by Jan van Eyck. This was a large, multi-wing altarpiece that soon became internationally famous. Questions abound regarding which brother painted which panels, the meaning of its subject matter, and its intended appearance, for it has lost its original frame. While most of what van Eyck did at court was short-lived, the paintings that brought him enduring renown are extraordinarily, meticulously, and miraculously detailed works. This is "realism of particulars," rather than the realism of PERSPECTIVE that Italian artists of the same period were striving for. Van Eyck achieved "microscopic-telescopic vision," as PANOFSKY called it, made possible by his development and mastery of the oil GLAZE technique. Though van Eyck did not invent OIL PAINTING, as was once believed, he did perfect the use of transparent glazes that yield rich effects of light, color, and transparency. His approach to painting is consistent with the philosophy of NOMINALISM, which limits human understanding to what humans are able to see. The complex symbolism in his paintings inspires lively debate, whether the image is apparently secular (*Arnolfini Double Portrait*, 1434), overwhelmingly spiritual (*Lucca Madonna*, c. 1434–35), or a combination of the two (*Madonna with Canon George van der Paele*, 1436). Yet while his jewels and brocades look bona fide, his spatial relations were eccentric rather than rational. And if his church settings are specifically and in-

tricately detailed, they do not correspond with any real buildings. "How can we understand something so vividly realized and yet precious, mystical and, ultimately, ideal in its result?" the historian Craig Harbison asks. Among the answers Harbison proposes is that van Eyck and his PATRONS were struggling with a fundamental spiritual paradox: how to reconcile the importance to the Church of material wealth and beauty with the Christian idea that such wealth and beauty must be renounced in order to enter heaven.

F

Fabritius, Carel
1622–1654 • Dutch • painter •
Baroque

*Who does not mourn him on bended
knee / He who loves Pictura, Goddess
of Art / He was her favorite darling.*
Dirck van Bleyswijck, 1667

Fabritius's short career began as a student in REMBRANDT's studio and ended when he was just 32—he was killed when a gunpowder magazine exploded and destroyed much of Delft, and probably most of his paintings. The lines excerpted above are from a long poem which also asks: "Why, Death, did you have to take him prematurely / When he was painting so cleverly with his / distinguished brushes. . . ." His earliest dated work is from 1642, which means that by then he had left Rembrandt's studio, as pupils were not allowed to sign their own works. He took a great deal of the master's technique with him when he moved to Delft in about 1650—the broad, fluctuating stroke of the brush and thick paint. But instead of painting a portrait against a dark ground, for example, he would choose a light one, and his colors were more silvery than brown. His treatment of the atmospheric effects of clear daylight was another independent step. He was highly praised by his contemporaries for his PEEPSHOW BOXES with their PERSPECTIVE trickery. The little painting *Goldfinch* (1654), with its color harmonies, sense of composition, and confident brushwork, demonstrates why Fabritius has been called a link between Rembrandt and VERMEER.

Faiyum (also Fayum/Fayyum) portraits
In a fertile, cosmopolitan district some 60 miles south of Cairo, Egypt, called the Faiyum, CLASSICAL, Greco-Roman influence merged with local tradition. While the ancient Egyptian practice of covering a mummy case with a representation of the individual therein continued, the period of Roman occupation during the 2nd century CE brought a stylistic innovation that is seen in an extraordinary body of more than 1,000 mummy portraits. Unique, individualized paintings on wood, many in ENCAUSTIC, these show the NATURALISM of Classical influence, and yet the intense gaze of the large, dark eyes is non-Classical, perhaps even intentionally anti-Classical (see SUBANTIQUE). A late Faiyum portrait titled *Septimus Severus, Julia Domna, and Their Children, Caracalla and Geta* (c. 200 CE) may have been a souvenir of an imperial visit to Egypt. Geta's features

have been erased, perhaps because he grew up to be a ruthless dictator.

fakes/forgeries

Fakes must be distinguished from images that were made to emulate the look of a MASTER or a teacher, or to pay homage to the past—for centuries students have learned by copying what has gone before—and, in many instances, from works produced in WORKSHOPS. Artists who ran large workshops signed pictures and sculptures that had been executed by students according to their instructions, perhaps adding only the finishing touch themselves. Fakes and forgeries are works that are made to deceive people, usually for profit. Famous among deceivers is Hans van Meegeren (1889–1947), a Dutch artist who was tried and found guilty of forgery in 1947. Van Meegeren devised methods of painting over old canvases, using the kinds of PIGMENTS the original artist would have used, combining elements from two or three different works of the artist he was imitating and inventing methods that would give an antique look and qualities to his paintings. His most notorious success was with a painting he passed off as *Supper at Emmaus* by VERMEER; it was authenticated by a highly esteemed Dutch art historian and collector, Abraham Bredius (1855–1946)—Bredius was 82 and had bad eyesight at the time—bought by the Boymans Museum in Rotterdam, and celebrated in *The Burlington Magazine,* a leading art history journal. One of the vexing questions raised by a forgery is, Why does it lose value when it is the same work that was praised while its maker was believed to be famous?

Falconet, Étienne-Maurice

1716–1791 • French • sculptor • Rococo

The worthiest aim of sculpture— viewed from its moral aspect—is to perpetuate the memory of illustrious men and to give models of virtue. . . . When sculpture treats subjects that are simply decorative and pleasant, it has another, and an apparently less useful aim; but even then it is no less capable of leading the heart towards good or evil. Thus a sculptor, like a writer, merits praise or blame as the subjects he treats are decent or licentious.

Falconet was chief modeler from 1757 to 1766 at the Sèvres porcelain factory. Founded in 1738 and catering to the luxury trade, Sèvres began to set the high style in ceramics (see POTTERY) during the later 18th century. Perhaps under the influence of his mistress, Madame de Pompadour, Louis XV was the principal Sèvres shareholder in the 1750s, and among other artists who worked for Sèvres were PIGALLE, HOUDON, and CLODION. Falconet modified the exuberance of the BAROQUE and the extravagance of the ROCOCO, giving his figures a more restrained, CLASSICAL elegance. One of his best-known works (carved in marble) is an idealized figure of a woman with the portrait head of Pompadour: *Madame de Pompadour as the Venus of the Doves* (1757–66). Falconet was a friend of DIDEROT, who secured for him a commission for a statue of Czar Peter the Great. From 1766 to 1782, Falconet worked on a bronze EQUESTRIAN statue of the czar on a rearing horse. During his years in Russia, Falconet was the empress Catherine's artistic adviser. In

1761 he wrote his *Reflections on Sculpture,* and in 1781 his *Complete Works* was published.

fancy picture

The word "fancy" as used here refers to the imagination. A much quoted letter written by GAINSBOROUGH reads, "I'm sick of Portraits and wish very much to take my viol-da-gamba and walk off to some sweet village, where I can paint landskips and enjoy the fag-end of life in quietness and ease." His own *Going to Market* (c. 1769–71) is the sort of picture he was talking about. This idyll, with feathery trees and peasant figures as decorative as the scenery, is built not from nature but from the imagination. Fancy pictures were also portrait subjects dressed in costume, often an aristocratic version of a peasant outfit.

Fantin-Latour, Henri

1836–1904 • French • painter • Academic/Impressionist Circle

I am giving a lot of thought to a large painting . . . showing Manet, at the center, painting at his easel, his model posing in front of him, the two of them surrounded by friends, acquaintances, a lot of people in the studio. This strikes me as a fine, picturesque motif.

Fantin-Latour received his artistic training from his father, starting at the age of 10. He also studied with a little-known teacher, Lecoq de Boisbaudran, whose unusual instruction method was to focus on the development of memory, insisting that students concentrate on essentials and details and then reproduce images from memory. To that end Lecoq sent his students to copy masters at the Louvre, a practice that Fantin-Latour continued for many years. Fantin-Latour met and befriended both MANET and WHISTLER at the Louvre. He painted STILL LIFE flowers with meticulous attention to each petal. One composition, *The Betrothal Still Life* (1869), he presented to his fiancée, whom he did not marry until 1876. The picture Fantin-Latour is musing about in the quotation above is *Studio in the Batignolles* (1870), a large group portrait set in an unusually elegant studio inhabited by eight gentlemen in suits, waistcoats, jackets—one even wears a hat. The cast of characters includes Manet seated at the easel painting a portrait; also present are RENOIR, Émile Zola, BAZILLE, and MONET. Renoir is placed so that his head is enclosed by a picture frame that hangs on the wall behind him. Absent are DEGAS, who probably declined the opportunity, and Fantin-Latour himself, who was the least avant-garde among the painters with whom he associated—working among IMPRESSIONISTS, he remained true to tradition in his own paintings. The work is also widely known as *Homage to Manet,* and it was favorably received at the SALON of 1870. Later in his career Fantin-Latour became quite experimental in his musical evocations, especially the operas of Richard Wagner.

Farnese Hercules

A gigantic (almost 10½ feet high) marble figure of the nude Hercules. It is considered an early-3rd-century CE marble copy by the hand of an Athenian sculptor, Glycon, after an original 4th-century BCE work by LYSIPPOS. It is believed to be an enlargement of the original, and scholars think that this

Hercules was taken from Athens to Rome by the emperor Caracalla. The figure is a weary hero resting on his club, holding the apples of the Hesperides. It was excavated from the Baths of Caracalla in 1540, and the missing hands and legs were sculpted by Guglielmo della Porta (died 1577) at MICHELANGELO's recommendation. Guglielmo did such a good job that when the original limbs were later found, it was decided to leave the substitutes in place. In 1787, however, the antique limbs were reattached. An engraving (c. 1592) by Hendrick Goltzius (1558–1617) of the figure's back, seen as if from below, dramatically illustrates the superhuman strength of the calves, buttocks, and back muscles. This *Hercules* and the *Farnese Bull*—a pyramid of human figures that seem to be wrestling a bull, also found in Caracalla's Baths—are named for the Farnese family, HUMANISTS and art PATRONS (Cardinal Alessandro Farnese became Pope Paul III in 1534). Their art collection (now in Naples) was in the Farnese Palace in Rome, designed by Antonio da Sangallo the younger (see SANGALLO) and Michelangelo.

Fauve/Fauvism

It was the violence of their colors and their untamed brushstrokes that led to a group of young artists becoming known as the Fauves, which means "wild beasts." Specifically, at the SALON D'AUTOMNE exhibition in 1905 the critic Louis Vauxcelles pointed to a statue that looked like a 15th-century sculpture and said, "Donatello among the wild beasts." (There is speculation that Henri ROUSSEAU's painting *The Hungry Lion* inspired the comment.) The name

caught on and has continued to refer to works of artists including MATISSE, DUFY, DERAIN, VLAMINCK, and BRAQUE. The rationale of Fauve color is its expressiveness, rather than its truth to "local" or actual color. However, Matisse, the central force of the movement, formulated his underlying belief with these words: "An artist must recognize that when he uses his reason, his picture is an artifice and that when he paints, he must feel he is copying nature—and even when he consciously departs from nature, he must do it with the conviction that it is only the better to interpret her." Thus, while the Fauve palette was liberated from convention, it was still built on the foundation of interest in the natural world. By 1908 the Fauve movement, as such, came to an end, though its influence persisted.

Federal Art Project
See WORKS PROGRESS ADMINISTRATION (WPA)

Federal Style
Term used to designate American art and culture from roughly the end of the Revolutionary War (1783) to about 1830. Even though Britain had been their foe, American artists went primarily to London for instruction in art during this period. They brought home the GRAND MANNER of painting that was rooted in Greco-Roman antiquity and the European old masters, but usually directed it to the glorification of the new nation. However, as artists such as TRUMBULL and VANDERLYN discovered, Americans in general were less enthusiastic about the Grand Manner than they were interested in having their portraits painted.

Feininger, Lyonel

1871–1956 • German/American •
painter • Expressionist

*Together let us desire, conceive and
create the new structure of the future,
which will embrace architecture and
sculpture and painting in one unity,
and which will one day rise toward
heaven from the hands of a million
workers like the crystal symbol of a
new faith.* (The Bauhaus, 1919)

The son of German musicians, born in
New York, Feininger went to Germany
in 1887 to study music. He became an
artist instead, and developed an idio-
syncratic style of CUBISM, expressing
architecture, boats, and the ocean
as faceted, geometric structures. Unlike
many of his contemporaries (e.g.,
NOLDE and MARC) who used brash and
bright colors, Feininger built his images
with delicately modulated colors. He
was allied with no single school or style
of art but borrowed from many. In
1919 Feininger became associated with
the BAUHAUS. The idea of the cathedral
as representative of the Bauhaus uto-
pian ideal is synthesized in Feininger's
starlit *Cathedral of the Future* (1919), a
woodcut that was used as the title page
of the first Bauhaus "Manifesto," from
which the quotation above is excerpted.
He returned to the United States in
1937.

Feke, Robert

1707–1752 • American • painter •
Colonial

*Of native-born painters before Copley,
Robert Feke was the most
accomplished. But less is known about
him than any eighteenth-century artist
of like importance. . . . William
Dunlap, the Vasari of early American
artists, knew nothing about him.*
(Lloyd Goodrich, 1946)

The American-born successor to SMIB-
ERT, but self-taught, probably from
PRINTS and the example of Smibert's
paintings, Feke did not, however, have
the understanding of composition and
freedom with brushwork of the Euro-
pean trained artist. He depended pri-
marily on his own observations and in
doing so created a milestone of Ameri-
can painting, the first in the COLONIAL
STYLE, *Isaac Royall and His Family*
(1741). While it is based on Smibert's
*Bermuda Group (Dean George Berke-
ley and His Family; 1729)*, it is more
carefully attentive to material texture
and details of fabric—accurate repre-
sentation of the visual world, not of
ideas or feelings. This will become even
more apparent in his successor, the first
outstanding Colonial artist, COPLEY.
Despite his significance, as the historian
Goodrich comments above, Feke's life
is little known.

Feminist art

During the late 1960s and early 1970s,
what was then called the Women's Lib-
eration Movement brought to interna-
tional consciousness the oppression
under which women had lived for cen-
turies. As women gathered everywhere
to break down barriers to their inde-
pendence and success, artists and their
supporters also organized. Different ap-
proaches predominated: In the United
States, women on the East Coast con-
centrated on the institutional sexism
and economics of the art world. Their
efforts included establishing coopera-

tive galleries devoted to showing the work of neglected women (e.g., NEEL). Women Artists in Revolution (WAR), started in New York in 1969, was the first women's art organization. The critic and artist LIPPARD was an important, constructive force in protesting the exclusion of women and in increasing awareness of their work in museums and galleries. On the West Coast, education and female consciousness were foremost: In 1971, Judy CHICAGO and Miriam SCHAPIRO, both teachers, established the first Feminist Art Program in the country to train women at the new California Institute of the Arts (CalArts). They also initiated an unusual project, *Womanhouse*, in 1972, designed to express women's strongest desires and greatest fears. They rented a house along the Los Angeles freeway that was slated for demolition, and Feminist Art Program members decorated it with evocative images: a macramé web in the hallway, perhaps to signify the way women were trapped in their houses; repellent images of eggs turning into breasts on the ceiling of a pink kitchen; a mannequin trapped in the linen closet. *Womanhouse* lasted only one month as the work of art they had created, but thousands came to see it and it symbolized a new era. This was the beginning of an effort that concentrated, at first, on bringing women into the mainstream. They supported collaboration rather than competition among artists. Soon feminists' goals evolved in favor of challenging and disrupting the "mainstream," or "establishment," rather than joining it. Initially the effort was to show that women were "as good as" or "the same as" men, but in the next step stereotypes and differences

were scrutinized. MENDIETA, for example, explored the traditional "mother earth" notion of women as closer to and representing nature while men, rational and intellectual, create culture. The photographer Barbara Kruger (born 1945) defied stereotypes with images such as *We Won't Play Nature to Your Culture* (1983), showing the head of a woman with leaves over her eyes. Feminists continue to challenge conventional definitions of art and to step over old boundaries of propriety (e.g., see Annie Sprinkles in BODY ART). In what is called the "second generation" of Feminist artists, Mary KELLY's work is theoretical and philosophically oriented. Where first-generation feminists brought to light the historic and cultural biases that suppress women and then sought a female essence, the second generation rejects that as "essentialism" and disputes the very construction of gender. Kelly, for example, investigates how the "self" is constructed in social, ideological, and psychological terms in order to DECONSTRUCT assumptions about it. These artistic investigations are paralleled by developments in FEMINIST ART HISTORY.

Feminist art history

Historical, theoretical, and critical inquiries from a feminist perspective began in 1971 with Linda Nochlin's essay "Why Are There No Great Women Artists?" She turned attention to the social and institutional circumstances "at academies, systems of patronage, mythologies of the divine creator and artist as he-man or social outcast." With Ann Sutherland Harris, Nochlin assembled a momentous exhi-

bition and produced a catalogue entitled *Women Artists 1550–1950* (1976), which serves as a foundation for later research about women in art. This kind of early work in Feminist art history was "archaeological," bringing to the surface names and works of artists whose identity had been buried by neglect since the beginning of ART HISTORY. From this kind of detective work, Rozika Parker and Griselda POLLOCK turned to question the foundations of the discipline. Their book, *Old Mistresses: Women, Art, and Ideology* (1981), examines "the structures and ideologies of art history, how it defined what is and what is not art, to whom it accords the status of artists and what that status means." Using new approaches that consider GENDER and PSYCHOANALYTIC THEORY, they challenged, or "deconstructed," the standard framework on which the discipline was built. Over the decades Feminist approaches to art history have evolved into a discipline in its own right, introducing numerous and diverse methodologies, ideas, and language to the field of art and to criticism and theory. Key Feminist writers on art, in addition to those above, include Laura Mulvey (see GAZE); Norma Broude and Mary Garrard, who edited *The Expanding Discourse: Feminism and Art History* (1992); and LIPPARD, author of numerous critical works. As first- and second-generation Feminist artists disagreed about how to question the concept of gender and understand the "self," historians divide along similar lines.

femme fatale

This well known phrase, literally translated as "deadly woman," stands for a theme that became popular, if not obsessive, during the 19th century. The femme fatale was beautiful, seductive, and dangerous. She infiltrated opera (Wagner, Massenet, Strauss), theater (Strindberg, Wilde, GOETHE), poetry (BAUDELAIRE, Mallarmé, Keats), philosophy (Schopenhauer), and art. She was painted in the guise of Salome, Eve, Lilith (Adam's first wife), even the Madonna and a sphinx. But she need not be portrayed as a specific character; she was as much a general type as a particular individual. Her 19th-century persona was formulated in paint by members of the PRE-RAPHAELITE BROTHERHOOD, especially ROSSETTI and BURNE-JONES. Then SYMBOLISTS and painters of the ART NOUVEAU movement took up the theme—MOREAU, RYDER, MUNCH, KLIMT, and BEARDSLEY are examples. Her most powerful 20th-century incarnations are in the paintings of PICASSO (especially *Demoiselles d'Avignon,* 1907) and DE KOONING (his *Woman* series of the 1950s in particular). This neurotic, obsessive vision of woman as simultaneous temptress and destroyer finds articulation in the psychoanalytic theories of Freud toward the end of the 19th century, at the same time that it reached its peak in painting. Historically, it was also the period during which women were making a strong bid for political and economic power.

fête champêtre

From the French, literally a "rustic or rural feast," more generally translated as "a picnic." The best-known example is GIORGIONE's *Fête Champêtre* (also known as *Pastoral Symphony,* c. 1510), and the second best-known is MANET's

parodic interpretation of it, *Le Déjeneur sur l'herbe* (*Luncheon on the Grass; 1863*).

Feuerbach, Anselm
1829–1880 • German • painter •
Neoclassicist

To begin with, as lonely as I may feel, I still praise loneliness. I have a charming, elegant little room; my view is over trees, the sea, the tower of St. Mark's.

Feuerbach studied under COUTURE in Paris. He also lived for many years in Italy, as did other German artists. The group, which included BÖCKLIN and came to be known as the Roman Germans, seemed to express a longing for the ancient Mediterranean world. The quotation above is from a letter to his mother, from Venice, written in 1855. Feuerbach painted mythological scenes such as *Iphigenia* (1862) in the NEO-CLASSICAL style of his mentor. Iphigenia was a popular figure for painters, and her story seemed to obsess Feuerbach. She was the daughter of King Agamemnon, who, because he had offended the gods, was required by them to sacrifice Iphigenia. In the picture of 1862, his first on the subject, Feuerbach painted his mistress as Iphigenia. She is in a dreamy, melancholy mood, gazing off across the water at some imaginary place or scene.

Ficino, Marsilio
1433–1499 • Italian •
philosopher/humanist

This age, like a golden age, has restored to light the liberal arts that were almost extinct: grammar, poetry, rhetoric, painting, sculpture, architecture, music.

Marsilio's father was a physician and associate of Cosimo de' MEDICI during a period when the increasing interest in CLASSICAL studies was helped by an influx of Greek scholars to Italy—a result of the conquest of Greek Constantinople by the Turks in 1453. Cosimo chose to sponsor the education of Marsilio, an avid student, in Greek language and literature. After about seven years of study, Marsilio began to translate PLATO into Latin. The book appeared in print in 1492. In the meantime, Marsilio was made head of the Platonic Academy in Florence, founded by Cosimo in 1462. As a Neoplatonist (i.e., influenced by Plotinus as much as by Plato), Marsilio reconciled ancient pagan texts with Christian dogma; his interpretations were strongly tinged with mysticism. NEOPLATONIC philosophy suggested a universal religion of which Christianity may be the ultimate manifestation but is not the only one. Part of Marsilio's importance to artists of the ITALIAN (and eventually the NORTHERN) RENAISSANCE was that rationales such as his enabled the introduction of ancient pagan mythology into the repertoire of art. Thus, images such as BOTTICELLI's *Birth of Venus* (c. 1484) could be reconciled with stories of the Virgin. In *Platonic Theology* (1484), Marsilio wrote that man was "almost the same genius as the Author of the heavens," and such a concept enabled an artist like MICHELANGELO to consider himself divinely inspired, on a level with the Creator.

Field, Erastus Salisbury
See FOLK ART

figure/figurative

Refers to visually recognizable forms—humans, animals, plants, or objects. Figurative art is often called representational. While some ABSTRACT ART is nonfigurative and nonrepresentational (e.g., MONDRIAN's geometrical compositions), not all is. The human forms in PICASSO's *Three Musicians* (1921), a defining example of *Synthetic* CUBISM, are figurative.

Filarete (Antonio di Pietro Averlino)

c. 1400–c. 1469 • Italian • goldsmith/architect/sculptor • Renaissance

Images of saints should also conform to their historical character . . . and if you are doing a St. Michael slaying the devil, he should not look timid.

This artist took the name Filarete because, from the Greek, it means "lover of virtue." He was born in Florence and is thought to have been working in GHIBERTI's studio when the first Florence Baptistery doors were in progress. Filarete designed and cast the bronze door for Saint Peter's in Rome between 1433 and 1445. In his *Treatise of Architecture* (written 1461–64), he outlined some of the virtues he believed to be important: the rendering of PERSPECTIVE, the harmony of COLOR, and the propriety of expression and dress for saints, as in the quotation above. In fact, he was quite scornful of DONATELLO's bronze doors, about which he wrote, "If you have to make apostles, do not make them look like fencers, as Donatello did in *S. Lorenzo* in Florence." His love of virtue notwithstanding, Filarete was charged with the attempted theft of a relic (a head of Saint John the Baptist) from a church, and forced to leave Rome. In 1451, Francesco SFORZA called him to Milan, where he worked on the castle and the Ospedale Maggiore and wrote his treatise. In the end, however, he had a falling out with Sforza, and dedicated the book to Piero de' MEDICI.

fine art

The term "fine art" reflects an effort to distinguish the work of painters, sculptors, and architects from that of "craftsmen," especially members of a GUILD. This distinction came about during the RENAISSANCE when the "cult of genius" sought to elevate the intellectual and social status of the artist. During the 20th century, efforts to reverse the trend ranged from the "ready-mades" of DUCHAMP in the early 1900s to the appreciation of OUTSIDER ART in the 1990s. Questions remain, however, about whether to "raise" the status of people working in métiers such as crafts, photography, film, computer arts, and advertising, or simply to demystify the fiction of artistic genius. In any case, judgmental distinctions between "fine" or "high" art and "commercial," "applied," "decorative," "popular," or "low" art are no longer tenable.

First Style

See MURAL

Fischl, Eric

born 1948 • American • painter • New Realist

When viewers have trouble with my paintings, it's because there's frequently a staring outward at them

by the subject. It can produce an alarming intimacy.

With SALLE and SCHNABEL, in the 1980s Fischl became highly visible and highly controversial. Not only is there a raw sexuality in his paintings, but also they allude to acts of voyeurism, incest, pedophilia, and bestiality within a middle-class, suburban ambience. Moreover, his canvases are enormous—e.g., *Bad Boy* (1981), 8 feet long and 5½ wide, with a naked woman whose genitalia are fully exposed to a young boy—which makes them that much more confrontational. "A precision of composition and figuration is what I'm working toward," Fischl has said. He added, "Art should create an experience. This is hard to do in abstraction. But it's what makes representation relevant and dramatic for me."

Fish, Janet
born 1938 • American • painter • Photorealist

. . . Janet Fish introduced new subjects into realist painting. (Whitney Chadwick, 1990)

Fish assembles STILL LIFE compositions and paints her objects with highly reflective surfaces that assault a viewer with something that verges on blinding light. *Three Pickle Jars* (1972), a picture of three glass home-canning jars, is an example of her hyperrealistic technique: The jars are brilliant beyond their real-life counterparts. At the same time, as an ironic commentary on their late-20th-century style, they allude to an old-fashioned process of preserving food. And, as the historian Chadwick comments above, they bring to art a

subject we are unaccustomed to seeing there. Later, in a painting of 1990 entitled *Man's Best Friend,* Fish's brilliantly colored fruits, flowers, and fabrics have a similarly aggressive impact on the eye, and an ironic effect results from a dog scratching itself on an Oriental rug, juxtaposed with the image of a man that decorates the belly of a vase. This painting is an example of POSTMODERN ambiguity.

Flack, Audrey
born 1931 • American • painter/sculptor • Feminist/Photorealist

For me art is a continuous discovery of reality. I believe people have a deep need to understand their world and that art clarifies reality for them.

Flack's large paintings fit into the PHOTOREALISM category according to definitions of technique and affect—highly finished, sharp edged, minutely detailed—but unlike most Photorealist work, hers is not cool or detached. On the contrary, it is autobiographical, even confessional—it is about things and people she cares for. *Marilyn (Vanitas),* of 1976–77, uses classical symbols of VANITAS compositions of the BAROQUE period—flower, candle, timepiece—along with photographs of Marilyn Monroe. "We were touched by some deep pain and beauty in her," Flack said of the movie star. Included in her painting is a photograph of herself as a child. In the 1990s Flack changed her focus from painting to large sculpture, all of women as powerful figures.

Flamboyant style
See GOTHIC

Flavin, Dan

1933–1996 • American • sculptor •
Minimalist

*. . . the actual space of a room could
be disrupted and played with by
careful, thorough composition of the
illuminating equipment.*

A leading Minimalist sculptor, Flavin
moved sculpture from figurative, CU-
BIST vocabularies to definitions of space
itself in INSTALLATIONS. The medium he
used was light, usually tubes of fluores-
cent lamps parallel and adjacent to one
another, in varying colors, numbers,
and sizes. Installed in rooms, their effect
was emotional, sometimes striking a
single chord, other times symphonic in
effect. He was generous, if not extrava-
gant, in dedicating his works to every-
one from TATLIN, the CONSTRUCTIVIST,
to the workers who installed them, and
to his golden retriever. Considering his
attraction to light, Flavin recollected
being an altar boy "curiously fond of
the solemn high funeral Mass, which
was so consummately rich in candle-
light, music, chant, vestments, proces-
sions and incense."

Flaxman, John

1755–1826 • English •
sculptor/illustrator/designer •
Neoclassicist

*The lines of Grecian composition
enchant the beholder by their harmony
and perfection.*

Flaxman's father made casts of plaster
molds for the Wedgwood Pottery, a
firm founded in Staffordshire, in 1759,
that became the most important English
pottery. Their frieze motifs were, and
are to this day, refined copies or adap-

tations of CLASSICAL Greek and Roman
designs. John Flaxman began studies at
the Royal Academy when he was 15,
and also worked for the pottery. He
was sent by Wedgwood to Rome, where
some of the company modelers worked.
A Chair of Sculpture was created for
Flaxman at the Royal Academy in
1810. However, his important influ-
ence on fellow artists (e.g., INGRES) was
via his illustrations of works by Homer,
Aeschylus, Hesiod, and Dante. In each
he chose an episode with a moral mes-
sage and made delicate line drawings
that were inspired by Greek vases. He
fused classical themes with a Christian
pathos that appealed to German artists,
especially the NAZARENES.

Flemish art
See NETHERLANDISH ART

Flinck, Govaert

1615–1660 • Dutch • painter •
Baroque

*In the burgomasters' room, above the
mantelpiece, on the side of treasury, by
Govaert Flinck, 1500 guilders.*
(Contract, 1655)

During the year he spent as one of REM-
BRANDT's students in the 1630s, Flinck
mastered his teacher's technique so that
some of his paintings were sold as au-
thentic "Rembrandts." In the 1640s he
abandoned the master's manner for a
lighter and more fashionable style. He
became very popular, and acquired
commissions from the ruling class that
escaped (or were not sought by) Rem-
brandt. Indeed, Flinck attracted more
patronage, especially for portraits, than
did any of his Amsterdam contempo-
raries. In 1656 he received the most im-

portant commission awarded to any Dutch painter of the 17th century—a series of 12 paintings for the new town hall, described in the quotation above. Their subject was the revolt led by Julius Civilis, leader of the Batavians (ancestors of the Dutch people), against the ruling Romans. This battle was seen as a metaphor for the recent War of Independence against Spain. Rembrandt was given only one of the pictures in the project (which was divided among a group of artists that included BOL and LIEVENS). Flinck died before he could execute his commission.

Fluxus

A loose group of artists formed in 1962 by George Maciunasz, an American, with Wolf Vostell, a German, and the Korean-American PAIK (who later became a renowned VIDEO artist). Maciunasz described Fluxus as "a fusion of Spike Jones, gags, games, Vaudeville, Cage and Duchamp." Fluxus was founded in Wiesbaden, Germany, but Maciunasz, its guiding light, moved to New York, where the movement peaked between 1962 and 1964. Much of its activity, like HAPPENINGS, involved single performances, for example, Paik's *Étude for Pianoforte* (1960), in which he broke off playing a Chopin *Étude,* burst into tears, and leapt into the audience, where he cut off John CAGE's tie and poured shampoo over him. In other works, Fluxus stressed multiples, printed ephemera, posters, and newspapers as its sources.

Folk art

There is no agreement regarding the definition of Folk art. Terms often used interchangeably are "vernacular," "primitive," "popular," and "naive," but they are unsatisfactory to the extent that they bear intimations of lack of skill, education, or knowledge of a "higher" art. Folk art is distinct from OUTSIDER ART and ART BRUT in that the latter are often driven by a rejection of tradition or HIGH ART, which is not the Folk artist's concern. Most Folk artists of the past were anonymous, but not all. In America, "mourning pictures" of bereaved family and friends weeping at the grave of the departed were a popular form of Folk art, and the name of Eunice Griswold Pinney (1770–1849) stands out among its practitioners. Quilts and other needlework, carvings, buildings such as barns—and their decorations—are in the Folk art category. American painters known as Folk artists include Ammi Phillips (1788–1865) and Erastus Salisbury Field (1805–1900), both of whom worked on the East Coast. Their portraits are straightforward documents, without artifice but with earnest intent. HICKS—painter of signs and numerous variations of Peaceable Kingdom images—MOSES, and PIPPIN were Folk artists. "Nonchalantly saying 'folk art,' we bring into collision a pair of short words heavily freighted with meaning . . . each word reaches back into time and pulls into the mind vast babbles of association," writes Henry Glassie, a scholar of American and international Folk art.

Fontainebleau

A town 37 miles southeast of Paris where FRANCIS I built one of his castles in the early to mid-16th century. Flo-

rentine artists ROSSO Fiorentino and PRIMATICCIO directed its decoration, bringing Italian MANNERIST style to the French countryside. CELLINI also worked there in a group that is known as the School of Fontainebleau. Later in the century, a second School of Fontainebleau, primarily French painters, worked under King Henry IV.

Fontana, Lavinia
1552–1614 • Italian • painter • Mannerist

If she lives a few years, she will be able to draw great profit from her painting, as well as being god-fearing and of purest life and handsome manners.
(Orazio Sammachini, 1577)

Women were admitted to the university of Bologna as early as the 13th century, and according to city records, in the 16th and 17th centuries 23 women were listed as painters, Fontana and SIRANI among them. Fontana studied in the studio of her father, Prospero Fontana, as did her husband, Gian Paolo Zappi, who assisted her in her successful practice. Sammachini, a friend and colleague of Fontana, made the comment quoted above when Lavinia was 25. She was fortunate to survive 11 pregnancies; however, most of her children died young. Fontana's best-known work, *The Stoning of Saint Stephen* (1603), was destroyed by fire in 1823. She also painted meticulous portraits of upper-class women wearing elaborate jewels and gowns, and often a marten skin hanging from a chain. Such animal skins were used to attract fleas away from the wearer's body and clothes. Of the 135 paintings by Fontana documented to date, less than half have been found, but it is still the largest oeuvre by a woman artist prior to the 18th century.

formal/formalism/formalist
As implied by the word itself, "formal" concerns the outward form or appearance of a work of art: its shape, contours, texture, color, composition, size, style—all those elements, in short, that can be described by looking at it. A formalist, in critical terms, is one whose study of art depends on its formal qualities. Most writers concerned with art, and artists themselves, have been formalists in one sense or another: from POLYKLEITOS and his *Canon* (5th century BCE), to THEOPHILUS and his instruction book, *On Diverse Arts* (c. 1100), to VASARI and his aesthetic judgments in *Lives* (16th century). In the 19th and 20th centuries, formalism underlay the comparative studies of WÖLFFLIN and the CONNOISSEURSHIP of BERENSON as well as GREENBERG's view of MODERNISM as vested in ABSTRACT EXPRESSIONISM. Greenberg and his "school" were determined to cleanse art of impurities, that is, any influence from outside its own medium. Thus, color—as an optical value and fact—was appropriate for painting, but storytelling, or narrative—a literary device—was not. "Formalism . . . is clearly the lingua franca of art criticism," the philosopher/critic Arthur Danto wrote in 1994, "and what is tacitly appealed to and contested in the issue of 'quality' that has lately so exercised the art world." Formalism is either supplemented or refuted by other approaches, such as ICONOGRAPHICAL,

CONTEXTUAL, and HISTORICISM, as well as PSYCHOANALYTIC, SEMIOTIC, MARXIST, FEMINIST, and numerous POSTMODERN analyses. Formalism is antithetical to NEW ART HISTORY.

Foucault, Michel
1926–1984 • French •
historian/theorist

In appearance, this locus is a simple one; a matter of pure reciprocity: we are looking at a picture in which the painter is in turn looking out at us. . . . And yet this slender line of reciprocal visibility embraces a whole complex network of uncertainties, exchanges, and feints.

In his wide-ranging studies Foucault has contributed greatly to the ideas and language of the NEW ART HISTORY. Foucault established a notion of "discourse"—large groups of statements—as the way in which knowledge is exchanged in society, keeping in mind that knowledge is associated with power. Discourse is articulated and disseminated according to conventions and systems. Thus, at a given moment in the history of the United States, for example, there will be a particular art historical discourse. Things have no meaning outside their discourse, though discourse can itself be used as tactical means to change discourses. Foucault shares some Poststructuralist attitudes, especially with regard to displacing the centrality of "man" in the HUMANIST project, and in undercutting the cult of genius surrounding art and artists (see STRUCTURALISM and POSTSTRUCTURAL-ISM). However, in contrast to dismissing the power of the author/artist as Roland Barthes does, and to rejecting distinctions of historical periods, Foucault describes the artist as one who circulates or promotes the discourse of his or her era. The sense of Foucault's ideas is contained in the passage above, excerpted from an essay he wrote about VELÁZQUEZ's *Las Meninas* (1656).

Found art
See JUNK ART

Fouquet, Jean
c. 1415/20–1481 • French • painter
• Early Northern Renaissance

[He] . . . is not only a more skillful painter than his contemporaries but also has outstripped all ancient ones. . . . And to convince yourself that I am not waxing poetic you may savor a sample [of his art] in our sacristy of the Minerva . . . the portrait of Pope Eugene, painted on canvas. (Francesco Florio, 1477)

Despite Florio's praise, in the quotation above, little is know about Fouquet. He may be the same "Fouquet" to whom Pope Nicholas V gave dispensation in August 1449 for having been born to an unmarried woman and a priest. During the second half of the 15th century, Fouquet was the foremost painter in the French court, with his studio in Tours. Though facts about Fouquet are scarce, a 2½-inch-diameter self-portrait, enamel on copper, inscribed with his name, shows him as a young man in a skullcap with a serious, almost worried expression. It was originally on the frame of the now disassembled *Melun Diptych* (after 1452). Kneeling on the side panel of this DIPTYCH, facing the Madonna and Child, is Fouquet's PATRON Étienne Chevalier. Chevalier

was the king's treasurer, for whom Fouquet had also made a lavish BOOK OF HOURS (c. 1452). The Madonna of the *Melun Diptych* is presented as a lady of fashion: She has a tiny waist and one high, plump bosom is exposed. It is thought to be a portrait of King Charles VII's mistress, Agnes Sorel, for whom Chevalier also carried a flame. She died just before the diptych was painted—perhaps it is her memorial. This strikingly "dangerous association of religious with amatory sentiments" represented, according to the historian J. Huizinga, the "depreciation of sacred imagery" as the Middle Ages drew to a close. "There is a flavor of blasphemous boldness about the whole, unsurpassed by any artist of the Renaissance," Huizinga concludes.

Fragonard, Jean-Hònoré

1732–1806 • French • painter • Rococo

The energy of Michelangelo terrified me—I experienced an emotion which I could not express; and on seeing the beauties of Raphael I was moved to tears, and the pencil fell from my hands. In the end I remained in a state of indolence which I lacked the strength to overcome. Then I concentrated upon the study of such painters as permitted me to hope that I might some day rival them. It was thus that Barocci, Pietro da Cortona, Solimena, and Tiepolo attracted and held my attention.

For his best-known painting, *The Swing* (1767), Fragonard has earned the reputation of being the "paradigm of late-ROCOCO artifice and venality," as a 20th-century writer described him. His

commission for *The Swing* was specific: to show a young man slyly gazing up his lover's skirts, as she flies above his head in a swing hanging from the branch of a gnarled and sinuous tree. The patron was a titled aristocrat who posed with his mistress for the picture. Fragonard was extremely popular, as both a man about town and a painter. He had studied with CHARDIN and BOUCHER, won the prestigious PRIX DE ROME, and traveled in Italy, the experience to which he refers in the comment quoted above. Though most general textbooks that include his work print reproductions of *The Swing,* there is a different genius in his less renowned portraits, including *Denis Diderot* (c. 1769)—of the famous thinker and critic of his age. Fragonard brushed on paint with verve and was, according to current opinion, adapting himself to his clients' taste for a sketchy style. But he was out of fashion by the end of his century and died in relative obscurity.

Francis I

(1494–1547)

The legendary phrase "All is lost save honor" is attributed to Francis I, king of France from 1515 to 1547. (What he really wrote to his mother after losing a battle was "Of all things nothing remains to me but honor and life, which is safe.") As a patron of the arts, he imported Italian artists to France. LEONARDO spent his last days in Francis's palace; CELLINI, del SARTO, and PRIMATICCIO worked for him, as did ROSSO Fiorentino, who became his court painter around 1530. Hunting, tennis, jewelry, women, and buildings were his passions. His castle at FONTAINEBLEAU became an art center. Por-

traits of Francis were painted by Jean CLOUET, probably from life, in 1525, and in 1538 by TITIAN, who worked from a medal.

Francis, Sam

1923–1994 • American • painter • Abstract Expressionist

Los Angeles is the best for me for light in my work. New York light is hard. Paris light is a beautiful cerulean gray. But Los Angeles light is clear and bright even in haze. I bring all my pictures here and look at them in the Los Angeles light.

Francis was a Californian who lived and studied in Paris for about 10 years and made a world tour that included a long stay in Japan. He returned to the United States in 1961. His work was influenced by the French Art Informel (see TACHISME and ABSTRACT EXPRESSIONISM) and also, it is thought, by Japanese traditions of contemplative art. Francis's NONOBJECTIVE paintings are structured by color, dripped or spattered onto the canvas. Sometimes the color is dense, and at others it floats more lightly on the surface. *Untitled, No. 11* (1973) is an elegant composition on a creamy ground, with careful spatters and daubs of red, yellow, black, and green in a controlled, framelike structure around an irregular empty shape. The importance of light to Francis is described in the quotation above.

François Vase

A famous BLACK-FIGURE vase with volute handles, the François Vase is the finest surviving KRATER from the AR-CHAIC period. Named for the man who found it in an ETRUSCAN grave site—Etruscans avidly collected Greek pottery—the vase is signed by the painter ("Kleitias drew it") and the potter ("Ergotimos made it"). Signatures on pottery first appeared in the beginning of the 6th century BCE; the estimated date of this krater is c. 575 BCE. Kleitias painted more than 250 figures inside parallel bands, or "friezes," that encircle the vessel. The theme is the wedding of Peleus, father of Achilles, which touched off a sequence of events including the Judgment of Paris and the Trojan War. The animated and detailed decoration presents a virtual pictorial encyclopedia of Greek mythology. While the François Vase is Archaic, traces of earlier styles remain: the GEOMETRIC organization of the design into strict parallel bands, for example, and an ORIENTALIZING influence evident in figures of fantastic animals, such as griffins. Also notable, the people and objects presented on the vase are identified by labels.

Frankenthaler, Helen

born 1928 • American • painter • Post-Painterly Abstraction

If you have a gift, it is your halo and your cross. . . . And what is inherent in that condition is the loneliness that goes with it.

By spilling thinned paint onto raw, unprimed canvas and allowing the paint to soak its surface, a process called "staining," Frankenthaler captures an expansive feeling of light and air. At first she used oils, but after the early 1960s she used ACRYLICS, and was able to achieve effects formerly available only with WA-

TERCOLOR. Her invention inspired and influenced numerous painters, LOUIS and NOLAND among them. Once her picture is complete, she lets it suggest a title; thus, a landscape may be evoked by a totally abstract painting. A work such as *Sea Picture with Black* (1959) summons up the impact of crashing waves and the vastness of sea and sky. Unpainted areas allow the picture to "breathe," while at the same time they remind us of its material substance: pigment on fabric.

Freake, Elizabeth Clarke and John, portraits of

The Freakes were a well-to-do family who lived in one of the finest homes in 17th-century Boston. The LIMNER or artist who painted their portraits is anonymous, but the paintings are the earliest masterpieces of American art. While there was no class structure based on heredity in the colony, the individual's position in society was signified by wealth, and the wealth of the Freakes, in *Elizabeth Freake and Baby Mary* (c. 1671–74), for example, is displayed in Elizabeth's fine satin dress with rich brocade, the ribbons that decorate the sleeves, and the lovely lace collar. All these, as well as her pearls, garnet bracelet, and gold ring, were imported and served to identify the Freakes as among the elite as well as the "Elect." The style, while expressing details of luxury, does so in a distinctly understated way, rather than in the manner then current in Catholic countries. This forward-facing (FRONTAL), non-expressive presentation is more MEDIEVAL in flavor than the BAROQUE that was then popular in Europe.

Freedberg, Sydney J.

1914–1997 • American • art historian

The Cinquecento was a quarter of the century away when, close to 1475, Leonardo demonstrated the idea of what we recognize to be the core of the High Renaissance style.

Freedberg studied and taught at Harvard University until his retirement, when he became chief curator of the National Gallery of Art in Washington, D.C. A legendary figure in the field of ITALIAN RENAISSANCE art, Freedberg was the author of comprehensive texts including *Painting of the High Renaissance in Rome and Florence* (revised 1985) and *Painting in Italy 1500–1600* (2nd edition, 1983), from which the quotation above is taken. Following that introductory remark, Freedberg shows the difference between LEONARDO's angel and that of his teacher VERROCCHIO in the same painting, *The Baptism of Christ* (c. 1475–85). Leonardo painted the angel to show its spiritual and mental state, something not yet accomplished by his predecessors: ". . . it commands us to feel it to be plausible as no image in art was before," Freedberg writes. During World War II, Freedberg was assigned to an American Army unit attached to British naval intelligence. His love of Italy and its art was so strong that he refused to work on projects involving Rome for fear his research might be used for military actions against the city. Nevertheless, Freedberg was made an honorary member of the Order of the British Empire (Military Division) in 1946. He was also honored by the Italian govern-

ment for his rescue work during the flooding of Florence in 1966, and received the National Medal of Arts, bestowed by the president of the United States.

Freer, Charles Lang
1854–1919 • American • collector/connoisseur

I need all the training and coaching I can get, I don't want to buy promiscuously until I know.

Freer's life is a vintage American success story. He was born in Kingston, New York, and at age 14 he worked in a cement factory. At 16 he clerked in a general store. He soon became associated with a man who introduced him to the railroad business, which took him to Detroit and in which he made his fortune. On a visit to England in 1890, he met WHISTLER, and was the first American to buy a painting from him. They became close friends, and Whistler guided Freer's taste toward Oriental art. (In 1901 Freer met Ernest Francisco Fenollosa, an expert on Japanese art, who also directed Freer's collecting in that area.) In 1900, at the age of 46, he retired from active business. From that time on he devoted himself to overseeing his investments and collecting art. Freer cared for Whistler when he became ill, and was a pallbearer at Whistler's funeral in 1903. Freer owned an immense collection of Whistler's work: in all 70 oils, 78 pastels, 48 drawings, and 900 prints. He bought the *Peacock Room* (1876–77)—the entire dining room Whistler had originally designed for the London residence of a shipping tycoon. It was meant to showcase his painting *The Princess of the Land of Porcelain*. The project created a scandal, however, when Whistler, outraged by the architect's interior, painted over the cordovan leather walls and the ceiling, transforming the room into a veritable peacock preserve. When the original patron rejected it, Freer bought both the room and the painting. He made four trips to the Far East, and it was during one of his early trips that he wrote the letter, quoted from above, in which he expresses doubts about his decisions. Freer also bought paintings by the American artists Thomas DEWING, THAYER, HASSAM, and SARGENT. The gift of his collection to the American public, through the Smithsonian Institution, was realized with the Freer Gallery of Art on the Mall in Washington, D.C., where the *Peacock Room* is now installed.

French, Daniel Chester
1850–1931 • American • sculptor • Neoclassicist

. . . the tall figure walking the village street, enveloped in a long black coat or shawl, and looking as I imagine Dante must have looked as he walked the streets of Florence.

When French was only 23 years old, the town of Concord, Massachusetts, commissioned him to sculpt a monument for the centennial of the famous Revolutionary War battle there. The result was *The Minute Man* (1874). That and *Abraham Lincoln* (1922) at the Lincoln Memorial, Washington, D.C., are the two best known of French's sculptures, and among the most famous in the country. Both express the expansive nationalism of the United States in the late 19th and early 20th centuries and the

cultivation of the arts that went hand-in-hand with the unprecedented growth of capitalism and great fortunes. Both are also rooted in the art of ancient Greece, *Minute Man* modeled on POLY-KLEITOS's *Doryphoros* (*Spear Bearer;* c. 450–440 BCE) and Lincoln on PHEI-DIAS's *Zeus* (after 438 BCE). French produced another important statue while he was in Concord, a man seated, like Lincoln, but of a more relaxed posture and expression. It is about that man, Ralph Waldo Emerson, that French speaks in the passage quoted above.

fresco

The term "fresco" (from the Italian meaning "fresh") refers primarily to painting on a plastered wall with PIG-MENT suspended in the medium of water. The technique called *buon fresco* (good or true fresco), pioneered by CAV-ALLINI and GIOTTO, involved painting on wet plaster. *Fresco secco* (dry fresco) refers to painting on a dry wall, a technique practiced in ancient times (e.g., the painted surfaces of Egyptian tomb walls were dry fresco). Because oil painting on plaster in a Mediterranean climate had been unsuccessful (as LEONARDO's *Last Supper* made clear), *buon fresco* was the technique of choice for most of the ITALIAN RENAISSANCE: As the wall dried, the color bonded with the lime in the plaster and became extremely durable. The first layer of such a fresco was the *arriccio,* or rough plaster, on which the SINOPIA was drawn. The second or top layer, the *intonaco,* was painted. Fresco painting required working quickly, before the plaster dried, and from the top down to avoid the risk of spoiling what was already finished. Walls were done in patches, called *giornata,* which meant a day's work. Some attempts to mix paints were made, but not until SEBASTIANO del Piombo was the effort to execute a fresco in oil successful. By the middle of the 16th century, *buon fresco* was considered an old-fashioned skill.

Freud, Lucian
born 1922 • German/British • painter • New Realist

. . . portraits [should] be of the people, not like them. Not having the look of the sitter, being them.

Not surprisingly, for he is the grandson of Sigmund Freud, Lucian Freud's paintings—often nudes and portraits—are intensely psychological. This approach explains his comment, above, distinguishing an interest in physical resemblance from his interest in deeper currents. His work has been exhibited with that of BACON, and among his own very unsettling paintings is a head of Bacon (*Francis Bacon,* 1952). It is a representation of the already emotionally vulnerable artist (as his own work reveals) further exposed because he is deep in thought so that we, the viewers, intrude on his privacy, like voyeurs, without his knowledge. This quality of seeing people unprotected, in a manner of speaking, characterizes Freud's paintings.

Friedländer, Max J.
1867–1958 • German • art historian/connoisseur

Art being a thing of the mind, it follows that any scientific study of art will be psychology. It may be other

things as well, but psychology it will always be.

Italian art CONNOISSEUR Bernard BERENSON's counterpart in the study of the NORTHERN RENAISSANCE is Friedländer, whose major work is the 14-volume *Early Netherlandish Painting,* first published between 1924 and 1937 (later translated into English). Friedländer believed that the true connoisseur uses intuition based on experience, not rational analysis, to recognize and authenticate works of art. The trained eye is superior to any documentation, which can, after all, be forged, as far as Friedländer was concerned. The comment by Friedländer quoted above is a motto that GOMBRICH uses to begin the introductory chapter of *Art and Illusion* (1960). It is taken from Friedländer's book *On Art and Connoisseurship (Von Kunst und Kennerschaft),* from 1942.

Friedrich, Caspar David

1774–1840 • German • painter • Romantic

Why, it has often occurred to me to ask myself, do I so frequently choose death, transience, and the grave as subjects for my paintings? One must submit oneself many times to death in order some day to attain life everlasting.

Like RUNGE, who was three years younger, Friedrich studied with Jens Juel (1745–1802) at the academy in Copenhagen. Friedrich also shared Runge's pantheism, but with a more objectively based foundation—Friedrich was a topological draftsman before he devoted himself to painting. He painted the wild Baltic coast, which appealed to the ROMANTIC taste of the era. Increasingly reverential, Friedrich's landscapes have an awe-inspiring silence and stillness: for example, *Cloister Graveyard in the Snow* (c. 1810), among barren trees in a misty setting, with toppling crosses and the skeleton of a church in the snow. In *The Monk by the Sea* (1809–10) the monk is a small, dark, distant figure at the sea's edge, standing beneath a vast sky that occupies three-quarters of the canvas. *The Cross in the Mountains* (1807–8) presents an Alpine peak with dark fir trees, clouds glowing in the sunset, light radiating as though from the ground, and a high crucifixion at the pinnacle of the hill. It appears as if to take the place of another tree, and, in fact, has foliage winding around its shaft. Friedrich was a Protestant, but his attitude toward religion transcended sectarianism—*The Cross in the Mountains* was bought by Catholics and used as an ALTARPIECE in their private chapel. Not everyone approved—the chancellor of the Saxon court and author of a treatise on aesthetics denounced the painting as endangering good taste and representative of the "calamitous spirit of the present times."

frontal/frontality

In both painting and sculpture, frontal has a double meaning: One sense is that the figure portrayed is facing and looking forward; the other is that there is only one way to look at the figure and that is from the front. Frontality, an early artistic convention, is clearly demonstrable in the rigid statues of ancient Egypt. The tradition was broken in the CLASSICAL period of Greek art. Frontality has to do with the intention

and purpose of a work: It represents an avoidance of the illusion of reality, and reflects the metaphysical rather than the physical, the symbolic rather than the representative, a type rather than an individual, the eternal rather than the temporal. Frontality is seen in BYZANTINE, MEDIEVAL, and ISLAMIC ART, and is also characteristic of FOLK ART.

frottage

From the French for "rubbing." Similar to the popular pastime of taking "gravestone rubbings," the frottage technique involves laying paper over a discernibly textured surface and rubbing the paper with pencil, charcoal, or crayon. The impression of the textured material is transferred onto the paper. ERNST combined frottage and COLLAGE —the process interested SURREALISTS, who used it as a prompt for subconscious imagery.

Fry, Roger

1866–1934 • English • critic/theorist

. . . we find the rhythmic sequences of change determined much more by its own internal forces . . . than by external forces.

Fry was a painter, for which he is forgotten, but he is remembered as an important teacher, lecturer, and critic. The quotation above derives from Fry's belief that, apart from a few historical eras, like the RENAISSANCE, when art and life seem symbiotic, Western art has a history and life of its own. This self-containment supported his belief in AESTHETICISM, or art for art's sake. It also complemented his belief in the clear distinction between the imaginative life lived by and through art and the "real" life that we experience from day to day. Fry was a founding member of London's dazzling literary/artistic Bloomsbury Group, along with Lytton Strachey, Virginia Woolf, and the painters Vanessa Bell and Duncan Grant. Clive Bell, Vanessa's husband, also wrote on art and was, with Fry, a great promoter of POST-IMPRESSIONISM. He used the term to distinguish painters such as CÉZANNE, whom he championed, from NEO-IMPRESSIONISTS such as SEURAT and SIGNAC. Fry organized England's first Post-Impressionist show, in 1910, at the Grafton Galleries in London. In 1913 he founded the Omega Workshops, a DECORATIVE ARTS company modeled on the ideas of William MORRIS and RUSKIN. In contrast to Morris's company, however, Fry's was financially unsuccessful. As the comment quoted above suggests, Fry was a FORMALIST, paying attention to form over content, in his critical writings.

Fugger

As did the MEDICI in Florence, the Fugger family of Augsburg, Germany, lent money to kings and bishops and served as broker to the pope for the sale of indulgences. The family were for the most part merchants and bankers, but the founder of the line was Johann Fugger, a weaver. Following the lead of Jacob Fugger "the Rich" (1459–1525), who trained for business in Venice, the Fuggers had interests in silver and copper mines and traded in spices, wool, and silk in almost all parts of Europe. Fugger made large loans to the emperor Maximilian I (see HAPSBURG), who in return bestowed land and various privileges on him. Fugger money also sup-

ported the ascent of Charles V to the throne in 1519, and according to one story, when Charles visited Anton Fugger in 1530, the merchant dazzled the emperor by lighting a fire with an imperial certificate of debt. The Fuggers expanded their operations to the New World, as well as to Asia. DÜRER, intent on demonstrating the supremacy of German artistry while working on a commission in Venice, painted *Feast of the Rose Garlands* (1506), in which the entourage of the Madonna and Child includes not only Maximilian and members of the Fugger family, but also, in the background, a self-portrait of the artist; he is holding a paper on which his signature appears as "Albertus Dürer, Germanus." Although the family were extravagant and generous patrons of the arts, their elaborate sepulchral chapel in the Church of Saint Anna at Augsburg (c. 1517), whose artist is unknown, nevertheless shows a strong Italian influence. Eventually the Fuggers were forced to go out of business when the Hapsburgs defaulted on their loans. The Fugger firm was finally closed in the mid-1600s.

Fuller, R. Buckminster

1895–1983 • American • architect • Modern

What would happen if the real potential of modern industry were to be applied directly to serving man's needs, say in housing, instead of operating as a by-product of weaponry?

In 1927 Fuller devoted himself to research intended to answer the question he posed in the quotation above. He believed that the redirection of "modern industry" from producing arms to building shelter was possible, and he played his part by designing structural systems that lent themselves to the erection of inexpensive housing. Fuller coined the term "Dymaxion," combining "dynamic" and "maximum," to express his goal of gaining the greatest advantage from the least investment of energy. The Dymaxion House is an easily assembled and readily movable, energy-efficient, and entirely self-contained building. In the 1930s Fuller designed a Dymaxion Car with similar economies of production and efficiencies of operation. Working on a mobile, flexible shelter system, Fuller developed the Geodesic Dome (patented in 1954), a superstructure able to span vast areas, and one of the most important innovations of the 20th century. In the late 1940s a Geodesic Dome was constructed at BLACK MOUNTAIN COLLEGE in North Carolina. In 1956, the design was accepted for use by the U.S. Marine Corps. Fuller held more than 2,000 patents. Of his 25 or so books, the most popular was *Operating Manual for Spaceship Earth* (1968), from which comes the phrase "I am a passenger on the spaceship earth."

Funk art

A visual arts counterpart of the literary Beat Generation, Funk art was a West Coast counterculture movement of the 1960s. Many works were ASSEMBLAGE and COLLAGE pieces, improvised with available materials. Bruce Conner (born 1933), for example, seated a wax figure wrapped with nylon and twine in a child's used highchair. The effect is unpleasant, at best. Joan Brown (1938–1990) painted a series of funky self-

portraits; *Self Portrait with Fish* (1970) is posed against a blood-red background, a FRONTAL image of the artist in paint-spattered work clothes holding a thick brush in her right hand and cradling a large yellow fish in her left arm.

Fuseli, Henry

1741–1825 • Swiss • painter • Romantic

Life is rapid, art is slow, occasion coy, practice fallacious and judgment partial.

First a student of literature, then ordained as a Zwinglian minister at age 20, Fuseli soon left the Church and his home in Zurich for England. In London, REYNOLDS sent him on to study in Rome, where he spent eight years before returning to live in London. Fuseli was influenced by a German literary movement known by the epithet Sturm und Drang—Storm and Stress. Its self-expression and emotion are exemplified in GOETHE's early masterpiece *Werther* (1774), about a man who could literally die for love. Sturm und Drang was an integral part of ROMANTICISM, and Fuseli is known as one of its early representatives, even though he attacked the "romantic reveries of platonic philosophy" and said that "the expectations of romantic fancy, like those of ignorance, are indefinite." Fuseli's "gothic" fantasies were nightmarish visions, the best known of which is actually entitled *The Nightmare* (first version 1781). In this painting a woman sleeps in a posture of self-abandon that calls to mind the BARBERINI FAUN. A grotesque, hairy creature sits on her stomach, and the head of a horse with bulging, terror-struck

eyes looks at her through a parted curtain. The mix of eroticism—intimations of rape and of intercourse with the devil—added new subject matter to painting. First exhibited at the Royal Academy in London, *The Nightmare* soon became one of the best-known and most copied images in history. It has even been discussed as a source for one of HOMER's masterworks, *The Life Line* (1884). Fuseli was a more immediate influence on BLAKE, who copied the elongated limbs and exaggerated muscles of Fuseli's figures as well as the dark dreams of Romanticism. Fuseli published a collection of aphorisms on art, one of which is quoted above.

Futurism

An EXPRESSIONIST approach that appropriated parts of CUBISM, but was adamantly independent of it, the Futurist movement began in Italy in 1909. The leading light was the poet Filippo Tommaso Marinetti, who issued several manifestos. It was the Futurist claim that "for the first time" they brought to art the force of motion, the "noise" and "power" of the city street and machinery. They put forth the ideas of "dynamism," of "force lines" adding movement to the Cubist project of showing multiple points of view. They demanded "the total suppression of the nude" in painting for 10 years, not, they insisted, because it was immoral but because of its "monotony." Combining several MODERNIST styles, Futurism influenced other movements (e.g., CONSTRUCTIVISM) and individuals (e.g., WEBER). Artists who signed and wrote the early Futurist manifestos include BALLA, BOCCIONI, CARRÀ, and SEVERINI. From its inception, Futurism cel-

ebrated all forms of violent struggle, including war, which was considered a purifying experience for the nation as well as the individual. World War I was a theme in several Futurist works. After that war, Marinetti was present at the birth of Italian Fascism, under the leadership of Benito Mussolini. In answer to Mussolini's 1926 call for a bold new Fascist art Marinetti wrote, "Futurist art is extremely Italian because it is virile, bellicose, joyous, optimistic, dynamic, synthetic, simultaneous, and colorful. . . . Here is futurist fascist art in perfect harmony with the . . . temperament of Benito Mussolini." Italian propaganda for and during World War II is a showcase of the adaptation of Futurism to totalitarianism.

G

Gabo, Naum (Naum Neemia Pevsner)

1890–1977 • Russian/American • sculptor • Constructivist

Above the tempests of our weekdays, / Across the ashes and cindered homes of the past, / Before the gates of the vacant future, / We proclaim today to you artists, painters, sculptors, musicians, actors, poets ... to you people to whom art is no mere ground for conversation but the source of real exaltation, our word and deed. The impasse into which Art has come to in the last twenty years must be broken.

Gabo went to Munich to study medicine in 1910, and first changed to mathematics and engineering. Then, inspired by an exhibition of Der BLAUE REITER works, lectures by WÖLFFLIN, his friendship with fellow Russian KANDINSKY, whom he met in Munich, and the fact that his brother, Antoine PEVSNER, was an artist, Gabo changed his direction. He also changed his name to avoid being confused with his brother. During World War I he was in Scandinavia, and he returned to Russia after the Revolution of 1917. He and his brother joined TATLIN and MALEVICH in their CONSTRUCTIVIST experiments and they coauthored *The Realistic Manifesto* (1920), which is quoted from above. In 1920 Gabo designed *Kinetic Construction*, a single, motor-driven vibrating rod that was a prototype for later KINETIC sculpture. Gabo continued making constructions and explaining the Constructivist idea ("The shapes we are creating are not abstract, they are absolute," he wrote) even though he left Russia in 1922, in conflict with Tatlin and others over the mandate for "Utilitarianism in art." In Germany he taught at the BAUHAUS. He sought to unify sculptural and architectural elements in one unit, a goal pursued by his followers. In the 1920s Gabo began working in plastics. In the 1940s, after moving from Germany to Paris, where he joined the ABSTRACTION-CRÉATION group, and then to London, he began constructing a distinctive sculptural form in which taut nylon threads are combined with transparent plastic sheets. These give a magical delicacy to geometric forms. In 1946 Gabo moved to the United States. He became an American citizen and taught at Harvard University.

Gaddi, Agnolo

active c. 1369–1396 • Italian • painter • Late Gothic

I was trained in this profession for twelve years by my master, Agnoli [Agnolo] di Taddeo of Florence; he learned this profession from Taddeo,

his father; and his father was
christened under Giotto. (Cennino
Cennini, c. 1400)

Son of Taddeo (see below), Agnolo
Gaddi is known for his major work, a
series of FRESCOES, *Legend of the True
Cross* (c. 1390), painted for the choir of
the church of Santa Croce in Florence
and adjacent to chapels decorated by
GIOTTO and his followers earlier in the
century. In some scenes Agnolo ignored
any suggestion of scale and distance in
favor of compressing figures, buildings,
and landscape into a meaningful NAR-
RATIVE scene, while in others, when
fewer people were involved, he demon-
strated that, if he wanted to do so, he
could quite competently provide the il-
lusion of depth. In either case, the ele-
gance of his decorations and his color
were appreciated by his student CEN-
NINI, whose praise of Agnolo is quoted
above.

Gaddi, Taddeo

c. 1300–1366 • Italian • painter •
Late Gothic

Taddeo Gaddi was a pupil of Giotto;
he was of marvelous talent, he did very
many chapels and very many frescoes;
he was a very learned master, and did
very many panels, finely made.
(Ghiberti, c. 1450)

Despite the respect bestowed on Gaddi
by GHIBERTI, quoted above, like most
painters in the time period close to that
of GIOTTO, Taddeo suffered increas-
ingly by comparison with his master.
VASARI's commentary a century later
was that "Taddeo always adopted
Giotto's manner but did not greatly im-
prove it except in the coloring, which he

made fresher and more vivid." Taddeo,
son and father of artists (see Agnolo
above), was Giotto's godson and
worked under Giotto for more than 20
years. One of Taddeo's FRESCOES (tra-
ditionally compared to a Giotto fresco
on the same subject) is *The Meeting of
Joachim and Anna* (1338) in the Baron-
celli Chapel, Santa Croce, Florence
(Giotto's of 1305–06 is in the Arena
Chapel, Padua). Critics tend to fault
Taddeo's loose and cluttered composi-
tion and extraneous details, such as an
elaborate cityscape in the background
and a distracting hunter. Yet Taddeo's
city is intriguing in its detail and its PER-
SPECTIVE exploration, and the hunter is
an interesting addition to the scene in a
cultural context. It could also be noted
that Giotto's strong convictions and
practices were known by his followers,
and moreover that Giotto was still alive
and even involved in the project when
Taddeo's *Joachim and Anna* was
painted. Taddeo is one of the few artists
who survived the Black Plague of 1348.

Gainsborough, Thomas

1727–1788 • English • painter •
Grand Manner

Gainsborough was tall, fair and
handsome, generous, impulsive to the
point of capriciousness, easily irritated,
not of bookish likings, a lively talker,
good at repartee. He was a most
thorough embodiment of the artistic
temperament. (William M. Rossetti,
1911)

It was said that by the time he was 10
years old Gainsborough had "sketched
every fine tree and picturesque cottage
near Sudbury," his birthplace. He was
one of nine children. Unlike the usual

passing of the mantle from father to son, it was Thomas's mother who painted and who encouraged him. Few paintings are more quickly recognized than Gainsborough's *Blue Boy* (c. 1770). The model is thought to be Jonathan Buttall, son of an ironmonger who owned property in Ipswich, where Gainsborough lived for a time. Gainsborough was an admirer of van DYCK, whose formula for portraying English aristocracy—typically in shimmering silk, with one arm akimbo, hand on hip, cane or hat in the other—had lasting effect. It is thought that Gainsborough kept a "van Dyck costume" available in his studio. Speculation by an early-19th-century writer suggests that *Blue Boy* was painted to dispute Gainsborough's arch rival, REYNOLDS, who argued that a cool color such as blue could not dominate a picture. When Gainsborough moved to London, he shared court patronage with WEST and general favor with Reynolds. He persisted in painting landscapes, which did not sell, but he was an extremely successful portraitist. In 1785 he painted the beautiful fifth Duchess of Devonshire, a woman of scandalous sexual immorality. The painting vanished in 1806, mysteriously reappeared in 1841, was auctioned off in 1876 for $51,540 (then the highest auction price for a painting), and was stolen again by an American who planned to use it for ransom but fell in love with the image of the duchess. It was recovered in 1901 and sold to Pierpont Morgan for $150,000, auctioned off by his heirs in 1994, and went for $408,870 to the 11th Duke of Devonshire. Gainsborough painted his friends—musicians, dramatists, and actors. *Mrs. Siddons* (1785) is a portrait of the actress (her real name was Sarah Kemble). Reynolds had painted her a year earlier as the "Tragic Muse." In Reynolds's picture she is distanced from the viewer and gazes theatrically into the heavens. Gainsborough's *Mrs. Siddons* is relatively down-to-earth, accessibly close to the PICTURE PLANE; she is fashionably attired—in a blue-striped dress. Before Gainsborough died, at 61, he sought a reconciliation with Reynolds. In his *Fourteenth Discourse,* Reynolds paid "tribute" to his former foe, but it was a mean-spirited dig in which he said that during their last conversation Gainsborough had "begun to see what his deficiencies were."

gallery

Originally an architectural term for a walkway covered by a roof, especially a long and narrow passageway. Such a corridor lends itself to the display of works of art, and the use of the Grande Galerie at the Louvre for public EXHIBITIONS constituted the first national "art gallery" (see SALON). Today the term "gallery" is used to designate a room or rooms within a museum (e.g., American art galleries at the Metropolitan Museum of Art) or the entire museum (e.g., the National Gallery), as well as a commercial venture for selling art (e.g., GOUPIL'S GALLERY). The first art gallery is believed to have been the *pinakotheke* or "picture chest" located in the north wing of the Propylaia (or gatehouse) on the ACROPOLIS in 5th-century BCE Athens. In villas of 1st-century CE Rome, the walls of a room were sometimes decorated with pictures that were arranged as if framed and hung there rather than—as they were in

fact—painted directly on the wall's surface.

Gaudí, Antonio

1852–1926 • Spanish • architect • Art Nouveau

Ornament has been, is and will be colored. Nature does not present us with any object that is monochrome or completely uniform in color, neither in plants, geology, topography, nor in the animal kingdom. There is always a more or less accentuated contrast in color and we should always learn from these examples that we must employ color entirely, or partly, in all architectural elements.

Gaudí's father was a coppersmith who made kettles and pots. Antonio himself trained as an ironworker before practicing architecture. He invented many of the building techniques that enabled him to realize his ideas, and these ideas were so clever, outrageous, and unprecedented that architectural historians have ventured so far as to call them "crazy." Combining Moorish, GOTHIC, and sometimes Moroccan elements, he incorporated them into his own freeflowing shapes. For his major patron, Count Esebio Güell, he designed the Palau Güell (1886–91) on a narrow street in the old city center of Barcelona. Its design makes several allusions to the Alhambra. It prompted a contemporary critic to write that it is "as if by magic art and by virtue of the wand of some Scheherazade all the dreams of oriental tales had taken body, leaving them suddenly materialized and converting them into tangible fact." Gaudí's Casa Milà (1906–10), also in Barcelona, is a luxury apartment building that wraps around the corner of a street in undulating waves. The roof, elaborated with curves of its own, is surmounted by a series of strange, towerlike chimneys that almost resemble massive human figures. Irregularly placed balconies have wrought-iron designs; inside, rooms have no straight walls. It is a testimony to the imagination and daring of his patrons that they commissioned such fantastic designs. Gaudí's use of variously textured and colored materials—stone, brick, glass, and ceramics—to reflect light is explained in his comment quoted above. Gaudí believed that light is "the soul of architecture."

Gauguin, Paul

1848–1903 • French • painter • Symbolist/Post-Impressionist

From now on I will paint every day.

Gauguin's life was always unconventional: Though born in Paris, he lived with his mother's family in Peru and sailed with the French navy as a teenager. He was a stockbroker until the 1883 crash, at which point his employers had to fire him. It was then that he made the declaration quoted above, left his wife and children, and devoted himself to art. PISSARRO, whom he called his "professor," sponsored and encouraged him. At first Gauguin worked and exhibited with the IMPRESSIONISTS, then he traveled: In 1887 he stopped in Martinique, went on to Panama and worked on the canal, went to Central America and the Caribbean, then went back to Martinique. On returning to France, in Brittany during 1888 Gauguin began to attract a following, sometimes known as the PONT-AVEN SCHOOL, as he forged the

SYMBOLIST style for which he is known. Seeking a new intensity, and working closely with BERNARD, he began to evolve the theory of SYNTHETISM, which, besides simplification of lines, colors, forms, and a suppression of detail, used the imagination to depart from reality, as in *The Vision after the Sermon (Jacob Wrestling with the Angel)* (1888). Japanese prints (see UKIYO-E) contributed to his interest in using flat planes of primary colors enclosed with dark contour lines (see CLOISONNISM). FLAXMAN and MANET had already exploited an outline style that rejects MODELING and notions of PERSPECTIVE, and it found new impetus in van GOGH, Bernard, and Gauguin—it suited their search for the "primitive," unsophisticated values they believed to be genuine. *Yellow Christ* (1889) exemplifies Gauguin's simultaneous reduction of forms while increasing the complexity of ideas contained in the picture: Christ is colored a golden yellow with green shading that harmonizes with the landscape behind him; three Breton women in local costume kneel at the foot of the cross while an ambiguous figure climbs over a distant stone fence. In his continuing efforts to penetrate "the mysterious centers of thought" and to escape the infringements of civilization on his creativity, on April 4, 1891, after a great and extravagant farewell party, Gauguin set off for Tahiti. The Scottish writer Robert Louis Stevenson and Americans Henry Adams (a historian) and LA FARGE, a painter, had recently returned from Tahiti. There were also French settlers on that beautiful, balmy island. "It is a mistake, however—a form of romanticizing like that which Gauguin

himself sank into . . . to think that this artist cut himself off completely from his European background and consciousness and from the European artistic tradition (or that he ever really intended to)," the historian Mark Roskill writes. "He took with him to Tahiti a whole archive of photographs, prints, and other mementos. . . ." In *La Orana Maria (Ave Maria;* 1891), Gauguin introduced Christian themes, using native women in sarongs as stand-ins for biblical subjects. He combined Christian and Polynesian symbols and rituals. Gauguin never found the perfect, unspoiled world he was seeking. His personal dismay drove him to attempt suicide in December 1897, and it permeates his strange picture, painted on burlap, *Spirit of the Dead Watching* (1892). This is yet another unusual interpretation of the reclining female nude, the theme that had been given a new look by MANET's *Olympia* (1863) some three decades earlier. Gauguin's dark-skinned Tahitian woman lies on her stomach looking out at the viewer with an expression that is difficult to interpret. The watching figure—a servant in earlier representations—is now an ancestral spirit shrouded in black. Gauguin spent the last 10 years of his life in Tahiti, returning to France only once. He wrote about his life there in the manuscript *Noa-Noa, voyage de Tahiti* (1897), and also recorded his thoughts in *Avant et Après* (1903), published posthumously in 1918.

gaze

Discussion of "the gaze" in ART HISTORY has to do with the dynamics of looking at art and asks questions such as: Who is the spectator presumed to

be? How does he or she interact with the work? What is his/her reaction to it? The gaze is often considered in relation to images of female nudes, recognizing that a male spectator is the anticipated audience. The implication is of erotic looking that tends to treat the female as object of desire (and source of fear, as in FEMME FATALE), and the term "male gaze" evolved to designate that kind of looking. The British art critic John Berger (born 1926) wrote a ground-breaking book on the subject: *Ways of Seeing* (1972). Recognizing issues of power and subjugation, and drawing on the PSYCHOANALYTIC theories of Freud and of Jacques Lacan, Laura Mulvey gave the term its newly important meaning in her essay *Visual Pleasure and Narrative Cinema* (1975). Mulvey focused on film, but her ideas sparked many others in art historical writing. Interpretations change depending not only on the angle of the spectator's looking, but also on "the gaze" of the person within the image: Is she sleeping, looking in a certain direction, or looking back at the supposed spectator? Not all discussions of the gaze have to do with gender and sexuality. Roland Barthes, for example, wrote about REMBRANDT's *Syndics of the Clothmakers' Guild* (1662)—the group portrait of men who look not only at a presumed audience within the room in which they are seated but also at "us," their flesh-and-blood audience: "It is the gaze that is the numen [presiding divinity] here, the gaze that disturbs, intimidates, and makes man the ultimate term of a problem. To be stared at by a portrait is always disconcerting. . . . They [the syndics] are gathered together . . . to look at you, thereby signifying an existence and an authority beyond which you cannot go. . . . [Their gaze] posits you, implicates you; makes you exist." The historian Margaret Olin sums up: "A work of art is to look at. Theories of the gaze attempt to address the consequences of that looking. Sometimes, however, it is important to look at ourselves (looking). We not only need to 'see ourselves as others see us,' we also need to see ourselves seeing one another. But to visualize looking is not as easy as it might appear. What might seem to be a purely visual theory, or a theory of pure vision, has become lost in the mysteries of human relationships."

Geertgen tot Sint Jans

c. 1460–1490 • Netherlandish • painter • Northern Renaissance

He was so great a master that the excellent Albrecht Dürer, visiting at Haarlem and looking at his works in great amazement, said of him: Truly he was 'ein Maler im Mutterleibe.' By which he meant to say that he was predestined by Nature or chosen before birth to be a painter. (Carel van Mander, c. 1604)

The translation of his name—Little Gerard who lives at Saint John's—refers to the monastery of the order of Saint John in Haarlem where Geertgen resided. He died at the age of 28. Influenced by van der GOES, Geertgen's *Night Nativity* (c. 1480–85) is one of the most famous night scenes—the dark is illuminated as if by the interior spirituality of the Christ Child and by the angel in the sky. Mary's face is almost

perfectly oval, sweet, and youthful. In *Burning of the Bones of Saint John the Baptist* (c. 1484–94), an ALTARPIECE commissioned by the Knights of Saint John in Haarlem and the first group portrait, Geertgen weaves the busy but solemn narrative in and out of a curiously rocky landscape. In *Saint John the Baptist in the Wilderness* (c. 1490) he presents a paradoxical scene: Wilderness though it may be, this gently rolling landscape is both lush and well ordered, pleasantly decorated with flowers and wildlife. John sits in introspective contemplation—a particularly engaging detail is the idiosyncratic way in which one bare foot rests on the other—a hand supporting his head, he gazes thoughtfully at nothing. PANOFSKY points out the resemblance of this work to DÜRER's *Melencolia I,* some 24 years later, describing both as "spiritual self-portraits," meaning that they record a state of mind, not necessarily a physical resemblance. Yet the difference is as important as the apparent similarity, for while Dürer's image imparts despair, Geertgen's suggests hope, even serenity: Sitting comfortably next to Saint John is a Lamb of God with a halo that matches John's own. Despite their different approaches, Dürer held Geertgen in high esteem according to van MANDER, who is quoted above.

Gender studies

In contrast to the biological sexes, gender studies recognize ideas about sexual identification as influenced by society and culture. Led by FEMINIST criticism and theory, gender studies have evolved from examination of how women are portrayed by artists, especially as "dif-ferent" or "other," to discussing the multiplicity of ways of considering gender, including alternatives to male and female. "Needless to say, gender systems or structures are complex, multiple, overlapping, and unstable at any given time and place and through time and across place," writes the historian Whitney Davis. "The outstanding theoretical issue concerns the origin of gender systems or structures," he adds. Within gender studies, a new field of inquiry called Queer Theory is applied to nonstandard gender representations.

genre

From the French word for "type" or "class," in art history "genre" usually refers to scenes of daily life among the merchant or peasant classes, in contrast to either religious or courtly images. As is true also of STILL LIFES and LANDSCAPES, genre painting came into its own in Northern Europe during the 16th and 17th centuries. Why it happened then, not earlier or later, is an intriguing question. It may be simply that the growing, powerful merchant class that had previously commissioned ALTARPIECES was increasingly interested in pictures of its occupations and preoccupations, albeit within a larger socioreligious and ethical context: The original (now lost) frame for MASSYS's genre picture *Money-Changer and His Wife* (1514) was inscribed with a biblical quotation about giving fair weight. BRUEGEL's boisterous peasant themes are packed with a mix of secular and sacred symbolism. One echo in the background of genre painting's rise in popularity was the Protestant Reformers' rejection of the luxury and patron-

age of the Catholic Church, in addition to the danger of iconoclasm (see ICON).

Gentile da Fabriano

c. 1370–1427 • Italian • painter • Late Gothic/International Style

Gentile da Fabriano had a talent suited to painting everything. His skill and thoroughness are especially well-known in painting buildings. . . . They say that Rogier van der Weyden, the notable painter . . . [was] caught up with admiration of the work and asking who the artist was, he ranked [Gentile] ahead of the other Italian painters, piling up much praise.
(Bartholemeus Facius, 1456)

Gentile is reputed to have painted a naval battle that took place on stormy seas so convincingly that it filled viewers with fear. That and other recorded works of his are lost, but his masterpiece, the *Strozzi Altarpiece* in the church of Santa Trinita in Florence (commissioned by Strozzi, the richest man in the city; completed 1423), secures his place in Italian art. The central panel, *The Adoration of the Magi,* has an exquisitely delineated and richly colored procession of worshipers making their way toward the Virgin and Child along a curved path. The clothing of the kings glitters, while the individualized faces of the more humble among the multitudes in the procession express awe and rapture. Conventionally classified as an International Style painter (see GOTHIC), an old rather than new style, Gentile seems to have been influenced by the LIMBOURG brothers. He is also retrospective in his lack of interest in PERSPECTIVE. Yet the psychological

acuteness of his perception, combined with the innovations of his three predella scenes (see ALTARPIECE), shows him to be forward-looking too: He may have been the first Italian painter to have a real sky rather than a gold backdrop, and to show a night scene. With canny and naturalistic effect, one light source is actually inside the picture in the form of the Christ child. He radiates the kind of illumination and casts shadows that are both poetic and persuasive, and leads a viewer to believe, as the historian Frederick Hartt writes, that Gentile made a model of his scene and burned a candle inside of it to study the effect. Gentile was particularly influential on PISANELLO, Jacopo BELLINI, and ANGELICO. As a member of the next generation points out in the quotation above, he was also appreciated by van der WEYDEN.

Gentileschi, Artemisia

1593–1652/53 • Italian • painter • Baroque

As for my doing a drawing and sending it, I have made a solemn vow never to send my drawing because people have cheated me. In particular, just today I found . . . that, having done a drawing of souls in Purgatory for the Bishop of St. Gata, he, in order to spend less, commissioned another painter to do the painting using my work. If I were a man, I can't imagine it would have turned out this way.

Despite her exceptional talent and accomplishments, and her commissions from important patrons and collectors, Gentileschi's work was overlooked by

scholars until FEMINIST art historians began to retrieve it in 1971. She was the daughter and student of a significant painter, Orazio GENTILESCHI, whose work was influenced by CARAVAGGIO. Artemisia, too, shows Caravaggesque tendencies in her bold, dramatic use of light and shadow. Also like Caravaggio's, her work has undercurrents of violence. These are sometimes explained as the result of her having been raped by an artist in her father's studio, Agostino Tassi—there was a trial in 1612 at which he was acquitted. The facts of this incident remain obscure, and what seems to have been most at issue, according to current scholarship, was concern about Orazio's property, including his daughter, rather than Artemisia's personal ordeal. (During the trial she was submitted to the thumbscrew to test her honesty.) The distress of Susanna in *Susanna and the Elders* (1610) is atypical of ways in which other artists (e.g., TINTORETTO and RENI) treated the subject. They tend to show Susanna as almost complicit in the males' voyeurism, but in Gentileschi's painting (which may have been a father-daughter collaboration), Susanna is clearly being tormented. Artemisia painted several images from the biblical story of Judith. *Judith and Maidservant with the Head of Holofernes* (c. 1625), for example, presents the Jewish hero who seduces and then decapitates an Assyrian general who was about to invade her land. Lighted by the flame of a single candle, the scene is gory and the atmosphere tense. An important biography of Artemisia Gentileschi, by Mary Garrard, was published in 1989.

Gentileschi, Orazio
1563–1639 • Italian • painter • Baroque

For instance, when I had placed a picture of the Archangel Michel at S. Giovanni de' Fiorentini, he [Giovanni Baglione] competed with me by putting a picture just opposite. And this picture which was called Divine Love *he had painted in competition with Michelangelo da Caravaggio's* Earthly Love.

In the comment above, Gentileschi is describing the competition among artists in an annual exhibition held in Rome under the auspices of the leading families. Orazio Gentileschi was one of the important CARAVAGGISTI and the father of Artemisia (above). He was also one of the few who were actually acquainted with CARAVAGGIO; it is recorded that Gentileschi borrowed swans' wings from Caravaggio to use when painting the wings of angels, and both artists were named in BAGLIONE's libel suit of 1603. One of Gentileschi's key works is *Annunciation* (1622–23). Its grace and refinement probably reflect the taste of his aristocratic patron, the Duke of Savoy, and also show his style moving away from Caravaggio's influence.

Geometric period
This is a stylistic term describing abstract geometric figures and patterns that also refers to a historic era. The beginning of Ancient Greece, which roughly coincides with the Geometric style, is in the 9th century BCE. The Olympiad, which began in 776 BCE, brought together the widespread, in-

dependent Greek-speaking states for competitive games. By the middle of the 8th century, the *Iliad* and *Odyssey* of Homer, oral narratives, had been edited and written down. This is the time when Athens became a center for POTTERY production, notably vases recovered from the Dipylon cemetery, decorated with geometric motifs. Also in this century, it is believed the first Greek TEMPLE was built, on the Gulf of Corinth. There are small Geometric bronze and ivory figures of animals (often horses) and people, but like the figures painted on pottery, these are rudimentary and abstract in form. The larger human figures of KOUROI and KORAI were developed in the following ARCHAIC period.

Gérard, Marguerite

1761–1837 • French • painter • Rococo

Tall, slender, with a distinguished air, her accent gave away her origin; but in her pretty mouth, it was a little provincial brogue which suited her ravishingly; she was in every way an accomplished person, whom we loved very much and little Papa Fragonard adored. (Mme. Lecomte, 18th century)

Originally from Grasse—the region to which Lecomte refers in the quotation above—Gérard arrived in Paris in the year 1775. She probably lived with her sister and brother-in-law, FRAGONARD, in their apartments in the Louvre. This association enabled her to meet some of the major artists of the day and to study private collections. Her own subjects were very different from those of Fragonard: She painted GENRE scenes of con-

temporary women engaged in domestic activities. There are precedents for her work in 17th-century Dutch painting, and one direct connection is seen when STEEN's *The Lovesick Girl* (early 1660s) is compared to Gérard's *Bad News* (1804). In each case the young woman is reacting to a disappointing letter she has just received, but where Steen's unhappy girl is comforted by a male doctor, Gérard's receives smelling salts from a female friend. Incidental details of interior decoration and clothing (a more elevated social class in Gérard's case) situate the picture firmly in its time and place, and also reflect a sympathetic approach to the small human dramas and simple preoccupations of everyday life. Gérard began exhibiting in the SALON when it reopened to women in the 1790s, after the Revolution, and her practice was successful and lucrative.

Géricault, Théodore

1791–1824 • French • painter • Romantic

If obstacles discourage the mediocre talent, they are, on the contrary, the necessary food of genius; they ripen and exalt it, where the easy road would leave it cold. Everything that opposes the triumphant progress of genius irritates it, and induces that fever of exaltation that overthrows and conquers all to produce its masterpieces. . . . Unfortunately, the Academy does better: it snuffs out those who have some sparks of the sacred fire.

An admirer of Jacques-Louis DAVID, whom he called "the most distinguished

of our artists," Géricault held opinions on the subject of the ACADEMY that resembled those of David. Géricault had both a ROMANTIC and, apparently, a reformist zeal. His best-known work, *Raft of the Medusa* (1818–19), is a melodramatic representation of a contemporary event. Afloat in a turbulent ocean, the raft is crowded with survivors of a French ship, the *Medusa,* which foundered off the west coast of Africa in 1816. Mismanagement of the ship, for which the government was deemed responsible, became a political controversy, as did Géricault's painting. He painted neither the cannibalism, the mutiny, nor the final rescue, but instead chose a moment of high tension and false hope—a ship in the distance passing by without seeing the raft. Géricault interviewed survivors, and his reportorial research was unprecedented. Compositionally, the figures of survivors and corpses form an X, with a black African waving a piece of white cloth at the top of one diagonal. Each figure seems to be matched by another that mirrors its pose: a man on his back counterbalanced by one on his stomach, the man standing at the peak, waving his flag, by another at the bottom, sitting despondently. Géricault's interest in human suffering also drove him to explore the faces of madness—the individual's loss of reason in an era once, but no longer, known as the Age of Reason. As did GOYA and others, he visited institutions for the insane and studied hospital inmates—he, himself, was a patient for a while. Scientific and artistic curiosity merged during the Romantic period, though at times (e.g., when Géricault studied heads severed by the guillotine) it is difficult to disentangle morbidity from intellectual inquiry. In another context, Géricault's paintings of horses are still unmatched for the intensity of their movement, alarm, and fury. The comment quoted above is excerpted from a manuscript found among Géricault's effects after his early death, at 33, resulting from a riding accident.

Gero Crucifix

Gero, Archbishop of Cologne, was an important PATRON of art during the OTTONIAN period. In about 970, Gero presented a painted wooden sculpture of the Crucifixion, a little over 6 feet high, to the Cologne Cathedral. Christ is gaunt and clearly in agony. Moreover, because the sculpture also served to hold the host in a receptacle in the head, to the faithful this image was, literally, the body of Christ. The *Gero Crucifix* is an important landmark in Western art, marking an era when individuals began to contemplate the life of Christ and cultivate a personal connection with him. (See also PASSION and CRUCIFIXION)

Gérôme, Jean-Léon
1824–1904 • French • painter/sculptor • Academic

Quick of vision and unmerciful in judgment, [Gérôme] dominated, by a singular magnetism, the student who gladly submitted to his terrible "ce n'est pas ça" [that's not it] and who scarcely felt elated with the seldom heard "pas mal" [not bad]—such confidence he inspired in his sincerity in holding before us the same high

standard of excellence toward which he also struggled. (S. W. Van Schaick, 1889)

Gérôme was the favorite student of DE-LAROCHE and learned from his teacher the meticulous study of details; these he used in paintings of scenes arranged as though they were theatrical acts. He went on to study with GLEYRE, who had several future IMPRESSIONISTS among his students. However, Gérôme re-mained distant from Impressionism with his carefully studied forms, sharp focus, enamel-like surfaces, and con-centration on HISTORY PAINTING. Gérôme's images seem perfectly objec-tive, descriptive, and photographic so that the critic Théophile Gautier wrote of his painting *Ave Caesar* (*Death of Caesar; 1859*): "If photography had ex-isted in Caesar's day, one could believe that the picture was painted from a photograph taken on the spot at the very moment of the catastrophe." *The Slave Market* (1866), in which a naked woman is being examined by Arab slave traders, one of whom looks at her teeth, exemplifies both Gérôme's technique and his affect—a high finish and erotic undercurrents. Gérôme taught at the ÉCOLE DES BEAUX-ARTS, where he had a number of American students, one of whom is quoted above. Another was EAKINS, who remained ever indebted to his teacher and full of praise for his methods, especially the importance of studying the nude from life.

gesso

Usually made from plaster of Paris, gesso applied to a surface prepares it for paint (both TEMPERA and OIL) or for the application of gold or silver. Wet when laid on, gesso hardens as it dries. Thickly applied, drying gesso can also be sculpted in RELIEF.

Gestural painting

In contrast to highly finished oil glaze painting, in which an enamel-like sur-face betrays none of the artist's touch, Gestural painting shows clear signs of brushwork. TINTORETTO, RUBENS, and van GOGH are artists who may be de-scribed as "gestural." The expressive-ness of the technique itself usually coincides with the mood or meaning of the picture on which it is used, and sometimes with the artist's own person-ality or, at least, personal style. ACTION PAINTING is sometimes known as Ges-tural ABSTRACT EXPRESSIONISM.

Ghiberti, Lorenzo

1378–1455 • Italian • sculptor • Renaissance

I, O most excellent reader, did not have to obey [a desire for] money, but gave myself to the study of art, which since my childhood I have always pursued with great zeal and devotion.

Ghiberti is one of the four sculptors whose genius marked the beginning of the ITALIAN RENAISSANCE. (DONA-TELLO, NANNI, and JACOPO della Quer-cia are the others.) Dating that debut is quite specific: In the winter of 1400–01, the important GUILD for finishers and dyers of wool fabric in Florence spon-sored a contest for the design of bronze doors for the Baptistery of San Gio-vanni, generally known as the Florence Baptistery. (Andrea PISANO had already done the south doors.) Open to "skilled masters from all the lands of Italy," it was the first competition of its kind.

Each entrant had to submit a 21- by 17-inch bronze panel illustrating the *Sacrifice of Isaac*. Ghiberti won. His and BRUNELLESCHI's are the only two submissions that survive. Brunelleschi's figures, some of which were cast separately and bolted to the panel, are dramatic and agitated. Ghiberti worked entirely in RELIEF, producing a dignified, fluent, and graceful design. While he followed along the lines of International Style (see GOTHIC), Ghiberti was also attuned to the new taste for ancient sculpture—he himself collected what he could—and his nude figure of Isaac was modeled after the ANTIQUE. He also experimented in suggesting distance by using higher relief in the foreground than in the background. Ghiberti worked for about 25 years on the Baptistery doors, which represent the transitional, Gothic-to-Renaissance moment. He also made some freestanding sculptures including *Saint John the Baptist* (c. 1412–16) for the Florentine church of Orsanmichele. When the first set of doors was finished, Ghiberti began work on another set. By then he was fully cognizant of Renaissance style, and his BRONZE foundry was a major WORKSHOP with MICHELOZZO, UCCELLO, and GOZZOLI among the apprentices. His second doors, completed in 1452, were so splendid that MICHELANGELO called them worthy of heaven; they were known thereafter as the Gates of Paradise. Toward the end of his life Ghiberti wrote three commentaries: The first is derived from VITRUVIUS and PLINY the Elder; the second contains the lives of 14th-century artists, based on his own learning. Also in the second is his autobiography—the first by an artist to take a literary form—from

which the quotation above is excerpted. In the third he drew from wide-ranging sources, including Arabian scholars, to discuss the theoretical basis of art.

Ghirlandaio, Domenico

1448/49–1494 • Italian • painter • Renaissance

. . . . the said Messer Francesco must give the above said Domenico three large florins every month, starting from 1 November 1485 and continuing after as is stated. . . . And if Domenico has not delivered the panel within the abovesaid period of time, he will be liable to a penalty of fifteen large florins; and correspondingly if Messer Francesco does not keep to the abovesaid monthly payments he will be liable to a penalty of the whole amount, that is, once the panel is finished he will have to pay complete and in full the balance of the sum due.
(contract of October 23, 1485)

Ghirlandaio was the leading painter of FRESCOes in Florence from the 1480s until his death in 1494 (e.g., *The Life of Saint Francis* cycle in the church of Santa Trinita, 1483–86). However, the contract quoted from above, regarding a PANEL rather than a fresco, was for the *Adoration of the Magi* (1485–89), which is still at the Ospedale degli Innocenti in Florence. In fresco painting Ghirlandaio gave up experimentation with techniques, especially the kind that had led to disaster in LEONARDO's *Last Supper,* and returned to the old-fashioned *buon fresco* prescribed by CENNINI. He may not have broken any new ground, but Ghirlandaio was a master of PERSPECTIVE, MODELING, and elegant detail of dress, as demonstrated

by a portrait believed to be *Giovanna Tornabuoni* (1488). In her portrait she is the epitome of breeding, taste, and style. She is painted in profile, and a Latin epigram pasted on the wall behind her reads: *Art, would that you could represent character and mind! / There would be no more beautiful painting on earth.* Recalling DONATELLO's imprecation to his sculpture, "Speak, damn you, speak!" the historian John Shearman relates this verse to an ongoing competition between poets and painters over whose power of communication was greater. If *Giovanna Tornabuoni* might leave the question unanswered, another of Ghirlandaio's works seems more affirmative of the painter's art. *Old Man and His Grandson* (c. 1485), believed to have been done from a death mask after the grandfather died, would seem, by bringing a dead man back to life, to count one up on poetry, since words could *say* but could not *show* it.

Giacometti, Alberto

1901–1966 • Swiss • sculptor • Modern/Expressionist figuration

A large figure seemed to me false and a small one equally unbearable, and then often they became so tiny that with one touch of my knife they disappeared into dust. But head and figures seemed to me to have a bit of truth only when small. All this changed a little in 1945 through drawing. This led me to want to make larger figures, but then to my surprise, they achieved a likeness only when tall and slender.

Giacometti studied in Switzerland and Italy before going to Paris, where he continued his studies in sculpture and became associated with the SURREALISTS. His most startling work of that period is *Woman with Her Throat Cut* (1932), a dismembered bronze corpse that looks rather like a crab's carapace. Expelled from the ranks for his reactionary attitude—he thought the Surrealists were taking him too far from actuality—Giacometti returned to studying the figure pared down to essentials, a process he described in 1947 in the letter to his dealer quoted from above. He developed the strangely elongated, pitted figures with tiny heads for which he is known. His personal style evades categories, yet his friendship with the philosopher Jean-Paul Sartre leads one to believe that Giacometti was influenced by Sartre's EXISTENTIALISM. His work may be called EXPRESSIONIST in that it embodies the angst of a philosophy that sees "man" as alone and responsible for his fate in an absurd world where little is reasonable or dependable. Still, one of Giacometti's most haunting sculptures is not a person. In *Dog* (1951), a relatively small bronze of about 17 inches high, the animal's head hangs low, its back slumps in a downward curve, its legs are spidery, and the whole form is as attenuated and emaciated as Giacometti's human figures. He identified with this starving animal: "It's me," he said. "One day I saw myself in the street just like that. I was the dog."

Giambologna (also Giovanni Bologna)

1529–1608 • Flemish/Italian • sculptor • Mannerist

He is the best person one can imagine, entirely unmercenary, as his poverty

proves, and dedicated only to glory. His dearest ambition is to equal Michelangelo, and in the view of many connoisseurs, he has already done so, and may surpass him if he lives. (letter from an agent to the Duke of Urbino, 1581)

In about 1771, JEFFERSON chose Giambologna's *Rape of the Sabine Women* (1582) as one of 13 sculptures he wanted for his home, Monticello. While there is no record that this work or a cast of it ever entered his art collection, Jefferson's choice is interesting. Technically and conceptually, this marble group, some 13 feet high, is as complex as it is powerful. The design draws from ANTIQUITY—both the statue of Hercules lifting Antaeus off the ground (which may have been in the collection of Giambologna's MEDICI patron) and two of the struggling figures from the LAOCOÖN were sources. It also profits from lessons MICHELANGELO taught about the expressiveness of the human form. Giambologna's three figures are constructed as if they revolve around a single, central axis, and to fully appreciate the work requires walking around it, an act that involves the viewer physically as well as visually. Curiously, the name, which relates to Romulus, the legendary founder of Rome, had nothing to do with the sculptor's intent. (Whether it meant anything to Jefferson is another question.) According to the ancient myth, when Romulus wanted to increase his power and territory, he had his soldiers kidnap and rape the daughters of his Sabine neighbors. The title of the sculpture, *Rape of the Sabine Women,* was given to the work by those who saw the end result. Giambologna

had endeavored to construct a complex work of art, not to illustrate a story. However, there is one meaningful tale he did tell in his old age: Born in Flanders, Giambologna went to Rome as a young man. One day he went to see Michelangelo with a model, probably of wax, that he had labored over and brought to a perfect, high finish, *coll'alito,* meaning "with his breath," as the expression goes. Instead of offering encouragement, Michelangelo destroyed the model and remade it as he saw fit, telling the young man to learn the art of modeling before he learned the art of finishing. Perhaps Michelangelo, who was paranoid about competition, was trying to crush the young sculptor's spirit as he had crushed his work. When Michelangelo died, Giambologna was his successor. In his mature work he mastered both modeling and finish, and he excelled in representing the human form in movement, leaving a heritage to be followed by BERNINI.

Giedion, Siegfried

1893–1969 • Swiss • architectural historian

The statement that only posterity can estimate the true values of a period is one of those thin excuses behind which we shelter to escape our responsibilities.

Giedion proclaimed himself a disciple of WÖLFFLIN, who in turn was a student of BURCKHARDT. Giedion's book *Space, Time, and Architecture: The Growth of a New Tradition* (1941) was a milestone in the discipline of architectural history and influenced several generations of architects and critics. He followed the historical approach that had been pio-

neered by his intellectual precursors in the study of the ITALIAN RENAISSANCE, but applied it to recent work. He was an apologist for MODERNISM in architecture, though toward the end of his life he recognized that one cannot throw out all history and tradition. The quotation above suggest his sense of engagement, as does another comment of his: "The historian cannot in actual fact detach himself from the life about him; he, too, stands in the stream," Giedion wrote. In that stream Giedion encountered "the Janus-headed influence of mechanization" and its effects on the psychological and cultural spirit of the time. Giedion was secretary general of the International Congresses of Modern Architecture (CIAM) from 1928 to 1954. He taught in Zurich and then in the United States, at the Massachusetts Institute of Technology and at Harvard University. He died a day after completing *Architecture and the Phenomena of Transition,* published in German in 1969 and English in 1971.

Gifford, Sanford Robinson

1823–1880 • American • painter • Hudson River School/Luminist

These studies, together with a great admiration I felt for the works of [Thomas] Cole developed a strong interest in Landscape, and opened my eyes to a keener perception and more intelligent enjoyment of Nature. Having once enjoyed the absolute freedom of a Landscape painter's life, I was unable to return to Portrait painting. From this time my direction in art was determined.

Gifford traveled through Europe, where he discovered TURNER and CONSTABLE, and later went to Fontainebleau and BARBIZON, where he met MILLET. Adding those influences to his love of nature and admiration for COLE, he devoted himself to landscape painting, as the quotation above suggests. The studies to which he refers were sketches of the Catskill and Berkshire Mountains. He also is reported to have said, "The really important matter is not the natural object itself, but the veil or medium through which we see it." For Gifford that veil is lucent; his work is characterized by attention to the effect of light in the atmosphere of his sweeping landscapes. *Sunset on the Hudson* (1879), in which the purple-pink glow on the horizon shimmers in the still water and white sails, is a transcendent tour de force.

gilt

A coating of gold leaf (gold beaten into paper-thin sheets) or a gold-colored paint applied to a surface—for example, a painting, sculpture, architectural decoration, picture frame, or an ILLUMINATED MANUSCRIPT. The preciousness of gold and its reflection of light made it an appropriate medium for the background of religious images, especially in MEDIEVAL art. HALOS were traditionally shown in gold.

Giordano, Luca

1634–1705 • Italian • painter • Baroque

Because Giordano's father wanted him to acquire the ability to work at great speed, he always stood at his side, never letting him out of his sight, and saying to him every so often, "Luca, do it quick." Thus . . . [he] was called

"Luca fa presto." (Francesco Saverio Baldinucci, c. 1705)

Giordano was prominent during the final flowering of the BAROQUE period. He was from Naples, where he came under the influence of the Spanish artist RIBERA (Spain controlled Naples at that time). Later he studied under CORTONA, but he loved Venetian coloring and the open brushwork of TITIAN, TINTOR-ETTO, and VERONESE. He traveled often, and was even called to work at the Spanish court. Although he was legendary for his speed and virtuosity, as the passage quoted above describes, his style varied. He combined the High Baroque and Baroque Classicism in a light, airy, decorative manner that presages the ROCOCO.

Giorgione

c. 1477/78?–1510 • Italian • painter • Renaissance

A painter is not an intellectual when, having painted a nude woman, he leaves in our minds the idea that she is going to get dressed again right away.... The nudes of Puvis de Chavannes never get dressed, nor do many others belonging to the charming gynaeceum of Giorgione and Correggio. (Odilon Redon, 1888)

Although we have no first-person documentation for Giorgione, in some ways we know what he felt far better than we know LEONARDO, who left an excess of documentation. One tremendous innovation of Giorgione's work is its mood; in his pictures mood is almost corporeal, tactile. His subjects seem contingent on the tangibility of atmosphere and sensuality. Consider his three best-known paintings, *The Tempest* (c. 1509?), *Fête Champêtre* (also known as *Pastoral Symphony;* c. 1510), and *Sleeping Venus* (c. 1510, left unfinished at his death). Even the artist's contemporaries were baffled by his intentions. A recent interpretation proposes that *The Tempest* is a political allegory concerning the Cambrian Wars of 1509. According to this view, the soldier, Fortitude, in the painting must be joined with Charity, the nursing mother, in times of trouble (see also X-RADIOGRAPHY). However obscure their "meanings," for nearly five centuries, viewers have understood these works intuitively, without fathoming them intellectually. In his method and experimentation with OIL PAINTING, Giorgione was also revolutionary. Instead of depending on preliminary drawings, he painted spontaneously, laying down landscape first and then figures, and changing things as he went along. Such freedom during the creative process was new. However, the three paintings mentioned above also represent half of Giorgione's known oeuvre. He was 35, at most, when he died of the plague. Some art historians attribute more paintings to him, but only five receive a near unanimous vote. What is known with some certainty is that Giorgione was born in Castelfranco, on mainland Venice, and that he worked with Giovanni BELLINI, who also explored the sensations of natural light and landscape, but as background rather than overall effect, as in Giorgione's case. VASARI describes Giorgione as well liked, something of a hedonist, and a great lover. Some of his works may have been visual translations of the pastoral poetry that contemporary HU-

MANISTS SO enjoyed. They were privately commissioned by members of what we might call the avant-garde. Giorgione's successful building up of color, tone by tone, especially in *The Tempest,* was achieved by no other artist except LEONARDO, which leads to speculation about whether the two ever met. TITIAN worked with Giorgione and continued his master's experiments with mood and color; it is thought that Titian completed paintings that were left unfinished at Giorgione's death. Certainly Giorgione's inventions have withstood time, and have been built on for centuries: *Venus* is the prototype for hundreds of reclining nudes; and *Fête Champêtre,* in which two nude women are in the company of two clothed men, was reimagined by MANET in *Le Déjeuner sur l'herbe (Luncheon on the Grass;* 1863). This correlation prompted the comment by the painter REDON, quoted above, to which he added, "But there is one, in Manet's *Déjeuner,* who will hurry to dress herself, after her boring ordeal on the cold grass."

Giotto di Bondone
c. 1266–1337 • Italian • painter •
Late Gothic/Early Renaissance

In a village near the city of Florence, called Vespignano, a boy of marvelous genius was born. (Ghiberti, c. 1450)

Giotto is a pivotal figure in the history of art, and his fame spread during and after his lifetime. In the century following Giotto's death, GHIBERTI told the story of CIMABUE coming upon a boy who was drawing a picture of a sheep on a rock. Cimabue was so awestruck

that he persuaded the boy's father to let him take the child home: "And Giotto grew great in the art of painting," Ghiberti wrote. If Cimabue did teach Giotto, his student took a new and entirely independent course, for Giotto abandoned the MANIERA GRECA. Other periods and styles are cited as his background influence, including the sculpture of the PISANOS. Essentially, working in true *(buon)* FRESCO (painted on wet plaster, adding only finishing touches on the dried surface) and colors that were remarkable for their springlike freshness, Giotto achieved a sense of spatial depth and restored NATURALISM, simplicity, and restraint to painting. He built on the foundation of his own sensibility, his understanding of human nature, and humor. Dramatic productions may have inspired Giotto: He painted stage curtains in his scenes, and sometimes portrayed secondary characters with their backs to us, the viewers, as they might appear onstage, an innovation that serves both to direct our attention to others in the scene and to make all observers (inside the picture and outside) part of the action. These qualities are present in his best-known work, the frescoes (executed 1305–06) of the Arena Chapel in Padua (so named because it was built on the site of an ancient Roman arena). Here incidents from the life of Christ move along, scene by scene, in three rows. Each picture has its ornamental "frame" painted around it (much as did the murals in ancient Roman houses), and the action takes place parallel to and in the front of the PICTURE PLANE. The effect is, again, to draw the viewer into the story. The emotional content of

his work is exemplified by a small angel hovering above the dead Christ with curved wings, straight, rigid arms, palms forward, and head thrown back to utter a grief-struck wail. Yet among the Arena images, Giotto's renowned wit breaks through in pictures of rotund Folly and the antics of sinners in Hell. Giotto made both God and humankind understandable. Also of importance, in the Arena Chapel, perhaps for the first time, architecture is secondary to art. As the critic John Canaday writes: "The temples of the ancient world and the cathedrals of the Middle Ages had summarized man's ideas about himself and his gods, with sculpture as a powerful corollary and painting as a decorative and didactic element. But with Giotto all this changed—not because he set out to change it, but because as a painter he became the instrument of change. The fact that the Arena Chapel is little more than a shell providing walls for the frescoes becomes symbolic." Artists of the High ITALIAN RENAISSANCE looked back to Giotto as their predecessor.

Giovanni di Paolo
c. 1399–1482 • Italian • painter • Early Italian Renaissance

Relationships with artists of the past are like relationships with living people. They start in a casual fashion, they deepen and mature, and if you are lucky you find in old age that you have a friend for life. . . . Why half a century ago did I settle on Giovanni di Paolo? Because he appeared to me a substantial and highly personal artist. His paintings spoke, or seemed to speak with a human voice. (John Pope-Hennessey, 1988)

A resident of SIENA and follower of its style, Giovanni was among those Early ITALIAN RENAISSANCE artists who generally rejected the forward-looking influence of contemporary Florence. Rather, he followed the lead of his GOTHIC predecessors. Among living artists, he was much taken with the work of GENTILE da Fabriano, who visited Siena on his way to Rome about 1425. If Giovanni frequently reverted to the example of Gentile and others, he did so with an engaging idiosyncrasy that gave his work the personality to which the historian Pope-Hennessey refers above. While his cast of characters are all quite somber, their expressive glances are often irresistible: In a version of *The Adoration of the Magi* that he painted late in life, Giovanni invents a timid Joseph glancing sideways at one of the kings, who, kneeling, is reverentially kissing the big toe of the baby Jesus. Even the cow, donkey, and horses show emotion. He was primarily a maker of many-paneled or POLYPTYCH altarpieces, most of which were disassembled and dispersed, but through his research Pope-Hennessey was able to identify and reconstruct related panels and even to reunite a number of them. After the election of a Sienese pope, Pius II, in 1458, Saint Catherine of Siena was canonized in 1461. Not many of Giovanni's paintings can be dated, but it is reasonable to assume that his 10 panels for the *Life of Saint Catherine*, in which she wears the halo of a saint, date from the 1460s. "Based on a life of the saint written by her confessor, Raymond of Capua, they tell the story of her inner life with undeviating concentration and incom-

parable sensibility," Pope-Hennessey writes.

Girardon, François

1628–1715 • French • sculptor • Baroque

The sun, having completed his course, descends . . . six of his nymphs are occupied with serving him, and offering him all sorts of refreshments. . . . One of them, kneeling and bent over, holds a cloth for washing his feet; another, standing by his side, pours water over the god's hands, a third, also kneeling, holds a pitcher. (André Félibien, 1679)

Girardon worked with LE BRUN at VERSAILLES, and his renowned group *Apollo Attended by the Nymphs* (c. 1666–73) is described by the contemporary architect/writer Félibien above. It was part of the propagandistic program linking Louis XIV, the Sun King, to the ancient myths of Apollo, the sun god. Appropriately enough, Girardon adopted a CLASSICAL style, emphasizing the clarity of the forms and their balance, harmony, and beauty. The figure of Apollo, though seated, resembles the pose of the APOLLO BELVEDERE—head turned, arm extended with his cloak draped over it. The marble work was for a grotto in the gardens of Versailles, but it stayed there only until 1684, when MANSART's grand designs for the palace involved the destruction of the grotto and relocating the sculpture elsewhere. Its original arrangement was altered when it was moved again in the 18th century. BLUNT has written about it as "the most purely classical work in French seventeenth-

century sculpture. The direct inspiration of Hellenistic work is strikingly evident . . . and can be accounted for by the fact that the artist paid a special visit to Rome during the execution of the group in order to refresh his memory of ancient sculpture there." It was Girardon who was asked to revise the EQUESTRIAN statue designed to honor Louis after it was decided that BERNINI's expressive intensity was too much for French taste. Girardon's statue, cast in bronze c. 1685, stood in the Place Louis le Grand (now Place Vendôme) in Paris until it was melted down during the Revolution.

Girodet-Trioson, Anne-Louis

1767–1824 • French • painter • Romantic Classicist

But as for . . . Girodet, it would not be hard to find in [him] a few slight specks of corruption, one or two amusing and sinister symptoms of future Romanticism—so dedicated [was he], like [his] prophet [David], to the spirit of melodrama. (Baudelaire, 1855)

As a student of Jacques-Louis DAVID, Girodet held to a NEOCLASSICAL style of painting: His forms are clearly outlined, carefully shaped, and logically composed, like a tableau in the front of the PICTURE PLANE. But the subjects he chose to paint, and their emotional fervor, are typical of ROMANTICISM. BAUDELAIRE refers to this combination in the commentary quoted above. In *The Sleep of Endymion* (1791), a Greek shepherd is cast into a state of eternal slumber for the pleasure of the moon goddess. The erotic charge of this de-

fenseless figure, bathed in the eerie light of a moonbeam, is strangely androgynous; he is soft, fleshy, and has long curly hair. Endymion is like the BARBERINI FAUN in pose and vulnerability, though less masculine. Fascinated with exoticism and sensuality, the Romantic temperament toyed with ideas of sexual violence (e.g., FUSELI) and, in this instance, sexual ambiguity. Girodet was a friend of Châteaubriand, whom he painted as a windswept poet contemplating the ruins of Rome. Napoleon said that Châteaubriand (out of favor at the time) looked like a conspirator who had come down the chimney. Actually, in the portrait Châteaubriand has the introspective, troubled expression of the prototypical Romantic. In fact, Châteaubriand's book *Atala,* written in 1801 when he returned from America, glorifying love among the "savages," was the linchpin for his own celebrity, for the Romantic movement in French literature, and for a famous painting by Girodet, *The Burial of Atala* (1808), which was one of the most popular works of the 1808 SALON.

Gislebertus
active early 12th century • French • sculptor • Romanesque

Gislebertus hoc fecit

Little is known about the sculptor who carved the words *Gislebertus hoc fecit* ("Gislebertus created this"), though they have pride of place on the ROMANESQUE cathedral of Saint-Lazare in Autun, France. Gislebertus's signature is beneath the feet of Christ on the tympanum (the area between the lintel and the arch) above the main door. It is believed

that Gislebertus worked in Autun from 1125 to 1135. Because his dramatic narrative style is evident throughout the church, the entire decorative program is credited to him. Usually a master mason carried out only the most important figures, leaving the rest to his apprentices. Some scholars have identified Gislebertus's hand at the monastic churches of CLUNY and Vézelay (specifically the central tympanum of the inner doorway at Vézelay, c. 1130). Autun's west portal is crowned by the *Last Judgment,* a scene that ranks among art history's most horrific: Elongated angels claim the worthy while dreadful, grinning, claw-footed devils grab their due. The mouth of hell, on a head that looks like a dinosaur's, disgorges one demon, who snatches passing souls, while another devilish agent stuffs people into a furnace. A line of woeful candidates await their turn in the lintel. The weighing of souls depicted here has precedents in ancient Egyptian art, such as the papyrus SCROLL from the *Book of the Dead* showing the *Psychostasis* ("soul-raising") *of Hu-Nefer* (c. 1290–1280 BCE).

Giulio Romano
c. 1499?–1546 • Italian • painter/architect • Mannerist

Among the countless pupils of Raphael, who mostly became excellent, no one imitated him more closely in style, invention, design and colouring than Giulio Romano, nor was any one of them more profound, spirited, fanciful, various, prolific and universal; he also was an agreeable

companion, jovial, affable, gracious and abounding in excellent qualities, so that Raphael loved him as if he had been his son, and employed him on all his principal works. (Vasari, mid-16th century)

Giulio was chief assistant in RAPHAEL's workshop and took charge when the master died in 1520. He loved to work in CHIAROSCURO and far exceeded Raphael's example in contrasting extremes of dark with light. In 1524 Giulio went to Mantua at the behest of Federigo GONZAGA. There, outside the walled city, in a region called the Tè (the source of the name is unknown), Giulio designed a stone palace and then its interior wall decorations. The facade of the Palazzo del Tè breaks with ITALIAN RENAISSANCE conventions of order and regularity by interrupting symmetry and confusing visual messages about, for example, whether it is one or two stories high. That exterior ambiguity becomes chaos inside, where ancient mythology decorates the walls—in sometimes lascivious detail. And nothing had ever been done before to compare with the FRESCOES in the *Room of the Giants* (1532–34). As if enclosed in a Disneyland nightmare, a visitor is surrounded by a continuous scene of destruction and slaughter within an apparently crumbling structure. The story is one familiar from ANCIENT Greece, the Battle of the Giants, who launched an assault on Mount Olympus. Just as the Greeks used myths as metaphors for current concerns, so Giulio's terrible extravaganza would have reminded his contemporaries of the recent sack of Rome, in 1527, when German and Spanish troops, out of control, went on a rampage.

Glackens, William

1870–1938 • American • painter • Impressionist

. . . unique in mind, unique in the appreciation of human character, with an element of humor and an element of criticism, always without fear. . . . There is something rare, something new in the thing that he has to say. (Robert Henri, 1910)

A Philadelphian, student of ANSHUTZ, and associate of HENRI, Glackens was one of the first newspaper illustrators whom Henri persuaded to become a painter. Several of Glackens's canvases were shown at the important exhibition of The EIGHT held in 1908 and at that of the Independent Artists in 1910—he was the founding president elected by the SOCIETY OF INDEPENDENT ARTISTS when it was organized in 1917. Henri's comments, quoted above, refer to Glackens's work exhibited in 1910. But Glackens did not follow suit with the ASHCAN members who expressed a Socialist point of view. Rather, Glackens enjoyed living and painting the "good life," as his best-known work, *Chez Mouquin* (1905), testifies. Chez Mouquin was a fashionable restaurant where members of The Eight liked to dine, and the picture shows the restaurant's owner seated at a table with an attractive young woman. The scene has the kind of glitter and is a subject such as French IMPRESSIONISTs of the SECOND EMPIRE painted, especially MANET and RENOIR, and in fact Glackens helped his friend BARNES form a notable

collection of French Impressionist works.

Glasgow School

The primary reference of this term is to the group of ART NOUVEAU architects and designers associated with MACKINTOSH and Frances and Margaret MACDONALD. They were also affiliated with the Glasgow School of Art. Another, distinct group known as the Glasgow Boys were advocates of painting out-of-doors (PLEIN AIR).

glaze

In POTTERY, the glassy coating fired on objects to seal and often decorate the surface. In OIL PAINTING the glaze is a thin, transparent layer of tinted oil paint applied over other colors. These translucent films change and enrich the underlying color(s) while adding a dimension of reflectivity to the image.

Gleizes, Albert

1881–1953 • French • writer/painter • Cubist

The word "Cubism" is here employed merely to spare the reader any uncertainty as to the object of our inquiry; and we would hasten to declare that the idea which the term evokes—that of volume—cannot by itself define a movement which tends toward the integral realization of Painting.

Though his paintings in the new manner broke no new ground, Gleizes's tract *On Cubism* (1912), written in collaboration with Jean Metzinger (1883–1956), provided the important theoretical foundations for CUBISM.

The passage quoted above is from that book. At the end of World War I, Gleizes became interested in spiritualism and wrote about it in relation to art.

Gleyre, Charles (Marc-Charles-Gabriel)

1806–1874 • Swiss • painter • Academic

M. Gleyre demands from his students a tight, conscientious approach in their drawings, but he is no tyrant, and he leaves each one free in thought and deed. (Paul Milliet, 1863)

Gleyre's merits as a teacher are described above by one of his students. When DELAROCHE closed his studio in 1843, he invited Gleyre to take it over. During his career Gleyre taught more than 500 artists in classes that ranged between 30 and 40 students. Most were Swiss and French, although there were 10 Americans, WHISTLER among them. Gleyre's students adopted diverse styles, from NEOCLASSICISM to REALISM[2], and a number became IMPRESSIONISTS, including BAZILLE, RENOIR, MONET, and SISLEY. In his own work, Gleyre specialized in HISTORY PAINTINGs based on religious, CLASSICAL, and modern—particularly Swiss—subjects. *Le Bain* (*The Bath*; 1868), in which two idealized nude women are bathing a baby in what looks like a large marble birdbath, is one of his works. He painted with tight brushwork and achieved a polished finish. As were Delaroche and COUTURE, Gleyre was known as an artist of the *juste milieu*, that is, one who operates between the extremes of ACADEMIC and ROMANTIC tendencies: He took the subject matter that would interest a Roman-

tic and rendered it in a style approved by the academy.

Goes, Hugo van der

c. 1440–1482 • Netherlandish •
painter • Northern Renaissance

. . . we can speak of two possible assumptions concerning the illness of our painter-brother converse. The first is that it was a natural one, a kind of frenzy. . . . The second possibility of explaining this disease is that it was sent by Divine Providence. (Gaspar Ofhuys, c. 1509–13)

Hugo suffered severe depressions, during one of which he attempted suicide. Some aspects of his paintings seem to show the effects of looking into the chasm of despair. *The Portinari Altarpiece* (c. 1473–78), an extremely large TRIPTYCH, is Hugo's masterpiece. It was commissioned by a wealthy Italian businessman, Tommaso Portinari, who was the head of the MEDICI bank in Bruges (for Bruges, see MEMLING). The central, interior panel, a Nativity, is a haunting portrayal of that event. It has a hierarchical arrangement with the Virgin, in the center, larger in scale than everyone else except Joseph, who is off to the left. Grim angels and dour shepherds surround the Virgin and infant Christ, who lies naked and isolated on a bare stone floor. This bone-chilling isolation, combined with the winter bleakness of the surroundings and solemn expressions on bystanders' faces, contributes to how this painting works on and troubles the mind. In addition, a hardly visible image of the devil lurks in the shadows of the stable. Anguish is sharpened by a dichotomy: In the foreground, next to a kneeling angel in bright white garments, is a beautiful STILL LIFE of flowers in front of a bound sheaf of wheat. Each element is realistically painted in scrupulous detail—the work of van EYCK had a powerful hold on him—and each detail has important symbolic meaning. The wheat, through the sacrament, represents Christ's flesh; clusters of grapes decorating the Spanish earthenware vase are symbolic of Christ's blood. A stalk of columbine represents the Holy Spirit; carnations, known as nail flowers, stand for nailing Christ to the Cross. Yet the overall impact of Hugo's creation, his perhaps unbearable genius, combined with his great compositional skill, expresses mysticism as well as the religious and political anxiety of the time and place in which he lived. The texture of suffering in his works leads some to believe that he belonged to the cult of *Imitatio Christi* (Imitation of Christ), whose members found mystic ecstasy by meditating on the pain of Christ. Hugo entered a monastery about the same time that he painted the *Portinari Altarpiece*. One of his confreres at the monastery, Gaspar Ofhuys, who is quoted above, speculated on Hugo's illness, attributing it to self-doubt—that he would be unable to fulfill his commissions—and to drunkenness. How much malice and how much truth is contained in Ofhuys's assessment is uncertain, but Hugo died, of causes unknown to us, a year after his failed attempt at suicide.

Goethe, Johann Wolfgang von

1749–1832 • German •
poet/philosopher/theoretician

Foolishly as a people which calls barbaric the entire unknown world, I

named Gothic that which did not fit into my system. . . . And so as I went I shuddered as before the sight of a misshapen, curly-bristled monster.

Productive in many fields—he was a poet, novelist, dramatist, scientist, philosopher, statesman, and even artist —Goethe led and embodied ROMANTICISM in its commitment to emotion, self-examination, and imagination. He was also devoted to reconciling the scientific interests of the ENLIGHTENMENT with the Romantic sensibility because the scientist could not, he believed, find nature's deeper truths while detaching himself from nature and approaching it with abstract or mechanical objectivity. Goethe's influence was vast: "I have no other wish than a close fusion with nature, and I desire no other fate than (according to Goethe's precept) to have worked and lived in harmony with her laws," MONET wrote in 1909, when he was nearly 70. Goethe's influence on art stemmed also, in part, from his explorations of color theory. In this context Goethe wrote, "Single colors affect us, as it were, pathologically, carrying us away to particular sentiments. At times they elevate us to nobility, at others they lower us to vulgarity. . . ." Goethe's insistent belief that ultimate truth resides in direct sensory experience led to some mistaken ideas, such as a belief in the indivisible purity of white light. This brought him into conflict with Isaac Newton's explication of the physical nature of the spectrum, its interdependence and continuous state of instability and change. TURNER read and was affected by Goethe's *Color Theory* (1810; English translation 1840). What Goethe describes in the introductory quotation is his enchantment and brief flirtation with GOTHIC architecture, inspired by a visit to the Strasbourg Cathedral (late 13th century). He had gone to Strasbourg expecting to find the embodiment of the irrational—a "curly-bristled monster"—and found instead "a sensation of wholeness, greatness [that] filled my soul. . . ." His impassioned appreciation sparked a Gothic revival in Germany, an example of which is SCHINKEL'S WAR MEMORIAL. (Such a revival had already begun in England— see WALPOLE.) Goethe's followers became ardently nationalistic in their interest in restoring Gothic cathedrals and castles. While Goethe's enthusiasm sparked this revival, Goethe himself returned to his interest in CLASSICAL style while acknowledging his emotional, or Romantic, approach to the Classical.

Gogh, Vincent van

1853–1890 • Dutch • painter • Post-Impressionist

I am feeling well just now. . . . I am not strictly speaking mad, for my mind is absolutely normal in the intervals, and even more so than before. But during the attacks it is terrible—and then I lose consciousness of everything. But that spurs me on to work and to seriousness, as a miner who is always in danger makes haste in what he does.

Thus, as quoted above, in October 1889, less than nine months before he killed himself, van Gogh described his state of mind. But it is important to stress that van Gogh's mental illness neither distinguishes nor explains his painting. What it did was to interrupt,

and ultimately end, his work. In that work van Gogh expressed the political and social concerns of the time in which he lived, in addition to his sharp and sensitive aesthetic vision. "These people, eating their potatoes, in the lamplight," as van Gogh himself wrote about *The Potato-eaters* (1885), "have dug the earth with those very hands they put in the dish, and so it speaks of manual labor, and how they have honestly earned their food." His appreciation of peasant life allies him with REALISTS. That connection is confirmed in *The Sower* (1888), a painting that shares title and subject with one by MILLET, whom van Gogh admired tremendously. Van Gogh's was painted the year after Zola's novel *La Terre* was published. Turning workers on the land into heroes was paralleled by seeking out the unspoiled rural landscape. This encouraged the growth of 19th-century artists' colonies (e.g., BARBIZON), and van Gogh, who lived in Paris with his brother Theo (see GOUPIL'S GALLERY) from February 1886 to February 1888, went to Arles for solace in the landscape and brilliant sun. He wrote to persuade his friends BERNARD and GAUGUIN to join him. It was during Gauguin's two-month visit, and the first of a series of breakdowns, that van Gogh mutilated his ear and painted a self-portrait of his bandaged head. In a letter to his brother he described how, in late spring, "the landscape gets tones of gold of various tints, green-gold, yellow-gold, pink-gold, and in the same way bronze, copper, in short starting from citron yellow all the way to a dull, dark yellow color like a heap of threshed corn. And this combined with blue—from the deepest royal blue of the water to the blue of the forget-me-nots, cobalt." As the critic HUGHES writes, van Gogh's work from Arles "offers one of the most moving narratives of development in Western art: a painter—and, needless to repeat, a very great one—inventing a landscape that invents him." Van Gogh's stylistic explorations were as fully contemporary as many of his subjects. In reaction to the IMPRESSIONIST blurring of outline, for example, he (as well as Gauguin and Bernard) restored the delineation of form, stressing contour in a style called CLOISONNISM. Such distinction, or reductiveness, of form is connected to the beginnings of MODERNISM in art, though van Gogh wrote: "My attention is so fixed on what is possible and really exists that I hardly have the desire or the courage to strive for the ideal as it might result from . . . abstract studies." After intervals at the hospital in Arles and in the asylum at Saint-Rémy, Van Gogh spent his last two months in Auvers, under the care of Dr. Paul Gachet, whose portrait he painted in 1890. In the picture, Gachet's elbow rests next to two novels by the GONCOURTS. (That portrait was sold in 1990 for $82.5 million, claiming the record for the highest price ever paid at auction for an art work.) Also during those two months van Gogh, who painted in extraordinary bursts of creativity, completed about 75 paintings. He died virtually unknown; his work had rarely been shown in public. With his first major retrospective, in 1901, which initiated the influence he would have on succeeding generations, prices for his work started to soar and counterfeiting of his paintings began. In the

late 1990s scholars began to question seriously the authenticity of many previously "secure" attributions.

Golden House of Nero *(Domus Aurea)*

The emperor Nero (ruled 54–68 CE) had a new palace built after Rome's great fire of 64 CE destroyed his old one. Part of an enormous and luxurious scheme, it overlooked an artificial lake that was later drained for the COLOSSEUM. The entire compound was eventually built over, and the Baths of Trajan covered part of it. That is where excavations, in the 1480s, uncovered a number of rooms in Nero's buried palace. Some still had signs of their rich decoration, with marble paneling and painted and gilded stucco. These decorations had great influence on artists of the ITALIAN RENAISSANCE, bringing the use of gold back into vogue in many imaginative ways, from BOTTICELLI gilding the blond hair of Venus, to sparks under the cauldron in which John is being boiled in Filippino LIPPI's *Martyrdom of Saint John the Evangelist* (1490s). Excavation discoveries also brought about a passion for GROTESQUE decorations, which soon began to appear on FRESCOes, even incorporating raised RELIEFS (see PINTURICCHIO), as well as on architectural detailing.

Golden Section (Golden Mean)

The ancient Greeks were philosophically and aesthetically absorbed with the concept of perfect proportions, and were intent on devising CANONS to express such relationships (see POLYKLEITOS and IDEAL). One ideal ratio, supposed to express visual harmony, was the Golden Section (or Mean). Aristotle saw it as an ethical metaphor, and, later, MEDIEVAL scholars called it "divine." During the ITALIAN RENAISSANCE, it became the subject of intense study and speculation: LEONARDO drew illustrations for a mathematical tract on the subject, and PIERO della Francesca wrote a thesis, in Latin, entitled "On the Five Regular Solids," that was published in Italian, in 1509, in a treatise entitled *Divine Proportion*. The Court of the Lions at the Alhambra palace (1354–91) in Granada, Spain, is proportioned according to the Golden Section, and the CUBIST sculptor LIPCHITZ, among others, based many of his works on it. Painters like SEURAT and architects like LE CORBUSIER made reference to the Golden Mean. In essence the Golden Mean depends on dividing a line into two segments so that the ratio of the smaller segment to the larger one is the same ratio as the larger segment to the whole. The concept is most easily visualized in terms of the proportions of a rectangle. However, the mathematical value concerned cannot be expressed in whole numbers. The closest numerical expression of the Golden Section ratio is about 8:13 or 1:1.6180339 . . .

Golub, Leon

born 1922 • American • painter • Neo-Expressionist/political

. . . attempt to reinstate a contemporary catharsis, that measure of man which is related to an existential knowledge of the human condition.

Golub (who is married to SPERO) was a member of the Chicago Monster Roster

(which included Cosmo Campoli, born 1922). German EXPRESSIONISM, PSYCHOANALYSIS, and EXISTENTIALISM were important influences on their work, especially the existential ideas expressed by the theologian Paul Tillich, then teaching in Chicago. Golub's description of his work, quoted above, articulates such concerns. In the series *Mercenaries,* which he began around 1980, Golub painted images of strange, arrested violence, of uncertain cause and result. On enormous canvases he painted soldiers, some double life-size, wearing miscellaneous uniforms; their direct gazes suggest undercurrents of illicit pleasures in which the viewer is made to feel complicit. Golub's implied antiviolence and anticorruption messages, and politics, elicit strong reactions. HUGHES describes Golub's work with the power it deserves: ". . . the size of Golub's figures seemed justified and even necessary. Only by monumentalizing their documentary content could he give it the fixity and silence it needed, and only in that way could he strike his peculiar balance between the sacrificial and the banal and so get rid of that suspicion of pornography that attends images of extreme violence."

Gombrich, Ernst
born 1909 • Austrian/English • art historian

Why is it that different ages and different nations have represented the visible world in such different ways?

Born in Austria, Gombrich has lived in England since 1936 and has taught in America as well as in England. He is best known for *The Story of Art* (1950), which is translated into 13 languages.

During the last quarter of the 20th century, Gombrich's ideas, expressed in *Art and Illusion* (1960), were challenged by writers of the NEW ART HISTORY and by BRYSON in particular. The reason for this is hinted at in the subtitle of Gombrich's book—*A Study in the Psychology of Pictorial Representation*—and in Gombrich's effort to, as he wrote, go "beyond the frontiers of art to the study of perception and optical illusion." He also wrote, "It is almost as if the eye knew the meanings of which the mind knows nothing." Missing from this "perceptualist" account, in which artists endeavor to record and transmit to the viewer accurately transcribed images, is, according to Bryson, "that it leaves no room for the question of the relationship between the image and power," and a relationship played out through the activation of "codes of recognition" that are socially learned. Nevertheless, Gombrich's concern with ideas of cognition, perception, and optical truth broaden art historical knowledge and continue to have wide influence, answering, to the satisfaction of many, the question he himself posed in the quotation above.

Goncharova, Natalia
1881–1962 • Russian • painter/designer • Rayonist

Time should be divided over a long period in such a way that there should be enough for painting and work for the theatre—these are, of course, inseparable, but painting is an inner necessity for theatrical work, and not vice versa.

In 1871 the Russian Academy of Arts was opened to women, and during the

next decade art schools were established in major cities and attracted female students. Goncharova began her studies in Moscow in 1892, and in 1906 her work was included in Diaghilev's WORLD OF ART exhibition. She was rebellious in behavior as well as ideas, masquerading and posturing: She made several public appearances barebreasted with abstract designs painted on her body. With LARIONOV, whom she married, and others, Goncharova pursued an interest in native Russian arts and crafts, especially the bright colors of peasant art, fabrics, and ICONS, a field plowed by VRUBEL and cultivated for Diaghilev's Ballets Russes. Goncharova's *Haycutting* (1910) is an example of her interest in Russian peasant life. She and Larionov went to Paris in 1915 and worked on designs for Diaghilev. She made wooden dolls, puppets, and marionettes, often drawn from Russian mythology. But other impulses and explorations also ran through her career. In 1913, for example, she painted a picture that combined analytical CUBISM and speed-obsessed FUTURISM, *Aeroplane over Train*. During the last decades of her life Goncharova painted images inspired by the exploration of space. After the Soviet launch of Sputnik in 1957, she produced a series of paintings on the theme of the cosmos that were exhibited in Paris in 1958.

Goncourt, Edmond Huot de
(1822–1896) and **Jules de**
(1830–1870) • French •
writers/collectors

Living in the nineteenth century, in a time of universal suffrage, democracy, liberalism, we asked ourselves whether what one calls "the lower classes" have no right to the Novel.

The Goncourt brothers were very influential on the art of the 19th century. They collaborated on novels—the passage quoted above is from the preface to *Germinie Lacerteux* (1865), a story of a servant girl—published a journal, and wrote books that looked back to 18th-century French art (*L'Art du dix-huitième siècle;* 1859–75) and studies of Japanese artists. These texts promoted the popularity of both the ROCOCO and Japanese prints (see UKIYO-E). Van GOGH's *Portrait of Dr. Gachet* (1890) contains an allusion to them: Two of the Goncourt novels are on the table where the doctor rests his elbow. The Goncourts regarded their own age, cynically, as being without values or moral structure, and they provided a spark to the social consciousness of REALISM[2] in both painting and literature. They themselves were independently rich. The historian Linda Nochlin demurs regarding their intentions: "Those fastidious snobs, the de Goncourts, as jealous of their *particule* as of their *recherché* art collection, no less than the democratic, ultimately socialist Zola, sought their documentation in the seamier sides of Parisian life—though their motives may be questioned." One perhaps less ambiguous result of their privileged lives was the bequest of the support for an annual prize in literature, the Prix Goncourt.

Gonzaga family
This Italian family may be traced back to the early 13th century, when Luigi I wrested control of the northern terri-

tory of Mantua from his brother-in-law. The first notable art PATRON was the second Marquis of Mantua, Ludovico II (ruled 1444–78), who made MANTEGNA his official court painter in 1459. In the same *Camera degli Sposi* of the Gonzaga palace where he painted a humorous, illusionistic ceiling open to the sky, Mantegna painted a fascinating FRESCO, *Ludovico Gonzaga, His Family and Court* (completed 1474). This informal family portrait might be subtitled "A Day in the Life at Court." Francesco Gonzaga II (ruled 1484–1519), grandson of Ludovico, married the brilliant Isabella d' ESTE, and they continued to support Mantegna and other artists. Mantegna's death in 1506 was considered a family tragedy by the Gonzagas. (He is buried in Mantua, in the church of San Andrea, designed by ALBERTI.) Francesco and Isabella's son, Federigo II (ruled 1519–40), was made a duke in 1530 by his ally, the emperor Charles V. It is for Federigo that GIULIO Romano designed the Palazzo del Tè (1527–34) and the outrageous frescoes for its *Room of the Giants* (1532–34). Federigo was an avid horse breeder, and another of the rooms in the palace, the *Camera dei Cavalli,* is decorated with portraits of his favorite horses. Before Gonzaga patronage came to an end with the sack of Mantua in 1630, RUBENS and van DYCK were among the artists who served the ducal family.

González, Julio

1876–1942 • Spanish • sculptor • Abstraction

The age of iron began many centuries ago. It is high time that this metal cease to be a murderer and the simple instrument of an overly mechanical science. Today the door is opened wide for this material to be—at last!—forged and hammered by the peaceful hands of artists.

From a Barcelona family that forged ornamental iron for three generations, González went to Paris in his 20s. There he continued working in the craft until he turned 50. Then, inspired by sculptors, including PICASSO, who employed his welding, forging, and soldering skills, González began to create his own body of work. His techniques of welding iron opened a new era, enabling a move from CLOSED to OPEN FORM. Most of his creations, such as the bristly *Cactus Man* (1939–40), are abstract creations, but his best-known work, *Montserrat* (1937), is figurative, representational, and symbolic: A larger-than-life-size peasant woman, she stands for the Spanish resistance to Fascism.

Gorky, Arshile

1904–1948 • Armenian/American • painter • Surrealist/Abstract Expressionist

It is as if some ancient Armenian spirit within me moves my hand to create so far from our homeland the shapes of nature we loved in the gardens, wheatfields and orchards of our Adoian family in Khorkom. Our beautiful Armenia which we lost and which I will repossess in my art.

When Gorky was four years old, his father avoided conscription into the Turkish army by fleeing their home in eastern Turkey for the United States. As Christians persecuted by the Islamic

Turks, in 1915 Gorky and his mother and sisters set out on foot from their home to Caucasian Armenia. They were part of a "death march" in which stragglers were killed; before it was over, one and a half million Armenians had been slaughtered. His mother died of starvation. A year later Gorky arrived at Ellis Island. He created, or re-created, himself in America, beginning with his name: Arshile refers to the mythological Greek hero Achilles, Gorky means "bitter" in Russian, and is also the pseudonym for the writer Maxim Gorky. This prompted the critic Harold Rosenberg to write, "In making someone else's alias his own name, Arshile involved himself in the higher mathematics of pseudonymity." He cultivated other eccentricities in creating and changing his biography, behavior, and identity as he went along, constructing his own reality in SURREALIST fashion. But he opposed the Surrealist use of automatism, a process of encouraging and expressing spontaneous thoughts, saying, "I do not believe in anarchy in art. There must be some structure. . . ." Part of what structured his work were his memories: *The Artist and His Mother* (c. 1926–36) is based on a photograph taken when he was eight years old, and *Garden in Sochi* (c. 1943) is a free-form image of the past. "For me, art must be a facet of the thinking mind . . . unrelenting spontaneity is chaos." Also in the 1940s, when he made the comment about Armenia quoted above, he painted *The Liver Is the Cock's Comb* (1944), a 6-by-8-foot canvas of brilliant colors and strange, indefinite forms. Figures emerge but disappear again just as their identity seems within grasp. It is haunted by discombobulated references to some jagged shapes in PICASSO's *Guernica* (1937). The title is as much a play on meanings as are the painting's forms; for example, "liver" may mean one who is living as well as an organ. The last years of Gorky's life were shadowed with tragedy and depression—his work was lost in a studio fire, he was operated on for cancer, then his neck was broken in an automobile accident. He ended it in suicide, leaving a note that read "Goodbye, my loveds" on the wall of the woodshed where he hanged himself.

Gossaert, Jan (Mabuse)
c. 1478–1532 • Netherlandish • painter • Northern Renaissance

Quentin Massys and Jan Gossaert are virtuosi. They exhibit their mastery as a personal performance. We hear how they speak before we perceive what they say. Quentin's emotional debauches are no less artificial than Gossaert's acrobatics. (Max Friedländer, 1949)

Philip of Burgundy (see VALOIS) escorted his protégé Gossaert to Rome in 1508, and if the patron's intention was to Italianize the artist, the outcome was ambiguous. Rather than studies of PERSPECTIVE, or of MICHELANGELO's works, Gossaert returned home with elaborately detailed drawings of ANTIQUE helmets, sandals, and sculpture. In Gossaert's well-known painting *Danaë* (1527), the subject is seated in a tower, surrounded by finely rendered marble columns through which can be seen a fantastic cityscape combining both CLASSICAL and GOTHIC elements. She has the chubby, rosy cheeks of a

northerner, and her blue robe falls seductively from her shoulder, localizing and distancing Gossaert's work from the ITALIAN RENAISSANCE. Gossaert's Madonnas and secular portraits (e.g., *Madonna and Child,* c. 1525–30, and *Portrait of a Merchant,* c. 1520–25) are characterized as typical of Northern MANNERISM, yet they can also be seen as reviving the meticulous attention to surface, light, and detail from the work of van EYCK almost a century before. In addition, they have the virtuosity that FRIEDLÄNDER comments on in the quotation above.

Gothic

c. 1140–1500, the final period of MEDIEVAL ART. Subdivisions within the Gothic era are:

Early, c. 1140–1200, an experimental style (e.g., the Cathedral of Nôtre Dame, Paris, begun 1163).

High, c. 1200–1300 (e.g., Reims Cathedral, begun 1211). *Rayonnant* (radiant) is a style of *High Gothic.* It is characterized by walls of STAINED GLASS, and figures that curve sinuously (called the S-curve).

Late, c. 1300–1500. The *Flamboyant,* named for its flamelike architectural tracery, appeared during the *Late Gothic* period, at the end of the 1400s. The *International Style* is also a *Late Gothic* development: It was introduced in Paris c. 1375, flourished in AVIGNON, and is so named because it drew artists from France and Italy to Avignon and then spread through Europe. The *International Style* was characterized by an attention to observed detail—"realism of particulars" directly perceived by the senses (see NOMINALISM)—approximation of believable space, and DRAPERY with elegant and exaggerated folds. The *International Style* was a courtly art and is exemplified by work such as that of the LIMBOURG brothers, who painted with exquisite, rich color and elaborate renderings of the materials and pleasures of life, from brocaded fabrics to fabulous feasts.

Although this period is known as Gothic, it has nothing to do with the Germanic people called Goths. Italian writers of the 15th century first used the term to disparage an art that they considered crude, as in the manner of the Goths. During the 18th and 19th centuries, French, German, and English scholars recognized and studied it. "Both Romanesque and Gothic art still make a powerful impact on the mind and the emotions of the viewer. However, the final impression created by Romanesque art is one of naked power; that of the Early Gothic of humanized force. The Romanesque artist seemed to expect the Apocalypse; Gothic artists hoped for salvation and the joys and splendor of paradise," writes Marilyn Stokstad. The Gothic period witnessed increasing urbanization, the growth of universities, and a new middle class. A great, distinctive architecture began on the Île-de-France and spread to cities throughout France and the rest of Western Europe. Gothic architecture came to be characterized, especially in France, by walls of stained-glass windows, and both windows and masonry decorated by tracery—ornamental stonework. Elaborate, pointed ARCHes, rib vaults (masonry ribs inside the vault for support as well as decoration), and exterior wall buttresses (to shore up the structure)—especially decorative "flying buttresses"—were also

characteristic. A belief in the sanctity of light (as representing God) was accompanied by an ever more ambitious reach to the sky that led, ultimately, to the vault collapse at Beauvais Cathedral (begun 1247). Increasing the height of the cathedral seemed an obsession of French builders, and at Beauvais they hoped to surpass their predecessors with a height of 157 feet. In 1284, however, the Beauvais vault crashed. The abbot SUGER's building program for the Abbey Church of Saint-Denis, under way by 1137, had launched the Gothic era; the cathedral at CHARTRES was a chronicle and measure of Gothic architecture, sculpture, and stained-glass artistry.

Gottlieb, Adolph
1903–1974 • American • painter • Abstract Expressionist

The images appeared at random, then they established themselves in a new system. That was why all those years I was able to use very similar images, but by having different juxtapositions there will always be a different significance to them.

Seeking an alternative to prevailing and competing modes of painting in America during the 1930s (such as SOCIAL REALISM and REGIONALISM), Gottlieb found inspiration in the work of foreign artists. These included not only major European painters like PICASSO, MONDRIAN, MIRÓ, and KLEE, but also a Uruguayan, Joaquín Torres-García (1874–1949), who incorporated PICTOGRAPHS, or symbols, in his work. Gottlieb was interested in pre-Columbian, African, and Native American objects, and in these he discerned

images, or symbols, from which he developed his own pictographic language—the images to which he refers in the comment quoted above. He painted grids of irregular squares and rectangles as a framework or "windows" in which to present his pictographic symbols (e.g., *Pictograph No. 4, 1943*). Imaginative and evocative, they sometimes suggest faces, sometimes birds, or ancient symbols of flight. Much as earlier artists had objectified and romanticized Middle Eastern cultures, Gottlieb and other ABSTRACT EXPRESSIONISTS looked for truth—of human nature—in non-Western "primitive" and "archaic" cultures. Gottlieb expressed his motivation, a phenomenon of post–World War II angst: "Today when our aspirations have been reduced to a desperate attempt to escape from evil, and times are out of joint, our obsessive, subterranean and pictographic images are the expression of the neurosis which is reality. To my mind, so called abstraction is not abstraction at all. On the contrary, it is the realism of our time."

gouache
An opaque WATERCOLOR paint. In contrast to transparent watercolor in which the paper (GROUND) contributes to the picture's color, gouache depends on white PIGMENT for its high value. In general, opaque paint is dull and looks chalkier than transparent paint.

Goujon, Jean
c. 1510–c. 1568 • French • sculptor • Mannerist

[He is] the artist who dominates French sculpture in the middle of the

sixteenth century. Goujon created the style current in Paris and widely imitated in the provinces, and invented a form of Mannerism as exquisite as the finest production of the school of Fontainebleau in painting and decoration, but flavoured with a personal type of classicism. (Anthony Blunt, 1953)

Both the beginning and the end of Goujon's life are a mystery: He is first known as the carver of columns for the organ loft of Saint-Maclou at Rouen (1541) when he was a mature artist, but there is great uncertainty about his career from 1562 until his death. In 1544 he was in Paris, where his most celebrated works were done. These include the sinuously curving, elegantly draped nymphs in a RELIEF for the Fontaine des Innocents (1547–49) and the four *Caryatids* (1550–51) at the Louvre. The CARYATIDS, probably inspired by a description in editions of VITRUVIUS, or perhaps by its illustrations, were novel in France. The architect with whom Goujon worked on the Louvre was Pierre Lescot (c. 1500/10–1578), and the assessment of the collaboration by BLUNT (who is also quoted above) is that ". . . Lescot's architecture was perfectly conceived to display sculpture, and Goujon's reliefs or caryatids were planned to decorate a building, so that the two men worked in full harmony, almost as one mind."

Goupil's Gallery

A business, founded in 1827 on the boulevard Montmartre by Adolphe Goupil, published high-quality EN-GRAVINGS after paintings. Goupil's daughter married GÉRÔME. A branch of

Goupil's opened in New York in 1846. By the end of the 1860s, with several galleries as well as the printing shop in Paris, it was a worldwide business. (Michel Knoedler, who had founded the New York establishment for Goupil, bought him out, and Knoedler & Company continues its operation to this day.) Through family ties, Vincent van GOGH worked for just under a year at Goupil's, starting in May 1875. In 1878 Vincent's younger brother, Theo van Gogh, was put in charge of the small Goupil gallery on the boulevard Montmartre. (The establishment was actually named Boussod & Valadon, though it was still known as Goupil's.) Theo's taste for IMPRESSIONISM was more avant-garde than that of his employers, and his competitors at the time were the substantial gallery of DURAND-RUEL and the later arch rival Georges Petit, who ran an endeavor expansively named Expositions Internationales. Theo van Gogh fought the battle on behalf of Impressionist artists, and his struggles and successes have been documented by the art historian REWALD, who shows "Theo as the friend in need he was not only for his brother, but also for the many artists with whom he came into contact, even those with whom he did not form a close relationship." It was both Vincent's and Theo's hope that Theo would be able to open his own gallery. Financially, Theo took care of a wife and child as well as his brother. But it all ended badly: After shooting himself, Vincent died in his brother's arms on Tuesday, July 29, 1890. In October that year Theo also had a breakdown, and in January 1891 he, too, died. Goupil's—or Boussod & Valadon—went out of business on

March 3, 1919, selling off works by COROT, DAUBIGNY, Théodore ROUSSEAU, and others—but not a single Impressionist. The auction was held, with full-blown irony, at the gallery of Georges Petit.

Goya, Francisco de
1746–1828 • Spanish • painter/printmaker • Romantic

The artist is convinced that censuring human errors and vices—though it seems the preserve of oratory and poetry—may also be the object of painting. He has chosen as appropriate subjects for his work . . . those he has deemed most fit to provide an occasion for ridicule and at the same time to exercise his imagination . . . On sale at N. 1 Calle de Desengaño, the perfume shop, at the price of 320 réales for each set of 80 prints.

The words above were written by Goya to accompany the sale in Madrid, beginning on February 6, 1777, of his satires of Spanish life and mores known as the *Caprichos*. (The perfume shop was in the building in which Goya had lived for many years.) Goya sharply attacked everything from child-rearing practices to prostitution, but the best-known image, *Capricio 43*, is entitled *The Sleep of Reason Produces Monsters*. In this picture the artist has fallen asleep while a lynx, wide-eyed with alarm, watches as a covey of owls and bats surround him. The meaning is debated now as it was then, but it seems a direct reference to the rationalism of the ENLIGHTENMENT and the dangers in store when reason has departed. The 80 ETCHINGS were on sale for just a few days. Only 27 sets sold before they were

withdrawn, and Goya was denounced before the Inquisition. Powerful friends protected him, and the king, accepting the plates as a gift, granted a pension to the artist's son in return. Goya became the court painter; *Family of Charles (Carlos) IV* (1800) refers to VELÁZQUEZ's *Las Meninas* of 1656 in that the artist at his easel is included in the scene. But Goya lines up his overdressed and ineffectual royal family across the canvas with little respect but much mockery. The range of his subjects was vast: royalty, nobility, intellectual reformers, witches, giants, prostitutes, the insane, prisoners, milkmaids, and, in another series of PRINTS, warfare—the so-called *Disasters of War*. Regarding war, few works have more impact than Goya's oil painting *The Third of May 1808* (1814). French forces had occupied Spain from 1808 to 1814, and Spanish resistance was mercilessly suppressed. Goya's painting records the moment when French troops executed Spanish prisoners, a massacre we see almost as though we are witnessing it in a television news clip: The soldiers are lined up with their rifles as the civilians walk up the stairs to be killed, one by one, at point-blank range. Fear, surprise, and horror are all palpable. The current victim, illuminated as if by klieg lights, has thrown up his arms; a reference to the Crucifixion is implicit. Yet unlike *The Death of Marat* (1793), by Goya's contemporary, Jacques-Louis DAVID, in which the figure of Christ is invoked to suggest the victim's heroism, there are no heroes, and there is no morality in Goya's picture. The darkness of Goya's vision is also found in his "Black Paintings," which reject any semblance of a comprehensible world.

In *A Dog* (1820–23), the small, pitiful head of a dog appears in a vast emptiness of undefined landscape. More famous is *Saturn Devouring His Son* (1820–23): The giant, pop-eyed monster devours the small-scale torso of a strange, bloody body. In 1824 Goya left the oppressive political situation in Spain, which doubtless inspired his Black Paintings, and lived mainly in Bordeaux, France. His last great painting, *The Milkmaid of Bordeaux* (c. 1827), is a freely rendered picture of a lovely young woman. In its background the ghost of a face almost emerges to the surface of the canvas—it is either something painted over from an earlier use of the canvas or a purposely ambiguous image. This phantom face tilts up toward the milkmaid's as if to kiss her.

Goyen, Jan van
1596–1656 • Dutch • painter • Baroque

If van Goyen with unswerving singleness of vision prefers cloudy skies and dull weather, it is not enough to point to meteorological phenomena as the basis of his preference; we must rather infer a certain sort of feeling that was in harmony with the lusterless and melancholy atmosphere. The expression of the countryside was always changing, but only with just this expression did it become, for him, pictorial and (artistically) worth looking at. (Max J. Friedländer, 1949)

A pioneer in Dutch landscape painting of the 17th century, van Goyen sensitively embraced every nuance of light and clouds. His colors were so subdued as to be nearly monochrome, yet they were based on subtle contrasts of warm and cool tones. Views, such as *View of Dordrecht* (1653), portray a world of sky and water where clouds shift, change shape, and dissolve and sails billow with the breeze. His light brushwork itself suggests mutability. The windmill is a symbol of mechanical power and commerce, while the GOTHIC church is a familiar landmark of his paintings. Characteristic of his landscapes, and those of his Dutch contemporaries, is a lowered horizon, which had the effect of unifying foreground, middle-, and background. Van Goyen's interests were wide ranging. While he may have had the melancholy disposition described above by FRIEDLÄNDER, nevertheless he traveled frequently throughout the Netherlands, acted as an appraiser and seller of art, sometimes arranging auctions, and he also speculated in the market for everything from tulip bulbs to houses. He worked in The Hague for some 25 years, rose to be president of his GUILD, and was a prosperous man who owned land and houses when he died. His daughter, Margaret, married STEEN.

Gozzoli, Benozzo
c. 1420–1497 • Italian • painter • Renaissance

I would have come to talk to you; but this morning I started to apply the light blue and I cannot leave it. The weather is very hot, and the glue spoils quickly.

It is said that Gozzoli was the most prolific painter of his time, that he never turned down a commission, and that he

painted for everyone, from obscure country priests to the MEDICIS. The peak of Gozzoli's long career was a commission to paint the walls of the chapel in the Medici-Riccardi Palace (see MICHELOZZO) in 1459 (completed in 1461). It is a small chapel, and Gozzoli decorated it with a continuous panorama, *Procession of the Magi.* This sinuous procession had formed the background of GENTILE's earlier, magnificent ALTARPIECE, for which Virgin and Child were the focal point. Here, however, Gozzoli detailed the luxurious excesses of the Magi's finery with its spectacular richness as an end in itself. Along the curving route are castles and villas that belonged to his patrons, and members of the royal train are thought to be Medici family portraits. During the summer, Gozzoli had vexing problems in applying blue paint because of the heat, as he wrote in the letter to his PATRON, Piero de' Medici, quoted from above.

Grafton Galleries
See FRY

Grand Manner
Pertains to HISTORY PAINTING and its lofty themes promoted by the ACADEMY as the noblest kind of art. Though REYNOLDS is usually credited with articulating the Grand Manner in his *Discourses* at the Royal Academy in 1770 and 1771, Antoine Coypel (1661–1722) had addressed the same topic half a century earlier. Coypel said, in part, "The painter in the grand manner must be a poet; I do not say that he must write poetry . . . but he must of necessity know its rules, which are the same as those of painting. . . . Painting must do for the eyes what poetry does for the ears." The painter in the Grand Manner needed acquaintance with sacred, profane, and "fabulous" history, geography, geometry, perspective, architecture, and physics. "Unless he has some knowledge of the part of oral law which teaches us of the passions," Coypel asked, "how can he draw the visible images of these movements of the soul?" In his third and fourth *Discourses,* Reynolds urged artists to look back both to the ANTIQUE and to the ITALIAN RENAISSANCE for models. He extended the Grand Manner from History Painting to his own métier of portraiture.

Grand Tour
From the late 1600s into a good part of the 19th century, well-to-do young British, Northern European, and, later, American "gentlemen" (and sometimes "ladies") traveled to visit the cultural sights of France and Italy. These sights included museums, Roman ruins, and the scenery of the Alps. The enduring allure of Rome, Florence, Venice, and Naples often attracted colonies of expatriates, from the 17th-century BAMBOCCIANTI to the group of American women sculptors whom Henry James called "the white marmorean [marble] flock" (see HOSMER and Edmonia LEWIS). Local artists (e.g., CANALETTO, GUARDI, PANINI, and PIRANESI) profited by selling paintings and prints of popular sights, scenery, and events to Grand Tour visitors.

Grandma Moses
See MOSES

Grant, Duncan

See FRY

graphic art

Derived from the Greek word for "writing," combined with "art," the term historically refers to drawing, and images derived from drawn lines, especially for PRINTMAKING. Graphic art today includes commercial art, and is applied as well to much art produced on computers, especially that destined for print media.

Graves, Michael

born 1934 • American •
architect/designer • Postmodern

It's not that one has softened today, but the manifesto is much more gentle now. I would not say we are not reformers, however. We are, in the best sense of the word, re-formers. We are trying to establish form as it relates to us more than to the machine. . . .

Designs by Graves for buildings and DECORATIVE ARTS take a POSTMODERN turn in their rejection of rational utilitarianism and stylistic limitation or prescription, as well as in their attention to the importance of the "enclosing membrane." He borrows or alludes to motifs from various periods—a CLASSICAL COLUMN, a modernist cube—with purposeful disregard for rules of consistency that previously governed their use. "In Cubist fashion he assembles fragments which, changed in scale and function and placed in unexpected contexts, acquire new and potent meanings," wrote Helen Searing in 1981. "Graves's recent projects have a hauntingly poignant quality, like a poem whose verses we can only dimly recall." Graves describes his work as "figurative," meaning that it is always related to the human figure, the "us" to which he refers in the quotation above. A sense of whimsy and an interest in color characterize his buildings. On the Greek TEMPLE-like facade of the Team Disney Building (1987) in Burbank, California, he uses the Seven Dwarfs as if they were CARYATIDS. Such playful parody is another Postmodern device. The brick Denver Public Library (1993), in contrast, is a composite of cylinders, rectangles, squares, and a sharp triangular roof, unadorned, but colored in shades of red, blue, wheat yellow, and light green. The expressive architecture of LEDOUX is an influence in Graves's work.

Graves, Nancy

1940–1995 • American •
sculptor/printmaker/painter/filmmaker
• Surrealist/Postmodernist

When I think of Nancy Graves I come up with a series of action verbs. She's as fast as light and luminous as she goes. (Trisha Brown, 1996)

In the late 1960s Nancy Graves exhibited and became known for her witty, life-size sculptures of camels. She also constructed whimsical shapes from found objects that she laid out on the floor and then assembled, without premeditation, in trial-and-error fashion. She identified her work with SURREALIST ideas of spontaneity, and usually painted her constructions in bright colors. In 1972 Graves worked on abstract paintings based on maps and charts. Later she shaped objects in handblown

glass and bronze. From 1994 to her death in 1995, she used bones, leaves, and giant flowers, combined with domestic artifacts like colanders and baseball bats, as well as antique heads and musical staffs; cast them in bronze; and defined them by the application of different PATINAS, which yielded a range of greens and golds. The recollection above, from a friend, the dancer Trisha Brown, alludes to Graves's often mentioned energy, the ebullience of which is borne out in the artist's oeuvre.

Greco, El (Doménikos Theotokopoulos)

c. 1541–1614 • Spanish • painter • Mannerist

I was greatly surprised—forgive me this anecdote which I am not relating out of envy—when, having asked Dominico Greco in the year 1611: "Which is the more difficult, drawing or coloring?" he answered: "Coloring." (Francesco Pacheo, 1649)

Because he was from Crete, which was under Venetian rule, Theotokopoulos, who trained in VENICE, was called El Greco—the Greek. After 10 years in Venice he went to Rome, and then, around 1576, settled in Toledo, a major center of learning and of the Catholic Counter-Reformation. Mysticism permeates his works, tremors of an ethereal and visionary spiritualism echoing the Spanish priest Saint Ignatius of Loyola, founder of the Jesuits in 1534 and a Counter-Reformation leader. This emotional content, though not characteristic of MANNERISM, El Greco uses with many of its conventions: attenu-

ated figures and strong, artificial color, often with metallic and acidic hues. *The Burial of Count Orgaz* (1586–88) is a masterpiece that illustrates how important it is to understand a work in its intended setting: The painting, which shows the body of the count being lowered into a tomb, was made for an alcove in a church above the count's actual final resting place. The lower section of the picture, where the earthly burial is portrayed, uses earlier artistic conventions, with the figures more or less lined up across the canvas. The upper two-thirds, showing the count transported to heaven, uses the exaggeration of Mannerism. Thus, as one stood in front of the grave itself, one would look at a painting that links the temporal and the eternal. Though he had little influence on his own century, or indeed for the next three, in the 20th century echoes of El Greco's style are found in the work of PICASSO. He also became a point of reference for EXPRESSIONISM. The oddness of El Greco's figures was once attributed to a presumption that he had distorting eyesight (an astigmatism). Today it is understood to have derived from the artist's early study of BYZANTINE art.

Greek art

For important Bronze Age antecedents (c. 3000–1200 BCE), see CYCLADIC, MINOAN, and MYCENAEAN. The regions to which we now look for Aegean and Greek art endured invasion and upheaval during what are characterized as the Dark Ages, c. 1200–1000 BCE, and the Proto-Geometric era, c. 1000–800 BCE. Little notable art has been recov-

ered from these periods. For other periods in Greek art, see GEOMETRIC, ARCHAIC, CLASSICAL *(Early, High,* and *Late),* and HELLENISTIC.

Greek Revival

In architecture, styles that refer back to ancient Greece. The distinction between Greek and Roman buildings was not known in the West until the mid-18th century. A fashion for Greek art and architecture began around the 1780s and reached its peak in the 1820s. Among architects who worked in Greek Revival were LEDOUX, SOANE, SCHINKEL, JEFFERSON, and Alexander Jackson DAVIS.

Greenaway, Kate

1846–1901 • English • illustrator • Aestheticist

Kate Greenaway dressed the children of two continents. (Encyclopaedia Britannica, 1911)

Greenaway made illustrations for greeting cards and for children's books—including *The Birthday Book* (1880), *Mother Goose* (1881), and a series of *Kate Greenaway's Almanacks* between 1888 and 1897—and became extraordinarily popular and wealthy. She single-handedly created a revolution in illustration with her signature style of freshness, simplicity, and humor as well as delicacy and grace. She was praised by RUSKIN and by leading art critics around the world. Greenaway was elected to membership in the Royal Institute of Painters in Water Colours in 1890, and exhibited at the gallery of the Fine Art Society. Her contribution to fashion was the revival of early-19th-century costume, leading to the comment quoted above. Her subjects were mainly young girls, children, flowers, and landscape.

Greenberg, Clement

1909–1994 • American • art critic

There is nothing in the nature of abstract art which compels [its superiority]. The imperative comes from history. . . . Abstract art cannot be disposed of by a simple minded evasion. Or by negation. We can only dispose of abstract art by assimilating it, by fighting our way through it.

When he rose to prominence after World War II, Greenberg was the most important art critic the United States had produced. He maintained that quality and purity in art resides in its assertion of the shape and flatness of the canvas and the properties of paint. He was the supporter of and theoretician for ABSTRACT EXPRESSIONISM, and brought that movement, especially the paintings of Jackson POLLOCK and the sculpture of David SMITH, into focus and prominence. Influenced by lectures of HOFMANN on modern aesthetics, Greenberg called Hofmann's ideas "the core of the artistic sensibility and intelligence of our age." He promoted the FORMALIST assessment and the AESTHETIC approach to art. He believed that painting and sculpture should never try to be representational, or create illusions, that they should, rather, pursue the cultivation of their own medium, their own self-consciousness and self-definition. By 1960 Greenberg had inspired a school of young critics, including Michael Fried and Rosalind Kraus. They all stood in opposition to the developing trends of HAPPENINGS

and POP ART, and to its theoreticians, such as CAGE. (Cage's book *Silence* and Greenberg's *Art and Culture* were both published in 1961.) Greenberg's doctrinaire positions are generally rejected today, especially his distinctions between "high art" and debased "kitsch." In his denunciations as in his praise, Greenberg lived up to BAUDELAIRE's mandate that a critic be "partial, passionate and political."

Greenough, Horatio

1805–1852 • American • sculptor • Neoclassicist

Resolved, that the President of the United States be authorized to employ Horatio Greenough, of Massachusetts, to execute, in marble, a full length pedestrian statue of Washington. (U.S. House of Representatives, 1832)

Greenough studied in Rome and in Florence, where he lived for 23 years. His most important commission was also a first: In 1832 the government of the United States, which had never before tapped an American artist, asked Greenough for a statue of George Washington to be placed in the center of the rotunda of the Capitol building (the statue was completed in 1840; Washington had died in 1799. Greenough chose HOUDON's bust of the president as his model, and he based the seated marble figure of Washington on PHEIDIAS's colossal ivory and gold *Zeus* (after 438 BCE). This NEOCLASSICAL pretension was not at all in tune with Americans' evolving self-image. The sculpture was so disdained by the public that it was taken from the rotunda and left outside in the weather. Today it is in the National Museum of American Art.

Greuze, Jean-Baptiste

1725–1805 • French • painter • Romantic

Should [Greuze] meet a head which strikes him, he would willingly throw himself at the feet of the bearer of that head to attract it to his studio. He is a ceaseless observer in the streets, in the churches, in the markets, in the theaters, in the promenades, in public assemblies. Meditating on a subject, he is obsessed by it. . . . Even his personality is affected: he is brusque, gentle, insinuating, caustic . . . according to the object he is rendering. (Diderot, c. 1765)

Greuze arrived in Paris from the provinces in 1745, and by the 1760s he was the dominant personality in the SALONS. The genre that made him famous was modest household scenes of the provincial bourgeoisie—humble but honest, poor but pious—akin in subject matter to the bourgeois melodramas written by DIDEROT. The elderly father with shoulder-length gray hair, reading the Bible or admonishing one of his many children, is usually the focus of a picture. There is an underlying allusion to Protestantism, forbidden in France at that time. His work resembled the dramatic tableaux that HOGARTH portrayed, but Greuze treated his characters with sympathy rather than satire. *The Village Bride* (1761) exemplifies the type: The family is gathered in the kitchen for a wedding—and an exchange of documents and money. The inclusion of a hen and her brood alludes to the anticipated increase in the human family. When the picture was exhibited, it could barely be approached for the rapturous crowds that surrounded it.

Yet Greuze's fortunes changed when he unveiled *Septimus Severus Reproaching Caracalla* in 1769. He had been accepted as a painter of everyday GENRE scenes, but he aspired to be a History Painter. In the hierarchy of the ACADEMY, only certified History Painters could be professors or hold any position of honor; to present oneself as a History Painter, as Greuze did, without having been admitted to academic membership in that category, and to do so in a surprise move, led to rejection and humiliation. Even his greatest supporter, Diderot, whose appreciation is quoted above, became dismissive: ". . . the picture is worth nothing," he said. Greuze was reduced to poverty by the Revolution, changes in taste, and divorce. (See also HISTORY PAINTING)

Gris, Juan

1887–1927 • Spanish • painter • Cubist

I try to make concrete the abstract. . . . Cézanne turns a bottle into a cylinder, but I make a bottle—a particular bottle—out of a cylinder.

A fellow Spaniard, Gris joined PICASSO's circle in Montmartre. His innovations in CUBISM were also very important; one step he took was to combine the variegated, complex, faceted Cubist views with the traditional PERSPECTIVE of the ITALIAN RENAISSANCE. This is apparent in a painting such as *La Place Ravignan, Still Life in Front of an Open Window* (1915). Planes representing the objects in front of the window are sliced, tilted, and overlaid on each other in a typical Cubist manner, yet the street scene "outside" the window is seen without ambiguity, from a single point of view. At the same time, Gris confounds inside/outside by continuing elements from the street (window shutters, a lamppost) on the interior walls of the room. Of the Cubists, Gris seems—albeit unintentionally—most prescient of the irony and indeterminacy of POSTMODERN thought.

grisaille

Painting, or STAINED GLASS designs, in shades of one color, usually gray (*gris* is French for "gray"). PUCELLE's manuscript illumination was in grisaille. Grisaille was often used on the outer panel of an ALTARPIECE, seen when its wings were closed. It is notable that as altarpieces and ILLUMINATED MANUSCRIPTS gained in popularity, they displaced sculpture to a great extent; perhaps the grisaille, a kind of imitation of marble sculpture, was the painter's challenge, or tribute, to stone carvers. Van EYCK's *Ghent Altarpiece* (c. 1423–32) and van der GOES's *Portinari Altarpiece* (c. 1473–78) have grisaille fronts.

Grooms, Red

born 1937 • American • painter/performer/sculptor • Installation

I'm against violence and war. Artists are traditionally liberal on these issues, and I certainly am. Yet there's a part of me that looks at all the horrors of life, of history, with a kind of existential fatalism. Violence occurs and it wouldn't make much sense to me as an artist to ignore it. The only thing you can try to do is defuse it, maybe. Laugh at it. But not just laugh at violence and everything in life that is

*troubling and difficult to deal with.
The artist has to confront it in a work
of art.*

A producer and star of HAPPENINGS in
the 1950s, Grooms developed an indi-
vidual style in his three-dimensional
"stick outs," scenes rather like large,
permanently fixed pop-up books. His
people are CARICATURES; there is a slap-
stick effect to them that carries over
into his paintings as well as his large IN-
STALLATIONS, such as *Chicago* (1968),
in which he has a cartoonish elevated
train riding its tracks, a horse-drawn
wagon racing in front of it, and other
miscellaneous, carnivalesque creations.
One serio-comic work that contains the
confrontation and humor described in
the quotation above is *Shoot-out*
(1980–82): a wagon in which a seated
Indian and cowboy are in a face-off.
This is a large, 27-foot-long work of
cast and fabricated aluminum painted
in vivid colors, silly enough to make us
laugh, but also to make us question the
stereotypes they represent.

Gropius, Walter
1883–1969 • German • architect •
Modern/International Style

*It is true that the creative spark
originates always with the individual,
but by working in close collaboration
with others toward a common aim, he
will attain greater heights of
achievement through the stimulation
and challenging critique of his
teammates, than by living in an ivory
tower.*

With his design for the Fagus factory in
Alfeld, Germany (1911–13), where
shoe trees were manufactured, Gropius
synthesized developments of architec-
ture to date with the socioeconomic
belief that improving the workers' envi-
ronment would increase production.
Fagus was a purely functional building
with an undecorated cubic shape and a
glass "curtain wall" (non-load-bearing
walls) construction. Founder of the
BAUHAUS in 1919, Gropius left Ger-
many after Hitler rose to power. In
1937 he began to teach at Harvard,
where he was made chairman of the De-
partment of Architecture. "My inten-
tion is not to introduce, so to speak, a
cut-and-dried 'Modern Style' from Eu-
rope, but rather to introduce a method
of approach which allows one to tackle
a problem according to its peculiar con-
ditions," Gropius insisted. He formed
The Architects' Collaborative (TAC) in
Boston, a group of younger architects
who, working with him, designed the
Harvard Graduate Center (1948–50),
among other projects.

Gros, Antoine-Jean, Baron
1771–1835 • French • painter •
Baroque Romantic

*Gros and Géricault, without
possessing the finesse, the delicacy, the
sovereign reason or the harsh austerity
of their predecessors, were nevertheless
generous temperaments.* (Charles
Baudelaire, 1846)

A favorite student of Jacques-Louis
DAVID, Gros was as dazzled by
Napoleon as was his teacher. He
painted several pictures that glorified
the emperor, swept up in the ROMANTI-
CISM sparked by Napoleon's travels to
exotic places. To his dismay, Gros was
included on only the Italian campaign.
Leaning more toward the BAROQUE

than to David's NEOCLASSICAL style, in *Napoleon at Jaffa* (1804)—for which he used another artist's sketch—Gros portrays Napoleon visiting plague victims in North Africa. He shows Napoleon touching the sores of one of the stricken, drawing parallels between Napoleon and Christ the Healer. When the painting was shown at the SALON of 1804, it was wreathed with laurel by admiring younger artists and praised by David. After Napoleon's demise, David went into exile and left the direction of his studio to Gros. Comparing Gros and GÉRICAULT to David in the quotation above, BAUDELAIRE found the two wanting, though he went on to write, "There is a sketch by Gros at the exhibition [of 1846] . . . which is very arresting and strange. It reveals a fine imagination." To art historians, Gros is a transitional figure, a bridge between the Neoclassical David of the 18th century and the Romantic DELACROIX of the 19th. In his own mind, Gros had satisfied neither ideal, and in fact felt guilty for having brought about the decline of David's leadership. Overcome by melancholy in his old age, Gros committed suicide.

Grosz, George

1893–1959 • German/American • painter/draftsman • New Objectivity

I left because of Hitler. He is a painter, too, you know, and there didn't seem to be room for both of us in Germany.

A CARICATURIST and political satirist in the tradition of HOGARTH and DAUMIER, Grosz had a dark side that emerged when, to help support his studies, he drew scenes of Berlin's seamy nightlife. His disgust with human behavior during and after World War I, in which he was twice called to serve and twice discharged as unfit, echoes in his drawing *Fit for Active Service* (1918): In a room of awful self-satisfied officers, a doctor examining a skeleton pronounces it "OK" for military service. Outside the windows, smoke billows from factories, a caustic reminder of the military-industrial complex Grosz so hated. He was part of the Berlin DADA group and in the 1920s worked in the SURREALIST mode of de CHIRICO, but his work fits most appropriately into the form of Social Realism called NEW OBJECTIVITY. His painting *Republican Automatons* (1920) is a satirical image of faceless, mutilated robots in an urban landscape. It evokes cold estrangement. Grosz denounced all aspects of German corruption and obscenity, and was himself frequently denounced by the authorities, and even prosecuted for blasphemy and obscenity. He fled the Nazis in the 1930s and settled in the United States. The joking comment about his departure, quoted above, is a mild example of Grosz's dark humor.

grotesque *(grotteschi)*

A potentially misleading term, "grotesque" in art does not have unpleasant connotations. Rather, it refers to particular ornaments used in ANTIQUITY: medallions, vines, foliage, lamps, urns, masks, human figures, and imaginary creatures such as sphinxes. The root word for grotesque is *grotte,* which refers to subterranean Roman ruins where the kind of ornamentation described above was found during the 15th century (see GOLDEN HOUSE OF NERO). Filippino LIPPI used grotesques in his Strozzi Chapel FRESCOES (1497–

1502), and along with GHIRLANDAIO was among the first ITALIAN RENAISSANCE artists to do so. PINTURICCHIO followed suit in his Piccolomini Library frescoes (1503–08). In 1518–19 RAPHAEL used grotesques as a complete decorative design scheme in the Vatican Loggie. But for the addition of figures— e.g., humans, monkeys, and sphinxes— grotesques resemble ARABESQUES. In 1612 a writer called grotesques "an unnatural or unorderly composition for delight's sake, of men, beasts, birds, fishes, flowers, etc. without (as we say) Rime or Reason." By then they had spread to every medium, and they became an integral part of ROCOCO decoration.

ground

Refers to the prepared surface on which paint or other mediums are applied. Thus, wet plaster is the ground for FRESCO painting, GESSO on wood is the ground for PANEL painting, and the undercoat of paint on CANVAS, when it is used to minimize fabric absorbency (i.e., primed), is the ground for OIL PAINTING. In transparent WATERCOLOR and in COLOR FIELD painting, where paint is directly applied to untreated surfaces, the paper or canvas itself is the ground. When it is not the ground, it is called the SUPPORT.

Group of Seven

In the catalogue of their first joint exhibition at the Art Museum of Toronto in 1920, the artists wrote, "The group of seven artists whose pictures are here exhibited have for several years held a like vision concerning Art in Canada. They are all imbued with the idea that an Art must grow and flower in the land before

the country will be a real home for its people." The seven artists of the group were Franklin Carmichael (1890–1945), A. Y. Jackson (1882–1974), J. E. H. MacDonald (1873–1932), Lawren Harris (1885–1970), Arthur Lismer (1885–1969), Frederick Varley (1881–1969), and Tom Thomson (1877–1917), a founding member who died before the exhibition took place (Frank Johnston, 1888–1949, took Thomson's place at the 1920 exhibition). Each painted the Canadian landscape, most often with bold strokes and thick, sometimes brilliant, sometimes murky, colors. The organization of the group was loose; members met only once or twice a year to discuss forthcoming exhibitions and the admission of new members. They disbanded in 1933, making way for the more broadly based Canadian Group of Painters. The largest selection of their works is on display just north of Toronto, at the McMichael Canadian Collection in Kleinburg, Ontario. The museum is located in the region where these artists painted.

Grünewald, Matthias

c. 1475/80–1528 • German • painter • Northern Renaissance

It is regrettable that the works of this outstanding man have fallen into oblivion to such a degree that I do not know of a single living person who could offer any information whatsoever, be it written or oral, about the activities of the master. I shall, therefore, compile with special care everything that I know about him, in order that his worth may be brought to light. Otherwise, I believe his

memory might be lost completely a few years hence. (Joachim von Sandrart, 1675)

During the period from 1470 to 1500, the chapel at the Monastery of Saint Anthony in Isenheim, along the Rhine River between Basel and Colmar, was rebuilt, and Grünewald received the commission for a new chapel ALTARPIECE, the *Isenheim Altarpiece* (1512/13–15), as it became known. Saint Anthony was believed responsible both for causing the plague and for healing, and he is linked to skin diseases that were treated in a hospital attached to the monastery. One such disease was called Saint Anthony's fire. Of enormous size (almost 18 feet wide), the *Isenheim Altarpiece* had many scenes within its wings, but in its closed position it shows the Crucifixion. This is, arguably, the most tormented and troubling CRUCIFIXION image in history: The sky is black; the background is barren, flat, and stony; Christ is dead—rigor mortis has set in. Most unsettling, even repellent, is that Christ's body has pieces of wood and thorns, or splinters, knitted into the flesh. This emphasis on the flesh must have represented Grünewald's idea of the pain experienced by patients at the hospital as much as that endured by Christ, and praying in the chapel must have shored up the priests' will to help. Whether the patients themselves became more or less hopeful of being healed by looking at the painting is uncertain, but they may at least have felt hopeful for their souls' salvation. The interior PANELS were opened on Sundays and special feast days, and in contrast to the outside, the joyous *Annunciation, Incarnation,* and *Resurrection* were revealed, brilliant with color and, the latter panel especially, ecstatic in mood. This is not Grünewald's only identified work, yet it powerfully eclipses the others. His own background is uncertain, but it is known that he moved to Frankfurt in 1526 and is recorded as a designer of fountains. Although the subjects of his paintings were Catholic, the contents of a chest belonging to him and inventoried after his death include writings by Martin Luther.

Guardi, Francesco

1712–1793 • Italian • painter • Rococo

. . . very spirited, much in demand, perhaps because nothing better is to be found. But as you know this painter worked for a daily stipend, bought canvases not only second hand but bad, prepared with the thinnest of primings, and used oily colors. (Pietro Edwards, late 18th century)

Painting views of Venice for the tourist trade, resident foreigners, and local PATRONS was Guardi's primary activity in the late 1750s. In 1784 he was appointed Professor of Perspective at the Venetian Academy. He was also employed by the government to record state occasions, such as the visit of Pope Pius in 1782. *The Fire at S. Marcuola* (1789–90) is probably his best-known image. The canal is ablaze from burning oil. On its far side figures pour water on tile roofs, while on the near side watchers are lined up with their backs to us. Some of Guardi's views have a melancholy air leading to speculation that he

was mourning the dying Venetian Republic; however, that interpretation is challenged. Never as popular as CANALETTO, to whom he was often disparagingly compared, Guardi had his defenders who praised the movement, color, vivacity, and sparkling light of his paintings. Yet the reservation with which his work was praised is exemplified by the criticism of his contemporary Pietro Edwards, quoted above. Edwards served as an adviser to art collectors.

Guercino, Il (Giovanni Francesco Barbieri)

1591–1666 • Italian • painter • Baroque

[Guercino] refused to accept, as he did not want to have dealings with heretics and thus contaminate his angelic character; nor did he want to undertake such a dreadful journey in a climate so different from that of his own country. (Carlo Cesare Malvasia, 1678)

What Guercino refused, according to MALVASIA, was the effort of King Charles I to lure him to England—almost as soon as he ascended to the throne in 1625, Charles attempted to bring a leading Italian painter to his court, and Guercino was his first choice. In the second generation of BAROQUE painters, often called High Baroque, Guercino is best known for *Aurora* (1621), a FRESCO that covers ceiling and walls with illusionistic architecture (see QUADRATURA) as well as an allegorical scene. Looking up, the spectator sees Aurora, or Dawn, racing across the sky in her horse-drawn char-

iot. Behind her the personification of Day floats in, and at the opposite end of the room Night lurks with her children, Sleep and Death. The topic, conceived in response to RENI's *Aurora* painted eight years earlier, becomes far more daring here, using PERSPECTIVE trickery, including radical foreshortening. In addition to painting, Guercino cultivated drawing as an art form, and his pen and WASH drawings were avidly collected by PATRONS as well as artists. *The Martyrdom of Saint Bartholomew* (1636), a study for a painting commissioned by the church of San Martino in Siena, is in pen and brown wash. It shows executioners flaying the martyr's skin with knives, and is an example of the taste for cruelty and bloodshed found in Baroque art (see also RIBERA.) Although at the beginning of his career Guercino's style was influenced by CARAVAGGIO, over the course of his life it became more restrained and CLASSICAL. In the *Burial and Reception into Heaven of Saint Petronilla* (1623), there is already a hint of the Baroque Classicism that will soon be favored over the more violent, earlier style.

Guerrilla Girls

A group of professional women in New York founded a collective organization they named Guerrilla Girls in the wake of a 1984 *International Survey of Contemporary Art* exhibition held at the Museum of Modern Art. They were outraged at the absence of women and minority artists in the exhibition. They appeared in public wearing rubber gorilla masks, and they produced confrontational leaflets and posters to get their point across. *Do Women have to*

be naked to get into the Met. Museum? (1989) is one of their posters. It is a parody of INGRES's naked ODALISQUE, with the substitution of a gorilla's head. The question in the title is inscribed across the top of the poster, and grim statistics run along the bottom: "Less than 5% of the artists in the Modern Art Sections are women, but 85% of the nudes are female." They have continued to make acidly witty posters and appear in their gorilla masks (their "mask-ulinity"), and to mount antidiscrimination campaigns.

Guggenheim, Peggy
1898–1979 • American • patron/collector/dealer

I wore one of my Tanguy earrings and one made by Calder, in order to show my impartiality between Surrealist and abstract art.

Guggenheim played an important role in introducing artists to one another and in encouraging both SURREALISM and ABSTRACT art. Before World War II, Guggenheim was advised in her own purchases of art by DUCHAMP, READ, and Petra von DOESBURG, Theo's widow. Guggenheim was instrumental in helping European artists make their way to the United States as the war began, and in that context met André Breton (see SURREALISM) and ERNST, to whom she was married for a time. The comment quoted above was made about the opening in 1942 of Art of This Century, a combined sales gallery and museum in New York City that she founded. The list of artists exhibited there is a litany of the foremost European and American painters of the 20th century to date. The Surrealist section was called "Fantastic Art, Dada, and Surrealism," and the catalogue included a history of Surrealism by Breton as well as essays by MONDRIAN and ARP. The Abstract section held works by leading CUBISTS and FUTURISTS. Jackson POLLOCK flourished under her sponsorship: "Pollock became the star of the gallery and for five years I supported him and launched him by selling his paintings, which in those days was very difficult," she later wrote. In 1947 she closed her gallery and returned to Europe, choosing to settle in Venice. Peggy Guggenheim's father, Benjamin, drowned in the sinking of the *Titanic* in 1912. Her uncle Solomon Guggenheim was the founder of the Solomon R. Guggenheim Foundation and of the museum in New York also named for him, and designed by Frank Lloyd WRIGHT.

guild
During the MEDIEVAL period, associations of artisans and merchants formed to regulate production and prices in the rapidly growing commerce and industry of an increasingly urbanized civilization. These guilds became monopolies, but they also set and maintained high standards of workmanship (see MASTERPIECE and WORKSHOP), and monitored the education and welfare of members as well as providing social services for them. Confraternities, formed under the aegis of guilds, had their patron saints for whom they supported chapels and commissioned ALTARPIECES. For example, it is believed that ANTONELLO's *Sebastian* is the wing of an altarpiece commissioned by a confraternity. The evangelist Saint LUKE became the patron saint of artists, and

guilds throughout Europe were named after him.

Guillebon, Jeanne Claude de
See CHRISTO

Guston, Philip (Philip Goldstein)
1913–1980 • American • painter • New Image

My whole life is based on anxiety, where else does art come from?

Guston moved from painting political murals in the 1930s to ABSTRACT EXPRESSIONISM in the 1950s, and in 1970 to FIGURATIVE imagery with references to history, political events, literature, and art history itself. These references appear in figures with Ku Klux Klan–type hoods, the soles of their shoes studded with nails, assembled in strange landscapes and accompanied by odd mechanical contraptions that may look like insects or the rear end and tail of a horse. These shoe soles bring to mind a moving painting by van GOGH of worn old work boots (*Three Pairs of Shoes*, 1886–88), in which the bottom of one boot is visible. Probably more than any other piece of clothing, old shoes express their owner's life, and perhaps the anxiety that Guston speaks of in the comment quoted above. Guston's art of the 1970s was disdained by many, but as the critic Michael Kimmelman wrote in 1996, "times change, and . . . the '70s paintings look different. Actually they now seem among the best art to come out of the decade: uncompromising, independent, darkly funny and even tragic."

H

Haacke, Hans

born 1936 • German/American •
nonobjective • Conceptual/political

*An artist is not an isolated system but
must constantly interact with the
world around him.*

To Haacke the artist is almost an inter-
active exhibit of a CONCEPTUAL theme.
He or she is also defiant and controver-
sial. For example, at an exhibition at
the Museum of Modern Art (MOMA)
in New York City, Haacke balloted
visitors about Gov. Nelson Rocke-
feller's support of President Nixon's
Indochina policy (*Proposal: Poll of
MOMA Visitors, 1970*). MOMA was
founded by the ROCKEFELLER family
and Nelson was a principal trustee.
(The results of the poll were two to one
anti-Rockefeller, which, Haacke com-
plained, the museum did not properly
report.) The following year the director
of the Solomon R. Guggenheim Mu-
seum, also in New York, canceled an
exhibit in which Haacke planned to
document the slum real estate holdings
of various museum trustees. (The CURA-
TOR resigned in protest.) As were stu-
dent demonstrations of the decade,
much of the art of the 1970s was simi-
larly confrontational, devoted to politi-
cal action challenging the status quo.

Hagia Sophia

Hagia Sophia means "Holy Wisdom,"
and is the name of the palace church of
Constantinople. Its architects were AN-
THEMIUS OF TRALLES and Isidorus of
Miletus; it was built from 532 to 537.
When the emperor Justinian entered
Hagia Sophia for its dedication, he is re-
ported to have exclaimed, "Solomon, I
have surpassed you!" His reference was
to the builder of the First Temple in
Jerusalem (see TEMPLE). The dimen-
sions of Hagia Sophia are awesome—
some 270 feet long and 240 feet wide,
with a dome 108 feet in diameter rising
180 feet above the floor. The interior of
the DOME is embellished with gold mo-
saics; the stone and marble walls are of
many colors, including green, white,
and purple; and the windows are col-
ored glass. But, above all, literally and
figuratively, is the "necklace of light"
from 40 windows at the base of the
dome. As the historian Procopius wrote
when the church was still quite new,
these windows made it seem as if
". . . the place were not illuminated
from the outside by the sun, but that the
radiance originated from within, such is
the abundance of light which is shed
about this shrine." The architects
spanned the great central space with a
shallow DOME on four pendentives (the

inward-curving triangular sections of masonry built between the arches). Two half-domes cover circular niches that flank the central dome. The plan of Hagia Sophia successfully unites its longitudinal axis with the vertical axis of its domed space, thus fusing the directional focus on the high altar and its ceremonial function with the upward-soaring, spiritually symbolic significance. Domed ceilings were metaphors for the roof of heaven, and as such the dome of Hagia Sophia is more divine than most. After the Turkish conquest of Constantinople in 1453, the building became a mosque, which explains the four minarets around the building and calligraphy on the interior. Today it is a museum.

halo

The halo is an aura of light usually surrounding the head of a holy, deified, blessed, or otherwise singular individual. Representing the illumination of the sun, halolike disks appear as early as ancient Egyptian art. Ancient gods of India and China were sometimes shown with halos. There is a clear line of descent from the halo-crowned heads of pagan gods—Apollo/Helios/Sol Invictus/Mithras—to that of Christ, who began to be portrayed with a halo sometime around the 5th century. In Christian art the halo was at first given only to the three persons of the Trinity. Later apostles, saints, and others, including Roman emperors, were also shown with halos. Sometimes a halo would even be attached to the individual's symbol or ATTRIBUTE; thus, the lamb on the altar of the van EYCK *Ghent Altarpiece* (1432), representing Christ, has one. The halo takes many forms, ranging from an undefined luminescence to gold lines that radiate toward a visible or invisible circumference, like spokes on a wheel, and from the well-known and widely used flat gold plate (MEDIEVAL) to one that appears as a ring, that is, with an empty center (RENAISSANCE). Sometimes the halo is shown as if it were floating above the wearer's head rather than framing it (as in CARAVAGGIO's *Death of the Virgin*, 1605–06). God the Father may wear a triangular halo to symbolize the Trinity; contemporary, living people (e.g., the pope, an emperor, or a donor) were sometimes given a square halo. Between the square halo and the circular one might be a polygonal halo, used perhaps for an allegorical figure such as one of the Virtues. Though less used after the BAROQUE era, the halo was not forgotten: Witness GAUGUIN's *Self-portrait* (1889), in which he portrays himself torn between vice, represented by a snake and apples, and virtue, signified by a halo. (See also AUREOLE and MANDORLA)

Hals, Frans
c. 1581/85–1666 • Dutch • painter • Baroque

[Hals was] . . . somewhat merry in his life. (Matthias Scheits, 17th century)

The assessment by Hals's contemporary quoted above is part of the bon-vivant reputation that has attached to the artist, partly from the pictures he painted and somewhat from hearsay—Scheits studied under a man who had been Hals's student. The sitters for Hals's many portraits gaze out to meet our eyes with a twinkle in theirs; a smile plays at the edges of their mouths. The

spontaneity in Hals's pictures is also reflected in his method of painting: He was one of the earliest European painters to work directly on the canvas without underpainting—ALLA PRIMA. Hals's first masterpiece—called the first monumental masterpiece of 17th-century Dutch painting—was a group portrait of a dozen men, *Banquet of the Officers of the Haarlem Militia Company of Saint George* (1616). The men are all seated or standing around a table, and react as if interrupted in the midst of their banquet—it is the same "candid camera" effect pioneered by MASSYS 100 years earlier and taken up again by REMBRANDT in *Syndics of the Clothmakers' Guild* (1662). The individuality of each man seems bolstered by a current of optimism, which may be attributed to the new Dutch Republic that these militiamen had helped secure. Hals himself was a member of the company. When juxtaposed with a rendering of the same militia company, also gathered around a table, painted several years before by Cornelis van Haarlem (1562–1638), the works serve well to illustrate WÖLFFLIN's point-by-point contrasts between the art of the RENAISSANCE (ITALIAN and NORTHERN) and that of the 17th-century BAROQUE. Hals also introduced a new measure of vitality to pictures of the working classes, whom he represented with frankness, affection, and sometimes wicked humor, as in *Malle Babbe* (c. 1633–35): A disreputable-looking woman holding a huge tankard of beer, an owl on her shoulder, seems to be laughing and shouting at once. Observers tend to infer sincerity from a spontaneity of manner such as that of Hals, but little is known about his character, personality, or working methods—not a single DRAWING, ETCHING, or ENGRAVING by his hand is securely known. Records do show that he was sued by his butcher, baker, and shoemaker, suggesting that he was a poor financial manager. His first wife died, and his second, who gave birth nine days after the marriage, got in trouble more than once for brawling. Five of his sons were among his pupils, as were LEYSTER, van OSTADE, and BROUWER. The originality of his approach is most apparent when a canvas is looked at from close range, where it seems a mass of disparate, loose, irregular strokes and daubs of paints. But stepping back from the canvas brings it coherence. Hals's popularity and importance as a portraitist declined in the 1640s as Dutch taste turned to a more refined and aristocratic style. Yet his most sensitive and penetrating representations of a wide range of personalities also date to his last decades. In 1664, when he was about 80 years old, he painted *Regentesses of the Old Men's Home.* In portraying these five elderly women Hals showed the range of both his psychological and his painterly skill. Nevertheless, his influence declined and it was not until Hals was admired by the Impressionists (the American CHASE included a reproduction of *Malle Babbe* in one of his own works) that his paintings were rediscovered, and then sold for huge sums of money.

Hamilton, Richard
born 1922 • English • painter • Pop Art

Journalism, Cinema, Advertising, Television, Styling, Sex symbolism,

Randomization, Audience participation, Photographic image, Multiple image, Mechanical conversion of the imagery, Diagram, Coding, Technical drawing.

In 1956, with a group of other artists, Hamilton built a POP ART fun house for an exhibit at a London gallery. Called *This Is Tomorrow,* it included films, a live microphone for audience participation, a working jukebox, and a 14-foot-high blowup of Robby the Robot carrying off a swooning woman. Hamilton was a member of the English Independent Group, and he is best known for his own, small COLLAGE, *Just what is it that makes today's home so different, so appealing?* (1956). Using commercial design techniques and cutouts from magazines and other popular sources, he composed an interior scene that catalogues the materialism of "modern culture." It is a composition that illustrates the list of concerns he enumerates in the quote above.

Hanson, Duane
1925–1996 • American • sculptor • New Realist

Sometimes [I buy clothes], especially when you have something as large as that fat lady over there. I have to go to great lengths to buy them. Twenty-five dollars for her bathing suit. You can't just go to a thrift shop. This lady vacuuming is my aunt. Those are the clothes she actually wears. She gave me those.

Using polyester resin to form his figures, which are made from body casts, Hanson dresses them in clothes appropriate to the persona he is creating

at the time. His subjects are ordinary people: a boxer, a plumber, and an overweight woman perhaps sunbathing or, in *Supermarket Shopper* (1970), pushing a loaded shopping cart. Her hair is in large curlers, a cigarette dangles from her mouth, she bulges unpleasantly in her clothes that fit too tightly—she is the epitome of 20th-century excess and overindulgence. Although his work might be categorized as NEW REALISM, Hanson differentiates himself from the standard definition of that style as objective. During the same 1972 interview in which he made the comment quoted above, he said, "To me that wasn't enough. . . . I feel that I have to identify with those lost causes, revolutions and so forth. I am not satisfied with the world. Not that I think you can change it, but I just want to express my feelings of dissatisfaction."

happening
A development of the late 1950s, pioneered by CAGE at BLACK MOUNTAIN COLLEGE and introduced as a movement in art by KAPROW. Happenings were part of an effort to surpass ABSTRACT EXPRESSIONISM and its dynamic between the physical activity of the artist and its representation on the canvas. It did this by eliminating the canvas altogether. And where Abstract Expressionists expanded the PICTURE PLANE so wide as to include a viewer's peripheral vision and more or less incorporate him or her into the work, in happenings the inclusion was achieved by audience participation. Kaprow's first public happening was *18 Happenings in 6 Parts* (1959). "A Happening is *generated in action* by a headful of ideas for a flimsily-jotted-down score of 'root' di-

rections," Kaprow explained. Other artists inspired to create happenings were OLDENBURG and GROOMS. "Happenings were definitely the 'in' thing for a period. Everyone sensed the excitement and vitality of a genuine revolution in the definition of art. Yet because they did not leave museum objects and their life span was short, they may seem less important in retrospect than they actually were," writes the historian Jonathan Fineberg. PERFORMANCE ART shares some characteristics with happenings, but is distinct. (See also FLUXUS)

Hapsburg (Habsburg)

Dating back to the 10th century, the Hapsburg dynasty was one of the oldest and most important in European history. With the marriage of Maximilian I (1459–1519) to Mary of Burgundy in 1477, the Hapsburg line joined and then superseded that of the Burgundian VALOIS, and Maximilian increased his power vastly. DÜRER is best known among the artists employed by Maximilian. The Hapsburgs ruled the Low Countries (Holland in the north and Belgium in the south) for almost a century. Maxmilian's son Charles V (1500–1558) held not only Austria and all of Spain—as a grandson of the Spanish rulers Ferdinand and Isabella by his maternal descent—but extensive Spanish possessions in Italy and America as well. Pieter BRUEGEL the Elder was patronized by the Hapsburg court, and Charles (Holy Roman Emperor, as was his father) is best known, visually, through his portraits by TITIAN, especially the heroic EQUESTRIAN *Emperor Charles V* (1547) in full armor. Under Charles, the Hapsburgs reached the summit of their power, backed by the wealth and commerce of the Netherlands and of Spain and the Spanish colonies. In 1556 Charles, who had stood in opposition to Martin Luther and the Reformation, abdicated and retired to a monastery.

Hard Edge Painting

Refers to paintings that contain forms with ruler-sharp (although not necessarily straight) contours or outlines. The style was named in 1959 by the art critic Jules Langsner. It was developed during the 1960s by artists like Ellsworth KELLY, NOLAND, and Frank STELLA. Often an extension of COLOR FIELD PAINTING, Hard Edge rejected the artist's involvement as characterized by ABSTRACT EXPRESSIONISM: Many Hard Edge paintings look as though they have been created by machines, especially because their colors and lines are so precise and even. In this they may be related to the NEO-PLASTICISM of MONDRIAN as well as the PRECISIONISM of SHEELER.

Hardouin-Mansart, Jules
1646–1708 • French • architect • Baroque

Having come to see the construction that was to decorate Place Vendôme, it happened that Louis XIV's glance fell on the young Mansart who was occupied in carving a stone. The graceful figure of this youth, his pleasing appearance, and even more the ardor and dexterity with which he worked held the attention of the great King who ... spoke to him kindly, and learned that he was the nephew of François Mansart. His Majesty had

just asked for a drawing of a particular architectural detail, and young Mansart, seeing that the architect to whom the King addressed the request had not promptly complied, himself sketched the figure with a pencil, and erased it almost immediately fearing the envy of his companions, and perhaps the jealousy of the Master under whom he worked. (Abbé Lambert, 17th century)

There are several stories, or legends, about how Jules Hardouin-Mansart was introduced to the king, and the quotation above is one of them. According to Abbé Lambert's history of the reign of Louis XIV, the MANSART family could be traced back to ancient Rome, but had been established in France for almost 800 years, and, Lambert wrote, "had occupied successively and almost without interruption the roles of architect, painter and sculptor to the king." Jules was the nephew of François Mansart. He showed a sure sense of the GRAND MANNER—lofty and impressive—that was wanted for the glorification of the Sun King, Louis XIV. The *Galerie des Glaces* (*Hall of Mirrors;* begun 1679) displays the elegance and refinement of this endeavor. A long hall, it has a procession of high mirrors opposite windows that, with their views, were reflected in them. Mirrors, and the illusions they create, were a favorite conceit of the BAROQUE period. (The ceilings were by LE BRUN.) As fine an accomplishment as the *Galerie des Glaces* was, it required changes to the outside that ruined the integrity of the design by Louis Le Vau (c. 1612–1670). Hardouin-Mansart took over as superintendent of royal buildings in 1699. He installed de PILES as chief theoretician of the French Academy with the mandate of formulating the "infallible principles" by which it would be governed.

Haring, Keith
1958–1990 • American • painter • Graffiti

See, when I paint, it is an experience that, at its best, is transcending reality. When it is working, you completely go into another place, you're tapping into things that are totally universal, of the total consciousness, completely beyond your ego and your own self. That's what it's all about.

The New York City transit authority pasted black sheets of paper over subway system advertisements after their rental time expired, and Haring used those blank surfaces as his "canvas." His anonymous, cartoonlike figures became familiar to underground travelers, as well as to gallery-goers, who recognized and began to look for them. His humor was a gloss on a disturbing undercurrent of violence and political commentary. Haring's PICTOGRAPHs, a language of his own invention, follow a tradition that winds from prehistory to artists such as KLEE and GOTTLIEB in the 20th century. Haring died of AIDS at the age of 31.

Harlem Renaissance
After World War I a massive migration from the rural South to urban centers began. The black population of New York City increased from 91,709 in 1910 to 327,706 in 1930. Harlem was fondly called "the black capital of the world." Postwar optimism about new

possibilities led to the term "renaissance," and the period is generally called the Harlem Renaissance. While artistic ferment was great in Harlem, it also flourished among the African-American populations of Philadelphia, Chicago, Boston, Baltimore, and San Francisco. The artist most closely associated with the Harlem Renaissance was DOUGLAS. Augusta Savage (1892–1962), "brilliant, friendly, fierce, and difficult at times even for her friends," as described by BEARDEN and Harry Henderson in *A History of African-American Artists* (1993), was both a sculptor and a supporter of young black artists in New York. She was, they add, "one of the most significant leaders of black artists to emerge in the 1920s. She was perhaps the first who could be identified as a black nationalist." The first large exhibition of work by African-American artists—nearly 200 paintings and sculptures—was displayed in the Harlem branch of the New York Public Library in August and September 1921. But postwar optimism vanished during the Depression. Frustration and anger caused, as an official investigation found, by the "resentments of the people of Harlem against racial discrimination and poverty" led to a riot in Harlem in March 1935. During the same month Douglas, Savage, and Charles Alston (painter, sculptor, and teacher, 1907–1977), with nearly 100 influential black New Yorkers, formed the Harlem Art Committee. Later that year the WORKS PROGRESS ADMINISTRATION gave work to numerous black artists. Alston converted an old redbrick stable at 306 West 141st Street into a studio for his WPA classes. "306," as it was known, quickly be-

came a gathering place for artists from all disciplines, poets, dancers, and actors included, promoting a vibrant sense of community.

Harnett, William Michael

1848–1892 • American • painter • Trompe l'oeil

I want my models to have the mellowness of age . . . the rich effect that age and usage gives.

Harnett became the most successful TROMPE L'OEIL painter of STILL LIFES in America. It is written that he began painting objects because he could not afford human models, but that does not explain why, with financial as well as artistic success, he continued to paint them. He invested these things, his "models," with personality or, perhaps, pried loose the character they had accumulated, through usage, over time. It has been suggested that we look at Harnett's subjects within the context of the materialism of America's Gilded Age, but it is well to keep in mind that it was also a time when Americans were nostalgic for the antebellum past, which Harnett's paintings may also conjure up. The objects he arranged for display were resolutely masculine: thick, old leather books; money; newspapers; and pipes, often with still-glowing embers in their bowls. The best-known work is *After the Hunt* (1885), a large, almost 6-foot-high arrangement of a battered old hat, hunting horn, powder horn, rifle, dead hare and birds, and other objects that are nailed on a wooden door with beautiful brass hinges, all darkened, burnished, and mellowed by time. After studying at the Pennsylvania Academy of the Fine Arts and the Na-

tional Academy in New York, Harnett spent four years studying in Munich.

Hartigan, Grace
born 1922 • American • painter • Abstract Expressionist

I spent most of my childhood sitting in an apple tree looking at Gypsies camped in a field next to our house. . . . Living on the Lower East Side of New York, I found the same thing. Pushcarts. Jewish peddlers. Barrels of pickles. So I took the "overall" manner I learned from Hofmann and painted my "City Life" shows of '54 to '58.

Among the second wave of ABSTRACT EXPRESSIONISTS whose subjects were figures, Hartigan uses rough, expressive forms that, while barely hinting at people, she manages to endow with emotionally expressive attitudes. Both her colors and manner are bold, and while a scene such as that of *River Bathers* (1953) may at first look like a thicket of paint strokes, it resolves itself into distinguishable individuals with presence and purpose. At the end of the 1960s, Hartigan began to free herself from earlier influences, like that of HOFMANN, mentioned above, as well as KLINE, GUSTON, and others, and worked in a style that sometimes combined COLLAGE with painting and included history and memoir.

Hartley, Marsden
1877–1943 • American • painter • Modernist

And so I say to my native continent of Maine, be patient and forgiving. I will soon put my cheek to your cheek,

expecting the welcome of the prodigal, and be glad of it.

As a protégé of STIEGLITZ, who dispatched him to Europe, Hartley arrived in Paris, where he became acquainted with the avant-garde MODERNISTS. Then, in 1913, he was in Berlin, where he found an empathetic community, including KANDINSKY and MARC. He was fascinated by the trappings of German militarism and fell in love with a young man whose death, early in World War I, he commemorated in his most renowned painting, *Portrait of a German Officer* (1914). This ABSTRACT work, built up of strongly colored and thickly painted ribbons, diamonds, and triangles, is coded with mementos such as initials and military regalia that signified his lost friend. Hartley returned to America, and later, seeing abstraction as too derivative, painted forceful landscapes of the Maine coast, of which he speaks in the quotation above. He also painted a series of moving elegies to a Nova Scotia fishing family with whom he had lived. He felt especially attached to one of their two sons—both were lost at sea. At a moment when FOLK ART was coming into favor, Hartley painted this family in the frank, two-dimensional, forward-facing folk manner: *Fisherman's Last Supper—Nova Scotia* (1940–41), for example.

Hassam, Childe
1859–1935 • American • painter • Impressionist

His most memorable subject . . . was the American flag. . . . Monet, Pissarro, and Manet had all painted Parisian

*streets decked with banners. . . .
Hassam's purpose was different. He
wanted his flags to be entirely legible
as flags, because he was constructing
images of American patriotism and of
Allied cooperation: he wanted to
symbolize the good guys' power to
win.* (Robert Hughes, 1997)

Hassam's career began as an illustrator.
He made a tour of Europe in 1883, and
before going back to study in Paris
(1886–89), he returned home to Massa-
chusetts, where he painted *Rainy Day
in Boston* (1885). In this well-known
picture Hassam captures the mood, col-
ors, and slick pavements—the look of a
vital city. However, it was not the fash-
ionable Back Bay residential neighbor-
hood, as many commentators believe; it
was the middle-class South End, where
Hassam himself lived. The tonal quali-
ties in Hassam's work changed after his
studies in Paris, as did his address. He
moved to New York City and became
the consummate watcher and recorder
of its daily, uptown life. Under the in-
fluence of French IMPRESSIONISM, his
colors were brighter, his brushstroke
more broken, with the one-stroke dex-
terity Impressionists used to render
form. Yet looking closely at Hassam's
canvases, one still sees forms that are
more congealed than those of his
French counterparts, something that
holds true for most AMERICAN IMPRES-
SIONISTS. Not until he was nearly 60
did Hassam begin to paint what the
critic Hughes, in the quotation above,
describes as his "most memorable sub-
ject": the American flag. Its message, as
Hughes interprets it, was "Buy Liberty
Bonds."

Heade, Martin Johnson

1819–1904 • American • painter •
Hudson River School/Luminist

*The artist [Heade] evidently looks on
nature with a poet's eye, and transfers
his emotion to the canvas. (Boston
Transcript, Feb. 27, 1861)*

Little personal information about
Heade survives other than that he was
born in Lumberville, Pennsylvania, the
son of a well-to-do farmer, that he stud-
ied with folk artist HICKS, that he first
exhibited in Philadelphia in 1841, and
that he traveled avidly until he married
in 1883, at the age of 64, and settled in
Saint Augustine, Florida, where he died
at 85. Heade was entirely forgotten
until 1942, when his painting *Thunder-
storm, Narragansett Bay* (1868) was
found in a Larchmont, New York, an-
tique store. Unique, not only in Heade's
oeuvre but also among marine paint-
ings of any era, the mood of the picture
is dark, eerie, and ominous. In the LU-
MINIST style, Heade's technique is hard-
edged and his brushstroke is invisible.
Unappreciated during the artist's life-
time, as was Heade himself, *Thunder-
storm* is now being examined with new
ideas about the artist's intention vis-à-
vis the history of slavery, the Civil War,
and industrialization. Although he
painted portraits earlier in his career,
after 1860 people appear only as small,
symbolic presences in the landscape.
Besides his maritime scenes, during his
long career Heade painted a few themes
in perhaps obsessive series: humming-
birds, magnolias, and more than 100
pictures of salt marshes. The latter call
Ecclesiastes to mind: "Vanity of vani-
ties; all is vanity. . . . All the rivers run

into the sea; yet the sea is not full; unto the place whence the rivers come, thither they return again."

Heckel, Erich
See Die BRÜCKE

Heemskerck, Maerten van
1498–1574 • Netherlandish • painter • Northern Renaissance/Mannerist

With his unusual zeal, Maerten practiced so much that finally he surpassed the master ... who was afraid that his reputation was at stake, in the opinion of some people, [he] sent his pupil away; for he was jealous. (Carel van Mander, c. 1604)

The master referred to above was van SCOREL of Utrecht, and his student departed in 1529. By 1532 van Heemskerck was accepted as a master in the painters' guild of Haarlem, and that same year he painted *Saint Luke Painting the Virgin,* whose theme both confirms the authority of painting religious subjects and shores up the role of the artist (see Saint LUKE). He then took a trip to Italy, as his teacher had done before him, and stayed there more than three years. When he returned home, his style was greatly changed. He added scenes of pagan mythology to his repertoire, as was current in Italy. Also, influenced by the muscularity and physical energy expressed by both MICHELANGELO and GIULIO Romano, and adapting a Mannerist approach, his paintings became exaggerated and highly emotional (see MANNERISM). The *Crucifixion* he painted in 1543 explodes with writhing, anguished figures and unnatural color. Some 20 years

after his trip, van Heemskerck produced an interesting *Self-portrait before the Colosseum* (1553). In fact, on close examination van Heemskerck, whose likeness is in the foreground, paints not just the remains of the COLOSSEUM but includes another artist in the distance as well, seated before the ruins and also recording the scene. Van Heemskerck's interest in ancient ruins and his double self-portrait (as it is presumably his earlier experience that he is painting) further connect him to the spirit of the ITALIAN RENAISSANCE, which combined its fascination for antiquity with absorption by a cult of the artist.

Hegel, Georg Wilhelm Friedrich
1770–1831 • German • philosopher

The history of the world is none other than the progress of the consciousness of freedom.

Hegel founded a philosophical system based on the principle that ideas (not material possibilities) underlie all forms of reality. Ideas were expressed in what he called the spirit *(Geist);* and he believed this spirit realized itself more fully with each successive age. The history of art may thus be studied as part of the sequence, the "progress" of ideas in the context of consciousness referred to in the quotation above. Hegel defines stages of art starting with the Symbolic, especially seen in ancient Egyptian art, which endeavors to but does not succeed in deciphering the spirit. The second phase is CLASSICAL, beginning with Greek art of the 4th century BCE. For Hegel this is a more successful stage, being more rational and using the human body to reveal spirit. In the third

phase of Christian art and German ROMANTICISM, the balance between nature and spirit changes; spirit—of nation and of the age—is transcendent. While Hegel changes the Aristotelian march of progress toward the ideal to that of a realization of spirit, he still sees a sort of spiral evolution. It is based on the perpetual struggle of thesis and antithesis leading to synthesis, which, itself becoming thesis, continually renews the dialectic. (This is, in other words, a teleological struggle in which the end of a sequence is implicit in its beginning.) The ultimate goal, through successive ages, is self-realization. BURCKHARDT writes that Hegel "develops the fundamental idea that history is the record of the process by which mind becomes aware of its own significance; according to him there is progress towards freedom." Hegel's ideas were communicated in a series of lectures given between 1823 and 1829 that were published posthumously as *Aesthetics, Lectures on Fine Art* (1835). They were developed by RIEGL and extremely influential on everyone from Marx (see MARXISM) to FOUCAULT. PANOFSKY humorously described Hegel's all-consuming effect by calling him a "boa constructor."

Hellenistic art
331–323 BCE

The triumphs first of Philip of Macedon and then of his son Alexander the Great changed the experience of the ancient world. Alexander carried Greek influence as far as India; it was his conquest of the Persian Empire that inaugurated the Hellenistic Age. Alexandria, which he founded in 331 BCE, became the Hellenistic empire's capital after his death in 323 BCE. The narrow, polis-centered Greek worldview was then infused with a new spirit of travel, migrations, and political realignments. Whether art of the new era was a continuation of the preceding Late CLASSICAL style or whether it merits a new definition is not agreed upon by scholars. It is true that the dissolution of Athenian power had already been accompanied by the dissipation of many earlier artistic conventions, particularly those of moderation and restraint. Certain attitudes, or states of mind, that do seem to color the spirit of the new era have been enumerated by J. J. Pollitt: "an *obsession with fortune,* a *theatrical mentality,* a *scholarly mentality, individualism,* and a *cosmopolitan outlook.*" There seems to be an unprecedented interest in ethnic types as well as in suffering, both of which are expressed in the DYING GAUL. Theatrical extremes of suffering (LAOCOÖN), as well as sensuality (BARBERINI FAUN), are found, while Classical devotion to the IDEAL is supplanted by interest in specific types, from market women to boxers.

Hemessen, Caterina van
1528–after 1587 • Flemish • painter • Northern Renaissance

I, Caterina van Hemessen, painted myself in the year 1548. Her age 20.

Van Hemessen learned how to paint because her father was an artist, as was usually the case for RENAISSANCE (NORTHERN and ITALIAN) women. As also proved true all too often, once she married, in 1554, she put aside her artistic ambitions. The signed works of hers that remain are small portraits. Among the most engaging is a self-

portrait of 1548; she sits at her easel on which, oddly enough, is a fully framed though nearly blank panel—the outline of a head she seems to be in the process of painting is in the upper-left-hand corner. In her left hand she holds a small palette and a long MAULSTICK, with which she steadies her right hand. Van Hemessen has a round face, wide-spaced dark eyes, and she has a serious but gentle expression on her face. She is dressed in a beautifully rendered burgundy velvet shirt. Her claim to and pride in her profession are clearly represented, and are reinforced by the inscription, quoted above. Van Hemessen was employed by Mary of Hungary, sister of Charles V of Spain.

Henri, Robert

1865–1929 • American • painter • Realist

The subject can be as it may, beautiful or ugly. The beauty of a work of art is in the work itself.

Because his father, John Jackson Cozad, was a riverboat gambler who killed a man and became a fugitive from justice, the family name was changed and the son became known as Robert Earl Henri. He trained in Philadelphia, at the Pennsylvania Academy of the Fine Arts, where the influence of EAKINS, who had just recently been fired, was still strong (and whose painting the *Gross Clinic* Henri called the most wonderful painting he had ever seen). His teacher at the academy was ANSHUTZ. Henri also had ACADEMIC training in Paris, where he took note of IMPRESSIONISM, but he was even more impressed by the old masters HALS, VELÁZQUEZ, and GOYA. Ultimately,

while he retained the "slashing" brushstroke and dark tones, it was his subject matter and ideas that signified most and prevailed. Henri was the center, first in Philadelphia and then in New York City, of the renegade and Socialist artists of The EIGHT and the ASHCAN SCHOOL. SLOAN, GLACKENS, LUKS, and SHINN followed him from Philadelphia to New York. It was Henri who, as a juror, dramatically resigned when his friends' paintings were slighted for an exhibit at the National Academy of Design. The life of the city was Henri's subject, and he embraced it, embracing also, in portraits, the vitality of its new immigrant population. The rapid, coarse energy of his work matched the bold energy he saw in their faces and in the street scenes he recorded. Henri taught first, along with CHASE, at the New York School of Art (which Chase founded), and after 1909 at a school he started himself on upper Broadway. He was an inspiring teacher —BELLOWS, HOPPER, MACDONALD-WRIGHT, and Stuart DAVIS were among his students. In 1910 Henri organized an exhibition in which some 200 artists joined The Eight, and their works were democratically hung in alphabetical order. Crowds thronged to the show, and police were summoned when a riot seemed imminent.

Hepworth, Dame Barbara

1903–1975 • English • sculptor • Modern/Abstraction

In the contemplation of nature we are perpetually renewed, our sense of mystery and our imagination is kept alive, and rightly understood, it gives us the power to project in a plastic

*medium some universal or abstract
vision of beauty.*

Hepworth studied first in England,
then—awarded a scholarship—in Flo-
rence and Rome. She, NICHOLSON (her
second husband), and MOORE became
the center of Unit One, the ABSTRACT
movement in England. Both Hepworth
and Nicholson joined the ABSTRAC-
TION-CRÉATION group on one of their
sojourns in Paris. As a new means of
defining emptiness, Hepworth experi-
mented with the use of taut strings
drawn across the opening of a sculpted
form. Unlike GABO, who used threads
within a transparent material, Hep-
worth used strings that reached across
open space. *Wave* (1943–44) is an or-
ganic, wooden shape that curls deli-
cately over itself, as if it had a head and
tail. The natural wood on the outside is
highly finished; stretched across the
curved interior void, which is painted
white, tight strings, spreading like a fan,
accent and define the space they cover.
From covering, interrupting, or defin-
ing emptiness she went on to create it:
Later in her career, she began penetrat-
ing solids with holes. The startling ef-
fect was to reveal how an abstract form
is changed, the "inside" and "outside"
confounded, and mass and balance rad-
ically altered by creating such openings.
The shapes with which Hepworth
worked are organic rather than geomet-
ric. Sometimes she carved a group of
small, thin, and transparent figures of
finished marble; sometimes she worked
with roughly textured stone or bronze.
One of her late works, *Ancestor II:
Nine Figures on a Hill* (1970), is an
amusing stack of blocklike, hollowed
forms, almost 9 feet high, in an outdoor
setting. Hepworth died tragically in a
fire in her Saint Ives studio, which is
now a museum devoted to her work.

herbal

Books about plants, herbals are usually
concerned with their medicinal proper-
ties. The term "herbal" was first used
during the early 16th century, but the
tradition to which it refers began with
civilization itself. While the earliest ex-
tant copy of the *Papyrus Ebers* dates
from about 1550 BCE, it contains mate-
rial originally written from 500 to
2,000 years earlier. A Sumerian tablet
from around 3000 BCE has about a
dozen prescriptions with ingredients
that include herbs. Circa 2700 BCE the
Chinese emperor Shen Nung wrote out
some 100 herbal remedies. In the West,
sources of information for herbals were
ancient Greek texts rather than direct
observation. Pedanios Dioscorides' c.
65 CE *De materia medica* was the au-
thoritative source for more than 1,500
years. In his 37-volume *Natural His-
tory*, PLINY the Elder also devoted sub-
stantial text to medicine obtained from
plants. Herbals were often but not nec-
essarily illustrated. However, one col-
lection of colored drawings in a
manuscript now at the British Library
(MS Add. 29301) includes 68 English
herbs unaccompanied by text. They are
presented in three registers per page, be-
ginning with Avence (wood avens, herb
bennet) and ending with Cromyll
(gooseberry). In her survey of ILLUMI-
NATED MANUSCRIPTS in the British Isles
from 1390 to 1490, codicologist (one
who studies the history and physical as-
pects of a book) Kathleen Scott specu-
lates that the apparent randomness of
their sequence "may reflect an arrange-

ment by order of disease in a treatise formerly coupled with the drawings in earlier copies." It is estimated that more than 100 manuscripts with treatises on herbs were produced in England during the 15th century, but only two of them contain drawings of the herbs.

Herculaneum

Founded by Hercules, according to legend, this small town at the foot of Mount Vesuvius was destroyed by volcanic eruption in 79 CE. Unlike POMPEII, which was buried in stone and ash, Herculaneum was drowned by a river of boiling mud that encased it as if in a time capsule. Tunneling into the city and looting its treasures began in the early 18th century. In mid-century, WINCKELMANN was important in calling attention to the destructive, nonscientific manner in which excavation was carried out. Both Pompeii and Herculaneum became attractions along the aristocratic GRAND TOUR. Among the important discoveries unearthed at Herculaneum are wall paintings that refer to Hercules and a STILL LIFE, *Peaches*, that reveals attention to the effect of light on objects such as a clear glass jar containing water. MOSAICS were also uncovered, including a masterpiece on the wall of the House of Neptune and Amphitrite. This richly colored picture combines idealized human figures with elaborate decorative details and patterns.

Hesdin, Jacquemart de

active c. 1384–after 1413 • Franco/Flemish • Medieval/International style

And since the articles of faith are the way and the gates to enter into

Paradise, I am putting the twelve gates of the heavenly Jerusalem above the twelve apostles, and the Virgin Mary, through whom the door was opened to us.

Jacquemart was the leading manuscript painter in the court of the Duke of Berry from about 1384, preceding and overlapping with the LIMBOURG brothers, who arrived around 1404. The duke owned two masterpieces by PUCELLE, whose influence on Jacquemart was great. Jacquemart absorbed the ideas of his predecessors and added an interest in landscape and seasonal changes, as well as an innovative, diagonal version of Pucelle's space-defining cubicle. On a less elevated plane, Jacquemart was involved in a lawsuit in 1398, accused of breaking into another painter's strongbox to steal various paints and patterns.

Hesse, Eva

1936–1970 • American • sculptor • Minimalist/Process

Everything is process . . . I never thought of it for any other reason than the process was necessary to get where I was going.

During the last decade of her life, Hesse moved from conventional drawing to making three-dimensional sculpture. In some of her experimental works she used soft, flexible materials, such as latex over rope, and hung them in front of a wall, so that the sculpture ended up looking very much like drawings in the air (e.g., *Untitled [Rope Piece]*, 1970). Hesse's comment, above, explains that her interest was in ideas about the materials, their form, and how and where they would be hung or placed. This dis-

tinguishes her endeavor from PROCESS ART, which is devoted to the integrity of procedure, at least in shifting the emphasis from the artist in action to the work. What Hesse managed to accomplish was an almost impossible seeming feat: She gave character, sexuality, and gender to the bare bones of Minimalism. *Accession II* (1969) is a gray steel-mesh box without a lid. It is lined with hairy-looking threads of gray plastic tubing that make it as disconcerting a work as is the fur-lined teacup by OPPENHEIM. The total image, Hesse said of her works, had to do with her own complex personality and the "absurdity of life." She said this in 1970, the year she died of cancer. It was the end of a brief, tragic life. She and her sister, German Jews, had escaped to Amsterdam in 1939. Their parents rescued them from an orphanage there and took them to the United States. Then the parents divorced and her mother committed suicide. In an incomprehensible continuation of this tragedy, Eva's husband left her in 1965 and her father died in 1966. Her own early death seems almost preordained. But before that happened she produced what the historian Ellen Johnson calls "some of the masterpieces of contemporary American Sculpture."

Heyden, Jan van der
1637–1712 • Dutch • painter • Baroque

A View of a church by Vender Heyden, his best; two black friars going up steps. Notwithstanding this picture is finished as usual very minutely, he has not forgot to preserve, at the same time, a great breadth of light. His pictures have very much the effect of nature, seen in a camera obscura. (Sir Joshua Reynolds, 1781)

In his book *Journey to Flanders and Holland* (written 1781, published 1797), quoted from above, REYNOLDS spoke of van der Heyden's paintings as bringing the CAMERA OBSCURA to mind. During the next century, when the camera as we know it was invented, observers thought of photography when they looked at van der Heyden's scenes. But his recording of detail goes beyond the mechanics of either device to a near obsession with detail, it almost seems, so that one might begin to count the bricks on the facades of van der Heyden's buildings. He painted mainly in Amsterdam, and his interest in the microscopic, or at least the manipulation of sight, is reminiscent of the "realism of particulars" in van EYCK's painting. It may be related to van der Heyden's business of making and selling mirrors, which were often used in artists' studios. He was also a civic-minded individual who is thought to have invented the fire hose—he wrote and illustrated *The Fire Engine Book* (or *Description of the Newly Discovered and Patented Fire Engine Hose and Her Way of Putting Out Fires*) in 1690. Van der Heyden primarily painted town views, not only of his native Amsterdam; he also traveled to the southern Netherlands and Germany. His work of combining architecture and townscape was an inspiration to 18th-century painters like CANALETTO.

Hiberno Saxon
Hibernia, the Latin name for Ireland, is derived from the word for "winter."

Saxon refers to Germanic tribal origins. MEDIEVAL ART from Scotland and northern England as well as that from Ireland is known as Hiberno Saxon. The terms "Celtic" (from the ancient inhabitants) and "insular" (to distinguish it from Continental European) are also often used for this culture. The Hiberno Saxon Church was rural and monastic in contrast to the more urban Roman Church. The specific origin of Hiberno Saxon practice is not known, but there is speculation that it may have begun with 5th- and 6th-century churchmen from Britain or Gaul escaping "barbarian" invasions (see MIGRATION), and perhaps Greek churchmen from the eastern Mediterranean who followed trade routes to Ireland during the late 6th and early 7th centuries. The latter would have brought both their language and texts, not found elsewhere in Medieval Europe, and that would explain the Irish scholars' singular knowledge of Greek; if a churchman in Western Europe knew Greek, during the 7th to 9th centuries, he was assumed to have come from Ireland. Irish monks were zealous missionaries who founded monasteries in Italy, Switzerland, Germany, and France and established footholds on the British mainland. They were intensely devoted to education, and theirs were the preeminent centers of learning in Western Europe in the early 7th century. The Irish SCRIPTORIUM produced ILLUMINATED MANUSCRIPTS of extraordinary complexity and beauty that combined ANIMAL STYLE figures, Celtic, and INTERLACE design with some naturalistic and didactic images. The *Lindesfarne Gospels* (c. 698) and the BOOK OF KELLS (early 9th century) are two examples. After 800 the Irish no longer played a significant role in Europe's cultural life, which was then in the midst of the CAROLINGIAN period, with its ROMAN orientation, and the Hiberno Saxon/Celtic Church rapidly declined.

Hicks, Edward
1780–1849 • American • painter • Fantasy/Folk Art

. . . how awful the consideration: I have nothing to depend on but the mercy and forgiveness of God, for I have no works of righteousness of my own. I am nothing but a poor old worthless insignificant painter.

Hicks was a Quaker minister who decorated carriages and made signs as well as the paintings for which he is famous: numerous renderings of the *Peaceable Kingdom*. These illustrate a passage from Isaiah: "The wolf also shall dwell with the lamb, and the leopard shall lie down with the kid; and the young lion and the fatling together; and a little child shall lead them." Hicks repeated this theme in a number of settings and alternative groupings, but always with great sensitivity and charm, in the style of FOLK ART. His lament, quoted above, was written toward the end of his life.

Hildegard of Bingen
1098–1179 • German • painter • Medieval

In the year 1141 of the incarnation of Jesus Christ the son of God, when I was forty-two years and seven months of age, a fiery light flashing intensely, came from the open vault of heaven and poured through my whole brain. . . . And suddenly I could

*understand such books as the Psalter,
the gospel and the other catholic
volumes of the Old and New
Testament actually set forth.*

With the words quoted above, and a picture illustrating the event described, Hildegard introduces her visionary book of knowledge, the *Scivias* (1142–52). The "fiery light" is represented by flames emanating from her head. Born into an aristocratic German family, Hildegard entered a convent as a child. In about 1147 she founded a new convent near Bingen. She had had divine visions, as she understood them, since childhood, and with the assistance of a monk, who is also portrayed in the illustration discussed above, she began to record them. The book's title, *Scivias,* is from the Latin *scite vias lucis,* meaning "know the ways of the light." It consists of 35 visions relating and illustrating the history of salvation. It is generally believed that Hildegard closely supervised the text and illustration of the book, and recent scholars point out that it shows she was familiar with the works of Saint Augustine and Boethius as well as contemporary scientific and philosophical writings. This is all the more remarkable in that "[women] were excluded from the intellectual life of cathedral schools and universities in which students were legally clerics, a rank not open to women," as the historian Whitney Chadwick writes. "Instead, they turned increasingly to mysticism and, through vivid imagery and inspired commentaries, were influential in an alternative discourse, though one certainly not unique to women."

high art

In contrast to "low art," which is synonymous with the artifacts of POPULAR CULTURE, high art implies works of elevated status, traditionally belonging to the CANON and with CLASSICAL ancestry. Like FINE ART, high art presumes an elitism that was increasingly rejected during the 20th century.

High Classical
See CLASSICAL

Hilliard, Nicholas
1547?–1619 • English • painter • Late Renaissance

*. . . for the lyne without shadows
showeth all to good judgment, but the
shadowe without line showeth
nothing.*

Renowned especially as a painter of MINIATURE portraits, Hilliard was appointed goldsmith, carver, and portrait painter to Queen Elizabeth, and he engraved the Great Seal of England in 1586 (see SEAL). He was also favored by King James I, who in 1617 granted him sole license for royal work for 12 years. (Although he died before the contract ran out, his son, Lawrence, also a miniature painter, fulfilled its terms.) Among the miniatures for which Hilliard is known are portraits of Elizabeth, Sir Frances Drake, and Sir Walter Raleigh. A portrait of Shakespeare was attributed to him, but that is now doubted. One of his best-known works is *Young Man Amid Roses* (1588), an oval 5¼ inches high. The young man in question, in white tights, short jacket, and with a lace ruff at his neck, leans against the trunk of a tree amid

lacy greenery—the archetype of an Elizabethan gentleman. Hilliard used opaque color, sometimes embellished with gold. He preferred to outline his figures and use flat color rather than shading, as the quotation above describes. It is taken from Hilliard's treatise *The Arte of Limning*.

Hine, Lewis
See RIIS

Hiroshige, Ando
1797–1858 • Japanese • printmaker/painter • Tokugawa period

I leave my brush in the East / And set forth on my journey. / I shall see the famous places in the Western land.

Hiroshige had been so impressed by HOKUSAI's great success with his series of Mount Fuji landscapes that he produced his own series, *The Famous Views of Edo* (c. 1826) and *The Fifty-three Stations of Tokaido* (1833–34). The "Western land" to which Hiroshige refers in the poem above is specifically the paradise of the Buddha Amida; however, the poem as a whole suggests the trip he took for his *Tokaido* album. About that he wrote, "These pictures are not realistic. I took the general idea [from the actual scene] . . . but otherwise the landscapes came out of my head." Though he was 37 years younger than Hokusai, Hiroshige's popularity eclipsed that of his predecessor. Besides their landscapes, both artists painted birds, flowers, and legendary scenes using the WOODBLOCK color printing process perfected by the Japanese (see UKIYO-E). Hiroshige's works are less grandiose in conception than Hokusai's, and are noted for their strong diagonal lines. An example is *Rain Shower on Ohashi Bridge:* The bridge arcs gently across the lower part of the picture, slanted sheets of rain pelt down, and a small boat in the middle distance cuts across the water, making its own horizontal line and wake. While portraying movement, Hiroshige simultaneously creates balance and captures stillness.

Historicism
There are distinct senses in which this term is used. Generally, in architecture and the DECORATIVE ARTS, "historicism" refers to a revival of the styles of various historic periods. More specifically, historicism denotes the style of architectural revivalism predominant from the end of NEOCLASSICISM (around the early 19th century) to the beginning of ART NOUVEAU (about 1880). The term was coined in the 1880s to describe a preoccupation with history, and was a negative assessment of efforts to develop theories of history; it was used dismissively against ideas based on HEGEL. Today historicism has a new significance altogether: It refers to the practice of interpreting the arts in reference to a multivalent context that includes aesthetic, cultural, and historical information. Called "cultural materialism" in England, the approach is known as NEW HISTORICISM in the United States.

historiography
As the discipline of ART HISTORY concerns the study of art and artists, historiography studies the discipline of art history itself.

history painting

The term refers not only to portrayal of topics from the past, but also to biblical, mythological, and CLASSICAL themes. Generally text-based, history painting was long held in the highest esteem, especially at the ACADEMY, where the hierarchy of subject matter was clearly established. In fact, as van MANDER insisted, history painting was considered more than a mere subject category, as it included and subsumed all the other skills that were expressed in specialties such as STILL LIFE, LANDSCAPE, and GENRE. Van Mander and other Northern art theorists promoted specialization in art, and this encouraged the sort of collaboration that became prevalent in Flemish art of the 17th century. Deference toward history painting lasted into the 19th century. Its grip began to loosen as artists, following the example of WEST, treated contemporary events as if they were "history paintings."

Hitchcock, Henry-Russell

1903–1987 • American • architectural historian

. . . I have made no attempt at a cold, semantic precision of statement and I even doubt whether any matter connected with the arts can be profitably discussed without warmly connotative words and phrases.

Hitchcock's reputation as a historian was established with his books *Modern Architecture: Romanticism and Reintegration* (1929) and *Architecture: Nineteenth and Twentieth Centuries* (1958). He defined, wrote about, and with Philip JOHNSON and BARR mounted an influential exhibition of the INTERNA-TIONAL STYLE of modern architecture. His book on Frank Lloyd WRIGHT, *In the Nature of Materials* (1942), was and is the foundation for subsequent studies. Hitchcock's approach to his discipline is expressed in the quotation above, and his own accomplishments are listed by his colleague Helen Searing, who wrote in 1982: "Museum director, traveler, curator, collector, supporter of the avant-garde in music and theater as well as in art and architecture, reviewer of Marcel Proust, Virginia Woolf, and 1928 movie magazines, epicure and chef . . . designer and dandy, Professor Hitchcock is . . . [a] stimulating teacher, intrepid critic, and esteemed historian."

Hobbema, Meyndert

1638–1709 • Dutch • painter • Baroque

He pleases with inviting countrysides, mills embedded in luxuriant masses of trees. . . . With his sensuality, the pomp and panoply of his summer ripeness, he won the hearts of art-lovers and collectors, particularly the English.
Max J. Friedländer, 1949

Hobbema was a student and lifelong friend of RUISDAEL. The painting for which he is best known, *The Avenue of Trees at Middelharnis* (1689), is a masterpiece, unlike any of Hobbema's earlier landscapes, and also very different from paintings by anyone else. Three-quarters of the canvas is sky, lightly covered with clouds. The ground is flat; a road in the center of the picture vanishes to a point on the flat horizon. Though there are tiny figures in the painting, the real cast of characters consists of two rows of extremely tall,

spindly trees that border the avenue. They face each other as if partners in a minuet. Some even bow slightly. (The courtly minuet, danced to music in a 3/4 rhythm, is an exercise in polite deportment that became extremely popular around 1650 at the court of Louis XIV. Despite political conflicts between France and Holland, the influence of French taste remained strong.) In 1668, when he married and received a well-paid position, Hobbema seems to have given up painting. *The Avenue* was executed after more than 20 unproductive years. With this work, as FRIEDLÄNDER, who is quoted above also comments, "great talent becomes—for once—genius."

Höch, Hannah
1889–1978 • German • collage/photomontage • Dada

Our whole purpose was to integrate objects from the world of machines and industry into the world of art. . . . In an imaginative composition, we used to bring together elements borrowed from books, newspapers, posters, or leaflets, in an arrangement that no machine could yet compose.

One of the originators of DADA's PHOTOMONTAGE technique, Höch was a member of the Berlin Dada group. She used pictures taken from the sources mentioned in the quotation above—mechanical reproductions—and assembled them in disconcerting juxtapositions. *Cut with the Dada Kitchen Knife Through the Last Era of the Weimar Beer Belly Culture* (1919) illustrates both the compositional process described and the political/social situation in post–World War I Germany. The

work is simultaneously confusing and fascinating: The viewer's eye moves through a chaos of heads (often on disproportionately small bodies), wheels, crowds, and animals as if being rapidly shuttled through a threatening, nightmarish world. Höch was the only woman associated with the Berlin Dada Club, and was sidelined because of her gender. However, as she was also romantically involved with a prime mover in Berlin Dada, Raoul Hausmann, and he threatened to withdraw his own contributions if hers were refused, Höch's work was shown at the first Dada exhibition in Berlin, in 1920.

Hockney, David
born 1937 • English • painter • Modern/Figurative

I've still got a lot of the child in me. To be still thrilled by the world is like being a child.

Hockney has gone through several stages or styles in his work, but he is best known for his strangely still, precisely rendered forms and flat, pure pastel coloring—salmon, turquoise and yellow—in paintings such as *A Bigger Splash* (1967). This is one of a series of swimming-pool pictures in which the spray of a diver, a foamy white explosion, seems frozen in space. In paintings such as this, Hockney synthesizes both the superficiality of Hollywood, and the *idea* of that superficiality. Hockney has also made a series of photographic COLLAGES. He might cut and reassemble a scene so that it becomes an obviously re-compiled, or re-collected, panorama. With *The Grand Canyon Looking North, Arizona, September 1982* (1982) he composed a complex

mosaic by photographing and assembling numerous images of the same vista. Hockney is constantly experimenting and perpetually inspired by artists of previous eras (CUBISM echoes in his photocollages). Born in England, he studied at the Royal College of Art. He is a longtime friend of KITAJ, whom he quotes: "[Kitaj] said, 'Why don't you paint all the things you talk about?' So I did—the politics, the vegetarianism, the gay thing." The "gay thing" is a well-known part of Hockney's life as an expatriate on the West Coast (the reverse of Kitaj's expatriatism in England). His eccentricity also proclaims itself in that, after hearing a television commercial pronouncement that "blonds have more fun," he colored his dark hair a shade of bright yellow. In addition to painting and making collages Hockney designs sets for the theater.

Hodler, Ferdinand
1853–1918 • Swiss • painter • Symbolist

The mission of the artist . . . is to give expression to beauty, the external element of nature: to extract from nature essential beauty.

In the early 1890s Hodler's fairly unimaginative work changed, showing a new affinity with the values of SYMBOLISM, its mysticism, and its synthetic style. Part of this change may be attributed to a vision he had when his son was born. He represents the event in *Chosen One* (1893) in which he painted his son as a new Christ child, naked in the Swiss landscape, accompanied by six plain but pleasant-faced angels. Their benevolent faces look like those of next-door neighbors, but their ordinariness is belied by the fact that they all levitate a foot or so above the earth. Hodler drew inspiration from Swiss history and the Swiss landscape. Though not all his subsequent work was so apparently Symbolist as *Chosen One,* he did exhibit in the SALON DE LA ROSE + CROIX.

Hofmann, Hans
1880–1966 • German/American • painter • Abstract Expressionist

I have students all over the world, many thousands of them who have become ambassadors for the spread of my basic ideas, and every one of them is doing it in his own individual way.

Born in Germany, Hofmann studied in Paris for 10 years as the FAUVE movement gained strength. In 1934 he settled in America. Avid about color and the importance of the PICTURE PLANE, Hofmann pioneered in experimenting with the application of paint by gesture rather than brushing in the traditional manner. He splashed, splotched, and dripped long before Jackson POLLOCK, although with different motives. *Effervescence* (1914) is an example of his work that might be called ABSTRACT EXPRESSIONIST before the fact. Hofmann was a teacher of tremendous inspiration and influence. Among his students were KRASNER, FRANKENTHALER, MARISOL, MOTHERWELL, RIVERS, and GROOMS. He taught drawing and lectured on pictorial structure, handling paint, and the expressive value of materials. He had a thick accent and was hard of hearing, which made interaction difficult but nevertheless gave his pronouncements a

certain omnipotence. Rectangles are among the signature shapes on his own paintings. He moved cutout, colored rectangles around his canvas until they looked the way he wished, then traced them and painted them in. "The artist's technical problem," Hofmann wrote, "is how to transform the material with which he works back into the sphere of the spirit."

Hogarth, William
1697–1764 • English •
painter/printmaker • Rococo satire

I therefore turned my thoughts to . . . painting and engraving modern moral subjects. . . . I have endeavored to treat my subjects as a dramatic writer; my picture is my stage, and men and women my players, who by means of certain actions and gestures, are to exhibit a dumb show.

At the beginning of the 18th century, although there were top-quality silversmiths, cabinetmakers, and architects, Hogarth was the only outstanding English-born painter. (There were still no significant sculptors.) For important commissions, painters such as RUBENS and van DYCK were brought over to England from the Continent. Hogarth examined the mores and activities of all economic classes and might as well have written the words of his contemporary John Gay (1688–1732), the author of the popular *Beggar's Opera* (1728): "Life is a jest; and all things show it. / I thought so once; but now I know it." Hogarth used the bite of satire (as did his friend Henry Fielding) in his series of "moral works," which were painted initially and then engraved (his early

training was in ENGRAVING). The first of the series was *A Harlot's Progress* (published 1732). In six scenes he shows the downward spiral in the life of a prostitute, expanding on the GENRE topic of the brothel that was popularized in NETHERLANDISH art of the BAROQUE and examining its social consequences. The series was an immediate success: Bits of it were reprinted on fans, cups, and saucers. It was also pirated, which led to Hogarth's efforts on behalf of including prints in the Copyright Act, a protection finally passed by the British Parliament in 1735. (It may have inhibited the plagiarism, but it did not end it.) The *Harlot's Progress* bares the perils of the lower class; *A Rake's Progress* (1735) looks facetiously at the newly prosperous middle class; and Hogarth's masterpiece, a series of eight paintings entitled *Marriage à la mode* (1743), caustically portrays upper-class society of the 18th century. Hogarth subverted the decorative niceties and artifice of the ROCOCO to degrade rather than romanticize. As we follow his cast of characters through their exaggerated gestures, it is—as Hogarth suggests above—as though we are watching scenes in a play. During the 18th century, theater was of central importance to all the arts and to philosophical discourse.

Hokusai, Katsushika
1760–1849 • Japanese •
painter/printmaker • Tokugawa period

If Heaven would grant me five more years, I would become a real painter.

Born in Edo (now Tokyo), he used some 50 names, but the one that endures is

Hokusai, which means "Star of the Northern Constellation." He also lived in more than 90 different houses, moving, it is said, when the mess on the floor, where he threw his drawings, got too deep. Stories abound about Hokusai's eccentricities: He is said to have pleased a crowd outside a temple by drawing an enormous picture of Buddha using a broom-sized brush. According to another legend, he drew birds in flight on a single grain of rice. Hokusai is best known for his *Thirty-six Views of Mount Fuji* (1831), a series from which the most famous single image is *The Great Wave*. This colored WOOD-BLOCK print has reappeared, over time, in everything from vodka advertisements to political cartoons. IMPRESSIONISTS especially were intrigued by the off-center composition, diagonals, flat planes, and radical cropping of objects and figures that characterized Japanese prints in general, of which Hokusai's works are outstanding examples. One historian believes that the American REALIST Winslow HOMER was inspired by *The Great Wave* in his painting *The Life Line* (1884). Hokusai's modesty is as renowned as his draftsmanship, and the comment quoted above is reportedly what he cried out on his death bed. (See also UKIYO-E)

Holbein, Hans, the Younger

1497/98–1543 • German • painter • Northern Renaissance

Your friend is a wonderful artist. (Sir Thomas More, c. 1526, writing to Erasmus of Rotterdam)

Hans the Younger trained with his father in Augsburg, Germany, then left to settle in Basel, Switzerland, around 1514. Basel was also home to Erasmus of Rotterdam, the great Catholic HUMANIST, who became Holbein's friend. In 1521/22, probably as the predella for a large ALTARPIECE, Holbein painted a macabre *Christ in the Tomb (Dead Christ):* a life-size cadaver laid out horizontally, at eye level. Holbein spared none of death's horror, including a lurid coloring of the corpse and the look of rigor mortis. He brings MANTEGNA's notorious *Dead Christ* (c. 1500) to mind—it is as though Holbein decided to move the viewer from the end of the stone slab where Mantegna stood to an uncomfortably close position, almost inside the sarcophagus. Contemplating such images of Christ, indeed, to "dwell in the wounds of Christ," as Thomas à Kempis recommended, was a popular form of mysticism, the *devotio moderna* (modern devotion), of the 15th and early 16th century. As Protestant influence spread and Church commissions declined, Holbein concentrated on portraits and then, in 1526, left for England with a letter of introduction from Erasmus to Sir Thomas More. More's response is quoted from above. Holbein's portraits of both men are among his best known. More became lord chancellor in 1529 but resigned the post in 1532 because he could not condone King Henry VIII's wish to divorce. In 1535, More was beheaded for his intransigence. In the meantime, Holbein had been receiving commissions from members of the court and by 1537 he became court painter. He made several portraits of Henry, and was sent on missions to paint likenesses of the king's prospective brides. Holbein's meticu-

lous, microscopic details and his evocation of rich, deep light and texture are compared with van EYCK's. Also like van Eyck, Holbein used elaborate symbolism, especially in *The French Ambassadors* of 1533, a full-length portrait of two friends, one a cleric, the other a wealthy nobleman. Every element in this large work (almost 7 feet square) is charged with meaning: A nearly hidden crucifix suspended in the upper left corner reminds one of the uncertain status of the Catholic Church during the period; celestial and terrestrial globes bring to mind that Holbein was painting in the great Age of Exploration. More ambiguous, and certainly suggestive, are a lute with broken string, a book of hymns open to a page of songs by Martin Luther, and, most famously, an exceedingly strange object on the floor. It is an anamorphosis (from a Greek word meaning "transform"), a trick of PERSPECTIVE: When seen at an acute angle, its true form—that of a skull—is revealed. A skull was the personal emblem of one of the noblemen in the picture. It also relates to the ICONOGRAPHY of the Crucifixion, pictures of which, beginning in the 9th century, often showed "Adam's skull" on the ground below the Cross. In addition, the name Holbein actually means "hollow bone," which can be interpreted as "skull." Skulls have several other symbolic meanings, but with his anamorphic rendering Holbein may have been enjoying a game of one-upmanship at the expense of his contemporary DÜRER. Dürer invented a perspective drawing system for which he used a lute as an illustration. Holbein's lute is foreshortened, as was

Dürer's, but Holbein's skull is seen from a more radical and far more complex perspective. This perspective and metaphorical play of skull and (broken) lute offers absorbing interpretive challenges to art historians.

Holt, Nancy

born 1938 • American • sculptor • Site works

Time is not just a mental concept or a mathematical abstraction in the desert. The rocks in the distance are ageless; they have been deposited in layers over hundreds of thousands of years. Time takes on a physical presence.

Holt was born in Massachusetts. Her first trip to the Nevada desert was made in 1968 with her husband, SMITHSON, and with Michael Heizer (born 1944), another innovator in EARTH AND SITE ART. Unlike the two men, who changed the look of the landscape, Holt finds nonintrusive ways to watch and become part of nature. She builds or installs places, or things—there is simply no generic term for what she makes— that allow people to look at the sky or the land with a unique perspective. Her first outdoor Site work, *Views Through a Sand Dune* (1972), in Narragansett, Rhode Island, was on a secluded beach. She set a single pipe in the dune that blocked an ocean view. Looking through the pipe, the ocean and sky became visible. She set four *Sun Tunnels* (1973–76), huge, 18-foot-long concrete pipes with openings 9 feet in diameter, on the ground in the Great Basin Desert in Utah. Through holes bored in the concrete, sunshine casts changing patterns on the inside of each tunnel.

Moonlight casts different lights. Holt's creations allow a personal, direct enjoyment of nature. Many also have connections with prehistoric sites, like Stonehenge. They are all links to the idea of eternity: "I'm interested in conjuring up a sense of time that is longer than the built-in obsolescence we have all around us," Holt explains.

Holzer, Jenny
born 1950 • American • language • Conceptual/Postmodern

PROTECT ME FROM WHAT I WANT.

The words above are among Holzer's messages that have appeared in print, on billboards, engraved into benches, and on an advertising display board in Times Square, where, during 1977–79, Holzer installed a continuous sequence of provocative phrases. Her sentences, sometimes incomplete, are enigmatic enough to invite speculation: Is she referring to emotional or social want, sexual or material desires? It is ironic (and POSTMODERN) that, in Times Square at least, she is able to use an advertising medium to call advertising into question. Holzer was inspired to make this kind of art as a result of a course in the history of contemporary art that she took at the Whitney Museum of American Art in New York. The course included readings in theory, such as SEMIOTICS, in which language—its constructions and effects—is challenged. Other of her messages include "Any Surplus Is Immoral," "Morality Is for Little People," "Abuse of Power Comes as No Surprise," and "Murder Has Its Sexual Side."

Homer, Winslow
1836–1910 • American • painter • Realist

If a man wants to be an artist he should never look at pictures.

Homer was an exceptionally taciturn man whose rare comments about art, such as the one quoted above, might sound more doctrinaire than he probably meant them to be. His point here was that an artist should look to nature, rather than tradition or convention. That is what he did in his own career, which began with drawing for magazines, especially *Harper's Weekly*. During the Civil War, Homer reported on life just behind the front lines, the wounded soldier writing home, and poignant moments, such as that shown in his oil painting *Prisoners from the Front* (1866), in which a group of Rebel soldiers surrenders. Homer went to France after the war and came home with a lightened palette and a preoccupation with leisure activities such as the French IMPRESSIONISTS were painting. Yet his concerns also seemed particularly American and often focused on the new generation: *Snap the Whip* (1872) shows young, barefoot boys holding hands in the familiar game of that name. They go faster until momentum breaks the chain—of friendship, innocence, or whatever one chooses to read—and throws each child, separately, to the ground. He painted schoolhouse scenes, and a lovely teacher whose model was supposed to have been his romantic interest. However, his career, and subsequently his style, was interrupted in the 1880s by a

two-year sojourn on the British sea-coast, prompted, some think, by disappointed love. Others incline toward attributing his departure to dismay with the character of America during the Gilded Age. In England, the power of the sea and human vulnerability in the face of nature absorbed him. On his return to the United States, Homer settled on the coast of Maine, and there his work acquired a sense of high drama, in seascapes and landscapes that both include and exclude people and animals. Homer had a mastery of design and composition that allowed him to experiment with extraordinary perspectives. In *The Life Line* (1884), he shows a dangerous rescue at sea from a PERSPECTIVE that seems as if the artist were also suspended above the roiling water. The point of view is even more vertiginous in *Right and Left* (1909), in which it seems as if the artist, and therefore the viewer, is flying high above the water with two doomed ducks, one of which has just been shot. The hunter is in a small, open boat located far below. We can barely see him or the spot of red and puff of smoke coming from his gun barrel. Interpretations of this picture's theme have ranged from sporting to metaphysical (especially considering that it was painted about a year and a half before Homer died). His oil paintings are accompanied by a rich collection of watercolors, a medium of which he was the consummate master. It is a fact rarely mentioned but certainly of significance that Homer's mother was an accomplished watercolorist. He had almost no formal education, and his mother's influence must have been important.

Honthorst, Gerrit van

1592–1656 • Dutch • painter • Baroque

. . . his gay, light-hearted gatherings . . . set a precedent for similar scenes done in the 1620s at Utrecht. Utrecht artists favored the erotic rather than the ascetic side of Baroque art. (Jakob Rosenberg, Seymour Slive, and E. H. ter Kuile, 1966)

Believed to have been in Rome about 1610, Honthorst was a Dutch follower of CARAVAGGIO and brought home to Utrecht the drama of the Italian's CHIAROSCURO. Honthorst's study of artificially lighted night scenes earned him the nickname Gherardo delle Notti (Gerrit of the Night) while he was still in Italy. Cardinal Scipione BORGHESE was one of his PATRONS. *The Merry Company* (of 1620; also known as *Supper Party*), to which the quotation above refers, is a scene in which a group of candlelit revelers interact around a table. On one level it is a typical GENRE scene with laughing faces boldly highlighted against the background of a shadowy darkness. But on another level it may be read as an allegorical portrayal of the senses, a theme popular among BAROQUE painters. In this case the lutenist specifically represents hearing; other figures symbolize eating, touch, and so on. Such pictures might also be related to the biblical story of the Prodigal Son (who squandered his inheritance on riotous living), in which case their moralizing subtext takes the form of a warning against overindulgence. Not all art historians accept these interpretations, prefer-

ring to see Dutch art as forthrightly descriptive rather than symbolic or allegorical.

Hooch, Pieter de
1629–1684 • Dutch • painter • Baroque

. . . a new type of genre painting with unprecedented spatial order and naturalism. (Peter C. Sutton, 1998)

As contemporaries and residents of Delft, de Hooch and VERMEER may have influenced each other, but it is interesting to compare their works for their differences. While both painted interior domestic scenes, for example, Vermeer directs the viewer to the subtle effects of light on the presence and activities of people and things, whether musical instruments or a pitcher of milk. In a painting by de Hooch, the light is warmer, sunnier, and often plays against dark shadow. He is also more interested than is Vermeer in moving the viewer through space, as the art historian Peter Sutton comments above: We see through doorways and passages in both interior spaces and outdoors, almost as if de Hooch were showing us the interior of one of HOOGSTRATEN'S PEEPSHOW BOXES. There is a quiet serenity and dignity to his portrayals of women and children at their chores. After he moved to Amsterdam, in the late 1660s, de Hooch's style changed, becoming more pretentious. It was the period when French taste and culture were beginning to permeate Europe and interest in the simple life of the Dutch middle class declined. De Hooch died in the Dolhuis—an insane asylum.

Hoogstraten, Samuel van
1627–1678 • Dutch • painter/theoretician • Baroque

I say that a painter, whose work it is to fool the sense of sight, also must have so much understanding of the nature of things that he thoroughly understands the means by which the eye is deceived.

A student of REMBRANDT during the 1640s, Hoogstraten painted biblical subjects in his teacher's style, as well as GENRE, PORTRAIT, and TROMPE L'OEIL. He was particularly interested in illusion achieved by PERSPECTIVE and by using the CAMERA OBSCURA. In 1678 he published a treatise on painting in which he describes erecting a camera obscura. He wrote, "I am certain that vision from these reflections in the dark can give no small light to the sight of the young artists; because besides gaining knowledge of nature, one sees here what main or general [characteristics] should belong to truly natural painting." Hoogstraten was just as well known for his PEEPSHOW BOXES, with their perspective tricks. In addition to his interest in painting as deception, he also—and somewhat in contradiction—promoted in his writings the importance of biblical, mythological, and allegorical subjects.

Hopper, Edward
1882–1967 • American • painter • American Scene/Realist

I never tried to do the American Scene. . . . I always wanted to do myself.

Hopper was a student of HENRI, and had the social consciousness of the ASH-CAN tradition. His work developed an unmistakable individuality characterized by pervasive, oppressive isolation, loneliness, emptiness, and gloom, often in an urban setting. Even before the Great Depression, Hopper's scenes were stark and seedy. During and after the 1930s the mood simply persisted, as the artist became ever more sophisticated at conveying the discomfort of impending though undefinable disaster. As in the work of SLOAN, we see many of Hopper's tableaux through windows, which compromises us as voyeurs; on the other hand, many of his subjects stare blankly, unemotionally, out of a window, imparting a feeling of impotence and entrapment. Often there is an underlying erotic charge: In *Eleven A.M.* (1926) a naked woman in a third-rate hotel room, wearing just her shoes, sits in an armchair by the window, gazing at the geometric forms of surrounding buildings. We cannot see her face: We do not make eye contact with Hopper's people, nor do they look at one another. *Nighthawks* (1942), said to be reminiscent of, if not inspired by, Ernest Hemingway's 1927 story "The Killers," has the ambience of that story's diner, in which two killers await their victim. The garish fluorescent lighting adds to the lugubrious atmosphere. Hopper is rarely surpassed in his ability to set the stage for despair.

horror vacui
Literally translated, the term means "fear of empty space." It refers to crowded designs such as those of Medieval ILLUMINATED MANUSCRIPTS.

Horta, Victor
1861–1947 • Belgian • architect • Art Nouveau

If it is true that logic underlies the most elemental reasoning of creatures, I consider that it need not prevent us from dreaming of "charm," that delicate luxury that is often added to base necessity.

The avowed intention of ART NOUVEAU, as with the ARTS AND CRAFTS movement, was to erase the distinction between "fine" and decorative arts and crafts. This is evident in the designs of Horta, whose ironwork turns metal into sinuously curved plant forms. In his interior stairwell for the Hôtel Tassel in Brussels (1892–93; now the Mexican Embassy), the wrought-iron banister coils gracefully in S-curves that are repeated in designs on the floors and walls. It has been called Art Nouveau architecture at its boldest.

Hosmer, Harriet
1830–1908 • American • sculptor • Neoclassicist

I grant that the painter must be as scientific as the sculptor, and in general must possess a greater variety of knowledge, and what he produces is more easily understood by the mass, because what they see on canvas is most frequently to be observed in nature. In high sculpture it is not so. A great thought must be embodied in a great manner, and such greatness is not

to find its counterpart in everyday things.

After her mother and three siblings died of tuberculosis, Hosmer's father determined to build up her endurance through outdoor activities, including mountain climbing. In addition to physical fortitude and daring, she developed an independence of character and style. Hosmer studied in Rome and became famous not only for her work but for her unconventional behavior as well. For example, she loved to ride horseback outside of the city at midnight. Several American women sculptors joined Hosmer in Rome. They worked in marble and sometimes in bronze, in a NEOCLASSICAL style. Included in Hosmer's circle were Vinnie Ream Hoxie (1847–1914), Margaret Foley (1827–1877), Edmonia LEWIS, and Anne Whitney (1821–1915), who competed anonymously and won an 1875 competition for a statue of Charles Sumner. (The committee rescinded after discovering the winner was a woman. In 1902, when Whitney was 80, her model was cast and placed in Harvard Yard.) Often at the center of controversy, Hosmer shocked her contemporaries when she attended an all-male medical college in Saint Louis in order to study anatomy. Her belief in the superiority of sculpture over painting is expressed in the quotation above, excerpted from a letter she wrote to her PATRON just before leaving for Rome.

Houdon, Jean-Antoine
1741–1828 • French • sculptor • Neoclassicist

One of the finest attributes of the difficult art of sculpture is truthfully to preserve the form and render imperishable the image of men who have achieved glory or good for their country.

Houdon's comment, quoted above, neatly packages the combined moral and didactic intentions of his work. A primary example is his heroic, life-size marble statue of George Washington (1788). Washington was an international celebrity by then, and Houdon, who had already made busts of JEFFERSON and Benjamin Franklin, was brought to America from Paris at Jefferson's recommendation. He then spent two weeks modeling and drawing at Mount Vernon. Washington wanted to be portrayed in his military uniform rather than in the typical NEOCLASSICAL toga, but the statue's symbolism is nevertheless from ancient Rome, especially the plow behind him. It draws an analogy between Washington and the 5th-century BCE Roman soldier Cincinnatus, who relinquished his military command in favor of farming. Less formal, as were the works of many late-18th-century portraitists when representing their friends, Houdon's bust *Diderot* (1771) is a more candid and lively portrait. The bust shows DIDEROT turning his head as if to answer a question.

Hudson River School
The name given to American landscape painters who followed after COLE in recognition of the region where Cole developed his style. (Neither Cole nor his successors painted in that locale exclusively.) The roster of Hudson River School painters includes artists who went West to paint the landscape, as

well as the LUMINISTS, who often painted harbor scenes and marine-scapes, especially on the East Coast.

Hughes, Robert
1938– • Australian • art critic

As I was reading the papers a few weeks ago, hoping to find out what some deranged car salesman in San Diego might have paid for Mrs. Kennedy's diaphragm, I had a small revelation.

Hughes's revelation, described in pre-senting an award to the NATIONAL EN-DOWMENT FOR THE ARTS in 1996, had only passingly to do with the auction of Jackie Kennedy's estate. Its main topic was public commitment to the arts, but the humor and the irreverent tone are vintage Hughes. His own, private com-mitment takes the form of critical essays he has written for *Time* magazine since 1970. Hughes won the College Art As-sociation award for distinguished criti-cism and has published several books on art including *The Shock of the New,* 1981; *Nothing If Not Critical,* 1990; and *American Visions,* 1997. Hughes's writing is not only exceptionally bold and challenging, but it is also extremely learned and extraordinarily interesting. Both *The Shock of the New* and *Ameri-can Visions* were serialized for televi-sion. Hughes concluded his remarks about the NEA by explaining that "to make and experience art is an organic part of human nature, without which our natures are coarsened, impover-ished, and denied, and our sense of community with other citizens is weak-ened. . . . I know it in my heart, my sometimes mean and irritable writer's heart. The arts are the field on which we

place our own dreams, thoughts, and desires alongside those of others, so that solitudes can meet, to their joy some-times, or to their surprise, and some-times to their disgust. When you boil it all down, that is the social purpose of art: the creation of mutuality, the pas-sage from feeling to shared meaning."

Humanism /Humanist
Term coined by 19th-century scholars to describe what they understood to have characterized the intellectual preoccupations of the ITALIAN RENAIS-SANCE. The origin of humanist phi-losophy is 5th-century BCE Greece; humanists emphasized the study of an-cient Greek and Roman literature, ideas, and art. Artists studied ancient relics, and when these were not at hand, they read about them in texts (see EKPHRASIS). Basic to Humanism was the concept of man at the center and as the measure of all things. Humanists also supported the ancient Greco-Roman belief that history is cyclical, in contrast to the Judeo-Christian concep-tion of linear development. Thus, hu-manists could believe in their own era as a "rebirth," or renaissance, from what they considered the darkness of the Middle Ages. PETRARCH and BOC-CACCIO were the preeminent theorists of the Humanism that flourished in Italy, where the rich, urban middle class was acquiring power in both secular and religious realms; the MEDICI family is a prime example. Lorenzo de' Medici was among the great humanists and PA-TRONS of art. Giovanni Pico della Mi-randola (1469–1533) summed up the combined spirit of NEOPLATONISM and Humanism, especially with the publica-tion of his *Oration on the Dignity of*.

Man in 1496. The influence of Humanism on Italian art was greater than on that of the northern countries, where the impact of NOMINALISM was more direct and enduring.

Hunt, Richard Morris

1827–1895 • American • architect • American Renaissance

If they want you to build a house upside down, standing on its chimney, it's up to you to do it and still get the best possible result.

Brother of the painter William Morris HUNT (below), both sons in a prosperous Vermont family, Richard spent more than a decade studying in France and was the first American to receive the architecture diploma from the ÉCOLE DES BEAUX-ARTS. When he returned to the United States to practice architecture, his clients were members of the new American aristocracy of the Gilded Age, and his attitude, according to the comment attributed to him and quoted above, was accommodating. From about 1885 to 1920, American industrialists saw themselves as counterparts of European merchant princes of the 16th and 17th centuries. The Vanderbilts, Morgans, and Fricks wanted public buildings and homes that looked like MEDIEVAL, RENAISSANCE, and BAROQUE palaces, and Hunt was eminently qualified to provide them. Fifth Avenue in New York City had a dozen of his mansions, and he designed "cottages" too, such as Alva Vanderbilt's Marble House (1888–92) in Newport, Rhode Island. The volume of carvings, rare marbles, and other objects imported from Europe for this project was so vast that the Vanderbilts needed their own wharf, warehouse, and 10-ton derrick to get them ashore. The Vanderbilt home in Asheville, North Carolina, Biltmore (1888–95), also by Hunt, is an example of "château" (castle) style. The palace at FONTAINEBLEAU was his primary point of reference. Built of limestone, with 255 rooms, Biltmore has steeply pitched roofs sheathed with slate. As chairman of the Board of Architects, Hunt was in charge of the architectural plans for the 1893 World's Columbian Exposition in Chicago, an extravaganza that was named the Great White City because its plaster buildings resembled the marble ones of antiquity. A minority of architects, with SULLIVAN in the forefront, dissented from the scheme of Hunt and his partisans because it neglected, and rejected, the development of an indigenous architecture.

Hunt, William Holman

1827–1910 • English • painter • Pre-Raphaelite

. . . another subject which I am sanguine about . . . I wonder it has never before been done, it is so full of meaning (one reason however against it) and it is so simple — The scapegoat in the Wilderness by the Dead Sea somewhere, with the mark of the bloody hands on the head.

Throughout his career Hunt remained faithful to the meticulous, hard-edged, hyperreal technique (reminiscent of van EYCK) that characterized the early painting of the PRE-RAPHAELITE "brothers." He also maintained his interest in religious, moralizing themes, albeit with

extremely individualized approaches. His *Awakening Conscience* (1853–54) is about a "fallen" young woman: She rises from the lap of her lover, who is seated at the piano, as from the sudden realization of the error of her ways. The clutter of objects in the picture all have symbolic meaning, from a cat tormenting a bird under the table to a mantel clock that shows high noon just moments away. RUSKIN wrote a letter to *The Times* praising this picture. When Hunt traveled to Palestine he was inspired to paint *The Finding of the Saviour in the Temple* (1854–60). Because the purpose of his work was questionable to them, he had a difficult time convincing Jewish models to pose for him in Jerusalem; he had to find his sitters when he returned to London. The other painting he conceived in the Holy Land was *The Scapegoat* (1854–55), which he wrote about to his friend, PATRON, and business adviser, Thomas Combe, in a letter that is quoted from above. This is a strange scene, with a rainbow arching into the water where the goat stands looking out at the viewer. The source of the picture is Leviticus 16, in which the Day of Atonement ritual is described. After 1860, Hunt remained the only artist of the group faithful to the Pre-Raphaelite ideals, continuing to paint biblical and modern life subjects in his highly wrought style. In Florence with him, in September 1866 his wife gave birth to their child, became ill, and died in December, after they had been married just a year. *Isabella and the Pot of Basil* (1866–68), a picture on which Hunt had been working, became a memorial to her. It was probably inspired by a poem of Keats: Isabella is worshiping at a shrine she has erected in her lover's memory. Hunt returned to England, traveled again to Florence and Jerusalem, and in 1872 married his sister-in-law. The wedding took place in Switzerland because marriage with a deceased wife's sister was then illegal in England.

Hunt, William Morris

1824–1879 • American • painter • Realist

When I look at nature I think of Millet, Corot, and sometimes of Daubigny.

As Hunt's comment, quoted above, suggests, he was strongly affected by painters of the BARBIZON SCHOOL. That followed a period of studying sculpture at the art academy in DÜSSELDORF, where he learned to fix on detail, and of instruction in painting in Paris with COUTURE, who placed strong emphasis on the importance of the rough sketch, or *ébauche*, which remained visible on the canvas despite thick paint and layers of GLAZE. On visiting and working with MILLET, Hunt took up the Barbizon-inspired interest in peasant subjects. His best-known work, *The Belated Kid* (1857), is in the Barbizon mode of painting directly from nature, painting outdoors, rather than in the studio, and giving a rural subject the sense of quiet, religious dignity. This tranquil picture shows a barefoot girl holding a kid while its mother nuzzles it. Returning home in 1855, Hunt introduced French painting to America and became Boston's most prominent artist, teacher, and adviser to collectors. His

students included LA FARGE and both William and Henry James. Things went badly for William Hunt during the 1870s, however. The Boston fire of 1872 destroyed his studio, and he and his wife separated the following year. Five years later his work for the New York State Capitol in Albany was unen-thusiastically received. Depressed, Hunt died by drowning in November 1879. His younger brother was the architect Richard Morris HUNT.

Hyperrealism

A synonym for both Superrealism and PHOTOREALISM. See REALISM[1]

I

icon

Derived from the Greek word for "image," an icon generally is something emblematic or symbolic. Saint LUKE, one of the four evangelists, was popularly supposed to have painted portraits of the Virgin, and images or icons of Christ, the Virgin, and the saints were said to follow from this tradition. These sacred icons were important in BYZANTINE art, where they were censed and venerated. Confessions often were made before them. An icon served as a substitute for the divine presence it represented. With their inexpressive faces and large "all-seeing" eyes, Byzantine icons have stylistic antecedents in paintings like the FAIYUM mummy portraits. Some icons were endowed with miraculous power—a famous example is the 12th-century Byzantine-Russian painting *The Vladimir Madonna*. It is credited with saving the cities of Vladimir and Kazan, and later all of Russia, from invasion. In the Hebrew Bible the use of icons is forbidden by the Second Commandment and Deuteronomy, and icons have been controversial in Christianity: A violent conflict broke out in the 8th century and resulted in widespread iconoclasm—destruction of icons. During the 15th century Byzantine icons were imported to the West, where they were honored and copied by artists, a practice that may have been prompted by contemporary efforts to reunite Orthodox and Roman Christianity. In the 16th century, during the Protestant Reformation and later during the Counter-Reformation (peaking in the 1560–70s), religious images once again came under attack, and iconoclasts destroyed multitudes of works of art. Prior to the Reformation, in 1500, DÜRER painted one of the most controversial self-portraits in history, an icon-like image in which he assumes the persona of Christ.

iconoclasm

See ICON

iconography

The study of the meaning of a visual image rather than its form, based on the assumption that a work of art conveys a message through the signs and symbols it contains. A broad iconographic discussion of HOLBEIN's *French Ambassadors* (1533), for example, names, describes, and identifies the two men portrayed, the room in which they stand, and the objects that surround them. To take the meaning further involves ICONOLOGY. (See also PANOFSKY)

iconology

PANOFSKY is the art historian responsible for the interest in iconology during

the 20th century, and it is he who distinguishes between iconology and ICONOGRAPHY. Although the terms are sometimes used interchangeably, iconology goes beyond iconography, according to Panofsky, and investigates the deeper meaning or "hidden symbolism" in a painting. An iconological study of HOLBEIN's *French Ambassadors* (1533) would, for example, discuss objects on the table, such as the globes and navigational instruments, and associate them with exploration contemporary to the early 16th century, scientific advances of the period, or literary accounts that might be pertinent.

iconostasis

A screen separating the sanctuary from the public or congregational part of the church in BYZANTINE churches. During the 9th and 10th centuries, the rituals of the Orthodox Church became increasingly complex and mysterious. The rituals were hidden from the congregation even more than they had been—the choir screen growing, finally, in the 14th century, to a high, solid wall with three doors leading to the altar area. Its surface was covered with ICONs, thus the name "iconostasis." The Katholikon, in Hosios Loukas, Greece (1011–22), has an example of an iconostasis with painted icons.

Ictinos (Ictinus/Iktinos)

active 5th century BCE • Greek • architect • Classical

Pericles, a careful observer and visitor to artists' workshops, knew where the talent was. He commissioned Ictinus and Callicrates as architects and he could not have chosen more painstaking craftsmen. (Finley Hooper, 1967)

Ictinos was the leading architect of Periclean Athens and most notably of the PARTHENON, on which Callicrates (Kallikrates) collaborated. Ictinos is also believed to have designed the Temple of Apollo at Bassae (c. 430–400 BCE), constructed on a wild, primitive mountain site at the edge of a deep gorge. The historian SCULLY speculates that the unusual placement of a door into the TEMPLE on the side rather than the end of the building may have enabled the cult statue within to have a clear view of sacred Mount Lykaion. One of Scully's students tested his hypothesis by sleeping in the temple on the eve of Apollo's feast day and "was awakened by the sun rising exactly on the summit of Lykaion as seen between the columns," Scully writes. Another of Ictinos's innovations at Bassae was to place parallel Corinthian COLUMNS (not used before) in the interior of the temple. With its foliage capital, the Corinthian column might theoretically symbolize the tree beneath which Apollo was born.

ideal

The concept of a transcendent, archetypal principle that embodies the ideal characterized the worldview of ancient Greece. This may be seen in Greek art as early as the ARCHAIC period, when artists tried to hone a concept of perfection in architectural design and in figural composition, rather than to create functional space or to show true-to-life individuals. The possibility of human

achievement approaching the ideal seemed closest at hand during the High CLASSICAL period in Athens. It may be no coincidence that the decline of Athenian primacy, beginning in 430 BCE, was accompanied by a shift from idealizing to naturalizing and individualizing in Greek art (see NATURALISM). This was well established by the time of PLATO (427–347 BCE), who censured art as imitation—MIMESIS—of that which is already one step removed from the ideal prototype. To Plato, because the artist's production dealt with appearance, "his is the world of illusion, the world of mirrors that deceive the eye," as GOMBRICH writes. Neoplatonists were less acerbic than Plato about art's pretensions, and in subsequent Classical revivals, especially during the ITALIAN RENAISSANCE and the 17th century, both practice and theory restored respect for artistic pursuit of the ideal. (See also NEOPLATONISM and GOLDEN SECTION)

illuminated manuscript

Both "manuscript" (written by hand) and "illumination" (reflecting light) now have broader meaning than their strict definitions. The term "illuminated manuscript" usually refers to books produced from the 5th century, when the CODEX of PARCHMENT replaced the papyrus SCROLL, to the early 16th century, when PAPER and the printing press took over. As early as the 3rd century, luxurious vellum pages were stained with a rich purple dye, and their texts were inscribed in gold and silver, which reflected light (though most MEDIEVAL manuscripts were practical, serviceable books with no gold or silver). Pictorial decorations of illuminated manuscripts, or illustrations, are called MINIATURES. As early as the 5th century, artists worked under instruction from a literate adviser. Medieval manuscripts were produced in the SCRIPTORIUM of a monastery and in royal court WORKSHOPS before they became, along with urban and middle-class growth, part of secular commerce. Even then, exceptionally beautiful books, made for the princely or merchant nobility, remained expensive. In France, where they flourished during the late Middle Ages, the best illuminated manuscripts ranged from 100 to 600 francs, more costly than the most expensive horse. Besides gospels, PSALTERS, BOOKS OF HOURS, and specific liturgical texts, illuminated manuscripts included BESTIARIES and HERBALS.

illusion/illusionistic

See MIMESIS

Imhotep

active c. 2600 BCE • Egyptian • architect • Old Kingdom/3rd Dynasty

The political system of the Egyptian state may have been founded by warrior kings, bearing such significant names as Scorpion, Fighter and Serpent, but Egyptian high culture was the creation of a sage, Imhotep, to whom at the end of its long history a Greek pharaoh kneels in supplication on the walls of the temple of Kom Ombo. (Cyril Aldred, 1980)

Figuratively speaking, Imhotep's reputation is as colossal as his most famous achievement, the Stepped Pyramid of King Zoser at Saqqara, c. 2600 BCE.

This burial mountain set the standard for Egyptian building over the next 2,500 years. It was the first large building in the world made entirely of quarried stone, and Imhotep is the first architect/artist we know of whose name was actually recorded for posterity—it appears on a statue of the king, where Imhotep's titles of Chancellor, Prince, High Priest of Heliopolis, and Sculptor were also recorded. Imhotep's authority was so great that he was deified after his death and became a god of healing, associated in Greek times (when he was called Imuthes) with Aesculapius, god of healing and patron of physicians.

impasto

Paint thickly applied either with a "loaded" brush or with a palette knife. Sometimes impasto is so thick that it stands up from the surface of the picture in lumps. REMBRANDT and TINTORETTO used impasto for emphasis and texture. The impasto on many of van GOGH's paintings defines his brushstrokes.

Impressionism/Impressionist

With urbanization and the growth of the railroad, new recreation centers flourished near Paris, and artists went there to paint. Boating, fishing, swimming, picnicking, and dancing were among the pastimes they recorded, and the spontaneity of those activities is reflected in the apparent spontaneity of their painting. In some ways the origins of the movement are firmly embedded in REALISM[2]: Impressionists, as Realists, rejected the restrictions of traditional subjects (e.g., religious, ideal, imaginary, literary, and historic) in favor of the visible contemporary world. But they intensified the real-time immediacy of their focus, objectivity, and an interest in monitoring and understanding the eye's perceptions. Yet, as recent scholars stress, theirs is also a very personal visual perception; emotional reaction to visual stimuli links Impressionism to ROMANTICISM, it is argued, rather than (or in addition to) Realism. Impressionists modified their techniques to accommodate their intentions: Unmixed color applied with shortened, quickened brushstrokes approximates the flickering impressions they meant to record. Realists had already lightened the PALETTE of the BARBIZON landscape painters; Impressionists maintained the high-key COLOR. Known for working in PLEIN AIR, besides pure landscapes and figures in the landscape, Impressionists painted portraits, nudes, STILL LIFES, and various scenes of modern life. In many respects, as they painted leisure activities of Parisians, they were celebrating the urban projects—parks, racetracks, gardens, widened streets, and picturesque perspectives—promoted by Louis-Napoléon during the SECOND EMPIRE. By 1868, as Impressionist concerns coalesced, interest shifted from the subject presented on the canvas to the means of representation. Japanese art was a strong influence on Impressionist painters. With flat, unmodulated paint surfaces and disregard for one-point PERSPECTIVE, Japanese art introduced radical cropping and empty foregrounds. UKIYO-E prints also presented artists with a new range of colors and sometimes a tilted PICTURE PLANE. Among signature paintings of Impres-

sionism were views of the same waterfront scene, *La Grenouillère,* painted by both RENOIR and MONET in 1869. The painting that gave the style its name was Monet's *Impression, Sunrise* (1872). An alternate label for Impressionism is *New Painting.* When it was exhibited in the first group show of the new-style paintings in 1874, a derisive critic coined the term "Impressionists." The last Impressionist group show was in 1886, by which time the reactionary group of POST-IMPRESSIONISTS had formed.

Indiana, Robert (Robert Clark)
born 1928 • American • painter • Pop Art

Pop is everything art hasn't been for the last two decades. It is basically a U-turn back to a representational visual communication. . . . It is the American Dream, optimistic, generous and naive. . . . Pure Pop culls its techniques from the present-day communicative process.

Clark took the name of his home state to sign his work "Indiana." He was fascinated by word and number images, and generally used them to critique contemporary culture. He did this by writing, with stencil-like lettering, words such as ERR, DIE, HOG, EAT, USA in clashing colors. Nothing is more ironically symbolic of its age than the commercialization of his painting *LOVE* of 1966, with the *L* and *O* on one line, *V* and *E* below. It showed up on rugs, ashtrays, key chains, rings, posters, pillows, and multitudes of other commodities, as well as millions of red, emerald, and violet postage stamps.

Ingres, Jean-Auguste-Dominique
1780–1867 • French • painter • Romantic Classicist

. . . drawing is the first of the virtues for a painter, it is the foundation, it is everything; a thing well drawn is always well enough painted.

Ingres studied in Jaques-Louis DAVID's studio. Then, having won the PRIX DE ROME, he went to Italy in 1806 and remained there for 18 years. Of the two theoretical currents that again divided artists' camps—drawing vs. painting (or LINE VS. COLOR)—Ingres allied himself with the drawing/line camp. That does not mean he was a poor colorist, as anyone looking at the skin and fabric tones of his famous *Odálisque* (1814) quickly realizes. Rather, it means that he was more interested in the contours of a form or figure. Art historians find numerous sources for Ingres's style, including the decorations on ARCHAIC Greek POTTERY. Decorations on such vases were LINEAR in the most basic sense of the term. Ingres told his students, "Study vases, it was with them that I began to understand the Greeks." RAPHAEL, another influence, was the master whom Ingres most admired. While working in a CLASSICAL vocabulary, Ingres was inevitably influenced by the ROMANTIC spirit of his time, a spirit intrigued with the exotic (*odalisque* is the Turkish word for "harem slave girl") and with emotional states. Though he did not express rousing, driving emotion in the manner of his acknowledged rival DELACROIX, Ingres was sensitive to the mood and character of his subject, as his portraits show. Romantic Classicist is the commonly used

term to describe Ingres, in contrast to Delacroix, whose style was Romantic Baroque.

Inkhuk (Institute of Artistic Culture)

Notorious organization in the Soviet Union that, when charged in 1921 with formulating a role for art in a Communist society, condemned easel painting as "outmoded." (See also CONSTRUCTIVISM, RODCHENKO, and TATLIN)

Inness, George

1825–1894 • American • painter • Barbizon influence/impressionistic

I love [the civilized landscape] and think it more worthy of reproduction than that which is savage and untamed. It is more significant. Every act of man, every thing of labor, effort, suffering, want, anxiety, necessity, love, marks itself wherever it has been . . . every thing in nature has something to say to us.

In the beginning of his long career, George Inness painted in the scrupulous, tight, detailed style of the HUDSON RIVER SCHOOL and composed pictures with attention to the classical Claudian conventions (see CLAUDE LORRAIN). Specificity in his early landscapes allowed the viewer to recognize a particular bend in the river, grazing cattle, the settlement in the distance, a roundhouse, and even the lettering on the engine of a train, as in *The Lackawanna Valley* (1855), commissioned by a railroad company. This painting, now canonical, was rediscovered by Inness himself, many years after he had painted it, in a junk shop in Mexico City. He painted the civilized landscape

rather than the wilderness, and his pictures might seem to celebrate industry and progress, yet they also seem to have a certain wistful or nostalgic ambiguity, seen in details such as the figures of small poets contemplating the trees that have been felled, and a covered wagon trundling along in the wake of the locomotive. Or in *Delaware Water Gap* (1861), on the eve of the Civil War, the broken rainbow may be read as a symbol of the imminent break between North and South. His travels in France acquainted Inness with the BARBIZON SCHOOL. Its influence loosened his visual approach and his brushstroke, softening color and contour. Born in New Jersey, Inness was frail, epileptic, reclusive, melancholic, and volatile. In the mid-1860s, he became a follower of the 18th-century mystic Emanuel Swedenborg, and his landscapes seem increasingly to be filtered through the dematerialized spiritual world in which he was immersed. While his scenes of this era, such as *Home at Montclair* (1892), may appear impressionistic in a general sense of the word, he had no tolerance for the movement: "Impressionism is the sloth enwrapped in its own eternal dullness," he wrote. Recognition did not come until Inness reached his 50s. He was a transitional figure whose life was divided by the Civil War and whose work was a bridge between the old and the avant-garde.

installation

Refers to works that are assembled or constructed in the gallery or landscape or other space in which they are exhibited. It is a loose term that may be applied equally to sculptures of MINIMALISTs like Robert MORRIS and HESSE

and the personalized expression of a work by Ann Hamilton (born 1956) such as *Malediction:* In a New York City gallery, in December 1991, Hamilton sat at a long table continuously putting wads of dough in her mouth, taking them out, and placing them in a wicker container. She was surrounded by signs of housekeeping chores—to approach her a visitor stepped over a floor strewn with rags—and for sound and atmospheric effect, a woman's voice monotonously read Walt Whitman's *Song of Myself* and *Body Electric.* Hamilton's *Malediction* was both PERFORMANCE ART and Installation.

intaglio

One of the four basic processes for making a print. From the Latin meaning "to cut," intaglio is a procedure in which the lines of the image that will be reproduced are engraved or etched into the surface of a metal plate such as copper or steel. When lines are cut into the surface with needle-sharp steel points, the process is called drypoint. Drypoint prints are freer than those made by EN-GRAVING, and their lines have softer edges, more like drawing with a pencil or crayon than with a pen. PASCIN worked in drypoint. The quality of a line—thickness or darkness, for example—is determined both by the tools and by the amount of pressure used to make the cuts. Intaglio processes include MEZZOTINT and AQUATINT. To produce a print, the plate is inked, then its surface is wiped clean. Ink remains in the lines of the image that is cut into that plate. Pressure is applied to transfer ink from the plate onto paper. Intaglio printmaking began in the first half of the 15th century. DÜRER is renowned for his work in this demanding, exacting medium.

intensity (also saturation)

One of the three variables that define the quality of a PIGMENT (*value* and *hue* are the other two). The intensity describes the relative purity or visual strength of a pigment. It is a measure of vividness. For example, bright orange has a high intensity (saturation); beige has a low intensity (or saturation). (See also COLOR)

interlace

A style especially characteristic of the MIGRATION period, interlacing describes the process of weaving lines and designs over and under and in and out of each other. Interlacing reached one pinnacle of complexity in HIBERNO SAXON manuscripts, such as the *Lindesfarne Gospels* (c. 698). Interlacing is also intrinsic to ISLAMIC ART in vegetal ARABESQUES—sinuously curving plant forms—and with words and letters. The Ottoman (Turkish) sultan's imperial *tugra*—the equivalent of his signature or coat of arms—combined the two. The *tugra* interwove calligraphy with flowers, trees, scrolls, and leaves, predominantly blue and gold, all flowing together in minutely exquisite splendor.

International Style (modern architecture)

Known in Europe as International Architecture, the term "International Style" was coined by HITCHCOCK and Philip JOHNSON for their 1932 exhibition at the Museum of Modern Art in New York City—*The International Style in Architecture Since 1922.* Developed during the 1920s, especially in

Holland, Germany, Russia, and France, the International Style spread to other countries, including the United States. Promoted at the BAUHAUS, its proponents advocated functionalism, mass production, and the marriage of architectural design and technology without historical references or ornamentation. As did Russian CONSTRUCTIVISM, the International Style espoused the concept of "truth to materials" and a structural system that was neither hidden nor disguised. International Style was also allied to the geometric, rectilinear discipline of De STIJL. Leading International Style architects are MIES VAN DER ROHE, LE CORBUSIER, and GROPIUS and his partner, until 1941, BREUER. Gropius's design for the Bauhaus building in Dessau (1926) embodies ideas of the International Style. The Philadelphia Savings Fund Society Building (1929–32), designed by the American George Howe (1886–1955) in collaboration with the Swiss-born architect William Lescaze (1896–1969), was the first important International Style skyscraper in the United States. The preeminent American practitioner of the International Style for many years was Philip Johnson, who had collaborated with Mies van der Rohe on the Seagram Building (1954–58). Johnson is renowned for The Glass House (1949) he built for himself in New Canaan, Connecticut, perhaps the earliest building designed entirely by an American architect working in the International Style.

International Style (painting, sculpture)
See GOTHIC

Intricate/Fourth Style
See MURAL

Isidorus of Miletus
Codesigner of HAGIA SOPHIA. (See also ANTHEMIUS OF TRALLES)

Islamic art
Islam was born in Arabia in 622 when the prophet Muhammad left his home in Mecca and settled in Medina, where he preached and attracted followers to his new faith. In three generations, Muhammad's religion, which drew on the Judeo-Christian tradition, spread faster and farther than Christianity had in its first 300 years. Unlike the term "Christian art," which refers to religious subject matter, what is known as the art of Islam includes both secular and religious subjects. It is thus perhaps more accurately seen as Arabian, Persian, Egyptian, Turkish, Indian, North African, and Spanish art. In terms of religious subject matter, the Islamic prohibition against figurative, or representational, art in places of worship encouraged a repertoire of incomparably beautiful abstractions, designs, and colors. Some of these were based on the written word. Others were foliate—flower and leaf forms; ornamental ARABESQUES and patterns on textiles, POTTERY, tiles, and other DECORATIVE ARTS; and ILLUMINATED MANUSCRIPTS. (The prohibition against representation, though explicit in both religions, was not strictly followed in either Islamic or JEWISH ART.) As was true of much MEDIEVAL Christian art, early Islamic book illustrations were not designed to present reality; they were flattened and symbolic, showing a land-

scape, for example, as elaborately patterned with trees and flowers rather than invested with PERSPECTIVE. Over the centuries, the impact of the art created in countries where Islam predominated on that produced in predominantly Christian countries, and vice versa, has been substantial. It can be seen in the multitudes of NORTHERN and ITALIAN RENAISSANCE (and several early American COLONIAL) paintings that have Oriental carpets as part of their setting. During the 19th century, a passion for ORIENTALISM, as it is now called, swept Europe and America. This interest in the countries where Islam flourished is seen in paintings of DELACROIX, textile designs of William MORRIS, and even the style of CHURCH's home Olana (c. 1870) in New York state. MATISSE was greatly affected by exhibitions of "Islamic art" in Europe and went to Algeria in 1907. He took his interest further than other Western artists: Where Delacroix, for instance, painted things and events he had seen in Algiers, Matisse showed French domestic scenes, including those of his own family, using an Oriental vocabulary of flattened perspective and forms, rich but unmodulated coloring, and the decorative patterning of Persian MINIATURES.

Israëls, Jozef

1824–1911 • Dutch • painter • Realist

In Amsterdam I saw two pictures by Israëls, The Fisherman of Zandvoort, and—one of his very latest—an old woman huddled together like a bundle of rags near the bedstead in which the corpse of her husband lies. Both pictures are masterpieces, I think. (Vincent van Gogh, 1885)

A Jewish painter whose father was a money changer, Israëls studied in Amsterdam and Paris. He painted in a REALIST[2] vein, showing the harsher aspects of rural life in Holland. A founder of The Hague school, he was the most important Dutch painter of his century, his reputation eclipsed later only by van GOGH, quoted above, who admired him greatly. *Growing Old* (1878), a well-known work, shows a lonely old woman warming herself in front of a fire. Its sentimentality is not characteristic of Israëls's works. The flat Dutch landscape and peasant life were preoccupations of Israëls, but his pictures of Jewish life are now well appreciated after having been largely overlooked. Only four, or perhaps five, of these paintings are known. One, *The Son of the Ancient Race* (1889), shows a weary peddler sitting on a doorstep and is painted in dark brownish tones reminiscent of REMBRANDT. Important in England, France, and America as well as Holland, Israëls had more than 40 works in an individual exhibition at the 1910 VENICE BIENNALE. His funeral in 1911 was the occasion for national mourning in Holland.

Italian Renaissance

c. 1400–c. 1520. Unlike the NORTHERN RENAISSANCE, the Renaissance in Italy was strongly influenced by texts and works of art from ancient Greece and Rome. Not only was the Greco-Roman world part of Italy's heritage, but ANTIQUITY also was accessible, espe-

cially in Rome, where many monuments were still standing and many artifacts awaited discovery. Through the wealth and patronage of the MEDICI family, and largely as a result of the writings of VASARI in the 16th century and BURCKHARDT in the 19th, Florence's reputation as the source and center of Renaissance art gained currency. Today this preeminence is challenged by scholars who point to other important Italian centers—Rome, Pisa, Milan, Mantua, Ferrara, Urbino, and VENICE. Unprecedented REALISM[1], especially in observation of the human form, and a new understanding and use of PERSPECTIVE are developments that characterize the Renaissance. In Florence, GHIBERTI's winning panel in the 1401 competition for the bronze doors for the Cathedral Baptistery, the architecture and theories of BRUNELLESCHI, sculpted figures by DONATELLO, and the paintings of MASACCIO traditionally introduce the period. In the second half of the century, not only did artists like Donatello travel to other cities, but also ALBERTI was working in Mantua, Rimini, and Rome; PIERO della Francesca in Urbino, Ferrara, and Rome; and Giuliano da SANGALLO and BOTTICELLI were also in Rome. LEONARDO was a youth when he moved to Florence, but he spent much of his career elsewhere. That was true too of RAPHAEL, who was, however, a skilled artist when he went to Florence from his home in Urbino. He left for Rome in 1508. MICHELANGELO, who grew up and worked in Florence, spent the last 30 years of his life in Rome. As the Renaissance progressed, the initial interest in realism frequently evolved into highly animated and expressive figures (e.g., POLLAIUOLO and Michelangelo), which in turn became attenuated and exaggerated by MANNERISM. Mastery of perspective led artists to imagine and portray ever more extraordinary and extravagant illusionistic scenes, especially on ceilings (MANTEGNA, Raphael, and CORREGGIO), in turn extended by the Mannerist GIULIO Romano to an entire room. During the course of the Renaissance, perhaps inspired by scholarly HUMANISTS (although art historians disagree on the degree to which they participated in artistic endeavors), artists added themes from pagan mythology as well as portraiture to their repertoire of biblical subjects. Also, the medium of painting changed from primarily TEMPERA to OIL PAINTING.

J

Jack of Diamonds
See LARIONOV

Jacopo della Quercia
c. 1374?–1438 • Italian • sculptor •
Early Renaissance

*On the base of a tomb [for the wife of
the lord of Lucca, Paolo Guinigi,] he
executed some marble putti carrying a
garland in so polished a fashion that
they seemed made of flesh.* (Vasari,
mid-16th century)

Jacopo, who was from SIENA, was one
of the four sculptors whose genius
marked the early ITALIAN RENAISSANCE.
(DONATELLO, GHIBERTI, and NANNI di
Banco were the others.) He was among
the unsuccessful competitors to design
the Baptistery doors in Florence—
the job was won by GHIBERTI. Jacopo's
most important commission was in
Bologna, where from 1425 to 1439 he
completed a number of sculptures for
the main door of San Petronio. His fig-
ures, carved in stone in low RELIEF, are
vigorous and well built, looking for-
ward to the work of MICHELANGELO,
who was much impressed by their dra-
matic intensity and expressiveness. Ja-
copo's *The Expulsion from the Garden
of Eden* (c. 1430) captures the anxious
fear and humiliation of Adam and Eve
as an angry angel virtually pushes them
out of the Garden. The tomb described
by Vasari in the quotation above is one
of the most celebrated sculptures in
Italy. When the hated lord of Lucca was
ousted, the tomb was nearly destroyed,
but according to legend it was so beau-
tiful that even his enemies spared it.

Japonism
Refers to the profound and expansive
influence of Japanese art and artifacts
on Western artists and architects begin-
ning after the mid-19th century. LA
FARGE and WHISTLER are among the
first American artists who incorporated
pictures of objects from Japan in their
paintings, as well as Japanese ideas of
composition and themes. SARGENT's
magnificent painting *The Daughters of
Edward Darley Boit* (1882) includes
two huge blue-and-white Japanese por-
celain vases that are taller than the four
little girls of the title. Ernest Francisco
Fenollosa (1853–1908), the American
expert on Japanese art, was a catalyst
for the collecting of FREER, who was
also inspired and advised in his collect-
ing of Oriental art by Whistler. Freer
bought several of Whistler's paintings
in which the artist used Oriental princi-
ples to express Occidental feeling, in-
cluding *Caprice in Purple and Gold:
The Golden Screen* (1864). In this pic-
ture Whistler's mistress, dressed in a ki-
mono, examines a print by the Japanese
artist HIROSHIGE. Four years later MAN-

ET's portrait of Émile Zola shows the novelist seated near a Japanese screen, a print of a Japanese wrestler on the wall above his head. In Paris and London during those years artists gathered at shops that sold imported Japanese and Chinese art (see CHINOISERIE). Japanese UKIYO-E prints in particular brought into the Western artists' vocabulary ideas of asymmetry, flat rather than MODELED surfaces, the forward-tilting PERSPECTIVE, outlined forms, and unmodulated color. They inspired interest in subjects such as the sybaritic "floating world" of Japanese pleasure seeking. IMPRESSIONISM was particularly indebted to Japonism. (See also HOKUSAI) In 1916 Frank Lloyd WRIGHT completed his commission for the Imperial Hotel in Tokyo, and when he returned home, subtle references to Far Eastern architecture could be detected in his designs.

Javacheff, Christo
See CHRISTO

Jazz Modern/*moderne*
See ART DECO

Jefferson, Thomas
1743–1826 • American • statesman/president/architect • Federal

I received this summer a letter from Messrs. Buchanan and Hay, as Directors of the public buildings, desiring I would have drawn for them, plans of sundry buildings, and, in the first place of a capitol. . . . We took for our model what is called the Maison Quarrée of Nismes, one of the most beautiful, if not the most beautiful and precious morsel of architecture left us by antiquity.

Jefferson was educated at William and Mary College in Virginia, which had, at the time, the most architecturally sophisticated buildings in the colonies —they may have been constructed according to plans provided by WREN. Jefferson's later travels in Europe gave him firsthand knowledge of the NEOCLASSICAL buildings he used as prototypes for his designs. Their appeal was idealistic as well as aesthetic, as they represented to Jefferson the style associated with the first democracy in ancient Greece. The Maison Carrée, to which he refers in the letter quoted above, is a small Roman temple of c. 1–10 CE. Jefferson had only seen pictures of the Maison Carrée when it became his inspiration for the United States Capitol, but when he saw the actual building, some 12 years later, the wisdom of his choice was confirmed. Jefferson's well-known architectural projects include his own house, Monticello (c. 1767–1809), and the plans for the University of Virginia (1817–26) at Charlottesville (where he also designed the curriculum). As president, Jefferson appointed LATROBE surveyor of public buildings.

Jewish art
Although still largely bypassed in art history texts, the existence and significance of Jewish art is gradually being taken into account. In his 1988 assessment "On the State of Medieval Art History," published in *The Art Bulletin*, Herbert Kessler wrote: "And since the unearthing in 1932 of the synagogue at

Dura-Europos, which is widely accepted as a bridge between Roman and medieval art, Jewish art is now seen more as a parallel manifestation within the intricate configuration than as a formative precursor. Drawn from the same pictorial repertoire, Jewish art seems to have stimulated the expansion of Christian imagery as an aspect of rivalry between Judaism and Christianity; in turn, it may have been influenced by Christian art." (DURA-EUROPOS was a town in Syria, founded by the end of the 2nd century BCE; the synagogue dates from c. 245 to 256 CE.) Broader discourse on Jewish art is often complicated by discussions of definition about whether "Jewish" is a cultural, religious, ethnic, or national reference.

John, Gwen
1876–1939 • British • painter • Modern

My religion is my art; for me it is everything in life.

Born in Wales and educated in London with her brother, Augustus John (1878–1961), who is best remembered as a portraitist, Gwen John spent most of her life in France. She was almost unknown during her lifetime, though she did once exhibit jointly with Augustus, and she had work at the ARMORY SHOW. Her brother predicted that she would someday be considered a better artist than he was, and he proved to be correct. Unfortunately, her renown followed her death. Where he was outgoing and flamboyant, she was retiring and shy. For a time she was RODIN's mistress, but in 1913 she converted to Catholicism and moved outside of Paris, where she lived a quiet, reclusive life. Her subjects were mainly women churchgoers, nuns, and children. She simplified the forms of her figures, and presented the women in three-quarter-length, often seated poses (e.g., *Seated Girl Holding a Book,* c. 1922). Her colors are subdued, reminiscent of WHISTLER, from whom she took lessons in Paris. She liked the rapidity and spontaneity of drawing and considered her finished drawings as important as her paintings. Over 1,000 of her drawings and watercolors are in collections around the world.

Johns, Jasper
born 1930 • American • painter • Pop Art

I decided to do only what I meant to do, and not what other people did. When I could observe what others did, I tried to remove that from my work. My work became a constant negation of impulses . . . I had a wish to determine what I was . . . what I wanted to do was to find out what I did that other people didn't, what I was that other people weren't.

In the spring of 1954, when he met RAUSCHENBERG and CAGE, Johns, at 24, became part of the New York art scene. He moved away from ABSTRACT EXPRESSIONISM by, as he comments in the quotation above, doing what others did not. He *did* paint objects—flags, targets, letters, and numbers. He did *not* use oil paint, or even the alternative materials of some of his contemporaries (e.g., the house paint of KLINE); rather, he used the ancient ENCAUSTIC technique, mixing heated wax with pig-

ment. Although his method of painting with encaustic did create a rich, textured surface in a work such as *Three Flags* (1958), his images are not painted for the expressiveness of the surface, as are those of other artists. Instead they are painted as expressions of the object in itself, bringing to mind an idea current at the time, that "the medium is the message." The largest of the *Three Flags* is the full size of the painting; the other, smaller flags are set within it. Rauschenberg and Johns were celebrated as the founders of POP ART, but Johns adamantly refused the label. While his early works have a cool detachment, after the dissolution of his close relationship with Rauschenberg, a strong emotional expressiveness entered Johns's art. He acknowledged that change in 1978: "In my early work I tried to hide my personality, my psychological state, my emotions . . . but eventually it seemed like a losing battle. Finally one must simply drop the reserve." Johns sometimes used words with his paintings and, considering that he was an avid reader of philosophy, it is tempting to connect current ideas of SEMIOTICS with his work.

Johnson, Eastman

1824–1906 • American • painter • Realist/genre

In all his works we find vital expression, sometimes naïve, at others earnest, and invariably characteristic; trained in the technicalities of his art, keen in his observation, and natural in his feeling, we have a genre painter in Eastman Johnson who has elevated and widened its naturalistic scope and its national significance. His pictures are in constant demand, and purchased before they leave the easel. (Henry T. Tuckerman, 1867)

Johnson studied in DÜSSELDORF, The Hague, and Paris, and when he returned home to Washington, D.C., in 1855, he was the best-trained painter in the country. His painting entitled *Negro Life at the South* (also known as *Old Kentucky Home;* 1859) shows the attention to detail and the high surface finish he learned in Düsseldorf. The theme, while reminiscent of Dutch GENRE topics, was freighted with contemporary American concerns on the eve of the Civil War. Set in the yard of a tumbledown African-American house in the District of Columbia, not Kentucky, next door to Johnson's own house, the family portrayed is both stereotyped (banjo player, child dancing) and treated affectionately (a flirting couple, mother and child). At the edge of the painting, a well-dressed white woman, followed by her black maid, is entering the scene. Both pro- and anti-Abolitionists interpreted the painting to serve their own convictions. The historian John Davis makes a strong argument in favor of Johnson's anti-slavery sympathies. A touch of nostalgia and sense of ambiguity lurks in many of Johnson's subsequent works, and also a celebration of uniquely American agrarian pursuits: He painted maple sugaring and cranberry harvesting, and these latter paintings especially show the influence of COUTURE, with whom Johnson had studied in France, in the brushstroke and attention to the dignity of the working class. Johnson's popularity is described above in the words of Tuckerman, an important writer on

American art and a contemporary of Johnson.

Johnson, Philip
born 1906 • American • architect • Modern/Postmodern

People think of me as a chameleon. . . . It's true.

The outstanding American practitioner of the INTERNATIONAL STYLE, Johnson was associated with MIES VAN DER ROHE on the Seagram Building. He was the first head of the architecture department of the Museum of Modern Art, where in 1932, with the museum's director BARR and architectural historian HITCHCOCK, he organized the major exhibition *The International Style: Architecture since 1922.* In 1949 Johnson designed the Glass House, in New Canaan, Connecticut, which is usually cited as his major work. During his long career he has tried various approaches—as his comment quoted above concedes—including POSTMODERNISM. That is seen in the AT&T Building (1979–84; now the Sony Building), a New York City skyscraper with a keyhole opening where the pitched roof should peak. While commonly described as a "Chippendale" detail, after a style of furniture, Johnson's actual source of inspiration was BOULLÉE. The critic Brendan Gill encapsulated Johnson's long and controversial career and personality with the words "defiant cheekiness."

Johnson, William
1901–1970 • American • painter • Modern/Expressionist

I must say to you that you shall demand a higher price for my paintings for I am no ordinary American Negro painter. I am recognized by known Americans and Europeans as a painter of value so I must demand respect.

A poor African-American from South Carolina determined to study art, Johnson moved to New York City in 1918 and worked as a stevedore. He endured great hardship to earn money enough to help feed the family, but in three years had saved enough to study at the National Academy of Design. His teachers, who later included LUKS, encouraged and supported him and helped him go to Paris in 1926. Despite his bold declarations, such as the one quoted above from a letter to Mary Beattie Brady, recognition eluded Johnson. Brady worked for the Harmon Foundation, which was established in the 1920s to provide Negro Achievement Awards. In 1930 Johnson had won the Harmon gold medal and the $400 first prize. But it was later, when he began, as he says, "to give, in simple and stark form the story of the Negro as he has existed," that Johnson's method developed: simplified, without spatial accuracy, but with bright, expressive color in an emotional, stylized "folk" approach that was influenced both by PIPPIN and Jacob LAWRENCE. He painted street musicians, bicyclists, baptisms, churchgoers—the ordinary life of black Americans—with sympathy and humor. *Going to Church* (1940–41) is such a picture, and in addition to the GENRE theme, is a sophisticated composition of bold forms and strong colors.

Johnston, Henrietta
?–1728 • American • painter • Colonial

... on April 11, 1705 were married Gideon Johnston and Henrietta Deering. (records of Saint Andrews Church, Dublin, Ireland)

Johnston was America's first well-recognized female portraitist. She was born in either England or Ireland, and when she and her husband moved to Charleston, South Carolina, in 1708, she brought her supply of PASTELS with her. The church record quoted above secures the date of her marriage to Johnston, a clergyman who already had two children. Very little more is known about her life. Charles Town, as it was then called, was reputedly the most exciting and bustling southern metropolis of the pre-Revolutionary era. Its population was around 12,000 and whether it was a sophisticated city, as some insisted, or a primitive village with muddy lanes and mosquitoes, as others said, is debatable. After Reverend Johnston came down with malaria, a mosquito-borne disease, his wife was able to supplement his income, if not support her family, by making portraits of notable local people. To the best of our knowledge she worked uniquely in pastels, and the pictures she did of her doctor's family may well have been in payment for services rendered.

Johnston, Joshua
active c. 1789–1824 • American • painter • Colonial

As a self taught genius, deriving from nature and industry his knowledge of the Art; and having experienced many insuperable obstacles in the pursuit of his studies, it is highly gratifying to him to make assurances of his ability to execute all commands, with an effect and in a style, which must give satisfaction.

He was the first artist of African ancestry to gain public recognition in the United States, but information about Johnston's early life is sparse. He may have been the slave of a portraitist from the West Indies, but as a free man, his professional credentials are established by his being listed in the Baltimore directories as a portrait painter or a LIMNER between 1796 and 1824. While most of his commissions came from wealthy, white, slaveholding families, *Portrait of a Cleric* (c. 1805) is of an African-American. Johnston's style is typical of the COLONIAL approach to portraiture: stiff figures arranged in a line across the front of the PICTURE PLANE, with great attention paid to such details as lace collars and coat buttons. In *The Westwood Children* (c. 1807), the three boys are joined by a small black dog in profile that proudly carries a large bird in its mouth. They all have heads slightly too large for their bodies, including the dog. The words quoted above are from Johnston's first advertisement in the *Baltimore Intelligencer,* December 19, 1798.

Jones, Inigo
1573–1652 • English • architect/stage designer/painter • Baroque

I find no pleasure other than learning.

Jones worked on stage designs for Ben Jonson, probably knew Shakespeare,

and was a friend of, as well as architect for, King Charles I—his title was Surveyor of the King's Works. He traveled to Italy in 1613 and was inspired by CLASSICAL buildings and by PALLADIO's treatise on architecture. The Banqueting House (1619–22) for the royal palace of Whitehall in London is his masterpiece: The two-story stone facade is harmonious, symmetrical, and elegant. Seven windows on the top floor match seven on the bottom, and each is bracketed either by engaged (i.e., nonstructural, attached) COLUMNS or by pilasters (which have the appearance of flattened columns). Alternate windows on the first floor are surmounted by curved or triangular pediments that call Palladio to mind. While the windows on the second story have no pediments, there is a delicate stone garland just below the roofline. Inside is one long room, with ceiling paintings by RUBENS that were installed in 1635. These show a series of royal triumphs culminating with the king's exalted rise heavenward. Charles admired the ceiling so much that he moved entertainment to another building rather than chance that smoke from lighting fixtures might ruin it.

Jongkind, Johan Barthold
1819–1891 • Dutch • painter/printmaker • Naturalist

His painting was too new and too artistic in tone to be rightly appreciated in 1862. Also, no one knew less than he how to show one's qualities. He was a good man, very simple, speaking very bad French, and very shy. . . . He asked to see my sketches, invited me to go to work with him, explained to me the how and why of his manner and completed the teachings I had received from Boudin. From this moment on, he was my true master, and it is to him that I owe the final education of my eye. (Claude Monet, 1900)

The fame of the painter who spoke the words quoted above far outshone that of the man he wrote about so appreciatively. Jongkind left home for Paris in 1846 and studied with both a marine painter (Eugène Isabey) and a figure painter (François Picot). His first commercial success was a series of ETCHINGS, *Six Views of Holland* (1862). He, BOUDIN, and MONET became painting companions in the 1860s. Jongkind's luminous and fluidly painted harbor views, especially in Normandy, impressed both younger men, and Monet also commented that Jongkind was "the only good painter of marines that we have." His work was pre-IMPRESSIONISM and, as is that of BOUDIN, is often described as NATURALISM.

Jordaens, Jacob
1593–1678 • Flemish • painter • Baroque

The degree to which Jordaens was truly censorious in delivering his moral message . . . is unclear; like other great moralists before and after him, such as Jan Steen, he comically conscripted vice in defense of virtue. (Peter C. Sutton, 1993)

At the age of 14, Jordaens became an apprentice to the painter Adam van Noort, with whom RUBENS had also studied. (Jordaens later married his

teacher's daughter.) He also worked in Rubens's studio as a collaborator. With Rubens and van DYCK, Jordaens was one of the three most renowned Flemish painters of the 17th century. In contrast to theirs, his PATRONS were mostly the Flemish bourgeoisie and clergy rather than members of the court. He painted portraits with the high quality and strong color and lighting that also characterized Rubens's painting. Jordaens's *Portrait of a Young Married Couple* (c. 1621–22) was attributed to Rubens before stylistic analysis of particulars such as a rougher, more vigorous brushwork, florid skin tones, and other distinctive touches secured Jordaens's authorship. He painted biblical and mythological HISTORY PAINTINGS and, most marvelously, a series of illustrations of a popular saying, "As the old ones sing, so peep [sing] the young." These bore the message that the older generation should set a good example—but didn't. However, the boisterous scenes with which he conveyed the message seem more humorous and bawdy than cautionary, as the comment by Sutton, quoted above, acknowledges. The aphorism about setting an example was among those in the EMBLEM BOOK of the Calvinist poet Jacob Cats. After Rubens died, Jordaens succeeded him as the leading master of the Antwerp School, and once relations between the Northern or United Provinces and the Flemish or Southern Netherlands had been restored with the Peace of Münster in 1648, he was commissioned to paint an apotheosis, or allegorical deification —*The Triumph of Prince Frederick Henry* (1649–52)—in a house near the Hague. Jordaens tried to but could not surpass Rubens's earlier, epic apotheoses. Jordaens was raised a Catholic (he had a sister who was a nun and a brother who was a priest), and although he painted numerous ALTARPIECES for Catholic churches, toward the end of his life he became a fervent Protestant.

Judaica

Usually refers to ritual objects, like the menorah, but includes books and ephemera of all kinds.

Judd, Donald

1928–1994 • American • sculptor • Minimalist

Three dimensions are real space. That gets rid of the problem of illusionism and of literal space, space in and around marks and colors—which is riddance of one of the salient and most objectionable relics of European art. . . . The use of three dimensions makes it possible to use all sorts of materials and colors. Most of the work involves new materials, either recent inventions or things not used before in art.

Judd's simple, boxlike forms, first exhibited in 1963, helped launch the MINIMALIST movement. He had studied painting at the Art Students League in New York City and philosophy and art history at Columbia University. His Minimalist goal was to rationally order shape, volume, color, light, and material with no illusionistic, symbolic, or realistic references at all. Thus his works were not only untitled, but to avoid them being seen in a historic sequence, they were also unnumbered. Among his best-known sculptures is a stack of shiny, stainless-steel, shelflike units, each one precisely measured at $9\frac{1}{16} \times$

$40\frac{1}{16} \times 31\frac{5}{16}$ inches — *Untitled* (1967). At his death, Judd was working on designs for a fountain in Winterthur, Switzerland, and a facade for a railway station in Basel.

Jugendstil
See ART NOUVEAU

Julius II
See MICHELANGELO and BRAMANTE

Junk art (Found art)
Although DADA artist SCHWITTERS and others had incorporated discarded objects, the Junk art of the 1950s and later, which often included the work of RAUSCHENBERG, had as its more particular goal the intention of breaking the barrier between everyday objects and so-called HIGH ART. In 1955 the sculptor Richard Stankiewicz (1922–1983) said that using junk was, for a New York City artist, equivalent to a South Sea Islander using shells. For him and for other sculptors who used junk (e.g., Mark di Suvero, born 1933, and John Chamberlain, born 1927), the materials they employed were appropriate to the industrial world: crushed automobile bodies, girders, and miscellaneous parts of machinery, for example.

K

Kahlo, Frida

1907–1954 • Mexican • painter •
Surreal/Folk/Feminist

*I paint my own reality. The only thing
I know is that I paint because I need
to, and I paint always whatever passes
through my head, without any other
consideration.*

Kahlo associated herself with the pre-
Columbian and revolutionary history
of her country. Ignoring her 1907 birth
certificate, she listed her birth year as
1910, the year of Mexico's rebellion
against dictatorship. As a child she had
polio, and was left with one weak leg.
At 18 she was in a bus and trolley colli-
sion that broke, twisted, and crushed
her entire body, and as a result,
throughout the course of her life she en-
dured more than 30 operations. When
she died, at age 47, Kahlo left more than
200 works, mostly self-portraits in na-
tive Mexican dress in the FOLK ART tra-
dition. Her paint is flat, she used little
MODELING, her figures are forward fac-
ing (FRONTAL), without expression, and
stare straight ahead. At times she
adapted the small, Mexican EX VOTO
painting on tin, popular since Colonial
times, as her medium. One of her most
powerful and puzzling works, *The Two
Fridas* (1939), shows her dual Euro-
pean (Jewish) and native Mexican her-
itage. In this double self-portrait, she
sits on a bench in almost identical
poses, but one figure wears a prim
white Victorian dress and the other a
peasant costume the colors of earth,
sky, and sun. Most unsettling and sym-
bolic, the women's hearts are painted
outside their clothing, attached by an
artery that starts in a small picture
of RIVERA, Kahlo's husband, held by
the self in native costume, and ends in
the hand of the other. The artery is
stanched with surgical scissors. She and
Rivera were divorcing at the time the
picture was painted, though they later
remarried. Their relationship was diffi-
cult and complex throughout their as-
sociation, and while Rivera's fame and
support of her work allowed her entrée
into the art world, she lived in his
shadow despite her own stunning origi-
nality. European artists claimed Kahlo
as a SURREALIST and showed her work
in Paris. As in the quotation above,
however, she protested that she painted
her own reality, not dreams. Her work
is rich not only with cultural national-
ism but also with her personal experi-
ence and pain, both emotional and
physical. In several self-portraits, an
image of Rivera's face is painted on her
forehead. *The Broken Column* (1944)

refers to her injury: Body pierced by nails, her spine replaced with a multiply fractured column, her torso is strapped into a white brace. Kahlo also painted previously unexplored subjects of menstruation, abortion, miscarriage, and sexual rejection with forthright candor, long in advance of FEMINIST art. Kahlo and Rivera were political radicals inspired by Communism; she had an affair with Leon Trotsky during his stay in Mexico. Kahlo's standing and reputation began to grow in the 1970s along with the feminist movement, and her extraordinary innovations and contributions continue to build her expanding reputation.

Kahn, Louis I.

1901–1974 • American • architect • Modern

Form is what. Design is how.

International recognition came to Kahn rather late in life, celebrating his museum designs, the most innovative of which is the Kimbell Art Museum in Fort Worth, Texas (1967–72). Kahn spoke of what a building "wanted to be," that is, the form that was appropriate for the building's purpose; for example, as he said, "a school is an environment of spaces in which it is good to learn." His projects began as abstract, philosophical concepts from which the building emerged. In the case of the Kimbell, five long parallel galleries look very much like Roman barrel vaults (see ARCH). Kahn also said, "My mind is full of Roman greatness and the vault so etched itself in my mind that . . . it's always ready." The vaults have skylights to illuminate the galleries with natural light. Kahn had many students and other disciples for whom his comment, quoted above, was a kind of mantra.

Kahnweiler, Daniel Henry

1884–1976 • German/French • art dealer

This new language [of Cubism] has given painting an unprecedented freedom. It is no longer bound to the more or less verisimilar optic image which describes the object from a single viewpoint.

Best known as a series of overlapping, tilted planes of geometric shapes in delicate browns, grays, pink beiges, and cream colors, Kahnweiler was the subject of one of PICASSO's most renowned examples of Analytic CUBISM, a portrait painted in 1910. Born in Germany, Kahnweiler moved to France in 1907, opened a small art gallery, and became Picasso's exclusive dealer—until the beginning of World War I, when his possessions were confiscated by the French government. (He became a French citizen in 1937.) Kahnweiler supported FAUVES and CUBISTs in his gallery in Paris, was also friend and biographer of GRIS, and wrote an autobiography, *My Galleries and Painters* (1971), as well as *The Rise of Cubism* (1949), quoted from above.

Kalf, Willem

1619–1693 • Dutch • painter • Baroque

One must see this picture [by Kalf] in order to understand in what sense art is superior to nature and what the

*spirit of man imparts to objects.
For me, at least, there is no question
that should I have the choice of a
golden vessel or the picture, I
would choose the picture.* (Goethe,
1797)

The Netherlands was the first European society to experience wealth far beyond its needs and dreams. From 1608, when it broke from Spanish rule, until the late 1660s, when it was surpassed by rival powers (especially Britain), the Netherlands was the richest nation the Western world had ever known. This was the "Golden Age" of STILL LIFE painting, and the period of Kalf's life. He developed a new and unique type of *pronkstilleven* or banquet still life: the arrangement of extremely expensive, lavishly wrought and decorated silver, porcelain, and glass objects with a few pieces of fruit. This differed from most still lifes with fruit in that it was the objects, rather than the edibles, on which he lavished attention. And these objects were masterpieces of their kind: exquisite silver serving pieces, rare painted Chinese porcelain, the finest Oriental rugs, superb Venetian glassware. As the historian Svetlana Alpers writes, "Kalf seems to have been competing with other human craftsmen rather than with nature. His works make the claim that he could paint with his craft a finer silver plate or glass goblet than the silversmith or glass blower could make. . . . Such a painter lays claim to being supreme among human craftsmen. And he paints his pictures for wealthy Dutch merchants who are buying expensive illusions of expensive possessions." It is clear from the quotation above that in GOETHE's eyes, Kalf

was the winner of the competition between painter and craftsman.

Kamares ware
See POTTERY

Kandinsky, Wassily (Vassili)
1866–1944 • Russian/German/French • painter • Expressionist/Der Blaue Reiter

Painting is the vast, thunderous clash of many worlds, destined, through a mighty struggle, to erupt into a totally new world, which is creation. And the birth of a creation is much akin to that of the Cosmos. There is the same vast and cataclysmic quality belonging to that mighty symphony—the Music of the Spheres.

Kandinsky's paintings are highly charged with color and feeling. They are entirely NONOBJECTIVE; the discovery that he needed no identifiable object but only bright color patches was nearly an epiphany to him. In 1896 he left a career of teaching law in Russia to study painting in Munich. In Germany he immersed himself in avant-garde movements, including ART NOUVEAU and the Berlin Sezession (see SECESSION). In 1909, rebelling against the Munich Sezession, he formed the NEUE KÜNSTLER VEREINIGUNG (NKV). Two years later, with MÜNTER and MARC, Kandinsky left the NKV (which had rejected one of his works), and with them founded Der BLAUE REITER, a group that was named after Kandinsky's own illustration for the cover of their publication. He was spokesman for Der Blaue Reiter and the author of an influential book, *On the Spiritual in Art* (1912). Kandinsky's writings are as

exuberant as his paintings. His aim was to remove from his art all traces of the physical world, and to express his spirituality. He was influenced by Theosophy, a popular mysticism that anticipates the end of the material world, leaving behind "essence" peopled by elect souls who communicate in abstract and ideal "thought forms." Kandinsky's art is well described by his comment quoted above. *Sketch I for Composition VII* (1913), for example, has "thunderous clashes," "eruption," a "cosmic" and "cataclysmic" quality in vibrant streaks of reds, golds, and blues that burst and collide. Kandinsky felt great affinity for music, the most immaterial and ethereal of the arts. Kandinsky left Germany during World War I, returned to Russia, then returned to Germany. He exhibited and was important to art and artists of both countries. In 1922 he began teaching at the BAUHAUS and had a close working association with KLEE. He became a German citizen in the late 1920s, then left Germany for France in 1933, the year Hitler became chancellor and assumed dictatorial powers, and the Bauhaus closed. Kandinsky was among artists whose work was shown in the Nazis' exhibition of DEGENERATE ART in Munich in 1937, the year he became a French citizen.

Kant, Immanuel
1724–1804 • German • philosopher

The beautiful is that which apart from concepts is represented as the object of a universal satisfaction.

Very little of Kant's writings was directly concerned with works of art, but his ideas have had great influence on the ways in which historians, theoreticians, and critics think about art. The intellectual challenge of Kant's time, in the wake of the ENLIGHTENMENT, was a resolution of the dichotomy between rationalism and empiricism. To meet the challenge, Kant developed theories about the fundamental structure of the human mind and its operation. His conclusion is that the world we know does not exist outside of our mind's ability to know it (though our mind can never know itself). The laws of nature observed by the intellect are, in fact, laws that reflect the mind's own unconscious organization. Similarly, the source of our perception of beauty is in our minds (the "eye of the beholder"). Kant systematically connected beauty with pleasure in his formulation of a theory of AESTHETICS. He also distinguished the philosophy of art from other philosophies and insisted that it be judged by its own standards. His ideas led to AESTHETICISM and a FORMALIST critique of art, such as that practiced by FRY.

Kaprow, Allan
born 1927 • American • performance • Happenings

But what do we do now?

In 1958, faced with what he understood to be the preemptive effect of Jackson POLLOCK on art, Kaprow asked the question above: "What do we do now?" Pollock had so challenged art that later artists, seeking to make their original mark, often felt compelled to move out of the painting tradition entirely. In struggling to overcome or surpass Pollock, Kaprow copied one of Pollock's methods and made it his means: Where Pollock used his whole

body and gestures in painting canvas, Kaprow got rid of the canvas, the paint, and the permanence of art. His body itself, and those of other participants, became his artistic medium. Part theater, part improvisation, part CONCEPTUAL ART before that became a distinct definition, events were staged by Kaprow as a one-time-only affair, a HAPPENING. Happenings such as *Words* (1962), in which participants added phrases to what had been written, exist only in photographs or verbal descriptions. In *Environment* (1960), a multitude of old tires were strewn on the gallery floor, and for those stepping through the tires it was like being inside a Pollock painting, not just mentally but also physically. These Happenings were much like the throwaway culture of America, but paradoxically, they were also like religious rituals throughout history, from pagan sacrifice to Native American sand painting, that end or are destroyed once they serve their purpose. Kaprow had studied with HOFMANN and was painting in an ABSTRACT EXPRESSIONIST style when he began to take courses with the musician CAGE, a pioneer of Happenings.

Katz, Alex
born 1927 • American • painter • New Realist

I'd like to have style take the place of content, or the style be the content. . . . I prefer it to be emptied of meaning, emptied of content.

Katz adapted the flat paint and advertisement style of POP ART to paintings of people in his personal world, especially his wife, Ada, who is often seen wearing black. A shallowness in both the spatial and emotional sense characterizes the everyday scenes he paints. Yet, almost in the vein of HOPPER, his people seem doomed to isolation, whether they know it or not. *Supper* (1974), for example, is set in the painter's dining room, or kitchen, and he seems to have just stepped away—his vacant place at the table is obvious—to record the scene. Although it is clearly a casual gathering of good friends, several devices disconnect them from each other: a different kind of empty glass at each person's place mat, lack of eye contact, the distinct void around each figure. This is a commentary as much on the pretensions of intimacy as on the sterility of late-20th-century social intercourse.

Kauffman, Angelica (also Kauffmann/Kaufmann)
1741–1807 • Swiss • painter • Neoclassicist

Her heroines are herself. (John Henri Fuseli, 18th century)

Born in Switzerland, Kauffman spent her early years in Italy, where she studied and copied the old masters. In 1766 she went to England and lived there for 16 years. Despite women's difficulty in enjoying full-fledged participation in the art world, Kauffman was able to work successfully in London along with REYNOLDS and WEST, and was one of two women among founding members of the Royal Academy in 1768. (The other woman, also Swiss, is Mary Moser, 1744–1819). In a portrait of Royal Academy members painted by Johan Zoffany c. 1772, Kauffman's (and Moser's) likeness appears as a picture on the wall, rather than among

other members. Because the painting includes a nude male model, it was considered indecorous for females actually to be present. To the historian Griselda POLLOCK, this event signals the moment that the distinction "woman artist" was made. That is, men were artists, defining the term, while Kauffman and other females were differentiated from the profession by the modifying term: "women" artists. Kauffman's commissions were mainly for portraits of wealthy PATRONS, decorative paintings, and she designed numerous PRINTS for the contemporary market, often after her own paintings. But she also wanted to do HISTORY PAINTING, epic scenes, often with biblical or mythological themes, as these ranked highest on the hierarchical, ACADEMIC scale of importance. Her *Zeuxis Selecting Models for His Picture of Helen of Troy* (c. 1765), illustrating the legendary anecdote from the life of ZEUXIS, is one such work. History Paintings required knowledge of both important subjects and techniques (e.g., anatomy and PERSPECTIVE) that women were not ordinarily trained in. Moreover, History Paintings were usually painted on large canvases, also outside the "feminine" realm. Kauffman was highly accomplished, and when her scenes included women, she often, as FUSELI remarks in the quotation above, painted her own portrait as one of the historic figures. She does so most forthrightly in *The Artist in the Character of Design Listening to the Inspiration of Poetry* (1782). Here we see her persona absorbed into that of the Muse, a clear sign of how strong her identification with her profession was, despite the academy's formal differentiation.

Kelly, Ellsworth
born 1923 • American • painter • Post-Painterly Abstraction

. . . a shape can stand alone.

Kelly's work is called HARD EDGE PAINTING because of the clean, sharp contours of the forms he painted. The shapes have both straight and curving silhouettes, and they are in colors as strong, clean, and pure as their edges. These have a powerful effect on the eye—and the mind—which is compelled to see them as distinct, shapes that stand alone, as Kelly says above, and yet cannot resist the appeal of the colors both in themselves and in relation to one another (e.g., *Blue, Red, Green,* 1962–63). Unlike that of gestural ABSTRACT EXPRESSIONISTS, the brushwork or motion of coloring on Kelly's canvases leaves no trace; there is thus no record on their surfaces of the act of their creation.

Kelly, Mary
born 1941 • American • mixed media • Feminist/Conceptual

(age 3.8) C IS FOR CAKE. This is the only letter he doesn't describe. He writes it backwards.

In protest against conventional representations of women, and even against some FEMINISTS' expropriation of those images for their own purpose (see CHICAGO), Kelly rejected any direct representations of women in her work. Instead she uses text and images to indirectly argue, expose, and explore the issues, especially of sexuality, that interest her. In 1979 she exhibited the first part of her 165-part *Post-Partum Document,* which she had begun in

1973. The subject is her son's early life and her relationship with him. The work is steeped in psychoanalytic theory and the ideas of FOUCAULT, especially his argument that sexuality is determined by social and institutional discourse. The quotation above is a detail of *Documentation VI* from *Post-Partum Document*. The carefully printed words on black board are surmounted by what look like a child's efforts to write in white chalk. Discussion of *C* goes on with fanciful associations—"C IS FOR ALLIGATORS CATCHING COLDS. C IS FOR A COW PUSHING A CART FULL OF CUPS PAST A CAT WITH A CAMEL ON A CHAIN." And in typescript below Kelly writes about looking for a nursery for her son. Her work is central to the study of Feminist art.

Kelmscott Press
See William MORRIS

Kensett, John Frederick
1816–1872 • American • painter • Hudson River School/Luminist

. . . from the simplicity of indigence and ignorance to the simplicity of strength and knowledge.

In contrast to the crowded harbors of LANE and the nearly flat vistas of HEADE, Kensett's quiet coastal scenes include large, looming masses, sometimes rock and sometimes hills. He was much more low-key than other LUMINISTS, with a subtly poetic vision, a restrained range of color, and relatively few elements in his composition. *Lake George* (1869), a late work, is not an accurate picture of the scene—he left out some small islands—rather, it presents landscape as a state of mind. The scene is divided into rocks and vegetation in the foreground, the still waters of the lake in the middle ground with two small islands eccentrically placed at the left, and majestic hills in the background. The hills enclose the water while defining the sky, which, heavy with clouds, occupies almost half of the picture. The historian Wayne Craven describes Kensett's paintings as "landscape of essences." The quotation above, from Kensett's journal, explains what he hoped to accomplish when he left to study in Europe in 1840. He stayed for seven years and, it cannot be doubted, fully achieved his goal.

Kiefer, Anselm
born 1945 • German • painter • Neo-Expressionist

. . . in order to understand the madness.

Born in the final weeks of World War II, Kiefer has seemed to put images of the destruction wrought by that war, along with the entire history and mythology of German antagonisms, into his art. For *March Heath* (1984) he used oil, ACRYLIC, and shellac on burlap, browns and black that intimate barrenness and desolation. In 1990 he constructed *Breaking of the Vessels,* a bookcase with three steel shelves on which sit 15,000 pounds of "books" with lead pages. The floor is covered with shards of glass. His reference is to a mystic Jewish text, the *Zohar,* and its ritual symbolism. The shattered glass alludes to both the broken dome of heaven and to Kristallnacht, the November night in 1938 when rampaging Nazis all over Germany smashed the glass of Jewish-owned businesses. The thread of mor-

bidity and German ROMANTICISM that historians identify in Kiefer, and, in fact, in the great majority of German artists, may or may not be present. Certainly he appears to have a long-term obsession with Fascism: At the age of 24 he compiled a book of photographs of himself giving the Nazi salute, "Heil Hitler!" in front of monuments in Italy and France. Was it to understand the elation of conquest? An expression of guilt by association? As with most contemporary art, Kiefer's is ambiguous. He is generally labeled NEO-EXPRESSIONIST, yet his work seems less emotional than intellectual. Whether it awakens notions of social responsibility is also difficult to determine, though such an idea has support in that BEUYS was his teacher.

Kienholz, Edward
1927–1994 • American • sculptor • Found objects

All of my work has to do with living and dying, and fears of death.

After his funeral in 1994, Kienholz was buried in his beloved 1940 Packard coupe. In the backseat was a box containing the ashes of a favorite dog, and in the glove compartment, a bottle of 1931 vintage Italian wine. Embalmed, he wore black pants, a checked shirt, and a turquoise bracelet, and in his pocket was a deck of cards and a dollar bill. The tape deck played Glenn Miller's "In the Mood" and other tunes to which he had been dancing the night before he died. The scene was as bizarre as the ASSEMBLAGES or tableaux he usually constructed from found objects: strange, disturbing scenes from a Las Vegas brothel, the operating table in a

hospital room, or a Victorian room in which an old lady waits to die. *Back Seat Dodge '38* (1964), in which a couple appear to be copulating, angered Los Angeles city officials, who denounced the work as pornographic. Mild by later standards, it, along with all of his other work, has an essentially moralistic core.

Kinetic art
From the Greek *kinetos* for "moving," the term is used to describe machine-driven works (e.g., TINGUELY's *Homage to New York,* 1960), as well as those driven by air currents (e.g., CALDER's MOBILES). Paintings that use optical techniques to give the illusion of movement (OP ART) are sometimes also considered a branch of Kinetic art (e.g., works by RILEY). In the 1890s, a "kinetoscope" was invented to project the sequences of time-lapse photographs taken by MUYBRIDGE to study motion.

Kirchner, Ernst Ludwig
1880–1938 • German • painter/printmaker • Expressionist

With a profound belief in growth, a belief in a new generation of creators and appreciators, we summon the younger generation—and as the youth which carries within it the future, we wish to provide ourselves with a sphere of activity opposed to the entrenched and established tendencies. Everyone belongs to us who portrays his creative impulses honestly and directly.

An architecture student in Dresden, Kirchner was one of the founders of Die BRÜCKE. Although many influences of the period can be seen in his work, espe-

cially CUBIST volume and FAUVE color, it is German EXPRESSIONISM, and the sharp, jagged lines associated with ME-DIEVAL German woodcuts (see WOOD-BLOCK), that is most strongly felt. Kirchner not only made woodcuts, but he also carved and painted wood sculptures. He is best known, however, for his paintings of upper-class men and women, bedecked in furs and top hats, who exude wickedness and an aura of transgressive sexuality. In *Dodo and Her Brother* (1908–20), for example, a combination of crass and acrid colors, roughly applied, shows Dodo holding her pink fan, in a black-gloved arm, over her pubic area. Her brother flashes a demonic grin, and the picture reeks with intimations of incest. As emotionally troubled as his paintings suggest, Kirchner suffered long crises of depression and illness that ended with his suicide in 1938.

Kitaj, R. B.

born 1932 • American • painter • Modern/Figurative

Some books have pictures, and some pictures have books.

Kitaj has lived as an expatriate in London since 1959. Supported by the GI Bill, he studied at the Royal College of Art and, in 1976, introduced the term "School of London" to designate his interest in FIGURATIVE art and that of his colleagues—including BACON, FREUD, Frank Auerbach (born 1931), Leon Kossoff (born 1924), and Michael Andrews (1928–1995). Though all paint the human form, their individual styles are entirely different. Kitaj uses hard, sometimes sketchy outlines, often with hard colors that affect a tense presenta-

tion. "Kitaj draws better than almost anyone else alive," HUGHES has written. Kitaj also relies on literary or textual references, to which his quotation above alludes. *If Not, Not* (1975–76), for example, is a meditation on T. S. Eliot's poem *The Waste Land*. The Holocaust began to haunt many of his pictures in the form of death camp chimneys and guardhouse gates. Other Jewish themes include *The Wedding* (1989–93), based on his own religious ceremony, of 1983, at which HOCKNEY was best man. For the painting, his wife modeled herself after REMBRANDT's *Jewish Bride:* Kitaj was always controversial, and when a retrospective of his work was savagely reviewed in London during 1994, the lacerating attack was analyzed on both sides of the Atlantic, and there were accusations of anti-Semitism and chauvinism. His wife died the same year, and during an interview in 1997, Kitaj told a reporter of his conviction that the criticism in 1994 of his work precipitated his wife's death.

Klee, Paul

1879–1940 • Swiss/German • painter • Expressionist/Abstract fantasy

Art does not reproduce the visible; rather, it makes visible. A tendency toward the abstract is inherent in linear expression: graphic imagery being confined to outlines has a fairy-like quality and at the same time can achieve great precision. The purer the graphic work—that is, the more the formal elements underlying linear expression are emphasized—the less adequate it is for the realistic representation of visible things.

Klee proves to be among the most difficult of MODERN artists to describe, for in a single work he may be both FIGURATIVE and ABSTRACT, delightful to look at and difficult to interpret. "Inventive" is the adjective almost uniformly resorted to, and while true, it neither describes nor explains his pictures. These are so individual and so immediately identifiable, it is as if he expressed himself in a language of his own invention, with different dialects but a root grammar and vocabulary. The key to his language may be the comment in the same text, *Creative Credo* (1920), quoted from above: "The formal elements of graphic art are dot, line, plane, and space—the last three charged with energy of various kinds." In contrast to CÉZANNE's proclamation that art has form via cylinder, sphere, and cone, Klee's fanciful shapes and colors are as likely to involve flat circles, triangles, diamonds, rectangles, and squares (e.g., *Postcard no. 4,* 1924) as they would wirelike figures with bird heads (*Twittering Machine,* 1922). There is a devotion to play in much of his work, especially during the later years, when he developed ideograms or PICTOGRAPHS, personalizing his language in fact as well as effect. Two of these contrast his sense of play with his premonitions of disaster: In *Park Near Lu(cerne)* (1938), thick black lines robed in color allude to plants and trees, while in *Death and Fire* (1940) a few heavy lines and morose colors represent human beings. Soon after *Death and Fire,* Klee died of the rare skin disease scleroderma, from which he had suffered since 1935. Born in Switzerland, Klee studied in Munich and worked for a good part of his life in Germany, becoming a German citizen. He was drafted into the German army during World War I and later taught at the BAUHAUS. He and KANDINSKY knew each other well and interacted professionally, personally, and through their art. They were, Mark Roskill writes, ". . . like a musical partnership—pianist and violinist, vocalist and accompanist . . . even while their 'styles' of performance and commentary remained entirely different in cast." Klee left Germany in 1933, and in 1937 his work was exhibited in the Nazi exhibition of DEGENERATE ART (as was Kandinsky's). Klee's last years of illness and disappointment—he was denied his request for French citizenship—were nevertheless productive, and successful in that he was exhibited internationally.

Klein, Yves

1928–1962 • French • painter • New Realist

I espouse the cause of Pure Color, which has been invaded and occupied guilefully by the cowardly line and its manifestation, drawing in art. I will defend color, and I will deliver it, and I will lead it to final triumph.

When he was 20, Klein became interested in the teaching of Rosicrucians (see SALON DE LA ROSE + CROIX). That led to his absorption with color, blue in particular, which to him embodied a new age in which spirit would be liberated. He painted canvases with a single color, uniformly applied from each end of the canvas to the other. He saturated sponges in paint. He burned blue, pink, and gold PIGMENT—a Rosicrucian trilogy of the colors of fire—into asbestos in *Fire Painting* (1961–62). He had

women cover themselves with paint and make marks on the ground in what he called *Anthropométries*. He himself "flew" out of a window—*Leap into the Void, near Paris, October 23, 1960*—which was recorded by a photographer. Altered to remove the tarpaulin on which he landed, the photograph of his feat appeared on the front page of a newspaper that he created and distributed on Sunday, November 27, 1960. Klein's writings and his work are filled with ecstatic prophecy and mysticism, but toward the end of his life, before he died of a heart attack, he found himself portrayed as a bizarre eccentric rather than a prophet.

Kleitias
See FRANÇOIS VASE

Klimt, Gustav
1862–1918 • Austrian • painter • Modern/Art Nouveau

I can paint and draw. I believe as much myself and others also say they believe it. But I am not sure that it is true. Only two things are certain:

1. I have never painted a self-portrait. I am less interested in myself as a subject for a painting than I am in other people, above all women. But other subjects interest me even more. I am convinced that I am not particularly interesting as a person. There is nothing special about me. I am a painter who paints day after day from morning until night. Figures and landscapes, portraits less often.

2. I have the gift of neither the spoken nor the written word, especially if I

have to say something about myself or my work. Even when I have a simple letter to write I am filled with fear and trembling as though on the verge of being sea-sick.

The quotation above, from an undated typescript called *Commentary on a non-existent self-portrait,* is the only record of Klimt's view of himself. In about 1891, his previously straightforward style changed. His new paintings had brilliant decorative patterns and strong colors that seem to overwhelm the people swathed in and surrounded by these bold patterns. The figures often float, embrace one another, and seem transported with erotic pleasure or longing. But an observer feels a pervasive angst, a nervous tension, perhaps because space becomes unfathomable, and perhaps from an impulse to disentangle what seems real and three-dimensional (e.g., faces) from what is flat, abstract design (e.g., *The Kiss,* 1907–08). If Klimt's experiments in submerging people in patterns are reminiscent of VUILLARD, and his FEMME FATALE types call to mind those of MOREAU, his mood of pre–World War I despair and decadence is like that of MUNCH and ENSOR. With the formation of the Vienna SECESSION in 1897, Klimt became its leader and began to earn an international reputation as an ART NOUVEAU painter. The group's exhibitions introduced Vienna to the work of MACKINTOSH, the French IMPRESSIONISTS, and POST-IMPRESSIONIST art. Klimt ended his brief self-analysis quoted above with the comment, "Whoever wants to know something about me—as an artist, the only notable thing—ought to look carefully at my

pictures and try to see in them what I am and what I want to do."

Kline, Franz
1910–1962 • American • painter • Abstract Expressionist

Since 1949 . . . I've been working mainly in black and white paint or ink on paper. Previous to this I planned painting compositions with brush and ink using figurative forms and actual objects with color. The first work in only black and white seemed related to figures and I titled them as such. Later the results seemed to signify something—but difficult to give subject or name to, and . . . I find it impossible to make a direct, verbal statement about the paintings in black and white.

Kline grew up in Pennsylvania's coal country. In some ways his paintings resemble marks made by scraping chunks of soft coal on a white wall. They may also reflect his interest in trains—his father was a railroad foreman—in the sense of the speed and movement of his brushstroke. He worked in black and white, as he says in the quotation above, dark and light sometimes colliding and clashing, sometimes blending, in a variety of tones. Unlike his friend DE KOONING, Klein totally abandoned the figure in his ABSTRACT EXPRESSIONISM, but like de Kooning (and Jackson POLLOCK) he was an Action painter whose physical movement, energy, exerted in the very act of painting, becomes part of the image (see ACTION PAINTING). The term "calligraphic," alluding especially to Chinese calligraphy, is frequently applied to Kline's paintings, yet except for the use of black and white, it could hardly be more inaccurate. The rapid, slashing, successive layers of his wide marks on the canvas are nothing like the careful, precise, delicate elegance of calligraphy. Kline used commercial paint from a gallon can and a broad-bristle house painter's brush. Needing a hard surface to absorb the pressure of his brushstroke, he tacked his canvas on a wall. Although his forms look spontaneous, Kline explored shapes and ideas in a multitude of ink studies before committing them to canvas. In the 1950s Kline introduced color to his paintings, as in *Composition 1953*, where, on looking very closely, one discovers shapes or spots of color—red, yellow, green, silver. A great talker and storyteller, Kline was, however, reticent when asked to explain his paintings. He once quoted the bandleader Louis Armstrong, who said, "Brother, if you don't get it, there is no way I can tell you."

Kokoschka, Oskar
1886–1980 • Austrian/English • painter • Expressionist

The state of awareness of visions is not one in which we are either remembering or perceiving. It is rather a level of consciousness at which we experience visions within ourselves.

Kokoschka moved from an early encounter with ART NOUVEAU, in Vienna, to the enduring influence of EXPRESSIONISM, especially after he went to Berlin in 1910. *The Bride of the Wind* (1914), painted two years after he wrote the essay "On the Nature of Visions," from which the quotation above is taken, is both a romantic vision and an ecstatic image of his three-year love

affair with Alma Mahler, widow of the composer Gustav Mahler. They float together between dream and memory, against a background of the night sky and a mountain landscape. They are surrounded by a swirl of thick paint strokes, their bodies, too, built up of heavy IMPASTO strokes. When Alma Mahler left him for GROPIUS, Kokoschka had a dollmaker fabricate a life-size effigy of her. During the day the doll accompanied him about town, it slept in his bed at night, and it appears next to him in *Self-Portrait with Doll* (1920–21). After a drunken revel he "murdered" the doll and threw it onto a garbage truck. Kokoschka had served and been seriously wounded in World War I. He began to travel in the 1920s, painting dynamic urban scenes with the emotions they provoked. He opposed the Nazis, and his work was confiscated by them and shown in their exhibition of DEGENERATE ART. In 1937, the same year of the exhibition, he painted a self-portrait entitled *Portrait of a "Degenerate Artist."* He moved first to London, where he became a British citizen, and then to Switzerland, where he continued to paint in the Expressionist mode.

Kollwitz, Käthe Schmidt

1867–1945 • German • printmaker/sculptor • Expressionist/Social Realist

One can say it a thousand times, that pure art does not include within itself a purpose. As long as I can work, I want to have an effect with my work.

Kollwitz expressed her concern with the suffering of the poor in prints, for which she is best known, and in sculpture. Her interest in the downtrodden began when she was at the Berlin School for Women Artists, in which she enrolled at the age of 17. Her parents were Socialists, and she joined the Socialist Democratic party. Her husband, a doctor, was also a member of the party. Kollwitz was the first of the German SOCIAL REALISTs who developed out of EXPRESSIONISM during and after World War I. (Others were DIX and GROSZ.) She worked in several types of PRINT mediums, and in one of her major series, *The Peasants' War* (1902–08), she combined the techniques of AQUATINT and soft ground ETCHING. This group of seven prints shows moments in a peasant rebellion of the 16th century and commemorates the leadership of "Black Anna," who, in *The Outbreak* (plate #5 in the series, 1903), is shown from the back, forcefully leading the peasants' advance. Her strength is not only in the energy of her own form, but is reflected in the faces of the surging mass of protesters as well. It shows the power of people who share a common cause, and Kollwitz said she modeled the figure of Anna on her own. Her commitment to social action is expressed in the comment quoted above; she was also a feminist (founder of the Women's Arts Union [Frauen Kunstverband] in Berlin in 1913), and a pacifist. She lost her son in World War I and her grandson in World War II. She was absorbed throughout her career by the concept of death; it was the subject of her last cycle of large-format LITHOGRAPHs, begun in 1934. *Call of Death* (1934) is a self-portrait made with the thick lines of the lithographic crayon; it shows her darkly shadowed head turning toward a hand that touches her on the shoulder.

Komar and Melamid (Vitaly Komar, born 1943, and Alexander Melamid, born 1945)
Russian • painters • Social Realists/Conceptual

The most important thing in art isn't line or paint or brushwork but power. That's what art is about. Since we know what people want, we can even rule the people. All great leaders and great artists know the people. (Komar speaking for his collaborator and himself)

Komar and Melamid immigrated to America (via Israel) from the former Soviet Union in 1978. They had exhibited their unappreciated "dissident" work in the USSR in 1972, the famous outdoor "Bulldozer Show" that was destroyed by the secret police, who beat and arrested many of the artists. Success came to them in New York. They ridiculed Russia's political scene with pictures such as *Stalin and the Muses* (1981–82), which, mimicking art of the GRAND MANNER, poses a heroic Stalin with the Greek goddesses of creative inspiration. Clio, goddess of history, hands him a large tome on which to make his mark. Komar and Melamid named their absurd satire "Sots" art, combining SOCIAL REALISM and POP ART. If art was controlled by the state in Russia, then painters, critics, historians, and museum officials, as well as rich collectors, they discerned, dominated art production in America. So in 1993 the two artists decided to collect information about what "genuine people"—the American public—would want if their taste were polled. "Would you rather see paintings of outdoor scenes or indoor scenes?" was one of the 102 questions their telephone callers asked a sampling of 1,001 Americans. *America's Most Wanted* is the picture that resulted from their survey. It is a vast landscape with gentle mountains, a lake, and two deer, an American family, and, in the middle foreground, George Washington. "I must confess it's not the best picture in the world," Melamid said apologetically. Eventually, Komar said, they will create "the painting of humanity." He added, "We're quite ambitious." In 1997 their project was documented in an ironic, mischievous book, *Painting by Numbers*.

kore, korai (pl.)
From the Greek meaning "maiden," "kore" refers to the sculpted, standing, clothed female figures of the ARCHAIC period in Greek art. (See also KOUROS)

Kosuth, Joseph
born 1945 • American • installation • Conceptual

The art itself, which is neither the props with which the idea is communicated, nor the signed certificate, is only the idea in and of the work.

A pioneer of CONCEPTUAL ART and an advocate of its intention to dematerialize the art object, Kosuth proclaims that one does not need a painting, sculpture, or even a found or manufactured object to create art. The intention of the Conceptual artist is to engage the "viewer's" or audience's mind directly, rather than her or his visual, auditory, or tactile sensations. There are, in fact, objects in Kosuth's *One and Three Chairs* (1965): A real chair sits on the floor, a full-size photograph of a chair is

on the wall, and next to it is a printed definition of the word "chair." But they are not important. What matters is that a work such as this may raise questions that include the meaning and role of language (see SEMIOTICS), the relationships of words and things and images. Kosuth also uses quotations from the German cultural critic Walter BENJAMIN in his textual works. At a dinner party held in honor of Kosuth's 50th birthday, an unblinking neon sign mounted on the wall bore one of his exhortations: SELF-DESCRIBE SELF-DEFINE.

kouros, kouroi (pl.)

Kouros is Greek for "young man" and refers to the sculpted, standing male figures of the ARCHAIC period in Greek art. The FRONTAL kouros pose probably owes its origin to the ancient Egyptian sculptural tradition. Through trade and settlement in the Nile Delta, Greek artisans learned stone quarrying and cutting techniques from the Egyptians. They adopted the rigid, frontal, expressionless appearance, as well as the unforgiving symmetry and domineering monumentality of the Egyptian prototype. They also imitated the pharaonic posture: straight arms with clenched fists, one stiff leg advanced in front of the other. The Greek figure, however, was sculpted of marble, instead of the hard nephrite or diorite of Egyptian work; its arms were not of a piece with the sides of its body, as the Egyptian was; and the Egyptian's standard back support was removed so that the Greek statue might be freestanding. Most distinctive, the kouros is naked (see NUDITY). The female statue, the KORE, remained clothed for another two cen-

turies. Kouroi and korai represented aristocratic young women and men at the peak of their beauty and strength. They replaced vases as grave markers, and stationed around temples, were used as votive offerings to the gods. The human form was the primary focus of Greek art, and the kouros and kore, which were originally painted, were IDEAL, generic types rather than individuals. An upturned mouth, known as the "archaic smile," appears in many mid-6th-century statues.

Kraft, Adam
active 1490–1509 • German • sculptor • Late Gothic/Early Renaissance

The forenamed master Adam has promised . . . to complete this work, with God's help, within more or less the next three years, as counted from the date of this contract, and for such work . . . shall not have the right to ask more than seven hundred guilders altogether. (contract, 1493)

In 1493, Kraft and his WORKSHOP created an enormous stone sculpture for the church of Saint Lorenz in Nuremberg, Germany—a shrine more than 60 feet high—for storing communion wafers. This eucharistic tabernacle is interesting on grounds other than its elaborate and skillful carving: An understanding of contractual practices comes from reading the agreement between Kraft and his wealthy PATRONs, the Imhoff family, quoted from above. It stipulates details such as completion date, quality of materials, and payment. The structure itself includes elaborately carved scenes of the life of Christ. But at the base of the towering shrine, appear-

ing to hold up the entire structure, is something of a surprise: three life-size human figures, contemporary in appearance. One, kneeling, is a well-built man with a tightly curled beard. He wears a workman's costume and holds the tools of his trade. This is believed to be Kraft's self-portrait, a highly significant symbol in that the sculptor includes himself in the purpose and meaning of the work, occupying a low but absolutely critical and supportive position. The other two figures under the base may be Kraft's assistants.

Krasner, Lee

1911–1984 • American • painter • Abstract Expressionist

I think it does suggest hieroglyphics of some sort. It is a preoccupation of mine from way back and every once in a while it comes into my work again.

Fascinated with writing—Hebrew, Kufic (an ancient Arabic script), as well as hieroglyphs—Krasner incorporated them in her paintings, usually in dense, overall images that imply metalan-guage, that is, the connection between language and other cultural phenomena, such as folk tales—a combination of the visual and the verbal. Krasner studied with HOFMANN and married Jackson POLLOCK, whose work overshadows hers and whose turbulent life made hers chaotic.

krater

A tall bowl with a wide mouth for mixing wine and water, the usual drink for Greeks. Also used for grave site offerings. (See also POTTERY)

Krimmel, John Lewis

See NEAGLE and RUSH

Kritios Boy

See CONTRAPPOSTO

kylix

A shallow drinking cup on a stem, often decorated with Dionysian (pertaining to Dionysus, the Greek god of wine) themes, e.g., *Dionysus in a Sailboat* (c. 550 BCE) by EXEKIAS. (See also POTTERY)

L

La Farge, John

1835–1910 • American • painter/
designer • Aestheticist

*Rembrandt would be happy here [in
Samoa], especially in the evenings,
when the coconut fire . . . makes a
center of light.*

La Farge grew up in New York City,
where his French émigré parents pro-
vided highly cultivated, privileged sur-
roundings. He first studied law, but a
trip to Europe in 1856 changed his di-
rection. He was briefly in COUTURE's
studio, then in that of William Morris
HUNT in Newport, Rhode Island. His
circle of friends included artists as
diverse as HOMER and BARTHOLDI,
along with the lettered elite: He became
good friends with Henry and William
James while they, too, studied with
Hunt, and the historian-philosopher
Henry Adams was his travel compan-
ion. La Farge and Adams visited
Japan—La Farge had already been
among the first Westerners to collect
Japanese art, which, along with many
other styles and ideas, he absorbed
and reflected—and subsequently went
around the world starting from San
Francisco and stopping in Hawaii,
Samoa, and Tahiti. His high level of so-
phistication and wide range of accom-
plishments in a variety of mediums
contribute to making La Farge essen-
tially uncategorizable. For example, in
1861 he painted a small STILL LIFE, 22
inches high by 12 wide, *Agathon to
Erosanthe, A Love Wreath,* based on a
GREEK tradition of leaving a wreath of
flowers as a token of love outside the
home of the beloved. The background
for this wreath appears to be a plain
white wall, yet it is anything but plain
or white. The paint is thickly applied,
dragged roughly across the surface, and
interlaced with pinks, blues, grays, and
creams. Not only is the texture almost
tactile, but so too is the strong light that
strikes the subtly and impressionisti-
cally painted circle of flowers and laurel
leaves. It is unlike any other still lifes
being painted at the time. Later, La
Farge led a revival of mural art in Amer-
ica. In 1876, the architect RICHARDSON
put him in charge of the interior decora-
tion of Trinity Church in Boston, for
which he designed and executed murals
as well as STAINED GLASS windows. Ac-
cording to legend, La Farge began ex-
perimenting with stained glass in the
1870s after noticing how light struck a
blue bottle on the windowsill while he
was in bed, recuperating from an ill-
ness. Although TIFFANY is often given
credit, it was La Farge who invented
opalescent glass—several colors fused
together to create an irregular texture
and expressive shadings. Flower designs
were among his most beautiful glass
creations, and peonies among his fa-
vorite flowers—*Peonies Blown in the*

Wind (1878–79), for example. Not only is the peony rich in Oriental symbolism, but La Farge also framed his design to resemble a Japanese hanging scroll. At the same time he worked with glass, La Farge began painting in WATERCOLOR—flower and landscape studies, and cultural studies from the South Seas islands, to which he voyaged.

La Tour, Georges de

1593–1652 • French • painter • Baroque

Scratch almost any great seventeenth-century painter except Poussin, and traces of Caravaggio will appear. . . . The best French painter to fall under Caravaggio's spell was Georges de La Tour. (Robert Hughes, 1987)

Although it is not known how the influence of CARAVAGGIO reached him—apparently he never went to Rome—it is clear from his dramatic use of light and shadow that La Tour was among the CARAVAGGISTI, as HUGHES points out in the quotation above. His personal interpretations of the prototype were by night scenes in which the flame of a candle selects and illuminates the subject with a spiritual glow. *Christ and Saint Joseph in the Carpenter's Shop* (c. 1645), for example, is a unique depiction of Joseph, who bends over his carpentry work while the young Christ kneels next to him holding the candle. Light is shed on what is important: Joseph's strong arm and high forehead; Christ's face, which is even brighter than the flame; and Christ's hand, which, next to the candle, is nearly transparent. His hand is also in the familiar gesture of blessing. La Tour pared down the elements in a picture to essentials, and in his later works they appear almost to be reduced to geometric surfaces reflecting light as pure, simplified forms. He seems able to distill emotion through purified form. In paintings such as *The Cheat with the Ace of Diamonds* (two versions, both before 1630), the light is harsher, and the wily subjects wear elaborate, low-cut gowns and brocaded silks. The theme is believed to be a moralizing one: The man duped by card players is likely a metaphor for the biblical Prodigal Son. Along with the stylistic influence of the Dutch Caravaggisti, an actual painting by Caravaggio, *The Cardsharps* (c. 1595–96), may have been the inspiration for La Tour's example of innocence deceived. The theme of repentance, a popular Counter-Reformation subject, is often seen in La Tour's work—in images of penitent saints (e.g., *Saint Jerome,* 1620–25, and *Saint Peter,* 1645) and many versions of Mary Magdalene from the 1630s and '40s.

Labrouste, Henri

1801–1875 • French • architect • Romantic Rationalist

Henri Labrouste is without doubt the architect of the middle nineteenth century whose work possessed the most significance for the future. His time, of course, dictated the use of Renaissance or classical shapes, and he used them with the greatest artistic distinction. But it was in his methods, in the way he analyzed and executed a task in building, that he stood far in advance of his times and of his colleagues. (Siegfried Giedion, 1941)

Labrouste won the GRAND PRIX when he was 23 and spent five years in Rome, but he was more interested in solving contemporary problems with new ideas than with those established by the ACADEMY. He opened his own atelier, or school, in which rationalism—including his belief that "form must always be appropriate to the function for which it is intended"—was part of the controversial teaching method. His opposition to the academy contributed to Labrouste's lack of significant commissions until, in 1843, he was given the design of the Library of Sainte-Geneviève in Paris. This library was the first important public building to use cast- and wrought-iron construction from the foundations to the roof. The iron does not here substitute for exterior masonry, as it later will do; rather, it serves for interior structural support: columns, beams, and roofing. Labrouste's masterwork is the Bibliothèque Nationale, or National Library, in Paris (1858–68), in which he takes another step with iron, using gridiron floors that allow natural light to penetrate the stacks on every level. Combining innovation and logic is the approach for which GIEDION commends Labrouste in the quotation above.

Lachaise, Gaston

1882–1935 • American • sculptor • Modern

Simplify and amplify: amplification and simplification.

Born in France and a student at the ÉCOLE DES BEAUX-ARTS, Lachaise fell in love with an American woman and fol-lowed her to the United States. He was devoted to sculpting the female form, especially that of his beloved Isabel Nagle, whom he represents as hyper-voluptuous, Amazonian in form with gigantic arms, breasts, and thighs. In concert with the enormity of his conceptualization, the bronze figures themselves are larger-than-life: *Standing Woman* (1932), for example, is more than 7 feet high. Lachaise's credo, quoted above, describes his volumetric, bulging, smoothly polished forms.

Laer, Pieter van

c. 1599–1642? • Dutch • painter • Baroque

Every day he would paint pictures of varying size but with small figures, about one palm [about 9 inches] high—never any bigger. (Giovanni Battista Passeri, 1772)

Van Laer went to Rome from the Protestant town of Haarlem in 1625, and he was one of an association of NETHERLANDISH painters called the Bentveughels or Birds of a Feather. He was credited with—and accused of—introducing a new subject to Italian art: the everyday life of working-class people, beggars, shepherds, and the poor of various occupations and preoccupations—GENRE paintings. Van Laer's stunted physique gave him, and the movement he initiated, the slang name BAMBOCCIANTI, a term describing a malformed doll or puppet. He sold his genre scenes at fairs, to dealers, and anywhere else he could find a buyer, for he was most unlikely to attract a PATRON. Ironically, van Laer became popular and expensive, as well as controversial, and he was despised by

artists of the establishment. The description quoted above is by an art chronicler of the 18th century.

landscape

A wall painting from the Neolithic town of Çatal Hüyük in Anatolia (c. 6150 BCE) may be the first known "pure" landscape—that is, one standing on its own merits, not as background for a narrative scene. It is believed to show the town, an erupting volcano, and a mountain. From the late Bronze Age, MINOAN paintings on the walls of houses on the island of THERA have remarkable scenes (c. 1500 BCE): hills and lilies in one; the sea filled with ships, the shoreline, hills beyond, and incidental activity in the other. During the 1st century BCE Roman walls were painted with idealized landscapes. PLINY the Elder wrote about a landscape painter who ". . . painted villas, porticos and parks, groves, copses, hills, fishponds, straits, rivers, shores, as anyone could wish." A MEDIEVAL manuscript, *Carmina Burana* (early 13th century), contains a poem to spring illustrated with an ornamental, stylized representation of a landscape, and like its predecessors it makes no pretense of recording a factual topography. Both idealized and realistic landscapes decorated the backgrounds of MEDIEVAL and RENAISSANCE art—embellishing on Pliny, ALBERTI wrote: "Our minds are cheered . . . by [paintings of] the delightful countryside. . . ." But it is during the 16th century that the landscape background became increasingly detailed and important, leading to the concept of landscape as a specialty in its own right. DÜRER was one of the first to use the term "landscape" when, in 1520, he described the paintings of PATINIR. A household inventory in Venice, c. 1524, listed "landscape paintings," and in 1530 GIORGIONE's *Tempest* (1505–10) was described as a landscape even though it has prominent foreground figures, thus complicating the definition. Italians (e.g., Federigo Pericles) collected what were called landscapes. Both collectors and connoisseurs looked to Northern Europe for landscape expertise; three Flemish painters were employed in TITIAN's workshop for their landscape painting skills. If Italians were happy to relinquish the landscape to northerners, it was because they claimed the more highly valued HISTORY PAINTINGS, which were dependent on CLASSICAL scholarship, for themselves. Meanwhile, in the northern countries during the 16th century, landscapes also became a distinct interest. Their appeal drew in part on people's travels and also on the fact that a newly enriched middle class became able to buy both land and pictures of it. Interest in the landscape was then also inspired by descriptions brought back from the New World—reports of its virgin and primitive resources directed attention to the shrinking local forests and countryside. Moreover, the Protestant Reformation, discouraging church adornment, served to encourage landscape painting. In 17th-century Holland, landscape—quite independent of human figurative interest—became its own raison d'être, the full orchestra and orchestration of the work, with matchless mood and refinement (e.g., SEGERS, van GOYEN, van RUISDAEL, and HOBBEMA). It was the century of mapping and exploration, what has been called the Age of Obser-

vation, and those artists describe the world observed. (See also BARBIZON SCHOOL, NORWICH SCHOOL, HUDSON RIVER SCHOOL and PLEIN AIR)

Landseer, Sir Edwin
1802–1873 • English • painter • Romantic

[Concerning] a dog of Edwin Landseer ... the outward texture is wrought out with exquisite dexterity of handling, and minute attention to all the accidents of curl and gloss which can give appearance of reality; while the hue and power of the sunshine, and the truth of the shadow, on all these forms are neglected, and the large relations of the animal, as a mass of colour, to the sky or ground, or other parts of the picture, utterly lost. This is realism at the expense of ideality; it is treatment essentially unimaginative. (John Ruskin, 1843)

In the ROMANTIC repertoire, when man confronted nature, the awesome power of nature prevailed (see SUB-LIME). This is the theme of Landseer's strange painting, *Man Proposes, God Disposes* (1863–64). It is based on an actual expedition to find the Northwest Passage that ended in tragedy in 1855. News about the discovery of the Arctic shipwreck in 1857 inspired Landseer's portrayal of a glacial landscape with two ferocious polar bears who explore, with apparent rage, the evidence of man's incursion into their domain. One of the bears may be chewing on the re-mains of a human rib cage. This picture was disdained by some critics for its "occult pathos." Landseer became a celebrity known for the speed with which he could paint and for his re-markable ambidexterity: It was re-ported that he performed the feat of si-multaneously drawing a stag's head with one hand and the head of a horse with the other. He was Queen Victo-ria's favorite painter and the most fa-mous of 19th-century animal painters. He was given a state funeral and a tomb at Saint Paul's Cathedral, alongside REYNOLDS, LAWRENCE, and TURNER. The animals scattered around his paint-ing *Windsor Castle in Modern Times (Portrait of Victoria, Albert and the Princess;* 1841–45) are domestic—four dogs—and the only sign of raw nature is the collection of dead birds that Prince Albert has brought home from the hunt. To RUSKIN, quoted above, and to later critics, Landseer fell into a num-ber of faults—triviality, sentimentality, and distortion. An example of that is *Dignity and Impudence* (1839), in which a large and a small dog peer out of the doghouse. Despite its sentimen-tality, it was the most popular picture of the 19th century. His portrayal of black and white Newfoundland dogs led to Newfoundlands of that coloration being named "Landseers." The four great lions at the base of Nelson's Col-umn in Trafalgar Square, executed from Landseer's models, are his best-known works. His last years were, according to a biographer, "full of suf-fering, mainly of broken art and shat-tered mental powers."

Lane, Fitz Hugh
1804–1865 • American • painter • Romantic/Luminist

Standing on the bare ground—my head bathed by the blithe air, and uplifted into infinite space—all mean

egotism vanishes. I become a transparent eyeball; I am nothing; I see all; the currents of the Universal Being circulate through me; I am part or parcel of God. (Ralph Waldo Emerson, 1836)

Emerson's famous recitation of the Transcendentalist vision, quoted above, had immense influence. The historian Barbara Novak connects this and other Emersonian ideas with Fitz Hugh Lane, whose art "is perhaps the closest parallel to Emerson's transcendentalism that America produced: of all the painters of the mid-century," she writes, "he was the most 'transparent eyeball.' " The archetypal LUMINIST painter, Lane created pictures characterized by precisely delineated forms, an absence of visible brushstrokes, and a devotion to portraying the quality of light, particularly at sunrise and sunset. He specialized in harbor scenes around his home in Gloucester, Massachusetts, and the Boston area. *Boston Harbor* (1850–55) shows the bay and the many-masted sailing ships bathed in the light of the setting sun. Lane's scenes were TRANSCENDENTAL in their spirit of luminous tranquillity, but they were also glorifications of commerce, representing, as they did, the flourishing maritime trade in glowing terms.

Lanfranco, Giovanni
1582–1647 • Italian • painter • Baroque

Lanfranco made a good deal of money. . . . He did not leave much when he died to his son . . . but together with his family he led a splendid life. He spent three thousand a year in Naples where he had a house. In Rome he had a vineyard at San Pancrazio with a villa which he and his friends painted. (Bellori, 1672)

Lanfranco was born in Parma, where CORREGGIO's ceiling FRESCOes in the cathedral—dramatic, illusionistic renderings of figures swept up into the firmament—worked their magic on him. He was also enthusiastic about CARAVAGGIO's drama, which his biographer, BELLORI, quoted above, was not at all in favor of. But Lanfranco absorbed his lessons and used them to good advantage when he, himself, painted the ceiling fresco, *Assumption of the Virgin* (1625–27), in the dome of San Andrea della Valle in Rome. That, in its turn, served as a model for artists over the next 100 years. Lanfranco's ceiling is bathed in light, which seems to radiate from Christ (and also comes through the dome's lantern, or opening). The Virgin gazes ecstatically toward the light with her arms outstretched. Lanfranco was an important bridge between the BAROQUE classical tradition followed by the CARRACCI FAMILY (with whom Lanfranco trained) and the High Baroque of CORTONA.

Lange, Dorothea
1895–1965 • American • photographer • Social Documentary

The contemplation of things as they are, without substitution or imposture, without error or confusion, is in itself a nobler thing than a whole harvest of invention. (Francis Bacon, 16th–17th century)

An artist employed by the Farm Security Administration, Lange traveled

widely across America to document conditions of the Great Depression. Her photograph *Migrant Mother, Nipomo, California* (1936)—a grim woman gazing into space with her two children, who hide their eyes on her shoulders—became symbolic of the hopelessness of poverty. It has been called "the world's most reproduced photograph," and was effective in contributing to improvements in the migrant camp at which it was taken. Nevertheless, the woman who posed for the picture complained, when interviewed 42 years later, that it had done her, personally, no good at all. Discussion today focuses on ethical questions about such pictures and the degree to which they exploit their subjects. Another of Lange's Depression-era pictures has no visible human subject, though human exploitation of a different kind is its theme: *Tractored Out, Childress County, Texas* (1938) is a picture of an abandoned farmhouse that sits atop a pattern of curved tractor furrows in the dry earth. The story it tells is that, through overuse, a different kind of exploitation, this farmland has become a wasteland. Not just a powerful documentary photograph, it is also a beautiful, abstract composition. It follows the spirit of the English essayist Francis Bacon, whose words, recorded above, Lange pinned over her darkroom door.

Laocoön

"Laocoön, which stands in the palace of the Emperor Titus, [is] a work to be preferred to all that the arts of painting and sculpture have produced," wrote PLINY the Elder. "Out of one block of stone the consummate artists Agesander, Polydoros and Athenodoros of Rhodes fashioned Laocoön, his sons, and snakes marvelously entwined about them. . . ." In 1506, excavations at the Baths of Titus based on Pliny's words turned up a group of marble figures. Experts called in to assess the work, including MICHELANGELO, were as enthusiastic as Pliny, even though they saw that more than one block of marble had been carved—the current count is six. Until recently the excavated *Laocoön* was considered a HELLENISTIC original (before 31 BCE), sculpted by the artists Pliny cites. Now it is thought by some art historians to be a Roman copy from the 1st century CE, but there is no general agreement about that—the date and status of *Laocoön* are still unsettled. In any case, the story it illustrates may be interpreted as having political as well as dramatic impact: Laocoön was a priest who warned the people of Troy about the wooden horse in which invading Greeks were hidden. Angered at Laocoön's effort to thwart his plans, Neptune sent two huge sea serpents to kill the priest and his two sons. The father, his head thrown back, is contorted with pain as a snake bites his side; the boy on his right is also doomed, but the alarmed child on his left may yet escape. Contemporary Hellenistic Greeks might have seen this as a metaphor for Greece, which was, at that time, in its own death throes. The ascendant Romans who captured, admired, and copied *Laocoön* could also have found a metaphor in the sculpture: The event it describes is one that forewarned Aeneas in time for him to flee Troy for Italy. Aeneas was reputedly an ancestor of Romulus and Remus, the legendary founders of Rome. To Romans of the ITALIAN RENAISSANCE who rediscovered

Laocoön after it lay buried for as many as 1,300 years, it surfaced at a time when Rome was again a center of power, as well as of art, yet its power and wealth were also waning. (Warfare was incessant between 1499 and 1527; aided by successful voyages of exploration and trade, Spain was gaining supremacy; and excesses of the Roman Catholic Church provoked agitation for reform.) How many of these analogies successive artists, patrons, and historians have read into *Laocoön* is conjecture, but the sculpture's influence has been vast. Michelangelo studied and sketched it (as did many other artists), and his *Dying Slave* (c. 1513–16) is based on it. TITIAN borrowed poses from the group for some of his paintings, then, as if in rebellion against the reverence accorded it, sometime around 1532 he drew the father and his two sons as monkeys. El GRECO painted his own MANNERIST version of *Laocoön*. In 1843, in *A Christmas Carol,* Dickens compared Scrooge putting on his stockings to the struggling figures in the sculpture. Interpretations of and quotations from the work are unending, as are critical assessments. Enthusiasm peaked during the 18th century, led by WINCKELMANN, who wrote, "The expression of such a great soul goes far beyond what beautiful Nature may accomplish. The artist had to feel in himself the power of the spirit which he impressed into his marble. Greece had artists and philosophers in one person." Winckelmann's effusions were followed by LESSING's celebrated 1766 essay on aesthetics entitled *Laocoön.* Many critics of the 19th and most of the 20th century find the pathos overheated, or, as Janson's *History of Art* puts it, "somewhat calculated and rhetorical, and its meticulous surface finish . . . a display of virtuoso technique."

Larionov, Mikhail
1881–1964 • Russian • painter • Rayonism

Painting is self-supporting. It is an autonomous art which has its proper forms, its proper colors and its proper tones. Rayonism created forms in space. These forms are born from the intersection of luminous rays emitted by different objects. These are liberally interpreted by the artist-creator and subjected to his will of aesthetic expression.

In Moscow, in 1910 Larionov organized a group of painters, including GONCHAROVA and MALEVICH, who exhibited under the name Jack of Diamonds. Later, with Goncharova, whom he married, Larionov started the RAYONISM movement—the quotation above is taken from his manifesto of 1912—and organized the 1913 exhibit *Target,* in which the first Rayonist art was shown. Larionov was almost doctrinaire in his insistence that he adhered to no doctrine, but the new style was related to CUBISM in its use of geometric form and to FUTURISM in its dynamic lines of movement. Scientific and philosophical ideas of Albert Einstein and Ernst Mach also interested Larionov and other Rayonists, and they tried to express the new concepts of time and space in part by using lines that cross and cut off one another. *The Beef Rayonism* (1910) is the head of a cow in slashes of yellow and white with some black outlining. Rayonism was short-

lived, but had an impact on the later SUPREMATISM. Larionov and Goncharova left Russia in 1915 and settled in Paris, where both designed for Diaghilev's Ballets Russes, reviving their interest in Russian history and FOLK ART.

Lastman, Pieter
1583–1633 • Dutch • painter • Baroque

... now in Italy there is a certain Pieter Lastman who shows great promise. (Carel van Mander, c. 1604)

Before he returned home to Amsterdam to fulfill the assessment of van MANDER, quoted above, Lastman was impressed by the German expatriate landscape painter living in Italy—ELSHEIMER—and the pervasive influence of CARAVAGGIO. Back in Holland by 1607, Lastman painted religious and mythological pictures that show drama, BAROQUE composition, and an interest in light and shadow. He liked to use crowds of people to dramatize the stories he told. In *Nausicaa and Odysseus* (1619), Odysseus arrives unexpectedly, and naked, to the surprise of Nausicaa and all others present. His alarming appearance shocks and stops everyone short, from women carrying laundry in the distance to the horse in the front of the picture, which seems to have screeched to a halt. REMBRANDT studied with Lastman, and was greatly influenced by him.

Late Antique
See EARLY MEDIEVAL

Late Classical
See CLASSICAL

Latrobe, Benjamin Henry
1764–1820 • American • architect • Federal/Neoclassicist

I have heard with the deepest mortification that I have had the misfortune to displease you. . . . I am convinced by the evidence of my senses in innumerable cases, by all my professional experience for near 20 years, and by all my reasonings, that the panel lights must inevitably be destroyed after being made.

Born in England to an American mother, Latrobe received his architectural training there. He also studied in Germany and traveled in France and Italy. After almost all building in England stopped because of the Napoleonic War, Latrobe moved to the United States in 1796. He brought with him a new, more austere NEOCLASSICAL style than that of his predecessors and contemporaries (e.g., BULFINCH), one that synthesized Greek, Roman, and "Revolutionary Classicism," that is, an architectural style and content that reflected the intellectual, political, economic, and technological revolutions of the new age. The Bank of Pennsylvania (1799–1801; destroyed 1867), with its Classical front, geometric symmetry, and rationality, is an expression of this style. In 1803 President JEFFERSON appointed Latrobe Surveyor of the Public Buildings for the United States, giving him supervisory power and design authority for government projects. Foremost among these was the unfinished Capitol building. The Capitol's completion was fraught with problems, delays, and difficulties that included disputes with Jefferson. One difference of opinion concerned the lighting source of the

building's great domed roof. It is in answer to the president's ire, when it appeared to him that Latrobe was not following his directions to install wedge-shaped skylights, that the architect wrote the letter quoted from above. (The president prevailed, although the skylights became a series of relatively small squares, and Latrobe's prophecies proved true: Condensation, leakage, and glaring light were problematic.) In the building, Latrobe Americanized his Classicism with details such as tobacco leaf and corncob capitals on the COLUMNS. Other difficulties included conflict with his clerk of the works and the accusation of extravagance by some members of Congress. Latrobe resigned his post in 1817 and was succeeded by Bulfinch. Latrobe died tragically. Having accumulated a morass of debts and failed business ventures, he was almost forgotten and financially ruined.

Laurencin, Marie

1885–1956 • French •
painter/illustrator • School of Paris

My pictures are the love stories I tell myself and which I want to tell others.

Closely associated with the CUBISTS before World War I and familiar with DADA afterward, Laurencin cultivated a style that remained purposefully distinct from those movements. Enchanted and lyrical, her paintings are more reminiscent of CHAGALL and STETTHEIMER; Laurencin invented floaty, delicate women and gentle animals. Using soft color, she set her figures in an indistinctly contoured ARCADIAN landscape (e.g., *Nymph and Hind,* 1925). She also designed sets for the Ballets Russes and illustrated many books. "Like the

dance, [her painting] is an infinitely gracious and rhythmical art of enumeration," wrote APOLLINAIRE. He was her lover before her marriage in 1914. After her divorce in 1920, she had her most productive years, painting scenes of simplicity and charm.

Lawrence, Jacob

born 1917 • American • painter • Modern/Expressionist

I remember folks in the street in Harlem tell the stories of John Brown and Harriet Tubman in such a passionate way.

Lawrence's parents had migrated from the South, and he was born in Atlantic City, New Jersey. Harlem was in its heyday when Lawrence and his mother settled there in 1930. He met important personalities in the arts community, known as the HARLEM RENAISSANCE, including the poet Langston Hughes and the sculptor SAVAGE, and studied African-American history, whose heroes he painted. Though without formal schooling in art, he was greatly inspired by visits to the Metropolitan Museum of Art; as a teenager he walked the 50-odd blocks from home to the museum and went straight to the galleries with ITALIAN RENAISSANCE paintings. Success and fame were his in 1941 when *Fortune* magazine printed pictures from his cycle entitled *Migration,* about the movement of blacks to the urban North from the rural South after World War I. Lawrence painted a narrative series of 32 pictures on the life of Frederick Douglass (1938–39), and 31 on Harriet Tubman (1939–40). Beginning in 1937, he worked on a series that told the inspiring story of Toussaint

L'Ouverture, a Haitian revolutionary leader. His figures are large masses, abstracted in his own flattened, energetic style, and rendered in rich, bold, unmodulated color. Lawrence says that the *Katzenjammer Kids* and *Maggie and Jiggs* comic strips and the movies inspired him, adding that he was impressed by everything in his environment and was particularly interested in telling stories.

Lawrence, Sir Thomas

1769–1830 • English • painter • Grand Manner

Master Lawrence takes very striking likenesses of ladies and gentlemen for a charge of one guinea for an oval crayon. (Bath Chronicle, 1782)

One of 17 children, son of an innkeeper, Lawrence was so skilled at crayon portraiture that he was already earning money, perhaps even supporting his family, at the age of 10. At 13, when they moved to Bath, his father put an advertisement, quoted above, in the local newspaper. As is true of other major British portraitists of his period (e.g., RAEBURN and ROMNEY), Lawrence was largely self-taught. When he was 17 he thought he could compete with any painter except REYNOLDS, so he went to London to confront the master. At the Royal Academy he studied Reynolds's social style more carefully than his artistry, and he was soon painting portraits of the leaders of high society, including Queen Charlotte (1789). When Reynolds died in 1792, Lawrence, only 22, succeeded him in the post of Painter to the King. He made one unsuccessful stab at HISTORY PAINTING and then returned to his prosperous portraiture.

He was knighted and dispatched to the Continent by the king: His mission was to paint portraits of the European leaders important to the defeat of Napoleon. Besides charming his way through cosmopolitan society, Lawrence studied portraits by TITIAN and VELÁZQUEZ in collections abroad. To most critics, he never seems to have gone beyond virtuoso flattery and an ability to give pleasure. To Marie-Henri Beyle, whose pen name was Stendhal, he did not even accomplish that. Stendhal wrote, in 1824: "M. Lawrence's manner is a caricature of the carelessness of genius. I admit I do not understand the reputation of this painter. . . . His figures do not have a wooden appearance . . . but truthfully, they possess very little merit. . . . M. Lawrence must be very clever, or else our London neighbors must be very poor connoisseurs." Like SARGENT at the end of the 19th century, Lawrence was a brilliant mirror of a certain class at a certain moment in time.

Lawson, Ernest

1873–1939 • American • painter • Impressionist

I would like to communicate the artist's point of view which is at its best, the power to see beautifully, which is almost all that is worth bothering about.

Lawson made an unusual, if not incongruous, combination: IMPRESSIONIST in style and technique, unlike their hedonistic subjects, his paintings related to the working classes, the same people whose lives were so vigorously explored by the so-called Apostles of Ugliness, artists of the ASHCAN SCHOOL. Lawson

studied with the AMERICAN IMPRESSIONISTS WEIR and TWACHTMAN even before he went to Paris in 1893. In Paris, Lawson worked alongside Somerset Maugham, who named and modeled the artist in his novel *Of Human Bondage* (1915) after his studio mate. In Lawson's oeuvre, sometimes what seems to be a rural landscape is actually a city scene in which industrial buildings hover benignly at a distance. Lawson especially liked to paint New York's rivers and bridges (e.g., *Winter Landscape: Washington Bridge,* 1905–15), and while often his PALETTE was soft and light, sometimes his brushstroke was thick and his colors bright: a pink factory with a blue roof, a tugboat in green, red, orange, and blue. Lawson exhibited as one of The EIGHT. He seldom spoke about his work, but in his later years he wrote down what he called "The Credo," which is quoted from above.

Le Brun, Charles

1610–1690 • French •
painter/administrator • Baroque

The Motions of this Passion [love], when it is simple, are very soft and simple, for the Forehead will be smooth, the Eye-balls shall be turned. The Head inclined towards the Object of the Passion, the Eyes may be moderately open, the White very lively and shining, and the Eyeball being gently turned towards the Object, will appear a little sparkling and elevated.

Louis XIV took over the government of France in 1661. His chief adviser was Jean-Baptiste Colbert, and their joint mission was the glorification of France, which became the strongest power of Europe. Colbert delegated artistic autocracy to Le Brun, who supervised all the king's projects related to art and architecture. Le Brun controlled a workforce of painters, sculptors, engravers, weavers, dyers, goldsmiths, and so on, devoted to providing the Sun King with the most magnificent surroundings. The first project was the completion of the Louvre palace, in process for more than 100 years. The Palace of Versailles was begun in 1669. The preferred style was a modification of extravagant Italian BAROQUE with French CLASSICISM. During this period, despite political antagonisms, French style permeated other Western European countries. Not only did he control the commissioning of artists, but Le Brun also established a new system for educating them at the Royal Academy of Painting and Sculpture in Paris. He became its director in 1663. In a lecture delivered in 1668, Le Brun discussed the human face and the emotions it could show, systematizing and categorizing the passions, as described in the segment quoted above. Ironically, in Le Brun's own paintings (rare during his artistic dictatorship but more substantial once Colbert died in 1683 and Le Brun was displaced from his position), he followed the quasi-CARAVAGGESQUE manner of lighting and imparted an emotional atmosphere more personal than his lectures would suggest. (See also VERSAILLES)

Le Corbusier (Charles-Édouard Jeanneret)

1887–1965 • Swiss • architect •
Modern/International Style

*Phenomenon of visual acoustics. . . .
The shell of the crab.*

Le Corbusier began his career building houses that he called "machines for living." The masterpiece of his "machines" is the Villa Savoye in Poissy-sur-Seine, France (1929–31). Elevated above the ground on slender concrete pillars, it is a rectangular box with flat white surfaces divided by strips of windows. The interior, with glass walls, surrounds a courtyard. Le Corbusier was interested in the interpenetration of interior and exterior space, and while to the passerby the house presents a stern facade, for inhabitants it opens up to the outdoors with freedom and light. While the Villa Savoye's concrete surfaces were smooth, for later projects Le Corbusier inaugurated a new style, later called New Brutalism, using rough concrete. It was part of the "truth-to-materials" doctrine also expressed by artists and architects as diverse as TATLIN and Frank Lloyd WRIGHT, among others. During the 1950s, Le Corbusier received a major commission to plan the new city of Chandrigarh in India. In his later work Le Corbusier explored free, organic forms, still using concrete. Nôtre-Dame-du-Haut, in Ronchamp, France (1950–55), is as upsweeping in its curves as the Villa Savoye is rigorously geometrical. About Ronchamp, as the building is familiarly known, Le Corbusier wrote the words quoted above, and went on, "In the brain the idea is born, indefinite it wanders and develops. On the hill I had meticulously drawn the four horizons. . . . It is they which unlocked, architecturally, the echo, the visual echo in the realm of shape." The architect Raphael Soriano (1904–1988) wrote, "Nearly every architect loves the Ronchamp Chapel."

But Soriano also challenged Le Corbusier's ideas, like those above, saying, "These are all marvelous-sounding words—but just find the content. If this is not voodoo I would like to know what is. What you learn . . . is nothing."

Le Moyne de Morgues, Jacques

1533–1588 • French • painter • Northern Renaissance

My special duty when we reached the Indies would be to map the seacoast and harbors, indicate the position of towns, plot the depth and course of the rivers.

Le Moyne sailed from France with an expedition to Florida in 1564. His assignment was to document the journey, as in the quotation above, but the only remaining original picture of his excursion is entitled *René Laudonnière and the Indian Chief Athore Visit Ribaut's Column* (c. 1570). It was painted after he returned home and records a monument erected by the French as a territorial claim. This garlanded column with the French coat of arms is treated as a sort of altar, surrounded by food offerings and rows of kneeling Native Americans. The tribal chief, in the idealized "noble savage" role, rests his hand on the shoulder of the explorer Laudonnière. Designed to satisfy European curiosity, this small GOUACHE on PARCHMENT is more fanciful than accurate, presenting the Native peoples with blond hair, for example, and vegetables that do not grow in Florida. Le Moyne's style is recognizably that of the FONTAINEBLEAU painters (e.g., Jean and François CLOUET), and especially of a contemporary portraitist of great repute at the time, Corneille de Lyon

(c. 1500/10–c. 1575). Le Moyne was a Calvinist and may have left France for religious reasons. He went to England, where he was taken on by Sir Walter Raleigh. Some of his New World paintings were translated into ENGRAVINGS and used to illustrate *America* (1590), published by Théodore de Bry.

Le Nains, The (Antoine c. 1588–1648, Louis c. 1593–1648, Mathieu c. 1607–1677)
French • painters • Baroque

They are historians. (Champfleury, 1850)

"More ink has been spilled over the 'le Nain problem' than over any other question in French seventeenth-century art," wrote BLUNT in 1953, "and the process will assuredly continue, because, though at certain moments a solution has seemed to be near, new evidence has always been produced which has necessitated a re-examination of the whole problem." The problem Blunt refers to concerns which of the three Le Nain brothers painted what. Their individual hands have been hard to distinguish, as their works are all signed LE NAIN, and that, as Blunt adds, "has greatly exercised the minds of historians." Perhaps they collaborated, perhaps not. The important paintings usually, though uncertainly, attributed to Louis, such as *Peasants at Supper* (c. 1642), were long described as combining a sensitivity to the lives of poor peasants with an interest in the use of dramatic lighting to reveal strength of character. The observation about lighting is true; however, titles aside, the rest may be misleading. Research into details of the clothing worn and objects present in these paintings indicates that the people portrayed are more likely members of the newly emerging class of small landowners than peasants, and that they may even be the PATRONS of the paintings. The social circumstances of these sober country people are very close to what is known about the Le Nain family itself. In this context, the comment by Champfleury, quoted above, may signal the most meaningful approach to the Le Nain oeuvre: the painters as historians. In any case, their range of color is often limited to shades of brown and white, and the indirect light is shed on an arrangement of people that is almost like a STILL LIFE composition.

Ledoux, Claude-Nicolas
1736–1806 • French • architect • Neoclassicist

The artist demonstrates his character in his works.

The phrase *architecture parlante* (architecture that speaks) is frequently used to describe the work of Ledoux as well as that of his contemporary BOULLÉE. The ideas communicated by Ledoux's designs derive from the ENLIGHTENMENT period in which he lived, a time in which the CLASSICAL past could be embraced with defiant individuality. Such is the case, for example, of Ledoux's Barrière de Villette (1785–89) in Paris. Of the 50 tollgate structures Ledoux designed for the new walls built around the city toward the end of the 18th century, this (restored) example is one of only four that still stand. The rest were destroyed during the French Revolution, when Ledoux himself was jailed for his association with royal patron-

age. The Barrière de Villette has a circular rotunda approached through a portico that immediately suggests the PANTHEON. Yet there is no dome over the rotunda, and its large scale defies the proportions of its Roman prototype. Moreover, the eight Corinthian COLUMNS of the Pantheon's entryway have become eight starkly unadorned pillars. These and other differences in the structure and its prototype defy CLASSICISM while alluding to it, speaking in the language of a new, irreverent age. This is similar to the way in which 20th-century POSTMODERN architects use Classical examples, giving them complex, ambiguous, and ironic inflections. If the comment above expresses Ledoux's belief in the artist's individual expression, it also poses the question of whether the artist's character should be "read" through interpretation of the buildings, or if the buildings' meanings, or intentions, are better understood using what we may learn of the architect's character. The historian Emil Kaufmann stresses the importance of Ledoux's personality, which he describes as "uncompromising." He calls the book Ledoux wrote and published, at his own expense, *L'architecture considéré sous le rapport de l'art, des moeurs et de la législation,* in 1804, just two years before his death, "the passionate outburst of a deeply disappointed man, the resentful remembrance of bitterly felt indignities." Ledoux was an idealist with the reformist, nature-based mysticism of Jean-Jacques Rousseau. His humanitarian ideals are expressed in ENGRAVINGS of houses for the poor, for a scientist, and a House of Communal Life, an idyllic shelter in the woods for 16 families who would live on the harvest of their gardens, vineyards, and orchards.

Léger, Fernand
1881–1955 • French •
painter/sculptor • Cubist

One can assert this: a machine or a manufactured object may be beautiful when the relation of the lines which define its volume are balanced in an order corresponding to those of preceding architectures. We are not, then, in the presence of an intrinsically new phenomenon, but simply of an architectural manifestation like those of the past.

Léger focused the CUBIST's kaleidoscopic vision on a subject that Cubists had not yet treated: the industrial city and the machine aesthetic. Earlier artists (e.g., the IMPRESSIONISTs) had celebrated leisure activities of the sophisticated, urban middle class; Léger focused on high buildings and smokestacks, signs, stairways, and metal grids (e.g., *The City,* 1919), which he portrayed in semi-abstract, volumetric compositions. In contrast to RUSKIN and Robert MORRIS, who reacted with horror at the evil effects of industrialization, Léger found the Machine Age beautiful. In *Three Women* (1921), large nudes are transformed into figures of columns and spheres that look both machine-made and machine-like. Posed on a divan and surrounded by ART DECO patterns, the women are simultaneously glamorous and daunting—technological versions of the FEMME FATALE. The inventive progression of Léger's styles, in sculpture as well as painting, was increasingly fanciful as he began to shape his figures with thick

LEIGHTON, FREDERIC 387

black outlines and to flatten them. Also capricious, he showed the interwoven forms of people tumbling through space (*The Polychrome Divers*, 1942–46), seemingly a conflation of LIPCHITZ's *Joy of Life*, 1927–60, and MATISSE's ecstatic nude dancers in his *Joy of Life* (1906). Léger might also pose his figures as if in a tableau: *The Great Parade* (1954) is made up of highly simplified circus performers in frozen poses. Here, through transparent swaths of color and various combinations of lines, Léger has created a picture so animated that it seems to jump off the canvas. Whether his figures move in space or space seems to move around them, Léger looked at the contemporary world in surprising new ways, trying to produce art that appealed to a proletarian as well as to an elite audience.

Lehmbruck, Wilhelm

1881–1919 • German • sculptor • Expressionist

. . . sculpture is the essence of things, the essence of nature, that which is eternally human.

An outstanding German EXPRESSIONIST, Lehmbruck assimilated many influences, especially MAILLOL—he was in Paris from 1910 to 1914—but filtered them through his own sensitive point of view. A larger-than-life bronze, *Standing Woman* (1910), has the shape of a sculpture by Maillol, but where Maillol would express the challenges of form and balance, Lehmbruck shows a delicacy of attitude and a posture of introspection. Some of Lehmbruck's elongated figures seem to have been inspired by a Belgian sculptor, Georges Minne (1866–1941). Working in a hospital

during World War I, Lehmbruck fell into a depression that led to his suicide.

Leibl, Wilhelm

1844–1900 • German • painter • Realist

Several peasants came to look at [the painting] just lately, and they instinctively folded their hands in front of it. One man said, "that is the work of a master." I have always set greater store by the opinion of simple peasants than by that of so-called painters, so I take that peasant's remark as a good omen.

Leibl made the comment quoted above in a letter to his mother written in 1879. The picture to which he refers, *Three Women in Church*, took him four years to finish (1878–82) and is his masterpiece. Like COURBET, Leibl paid homage to the hardworking laborers, "simple peasants," as he said in the passage above. Despite its title and the fact that the women are kneeling, two with books in hand, *Three Women in Church* shows none of a church's standard religious objects, but the women's costumes and the carved woodwork of the pews are executed with painstaking detail. Leibl and his circle were important influences on a group of American artists in the early 1870s. (See also MUNICH SCHOOL)

Leighton, Frederic

1830–1896 • English • painter • Academic

[I am] passionate for the true Hellenic art and am touched beyond everything by its noble simplicity.

Leighton painted a theme that was widespread and popular during late

Victorian times but that has generally been out of favor since: languorous, beautiful women, clothed in vaporous gowns, inhabiting an unreal world. These women seem to have emerged from the beauties of both PRE-RAPHAELITE and SYMBOLIST painters, yet they are unlike those dangerous FEMMES FATALES. Rather, they appear detached and seem mainly objects of desire, without character or substance. Leighton's *Flaming June* (1894–95) is an archetype: The woman is curled on a bench in innocent sleep, thus entirely vulnerable to the lascivious GAZE and sexual fantasies. To heat those fantasies, she is lightly covered in a transparent orange gown, and glistening behind her is the broad reflection of sunset on lightly rippled water. The source for *Flaming June* is the "Hellenic art" to which Leighton refers in the quotation above, specifically the sculpted marble *Three Goddesses* (c. 438–432 BCE) from the east pediment of the PARTHENON, by then in London as part of the ELGIN MARBLES. Setting this Victorian type in historic context, it is noted that during Leighton's era, as women pressed to acquire the right to vote and some measure of equality, so efforts to suppress them were manifest and found expression in imagery such as the pictures of Leighton, ALMA-TADEMA, and others.

Leochares

active c. 350 BCE • Greek • sculptor • Late Classical/Hellenistic

Leochares made an eagle, which is aware of just what it is abducting in Ganymede and for whom it carries him, and which therefore refrains from injuring the boy with its claws, even through his clothing. (Pliny the Elder, 1st century CE)

Known through literature rather than for specific works, Leochares was employed by both Philip of Macedon and his son, Alexander the Great. He is reported as having carved several individual sculptures, including one renowned statue of Zeus and another of Apollo (which may be the APOLLO BELVEDERE). Leochares was also employed to work on the MAUSOLEUM OF HALICARNASSUS, and although scholars are able to discern distinctive styles in surviving fragments of its frieze, specific attributions to one artist or another are not agreed on. The lost work to which PLINY the Elder refers in the quotation above would have represented the myth of Ganymede, a shepherd with whom Zeus fell in love. The god changed himself into an eagle in order to carry off Ganymede to Olympus, where the boy became the god's wine cup bearer. This story is interpreted as an example and approbation of homosexual love.

Leonardo da Vinci

1452–1519 • Italian • painter • Late Renaissance

It happened to me that I made a religious painting which was bought by one who so loved it that he wanted to remove the sacred representation so as to be able to kiss it without suspicion. Finally his conscience prevailed over his sighs and lust, but he had to remove the picture from his house.

Just a few worn and damaged paintings by Leonardo remain, not only because

of the ravages of time, but also because he left so many projects unfinished. Yet the power of his imaginative, innovative mind still shines, and in the drawings and writing, as well as the paintings, that are left, there is ample evidence of both his personal genius and the changes in artistic ideology he initiated. Among these was his determination to prod beyond mood and emotion to psychology. That distinguishes his *Last Supper* (1495–97/98) from those of other artists: Where they chose to paint the drama of Christ singling out Judas, and to accentuate the bread and wine as foretelling the Eucharist (see RAPHAEL's *Disputa* and TINTORETTO's *Last Supper*), Leonardo illustrated both an earlier moment, when Christ announced that one among them would betray him, *and* the Eucharist, symbolically, through Christ's role at the table. Leonardo was interested in and conveyed reaction of each individual apostle to Christ's startling news, each one's self-examination and self-doubt. "A good painter has two chief objects to paint," he wrote, "man and the intention of his soul." Leonardo also developed new techniques, including his system of MODELING in the early stages of painting—he considered modeling the very essence of a painting. To model, he used a single color, probably in TEMPERA and OIL PAINT, and pre-painted the picture with his desired range of dark and light, CHIAROSCURO. Transparent oil GLAZES, tinted with PIGMENT, were applied over this. Leonardo's system cannot be detected by scientific method; although infrared REFLECTOGRAPHY is able to penetrate painting, it can pick up only carbon black, which Leonardo did not

use. Rather, his unfinished *Adoration of the Magi* (c. 1481) reveals his method. Another innovation is his famous SFUMATO (smoky) mode of coloring in which the range of COLOR is kept at mid-value and low intensity, and transitions from one color to the next are gradual and hazy. This created a pearly mist for atmospheric PERSPECTIVE, evident in the background of his *Mona Lisa* (begun c. 1500–03). The technique was new and the idea behind it revolutionary, for in revealing that combinations of light, humidity, and color are interrelated (transient atmospheric variables), he translated into paint the concept of time passing. Until then, painting was given to the expression of eternal values. "This profoundly radical change ushered in a new style, making possible the great dramatic effects [in 16th-century] painting that depend, like the theater, on the ability to control both space and time," writes Marcia Hall.

Leonardo developed the pyramidal type of composition, building figures or lines of movement to reach the summit of a triangle. This system supplanted the earlier tendency to line up the action along parallel PICTURE PLANES. Modifying and rejecting the rules and regulations set by his predecessors, Leonardo constantly experimented. Sometimes, as with *Last Supper,* where he tried to paint a mural with an oil-base paint of his own concoction (efforts to analyze it have been unsuccessful) rather than *buon* FRESCO, they were disastrous—the painting began to self-destruct during his own lifetime. A more fanciful experiment was his construction of lizard-skin wings on gold wires with which he outfitted a tamed lizard (to which he also appended a beard).

Whether he wished it to fly or merely to discourage uninvited visitors is not known. Some revisionist approaches to the ITALIAN RENAISSANCE include the reassessment of Leonardo's reputed inventive genius, casting doubt on whether he ever conducted a valid scientific experiment to test his theories. Yet he did all he could to build a flying machine that was based on his painstaking study of the flight of birds—it was a mechanical bird, not an airplane as is generally said—that Leonardo insisted was within the realm of engineering accomplishment.

Impatience with the standard modus operandi probably explains the many unfinished projects Leonardo left, as well as his hundreds, perhaps thousands of ideas and inventions in fields that range from aeronautics and hydraulics to human anatomy and reproduction. He left behind thousands of pages of his notes, and what survives is estimated to be but a third of what he actually wrote. Whether larger than life or not, the few particulars of his biography combined with his oeuvre have stirred the imagination of BAUDELAIRE, Freud, and DUCHAMP (who added a goatee and an obscenity to a photograph of the Mona Lisa). Leonardo, born out of wedlock, was adopted into his father's family. He trained with VERROCCHIO and was patronized by the major, and sometimes warring, powers of his era, moving among Florence, Milan, and Rome. It was at the Vatican, where he lived at the invitation of the pope, that he made his winged lizard. While religious and political upheavals may have determined his patronage and place of residence, Leonardo was, like RAPHAEL and CELLINI, detached from the political and religious controversies of his era. From 1517 until his death, he was in France as a guest of King FRANCIS I, who asked only that Leonardo honor him with conversation.

Leoni, Leone
c. 1509–1590 • Italian • sculptor • Mannerist

. . . as many of the celebrated works, carved and cast, antique and modern, as he was able to obtain. (Vasari, mid-16th century)

VASARI, quoted above, is speaking with admiration of the remarkable collection of plaster casts Leoni had installed at his house in Milan, and particularly the EQUESTRIAN *Marcus Aurelius,* which stood in the courtyard. Some of these were no doubt from molds Leoni bought from PRIMATICCIO, who had made them from CLASSICAL statuary for the king of France's palace at FONTAINEBLEAU. As a result of his purchase, actually on behalf of his PATRON, Queen Mary of Hungary, so that he might make bronze casts, Leoni possessed what was at the time probably the largest private collection of casts after ANTIQUE sculptures. Among the most impressive of his own works is a life-size bronze of another of his patrons: *Charles V Triumphing over Fury* (1549–55). Straddling his foe—the personification of Fury—youthful, handsome, and elaborately armored, Charles is in the pose of POLYKLEITOS's embodiment of perfection, *Doryphoros* (c. 450–440 BCE). Leoni's coup de grâce was to cast the armor separately so that it might be removed to reveal a perfect, heroic NUDE.

Les Vingt
See VINGT, Les

Lessing, Gotthold
1729–1781 • German • writer

The details, which the eye takes in at a glance, [the poet] enumerates slowly one by one [but] when we look at an object the various parts are always present to the eye. It can run over them again and again.

Though most of Lessing's writing was for the theater, he was inspired to critical dissent by WINCKELMANN's discussion of Greek art, especially Winckelmann's comments about LAOCOÖN. The full title of Lessing's famous essay is "Laocoön, or On the Boundaries between Painting and Poetry" (generally known as "Laocoön"; 1766). Lessing allowed that the statuary group, which Winckelmann had seen in the Vatican but Lessing had not, preserved its serene dignity and grandeur despite the mortal pain its figures endured. However, he took issue with the concept of UT PICTURA POESIS—as in painting so in poetry. Lessing held that each pursuit should follow, and be defined by, its own intrinsic concerns. Thus, poetry should be concerned with events that unravel in time and should not endeavor to describe objects in space. The proper sphere for painting, in contrast, is the description of objects in space— they should not try to tell a story. The disadvantage of Lessing's idea was the confounding of sculpture, which is created to occupy three-dimensional space, with painting, which is executed on a flat surface—as MODERN artists would later so adamantly argue. With his insistence that the FINE ARTS not endeavor to portray events in time, Lessing went far toward liberating them from a narrative or literary raison d'être, although his intention was more directed toward defending the realm of poetry against what he saw as an invasion by the visual arts.

Leutze, Emanuel
1816–1868 • American • painter • Romantic

... the romantic ruins of what were once free cities, with their grey walls and frowning towers, in which a few hardy persevering burghers bade defiance to their noble oppressors ... led me to think how glorious had been the course of freedom from those small isolated manifestations of the love of liberty to where it has unfolded all its splendor in the institutions of our own country.

HISTORY PAINTING finally succeeded in America in the hands of Leutze after earlier painters (e.g., VANDERLYN and ALLSTON) had failed to import it. Born in Germany, Leutze returned there to study at DÜSSELDORF, and remained in Europe for 20 years. That was where he painted his major opus, overwhelming in size (12 feet 5 inches by 21 feet 3 inches) as well as concept: *Washington Crossing the Delaware* (1851) was as idealized and dramatic a representation of America's first hero as anyone could imagine. Washington had died 50 years earlier. Although he had surprised the enemy by crossing the Delaware River at night, the rest—Washington standing in what would have been a foolish pose on the bow of an overpopulated boat that is being paddled through ice floes—has no basis in fact. (WHIT-

TREDGE posed for hours both as Washington and as his helmsman.) It was all part of the mythologizing of Washington, captain of the metaphorical ship of state. With that success in hand, Leutze was asked to paint a mural for the U.S. Capitol: *Westward the Course of Empire Takes Its Way* (1860). It was a glorification of America and Manifest Destiny (for Manifest Destiny, see COLE). The ruins of which Leutze speaks in the quotation above are those he saw when visiting his birthplace in Swabia. That train of thought led to his formulation of the ideas for his American history paintings.

Lewis, Edmonia
active 1845–after 1911 • American • sculptor • Neoclassicist

My mother was a wild Indian and was born in Albany, of copper color and with straight black hair. There she made and sold moccasins. My father, who was a Negro, and a gentleman's servant, saw and married her. Mother often left her home and wandered with her people, whose habits she could not forget, and thus we, her children, were brought up in the same wild manner. Until I was twelve years old, I led this wandering life, fishing and swimming . . . and making moccasins.

Lewis's parents died when she was four, and she was raised in her mother's Chippewa tribe under the name Wildfire. She studied at Oberlin College, the first coeducational and interracial college in the United States, and went to Rome in 1845, where she worked with HOSMER in a group of sculptors Henry James called "the white marmorean [marble] flock." Her subjects were related to her own background; for example, *Forever Free* (1867) represents two former slaves who have broken their chains of bondage. She also made a number of sculptures based on Henry Wadsworth Longfellow's *The Song of Hiawatha* (1855). Lewis seems to have faded away toward the end of her life, and the date and circumstances of her death are unknown.

Lewis, Percy Wyndham
1882–1957 • English • painter/writer • Vorticist

By vorticism we mean (a) Activity as opposed to the tasteful Passivity of Picasso; (b) Significance as opposed to the dull and anecdotal character to which the Naturalist is condemned; (c) Essential Movement and Activity (such as the energy of a mind) as opposed to the imitative cinematography, the fuss and hysterics of the Futurists.

The founder of VORTICISM, Lewis described its intentions in a nutshell in the catalogue of the style's only exhibition, in 1915, quoted from above. If Lewis scoffed at other current movements, he was in turn harshly put down by FRY and Clive Bell, who berated the "little backwater, called English Vorticism, which already gives signs of being as insipid as any other puddle of provincialism." Vorticism was closely related to FUTURISM's artistic goals, but highly critical of its militarism. Lewis's paintings are strong and structural abstractions: *A Battery Shelled* (1917–18) describes his wartime experience in the trenches, stopping and solidifying movement and even the smoke of battle.

LeWitt, Sol
born 1928 • American • sculptor • Conceptual

These sentences comment on art, but are not art.

LeWitt is often called the father of CON-CEPTUAL ART. The designation applies to his sculptures, usually white constructions such as *Wall/Floor Piece # 4* (1976), a grid of identical open cubes that, while assembled according to strict, predefined numerical ratios, are, once executed, visually complex and intriguing. As one looks at them, they repeatedly change pattern, shape, and depth, and seem continually to escape definition. LeWitt may present his concepts to assistants on paper, or sometimes on the very wall where they are to carry out his instructions. Often impermanent, non-collectible, and noncommercial (and unsigned), these wall drawings, like the sculptures, are absorbing and frequently beautiful. LeWitt's patrimony of the genre is also connected to his *Paragraphs on Conceptual Art* (1967) and subsequently his series *Sentences on Conceptual Art* (1969), from which the concluding sentence is quoted above. The first two sentences are "Conceptual artists are mystics rather than rationalists. They leap to conclusions that logic cannot reach."

Leyden, Lucas van
c. 1494–1533 • Netherlandish • printmaker/painter • Northern Renaissance

I know of none who was the equal of the gifted Lucas van Leyden. . . . Nearly incredible stories are told by those who still know, that when he was but a child of nine he produced engravings of his own composition, extremely well done and subtle. (Carel van Mander, c. 1604)

It is known that he studied with his father, a painter, and with another painter, Cornelis Engelbrechtsz (1468–1533), also of Leiden (Leyden), but there is not much information about how Lucas became so extraordinarily accomplished as a printmaker. (Although he also painted, he is best known for his ENGRAVINGS.) Lucas was above all a narrative and landscape artist—telling stories in provocative ways and integrating them into an effective atmospheric, natural environment. Once he mastered the medium of printmaking (see PRINTING), which was relatively new and promised a vast audience, he also used it to express ideas that were then on people's minds. One such contemporary question had to do with the rite of baptism, and whether it was appropriate for infants or only for adults. He raised that issue in *Baptism of Christ* (c. 1510), and to make the point of the issue clearer, he showed a child watching Christ's submersion in the water from its banks. There are anonymous bystanders in the foreground engaged in conversation, which the image hoped to provoke among its audience without necessarily revealing any stand the artist might take. To make his subject even more eye-catching, he devised the technique of "inverted composition," with the main topic of the scene in the background and more incidental figures in the foreground. This was a style he increasingly adopted during the course of his career.

Moreover, as Craig Harbison has observed, Lucas's illustrations of this topic preceded any written exegesis of it, providing the example of an instance in which visual imagery preceded the text. The "text" ultimately reached print not only in the form of theological argument in the 1520s, but also in a movement that culminated in the Anabaptist revolution in Münster during the 1530s. Harbison writes, the "very suggestiveness of art seems to have been an active agent in the formulation of religious thought and feeling."

Leyster, Judith

1609–1660 • Dutch • painter • Baroque

From her death in 1660 through the end of the nineteenth century, no painting was publicly sold with an attribution to Leyster. (Frima Fox Hofrichter, 1993)

Leyster was one of the few Dutch women who were able to succeed without depending on a male relative. In her early 20s she became a master in the Haarlem Guild, set up her own shop, and was the only woman painter in Holland who had students. A skilled businesswoman, after her marriage to fellow artist Jan Miense Molenaer in 1636, she ran his studio, but apparently she no longer painted. Both Leyster and Molenaer had studied under HALS. Leyster's subject matter was typical of her era: many everyday, GENRE scenes, including one, *Man Offering a Woman Money* (1631), understood as an allusion to prostitution. Numerous followers of CARAVAGGIO painted the prostitute as temptress, but Leyster showed a different point of view: Bent

over her sewing, the woman ignores the man's offer of coins. From the evidence of Leyster's *Self-portrait* (1633), she was confident and self-possessed. Even though her neck is encased in a large stiff collar and her head is covered by a starched hat, she smiles easily and leans back casually. Her work fell into oblivion and was discovered only by accident in the late 19th century when her monogram, JL attached to a star, was discovered on a painting attributed to Hals, *The Jolly Companions* (1630). The star was a pun on "Lodestar," a name taken from her father's brewery. Since the 1970s, much research has been done in the effort to recover Leyster's work and restore her reputation.

Lichtenstein, Roy

1923–1997 • American • painter • Pop Art

Oh, I'm in my dotage, I suppose. But I don't think a change in subject really matters that much.

In the manner of POP ART, a major reaction against ABSTRACT EXPRESSIONISM, and with Pop's devotion to emblems of POPULAR CULTURE, Lichtenstein used in his art ideas and techniques from the comic strips. However, he made his images as single panels and vastly enlarged them. Painting in OIL and ACRYLICS, he used the same limited, flat colors and precise, dark outline drawing that was popular in newspaper features like *Dick Tracy* and *Wonder Woman*. He also mimicked the characteristic BEN DAY mechanical printing process, in which dots express tone, achieving a kind of ersatz POINTILLISM. Lichtenstein used comic-strip-like characters, whose words fill balloons, in some of

his paintings, and in others he freely copied works by PICASSO and MONDRIAN, for example, in his comic-book style. Not until 1995 did he begin to paint nudes, a preoccupation with the human body that seemed new in his work. Asked about the change, Lichtenstein made the comment quoted above. More seriously, he added, "I had the idea that the nude would be a kind of undulating surface that would show off light and shade. Also, I liked the idea that the heavy lines and dots were so unrealistic and unsensual, contrary to the way we think of human flesh."

Lievens, Jan
1607–74 • Dutch •
painter/printmaker • Baroque

[My portrait is] . . . out of the hand of Mr. Levinus, the Duke of Brandenburg's paynter. He duelt at the signe of the fleur-de-luce and you may be sure of a good one. He ist the better because he hath so high conceit of himself that he thinks here is none to be compaired with him in all Germany-Holland, nor the rest of the 17 provinces. (Robert Kerr, Earl of Ancram, 1654)

His artistic training began at the age of 8; before he was 11, Lievens was studying with Pieter LASTMAN in Amsterdam; and by 13 he was working on his own in Leiden. Lievens became a friend of REMBRANDT when the latter began his apprenticeship in Leiden. They developed along different lines; Lievens was less interested in psychology than he was in melodrama and was also inclined to a larger scale; however, a number of works attributed to Rembrandt were probably by Lievens. The two parted in

the early 1630s, and while he received commissions for allegorical subjects, HISTORY PAINTINGS, and portraits, as the quotation above illustrates, Lievens's contribution to the history of art is relatively slight.

Limbourg, Pol, Herman, and Jean de
died 1416 • Franco/Flemish •
painters • Late Gothic/International Style

A counterfeit book, made from a piece of wood and painted to look like a book, though it has no pages and nothing written. (Robinet d'Etampes, 1411)

The book described above was both a gift and a joke of the Limbourg brothers, who presented it to their PATRON, Duke Jean de Berry. With the words quoted above, Robinet, court librarian, listed the book for the duke's inventory. Earlier the Limbourgs had worked for Philip the Bold, Duke of Burgundy (see VALOIS)—their uncle, Jean Malouel, was an artist in Philip's court and probably introduced them—and earlier still, prior to 1400, they were in a Parisian goldsmith's workshop. By 1402 all three were painting MINIATURES for Duke Philip. When Philip died, they went to work for his brother, Jean. *Les Très Riches Heures,* one of the most renowned and beautiful books in history, was under way when they, and their patron, died in 1416, probably victims of the plague. Their masterpiece was left unfinished. Much discussion has revolved around which brother did which pages, but there is no consensus. Their work is a marvel of precise detail and rich color, a visual REALISM[1] that

characterized their era. They followed the duke's peripatetic court, and several of his fairy-tale-like castles appear in the background of their illustrations. One building they painted, Mont-Saint-Michel, had not yet been completed as planned, and never was, although the artists presented it as if it were. *Les Très Riches Heures* is a BOOK OF HOURS with full-page representations of the months, each showing appropriate seasonal activities, alternating scenes of the nobility in their leisure and the peasants at work. Topographically as well as architecturally descriptive, the pictures reveal the social graces of nobles and occupations of the laboring class. In the foreground of *October,* for example, a field is being sown with winter wheat, and shimmering in the background is the Louvre palace in Paris. Moreover, for the first time since CLASSICAL ANTIQUITY, figures cast shadows. The *February* miniature shows one of the earliest snow-covered landscapes in the history of Western art.

limner

A MEDIEVAL term for a painter of ILLUMINATED MANUSCRIPTS. In Britain, during the 15th century, and later, during the 16th and 17th centuries in New England, "limner" was used to mean painters in general, especially portraitists.

Lin, Maya Ying
born 1959 • American • architect/sculptor • Modern

Even my earliest work was influenced by geology and topology. I saw the Vietnam Veterans Memorial not as an object placed into the earth but as a cut in the earth that has then been polished, like a geode. Interest in the land and concern about how we are polluting the air and water of the planet are what make me want to travel back in geologic time—to witness the shaping of the earth before man.

Lin won a competition to design the Vietnam Veterans Memorial in Washington, D.C. (1981–83), when she was a 20-year-old undergraduate student in architecture at Yale University. Made up of seven slabs of highly polished granite engraved with the names of Americans killed in the war, the memorial is located on the Mall. Although there were protests when the design was chosen, and a conventional group of statues commemorating the soldiers was later erected to satisfy those dissenters, Lin's work has proved to be unparalleled in the profundity of its effect. Besides the beauty of its MINIMALIST simplicity, she has tapped into our human response to the power of a name: Visitors to the wall earnestly seek identification of the individual they are mourning, sometimes make rubbings of his or her name, and leave behind letters, photographs, and other tokens (some of these items are now on display at the National Museum of American History). Moreover, the polished surface acts as a mirror linking the living with the dead. Lin has received a variety of other notable commissions that include additional public monuments and buildings, and for New York City's Pennsylvania Station, she designed *Eclipsed Time* (1994), a clock that suggests the movement of an eclipse.

line vs. color

The debate about the value of line vs. color is also known as the battle of the Ancients (representing "line") and the Moderns (representing "color"), and as Poussinistes (admirers of POUSSIN, who followed the example of CLASSICAL art) versus Rubenistes (after RUBENS, who was an outstanding colorist). Education at the ACADEMY had long defended the line/Ancient/Poussiniste position, which was debated especially hotly in the French Academy during the 17th century. The Poussinistes were championed by LE BRUN and the Rubenistes by the critic de PILES. By the end of the century, the views of the Rubenistes had gained the lead. "Line" here refers to defining edges, clear outlines. For example, line is emphasized in Greek POTTERY and in works by FLAXMAN and INGRES, besides those of Poussin. Among painters whose emphasis is on color are CARAVAGGIO, TITIAN, van DYCK, and REMBRANDT, in addition to Rubens. It should be kept in mind, however, that these are relative preferences, or values, and the dichotomy is not absolute. It has to do with emphasis within a spectrum that might have a line drawing at one end and an image defined entirely by color relationships at the other.

linear

A term introduced to ART HISTORY by WÖLFFLIN, "linear" describes the concept of line, often as outline, leading the eye and defining the surfaces and contours in a painting, making them tangible and finite. Linear forms may be modulated by light and shadow, but we never lose the sense that they have edges, or boundaries; there is no melding of, or fluidity between, forms. BOTTICELLI's *Birth of Venus* (c. 1484) is a linear picture.

Linked Ring

See SECESSION

Lipchitz, Jacques

1891–1973 •
Lithuanian/French/American •
sculptor • Cubist

The problem was to combine light and shade in my likeness, not by copying my face and then simplifying it, nor by deforming it afterwards on the pretext of style . . . the capture of likeness was a very long affair . . . and the day in which the two savage beasts understood each other to perfection and became domestic animals, Lipchitz decapitated me. (Jean Cocteau, 1922)

Born in Lithuania, Lipchitz studied in Paris and, between 1915 and 1925, sculpted in a CUBIST manner. He began by simplifying figures in overlapping vertical and horizontal planes. One might think of *Head* (1915) as a detail of a painted Analytical Cubist portrait translated into bronze. Less abstract but still simplified in form is his *Portrait of Jean Cocteau* (c. 1920), about which the subject wrote an essay that is quoted from above. Lipchitz's work progressed, expressing alternately stillness—as in the humorous, totemic *Figure* (1926–30), in which eyes seem to look out from a disk attached to a three-part body—and boisterous activity, as in the 11-foot-high *Joy of Life* (1927–60), in which curved forms are acrobatically linked. Between 1944 and 1953, Lipchitz used a mythological figure for a contemporary analogy: *Prometheus*

Strangling the Vulture shows Prometheus as the Allied victory in World War II and the eagle as symbolic of the Axis powers. Lipchitz had moved to the United States in 1941. After the war he was chosen to design a shrine to the Madonna (1948) for a church in France. Lipchitz expressed his deep appreciation that he, "a Jew, true to the faith of his ancestors," as he put it, was awarded that commission. The Virgin's figure is continuous with and surrounded by a heart-shaped MANDORLA. Such continuity of forms, of one shape uniting with and becoming another, is characteristic of his work throughout his career. In this way, each one of his sculptures, regardless of how radically different it may seem, in fact expresses its evolution from and continuity with all of his work.

Lippard, Lucy
born 1937 • American • critic/artist • Feminist

Horst Janson's standard textbook— History of Art—does not include a single woman. This absence of women from art history, added to emotional needs for gender affirmation, is one of the reasons feminist artists have taken the conventional history of art with a massive grain of salt.

In the effort to devise a specifically FEMINIST art criticism, Lippard was one of the most important writers in what is now called the "first generation" of Feminist art critics. Her METHODOLOGY has no rigid theoretical "system" such as MARXISM, Socialism, or DECONSTRUCTION, though it may incorporate those points of view. She covers much ground and has contributed greatly by discovering and writing about art and artists outside the establishment. Among her books and articles is *Overlay: Contemporary Art and the Art of Prehistory* (1983), from which the quotation above is taken. In 1985 Lippard was fired from a supposedly progressive publication of the popular press, the *Village Voice,* and this virtual censorship of a Feminist spokeswoman in such a context signals how controversial the Feminist point of view remains.

Lippi, Filippino
1457–1504 • Italian • painter • Renaissance

Filippino's invention was so copious, and his ornamentation so curious and original, that he was the first among the moderns to employ the new method of varying the costumes, and to dress his figures in the short antique vestments. (Vasari, mid-16th century)

Filippino studied first with his father, Fra Filippo (see below), then with BOTTICELLI, who was in his father's workshop. He combined their LINEAR style with the SFUMATO (smoky) manner of LEONARDO. His later works are far more emotional than those of his teachers, particularly *Saint Philip Exorcising a Demon in the Temple of Mars* (1497–1502). The "short antique vestments" to which VASARI refers in the quotation above are interspersed with other richly imaginative costumes, but above all, as the historian Frederick Hartt writes, "Filippino's fresco is, in the last analysis, the painting of a bad smell." Hartt is referring to the demon that, bursting from the base of a statue of Mars, emits such terrible and poisonous fumes that the king's son falls

dead. Besides its cast of overwrought characters, some of whom hold their noses, this painting also makes reference to the GOLDEN HOUSE OF NERO, which had just been found beneath the ruins of the Roman Baths of Trajan. Filippino had gone to see the discovery and adapted its decorations—urns, lamps, masks, lions' feet, known as GROTESQUES—to the architectural details in his own picture. The strangeness of this picture may be related to the turn-of-the-century millennialism that seemed also to affect BOSCH and BOTTICELLI.

Lippi, Fra Filippo

c. 1406–1469 • Italian • painter • Renaissance

You reply . . . you cannot give me another farthing. This has been very painful to me . . . I am clearly one of thy poorest friars in Florence—that's me. God has left me with six nieces to find husbands for, all sickly and useless. . . . Tears come to my eyes when I think that if I die . . . (Letter to Piero de' Medici, Aug. 13, 1439)

After he was orphaned, Filippo's relatives put him in a Carmelite monastery, a most unsuitable placement. His misdemeanors there ranged from forgery to the abduction of a nun, with whom he had a child, Filippino (see above), who also became a painter. It is speculated that Fra Filippo met MASACCIO at the church associated with his monastery, Santa Maria del Carmine in Florence, where the Brancacci Chapel that Masaccio decorated is located (and where Filippino would eventually complete the frescoes in 1484). Fra Filippo's early work, now largely destroyed, may

have resembled the bold, natural approach Masaccio favored, but Filippo's later style was LINEAR and more decorative. This linear definition of form was adopted by Fra Filippo's best-known student, BOTTICELLI.

Lipton, Seymour

1903–1986 • American • sculptor • Abstract Expressionist

It is a new consciousness of the wonder of the regenerative processes in nature, yet seen through and incorporated in its polar opposite, science and technology. This work suggests a nostalgia for nature in a frame of technological vision. What results plastically is neither, but something new, consistent with the will and courage deriving from a new and tragic cultural situation. It is a new metaphysics for man. We cannot return to virgin nature, nor allow destruction by the machine. Somewhere in this polar tension lies the plastic solution for sculpture as I see it.

Trained as a dentist, Lipton began making sculpture in the 1930s. His forms were generally BIOMORPHIC, or protoplasmic, rather than recognizable representations. His earliest works were aggressive in attitude, but later his shapes were rounded and less vicious-looking. A work like *Sanctuary* (1953), of nickel-silver over steel, may call to mind the unfolding bud of a flower, yet in its center are sharp, angular shapes. The quotation above refers to a work entitled *Earth Forge #2* (1955) and clearly expresses Lipton's interest in the problem and play of dichotomies.

Lissitzky, El (Lazar Lisitsky)

1890–1941 • Russian •
painter/sculptor/illustrator/architect •
Folk Art/Suprematist/Constructivist/
Proun

*[Proun is] the creation of form
(control of space) by means of the
economic construction of material to
which a new value is assigned.*

Denied admission to the Academy of
Art in Saint Petersburg because its Jew-
ish quota was achieved, Lissitzky went
to Germany to study. He returned to
Russia when World War I began, and,
sponsored by the Jewish Ethnographic
Society, explored synagogues and JEW-
ISH ART along the Dnieper River. Dur-
ing this era, when artists in Germany
and Russia were interested in FOLK ART,
Lissitzky, like CHAGALL, researched the
folklore of the region's Jews. Lissitzky
illustrated both religious texts and chil-
dren's books, integrating the inspira-
tion of painted wooden synagogues,
bright folk art colors, and folk-based
Hebrew typology with a combination
of CUBISM and FUTURISM. Later he
continued these experimental mixes
with non-Jewish themes in a style he
called by the acronym *Proun* (*Proekt
utverzhdeniia novogo*—Project for the
Affirmation of the New). *Proun Com-
position* (c. 1922) is an example: Simple
geometric shapes at first glance, their
shading and solidity, the repetition of
forms, allusions to a cross and triangu-
lar shapes, increase their complexity.
Under Chagall, and then his successor
MALEVICH, Lissitzky taught architec-
ture at the Vitebsk School of Art and be-
came interested in SUPREMATISM. In the
face of the Russian revolutionary gov-
ernment's conservatism, however, he
returned to Berlin in 1921 and worked
with members of the avant-garde that
included De STIJL and BAUHAUS artists.
He also traveled and worked in France,
Holland, and Switzerland.

lithograph/lithography

Originally from *lithos,* Greek for
"stone," lithography refers to a process
developed in Munich by Alois Sene-
felder (1771–1834) between 1796 and
1799. The smoothed surface of a block
of stone receives the image to be
printed. Unlike other processes devel-
oped for PRINTING, the image is not cut;
rather, based on the principle that oil
and water do not mix, it is drawn with
a lithographic pencil, crayon, or sub-
stance that contains some kind of
greasy, water-resistant material that
will absorb a greasy printing ink. When
the surface of the stone is wet and then
inked, the ink adheres only to the areas
impregnated with the greasy crayon,
and paper pressed on it will take up
those markings. The artist may draw
more freely than he or she can in other
forms of printing that require painstak-
ing cutting. Thus, a lithographic print is
likely to be more directly from the
artist's hand than is a copy of a work in
another medium that may have been
done by a specialist in ENGRAVING, for
example. As do copies made from pre-
existing images, the end product of lith-
ographs reverses the design of the
original. Lithographers take this into
account when drawing directly on
stone, and draw their picture in reverse
of the image they want printed. Thou-
sands of lithographic prints, called lith-
ographs, may be made from an image

on stone. (Metal plates with grained surfaces are usually used in commercial "lithography.")

Lochner, Stefan

active c. 1440–after 1453? • German • painter • Late Gothic/Early Northern Renaissance

If allowance is made for the difference entailed by an interval of more than sixty years, this famed altarpiece [Lochner's Adoration of the Magi] may be said to anticipate much of what strikes us as new in Dürer's composition: the symmetrical, yet by no means schematic arrangement of the whole; the quiet dignity and comparative heaviness of the individual figures; the magnificent contrast between a solemn pyramidal group in the center and lively throngs of worshipers unfolding in the second plane; and even the detail of a cloth of honor spread out by two angels.
(Erwin Panofsky, 1943)

Lochner, who settled in Cologne, has been called the Fra ANGELICO of the North. His paintings have a similar serenity and love of color, his saints the same sweet faces. In his masterpiece, *Virgin and Child in a Rose Arbor* (c. 1440), a sense of otherworldly purity is achieved by setting the Virgin, "a rose among thorns," against a tooled gold background. She is surrounded by angels—those at her feet play musical instruments—and a trellis of roses rises behind her. A traditional representation following MEDIEVAL conventions, its religious purpose was to draw the viewer into mystical contemplation. Lochner's composition and others similarly in-

spired during the 15th century were also related to BYZANTINE art. Efforts to reunite the Orthodox and Roman Churches were under way at that time and Byzantine ICONS were imported into the West, where they were copied. On one of his trips along the Rhine, DÜRER stopped and, as he recorded in his diary, paid to see Lochner's *Adoration of the Magi* (c. 1440–45) in the Cologne Cathedral. PANOFSKY remarks on the effect of that visit in the passage quoted above and adds, "And it is therefore understandable that Dürer's first painting to deserve the title of a Late Renaissance work reveals both the manifest influence of Giovanni Bellini and a recollection, perhaps unconscious, of Stephan [*sic*] Lochner."

Lomazzo, Giovanni Paolo

1538–1600 • Italian • writer/painter • Mannerist

Naples yellow and orpiment [bright, goldlike yellow] cannot be better shadowed than with ocher. But German yellow, being darker, requires a darker ocher. . . . Brown of Spain shadows burnt orpiment.

Lomazzo painted portraits and FRESCOes in and around his hometown of Milan before going blind at the age of 33. He then turned to writing poetry and tracts about painting. The quotation above is from his *Treatise on the Art of Painting* (1584), in a section entitled "Correspondence of Light and Dark Colors," which he began by saying, "It is necessary for the painter to be perfectly acquainted and familiar with the aptitude that each color may have to shadow or illuminate any other. . . ."

(This text was soon translated and published in French and English.) Lomazzo rejected VASARI's preference for drawing over the use of color (see LINE VS. COLOR), holding each to be equal. He also wrote the first systematic account of landscape painting.

Lombardo family
c. 1435–1532 • Italian • sculptors • Renaissance

As a portraitist Tullio was among the first Renaissance artists to be fully aware of the precise angle of the head. The tilt of its axis . . . and turn of the face to the left or right, play a decisive role in creating psychological animation. His ability to utilize such devices effectively probably derived in the first instance from study of Hellenistic sculpture and its formulas for pathos. (Wendy Stedman Sheard, 1978)

The father, Pietro (c. 1435–1515), and two sons, Tullio (c. 1455?–1532) and Antonio (c. 1458?–1516?), though originally from Lombardy, were active in Venice. Primarily sculptors of marble architectural ornament, their style became known as Lombardesque after their ornamentation of the triumphal arch and large chapel (chancel) in the church of San Giobbe in Venice. They used lush vegetation, such as the acanthus leaf, flowers, birds, PUTTI, and other elements of GROTESQUE decoration. The Lombardo WORKSHOP was especially busy in the 1470s and '80s and employed numerous stoneworkers. Tullio was fond of ANTIQUITIES and a collector of relics. The HELLENISTIC influence, mentioned by Sheard in the quotation above, is visible in a small (about 5 inches high) bronze *Head of a Woman* (c. 1490–95).

London Group
Persuaded of their importance by WHISTLER, Walter Richard Sickert (1860–1942) went to Paris to see the IMPRESSIONISTS and POST-IMPRESSIONISTS. He then became the center of a group that met at his studio in Camden Town. It was first known as the Camden Town Group, then, in 1913, became the London Group. The painter Percy Wyndham LEWIS, the sculptor EPSTEIN, and the critic FRY were among the members.

Longhi, Pietro (Pietro Falca)
1700/02–1785 • Italian • painter • Baroque

Longhi, you summon my sibling muse; your pen like mine is seeking truth. (Carlo Goldoni, 1750)

Carlo Goldoni, quoted above, was a playwright whose plots were based on real life in defiance of the then popular traveling companies, the commedia dell'arte ("professional comedy"). The true-to-life GENRE pictures Longhi painted—"conversations, meetings, playful scenes of love and jealousy"—have an affinity with Goldoni's plays. *The House Concert* (c. 1750), in which a pleasant bourgeois family is gathered for a musical interlude, is typical of his anecdotal subjects, and he was highly thought of by members of Venetian society. Although the BAROQUE era had passed elsewhere, it lingered in VENICE until the downfall of the Republic at the end of the 18th century, and Longhi

shared Baroque tendencies of the earlier period. However, there is one disarming and perplexing painting of his, *The Rhinoceros* (c. 1751). The animal in question, from India, was exhibited in three German cities as well as Paris and Verona before arriving in Venice, where, during the Carnival of 1751, it was put on display. Other portraits of the rhino were produced, as well as a dissertation on the animal, as it followed its itinerary. Longhi's picture is most unusual in his sense of the bizarre. The asymmetrical composition clusters the audience to the right. It includes the nobleman who commissioned the picture, the animal's owner holding its removed horn, and six others dressed in carnival finery, two with masks. The setting is barnlike and otherwise empty except for the rhinoceros, which stands unattractively in full profile, center front, munching on straw amid piles of dung. In this picture Longhi's recording of Venetian life is unprecedented, and could hardly be more distant from those appealing views painted by his contemporary CANALETTO.

Loos, Adolf
1870–1933 • Austrian • architect • Modern

The evolution of culture is synonymous with the removal of ornament from utilitarian objects.

The quotation above is from the essay *Ornament and Crime* (1908). Loos was fiercely opposed to ornamentation, which he considered a sign of weakness. He was in favor of cubic shapes and fine materials and a believer, as Nikolaus PEVSNER writes, "in the engineer and the plumber." More than his architectural designs, Loos's writing had great influence on the evolution of MODERN architecture, but when named a founder of modernism, Loos demurred. While the facades of his buildings, such as the Steiner House in Vienna (1910), were stark, the interiors might be colorful and sumptuous.

Lorenzetti, Pietro (active 1320–1348) and Ambrogio (active 1319–1348)
Italian • painters • Late Gothic/International Style

The city of Siena had most excellent and learned masters, among whom was Ambrogio Lorenzetti. He was a most famous and unusual master and did very many works. (Ghiberti, c. 1450)

These two brothers studied and worked in SIENA, where, once MARTINI had left for AVIGNON, they became the leading painters. Both probably died during the bubonic plague (Black Death) of 1348. Their work contains an amalgam of styles, including that of their teacher, DUCCIO, and of GIOTTO. Among Pietro's most interesting paintings is *Descent from the Cross* (1320s–30s). It shows expressiveness on the mourners' faces and even, although not so successfully as Giotto, presents one figure from the back. Pietro's composition, combining the diagonal (already stiffening) body of Christ with a pyramid of mourners, is weighed down by the long, grainy, bloodstained crossbar of the crucifix. In Pietro's *Birth of the Virgin* (1342), Saint Anne, Mary's mother, reclines on her bed, which is neatly cov-

ered with a plaid spread. Historians particularly note the framing of this AL-TARPIECE, which seems devised to incorporate spatial illusion. (It may have been a later addition.)

Ambrogio's most wonderful and revolutionary paintings were FRESCOes on three walls of a chamber in Siena's city hall (the Palazzo Pubblico). These allegorical personifications, called *Good Government* and *Bad Government* (1338–39), illustrate how such government affects life in the town and the country. The works are particularly significant because that was the period when Florence and Siena were vying for power. As poetic justice, perhaps, *Bad Government* has been seriously damaged by time (and vandals). The *Good Government* landscapes show us 14th-century Siena and its environs. We see the crenellated city wall, towers and rooflines, and multicolored buildings (one of which is under construction), and we see people who are clearly thriving, dancing in the streets. Outside the walls peasants harvest grain and tend the vines in fertile fields. Meanwhile, members of the leisure class set out on horseback for a day of hawking. These are amazing panoramas.

Lorenzo Monaco (Lawrence the Monk, Piero di Giovanni)
c. 1370–c. 1425 • painter • Italian • Late Gothic/International Style

For Lorenzo Monaco's visual poetry is essentially imaginative and unreal; the crucial developments of the early Quattrocento, on the other hand, were based on a new early evaluation of the reality of day-to-day experience, and of the human being who experiences.

This new evaluation Lorenzo Monaco could not share. (Frederick Hartt, 1969)

In 1391 Lorenzo joined the mystical Camaldolite order in Florence, though in 1402 he registered for art school using his lay name (Piero di Giovanni). Lorenzo used luminous color, and his human forms are ethereal rather than solid. His masterwork is the *Coronation of the Virgin* (1414), an ALTAR-PIECE in which exultant multitudes are painted against a gold background. It has predellas that are set inside quatrefoils (four-lobed shapes) that remind us, as they probably did his contemporaries, that the designs for GHIB-ERTI's Baptistery doors were also set in quatrefoils. Lorenzo was among the last practitioners of the Late GOTHIC International Style, a conservative tendency to which the historian Hartt refers in the comment above.

lost wax process (*cire perdue*)
See BRONZE

Lotto, Lorenzo
c. 1480–1556 • Italian • painter • Renaissance/Mannerist

He shows us people in want of the consolations of religion, of sober thought, of friendship and affectation. They look out from his canvases as if begging for sympathy. (Bernard Berenson, 1894)

Although TITIAN professed to admire him, Lotto chose a more conservative route and failed to explore the ground his somewhat younger contemporary broke in the handling of color and paint. Rather, Lotto showed such a

multitude of stylistic influences that he is often called a chameleon. Still, he was individualistic—he has also been called the most idiosyncratic Venetian artist of the 16th century—and was sometimes inspired in his presentation of ideas. In *Annunciation* (1520s), for example, the unexpected angel Gabriel arrives on the scene with a long stalk of white lilies, and Mary's own great surprise is mirrored by that of a startled cat. Lotto's pleasure in novelty and humor is also apparent in the painting *Saint Jerome in the Desert* (1506). Jerome is seen from above as a small, frail figure among looming rocks. One must search the canvas to locate the saint's constant companion, the lion from whose paw Jerome removed a thorn, but it is finally to be found emerging from the shadow between the rocks. In this work CLARK sees the influence of DÜRER on Lotto, especially because it "contains rocks and trees remarkably similar to the drawings which Dürer did on his journey home from Italy in 1495." The Northern echo of GRÜNEWALD is seen in Lotto, too, in some of his dark and clashing, un-Venetian colorings. Noting that Lotto did portraits of Luther, scholars speculate about his interest in Protestantism. BERENSON, in the quotation above, makes an interesting, related comment.

Louis, Morris

1912–1962 • American • painter • Post-Painterly Abstraction

You have something to say, you say it.

In 1953, Louis visited FRANKEN-THALER's studio and found her method of soaking and staining an unprimed canvas a revelation. He then began his own experiments with the materials of painting, especially the staining techniques she was using. In the belief that he had lost his way, in 1957 Louis destroyed many of the paintings done between 1954 and 1957. Then he resumed working in a series called *Veils*—an apt allusion to the impression given by his transparent colors, which seem to have floated in gently and settled onto the canvas. The technique Louis typically used was to allow extremely dilute, liquid ACRYLIC PAINT to flow over a tilted, unstretched canvas. It was the canvas itself that acted as resistance to the paint. This is in contrast to ABSTRACT EXPRESSIONISTs like KLINE and DE KOONING, whose canvases provided resistance to their attacklike gestures of painting. Striving for a luminosity unrelated to material things, Louis worked, in 1959, with muted colors in what look like tonal waves. He also tried painting with stripes of brilliant color. His artistic explorations were ended by his early death, in 1962.

low art

See HIGH ART

Luke, Saint

One of the four evangelists, author of the third Gospel, Saint Luke is supposed to have painted portraits of the Virgin—the theme of Saint Luke painting the Virgin was especially popular among artists of the early NORTHERN RENAISSANCE (e.g., van der WEYDEN's *Saint Luke Portraying the Virgin*, c. 1435–40). Indeed, the precedent of Saint Luke's picture is taken both as the prototypical Madonna and Child and as a justification for the ICON. Luke became the patron saint of painters;

many painters' GUILDS were dedicated to him and named after him.

Luks, George
1867–1933 • American • Painter • Realist

[I can paint with] a shoe string dipped in pitch and lard.

The exuberant claim quoted above was made by Luks, who had previously limited himself to drawing, after GLACKENS persuaded him to try his hand at pastels and oils. Unfortunately, the result of such experiments was paintings that cracked and generally deteriorated. The infamous show of The EIGHT in 1908 was partly a result of National Academy of Design jurors rejecting a painting by Luks called *Man with Dyed Mustachios,* which is now lost. Luks was a member both of The Eight and of the ASHCAN SCHOOL. His interest in urban life is epitomized by a 1905 painting, *Hester Street,* which sweeps the viewer into and through the teeming life of the Jewish neighborhood of New York City's Lower East Side. An artist-reporter for the *Philadelphia Press* along with SHINN, GLACKENS and SLOAN, like them he followed HENRI to New York, and like Henri he admired and was inspired by HALS (Luks studied art in Europe). Luks also painted wrestlers with a brushwork and brutality similar to BELLOWS's pictures of boxers, and especially raw in comparison to the wrestlers and boxers of his predecessor EAKINS.

Luminism
As applied by John Baur in 1948 and by Barbara Novak in 1969, the term "Luminism" asserted the existence of a particular tradition in American painting, especially seen in landscapes of the third quarter of the 19th century. Novak points to characteristics that include hard, smooth surfaces; outlined forms; horizontal organization; and strong, clear light. She describes Luminists as conceptual—revealing what the mind knows rather than what the eye perceives—in contrast to IMPRESSIONISTS, for example, who sought to report visual sensations of light and form. Prominent Luminists were GIFFORD, HEADE, KENSETT, LANE, and WHITTREDGE. Frequently considered a branch of the HUDSON RIVER SCHOOL, Luminism was also steeped in TRANSCENDENTALISM and equally concerned with the fate of the American landscape under pressure from industrialization, railroad building, and westward expansion. Subsequent to Novak's account, "Luminism" was used so wantonly that it lost significance and muddled distinctions instead of serving as a useful definition. It has thus become controversial among historians.

Lysippos
active c. 360–300 BCE • Greek • sculptor • Late Classical/Hellenistic

Alexander gave orders that Lysippos only should make portraits of him since Lysippos only, as it would seem, truly revealed his nature in bronze, and portrayed his courage in visible form, while others . . . failed to preserve his masculine and leonine aspect.
(Plutarch, 1st–2nd century CE)

During his long and productive life—according to PLINY the Elder he made 1,500 sculptures "all of such artistic value that each would have sufficed by

itself to make him famous"—Lysippos bridged the late CLASSICAL and HELLENISTIC periods. His interest in the Polykleitan CANON led him to modify it: The earlier ratio of head to body was 1:7; Lysippos used a ratio of 1:8. Thus his figures looked slimmer, sinuous rather than compact. It was his conceit that while earlier sculptors showed men as they really were, he represented them as they *appeared*. Whether this has to do with the concept of optical illusion or with the "real" as IDEAL prototype is uncertain. Regardless, the Lysippian proportions gained favor. Another Lysippian innovation was to take command of surrounding space as artists had not yet done—breaking into the viewer's space, in a manner of speaking. His *Apoxyomenos* (known only by its Roman marble copy in the Vatican), an athlete scraping the oil and dirt from his skin, extends his right arm at shoulder height, straight in front of his body. The *Apoxyomenos* is further storied: According to Pliny the Elder, the emperor Tiberius developed an uncontrollable passion for it and had it taken from the baths where it stood and set in his own bedchamber. This so angered the populace of Rome that Tiberius was forced to return the statue. As court artist for Alexander the Great, Lysippos must have captured the man's character and personality, at least enough to please him, as the above quotation from Plutarch reports. Plutarch also described Alexander's successor as having been struck with dizzying fear when he stumbled on a portrait of his predecessor. It is unknown if this bronze or another statue was the one that captured the Emperor Nero's fancy, but he was so enamored of a statue of Alexander that he had it entirely covered in gold. "Afterward," Pliny relates, "since the charm of the work had vanished, though its value had increased, the gold was removed, and it was esteemed more valuable in this state even though the scars and incisions which had contained the gold still remained." Interest in showing personality became increasingly important for Hellenistic artists, due, probably, to Lysippos's success. Besides Alexander's courage, Lysippos conveyed his intensity, energy, and willfulness. Similarly, a portrait of Aristotle tentatively attributed to Lysippos shows a deeply thoughtful, concerned if not worried man of letters. Lysippos could also impress with both overstatement and understatement. Consider the gigantic FARNESE HERCULES (known from an early 3rd-century CE Roman version by Glycon after a Lysippian original) in contrast to the very small *Herakles Epitrapezios* ("Hercules on the table," 1st century CE). As the historian J. J. Pollitt suggests, Lysippos's purpose was not just to overwhelm or amaze the onlooker. He also wanted "to stimulate curiosity and thought by confounding expectations."

M

Macchiaioli

Meaning "spot painters," the name applies to a group of nine young Italian artists who began gathering at the Caffé Michelangiolo in Florence during the mid-1850s. One member of the Macchiaioli was Adriano Cecioni (1838–1886), a sculptor and painter but best known as a writer on art. He articulated the aims and stylistic characteristics of the Macchiaioli: "Their art consisted not in a research for form but in a mode of rendering the impressions received from reality by using patches of color, or of light and dark; for instance, a single patch of color for the face, another for the hair, a third, say, for the neckerchief, another for the jacket or dress . . . and so with the ground and the sky." Giovanni Fattori (1825–1908) was the outstanding Macchiaioli artist, known for using large patches of simplified color in military scenes and landscapes as well as in figure paintings. In their rebellion against ACADEMIC painting, they are sometimes associated with the IMPRESSIONISTS, whom they predated. They were closer in spirit to the BARBIZON SCHOOL, especially in working outdoors and avoiding subjects prescribed by the academy.

Macdonald, Jock

1897–1960 • Canadian • painter • Abstract Expressionism

Hearing him lecture . . . was an eye opener to many students who were seeking the answer to the question "Why Abstract?" He makes one see clearly what a very deep and searching problem it is. (Alexandra Luke, 1945)

Born in Scotland, Macdonald settled in Canada in 1926 and was first associated with the GROUP OF SEVEN. Spiritualism, especially that in the writings of KANDINSKY, was an undercurrent in his art. An interest in abstraction grew strong during two summers when he studied with HOFMANN. Macdonald himself was an important teacher, as the words of one of his students, quoted above, testify, and he became the leader of the experimental vanguard in Toronto, the artists known as Painters Eleven. They were closely allied with American ABSTRACT EXPRESSIONISM, and Macdonald was encouraged and greatly influenced by the critic GREENBERG. He devoted himself to painting large, forceful canvases such as *Fleeting Breath* (1959).

Macdonald, Margaret

(1865–1933) and **Frances** (1874–1921)
Scottish • designers • Arts and Crafts

New Women [who make] rather weird adaptions of the human form.
(*Glasgow Evening News,* 1895)

Sisters Margaret and Frances both trained at the Glasgow School of Art and worked in metals, STAINED GLASS, and embroidery. Margaret married MACKINTOSH, Frances married his partner, J. H. McNair, and their artistic collaborations led to their being known as The Four, or sometimes Mac's Group. It was their credo that design should evolve from specific geographic conditions and traditions, a belief expressed in works of theirs that were inspired by INTERLACE patterns of HIBERNO SAXON origin. One example is a silver pendant of birds in flight entwined in loops and overlapping each other. Margaret and her husband collaborated on this necklace in 1902. A mirror frame of beaten tin by Margaret and Frances, named *Honesty* (c. 1896), has sinuously elongated figures enclosing the mirror. These figures resemble animated initials (usually the first letter on a page, known as a historiated initial) used in ILLUMINATED MANUSCRIPTS of the MEDIEVAL period. It was this kind of figure to which the newspaper reviewer referred in the comment quoted above.

Macdonald-Wright, Stanton

1890–1973 • American • painter • Modern/Synchromist

Form to me is color. When I conceive of a composition of form, my imagination creates an organization of color that corresponds to it. . . . Each color has an inevitable position of its own in what could be called "emotional space" and has also its precise character. I conceive space itself as of plastic significance that I express in color.

Macdonald-Wright ran away from home at 14 and studied art in Los Angeles. Later he studied in Paris, where he and his American colleague RUSSELL began to develop the movement called SYNCHROMISM. They were inspired by a Canadian artist, Ernest Percyval Tudor-Hart, whose system of color harmonies established correspondences between tonal sound and color. In their system the use of a certain color had to do with its volume and position in space. Warm colors, like red and yellow, were "convex" and advancing; "concave" colors, like blue, receded. Macdonald-Wright's interpretation of this system can be seen in a work such as *Abstraction on the Spectrum (Organization, 5)* (1914–17). Macdonald-Wright considered Synchromism to be the culmination of MODERN painting.

Mackintosh, Charles Rennie

1868–1928 • Scottish • architect • Art Nouveau

Old architecture lived because it had a purpose. Modern architecture, to be real, must not be a mere envelope without contents.

Both as an architect and as a designer of DECORATIVE ARTS, Mackintosh was a prominent international figure in the ART NOUVEAU movement. He is known as a leader of the GLASGOW SCHOOL,

which, in effect, acknowledges his association with the Glasgow School of Art, where he studied and for which he designed a new building in 1895 (construction began in 1896). This building, while fairly austere and clear in its overall design, had fanciful metalwork with delicate Art Nouveau curves. The combination of traditional sturdy, straightforward Scottish architecture with the elegant new art fulfilled his mandate as quoted above. He also designed several "tea rooms" in Glasgow, outfitting them with white enamel chairs and cupboards containing inlays of mauve, pink, and mother-of-pearl. He designed with natural and stained wood as well. Mackintosh was noted for combining rectangular forms, painted white, with gentle curves as decorative motifs. "There was no one else who could combine the rational and the expressive in so intriguing way," writes Nikolaus PEVSNER. Mackintosh had considerable influence in Austria and Germany, but little in either Scotland or England. Margaret MACDONALD was Mackintosh's wife and collaborator.

MacMonnies, Frederick William

1863–1937 • American • sculptor • Eclectic

Well, if you think you can do it better, go ahead and change the arm.
(Augustus Saint-Gaudens)

MacMonnies, who started but could not afford to keep up his studies at the Art Students League and National Academy of Design in New York, worked as a cleanup boy in the studio of SAINT-GAUDENS. When he overheard MacMonnies criticize the arm on a clay statue, Saint-Gaudens challenged him to improve it, allegedly with the words quoted above. Apparently MacMonnies did so, and then was made a studio assistant. Later, he studied in Paris. His best-known work was made for the World's Columbian Exposition in Chicago: MacMonnies created an extravaganza known as *The Triumph of Columbia,* or *The Barge of State* (1893). It is an amalgam of styles but preeminently neo-BAROQUE; Columbia, holding a torch, sits in a chair that is set atop a high pedestal on a "barge" that somewhat resembles one of the ships in Columbus's fleet. Below her a crew of women personifying the Arts and Industries hold long oars with decorative paddles. Time handles the rudder and Fame is on the bow. Made of a mixture of plaster and straw (called staff material) and placed in a great basin of water, the work did not last long after the exposition was over. In 1893 MacMonnies created a scandal in Boston with *Bacchante and Infant Faun* (1893): The naked bacchante, or female follower of the god of wine, dances with an infant in one hand and a bunch of grapes in the other. It had been commissioned for MCKIM, MEAD AND WHITE's library, but the public protested and the sculpture was banished—to the Metropolitan Museum of Art.

maestà

Italian for "majesty," the term refers generally to representations of the Virgin and Child enthroned, adored by saints and angels, especially as shown in the 14th and 15th centuries. This image may be traced back to ICONS of the BYZANTINE period. The most famous

maestà painting, known as the *Maestà*, is DUCCIO's 1308–11 masterpiece, the ALTARPIECE for the Siena Cathedral.

Magic Realism

The line is difficult to draw, but Magic Realism (also called Precise Realism or Sharp-Focus Realism) differs from SUR-REALISM mainly in subject matter. Developing parallel with Surrealism, Magic Realism does not depend on the subconscious or automatism for inspiration; rather, it very consciously plays with the everyday, waking world and, by creating bizarre circumstances and juxtapositions, makes it unreal. (See also MAGRITTE)

Magritte, René

1898–1967 • Belgian • painter • Magic Realist

Ceci n'est pas une pipe.

One of the famous phrases in art history, quoted above, means "This is not a pipe." It was written by Magritte beneath an outstandingly real-looking painting of a pipe. The picture is entitled *The Treachery (or Perfidy) of Images* (1928–29). It is not a pipe because, of course, it is a *picture* of a pipe. It is a statement about the illusionistic nature of painting, and it is an example of MAGIC REALISM: sharply focused, photograph-like pictures. Magic Realism is also the style Magritte used for the earlier and eternally perplexing painting called *The Menaced Assassin* (1926). This is a murder scene set in a room empty of everything except the victim (a store mannequin) and a man in a suit staring wistfully into the large horn of an old gramophone. Strangeness is mul-

tiplied by a view through the window of an elaborate wrought-iron balcony with three male heads looking over it, triplicates of the man at the gramophone, and mountain peaks beyond. Hiding on the near side of an interior wall, two identical men in bowler hats (detectives?) flank the entryway; one holds a club, the other a net. All is mystery, allusion to uncertain crimes in deceptively ordinary places. Magritte went to live in Paris in 1927, but tiring of the pace, and the art world arguments, he returned home to live and work in Brussels in 1930. He chose to define himself in opposition to leading SURREALISTS (MASSON, ERNST, and DALÍ), rejecting fantasy and, rather, subverting the ordinary: the pipe, for example. *Le soir qui tombe* (*Evening Falls;* 1964) is another example: Fragments of shattered windowpane, having fallen to the floor, still hold the image of the sun setting outside, which is also seen beyond the window. Besides presenting a confounding statement about vision, as a painting of a window it also plays with the most ancient of painting's own subjects and devices and ideas: the window itself. Tricky, too, is the literal translation, "Evening Falls," referring to the fallen glass and the "fallen" sun. Here Magritte's humor sharpens the edges of his Magic Realism.

Maillol, Aristide

1861–1944 • French • sculptor • Modern Classicist

[Rodin] sometimes says, "It's decorative." And he passes by. He's not interested in that. It's decorative! Me,

*I'm quite the opposite—that's my
point of departure, from the great
decorative line.*

Maillol began sculpting when he was
nearly 40, after working as a painter
and TAPESTRY designer and exhibiting
with the NABIS. Trouble with his eyes
led him to modeling in clay. Defining
himself very much in reaction to the EX-
PRESSIONIST brutalism of RODIN, Mail-
lol concentrated on a restatement and
modernization of CLASSICAL idealism,
expressing harmony and balance and
working to a highly polished finish. "I
wanted to see how the ancients came to
terms with reality. I looked at a
woman's head outside, in the street,
then I went into the Louvre and looked
at an antiquity, and I saw how they had
come to extract the beauty from life,"
he said. With little diversion he concen-
trated on portrayal of the female nude
in large scale, and usually in bronze,
though his wealthy, gay, German pa-
tron, Count Harry Kessler, encouraged
him to sculpt the male nude, which he
did on a couple of occasions. Among
Maillol's best-known female figures is
an example of Classical equilibrium
and restraint, *The Mediterranean* (c.
1902–05), a seated woman whose
crooked arm holds her head while her
elbow rests on a bent knee. *The River*
(c. 1938–43) challenges equilibrium
spectacularly to become, in a sense, its
epitome: the huge (7½ feet long) lead
figure of a reclining woman rests, or
pivots, on her hip. The work is simulta-
neously stable and unstable, achieving a
moment of eternity between the two,
much as a river expresses the di-
chotomies of constant flow and eternal
change.

Malatesta family

Warriors and landowners, the Malates-
tas ruled papal territory in southern Ro-
magna during the 14th and 15th
centuries. Their reputation for ferocity
and immorality was notorious, and
Sigismondo Pandolfo Malatesta
(1417–1468), accused of all manner of
sins, from sexual irregularities to mur-
dering his second wife, was officially
and ceremonially condemned to hell by
Pope Pius II—while he was still alive.
Not the least of his transgressions was
having a monastic church in Rimini
(San Francesco) turned into a temple to
himself. The architect who designed
what is now known as the Malatesta
Temple (c. 1450) was none other than
ALBERTI. The building was never com-
pleted, but the arcaded lower story of
the west side and the front reveal Al-
berti's mastery of the CLASSICAL vocab-
ulary and the dignity of his invention. A
medal struck for the laying of the build-
ing's cornerstone shows that the plan
called for an ARCH over the main portal
as well as a DOME.

Mâle, Émile

1862–1954 • French • art historian

*To the Middle Ages art was didactic.
All that it was necessary that men
should know—the history of the world
from the creation, the dogmas of
religion, the examples of the saints, the
hierarchy of the virtues, the range of
the sciences, arts and crafts—all these
were taught them by the windows of
the church or by the statues in the
porch.*

In his preface to *The Gothic Image*
(1898; translated into English 1902,

into German 1907), quoted from above, Mâle explains what he believes was the purpose of MEDIEVAL cathedrals and Medieval art in general—his field of study. To Mâle the sculpture of a CATHEDRAL was like an encyclopedia in stone, and he writes about it, and about its STAINED GLASS windows, with feeling and eloquence. Each cathedral shows its individuality to him: CHARTRES "is medieval thought in visible form," Amiens "messianic, prophetic." At Nôtre-Dame of Paris the Virgin "is the center of all things," while at Laon "Knowledge" takes first place with "Philosophy sculptured on the facade and painted in one of the rose-windows." Each cathedral Mâle describes was, as he says, an expression of the Church, and the artists were a channel for that expression, "simply the interpreters of her thought." In this opinion Mâle argues with the writer Victor Hugo (1802–1885), who thought that the artists of the great cathedrals were more like priests than illustrators, and with VIOLLET-LE-DUC, who thought of GOTHIC art as an "outlet for minds always ready to react against the abuses of the feudal system." Not so, according to Mâle. Neither thinker or prerevolutionary protester, the Medieval artist was, to Mâle, "the docile interpreter of the great ideas. . . ."

Malevich, Kasimir (also Kazimir)
1878–1935 • Russian • painter • Suprematist

In 1913, trying desperately to liberate art from the ballast of the representational world, I sought refuge in the square.

In Moscow's small cell of earnest intellectuals the atmosphere was ripe for artistic as well as political revolution. After having absorbed the new ideas of CUBISM and FUTURISM (without actually having left Russia), Malevich proposed the purest and most radical NONOBJECTIVE, abstract picture yet seen. It was a pencil drawing and "nothing more than a black square on a white field," he said. He called the drawing *Basic Suprematist Element,* named its style SUPREMATISM, and explained it as "the supremacy of pure feeling in creative art." Everything else was meaningless. Suprematism became a movement in 1915 when its first paintings were shown. It was visionary and spiritual, and the forms Malevich painted—triangles, squares, circles, irregular bars—float, liberated from constraints of earthbound gravity, in the sense of seriousness as well as of weight. The freest, most sublime series of his compositions are white squares that float on white grounds (e.g., *Suprematist Composition: White on White,* 1918). "We must prepare ourselves by prayer to embrace the sky," Malevich wrote. Aviation, then in its early years, was part of his inspiration; he described his intention to convey the idea of flight. He also explored architectural ideas with drawings and models that were important to the development of CONSTRUCTIVISM in Russia as well as to the BAUHAUS in Germany.

Malvasia, Count Carlo Cesare
1616–1693 • Italian • writer

One day while I stood watching [Reni] paint he asked me if someone could cast a spell on a person's hands so that

either he could no longer use his brushes or would have to use them badly.

During the 17th century, for the first time, some writers specialized in the biographies of artists from a particular region. Malvasia wrote about Bologna, which was the center of the universe as far as he was concerned. His biography of RENI portrays a very strange man, as in the quotation above, who, however, painted divinely. Malvasia's two-volume *Lives of Bolognese Painters* (1678) is dedicated to Louis XIV in the hope of drawing the French king's patronage to Bologna. The text is both a valuable and an untrustworthy source. For example, his editing of an exchange of letters between SACCHI and his teacher about the BAMBOCCIANTI, a group of street-scene painters, is questionable, as is his "doctoring" of other correspondences and his reporting of anecdotes. As is true of most sources used today that formerly may have been taken for gospel, the motives of the writer now receive serious scrutiny.

Man Ray (Emmanuel Radenski)
1890–1976 • American • painter/photographer • Dadaist

I was planning something entirely new, had no need of an easel, brushes and the other paraphernalia of the traditional painter. . . . It was thrilling to paint a picture, hardly touching the surface—a purely cerebral act, as it were.

Man Ray was an innovative artist and photographer. A 6-foot-long painting that looks like a COLLAGE, *The Rope Dancer Accompanies Herself with Her Shadows* (1916) is his best-known work on canvas. The idea for it came to him when he was cutting away pieces of a drawing on colored paper of the dancer's positions. It was the discarded pieces of paper that inspired the painting. The following year, his association with ARENSBERG and DUCHAMP motivated Man Ray to free himself from the direct manipulation of paint (as had Duchamp). He began to use an AIRBRUSH to spray paint onto the picture surface, and was probably the first noncommercial artist to use that technique. He was also the first American to make a purely DADAist ASSEMBLAGE: *Self-Portrait* (1916) has two electric bells, a push-button, and his palm print as a signature. Adding to his credentials, Man Ray was a leading photographer. As he had changed trash into the *Rope Dancer*, so too did he turn accidentally unexposed paper from the developing tray into a "photogram" by setting objects on it and then exposing it to light. He called this the Rayogram. A famous example of his "straight" photography is based on a painting by INGRES of a woman's back, *The Bather of Valpinçon* (1808). Man Ray has photographed a woman's back, but only after having drawn marks on it that resemble the designs on the body of a violin. He named it *Le Violin d'Ingres* (1924). Man Ray was a cofounder of the SOCIÉTÉ ANONYME, which sponsored avant-garde artists.

Mander, Carel van
1548–1606 • Netherlandish • writer/painter • Northern Renaissance

When I endeavored to ascertain who were the most outstanding men in our

art, so that I might arrange them in order one after the other and be careful to call the earliest one first upon my stage, I was surprised to learn of Albert van Outwater, painter of Haarlem, that he had become so skillful a painter in oils at so early a time.

Van Mander wrote the first vernacular treatise on Dutch painting, which is quoted from above. His text is the principal source of information about the art and artists of the NORTHERN RENAISSANCE. He wrote about the artists' education and characteristics of their works, and he described particular paintings. Van Mander was inspired, if not prompted, to write his tribute to Northern artists, *Het schilder-boek* (*The Book of Painters*, published 1604), by VASARI's 16th-century Italian text. He does, however, include Italian artists with information derived from condensations of Vasari's *Lives* enhanced by his own travels and up-to-date research. As is also true of Vasari, van Mander may be called a "patriotic biographer," as the excerpt quoted above reveals; PANOFSKY points out that van Mander describes Albert van Outwater as a contemporary of van EYCK in order, it would seem, to give his and van Outwater's hometown of Haarlem artistic preeminence over Bruges, where van Eyck worked for the Burgundian court (see VALOIS). In truth, van Outwater was of a younger generation than was van Eyck. *Het schilder-boek* includes chapters on landscape and figure painting, composition, proportion, drawing, color, and reflections, and references to CLASSICAL and ITALIAN RENAISSANCE painting are in-

cluded throughout. Van Mander was also a painter, but the importance of his writing far outweighs that of his art.

mandorla
From the Italian for "almond," refers also to the "glory" or AUREOLE of light in an almond shape sometimes shown as surrounding a divine being. (See also HALO)

Manet, Édouard
1832–1883 • French • painter • Impressionist/Post-Impressionist

[Academicians] thought they were doing the right thing; they were mistaken; they didn't see that in installing licensed opticians they not only killed competition, but that these opticians, accustomed to using a certain formula, would put glasses of the same strength on the noses of their pupils. The result has been a succession of the near-sighted and the far-sighted, depending on the distance that their professors saw.

With his relatively flattened surfaces and color, Manet avoided imitating nature, and his paintings were neither highly emotional nor forthrightly sociopolitical. For these rejections of both ROMANTICISM and REALISM, respectively, Manet was claimed by and grouped with IMPRESSIONISTS. While he shared many of their subjects, Manet did not, however, share the Impressionist preoccupation with a fleeting sense of light and sensation as did MONET, for example, nor did he reject historical precedent, although he used it with a great measure of parody. The composition of Manet's *Le Déjeuner sur l'herbe* (1863) looks back to a famous engrav-

ing by RAIMONDI that claimed to be based on a lost work by RAPHAEL, and the ambiguity of portraying disrobed women in the presence of overdressed men in an ARCADIAN setting looks to GIORGIONE's *Fête Champêtre* (c. 1510). Manet's *Olympia* (also 1863), while in a long line of reclining nudes, is most directly a reference to TITIAN's *Venus of Urbino* (1538), a painting that introduced the frankness of a nude woman looking out of the picture at the observer. But where Titian's model is shy and tentative, Manet's is bold and looks directly, almost confrontationally, at the viewer. Thus looking out at those who are looking at her, she defies the age-old objectification of undressed women (see also GAZE). And with her candid, un-idealized appearance, she is a frankly "naked" woman defying a tradition of prettified, ACADEMIC "nudes." When *Déjeuner* and *Olympia* were exhibited, reaction went from outrage at their immorality—"Abuses rain upon me like hail," Manet wrote to his friend BAUDELAIRE—to lascivious approval. Guards were stationed by *Olympia* to protect it from vandals. To what extent was it Manet's intention to shock, to aggravate, and to attract attention? It is noted that he sent *Olympia* to the SALON of 1865 along with *Jesus Mocked by Soldiers* (1865), a provocative gesture. With all the uncertainty regarding their intended meaning, there is one undeniable truth: *Déjeuner* and *Olympia* changed both images and discussions of nude women in art. In 1889, six years after Manet's death, *Olympia*, once called an offense to both art and morals, was accepted for the collection at the Luxembourg Palace, and in 1908 it went into the Louvre.

maniera greca

Maniera greca refers to images in the "Greek manner," but *not* CLASSICAL, or pre- or post-Athenian Greek. To understand the logic behind this term one has to remember that the town of Byzantium (now Istanbul, Turkey) was originally Greek. So looking back to Christianized Byzantium, *maniera greca* describes Italian painting of the 13th century that was strongly influenced by BYZANTINE style. One channel of that influence may have to do with the occupation of Orthodox Christian Constantinople, in 1204, by the armies of the Fourth Crusade. This conquest contributed to the downfall of the Byzantine Empire but, paradoxically, it also reinvigorated Byzantine style in Italy. Artists whose works are associated with the *maniera greca* include CIMABUE, BERLINGHIERI, and DUCCIO.

Mannerism

After 1520 to c. 1600. Overlapping with the Late ITALIAN RENAISSANCE, Mannerism is said to have evolved from the writhing, twisted figures of MICHELANGELO's late years, his "manner." Where Renaissance artists strove to achieve a reasoned balance and harmony, the Mannerist style is characterized by instability and exaggeration, most explicit in unnaturally elongated bodies and dramatic gestures. Painters usually labeled Mannerist include PONTORMO, BRONZINO, FIORENTINO, PARMIGIANINO, El GRECO, and the NORTHERN RENAISSANCE artist GOSSAERT; sculptors include CELLINI and BOLOGNA. Their figures bear some resemblance to the HELLENISTIC phase of GREEK ART; in fact, around 1610 El Greco painted at least three interpreta-

tions of the 2nd-century BCE LAOCOÖN sculpture group, which had been rediscovered in 1506 (and also had a strong effect on Michelangelo). The expressive power, restlessness, and distortion of Mannerism cannot be disassociated from the spiritual upheavals of the Reformation and Counter-Reformation. Thus, while some scholars describe the lack of emotional expressiveness in Mannerist paintings as disinterest in the emotional or inner life, others see it as a manifestation of inner vision. Miguel de Cervantes and William Shakespeare were writing during this period.

Mansart, François
1598–1666 • French • architect • Baroque

Art hid itself in the guise of nature, / the eye, satisfied, embraced its structure, / Never surprised and always enchanted. (Voltaire, 18th century)

Whereas in Rome the Counter-Reformation led to ecclesiastical autocracy, in France, under Henry IV, Richelieu, and Mazarin, a new secular monarchy subordinated the Church to the needs of the state. French art took many forms but was dominated by non-religious, rational CLASSICISM that contrasted with the emotionalism of the Roman BAROQUE. Mansart's style developed through designs he made for wealthy PATRONS who demanded luxurious houses. He combined a Classical simplicity and restraint with rich, elegant decorative elements. Voltaire's words, quoted above, express pleasure with Mansart's style and skill. The Château de Maisons (1642–51; now Maisons-Laffitte) at Yvelines, near Paris, is an outstanding example of his style. It has the "mansard" roof to which he gave his name—a steeply sloping triangular shape with its peak sheared or modified. Little is known about Mansart's life, but it is thought that his practice was limited by his difficult personality; he was reputedly intractable and arrogant. The eclectic SECOND EMPIRE style of the 19th century looked back to the 17th century, and design ideas derived from Mansart were not only seen in Paris, but were also imported to the United States by many young Americans who received their architectural training at the ÉCOLE DES BEAUX-ARTS.

Mansart, Jules Hardouin-
See HARDOUIN-MANSART

Manship, Paul H.
1885–1966 • American • sculptor • Art Deco

The credo of the artist must be the result of his education and environment. He cannot depart from his age, and its spiritual and material influences.

Manship won the American PRIX DE ROME in 1909 and studied at the American Academy in Rome for three years. He returned home and achieved great success. His subjects were often taken from ancient mythology, and his style was influenced by the ACADEMIC tradition to which he often added a pared-down, mechanistic, ART DECO look. One of his most familiar works is the gilded bronze statue of the Greek god Prometheus (c. 1933–36) at Rockefeller Center in New York City. Prometheus, who stole fire from the other Olympians to bring it to humankind, floats

above the sidewalk with his flaming gift in hand.

Mantegna, Andrea

1430/31–1506 • Italian • painter • Renaissance

It is said that the Pope, on account of his numerous engagements, did not pay Mantegna so often as the artist's needs required, and that the latter, in painting some of the Virtues in [a chapel] introduced Equity. The Pope, going one day to see the work asked what the figure was, and on learning that she represented Equity he replied, "You should have associated Patience with her." The painter understood what was meant and never uttered another word. (Vasari, mid-16th century)

Mantegna grew up in the stimulating atmosphere of Padua, which had an internationally important university, its own Roman ANTIQUITIES, and a circle of humanist scholars (see HUMANISM). He entered the first private art school in northern Italy, run by Francesco Squarcione (1397–c. 1468). At the age of 26, working on a FRESCO in the Ovetari Chapel of the Church of the Eremitani in Padua, Mantegna developed a powerful and distinct new style. His figures are unusually solid and hard-looking, as if they were carved rather than painted. Even more singular, he used PERSPECTIVE to unite two independent but sequential scenes in the life of Saint James, giving each the same vanishing point. Then, painting *Saint James Led to Execution* (c. 1453–54) in the same chapel, he radically changed the perspective so that a viewer has the sense of looking up at the scene from ground level—sometimes called a worm's-eye view but more formally known as *di sotto in sù* ("from below upward"). This is a perspective that puts the viewer into a newly challenging position, seemingly drawn in to the action. Spectator involvement is even more daunting, or amusing, in the room Mantegna finished in 1474 for the GONZAGA ducal palace in Mantua. He painted all the walls and ceiling of the so-called *Camera degli Sposi* (Room of the Newlyweds), including its lavish architectural detailing, which he modeled on ANTIQUE decorations. Looking up at the ceiling one sees a circular opening (an oculus, like that in the PANTHEON). Peering over a parapet and smiling down (observing the observer, so to speak), with the sky behind their heads, are five women (all portraitlike, and one woman is black), a peacock, and a group of chubby PUTTI, three of whom have mischievously climbed over the parapet into very precarious positions. But most threatening is a large tub of plants sitting on an unstable pole, poised to tumble on a spectator's head. It is all painted illusion, including the oculus. Mantegna continued his perspective explorations, and in c. 1500 painted (on canvas) *The Dead Christ* from an astounding angle: We look at Christ as though standing near his feet, which are punctured by nail holes. This unexpected and disconcerting perspective is dependent on severe foreshortening (see PERSPECTIVE). Yet Mantegna put the integrity of his picture before methodical accuracy: He reduced the size of Christ's feet, which would, in reality, have looked much larger from that point of view. For nearly half a century Mantegna was employed by the

Gonzaga family. His influence was especially great, for he was also an engraver, and his PRINTS were widely disseminated. DÜRER was among the artists who admired Mantegna. Mantegna's feats of illusory virtuosity became an ever-increasing obsession of BAROQUE painters

Manzù, Giacomo
born 1908 • Italian • sculptor • Expressionist Figuration

When I compare the results of my endeavors with my far-off childhood dreams and my present-day intentions, then it seems to me that everything has stopped half-way. Just the same I start work early every day as if it were my first morning, and I find in my work my daily task and my confirmation. I know that this is very little, but this is the only true and honest thing I can say of myself as a man and as a sculptor.

While most artists of renown worked in some kind of ABSTRACTION, or at least distorted their figures, Manzù continued to use the human form in a quite straightforward way to express a sense of endurance and dignity. He created a series of life-size bronze cardinal figures engulfed in ecclesiastical robes and headgear, with only their faces and hands visible. They convey a great sense of serenity, a rare commodity in 20th-century art. Manzù has received important religious commissions that include bronze doors for Saint Peter's in Rome, and the Salzburg Cathedral. REWALD visited Manzù in his studio outside of Rome in 1965, and it was to Rewald that Manzù communicated the thoughts quoted above.

Mapplethorpe, Robert
1946–1989 • American • photographer • Modern Classicist

I've always found it irritating to hear people say erotic when they mean sexual material. I'm not afraid of words. Pornography is fine with me. If it's good it transcends what it is.

In the year that he died of AIDS, 1989, Mapplethorpe's work precipitated a crisis in American art and culture that still has not been fully assessed. The cataclysm followed a last-minute cancellation by the Corcoran Gallery of Art, in Washington, D.C., of an exhibit of Mapplethorpe works that included the X *Portfolio* of sadomasochistic/homoerotic photographs. The cancellation led to accusations of censorship from liberals and most people in the art world on one side and, on the other, attacks against the NATIONAL ENDOWMENT FOR THE ARTS, which had contributed funds to the assembling of the exhibit. The exhibition continued its tour, and in early 1990, when it opened in Cincinnati, the museum's director, David Barrie, was arrested. He was tried, in June, for pandering obscenity and child pornography. Defying the presiding judge, the jury decided that Barrie was guilty of neither. Before 1989 Mapplethorpe was best known for portraits of famous people and for the formal, cool, immutable CLASSICISM of his images, especially of flowers and nudes. His lifestyle as well as his art was described as "radical chic." After his death and the controversial exhibit, Mapplethorpe became a symbol of the victimization of gays both by society and by AIDS. The exhibit served to polarize historically antagonistic conservatives and progres-

sives on questions of morality and responsibility. More subtly, public consciousness of his transgressive work probably helped to clear the path for sexually suggestive imagery not only in art, where it already had a long tradition, but also in popular culture.

maquette

French for a small, rough model in a material such as clay or wax, used as a preliminary study for a sculpture.

Maratta (also Maratti), Carlo

1625–1713 • Italian • painter • Classical Baroque

When he was eleven years old Carlo Maratta was sent to Rome in the care of Bernabeo [his brother]. . . . After a year he enrolled him in the school of Andrea Sacchi, a master whose great worth is well-known. . . . There Carlo went about his studies with such enthusiasm and studied with such perseverance that he stayed there for twenty-five years, up until Sacchi's death. (Bellori, c. 1696)

BELLORI, quoted above, worked on Maratta's biography from about 1625 until his death in 1696. The two men were close friends; Bellori secured for Maratta his first public commission, and it was Maratta whom Bellori chose to paint his own portrait. Maratta looked back to the work of RAPHAEL for inspiration. He was in the CLASSICAL wing of the BAROQUE era, a backlash to the emotive, agitated style of painters like CARAVAGGIO and CORTONA and the earlier MANNERISM. Maratta became fashionable and was so highly paid that sarcastic comments were made about his fees and whether he would "conde-

scend" to take a would-be patron's money. But many painters appreciated him for raising the status of the profession. During the papacy of Innocent XI (1676–89), Maratta was commissioned to cover the immodestly exposed breast of the Virgin Mary in an earlier painting by RENI.

marble

Metamorphosed limestone that lends itself to polishing is called marble, the Greek word for which, in fact, means "shining stone." Marble's lustrous sheen is the result of light penetrating the surface to a certain extent before being reflected by interior crystals. The best-known marbles are Pentelic, from Mount Pentelicus in Greece, which was used for the PARTHENON; Parian, from the Aegean island of Paros, used for APHRODITE OF MELOS; and Carrara, quarried in the Italian Apennines, used for architectural structures in ancient Rome, and later, after the pure white varieties were found, for sculpture. The most renowned block of marble, originally 18 feet high and known as the Giant, was the Carrara stone from which MICHELANGELO carved his *David* (1501–04).

Marc, Franz

1880–1916 • German • painter • Expressionist

Is there any more mysterious idea for an artist than the conception of how nature is mirrored in the eyes of an animal? How does a horse see the world, or an eagle, or a doe, or a dog?

In 1911, with KANDINSKY and MÜNTER, Marc was a founding member of Der BLAUE REITER. Before he was killed in

action during World War I, Marc had only about five short years in which to paint in his evolving mature style, and animals, especially horses, were his most frequent subjects. He used luminescent colors, the blues, reds, greens, and yellows of STAINED GLASS windows. From *Blue Horses* of 1911—in which the vigorously curving lines of beautiful blue animals are in harmony with the soft curves of the brilliantly colored hills—to the nearly ABSTRACT *Fighting Forms* of 1913, his colors are dazzling. Marc was absorbed with the mystery, poetry, and symbolism of color, which had been liberated from its dependence on the natural world by the FAUVES and was being experimented with by DELAUNAY, whom Marc visited in Paris in 1912. The quotation above is from Marc's *Aphorisms* (published 1920), in which he also expressed an ecstatic spirituality: "Only today can art be metaphysical, and it will continue to be so. Art will free itself from the needs and desires of men. We will no longer paint a forest or a horse as we please or as they may seem to us, but *as they really are.*"

Marin, John

1870–1953 • American • painter/printmaker • Modern

I try to express graphically what a great city is doing. Within the frames there must be balance, a controlling of these warring, pushing, pulling forces.

Before he became a painter, Marin was an architectural draftsman, and as his love of painting developed he often used his brush, in WATERCOLOR primarily, to paint pictures of buildings. After brief studies in art, in 1905 Marin went to Paris, where he made ETCHINGS of landmarks such as the cathedral of Nôtre-Dame to sell to tourists. In Paris he met the photographer STEICHEN, who introduced him to STIEGLITZ, and on his return home he became a member of the Stieglitz Circle. Unlike painters of the ASHCAN SCHOOL, Marin was not interested in New York City life as seen in the people on the street; rather, he looked at buildings as if they were individual characters with dynamic interactions and personalities as well as distinctive forms (e.g., *Saint Paul's, Lower Manhattan,* 1912). Marin borrowed the tilted axis of FUTURISTS to express the force of movement and vitality in the new architecture. He is a good example of the way in which American artists absorbed various phases of European MODERNISM. Marin also painted landscapes in Maine and, later, around Taos, New Mexico.

Marini, Marino

1901–1980 • Italian • sculptor • Expressionist

Now I must speak about the "Riders"—a search for (what should I call it?) a combination of bodies in space. . . . For many centuries the image of the rider has maintained an epic character. . . . However, the nature of the reactions which have existed for so long between men and horses . . . has been greatly changed during the last half century. . . . It can even be said that, for the majority of our contemporaries, the horse has acquired a mythical character.

A horse with a nude male bareback rider is a dominant image in Marini's sculpture. He works with bronze, leav-

ing its surface rough, and his figures are without details. Within his limited theme he has invented an unlimited range of expression. In one *Horse and Rider* (1952–55), for example, the animal stands on widespread, spindly legs, its elongated neck thrown back and its head raised as if neighing in fear, while the rider leans, or falls, backward, arms spread wide. During a late stage of his career, Marini translated his subject into a block of stone that he carved as though horse and rider had become a mountain. (See also EQUESTRIAN)

Marisol (Marisol Escobar)
born 1930 • Venezuelan/American • sculptor • Modern/Assemblage

The first girl artist with glamour.
(Andy Warhol, 1962)

Born in Paris to Venezuelan parents, Marisol studied at the ÉCOLE DES BEAUX-ARTS and the ACADÉMIE JULIAN. In 1950 she moved to New York and continued her studies with HOFMANN and at the Art Students League. She created a distinct cast of characters whose rectangular torsos are usually boxes with heads, legs, and hands, if not arms, added. They may be families or famous people, but a likeness of her own face is often among them. The comment by WARHOL quoted above was made after her first exhibition, in 1962. Marisol's constructions are amusing, but with an edge of uneasiness (e.g., *Women and Dog*, 1964). Her more recent sculptures include *General Plywood,* a plywood EQUESTRIAN statue of Joseph Stalin. Inside the horse's body is a lighted tomb containing a picture of the dead Stalin in repose. Her ASSEMBLAGES may be carved and/or cast, painted and/or

drawn, and perhaps set on wheels, and whether obviously political or not, all are humorous.

Marsh, Reginald
1898–1954 • American • painter • Realist

I like Coney Island because of the sea, the open air, and the crowds—crowds of people in all directions, in all positions, without clothing, moving— like the great compositions of Michelangelo and Rubens.

Marsh was interested in painting "the characteristic life" of his time, which included movie theaters, subway stations and street workers, as well as the beach scenes he speaks of in the quotation above. As did BELLOWS, LUKS, and other New York followers of HENRI, Marsh captured the street life of the city. Like them, too, his pictures were social commentaries about the plight of the poor. But Marsh's scenes are sleazier, his urbanites more disreputable. *Tattoo and Haircut* (1932), for example, named for a sign advertising a tattoo parlor and a barbershop, is set underground in a subway station. The men in the picture are loafers with an air of unpredictable meanness, and the only woman in the scene is noticeably anxious at having to cross their path. Unlike most ASHCAN SCHOOL artists who painted with OIL, Marsh worked in TEMPERA.

Martin, Agnes
born 1912 • Canadian/American • painter • Abstraction

The Greeks knew that in the mind you can draw a perfect circle, but you can't

*really draw a perfect circle. Everyone
has a vision of perfection, don't you
think? Even a housewife wants to
have a perfect home.*

Martin made the observation quoted
above in an interview with the critic Holland Cotter of *The New York Times*. She
added, "I'm so anxious to be nonobjective, nothing in this world applies to my
art. It's beyond the world. I paint about
happiness and innocence and beauty."
Born in Canada, Martin became a citizen of the United States in 1950, and her
thoughts are influenced by studies
of Buddhism as well as Emersonian
TRANSCENDENTALISM. She is frequently
grouped with MINIMALISTS but rejects
that category. More appropriately described as FORMALIST abstraction, her
works have barely visible grids and delicate pencil lines with graded shades of
off-white horizontal bands (e.g., *Untitled No. 9, 1990*). Her paintings have
been described by viewers as transmitting happiness, optimism, joy, spirituality, and feelings of infinite expanses;
Martin herself has said, "They are light,
lightness, about merging, about formlessness breaking down forms."

Martin, John

1789–1854 • English • painter •
Romantic

*Enough ... is stated in the Old
Testament, and by Herodotus ...
and subsequent ancient historians, to
afford sufficient materials to a Painter
of genius for a work of magnificent
object and effect; a work, such as Mr.
Martin here surprises us with, of
mingled Poetry, Fiction, and Fact.*
(Robert Hunt, 1819)

Martin remained outside of and violently opposed to the art establishment,
which also kept him at bay. Though he
could not exhibit under the aegis of the
Royal Academy, he did so on his own,
and with huge popular and financial
success: The quotation above appeared
in a review in *The Examiner* of London
when Martin showed his *Fall of Babylon* in 1819. When he exhibited *Belshazzar's Feast* (1821) at the British
Institution, the audience was so great
and enthusiastic that the exhibit had to
be extended for three weeks. Later, it
attracted 5,000 paying visitors when it
was shown privately. Martin wrote
pamphlets that described the hordes of
people, the buildings, and even the
heights of the great mountains in
his paintings. He also made money
from selling PRINTS. His pictures were
melodramatic, cataclysmic, often biblical fantasies, full of SUBLIME terror, anticipating the movies of Cecil B. De
Mille, and though academicians found
them vulgar, he was extremely influential, not only with the public, but
among American landscape artists
as well.

Martini, Simone

c. 1284–1344 • Italian • painter •
Late Gothic/International Style

*But, Simone, thou was then in
Heav'n's blest sky, / Ere she, my fair
one, left her native spheres, / To trace a
loveliness this world reverses / Was
thus thy task, from Heav'n's reality /
... The soul's reflected grace was
thine to take, / Which not on earth
thy painting could achieve, / Where
mortal limits all the powers confine.*
(Petrarch, early 14th century)

Simone studied under DUCCIO in SIENA. There is a flavor of MANIERA GRECA in the three-quarter-view, almond-shaped faces and aloof expressions in his 1333 *Annunciation,* the central panel of an ALTARPIECE. (Its elaborate French GOTHIC frame was added during the 19th century.) Setting his figures against a gold background, Simone used rich colors, in contrast to the lighter PALETTE of his contemporary GIOTTO. Simone's Mary, interrupted in her reading by the appearance of the angel Gabriel, seems anxious. Gabriel (whose cloak is patterned with plaid and who carries an olive branch) says to her "Hail, favored one! The Lord is with you," in words inscribed so as to reach from his lips to her ear. Simone apparently enjoyed painting the idea of flight; it is easily deduced from the flutter of Gabriel's cape that he has just flown onto the scene. Another, slightly less refined but equally ambitious instance of flight appears in his earlier *Blessed Agostino Novello and Four of His Miracles* (c. 1330). With the immediacy of a news photograph, Simone portrays Agostino swooping down from the sky to rescue a child who is falling from a balcony. The child's amazing restoration is also shown in the same picture (see CONTINUOUS NARRATION). In 1339, at the height of his career, Simone was called to AVIGNON, then the seat of the papacy, where he contributed to the International Style (see GOTHIC). Simone's praise was sung by the great poet/humanist PETRARCH, quoted above, for whom Simone made images of the Virgin and of Laura, the woman immortalized in Petrarch's sonnets.

Marxism

Based on the writings of Karl Marx (1818–1883), the German philosopher, political economist, and founder of Communism. Marx's belief in the primary role of economic circumstances in determining human history, especially after the beginning of the Industrial Revolution, was expressed in the work of Francis Klingender (1907–1955). Klingender began writing in the mid-1930s, defining art as "the most spontaneous form of social consciousness." He focused on responses to economic oppression, especially as seen in the paintings of GOYA and HOGARTH. During the next decade, Marxism gained importance in ART HISTORY with the publication first of *Florentine Painting and Its Social Background* (1948), by ANTAL, and then of *Social History of Art* (1951), by Arnold Hauser. Marxism still finds expression in a variety of approaches other than purely Marxist. PATRONAGE and FEMINIST analyses, for example, bring Marxist socioeconomic ideas into play. As a political ideology, Marxism, in addition to the French Utopian Socialism expressed by comte de Saint-Simon (1760–1825), was directly related to the works of 19th-century REALISTS, and to later Russian CONSTRUCTIVISTS and SOCIAL REALISTS. Marxist studies in art history are CONTEXTUAL.

Masaccio (Tommaso di Ser Giovanni di Mone)

1401–1428 • Italian • painter • Renaissance

He was a very absent-minded and careless person, as one who, having

fixed his whole mind and will on the matters of art, cared little about himself, and still less about others. (Vasari, mid-16th century)

"Masaccio" is a fond nickname that means "careless," "hulking," or "Big Tom," referring to the qualities described above by VASARI. This artist lived less than 27 years, and though he died, as Vasari wrote, "in the flower of his youth," during his relatively few productive years he revolutionized painting. As DONATELLO had in sculpture, Masaccio introduced linear and atmospheric PERSPECTIVE to painting. Another giant step he took was to approach the MODELING of forms as an effect of natural light from a single source outside the PICTURE PLANE—that is, the sun. Earlier artists had assumed a diffuse, evenly present kind of light. Masaccio's advances are visible in his FRESCOES for the Brancacci Chapel in Santa Maria del Carmine, Florence, where he painted events in the life of Saint Peter. The part of the cycle entitled *The Tribute Money* (c. 1427) shows three distinct episodes (CONTINUOUS NARRATIVE) in the story of how, when it came time to pay imperial taxes, Christ informed Peter that he would find money in a fish's mouth. With his disciples, Christ stands in the center speaking to Peter. At the far left, Peter retrieves the coin from the fish, and at the right side Peter hands the money to the tax collector. The sun is imagined off to the right, and its light slants into the picture at an angle, as if entering through the actual window over the altar in the chapel. On the fresco, the light strikes some surfaces of the men's voluminous robes and their heads and

their hair, and casts long shadows of various intensity. It also creates more subtle tonalities in the landscape. There was a contemporary political subtext for this picture: The Great Schism that had divided the papacy had just ended, the pope had returned to Rome, and Masaccio's PATRON, Brancacci, wanted people to support the pope by paying their taxes. Thus, the artist collaborated with his patron in painting a fresco with a propagandistic agenda.

Masolino da Panicale
1383–after 1435 • Italian • painter • proto-Renaissance

Masolino . . . called on Masaccio to draw out the lines of buildings in perspective. And in the head of Christ in The Tribute Money *where mildness of expression was appropriate, Masolino's softer and sweeter manner lent itself to this end, as against Masaccio's severity.* (Mark Roskill, 1989)

As is true of MASACCIO (see above), Masolino is also a nickname based on Tommaso, but in this case it means "Little Tom." The artists not only shared a name, but both also came from the region south of Florence, and they also worked together on at least one project: the mid-1420s FRESCO cycle for the Brancacci Chapel in Florence. This collaboration has provided art historians with material for analysis, perplexity, and speculation in their efforts to determine which artist was responsible for which details. The harmony of their efforts is highlighted by the historian Mark Roskill's commentary, quoted from above. It was, he says, "probably a matter of each recognizing where the

true strengths of the other lay and could suitably be applied." Masolino was the older of the two, and his style is retrospective, relating to the lyrical, spiritual idealism of International Style GOTHIC. Around 1424–27, both artists painted their own *Adam and Eve* in the chapel, providing a fascinating opportunity for contrast. Masolino's couple are light on their feet, lithe and complacent, portrayed before the fall, with the serpent hovering benignly above their heads. In Masaccio's image the pair are harshly lighted, heavy, and wrought with despair and disgrace; Eve grimaces and Adam hides his face while the angel above, brandishing a sword, vehemently casts them out of Eden. At times their styles came close enough to be indistinguishable, but after Masaccio died, when Masolino moved on to other projects in Rome and elsewhere, he reverted to his earlier style. This is seen in the fresco *Baptism of Christ* (c. 1435) executed for a church in Castiglione d'Olona, a small town north of Milan. Here there are only traces of Masaccio's massive figures, and Masolino's stylized water and landscape formations have a sense of light and pattern rather than real depth or space.

Masson, André
1896–1987 • French • painter/theoretician • Surrealist

For us, young surrealists of 1924, the great prostitute was reason.

A leading proponent of SURREALIST art, Masson was also a passionate revolutionary. His distrust of power and reason was fortified by the experience of World War I, in which he was seriously wounded. In Paris, he was a friend of Surrealist poets and a great advocate for AUTOMATISM—the stream-of-consciousness means of prompting images. An example of his automatism is the drawing *Battle of the Fishes* (1926), an undersea vision of fishes attacking one another. He created it by spilling glue on the canvas, pouring sand over it, and using the shapes produced as a means of free association. In the next step he used oil, pencil, and charcoal marks to bring out ideas that the random forms suggested. During World War II Masson lived in the United States and was an important resource for ABSTRACT EXPRESSIONISTS, who also called on automatism for inspiration. There were several points of connection between his Surrealism (although he left the fold in an argument with André Breton) and Abstract Expressionism. For example, Masson was absorbed with ideas of metamorphosis in general and its presence in alchemy in particular. This interest led him to the 16th-century alchemist, theologian, and heretic Paracelsus, who sought a key to nature's secret and, through nature, to God. The theme was also used by the Abstract Expressionist GOTTLIEB in several of his paintings. In 1945, Masson returned to France.

Massys, Quinten (also Matsys/Metsys)
c. 1466–1530 • Netherlandish • painter • Northern Renaissance

In iconography, Massys' picture was inspired, I believe, by his good friend Erasmus of Rotterdam; it shows a horrifying example . . . of those foolish

old women who, to quote from the Praise of Folly, still wish to "play the goat," "industriously smear their faces with paint," and have no hesitation to "display their foul and withered breasts." (Erwin Panofsky, 1953)

Massys was the first artist to emerge with distinction from the great numbers who flocked to Antwerp, and he made a name for himself as well as a fortune, rising from blacksmith's assistant to foremost artist. Antwerp was a city in its zenith in 1520. It had replaced Bruges as the center of international commerce and the premier seaport, and it was an equally busy art market. The only city that was at all comparable was VENICE (which handled well under 10 percent of the commercial traffic that Antwerp did). Massys's early religious paintings, such as *Madonna Enthroned* (c. 1495) and the *Altarpiece of the Holy Kinship* (1507–09), carry on the traditions of CAMPIN, van der WEYDEN, and van EYCK. Based on a change in his style and the way he used color, it is thought that Massys may have traveled to Venice and brought back a new PALETTE that included a range unfamiliar to Northern artists—soft blues, rose, orange, and violet, as well as crimson and blond hues. Besides his innovations with color, Massys added an unprecedented affectation to portraiture in 1515 with *Portrait of a Man with Glasses:* an intimation that the viewer has intruded on the subject, who looks up from his book with a slightly annoyed expression and raises his hand in a spontaneous gesture of surprise. This reaction represents a major event in painting, a new dynamic of interaction

between the spectator and the person in the portrait. It introduces a sense of the momentary, like a snapshot, an allusion to time passing. Massys also painted GENRE scenes, the best known of which is *Money-Changer and His Wife* (1514). This picture comes freighted with a moral homily about honesty, as well as the worldly versus the spiritual. To his other innovations we must add one of the strangest portraits ever painted, *The Ugly Old Woman* (c. 1513), and ugly is an understatement for this simian hag who is the subject also of PANOFSKY's ruminations quoted above. This painting closely resembles studies of strange faces and heads found in the notebooks of LEONARDO da Vinci. Massys's picture in turn inspired the illustrator John Tenniel's dreadful Duchess in Lewis Carroll's *Alice's Adventures in Wonderland.*

Master Francke

active c. 1424–30 ● German ● painter ● Late Gothic/International Style

It may seem strange that the mystical content is reversed in Master Francke's painting with the human and mundane aspects of the Passion stressed, but this is in keeping with the brand of mysticism [promoted] in the Rhineland by . . . mystics who counted every drop of blood on Christ's body during his execution. (James Snyder, 1985)

He was one of the most gifted artists of his era, but little is known about this anonymous painter who settled in Hamburg. His work relates to the GOTHIC International Style, and has

been compared with Parisian ILLUMI-
NATED MANUSCRIPTS. It is in reference
to the *Englandfahrer Altarpiece* (c.
1424) that the historian James Snyder
makes the comment quoted above.
Besides the intent of evoking Christ's
suffering, the ALTARPIECE contains in-
teresting juxtapositions of, for example,
richly textured and patterned back-
grounds and symbols of nobility with
proletarian details such as tiny shep-
herds tending their flock in the distance.
All is framed in an aura of transcendent
spiritualism. One of Master Francke's
last-known works that is especially in-
teresting to historians is *Christ as Man
of Sorrows* (c. 1425–30). It contains de-
tails unprecedented in Northern art,
one of which is its elegant drapery and
"cloth of honor" held by angels; an-
other is the way in which Christ touches
his open wound.

Master (of . . .)

For the origin of the term, see MASTER-
PIECE. With the development of ART
HISTORY and the desire to be able to
identify an anonymous artist for the
sake of discussion, the expression
"Master of" is attached to a phrase that
usually refers to a particular work,
a characteristic of several works, a
strength, or a subject—the Master of
the Smiling Angels, for example, was a
sculptor who worked at Reims Cathe-
dral about 1250. A recurrent theme
names the Master of the Playing Cards
(active c. 1425–50, in France)—card
playing was popular during the mid-
15th century—the first engraver for
whom an oeuvre has been identified
(see ENGRAVING). The Master of the
Banderoles (active c. 1450–75, north-

ern Netherlands) is known for inscribed
banners. An artist whose prints were
signed E. S. is called Master E. S. (active
c. 1450–67, Germany). The contribu-
tion of E. S. to our understanding of pil-
grimages and the CULT OF SAINTS is
important because he (or perhaps she)
designed souvenir prints for pilgrims.
Many important 15th-century Flemish
painters are known from the cycles of
the saints' lives they painted: for exam-
ple, the Master of the Saint Lucy Leg-
end, the Master of the Saint Barbara
Legend, and the Master of the Saint
Catherine Legend (all active late 15th
century). Art historians do their best to
attach true, historic names to such
anonymous artists. One important
artist formerly called the Master of Flé-
malle is now identified as CAMPIN (c.
1375/79–1444); a painter of a particu-
larly gory set of pictures about Saint Se-
bastian, long known as Master of Saint
Sebastian, has been identified as Josse
Lieferinxe (also Lifferin/Lifferinxe; ac-
tive 1493–1505).

Master of Saint Giles

active c. 1490–1510 • Franco/Flemish
• painter • Late Medieval/Early
Northern Renaissance

*At one time the Altarpiece of Saint
Denis [by the Master of Saint Giles]
must have been one of the most
fascinating treasures of the abbey
church.* (James Snyder, 1985)

The anonymous artist of several works
that are related stylistically and themat-
ically, this MASTER has left behind pic-
tures that, like those of van EYCK,
combine meticulous attention to realis-
tic detail with a cavalier, or obstinate,

upending of realistic scale and PERSPEC-TIVE. While he worked in France, the Master of Saint Giles's stylistic connections to Flemish artists—for example, BOUTS and van der GOES—indicate that he may have been from the North himself. His *Mass of Saint Giles* (c. 1500) is an extraordinary visual record of the altar furnishings and interior of the Abbey Church of Saint-Denis near Paris (see Abbot SUGER). The painting shows the legendary Charlemagne kneeling before the altar and provides accurate representations of CAROLINGIAN treasures that have also been documented in writing. At the same time, details are objectively precise: There is an Oriental carpet painted at a vertiginous angle—were the floor really so slanted, it would send all present tumbling out of the church. This "realism of particulars" that keeps some and breaks other rules of observation is characteristic of NOMINALISM as it was expressed in the early NORTHERN RENAISSANCE. Snyder's assessment of the *Mass*, which he believes part of an ALTARPIECE with a side panel showing *The Baptism of Clovis,* is quoted above.

masterpiece

The concept of a masterpiece is a MEDIEVAL invention that was derived from GUILD practices. After training as an apprentice and perhaps as a journeyman (the next step up), a candidate for the title of Master and for membership in the guild made an exemplar of his work: a masterpiece. Masterpieces were required of barbers, bakers, tailors, and locksmiths as well as artists and architects. Assigned their subjects—an image of the Virgin Mary, or the Crucifixion,

for example—painters usually had to produce a work of specified dimensions; sculptors submitted a statue; glaziers, a panel of STAINED GLASS. Judges of submissions were Masters, and if they disagreed about a work, arbitration procedures were followed. The title "Master" began to appear as part of artists' signatures toward the end of the 12th century. (See also WORKSHOP)

Matisse, Henri

1869–1954 • French • painter/sculptor • Post-Fauve

I found myself or my artistic personality by looking over my earlier works. They rarely deceive. There I found something that was always the same and which at first glance I thought to be monotonous repetition. It was the mark of my personality, which appeared the same no matter what different states of mind I happened to have passed through.

Matisse's paintings are saturated with bright color. He grew up in Bohain, where weavers created fabrics in many rich colors and patterns. Stylistic affinities with his contemporaries are easily pointed to: the outlines of GAUGUIN that simplify and flatten forms (e.g., *Large Reclining Nude,* 1935); the unnatural colors of his FAUVE friends DERAIN and VLAMINCK, with whom he exhibited in the famous 1905 SALON D'AUTOMNE (e.g., *Portrait of Madame Matisse,* 1905, her face half yellow, half pink, with a green stripe down the middle); the thick brushfuls of paint applied in short, bold van GOGH–like strokes, yet so different in their inviting color (e.g.,

Open Window, 1905). Matisse was entranced by ISLAMIC art, which echoes in his paintings, in which the all-over patterns of walls, tablecloths, and flattened figures and objects seem like pages from a Persian manuscript. "I have never shunned outside influences," Matisse said. "I should consider that an act of cowardice and bad faith towards myself. I believe that the struggles an artist undergoes help him assert his personality." When DENIS advised that he restudy CLASSICAL tradition (which he had done as a student of MOREAU), Matisse turned to Agostino CARRACCI's *Reciprico Amore* (1589–95) as a source, it is believed, for his circle of ecstatic nude dancers in *Joy of Life* (1905–06). Sometimes Matisse's response to his contemporaries could be ambiguous: *Bathers with a Turtle* (1908), a picture of three women feeding lettuce to a turtle, is said by the historian John Elderfield to be a response to PICASSO's fierce *Demoiselles d'Avignon* (1907). (Elderfield organized the great Matisse retrospective exhibition of 1992.) Though Matisse's large and lumpy female figures are no more idealized than Picasso's fractured, looming, sharp-edged demons, they are certainly more friendly. An often told story is that Matisse had studied law and in 1890 was working in a law firm, until, when he was nearly 21, he had to have an appendectomy. During his convalescence his mother gave him a box of paints, a set of brushes, and an instruction book. "When I started to paint I felt transported into a kind of paradise. . . . I felt gloriously free, quiet and on my own," he later said. The beneficent effect painting had on Matisse is conveyed to his audience. The most complaining of critics are undone by Matisse.

Matta (Sebastian Antonio Matta Echaurren)
born 1912 • Chilean/French • painter • Surrealist/Abstract Expressionist

I had some kind of trauma when I realized what the war was, and the concentration camps, and I went one step further in my understanding.

Matta went to Paris in 1933, studied architecture with LE CORBUSIER, met DALÍ, and became a member of the SURREALIST group in 1937, painting what he called "Psychological Morphologies," and "Inscapes." In the United States from 1939 to 1948, Matta helped to bridge the gap between Surrealism and ABSTRACT EXPRESSIONISM. The comment he made above prefaces Matta's description of a transition from the inwardness of Surrealism's imagery to "cultural expressions, totemic things, civilizations." The difference was in seeking to give an individual's inner life universal rather than personal meaning. An example of his effort is *Disasters of Mysticism* (1942), which seems to allude to outer space as if it were seen through partly cracked glass. There is a pinwheel effect, and a cluster of blood red forms, but it is difficult to find a focal point, and one's attention is shuttled from a single point to the whole, as if caught in the turmoil of battle. Matta returned to France and became a French citizen in 1959.

maulstick (mahlstick)
From the Dutch terms meaning "to paint" and "stick," refers to a long,

wooden rod artists use to support and steady the hand that holds the paintbrush. There are several self-portraits in which the artist holds a maulstick, for instance, by the 16th-century painters van HEMESSEN and ANGUISSOLA. Another, of ROCKWELL, appeared on the cover of *The Saturday Evening Post* in 1960.

Mausoleum of Halicarnassus
Mausolus was a 4th-century BCE satrap, or governor, for the Persian empire. Although he warred with the Greeks, Mausolus was an avid Grecophile and employed Greek artists at Halicarnassus, the city he made his spectacular capital. Mausolus died in 353 BCE. The great memorial he planned was probably begun during his lifetime; it was finished about 350 BCE. It was 160 feet high and rectangular at its base. It had 36 Ionic COLUMNS, 40 feet tall, surrounding the upper section, and a stepped pyramidal roof. Its elaborate sculptural program was carried out by renowned Greek artists, including SCOPAS, Bryaxis, Timotheus, and LEOCHARES. It was named one of the SEVEN WONDERS OF THE ANCIENT WORLD, and we know it primarily from PLINY the Elder's descriptions (which do not all quite add up) and from recovered fragments of sculpture, mostly in the British Museum, thanks to archaeological work started by Sir Charles T. Newton in 1856. The structure, designed by Pythis and Satyros, was faced with white marble; a carved marble chariot driven by Helios and drawn by four horses crowned the roof. Groups of freestanding statues—88 life-size Greeks and Persians in battle, 72 even larger warriors and huntsmen above

them, and 36 colossal statues of Mausolus's ancestors between the columns— as well as three carved friezes with traditional battle themes of Lapiths fighting Centaurs and Greeks fighting Amazons, were all highlighted by blue and red paint. Lions parading around the base of the roof were painted yellow-ocher. In the second century CE, PAUSANIAS wrote that the Romans were "utterly astounded" by this building and adopted the word "mausoleum" for their own great tombs. It was an inspiration to the historicizing architects of the 19th and early 20th centuries (see HISTORICISM). In Washington D.C., an adaptation of the memorial to Mausolus reemerged as the council building of the Scottish Rite of Freemasonry (1911–15), designed by John Russell Pope (1874–1937).

McKim, Mead and White
The architectural firm formed in 1879 whose partners were Charles Follen McKim (1847–1909), William Rutherford Mead (1846–1928), and Stanford White (1853–1906). Together with Richard Morris HUNT, this company set the style for the Gilded Age in America. In opposition to the indigenous styles developed by midwestern architects like SULLIVAN, these architects based their plans on grandiose European examples. An exception was the Isaac Bell House in Newport, Rhode Island (1881–83). Though grounded in English prototypes, it was in the so-called Shingle style—facade covered with wood shingles—and was less ostentatious and more informal than most Newport mansions. The firm also designed the Boston Public Library (1887–95), a square, white-granite building with an

open courtyard. The exterior has Roman ARCHes enclosing the windows of the second floor and three arched openings that serve as the entrance. It was designed to be a "palace of the people," and was the largest public lending library to date.

Medici

Throughout the ITALIAN RENAISSANCE and into the 18th century, Florence was nominally a republic and actually an oligarchy ruled, on and off, by the Medici family. Their wealth derived from banking houses in Italy and throughout Europe. Their power was both secular and religious—several members of the family became popes, most famously Leo X (Giovanni de' Medici) and Clement VII (Giulio de' Medici). Medicis were the main patrons of art in Florence. Giovanni di Bicci (Giovanni di Averardo de' Medici, 1360–1429), founder of the family fortune, gained wide support by championing the city's poorer population against taxation. He was BRUNELLE-SCHI's first PATRON, awarding him the commission for the Old Sacristy of San-Lorenzo (1421–25).

Cosimo the Elder, 1389–1464, was one of Giovanni's two sons. Artists he commissioned included Brunelleschi, DONATELLO, GHIBERTI, and della ROB-BIA. Their works were frequently symbolic of Florentine legends, victories, and the exploits of the Medici. UC-CELLO's *Battle of San Romano* (mid-1450s), for example, commemorates a Florentine victory of 1432. It was destined for the bedroom of the Palazzo Medici-Riccardi (begun 1444), which was designed for Cosimo by MICHEL-OZZO. Ironically, even as Medici largess in the arts was dispensed, the family's banking houses were failing during the second half of the 15th century. Cosimo had young FICINO trained in philosophy and Greek in order to have PLATO translated into Latin, and he founded the Platonic Academy, putting Ficino at the head of it.

Piero (the Gouty) di Cosimo de' Medici (1416–1469) enjoyed (or endured, considering his crippling infirmity) only a five-year reign. It was probably he who chose GOZZOLI to paint the *Procession of the Magi* in 1459 (completed 1461) in the Medici palace. This FRESCO was of a favorite subject of the Medicis, who belonged to the Company of the Magi, one of the many religious organizations that flourished during the Renaissance.

Lorenzo the Magnificent (1449–1492) took over the reins from Piero, his father, in 1469, at the age of 20. He had studied under Ficino and had literary as well as political ambitions. He was an extremely power-hungry tyrant who exercised his will fiercely. Lorenzo's conspicuous consumption and immorality were notorious enough to provoke popular uprisings (see SAVON-AROLA). Yet the arts flourished during his rule. MICHELANGELO was invited by Lorenzo to live at the palace and study in an art school established in the nearby Medici Garden (now vanished). In the 1480s, SANGALLO designed a villa for Lorenzo (the Villa Medici at Poggio a Caiano). Though it is uncertain whether Gozzoli's above-mentioned *Procession of the Magi* was actually conceived by Lorenzo or by his father, it was installed in the palace

chapel, and a portrait of Lorenzo himself appears as part of the procession in the painting. POLLAIUOLO and VERROCCHIO were Lorenzo's favorite artists. BOTTICELLI's paintings contain many Medici symbols, allegories, and portraits: Then already deceased Cosimo, for example, is in *Adoration of the Magi* (early 1470s). In Botticelli's striking portrait *Young Man with a Medal* (1470s?), although the young man's identity is uncertain, the large medal he holds is clearly a likeness of Cosimo. A hundred years ago historians described Lorenzo as a heroic, beneficent figure and patron of the arts. That estimate has been revised to the extent that one of the many events in Italy commemorating the fifth centenary of his death, in 1992, was a resolutely anti-Lorenzo exhibition.

Lorenzo di Pierfrancesco (1463–1503) was a younger second cousin of Lorenzo the Magnificent. Because VASARI recorded seeing two of Botticelli's most important pictures, *Primavera* (c. 1478) and *Birth of Venus* (c. 1484), on the walls of the villa in which Lorenzo di Pierfrancesco lived, it had long been assumed that he commissioned them. When a 1498 inventory of the villa's contents came to light, they contained no record of those pictures, so his patronage is today refuted, and the elder Lorenzo seems the more likely patron. But it is still possible, as Frederick Hartt suggests, that the young man in *Young Man with a Medal,* described above, is none other than Lorenzo di Pierfrancesco.

Cardinal Giovanni de' Medici (1475–1521), son of Lorenzo the Magnificent, became Pope Leo X in 1513.

He favored RAPHAEL and is the patron who fanned the flames of competition between MICHELANGELO and Raphael (see SEBASTIANO). Upon becoming pope, he enabled Raphael to reach a position of power never enjoyed by any other artist. Besides being showered with commissions, Raphael was named the first Superintendent of Antiquities and given authority over all excavations in the papal dominions.

Cosimo I, first Grand Duke of Tuscany (1519–74), was from another branch of the Medici family. Besides becoming a supporter of Mannerist art (see MANNERISM), Cosimo I played a large part in forwarding Vasari's project of recording the lives of Italian artists, and, no doubt, in contributing to its Tuscan bias. Later members of the family also played their parts, but never with as much panache as had their predecessors. One exception is Marie de' Medici (1573–1642), who married Henri IV and reigned as queen of France after his assassination in 1610. RUBENS was commissioned to paint a cycle of pictures based on her life.

Medieval art
3rd–15th century

The Latin roots of the term "Medieval" mean "middle" and "age," and this period is alternatively called the Middle Ages. Once known as the Dark Ages, it was then considered a vast empty space between the end of the Greco-Roman CLASSICAL world (sometime during the first centuries BCE) and the beginning of the ITALIAN RENAISSANCE. That opinion is long outdated. On the contrary, the Medieval period is admired and studied in its own right, its boundaries are far

more permeable, and the dynamic of cross-fertilization enriches art throughout all the Medieval centuries. Still, dating and defining its beginning and its end is entangled in problems of PERIODIZATION, even as the notion of periodization is itself contested. The Church was the main PATRON and material beneficiary of the arts throughout the Medieval period. It provided a setting for communal and formal liturgy and for private worship. In its architecture and works of art, it could provide the illusion of heaven on earth, a transcendental stage setting for spiritual, often mystical, experience. However, as the relationship of church and state was the continuing theme of European politics from the time the emperor Constantine pledged his allegiance to Christianity in the early 4th century, politics also influenced Medieval art.

After 430, imperial forces could not defend from "barbarian" tribes (see MIGRATION) either the city of Rome itself or the western provinces of the Roman empire. The western part of the empire collapsed as a political entity and the emperor was replaced by German rulers, who divided the territory into kingdoms. Christianity survived in the West thanks in great measure to the zeal of Irish missionaries (see HIBERNO SAXON), and then to the vigor of Charlemagne's support (see CAROLINGIAN). Later, the eastern portion of the empire came to be called Byzantium. Thus, Medieval art is separated into two ultimately competing entities, led by the emperor in the West and the patriarch in the East. In the East, where the Orthodox Church made little distinction

between the power of church and that of state, the patriarch held temporal and spiritual power (caesaropapism), and BYZANTINE ART flourished for 1,000 years. In the West, the pope was spiritual leader and the emperor or king ruled secular affairs (nominally as vicar of God). While Byzantine art developed in the East, the West hosted a succession of styles: Hiberno Saxon, Carolingian, MOZARABIC, OTTONIAN, ROMANESQUE, and GOTHIC. Among differences that can be cited is the veneration of images of Christ and the saints in the East (except for one period of time; see iconoclasm under ICON), while in the West the purpose of images was ostensibly for instruction. Yet crosscurrents of stylistic influence can hardly be overemphasized.

medium

The material or technique an artist uses as a means of expression or communication: e.g., MARBLE, LITHOGRAPHY, PERFORMANCE, and PHOTOGRAPHY. In painting, medium also refers to the substance (e.g., oil, water) in which PIGMENT is suspended (for example, see OIL PAINTING and WATERCOLOR).

Meissonier, Ernest
1815–1891 • French • painter/sculptor • Realist

. . . .defenders slain, shot down, thrown from the windows, covering the ground with their corpses, the earth not yet having drunk up all the blood.

Before the slaughter of the French Revolution of 1848 and the riots that ensued, Meissonier painted pleasing,

everyday GENRE subjects with meticulous attention to detail. Called to duty as a captain in the National Guard, and on scene to defend the Hôtel de Ville during the "June days," he was an eyewitness to the massacre he describes in the passage quoted above. *Memory of Civil War (The Barricade, rue de la Mortellerie, June 1848; 1848)* is a gory presentation of what he saw. Later, during the Franco-Prussian War, after having recorded the military triumphs of both Napoleon I and Napoleon III, Meissonier was a colonel in the National Guard. *The Siege of Paris* (1870) is his updated massacre, but it is as operatically heroic as the earlier work was mordant. Here again are dead and dying, but this time they appear in uniform rather than as peasants, the mood is courageous, and allegory reigns: The city of Paris is personified as a woman standing in front of the *tricolore* wearing a helmet fashioned as a lion's head; the Prussian eagle and a personification of famine hover ominously overhead.

memento mori
Latin term that means "remember you must die." Memento mori in art refers to symbols of mortality such as a skull, hourglass, candle, and flowers, which, at the peak of their beauty, will soon wilt and die. Memento mori are especially prevalent in STILL LIFE paintings. (See also VANITAS)

Memling, Hans (also Memlinc)
1430/40–1494 • Netherlandish • painter • Northern Renaissance

Hans Memling was the most accomplished and excellent painter in the entire Christian world. (Written at Memling's death by the notary of Saint Donation in Bruges)

Memling arrived in Bruges in 1464, after van der WEYDEN's death. Fifteenth-century Bruges (then Burgundian, today Belgian) did not look so very different from the cityscape that has been preserved to this day. We find it in the background of several 15th-century paintings where it seems to embody an ideal town in which sacred and secular, church and state, existed in harmony and prosperity reigned. However, as the historian Johan Huizinga wrote, "It is a general phenomenon that the idea which works of art give us of an epoch is far more serene and happy than that which we glean in reading its chronicles, documents, or even literature." In fact, Bruges, although a center of trade and manufacture, was in economic and political crisis that led to its ceding its place to Antwerp by the beginning of the 16th century. Memling was an assimilator rather than an inventor of styles, but his bright, restrained narratives are beautifully set in idyllic panoramas, as though he were able to change contemporary reality, as Huizinga suggests, by manipulating the landscape. *Scenes from the Life of the Virgin and Christ* (1480) contains no fewer than 25 biographical moments in the lives of Mary and Jesus. The setting is outside of Jerusalem, and while the tidy little city in the background may be an imaginary Jerusalem, the topographical details of hills and rock outcrops, as well as the pleasant harbor in the distance, make it possible to associate it as

much with Bruges as with the Holy Land. For the Hospital of Saint John in Bruges, in addition to two ALTARPIECES and other works, Memling created the *Shrine of Saint Ursula* (1489), a RELIQUARY in the form of a small church. Narrative scenes from the saint's life are painted between gilded wooden arches on the exterior. Some of the story takes place in Cologne, another city that Memling was familiar with, judging from the accuracy of the cityscape that he depicted.

Mendieta, Ana
1948–1985 • Cuban/American • performance/body artist • Feminist

. . . a dialog between the landscape and the female body (based on my own silhouette) . . . a return to the maternal source.

Mendieta moved to Iowa from Cuba in 1961 and studied art at the University of Iowa, where, in 1973, she began to use her own body to make her art. The purpose of her BODY ART is described by her comment above. In the *Tree of Life Series* (1977) she covered her naked body in mud and stood before a wide tree trunk, almost four times her own width. Her arms are raised above her head in a way that identifies her with prehistoric Egyptian TERRA-COTTA figurines, fashioned from Nile River mud about 4000 BCE, often called goddesses. These and subsequent figures of women are also called the Great Mother, the Primordial Mother, the Archetypal Feminine, and Mother Earth. It is this image that Mendieta's work celebrates. It is seen today only in the color photograph taken of her at the time she made

Tree of Life. Mendieta died in a fall from an apartment window in New York in 1985.

Mengs, Anton Raphael
1728–1779 • German • painter • Neoclassicist

By the ideal I mean that which one sees only with the imagination, and not with the eyes; thus an ideal in painting depends upon selection of the most beautiful things in nature purified of every imperfection.

After a period as court painter in Dresden, Mengs, who had studied in Rome, settled there in 1751. A representative of the anti-BAROQUE, he was a proponent of NEOCLASSICAL purity, clarity, and nobility upheld by his mentor, WINCKELMANN. He distinguished between copying the ANTIQUE and imitating it, arguing in favor of the latter because it required consideration while the former was mere plagiarism. Both he and Winckelmann were confounded by the important finds at HERCULANEUM and POMPEII, in 1738 and 1748 respectively, which seemed to them pale imitations of the best of the antique. As a ruse, Mengs painted *Jupiter and Ganymede* (1758–59), one of Winckelmann's favorite subjects, in imitation of Herculaneum, and Winckelmann was, indeed, deceived by it. Mengs was the tutor of the American painter WEST.

Menzel, Adolph
1815–1905 • German • painter • Realist/Impressionist

[I approach the painting] with a beating heart and full of enthusiasm

for the ideas for which the victims had fallen.

In his paintings Menzel moved between portraying intimate family moments, as in *The Artist's Sister with Candle* (1847), and momentous public gatherings, as in *Funeral of the Martyrs of the Berlin Revolution* (1848). It is about painting the latter that he wrote the comment quoted above. Menzel blurred the boundaries between everyday, GENRE scenes and Grand Opus HISTORY PAINTINGS. He enjoyed an early success, in Berlin of the 1840s, with 400 ENGRAVINGS he did to illustrate a life of Frederick the Great. He was again called on to celebrate German nationalism during the Franco-Prussian War, when a collector in Berlin asked him to paint the military pageant that accompanied the departure of the Prussian king for the front. Menzel's commission came well after the event and its outcome—Prussian defeat of Napoleon III, the eclipse of France's SECOND EMPIRE, and unification of Germany under Wilhelm as emperor. *Departure of King Wilhelm I for the Army on July 31, 1870* (1871) resembles the great Parisian crowd scenes of the IMPRESSIONISTS rather than a conventional propagandistic or historic painting. The street, observed from above, bustles with people; Prussian and German flags flutter in the breeze and wrap around their posts; the king and queen are but barely visible in their carriage. This has the gaiety of MANET's *Concert in the Tuileries Gardens* (1862) and the detached point of view (but with less-distant elevation) of MONET's *Boulevard des Capucines, Paris* (1873).

Menzel's exuberant throng provides a curious contrast to MEISSONIER's *The Siege of Paris* (1870), which shows the ravages of the German victory that Wilhelm is, in Menzel's picture, setting off to accomplish.

Merovingian art
See MIGRATION

metalpoint
See SILVERPOINT

Metaphysical School (Scuola Metafisica)
See CARRA and de CHIRICO

Metcalf, Willard Leroy
See AMERICAN IMPRESSIONISM

method/methodology
Refers to a practical or theoretical approach to discussing and understanding art. From purely descriptive (EKPHRASIS) through CONNOISSEURSHIP, FORMAL, and RECEPTION, the concept of methodology presumes a conscious choice of analytic procedure or an alliance to a point of view (e.g., MARXISM and FEMINISM). Methods in ART HISTORY is itself a field of study in the discipline.

metonymy
The structural linguist Roman Jackobson described metaphor and metonymy as the two primary dichotomies of human language. As a figure of speech, or in a picture, a metaphor is an associative relationship: It brings together ideas or images, so that a painting of a sunset, for example, might stand for old age. A metonymy, also a figure of

speech, needs a more direct relationship: A metonymy is a displacement rather than an analogy, or condensation of an image and its meaning. For example, one might use as metonymy the White House standing for the president. The relationship or connection of the image to its signification is critical. A synecdoche is a kind of metonymy in which a part is used to represent the whole; the word "bloodshed," or the color red, might a be a synecdoche for war. Jackobson was an important influence in bringing the principles of SEMIOTIC systems to ART HISTORY. Both metonyms and metaphors are TROPES.

Metzinger, Jean
See CUBISM

mezzotint
Meaning "half-tint" or "half-light," or "shadows," this is a process employed in making prints. Mezzotint is used sometimes for the entire image, sometimes for just a portion. The process produces a wide and subtle range of light and dark tones. The metal surface on which the image is to be drawn is first textured with an overall pattern of dots or "burrs" by an instrument called a rocker. If this surface were printed, the result would be a page of solid black. However, a picture drawn on this surface smooths the tiny dots so that they no longer hold the ink so efficiently—gradations of light and shadow are possible—and the final image appears in the print against a background that remains black, or whatever color the ink, to the extent that any of the original "rocked" surface is left. Mezzotint is distinguished, on close inspection, by the rows of minute dots that make up its tones. Unlike other INTAGLIO methods, the lines of a mezzotint are not sharply cut, but, rather, are more subtly graded. Mezzotint refers both to the process and to the end product. Invented in the 17th century, mezzotints became popular during the 18th, when portraits by REYNOLDS and GAINSBOROUGH were reproduced by this means. Peter Pelham, COPLEY's stepfather, was highly skilled at mezzotint work and his *Cotton Mather* (1727), a portrait of the Puritan leader—so finely worked that it looks almost like an oil painting—is one of the earliest prints made in the American colonies. (See also PRINTING)

Michelangelo Buonarroti
1475–1564 • Italian • sculptor/painter/architect • Renaissance

Every beauty which is seen here below by persons of perception resembles more than anything else that celestial source from which we all are come. . . . The best artist has no concept which some single marble does not encase within its mass.

Michelangelo's famous saying—that the artist must find his idea locked inside the stone—has seemed to embody the essence of creative genius for almost five centuries, containing the notion that the greater the artist, the more surely he, or she, will be able to find and reveal life's hidden truths. However, Michelangelo's artistic hierarchy was quite specific: Sculpture came first, painting second. In addition, he dismissed "additive" sculpture—achieved by MODELING a form with materials like clay—as being too much like paint-

ing. Stone was Michelangelo's medium; his wet nurse was from the town of Settignano, a village of stonecutters (see DESIDERIO and ROSSELLINO), and he liked to say that he absorbed the love of stonecutting as an infant. As if to confirm that idea, he frequently chose to represent the Virgin Mary feeding the baby Christ. As certainly as he determined his medium, he also knew his subject: the human body. In that "mortal veil," as he called it, he saw divine intention; and he was not loath to think himself godlike in his ability to liberate a human being from matter. Landscapes, clothing, even facial cast were insignificant in relation to the physical attitude and presence of the figures Michelangelo both sculpted and painted; he was the first to endow the body with such expressive power. His marble *David* (1501–04), more than 14 feet tall, exemplifies heroic, muscular strength and beauty, while it is simultaneously a political metaphor for the Florentine Republic, which had just (although temporarily) shaken the grip of the MEDICI family. *David* is rarely photographed from the angle at which Michelangelo intended the statue to be seen—sideways, situated as if overlooking the city—but he clearly bears scant resemblance to his smooth-skinned, delicate-boned, bronze predecessors made by DONATELLO and VERROCCHIO.

Michelangelo began his artistic training with GHIRLANDAIO, but was soon invited to live at the palace of Lorenzo de' Medici, where an informal school had been established. When Lorenzo died and Florence was in chaos, Michelangelo worked for a time in Bologna, then in Rome, where he carved the *Pietà* (1498–1500). After his return to Florence, where he finished *David* during a four-year stay, Pope Julius II called him to Rome. Known as the warrior pope, Julius was, like the ITALIAN RENAISSANCE itself, interested in both secular and religious power, and he sought both temporal and eternal glory. For the latter he commissioned Michelangelo to design and carve a tomb to rival the MAUSOLEUM OF HALICARNASSUS. After a year of work, fraught with difficulties of temperament and logistics, that project was abandoned. Had it not been stopped, Michelangelo would have spent the next 40 years on Julius's tomb. Instead, he spent 18 months on a bronze statue of the pope (subsequently destroyed and melted down), and then began work on the Sistine Chapel at the Vatican. Though he was reluctant to paint, especially such a vast project—some 5,800 square feet, about 70 feet above the floor—he designed special scaffolding for the purpose and completed the ceiling in less than four years (1508–12), entirely by himself. The theme is the Creation, Fall, and Redemption, surrounded by prophets and sibyls—hundreds of figures altogether. In the center God floats in the firmament, pointing his finger and bringing Adam forth from primeval earth to flesh and blood. Michelangelo's analogy of the sculptor creating his form is inevitable. Many of the hundreds of preliminary drawings Michelangelo made for the ceiling survive, though the CARTOONS are gone. These were laid on the fresh plaster for each day's work, in the process called *buon* FRESCO. The cleaning of this ceiling fresco, from 1985 to 1990, removing hundreds of years of grime, uncovered unexpectedly

brilliant color and caused unprecedented controversy. Critics insist a surface layer, fresco *secco,* was mistakenly removed, giving Michelangelo's painting an unwarranted garishness. Others believe that the colors are true, and point to how they resemble what the next generation of Mannerists would adopt (see MANNERISM). The historian Marcia Hall agrees, pointing out that he used strong color selectively, rather than uniformly, and adds that Michelangelo was "as significant a pioneer in color as he was in form, inventing here the *cangiatismo* mode." This mode is described as purposely artificial and ornamental, juxtaposing highly contrasting colors. The gulf between those for and those against the cleaning may remain unbridgeable. Michelangelo returned to the Sistine Chapel to paint *The Last Judgment* from 1536 to 1541 (also cleaned, 1990–93), a morbid, turbulent scene that includes his self-portrait on the flayed skin of Saint Bartholomew. In the interim, the Medicis had returned to power, and Michelangelo designed the Medici Chapel and tomb sculptures in San Lorenzo, Florence. He proceeded with the tomb for Julius II, who died in 1513, beginning three extraordinary sculptures for it in 1513: a fierce, muscular *Moses* with horns (see SLUTER) and two tormented yet sensuous *Slaves* for which there was no room on the diminished version of the tomb that was finally dedicated in 1545.

Michelangelo was caught up in the apocalyptic fervor that gripped Florence in the wake of SAVONAROLA's sermons, and, as his poems attest, he was also tormented by turbulent, sometimes unfulfilled love affairs with young men.

His close relationship with Vittoria Colonna, a Catholic reformer steeped in mysticism, began around 1536 and had a profound impact on his spiritual life. She died in 1547, when Michelangelo was in his 70s. A melancholy, sometimes morose mood permeated Michelangelo's poetry and sculpture during his late years, and after Colonna's death he seemed to renounce all love other than that of Christ. Failing eyesight and strength inhibited his ability to paint, yet he designed two of his most important architectural projects: the Medici family's Laurentian Library with its great, flowing stairway (begun 1524), and Saint Peter's in Rome. Saint Peter's had a long history, dating back to the 4th century, and during the Renaissance it had been redesigned by both BRAMANTE and Antonio da Sangallo (see SANGALLO). Michelangelo simplified Bramante's design, creating a single space covered with a hemispherical DOME (completed after his death; the final plan was redesigned during the early 17th century). In contrast to LEONARDO, RAPHAEL, and CELLINI, who remained aloof from the political and religious upheavals of the era, Michelangelo felt the problems acutely and reflected them in a number of his works. He was the subject of two biographies during his lifetime, the first by VASARI. The later, by CONDIVI, was authorized by the artist and believed to be a corrective for the first. There is, today especially, some question of the extent to which Michelangelo himself crafted the alternately persecuted and persecutor reputation by which he is known. There is also a revisionist perspective that assesses him as a conscientious and even benevolent entrepreneur,

managing a community of workmen in a well-organized and well-run workshop.

Michelozzo di Bartolommeo
1396–1472 • Italian • sculptor/architect • Renaissance

When Cosimo was exiled in 1433, Michelozzo, who greatly loved him and was very faithful to him, voluntarily accompanied him to Venice, and was with him during his stay there. Accordingly, besides the many designs and models which he made there of public and private dwellings for the friends of Cosimo, and for many noblemen, he made by Cosimo's order, and at his expense, the library of the monastery of S. Giorgio Maggiore. . . . This constituted the diversion and pastime of Cosimo until . . . he returned in triumph and Michelozzo with him. (Vasari, mid-16th century)

Michelozzo worked with GHIBERTI on the bronze doors to the Florence Baptistery and with DONATELLO on several projects, especially tomb sculpture. He also worked with BRUNELLESCHI, and if he seems to have been always an understudy and never a star, he did gain independent fame as an architect, though somewhat by default. His best-known work is the Medici-Riccardi Palace, begun in Florence c. 1444, named in part after the Riccardi family, who bought it at the end of the 17th century. Cosimo de' MEDICI's fondness for Michelozzo is described by VASARI above. Brunelleschi had also submitted a design for the palace but it was rejected because it was more ostentatious than the proposal offered by Miche-

lozzo. Having experienced a year of exile (1433–34), Cosimo decided that discretion was wiser than conspicuous consumption. Michelozzo's relatively modest but immensely dignified plan is three stories high. Large blocks of rusticated, or rough-cut, stone on the ground level are reminiscent of ancient Roman monuments. The stones flatten out and diminish in size on the second and third stories, which also decrease in height.

Middle Ages
See MEDIEVAL

Mies van der Rohe, Ludwig
1886–1969 • German • architect • Modern/International Style

I don't want to be interesting. I want to be good.

Mies van der Rohe succeeded GROPIUS as director of the BAUHAUS, then left Germany to teach in Chicago in what is now the Illinois Institute of Technology. He also designed the school's campus. Mies is considered the archetypal architect of the INTERNATIONAL STYLE. Among his best-known works is the amber-tinted glass Seagram Building in New York City (1956–59), a slender, rectangular, elegant, and aloof skyscraper with its own plaza and reflecting pools. It is a classic illustration of the concept that "less is more," a phrase that Mies van der Rohe used. The critic Louis Mumford called Mies van der Rohe's steel-and-glass structures "elegant monuments of nothingness" that "had no relation to site, climate, insulation, function, or internal activity; indeed, they completely turned their backs upon these realities, just as the

rigidly arranged chairs in his living rooms openly disregarded the necessary intimacies and informalities of conversation." This harsh assessment neglects the truth that Mies's cool, sleek building was a stunning and appropriate expression of the anonymous corporate world to which it belonged and for which it was designed.

Migration period

4th–7/8th (sometimes dated 5th–7th) century. Refers to the period of movement and settlement in Western Europe of Germanic and Slavic tribes. These peoples were called barbarians by RO-MANS, who were following a GREEK precedent of so naming outsiders whose incomprehensible language sounded like stuttering—bar bar—to them. These tribes gained power over Rome and its western empire. Their people were herders in search of land, and they had deep-rooted cultural traditions as well as highly accomplished, richly ornamented works of art, especially in gold and bronze. Their art was generally portable and included personal ornaments, weapons, and implements. Three elements characterize art of the Migration period: the ANIMAL STYLE (fantastic animal forms), INTERLACE and spiral designs, and HORROR VACUI (fear of vacant space), which inclined them to fill all surface space with decoration. As barbarians were Christianized, Christian art assimilated barbarian forms. An example is provided by Merovingian art. Named after a Frankish ruling dynasty that claimed descent from a hero named Merovich, the Merovingians were Christianized under the reign of Clovis I (481–511). Merovingian architecture and artifacts incorporated the ornamental Animal Style.

Millais, John Everett

1829–1896 • English • painter • Pre-Raphaelite

I hope it will not have any bad effects upon her mind.

With fellow students William Holman HUNT and ROSSETTI, Millais was one of the three founders of the PRE-RAPHAELITE BROTHERHOOD. Their first meeting was at his house in London, around the corner from the British Museum, in 1848. He was then 19 years old. Millais worked out the "wet white" technique: transparent colors applied over white paint that was still wet. Others adapted this method to achieve a high, fresh, sunlit look. Millais's painting *Christ in the Carpenter's Shop* (1849–50), showing Joseph in his workshop with Mary and young Christ, whose cut hand prefigures his Crucifixion, resulted in reviews so ferocious that they are now legendary. Among those incensed was Charles Dickens, who described Millais's Christ as "a hideous, wry-necked, blubbering, red-haired boy" and Mary as "so horrible in her ugliness . . . that she would stand out from the rest of the company as a monster in the vilest cabaret in France or the lowest gin-shop in England." Amid the uproar, Queen Victoria had the picture removed from exhibition and brought to her, at which point Millais made the sardonic comment quoted above. *Christ in the Carpenter's Shop* is painted with meticulous attention to detail. Millais spent time in a carpentry shop to research procedures, tools, and so forth, and one can count the number

of curls in a wood shaving or the strands of hair that cross Joseph's balding head. While the artist's own father modeled for Joseph's face, for Joseph's arm Millais studied the arm of a real carpenter to be sure the muscle structure was accurate. He used sheep heads from a butcher for representing the flock outside the door. Such pedestrian, GENRE treatment of a holy subject was partly responsible for the picture's scalding reception, but the existence of the newly revealed secret society of the Pre-Raphaelite Brotherhood also influenced the reaction, inciting fear that they were a subversive group of young renegades. Millais fell in love with RUSKIN's new wife, who had her marriage annulled in order to marry Millais. He went on to enjoy fame and wealth, especially from paintings of children, one of which became famous as an advertisement for Pears soap (*Bubbles*, 1886). He also painted portraits of prominent figures, including *Thomas Carlyle* (1877), *William Gladstone* (1879 and 1885), and *Benjamin Disraeli* (1881), and large-scale landscapes of the Scottish countryside, such as *Chill October* (1870). In 1885 he became the first artist to be made a baronet.

Millet, Jean-François
1814–1875 • French • painter • Rural Realist

I have avoided (as I always do with horror) anything that might verge on the sentimental.

Best known for his scenes of humble, pious peasants working in the fields, Millet lived in the village of Barbizon and associated with the BARBIZON SCHOOL painters who worked around the Forest of Fontainebleau, but he is not strictly a Barbizon landscapist. The historian Kermit Champa argues that Millet and his friend Théodore ROUSSEAU, a founder of the Barbizon group, are "two halves of one artist." Where Rousseau evokes human presence and feeling in his landscape paintings, Millet's human figures, natural and at home on the earth, evoke the character of their landscape environment. From a fairly well-to-do family of pious Norman peasants himself, Millet studied in Paris with DELAROCHE. His paintings of toiling peasants created a sensation at the SALONS of the 1850s. Because of his subject matter, the police were asked to check his credentials before he received a state-sponsored commission. Any suspicions that he was politically radical were wrong. As his contemporary biographer Alfred Sensier wrote, "Millet had never caused any trouble in any way, he seemed to be quite satisfied with simply painting, staying very quietly at home, or walking around gazing at the sky, the fields, and the trees." His own politics aside, antiestablishment writers approved and admired the moralizing they chose to find in Millet's paintings. They saw it in paintings like *The Sower* (c. 1850), in which a laborer is casting seeds onto the field. This picture represents a way of life that was succumbing to changes brought about by the Industrial Revolution. The writer Alexandre Dumas père equated Millet's critical reception to that of COURBET some years earlier—indignation on the one hand, admiration on the other—and concluded that a mediocre artist would not prompt such reaction.

mimesis

From ancient Greek, mimesis means "to imitate," or "mimic," primarily referring to things in nature. Thus, mimesis defines the artistic process of representation. Discussion of mimesis is important to art theory. PLATO diminishes art in mimetic terms as being a copy of a copy of what is in the "real" or IDEAL world. Speaking on behalf of art in the *Poetics,* Aristotle, Plato's student, argues that the artist represents nature not as it is but as it should or could be. Plotinus, founder of NEOPLATONISM, elaborated on mimesis, saying that art does not simply imitate what is seen, but rather, through creative ability, the artist understands underlying principles of what is or could be seen. The example Plotinus uses for illustration is the sculptor PHEIDIAS's *Zeus,* which is based not on seeing Zeus, but on knowing how the god would look should he appear in human form. In contemporary discussions of mimesis, GOMBRICH uses the idea to formulate an argument in support of an artist's individualized perception being used to modify historic conventions of representation. Borrowing from WÖLFFLIN, who wrote "the effect of picture on picture as a factor in style is much more important than what comes directly from the imitation of nature," Gombrich wrote, "All paintings . . . owe more to other paintings than they owe to direct observation." BRYSON disputes what he calls Gombrich's "Perceptualist account" with the argument that Gombrich entirely neglects the play of power vested in the patron and audience of the artist's work. Painting, Bryson insists, ". . . is bathed in the same circulation of signs that permeates or ventilates the rest of the social structure."

miniature

Minium, a red PIGMENT from lead, was originally used to draw pictures in ANCIENT and MEDIEVAL manuscripts—they were thus "miniated." By an extension of meaning, and perhaps in confusion with *minimus,* Latin for "the smallest," the diminutive scale of those decorations led to "miniature," signifying the paintings or drawings in manuscripts, books, and other small, independent pictures. Christine de Pisan, the first professional woman writer in Western history, names her contemporary, a woman by the name of Anastaise, as an accomplished early-15th-century miniaturist. In Pisan's *The City of Women* (1405) she writes that Anastaise is "so skilled in painting the borders of manuscripts and miniatures" that she is unrivaled in Paris, which is "the center of the best illuminators in the world." Scholars have not yet been successful at identifying Anastaise's work. Portrait miniatures, in this case directly related to size, became popular in Europe, especially in England, during the 16th century.

Minimal art/Minimalism

As its name suggests, Minimal art refers to pared-down, usually regular, geometric, frequently machine-made, and sometimes repetitious forms. In their reductiveness, embrace of mass production, and use of new materials, POP and Minimalism have much in common. Roots of Minimalism may be found in REINHARDT and Frank STELLA and perhaps DUCHAMP. Its early practitioners in the 1960s include JUDD, ANDRE, and

FLAVIN. In contrast to CONCEPTUAL art (see KOSUTH), which followed on the heels of Minimalism, the object is central to Minimal art. In fact, one tributary of the movement is "process art," in which the procedures and materials used for making an object and the signs or symptoms of its being made (e.g., saw marks, or the weight of its own form) are central to the finished work (see Robert MORRIS). Explanations are also critical, as the historian Jonathan Fineberg writes: "Minimalism depended upon a prodigious amount of polemic—written largely by the artists themselves—to reveal the motives behind these apparently simple works." (See also ABC)

Minoan art
c. 2800–1500 BCE

The Aegean island of Crete was the center of Minoan civilization, named for the legendary King Minos. Little is known of the settlement and history of Crete, or of nearby THERA, with its elaborate houses and wall paintings recently excavated, and the dates cited above are somewhat arbitrary. The maze-like Palace of Knossos on Crete (c. 1600–1400 BCE; occupied in its latest phases by MYCENAEANS from mainland Greece), which is partially reconstructed from ruins, may be the labyrinth of the Minotaur legend. Although in close contact with both cultures, Minoan art differs from that of contemporary Egypt and Mesopotamia primarily in its spontaneity and interest in showing movement. Minoan images are colorful and rich with observation of the natural world, including swimming dolphins, birds, and landscapes. On the walls of the palace is the famous *Toreador Fresco* (c. 1550 BCE), which shows acrobatic "bull leapers" grasping a bull by its horns and vaulting over its body. Whether this was a game or a rite of passage is not known, nor is the reason for the darker coloring of what seem to be the male figures. Also found at Knossos were faience (pottery made with an opaque glaze) figures today called snake goddesses (c. 1600 BCE), but their votive role is hypothesized—little is known of Minoan religion. Introduction of the potter's wheel led to stylistic and commercial advances on Crete (see POTTERY).

minor arts

Painting, sculpture, and architecture were long considered the premier arts, and the rest—usually known as decorative, domestic, and craft arts—as secondary or "minor." Today the term is nearly extinct, and it is certainly vexed. (See also DECORATIVE ARTS, FINE ART, HIGH ART, and POPULAR ART)

Mir Iskusstva
See WORLD OF ART

Miró, Joan
1893–1983 • Spanish (Catalan) • painter • Surrealist

You must always plant your feet firmly on the ground if you want to be able to jump up in the air.

When he went to France in 1919, Miró joined the circle of Spaniards with PICASSO at its center. Miró worked in FAUVE and CUBIST styles before adopting the SURREALIST mode. The first group exhibition of Surrealist artists in 1925, in Paris, included his paintings. Prompted by Miró's use of

AUTOMATISM—explorations of the subconscious through automatic writing—André Breton, spokesman for SURREALISM, predicted that history would prove Miró to be the most surreal of the group. Besides making clear that he started with his feet on the ground, as in the quotation above, Miró himself said, "I begin painting and as I paint the picture begins to assert itself, or suggest itself, under my brush. The form becomes a sign for a woman or a bird as I work." In America, he became one of the best-known Europeans and was an inspiration for ABSTRACT EXPRESSIONISM as it coalesced after World War II. His later paintings, like *Blue II* (1961)—a canvas filled with blue paint on which a line of irregular, solid black circular forms leads to a blood red vertical brushstroke—reveal that he was, in turn, influenced by American Abstract Expressionists, especially the COLOR FIELD painters. Miró's images are often animated with a sense of gaiety and humor. His BIOMORPHIC blobs are joined by squiggles, circles, stars, and energetic lines in black as well as bright colors. Shapes are frequently associated with male and female genitalia and what the historian Robert Rosenblum calls "the sexy throb of biology." *Painting* (1933) has solid black and outlined shapes as well as some in white, red, blue, and green. Though *Painting* is generally described as the most nonfigurative of Miró's work, allusions to icons such as PICASSO's bull horns and suggestions of human and animal shapes do emerge. Miró was overtaken by dismay during the Spanish Civil War (1936–39) and the pre–World War II period; *Head of a Woman* and *Nursery Decoration*, both

from 1938, have something ferocious and demonic about their fanged beaks and bug eyes. During World War II, Miró settled permanently in Palma de Mallorca. There he worked with the ceramicist José Artigas, making POTTERY sculpture and ceramic tile murals; two of the murals were for UNESCO headquarters in Paris. Prehistoric cave paintings at Altamira, Spain, as well as Spanish architecture and painting, were Miró's inspiration. He said, "I sought a brutal expression in the large wall, a more poetic one in the smaller. Within each composition I sought at the same time a contrast by opposing to the black, ferocious and dynamic drawing, calm colored forms, flat or in squares."

Mitchell, Joan

1926–1992 • American • painter •
Abstract Expressionist

. . . even today a vastly underappreciated painter. (Arthur Danto, 1987)

Mitchell was in the second generation of ABSTRACT EXPRESSIONIST painters. Her apparently spontaneous paintings are, in fact, carefully constructed. Often based on landscapes, a painting such as *Dirty Snow* (1980), for example, builds thick layers of color: pale gray, cobalt blue, and lavender. The ground, and perhaps moving figures, is suggested by black forms and dark colors on the bottom of the canvas, while paint-laden strokes of white blend with and cover darker tones, giving a mauve-blue tint to the putative sky and suggesting the snow of the title. Mitchell exhibited regularly in New York, even after moving to Paris in 1955. Despite the significance of her work, Mitchell has not re-

ceived the attention she merits, as the philosopher-critic Arthur Danto comments in the quotation above.

mobile

Term coined by DUCHAMP in 1932 to describe the sculptures of CALDER. A mobile is a work with moving parts, usually suspended by wires, that are finely balanced. In a long tradition of popular constructions, such as balancing toys, mobiles may be moved by anything from the slightest air current to a mechanical driver. Each movement creates a new set of relationships.

modelbook

Also called pattern books, modelbooks contained drawings of, for example, faces, hands, animals, the head of Jesus crowned with thorns, or that of a stereotypical queen. Not always in the form of a book, some images, about 3 × 3 inches, were mounted, framed, and stored in a small wooden box. These drawings served as exemplars for artists to copy. The modelbook sources for many MEDIEVAL paintings can quite easily be traced. Modelbooks were valuable assets.

modeling

In its first sense, "modeling" refers to shaping a work in a plastic medium such as clay or wax. The term is also used in relation to paintings that endeavor to achieve the illusion of three-dimensionality through the use of dark and light shading. In *The Book on Art* (1437), CENNINI describes modeling that used pure COLOR in the shadows, adding gradations of white for the mid- and light tones—"up-modeling." GIOTTO and his followers practiced

up-modeling. The system of modeling promoted by ALBERTI in *On Painting* (1435) creates shadows by adding black and is called down-modeling. LEONARDO used this technique. Other means of showing the plasticity, solidity, or depth of form have also been explored, for example, manipulation of the thickness or darkness of lines, hatching and cross-hatching (i.e., with parallel lines), and exploiting the expressive properties of color: "Hot" and "warm" colors like red, orange, and yellow seem to advance, while "cold" and "cool" colors, such as blue, green, and brown, seem to recede. Juxtapositions of advancing and receding colors participate in modeling systems.

modello, modelli (pl.)

An Italian word that refers to the small version of a larger painting, usually executed on paper, but often on wood. A modello is more elaborate than a sketch, and was often made to show to a client for approval before the final painting went forward. Although PAPER and PARCHMENT were widely available, no modelli for FRESCO scenes from before 1340 are known. After that date, modelli themselves were collected as works of art.

Modern/Modernism/modernity

Several characteristics distinguish Modernism in art, and dating its advent depends on which characteristic is stressed. BAUDELAIRE's direction of attention toward problems and activities of contemporary urban life around 1850 is one marker. According to this guideline, REALISM² would then be the first important Modern movement. Others argue that Modernism begins

later, with rejection of the ITALIAN RE-NAISSANCE convention of the picture as a window opening onto a world of objects in mappable PERSPECTIVE. According to this way of thinking, it is the very assertion of artifice, an insistence on consciousness of the act of seeing and painting (the IMPRESSIONIST's flickering light, the visible brushstroke, the texture of paint), that defines Modern art. Photography played a large part in Modern art; the first daguerreotype of 1839 might be seen as heralding Modernism. Painting and photography interacted as prompt, provocation, and competition. Modernists were generally suspicious of and often hostile to science, technology, and industrialization until FUTURISM embraced them. The era of Modernism stylistically considered covers everything from Realism to MINIMALISM. To some, POSTMODERNISM is a continuation of Modernism; to others, it is new and distinct. Modern and Modernism refer to art and an artistic movement of which PICASSO's *Demoiselles d'Avignon* is the most familiar icon. The term "modernity" is frequently used interchangeably, but it more properly refers to the historical period, not to any movement.

moderne
See ART DECO

Modersohn-Becker, Paula
1876–1907 • German •
painter/graphic artist • Expressionist

Don't be sad about me. If my life won't take me back to Worpswede, that does not mean that the eight years that I spent there were not good. I found Otto very touching. This, and thoughts of you, make my path a difficult one.

Modersohn-Becker, a major influence on MODERN art in Germany, was the first German painter to use POST-IMPRESSIONIST ideas in her paintings. She studied at the Berlin School for Women Artists and at the German artists' colony of Worpswede, where she met her teacher and future husband, Otto Módersohn. She left Worpswede to study in Paris in 1900, the first of four trips to that city. After her marriage in 1901, back in Germany, she was torn between her domestic responsibilities and her drive to express herself through art—a compulsion fed by EXPRESSIONIST manifestos. She fled to Paris. Her family implored her to return, and the passage quoted above is from a letter to her mother. In Paris she studied literature as well as art, and was a friend of the poet Rainer Maria Rilke, whom she had met at Worpswede and who had been RODIN's secretary in Paris. Her numerous self-portraits have unusual candor and depth, belied by a highly simplified use of color and line. Her style shows several current trends: The geometric, volumetric planes of the face in her 1906 *Self-Portrait with Amber Necklace,* for example, may recall both MATISSE's portraits of his wife and PICASSO's *Gertrude Stein* (1905). But more important is her nudity and that in *Mother and Child Lying Nude* (1907). Modersohn-Becker and VALADON were among the first women to concentrate on painting the female nude. This was a bold step, proclaiming independence from the tradition of representing the female body for the erotic

pleasure of males, as FEMINIST historians and critics explain. Modersohn-Becker's promising career ended when she died, soon after childbirth, at the age of 31. In her writings she had expressed premonitions of an early death. As short as her career was, she left behind some 400 paintings and studies and 1,000 drawings.

Modigliani, Amedeo
1884–1920 • Italian • painter/sculptor • School of Paris

Here is my passport!

Born into a well-to-do Jewish family in Livorno, Italy, Modigliani first went to Paris in 1906. Riddled with tuberculosis, drugs, and alcohol, he spent a good part of his short, dissolute life in the cafés of Montparnasse, constantly and obsessively sketching, often paying for his drinks with his art. Once, when a policeman asked him for identification papers, he waved a bunch of his drawings at him with the exclamation quoted above. Modigliani died at the age of 35, reportedly murmuring, "Cara, cara Italia!" It is also said that his lover committed suicide so as not to survive him. These stories, true or not, contribute to a Modigliani legend, and contribute also, indirectly, to understanding his art. There is a kind of plaintive asceticism in the spare grimness of the figures he painted, often in dark clothes. They have elongated forms, exceedingly long necks, and oval faces. "Mannered" best describes the affectation of his forms. They are forward-facing (FRONTAL), seem expressionless yet sad, and have unusual psychological depth. His portrait of his friend, *Chaim Soutine* (1917), is a good example of Modigliani's distinctive style: an almost complete absence of detail, save a nearly empty glass on the corner of a table, roughly but thinly applied paint, an oval face with its distinctive characteristics—wide nostrils, thick lips, uneven, almond-shaped eyes—all delicately outlined (see SOUTINE). Though he exaggerates features, Modigliani never makes fun of his subjects nor renders them grotesque. Rather, he shows heightened sensibility to the individuality of his model.

Moholy-Nagy, László
1895–1946 • Hungarian • sculptor/painter • Constructivist

The receding and advancing values of the black and white, grays and textures, are here reminiscent of the photogram.

An important teacher at the BAUHAUS, Moholy-Nagy applied its principles at the New Bauhaus, which he founded in Chicago in 1937. (It later became the Institute of Design, and is now part of the Illinois Institute of Technology.) His writings, including *The New Vision* (1932), are elucidations of the Bauhaus vision and of his own interest in technology and industry. He pioneered in the construction of machines that combined light and motion and set the stage for later mechanized KINETIC sculpture. He called his machines "light modulators." Moholy-Nagy also worked in photography. He began by using the work of others in PHOTOMONTAGES, and went on to make his own images both with the camera and without: Like MAN RAY, he made "photograms" by

laying objects on light-sensitive paper and then exposing them to light. He also took pictures from dizzying heights, "Rodchenko perspectives," named for his Russian counterpart RODCHENKO, with whom he shared mutual admiration. The quotation above refers to an aerial view Moholy-Nagy photographed from such a height, *Berlin Radio Tower* (c. 1928), a fascinating if disorienting essay in black and white, circles and angles, shot from high up in the tower.

Momper, Joos de, the Younger
1564–1635 • Flemish • painter • Baroque

Mio amico Momper [My friend Momper]. (Jan Bruegel the Elder, 1622)

Both his father and grandfather were painters and Joos de Momper became a MASTER in the Antwerp Guild of Saint Luke in 1581 while his father was its dean. He became dean himself in 1611. Of his 10 children, two sons were painters. In 1626 de Momper was exempted from wine and beer taxes and other civic duties in recognition of his years of working for the archdukes. His fortunes declined, however, and, though he traded paintings for spirits, he was in debt to the local tavern when he died. He is famous for his infinite variety of fantastic mountainous landscapes, as well as his grottoes and seasonal scenes, but there are few signed works and only one that is dated: *Mountain Landscape with Travelers* (1623), both signed and dated, is a large (6 feet high, 11 feet wide) and majestic vista, the fantastic bluish mountains in the background of a sunlit wooded scene. Partnership among artists was common practice, and while he worked with many others, de Momper was a frequent collaborator and friend of Jan BRUEGEL (as reflected in the quotation above). About 80 joint efforts are mentioned in 17th-century inventories, including several winter landscapes. It is hypothesized, but not documented, that de Momper may have crossed the Alps, which would have contributed to his imagination of the soaring mountains he painted.

Mondrian, Piet (Pieter Mondriaan)
1872–1944 • Dutch • painter • De Stijl/Neo-Plasticism

In the future, the tangible embodiment of pictorial values will supplant art. Then we shall no longer need paintings, for we shall live in the midst of realized art.

Following his early (c. 1914) work in church decoration, Mondrian's painting progressed, with what almost seems preordained determination, from representational landscapes to straight lines, in the style for which he coined the term NEO-PLASTICISM. His lifelong quest for "pure plastics" (plasticism) led to a gradual awareness that "(a) in plastic art reality can be expressed only through the equilibrium of dynamic movements of form and color; (b) pure means afford the most effective way of attaining this," as he explained. In translation onto canvas, this came to mean only straight lines, right angles, and primary colors plus black and white. Neo-Plasticism was, for Mondrian, more than a style of painting. It was equally philosophy and religion.

Art in harmony with universal principles would, he believed, bring all aspects of life into line with these principles, ultimately obviating art, as explained in the comment quoted above. Mondrian's belief in Theosophy provided the underpinning for his variations of lines and squares or rectangles of color, which were designed to represent the underlying structure of nature. A cofounder of De STIJL with van DOESBURG, Mondrian left the movement in 1925 when his colleague endeavored to achieve more dynamic expression through diagonal lines. Mondrian continued his explorations of the dynamic balancing of vertical and horizontal structures and basic colors. A problem that troubled him was that his red, blue, or yellow shapes seemed, visually, to occupy the foreground, disrupting the spatial unity he sought. His solution was to devise a system of using heavy lines as though they move through rectangles of color. In works like *Tableau II* (1921–25)—blue, red, yellow, black, and two shades of gray—he achieves his goal: Everything, under tight control, holds its place. Mondrian's experimentation continued. He taught at the BAUHAUS, lived in Paris, then briefly in London, and moved to the United States in 1940. In *Broadway Boogie-Woogie* (1942–43), Mondrian returns to "landscape," translating New York City streets into a grid composed of squares and rectangles via lines in (still primary) color. The picture expresses the jazzy life and spirit of Broadway. Mondrian's influence on succeeding generations extended to the INTERNATIONAL STYLE in architecture as well as ABSTRACT EXPRESSIONISM and, later, styles from OP ART to MINIMALISM.

Monet, Claude

1840–1926 • French • painter • Impressionist

When you go out to paint, try to forget what objects you have before you—a tree, a house, a field, or whatever. Merely think, here is a little square of blue, here an oblong of pink, here a streak of yellow, and paint it just as it looks to you, the exact color and shape, until it gives your own naive impression of the scene before you.

On December 27, 1873, a group of artists, calling itself the Société Anonyme des artistes peintres, sculpteurs, graveurs, etc. . . ., met to plan an exhibition of their works to be held on April 15, 1874, two weeks before the opening of the official SALON. They were dissatisfied because even the "alternative" SALON DES REFUSÉS used juries to select from among rejected works, and they wished to turn their backs on all forms of discrimination. Their exhibition was hung alphabetically and in only two rows, giving everyone equal opportunity to be seen. It was at this exhibition that one of Monet's five paintings, called *Impression—Sunrise,* gave its name to the movement that had begun over a decade earlier. The painting was ridiculed and IMPRESSIONISM was at first a term of derision. Yet it revealed Monet's intent, as quoted above, and reported by one of his students, an American artist, Lilla Cabot Perry (AMERICAN IMPRESSIONISM). The goal of these painters, as finally understood, was "not to render a landscape but the sensation produced by a landscape." Monet and others explored the individualized nature of sensation, in

part by painting the same subject at the same time as another artist did (see RENOIR). Monet also studied the temporal nature of sensation by painting the same subject from the same point of view at different times of day, in different seasons or weather conditions. In the latter category is his 1890s series *Rouen Cathédral*—some 40 views—his numerous haystacks, and about 16 views of Waterloo Bridge in London. In 1899 he began painting *Water Lilies,* from those in the water garden he constructed at his home in Giverny. He even built a special studio so he could paint them on outsize canvases. In Monet's paintings, each short, thick brushstroke of unmodulated color was correlated to a visual sensation, and the effect was to dissolve form as conventionally seen and to reconstitute it, or at least express it, in terms of light (in which color is implicit). Summing up to Gustave Geffroy, his friend and biographer, in 1909 Monet wrote: "I have painted for half a century and will soon have passed my sixty-ninth year, but, far from decreasing, my sensitivity has sharpened with age. As long as constant commerce with the outside world can maintain the ardor of my curiosity, and my hand remains the prompt and faithful servant of my perception, I have nothing to fear from old age."

monograph

An art history monograph is usually an article or book devoted to a single artist or one work of art. This is in contrast to writing devoted to themes or periods, for which there is no specific term. Monographs serve an important role in presenting new information in a cogent biographical or CONTEXTUAL frame-

work, and also in focusing attention on neglected artists. For example, with the growth of FEMINIST and REVISIONIST art history, previously ignored and marginalized artists (e.g., ANGUISSOLA, KAHLO, and PIPPIN) have been the subjects of monographs. However, the idea of the traditional monograph is also challenged and complicated by current critical theorists, especially followers and interpreters of Roland Barthes, Michel Foucault, and the SEMIOTIC approach. These writers are likely to consider artist (as "author") or work (as "text") as an individual's progression through the dominant social and cultural forces of the time. Thus, Griselda POLLOCK writes, "Van Gogh becomes historically useful by throwing into relief those cultural formations [i.e., Dutch and French avant-garde] precisely through the degree that van Gogh was incapable of accommodating his practice to them and normalizing their protocols and concerns." (See also NEW HISTORICISM)

monotype

As its name implies, monotype is a means of transferring one image in paint or ink from the surface on which it is painted or drawn (e.g., glass or metal) to another surface (e.g., PAPER). Only one copy is made, in contrast to multiple copies from most PRINT mediums, so each monotype is unique. DEGAS produced monotypes in a series of brothel scenes (e.g., *The Client,* c. 1879).

montage

COLLAGE and montage are often used interchangeably, as both involve applying, or superimposing, materials like

colored paper, newspapers, and sticks on a surface. The main difference derives from the French root of each word: *Coller* refers to pasting or gluing things together (a MATISSE paper "cutout" is called a collage); "montage," from *monter,* refers to mounting by whatever means, be it paste, nails, knots, or clamps. There is usually a sense that collage is used more for pattern and color while in montage things are used more symbolically, but this is a rule with many exceptions. ERNST's *Two Children Are Threatened by a Nightingale* (1924) is a montage. A kind of conceptual cinematic sequence, also called montage, was used by Sergei M. Eisenstein in the film *Battleship Potemkin* (1925)—one powerfully evocative montage followed an image of a firing pistol by one of a teeming crowd, that image succeeded in turn by a falling statue. (See also PHOTOMONTAGE and ASSEMBLAGE)

Montefeltro, Federigo II da
In the later 15th century, Urbino, in central Italy, was a preeminent cultural center. The house of Montefeltro's reign over Urbino dated back to the early 13th century. Federigo II (1422–1482), born out of wedlock and illustrious for his military victories, became Urbino's most enlightened ruler and a generous patron of the arts. He and his bride, Battista SFORZA, were painted by PIERO della Francesca (c. 1472), whose intriguing *Flagellation* (mid-1450s) is still in the ducal palace there. The palace was built in several stages from the 1440s to the 1470s. The palace architect, Luciano Laurana, designed a glorious courtyard with an elegant arcade and two friezes inscribed with words enumerating the virtues of Federigo. BRAMANTE, born near Urbino, was inspired by the design of this building. The walls of the duke's study *(studiolo)* at Urbino are celebrated: They are composed of inlaid cabinetwork of various colored woods (intarsia). Designed to resemble latticed cupboards, in one section the TROMPE L'OEIL composition simulates a door left open to reveal the cupboard's "contents." On an upper level, the pretense includes niches with statuary and views to the outdoors. Federigo's interests are represented by the illusory books, musical instruments, and armor. Federigo had a similar room created for his home in Gubbio. This *studiolo* was made in Florence in the WORKSHOP of Giuliano da Maiano (1432–1490) between 1478 and 1483, and Federigo did not live to see it assembled. (Under restoration for almost 30 years, it was returned to public view at the Metropolitan Museum of Art in New York in 1996.) Federigo's son, Guidobaldo (1472–1508), although infirm, was a strong military man and patron of the arts; his court was praised in CASTIGLIONE's *The Courtier.* Cesare Borgia, who came to power in the area of Urbino around 1499, looted the priceless Montefeltro collections of their art and other treasures.

monument
Conventionally, a structure or sculpture serving as a memorial, triumphal, or otherwise important landmark. The word "monument" has another application: Important works of art subject to study and analysis, whether painted, sculpted, or built, are called monuments in ART HISTORY.

Moore, Charles W.
1925–1993 • American • architect • Postmodern

I have believed for some time that sense might be made of the opposing views [of Modernism and its detractors] in the terms of "yin" and "yang," the Chinese diagram of opposites complementing one another. If our century's predominant urge to erect high-rise macho objects was nearly spent, I thought we might now be eligible for a fifty-year-long respite of yin, of absorbing and healing and trying to bring our freestanding erections into an inhabitable community.

Moore first gained national attention as one of the designers of Sea Ranch (1963–65), a housing complex north of San Francisco. Its weathered wood siding and "shed" roof (i.e., with just one sloping plane) soon became a popular idiom. It also continued the ground-hugging tradition of Frank Lloyd WRIGHT's Prairie Style and his concept of a building in harmony with the landscape. While those innovations were in the spirit of MODERNISM, Moore went on to design with a POSTMODERN approach, mixing historical periods and incorporating colorful and picturesque details at his pleasure, in the interest of "an inhabitable community," as described in the quotation above. Piazza d'Italia (1977–78) in New Orleans is from an early stage of Moore's rebellion against the rationality and formalism of "yang" design. To honor the Italian population of the city, Moore included a relief map of Italy, allusions to the triumphal arches of ancient Rome and to bell towers and fountains, all in the setting of a large Italian *piazza,* or plaza.

Moore, Henry
1898–1986 • English • sculptor • Modern/Figurative abstraction

When I was eleven I was in Sunday school and I heard a story about Michelangelo. I can't remember the story, but what I retained was that Michelangelo was esteemed the greatest sculptor who ever lived. That unremarkable bit of information moved me, then and there, to decide to become a sculptor myself.

Moore's signature reclining women usually are enormous, but they look huge even when they are relatively small. Early in his career, between 1926 and 1930, pre-Columbian art was the most important influence on Moore. His first masterpiece, *Reclining Figure* (1929), reveals its effect in the FRONTALITY of the figure and in the sharp angles at which the limbs bend. During World War II, in 1940, Moore was an official war artist in England. His drawings of Londoners huddled in underground bomb shelters touched the general population, making him one of England's best-known artists. But in sculpture it is his female figures, sometimes joined by infants, on which his reputation rests. He and HEPWORTH restored to sculpture the importance of carving in wood and stone. Since RODIN had reintroduced BRONZE casting, that is what sculptors had been concentrating on. Moore said, "It is only when the sculptor works direct, when there is an active relationship with his material, that the material can take its part in the

shaping of an idea." But later in the 1940s and 1950s, with his interest in solving spatial problems, and in opening large voids in his figures to connect one side to the other and more immediately achieve three-dimensionality, as he explained, Moore himself frequently turned to casting. Casting allows the penetration of forms with larger openings than carving does. In using these "holes"—he likened them to "the mysterious fascination of caves in hillsides and cliffs"—Moore followed the example of Hepworth. Their work differed, however, in that Hepworth's forms leaned more toward nonfigurative AB-STRACT concepts while Moore's great interest was the human figure (*Interior-Exterior Reclining Figure,* 1951). Among Moore's sculptures without openings are the great bronzes of *King and Queen* (1952–53). They have distinctive flattened bodies with small heads and spindly limbs. During his last decades Moore worked largely with three themes: rough-finished, mountainlike reclining figures; smoothly finished and contoured figures, reminiscent of the earlier types with voids; and huge skeletal-like forms, generally in bronze, with a variety of finishes. These latter countermand his earlier "truth-to-materials" intention, which held that stone should look like stone, and metal and wood sculpture should express the nature of its material. To change or vary textures of a material suggests, or acknowledges, that the artist is exerting his or her personal skill and authority. This contradicts the long-enduring principle that the intrinsic nature of a material should dictate the form the artist gave it.

Moreau, Gustave

1826–1898 • French • painter • Symbolist

O noble poetry of living and impassioned silence! How admirable is that art which, under a material envelope, mirror of physical beauty, reflects also the movements of the soul, of the spirit, of the heart and the imagination, and responds to those divine necessities felt by humanity throughout the ages. It is the language of God! . . . To this eloquence, whose character, nature and power have up to now resisted definition, I have given all my care, all my efforts: the evocation of thought through line, arabesque, and the means open to the plastic arts—that has been my aim!

Moreau painted scenes from the Bible, the classics, and other texts, and is sometimes called a "literary" SYMBOL-IST. His style was eclectic, his figures assume theatrical rather than natural poses, and his scenes are elaborated with a multitude of detail. As the contemporary Symbolist painter REDON remarked, Moreau's inner life was veiled by worldly artifice. Moreau repeated a type of languid, androgynous male figure, sensitive but doomed, and destructive, sinister women—a convention known as the FEMME FATALE. A watercolor, *The Apparition* (*Dance of Salome;* 1876), illustrated a story popular with PRE-RAPHAELITES as well as Symbolists. In Moreau's picture Salome dances, barely clothed but lavishly bejeweled, while the halo-encircled, luminescent head of John the Baptist, gushing blood, is suspended in midair. She strikes an aggressive pose, pointing

to but not looking at John. The colors are chilling—white, sapphire blue, and blood red. There is tension in Salome's frozen attitude—Moreau aspired to what he called "the beauty of inertia"—in the profusion of ornamental detail and in the combination of decadence and beauty. The inspiration was one of Moreau's favorite books, Gustave Flaubert's *Salammbô*, published in 1863. (Moreau also painted the Salome theme in OIL.) Moreau's work was attacked when he sent it to the SALON in 1869, but by the 1890s it was well recognized, and he was an important teacher at the ÉCOLE DES BEAUX-ARTS. Moreau lived and worked in seclusion, but devoted himself to helping students develop their own styles and influence, ROUAULT and MATISSE among them. When a colleague commented "Isn't that the end?" about a SALON DES INDÉPENDANTS that included the avant-garde work of TOULOUSE-LAUTREC and Henri ROUSSEAU, Moreau replied, "The end? No, it is only a beginning." On his deathbed Moreau said to Rouault, "I would leave my uniform of the Academy of Fine Arts to you, only you would burst all its seams."

Morelli, Giovanni
1816–1891 • Italian •
critic/connoisseur

. . . the history of art can only be studied properly before the works of art themselves. Books are apt to warp a man's judgment.

Morelli endeavored to make a science out of CONNOISSEURSHIP, devising ways to test the attribution of a painting by studying incidental details such as the representation of eyes, ears, and hands, which he believed each artist treated idiosyncratically. He questioned many widely accepted attributions. One example is a painting previously thought to be by Pordenone (1483?–1539) that Morelli reattributed to TITIAN based on details like earlobes and fingernails. His training as a physician contributed to his awareness of such physical traits and fueled his detractors' criticism that he was "a mere empiric," able, that is, only to believe what his own observations and experience dictated. Morelli's ideas on connoisseurship were published late in his professional life; having studied medicine in Switzerland and Germany, he served in the army during the Risorgimento, the Italian unification movement, of the 1860s. Once Italy became an independent nation, Morelli was a member of the senate, especially active on arts commissions. The comment quoted above is from the introduction to *Italian Painters* (1890) and was written in the first person. The book was published under the pseudonym Ivan Lermolieff, an anagram of Morelli's name with a Russian ending. It presents Morelli's opinions in dialogue form and is full of humor as well as sharp critiques of contemporary art history practices. In his essay on MICHELANGELO's *Moses*, Sigmund Freud cited Morelli in support of his approach. BERENSON was foremost among the followers of "Morellian criticism."

Morgan, Julia
1872–1957 • American • architect •
Eclectic

That [tree] is three inches out of line.

In the summer of 1917, on a mountain rising 2,000 feet above the Pacific Ocean about 200 miles south of San Francisco, the newspaper tycoon William Randolph Hearst announced to a gathering of his friends that they were on the very spot where he was going to build his house. He showed them a model prepared by the architect, Julia Morgan. She was a graduate in engineering at the University of California at Berkeley, where she was the only female student, and of the French ÉCOLE DES BEAUX-ARTS, where she was the first woman admitted to study architecture. For Hearst's compound, known as San Simeon, Morgan designed three palatial guesthouses and the main house itself, Casa Grande (1922–26), which resembles a castle more than it does any "house." The style is derived from that of the Spanish missionary churches of the Franciscan order in Mexico and southern California, the Mission Style. Elaborate twin towers with fretwork ornamentation surmount the building; they replaced the original towers that Hearst had torn down soon after they were finished because he considered them too severe. Morgan's insistence on perfection matched his, as illustrated by her comment quoted above, made when she was sighting along a line of plum trees. (The groundsmen moved the offending tree back three inches.) Morgan worked for a willful client who kept her on an annual retainer and budget for most of her career. She masterfully accommodated the unprecedented collection Hearst had assembled from European castles and cathedrals—entire rooms, carved ceilings, MOSAICS, staircases, STAINED GLASS, sarcophagi, TAPES-

TRIES, COLUMNS . . . whatever struck his fancy—and designed architectural environments and details to incorporate them. From the turn of the century until her retirement in 1951, Morgan designed 700 buildings, both private and public. One of her first commissions was the Bell Tower at Mills College, in California, and she built several YWCAs.

Morisot, Berthe
1841–1895 • French • painter • Impressionist

My ambition is limited to the desire to capture something transient, and yet, this ambition is excessive.

In 1896, on the first anniversary of Morisot's death, MONET, RENOIR, DEGAS, and the poet Stéphane Mallarmé opened a memorial retrospective in her honor. With those artists, along with her brother-in-law, MANET, who died in 1883, she was a founder of IMPRESSIONISM. Almost a century later, in 1987, another Morisot exhibition was held. "There are many reasons for the relative neglect of Morisot by collectors and historians since 1896, what we now call sexist attitudes chief among them," the introduction to the exhibition catalogue explained. Morisot's art had progressed within the Impressionist vocabulary. She applied paint with almost manic vigor, her brushstrokes crisscrossing each other. At close range the subject of a picture is virtually indistinguishable, and it looks like the work of an ABSTRACT EXPRESSIONIST concentrating on the evocative texture and color of paint, not on recognizable forms. But at a certain distance Morisot's subjects coalesce—a birdcage, a woman seated in a garden—and

open to allusions of time, place, and perhaps story. She painted landscapes and domestic scenes that are filled with the glow of light. That is true even in *Mother and Sister of the Artist* (1870) despite the black dress the mother wears. As remarkable as her accomplishments are, she still is studied relatively infrequently.

Morris, Robert
born 1931 • American • sculptor • Minimalist/Process art

The process of "making itself" has hardly been examined. It has only received attention in terms of some kind of mythical, romanticized polarity: the so-called action of the Abstract Expressionists and the so-called conceptualizations of the Minimalists. . . . American art has developed by uncovering successive alternative premises for making itself.

One of the founders of MINIMALISM, Morris also explored several other ideas, but he is especially well known for what is called Process art, which he describes in the quotation above. Educated in the liberal arts rather than a professional art school, conversant with philosophy and literature in addition to ART HISTORY, Morris was an important spokesman for new art endeavors during the 1960s and 1970s. One *Untitled* composition of 1967–68 (there are others) is among his best known and also serves to illustrate his definition of Process art. It is made up of 254 pieces of heavy, charcoal gray felt in strips of various widths and lengths. Piled in a mound on the floor, the random, casual assembly of the felt, acted on by gravity,

determines the size and shape of the finished work. The pull of gravity is exemplified here in three ways: the downward drape of the strips of felt on the wall; the position of the larger, heavier pieces of felt closest to the ground; and the down curves of the smaller strips of felt on the top of the pile. One could also say that as gravity insists on pulling objects toward the center of the earth, all these pieces seem to be seeking that core. "In these cases considerations of gravity become as important as those of space. The focus on matter and gravity as means results in forms which were not projected in advance," Morris writes. In one sense this example might be thought of as a compact, three-dimensional realization of the piled-up skeins of paint that poured from Jackson POLLOCK's paint cans, as strongly controlled by gravity as they were by Pollock. Morris speaks of both Pollock and LOUIS in terms of Process art, alluding to the way in which Louis moved his paint on the surface by tilting the canvas. Process art plays with philosophical ideas regarding indeterminacy, while from a purely visual point of view, Morris's *Untitled* is an intriguing tumble of gently curving and undulating forms. HESSE is the foremost example among those artists who were directly influenced by Morris.

Morris, William
1834–1896 • English • designer/craftsman • Pre-Raphaelite

All the minor arts were in a state of complete degradation, and accordingly in 1861 with the conceited courage of a young man I set myself to reforming

all that and started a sort of firm for producing decorative articles.

The firm Morris alludes to above was the successful Morris, Marshall, Faulkner & Co., formed in 1861 and reorganized in 1875 as Morris & Co. In 1890 he founded the Kelmscott Press. Many of the leading PRE-RAPHAELITE painters made designs for Morris's products, which ranged from STAINED GLASS and textiles to wallpaper, furniture, and exquisite books. His own reputation as a designer is largely associated with his printed textiles. For these he introduced a new range of vegetable dyes in order to revitalize a technique that had been discontinued, replaced by mineral colors of the later 18th century, and by aniline dyes derived from coal tar after the 1850s. Morris's all-over patterns of entwined flowers, leaves, and birds in rich blues and reds, often inspired by ISLAMIC art, remain popular. The crowning achievement of the Kelmscott Press was the folio *Chaucer* (1896), illustrated by BURNE-JONES, Morris's closest associate. (ROSSETTI and BROWN, as well as Burne-Jones, were partners in his original firm.) A leading figure in late Victorian DECORATIVE ARTS, Morris was also important as a political-social theorist. Rejecting the Industrial Revolution and things produced by machine, he looked back longingly to MEDIEVAL life, legend, and handcrafted objects. Morris wished to restore the GUILD workshop system, and wanted all classes of people to enjoy beautifully made things: "What business have we with art at all unless all can share it?" he asked. He helped found the Socialist League in 1884 and played a leading part in the ARTS AND CRAFTS MOVEMENT. That workers who so carefully handcrafted beautiful objects could not, in fact, afford to own them troubled him. He was also disturbed by feuding among Socialist leaders in the late 1880s. Morris visited Iceland twice in the 1870s and described the experience in his epic poem *Sigurd the Volsung* (1876). Beginning in the mid-1860s, Morris's wife, Jane Burden, posed for Rossetti, appearing in many of his paintings (e.g., *Astarte Syriaca*, 1875). She left Morris to become Rossetti's mistress. Burden, like Rossetti's first wife, Elizabeth Siddall, was one of several working-class women who had been drawn into the circle of Pre-Raphaelite artists, first as models, then as lovers, then as wives.

Morse, Samuel F. B.
1791–1872 • American • painter • Federal

. . . a masterpiece, an unrivaled masterpiece. (American Monthly Magazine, 1834)

Under ALLSTON's influence, Morse went to London to study. He returned home full of hopes for painting in the GRAND MANNER, but as were TRUMBULL, VANDERLYN, and Allston himself, Morse was unsuccessful in imposing the high-blown European style on the American public. *The Old House of Representatives* (1822), a painting more than 7 feet high and almost 11 wide, was a spectacular documentation of the building's interior (just recently completed by LATROBE), with its marble COLUMNs, its red drapes, and its great chandelier being lighted. When Morse

took the painting on tour to several cities, charging admission, he had less success than he had counted on. Despite effusive receptions such as that in the magazine quoted from above, the same fate awaited his great *Gallery of the Louvre* (1831–33), almost as large, a tour de force showing the greatest works of the Louvre, painted with careful detail. In 1826 Morse became the first president of the National Academy of Design in New York City. Also to his credit is the introduction of the daguerreotype to America (see DAGUERRE), and the invention with which his name is most famously linked, the telegraph, in the pursuit of which he gave up painting.

mosaic

Designs or pictures composed by fixing small fragments of colored materials, like pebbles, glass, and POTTERY, on a flat surface. The practice predates 4th-century BCE Greece; however, that is when we begin to note the impressive decoration of floors with heroic and mythological pictures made from pebbles of many colors. *The Stag Hunt* (signed by Gnosis, c. 300 BCE), from Pella, birthplace of Alexander the Great, is an early masterpiece. Later, fragments of marble, glass, and other substances—called tesserae (tessera, singular)—were shaped and fixed in place to create ever-more-elaborate designs on walls and ceilings as well as floors, a practice PLINY the Elder described as "after the fashion of painting." Mosaic work became increasingly sophisticated and refined: In the action-packed late-2nd- or early-1st-century BCE *Battle of Issus* mosaic (another

heroic moment in Alexander's life) from POMPEII, 50 separate tesserae were used to form an eye about 1¹/₂ inches wide. Roman mosaicists even created an amusing TROMPE L'OEIL of shells, bones, and a tiny mouse, no less, scattered underfoot on *The Unswept Floor* (c. 120 CE). At first, pictures in Christian churches resembled Roman prototypes, but soon, to gain impact from a distance rather than close-up elegance, great sparkling mosaics were created for churches by using larger, rough-edged pieces of glass, sometimes backed with gold leaf, in bolder, simplified designs. Adorning the apse of a church, these images would be seen first on entering the building, and would remain in sight for the length of the nave as one approached the altar. BYZANTINE mosaics were highly admired, and influenced early Islamic artisans—there is speculation that Byzantine mosaicists were imported to work on the Dome of the Rock in Jerusalem (late 7th century), and perhaps the Great Mosque of Damascus (c. 705–15) (see ISLAMIC ART). By the early ITALIAN RENAISSANCE, mosaic decoration in the Western world still flourished only in VENICE (where Byzantine influence had remained strong). The craft fell into disuse during the 14th and 15th centuries, and has never been revived with the same enthusiasm as was, for example, STAINED GLASS.

Mosan

Artists working in the Meuse (Moselle) River Valley, which runs from northeastern France into Belgium and Holland, and in its cities such as Aachen, Trier, Metz, Verdun, and Liège, devel-

oped a style known as Mosan, which flourished from the late 11th to the early 13th century. In the 12th century Liège, a center of CLASSICAL learning, called itself the Athens of the North. The intellectual interest in Classicism is reflected in a persistent thread of HUMANISM, regard for human nature and the human form; the art expresses harmony, simplicity, and restraint, especially relative to the intensity of some ROMANESQUE (11th–12th century) figures. A baptismal font executed in the early 12th century by Ranier de Huy is a foremost example of Mosan artistry: Resting on 12 bronze oxen (which stand for the 12 apostles), the bronze basin has Saint John baptizing Christ and Saint John preaching, in RELIEF. Each figure is individualized, yet they form dynamic, interrelated groups. Nicholas of Verdun's enamel and gold *Klosterneuburg Altarpiece* (1181) uses an elaborate allegorical technique, TYPOLOGY, in foretelling the New Testament with Hebrew Bible scenes. When Abbot SUGER (1081–1151) commissioned work in enamel and gold, their specialty, he employed Mosan artists.

Moses, Anna Mary Robertson (Grandma Moses)
1860–1961 • American • painter • Folk Art

I look back on my life like a good day's work. . . . I knew nothing better and made the best of what life offered. And life is what we make of it. Always has been, always will be.

Grandma Moses did not begin painting pictures until she was in her early 70s. She exhibited her work at country fairs along with her canned preserves. Her scenes of rural life—little cube houses, little figures, small-town activities in winter (e.g., *Hoosick Falls in Winter,* 1944) and in summer, all imbued with a sense of joy—were soon discovered by collectors in the late 1930s. Her expression of life's simple pleasures has made her one of America's best-known and best-loved artists.

Motherwell, Robert
1915–1991 • American • painter • Abstract Expressionist

I never think of my pictures as "abstract," nor do those who live with them day by day—my wife and children, for example. . . . I happen to think primarily in paint—this is the nature of the painter—just as musicians think in music. And nothing can be more concrete to a man than his own felt thought, his own thought feeling.

Despite his preference for the term "New York School," which he coined, art historians call Motherwell an ABSTRACT EXPRESSIONIST because his paintings are not representational in any discernible way. They are "expressionist" to the extent that they make human contact and touch human feelings, as he wished to do. Motherwell also said, in the 1955 statement from which the quotation above is excerpted, ". . . I love painting in that it can be a vehicle for human intercourse." Like KLINE, Motherwell painted mainly with black on white, but the shapes he painted are discrete forms rather than AE gestures. Motherwell avidly studied philosophy and ART HISTORY with

Meyer SCHAPIRO, and his engagement in the politics of his era is expressed by a lengthy series entitled *Elegies to the Spanish Republic,* composed of massive vertical pillars of paint connected by black ovals. He worked on this over a period of 30 years, ending the series at the death of Franco (1892–1975) and restoration of parliamentary democracy in Spain.

Motley, Archibald, Jr.

1891–1981 • American • painter • American Scene

It is my earnest desire and ambition to express the American Negro honestly and sincerely, neither to add nor detract. . . . [I] believe Negro art is someday going to contribute to our culture, our civilization.

Motley studied at the Art Institute of Chicago and was awarded a fellowship that provided a year of study in Paris. His early work was a joyous celebration of the vitality of life in the cities. In the vein of BELLOWS, LUKS, and SLOAN but with a focus on black culture, Motley differed substantially from his fellow African-American TANNER, in both intention and style. Where Tanner expressed simple piety, Motley painted street life and barrooms infused with boisterous, sensual energy. In 1963 he began a large painting to celebrate the 100th anniversary of the Emancipation Proclamation, but with the struggle for civil rights, the murders of John F. Kennedy and Martin Luther King Jr., and the bombing of an Alabama black church, his optimistic mood changed.

He never considered the painting to be finished.

Mount, William Sidney

1807–1868 • American • painter • Romantic/Genre

Paint scenes that come home to everybody. That everyone can understand.

When he attended classes at the National Academy of Design, Mount hoped to make his name with HISTORY PAINTING, but he found success after he returned home to rural Long Island, and devoted himself to painting everyday scenes with their pleasant interludes, such as *Dancing on the Barn Floor* (1831). Many of his pictures pose problems of interpretation for art historians. This is true of *The Power of Music* (1847): A black man stands outside the barn door, listening to the music, clearly isolated from the music-making white trio inside. Clues to the painting's possible hidden meaning, or moral, are a jug, perhaps of spirits, and an ax by the outsider's feet, while a pitchfork stands just inside the barn door. Exactly what these details signify is ambiguous, and the extent to which Mount's apparently sympathetic portrayal of African-Americans is more truly demeaning and stereotypical is also a matter of discussion. Where one interpreter may see "a wholesome simplicity, even virtue . . . truly American," another will note the picture's racism. In all cases, as was true of Northern European genre paintings of the 16th century, Mount's vignettes have underlying messages that were more quickly appar-

ent to his contemporaries than they are to us today. Mount pioneered in American GENRE painting, but was soon followed by others, foremost among them Francis William Edmonds (1806–1863) and Richard Caton Woodville (1825–1855).

Mozarabic

After the Islamic conquest of Spain in 711, Christians in the Arab territories were called Mozarabs, from the Arabic *mustarib,* meaning "would-be Arab." They adapted features of ISLAMIC ART to their traditional themes, evolving a colorful style known as Mozarabic. An example is a full-page painting in an IL-LUMINATED MANUSCRIPT that shows a large bird with sharp talons and a brilliant, crescent-shaped, starry halo (or perhaps a comb) reaching from its tail to its beak, in which it holds the head of a long snake. The image represents the victory of Christ, symbolized by the bird, over Satan, the snake. It was part of *Commentary on the Apocalypse,* by Beatus, an 8th-century abbot, compiled and illustrated for Abbot Dominicus, probably at the Monastery of San Salvador in Spain, and completed on July 6, 975. The colophon (page on which the manuscript's artists are credited) lists Senior as scribe, and two painters, Emeterius and a woman named Ende.

Mucha, Alfonse
1860–1939 • Czechoslovakian • illustrator/designer • Art Nouveau

Art is eternal, it cannot be new.

Mucha studied in Munich, Vienna, and Paris, where he designed a jewelry shop and very elaborate jewelry. He became renowned for his advertising posters, especially those produced in Paris for "the divine" Sarah Bernhardt, whom he also advised on theatrical productions. In the glitter of la Belle Époque, Mucha was the preeminent ART NOUVEAU illustrator, despite his rejection of the term—as in the quotation above. Nevertheless, the distinctive look of his major published works from 1895 to 1905 was in a mode that led, in France, to the phrase "le style Mucha" being used as a synonym for all work that was labeled Art Nouveau.

Munch, Edvard
1863–1944 • Norwegian • painter • Symbolist

I do not think that my art is sick—despite what Scharffenberg and many others believe. Those kind of people do not understand the true function of art, nor do they know anything about its history.

The Scharffenberg mentioned in the quotation above was a 26-year-old medical student who connected Munch's radical images with the incidence of mental illness in his family. Munch's considered reply is quoted above, though he also wrote, at one time, "Illness, madness and death were the black angels that kept watch over my cradle." The 1895 exhibition that drew attention to both his art and his sanity included Munch's best-known work, *The Scream* (1893). Also in that exhibit was a self-portrait in which he is smoking a cigarette. Late-19th-century moralists saw social decline in indul-

gences such as smoking: "A race which is regularly addicted, even without excess, to narcotics and stimulants in any form . . . begets degenerate descendants who, if they remain exposed to the same influences, rapidly descend to the lowest degrees of degeneracy, to idiocy, to dwarfishness, etc.," as the physician Max Nordau wrote in his study of deviancy, *Degeneration* (1894). Such was the backlash to the literary likes of Oscar Wilde (in whose *The Picture of Dorian Gray,* smoking is synonymous with eroticism), BAUDELAIRE, and Mallarmé, and artistic themes explored by SYMBOLISTs like BEARDSLEY. Cigarette smoking was still rare in Norway, and Munch's self-portrait could only reflect his belief that the creative artist found inspiration in living outside the boundaries of ordinary, "healthy" bourgeois life. It also allied him with the Bohemians of Paris, where he went to work and where he was much influenced by TOULOUSE-LAUTREC, van GOGH, and GAUGUIN. *The Scream* shows a figure on a bridge whose open mouth lets out some primal sound that seems to express unbearable terror and pain. (In 1994 *The Scream* was stolen from the National Art Museum in Oslo. During negotiations the thieves, who attempted to ransom the painting for $400,000, left fragments of its frame at various places around Oslo over a period of 10 days preceding the May 7 recovery.) Munch was also taken with the late-19th-century obsession with evil, especially the destructive FEMME FATALE, whom Munch portrayed in *Madonna* (1895). Munch sought the core of emotion and bore the brunt of that quest with a complete mental breakdown in

1908. After that, he returned home to Norway, and to paint less wrenching, anguished pictures.

Munich School

Dark coloration and vigorous brushwork using broad, fluid strokes characterized training at the Royal Academy in Munich and became known as the Munich Style during the later 19th century. It was a style based on the work of HALS and VELÁZQUEZ, influenced by the REALISM[2] of COURBET, and promoted by LEIBL. Many American artists studied in Munich, including CHASE, DUVENECK, and HARNETT.

Münter, Gabriele
1877–1962 • German • painter • Expressionist

[Kandinsky] explained things in depth and looked at me as if I was a human being, consciously striving, as being capable of setting tasks and goals.

Münter was one of KANDINSKY's first students, and he described her as a "natural" artist, saying there was nothing he could teach her. "What I can do for you is merely to guard your talent, to nurse it, and to make sure that nothing false touches it," he told her. Her work was included in the inaugural BLAUE REITER exhibition in Munich—she was one of the group's founders—and she and Kandinsky, who left his wife, lived and traveled together for many years, until he left her, too, for another woman in 1917. Münter used intense, bright colors and simplified shapes, typical of and perhaps inspired by the FOLK ART in a Bavarian village where she and Kandinsky had settled.

Staffelsee in Autumn (1923) is a landscape in brilliant reds, orange, green, and blue. While her shapes are simplified, and she abandoned perspective for flattened spaces, she did not abandon representational art, as Kandinsky did. During the Nazi era, Münter worked clandestinely, for her art was condemned as DEGENERATE ART.

mural/wall painting

From the Latin *murus,* for "wall," a mural is a painting made directly on the surface of a wall or painted on another surface that is then attached to the wall. From prehistoric caves to the present, walls have been used for pictures. Ancient Egyptians prepared their voyages to the other world by painting the walls of their tombs with salubrious images. Little is know about Greek wall paintings, other than that they existed. Roman wall paintings are divided into groups that are dated from the late 2nd century BCE to 79 CE, not as chronological periods but as overlapping and often coexisting styles. The First (or Incrustation) Style had no objects or figures; instead it had textured paintings of architectural veneers. The Second Style aimed to dissolve the walls with illusionistic scenes rather than to imitate marble panels, as did the First Style. (For examples of Second Style, see VILLA BOSCOREALE and VILLA OF THE MYSTERIES.) The Third (or Ornate Style) presented smaller, framed pictures arranged as if in a picture gallery; and the Fourth (Intricate) Style combined features of the earlier three. While the terms "mural" and "wall painting" are interchangeable, they are distinct from FRESCO, which refers to specific techniques. Because of their public nature, during the 20th century murals have been and remain important as political statements (e.g., RIVERA) and graffiti art (e.g., HARING).

Murillo, Bartolomé Esteban
1617–1682 • Spanish • painter • Baroque

Murillo was so modest that it might be said he died from pure modesty.
(Antonio Palomino, 1724)

Murillo founded the Academy of Seville in 1660 and was the leading painter in that city as ZURBURAN's popularity declined. While his work was also predominantly religious, Murillo's style and subjects were very different from his forerunner's. Instead of painting ascetics and martyrs, he painted gentler scenes, favoring the Immaculate Conception and rendering it as if following PACHEO's instructions to show the Virgin as the loveliest of all women (though certainly older than the prescribed 12 or 13 years of age). For the most part, as his art matured, Murillo's colors were soft, his faces kind, and his touch eloquent. His biographer, Palomino, a Spanish painter of modest skill and success, defended both Murillo and national art in general. Insisting that Madrid was the farthest from his home that Murillo ever went, Palomino wrote, "The fact is that foreigners do not want to concede fame to any Spanish painter who has not passed through an Italian customhouse." As for the modesty mentioned in the quotation above, Palomino goes on to explain that, after falling off the scaffolding while painting a large picture of

Saint Catherine, in order not to show weakness and because of his great modesty, Murillo would not let himself be examined and died from the accident. The tale concludes, "And he was such a generous man that when he died they found that in spite of all the many famous works he did, the only money he had was 100 réales that he had received the day before and sixty pesos in a drawer."

Murray, Elizabeth
born 1940 • American • painter • New Abstraction

All of my ideas about art came from looking at comic books. I remember writing to Walt Disney to ask if I could be his secretary. . . . I think cartoon drawing—the simplification, the universality, the diagrammatic quality of the marks, the breakdown of reality, its blatant, symbolic quality—has been an enormous influence on my work.

Murray's interest is in paint and the structure of the surface to which she applies it. She works on shaped canvases (as did Frank STELLA), but they are odd, fragmentary shapes, sometimes superimposed on one another. Her images, in bold color, are ABSTRACT but suggestive, as are cartoons, as she describes above. *Her Story* (1984), on a complex assembly of surfaces, is about her mother, who died in 1983: "I associated books with my mother. *Her Story* is really a portrait of her sitting with a book, holding a cup," Murray said. It is a challenge to make out the details, they have been so thoroughly abstracted. The historian Jonathan Fineberg writes, "The painting portrays simple ordinary things . . . yet it is layered with complexity in structure and allusion. It is a contemplative moment to do with reading, remembering, thinking about how all the pieces fit together (both literally and figuratively)."

museum
Latin *museum* (from the Greek *mouseion*) is the place of the Muses: the nine daughters of Zeus/Jupiter and Mnemosyne (Memory). These goddesses, companions of Apollo, are the creative inspiration of poetry, song, and other arts. The most famous museum of the ancient world was founded at Alexandria around the 3rd century BCE. It was a collection of interesting artifacts, from astronomical and surgical instruments to elephant trunks and animal hides, and it contained a botanical and zoological park. There were some statues of thinkers, but it was mainly an academic institution rather than an art museum. The Mouseion of Alexandria was destroyed during the 3rd century CE. The idea of the modern museum as a showplace evolved from the RENAISSANCE interest in the CLASSICAL world and its treasures. The public museum was a 17th-century development: The first university museum opened in Basel in 1671, and the Ashmolean Museum at the University of Oxford a dozen years later. The first permanent museum in America was started in 1773 by the Charleston (South Carolina) Library Society, intent on a well-documented natural history collection. PEALE's eclectic collection—"a Repository of Natural Curiosities"—included some mastodon bones that he had excavated, and also portraits of Revolutionary heroes. Peale's museum was started in his

home, and the collection eventually moved into what is now Independence Hall in Philadelphia. In 1822, Peale painted *The Artist in His Museum* with his self-portrait: He lifts a tasseled drape with one hand and gestures with the other, ushering the visitor into the long gallery that contains his treasures. Yale University, in New Haven, built a gallery in 1832 to show the historical paintings of TRUMBULL. The Wadsworth Atheneum in Hartford is usually designated the first true and continuing art museum in the United States. It opened in 1842 and displayed about 80 works by Trumbull, COLE, and other American artists. The history of art museums is tied up with the history of COLLECTING, both private and institutional. New York's Metropolitan Museum of Art was established in 1870. Museums like this one, striving to assemble collections that encompass the earliest to the latest works of art, are termed "encyclopedic." Their ambitious intentions were not always smoothly executed: The opening of the Museum of Fine Arts in Boston (also in 1870) was complicated when the arrival of 50 crates of ANTIQUE casts sparked debate about the placement of fig leaves on the nude statues.

Muybridge, Eadweard (Edward Muggeridge)

1830–1904 • English/American • photographer • Modern

When he went to say farewell to his grandmother, she with her usual kindliness put a pile of sovereigns beside him and said, "You may be glad to have them, Ted." He pushed them back to her, and said, "No, thank you,

Grandma, I'm going to make a name for myself. If I fail, you will never hear of me again. (Norma Selfe, 1963)

Muybridge's important invention for a series of stop-action photographs of horses was undertaken at the stud farm of American railroad baron and California governor Leland Stanford. It was to settle a bet, the story goes, as to whether a horse ever had all four hooves off the ground at the same moment. Muybridge set up a series of cameras whose shutters were opened as the horse, galloping past, tripped strings attached to them. He not only proved that horses were momentarily airborne, but also provided invaluable documentation of sequential movement. Muybridge published *The Horse in Motion* in 1878 and, from subsequent experiments, *Animal Locomotion* in 1887. DEGAS was one of the first artists to use the new knowledge Muybridge provided in his images of racehorses (e.g., *The Jockey,* 1889). EAKINS was also influenced by Muybridge, and decided to photograph and study motion himself. DUCHAMP's *Nude Descending a Staircase* (1912) and several FUTURISTS used Muybridge's information as well as that of the French biophysicist Étienne-Jules Marey, who also used stop-action or what he called a "chronophotograph" to analyze force. This also prompted dissension. Photographer Antonio Giulio Bragaglia (1889–1963), for example, believed that the blurred image of action gained via a single open shutter was a more truthful means of representing motion than the sequential one. Bragaglia's pictures were called photodynamic and he published them in *Fotodinamismo futurista* (1913). The

reminiscence above was provided by Muybridge's second cousin to the photographer's biographer, Robert Bartlett Hass. Just before leaving England, in 1852, Muybridge changed his name from Edward Muggeridge to Eadweard Muybridge. He began his experiments in recording motion through photography in the 1870s, a decade during which he was also tried in Napa Valley, California, for murdering his wife's lover, an act that he admitted committing and of which he was acquitted.

Mycenaean art

c. 1500–1200 BCE.

In the Peloponnese, on mainland Greece, was a warrior culture, the source of Homer's *Iliad,* a narrative fully formed only centuries later during the GEOMETRIC period. The origin of Mycenaean civilization is not known. Some scholars believe it was a MINOAN colony, but it has strong connections with the Balkans and Asia Minor. Homer said that the Mycenaeans loved gold, which seems confirmed by treasures like the gold *Vaphio* drinking cups (with designs evocative of MINOAN bull leapers), and a golden death mask from the royal tombs (both c. 1500 BCE). If Minoan influence is apparent in Mycenaean crafts, its effect on Mycenaean architecture is symbolic rather than structural, for in contrast to the natural security provided by the Minoans' island location, Mycenaeans needed for-

tified citadels. These were built of huge stones later called Cyclopean (after the mythical race of giants). In the *Lion Gate* at Mycenae (c. 1300 BCE), an entryway to a fortified palace, we see the use of Cyclopean stones in combination with two stone guardian lions that flank a tapered stone pillar, their forepaws on its base. This pillar resembles wooden COLUMNS used on Crete that are believed by some scholars to have represented sacred figures, especially because liquid offerings were poured on them.

Myron

mid-400s BCE ● Greek ● sculptor ● Early Classical/Severe style

He . . . cared only for the physical form, and did not express the sensations of the mind. (Pliny the Elder, 1st century CE)

We know Myron's *Discobolos* (*Discus Thrower;* c. 460 BCE) only from Roman marble copies (Myron's original was probably cast in BRONZE)—a 5-foot-high sculpture of an athlete who is poised at a peak of arrested energy, on the verge of launching the discus. This kind of investigation of patterns in motion, called rhythmos, considered action as built up of moments, such as those captured in modern time-lapse photography. Like the *Doryphoros* of POLYKLEITOS, Myron's sculpture is also an essay in dynamic symmetry, maintaining balance while expressing action.

N

Nabis

A secret society named from the Hebrew word for prophet, the Nabis was formed by a group of young SYMBOLIST artists. Led by painter Paul Sérusir (1863–1927), who had been influenced by GAUGUIN, the Nabis started meeting every Saturday at Sérusir's studio in Paris in 1888. Sometimes they explored the supernatural aspects of Eastern faiths, including a new cult of Theosophy that had been founded, in New York, by a Russian, Helena Blavatsky. Mystic symbols and cabalistic practices fueled the imagination and art of some Nabis, but not all: It does not characterize the works of painters DENIS, VUILLARD and BONNARD, or sculptor MAILLOL, all of whom were connected with the Nabis for a time. However *Christ and Buddha* (c. 1890) by Paul Ranson (1864–1909), in which a crucified Christ (who resembles the figure in Gauguin's *Yellow Christ*) is combined with both Buddhist and Hindu allusions, shows the mystical cross currents that did occur in Nabis art. Beyond the Nabis, the influence of Theosophy persisted well into the 20th century and influenced the art of KANDINSKY and MONDRIAN as well as the paintings of less renowned artists like the Russian Nicholas Roerich (1874–1947). Roerich, who had earlier designed sets and costumes for the Ballets Russes, made an expedition through Central Asia and painted haunting landscapes with symbols representative of Tibetan and Western mysticism.

Nadar (Gaspard-Félix Tournachon)

1820–1910 • French • photographer • Realist

Photography is a marvelous discovery, a science that has attracted the greatest intellects, an art that excited the most astute minds—and one that can be practiced by any imbecile. . . . To produce an intimate likeness rather than a banal portrait, the result of mere chance, you must put yourself at once in communion with the sitter, size up his thoughts and his very character.

Nadar was a novelist, journalist, caricaturist, balloonist, and successful portrait photographer whose wide-ranging clientele included Sarah Bernhardt, DAUMIER, COURBET, and MANET. He was also a friend of the IMPRESSIONISTS, who held their first exhibition in his studio. INGRES sent some of his clients to Nadar for photographic studies to be used in his painted portraits. Nadar also took the first aerial photographs from a balloon, and in the catacombs of Paris he took some of the earliest photographs illuminated by flash powder.

Nadelman, Elie
1882–1946 • Polish/American •
sculptor • Modern

*. . . each expression of sentiment is
made by a movement which geometry
governs. . . . I have adopted this
principle in building up my statuary,
simplifying and restraining always in
organizing the parts so as to give the
whole a greater unity.*

Nadelman was born and studied in
Warsaw, then went to Paris. At the out-
break of World War I, he moved to the
United States and became a member
of the STIEGLITZ Circle, exhibiting his
sculpture at the 291 Gallery. He was
among the first American MODERNISTS,
noted for life-size and larger bronze fig-
ures such as *Man in the Open Air* (c.
1915), a pared-down form whose legs
and arms taper to incredibly tiny feet
and hands. He strikes a jaunty pose and
wears a stylized bow tie at his neck and
a bowler hat on his head. Perhaps the
bow tie and bowler suggest a man of
the theater—performers were a subject
Nadelman enjoyed portraying. As
unique and eccentric as his interpreta-
tions may be, his grounding in "geome-
try," expressed above, depends on
universal principles.

naive art
Because of its judgmental connotations
(synonyms include simple, guileless,
artless) the term "naive" is infrequently
used in the United States, though it is
still current in Europe. Europeans call
Grandma MOSES a naive artist, but
Americans call her work FOLK ART.
Henri ROUSSEAU is best known among
artists labeled "naive." Although this
term, like PRIMITIVE and Folk, suggests
that the artist is unsophisticated and un-
schooled, many highly trained artists
affect a "naive" style.

Nanni di Banco
c. 1380–1421 • Italian • sculptor •
Early Renaissance

*Nanni di Banco . . . can be looked
upon at will as a Gothic artist in
contact with Renaissance style, or as a
Renaissance sculptor who retains some
features of Gothic art.* (John Pope-
Hennessey, 1955)

Nanni was one of the four sculptors
whose genius marked the early ITALIAN
RENAISSANCE. (GHIBERTI, DONATELLO,
and JACOPO della Quercia were the oth-
ers.) A Florentine, Nanni studied
Roman ANTIQUITIES. In his best-known
work, a group of life-size marble saints,
Quattro Santi Coronati (c. 1408–14),
he captures the attitudes of four men in
conversation. Draped in Roman-style
robes, this group is set into a deep niche
in Orsanmichele, a combined shrine for
the local GUILDs and the municipal gra-
nary in Florence. The spatial setting en-
abled the sculptor to make his figures
virtually independent of the architec-
ture. Yet they relate to the building,
which provides a kind of stage set, and
they relate psychologically to one an-
other. The figures represent four leg-
endary Christian sculptors who refused
to carry out an order from the emperor
Diocletian for a statue of a pagan god.
They were put to death around the year
300. Beneath the niche in which these
figures stand is a RELIEF of the four
sculptors at work. Nanni's early death

cut short a career that many believe could have rivaled that of Donatello.

narrative/narratology

As an account of either actual or fictional events, narrative has always been recognized as playing an important role in art, especially in illustration of mythological and biblical texts. Contemporary approaches to visual narrative are less concerned with the search for written sources, prefixed symbolic meaning, or historic reportage, and more inclined to regard the work of art—painting, sculpture, TAPESTRY, comic strip, and so on—as a visual "text" in and of itself. One route is to study the artist's particular techniques for presenting the visual narration (see COLUMN OF TRAJAN). Another involves consideration of audience, how the work was pitched to a particular group, their "reading" of it, and ways in which their interpretation(s) may in turn have impact on the work's "meaning." These studies involve the understanding of, as Richard Brilliant writes, "interdependent languages of narrative representation, the visual and the verbal." In effect, narratology is the study of a work's narrative methodology—how things are "said" more than what they "say."

Nash, John

1752–1835 • British • architect/town planner • Romantic/Picturesque

H. M.'s [His Majesty's] present ill humor is caused by the Duke [of Wellington] refusing to make Mr. Nash a Baronet. The King says he is the only sovereign in Europe without power to confer an honor of this kind. The Duke says Mr. Nash is in the public service, that his conduct is under a course of inquiry before the house of Commons and . . . that now was not the moment to grant him a favor from the Crown. (Mrs. Arbuthnot, 1829)

It is thought, but not certain, that Nash was born in Wales—his mother was Welsh. It is known that he worked for an architect in London from about 1767 to 1778. He inherited some money, married, speculated in real estate, lost both his fortune and his wife, and returned to Wales in 1783. He built up his practice with commissions for villas and country houses and became a foremost proponent of the PICTURESQUE theory, with its embrace of irregularity and variety. Nash was especially influential on landscape design. He worked in every imaginable style, including CLASSICAL, "Cottage," GOTHIC, and even Indian and CHINOISERIE. Back in London by 1795, in 1815 he was officially attached to the royal court, after which he stopped taking private commissions. His best-known work is The Royal Pavilion, Brighton (1815–22). This "stately pleasure dome" has a neo-PALLADIAN front topped with onion-shaped DOMEs and slender minarets. The style was called Indian Gothic, and sometimes Hindoo. A frequently reproduced view of its kitchen shows a vast space with COLUMNs shaped like palm trees. Nash designed Buckingham Palace (1825–30) for George IV and the Haymarket The-

ater (1820), the brilliantly imaginative Regent's Park (from 1812), and Regent's Street (from 1814), all in London. The park contains villas and make-believe villages and is surrounded by terraces and palatial private houses. The extravagance of Nash's designs depended on the prodigality of the king, and when Parliament became exasperated and the king lost favor, so did Nash, who was taken to task. The king tried to help him save face, at the least, by recommending that he be made a baronet. Both the king and Nash were rebuffed, as the commentary quoted above (from the journal of an informed contemporary) reveals.

National Endowment for the Arts (NEA)

Formed in 1965, the NEA is an agency of the U.S. government charged with funding artists and projects in American arts. The policies of the NEA came under fire at the end of the 1980s because of it its contributions to controversial art: Two of the more famous examples are *Piss Christ* (1987; a photograph of a cheap plastic crucifix in a jar of urine), by Andres Serrano (born 1950); and MAPPLETHORPE's photographs. In Congress, Sen. Jesse Helms led an effort to effectively censor the activities of the NEA, but the Helms amendment was voted down. Nevertheless, the conflict over moral and ethical values has taken a heavy toll on support for and the effectiveness of the NEA. In October 1997, Jane Alexander, the departing director, spoke of continuing congressional efforts to "drive a stake in the heart of Federal funding for the arts."

National Museum of Women in the Arts (NMWA)

During a trip to Europe in the 1960s, Wilhelmina and Wallace Holladay bought a painting by Clara PEETERS. They could not find her listed in any ART HISTORY textbook, but they were prompted by that work to seek out other art by women. Because there was no museum and no library on women in art, they founded the National Museum of Women in the Arts, in Washington, D.C., which opened to the public in 1987. The collection grows continually and the museum sponsors important exhibitions of art by women on a regular basis.

native art/arts

Generally refers to the art of the indigenous peoples of a land, but with unclear connotations: European art is excluded, as is art influenced by European artists. Yet the masks from Africa that influenced PICASSO, the Pueblo architecture painted by O'KEEFFE, and the American Indian sand paintings and blankets that inspired ABSTRACT EXPRESSIONISTS are described as native art. The work of indigenous artists who adopt European style is not called native art.

naturalism/naturalistic

This term is often used to describe the effort of artists to represent the world as the eye sees it, as accurately as possible. Often used interchangeably with REALISM[1], naturalism includes techniques such as PERSPECTIVE, MODELING, credible folds for DRAPERY, and intimations of movement such as CONTRAPPOSTO. At the opposite pole from naturalism are representations that are typically

ABSTRACT, FRONTAL, static, often hieratic in scale (i.e., size dependent on importance) and idealized (see IDEAL).

Nauman, Bruce
born 1941 • American • neon/video/installation • Conceptualist

I wanted to get time and sound into my work, and so Arnold Schönberg, Philip Glass, Steve Reich, Lamont Young, were important composers for me, especially John Cage. In terms of sound and time, other things interested me, too, of course, like Andy Warhol's films.

Nauman has explored most of the experimental movements of the last third of the 20th century. He has worked with language in neon, and as sound, with computers, and constructions—often combining these (e.g., his tapes of bellowing clowns) and perhaps other mediums. His works are aggressive—they confront and challenge the observer, provoking annoyance as well as a sense of anxiety. His INSTALLATIONS may be claustrophobic and disorienting, and are usually deeply unsettling. "Loud," "grating," "relentless," and above all "pessimistic" are terms frequently used to describe his work. Nauman's endeavor often had to do with his own body, or presence, and his self-consciousness. At one end of the spectrum, he made a construction entitled *Neon Templates of the Left Half of My Body, Taken at Ten Inch Intervals* (1966), a 5-foot, 8-inch-high series of neon green loops and dark cords that make an attractive free-form shape against a wall. At the other end, in-

spired by the musicians he mentions in the quotation above, he had others experience their bodies as he did his own: He hid a microphone behind a wall to pick up the friction of a viewer touching the wall's surface. Hidden speakers broadcast the sound so that the viewer became unusually self-aware, rather like hearing oneself breathe while snorkeling.

Nazarenes
A Lukasbrüder, or Brotherhood of Saint Luke (see Saint LUKE) group founded in Vienna in 1809 by Friedrich Overbeck (1789–1869) and Franz Pforr (1788–1812). Dissatisfied with its instruction, they staged the first 19th-century artists' secession by quitting the Vienna Academy. They went to Rome in 1810, where they were joined by Peter von Cornelius (1783–1867). Determined to renew the religious basis of German art, members of this movement became known as Nazarenes because they adapted biblical dress and hairstyles and used the abandoned Monastery of San Isidoro for their brotherhood. Some members converted to Catholicism. They wished to revive religious FRESCO painting, and developed a style dependent on precise contour lines and simple, flat colors but with a ROMANTIC sensibility. They looked back to MEDIEVAL practices of the GUILDS for their organizational practices. In honor of the Austrian emperor and empress, who visited Rome during Easter 1819, the city's German-speaking residents held the first-ever "national" exhibition, with 65 painters from the northern lands, Switzerland to Sweden. Among those on exhibit, the

Nazarenes' paintings were the most controversial, in part because of their German nationalism and in part because of their fervent mysticism. (Frederich von Schlegel, writing about the exhibition, came to their defense.) Their style made their compositions ideal for reproduction so that their work, in PRINT form, became widely distributed and known. Their elaborate allegories, as well as their Medievalism, influenced the PRE-RAPHAELITE BROTHERHOOD, which formed some 40 years after the Nazarenes first came together and some two decades after the exhibition in Rome.

Neagle, John

1796–1865 • American • painter • Federal/Romantic

April 28, 1826. Measured Mr. Lyon five feet six inches and three-quarters in his Boots. May 18, 1826. Began a study of P. Lyon for full length in the blacksmith's shop. May 19, 1826. Rode with Mr. Lyon in his gig to the blacksmith's shop again to study my composition for a picture of him.

Neagle spent almost his entire professional career in Philadelphia, where he began as an apprentice with a carriage painter. His talent brought him to the attention of the city's preeminent painters, PEALE, SULLY, John Lewis Krimmel (?–1822) and Bass Otis (1784–1821), with whom he studied portraiture. Neagle also went to Boston, in 1825, to study STUART's work firsthand. He had a steady stream of clients; *Pat Lyon at the Forge* (1826–27) is now the most acclaimed portrait and is especially interesting for

the story behind it. As a young man Lyon was imprisoned on false charges of bank robbery, and though he was able to become a successful and wealthy man, he always disdained members of the city's social elite who were responsible for his misfortune. Thus, he chose to be shown as a laborer at his forge; through the open window behind him is the cupola of the Walnut Street Jail, where he had been detained. In the passage quoted above from Neagle's journal, which he called the Blotter, he notes the beginning work for this portrait. Besides its personal history, the painting is provocative stylistically in that it is an example of the GRAND MANNER, usually reserved for HISTORY PAINTING, being redirected, if not subverted, into a statement about American democracy: that even someone of low social and economic rank might rise to financial well-being and preeminence in the community.

Neel, Alice

1900–1984 • American • painter • Modern

[I am] a collector of souls.

Neel's early work—showing distorted images of children—was haunted by the death of one of her children and the abduction of the other. After she moved from her home in Pennsylvania to New York City, she began to paint at a frantic pace, taking her friends, family, neighbors, and the life of the city as subjects. She worked for the FEDERAL ART PROJECT during the Depression and moved to Spanish Harlem in 1938. Her painting titled *T. B. Harlem* (1940) is a

striking portrait of one of her neighbors. The T.B. refers to tuberculosis, and the suffering young Latino rests in bed after surgery that removed 11 of his ribs. There are allusions to traditional paintings of Christ's suffering in this powerful work. Neel detached herself from the changing styles that swept through the art world during her productive career. Another of her portraits, *Andy Warhol* (1970), painted after WARHOL had been injured in an attack, shows the tracks of scars across his chest. His eyes are closed and this unusual representation unveils a sad vulnerability.

Nefertiti

Name of an Egyptian queen, wife of and possible co-ruler with Akhenaten. The translation of Nefertiti is "the Beautiful One Is Here." Akhenaten (Amunhotep IV) ruled from c. 1356 to 1339 BCE, during the 18th Dynasty, in the period known as the New Kingdom. Nefertiti's famous head—19 inches high, of limestone covered with plaster and painted—was found in a storeroom of the sculptor Tuthmose. It may have been a model for studio artists, a portrait likeness to be copied. Her neck is exceptionally long and elegantly curved, her cheekbones are high, and her mouth is full and sensuous. When found in 1912 by a German archaeologist, one of the rock crystal eyes was missing and could not be found despite careful sifting of the storeroom rubble. Its absence partly explains the profile view of the head usually shown. Virtually unknown to the general public is that likenesses of Nefertiti sculpted

throughout her life showed her as she aged, accumulating wrinkles, sagging jaw, and flabby contours.

Neoclassical/Neoclassicism

A reaction to ROCOCO, Neoclassicism was born of the ENLIGHTENMENT idea that human affairs should be ruled by reason and the common good rather than by tradition. From the mid-18th century, infatuation with the ANTIQUE encouraged the development of a Neoclassical movement in art throughout Europe. It was fueled by discoveries at POMPEII and HERCULANEUM, the writings of WINCKELMANN, and paintings by MENGS. The age of Neoclassicism included ROMANTIC artists. Among the great exponents of Neoclassicism in architecture was ADAM; in sculpture, CANOVA and THORVALDSEN; and Jaques-Louis DAVID in painting. (See also CLASSICAL and CLASSICISM)

Neo-Expressionism/New Expressionism

A daring, aggressive mood of the 1980s that came about in reaction to the cool detachment and rationalism of MINIMALISM and CONCEPTUALISM. Neo-Expressionist artists brought emotional impact back into art, using a variety of techniques—ASSEMBLAGE, COLLAGE, sculpture, photography, painting, metaphor, allegory, narrative—to communicate the artist's state of mind. Neo-Expressionists include BASELITZ, Sigmar Polke (born 1941), KIEFER, CLEMENTE, SCHNABEL, SALLE, FISCHL, BASQUIAT, and Robert Longo (born 1953). Blatant sexuality and APPROPRIATION often characterize their work, but they have little else in common with

one another in terms of style and theme. (See also NEW IMAGE)

Neo-Geo

A movement, rather than style, based on the writings of the French philosopher Jean Baudrillard on SIMULACRA. Founded on the notion that what seems false in America is true America, the movement was epitomized in work of Jeff Koons (born 1955), whose ceramic statue *Michael Jackson and Bubbles* (1988) carries the burden of making kitsch represent itself as what really matters.

Neo-Impressionism

See SEURAT, SIGNAC, and POINTILLISM

Neo-Plasticism

MONDRIAN's style and theory based on the proposal that art should be utterly ABSTRACT and NONOBJECTIVE, and use right angles with vertical and horizontal forms and just primary colors supplemented by white, black, and gray. (See also De STIJL)

Neoplatonism/Neoplatonic philosophy

In the 3rd century the pagan philosopher Plotinus bridged the gulf between rationality and the mystery religions (among which pagans included Christianity) that had such a strong foothold. His outlook, based on PLATO's doctrine of transcendent ideas, came to be known as Neoplatonism. Plotinus named an incomprehensible, all-sufficient being, perfect in truth, beauty, and goodness, that radiated, or emanated, throughout the universe— the One. The One was at the summit of a hierarchical ladder, on the lowest and most disparaged rung of which was matter. The goal of each person on earth was to achieve mystical union with the One, accomplished through contemplation and liberation from bondage to matter. The physical body should be denied, a goal made possible through asceticism. Plotinus's One could later be considered analogous to the Christian God. By the 6th century, Neoplatonic thought so infused Christian ideology that it affected pictorial art that was used as a vehicle for contemplation. This art was required to express the *essence* of things, rather than their superficial, physical, or material appearance. Thus, NATURALISM, with its sense of real bodies that have substance and cast shadows, was supplanted by symbolic idealism, while light and color, representing divine immanence, gained importance. And because the Neoplatonic goal was to reach outside of time, narratives, which tend to progress chronologically, were increasingly abandoned. The brilliant light and color reflected in MOSAICS in churches like SAN VITALE and HAGIA SOPHIA are examples of the transformation for which Neoplatonic theory may be considered responsible. During the ITALIAN RENAISSANCE, a school of Neoplatonism led by FICINO and Pico della Mirandola (1469–1533) also emphasized the contemplation of beauty as a means of rising above and beyond the baseness of the material world. BOTTICELLI, in paintings like the *Birth of Venus* (c. 1484), was the foremost artist of the Renaissance influenced by Neoplatonism.

Neo-Realism

see REALISM[2]

Neo-Romanticism

Paralleling and affected by the climate of SURREALISM in the 1930s, Neo-Romanticists overlaid a theatrical, romantic approach to their enigmatic scenes. Four artists are preeminently associated with Neo-Romanticism, the Frenchman Christian Bérard (1902–1949) and three Russian-born Americans: brothers Eugène Berman (1899–1972) and Léonid Berman (1896–1976), who painted under the name Léonid; and Pavel Tchelitchew (1898–1957). They sought a return to human emotion and were particularly attracted to seascapes, though there is sometimes a Surreal sense of mystery and strangeness in their works. They were often called on to design for the theater and the ballet.

Nervi, Pier Luigi

1891–1979 • Italian • architect • Modern

. . . [Nervi achieves] razor-sharp analysis of the stresses working upon the structure and [meets] these stresses face to face in a corresponding structural system—an organic system. Now, "organic" is not meant as a catchword, nor in a metaphysical or nebulous sense, nor as an excuse. "Organic" means a flow as real as the continuous strain starting at the shoulder, moving through the upper and lower arm, into the grip of the hand, fingers, and thumb. This is the real world of Nervi, the continuous stresses, branching out from support to girders, dividing into ribs and into the very fibers of the structure, only to combine again into ribs and columns. (Marcel Breuer)

BREUER's praise of Nervi, who was trained as a structural engineer and with whom Breuer worked on the Paris headquarters for UNESCO, is a tribute to the ingenuity with which Nervi used prestressed concrete to cover vast spaces. His Palazzetto dello Sport (Palace of Sports; 1957) in Rome is the most renowned example: A series of Y-shaped concrete buttresses around the circumference of the stadium support a shallow DOME with scalloped edges. The span covered is 330 feet in diameter, and the effect inside is that the roof seems to float as if suspended in the air, like that of HAGIA SOPHIA.

Netherlandish

"Nether" means "located beneath or below." "Netherlandish" is the term used to describe the area between Germany and France, territory also known as the Low Countries, during the 15th and 16th centuries. Though the borders have changed, they contained what is today Holland and part of Belgium (Flanders, a province), and Brabant, which has vanished. In the study of the art of this region during the period of the NORTHERN RENAISSANCE, the terms "Netherlandish" and "Flemish" are sometimes incorrectly used interchangeably. For example, van EYCK, who worked in Bruges, is called both. While Netherlandish may subsume Flemish, the reverse is not true. Albert Blankert explains: "When not blinded by the present borders, we see a Netherlandish art with various centers in the 15th and 16th centuries. The leading ones at that time were in Flanders and Brabant, with Holland in the 16th century becoming the most closely linked, 'fastest developing' area on the periph-

ery." War resulted in an arbitrary border: "The old principal province, the Duchy of Brabant, was torn apart. Its cities 's-Hertogenbosch and Breda became part of the North, Brussels and Louvain of the South." The present borders were defined by the Peace of Westphalia in 1648. LANDSCAPES, GENRE paintings, and STILL LIFES developed in the 16th century, in Flanders and Brabant (see, for example, PATINIR, Pieter BRUEGEL the Elder, and AERTSEN) and reached their peak in the 17th century both there (e.g., Jan BRUEGEL the Elder, JORDAENS, and SNYDERS) and in Dutch art (e.g., RUISDAEL, RUYSCH, de HOOCH, and STEEN), once Amsterdam had surpassed Antwerp in importance.

Neue Künstler Vereinigung (NKV, New Artists Association)

A revolt led by KANDINSKY against the Munich SECESSION. The NKV in turn split, in 1911, and Kandinsky spearheaded Der BLAUE REITER group.

Neue Sachlichkeit

See NEW OBJECTIVITY

Neumann, Balthasar

1686/87–1753 • German • architect • Rococo

I wish humbly to report to your Grace that at midday on the 24th, I inspected the church and painting at Heusenstamm. The painting is certainly good and rather beautiful, but the painter is not [suited] for your Grace's Residenz.

Neumann's church of Vierzehnheiligen (Fourteen Saints; 1743–72), near Banz in Germany, is an example of the RO-COCO style in religious architecture and is Neumann's masterpiece. The facade, with two extremely high towers, has undulating walls and a multitude of windows, and is adorned with gesturing sculptures. The interior, flooded with light, has gilded decorations on its white walls, which also curve in and out with complex turns. Neumann's Church of the Holy Cross, for the BENEDICTINE abbey of Neresheim, was begun in 1747. With four shallow domes and a high central dome, it too describes the delicate fantasy world of Rococo—in contrast to earlier, more somber BAROQUE—and creates effects of motion and variety as well as a sense of spiritual elevation. Neumann traveled in Austria and northern Italy and studied in Paris before he returned home to practice architecture. The complexity of his style has been compared to Bach's fugues. The quotation above is from a letter Neumann wrote to his PATRON, a bishop, and highlights the importance of decoration in his architecture.

neutron autoradiography

See AUTORADIOGRAPHY

Nevelson, Louise

1900–1988 • American • sculptor • Modern/Assemblage

Different people have different memories . . . some have memories for words, some for action—mine happen to be for form. Basically, my memory is for wood, which gives a certain kind of form—it isn't too hard and it isn't too soft.

Early in her career Nevelson worked with the MURAL painter RIVERA, which could explain her tendency to construct large wooden walls. She outfitted them with multitudes of compartments in which were objects, often bits and pieces of wood, all painted a uniform color, usually black, white, or gold (e.g., *Sky Cathedral*, 1958). Later she used other materials such as aluminum, epoxy, and clear Lucite. The play of light and shadow, and the interest of different shapes, preoccupies a viewer. "The effect is . . . rather like viewing the side wall of an apartment building from a moving elevated train or looking down on a city from the air," one art historian has written.

New Art History

Since the 1980s, an effort to update analytical, theoretical, and critical approaches to studying art has come under the heading "New Art History." It has been strongly influenced by the theoretical writings of Walter BENJAMIN, Jacques Derrida, and FOUCAULT, and by concepts of SEMIOTICS, the GAZE, and the SIMULACRUM. Beneath the New Art History heading are several theoretical frameworks or METHODOLOGIES including FEMINISM, PSYCHOANALYSIS, STRUCTURALISM, and MARXISM, plus combinations of two or more. In other words, the New Art History is open to a multiplicity of approaches. There is, as BRYSON, a foremost spokesman, wrote, "the absence of the sense of threshold, of border police ready to pounce." He also stresses the Semiotic foundation of the new approach.

New Artists Association

See NEUE KÜNSTLER VEREINIGUNG (NKV)

New Historicism

This critical approach was named and described by Stephen Greenblatt, a RENAISSANCE scholar, in 1982. In reading a painting as if it were a literary text, he situates a work in its contemporary historical period, taking account of everything from religious and political controversies to fashion and sanitary practices. As an interdisciplinary endeavor, New Historicism dissolves boundaries "between artistic production and other kinds of social production," as Greenblatt writes, thus eliminating the traditional hierarchies of the ACADEMY and the CANON, and also of MODERNISM, with its FORMALIST critiques. Greenblatt demonstrated the use of New Historicism as an art historical METHOD himself when he wrote about DÜRER's *Design for a Monument to Commemorate a Victory over the Rebellious Peasants* from the *Painter's Manual* (1525). He maintained that Dürer's *Design* does not reflect sympathy for the peasants in the Peasants' War of 1524–26 but, rather, supports and illustrates Martin Luther's remarks to the effect that the rebels should be stabbed without compunction. In this essay Greenblatt draws general conclusions about the coincidence of Dürer's intention and the historical situation. New Historicism, consistent with NEW ART HISTORY, challenges traditional approaches.

New Image

A term coined at the Whitney Museum of American Art in December 1978,

with the exhibition *New Image Painting*. The prime mover was GUSTON, and those in the group include ROTHENBERG, BOROFSKY, and BARTLETT. While their subjects, styles, and techniques are very different from one another, each works with the figure or landscape, rather than pure abstraction, though their figuration is usually not representational, and their painting is often loose and fast, in the manner of ABSTRACT EXPRESSIONISM. The works allude to NARRATIVE and partake of a POSTMODERN ambiguity. Unlike artists whose style might be seen as an expression of—or at least interdependent with—their subject, New Image artists distinguish and separate style and image, giving precedence to neither. New Image and NEO-EXPRESSIONISM are often interchangeable.

New Objectivity (Neue Sachlichkeit)

In Germany between the two World Wars, as hopes for social reform grew dim, a new movement full of disillusion and cynicism was formed. It received the name New Objectivity from a 1925 exhibition (held at the Mannheim Museum), though it was neither objective nor entirely new. Like 19th-century REALISM² it had a social/political agenda. While there was no stylistic uniformity among its practitioners, of whom GROSZ, DIX, and BECKMANN are the best known, they shared a determination to relentlessly show the face of evil, not abstractly but with recognizable, if exaggerated, characteristics that would drive home their point.

New Realism
See REALISM²

New York School
An alternative term, coined by MOTHERWELL, for ABSTRACT EXPRESSIONIST painters.

Newman, Barnett
1905–1970 • American • painter/sculptor • Abstract Expressionist

Esthetics is for artists like ornithology is for the birds.

Newman discovered a painting process that achieved, with a painting called *Onement I* (1948), the artistic expression he was striving for: not the "esthetics" in his comment quoted above, which he saw as "a meaningless materialism of design," but rather as a "living" thing. To create *Onement* he applied a strip of tape to the vertical center line of a small canvas that was painted a reddish color. Then he applied color to the entire canvas. When he stripped the tape from the canvas, Newman revealed a line of the earlier color moderated at its edges by the later—and an idea that led to a long series of so-called zip paintings. The title, *Onement,* refers to a unity of the inner and outer self. The "zip" is a kind of energy principle. The subject of this, as of all Newman's paintings, is an image of the self, "terrible and constant," in his own words. *Vir Heroicus Sublimis* (1950–51) is Newman's most renowned and, perhaps, as the title suggests, sublime painting. Almost 18 feet long, the rich red field, or background, is divided by thin vertical stripes or zips

of color. It is an elegant and harmonious image. In his sculptures, Newman turned his zips into three-dimensional forms.

Nicholson, Ben
1894–1982 • English •
painter/sculptor • Abstraction

I owe a lot to my father, especially to his poetic idea and to his still life theme.

Combining and juxtaposing flat, geometric shapes, Nicholson invented a kind of ABSTRACT construction, a RELIEF that has both depth and subtle color. His works are like paintings by MONDRIAN in their use and balance of form and line, but Nicholson's materials and colors are quite different, and his "lines" are material edges more often than painted lines. Dependence on overlapping forms gives his reliefs their depth. He made a series entitled *White Reliefs* by layering white shapes to achieve both surface flatness and perceptual depth. In Paris in 1933, Nicholson was influenced by the group of painters and sculptors of the ABSTRACTION-CRÉATION group. Nicholson and HEPWORTH were married and moved to Cornwall, where they became the center of a group of artists. With GABO they published *Circle: International Survey of Constructive Art* (1937), a program for abstract painting, CONSTRUCTIVISM, architecture, and design. Through *Circle* many BAUHAUS ideas arrived in England. Nicholson and Hepworth were divorced in 1951. In the comment quoted above he pays homage to his father, Sir William Nicholson (1872–1949), a skilled wood engraver, theatrical designer, and a founding member of the National Portrait Society in 1911.

Nike of Samothrace (Winged Victory)
Discovered by French excavators in 1863 and soon installed in the Louvre, the c. 190 BCE, HELLENISTIC goddess of victory, with wings outspread, is seen as if alighting on the prow of a ship. The sculpture was found in the ruins of a fountain, overlooking the harbor on the island of Samothrace. Her marble robes, clinging and seemingly transparent around her torso, also sweep about her thigh in deeply carved folds that dramatize light and shadow. A sense of movement is powerfully expressed; this Nike is especially interesting in contrast with the RELIEF *Nike Tying* (or *Fastening*) *Her Sandal* from the parapet of the Temple of Athena Nike on the Athenian ACROPOLIS, made some 200 years earlier. The diaphanous gown of the temple Nike is an exquisite study of DRAPERY falling and creasing according to its own texture and weight; the winged Nike's drapery billows and swirls as a result of the complex forces of movement and atmosphere combined with the properties of its own fabric. The Acropolis Nike is a detailed but detached, almost scientific observation; the Samothrace figure adds energy, engagement, and, it would seem, supernatural forces to those of observation.

nimbus
Also HALO, refers to the "cloud" or disk of light behind the head of an extraordinary person, such as Christ or a saint.

Niobid Painter
See POLYGNOTOS

Noguchi, Isamu
1904–1988 • American • sculptor • Modern

Interviewer: *What kind of art do you admire?*

Noguchi: *Actually, the older it is, the more archaic and primitive, the better I like it. I don't know why, but perhaps it's simply because the repeated distillation of art brings you back to the primordial . . .*

Born in California, of an American mother and Japanese father, Noguchi was taken to Japan as an infant and returned to the United States in his teens. He went to study with BRANCUSI in Paris, where he discovered the SURRE-ALIST forms of MIRÓ and ARP. Revisiting Japan in 1931, he studied POTTERY, and shapes of ancient Japanese ceramics joined his artistic vocabulary. Noguchi usually carved slate, though he also worked in metal. Best known as a sculptor, he also designed experimental stage sets for dancer Martha Graham and the UNESCO garden in Paris, and he collaborated on the bridges of Hiroshima's Peace Park. His paper "Akari" lamps, both hanging and on tripods, were immensely popular in the 1950s and '60s and returned to favor in the 1990s.

Nolan, Sir Sidney
1917–1992 • Australian • painter • Modern

Modern Australians have a thoroughly ambivalent attitude toward Ned. . . .

In these paintings, Nolan has set out to redeem the Kelly might, and restore to it, in the face even of his fellow countrymen, the full glory of an Australian saga. (Colin Macinness, 1957)

Nolan was searching for a way to make distinctly Australian MODERN art when he settled on the theme of Ned Kelly, his country's most infamous outlaw, who lived from 1855 to 1880. Nolan had heard tales about Kelly from his grandfather and from a policeman who had chased Kelly down. At first just a horse rustler, Kelly became a criminal when he shot a policeman who came to arrest him and abused his sister. Thereafter, Kelly and his gang roamed southeastern Australia for two years, robbing banks, charming hostages, and tricking and killing several policemen. At the final showdown Kelly wore armor made from plowshares, but he was shot in the legs, captured, and later hanged. In Nolan's paintings (series begun in 1946), the iron helmet becomes a strange, surreal contraption, a square black head with a slit (for the eyes) through which the sky is visible. With Kelly on his horse, Nolan evokes the desertlike plains, moist mornings, and blazing days in the Australian bush. Nolan has, indeed, created a distinctive Australian style that combines an unsophisticated folk idiom with a singular PALETTE of blue to yellow skies and dry, yellow-brown earth. He has also, as Macinness notes in the CATALOGUE for an exhibition he curated in 1957, quoted from above, given visual form to a national myth.

Noland, Kenneth

born 1924 • American • painter • Post-Painterly Abstraction

The thing is color, the thing in painting is to find a way to get color down, to float it without bogging the painting in Surrealism, Cubism, or systems of structure.

LOUIS, having been intensely affected by FRANKENTHALER's use of color, took his friend Noland to her studio. Both men returned to work in Washington, D.C., where they established what is called the Washington School of Color. Unlike Frankenthaler and his friend, Noland did not stain his canvases with color. Rather, using a synthetic PIG-MENT, he juxtaposed bright colors in precisely delineated stripes. And unlike the broad swaths of color that ROTHKO painted as growing toward and out of each other, Noland juxtaposed colors in a HARD EDGE PAINTING manner. Less interested in composition than in color relationships, Noland tended to repeat his explorations as bands in a triangular shape or in circles. In *Whirl* (1960), for example, concentric circles of color move out from a red sphere toward a blue halo. The off-white background also provides the color that frames each circle. The power with which the composition draws the eye to its center is quite amazing.

Nolde, Emil

1867–1956 • German • painter • Expressionist

Lying quiet and exhausted, resting for a few minutes free of pain, I heard a neighbor say on the other side of the drawn window curtains: "Is he dead?"

A pioneer in German EXPRESSIONISM and briefly a member of Die BRÜCKE, Nolde used brilliant, even violent color, often in religious paintings. His best-known work is a cramped, thickly and lividly painted image, *The Last Supper* (1909), in which Christ and those surrounding him have yellow-green, mask-like faces. Crowded together and radically cropped, they wear blood red and blue-black clothes, the table is covered with green cloth, and the scene is distressing. Just before he painted this picture, Nolde suffered the near-death experience he described in his autobiography, which is quoted from above. Nolde's landscapes are also rendered in strange, strong, garish color, paint thickly laid on (IMPASTO) and roughly textured. He was among the artists condemned and forbidden to paint by the Nazis (see DEGENERATE ART), but he worked in secret, producing small, luminous and haunting WATERCOLORS of old men and women, and children huddled together. He used watercolor because he feared that the smell of OIL PAINT would betray him should members of the Gestapo visit his house. These vignettes Nolde called "unpainted pictures," intending them as studies for larger works to be painted after the war. Nolde poses a problem for his admirers in that, although condemned by Nazis, he was, in fact, a member of the Nazi party and actively sought its recognition, hoping that his work would be seen as supporting their cause. There has been no secret about his politics: In 1967 *Horizon* magazine

described him as an "anti-Semite and a German jingoist." But in 1995 it was a point of contention when an exhibit at the Museum of Fine Art in Boston overlooked Nolde's past and was pressured, by an open protest, to acknowledge his Nazi sympathies in wall labels.

Nominalism

Historic circumstances during the GOTHIC period, from the collapse of the soaring aspirations of Beauvais Cathedral in 1284 to the Black Death in 1348, seemed to bring down with them confidence in reconciling reason and faith. Western intellectuals suffered a crisis of doubt, not about God but about the limits of human comprehension. To the extent that SCHOLASTICISM had endeavored to understand and interpret God rationally, the Nominalism that succeeded it emphasized God's unfathomable autonomy and omnipotence. Regarding worldly matters, Nominalism stressed only empiricism, concrete experience, perception through the senses—observation, study, and science rather than faith—as the basis for understanding. In art, Nominalism seems to be expressed in the Late Gothic International Style, and reveals itself especially in the minutely, exquisitely detailed "realism of particulars" in paintings such as those of van EYCK and other artists of the early NORTHERN RENAISSANCE. William of Ockham (c. 1285–1349—apparently he died of the plague) was the leading developer of Nominalist thinking.

nonobjective art

ABSTRACT art that retains no reference to figures and objects in the natural or manufactured world. While CUBISM may appear nonobjective, it was founded on new ways of breaking up, reassembling, and looking at people and things. True nonobjective art first appeared between 1910 and 1911 in the works of Americans MACDONALD-WRIGHT and RUSSELL as well as Frantisek Kupka (Czech, 1871–1957) and DELAUNAY in France, LARIONOV and MALEVICH in Russia, Percy Wyndham LEWIS and David Bomberg (1890–1957) in England, DOVE in the United States, and KANDINSKY in Germany, who used the term "nonobjective" in *On the Spiritual in Art* (1912).

Northern Renaissance

This term describes the cultural currents flowing through the Netherlands, Germany, and France during the 15th and 16th centuries, roughly parallel in time to the ITALIAN RENAISSANCE. Unique to the North, at first, was the development of OIL PAINTING, visible results of which were deep, intense tonality and an impression that light emanates from inside the enamel-like surface. The painstaking painting process lent itself to sharp focus, hard edges, and attention to detail. Unlike Italian artists, those of the North were less interested in geometric order and one-point PERSPECTIVE than they were in light, surface, and meticulous detail. In contrast to Mediterranean art, where the NUDE body was foremost, in the North, from the earliest times, it was the folds, texture, and ornamentation of objects, especially fabric (see DRAPERY), that received careful attention. Periods within the Northern Renaissance are:

Early Netherlandish, 1425–1500. The CLASSICAL tradition had little direct

influence on developments in the North compared to its role in the Italian Renaissance. Rather, precedent is found in ILLUMINATED MANUSCRIPTS of the GOTHIC International Style and work by painters and sculptors like the LIMBOURG brothers and SLUTER. Patronage came from the nobility or from the growing merchant middle class. Popular piety of the time was marked by pilgrimages and mysticism, and inclined more toward personal rather than communal worship. Pious individuals were rewarded with miraculous visions; much art of the period was created both to induce and to document such visions. PATRONS and DONORS appeared in religious paintings, sometimes on the wings of an ALTARPIECE (e.g., CAMPIN's *Merode Triplych*, c. 1425–28), sometimes in the biblical scene represented (e.g., van der WEYDEN's *Nativity Altarpiece of Pieter Bladelin*, 1452–55). Single portraits, which had not been produced since Roman times, also reemerged. Van EYCK, Campin, and van der Weyden were the founders and major influences of the period. All three had gone on pilgrimages. A mood swing distinguishes the sumptuous and optimistic beginning of the century from its pessimistic conclusion. Abuses by the Church caused a spiritual crisis that, at least in part, probably explains the strangeness and sense of instability expressed in works like those of van der GOES and BOSCH. Also, both before and after the turn of the century, a midmillennium-inspired fear of the impending apocalypse was widespread.

Sixteenth Century. The stage had been set for rebellion against the offenses of the Roman Catholic Church as, inside its sphere, the HUMANIST movement formed and subsequently, breaking out of it, the Protestant Reformation began. Although important, the Reformation's effect on art and artists is sometimes misconstrued. Certainly the Church's patronage declined, and fear of iconoclasm (see ICON) cut severely into conventional commissions like altarpieces, but artists had a variety of responses and alternatives. LANDSCAPES began to come into their own as a separate and distinct body of painting. Many artists, CRANACH and DÜRER among them, became wrapped up in the theology of reform and made portraits of Protestant leaders and didactic images for the new doctrines. Skills in the GRAPHIC ARTS had reached a peak in the work of SCHONGAUER and Dürer before the Reformation began. The development of the printing press in the mid-15th century led, during the 16th, to the wide dissemination of printed images in POPULAR CULTURE. Prints, often CARICATURES and satires, were used as propaganda both for and against the papacy (see PRINTING). Secular subjects—PORTRAITS, landscapes, and STILL LIFES—also grew in popularity during the 16th century. At least one prominent artist, HOLBEIN, sought commissions abroad; others went to Italy for education and inspiration (e.g., Dürer and GOSSAERT). GENRE scenes and mythical legends provided new sources of ideas not only in the FINE ARTS (e.g., van LEYDEN and Pieter BRUEGEL), but also in the work of the era's outstanding French writer, François Rabelais (c. 1494–1553). As the century progressed and Protestantism spread, reform within the Roman Catholic Church gained strength, although the Catholic human-

ists who had plowed the ground for reform were renounced. The Council of Trent (first convoked in 1545 and meeting several times until 1563) reaffirmed the doctrinal tenets that had come under attack, including transubstantiation, clerical celibacy, papal supremacy, and the selling of indulgences. Counter-Reformation theologians, dismissing the humanism of Erasmus, restored the SCHOLASTICISM of Saint Thomas Aquinas.

Norwich School

Founded in 1803 as the Norwich Society of Artists, the loose group of professional and amateur English LANDSCAPE painters was made up of friends, patrons, and students of John Crome (1768–1821), who lived in Norwich. Their stated purpose was "an Enquiry into the Rise, Progress and present state of Painting, Architecture, and Sculpture, with a view to point out the Best Methods of study to attain to Greater Perfection." John Sell Cotman (1782–1842), renowned for his WATERCOLOR landscapes and for his architectural ETCHINGS, joined the society. Norwich painters were influenced by Dutch landscape art and generally painted the East Anglia landscape. In 1805 the so-called Norwich School formed the first significant exhibition program outside of London. Its last exhibition was in 1825, and the group disbanded in the 1830s.

Novembergruppe

Formed after World War I in Berlin by a number of EXPRESSIONIST artists, later joined by DADAists. This generally left-wing group of artists hoped that out of the postwar chaos a more equitable society would emerge. GROPIUS was among the members, who included poets, musicians, and critics. The group lasted barely a decade before disillusionment and cynicism set in. In the meantime, the NEW OBJECTIVITY movement had emerged.

nude/nudity

The nude representation of human figures was a unique cultural convention of ancient Greece. From the earliest examples of the human figure in art, humans of consequence were usually clothed. True, in some pre-3000 BCE Mesopotamian images individuals approached a god without clothes on, but generally nakedness, a sign of vulnerability, was reserved for the conquered enemy and slave (e.g., the Egyptian *Palette of Narmer*, c. 3000 BCE, in which the king is clothed but the routed enemy is either naked or nearly so). About 900 BCE, during the GEOMETRIC period, Athenian artists began to portray naked males on vases. By the 7th century, the stone KOUROS was nude. Whether the kouros was a god, athlete, votive figure, or warrior, its nakedness, rather than denoting shame, was a sign of privilege, aristocracy, strength, and heroism, representing the Greek ideal of youthful beauty, often with overtones of homosexuality and perhaps the idea of purity before the gods. This was true only for males; female statues remained clothed until the Late CLASSICAL period. In politics, war, athletics, and at symposia, or drinking parties, male companionship was intimate. Pairing of older with younger men was even promoted as a means of socializing the young citizen. Nudity also made reference to the juxtaposition of Apollo, god of reason and restraint, and Dionysus,

god of inebriation, ecstasy, and abandon. While heroically nude males are usually unexcited and even have small penises, the wild members of the Dionysian cult are often represented on vases painted with fully erect phalluses. However, such display was not necessarily condemned: Herms—male busts mounted on pillars that had carved penises jutting out—were distributed around Athens as protectors of the city. Perhaps even more complex than male nudity was the dress code insisted on for "respectable" women. Because virtually all surviving documentation and visual evidence about women in Greece is by men, contemporary researchers today question the intentions of the image makers—why they portrayed women as they did—and what alternative representations of women's lives might have been. Later, ROMAN artists again shunned most nakedness other than that of mythological figures or heroic images of generals and imperial persons. During the MEDIEVAL era, nudes were considered indecent and idolatrous or were used symbolically— for example, nakedness as a sign of truth. Not until the ITALIAN RENAISSANCE, when DONATELLO cast his bronze *David* (1428–30), was the nude male once again idealized in sculpted form. Nudity in MICHELANGELO's art uses the body to its fullest power of expression. BOTTICELLI's *Birth of Venus* (c. 1484) broke the proscription against nude females, using pagan myth as its source and rationale for doing so. Thereafter, images of naked female bodies proliferated in art, particularly to appeal to a male audience (see GAZE). In 1956, CLARK wrote an encyclopedic and itself heroic survey—*The Nude: A Study in Ideal Form*. Contemporary art theorists like Jacques Lacan and FOUCAULT study attitudes toward the body in the context of psychology, sexuality, politics, culture, and the infliction of pain, while artists like Kiki SMITH and Karen Finley (born 1956) make audiences uncomfortable in encounters with their explicitly political and sexual works: Smith, for example, with her sculpture *The Sitter* (1992), shows a woman's back inscribed with deep scars, and Finley, during a PERFORMANCE, has removed her clothes and spoken and acted in ways calculated to confront, embarrass, and humiliate her audience. (See also BODY ART)

O

odalisque

French, derived from the Turkish word for a slave in a harem. A subject, inspired by ORIENTALISM, painted by 19th- and 20th-century artists, notably INGRES and DELACROIX, and subverted by MANET and VALADON.

Odo of Metz

Bishop, possibly architect for the emperor Charlemagne. (See also CAROLINGIAN)

offset (counterproof)

A method of reversing the orientation of an image by, e.g., dampening the original and compressing it against a clean piece of damp paper. This "backward" reproduction provides a model for a PRINTING process, such as an ENGRAVING; a direct copy would be improperly oriented and would print in reverse. Offset printing is also a term used to describe the photomechanical printing process used by large commercial presses.

oil painting

Particles of color (PIGMENT) suspended in an oil-based binding medium (e.g., linseed, nut, or poppy-seed oil) was known long before the 15th century, when it was first applied to PANEL painting. Van EYCK perfected the technique: Using a fast-drying oil, he built up his pictures by applying translucent paint layers, or GLAZES, on an opaque, monochrome underpainting. He and other early Flemish painters (see NETHERLANDISH) added some as yet unidentified substance that, in effect, allowed them to achieve deep, rich tones. Light reflected from layered glazes beneath the surface gives the impression of looking *into* the painting, as though it has greater depth. That reflectivity also makes it seem as if the painting were illuminated from within. The adoption and adaptation of oil paint, which replaced TEMPERA, progressed over the centuries as artists learned to manipulate and ventured to experiment with it. Oil paint is a flexible medium that, besides transparent glazes, may be used with an uneven, roughed-up appearance (e.g., SCUMBLING) or in thick (IMPASTO) applications. It may also be combined with other mediums and mixed with additives, such as sand, that vary its texture. The surface of a painting in oil may range from an enamel-like finish to one that is raised so much that it might even seem sculpted. Oil and pigment was mixed as a painting progressed from day to day during the early centuries. Although there is evidence that special boxes for open-air painting with oil and pigment existed as early as 1650, it is uncertain when or how the two were mixed outdoors.

Ready-made oil paints, packaged in small pigskin bladders that were punctured to squeeze out the contents, were available in the 18th century. Painting outdoors directly from nature was practiced by Claude-Joseph Vernet (1714–1789), a French LANDSCAPE painter, and recommended especially for marine painters by REYNOLDS in the 1750s. Thomas Jones (1742–1803), a Welsh painter whose work was relatively unknown until this century, made notably fresh and luminous oil sketches on paper during a visit to Naples during the 1780s. This kind of painting was categorized as sketching, however. The finished work would be done in the studio. Oil paint in tubes is an American invention, developed by John Rand in 1841.

O'Keeffe, Georgia
1887–1986 • American • painter • Modern/Precisionist

I desire to make the unknown known.

O'Keeffe derived her subjects largely from nature: flowers, the landscape of New Mexico, and the skeletal forms of animals. She also painted images of New York City, especially looking up at its nighttime vitality or out at its hazy, rooftop views. In her later years she painted vast panoramas of sky and land inspired by views from airplanes. In her early watercolors, O'Keeffe recorded her impressions with a few lines of color. An example is *Evening Star III* (1917), with thick green and blue lines suggesting earth and sky, and red, orange, and yellow circular shapes for the rising star. During the 1920s she painted flowers as they had never been painted before. Isolating them from nature, she focused as closely as if she were

a bee about to land, and vastly magnified them, often cropping tightly. This effectively turned them into abstract forms. Similarly, she abstracted the sun-bleached pelvis of a large animal, holding it up to see "the sky through the hole," as in *Pelvis with Moon, 1943*. O'Keeffe studied at the Art Institute of Chicago and at the Art Students League in New York City, and took classes with Arthur Wesley Dow at Columbia University. Dow led her to appreciate the abstract beauty of form and color. She married STIEGLITZ, 24 years her senior, in 1924, after a long affair and after having been a member of his famous "circle" of artists and photographers since 1917. She began spending summers in Taos in 1929, and after Stieglitz died, in 1946, settled permanently in Abiquiu, New Mexico. Much has been made of the sexual and erotic connotations of her work, though O'Keeffe constantly denied such intent and insisted it was in the eye of the beholder. The topic is still controversial. Some art historians believe Stieglitz profited by marketing O'Keeffe's work as sexual, and that he pandered to the idea that her erotic paintings flattered men (himself in particular) as both the cause and the object of women's desire.

Oldenburg, Claes
born 1929 • American • sculptor • Pop Art

My procedure was simply to find everything that meant something to me, but the logic of my self development was to gradually find myself in my surroundings.

In June 1961 Oldenburg rented a storefront at 107 East Second Street, on the

Lower East Side of New York City, and filled it with his sculptures of everything from a wristwatch, a piece of pie, hats, pants, and tennis shoes to a sewing machine. It was a carnival of stuff made of brightly enameled plaster. The store closed after two months because the objects did not sell. For an exhibition of his work the next year, Oldenburg was inspired by the cars in an automobile showroom to create enormous SOFT SCULPTURE, such as *Floor Cake* (*Giant Piece of Cake;* 1962), made of canvas filled with foam rubber and cardboard and then painted. It was as if he had actually given tangible form to the concept of those floppy watches so preposterously draped over objects by DALÍ (*Persistence of Memory,* 1931). Oldenburg then returned to hard shapes. One of his sculptures stands 46 feet high in the center of Philadelphia, flanked by office buildings: Made of Cor-ten and stainless steel—though it looks like a replica of its wooden original— *Clothespin* (1976) is a towering icon of old-fashioned domesticity, an Olympian goddess of washday. Many of Oldenburg's sculptures are clear analogies to the human body. "The erotic or the sexual is the root of art," he has said.

Olmsted, Frederick Law
1822–1903 • American • landscape architect • Picturesque

[A park should], in a directly remedial way . . . enable men to better resist the harmful influences of ordinary town life and to recover what they lose from them.

After DOWNING, Olmsted became America's leading landscape designer,

and his hand can be seen at many great estates (e.g., Biltmore; see Richard Morris HUNT), as well as on the grounds of Stanford University in Palo Alto, California, and at the World's Columbian Exposition in Chicago, 1893. He argued for the preservation of landscapes such as Yosemite and Niagara as reserves for the public, and spearheaded the country's city park movement. Central Park (1857–77) in New York City was a project he oversaw, in collaboration with Calvert Vaux (1824–1895), steering it between demands of the wealthy—who envisioned winding paths, museums, and educational institutions—and the general population, who wanted the park for sports and other relaxing diversions. Although some of the city's underprivileged dwellers had to be dislocated for the project, Olmsted designed an 800-acre park that satisfied most wishes. Laid out in the English PICTURESQUE manner, it was a pastoral idyll in the midst of a city that had, since the Civil War, doubled its population to three million inhabitants. As the comment quoted above makes clear, Olmsted believed parks important as retreats from the evils attendant on industrialization and urbanization.

Omega Workshops
See FRY

Op Art (Optical painting/art)
Playing and experimenting with optical illusion—as artists have done since the beginning of time—this style was named during the 1960s when a new generation of artists explored the possibilities of juxtaposing colors and shapes that are entirely nonrepresentational.

ALBERS is considered the movement's pioneer. Interests of Op artists were scientific, mathematical, and psychological, and their materials, other than paint, included, for example, neon lighting. Among prominent Op Art artists are the Hungarian-French painter Victor Vasarely (1908–1997), who wrote manifestos on the subject; the American Richard Anuszkiewicz (born 1930), a student of Albers; and the British painter RILEY.

open form
See CLOSED FORM

Oppenheim, Meret
1913–1985 • German/Swiss •
objects • Surrealist

When I met the group, end of 1933, I was twenty years old and I was not at all sure about political opinions. I made my work and did not worry about these discussions.

Oppenheim left Switzerland to study art in Paris at the age of 19. She soon fell in with the "group" of SURREALIST artists referred to in the quotation above, and to them she was a sort of wild child, known for her outrageous behavior. She was given to stripping in the middle of a café, for example, and was intimate with ERNST and MAN RAY, who called her the most uninhibited woman he had ever met. Thus, the sexual innuendoes of her most and only famous work, a fur-lined teacup, saucer, and spoon, are no surprise. The idea came to her when PICASSO and the photographer Dora Maar (1907–1997; also Picasso's lover) were admiring a fur-covered bracelet Oppenheim had designed, and Picasso said that anything

could be covered in fur. Meantime, her cup of tea growing cold, Oppenheim asked the waiter for a bit more fur. Later she bought a demitasse cup and covered it with fur from a Chinese gazelle. Although generally known as *Object* (1936), André Breton (see SURREALISM) actually named it *Déjeuner en fourrure,* or *Breakfast in Fur,* and it caused a great sensation at the gallery where it was shown. It is significant, especially to FEMINIST interpretation, that he gave her work its title, considering the importance of language and especially the right to "name" things, which is equivalent, or tantamount, to taking possession of them. This interpretation was described in a speech/performance about Oppenheim presented by Maureen Sherlock in May 1987 at the First National Women's Sculpture Conference in Cincinnati, Ohio.

orans
From the Latin *orant,* meaning "praying," refers to a figure whose hands are raised, palms forward, arms either bent or straight, to signify that he/she is praying. A common posture in EARLY CHRISTIAN ART found, for example, in the CATACOMBS, the orans figure derives from a pagan symbol for piety.

Orcagna (Andrea di Cione)
active 1343–1368 • Italian •
painter/sculptor/architect • Late
Gothic

Orcagna was a most noble master, extraordinarily skilled in both arts. . . . He was an outstanding architect, and executed with his own hand all the narrative scenes . . . [and] also carved

his own likeness marvelously rendered.
(Ghiberti, c. 1450)

Orcagna headed a large WORKSHOP (with his brothers Nardo and Jacopo) in Italy after the middle of the 14th century. In the *Enthroned Christ with Madonna and Saints* (1354–57), an ALTARPIECE for the Strozzi Chapel in Santa Maria Novella, Florence, Orcagna tightens and stiffens his figures and places them against a flat gold ground. It has been said that the horrors of the Black Death, the bubonic plague of 1348, might have contributed to this reversion to a more constrained manner than that so recently explored by GIOTTO, although this idea is disputed. GHIBERTI's near contemporary assessment of Orcagna, quoted above, is flattering, as is the translation of his name, a nickname that was local slang for "Archangel."

Orientalism

Rooted in the Latin word that refers to the rising sun, allusions to the Orient and thus to Orientalism have generically to do with Asian lands east of the Mediterranean. However, the term extends to areas of Africa, especially Morocco, Algeria, and Egypt. The influence of the East on western Mediterranean countries predates recorded history, as scholars increasingly point out. It is formally acknowledged in the naming of the 700–600 BCE ORIENTALIZING period in Greek art. While crosscurrents of influence, both subtle (e.g., see HALO) and obvious (e.g., Oriental carpets in RENAISSANCE paintings and CHINOISERIE), the interest in cultural differences became especially strong during the early 19th century (e.g.,

DELACROIX and INGRES), when the exoticism of foreign countries held great appeal. This was fueled by the conquests of Napoleon, and in France a number of artists known as Orientalistes specialized in North African and Near Eastern subjects. During the mid- and later 19th century, the appetite for both ISLAMIC and EARLY CHRISTIAN culture increased, and showed itself in artists as diverse as GÉRÔME, MATISSE, and CHURCH. After the 1850s, once trade with Japan was reestablished, the influence of Japanese art on both European and American artists was more critical to new styles than any previous Oriental contacts had been. (See also UKIYO-E and IMPRESSIONISM)

The term "Orientalism," and the practices it represents, presupposes a division between East and West, and traditionally it meant a scholarly or artistic study of "the Orient." During the last quarter of the 20th century, that benign meaning has been turned upside down, especially with recognition that it has always meant a "privileging," or preference given to the West—a practice now called Eurocentrism. Such prejudice has been found in Homer, who represents the Phoenicians as deceitful and dishonorable in the *Odyssey,* and is also traced back to the "father of history," Herodotus (5th century BCE). Writing about the Persian Wars, Herodotus split the world into East and West, discrediting the former in every way. An influential new perspective is articulated by Edward Said, especially in his book *Orientalism* (1978). Said describes Orientalism as "the corporate institution for dealing with the Orient—dealing with it by making statements about it, authorizing views of it,

describing it, by teaching it . . . as a Western style for dominating, restructuring, and having authority over the Orient." The premise of Orientalism is, thus, that it is an invention of non-Orientals for purposes they project on the idea they are creating. Said's point of view sparked much thought and several exhibitions and studies on the subject of Orientalism (from, e.g., *The Orientalists: Delacroix to Matisse* assembled by the Royal Academy of Arts in 1984 to an article by Marilyn Brown, *The Harem Dehistoricized: Ingres's Turkish Bath,* published in 1987). Another approach to countermanding the effect of Orientalism is seen in Martin Bernal's controversial book, *Black Athena: The Afroasiatic Roots of Classical Civilization* (1987). Bernal argues that, in fact, Western art and culture have black African origins. In POST-MODERN terms, Orientalizing derives from the impulse and politics of dominance that create the "Other," thereby excluding certain populations (e.g., women, people of color, non-heterosexuals, children) from the privileges one accords oneself as a member of the ruling establishment. As Orientalism is considered a trait of a colonizing, imperialistic society, the term "Postcolonial" is currently used to describe and study a society distancing itself from the subordination of another social group.

Orientalizing period
c. 700–600 BCE.
Increased trade with and colonial expansion in the Near East and Egypt influenced design in Greek Art, introducing fantastic lions, sphinxes, griffins, and other Egyptian and Meso-potamian themes. These show up especially on painted vases (POTTERY) and cast metalwork, such as bronze cauldrons used in sanctuaries. Eastern influence also appears in the first relatively large stone sculptures, usually of women, called DAEDALIC. Eastern influence during this period is undisputed, but recent scholarship sees a much earlier connection.

Ornate (Third) Style
See MURAL

Orozco, José Clemente
1883–1949 • Mexican • painter • Expressionist/Social Realist

[José Guadalupe] Posada used to work in full view, behind the shop windows, and on my way to school and back, four times a day, I would stop and spend a few enchanted minutes watching him, and sometimes I even ventured to enter the shop and snatch up a bit of the metal shavings that fell from the minium-coated metal plate as the master's graver passed over it. This was the push that first set my imagination in motion and impelled me to cover paper with my earliest little figures; this was my awakening to the existence of the art of painting.

Orozco was one of the three major Mexican artists (see also RIVERA and SIQUEIROS) whose role in decorating public walls with paintings that glorified Mexican history and culture was part of an effort, launched in 1920, to inspire social change. In the face of protests from conservatives, and with a new president, however, many such projects were suspended in 1924. Where Siqueiros temporarily aban-

doned painting and Rivera tenuously befriended the new regime, Orozco left Mexico and worked in the United States. (By the 1930s, all three artists were working in the United States.) Orozco's commissions included a project at Dartmouth College in New Hampshire, which he worked on from 1932 to 1934: *The Epic of American Civilization* is a MURAL made up of 24 compositions that, with passion and fury, follow an imagined history from the golden age of pre-Columbian culture, whose hero is Qetzalcoatl, to the evil of Spanish conquest under Cortés. The series continues through to the ultimate vision of a triumphant human spirit in the form of Christ, who destroys oppression and brings about the modern golden age. Messianic and utopian, Orozco's paintings preached political change less than his belief in the achievements that might reward physical and spiritual struggle. The quotation above, from his autobiography, describes the early encounter, when he was about seven years old, that led to his interest in art. The window in which Posada (1852–1913) did his ENGRAVING was that of a printing press in Mexico City.

Orphism (Orphic Cubism)

A movement of totally ABSTRACT style whose chief theorist was the poet APOLLINAIRE and whose main practitioner was DELAUNAY. Apollinaire described Orphism as "the art of painting new structures out of elements which have not been borrowed from the visual sphere, but have been created entirely by the artist." Because such painting shares with music an ability to create emotion without resorting to specific things seen in the natural world (besides color), the movement was named for the legendary poet Orpheus, whose musical genius charmed the animals and persuaded Pluto to allow Eurydice, Orpheus's wife, to follow him back from Hades. Orphists sought to produce pure color harmonies, evoking the idea of music pulsating through the universe. While Orphism was developing, two Americans, MACDONALD-WRIGHT and RUSSELL, also living in Paris, launched a similar movement they named SYNCHROMISM.

Ossian

Between 1760 and 1763, a number of prose poems reportedly written by a 3rd-century Gaelic poet named Ossian were "discovered" and published after translation into English by a Scotsman named James Macpherson (1736–1796). The effect was overwhelming. Ossian was translated into German, Italian, and French. Ossian was considered the northern equivalent of Homer, but less superstitious and amoral and more noble, humane, magnanimous, virtuous, and, in short, polite. "Ossian has replaced Homer in my heart," GOETHE's fictitious hero Werther wrote in 1774. JEFFERSON declared Ossian's poems "the source of daily and exalted pleasure." He added, "I am not ashamed to own that I think this rude bard of the North the greatest Poet that has ever existed." Napoleon said that the poems of Ossian "contain the purest and most animating principles and examples of true honor, courage and discipline, and all the heroic virtues that can possibly exist." Ossian made his

first pictorial appearance in Scotland when Alexander Runciman (1736–1785) decorated a ceiling with scenes from his life. (These were destroyed by fire in 1899, but some sketches for them remain.) The Swiss painter KAUFFMAN, the German RUNGE, and the American TRUMBULL illustrated scenes from Ossianic legends. Among Jacques-Louis DAVID's students, Ossian joined Homer and the Bible as sacred texts. GIRODET-TRIOSON's *Ossian Receiving the Generals of the Republic* (1802) and INGRES's *Dream of Ossian* (1812) were prompted by the verses, which also did much to stimulate the ROMANTIC movement, especially in literature. BLAKE adapted the format and meter of the Ossianic sagas for his own prophetic books. Ossian was, however, a great ruse, fabricated almost entirely by Macpherson.

Ostade, Adriaen van
1610–1685 • Dutch •
painter/printmaker • Baroque

The reason for the shift in Ostade's mood has not been established, but it is probably related to a change in his clientele, to his own conception of himself, and his ideas about his task as an artist. (Jakob Rosenberg, Seymour Slive, and E. H. ter Kuile, 1966)

There is no conclusive proof, but many scholars believe Ostade and BROUWER studied together in the Haarlem studio of HALS, and they posit that Ostade was strongly influenced by Brouwer. Ostade's paintings of peasant life, at first similarly rude and raucous, became more respectable, perhaps for reasons cited in the commentary quoted above.

Ostade converted to Catholicism after his marriage. Though quite wealthy, he continued to show the intimacy of peasant life. (See also GENRE)

Ottonian art
c. 936–1002

Following Charlemagne's death in 814, Viking and Magyar assaults ravaged his former empire and halted artistic advance until the arrival of a new Saxon line of German emperors, who ruled an area roughly corresponding to modern Germany and Austria. Three of the emperors who were called Otto gave their name to the period. The Ottonian leaders looked back to Charlemagne as their model: Otto I (the Great) was crowned at Aachen in 936. In the year 1000, according to legend, Otto III opened Charlemagne's tomb and found the *Coronation Gospels* on the emperor's knees. Thereafter, German emperors swore their coronation oaths upon that book. The emperors enhanced the political power of the Church by appointing their relatives to rule important monasteries and sees (bishops' territories). In art, BYZANTINE influence joined that of ancient Rome (CLASSICAL) and of Charlemagne (CAROLINGIAN), especially after Otto II married a Byzantine princess. This increasingly humanized art, evident in books such as the *Gospel Book of Otto III* (c. 1000), can be highly emotional in tone as well as emphatically didactic. In style and content it leads to the ROMANESQUE. An important architectural monument is BERNWARD's Abbey Church of Saint Michael (c. 1001–33) in Hildesheim, Germany (destroyed by bombs but rebuilt after World War II). A massive structure, its

most remarkable features are the great bronze doors with RELIEFS that pair dramatically rendered scenes from the Book of Genesis on the left with the Gospels on the right. Another important monument of the period is the startling GERO CRUCIFIX (c. 970), which shows Christ's extreme suffering.

Outsider art

A term for art that might alternate with FOLK, PRIMITIVE, or NAIVE. Outsider art refers to work that is free of ACADEMIC influence, outside of the elite mainstream, and sometimes produced by the uneducated, the insane, the criminal, and the underprivileged. Outsider art became so popular during the 1990s that an annual New York Outsider Art Fair was launched in 1993, and a Congressional Resolution hailed the new American Visionary Art Museum that opened in Baltimore, in 1995, as "the official national museum, repository, and educational center for American visionary and outsider art." This was defined, by congressional fiat, as art "produced by self-taught individuals who are driven by their own internal impulses to create." "Visionary," a subset of Outsider art, is frequently seen in buildings or their environments. The artists are often motivated, or driven, to make their creations by visions or voices. The *Throne of the Third Heaven of the Nations' Millennium General Assembly* (c. 1950–64), by James Hampton (1909–1964), is composed of 180 objects made from recycled materials such as hollow cylinders from carpet rolls, jelly glasses, and lightbulbs, all covered with gold and silver foil. The throne itself is an old armchair, but its arms sprout winglike extensions and the back has elaborate decoration. Hampton's creation was put on exhibit at the National Museum of American Art in Washington, D.C., in 1990. In a review written in 1996, the critic Wendy Steiner elucidated the irony of Outsider art's popularity: "[It] is flourishing because the art establishment have become the true outsiders of our day." She concluded, "Though outsider artists are almost invariably discovered by trained artists, curators and dealers, the carefully maintained myth of the isolate persists: that artworks can be produced and understood without reference to history or tradition but as immediately gratifying objects . . . that expertise and education interfere with beauty."

P

Pacheo, Francisco
1564–1644 • Spanish • writer/painter • Baroque

It would be hard to overstate the good that holy images do: they perfect our understanding, move our will, refresh our memory of divine things.

Pacheo was an undistinguished painter but an influential teacher whose greatest student (and son-in-law) was VELÁZQUEZ. Pacheo's most important work was his book, *The Art of Painting* (published posthumously, 1649). He worked on the text for 40 years. The center of a group of intellectuals in Seville, Pacheo was also the inspector of art for the Inquisition of Seville and subscribed to a belief in the role of painting as a servant of Catholicism, as expressed in the quotation above. Pacheo's adherence to the dictates of the Counter-Reformation and of the Council of Trent (first convoked in 1545 and meeting sporadically until 1563) also explains the philosophical underpinnings of his book and his development, with his friends, of prescriptions for religious symbolism. These formulas are quite definite. In describing paintings of the Virgin after the Immaculate Conception, he writes, "In this loveliest of mysteries Our Lady should be painted as a beautiful young girl, twelve or thirteen years old. . . . She should have pretty but serious eyes with perfect features and rosy cheeks, and the most beautiful, long gold locks."

Pacher, Michael
active 1462–1498 • German • sculptor/painter • Early Northern Renaissance

Item, at St. Wolfgang, while he completes and sets up the altar, we shall provide his meals and drink, and also the iron work necessary for setting up the altar, as well as help with loading wherever necessary. (contract between Pacher and the abbot of Mondsee for the Saint Wolfgang altarpiece, 1471)

From the Tyrolean region of south Germany, where wooden altar shrines were very popular and important, Pacher carved and painted a shrine of extreme intricacy, with sinuous GOTHIC figures in gowns that fold and flow extravagantly. Topped by a Crucifixion and surrounded by lacy architectural details, the sculpture is gilded. The exterior, movable wings are painted with scenes from the life of Saint Wolfgang. These show the influence of the ITALIAN RENAISSANCE (especially of MANTEGNA), and include PERSPECTIVE with very ex-

aggerated foreshortening. This is the *Saint Wolfgang Altarpiece* (1471–81) for which the contract quoted from above was signed, and which took the artist 10 years to complete. The written directions for what should be included are also specific regarding the subject matter. The last item in the contract does not seem to have been enforced. It reads, "If the altar is either not worth this sum [1,200 Hungarian guilders or ducats] or of higher value, and there should be some difference of opinion between us, both parties shall appoint equal numbers of experts to decide the matter."

Paik, Nam June
born 1932 • Korean/American • video artist • Modern

As collage technique replaced oil paint the cathode ray tube will replace the canvas.

Paik's innovations with electronic art shocked and amused the public in the early 1960s, and initiated a new field of artistic expression. He came to VIDEO art from music composition; his first art PERFORMANCE was *Étude for Pianoforte* in 1960 during which he leaped off the stage to cut off CAGE's tie with a scissors and shampooed Cage's head. Besides humor, there is an insistent defiance of social propriety in Paik's work, best known of which is *Bra for Living Sculpture* (1969). He staged *Bra* with Charlotte Moorman, a classical cellist. During her performance she wears a "brassiere" in which two miniature TV sets substitute for the cups. Moorman was arrested for indecent exposure during one of her performances with Paik (*Opera Sextronique*, 1967) and found guilty of "an art which openly outrage[d] public decency." In his decision the judge cited a London Sunday *Times* editorial that described current art as "a kind of brothel of the intellect."

painterly
A term introduced to ART HISTORY by WÖLFFLIN, who used it specifically to characterize BAROQUE art. Painterly (*malerisch* in German) style stresses the internal, intrinsic nature of form rather than its outline, silhouette, or edges. The painterly style leaves more to the viewer's imagination than does the LINEAR style, to which Wölfflin compared it. REMBRANDT's *The Return of the Prodigal Son* (c. 1665) is one of Wölfflin's examples of "painterly."

paleography
From the Greek *palaios,* meaning "ancient," paleography is the study and interpretation of ancient written documents.

palette
The usually flat, wood, curved board on which an artist mixes paint. "Palette" also refers to a characteristic color range: Either an artist's oeuvre or a picture might be said to have a dark, limited, or predominantly red palette, for example. A high- or low-key palette, like the musical metaphor on which it depends, is one in which colors are, respectively, light or dark in tone and value. (See also COLOR)

Palladian
Refers to the style of the 16th-century Italian architect PALLADIO, whose de-

signs and ideas have been widely adapted over the centuries (e.g., JONES). In the 20th century, the "Palladian window" remains popular. It was probably derived from BRAMANTE, but knowledge of it was spread by *L'Architettura* (in six parts, 1537–1551), illustrated texts of Sebastiano Serlio (1475–1554). This detail consists of a central arched window or opening flanked by smaller arched openings, and is also known as Serliana or the Serlian motif—but it was frequently used by Palladio. (See also ARCH)

Palladio, Andrea (Gondola, Andrea di Pietro della)

1508–1580 • Italian • architect • Late Renaissance

Guided by a natural inclination, I gave myself up in my most early years to the study of architecture . . . I proposed to myself Vitruvius for my master and guide.

The nickname Palladio, given Andrea by his benefactor, a poet, philosopher, mathematician, and amateur architect, is an allusion to Pallas Athena, goddess of wisdom and a subject of the long poem that his sponsor was writing. As had ALBERTI, Palladio followed the ancient Roman example, carefully examining and measuring ruins, but he developed a somewhat more rigid system for following this example than Alberti had. In 1570 he published *The Four Books of Architecture,* which provided a basis for much French and English building of the next centuries. Palladio's Villa Rotunda (1567–70), near his hometown of Vicenza, is a central-plan building and the first domestic structure to have a DOME. Identical TEMPLE fronts (a porch with COLUMNS and a pediment) adorn all four sides. He was mistaken in his belief that ancient Roman houses used such temple-front porticoes, but that design was widely adapted and is even seen in JEFFERSON's home, Monticello. The facade of San Giorgio Maggiore (1566–1610) in Venice, overlooking the water, superimposes an exceptionally high temple front over a lower, wider facade. Palladio's style is smooth, elegant, and intellectual and gave its name to PALLADIANism, a style whose first exponent was JONES.

panel

Before CANVAS came into use for free-standing pictures, wood boards, or panels, were used for paintings. Their surfaces were usually prepared with GESSO and their images were painted in TEMPERA or OIL PAINT. ALTARPIECES are panel paintings. Panel painting reached its zenith under the brush of van EYCK, whose development of the oil GLAZE technique enabled him to paint monochrome (GRISAILLE) figures that looked as though they had been sculpted, as well as sparkling gold and jewels, reflective surfaces, and luxurious fabrics. It bears noting that panel painting developed at the same time (early 15th century) as the new Northern European middle class grew wealthy and proud enough to pay for paintings of such jewels and sculpture that they might not be in a position to purchase outright. Panels were not the most expensive medium of their era—TAPESTRIES and ILLUMINATED MANUSCRIPTS were more costly.

Panini, Giovanni Paolo (also Pannini)

1691–1765 • Italian • painter • Rococo

. . . what remains to be discovered about Panini's studio practices, his approach to the genres and subjects he depicted, and the authenticity of individual paintings is considerable.
(Edgar Peters Bowron, 1994)

Trained as a set designer, Panini made a new kind of *capriccio*—"caprice," or imaginary scene—popular. He might, for example, place accurate depictions of famous ancient buildings and statues in Rome within an invented setting. Panini's *Interior of the Pantheon* (c. 1740) describes, better than could any photograph, a sense of the building's enclosed space; for that reason textbooks use it as an illustration of the PANTHEON. However, Panini "freely and imaginatively manipulated the existing pictorial and sculptural decoration . . . to create a more visually attractive and scenographic composition," as the historian Bowron, who is quoted above, points out. This is in contrast to his remarkable precision in rendering numerous views of the interior of Saint Peter's, also in Rome. Panini first painted Saint Peter's in 1730, and continued painting it during several decades, reflecting architectural modifications that were made over time. So far unexplained, Bowron adds, is "the subtlety of his intentions and approach," his reasons for fantasy in one instance and accuracy in another. In 1756 Panini was commissioned by the duc de Choiseul, French ambassador in Rome, to paint an imaginary palatial gallery stocked with ANTIQUE statues and paintings of the greatest monuments of ancient Rome. The DYING GAUL and LAOCOÖN are two of more than a dozen statues in the picture; the COLOSSEUM and PARTHENON are framed and hung among the many paintings on the walls of the invented interior. The gallery is populated by men and women in contemporary—that is, 18th-century—dress.

Panofsky, Erwin

1892–1968 • German • art historian

I rather feel like the dog in Correggio's Ganymede who looks up at the skies into which his master, borne aloft by the eagle, is about to disappear. But, like this dog, I have a dim consciousness of the fact that something extremely important is happening.

A Jew expelled from Germany, Panofsky settled in the United States in 1934 and taught, along with Albert Einstein, at the Princeton Institute for Advanced Study. His influence on the study of art is immense, though increasingly disputed. In the comment above, recorded by GOMBRICH, the aged Panofsky described his reaction to being challenged by dissident ideas. Gombrich adds, "Can one wonder that the writer of such a letter was idolized by his students and colleagues?" Panofsky's *Early Netherlandish Painting* (1953) in effect introduced and legitimized the study of NORTHERN RENAISSANCE art in America. Panofsky promoted a beguiling new approach to ART HISTORY (especially as CONNOISSEURSHIP became tainted by commercialism): the study of ICONOGRAPHY. As Panofsky defined it, iconography "concerns itself with the

subject matter or meaning of works of art, as opposed to their form." Going a step further, Panofsky discussed ICONOLOGY, which explores symbolic meaning. Iconography is descriptive; iconology, interpretive. Inspired by Panofsky's example, finding and interpreting "hidden symbolism" in works of art became an avid preoccupation. While scholars toward the end of the 20th century, rejecting Panofsky's authority, recast iconology and supported new models of scholarship, his importance to the discipline of art history is unchallenged.

panorama

Two distinct meanings are attached to this term. It may be used to describe a wide landscape view such as the "panoramic views" of CLAUDE LORRAIN and CANALETTO, or those produced by HOCKNEY during the 20th century using PHOTOMONTAGE to make a panoramic landscape of the Grand Canyon. A second definition of "panorama" has to do with pictorial representations that cover the inside of a cylindrical surface, running around 360 degrees. An observer standing and turning inside the panorama is meant to experience it as an approximation of the actual scene it represents. Suggested by a German architectural painter, the first constructed panorama made for public viewing was exhibited by Robert Barker in Edinburgh in 1788 and represented a view of that city; its title was almost as wonderful as itself: *Mr. Barker's Interesting and Novel View of the City and Castle of Edinburgh, and the whole adjacent and surrounding country.* In 1791 Barker coined the term "panorama" (which significantly shortened

subsequent titles). This first panorama was followed by views of London, of sea fights, and of battles of the Napoleonic wars, all displayed in the first rotunda built specifically to exhibit panoramas, in Leicester Square, London. After the Franco-German War, a panorama of the siege of Paris was exhibited in that city. The popularity of panoramic paintings spread throughout Europe and eventually to America in traveling exhibitions. Stationary, circular panoramas were followed by moving panoramas, in which a rolled-up painting was slowly unfurled in front of an audience, creating the illusion of traveling on a train or boat—views of the Mississippi River were especially popular. In 1818–19 the American artist VANDERLYN painted an impressive (immobile) panorama, *The Palace of Versailles*. It was originally 165 feet long and 18 feet high, but has lost some 6 feet in height from years of being trimmed. It has been permanently installed at the Metropolitan Museum of Art in New York City since 1988.

Pantheon

The best preserved of all monumental ancient Roman buildings (see ROMAN ART). As its name indicates, the Pantheon was dedicated to all (*pan*) the gods (*theos*—god) rather than a single deity, as was typical of most pagan temples. It was built in Rome (118–25 CE) for Emperor Hadrian, who wanted "something ineluctably Roman" that expressed the multifaceted culture of the empire, according to the historian William MacDonald. Some of the Pantheon's distinction came from the structural use of concrete, a material exploited with unprecedented success by

Roman builders. While the porch facade, with COLUMNS and pediment, suggests a Greek temple, that entry leads into a great, half-spherical rotunda covered by a 142-foot-diameter DOME. The dome's interior has decorative, recessed panels (coffers), each of which contains a gilded rosette. Natural light enters the building through a 30-foot-diameter oculus (meaning "eye" and suggesting the eye of Zeus) at the summit of the dome; open to the sky the oculus makes a dramatic spotlight that follows a path set by time of day and season. Corinthian columns alternate with niches for statuary. The floor (which has a shallow depression and drainage holes beneath the oculus) is paved with multicolored marble squares, alternating circle and square designs. Suggesting both the dome of heaven and the path of the planets, and the "unified, perfected, seamless, comprehensible whole," MacDonald writes, Hadrian's Pantheon expressed "the order of the empire, sanctioned and watched over by the gods." It is probably the most imitated structure ever built, a source of inspiration over two millennia. (See also PANINI)

paper

The word, from "papyrus," refers to thin sheets of material made from cellulose pulp derived from rags, wood, and/or certain grasses. Invented in China, probably during the 2nd century, it took 1,000 years for paper making to become popular in the West, even though the technique was known (see CODEX). By the 13th century, paper was manufactured in Spain and Italy—in France and Germany during the 15th—but not until the later 15th century was paper made in England. It was widely exported and imported before then, however, and between 1200 and 1400, paper largely replaced PARCHMENT. The first manuscripts made of paper were produced for administrative and accounting purposes, but inexpensive books for clerics and students were also soon inscribed on paper—rags from which paper was then made cost one-sixth the price of parchment. While it was still too scarce in GIOTTO's time (early 14th century) to prepare full-size CARTOONS—drawings—for FRESCO painting, a century later MASACCIO was able to use paper cartoons for the Brancacci Chapel. By 1300 European paper makers had begun using watermarks—small designs impressed in the paper, from lions to swans—to distinguish their products. With the spread of PRINTING in the 1450s, paper became a POPULAR CULTURE medium. But it was not shunned by princely libraries, one of which, in 1467, inventoried 20 percent of its 196 manuscripts as being on paper.

papier collé

French for "glued or pasted paper." (See also COLLAGE)

parchment

Animal skins were used for writing long before the 2nd century BCE, when an improved process of preparing them was developed in Pergamon, whence the word parchment ultimately derives. According to PLINY the Elder, the new invention came about when Eumenes II, ruler of Pergamon, wanted to enlarge his library. Jealous rulers of Egypt tried to interfere with his ambition by forbidding the export of papyrus, a plant that

then provided the standard writing material. Bred by necessity, the new manufacturing process, developed on Eumenes' behalf, involved scraping, polishing, stretching, and then rubbing the skins with chalk and pumice. The result was that both surfaces, "recto" and "verso," front and back, respectively, were good for writing on. Earlier, prepared skins, known as membranes, had only one useful side. The two-sided parchment was later beneficial in development of the CODEX. Skins of sheep, calves, and goats provided the best parchment, and that from calves, finer than the others, became known as vellum.

Parmigianino (Girolamo Francesco Maria Mazzola)
1503–1540 • Italian • Mannerist

217. The women of Raphael are either his own mistress, or mother. 218. The women of Correggio are seraglio beauties. 219. The women of Titian are the plump, fair, marrowy Venetian race. 220. The women of Parmigianino are coquettes. (Fuseli, c. 1790)

Inspired by seeing his reflection in a barber's convex mirror, in 1524 Parmigianino painted his self-portrait on a 9½-inch-diameter wooden sphere. Visual distortion, like that of the convex mirror, was pursued in many permutations in MANNERISM. Parmigianino, a student of CORREGGIO, is best known for his *Madonna with the Long Neck* (c. 1534–40), a painting in which the Virgin is elongated to an extent that defies the imagination, but treatises at the time described ideal female beauty in this way. The Christ child on her lap is similarly stretched out, and both are sinuously curved in ways that may remind one of the S-curve of the International Style (see GOTHIC). Also typically Mannerist, Parmigianino's colors seem eerie, if not artificial; the mossy tones of the Virgin's gown and darkish emerald of her cape cast a greenish pallor over all. This anemic aura adds to the strange lifelessness of the infant Christ, whose pose, especially the dangling arm, mimics that of a series of dead Christs going back to MICHELANGELO's *Pietà* (c. 1497–1500), PONTORMO's *Descent from the Cross* (1525–28), and RAPHAEL's *Entombment* (1505–07). Parmigianino was handsome and gifted and had worldly elegance—it was said that Raphael's soul had passed into Parmigianino's body, although FUSELI, whose numbered *Aphorisms on Art* are quoted from above, seems to disagree. Certainly Parmigianino's fate was unlike that of Raphael. At one point he was imprisoned for breach of contract, and during his last years he began to practice alchemy and became, according to VASARI, savage and wild-looking, with a beard and long hair. He died at 37, the same age Raphael was at his death.

Parrhasius
late 5th century BCE • Greek • painter • Late Classical

He first gave symmetria to painting, and was the first to give liveliness to the face, elegance to the hair, and beauty to the mouth; and it is acknowledged by artists that he was supreme in painting contour lines, which is the most subtle aspect of painting. (Pliny the Elder, 1st century CE)

Parrhasius's birth and death dates are unknown, but a contemporary wrote of a conversation between Parrhasius and Socrates, who died in 399 BCE, providing at least one parameter. According to written reports, Parrhasius is one of the greatest painters of ancient Greece, but none of his work survives. His own exploits are as legendary as the myths he portrayed. For a picture of Prometheus—punished for stealing fire from the gods by being chained to a rock where an eagle daily gnawed at his liver—Parrhasius was reputed to have bought a slave and tortured him to death so as to study suffering. (Some scholars find the story unlikely and argue that it was posited later, by Seneca, for the sake of teaching ethics and rhetoric.) Another recurrent story also involves birds: His competitor ZEUXIS had painted grapes so cleverly as to fool the birds, who pecked at them. Parrhasius then presented a picture of linen curtains so persuasive that Zeuxis told him to draw the curtains and show his picture behind them: the deceiver deceived. "On discovering his mistake [Zeuxis] surrendered the prize to Parrhasius," PLINY, also quoted above, reported. Parrhasius was the author of a text, *On Painting,* in which he elaborated on POLYKLEITOS's system of *symmetria,* but that, too, is lost.

Parthenon

Built on the Athenian ACROPOLIS, from 447 to 432 BCE, a white marble TEMPLE to Athena, goddess of war, wisdom, and the city of Athens. The original temple was under construction when it was demolished by the Persians in 480 BCE. By decree of PERICLES and over-seen by PHEIDIAS, the reconstructed Parthenon reused the foundations and some columns from the earlier building. There is speculation that some of the metopes (see COLUMN ORDERS) were also salvaged and reused. There are eight columns at each end, seventeen on the sides (counting the corner columns twice). The chief architect, ICTINOS, was assisted by Callicrates. The Parthenon's exterior style is the apogee of the Doric order, the interior is Ionic, and the combination signified Athenian unification and the protection of those two regions of the Greek world. In architecture and sculpture the Parthenon is the epitome of High CLASSICAL Greek art. Pericles said of it, "All the Old World's culture culminated in Greece, all Greece in Athens, all Athens in its Acropolis, all the Acropolis in the Parthenon." Two design anomalies—a slight convex bow of the stylobate (the platform on which the columns stand) and a slight cant inward of exterior columns—absorb scholars. VITRUVIUS speculated that the bow in the stylobate corrects our optical inclination to see long horizontal lines as if they were concave. However, a contradictory theory suggests that the bow is there to enhance the opposite effect of a straight stylobate, which, seen from below the building—that is, from the usual approach—would seem slightly convex. Rather than correcting illusion, this, combined with other irregularities, could serve the purpose of making the building appear even larger and loftier than it is. A third interpretation is that the structural deviations are intended to create psychological tension because one expects to see a straight line and upright columns but sees in-

stead a bowed line and tilted columns. "As a result, the mind struggles to reconcile what it knows with what the eye sees, and from this struggle arises a tension and fascination which make the structure seem vibrant, alive, and continually interesting," writes the historian J. J. Pollitt. The significance of the sculptural program and that of the colossal ivory and gold (CHRYSELE-PHANTINE) cult statue of Athena by Pheidias, now lost, that stood inside are more subjects for debate. While scenes of Greeks fighting Giants or Amazons, such as those on the metopes, were routinely assumed to conjure up the Greek defeat of Persian invaders, a new line of research questions why Athenians would continue to give prominence to that victory half a century later. An alternative interpretation suggests that the theme was a metaphor for contemporary Greek women: Were they, perhaps, striving for recognition or independence while the Parthenon was being built? Another new interpretation concerns the frieze, a band 3½ feet high and 524 feet long along the upper edge of the outer wall of the cella (see TEMPLE). Since the late 18th century, most scholars have thought it represented a contemporary procession honoring Athena. In the mid-1990s, a new analysis of the frieze that fits more securely with mythological conventions of Greek art has gained credibility. Joan B. Connelly suggests that the procession represents the sacrifice of King Erechthonius and his family, who gave their lives to save Athens.

Later history has left its mark on the Parthenon: The Romans inscribed Nero's name on it; in the late 6th century it became a Christian church; and after Athens fell to the Ottoman Empire, in 1456, the Parthenon became a mosque. In 1687 Venetians bombarded the temple, igniting a stash of Turkish gunpowder that destroyed much of the building; after the Turks recaptured Athens from the Venetians, they built a smaller mosque in the shell of the building. Later, trying to plunder the Parthenon's pedimental sculpture, they destroyed much of it. Adding insult to injury, in 1801 a British ambassador to Turkey, Lord Elgin, was able to remove large sections of the sculpture, which are now at the British Museum, where they are known as the ELGIN MARBLES. Before that, however, the Parthenon's rediscovery and publication in the 1750s gave a powerful stimulus to the Doric Revival, a phase of architectural Romantic Classicism that emphasized the heroic and the SUBLIME.

In the midst of a 30-year-long project, begun in 1976, restorers are dismantling, cleaning, and reassembling the Parthenon. They are trying to reverse damage resulting from earlier restorations while conserving some sense of the building's almost 2,500-year history by, for example, reconstructing several interior columns that may have been started by the Goths in 267 CE. At the same time they want to leave clear evidence of modern repairs, making sure they will be reversible by future conservators. One way they do this is to use a different color of marble for new work. Not the least of the problems restorers are grappling with is how to minimize future damage to the building, especially from modern pollutants such as acid rain.

Pascin, Jules (Julius Pincas)

1885–1930 • Bulgarian/American •
painter • School of Paris

*I love so much to squander money
about.*

Pascin was so skilled a draftsman that
some critics said his OIL PAINTINGS were
"drawings heightened by paint." He
worked as an illustrator and caricatur-
ist with an often biting edge, and he
chronicled his travels in Europe, Amer-
ica, and North Africa. His PRINTS usu-
ally were made by using a sharp needle
to draw directly on copper, called dry-
point (see INTAGLIO). A large part of
Pascin's oeuvre was devoted to erotic
studies of prostitutes, such as *Back
View of Venus* (1924–25), a nude, seen
from behind, strongly outlined to fol-
low the voluptuous contours and fleshy
volume of her torso. Pascin became so
closely associated with such images that
his work was sometimes called the
"mirror of prostitutes." The son of a
Sephardic grain merchant, Pascin
worked for his father before, at the age
of 17, he ran away from home to devote
his life to the art he had previously prac-
ticed in secret. He studied in Munich,
went to Paris in 1905, and changed his
name from Pincas to Pascin. He spent
time in the United States, becoming a
citizen, but returned to Paris in 1920.
While he lived in New York he wrote
the letter from which the quotation
above is taken. In the same letter he said
he was increasingly indifferent to suc-
cess and attracted to life's pleasures. But
he was also so absorbed by thoughts of
death that, in 1924, André Salmon ded-
icated a poem to him entitled *Death and
Her Mistresses.* Pascin committed sui-
cide in Paris in 1930, leaving behind a
strange letter with instructions for a
Jewish burial. "His gift seemed to excel
in handling unsavory themes in such a
manner as to discover an element of the
sublime in them," the historian Walde-
mar George has written. "In spite of
their morbidly erotic quality, his draw-
ings thus avoid becoming porno-
graphic."

Passion

From the Latin for "suffering," the fre-
quently illustrated Passion of Christ in-
cludes the Entry into Jerusalem and
Last Supper, Christ Washing the Disci-
ples' Feet, the Agony in the Garden, Be-
trayal of Judas, Denial of Peter, Christ
before Pilate, Flagellation, Crowning
with Thorns, Christ Carrying the Cross,
the Crucifixion, Descent from the
Cross, the Pietà, Entombment, Descent
into Limbo, Resurrection, and the As-
cension. By meditating on pictures of
Christ's Passion, and to a lesser degree
on those of the martyred saints, individ-
uals hoped to experience visions and to
find mystical union with Christ through
compassion. A movement, called the
devotio moderna, or Modern Devotion,
of the 14th and 15th centuries pro-
moted the Imitation of Christ (*Imitatio
Christi*) for which meditation on the
Passion was central. This empathetic,
emotional communion with Christ was
especially widespread in Germany,
where it is referred to in a type of devo-
tional image known as Andachtsbild.

pastels

Powdered PIGMENTs molded into sticks.
Pastel colors are generally paler and
more delicate than those of OIL PAINT
and TEMPERA, and less stable. Pastel
pictures, or pastels, often need to be se-

cured with a fixative that may somewhat dull the colors applied. In combination with white chalk, pastels were popular for portrait drawings in the 18th century (see Henrietta JOHNSTON). In the 19th century, DEGAS used pastels with great success, as did MORISOT.

Pater, Walter
1839–1894 • English • critic

She is older than the rocks among which she sits; like the vampire, she has been dead many times, and learned the secrets of the grave; and has been a diver in deep seas, and keeps their fallen day about her; and trafficked for strange webs with Eastern merchants.

"She" is Mona Lisa, and this famous passage from Pater's essay on LEONARDO quoted above is incomparably described by the critic HUGHES, who writes, "The famous Gioconda passage, which moved a whole generation of undergraduates in Cambridge and Boston to tears and secret fantasies, has become period fustian." About Pater, whose name is synonymous with the phrase "art for art's sake," writing in *Nothing If Not Critical* (1990) Hughes continues, "Nobody . . . in the 1880s could approach the Mona Lisa without the sinuous Muzak of these cadences in his head. Pater furnished his readers with a model of young revolt. Against the materialism of the Victorian bourgeois father, and the arrogance of the landed 'hearties,' Pater's writings set forth a new shudder, a more refined snobbery of floating and pollination: the dandyist ideal of life lived as a procession of exquisitely shaped moments." It remains to be said only that Pater's well-known *Studies in the History of the Renaissance* was published in 1873, and was called "the holy writ of beauty" by Oscar Wilde. (See also AESTHETICISM)

Patinir, Joachim
c. 1480–1524 • Netherlandish • painter • Northern Renaissance

I gave Master Joachim one florin's worth of prints for lending me his assistant and his colors, and I gave his assistant three pounds' worth of prints. (Albrecht Dürer, 1520)

Patinir's extraordinary LANDSCAPES both satisfied the contemporary taste for scenic views in the thriving port of Antwerp and contributed to a remarkable new interest in and attention to the environment. In fact, the first time the term "landscape" was used in German literature is when DÜRER called Patinir "the good landscape painter." Patinir's topography closely resembles that of southern Belgium near his hometown of Dinant, but one is struck by the gigantic and sometimes surreal terrain of a vast, boundless landscape. We see his scenes from above, as if from an omniscient point of view. Within these overwhelming panoramas, a small anecdotal moment is found, as in *Landscape with Saint Jerome Removing the Thorn from the Lion's Paw* (c. 1520) and *Landscape with Charon's Boat* (c. 1520–24), in which the River Styx divides the lush pastures of paradise from the rough peaks and canyons of hell. These "inverted" images, in which the story seems secondary (see AERTSEN and van LEYDEN), are variously interpreted by art historians. They may, albeit indirectly, reflect the fact that people were traveling a great deal in the period, for pilgrimages as well as commercial pur-

poses. But they may also be considered as "politically correct" for their own time: In the Post-Reformation period, images that foreground the scenery and put the religious story in the background were less likely to be condemned as idolatrous. In any case, one of ART HISTORY's most unforgettable faces is that of MASSYS's *Ugly Old Woman* (1513). It is found reproduced among the cast of characters in the foreground of a large (nearly 6 feet wide) image, the *Temptation of Saint Anthony* (c. 1520–24) by Patinir. While the human figures are painted by Massys, the vast landscape that fills the canvas is by Patinir.

patron/patronage
The root of this term, which in art refers to the artist's benefactor or customer, is the Latin word *pater,* meaning "father." Sources of patronage change along with fluctuating social and political circumstances. Thus, for example, the emperor was a primary patron of ROMAN ART, the Church commissioned art during the MEDIEVAL period, and wealthy merchants also came forward to sponsor artists during the ITALIAN and NORTHERN RENAISSANCES. During the 20th century the idea of patronage has so vexed artists that they have sought ways both to defy and to manipulate it, only to find, or to reassure themselves, that the "establishment"—museums and dealers as well as private individuals—embraced them nevertheless. The exception to that embrace is the government of the United States, which has taken a stand against funding art considered offensive, at least to certain of its members. Since the 1980s, government support of the arts, through the NATIONAL ENDOWMENT FOR THE ARTS especially, has been in upheaval. Studies of patronage are integral to the study of ART HISTORY. (See also DONOR)

Patroon Painters
Patroons were Dutch settlers along the Hudson River, and Patroon Painter is the name given to the anonymous LIMNERS who made their portraits. Native born and without ACADEMIC training, they based their compositions, poses, and even settings on what they saw on PRINTS imported from Europe. Thus, it was not surprising to see a settler in upstate New York looking very much like a British nobleman on his estate.

Pausanias
2nd century CE • Greek • geographer/traveler

Such (in my opinion) are the most famous of the Athenian traditions and sights; from the mass of materials I have aimed from the outset at selecting the really notable.

Pausanias was an intrepid tourist, and his travel notes include histories of the places he visited as well as their folklore, ceremonies, customs, and important things and sights to see. His 10-book *Description of Greece* has been a boon for archaeologists and art historians. His main interest is in the monuments of ancient art, and he is particularly drawn by those of the 5th and 4th centuries BCE. At Delphi, for example, he admires the work of POLYGNOTOS and describes his paintings minutely. J. G. Frazer, who translated and published Pausanias in English, wrote that "without him the ruins of Greece would for the most part

be a labyrinth without a clue, a riddle without an answer."

Peale, Charles Willson
1741–1827 • American • painter • Colonial

Can the imagination conceive anything more interesting than such a museum?—Or can there be a more agreeable spectacle to an admirer of the divine wisdom!

Roughly contemporary with COPLEY but a native of Maryland rather than Boston, Peale was a saddlemaker before he took up art—he received painting lessons from John Hesselius (1728–1778) in exchange for a saddle. He also went to Boston to see Copley, and made the ambitious artist's obligatory trip to London to study in WEST's studio before Copley did. Unlike Copley, though, Peale was eager to return home. He was also happy to leave the HISTORY PAINTING that West practiced and paint the portraits he knew would buy his meals—portraiture dominated American art well into the 19th century. The faces that look out from Peale's canvases have their mouths curved up in a particular smile that becomes recognizable as Peale's signature. Most of his subjects appear charming, and none more so than in *The Peale Family* (1773 and 1808). Gathered around a table, as were those in SMIBERT's important *Bermuda Group* (*Dean George Berkeley and His Family*) of 50-plus years earlier, the family members here are relatively informal and unpretentious; moreover, even the dog, whose head is in the front of the picture, has a sweet face. Peale painted many important Americans, and in *General George*

Washington before Princeton (1779) gave Washington the benevolent Peale smile. Four years before his death, the board of trustees of the Pennsylvania Academy commissioned a self-portrait from Peale, who had moved to Philadelphia just prior to the Revolutionary War. *The Artist in His Museum* (1822) shows Peale lifting a drape and providing a view into the natural history and science displays of the museum he founded and opened to the public in 1794. (It is his idea for this museum that he describes in the quotation above.) Shadow boxes hold specimens of North American birds along the wall, and in the foreground of the picture is an American turkey and the skeleton of a mastodon. Peale himself took part in digging up the prehistoric bones, and painted a picture of the excavation in progress: *The Exhumation of the Mastodon* (1806). The museum's intention was didactic, in line with Peale's commitment to education. He was convinced that painting was a skill to be learned, not a talent one is born with—and he inspired several members of his family to paint. He actively supported women's equality, and his liberality bore fruit: At least nine women artists can be linked to Charles Peale through either lineage or marriage. He gave his brother, James (1749–1831), his first lesson; three of James's daughters were painters, and two of them, Anna (1791–1878) and Sarah Miriam (1800–1885), were elected to membership in the Pennsylvania Academy of the Fine Arts. Charles's sons, Raphaelle (1774–1825), Rembrandt (1778–1860), and Rubens (1784–1865), were highly accomplished painters.

Pearlstein, Philip
born 1924 • American • painter •
Photorealist/New Realist

*I have made a contribution to
humanism in 20th-century painting—I
rescued the human figure from its
tormented, agonized condition given it
by the expressionistic artists, and the
cubist dissectors and distorters of the
figure, and at the other extreme I have
rescued it from the pornographers, and
their easy exploitation of the figure for
its sexual implications. I have
presented the figure for itself, allowed
it its own dignity as a form among
other forms in nature.*

Where WESSELMANN depersonalized the
female nude by painting nearly feature-
less figures in flat color, Pearlstein ac-
complished the same objectification
with excessive detail: bodies are all too
faithfully reproduced, and their features
are particularized and exaggerated as
if by hyper-photography. His figures
are "naked" rather than "nude," to
make a fine point of the artist's frank-
ness. Using large canvases, Pearlstein
(again, like Wesselmann) crops bodies
at will and brings the viewer uncom-
fortably close to his subject. He frames
and organizes his compositions so that
the human form may seems abstract,
like the fabrics and furnishings—intri-
cate shapes and carefully reproduced
patterns that surround them—to which
they seem equivalent. As his comment
quoted above implies, Pearlstein sees
the human figure as a form among
other forms, yet the question of its dig-
nity is more complex, unless that
dignity is seen to reside in a cold objec-
tivity that transcribes a body's folds,
wrinkles, and fat as religiously as the
taut curves and wrapped joints of a
rattan chair (*Model Seated on Rocking
Rattan Lounge,* 1984).

peepshow box
A box with painted interior panels that,
when seen through a small hole, seem to
become a three-dimensional scene. The
boxes employ tricks of PERSPECTIVE,
such as the severe distortion of anamor-
phosis, and depend on using only one
eye at the "peephole." Peepshow boxes
may have been devised earlier, but they
became popular during the 17th cen-
tury, when experimentation in optics
was so important. In the 1650s, HOOG-
STRATEN created marvelous peepshows,
such as one with two different views
(i.e., two peepholes) of the interior of a
Dutch house. It includes a peek into a
bedroom with, in the distance, the head
of someone asleep in bed, as well as a
brown-and-white spaniel with winsome
eyes whose top half, painted on one sur-
face, and bottom, painted on another,
come together through optical illusion.

Peeters, Clara
1590–after 1657 • Flemish • painter
• Baroque

*When [the Holladays] first saw her
paintings in Vienna and Madrid in the
early 1960s, they were particularly
struck by their beauty and, upon
returning to the United States, tried to
learn more about the artist. They
found that the standard art history
text by H. W. Janson did not at that
time contain reference to Peeters—or
to any other woman artist—and
decided to focus their collecting upon
works by women, thus forming the
nucleus of the National Museum of*

Women in the Arts. (M. L. Wood, 1987)

Peeters was one of the most important painters of the "tabletop still life," which she helped to make popular in Antwerp during the first half of the 17th century. Little is known of her life; documents recording her birth and marriage cannot be confirmed and she was never listed as a member of the artists' GUILD. It is not even known when she died, but there are paintings that bear her name dated from about 1608. She painted flowers, foods and delicacies, porcelain, glassware, and metal objects that comprise both a handbook of current DECORATIVE ARTS and superlative exemplars of the STILL LIFE genre. One subtype among the tabletop still life is a "breakfast piece" in which the table is pitched so that each thing set on it is distinct. *Still Life with Tart* (perhaps 1611) is an example: All objects are meticulously rendered, among them a plate of oysters, a porcelain pitcher and cup, fruit, pastries, and knives. Each object has significance beyond the perfection of its rendering. The tart, or pie, is traditionally served at wedding feasts; it is decorated with sprigs of rosemary, a symbol of eternity and, in this context, fidelity. Oysters were a delicacy and were believed to be an aphrodisiac. Peeters's signature is engraved on the shaft of a silver knife. Stunning in their skillfulness, her paintings are also historic documentation of contemporary customs and beliefs. The commentary quoted above is from the catalogue of the NATIONAL MUSEUM OF WOMEN IN THE ARTS. There was still no mention of Peeters in the 1995 edition of Janson's text, or for that matter in

the 1995 (10th) edition of the similarly standard *Gardner's Art Through the Ages,* although Marilyn Stokstad's *Art History* (1995) does contain an entry on Peeters.

pentimento, pentimenti (pl.)
Italian for "repentance," refers to marks on a work of art that reveal the artist's second thoughts, change of mind, additions, or corrections. Pentimenti are good clues to an artist's working methods. Although sometimes pentimenti are said to suggest originality, as a copyist is less likely to make such changes, they may also be the result of, for example, a master's correction of a WORKSHOP execution. Pentimenti are often obvious in DRAWINGS. More elusive in paintings, they may be revealed by an underdrawing or underpainting that has surfaced over time, or through scientific analyses such as X-RADIOGRAPHY and REFLECTOGRAPHY.

Performance art
An evolution of HAPPENINGS and FLUXUS during the 1970s. Performance artists were also inspired by avant-garde music and dance. Sometimes the artist performed (see ANDERSON), and sometimes he or she designed the performance. In 1969 the dancer-choreographer Trisha Brown (born 1936) had a man equipped with mountaineering gear descend a seven-story building in New York City. Two performance artists known as Gilbert and George (Gilbert Proesch, born 1943, and George Passmore, born 1942) are Britishers who collaborate as "Living Sculpture." In *The Singing Sculpture* ("*Underneath the Arches*"), performed in 1971, they painted them-

selves bronze and danced, with mechanical movements, on the top of a table. Under the table a tape played a song about two tramps, beneath the arches of a bridge, fantasizing in their dreams. Part of their rationale is that they, as artists (trained at Saint Martin's School of Art in London), could embody art and carry it out as they saw fit.

Pergamene School

During the HELLENISTIC period, the widely dispersed Greek influence was especially rich in the kingdom of Pergamon in Asia Minor, where the style is sometimes known as Hellenistic baroque. It is characterized by theatricality and suffering, exemplified by the sculpted figures on the *Altar of Zeus and Athena* (c. 175 BCE). Originally located on the Acropolis, or upper city, in Pergamon, this altar is now reconstructed in Berlin.

Pericles

died 429 BCE • Greek • statesman

Mighty indeed are the marks and monuments of our empire which we have left. Future ages will wonder at us, as the present age wonders at us now.

The central and organizing principle of Pericles' life was the political and cultural leadership of Athens, and from as early as 460 BCE until his death in 429 BCE, he exerted his influence on the city and on Greece. Despite an earlier Greek vow to leave the ravaged ACROPOLIS as it stood—a reminder of Persian barbarity—Pericles initiated a building program there. From one perspective Pericles' plans represented a HUMANIST belief in the potential of man to control

his world, but from another it was believed symptomatic of rash indiscretion. Financed in part with money paid to Athens by her allies for protection, the Acropolis building program was under way when in 431 BCE the Peloponnesian War broke out and in 429 BCE a plague decimated Athens. Many citizens saw the double scourge as punishment for breaking the promise, as well as for the misappropriation of funds (Pericles used money earmarked for the Delian League). This belief seemed confirmed, at least to his enemies, when Pericles himself died in the epidemic. His ambitions are expressed in the commentary quoted above, taken from his famous funeral oration honoring Athenians killed during the first year of the Peloponnesian War.

periodicity/periodization

Describes the process of distinguishing chronological eras in an effort to define characteristics of artistic STYLE in terms of historic period. A broad, general historic outline of the periodizations of Western art is (1) ANCIENT, c. 3000 BCE–300 CE, (2) MEDIEVAL, c. 300–1400, (3) RENAISSANCE/BAROQUE, c. 1400–1700, (4) MODERN, 1700–present. Sometimes only Ancient, Medieval, and Modern are used, incorporating Renaissance and Baroque with Modern. And at other times (such as in this text), more specificity is useful and Modern is located during the 19th century. (For subdivisions within periods, see the separate entries.) Stylistic periods are often named and defined after they have ended. This is sometimes an effort to discredit them (see GOTHIC, IMPRESSIONIST, and FAUVE). Many terms used to denote periods are taken

from disciplines other than ART HISTORY; for example, NEOCLASSICISM, ROMANTICISM, REALISM, and POSTMODERN are adopted from literary history and theory. Periodization is a subject of dispute involving not merely beginning and ending dates, or the boundaries of a "period," but also influences that initiated or concluded it. One complaint against the notion of periodicity is that it endeavors to homogenize diversity. Despite the validity of complaints against it, periodization serves the useful purpose of establishing landmarks (much like the CANON), which may then be contested.

Perry, Lilla Cabot
See AMERICAN IMPRESSIONISM

perspective
In art, perspective is a system for showing three-dimensional space on a (usually flat) two-dimensional surface. And in art, as in literature, one's perspective depends on one's point of view and vice versa: Technicalities of perspective are extensions of the way an artist sees the world philosophically as well as optically. Greek artists began to think about showing objects in space, and the Romans were even more absorbed with creating an illusion or resemblance of the perceived world. During earlier and later periods, scenes were portrayed as personal or spiritual experience, with the sense of being inside the picture rather than looking from outside. The first scientific explorations of perspective began in the ITALIAN RENAISSANCE. They depended on the egocentric, rational, circumspect, and HUMANIST belief that man was the center of the universe and could both understand and change the world. Renaissance perspective has been described as the difference between looking through a window to see the world, as humanists did, and the more spiritual, or experiential, approach of walking through the window to be inside the world. The latter approach characterized BYZANTINE art, and later CUBISM, SURREALISM, and other MODERN experiments.

The "inventors" of perspective were BRUNELLESCHI, who first demonstrated its principles, and ALBERTI, who described its underlying geometry and showed how it might be applied. (It was Alberti who first likened a painting to a window onto the visible world.) In his treatise *On Painting* (1435), he described the method for plotting "one point perspective," taking into account the artist's viewpoint, the horizon line, and a "vanishing point" where all "orthagonals" (i.e., lines drawn from the baseline to the horizon) hypothetically converge. Once rules of mapping perspective were established, like all rules they were manipulated: Objects and scenes were looked at from playful, odd, and unusual angles. MANTEGNA's ceiling in the *Camera degli Sposi* (1465–74), which gives the illusion of people looking down into the room through an opening into the sky, is a famous example. It is also an exercise in *di sotto in sù* ("from below upward") perspective, of which POZZO's ecstatic *Glorification of Saint Ignatius* (c. 1688–94) is an extraordinary example. Pozzo's *Ignatius*, as well as UCCELLO's *Battle of San Romano* (mid-1450s) and Mantegna's *Dead Christ* (c. 1500) contain examples of perspectival foreshortening, the result of focusing on a person or object by drawing a bead on its long

axis. Atmospheric or aerial perspective is an approach that recognizes how color and light appear to change in the far distance. The background of LEO-NARDO's *Mona Lisa* (begun c. 1500–03) is an example of atmospheric perspective. Anamorphosis, from the Greek word for "transform," explores the experience of seeing an object from a radical point of view that utterly distorts its form. The strange object on the floor in HOLBEIN's *The French Ambassadors* (1533), in truth the elongated perspective of a skull seen from a close, sharp angle, is an example of anamorphosis. Other methods of representing perspective have been invented and explored, and more will no doubt evolve from cyberspace and virtual reality, but whether measured on a grid or translated from a surreal dream or from an abstract concept, each serves to express the artist's own vision as part of the worldview of her or his era.

Perugino, Pietro

c. 1450–1523 • Italian • painter • Renaissance

Perugino was renowned as one of the early experimenters in central Italy with the technique of glazing in oil. . . . Flemish-style realism became the prevailing fashion in the 1480s, and in order to achieve it Perugino set about teaching himself the Flemish technique. (Marcia Hall, 1992)

The city for which he is named, Perugia, was put on the map by this artist, although he also worked in Florence and Rome, where on the walls of the Sistine Chapel he painted *Christ Delivering the Keys of the Kingdom to Saint Peter* (c. 1480–82). His FRESCO, in company with those of BOTTICELLI, GHIRLANDAIO, and SIGNORELLI, illustrates that moment in the Bible on which the rule of papal authority rests, Peter being the first father, or "pope," of the Church. The figures are lined up in a well-ordered tableau. Behind the actors, as if on a painted theatrical backdrop, is a PERSPECTIVE grid leading to the buildings along the horizon line. Whether in a Crucifixion or a Lamentation, Perugino's static figures are silent, and perhaps part of their appeal has to do with qualities that also make them anachronistic: little variety in poses and lack of expressiveness or psychological insight. But what makes a picture by Perugino irresistible is the reassuring background—frequently still, serene, beautiful landscape. An important contribution to his coloristic effect was due to his experimentation with OIL PAINTING, as Marcia Hall notes in the quotation above. Perugino and his Italian compatriots were suitably impressed and influenced by the *Portinari Altarpiece* (c. 1473–78), which had been commissioned from van der GOES and was delivered to his Florentine patron in 1483. One of the young painters whose reputation grew as Perugino's declined was his own student RAPHAEL.

Peto, John Frederick

1854–1907 • American • painter • Trompe L'Oeil

It does not take a Freudian psychologist to perceive that Peto's concern with used-up, discarded,

and rejected things parallels his own life. This has gently poetic implications. (Alfred Frankenstein, 1969)

A friend of HARNETT and also a Philadelphian who studied at the Pennsylvania Academy of the Fine Arts, like Harnett Peto painted TROMPE L'OEIL pictures. However, Peto's brushwork is more visible and his lighting more dramatic than Harnett's. While he also painted STILL LIFES of old rather than new objects, Peto's are more tattered and suggest a step down on the economic ladder from Harnett's world. An example of his work is *The Cup We All Race 4* (c. 1900), in which a battered tin drinking cup hangs from a nail, against a cracked, rough, painted background. The title is ambiguous, but critic Frankenstein's comment, quoted above, refers to Peto's failure to attract buyers for his work.

Petrarch (Francesco Petrarca)
1304–1374 • Italian • poet

[Giotto's] beauty amazes the masters of the art, though the ignorant cannot understand it.

Looking back 1,000 years to the cultures of ancient Rome and Greece, Petrarch launched a campaign to recover CLASSICAL works and to revitalize HUMANISM—in effect, he may have launched the ITALIAN RENAISSANCE. Much of Petrarch's poetry was addressed to a woman named Laura, whose actual identity is not known. He was crowned poet laureate on the Capitoline Hill in Rome in 1341, survived the Black Death of 1348, and was a friend and mentor to BOCCACCIO. Not only were his own works illustrated (see MARTINI), but also his likeness was often painted—e.g., by the BOUCICAUT MASTER early in the 15th century and by Andrea CASTAGNA later in that century. Petrarch established an elitist jargon as well as an aesthetic hierarchy, excluding the "ignorant" from the pleasure of art, which explains his comment about GIOTTO in the quotation above.

Pevsner, Antoine
1886–1962 • Russian • painter/sculptor • Constructivist

Space and time are reborn in us today. Space and time are the only forms on which life is built and hence art must be constructed.

With his younger brother GABO, Pevsner cosigned *The Realistic Manifesto* (1920), which laid down the CONSTRUCTIVIST idea; however, the extent of his contribution to the movement, or to the manifesto itself, is uncertain. In the late 1920s Pevsner began to make exactingly engineered ABSTRACT sculptures in metal. One of his most accomplished and unusual works, *Projection into Space* (1938–39), is hammered and polished, rather than cast BRONZE. Two curved, winglike planes, back to back, give the work a sense of continual rotational movement. Because movement presumes a change from past to present and present to future, the work alludes to time. It is a simple shape but a complex form: Space is drawn into its soft curves, and is defined by its curvilinear edges. Thus *Projection into Space* fulfills the space and time mandated in the manifesto as quoted above.

Pevsner, Sir Nikolaus

1902–1983 • German/English • art historian

A bicycle shed is a building; Lincoln Cathedral is a piece of architecture. Nearly everything that encloses space on a scale sufficient for a human being to move in is a building; the term architecture applies only to buildings designed with a view to aesthetic appeal.

Pevsner started his career in Germany before moving to England in the 1930s to escape the Nazi regime. His approach to ART HISTORY was "eclectic," according to the historian Eric Fernie, who writes, "He was first and foremost an empiricist of such energy that he has been described as an academic locomotive and a discerning vacuum cleaner." Pevsner compiled a series of books, *The Buildings of England*, an enormous— perhaps the most enormous—research and publication project in architectural history. He also published an important defense of MODERN architecture, *Pioneers of the Modern Movement from William Morris to Walter Gropius* (1936; retitled *Pioneers of Modern Design* in subsequent editions). Citing three ways in which architecture creates aesthetic sensations—through planes, which it shares with painting; masses, shared with sculpture; and volumes unique to the building profession— Pevsner argued that architecture was thus foremost among all the arts. This primacy is supported by the social dimension of architecture, a preeminently humanistic endeavor. Architectural style developed, Pevsner believed, in fulfillment of the spirit of its age, not in response to technology. (See also HEGEL and RIEGL) The quotation above is from Pevsner's introduction to *An Outline of European Architecture* (1942).

Pfaff, Judy

born 1946 • English/American • sculptor/installations • Contemporary/Abstract Expressionist

Swimming in the Caribbean off the coast of Mexico in Quintana Roo, I discovered a world undersea that corresponded to a new direction I had been struggling towards in my work.

Pfaff was born in London and trained in America at Yale University. She uses various materials that sway, dart, and hover as if far below the ocean surface, as her description of their source, quoted above, indicates. *Deepwater* (1980) is one example. About it Pfaff said, "In the ocean the deeper you go, the less light there is, and the stranger the life forms become. The formal vocabulary for this work became more abstract and visually dense. . . . [It] was about a deeper engagement and a greater risk." With entirely ABSTRACT forms in various materials, wonderful colors, and constant motion, Pfaff suggests seaweed, coral, fishes, and sensations of a magical deep-sea environment. Her INSTALLATIONS often fill a gallery space, and viewers sense they have entered another world.

Pheidias (also Phidias)

active c. 460–430 BCE • Greek • sculptor • High Classical

Pheidias supervised everything. (Plutarch, 1st–2nd century CE)

Pheidias was overseer of the PARTHENON's sculptural program. It is not known how much of the project Pheidias himself carved, but he may have prepared detailed models for craftsmen to follow. He was renowned for two colossal CHRYSELEPHANTINE (gold and ivory) cult statues—one of Athena, *Athena Parthenos,* for the Parthenon on the Athenian ACROPOLIS, and the other of Zeus for his temple at Olympia. Neither survives; however, written descriptions and copies in various MEDIUMS, including coins, allow some reconstructions. *Athena Parthenos* was 40 feet high, she wore her goatskin cloak, and the base she stood on as well as her accessories—helmet, sandals, and shield—were decorated with the familiar mythological metaphors that the Greeks used to express their current problems or concerns. The statue was also responsible for Pheidias's downfall, although it may have been enemies of PERICLES who wished to discredit the artist: Pheidias was accused of keeping for himself some of the precious materials designated for the sculptures, and he was condemned for carving his own portrait onto Athena's shield, where the struggle between Greeks and Amazons was represented. Whether undone by hubris, politics, or both, Pheidias went from Athens to Olympia, where he carved the cult statue of Zeus, which was later counted as one of the SEVEN WONDERS OF THE ANCIENT WORLD. It is not known whether Pheidias died in exile or if he was imprisoned and executed in Athens. But he was responsible for the Athenian style that characterized the visionary dream of Pericles. J. J. Pollitt wrote, "All Pheidian sculpture seems to have projected a state of mind which was detached but not remote, aware but not involved." Certainly succeeding artists were greatly influenced by the majesty of his style.

Phillips, Ammi
See FOLK ART

Philostratus
3rd century CE • Greek • philosopher

Purple figs dripping with juice are heaped on vine leaves, and they are depicted with breaks in the skin, some just cracking open to disgorge their honey, some split apart, they are so ripe.

Philostratus taught in Athens and Rome, and his book *Imagines* was written to acquaint students with painting. *Imagines* describes pictures in the collection of a wealthy Neapolitan. Whether it was a real or hypothetical collection is not known, but the text is key in a category of writing known as EKPHRASIS, exemplified by the excerpt from *Imagines* cited above.

photography
See PRINTING and REPRODUCTION

photomontage
A method of making a single image by combining two or more photographic negatives, or prints, and often photographing the finished composition. (The last step is not always taken.) During the 19th century, a form of photomontage was used to construct illusionistic scenes, from a vast political convention constructed of individual

portrait photographs, to a small family gathering in which, as occasionally happened, a deceased relative was able to rejoin the household through cutting, pasting, and rephotographing the assembly. DADA and SURREALIST artists (e.g., HÖCH and ERNST) irreverently combined photographs, often taken by others, removing themselves, as artists, from the traditional role of originator. "It was the perfect retort to the insanity of a world torn to pieces by war and revolution. . . . By dissembling the authorship of the assembled images they attacked the notion that what was valuable about them was the artist's intention," the historian David Travis writes. HOCKNEY's photomontages have included both panoramic (e.g., of the Grand Canyon) and other idiosyncratic collages of photographs. In the latter category, for *Pearblossom Hwy., 11–18 April, 1982, #2* (1986) Hockney combined fragments of hundreds of color prints in a composition that shows a littered, dry desert landscape traversed by a road, traffic signs, and an ironic street sign that reads PEARBLOS-SOM HWY.

Photorealism

Refers to paintings that look like photographs. Often the artist uses a photograph or slide as the resource from which the painting is made, and often the work on canvas goes beyond photography in its sharpness of focus, brightness, and the reflectivity of glass and other mirroring materials. This heightening of effect leads to Photorealism alternatively being called Superrealism and New Realism. Photo-

realists include ESTES, CLOSE, FLACK, and FISH.

Photo-Secession
See STIEGLITZ

Piazzetta, Giovanni Battista
c. 1682–1754 • Italian •
painter/draftsman • Rococo

. . . representing a life-size woman, seated with a boy between her knees, a basket of grapes in her hand, dogs, who catch sight of a duck in the water and two men in the distance. . . . A woman with an umbrella, a maidservant, a peasant, an idle boy, and the head of cow.

Although Venetian artists were notoriously late in adopting the light colors and decorative spirit of ROCOCO, Piazzetta might be considered more notorious for insistently *not* adopting them, and becoming nevertheless one of the two dominant artists in VENICE during the 18th century (TIEPOLO was the other). He carried out a number of commissions for Marshal Schulenburg, a professional soldier originally from Saxony but then retired and living in Venice. These included the canvases in the quotation above, bluntly described by the artist himself for his patron's inventory. Piazzetta was a disciple of CARAVAGGIO in his contrasting of light and dark (CHIAROSCURO). In 1750 he was appointed director of the new Venetian State Academy, where he taught until his death. Besides his usually religious oil paintings, Piazzetta was known for drawings of heads and half-figures, called *têtes de caractère*. He smudged

white chalk to heighten the black-chalk images and captured momentary scenes of interaction, such as in *A Bravo, a Girl and an Old Woman* (c. 1740), which shows a procuress whispering in a young woman's ear while a man dangles his purse. This socially as well as emotionally interesting moment is reminiscent of the brothel category of Dutch BAROQUE GENRE pictures.

Picabia, Francis
1879–1953 • French painter • Dada/Surrealist

. . . the resemblance of my interior desires.

Picabia had acquired a substantial reputation as an IMPRESSIONIST when, in 1912, he did an about-face and began painting pictures that are part ORPHISM and part DADA. These had nonsense titles such as *Catch as Catch Can* (1913), an entirely nonrepresentational linking of colors but greatly muted in comparison with those of the seminal Orphist, DELAUNAY. In 1915, in New York with DUCHAMP and MAN RAY, Picabia founded what would become International Dada. He painted a series of ironic *Machine Portraits* of himself and his colleagues. Although *Ici, c'est Stieglitz* (1915) is a drawing of a camera standing in for the famous photographer, STIEGLITZ, many of the machine pictures bear no relation, let alone resemblance, to their subject's profession. Under the influence of SURREALISM, Picabia painted *Transparencies*, a series superimposing layer upon layer of images—men, women, flowers, birds— over one another, creating a composi- tion difficult to decipher, enigmatic, and mysterious. It is to these *Transparencies* that he refers in the quotation above.

Picasso, Pablo
1881–1973 • Spanish • painter/sculptor • Cubist

The masks weren't just like any other pieces of sculpture. Not at all. They were magic things . . . intercessors, mediators. . . . They were against everything—against unknown, threatening spirits. I always looked at fetishes. I understood; I too am against everything. I too believe that everything is unknown, that everything is an enemy! Everything!

For almost 80 years it was conventional to describe CUBISM as a joint invention of Picasso and BRAQUE. The earliest writings of its promoters and explainers, including the poets APOLLINAIRE and André Salmon and the dealer KAHNWEILER, even focus on Picasso as though the honor of invention should crown him first. It was an exhibition at the Museum of Modern Art in New York City in 1989 that strongly reversed the order: "Braque had already evolved significantly in the direction of Cubism *before* he met Picasso," wrote the exhibition curator William Rubin. "The *earliest* form of Cubism was less a 'joint creation' . . . than an invention of Braque alone." This both sets the record straight and allows a new perspective on Picasso, and especially on his early work. *Les Demoiselles d'Avignon* (1906–7), previously named the first Cubist painting, need no longer be

watered down with discussions of its FORMAL geometric qualities. Rather, this alarming, nearly 8-feet-square canvas, named for a red-light district of Barcelona, may be examined on its expressive, contextual merits: an angry, totemic representation of women as threatening, aggressive, and dangerous—the FEMME FATALE of mid-19th-century PRE-RAPHAELITES through a newly distorted lens. Where their Jezebels were beautiful and erotic, Picasso's ugly prostitutes express "his deep-seated fear and loathing of the female body, which existed side by side with his craving for and ecstatic idealization of it," as Rubin writes elsewhere. Part of Picasso's rage resulted from his contraction of venereal disease at a brothel. While adding important perspective, this does not lessen the inventiveness of Picasso's incorporation of pre-Christian Iberian culture and African sculpture, especially the masks mentioned above, nor does the exorcism of his personal demons diminish the cataclysmic role that Demoiselles and Picasso played in the future of art.

Picasso's genius was enjoyed with and by friends and followers who gathered at his Montmartre studio, called Bâteau Lavoir (Laundry Boat), beginning about 1905. Art historians divide his production into "periods": the Blue Period, an early one in which his work often expressed the poverty he suffered and saw around him (e.g., Woman Ironing, 1904), and during which his palette was predominantly blue; then his Rose Period (e.g., Young Acrobat and Child, 1905). Once he did begin working with Cubism, and with Braque, in late 1909, his experimenta-

tion developed through its Analytic and Synthetic phases. (See also KAHNWEILER and CUBISM) In the year Analytic Cubism reached its peak, 1911, his and Braque's works were almost indistinguishable. They then began the even more fertile Synthetic Cubism in 1912 and explored it into the 1920s, making COLLAGE constructions and sculpture. (The pioneering collage was Picasso's Still Life with Chair-Caning, 1912, on which a piece of oilcloth imprinted with caning and framed with rope is pasted; use of such "alien" material flew in the face of artistic tradition.) As if in reaction to the flat planes of Cubism, Picasso began to paint massive, sculptural forms during the 1920s (e.g., The Race, 1922), a phase called his Classical Period. He also manipulated and combined both Analytic and Synthetic Cubism, with patterns that look like collage but are painted rather than pasted onto the canvas and forms that are often rounded and flattened rather than volumetric (Girl Before a Mirror, 1932). As Demoiselles is the masterpiece of his early years, Guernica (1937) is a masterpiece of the century. Inspired by the destruction of the Basque town of Guernica by German planes during the Spanish Civil War, the painting's description of war's obscenity and horror is unique. The hundred or so studies he made for it, the themes familiar from his earlier work, the symbolism—all contribute to its interest, yet nothing can satisfactorily approach an explanation of its power. Picasso's career continued, he lived largely in the south of France, and his output of paintings, sculpture, and decorations for POTTERY continued unabated in bursts of energy and invention.

pictograph

A pictograph is a highly simplified, shorthand symbol for a word or an idea. Prehistoric rock paintings, Egyptian hieroglyphs, as well as many Native American designs are pictographs. Often universal signs, such as a spiral, a pictograph may stand for water or the idea of a journey. KLEE worked in what might be called his own pictographic system, and ABSTRACT EXPRESSIONIST Adolph GOTTLIEB painted numerous pictographs derived from prehistoric and ancient mythological sources as well as his own inventions.

Pictorialism

A movement in photography to change and redefine the photographer's role from technician, more or less, to artist, and to promote the status of the photograph to art object. Pictorialism resembled AESTHETICISM, the art-for-art's-sake concept. Foremost among Pictorialists, STIEGLITZ insisted on the artistic, personal vision of photography. While some Pictorialists (e.g., STEICHEN) blurred the camera's focus or manipulated the image during the developing process, others, including Stieglitz, refused to use what they considered artifice. Stieglitz stressed choice and framing of subject matter, lighting, and natural atmosphere, such as fog or rain, to achieve his desired effects. Pictorialism became outmoded around 1912.

picture plane

Plane is from the Latin for a "flat surface"; combined with "picture," the term refers to a picture's surface, especially whatever is on it that appears closest to the viewer. If the ITALIAN RENAISSANCE analogy of looking out of a window is used, the visible object closest to the glass is in the front of the picture plane, or foreground; the vanishing point is on the most distant plane in the background. Between front and back, the image—scene, landscape, portrait, or whatever it may be—is constructed through imaginary parallel planes on which the illusion of distance is created by PERSPECTIVE. It is WÖLFFLIN who described depth in Renaissance painting as achieved along parallel planes, in contrast to BAROQUE artists moving into the distance by breaking through such planes along (at times circuitous) diagonal paths. When there is no effort to show distance or depth of field, as in MEDIEVAL painting, the work is described as "planar."

Picturesque, the

The Picturesque in painting, landscape architecture, and architecture stood on ground between the NEOCLASSICAL beautiful ideal and the ROMANTIC Sublime. In contrast to the SUBLIME, which could incite terror, the Picturesque, as William Gilpin wrote about it, beginning in the late 18th century, would stimulate reverie or admiration. The concept of the Picturesque was developed by Uvedale Price in *An Essay on the Picturesque as Compared with the Sublime and the Beautiful* (1794), some 37 years after Edmund Burke's dissertation on the Sublime. The Picturesque landscape might look like a scene set by CLAUDE LORRAIN: a composition characterized by the asymmetrical placement of forms and containing a variety of textures. In the 18th century, actual

landscapes (i.e., gardens, grounds, and parks) were designed to be Picturesque, that is to look more "natural" than they were in fact. Designers of Picturesque landscapes were the Englishman, and friend of Price, Humphrey Repton (1752–1818) and the 19th-century American DOWNING.

Piero della Francesca
c. 1415–1492 • Italian • painter • Renaissance

Many painters censure perspective. . . . I conclude that perspective is necessary, inasmuch as it determines as a true science the apparent size of each magnitude, indicating by means of lines how much each must be shortened or lengthened.

Piero was in DOMENICO Veneziano's Florentine WORKSHOP in 1439, but returned to his hometown, Borgo San Sepolcro, west of Florence, to live and work. Although outside of the mainstream, Piero was appreciated by his contemporaries—one named him "the monarch of painting"—but his reputation was obscured for five centuries in the shadow of the preference given, after VASARI, to Florentine artists. Piero's bent toward science, especially mathematics, is evident in the solid-looking, geometric forms with which even his human figures are constructed, none more so than the monumental Virgin of his *Madonna della Misericordia* (begun c. 1445). She is twice as large as the kneeling supplicants whom she shelters under her tentlike cape. Curiously, it was the pioneering style of CÉZANNE, who was also interested in portraying volumetric solidity, that prompted people to look back at Piero with new appreciation in the early 20th century. Piero had several portrait commissions, and those painted in c. 1472 for his most important PATRON, MONTEFELTRO, of Urbino, are particularly interesting: profile busts of the duke and his wife on one side, and the couple riding in horse- and unicorn-drawn carts on the other. In the backgrounds are panoramic landscapes that reveal the influence of contemporary Flemish painting. While Piero's most complex and renowned painting, in the Church of San Francesco in Arezzo, is the *Legend of the True Cross* (c. 1450s)—10 scenes that wind from the Book of Genesis to the victory of the emperor Constantine under the standard of the Cross—his most mathematically lucid but otherwise perplexing work is the *Flagellation* of the mid-1450s. The PERSPECTIVE is so exacting that scholars have been able to reconstruct the building in which the scene is set. Yet no one has been able to explain (1) why Christ and his tormentors have been set in the background, and (2) who the three apparently unconcerned men in the foreground are. Many identifications of the three have been proposed, one recently suggesting that the barefoot man in the center is the biblical criminal Barabbas, who was released just before the Flagellation took place, and that the other two represent the Roman who brought him and the Jew to whom he was released.

Piero di Cosimo
1461/62–1521? • Italian • painter • Renaissance

. . . he kept himself shut up and would not permit anyone to see him work. He would not allow his rooms to be swept . . . would never suffer the fruit-

trees of his garden to be pruned or trained, leaving the vines to grow and trail along the ground . . . he loved to see everything wild, saying that nature ought to be allowed to look after itself. He would often go to see animals, herbs, or any freaks of nature . . . his habitual food consisted of hard-boiled eggs, which he cooked while he was boiling his glue, to save the firing. He would cook not six or eight at a time, but a good fifty, and would eat them one by one from a basket in which he kept them. (Vasari, mid-16th century)

Piero was a remarkable eccentric, in both his personal life, described by VASARI above, and his painting. As interested in pagan mythology as were contemporary Neoplatonists, he read ancient sources for inspiration (see NEOPLATONISM); however, his interpretations were entirely different: more bizarre than high-minded, more humorous than deferential. For example, in stunning contrast to GHIRLANDAIO, POLLAIUOLO, and PIERO della Francesca, for whom portraiture was an opportunity to depict their subjects in elegant finery, in his *Simonetta Vespucci* (c. 1501), Piero shows his elaborately coifed lady bare-breasted, wearing a real snake as a "necklace." Piero's imagination was operating at full throttle in his series of small PANELS illustrating the beginnings of civilization, with a collection of cavorting and warring half-human/half-beast characters. Yet also he showed a touching tenderness in his portrayals of dogs, and a keen discernment of their habits and personalities. Vasari's litany of Piero's peculiarities includes additional puzzling idiosyncrasies: "The crying of ba-

bies irritated him, and so did the coughing of men, the sound of bells, the singing of the friars. When it rained hard he loved to see the water rushing off the roofs and splashing on to the ground. He was much afraid of lightning and was terrified of the thunder. He would wrap himself up in his mantle, shut up the windows and doors of the room and crouch into a corner until the fury of the storm had passed."

Pietà

From the Italian word for "pity" and "piety," the Pietà is that part of the PASSION when the Virgin Mary holds and mourns her dead son. (The term "Lamentation" describes the scene immediately after Christ is removed from the Cross and is surrounded by mourners.) There is no scriptural source for the Pietà, but it seems to have been a textual invention of the 13th century, acting as a foil to Virgin and Child imagery, with the intent of promoting imaginative visualization. Despite the word's Italian root, the first-known Pietàs in art were German, of the early 14th century. An anonymous early-14th-century painted wood carving, known as the *Roettgen Pietà*, represents the Germanic type, showing almost repellent physical details of Christ's tortured body and overt expression of suffering. MICHELANGELO's marble sculpture in Saint Peter's, nearly 6 feet high, is the most renowned *Pietà* (1498–1500).

Pigalle, Jean-Baptiste
1714–1785 • French • sculptor • Rococo

In our own days we have seen our soldiers sharpening their sabers on the

tomb of Maréchal de Saxe. (George Duplessis, 1881)

Pigalle's first marble portrait bust of Madame de Pompadour, Louis XV's famous mistress, was made in 1748, and thereafter he became her official "portraitist in stone." Considering the number and importance of the commissions that she gave him, he might also be considered the chief sculptor in her employ. This was, however, just a small fraction of his prodigious output. Much RO-COCO art was decorative, playful, and intimate, but there were occasional opportunities for the grandiose in 18th-century France, and Pigalle's *Tomb of the Maréchal de Saxe* (1753–76)—a heroic group more BAROQUE than Rococo—is a case in point. The work is installed in a church at Strasbourg. The Maréchal, a French soldier, is accompanied by allegorical figures that include a distraught Hercules and personifications of conquered countries. They appear as actors in a melodramatic tableau. Pigalle earned his success after a heroic struggle of his own: To pursue his early studies, he walked from Paris to Rome and endured sickness and poverty. Back in Paris, he became a leading sculptor; CLODION was one of his students. Almost 100 years after his death, according to Duplessis, quoted above, his *Maréchal de Saxe* was still able to provoke emotion.

pigment

Although from the Latin *pingere,* meaning "to paint," pigment is the insoluble coloring substance that gives paint its COLOR or hue. Pigment is carried by and applied via a MEDIUM such as OIL, water (WATERCOLOR and GOUACHE), wax (ENCAUSTIC), or egg white (TEMPERA). Originally derived from both organic and mineral substances—plants, animals, earth and rocks—today most pigments are synthetic. Yet some 20th-century artists still prepare and mix their own paints, Andrew WYETH among them. The quality of any pigment is defined by hue, value, and intensity.

Piles, Roger de
1635–1709 • French • critic/theoretician/painter • Baroque

[Rubens] was so strongly persuaded that the aim of the painter was to imitate nature perfectly, that he did nothing without consulting her, and there has never been a painter who has observed and who has known better than he how to give to objects their true and distinctive character.

De Piles was a major influence on French thought long before 1699, when HARDOUIN-MANSART made him chief theoretician responsible for formulating the "infallible principles" by which the French Academy would be governed. (Until then, de Piles was not a member of the Academy.) One of de Piles's objectives was to liberate the theory of painting from the dominance of literary theory, which was the doctrine of the early academy. De Piles played an outstanding role in the dispute between Poussinistes and Rubenistes (see LINE VS. COLOR). He defended the color of the Venetian painters, especially TITIAN, and stood against the French Academy in his ardent support of RUBENS, as in the quotation above. He wrote pam-

phlets defending his position, and in the *Principles of Painting* (1708) he graded the best-known painters according to how well they mastered Composition, Drawing, Color, and Expression— which he considered the "Four Principal Parts of Painting." Only RAPHAEL, with an 18 (the highest score), surpassed Rubens in Expression, but Rubens was assigned 18 in Composition, for which Raphael was graded 17. De Piles graded TITIAN 18 in Color, and Rubens only 17.

Pilon, Germain (also Pillon)
c. 1525–1590 • French • sculptor • Mannerist

Pilon does not hesitate to use gestures and features that are almost grotesque in order to heighten his effect.
(Anthony Blunt, 1953)

Pilon's best-known work is *The Three Graces* (1561–65), a group of three large marble figures designed to support an urn that held the heart of Henry II. Pilon's Graces have CLASSICAL proportions, long necks and small heads, and wear Roman robes. They recall PRIMATICCIO, in whose studio Pilon worked. Later Pilon's style became a good deal more expressive and Mannerist (see MANNERISM). This shows in the *Tomb of Valentine Balbiani* (1573–74), a *gisant*, or recumbent funerary effigy. It is a marble RELIEF of the dead woman lying on top of her sarcophagus, her curling, flowing hair, sunken cheeks, and emaciated body simultaneously repellent and fascinating. The effect is powerful, for reasons suggested by BLUNT in the quotation above. Appointed Controller General of the Mint

in 1572, Pilon produced a series of excellent medals showing that his talent as a portraitist and his skill working in bronze equaled his expertise in marble.

Pinney, Eunice Griswold
See FOLK ART

Pinturicchio (also Pintoricchio) (Bernardino di Betto)
c. 1452–1513 • Italian • painter • Renaissance

When he had attained the age of fifty-nine he was employed to paint a Nativity of the Virgin in S. Francesco at Siena. After he had begun it, the friars gave him a room to dwell in, entirely bare, as he desired, except for a large antique trunk, which they found too heavy to move; but Pinturicchio, who was very eccentric, made such a clamor that the friars in despair determined to take it away. In removing it they broke a plank, and out came 500 gold ducats. Pinturicchio was chagrined at this, and bore such a grudge against the poor friars for their good fortune, that he could think of nothing else, and it so weighed upon his mind that it caused his death.
(Vasari, mid-16th century)

Pinturicchio, a nickname that alludes to his small size, was from Perugia and worked with PERUGINO on the Sistine Chapel. He became the favored painter of the Borgia pope, Alexander VI, who aimed to re-create the luxury of imperial Rome. He also painted a series of FRESCOES for the Piccolomini Family Library in the Cathedral of Siena (c. 1502–08). It was the ITALIAN RENAISSANCE version of virtual reality: Elabo-

rate architectural details—pilasters (flattened, COLUMN-like wall decorations), arches, and vaults—in an illusionistic manner, sometimes even using raised RELIEF, with an impact that may be understood only by standing in a room that he created. The decor, GROTESQUES inspired by the GOLDEN HOUSE OF NERO, enclosed scenes dictated by his PATRONS to aggrandize their own claims to glory. In one such scene, supposedly set in Genoa though bearing no real relation to that town, is a storm that, in contrast to the town, looks very real indeed, with wind-driven rain, dark thunderclouds, and the optimistic touch of a rainbow. The Piccolomini Library occupied Pinturicchio until 1508, some five years before the event described by VASARI in the quotation above might have occurred.

Pippin, Horace
1888–1946 • American • painter • Folk art

I began to think of things I had always loved to do. First I got together all the old cigar boxes that I could get and made fancy boxes out of them. . . . In the winter of 1925 I made my first burnt wood panels . . . this brought me back to my old self.

Pippin had little formal education and no art training. His paintings use bright, flat colors and ignore PERSPECTIVE in favor of stylized forms that are reminiscent of both MOSES and WOOD. However, Pippin's subject was the life of African-Americans, both in history and in contemporary times. Shot in the shoulder during World War I, Pippin believed he would never be able to draw again, but as his comment quoted above

describes, he made his way back to drawing by burning lines into a board with a poker that was heated on the kitchen stove. The method he devised was to hold the poker steady in his right arm, and create the image by moving the board with his left. He always had to support his wounded arm, but as it grew stronger he was able to paint at an easel. *The End of the War: Starting Home* (1931) is a small painting in which the hand-carved frame, decorated with grenades and other military hardware, is part of the antiwar impact of the picture, especially distressing because of, rather than in spite of, the simplicity with which the exploding shells and expressionless, gesturing soldiers are portrayed. In contrast, Pippin also painted scenes (reminiscent of HICKS's *Peaceable Kingdom* series) where the grass in which the biblical lion and lamb lie down together is covered with wildflowers and the shepherd who tends them is a black man.

Piranesi, Giovanni Battista
1720–1778 • Italian printmaker/architect • Rococo/Romantic Neoclassicist

[I wish] to admire and learn from those august relics which still remain of ancient Roman majesty and magnificence, the most perfect there is of Architecture.

Before he was 20 Piranesi made his first trip from his home in Venice to Rome for the reason he cites above. He settled permanently in Rome in 1747. Though he found no patrons for the kinds of buildings that he wished to design, he published prints of his design ideas in 1743, thereby inventing his unique oeu-

vre of architecture on paper. His elegant ETCHINGS and paintings included a series of views of Rome (*Veduta di Roma*, c. 1748–78)—extraordinary vistas, such as one of the Vatican seen from above (*Veduta . . . Basilica Vaticana*). In his embrace of ancient ROMAN ART and architecture both in his art and in writing, Piranesi argued against those, like WINCKELMANN, who professed the superiority of GREEK ART. Moreover, Piranesi gave precedence to the influence of ETRUSCAN ART on ancient Rome over that of Greece. His interest in ancient culture also led him to investigate Egyptian antiquities, sparking a revival in Egyptian decorative styles. Piranesi's imaginary prison interiors, with their huge blocks of stone, barred windows, iron rings, bridges, and zigzagging staircases, are complex and exotic. His father was a stonemason and builder, and a feeling of the tactility of masonry is strong in Piranesi's drawing. An early biographer suggests that he studied stage design briefly, and prison interiors were a theme among stage designers. Still, the originality and power of Piranesi's set of etchings entitled *Fanciful Inventions of Prisons* (1749–50) are unique, and they have had great and enduring appeal. Some of the plates he reworked later, in 1761, darkening the image and the mood. Piranesi also drew a series of GROTESQUES, purely decorative conceits that went beyond earlier examples in the sense of excitement and meaning that he gave to the designs. They were phantasmagorias with nudes, skeletons, snakes, shells, and ancient ruins included among architectural and other strange, symbolic elements. These are all provocative details that entice speculation, but no generally satisfactory interpretation has yet emerged to unify their ambiguities. The vividness and melodrama with which Piranesi represented the ancient world is an example of the ROMANTIC sensibility applied to a NEOCLASSICAL style.

Pisanello, Antonio
c. 1395–1455 • Italian •
painter/sculptor • Renaissance

To painting he added the art of sculpture. Works of his in lead and bronze are an Alfonso, King of Aragon, a Philip, Prince of Milan, and many other Italian princes, to whom he was dear because of the eminence of his art. (Bartolommeo Fazio, 1453–57)

Pisanello worked for the courts of Northern Italy; the sculpture alluded to in the quotation above consists mainly of medallions cast in metal. As PAPER became increasingly available, artists carried sketchbooks and recorded details of things that would prove useful to them. Pisanello's sketchbooks include wonderful drawings of animals and, disconcertingly, a page of studies of hanged men. For a church in his native Verona, Pisanello painted *Saint George and the Princess* (c. 1433–38) and followed his teacher, GENTILE, in presenting his horses, with their elaborate trappings, in front and rear views. His princess is extravagantly dressed, and in the distance we see towers and turrets, as well as two dangling corpses. Pisanello combined an odd mix of the real and the fantastic. This is also notable in his *Vision of Saint Eustace* (c. 1430s): Out hunting with his dogs, the saint is on the verge of slaying a deer when he has a vision of the crucified

Christ between its antlers. Other animals are marvelously detailed, but all exist in a setting that disregards the AL-BERTIan PERSPECTIVE. His drawings show that Pisanello had mastered the techniques of perspective, but it seems that he was unwilling to be dictated to by theoretically or empirically based rationality.

Pisano, Andrea
c. 1290–1348 • Italian • sculptor • Late Gothic

In this year 1330, work was begun on the metal doors of San Giovanni. These are very beautiful and of marvelous workmanship and value; and they were molded in clay and then polished, and the figures gilded by a master named Andrea Pisano. They were cast in fire of furnaces by Venetian masters. (Giovanni Villani, 14th century)

Andrea is known for the gilded bronze south doors of the Florence Baptistery, cast in 1336, which preceded the more famous doors by GHIBERTI in the next century. Andrea's designs are simple, elegant, and restrained. Unlike Ghiberti's, which were cast by the *cire perdue* method (see BRONZE), Andrea's RELIEFS were cast separately and then inserted into their frames. The casting and setting up of Andrea's door was a great event, mentioned in several chronicles of the time, one of which is quoted from above. The other sculptures to which Andrea's name is attached are the reliefs and statues on the Campanile in Florence (c. 1334–before 1348), possibly designed by GIOTTO. Andrea is not related to Nicola or Giovanni Pisano—

Pisano, in translation, means "from Pisa."

Pisano, Giovanni
c. 1250–1320 • Italian • sculptor • Late Gothic

Now let us speak of the sculptors. . . . There was Giovanni, the son of Maestro Nichola. (Ghiberti, mid-14th century)

The son and student of Nicola (see below), Giovanni went on to design the lower portion of the facade of the Cathedral of Siena (c. 1284). He then executed a pulpit (1297–1301) for Sant' Andrea of Pistoia, 40 years after his father's in Pisa. Both his and his father's pulpits have Nativity scenes carved in high RELIEF and contain the same figures in similar placement, making for fascinating stylistic comparisons. Their surfaces are equally crowded with figures, but where Nicola's solemn but serene characters seem about to tumble out of their frame, Giovanni has established a stronger sense of spatial depth. Moreover, Giovanni's Virgin is not larger than the other figures (to signify her importance), as is Nicola's, and Giovanni's people make eye contact and interact, whereas those of his father seem to gaze impassively into space. In expression and in DRAPERY, Giovanni's style looks forward to SLUTER as much as it looks back to his father. GHIB-ERTI's effort to document the works of Giovanni in his *Commentaries,* quoted from above, goes on to mistakenly attribute the fountain of Perugia to him. It was actually the work of his father, but Giovanni finished the project after his

father died and he took charge of the WORKSHOP.

Pisano, Nicola
active c. 1258–84 • Italian sculptor • Gothic

In the year 1260 Nicola Pisano carved this noble work. May so gifted a hand be praised as it deserves.

The words quoted above are inscribed on the earliest documented work by Nicola, the pulpit of the baptistery at Pisa. (In EARLY CHRISTIAN building programs both baptisteries and mausoleums were often independent structures.) Work started on the Pisan cathedral complex in 1053; the baptistery itself was begun in 1153 (and the famous leaning bell tower in 1174). The rich sculptural program for the marble pulpit includes Corinthian-style columns (see COLUMN ORDERS) resting on the backs of curly-maned lions. A good deal of the carving derives from Roman models: Nicola may have worked for the Holy Roman Emperor Frederick II (ruled 1220–50), who sparked a revival of CLASSICAL art. Nicola's carved panels, densely packed with figures, look a good deal like Roman sarcophagi. In the course of his life, Nicola and his son, pupil, and successor, Giovanni (see above), worked together.

Pissarro, Camille
1830–1903 • French • painter • Realist/Impressionist/Neo-Impressionist

Decidedly, we no longer understand each other.

The senior member of the IMPRESSION-IST group, Pissarro venerated the tradition of NATURALISM and the solidity of MILLET's art. But he did not support the retrospective values held by William MORRIS and others whom his own son, Lucien, admired and followed. It was to Lucien that, when he was 70, Pissarro wrote the words quoted above. Born in the Virgin Islands, the son of a French Jewish merchant, for a time Camille Pissarro took up the family business. After deciding to become an artist, he returned to France, where he had attended boarding school, and lived at the edge of poverty until he was well over 60. Because of Pissarro's sympathy for socialist causes, RENOIR refused to exhibit with him. He was close to SEURAT and SIGNAC. CÉZANNE admired Pissarro more than any other of his contemporaries, and GAUGUIN was indebted to him. In the 1870s Pissarro's brushwork became more broken in the Impressionist mode, and in the mid-1880s he turned, for a few years, toward POINTILLISM. His greatest differences with the Impressionist conventions had to do with subject and intention rather than with style: Socialism and anarchism underlie his choice of painting views of rural and urban landscapes rather than the racetracks, the restaurants, and other leisure activities of the SECOND EMPIRE painted by DEGAS and Renoir, for example. Not only were Pissarro's landscapes more sober, but from 1897 to 1903 he also painted a series of city scenes looking down from the vantage points of various buildings. In these pictures people are reduced to antlike blots, as much a social commentary as an artistic observation of city life. One

of Pissarro's fans was Émile Zola, who wrote about *The Banks of the Marne in Winter* (1866), a work Pissarro managed to exhibit at the SALON, "M. Pissarro is an unknown artist, whom no one will likely mention. . . . This [picture] is no feast for the eyes. It is an austere and serious painting, showing an extreme concern for the truth and correctness, a bleak and strong will. What a clumsy fellow you are, sir—you are the one artist I like."

plane/planar
A plane is flat surface. (See PICTURE PLANE)

plastic/plasticity
From the Greek word *plastos,* meaning "formed," the general reference of plastic is to a solid but malleable substance, such as clay or wax. Sculpture and ceramics are called plastic arts. In painting, plastic or plasticity applies to the apparent roundness, solidity, and definition of a form.

Plato
427(?)–347 BCE • Greek • philosopher

Measure and commensurability are everywhere identified with beauty and excellence.

Plato was a student of Socrates and teacher of Aristotle. He endeavored, among other things, to distinguish essence from appearance, thought from feeling, and idea from image. Hierarchically minded, he held artists and the fine arts in low esteem, believing that the "real" world of IDEAL prototypes was accessible to philosophers through reason and contemplation, but that artists were reduced to making copies of copies (e.g., at the highest level is the concept of a chair, which the philosopher can understand; at a lower level is the fabricated chair, based on the idea; and lower still is the artist's image of a chair, based on the fabrication). Plato also criticized artists for distorting real proportions for the sake of appearances. J. J. Pollitt suggests that artists like SCOPAS, who was Plato's contemporary, may have aimed to elevate the intellectual status of their profession by portraying the personification of ideas such as peace, wealth, and pathos, or emotion. The artist could thus be giving form to concepts rather than merely copying things seen. For Plato a SIMULACRUM—any representation of an idea—is inferior to the idea, but the concept of the simulacrum is of particular interest to art theorists and historians of the POSTMODERN.

Platonic Academy
See ACADEMY

plein air
Outdoor or plein air painting has a long history preceding IMPRESSIONISM, in which it became a modus operandi. DÜRER, for example, made on-site LANDSCAPE studies in WATERCOLOR, which he used later for studio paintings. By the 17th century, working on the spot and recording what the eye saw—coherent with an interest in NATURALISM—became commonplace. During the 18th century, outdoor sketching in OIL, small studies from nature, was standard training; in fact, it was part of the curriculum of the French Academy in Rome (see PRIX DE ROME). During the first three decades of the 19th cen-

tury, English painters also concerned themselves with the natural landscape (e.g., CONSTABLE and members of the NORWICH SCHOOL), but all these painters completed their landscapes in the studio. That was true, too, of mid-19th-century PRE-RAPHAELITE painters, devoted to the study of nature, who executed precise and highly detailed renderings—of grass, blade by blade, for example—as efforts to describe what they saw as exactingly permanent rather than as a record of the momentary effect. Their French contemporaries, painters of the BARBIZON SCHOOL, were primarily plein air artists, and they narrowed the gap between the canvas painted outdoors and the finished work. The decisive step was taken in 1866 when MONET devised a special easel with an elaborate system of pulleys, and had a trench dug in the garden so that his huge canvas could be raised and lowered while he painted *Women in the Garden*. This was groundbreaking, so to speak, in its effort to capture the fleeting effects of light and air and an illusion of spontaneity in the figures in the scene. With this fully plein air painting, Monet thus set the agenda for Impressionism.

Pliny the Elder
23/24–79 CE • Roman • public official/naturalist/historian

The origin of painting is obscure. . . . All, however, agree that painting began with the outlining of man's shadow; this was the first stage, in the second a single color was employed, and after the discovery of more elaborate methods this style, which is still in vogue, received the name of monochrome.

A great deal of what we know about ancient art and artists we owe to Pliny the Elder. His 37-volume work, *Natural History*, was published in 77 CE. Besides an investigation of the natural sciences, he left the earliest preserved history of art. The comment quoted above is from book 35. Pliny valued Greek painting of the 5th and 4th centuries BCE most highly, and his texts had great influence on ITALIAN RENAISSANCE writers and artists, although they were unable to see the originals. He enumerated some of the most famous works of Greek sculpture to be found in Rome as well as describing techniques used to make them, including accounts of BRONZE casting and MARBLE carving. In his preface he notes that he has read 2,000 volumes, by Greek and Latin authors. During the eruption of Mount Vesuvius (see POMPEII), Pliny's intention of recording events ended in his death, as described by his nephew Pliny (called "the Younger"), whose narrative is the oldest-surviving description of a major natural disaster in Western literature. While Pliny the Elder is still a source for information on Greek art, scholars today are wary when using such authorities as he, remembering, first, that Pliny lived from 300 to 500 years after the artists he described, and second, that he may have been motivated as much by political, moral, rhetorical, and propagandistic motives as by objective curiosity.

Pluralism
Term used to describe American art during the 1970s, a movement that was

characterized by a diversity of styles, techniques, and approaches. PROCESS and CONCEPTUAL art, EARTH AND SITE and INSTALLATION sculpture, PHOTORE-ALISM, NEW IMAGE, PHOTOGRAPHY, VIDEO, and much PERFORMANCE work of the '70s is subsumed under the term "Pluralism." In addition to such identifiable approaches, certain artists whose work crosses or ignores the above categorizations are known as Pluralists. The work of many women came to the foreground during this era, as did that of black and Hispanic artists. Besides coming to be known as the Pluralist era, the decade of the '70s is also seen as the first POSTMODERN period.

pointillism (divisionism)

A process also called optical painting, pointillism is the application of tiny dots of brilliant color on the canvas. These dots merge in the viewer's eye. (See SEURAT)

pointing

A procedure invented to produce faithful replicas of sculptures, pointing was mastered by ancient Romans whose passion for Greek art led to an industry of reproduction (see also ROMAN ART). Today a pointing machine, based on the same principle that the Romans employed, is used to enlarge, decrease the dimensions of, or produce an exact copy of a three-dimensional work. The principle involves marking numerous points on the surface of the prototype, adjusting the machine to the desired degree of enlargement, contraction, or duplication, and drilling in corresponding points, to appropriate depths, on the roughly hewn stone (or other material) to be shaped. Once a sufficient number of these points are made, they define the contours of the statue to be carved. Then extraneous material is removed so that the duplication may be worked to the finished stages of reproduction.

Pollaiuolo, Antonio del

c. 1432–1498 • Italian • painter/sculptor • Renaissance

He always copied Nature as closely as possible, and has here represented an archer drawing the bowstring to his breast and bending down to charge it, putting all the force of his body into the action, for we may see the swelling of his veins and muscles and the manner in which he is holding his breath. (Vasari, mid-16th century)

The body under stress, and often in violent action, was of particular interest to Pollaiuolo. His technique was to outline the contours of his figures and delineate their muscles, as described by the quotation from VASARI above in reference to Pollaiuolo's painting *Saint Sebastian* (1475). In his ENGRAVING *Battle of the Ten Nudes* (c. 1470–75), the fighting figures wield saber, hatchet, bow, and dagger in a crowded melee set against a tangle of foliage. Several of the figures seem to mirror each other, so that we see a pose from two points of view. His paintings and sculptures of Hercules, commissioned by the MEDICI family, are Florentine metaphors—Hercules was the legendary founder of Florence, and the Medicis wanted to link their reputation with him. The explosion of energy as Hercules lifts Antaeus (who was powerful only so long as his feet touched the ground) lacks precedent. It is thought that Pollaiuolo watched, or perhaps even performed, autopsies to understand how the body works. Con-

versely, his *Portrait of a Young Woman* (1460s), a beautiful profile of sweet dignity personified, is quintessentially still. Ironically, less immobile is his sculptural program for the bronze *Tomb of Pope Sixtus IV* (1484–93). The portrait of the recumbent pope, surrounded by animated allegorical figures, is lifelike and anything but flattering.

Pollock, Griselda

born 1949 • English • art historian

What does [the negation of women in art] reveal about the structures and ideologies of art history, how it defined what is and what is not art, to whom it accords the status of artist and what that status means?

An early and foremost FEMINIST art historian, Pollock moved the study of women in art and women artists to a new plateau. She turned scholarly attention toward analysis of the underlying conditions within which art history exists. In *Old Mistresses: Women, Art, and Ideology* (written with Rozika Parker, 1981), she insisted that "the way the history of art has been studied and evaluated is not the exercise of neutral 'objective' scholarship but an ideological practice." This is a point of view that changed the playing field entirely, shifting it from an arena where equality was sought to one where routinely understood meanings, presumptions, and values are contested.

Pollock, Jackson

1912–1956 • American • painter • Abstract Expressionist

On the floor, I am more at ease. I feel nearer, more a part of the painting, since this way I can walk around it, work from the four sides and literally be in the painting. This is akin to the method of Indian sand painters of the West.

Pollock broke with traditions of painting that reached back to art's beginnings. He threw away pencil and brush and ignored conventions of subject. In a painting such as *Autumn Rhythm: No. 30, 1950* (1950), the title really tells nothing of the artist's intentions as he spattered black paint and threaded it in curving, scribbled-looking lines, or skeins. Black lines are superimposed on an off-white base and combined with other subtle colors. If you choose any single black line and pursue it, you lose yourself on a visual roller coaster, constantly colliding with other roller coasters. Foremost of the pioneering ABSTRACT EXPRESSIONIST painters of the 1940s and 1950s, Pollock accomplished what is now famously called drip painting by laying his canvas on the floor, as in the quotation above. Standing over it, he poured paint out of a can as he made his way around the canvas, guiding the stream of paint only minimally. "I prefer sticks, trowels, knives and dripping, fluid paint or a heavy impasto with sand, broken glass and other foreign matter added," he said. Although spontaneity and serendipity were invited into the process, the artist was in control, not only mentally but with his whole physical being as well. "I have no fears about making changes, destroying the image, etc., because the painting has a life of its own. I try to let it come through," he said. Pollock's approach inspired his contemporaries, each of whom, newly

liberated from conventional painting, sought his or her individual technique of self-expression. Where some of his paintings, such as *Autumn Rhythm,* are melodious, others are somber. He was an alcoholic; despair and self-destruction hounded him, and his death was sudden and violent—on an August night in 1956, he was driving under the influence of alcohol when his car went off the road. He and one of his two female passengers were killed. DE KOONING said about Pollock in 1956, ". . . every so often a painter has to destroy painting. Cézanne did it, Picasso did it with Cubism. Then Pollock did it. He busted our idea of a picture all to hell. Then there could be new paintings again." Pollock was married to KRASNER.

polychrome

A combination of the Greek words *poly,* for "many," and *khroma,* meaning "color," the word "polychrome" describes an object that has many colors. The term is applied mainly to sculpture, and its root is a reminder that, while only vague traces of color remain, GREEK and other ANCIENT sculpture, both architectural and freestanding, were originally polychromed. The practice of painting sculpture was also popular in MEDIEVAL art and that of both the ITALIAN and NORTHERN RENAISSANCE.

Polydoros

See AGESANDER

Polygnotos

mid-5th century BCE • Greek • painter • Early Classical

The look on the faces of all of them is that of people who have suffered a great disaster. (Pausanias, 2nd century CE, describing the sack of Troy as painted by Polygnotos in the Cnidian meetinghouse at Delphi)

Polygnotos is credited with revolutionary innovations that we can only imagine, for none of his paintings survives. He abandoned the traditional use of head profiles (in conjunction with forward-facing or FRONTAL torsos), and, more significantly, instead of organizing figures on a straight line, he placed them at various levels on the painted surface. As simple and apparently minor as this manipulation may seem, its implications are great because it treats those figures as though they exist in real space, a step en route to the systematization of PERSPECTIVE that would come about in another 1,000 years. Polygnotos limited his PALETTE to black, red, white, and ocher (almost as though he were a painter of vases), and he broke with the ARCHAIC convention of the expressionless face, moving toward a show of emotional reaction (pathos) and moral purpose (ethos). The path Polygnotos blazed is rarely apparent on vases, our only remaining tangible references for painting of that era; however, one fine example, known as *Muse and Maiden* (c. 440 BCE), is by the Achilles Painter. Against a white ground, which provided a better background on which to draw than either red or black, the design in this instance shows a distinct effort to imply not only recession, or moving back in space, but also a bit of landscape. Another vase painter who is thought to have been influenced by Polygnotos is known as the Niobid Painter.

Polykleitos

active c. 464–420 BCE • Greek
sculptor • High Classical

*He is considered to have brought the
scientific knowledge of statuary to
perfection, and to have systematized
the art of which Pheidias had revealed
the possibilities . . . the only man who
has embodied art itself in a work of
art.* (Pliny the Elder, 1st century CE)

Polykleitos of Argos, master of the
CLASSICAL male athletic figure, wrote a
treatise on art known as the *Canon*,
which was influential not only during
his own time but also for centuries af-
terward (see VITRUVIUS). Polykleitos's
concern was a useful definition of *sym-
metria:* ratio and proportion, the "com-
mensurability of parts." The Greek
obsession with finding perfect relation-
ships, expressed in numerical measure-
ments, was at the foundation of their
search for beauty and harmony—the
IDEAL. This ideal had spiritual or moral
value, not only aesthetic. Polykleitos's
written dissertation is lost, but it was
embodied in his bronze sculpture *Do-
ryphoros* (*Spear Bearer;* c. 450–440
BCE), which was fashioned to illustrate
his *Canon,* as stated in the comment by
PLINY that is quoted above. The original
of that statue has been lost too, but it
survives in Roman marble copies,
through which it has become a familiar
image. As did MYRON's *Discobolos,*
Polykleitos's sculpture captured a
pause, a moment when opposing forces
are in balance (bent left arm stabilized
by straight, weight-bearing right leg,
bent left leg offset by straight right
arm), although the dynamic symmetry
of his figure is "unwound," in contrast
to the tight coil of Myron's athlete. *Do-
ryphoros* was considered the standard
for the ideal of Greek Classical beauty.
Another of Polykleitos's well-known
exemplars of ratio and proportion is
Diadoumenos (*Youth Binding a Fillet
Round His Head;* c. 430 BCE). In com-
petition with PHEIDIAS for a commis-
sion to sculpt an Amazon for the
Temple of Artemis at Ephesus, Polyk-
leitos won. (See also CANON)

polyptych

From the Greek for "many folds," a
polyptych is usually an ALTARPIECE
made up of more than three parts. (See
also DIPTYCH and TRIPTYCH)

Pompeii

Approximately six and four miles, re-
spectively, from the summit of Mount
Vesuvius, the towns of Pompeii and
HERCULANEUM were embalmed by its
eruption on the morning of August 24
in 79 CE. Layers of pumice and ash
more than 16 feet deep buried Pompeii,
preserving it so effectively that archae-
ologists have uncovered tables still set
with meals and a bakery containing
loaves of bread put in the oven a few
seconds before disaster struck. While
the slow-moving mud flowing into Her-
culaneum gave its population time to
flee, inhabitants of Pompeii were taken
by surprise, their daily lives stopped as
if by a freeze-frame. About 2,000
people—one-tenth of the population—
perished. Excavations begun in 1748,
and continuing today, provide extraor-
dinary insights to life at that moment in
time, including examples of graffiti and
advertisements, as well as architecture,
wall paintings, and MOSAICS. Since the
late 1980s, computers have been used
to create "knowledge models" of Pom-

peii and surrounding areas, coordinat-
ing new maps with individual finds
(well over 12,000 entries), color images
of artifacts and FRESCOes, in addition to
technical data, excavation records, and
journals dating back to 1862. This un-
precedented graphic and verbal docu-
mentation assists both in conservation
and in making information about the
ancient city available to the public in an
interactive format.

Pont-Aven, School of

Refers to the artists colony that gath-
ered around GAUGUIN and BERNARD in
the late 1880s at the small coastal town
of Pont-Aven, in Brittany, France.

Pontormo, Jacopo da

1494–1556 • Italian • painter •
Mannerist

[The painter] is overbold, indeed,
wishing to imitate with pigments all
the things produced by nature, so
that they will look real, and even to
improve them so that his pictures
may be rich and full of varied
details.

Pontormo's comment, above, sounds
more contrived than immodest, but in
either instance, it provides no clue to
how very strange his paintings are. He
would pretend to construct symmetry
only to corrupt it, just as he might paint
a staircase that goes nowhere or a scene
so inexplicable that it seems invented
for the sole purpose of disorienting the
viewer. Early FRESCOes show that Pon-
tormo was already playing with the
"rules" of the ITALIAN RENAISSANCE—
in the *Visitation* (1514–16), a seemingly
balanced pyramidal composition is, at
second glance, not at all that, and a
strange cast of characters, including a
small nude boy who nonchalantly
scratches his leg, surround the main ac-
tion. An ALTARPIECE painted in
1525–28 in Florence is Pontormo's
masterpiece. It is as strange as it can be,
yet somehow moving and beautiful.
Two youths carry the (presumably)
dead Christ, but both are on tiptoe,
though one is crouching and neither
seems to, or could, considering their
poses, actually heft any weight. Al-
though it is sometimes called *Entomb-*
ment, it is uncertain whether they mean
to lift Christ to the waiting arms of God
the Father (whose image was originally
above the altar in the dome) or to lower
him from Mary's lap to the tomb (alter-
nate titles are *Descent from the Cross*
and *Lamentation*). Further complicat-
ing interpretation, behind Christ there
is a head to which a body cannot be as-
signed, there are odd lengths of fabric,
and a cluster of hands of uncertain
ownership appear in the center—the
area of the painting usually allocated to
an important figure or aspect in Renais-
sance works. The style is LINEAR, color
is bright and strange—hot pink, light
green, flame red—and utterly unnat-
ural. Its precedent, the historian Marcia
Hall points out, is in MICHELANGELO's
Sistine Chapel. The bizarre incon-
gruities, the disappearance of rational
space, let alone depth, and the overall
disorienting effect of Pontormo's work
are characteristics of MANNERISM. Ac-
cording to VASARI, Pontormo had stud-
ied with LEONARDO, PIERO di Cosimo,
and ANDREA del Sarto. He was as eccen-
tric as his paintings, becoming a recluse
in the studio he reached by climbing a

ladder, which he then drew in after him-self.

Pop Art

Short for "popular," and with subject matter and techniques borrowed from commercial art (advertisements, comic strips, packaging), Pop Art, like HAP-PENINGS, was a reaction against AB-STRACT EXPRESSIONISM, particularly in defiance of attitudes such as GREEN-BERG's rebuff of "kitsch." Pop artists portray clearly recognizable objects from the everyday world and the mass media, and their attachment to com-mercialism led to their being named New Vulgarians. In their spirit of mov-ing art out of the artist's head and back into the world, RAUSCHENBERG and JOHNS are considered the forerunners, if not the founders, of Pop. Pop itself was ushered in with exhibitions in America in 1962. Henry Geldzhaler, a friend of WARHOL, who became a curator at the Metropolitan Museum of Art, was a supporter and promoter of Pop and artists. HOCKNEY painted a portrait of him—*Henry Geldzahler and Christo-pher Scott* (1969)—using one of the stylistic techniques of Pop: the kind of flat colors and surface an AIRBRUSH provides, and sharp, clear outlines. Be-sides all manner of advertising art, Pop artists used comic books as a source of ideas. Artists whose names are associated with the movement are DINE, OLDENBURG, INDIANA, LICHTENSTEIN, Warhol, WESSELMANN, and ROSEN-QUIST. HAMILTON and Edouardo Pao-lozzi (born 1924) were leading pioneers of English Pop in the 1950s, forming what was called the Independent Group. While Abstract Expressionists might claim to be emotionally engaged with the "subject" of their art, espe-cially because of its self-expressive na-ture, Pop artists claim detachment. This is ultimately paradoxical, as the ab-stractions of the former seem removed from the pleasures and pains of daily life, while the images of the latter are quickly recognized as part of the very fabric of the quotidian. The emergence of Pop marks a philosophical change of direction from inward-looking EXIS-TENTIALISM and its concern with the in-dividual's fate to an outward-looking observation of the material world.

Popova, Liubov
1889–1924 • Russian • painter • Cubist/Futurist/Constructivist

No artistic success has given me as much pleasure as the sight of a peasant buying a length of material designed by me.

Her sure hand and brilliant colors emerged early in Popova's short career. She went to Paris in 1912 and studied with CUBIST painters. To this and FU-TURISM's influence she added the Syn-thetic Cubist use of incorporating writing into her images, but in her case Russian words in the Cyrillic alphabet. She described the "architectonic" value of a painting as "Energetics=direction of volumes+planes and lines or their vestiges+all colors." This formula, to the extent that it is comprehensible to an observer, is visible in a work such as *The Traveler* (1915–16), a painting in which faceted, volumetric forms in bold reds, blues, and greens are pressed against one another to give a sense of both controlled depth and energetic

or dynamic movement. Certainly the Cubist forms and Futurist dynamic are visible, and trying to discern a recognizable hint, such as a profile or a glove, is endlessly challenging. Before she died of scarlet fever, at the age of 35, Popova had joined those Russian revolutionary artists who renounced easel painting in favor of practical applied and industrial art. She triumphantly designed for the theater, textiles (about which she comments in the quotation above), and what she called "Space-Force Constructions," first using plywood, an industrial material, and covering it with mechanistic forms. These developed into extraordinary stage sets built up on a framework of scaffolding and the principle of functionality—ideas copied many times since. Her influence on CONSTRUCTIVISM was important.

popular culture

In contrast to a culture of the "elite," which *Merriam-Webster's Collegiate Dictionary* (1997 edition) defines as "the best of a class," popular culture belongs to "the great Unwashed," as Henry Peter, Lord Brougham, a 19th-century British peer, is said to have described the masses. Mass culture, as it was called before the term "popular culture" became . . . popular, designates FOLK ART, commercial, advertising, illustration, most GRAPHIC arts, and, in general, the low as opposed to high or "fine art." The distinction between high art and popular culture was upheld by art historians, even as the boundaries began to blur in art itself, with the rise of photography in the 19th century, and, during the 1950s–60s, the challenge of POP ART. True, peasants, workers, and revolutionary ideas were subjects for the art of Jacques-Louis DAVID and COURBET, van GOGH and SLOAN, but the people of those classes were neither its patrons nor its audience, and to the extent that it was bought, it remained securely in the bastions of fine art and high culture. Art historians long resisted the challenge of popular culture, primarily by teaching the CANON, which is accused on the one hand of being slow to change and on the other of being all too quick to "lower" its standards. Still more paradoxically, even as the argument to open the canonical gates gains ground and formerly marginalized artists are exhibited in mainstream museums (see OUTSIDER art), we witness sellout blockbusters of HIGH ART such as *The Greek Miracle* (1992–93) and CÉZANNE (1996). It may be the greatest irony of the intrinsically ironic POSTMODERN era that, as the great Unwashed finally show interest in art made for the elite, the elite have begun to lust after art made for the many.

Porter, Fairfield

1907–1975 • American • painter • Modernist

Before the war I was much influenced by some German refugees, radicals, Marxists, but not Trotskyists, or, of course, not Leninists or Stalinists. And one thing that impressed me was their manners in argument. They NEVER interrupted. They also really listened, even when what you said was by no means new to them.

Good manners, described in the quotation above, characterize the people Porter painted, although they were usually members of his upper-middle-class

family and social circle. In a sense he is the polar opposite of HOPPER, whose characters are alienated in an unfriendly, seedy environment of hard edges and implied want. Yet Porter's people, despite their privileged, airy, leafy, warm, and luminous surroundings, also seem isolated from one another, and the impending disaster one senses in Hopper becomes, in Porter's paintings, a sense of the fragility of good fortune. Porter once said that his style was a reaction to the powerful critic GREENBERG, who proclaimed that FIGURATIVE painting was out of date: "I thought, 'if that's what he says, I think I will do just exactly what he says I can't do! That's all I will do.'" Porter, too, was an art critic, writing for *ArtNews* and *The Nation.* He tended to describe the works he had under review by evaluating the process of their construction, so to speak, relationships between parts, use of materials, the effect of the whole. There was definite opinion but no emotional excess, always a distance in his writing, as, indeed, there was in his painting.

portrait/portraiture

Employing any of a variety of mediums (from sculpture to photograph), portraiture produces a recognizable image designed to capture the physical, and perhaps personality, traits of a specific individual. For the art historian, however, keeping the work's audience as well as its artist and subject in mind, the portrait becomes an unusually significant document. "Portraits exist at the interface between art and social life and the pressure to conform to social norms enters into their composition because both the artist and the subject are en-

meshed in the value system of their society," Richard Brilliant writes in a study of the topic. "Making portraits is a response to the natural human tendency to think about oneself, of oneself in relation to others, and of others in apparent relation to themselves and to others. . . . Portraiture challenges the transience or irrelevancy of human existence." Portraiture began in 5th-century BCE Greece in the form of full-figure statues, which were largely generic, or typological. In the latter part of the 4th century BCE, they became increasingly specific, especially in portraits of Alexander the Great and in the subsequent HELLENISTIC era. It was in Rome that both an accurate and expressive presentation of physiognomy flourished. Romans' reverence for ancestral death masks probably contributed to the rapid and extensive development of Roman portraiture. (This is described by PLINY the Elder: "In the halls of our ancestors, wax models of faces were displayed to furnish likenesses in funeral processions.") During the ITALIAN and NORTHERN RENAISSANCES and later, major artists fabricated both portraits and self-portraits. At times portraits of DONORS were included on the wings or in the central panel of an ALTARPIECE. GHIBERTI included a small, bronze self-portrait head on his second set of doors for the Florence Baptistery. Sometimes a portrait, rather like an inventory, records the individual's wealth and status (HOLBEIN's *Henry VIII,* 1539–40) or heroism (Jaques-Louis DAVID's *Napoleon at Saint Bernard,* 1800). While superficial likeness may be what defines the portrait, the "reading" of portraits is far more complex, for reasons such as those cited by Bril-

liant and because, as Oscar Wilde wrote, "Every portrait that is painted with feeling is a portrait of the artist, not of the sitter." It is also, one should add, equally a portrait of the period. Wilde's own fictional *Portrait of Dorian Gray,* in which the live subject of the painting remains idealized and immutable while his painted image changes to show the real depravity of Dorian Gray's life, highlights the notion of portraiture going distances and in directions beyond surface likeness. After the middle of the 19th century, on the presumption that cameras could do the job faster and better, photography in the service of portraiture lowered interest in, if not esteem for, much traditional portrait painting. But by the 1990s, interest in portraiture reemerged, and the portrait was reinvented by artists as various as NEEL, CLOSE, and SCHNABEL.

Post-Impressionism/Post-Impressionist

IMPRESSIONISTS had achieved recognition by 1882 and held their last group show in 1886. By then the gauntlet was in the hands of several painters in newer styles, each of whom expressed an individual response to the tenets of Impressionism. For want of a better term, they are called Post-Impressionists—a phrase coined by FRY, who was their champion. In its strictest application, Post-Impressionism refers to five painters: CÉZANNE, TOULOUSE-LAUTREC, SEURAT, GAUGUIN, and van GOGH. More broadly, the Post-Impressionist category includes the approach of painters who developed out of Impressionism but argued with some of its themes or intents, such as its absorption with the fleeting, momentary appearance. Often they wished to return to art what Impressionism had removed. Cézanne, for example, was interested in a more permanent underlying structure and composition.

Postmodern/Postmodernism

A movement that began around 1960. Although Postmodernism applauds the death of Modernism, and any definition of Postmodern depends on a definition of MODERN, not only are both terms fluid, but there is also ongoing discussion about whether Postmodernism is distinct from or actually a continuation of Modernism. In general, Modern art and architecture, as they developed during the 19th and 20th centuries, were conscious reactions to social and political change, especially as wrought by the Industrial Revolution. To the extent that Modern "isms" establish a FORMAL attitude to both the making and the critiquing of art, Postmodernism rejects that approach in favor of eclecticism. Where Modern rejects historic references such as CLASSICAL conventions (e.g., TEMPLE fronts on buildings) and RENAISSANCE adaptations (e.g., biblical stories in painting), Postmodern art and architecture embrace them and, moreover, willfully combine distinct period styles. Postmodernism rejects notions of "purity" and the concept of artistic authority. APPROPRIATION is a byword and irony is a trait of Postmodernism. The historian Charles Jencks has made a list of descriptive terms that apply to Postmodern architecture, but that also characterize the movement more generally. Ideological values on this list include " 'popular' and pluralist, semiotic form, traditions and

choice . . . elitist and participative, piecemeal, architect as representative and activist." Stylistic values include "hybrid expression, complexity, variable space with surprises, conventional and abstract form, eclectic, semiotic articulation . . . pro-organic and applied ornament, pro-representation, pro-metaphor, pro-historical reference, pro-humour, pro-symbolic." Helen Searing makes the point that "for most of the twentieth century, space (universal and fluid) and rationalized structure have been considered the only important architectural concerns. Now [i.e., the 1980s] the enclosing membrane again takes on weight, mass, figurative content, to create tangible boundaries which mark place and set up hierarchies of movement and activity." In arts besides architecture, PLURALISM is sometimes used as an alternative to Postmodernism, or other (sub) categories are suggested, such as NEO-EXPRESSIONISM and Neo-Conceptualism. Speaking generally, Postmodern artists and architects include SHERMAN, TANSEY, SALLE, FISCHL, CLEMENTE, VENTURI, Michael GRAVES, and Philip JOHNSON.

Post-Painterly (Color Field) Abstraction

In organizing an exhibit in 1964, GREENBERG used the term "Post-Painterly Abstraction" to describe the works of the 31 artists shown. Included were FRANKENTHALER, Ellsworth KELLY, LOUIS, NOLAND, Frank STELLA, and the Canadian BUSH. These artists, both HARD EDGE and COLOR FIELD, differed from the GESTURAL or "action" painters of ABSTRACT EXPRESSIONISM. As Greenberg described the distinction,

"Painterly (which Wölfflin applied to Baroque art to separate it from Renaissance art) means, among other things, the blurred, broken, loose definition of color and contour. The opposite of painterly is clear, unbroken, and sharp definition, which Wölfflin called 'linear.' " ("Painterly" is the term Greenberg used for Abstract Expressionist works by Jackson POLLOCK, HOFMANN, de KOONING, KLINE, and others.)

Poststructuralism

A development (not a contradiction) of STRUCTURALISM, in which it has its roots. Poststructuralism is a critical approach pioneered by the French philosopher Jacques Derrida (see SEMIOTICS). Poststructuralism disputes the assumption that if one looks carefully and gathers enough appropriate information, systems or structures will reveal themselves, enabling mysteries to yield their secrets and meaning and truth—such as an artist's intention and the "message" of the work—to be understood. To a poststructuralist critic there can be no revelation because there is no single, or singular, truth. By showing that there is always an unending complex of signifiers that identify what a sign—for example, a cat—is not, plus an equally interminable list of substitutions for each of those, Derrida reveals the impermanence and the "absent presence" of meaning. Meaning shifts constantly. Derrida used the term "*différence*" to describe how meaning is constantly deferred. (See also DECONSTRUCTION)

pottery (ceramics)

People have shaped clay and baked it—in the sun or by fire—into utilitarian

vessels and sculptures since prehistoric times. GLAZES have been used since at least ancient Egypt, where glazed canopic jars stored the organs of the mummified deceased. A great step forward from the technique of shaping objects entirely by hand was taken with the invention of the potter's wheel, known in Iran as early as 4000 BCE (and believed to have inspired wheeled transportation in Sumer c. 3200 BCE). Introduced on Crete around 2000 BCE, the potter's wheel enabled the "throwing" of pots, as the mechanized process is known, with thinner walls and more complex shapes. These vessels, called eggshell ware, were patterned after metalwork. Outstanding among them was a type named Kamares ware after the sacred MINOAN cave where they were first discovered, around 1900. Kamares decorations are characterized by bold, fanciful, and colorful painted geometric designs against a dark background, such as that on *Pitcher* from Phaistos (c. 1800–1700 BCE). Wheel-thrown pottery led to a thriving industry and the production of pots with increasingly inventive and often amusing designs, such as *The Octopus Jar* (c. 1500 BCE), with its staring eyes and waving tentacles covered with suction cups. Huge storage pots—*pithoi*—found in the Palace of Knossos were made for storing oil, grain, wine, and honey. Some *pithoi* were used for burial, as were decorated bathtub-shaped pottery coffins. Around 800 BCE, during the GEOMETRIC PERIOD, Athens became the main center for pottery production. Black designs on red clay, with a veritable dictionary of geometric forms, were contained within bands, or friezes, and

were interspersed by narrative scenes in which human and animal figures were reduced to symbolic, abstract forms. Indeed, now vases as tall as 6 feet served as grave markers, especially at the Dipylon cemetery outside the city of Athens. The dead were both cremated and interred: Some pots (AMPHORAe) held funerary ashes; some (KRATERS, with holes in the bottom) held honey, wine, and other offerings intended to nourish the dead buried below. Scenes painted on the outside of such vessels related to a funeral. During the ORIENTALIZING period, fantastic animals appeared on pots, or vases. This was true especially during the early 7th century BCE, when, having pioneered the BLACK-FIGURE TECHNIQUE of painting, potters in the mercantile city of Corinth produced the finest ware. Signatures on pottery first appeared in the beginning of the 6th century BCE. Around 530 BCE, a breakthrough was made in Athens with development of the RED-FIGURE TECHNIQUE, which allowed painters the opportunity to elaborate detail. White backgrounds came briefly and not very popularly into play during the mid-5th century BCE; although the white ground gave painters greater freedom to experiment with ideas of depth perception, their work paled in comparison with the great strides reportedly being made by wall painters (see POLYGNOTOS), and vase painting declined. Although no female artist ever achieved fame in Greek art, the decoration of a red-figured vase of c. 450 BCE has a scene in which a vase painter, surrounded by his assistants, is crowned by Athena. Among the workers portrayed is a female painter working on a large pot. Most scenes on

pottery used myth and legend as metaphors for current concerns. Along with decorative techniques and styles, a variety of pottery shapes were developed for different purposes. Potsherds—fragments of broken pottery —are the most common archaeological finds, and are used as the primary dating index for discoveries at a particular site. Local clays vary so much that, once fired, colors range from white to dark brown. In the past, dating potsherds depended largely on knowledge of changing pottery styles. Today, stylistic analysis is supplemented by analysis of the clay, plus RADIOCARBON and THERMOLUMINESCENCE dating.

Ancient Greek painted pottery is studied by art historians more widely than is that of other regions or periods partly because almost no examples of ancient Greek wall paintings remain, and because their iconographically rich repertoire of representation is so extensive. However, one should also take note of the refined, white-glazed ceramics of China that inspired 9th-century Islamic potters to invent a tin-based glaze in an effort at imitation. The ISLAMIC technique, which achieved its own magnificence (especially during the Ottoman Empire with Iznik ware), was the basis for exquisite Italian majolica (or maiolica) of the 15th and 16th centuries, as well as French faience, Dutch Delftware, and other ceramics of central Europe and Britain. In the United States, potteries were a particularly active and innovative part of the ARTS AND CRAFTS movement of 1880–1920, exemplified by the renowned Rookwood Pottery of Cincinnati and the Newcomb Pottery of New Orleans.

pounce

Pouncing was an ingenious way of making copies of a picture: Outlines of forms in the picture to be reproduced were drawn on a flat surface—generally paper—and pricked with tiny holes. The pricked original was then placed over the surface on which it was to be duplicated and dabbed, or "pounced," with powdered color or charcoal in a "pounce bag" of loosely woven cloth. This provided a dotted outline for the new image. For work on FRESCO or on other large surfaces, the picture was pounced from a CARTOON.

Poussin, Nicolas

1594–1665 • French • painter • Baroque Classicism

I neglected nothing.

Before he was 18, Poussin ran away from home to study art, an endeavor his parents disapproved of. He had two disappointing starts, then reached Rome at last in 1624, with the encouragement of the most famous Italian poet of his age, Giovanni Battista Marino. He worked in the studio of DOMENICHINO for a time. Poussin slowly became known, and was backed by Cassiano dal Pozzo, a cultivated and learned art PATRON with a passion for CLASSICAL antiquities. This Classical affinity grew in Poussin, too. In his earlier work Poussin had borrowed from and enriched his repertoire with references to artists such as TITIAN. Whether due to the poor reception of a major ALTARPIECE he had painted or because in 1629–30 he was ill with what was called the French sickness (venereal disease), when he recovered he changed his way of life as well

as his style and subjects of painting. Pozzo, secretary to Cardinal Francesco BARBERINI, remained his client, but Poussin retired from competition for grand, public commissions for projects like churches and palaces. His pictures became smaller, more poetic, and increasingly Classical. Poussin spoke of the spectator "reading" his paintings: ". . . just as the twenty-six letters of the alphabet serve to formulate our words and to express our thoughts, so the lineaments of the human body serve to express the soul's passions and to show outside what is in one's mind." To read Poussin is to read poses, gestures, and facial expression. Yet there is a stillness in his works that led BERNINI, gazing at one of Poussin's paintings, to exclaim, "What silence!" Poussin's figures seem frozen in place, like a *tableau vivant*. This is nowhere clearer than in his second version of *Et in Arcadia Ego*, painted c. 1655, during the peak of his accomplishments (an earlier version exists from c. 1628/29). It is a masterpiece of both stylistic clarity and interpretative enigma. What one superficially reads is that a stately woman and three shepherds are gathered at a tombstone in an ARCADIAN setting where *they* are *reading* the tombstone's inscription (also the title of the painting), the ambiguous words *I, too, in Arcadia* or, *Even in Arcadia [am] I*. The meaning(s) of this work is a favorite puzzle of scholars. PANOFSKY wrote a famous essay about it in 1936, "*Et in Arcadia ego:* On the Conception of Transience in Poussin and Watteau." To the regularity, clarity, and measure of Classical style, Poussin added the geometrical, rational mathematics of Descartes, his

contemporary, famous for his own maxim, *Cogito ergo sum,* "I think, therefore I am." That motto, emblematic of the age of ENLIGHTENMENT in which they lived, also fits the organized, contemplative images of Poussin, whose ideas influenced the doctrines promoted by the French Academy (see LINE VS. COLOR). In 1640 Poussin was lured back to Paris to live and work at the Louvre; however, the scale and grandeur of his commissions there were ill suited to him, and after a year and a half, he returned to Rome. Despite his wealth, he chose to live simply: When a man pitied him for having no servants, he in turn consoled the man for having many.

Poussinistes vs. Rubenistes

The stylistic conflict surrounding LINE VS. COLOR is sometimes named for the two artists who exemplified the dichotomy, POUSSIN (line) and RUBENS (color).

Powers, Hiram

1805–1873 • American • sculptor • Neoclassicist

Make me as I am, Mr. Powers, and be true to nature always. . . . I have no desire to look young when I feel old. (President Andrew Jackson, 1835)

Powers sculpted the marble bust *Andrew Jackson* (1835) with the fidelity and lines of age the president asked of him in the quotation above. Yet Powers's CLASSICISM shows in the Roman DRAPERY he hung from Jackson's shoulders. Soon after that commission, a wealthy patron from Cincinnati, where Powers worked before going to Wash-

ington, sponsored a trip to Italy for the promising sculptor. Powers settled in Florence in 1837 and spent the rest of his life there. In 1843 he sculpted a life-size nude, inspired by Greek Venus figures, called *The Greek Slave*. The primary reference was to the Greek efforts, during the 1820s, to win their freedom from the Ottoman Turks, and a secondary reference was to the issue of American slavery. The work was sent home, where its nudity rather than its political implications caused consternation when it toured the country. However, excuses on Powers's behalf included sermons such as one by a minister who declared, "*The Greek Slave* is clothed all over with sentiment, sheltered, protected by it from every profane eye."

Pozzo, Andrea

1642–1709 • Italian • painter • Baroque

In the middle of the vault I have painted the figure of Jesus, who sends forth a ray of light to the heart of Ignatius, which is then transmitted by him to the most distant hearts of the four parts of the world.

Of all the BAROQUE illusionistic ceilings, Pozzo's *Glorification of Saint Ignatius* (c. 1688–94) for the Church of Saint Ignazio in Rome is the most spectacular. For the ultimate example of *di sotto in sù* ("from below upward"; see PERSPECTIVE), first seen in MANTEGNA's *Camera degli Sposi* (1465–74), the artist worked his way up the walls, simulating the continuation of the architecture until the ceiling seems to burst open to the heavens as Saint Ignatius is

carried up to Christ. Earth and heaven, this world and the other, fuse in brilliant floating euphoria to achieve the mystical experience of making the spiritual and terrestrial world one. Pozzo had became a lay brother of the Jesuit order in 1665, at the age of 23. He was 38 when he was called to Rome for Saint Ignazio, but he was at first ignored because the man who summoned him had died. After he was finally able to execute the commission, he explained it in detail, from which the quotation above is excerpted.

Praxiteles

active c. 370–330 BCE • Greek • sculptor • Late Classical

Seeing her Cnidian self [Aphrodite] cried 'Oh, ye gods! Where did Praxiteles see me naked?' Plato, c. early 4th century BCE

None of his original work survives, but we have a 2nd-century or later marble copy of Praxiteles' *Hermes and Dionysus* (c. 340–330 BCE), found in the Temple of Hera at Olympia. Copies of his APHRODITE OF CNIDOS are varied, and it must be taken on faith that, by reputation, she was synonymous with perfection. Breaking a long tradition, perhaps for the first time, Praxiteles presented female nudity as erotically suggestive. According to PLINY THE ELDER, the people of Cnidos, who owned the statue, boldly refused the offer of King Nikodemes to discharge their public debt in exchange for it. Pliny wrote, "Multitudes have sailed to Cnidos to look at it." Praxiteles' statues are known for the sinuous, relaxed, S-shaped curve of their bodies, quite op-

posite to the taut, athletic figures of earlier artists (e.g., MYRON and POLYKLEITOS). Unlike most CLASSICAL Greek sculptors, who worked in bronze, Praxiteles sculpted primarily in marble, which reputedly became silken in his hands. Although still idealized rather than individualized (and their surfaces often tinted), Praxitelian figures are not heroic; rather, they appear soft, dreamy, effete, alluding to a very different sensuality from that of their predecessors. Praxiteles is also the creator of the adolescent male body in sculpture, as seen in copies of *Apollo Sauroctonos,* or *Lizard Slayer,* and the *Marble Faun* celebrated by Nathaniel Hawthorne, who, seeing it first in 1858, found himself "sensible of a peculiar charm in it: a sylvan beauty and homeliness, friendly and wild at once." Hawthorn's 1860 novel, *The Marble Faun,* spread the fame and popularity of the sculpture.

Precisionism

In the wake of World War I, feelings of patriotism mixed with a measure of anti-European sentiment contributed to the forging of a new MODERN style in the United States. This style was generally named Precisionism but also called Cubist Realism because it evolved from the earlier convention of seeing objects as flat geometric shapes. Artists working in this mode included SHEELER and DEMUTH, and in some ways O'KEEFFE. Precisionists idolized Americana, from Colonial houses and Shaker furniture to the newest in technology and industry. Their forms were hard-edged, pristine, and executed to look as though the painting might have been created by a machine rather than a man or woman.

There is no sign of human intervention, such as brushstroke, on the canvas, and usually no sign of human beings in the pictures, either. These works seem outside of time. It is in technique, and the exclusion of people, rather than in her subject matter, that O'Keeffe is a Precisionist.

predella
See ALTARPIECE

Prendergast, Maurice
1859–1924 • American • painter • Post-Impressionist/Modern

Prendergast. What does that name bring to the mind? Pictures gay, joyous. Trees and silver skies. Deep blue sea and orange rocks. People in movement, holiday folk in their saffron, violet, white, pearl, tan. (Charles Hovey Pepper, 1910)

Although he exhibited with The EIGHT in 1908, Prendergast did not pursue the Socialist concerns of those in the group who were known as the ASHCAN painters. It has been noted that Prendergast was the first American to truly understand French MODERNISM while it was developing. His outlined shapes, neither solidified nor shaded, were filled in with short thick strokes of bright color; they give something like a MOSAIC effect. The illusion of depth comes from overlapping forms rather than PERSPECTIVE, and his figures tend to move across the canvas in horizontal bands. Prendergast's imprint is so lively, exultant, and distinctive that his park and beach scenes seem to proclaim his signature at a glance. *Promenade at Nantasket* (c. 1900), with its parade of

strollers and the ocean in the background, is the sort of picture that the critic Pepper refers to in the quotation above.

Pre-Raphaelite Brotherhood

One of the few movements named by its own participants, and that began at a specific time and place: September 1848 at the London home of one of its founding members, MILLAIS, age 19. William Holman HUNT, 21 and the driving force of the group, and ROSSETTI, also 21, were present. These three, students at the Royal Academy of Art, spearheaded PRB (as their group became known) in reaction against the sterility of ACADEMIC art and training. They renounced all art from RAPHAEL to their time and looked back to MEDIEVAL art and legends for ideas. They were also inspired by the NAZARENES, Germans who began working in Rome some 40 years earlier and whose elaborate allegories and Medievalism appealed to them. The thrust of the PRB manifesto was to study nature, where they could find "genuine ideas." They rejected idealized and artificial forms of beauty such as were expressed by the late RENAISSANCE school in general, Raphael in particular, as well as the GRAND MANNER of the ACADEMY. They sought a new look to express their interest in an elaborate new technique, laying transparent colors on a wet white ground. It was a painstaking process, pursued inch by inch, much like FRESCO painters had proceeded, centuries earlier, on wet plaster. They wanted a high, fresh, sunlit effect, with clear, sharp focus, nearly microscopic in attention to detail. PRB paintings were heavily moralizing in the movement's early stages, and closely linked with literature. RUSKIN, also still in his 20s at the time, was one of their guiding lights, reinforcing the centrality of nature and the idea that every detail in a painting should have symbolic meaning—as in the Medieval world, animals and plants represented particular virtues and vices. Because they were a "secret society" with a manifesto of their own, the PRB members were highly suspect and their paintings savagely criticized at the first exhibition, in 1850, when their movement became known (see MILLAIS). They published a journal called *The Germ*. The PRB was hardly alone in its turn toward Medievalism, as PUGIN's slightly earlier promotion of GOTHIC architecture and its moral foundations testifies. The rebuilt Houses of Parliament (designed in 1835 by Sir Charles Barry and Pugin) had a Neo-Gothic style. With growing nationalism, the various countries in Europe each looked back into its historical past. With their literary interests, Chaucer was dusted off by Pre-Raphaelite painters, and illustrated both in painting (BROWN's *Chaucer,* 1851) and print (*Chaucer,* published in 1896 by William MORRIS's Kelmscott Press). The Arthurian legends, Shakespeare's and Marlowe's plays, and the poems of Tennyson also provided inspiration. The PRB attracted a number of followers. Each of its members developed his or her more individualized interests and styles (there were several women who were attracted to the movement), but only Hunt among the front-runners remained true to the Brotherhood's ideals. By 1860 Rossetti, painting sensuous women, moved

closer to the interests of AESTHETI-
CISM, while Millais worked a good deal
in portraiture and the Scottish land-
scape.

Primary Structures

An alternative term for MINIMALIST ART
used in 1966 to name a groundbreaking
exhibition at the Jewish Museum in
New York City, where Minimalist
sculpture was shown for the first time:
*Primary Structures: Younger American
and British Sculptors*.

Primaticcio, Francesco

1504/05–1570 • Italian • sculptor,
painter, architect • Mannerist

*When the Emperor Charles V came to
Fontainebleau in 1540, with only
twelve men, trusting himself to King
Francis, Rosso and Francesco
Primaticcio of Bologna between them
arranged the tournaments instituted by
the king in honour of his guest.*
(Vasari, mid-16th century)

In his early 20s, Primaticcio joined the
studio of GIULIO Romano while he was
in Mantua. He left for France in 1532
and began work on the palace of
FONTAINEBLEAU, joining ROSSO there.
His figures—female nudes, such as the
marble wall sculptures in the *Room of
the Duchess d'Étampes* (1541–44)—
are attenuated, delicate, and lithe, with
small heads and long legs. Primaticcio
planned some of the most important
decorations and events at Fontaine-
bleau, as Vasari notes above, but even
his "permanent" works are gone,
known only through drawings and EN-
GRAVINGS. Toward the end of his life he
practiced architecture at Fontainebleau,
but his buildings do not survive.

primitive, primitivism

From the root word meaning "first,"
these terms, when applied to art, sug-
gest that subsequent work will be more
advanced and better. The discomfort
caused by using "primitive" is com-
pounded by a grouping of prehistoric,
African, Oceanic, and American Indian
arts under the catchall heading of
"primitive" (and sometimes "naive"),
as well as that of unschooled European
or American artists (e.g., Henri ROUS-
SEAU and MOSES). Moreover, because it
was used by Westerners to describe art
made by non-Western "Others," primi-
tive is now seen as a distinction used by
colonial powers to describe colonized
peoples (see ORIENTALIZING). Even
when "the noble savage" is romanti-
cized, critics insist, a patronizing, judg-
mental, "ethnocentric" attitude is
implicit. To avoid the pejorative conno-
tations of primitive, it is preferable to
describe art as, e.g., African, or more
specifically, e.g., Yoruban. Whether the
terms "naive" and FOLK ART are appro-
priate for work of artists such as Rous-
seau, Grandma Moses, PIPPIN, and
others is debatable, but there are no
agreed-upon alternatives.

print

An image that is produced by PRINTING.
Prints are often named according to
their specific method of REPRODUC-
TION: an engraving from the ENGRAV-
ING process, a lithograph from
LITHOGRAPHY, an aquatint from
AQUATINTing, etc. A photograph is also
considered a print. As is true of ILLUMI-
NATED MANUSCRIPTs, which predated
them, prints are generally small, meant
to be seen at close range, and lend them-
selves to private rather than public con-

templation. Though each individual print may have a restricted audience, its original image may be reproduced in large multiples. Consequently, and paradoxically, an individual print ultimately has a wider public distribution than does a singular "public" work of art such as a painting or sculpture. It may be argued that the painting and sculpture are also reproduced and widely available by means of photography; however, they are intended by their maker to be seen in their unique, original state with what the theorist Walter BENJAMIN called their "aura" intact. Use of the print as a medium of mass communication has given it a didactic role in movements, beginning, most significantly, with the Protestant Reformation.

printing

There are four basic methods of printing. INTAGLIO is the process in which the image is carved or cut into the matrix from which the PRINT will be taken. Others are RELIEF (e.g., WOODBLOCK), planographic (i.e., using flat surfaces; see LITHOGRAPHY), and stencil (in which an opening is made or left through which an image emerges, e.g., SILK-SCREEN). The printing of images on PAPER had revolutionary significance. It began with wood-block printing in the first decades of the 15th century and then, in the second quarter of the century, intaglio (metal-plate ENGRAVING and ETCHING) produced ever larger numbers of inexpensive images. During the 16th century, such images were used for propagandistic purposes by promoters of both the Reformation and the Counter-Reformation. Persuasion aside, the development and distribution of printed copies of paintings and sculptures made the compositions and ideas of important works of art widely available to other, often distant artists unable to look at the original. Painters and sculptors sometimes prepared copies of their own work for printed reproduction, but that was usually done by specialists, occasionally to the dismay of the originating artist: DÜRER complained that RAIMONDI plagiarized his work. Not only did Raimondi popularize both RAPHAEL's and GIULIO Romano's paintings, with their approval, but he is also the person who truly established engraving as a reproductive medium. Besides learning from prints, many painters and sculptors received their artistic education as apprentices in the craft of printmaking (e.g., COPLEY and HOMER). And apart from what might be called the secondary purposes described so far, printmaking itself became an art form, especially in the hands of SCHONGAUER, Dürer, and REMBRANDT.

If a picture is copied directly onto the printing matrix—wood or metal—the image it prints is backward, unless special measures are taken to reverse it (see OFFSET). The number of reproductions, or prints, depends entirely on the type of process used—a MONOTYPE yields a single print, a lithograph may yield thousands. Photography, as mentioned above, and film, prints in their own right, fall within this category, and computer graphics are the most influential of contemporary methods for both creating and repeating images that are sometimes, although not always, translated into prints on paper. Apart from FINE ART prints, which are often numbered and signed by the artist, printed

posters provide affordable art for a
widely diverse population, democratiz-
ing what would otherwise remain an es-
sentially elite pleasure.

Prix de Rome
Established in the early 1660s, this prize
enabled a student at the French Acad-
emy to study in Rome for three to five
years at the expense of the state. In
1666 a French branch of the Parisian
Academy was established in Rome it-
self. Originally, the scholarship—for
which the student had to execute a
painting in a given number of days
under strict supervision—was awarded
only to painters, but printmakers, ar-
chitects, and musicians were later in-
cluded. The declared purpose was to
enable French artists to study master-
pieces of ANTIQUITY and to absorb the
quality described by the word *gravità,*
that typically ROMAN grandeur and
severity. They were not in Rome to
study contemporary Italian art, for
French authority in all spheres of life—
political and social as well as artistic—
was surpassing that of Italy. Through
the French Academy in Rome, French
artists were able to win local commis-
sions and competitions, and the French
absorption with antiquity renewed such
interest in Italy itself (e.g., see ALBANI,
WINCKELMANN, and PIRANESI). Indeed,
the Frenchman Le BRUN was made titu-
lar head of the Roman Academy of
Saint Luke in 1676–77, a post his
deputy, Charles Errard (c. 1606–89),
director of the French Academy in
Rome, filled on his behalf. Thus, French
academicians were, "symbolically at
least," as the historian WITTKOWER
writes, "masters of Rome." Although
BOUCHER and FRAGONARD, artists of

the ROCOCO style, were Prix de Rome
laureates, the primary impact of study
in Rome on both painters and sculptors
was a NEOCLASSICAL style and the pro-
duction of HISTORY PAINTINGS, in con-
cert with the ACADEMIC hierarchy.
Other Prix winners were HOUDON,
Jacques-Louis DAVID, and BOUGUE-
REAU. In the late 19th century the im-
portance of the Prix declined, and in
1968 it was abolished. At the ÉCOLE
DES BEAUX-ARTS in Paris, the current
French Academy, the Prix de Rome pic-
tures, hanging in proximity to one an-
other, provide a history of the taste that
dominated the Academy over more
than two centuries. Beginning in 1894,
a Prix de Rome was also offered by the
American Academy of Fine Arts for stu-
dents to study at the American Acad-
emy in Rome.

Process art
An outgrowth of MINIMALISM in which
the procedures and materials used for
making an object, and the signs or
symptoms of its being made (e.g., saw
marks, and the weight of its own form),
are central to the finished work. (See
also Robert MORRIS and SERRA)

Proun
See LISSITZKY

provenance
The known record of the whereabouts
and ownership of a work of art, from its
creation to the present, constitutes its
provenance. Provenance is increasingly
significant. Without evidence of its
past, one cannot be sure that a painting
or sculpture has not been obtained ille-
gally. This is especially critical for
ANCIENT works that depend on archae-

ological records to document when and where they were discovered, and who has owned them since then. A once casual attitude toward provenance on the part of museums is recently becoming more rigorous. Fraudulent documentation is still problematic.

psalter

A collection of the biblical psalms, believed to have been written by King David. Psalters were richly illustrated, especially during the MEDIEVAL era. Among the books Saint Augustine is believed to have taken to England in 597 is a luxurious psalter, once bound in silver, that still exists. It is known as the *Cotton Vespasian A. I,* now in the British Library. It may, however, have been made in the first half of the 8th century well after Augustine died in 604.

psychoanalysis

From the beginning of his researches, Sigmund Freud (1856–1939) applied his psychoanalytic theories to art. In 1910 he wrote *Leonardo da Vinci and a Memory of His Childhood,* which traces LEONARDO's presumed homosexuality and his creativity to events or fantasies of his childhood. This essay continues to prompt discussion among art historians as well as among psychologists. Artists, always sensitive to new ideas, were in turn inspired by Freud and his successors, especially Carl Jung (1875–1961), to explore the subconscious mind; the results are most notable in SURREALISM and ABSTRACT EXPRESSIONISM. Historians, too, have used psychoanalytic theory in their interpretations of art. FEMINISTS, while faulting Freud's sexist outlook, use his

writings to understand the patriarchal society with which women have had to contend. Feminist theorists are especially interested in exposing the importance of visual images in constructing sexual differences, how the male artist/audience has used woman as a visual sign (see SEMIOTICS and GAZE). ". . . through psychoanalytical theory we can recognize the specificity of visual performance and address," writes Griselda POLLOCK. "The construction of sexuality and its underpinning sexual difference is profoundly implicated in looking and the 'scopic field.' Visual representation is a privileged site (forgive the Freudian pun)."

Pucelle, Jean

active c. 1319–34 • French • painter • High Gothic

. . . a very small book of Hours . . . that Pucelle illuminated.
(will of Queen Jeanne d'Évreux; lived 1310–1371)

Pucelle's masterpiece is a BOOK OF HOURS given to Queen Jeanne d'Évreux of France by her husband, Charles IV, c. 1325–28; book and artist are mentioned in the queen's will quoted from above. It is only 3½ by 2½ inches, yet a marvel of refinement and detail. Pucelle used GRISAILLE—monochromatic ink washes—for shaping and MODELING figures, and color to pick out selected details. The figures are elegant and sway with High GOTHIC sinuosity; the fabric of their clothing is elaborately draped. The use of marginalia (figures, decoration, or scenes in the margins of the pages) enlivens the main text or illustration and draws in the spectator. Pucelle is also known as the artist who

brought to France DUCCIO's innovative ideas about spatial relations, specifically by placing a figure of Mary, in a scene of the Annunciation, inside a sort of cubicle with receding side walls and ceiling, and the angel Gabriel kneeling inside an entryway that is clearly defined. Giovanni PISANO's spatial innovations and emotional expression are also cited as influences on Pucelle.

Puget, Pierre

1620–1694 • French • sculptor • Baroque

I thrive on grand works, I am buoyed up when I work on them, and marble trembles before me, no matter how large the project.

Despite his great talent, Puget's moment in the sun was brief—both literally and figuratively. He was anathema to the taste promoted by Colbert at the court of Louis XIV, the putative Sun King, and it was not until shortly before Colbert's death that his most astounding sculpture, the marble *Milo of Croton Attacked by a Lion* (1671–82), was accepted there. Milo was an ancient Greek athlete attacked and killed by a lion after his hand had become wedged in a tree trunk. Puget's *Milo* has the emotional intensity, popped veins, and twisting body of the BAROQUE style, yet it also has elements of HELLENISTIC art: The pose is an echo of the priest LAOCOÖN (1st century CE). That the taste for Puget's work was short lived may have had as much to do with his own arrogance as with the ephemeral nature of taste at court. However, both his work and his personality appealed to ROMANTIC artists, DELACROIX in particular.

Pugin, Augustus Welby Northmore

1812–1852 • French/English • architect/writer • Gothic revival

. . . the external and internal appearance of an edifice should be illustrative of, and in accordance with, the purpose for which it is designed.

If Pugin's preference was for GOTHIC architecture, his life reads like a "Gothic romance"—shipwrecked in 1830, married in 1831 to a wife who died in 1832, married again in 1833—this wife died in 1844—married again in 1849, went mad, and died in 1852. His book *Contrasts* (1836) emerged from the early desecration and misery caused by the Industrial Revolution to proclaim a connection between artistic style and moral condition. He denounced Greek style, as it had been revived in NEOCLASSICISM, as pagan and sinful, and he believed that the ills of his era were due to the demise of Catholicism preceding the arrival of industrialization. For the frontispiece to *An Apology for the Revival of Christian Architecture in England* (1843), Pugin designed a city of Gothic towers. His rationale was cogent, not mystical, in describing the fitness and logic of the Gothic style to building requirements in England. He was, however, as opposed to the "castellated" or crenellated style (see WALPOLE) as he was to the false front of Neoclassical TEMPLES on Christian churches. The connection that Pugin made between ornament and structure, as in the quotation above, allies him with the concept that "form should follow function," an idea proclaimed decades later by SULLIVAN.

Purism

A variant of LÉGER's CUBIST machine aesthetic, Purism was developed about 1918 by LE CORBUSIER and the painter Amédée Ozenfant (1886–1966). They intended to simplify and, to their minds, purify Cubism by ridding it of the decorative elements with which it had become permeated. Their manifesto, *After Cubism,* was published in 1918.

putto, putti (pl.)

From Latin *putus,* for "little man," putti are chubby, often winged figures who cavort in RENAISSANCE, BAROQUE, and ROCOCO art especially. Originally from pagan mythology, where they represent Eros, god of love (son of Venus), they were quickly adapted to Christian symbolism: Carved on a surface of the 4th-century Christian *Good Shepherd* sarcophagus, small cherubs/putti crush grapes in a wine press—the wine, once sacred to Bacchus, became a symbol of the Eucharist.

Puvis de Chavannes, Pierre

1824–1898 • French • painter • Symbolist

I have a weakness I scarcely dare to avow. [It] consists in preferring rather mournful aspects to all others, low skies, solitary plains, discreet in hue, where each tuft of grass plays its little tune to the indolent breath of the wind of midday. . . . I wait impatiently for the bad weather to come, and I am already negotiating with a seller of umbrellas. I assure you that bad weather has more life than good.

Using a limited range of colors, chalky surface texture, and simplified, outlined, idealized CLASSICAL figures, Puvis continued the ancient tradition of wall painting. After France lost the Franco-Prussian War of 1870–71, Puvis portrayed all the French provinces as models of beauty and fertility, a paean to France. He covered multitudes of walls, not only in France but also at the Boston Public Library (by MCKIM, MEAD and WHITE). He was not universally appreciated during his lifetime, however: In 1884 Edmond de GONCOURT called one of his paintings "a dismal apology for paint" and added, "this Puvis de Chavannes nonsense has really gone on quite long enough." While his painting is decorative and seemingly anachronistic, Puvis nevertheless inspired diverse artists, from GAUGUIN to van GOGH and PICASSO. SYMBOLISTS claimed him—their spokesman Sâr Péladan called him "the greatest master of our time"—but he denied the affiliation and professed to have more affinity for the PRE-RAPHAELITE painter BURNE-JONES. However, the mysterious, ambiguous affect of his paintings, the half-light he favored, plus his own melancholy nature, make the Symbolist connection more insistent than would a similarly simplified image painted by FLAXMAN, for example. Like Flaxman, Puvis did wish to restore the serious and noble intentions of ACADEMIC art. His MURAL *Summer* (1891), at the Hôtel de Ville in Paris, is his masterpiece. Alternating blue, violet, green, and gold in the landscape, and dreamy, beautiful, Classical nudes, he creates the epitome of harmony. During a period when French culture was polarized by extremist political factions and many in the nation were looking for a definition of Frenchness, Puvis seemed to embody the grand

French tradition at its most serene. Yet he was also a resource for MODERN painters like DENIS and Gauguin, who evolved the theory of SYNTHETISM—calling for a simplification of lines, color, and form and a suppression of all detail—with Puvis as one of their points of reference.

Pythagoras
late 6th century BCE • Greek • mathematician/philosopher

It is an impressive discovery when the human mind first catches a glimpse of the eternal supersensuous laws ruling the seemingly casual appearances of the world of sense. This moment came to the Greeks early in their career in the course of Pythagorean and other geometric investigations. (Rhys Carpenter, 1959)

Little is directly known about Pythagoras, whose ideas were not written down until about a century after his own time, but his influence on the arts may have been considerable, as the assessment of the historian Rhys Carpenter, quoted above, suggests. Through studying music, Pythagoras discovered the significance of measure (length of string/where it was plucked/number of vibrations) in relation to the beauty or ugliness of sound. This led to the idea that proper numerical proportions—commensurability of parts—gives order and beauty to all things. Measure, order, and harmony—Pythagorean values promoted by his disciples—supported doctrines such as those expressed by POLYKLEITOS in his *Canon* and the architecture of Greek temples (see PARTHENON). At the core of Pythagorean tradition is the belief in an immutable IDEAL, a concept that helps to explain an essential similarity of Greek temples, all of which employ the same architectural elements (rectangular floor plan, post-and-lintel construction, colonnades, pediments)—rather than endeavoring to invent new systems.

Q

quadratura

Wall decoration painted with architectural elements—sometimes enhancing actual architectural details—that provides illusionary structural effects. COLUMNS, pediments, ARCHes, even doors may be painted. MANTEGNA's ceiling in the *Camera degli Sposi* (1465–74) and MICHELANGELO's *Sistine Chapel Ceiling* (1508–12) are famous examples from the ITALIAN RENAISSANCE. The idea of *quadratura* goes back to ROMAN ART and reached its zenith in BAROQUE Italy, where artists who specialized in this work were called *quadraturisti. Quadratura,* like that of the Sistine Chapel, gives a sense of structure, clearly marking off sections of the wall or ceiling. It can also be seen as a form of TROMPE L'OEIL, especially when the *quadratura* is made to be "read" by the viewer as actual architectural forms.

quadro riportato

The technique of "framing" pictures on walls and ceilings, especially vaulted ceilings, so that they look as if they were hanging in a gallery rather than creating PERSPECTIVE illusions. See CARRACCI's ceiling FRESCO for the Galleria Farnese (1597–1601) and RENI's *Aurora* (1614).

quattrocento

From the Italian, meaning "four hundred," actually refers to the 1400s or, more commonly in English, the 15th century.

Queer Theory
See GENDER STUDIES

Quidor, John

1801–1881 • American • painter/illustrator • Romantic

In all the time we were with Quidor . . . I do not remember of his giving us anything but easel room and one or two very common engravings to copy. (Charles Loring Elliot, n.d.)

In his own time, Quidor was known as a painter of signs and fire engine panels, but the pictures for which he is now remembered were inspired by stories told by his fellow New Yorker Washington Irving. Quidor painted in a satirical vein derived from HOGARTH, but more manic and bizarre. *The Money Diggers* (1832), from an Irving tale, mixes the grotesque and frightening with a claustrophobic ghostliness as the surreptitious diggers work by night. The black pit seems to hold the darkest fears of all who might look, or fall, into it. "The dark pit represents, however, not only

mystery and unfulfilled visions—a parody of Jacksonian aspirations—but an over-invented image of the mind of man," writes the historian Bryan Jay Wolf. Quidor was an apprentice to a portrait painter for four years, and brought suit against his master, John Wesley Jarvis, for not fulfilling his obligations. Quidor won the case. When he himself had students, Quidor also stinted his pupils, according to the comment made by one of them, who is quoted above.

R

radio carbon dating

A scientific means of determining the age of materials derived from plants or animals, such as those made of wood or ivory, based on the fact that, once dead, organic material loses its store of carbon 14 at a predictable rate. When dating an inorganic object, one made of BRONZE, for example, or any work that would be ruined by taking the sample that radio carbon dating requires, scientists might be able to substitute a presumably contemporary object (e.g., something found at the same stratum of an archaeological dig), or, perhaps, the frame of a painting, to date the object under study. As is true of DENDROCHRONOLOGY, radio carbon measuring determines only the earliest plausible date something may have been made—it is always possible that the material was not used for many years after the tree was cut down or the PARCHMENT (for another example) was prepared. (See also THERMOLUMINESCENCE DATING)

Raeburn, Sir Henry
1756–1823 • Scottish • painter • Romantic

I never knew Raeburn, I may say, till the painting of my last portrait. His conversation was rich, and he told his story well. His manly stride backwards, as he went to contemplate his work at a proper distance, and, when resolved on the necessary point to be touched, his step forward was magnificent. I see him, in my mind's eye, with his hand under his chin, contemplating his picture; which position always brought me in mind of a figure of Jupiter which I have somewhere seen. (Sir Walter Scott, c. 1826)

Born in Edinburgh, Raeburn spent his life and died there. Although he was sometimes called the Scottish REYNOLDS, and though he once met Sir Joshua Reynolds and did in fact incorporate some of the virtuosity of his style, Raeburn did not feel compelled to compete on the London scene, Reynolds's turf. He exhibited there, toyed with the idea of relocating, but resisted. He had been trained as a jeweler, and learned to paint by copying. As *the* portraitist of Scotland—it was said that every Scot above the level of a crofter seems to have had the means to have himself and family portrayed by Raeburn—he developed his own bold, spontaneous, and expressive style. Sir Walter Scott, who is quoted above, was painted no fewer than six times by Raeburn. Though the practice was uncommon at the time he adopted it, Raeburn painted his sitters directly on the can-

vas, as he saw them, swiftly and with certitude. When he was successful, as with the beautiful *Miss Eleanor Urquhart* (c. 1793), the result is splendid. The freshness and beauty of the sitter is captured by the touch of his brush, and her direct gaze mesmerizes the viewer, as it must have entranced the artist. The sketched-in sky and landscape attract admiration while leading the eye back to the sitter's face. For every success such as this, however, Raeburn produced several portraits in which a lack of enthusiasm and much reworking seem to have gotten the upper hand. Just two or three years after painting Miss Urquhart, Raeburn painted *Mrs. George Hill*, the subject of which is wearing what appears to be the very same dress. She is similarly seated, but a bit farther away from the artist and the viewer. It is clear that the same enchantment was not there. Raeburn was, nevertheless, so successful that during a 9 A.M.–5:30 P.M. workday, he painted a succession of three or four sitters. He also speculated in real estate and enjoyed the great Scottish game of golf.

Raimondi, Marcantonio

c. 1470/82–1527/34 • Italian • printmaker • Renaissance

[It was during] the first two decades of the sixteenth century that the mature image of Venus was formed, and one of the chief elements in its formation was, no doubt, the wide diffusion of engravings by Marcantonio and his imitators. (Arthur Clark, 1953)

More than any other artist, even DÜRER (whose *Life of the Virgin* he plagiarized in 1506), Marcantonio established the importance of PRINTING to art. His copies of the foremost artists' paintings were widely disseminated and studied by artists throughout the Western world. Not until the invention of photography, 300 years after Marcantonio's death, was the significance of the print eclipsed. Marcantonio's images are useful to art historians in many ways; for instance, from a portrait he engraved of the Italian writer Pietro Aretino, one scholar was able to identify an unknown figure in a painting by RAPHAEL. Marcantonio himself appeared, in person, as one of the bearers of the pope's chair in Raphael's *Expulsion of Heliodorus* (1512–14)— Raphael is the other. After c. 1510, Marcantonio worked mainly for Raphael, and his prints gave Raphael's compositions a popularity previously enjoyed by no other artist in history. In 1524, when he copied a series of erotic pictures by GIULIO Romano, Pope Clement VII ordered Marcantonio's imprisonment. Aretino, mentioned above, composed sonnets to accompany Marcantonio's prints, and had to flee Rome. He escaped imprisonment, but was brutally beaten when he returned to Rome.

Raphael (Raffaello Sanzio, or Santi)

1483–1520 • Italian • painter/architect • Renaissance

... but the most graceful of all was Raphael of Urbino, who, studying the labors of both the ancients and the modern masters, selected the best

from each. . . . Nature herself was vanquished by his colors. (Vasari, mid-16th century)

Raphael's oeuvre seems restrained in comparison to those of the other two stars of the High ITALIAN RENAISSANCE, LEONARDO and MICHELANGELO. In temperament as well as pictorial expression, Raphael appears to have been more task oriented and less interested in psychological conflict than was Leonardo, and not obsessed, as Michelangelo was, with the muscular beauty of the human form. (They were older than he by thirty and eight years, respectively; he died a year before Leonardo, and was outlived by Michelangelo.) But Raphael was strongly affected by the accomplishments of both artists, absorbing much of what he recognized as their innovations, as he had absorbed the influence of his early mentor, PE-RUGINO. Raphael's *Marriage of the Virgin* (1504), for example, closely follows the sedate, orderly composition and tranquil disposition of Perugino's *Christ Delivering the Keys of the Kingdom to Saint Peter* (c. 1480–82). It is wrong, however, to describe Raphael as a chameleon; while he may have adapted the stylistic innovations of others, he used them according to his own creative interpretation. He shared several of their PATRONS, and was working at the Vatican for Pope Julius II while Michelangelo was painting the Sistine Chapel ceiling. What he was able to see of Michelangelo's work—which was limited, as Michelangelo was quite secretive—seemed to impress Raphael profoundly. Still, Raphael had an intellectual detachment, combined with a calm, controlled spirituality, that both Michelangelo and Leonardo lacked. He aspired to a universal religion that reconciled Christianity and paganism, and strove to unify spiritual and material beauty. His Vatican commissions included a FRESCO regarding the doctrine of transubstantiation, which was heatedly argued at the time: In his *Disputa* (*Disputation over the Sacrament;* c. 1508–10), while the heavenly host is suspended overhead, learned but earthbound theologians debate their convictions about the matter. In the same room with *Disputa* Raphael painted his renowned *School of Athens* (c. 1510–12, so named during the 18th century). Here PLATO and Aristotle, amid a gathering of pre-Christian philosophers and scientists, also avidly deliberate their ideas. This painting, expressing clarity, harmony, spatial integrity, and CLASSICAL references, is emblematic of High Italian Renaissance values. Besides his own self-portrait, Raphael is thought to have painted his colleagues, including Michelangelo, among the ancient philosophers. Raphael was a supreme colorist, believed to be the first who matched his mode of applying paint, as well as the colors themselves, to the mood he wished to evoke. His many Madonnas are beautiful and serene, none more so than the *Sistine Madonna* (c. 1513–14), who walks on clouds, surrounded by barely visible, cloudlike angels; and the portraits of his contemporaries, especially that of his friend Baldassare Castiglione (c. 1514–15), are sophisticated in their suggestion of character. Before his premature death, at 37, Raphael's paintings, while still tightly controlled, seem more tor-

mented, as in the exorcism in the lower part of the *Transfiguration of Christ* (1517–20), which is combined with an extremely intense vision of Christ in the upper portion. Raphael received architectural commissions—at BRAMANTE's death in 1514 Raphael assumed the post of papal architect—but little of his architectural work remains. He was also named Superintendent of Antiquities, which gave him power over all excavations in the papal dominions. One of his projects was to map ancient Rome and its monuments.

Rauschenberg, Robert
born 1925 • American • Modern/"Combine Painting"

I want my paintings to be reflections of life . . . your self-visualization is a reflection of your surroundings.

Rauschenberg studied at BLACK MOUNTAIN COLLEGE, where he covered canvases with flat white paint. This was meant to direct a viewer's attention away from the mind and intention of the painter and toward the outside world, for which the canvases served to reflect shadows and ambient colors in the environment. He was attuned to the ideas of CAGE, for whose pivotal "Event," staged in 1952, Rauschenberg's *White Paintings* provided a backdrop. From the discovery of the "self" by probing deeply into the psyche, as pursued by DE KOONING and Jackson POLLOCK, Rauschenberg moved to understanding of the environment from which the "self" is formed. "I don't mess around with my subconscious. I try to keep wide-awake," he once said. Rauschenberg began making what he called "Combine Paintings," rather than ASSEMBLAGES, which they resemble. *Bed* (1955), for example, uses familiar objects and substances—pillow, quilt, toothpaste, fingernail polish. It is also a means of seeing oneself through vivid associations with external, familiar (or previously familiar) objects. Rauschenberg's effort to eliminate the artist from the work is explicit in one of his most notorious endeavors, *Erased de Kooning Drawing* (1953), in which he spent two months using an eraser to annihilate de Kooning's individual identity from one of de Kooning's own drawings—and failed.

Rayonism (Rayonnism)
An outgrowth of CUBISM in its fragmentation and faceting of form, and allied to FUTURISM in its emphasis on dynamic, linear light rays, the movement called Rayonism was started in 1912 by LARIONOV and GONCHAROVA. It was inspired by contemporary scientific work being done in the field of space and time.

Rayonnant style
See GOTHIC

Read, Sir Herbert
1893–1968 • English • poet/art historian

In spite of my intellectual pretensions I am by birth and tradition a peasant. I despise the whole industrial epoch— not only for the plutocracy which it has raised to power but also for the industrial proletariat which it has drained from the land. The only class in the community for which I feel any

real sympathy is the agricultural class, including the genuine remnants of the landed aristocracy.

Read's "intellectual pretensions" included teaching and writing prolifically. *Education through Art* (1943) is one of his outstanding contributions. As a supporter of the group UNIT ONE and editor of their text, *Unit One: The Modern Movement in English Architecture, Painting and Sculpture* (1934), he praised their "contemporary spirit," commending "that thing which is recognized as peculiarly *of today* in painting, sculpture and architecture." Read did not appreciate all contemporary art; in CONSTRUCTIVISM, ABSTRACT EXPRESSIONISM, and later movements he saw only nihilism and "deep despair." The quotation above is from *Poetry and Anarchism* (1938).

ready-made
See DUCHAMP

realism[1]
In art, any manifestation of realism or Realism (see below) is essentially representational. With a lower case *r*, the meaning of realism changes continually: For PLATO, the IDEAL form was real and versions of it on earth were copies. Thus, it is problematic to say that the immediately tangible, visible world is "real." Add the subjective and relative nature of such "presentist" (imposition of standards, values, and attitude of the present on the past) views of "reality," and the problem compounds. Art historians, in trying to sidestep controversy over "realism," may substitute NATURALISM or VERISM to suggest that

what is represented is what the eye sees. These terms confound the definition seeker and the writer. One means of drawing a circle around realism is to consider its prefixes, PHOTOREALISM, MAGIC REALISM, SURREALISM, *Super*realism, *Hyper*realism. For the 19th-century movement called REALISM, with a capital R, see below.

Realism[2]
With a capital R, Realism refers to a mid-19th-century movement. Preceded by ROMANTICISM and succeeded by SYMBOLISM, Realism flourished primarily in France from about 1840 until the 1870s. Portrayal of the contemporary world was characteristic of Realism. HISTORY PAINTING and idealized and imaginary subjects were rejected; beauty and literary references were not an issue. (See COURBET) The Realist was like a reporter on a fact-finding mission, showing things and people as they appeared before the artist's (theoretically, at least) impartial, objective eye. If the Realist was scrupulous in recording details—of shoes, for example—it was not for the sake of the details themselves so much as for what they revealed about the subject's character and circumstances. There was an underlying political agenda; many of these artists were, as the historian Linda Nochlin writes, "creating a visual compendium of social injustices [at the same time] they were also finding ways for declaring the heroism, dignity and probity of manual labor, without resorting to traditional symbolism or other hallowed pictorial devices." Upheavals of the French Revolution of 1848 coincided with the growth of the style, and Realism was at

its peak during the SECOND EMPIRE, a time of social and political cynicism. Courbet is often identified as the defining Realist painter, and *The Stonebreakers* (1849) is an outstanding example. Courbet's sympathies were certainly Socialist. Émile Zola and Honoré de Balzac were to literature as Courbet was to painting. But not all who painted in a Realist mode shared their political convictions. And not all were strictly Realists in all their work. The English artist BROWN, usually categorized as a PRE-RAPHAELITE, may be considered a Realist in a painting such as *Work* (1852, 1856–63), a contemporary street scene that records a collection of laborers, shoppers, and strollers—a medley of classes, occupations, and preoccupations. American Realists include EAKINS and HOMER. IMPRESSIONISM is sometimes viewed as a stage or continuation of Realism in the attention it pays to what the eye sees. During the later 20th century, two New Realisms appeared, one represented by artists like ESTES, FREUD, NEEL, CLOSE, FISH, HANSON, and FLACK. Other terms for their style or method are Super-, hyper-, and PHOTOREALISM. Another sort of New Realism is that practiced by TINGUELY and others, referring to their materials rather than their style.

reception/response theory

Sometimes known as reception aesthetics, reception or response studies examine the role of the audience of a work of art in giving meaning to that work. With appropriate substitutions in brackets, Terry Eagleton's description of reception theory in his book *Literary Theory* (1983) is a useful explanation of its operation in ART HISTORY, which also adopted reception theory as a method of study: "Reception theory examines the [viewer's] role in [art,] and as such is a fairly novel development. Indeed one might very well periodize the history of modern . . . theory in three stages: a preoccupation with the [artist] (Romanticism and the 19th century); an exclusive concern with the text [(Formalism)]; and a marked shift of attention to the [viewer] over recent years. . . . For [art] to happen, the [audience] is quite as vital as the author/[artist]." One ("historicizing") approach of reception study ascertains how a work was received by its contemporary public. Another approach is to assess current attitudes.

recession
See PICTURE PLANE

red-figure technique

A style of painting POTTERY, developed in Athens c. 530 BCE, that uses, or reserves, the natural color of the clay for the pictorial decoration, which is set against an applied black background. Red-figure work soon replaced its predecessor, BLACK-FIGURE TECHNIQUE. Among its advantages, it enabled the painter to manipulate GLAZES for raised effects. But most important, the clay color enabled artists to paint in details with fine, wiry lines. This flexibility allowed vase painters to experiment with anatomy, foreshortening, and the concept of recession (see PICTURE PLANE), and to present the first known example of CONTRAPPOSTO. This is found on the *Revelers* KYLIX signed by the BRYGOS PAINTER, c. 490 BCE. ANDOKIDES is known as the first to use the red-figure method. Many of the earliest examples

of red-figure technique were on vases that did not make the switch from black figures to red immediately. Rather, the red technique would be used on one side and black on the other, giving the name "bilingual" to such pottery.

Redon, Odilon
1840–1916 • French • painter/printmaker • Symbolist

The sense of mystery is a matter of being all the time amid the equivocal, in double and triple aspects, and hints of aspects (images within images), forms which are coming to birth, or which will come to birth according to the state of mind of the observer.

Redon believed his own originality to be in fashioning beings that are "impossible according to the laws of possibility." Among his bizarre creatures were free-floating eyeballs (from the idea of an all-seeing eye of God); a boa constrictor whose uncoiling head becomes the figure of a man; severed heads; and weirdly preposterous creatures as in *The Grinning Spider* (1881), which seems to be winking as well as grinning. Redon was influenced by GOYA's prints and "Black Paintings" (e.g., *Saturn Devouring His Children*, 1819–23) and literature. Like MOREAU, Redon is sometimes labeled a "literary" SYMBOLIST: Edgar Allan Poe (translated into French by BAUDELAIRE and Mallarmé) inspired Redon. His use of masks, snakelike monsters, detached heads, and dangerous women was characteristic of Symbolist painters. At first Redon worked only in black and white, primarily charcoal drawings and LITHOGRAPHY. He began experimenting with color in his paintings during the mid-

1890s. After 1900, having survived illness and personal religious crisis, his work changed, becoming brighter and more spiritual. Vases of flowers in brilliant colors, often with anemones among them, was one of his themes, and these proved popular with American collectors after a number of Redon's pictures were exhibited in the 1913 ARMORY SHOW.

reflectography
This technique, developed in the 1970s, is used to reveal underdrawings of paintings. Film that is sensitive to the infrared spectrum penetrates beneath the surface and projects drawings and PENTIMENTI onto a television monitor, where they may be photographed.

Regionalism
During the 1920s and 1930s, "regionalist" SCHOOLS that focused on local history, landscape, and culture took hold throughout the American Midwest. Preceded by writers like Hamlin Garland, Willa Cather, Booth Tarkington, and Sinclair Lewis, whose books explored rural life, painters also took up the subject. The Regionalist movement was motivated in part by the nationalism that followed World War I and by the self-absorption that accompanied the Great Crash of 1929 and the subsequent Great Depression. European-born ideas that had gained currency after the 1913 ARMORY SHOW were vigorously rejected by Regionalists. Although the artists were not united by any particular style of painting, local anecdotes and lore, scenery, values, and problems and concerns, from weather to crime and politics, were subjects they held in common. The most familiar

names among these artists are CURRY, BENTON, and WOOD.

Reinhardt, Ad

1913–1967 • American • painter • Abstraction/proto-Minimalist

The one thing to say about art is that it is one thing. Art is art-as-art and everything else is everything else. Art-as-art is nothing but art. Art is not what is not art. . . . The one standard in art is oneness and fineness. . . . The one thing to say about the best art is the breathlessness, lifelessness . . . spacelessness and timelessness. This is always the end of art.

To the extent that ABSTRACT EXPRESSIONISM, especially in the hands of ACTION PAINTERS, was emotional—thus "romantic"—and an autobiographical record of gesture, Reinhardt opposed it. In paring down canvases to the visual expression of a color, he expanded them, at the same time, to the vast possibilities of the darkness and relative lightness of a single color. The duality in comments such as that quoted above is also evident in his work. When he speaks of the "end" of art, the word might be understood both as goal and as finality. He painted large geometric lines of red against red, blue against blue, in perfectly symmetrical compositions. In the 1960s he worked all in black, varying the value of a black form by deepening it with a color (e.g., *Black Painting No. 34*, 1964). Reinhardt was influenced by MALEVICH, and he in turn had a strong influence on MINIMALISTS.

relief

With the exception of "sunken relief," relief sculpture protrudes from the surface surrounding it. Relief carving is subtractive—extraneous material is removed from the surface to achieve the desired effect. If not carved, plastic materials such as clay, plaster, and wax might be shaped by MODELING or molding the raised surfaces. Metal relief, REPOUSSÉ, is hammered from the back side, raising the design on the face.

Low relief, also *basso rilievo* in Italian, or *bas-relief* in French: The design projects only slightly from its background, and its surface may be somewhat flattened. Tombstones are often decorated with low relief. Extremely low, thin, or shallow relief, called *rilievo schiacciato,* was perfected by DONATELLO in works such as the bronze *Miracle of the Irascible Son* (1443–53). With this technique, distance and PERSPECTIVE are achieved by optical suggestion rather than by sculptural projection.

High relief—sculpted figures that stand out substantially from the surface plane, which makes them more easily visible from a distance. Pedimental sculpture is likely to be high relief.

Medium relief—applies to sculpted surfaces between high and low, all of which definitions are relative rather than exact.

Sunken relief—a kind of INTAGLIO (used frequently in ancient Egypt) in which the composition is carved out of the flat surface. Instead of removing the background, the design itself is subtracted and appears beneath or behind the surface plane, as on a butter mold.

Variations in the depth of relief create a play of light and shadow and sense of movement. Many works employ a mix of relief to achieve their effects. An example is SAINT-GAUDENS's *Rob-*

ert *Gould Shaw Memorial* in Boston (1884–97), a tribute to African-American soldiers in the Civil War. The general on his horse is a nearly freestanding EQUESTRIAN statue; the marching soldiers with their rifles stand out in high relief against the wall behind him; the foremost soldiers are the most detached, and the more distant troops are in somewhat lower relief. The Angel of Victory, carved above their heads, is in medium to low relief. Thus, in a relatively shallow space, Saint-Gaudens has created a scene that has a great sense of depth.

reliquary

A container to hold the remains of saints, or objects associated with them. (See also CULT OF SAINTS)

Rembrandt Harmensz. van Rijn

1606–1669 • Dutch • painter • Baroque

Rembrandt's style seems to have communicated itself to those who write about him. In the literature on Rembrandt, the artist soaks up all the light . . . while all the other people in his life are shadows in the background of whom we are told nothing more than their name and function. (Gary Schwartz, 1985)

Unanswered questions about Rembrandt are mountainously troublesome because his reputation is simultaneously so lofty and so controversial. While that makes thinking about Rembrandt exciting for art historians, it makes writing about him treacherous, as Schwartz, who is quoted above, suggests. Schwartz himself brought the artist into focus by looking at the social

dynamics of the world in which he operated, examining records of his dealers, friends, students, and customers and even searching for evidence that was missing: "no one ever asked Rembrandt to be the godfather of their child, or even to witness a document for them," Schwartz writes. He concluded that Rembrandt failed to attract important commissions and patrons due to his nasty personality: "bitter, vindictive, attacking the adversary with all means, fair and foul . . . underhanded and untrustworthy even to his friends . . . arrogant to those who admired him." Schwartz is apologetic for thus characterizing an artist who is famous for the insights with which he painted men and women, a sensitivity that naturally leads his admirers to assume he must have been of good character. "It would hurt me if the reader thought that I was painting too black a picture of Rembrandt, leaving out evidence of his humanity," Schwartz writes. "Believe me, this is not so. If anything I have spared him of even worse, such as the testimony that he stole some of the savings of his daughter, Cornelia, half of which belong to [his son] Titus's widow."

Complicating doubts about the artist's integrity is the work of the Rembrandt Research Project (RRP), a team of Dutch art scholars that has been examining the entire known body of his work since 1968. The constantly expanding and contracting number of paintings attributed to him once reached nearly 1,000. Informed estimates now put the number closer to 300. Even one of "his" best-loved paintings, the *Polish Rider* (1655), was thrown into doubt for several years (see

DROST). While such information is bound to disappoint those who romanticize his art as the work of a single, inspired genius, it is not disconcerting to the scholar Svetlana Alpers. She believes that Rembrandt succeeded in his goals, which were "mastery in the studio and the establishment of value in the marketplace." Students worked with him throughout his career; names of more than 50 were recorded. He wished to be free from catering to individual patrons and chose to sell the works from his large studio on the open market. His art became, mutatis mutandis, a commodity—a concept that troubles some historians even more than does de-attribution. Regardless of his motives or success, Rembrandt, who spent lavishly on his house as well as his collections of art and other objects, fell deeply in debt, especially with creditors to whom he owed paintings. At one point, he had to declare bankruptcy.

However fluctuating Rembrandt's reputation, the characteristics of "a Rembrandt" are unmistakable. Conventions of the BAROQUE are recognizable: significant contrasts of light and shadow, movement and drama; not the energetic drama of his contemporary RUBENS, but a more introspective, silent drama. In fact theatrics was a particular interest; Rembrandt was a great collector of costumes and other paraphernalia, from gold chains to brass helmets, that he used as props in his paintings. His use of his medium was also theatrical—Rembrandt applied paint thickly, so that it embodied texture (sometimes it was even sculptural) and imparted meaning in and of itself. His use of the medium to expressive effect was increased by the perpetual reworking of his paintings and ETCHINGS. Best known among his etchings is the *Hundred Guilder Print* (c. 1648), the subject of which is Christ healing the sick. The title alludes to the high price allegedly paid soon after the work was made. It exemplifies Rembrandt's magisterial handling of light and shadow, awe and spirituality, even in black and white. His wide-ranging subjects include lively group portraits (*Syndics of the Clothmakers' Guild*, 1662; see GAZE), moving biblical subjects (*Prodigal Son*, c. 1665), pictures of his family (*Titus at His Desk*, 1655), and an extraordinary sequence of self-portraits, in a variety of costumes, that map his physiognomy and record his various self-images, or role-playing. Though surviving documents recorded his business, located in Amsterdam, there is little in his own words to describe his ideas; however, one of his students did write down one of Rembrandt's answers to a pupil who was asking too many questions: "Take it as a rule to use properly what you already know; then you will come to learn soon enough the hidden things about which you ask."

Remington, Frederic
1861–1909 • American •
painter/sculptor • Western/Romantic

Big art is the process of elimination. Cut down and out—do your hardest work outside the picture, and let your audience take away something to think about—to imagine.

In the 1830s CATLIN went West to document the life of Native Americans; in 1859 BIERSTADT documented the scenery of the West; and in the late 1880s Remington, from upstate New

York, began to portray the new popular hero, the western cowboy. He became the most popular magazine illustrator on the subject. His cowboy was the heroic broncobuster, and he showed the frontier as a life and death struggle. One of his best-known paintings is a dramatic picture of eight cowboys on their horses galloping straight toward the viewer with a band of Indians in hot pursuit—*A Dash for the Timber* (1889). He probably used MUYBRIDGE's motion photographs to understand the horse in full gallop. Remington began sculpting, also cowboys, in 1895. He portrayed what his contemporary Frederick Jackson Turner called the "restless, nervous energy; that dominant individualism, working for good and for evil, and withal that buoyancy and exuberance which comes with freedom." But the West as he first saw it changed rapidly. In 1903 Remington said, "My West . . . put on its hat, took up its blankets, and marched off the board." His words echo those of Turner who said, "And now, four centuries from the discovery of America, at the end of a hundred years of life under the Constitution, the frontier has gone, and with its going has closed the first period of American history."

Renaissance

See ITALIAN RENAISSANCE and NORTHERN RENAISSANCE

Reni, Guido

1575–1642 • Italian • painter • Baroque

I should have liked to have an angelic brush and heavenly forms for delineating the Archangel, and to see him in Paradise. But I was unable to ascend so high, and I sought him on earth in vain. So, I had to look to the idea of beauty conceived in my mind.

Reni studied in the academy founded by the CARRACCI FAMILY in Bologna. He went on to Rome and was, briefly, among the CARAVAGGISTI. But he was accused, by the artist himself, of "stealing" CARAVAGGIO's style, and Reni changed to a more ethereal art, which he alludes to in the quotation above. His contemporaries then praised his refinement and likened his style to that of an angel, as he would have hoped. This heaven-inspired touch was at its most eloquent in his ceiling FRESCO *Aurora* (1614), in the Casino Rospigliosi, Rome. This framed, or QUADRO RIPORTATO, picture shows the airborne goddess, Dawn, spreading flowers on the earth and leading the way for Apollo. His chariot is drawn by dappled horses and is surrounded by dancing maidens, who represent the hours. Concern with time was central to the spirit of the BAROQUE age. As PANOFSKY wrote, "No period has been so obsessed with the depth and width, the horror and the sublimity of the concept of time as the Baroque, the period in which man found himself confronted with the infinite as a quality of the universe instead of as a prerogative of God." According to his biographer, MALVASIA, Reni was asexual, and phobic about women. Other than his mother, with whom he lived, Reni would not allow them in his house, fearing both witchcraft and poisoning. Yet he was devoted to the Virgin Mary. He made his own self-portrait as a beautiful woman in a turban in one scene in the cycle of the *Life*

of Saint Benedict. His paintings may have been considered celestial during his lifetime, but Reni's star fell so far that at the start of the 20th century BERENSON would say, "We turn from Guido Reni with disgust unspeakable." If Reni seemed insipid and hypocritical then, today his style and grace and his points of reference are again interesting.

Renoir, Pierre-Auguste
1841–1919 • French • painter • Impressionist

It is not enough for a painter to be a clever craftsman; he must love to "caress" his canvas too.

Renoir made his debut in 1864 when he participated in the SALON for the first time. He studied with GLEYRE, befriended BAZILLE, SISLEY, and MONET, and participated fully in the pleasures of the SECOND EMPIRE recorded by IMPRESSIONISTS. As Bazille and Sisley had painted the same STILL LIFE (an event that Renoir recorded), two years later Renoir and Monet, working together, painted the same outdoor scene, *La Grenouillère* (1869), several times. La Grenouillère was a fashionable bathing spa with an outdoor café on the Seine near Bougival. Their canvases diverge in several ways that distinguish their approaches and interpretation: Renoir's colors are softer and more subtle, his touch skips more lightly over the surface. Whereas Renoir's screen of trees is painted predominantly in blue-greens, Monet's are yellow-green. Moreover, the tendencies of each, as seen in this juxtaposition, became more pronounced in their later works. While Monet's brushwork and vision was increasingly broken, Renoir's became

ever softer and more lightly fused. This is especially evident in Renoir's paintings of rosy-cheeked women, children, and nudes, who have the tactility Renoir, quoted above, describes as "caressing" the canvas. His buxom, sculptural-looking nudes in *Bathers* (c. 1884–87) were inspired by studies of CLASSICAL examples. Like PRAXITELES, Renoir depended on his models to the extent that his wife remarked that their housemaids were chosen if "their skin took the light well."

Repin, Ilya
1844–1930 • Russian • painter • Academic Realist

Life, life! Why do painters pass it by?! The devil may take it, I shall quit all these resurrections of the dead, all these populist-ethnographic scenes, move to Saint Petersburg and begin painting pictures on the ... most pulsating reality that surrounds us, that is understandable to us, and that excites us more than all the events of the past.

In rebellion against the Saint Petersburg Academy's promotion of typical ACADEMIC subject matter, in 1870 Repin and his colleagues formed a group called WANDERERS, so named because they aimed to show their works in traveling exhibitions. After 1880 Repin's important paintings were in response to political events, and he wrote the passage quoted above in a letter expressing his interest in the life of his times and the world around him. In *They Did Not Expect Him* (1884), the unexpected homecoming of a political exile takes his family, sitting in the parlor, by surprise. Repin's huge painting *Ivan the*

Terrible Kills His Son (1885, more than 6½ feet high and nearly 8½ feet wide), while based on the past, served an anti-czarist sentiment with melodramatic pathos: The half-mad Ivan, having attacked in a rage, sits on the floor with his dying son in his arms. Politics aside, the picture created a public uproar because of its graphic rendition of gore and suffering. People fainted and riots threatened when it was exhibited, to the extent that mounted policemen were called in for crowd control. A professor of anatomy gave a lecture on the picture from a medical standpoint; he maintained that such profuse bleeding could not result from a head wound. As a portraitist, Repin painted Tolstoy and other important people of his time. He worked at Abramtsevo, the Russian artist colony, and, ironically, in 1894 returned to the Saint Petersburg Academy, where he became a professor of HISTORY PAINTING.

repoussé
RELIEF sculpture is often shaped by hammering a sheet of pliable metal, from tin to gold, into a hollow mold, creating a raised design on the front surface. Figures on the DERVINI KRATER (4th–2nd century BCE) and bronze reliefs on the pulpit at San Lorenzo, Florence, by DONATELLO (c. 1457) are examples of such repoussé sculpture.

repoussoir
From the French meaning "to push back," the repoussoir is a compositional technique designed to direct the viewer's attention as he or she contemplates a picture. Figures and/or trees placed in the front of the picture, often, although not always, at the side(s), may serve the purpose. Repoussoir generally serves to frame a landscape, and gives depth to the scene behind the foregrounded figures. CLAUDE LORRAINE is known for his repoussoir approach.

reproduction
As recently as 1971, the historian W. Eugene Kleinbauer listed non-reproducibility and uniqueness as intrinsic characteristics of a work of art, a point of view subverted by the German theorist Walter BENJAMIN. Since the early 20th century, the concepts of art and reproduction have been changing. While PRINTs were always in the realm of FINE ART, photography joined them then. DADA period PHOTOMONTAGES and DUCHAMP "readymades" made art from what was already a reproduction, and later WARHOL used reproduced images, such as news photographs, to compose an image that would again be reproduced. Sweeping technological advances allow artists to work with everything from photocopy machines to computers; value is placed on vision and imagination, not skill of execution. The definition of reproduction is stretched when a CONCEPTUAL artist like LEWITT designs instructions for others to execute: Perhaps they reproduce knowledge. POSTMODERN theorists challenge and play with notions of originality and call into question not only the hierarchy of original versus copy but also the entire concept of uniqueness. This is exemplified by SHERMAN, who makes photographs of photographs made by other artists.

reredos
From the French for "behind," the reredos in a church is a painted or sculp-

tured screen that stands behind the altar.

retable

Same as REREDOS

Rewald, John

born 1912 • German/American • art historian

Realizing that it was too late for him to form pupils, Cézanne decided to leave to posterity what might be called a system of painting. Despite his frequently expressed contempt for theories, he now did not hesitate to formulate some of his own, glad to be sought after and to have his advice esteemed.

Known for their scholarly rigor, Rewald's writings, especially on IMPRESSIONISM, beginning during the 1940s, established the interpretative approach to the movement. Rewald's FORMALISM held sway until, during the last decades of the 20th century, newer approaches (e.g., CONTEXTUAL) prevailed. Rewald's books include *History of Impressionism* (1946) and *Post-Impressionism: From Van Gogh to Gauguin* (1956). He is the authority on the work of CÉZANNE, whose studio he visited in the early 1930s; although Cézanne had died some 25 years earlier, the studio was still virtually unchanged. Rewald wrote the commentary quoted above for the magazine *ArtNews* in 1948. In 1996 Rewald's authoritative two-volume CATALOGUE RAISONNÉ, *The Paintings of Paul Cézanne,* was published. Rewald taught at the University of Chicago and at the City University of New York.

Reynolds, Sir Joshua

1723–1792 • English • painter • Romantic/Grand Manner

[Painting] ought to be as far removed from the vulgar idea of imitation as the refined civilized state in which we live, is removed from a gross state of nature; and those who have not cultivated their imaginations, which the majority of mankind certainly have not, may be said, in regard to the arts, to continue in this state of nature.

The comment above is from Reynolds's *Discourses on Art* (1778), an influential doctrine of the eclectic GRAND MANNER. He was the first president of the Royal Academy and his preaching of this grandiosity had great impact. So did his disapproving judgments on NETHERLANDISH art rendered in his *Journey to Flanders and Holland,* written in 1781 and first published in 1797 (for example, see STEEN, CUYP, and van der HEYDEN). His attitude of disdain extended to the other side of the Atlantic: In response to the American COPLEY, who had sent his best painting, *Boy with a Squirrel* (1765), to London, Reynolds advised Copley to bring his talent to Europe before it was too late. Some of his contemporaries (e.g., GAINSBOROUGH) were interested in the "natural" world, but Reynolds's goal was to transcend base nature, as in the quotation above, and to glorify on canvas individuals who merited it. Thus, Reynolds did not strive to report an accurate likeness of his sitter so much as to orchestrate a fantasy. He found landscape interesting to the extent that it expressed the greatness of his sitter. The effect of his ideas is beautifully illustrated by comparing

two portraits of the same man that are conveniently located in the same place, in Amherst College's Mead Art Museum (Amherst, Massachusetts). Reynolds's portrait of Lord Jeffery Amherst (1765) presents a handsome, youthful, pensive hero in full armor with a sword at his side, his helmet sitting on a map. (Amherst had been made Britain's commander in chief in America by William Pitt—his assignment: to rout the French.) Dark storm clouds pass behind him, but the lower portion of the sky is light, a conceit intimating that, thanks to Sir Jeffery's efforts, the land was now safe. (This metaphor pleased Reynolds, who used it for other military victors.) Five years before Reynolds painted him, BLACKBURN, a little-known English-trained artist who worked in America, also made a portrait of Sir Jeffery. Already 43 at the time of Blackburn's portrait, Amherst looks it. He has a double chin and flushed cheeks, and wears his "red coat" with its brass buttons straining over a middle-aged paunch. He is against a plain dark background and stares directly out of the picture at the viewer, rather than gazing pensively into the beyond, as in Reynolds's portrait. The comparison highlights not only the artifice of the Grand Manner, but also its use as a coordinate of political aggrandizement.

rhyton
From the Greek for "flowing," a rhyton is a drinking vessel often shaped like an animal's horn or in the shape of an animal's head. It may be made of POTTERY, stone, or metal, and is also used for libations, or liquid offerings, to the gods. Rhytons have an extensive history in ancient civilizations. The simplest among them, elongated cones with wide necks, are seen in several wall paintings, such as *The Cupbearer* (c. 1500 BCE) from the Palace of Knossos on Crete (see MINOAN ART). Some exquisite and renowned rhytons are those with finely carved animal heads, for example, the famous black stone bull's head (c. 1500–1450 BCE), also from Knossos. Its eyes are painted crystal, its muzzle has shell inlay, and decorative incising shows its curly, shaggy fur. A gold rhyton, in the shape of a lion's head, made some 1,100 years later, the *Achaemenid Gold Vessel* (c. 5th century BCE), is from Persepolis, where, after ruling for two centuries, the Achaemenid Dynasty was ended by the conquests of Alexander the Great in 331 BCE.

Riace Bronzes
Found in 1972, these are two Early CLASSICAL statues, life-size figures named for the site where divers discovered them—in the sea off Riace, on the Calabrian coast. Where these bronzes were originally cast or installed is unknown, and some argue that they were made by different artists or WORKSHOPS. Their measurements are virtually identical, though added details differ, and it is clear that they follow the same prototype. Presumed to represent warriors, each is 6 feet tall, bearded, and muscular; their lips and nipples are copper, teeth silver, and eyes, now incomplete, were ivory and glass paste. While recognized as Greek, their identity and that of their maker(s) is a puzzle, and they are the subject of much

conjecture. To some they are the pinnacle of Early Classical style; to others they are as troublesome as they are intriguing: Scholars wonder, for example, why their faces seem somewhat individualized while their bodies are so similar.

Ribera, Jusepe de (Lo Spagnoletto)

1591–1652 • Spanish • painter • Baroque

Spagnoletto tainted his brush with all the blood of all the sainted. (Lord Byron, 1819)

Ribera was the favorite painter of the Spanish viceroys who lived in Naples, which was then under Spanish rule. He had studied in Rome, where he absorbed CARAVAGGIO's style, and was in Naples when Caravaggio fled there in 1606 after killing a man. Ribera started a school of his own, producing religious paintings such as *Saint Jerome and the Angel of Judgment* (1626) which shows the intense lighting, dark background, and dramatic effect inspired by Caravaggio. *Boy with a Clubfoot* (1642/52?) is a street urchin with a grin on his face and a note in his hand that reads, "Give me alms, for the love of God." Ribera's *Martyrdom of Saint Philip* (c. 1630; previously thought to be of Saint Bartholomew) is an example of the BAROQUE taste for cruelty and bloodshed (also apparent in GUERCINO's treatment of the same subject). Justification for the horrifying scenes is the notion of mystical transcendence and ecstasy enjoyed by those who are lifted above bodily sensation in their union with God. The emotion Ribera expressed was appreciated by ROMANTIC poets like Byron, who wrote about the artist, calling him by his nickname "Spagnoletto" (Little Spaniard) in *Don Juan,* quoted from above. The real Don Juan, who led an uprising against the regent queen mother and put down a rebellion against Spanish rule in Naples, was painted, on horseback, by Ribera in his late, more mellow style. This Don Juan also seduced Ribera's daughter. VELÁZQUEZ visited Ribera and was influenced by his countryman's work.

Ricci, Sebastiano

1659–1734 • Italian • painter • Rococo

I've heard it said . . . that, as soon as he arrived in Rome and began to study Raphael's frescoes, he immediately wanted to return to Venice, saying that the style of that great man might compromise his own. (Pierre-Jean Mariette, c. 1853)

At the age of 12, Ricci was working in the studio of an artist who rejected the strong contrasts of light and dark (CHIAROSCURO) popular among BAROQUE artists. In 1681 he fled Venice after threatening to kill a woman he had seduced. His travels took him to the major Italian cities and provided an education as well as contacts and commissions. In Bologna he ran off with another painter's daughter and would have been punished by death had not Duke Ranuccio saved his neck and offered refuge in his palace in Rome—but he did not stay long in Rome, according to Mariette, who is quoted above. Ricci returned to Venice in 1696, married, and at the turn of the century, as the foremost painter of his generation, launched Venetian painting into a new age—for most of the 17th century

VENICE had had little excitement in artistic realms. Ricci's style was fluid and dynamic in a ROCOCO manner, his subjects largely biblical and mythological and their spirit highly energized, often joyful. Ricci's drawings and sketches were decorative and airy, extraordinarily skillful and beautiful, especially when he worked in pen and brown ink WASH, as he did on *Saint Mary Magdalene Anointing Christ's Feet* (c. 1725).

Richardson, Henry Hobson
1838–1886 • American • architect • Richardsonian Romanesque

The architect acts on his building, but his building reacts on him—helps to build itself . . . and if when [a building] is begun it fails to look as it should, it is not only the architect's privilege but his duty to alter it in any way he can.

Richardson was the first American architect to gain an international reputation. He was born in Louisiana and educated at Harvard and at the ÉCOLE DES BEAUX-ARTS. Richardson integrated an interest in MEDIEVAL art with his own genius, developing a style that has become known as Richardsonian Romanesque. In 1872 he won his first major commission in a competition for the design of Trinity Church in Boston, for which the designs of two or three ROMANESQUE churches in France and Spain were combined and transformed. This inspiration was based on illustrations—he did not actually see the buildings firsthand until 1882. Rusticated (rough, or quarry-faced) stone, rich and bold in texture, was his favorite and signature building material. He wanted to achieve "a quiet and massive treatment of the wall surfaces," as he told his clients. He preferred reddish brown granite, but he played different colors and textures of stone against each other, and even used boulders in one extraordinary design for a gatehouse. Richardson built libraries, houses, churches, and commercial buildings— his most renowned building after Trinity Church (completed with interior decoration by LA FARGE and dedicated in 1877) was the Marshall Field Warehouse (1885–87; destroyed 1930) in Chicago. He was working on it when he died at the age of 48. He was a huge man, almost 400 pounds, and his buildings were also huge, but they were increasingly simplified in form and decoration as his style matured. It was characteristic that the massing and definition of his buildings' facades clearly expressed the size and shape of the interior spaces that they covered. Richardson's students included McKim and White of MCKIM, MEAD AND WHITE, and SULLIVAN came under his influence.

Riegl, Alois
1858–1905 • Austrian • art historian

Every style aims at faithful rendering of nature and nothing else, but each has its own conception of Nature.

Riegl used the term *Kunstwollen* to express a "will-to-form," his concept of the creative spirit or driving force that is part of an age and inspires the creation of art. He built on the romantic evolution powered by what HEGEL called *Weltgeist,* meaning "world spirit." Riegl believed that every work of art is a link in a chain of development. A major change along the chain is progress from

tactile to optic, both a necessity and motivation for continued development. As examples of tactile or haptic art he cites the clearly outlined, flattened forms in (objective) images with little or no sense of depth, like ancient Egyptian carvings. Optic forms, which depend on light and MODELING, have depth and are more subjectively felt, as, for example, a MICHELANGELO sculpture. Riegl's distinctions have been parodied by imagining that, for instance, an ancient Egyptian actually saw people as flat shapes, in profile. The problem with Riegl's idea is that he understood each phase in art's progress as racially based, and considered the Germanic tribes, being more inclined to subjectivity, as able to move art's evolution to a higher plane.

Riemenschneider, Tilman

c. 1460–1531 • German • sculptor • Northern Renaissance

To wit: below in the predella next to the sacrament niche, two angels, one kneeling, about one and one half feet high, and two others placed on its side; further, in the shrine the Last Supper of Jesus Christ with His Twelve Apostles and all other things pertaining to it, each figure about four feet high. . . . (Contract for *Holy Blood Altarpiece,* 1501)

Riemenschneider carved images in stone as well as many in lindenwood, for which he is best known. The one described in the contract quoted above is a 29½-foot-high shrine, the *Holy Blood Altarpiece,* that holds a relic of the Holy Blood in a crystal that is embedded in a cross. The intricacy of his carving, with its vibrant, lacy architectural details, is like the Flamboyant or flamelike tracery in Late GOTHIC architecture, and Riemenschneider's DRAPERY has those deep, expressive folds also characteristic of the courtly International Style. Yet the faces of the Virgin and Christ look more like those of plain people rather than of aristocrats. Unlike many of his contemporaries, Riemenschneider did not choose to paint or gild a major part of this ALTARPIECE. For one thing, that made it less costly. But his decision could have been more circumspect: an effort to avoid accusations of ostentation such as were directed against works of art designed for the Roman Catholic Church in this period, just before the Protestant Reformation. It is significant that the *Holy Blood Altarpiece* (1501–05) in Rothenburg, Germany, was left intact when the town adopted the Reformed faith in the 1520s.

Rietveld, Gerrit Thomas

1888–1964 • Dutch • architect/designer • Modern/De Stijl

No one had ever looked at this little lane before this house was built here. There was a dirty crumbling wall with weeds growing in front of it. Over there was a small farm. It was a very rural spot, and this sort of fitted in. It was a deserted place, where anyone who wanted to pee just did against this wall. . . . And we said, "yes, this is just right, let's build it here."

In the quotation above, Rietveld describes how he and his client Truus Schröder chose the site in Utrecht where they built the Schröder house (1924).

The strict, rational, geometric forms of the house seem a three-dimensional expression of MONDRIAN's compositions. Both the house and his *Red-Blue Chair* (1923), which Rietveld said he had in mind when designing the house, are seminal icons of MODERNISM. A furniture maker before he practiced architecture, Rietveld designed the chair specifically for mass production. It is composed of two long boards—red back, blue seat—set into a black, scaffoldlike, rectangular frame. Its abstract geometry is more perfect than its anatomical comfort.

Rigaud, Hyacinthe
1659–1743 • French • painter • Baroque

All the particular, special majesty of a portrait of Louis XIV by Le Brun or Rigaud will by conquered by the humility of a tuft of grass clearly lit by a ray of sun. (Théodore Rousseau, 1859)

Court painter for the "Sun King," and most renowned for the portrait *Louis XIV* (1701): Swathed in ermine and wearing a royal blue cape embroidered with gold fleurs-de-lis, his long hair curling over his shoulder, Louis points his toe in the dainty manner of the minuet, a dance that became popular at his court. A scrupulous record of opulence, the painting is also a sympathetic likeness of the king, who patronized art most lavishly; vibrant color shows the French interest in FLEMISH art that was supplanting the earlier emphasis on DRAWING upheld by POUSSIN's followers (see also LINE VS. COLOR). But Rigaud's portrait of Louis was not ap-

preciated by Théodore ROUSSEAU, who wrote the passage quoted above close to a century after Rigaud's death.

Riis, Jacob
1849–1914 • Danish/American • photographer • Documentary

Among the Italians hands would be sometimes placed on knives and on stilettos when the party disturbed the rest of the owners. They could be appeased by being greeted with smiles, for an Italian will almost always return a smile and be put in a good humor. Then the powder would be exploded and the photographers take to their heels without waiting to witness the surprise of the victims.

Working as reporter for *The New York Tribune* after he came to America from Denmark in 1870, Riis used his camera to expose the plight of the unfortunate and the sordid life of the slums. He also gave illustrated lectures in his reformist endeavor. In contrast to painters like HENRI, LUKS, and SLOAN, Riis presented the people in his pictures in all their misery: "pictures of reeking, murder-stained, god-forsaken alleys and poverty stricken tenements" is how they were described in a contemporary account. *In Poverty Gap: An English Coal-Heaver's Home* (c. 1889) is an example. As a result of Riis's photographs (many published in his book *How the Other Half Lives: Studies Among the Tenements of New York*, 1890), some tenements were torn down and new housing was built. One of his pictures, *Bandits' Roost, Mulberry Street, New York* (c. 1888), in which he photographed a menacing gang of men and

boys, was used as evidence in a murder trial. No one questions that Riis was the leader in American social documentary photography, or that his crusade was effective, but in recent years scholars have brought his ethics and intentions under their own sharp focus. They find not only that he was self-serving, but also that he disregarded the humanity and integrity of his subjects, wreaking havoc with the dangerous "flash powder" he invented for taking pictures, as he himself describes in the account, quoted above, of his crew's outings. Calling his character into question as well, it seems clear that Riis was unconscionably bigoted regarding the people he championed. Following Riis, social documentary photography was taken up by Lewis Hine (1874–1940). Hine was far less confrontational than Riis as he recorded the plight of immigrants, following them from their arrival on Ellis Island to jobs in factories and coal mines, where young children were often exploited.

Riley, Bridget
born 1931 • English • painter • Op Art

In music, you listen, your ear is doing something, you become aware of more than you are actually listening to.

A founder of OP ART in the 1960s, Riley became known through a series of exhibitions during that decade. One exhibit, *The Responsive Eye,* at the Museum of Modern Art in New York in 1964, used her painting for the cover of its CATALOGUE, and she became internationally known. The title, "responsive eye," serves well to describe the intention of her work: experimentation with perceptual illusion and the neural-retinal experience of seeing. Her paintings play visual havoc with the eye: with repetitive lines, shapes and patterns, her images seem to advance and recede, sometimes with dizzying effect. The result might be equated to the effect of music as Riley describes it in the quotation above. She began her experiments using only black and white paint. Later she added gradations of gray, and later still color. *Winter Palace* (1981), for example, is a sequence of narrow vertical stripes in blues, reds, yellows, black and white.

Rimmer, William
1816–1879 • American • sculptor/painter/physician • Romantic

The scene is the interior of an Oriental sanctuary, into which a murderer is fleeing for refuge, while in the distance an avenger is seen hurrying to intercept him. A shadow projected into the right hand corner indicates that other pursuers are behind. (Providence Daily Journal, n.d.)

The strange circumstances of Rimmer's life are reflected in the inexplicably bizarre sculpture and paintings he produced. He was persuaded, by his father's own insistence, that, as the grandson of Louis XVI, he was the rightful heir to the French throne. A belief in the threat of assassination hovered over his childhood. He took a variety of jobs to support his art, from soap-maker to sign-maker; he took care of the sick, and, aside from some tutoring by a physician, was mainly self-taught in medicine. Rimmer also held

numerous posts teaching drawing and anatomy. Unlike other 19th-century American sculptors, Rimmer did not go abroad and thus did not adopt the NEO-CLASSICISM of, for example, POWERS or CRAWFORD. ROMANTICISM is a convenient label for his work, which is certainly evocative of strong emotion, but it is a fantasy- or perhaps visionary-based emotion; one might call it symbolic, if only the symbols were understandable. His best-known sculpture is *Dying Centaur* (c. 1871), a small (21 inches high) bronze representing the death throes of a man with a muscular torso and body of a horse. The painting, *Flight and Pursuit* (1872), shows a bearded man in a short tunic with a knife in his belt and a cape on one shoulder running through the hall of a Moorish building. His flight is paralleled by that of another shadowy figure in the distance. Although the analysis of a contemporary reporter, writing for a daily newspaper, quoted above, weaves one story, in fact this picture is one of ART HISTORY's most perplexing riddles.

Ringgold, Faith
born 1930 • American •
installation/performance • Feminist

If your work is to survive for the next generation, hearing about it by word of mouth is not good enough. It simply has to be seen, and the museum is the place for that.

Ringgold's concern in the quotation above was also expressed in activism: In 1970 Ringgold was among FEMINISTS who brought to public attention the failure of museums to exhibit women's work. With Women Students and Artists for Black Art Liberation, she confronted the Whitney Museum of American Art with requests for representation, and the group staged a series of demonstrations that culminated with the Whitney's December sculpture show. That year 22 of the 103 exhibitors were women, compared to 8 out of 143 the year before. Welcome or not, the improvement was considered tokenism. Ringgold's art is also bound up in sociopolitical concerns. She fabricates larger-than-life SOFT SCULPTURES —*Aunt Bessie and Aunt Edith* (1974)— as part of a PERFORMANCE that depicts the life of American black women. She travels and narrates this and other series in which stories about various family members are told. The figures of Bessie and Edith are clothed in richly textured, boldly colored and patterned African textiles, details drawn from African sculpture. Ringgold often installs these figures with real props, in settings that evoke African-American and Latino "yard shows." Yard shows conjure up magic through both made and found objects.

Rivera, Diego
1886–1957 • Mexican • painter •
Social Realist

[This is] the beginning of the realization of my life's dream.

A leading Mexican artist who studied and worked in Paris for many years, Rivera returned home in 1921 to support the new, revolutionary government and participate in its program of MURAL painting—the preeminent form of public art. His politics were Marxist, and a theme of great importance for

him and for his wife, KAHLO, was the pre Columbian/pre-colonial history of his country. His commissions in Mexico City included murals for the courtyard of the Ministry of Education, where one of his scenes, known as *Night of the Rich* (1923–28), shows the debauchery of wealthy Europeans. He packed his figures tightly together, exaggerated their size, shape, and behavior, and used strong colors and simplified forms. Rivera's impact on the younger generation was great, both in Mexico and in the United States, where he had several mural commissions. One, in the early 1930s, was for the Ford Motor Company's River Rouge plant. It is a vast celebration of industry and workers, with gigantic machines that bear some correlation to ancient sculptures of Aztec gods. Controversy surrounded Rivera's projects: Local critics found sacrilegious and/or Communist and/or obscene the murals he painted at the Detroit Institute of Arts. When a large group of factory workers took on the responsibility of guarding his murals, Rivera's gratitude was expressed in the comment quoted above. In New York City, where he was commissioned to paint murals under the title *Men at the Crossroads Looking with Hope and High Vision to the Choosing of a New and Better Future* (1933) at Rockefeller Center, the irony of an avowed Communist working for a leading capitalist ended in disaster. The controversy came to a head when Nelson Rockefeller asked him to paint out the easily recognizable face of Lenin. Rivera's refusal led to his being fired from the project; there were demonstra-

tions on his behalf, but ultimately the mural was destroyed. Nevertheless, the spirit of Rivera's art served as an example for American artists, during the Depression especially. (See WORKS PROGRESS ADMINISTRATION; see also OROZCO and SIQUEIROS)

Rivers, Larry
born 1923 • American • painter • Abstraction/figuration

I wanted to do something the New York art world would consider disgusting, dead and absurd. I was branded a rebel against the rebellious abstract expressionists, which made me a reactionary.

A student of BAZIOTES and of HOFMANN, Rivers absorbed the ABSTRACT EXPRESSIONIST style, but he used recognizable representations, sometimes writing, sometimes as figures, making his own defiant gesture, as described above. In *The Studio* (1956), for example, a series of figures is presented almost as scenes in sequential frames, yet they do not seem to have any narrative relationship to one another. Some are clothed, others are nude, some are clearly painted, others are partial, or sketchy; but details—such as the checkered pattern of a dress—are distinct. In a twist of abstract convention, Rivers seems to use these figures themselves as abstract patterning. The effect of the 16-foot-long *The Studio* is of coherence, even without a narrative connection. The story, or connection, is distinctly made by the artist's hand, as surely as it is in the signature works by Jackson POLLOCK and DE KOONING.

Robbia, Luca della

c. 1399/1400–1482 • Italian •
sculptor/potter • Renaissance

*. . . he devoted himself so thoroughly
to sculpture that he did nothing else,
spending all his days in chiseling, and
his nights in designing. So diligent was
he that frequently at night, when his
feet grew cold, he would put them in a
basket of shavings, such as carpenters
leave by planing, to keep them warm,
so that he need not leave his designing.*
(Vasari, mid-16th century)

Luca's best-known work is the 17-foot-
long marble choir gallery or *Cantoria*
he carved for the Florence Cathedral
(1431–38). It is filled with music-
making children. DONATELLO also
carved a *Cantoria* (1433–39) that was
placed opposite Luca's, and comparing
the two shows Luca stricter in his CLAS-
SICISM and quite restrained next to Do-
natello's exuberant, wildly gleeful
merrymakers. Luca went on to develop
a formula for glazed terra-cotta, usually
decorated with white figures on a blue
background, that ornamented many
buildings in Florence. Thus, from the
difficult beginnings described by VASARI
above, he achieved success. His family
joined in and carried on the thriving
business that he started with his inven-
tion.

Robert, Hubert

1733–1808 • French •
painter/etcher/landscape designer •
Rococo/Romantic

*But Robert, you have been making
sketches for so long, couldn't you
do a finished picture?* (Diderot,
1781)

As much as Diderot admired Robert's
painting, his remark quoted above,
made in his last SALON review, reflected
a preference for tighter brushwork,
more like that of POUSSIN. Robert's
scenes of ruins—inspired by PIRANESI
and PANINI, his friends during an 11-
year stay in Rome—brought him suc-
cess when he returned to Paris in 1765,
and earned him the nickname Robert of
the Ruins (e.g., *Pont de Garde*). He was
also a friend and traveling companion
of FRAGONARD, with whom he ex-
changed stylistic, though not thematic,
influence. One of the first CURATORS at
the Louvre, Robert presented a suite of
oil sketches for the museum's proposed
renovations (under the Ancien Régime,
soon to be overthrown). Included in this
series is *Project for the Disposition of
the Grande Galerie* (1796), a rendering
of his ideal picture gallery: a long corri-
dor with skylights, divided into ample
bays and hung with triple rows of pic-
tures. Sculpture is interspersed along
the floor, and animated visitors as well
as artists are portrayed studying the art
works. Among the artists in the in-
tended gallery is none other than
Robert himself, carefully copying one
of the paintings. The not-so-grand fi-
nale of Robert's sequence of solutions
to specific design problems at the Lou-
vre was *Imaginary View of the Grand
Galerie in Ruins,* in which he portrayed
a melodramatic view of cataclysmic dis-
aster resulting from neglect. Only the
APOLLO BELVEDERE remains standing in
the ruins—and sure enough, it is being

copied by an intractable artist. The statue looks quite green in the dusty light, but perhaps it is meant to be the bronze replica cast for Francis I c. 1540. Or could Robert have painted it in anticipation of the arrival of the original *Belvedere* in Paris? Pope Pius VI would surrender the *Belvedere* to the French in February 1797. (It was received in a triumphal procession in July 1798, but was sent back to Rome in 1816.) Robert's building project was carried forward, but not until the 20th century.

Robinson, Theodore
See AMERICAN IMPRESSIONISM

rocaille
French for "rock- or grotto-work," this term refers to the highly ornamental decoration of the ROCOCO style. Rocaille was derived from the decoration of grottoes with irregular shells and stones. It is asymmetrical and abstract, extravagantly curved into shell- and coral-like forms. These forms might be carved from wood or molded in plaster and were often gilded. They were applied to walls, ceilings, mirrors, and door and picture frames. Exotic seashells, avidly collected during the 18th century, inspired much rocaille decoration. One of the most spectacular examples is the decoration of the Salon de la Princesse (1735–39) at the Hôtel de Soubise in Paris, designed by Germain Boffrand (1667–1754).

Rockwell, Norman
1894–1978 • American • illustrator • realist

Some people have been kind enough to call me a fine artist. I've always called myself an illustrator. I'm not sure what the difference is. All I know is that whatever type of work I do, I try to give it my very best. Art has been my life.

Rockwell was the chronicler of small-town life, local people, neighborhood children, and ordinary situations like Thanksgiving dinner and going to the doctor. He worked most often as the illustrator for *The Saturday Evening Post,* averaging about six covers per year for 47 years. His wide-ranging, insightful social commentary included a nostalgic picture of a child offering her doll up for the physician's stethoscope, *Doctor and Doll* (1929), and *The Problem We All Live With* (1964)—a small black child walking to school protected by four deputy U.S. marshals. The background for the latter picture is a dirty wall with a shadow of graffiti reading "nigger" and the splatter of a smashed tomato. The child, at a viewer's-eye level, is the height of the marshals' elbows, and they are cropped above the shoulders. Rockwell usually signed his works—each cover was made from a full-scale painting—with small, stamplike letters, but he signed *The Problem We All Live With* in large script on the ground between the men's feet and beneath those of the little girl.

Rococo
Combines *barroco,* the Portuguese word for a large, irregularly shaped pearl, from which BAROQUE is said to be derived, and ROCAILLE, the ornamental rock-and-shell motif used as decorative ornament. Rococo style became popular in France during the 1720s. It was an

outgrowth of the Baroque (or, as sometimes defined, a continuation of Baroque) and is extremely ornamental, favoring pastel colors, gold embellishment, daintiness, delicacy, curving forms, and a generally lighthearted mood. It is seen as a reaction to the heaviness and solemnity of the Baroque, and also to the formality of the court of Louis XIV. Originating in France, Rococo's influence spread to other countries. It is found in architecture and interior design (e.g., NEUMANN), the DECORATIVE ARTS, sculpture (FALCONET), and painting (WATTEAU, FRAGONARD, and TIEPOLO). Rococo was gradually superseded, beginning in the 1750s, by NEOCLASSICAL influence.

Rodchenko, Alexander

1891–1956 • Russian • sculptor/painter/designer/photographer • Constructivist

We are discovering all the miracles of photography as if in some wonderful fantasy, and they are becoming a staggering reality.

Rodchenko experimented with CONSTRUCTIVIST ideas, and in *Hanging Construction* (1920) he introduced actual movement (in contrast to the suggestion of movement) into sculpture. He did it with a multitude of circles within circles, decreasing in diameter, and suspended so that they would move slowly in currents of air. Committed to the Russian revolution, he supported its Utilitarian goals for art and devoted his efforts to engineering, architecture, and industrial design. But he became so enamored of a hand-held camera he

bought in Paris in 1925, and used it for such outlandish points of view—nicknamed "Rodchenko perspectives" in Moscow—that comrades took him to task for veering from their political goals. His enthusiasm about the camera's possibilities is evident in the quotation above and in his photograph *Assembling for a Demonstration* (1928). This is taken from high above ground, looking down on apartment balconies with their own onlookers and on the scene of a rally in the street below. The vertiginous angle of vision, lighting, and drama of Rodchenko's photographs had an impact on other photographers and on filmmakers, including Sergei Eisenstein.

Rodin, Auguste

1840–1917 • French • sculptor • Impressionist/Expressionist

The vulgar readily imagine that what they consider ugly in existence is not fit subject for the artist. They would like to forbid us to represent what displeases and offends them in nature. It is a great error on their part. What is commonly called ugliness in nature can in art become full of great beauty.

Although he ultimately became the outstanding sculptor of the 19th century, Rodin was denied recognition for many years. He was not accepted at the ÉCOLE DES BEAUX-ARTS, but studied anatomical drawing with BARYE at the Natural History Museum in Paris. He also went to Italy and there studied the early masters. In defiance of the academy, Rodin submitted *The Man with the Broken Nose* (1863–64) to the SALON. It was beautifully MODELED and highly fin-

ished, but it was rejected because its frank REALISM[2] was incompatible with the idealism promoted by the ACADEMY. Also, because Rodin had left the back of the head unfinished, it was considered an incomplete fragment. But as the historian H. H. Arnason writes, "Rodin looked at Donatello and Michelangelo as though they were masters of his own time to whom he was apprenticed, and thus he achieved the anomaly of turning their own gods against the academicians." Rodin remained confirmed and uncompromising in his vision and, Arnason maintains, "re-charted the course of sculpture almost single-handedly." *The Age of Bronze* (1875–76), his first major signed work, was accepted by the Salon of 1877, though its truth to life brought accusations that he had cast it from a living man. In time his work became increasingly expressive, especially through the roughness of surface texture and the drama, tension, and energy he was able to impart to his forms. As an IMPRESSIONIST, he stopped and solidified movement and experimented with effects of lights on the surface of solid objects. Unlike Impressionists but akin to EXPRESSIONISTS, he was interested in the power of emotion. This is clearly seen in the despair of six bronze figures, heroic hostages, a group known as *The Burghers of Calais* (1886). In 1880 Rodin was commissioned to create a modern counterpart to GHIBERTI's Florentine *Gates of Paradise* (finished 1452), *The Gates of Hell*. He completed some 200 figures, several of which, including *The Thinker*, evolved into individual sculptures, but he never completed the project. His *Monument to Balzac* was started in 1891, some 40 years after Balzac's death. Rodin con-

sulted every known portrait of Balzac and even contacted Balzac's former tailor before he found a model with Balzacian dimensions. The years of study, numerous models, and struggles to define his subject culminated in a draped body that looms eerily, a cloaked mountain of a man with a strange, massive head. Beneath his robe, Rodin implies, is a sexual power that fuels the author's intellectual creativity—in a prior nude study he had modeled a powerful, robust man grasping his penis with his right hand and clasping his right forearm with his left hand. This is a plunge into Freudian ideas at the moment that Freud was becoming known (though not by Rodin), but whether it is Balzac or Rodin whose isolation, genius, torment, and sexuality we observe in this statue is debatable. The work was not accepted by the Writers' Association, which had commissioned it, but Rodin said, "Nothing I have ever done satisfied me so much, because nothing ever cost me so much; nothing sums up so profoundly what I believe to be the secret law of my art."

roll
See SCROLL

Roman art
509 BCE–312 CE

In 509 BCE an ancient Latin people, whose origins are unknown, overthrew the ETRUSCANS, established a republic headquartered in Rome, and launched a program of conquest. By about 200 CE, Rome was the capital of the largest empire ever known, reaching from Scotland to Arabia. Roman history is divided into two periods. The first was the *Republican* (509–27 BCE), during

which energy was devoted to expansion and the artistic legacy is largely commemorative sculpture; coinage; portraiture; religious, urban, and domestic architecture; and interior decoration. It was during the second, *Imperial* period (27 BCE–c. 312 CE) that Roman art developed its most distinctive characteristics. It began concurrently with the reign of Emperor Augustus and ended approximately with the adoption of Christianity under Emperor Constantine. Though awed and strongly influenced by the Greeks, whose lands they conquered and whose art and artists they brought back to Rome, ultimately Roman art mirrored their cultural differences. Romans were interested in individuals rather than the types and prototypes that had preoccupied Greeks, for example. Yet, paradoxically, in contrast to the fame of many artists in ancient Greece, Roman artists rarely signed their works, and few of their names have come down to us. Most significantly, beginning with Augustus, art became a purposeful agent for propaganda and change. "Augustus reformed public opinion and private attitudes by means of an effective, congratulatory rhetoric, presented by works of art and literature of extraordinary quality and persuasive authority," Richard Brilliant writes. "After his reign Roman art was forever defined by the agendas established and pursued by Augustan artists and architects, if not necessarily by the formal language adopted in their pursuit." The *Ara Pacis Augustae* (*Altar of Augustan Peace*; 13–9 BCE) is the outstanding example of this monumental rhetoric. Augustus used Greek precedents from the CLASSICAL era as the altar's stylistic vocabulary and Greek mythological characters mixed with contemporary individuals, including Augustus and his family, for its decoration. Thus did he claim authority over both past and present, while declaring the Golden Age to be a contemporary reality of which he was the benevolent provider. Although scholars debate the exact meaning of its sculptural program, there is little doubt that the *Ara Pacis* served a propagandistic purpose. Later examples of Roman self-promotion include EQUESTRIAN statues and great triumphal monuments such the ARCH OF TITUS and the COLUMN OF TRAJAN. It has been written that Rome was a city in which statues outnumbered people. Two public inventories of the late 300s CE list almost 4,000 bronze statues in addition to 36 triumphal arches, 22 equestrian statues, and many other individual works. That does not even touch on the countless marble statues and busts on public buildings, or on privately owned works. The ancient city's population reached about one million, so the hyperbolic-sounding statement actually could have been true.

Important distinctions should be made between Greek and Roman architecture. Where Greek TEMPLES allowed scant provision for people entering and moving about inside, Roman builders (as well as city planners) excelled in designing interior spaces for the comfort, circulation, and control of people (see COLOSSEUM); entrances to buildings were well defined, and interiors were awe inspiring (PANTHEON). Roman architectural innovation was advanced by the development of concrete and vaulting systems (see ARCH). In contrast to the Greeks' traditional awe of and re-

spect for the natural landscape, Romans were, from the start, intent on altering and shaping nature for their own needs and pleasures—in terms of gardens as well as buildings. One might, for example, compare how the Greek Theater at Epidauros (c. 350 BCE) is fitted into the side of a hill, following its contours, while in contrast, Romans were more likely to build their theaters and amphitheaters on level ground, or to transform the landscape to accommodate their design. Whereas the Greek theater was open to the air, the Roman structure, which often had a roof, was enclosed inside walls. Rome's instinct, writes the architectural historian SCULLY, "is to enclose, to keep nature out, to trust in the manmade environment as a total construction. . . ." Domestic architecture, preserved especially at POMPEII and HERCULANEUM, enclosed the all-important family. (For styles of Roman wall paintings, see MURAL.) As persuasively as Augustus heralded the glory of Rome, so was the breakup and erratic decline of the Empire reflected in later works such as the marble portraits *Caracalla* (215 CE) and *Philip the Arab* (240s CE); both emperors look wary and haunted. That anxiety was later translated into LATE ANTIQUE style, rigid and FRONTAL, embodied in the cluster of rulers entitled *Tetrarchs* (c. 305 CE), who huddle together as if for mutual protection, and in the gigantic head *Constantine* (c. 330 CE), of the first Christian ruler.

Romanesque

Mid-11th to mid-12th century. The Romanesque was so named in the 19th century by a French scholar who connected the art of this period to the emer-gence from Latin of the Romance languages (Italian, Spanish, Portuguese, French, etc.). The Romanesque period was marked by the ascendancy to power of monastic orders, a feudal aristocracy supported by the manorial system, the CULT OF SAINTS, and great popularity of pilgrimages to visit saints' shrines and relics; and the fervor of the Crusades, the first of which was in 1095. Also during the Romanesque period, in 1054, the final break between the Eastern Orthodox and Western Roman Churches took place. Romanesque architecture evolved from the Roman BASILICA, with an oblong plan, round ARCHes, heavy walls (a core of rubble faced with concrete), masonry vaults (groin and tunnel), and clerestory windows. Romanesque sculptural RELIEFS and paintings tell the Christian story with highly animated figures, often unnaturally shortened or elongated to fill all available space. Expressive Last Judgment scenes fill the semicircular space above the main portal, or the tympanum (see GISLEBERTUS); the central post of the portal—the trumeau—might be transformed by twisting and turning figures, humans and beasts, such as *Lions and the Prophet Jeremiah (?)* at Saint Pierre, Moissac (early 12th century). Author portraits are found in ILLUMINATED MANUSCRIPTS, including EADWINE in the *Canterbury Psalter* (c. 1150). Vivid accounts of contemporary events, like the conquest of England, are illustrated in the BAYEAUX TAPESTRY (1070–80).

Romanticism

A broad cultural manifestation that is not a STYLE, but may incorporate styles like NEOCLASSICISM and REALISM[2]. Ro-

manticism is conventionally dated from the late 18th through the early 19th century. It cuts across national boundaries, finding expression in England (e.g., TURNER), Germany (FRIEDRICH), and France (GÉRICAULT and DELACROIX, though Delacroix shunned the label). Yet, as it has no clear beginning, middle, or end, no common denominator of style, and no all-encompassing definition satisfies, it is more helpful to look at Romanticism as a concept rather than as a movement. Géricault may be seen as a turning point, moving away from the rationalism of the ENLIGHTENMENT and from Neoclassical restraint (e.g., Jacques-Louis DAVID) toward the highly personalized treatment of the modern subject matter that will eventually characterize Realism² (e.g., COURBET). There was a shift in emphasis from imitating the visual world to expressing emotions; bywords of Romanticism are imagination, sincerity, sensibility, spontaneity, individuality, and inner truth (as opposed to timeless, universal values). As BAUDELAIRE wrote in 1846, "Romanticism is precisely situated neither in choice of subjects nor in exact truth, but in a mode of feeling." The stereotype of "The Artist" as tormented genius, the outsider who dies young (e.g., Géricault), originates during this period. Romanticism thrived on the late 18th century's cult of the SUBLIME, its concern with mystery, and interest in MEDIEVAL ideas and works. GOETHE was a Romantic apologist. Some recurring Romantic themes include personification of ideas (RUDE's and Delacroix's personifications of Liberty), images of nature's power vs. human vulnerability (Géricault's The Raft of the Medusa,

1818–19, and Turner's Snowstorm: Steamboat Off a Harbour's Mouth, 1842); and people in distress (Delacroix, Massacre at Chios, 1824).

Romney, George
1734–1802 • English • painter • Grand Manner

The fortunate chance which led him to a cultivation of the particular art he was destined to profess was simply this. In his youth he observed great singularity of countenance in a stranger at church; his parents, to whom he spoke of it, desired him to describe the person. He seized on a pencil, and delineated the features from memory with such strength of resemblance as amazed and delighted his affectionate parents. (William Hayley, 1809)

Hayley may have romanticized the "fortunate chance" that led Romney to his profession, as quoted above, but Romney is among the top 18th-century British portrait painters, a list that includes REYNOLDS, GAINSBOROUGH, RAEBURN, and Sir Thomas LAWRENCE. They all painted heroic men, beautiful women, and children that are above average. Flattery of the English upper classes—more than insight into psychology, character, or truth—was their goal. Romney wished for success in HISTORY PAINTING and could not achieve it, but his portraits satisfied his clients; his colors were rich, the sitters' glances intelligent. He settled in London and competed with Gainsborough and Reynolds. He had a falling out over money with the latter, and was thus never elected to the Royal Academy, which Reynolds headed. Romney's

story took an interesting turn in 1782 when, near the age of 50, he fell madly in love with a 17-year-old—the famous Emma. He painted her more than 50 times. She married Sir William Hamilton, whose portrait Romney also painted but probably no more than once, and she became the mistress of Britain's naval hero Lord Nelson. Romney's obsession persisted until his health broke, his talent weakened, and he retired to the north of England, rejoining his wife whom he had abandoned 27 years earlier. She nursed him until he died, quite senile, at the age of 68.

Rosa, Salvator

1615–1673 • Italian • painter • Baroque

. . . go to a brickmaker as they work to order.

Embattled, effusive, contrary, Rosa hated to work on commission, as his comment quoted above makes clear. He showed his work as widely and often as he could, especially in the two major public exhibitions held in Rome each year. He also kept a large selection of pictures in his studio where potential buyers could browse through them and make their selection. Their choices, however, did not fail to infuriate and frustrate him: "Always they want my small landscapes, always, always, my small ones," he wrote. Famous and sought after for those small landscapes and for his small exotic scenes, especially esoteric images of witchcraft, he wanted to be appreciated for his large, allegorical, and HISTORY PAINTINGS, the great dramas, heroic tragedies. Rosa expressed an intellectual attraction to and advocacy of Stoicism, a detached and incorruptible private morality, distinct from the church or state. This is illustrated by his painting *Fortune* (1659), in which a nude woman profligately showers a cornucopia of riches on various animals including a goat and donkey. This painting nearly caused him to be jailed for the presumed allusion to political (papal) patronage. But despite his stoic proclamations, Rosa was an incurable romantic, and it was the imaginative appeal of his rugged, agitated landscapes of crags and cliffs, with wild animals and bandits in the wings—the very opposite of POUSSIN's tranquil ARCADIA—that especially influenced later painters, leading to the taste for the SUBLIME that would, in turn, inspire ROMANTIC artists.

Rosenquist, James

born 1933 • American • painter • Pop Art

I decided to make pictures of fragments, images that would spill off the canvas instead of recede into it . . . I thought each fragment would be identified at a different rate of speed, and that I would paint them as realistically as possible. Then I thought about the kind of imagery I'd use . . . I wanted to find images that were in a "nether-nether-land."

The comment quoted above, made in relation to the paintings Rosenquist began in 1960, aptly describes his work. It leaves out one major component, however: the large scale of his compositions. *F-111* (1965), for example—a sequence relating to the Air Force fighter-bomber, painted when the United States began to bomb North

Vietnam—although painted on canvas, is an 86-foot-long mural. His colors are a gaudy, Day-Glo assault. "Rosenquist's ingenuities as a formal artist have floated to the top. And the subject is clearer: the vicissitudes of a certain kind of American dream," HUGHES wrote in 1986.

Rossellino, Bernardo,
c. 1407/10–1460, **Antonio,**
c. 1427/28–1479 • Italian •
sculptors • Renaissance

At San Miniato al Monte, a monastery of the white monks outside the walls of Florence, [Antonio] was employed to make the tomb of the Cardinal of Portugal, which was executed so marvelously and with such diligence and art that no artist can ever expect to see anything to surpass it for finish and grace. . . . It contains angels which in their grace and beauty, with their draperies and attitudes, seem not marble creations but living beings. One of them holds the cardinal's crown of virginity, as he is said to have died chaste; another raises the palm of victory which he won against the world. (Vasari, mid-16th century)

All five Rossellino brothers were stonecutters from Settignano, a village on a hill in Tuscany known for its sculptors, including DESIDERIO DA SETTIGNANO and MICHELANGELO, who lived there when young. Bernardo and Antonio are the most renowned of the brothers, and the nickname, Rossellino, which means "little redhead," was first Antonio's and later given to the whole family. Bernardo was an architect as well as a

sculptor. His important tomb sculpture (c. 1446–48) of an eminent HUMANIST scholar, the Florentine Chancellor Leonardo Bruni, is set into a wall niche in Santa Croce, Florence. This work established a standard and prototype. Bernardo placed Bruni, in white marble and holding one of his books, lying above his bier. There is little religious imagery in this highly decorative tomb. Antonio, considered the more gifted of the two, created an extraordinarily ornamental tomb (1461–66) for the Cardinal of Portugal in San Miniato al Monte, Florence. This is the work described by VASARI in the quotation above. Where earlier tombs were restrained and stolid, Antonio's angels and PUTTI are caught in full motion and emotion, and even the cardinal seems to be sleeping content. From the center of a wreath above the tomb, the benevolent Virgin and Child smile down on him. This foretells an increasing interest in the human and momentary over the sublime and eternal.

Rossetti, Dante Gabriel (Gabriel Charles)
1828–1882 • English • painter •
Pre-Raphaelite

Lo! it is done. Above the long, lithe throat / The mouth's mould testifies of voice and kiss, / The shadowed eyes remember and foresee. / Her face is made her shrine. Let all men note / That in all years (O Love! Thy gift is this) / They that would look on her must come to me.

Rossetti's father (Gabriel Pasquale Rossetti) was a Neapolitan poet and Dante scholar who had fought patriotically for a constitution against the Austrian

king Ferdinand. He was forced to flee Italy and settled in London, where he taught at King's College. At the age of 13 young Rossetti—whose adopted name testifies to his and his father's literary interests—spent his time reading and illustrating Shakespeare, GOETHE, Byron, and Scott. For him, art and literature were inseparable, and although undecided whether painting or poetry should be his profession, it was understood that the former could be more lucrative. At 20 he was the instigator when he, with friends and fellow Royal Academy of Arts students William Holman HUNT and MILLAIS, launched the PRE-RAPHAELITE BROTHERHOOD. The three began to forge the first true Pre-Raphaelite manner in which outlines were hard, poses stiff and awkward, and shadows were not cast. In time Rossetti's subjects changed from legends and NARRATIVE topics to a series of bust-length pictures of beautiful, sensuous, extravagantly costumed, languorous, melancholy women. Fanny Cornforth, his mistress for 10 years, was the model for the first in the series that began, in 1859, with *Bocca Baciata*. The title is inspired by a poem of BOCCACCIO that says, "The mouth that has been kissed loses not its freshness; still it renews itself even as does the moon." The obsessive series continued during the 1860s. Another model was Elizabeth Siddall, a frail, consumptive, tragic "shop girl" whom he fell in love with and married in 1860. She died of an overdose of laudanum in 1862. He painted a memorial to her as his "Beatrice" (*Beata Beatrix,* c. 1864–70), an allusion to the Beatrice who was Dante's muse. Still another model was Jane Burden Morris, the wife of his friend

William MORRIS. In 1868 she became his mistress. Rossetti's paintings inspired passion in their beholders; A contemporary wrote about *Bocca Baciata*'s owner, "Boyce has bought it and will I expect kiss the dear thing's lips away before you come to see it." (BURNE-JONES's pictures also attracted kisses.) The women in Rossetti's series appear tightly confined, pushed to the front of the PICTURE PLANE, often with flowery wallpaper behind them that seems to cramp their freedom even more. These women are "being seen, while *unseeing,*" the historian Griselda POLLOCK writes. They serve, fetishlike, to identify and enable male sexual self-definition in a circle of bourgeois intellectuals and artists. "This is therefore a question of sexuality and the mode of representation. . . . Rossetti's works predate Freud and the Hollywood cinema. But out of the same formations and its ordeals came both the analytic theories of Freud and the representational project of classic Hollywood cinema," Pollock concludes.

Rossi, Aldo
1931–1997 • Italian • architect • Modern/neorationalism

I saw the structure of the body as a series of fractures to be reassembled.

In the quotation above, Rossi is describing an idea that changed his career as an architect—the impulse to reconcile diverse parts. It came after an automobile accident he had in 1971, and is prescient of the timeless, spare, and surreal design he did soon afterward for the Cemetery of San Cataldo (1971) in Moderno, Italy. Rossi was preoccupied with combining geometrical shapes in

bold and original ways, while looking back to the work of LEDOUX and BOUL-LÉE. This absorption is expressed in the town hall (1986–90), in Borgoricco, Italy. In this building are allusions to industry, such as the form of a smokestack, and to local domestic shapes, such as houses with slanting roofs. He also combines the soft texture and color of brick with the harder look of concrete.

Rosso, Medardo
1858–1928 • Italian • sculptor • Impressionist

Was not [Baudelaire] right to treat sculpture as an inferior art when he saw sculptors make a being into a material entity in space, while in actuality every object is part of a totality and this totality is dominated by a tonality which extends into infinity just as light does?

Rosso spent much of his career in Paris, read BAUDELAIRE, and met RODIN, who admired his work and, Rosso later insisted, copied it. Trained as a painter, he was a boldly experimental artist who endeavored to capture in three-dimensional form the effects that IM-PRESSIONIST painters sought to convey on canvas: the immediate, momentary impact of the visual world, the effect of light on the subject, and the dynamics of a subject in its environment. Also, as in traditional painting, Rosso wanted to see the sculpted form from a single viewpoint, in opposition to the convention of sculpture as a three-dimensional object to be seen from all sides. *The Concierge* (1883) is an impression of a head emerging from a roughly textured, undefined form. The material he used,

wax over plaster, allowed him great leeway in the melding of different shapes. Rosso's ideas and accomplishments were highly praised by Italian FUTUR-ISTS, who both shared and exaggerated them, especially the idea of a dynamic fusion of a subject and its setting. Rosso's comment, quoted above, refers to Baudelaire's essay entitled "Why Is Sculpture So Boring?" (1846), and a longer article of 1859. Rosso added, "What is important for me in art is to make people forget matter. The sculptor must, through a summary of the impressions he receives, communicate everything that has touched his own feelings, so that, looking at his work, one can feel completely the emotion that he felt when he was observing nature."

Rosso Fiorentino (Giovanni Battista Rosso)
1494–1540 • Italian • painter • Mannerist

Besides his skill in painting, Rosso possessed a handsome presence, was gracious and grave in speech, an accomplished musician and a well-versed philosopher, while more important than all were his poetical fancy in the composition of figures, his bold and solid design, light style, beautiful composition and the forcefulness of his grotesques. (Vasari, mid-16th century)

Rosso's compositions, like those of his friend PONTORMO, convey a sense of utter instability, but where Pontormo's *Descent from the Cross* (also known as the *Entombment* or *Lamentation;* 1525–28) intimates a kind of floating weightlessness, Rosso's *Descent from the Cross* (also *Deposition;* 1521) has

the opposite effect. Here it seems that the gesticulating men who have climbed the ladder, and Christ himself, will all momentarily crash to the ground and crush the mourners below. Like most Mannerists, Rosso (a nickname meaning "redhead") forced his figures into unreasonably compressed space, creating a feeling of tremendous anxiety (see MANNERISM). That anxiety is soon explosive in *Moses Defending the Daughters of Jethro* (1523): a swirling mass of entangled, muscular bodies caught in a violent melee. Anyone who tries to name the participants, and to translate the scene, ends up in a quandary. Rosso lived through the 1527 sack of Rome, and one would be less surprised by his *Moses* had he painted it after that. In 1530 Rosso went to work for FRANCIS I and became a founder of the SCHOOL of FONTAINEBLEAU, where he shared the limelight with PRIMATICCIO. VASARI's appreciation of Rosso, quoted from above, includes a long anecdote about the painter's fondness for his pet baboon: "loving it like himself." The baboon, for its part, was fond of a handsome apprentice called Battistino, for whom the animal stole grapes from the friar's garden. The story has all the earmarks of slapstick comedy, with the baboon getting caught, wreaking havoc, being restrained by a ball and chain made by Rosso, but taking his revenge on the humorless friar in the end.

Rothenberg, Susan
born 1945 • American • painter • New Image

In the early years, I had ambiguous feelings about the horse and what it meant to me. My formalist side was denying my content side. Eventually, I began tearing it apart to find out what it meant. It obviously became a vehicle for certain kinds of emotions.

Rothenberg painted her first horse in 1974 in a sienna color like the earth and in an outline style like those of prehistoric cave paintings. She continued painting horses, in part, she said, to avoid painting people. She described her images as "placement in space," a FORMALIST idea, as alluded to above. Although the animal is always recognizable as a horse, it is never only that, and it is often sabotaged by interruptions of one kind or another: For example, by dividing the canvas on which a horse is painted into different colors, Rothenberg maintains the integrity of the painting surface over that of her subject. Later, as her comment also suggests, she painted strange, dismembered parts of the horse, such as *Untitled (Upside-Down Horse Legs),* 1979. In her later works the horse only occasionally appears, as Rothenberg alludes rather to her new life in the New Mexico desert, where she settled with her husband, NAUMAN, in 1989. In these, as the critic Michael Kimmelman writes, "The painting is thick but no longer clotted, the images often fantastical and lightheaded, and they occasionally refer to the animals and the red earth . . ."

Rothko, Mark
1903–1970 • American • painter • Abstract Expressionist

The unfriendliness of society to his activity is difficult for the artist to

accept. Yet this very hostility can act as a lever for true liberation. Freed from a false sense of security and community, the artist can abandon his plastic bank-book, just as he has abandoned other forms of security. Both the sense of community and of security depend on the familiar. Free of them, transcendental experiences become possible.

Rothko traveled from boyhood in Russia, to adolescence in Portland, Oregon, to maturity as a founding member of the New York group of ABSTRACT EXPRESSIONISTS. His artistic journey included a spell at Yale University and studies at the Art Students League in New York with WEBER. He kept appointments with fairly standard current styles until he arrived at his extraordinary and groundbreaking paintings of color—color, that is, expressing both the subject and the object, covering an entire canvas. Sometimes two great rectangles of colors, albeit without edges—for example, *Orange and Tan* (1954) —meet as boiling blood might meet blazing sun, an image that seems to express MOTHERWELL's description of Rothko as a cauldron of "seething anger [that] would sometimes blow up, completely irrationally." Among his late works are the canvases he painted for the walls of a chapel in Houston, Texas, in 1968—very large, almost monochromatic canvases that steep a viewer in what seem to be endless depths of darkness. For some these murals bring transcendence; for others, morbidity. Rothko himself must have been among the latter, for he committed suicide not long after finishing them.

rotolus
A long manuscript roll or SCROLL.

Rouault, Georges
1871–1958 • French • painter • Expressionist

In Paris there were hours in Braque's outlandish studio above the roofs of Montmartre, visits with Matisse in his garden at Calmart, talks at the Gustave Moreau Museum with Rouault, pale and pinched, to whom Quinn had been regularly sending $600 a year above his purchases. (Aline Saarinen, 1958)

With forms delineated by thick black outlines that are filled with intense color, Rouault's paintings immediately call to mind STAINED GLASS windows. The connection is not accidental, as Rouault was apprenticed to a stained-glass artisan in his youth. As were many artists of his time, Rouault was much affected by injustice and by the bourgeois complacency that overlooked it. Prostitution seems to symbolize the social decay that absorbed him, and he painted prostitutes with bitter repulsion, rather than with the sympathy expressed by other artists of the era (e.g., TOULOUSE-LAUTREC). Later, religious paintings, taken from the Gospels, as well as clowns and saints, were his subject. *The Old King* (1916–36), with its heavy black outlines, thickly laid-on paint, and sense of tragedy, is among his best-known works. MOREAU's favorite student, Rouault was the first curator of the museum in Paris devoted to his teacher's work. It was there that the American patron and collector John Quinn, following his art world itinerary, went to visit Rouault, as described

by Saarinen in the passage quoted above.

Rousseau, Henri

1844–1910 • French • painter • "Naive"/Personal fantasy

The hungry lion, throwing himself upon the antelope, devours him; the panther stands by awaiting the moment when he, too, can claim his share. Birds of prey have ripped out pieces of flesh from the poor animal that sheds a tear!

In the words quoted above, Rousseau described *The Hungry Lion* (1905), which was on exhibit at the SALON D'AUTOMNE of 1905. Works by MATISSE, DERAIN, BRAQUE, ROUAULT, VLAMINCK, DUFY, and others hung nearby. It was this SALON at which the critic Louis Vauxcelles first used the word "fauves," or "wild beasts," to describe the paintings he saw, and thereby named a new movement (see FAUVE). It is often said that Rousseau's *Hungry Lion* is what prompted Vauxcelles's comment. Rousseau was mythologized, primarily by the poet/critic APOLLINAIRE, who told this anecdote: "Rousseau had so strong a sense of reality that when he painted a fantastic subject, he sometimes took fright and, trembling all over, had to open the window." Traditionally called *douanier,* which means customs inspector, Rousseau was never that. Rather, he was a *gabelou,* an employee of the municipal toll service. Putting aside diverse erroneous stories, he was an untutored, unsophisticated "Sunday painter" who left his job and lived in poverty to devote himself to his avocation. He found the animal and botanical specimens that he painted at the Jardin des Plantes in Paris. Those who saw his work marveled at it and urged him to keep his "naiveté." Though he admired the ACADEMIC painters of the Salon, its juries rejected him. He exhibited at the unjuried Salons, which he commemorated in his 1906 painting, *Liberty Inviting Artists to Take Part in the Twenty-second Exhibition of the Société des Artistes Indépendants.* Many of Rousseau's paintings are of lions and other wild animals, and they are usually more peaceable than *The Hungry Lion,* described above. On the frame of *The Sleeping Gypsy* (1897) Rousseau inscribed, "The feline, though ferocious, is loath to leap upon its prey, who, overcome by fatigue, lies in a deep sleep." This is his best-known work and, naiveté notwithstanding, it is extremely sophisticated—the lion's tufted tail, juxtaposed with the full moon, somehow distributes and anchors the weight of the figures below. The colors, placement of forms, and the inexplicable mystery of the event portrayed contribute to making this one of the most unforgettable pictures in the Western world.

Rousseau, Théodore

1812–1867 • French • painter • Barbizon School

Good God, what endless talk to say that in art it is better to be honest than clever! But the times belong to the spiteful, and we talk to the mute and the deaf.

Rousseau and other BARBIZON SCHOOL artists had been painting landscapes for some 30 years and were professionally recognized, though not popular, when he made the comment above. It con-

cluded his answer to a critic's question regarding his preference for the work of INGRES or of DELACROIX. Rousseau was equally emphatic in explaining that he chose Delacroix despite "his exaggerations, his mistakes, his visible failures, because he belongs only to himself, because he represents the spirit, the form, the language of his time." That Rousseau "belonged to himself" is implicit: After the mid-1830s, his republican sympathies excluded him from showing in the SALON. His politics having ended his career in a conventional sense, he cultivated the position of outsider and protester. His *Oak Trees in the Gorge of Apremont* (1850–52) looks like a family portrait of magnificent trees. In fact the oaks, near a house Rousseau owned, were endangered by plans to introduce a pine plantation where they stood. BAUDELAIRE, George Sand, and THORÉ (with Baudelaire, an important art critic) came to his support. Despite his left-wing inclinations and those of his literary supporters, Rousseau's clients were rich and conservative, and included Baron Nathan de Rothschild. Rousseau himself was very well-to-do: His studio was in one of the richest sections of Paris, he attended the opera regularly, and he collected rare coins. At the same time, he painted and promoted the undeveloped landscape and humble rural peasant. As the historian Gary Tinterow writes, "There was a dramatic dichotomy between the life Rousseau led and the vision he promoted." MILLET was Rousseau's closest friend, and at his bedside when he died.

Royal Academy of Arts
See ACADEMY

Rozanova, Olga
1886–1918 • Russian • painter • Constructivist

Only modern Art has advocated the full and serious importance of such principles as pictorial dynamism, volume and equilibrium, weight and weightlessness, linear and plane displacement, rhythm as a legitimate division of space, design, plane and surface dimension, texture, color correlation and others. Suffice it to enumerate these principles . . . to be convinced that they are the qualitative . . . New Basis which proves the "Self sufficient" significance of the New Art. They are principles, hitherto unknown, which signify the rise of a new era in creation— an era of purely artistic achievements.

Rozanova's CONSTRUCTIVISM follows the "truth-to-materials" dictate of TATLIN in the use of paint itself. Her remarkable, small (just over 2 feet high) *Untitled (Green Stripe)*, 1917, covers a canvas with cream-colored paint and a thick green stripe down the center. The surface is textured and patterned, and derives its entire character from the very paint-ness of paint: its color and substance, its intrinsic qualities expressed according to how thickly/thinly, heavily/lightly, up and down or at an angle it has been applied to the canvas. Needless to say, the canvas, too, with its particular weave, size, and any other intrinsic quality, expresses its own material presence. This painting anticipated NEWMAN's work some 30 years later. Rozanova threw herself into the Russian revolutionary spirit and collapsed in an aerodrome while putting

up posters to mark the first anniversary of the October Revolution.

Rubenistes
See LINE VS. COLOR

Rubens, Peter Paul
1577–1640 • Flemish • painter • Baroque

I do not know what to praise most in my friend Rubens: his mastery of painting . . . or his knowledge of all aspects of belles lettres, or finally, that fine judgment which inevitably attends such fascinating conversation.
(Gaspard Scioppius, 1607)

Because the vastness as well as the variety of Rubens's accomplishments is daunting, it is instructive, if not sobering, to note his inauspicious background. His father, Jan, a lawyer, became a Calvinist and was forced to flee Antwerp when the city became Catholic under the Spanish in 1568. (Peter Paul was born in Westphalia.) Jan was convicted of adultery with his employer, Anne of Saxony, Princess of Orange, and sent to the castle's dungeon. As one historian has commented, "Letters from Rubens's mother . . . written to her jailed husband and in entreaty to the House of Nassau suggest that Rubens may have inherited his strength and nobility of character from his mother." Returning home to Antwerp with his mother after his father's death, Rubens apprenticed with three different artists and then traveled to Italy, where he avidly studied the works of the major Italian artists, from CARAVAGGIO and CORREGGIO to MANTEGNA, and also the art of ANTIQUITY. His clients were among the nobility,

and in 1603, when he was 26, one of them, Vincenzo GONZAGA, duke of Mantua, sent him to Spain on his first mission as a political ambassador. He returned to Antwerp at his mother's death in 1608 and became court painter to the Archduke Albert and his wife Isabella, with special permission to remain in Antwerp (the court was at Brussels). Well mannered, with many languages and social graces, he would later receive more diplomatic assignments. His favored position enabled him to sidestep the local GUILD and freely establish his immense studio, exempt from registering his students. Thus, although it is believed that he had a great many assistants, the number is uncertain. Contemporary accounts describe a busy scene in which numerous young men worked on paintings for which Rubens had made sketches and to which he would apply the finishing touches. Meanwhile, he had Tacitus read aloud to him as he painted, listened, dictated letters, and answered visitors' questions. His well-organized and highly efficient WORKSHOP was expanded to include a staff of printmakers who copied his paintings for REPRODUCTION (see also PRINT and PRINTING). Occasionally Rubens had to replace a painting that a client complained was unsatisfactory, but he reminded clients that if they wished something entirely by his own hand, that should be specified in the contract. As specialization had grown, so did collaboration, and Rubens frequently worked in partnership with others: Jan BRUEGEL, SNYDERS, JORDAENS, and van DYCK among them. It has been said that no artist in the southern Netherlands was unaffected by Rubens, and that is

probably accurate, if not an understatement. However, he was not primarily a successful entrepreneur; it must be stressed that Rubens was an inventive genius at his art. His figure paintings of nude women especially led to coinage of the term "Rubenesque." His portraits, while as exacting in details of fashion, fabric, and jewels, broke with earlier traditions of formality, first by inventing informal poses and then by his sensitivity to the personality of his subject. His HISTORY PAINTINGS explode with BAROQUE energy and powerful illumination, their composition frequently exploiting a diagonal movement that increases their energy. This is true of two of his major ALTARPIECES, *Raising of the Cross* (1610–11) and *Descent from the Cross* (1612–14). In both, the overwhelming presence and muscular tension of the bodies are unmistakable, yet Christ seems both physically solid and weightless at the same time. Rubens was a devout Catholic, closely associated with the Jesuits. He was also happily married—twice, in fact; after his first wife died, he remarried in 1630, at the age of 53. His bride, Hélène Fourment, was 16. She was his model for several paintings, including the well-known, full-length image of a nude in a fur coat, *Het Pelsken* (*The Little Fur*, or *Venus*, c. 1635–39).

Rublëv, Andrei
c. 1370–1430 • Russian • painter • Late Byzantine

In the spring of that year [1405] the stone church of the holy Annunciation in the Grand Prince's palace—not the one that is standing now—began to be painted. The masters were the Greek

icon painter Theophanes, the elder monk Prokhor from Grodets and the monk Andrej Rublëv. They finished the same year. (Trojtskaja Chronicle, 1408)

The *Trojtskaja Chronicle,* quoted from above, was composed in Moscow, where Rublëv worked with and was influenced by THEOPHANES the Greek. Rublëv went on to develop an individual style and become a highly renowned Russian artist. Best known is Rublëv's *Old Testament Trinity* (c. 1410). It was made to hang on an ICONOSTASIS—the screen that divides the sanctuary of an Orthodox church from the rest of the interior. Rublëv's vivid colors, strong enough to be seen in candlelight and through the smoke of incense, were also sophisticated juxtapositions of complementary colors: blue and green folds of DRAPERY contrasted with a red robe and gilded wings. This picture of three graceful angels seated around a table illustrates the biblical story of Abraham and Sarah welcoming three strangers who were, in fact, divine beings. It serves as a prefiguration of the Holy Trinity (see TYPOLOGY).

Rude, François
1784–1855 • French • sculptor • Romantic

"Who is persecuting me?" growled the painter [Ingres], who hated interruption. "It is a river-god who is waiting," answered [Madame Ingres], who had taken Rude for a model. (Philip Gilbert Hamerton, 1878)

The dialogue quoted above is reported by Hamerton in his brief biography of Rude to describe the sculptor's appear-

ance in advanced age. Rude had a "vast white beard," as alluded to in the "river-god" description. His friendly visit to INGRES aside, Rude was more aligned with the impassioned style of Ingres's rival, DELACROIX, than with his host's cool NEOCLASSICAL style. This is evident in the fervently nationalistic high RELIEF he sculpted for the Arc de Triomphe in Paris. The work, popularly known as "La Marseillaise," though officially named *The Departure of the Volunteers in 1792* (1833–36), seems related to the HELLENISTIC frieze at Pergamon (see PERGAMENE SCHOOL). Rude dramatized the idea of French volunteers heroically marching off to defend the borders of the Republic against foreign enemies in the 1792 revolution; his own father had been among the volunteers whom the sculpture commemorated. François Rude had supported Napoleon's return from Elba and left France to live in Brussels for 12 years of the Bourbon Restoration. The Arc de Triomphe project was Louis Phillipe's effort at national reconciliation. While some of the troops Rude carved are in the heroic nude tradition, he dressed others in CLASSICAL armor. The patriotic group is surmounted by a winged female, the "Genius of Liberty," who, though fully robed and armed, nevertheless brings to mind the spirit of Delacroix's *Liberty Leading the People* (1830). Later, Rude made a bronze statue, *Napoleon Awakening to Immortality* (1845–47), which depicts the hero roused from his slumber on a rock, below him the corpse of an imperial eagle whose wings resemble those of his "Genius of Liberty." It is one of the most tremendous sculptures of the 19th century.

Rudolph, Paul

1918–1997 • American • architect • Modern

Why can't we enjoy design? Why not picturesqueness? Why do we have to be so grim?

Rudolph was one of the two (with KAHN) most influential architects of the 1960s. His authority derived from his own works and through his position as head of Yale University's School of Architecture from 1957 to 1965. His design for the Art and Architecture building at the New Haven campus (1960–63) is one of his best known. This austere, textured-concrete structure was set on fire in the 1960s by students who saw its design as symbolic of the administration's suppression of creative life on campus. If his work, and that of his teachers (he studied under GROPIUS at Harvard University), lost favor, it was in part because he was too rigorously grouped with the BAUHAUS style that he, in fact, abandoned. That is the import of the words above, spoken in an address to the American Institute of Architects in 1950, as reported by a Harvard classmate of Rudolph's. The Yale building was less brutal than sculptural on the exterior, and more inventive than severe: Within its 10 stories he nested 37 levels of interlocking space, changing levels and ceiling heights, and playing wide and narrow and large and small areas against one another. Fossils and shells were embedded in the walls, and plaster casts of CLASSICAL sculpture were discreetly placed. Joseph Giovannini, a student of Rudolph's at Yale, speaks of "the symphonic complexity of his composition, conceived at a time

when simplicity was the cardinal virtue."

Ruisdael (also Ruysdael), Jacob van

1628/29–1682 • Dutch • painter • Baroque

While the weather in van Goyen's pictures makes you feel: it's going to rain, you feel with Ruisdael's rather: it's been raining, a fresh breeze has driven the rain away. (Max J. Friedländer, 1949)

In the mid-17th century, building on earlier landscape painting that was strongly influenced by Italian style (see ELSHEIMER), a new and different vigor became apparent in Northern European painting, especially in the work of Ruisdael. He was interested in a variety of geographic features, from sand dunes near his home in Haarlem to the dramatically wooded countryside near Germany. He painted thickly, in IM-PASTO, and boldly, turning trees into players in a windy drama. Ruisdael's work represents the classical phase of Dutch landscape painting, in which the atmospheric effects earlier achieved with TONAL PAINTING are combined with a more structured composition. In *Bentheim Castle* (1653), a hill rises from the right of the canvas to peak in the left quadrant—an asymmetrical but diagonal, BAROQUE movement. The *Jewish Cemetery* (two versions, both c. mid-1660s) is an imaginary scene filled with the power of untamed nature: stormy sky, ruins of a church in the background, one broken and another strangely gesticulating tree in the foreground, and three tombstones, one bathed in eerie light. The theme is the transience and vulnerability of civilization and religion. But the mood is not entirely morose, for in the distance a rainbow arcs onto the scene. This painting foretells the awe of the SUBLIME that would be formulated in the next century. There is another, equally awesome side of Ruisdael's landscape. In *View of Haarlem* (c. 1675), the flat horizon is barely interrupted by the distant skyline of the city, the bright blue, cloud-filled sky owns the canvas, filling two-thirds of it, and beneath the moody sky, people too tiny to distinguish spread on the ground long strips of fabric to be bleached in the sun. The juxtaposition of human fragility and the power of nature is again intense, and once more Ruisdael holds out promise, now in patches of sunlight that shine on the ribbons of white, the symbol of human labor. To the description quoted above FRIEDLÄNDER adds, ". . . in him Dutch landscape-painting reaches its peak. In this I am at least obeying the idea of him that has become current—indeed, something of a convention."

Runge, Philipp Otto

1777–1810 • German • painter/theorist • Romantic

. . . each leaf and each blade of grass teems with life and stirs beneath me, all resounds together in a single chord. . . . I hear and feel the living breath of God who holds and carries the world, in whom all lives and works; here is the highest that we divine—God!

Northern Germany and Scandinavia were the first places where the use of landscape to express spirituality was found. Runge and his contemporary,

FRIEDRICH, received their early training at the Academy in Copenhagen, where Jens Juel (1745–1802), a successful portraitist as well as a landscapist, taught. Runge wanted to develop a new art of symbolic forms and color—he wrote a treatise on color theories from which GOETHE borrowed—and often used childlike genies as well as flowers to express the manifestation of the Divine and the sense of ecstasy when "everything harmonizes in one great chord." His unfulfilled ambition was to create a series, *The Four Times of Day,* for a chapel dedicated to the new mystical religion of nature that he followed, and that is suggested in the quotation above. He died at 33 with only a small part of his visionary project completed. In *Morning* (1808), genie-like infants emerge from the blossom of a great white lily—a symbol of divine knowledge and purity. The goddess Aurora walks on air above the earth where a baby, alluding to the Christ child, lies on a bed of flowers. This combination of pagan and Christian mythology has a transcendent radiance of light and color. Runge's highly personal symbolism was difficult for others to appreciate, and he spent the final seven years of his life in Hamburg, supported by his brother.

Rush, William

1756–1833 • American • sculptor • Neoclassicist

Few Citizens of Philadelphia are more deserving of commendation for their excellence in their profession than this gentleman, as a shipcarver. (John Watson, 1845)

A woodcarver in the craft tradition, Rush worked in Philadelphia and received commissions for a number of ship's figureheads for which Watson, quoted above, acknowledged him in the *Annals* of Philadelphia. Aspiring to a more "elevated" career, Rush became one of the founders, with PEALE, of the Pennsylvania Academy of the Fine Arts in 1805. *Water Nymph and Bittern* (c. 1809), a sculpture carved in wood and painted white to imitate marble, was for a fountain outside a small NEOCLASSICAL pump house, the Fairmount Waterworks, that brought in water from the Schuylkill River. The pump house was designed by LATROBE. Rush's sculpture, and the crowd in the surrounding park gathered to celebrate Independence Day in the Early Republic, was first immortalized by John Lewis Krimmel (?–1822) in the painting *Fourth of July in Center Square, Philadelphia* (1810–12). (The picture also contains a moralizing statement in that the scene is half in full sun and half in shadow, and those revelers in the shadow are clearly imbibing of spirits while the figures in sunlight—including Rush's sculpture—the more finely dressed, are sober and well mannered. Interestingly, while a naughty little black child is in the shade, a black couple, standing near the fountain, is not.) A contemporary commentator wrote, "We are much gratified that Mr. Rush begins to employ his chisel on subjects more durable, and more likely to perpetuate his fame, than those he has in general hitherto executed." Ironically, the wood rotted in the fountain's spray and Rush was all but forgotten until EAKINS painted *William Rush Carving His Allegorical Figure of the Schuylkill River* in 1877.

For his research, Eakins had both Krimmel's painting and a bronze cast that had been made at mid-century.

Ruskin, John
1819–1900 • English • writer/painter • Romantic

Great nations write their autobiographies in three manuscripts: the book of their deeds, the book of their words, and the book of their art. Not one of these can be understood unless we read the two others; but of the three, the only quite trustworthy one is the last.

Though Ruskin was an accomplished artist, his importance was as art critic and social reformer, and the sweep of his tone is embodied in the quotation above. He grew up in a privileged atmosphere where he could give himself over to contemplating what was beautiful and unique in art. Even before he entered Christ College, Oxford, Ruskin had published essays on natural science and art and had written in defense of the artist he held above all others, TURNER. After leaving the university, he continued his writings about Turner, and in the preface to the third edition of *Modern Painters,* Volume I (1873), Ruskin wrote, "The work now laid before the public originated in indignation at the shallow and false criticism of the periodicals of the day on the works of the great living artist [Turner] to whom it principally refers." GOMBRICH wrote about *Modern Painters,* "This vast treatise is perhaps the last and most persuasive book in the tradition that starts with Pliny and Vasari in which the history of art is interpreted as progress toward visual truth." To Ruskin, with

his ROMANTIC vision, the artist was meant to be a seeing, feeling creature, "an instrument of such tenderness and sensitiveness that nothing shall be left unrecorded." Ruskin did much to free art from the grip of NEOCLASSICISM. Following the publication of his earlier book, *The Stones of Venice* (1851–53), where he fervently advocated the use of GOTHIC architecture as the true Christian style and described the CLASSICAL Roman examples as pagan and debased, the fashion for forming collections of ancient Roman sculpture faded. Ruskin's indictment of industrialization, mass production, and the resultant social and economic problems was also influential. He was an enthusiastic champion of the PRE-RAPHAELITES, many of whom were inspired by him. William MORRIS was among his followers. Ruskin's personal life collapsed in a kind of tragicomedy. His marriage was annulled on the ground that it was not consummated (his "wife" then married MILLAIS), sordid involvement with young women led to one of them committing suicide, and he lost, on principle, a famous libel case brought against him by WHISTLER, whose work Ruskin had described as "flinging a pot of paint in the public's face."

Russell, Morgan
1886–1953 • American • painter • Modern/Synchromist

The word was born . . . by my searching a title for my canvas . . . at the Salon—a title that would apply to painting and not to the subject. My first idea was . . . Synphonie but . . . I found that Syn was "with" and "phone" sound—the word

*"chrome"... immediately flashed in
my mind ... and there you are.*

Among Russell's teachers was the ASH-
CAN painter HENRI, but he also studied
in Paris and was acquainted with mem-
bers of the avant-garde in literature as
well as art. About 1911, Russell collab-
orated with MACDONALD-WRIGHT, and
it was Russell who exhibited the first
SYNCHROMIST painting. His best-
known work, *Synchromy in Orange: To
Form* (1913–14), evolved from a draw-
ing of MICHELANGELO's sculpture
Dying Slave (1513–16). This origin re-
mains visible in Russell's shaping of the
forms containing segments of orange,
red, blue, and green patches. They are
structured in curves that echo the ex-
travagant CONTRAPPOSTO of Michelan-
gelo's slave.

Ruysch, Rachel

1664–1750 • Dutch • painter •
Baroque

*As the creator of pictures of perfect
beauty she was heaped with
commissions and honours, but her
poise never altered. She never
succumbed to flattery and demand, but
continued to work as fastidiously as
ever.* (Germaine Greer, 1979)

Flower paintings by Ruysch, a native of
Amsterdam, were held in high esteem
and earned her a fortune as well as
fame. During the 60-odd years of her
working life, flower STILL LIFES gained
and then declined in popularity. She
and her husband, Juriaen Pool (1665–
1745), a portraitist, were court painters
to the Elector Palatine in Düsseldorf
from 1708 until the prince's death in
1716. Ruysch's style, in line with that of

her teacher, Willem van Aelst (c.
1625–c. 1683?), was to construct asym-
metrical bouquets in a sort of S-curve.
These were set against a dark back-
ground and rendered clearly and pre-
cisely, in rich colors. Her family
encouraged her interests, and her fa-
ther, a well-known professor of botany
and anatomy, was also an amateur
painter. (Her mother was an architect.)
The flowers by Ruysch and other Dutch
flower painters are, for the most part,
cultivated specimens, often from a hot-
house rather than the garden. They thus
signify privilege and wealth as well as
scientific interest: During the 17th cen-
tury, just about every ship captain who
left Holland had instructions to bring
back botanical specimens. The first
botanical gardens had been founded in
Holland at the end of the 16th century,
and the process of observation, classifi-
cation, and botanical drawing flour-
ished. Rare specimens of flowers were
coveted—tulips, introduced from what
is now Turkey, became a stock market
commodity. This brought about an eco-
nomic disaster known as tulipomania.
Perhaps Ruysch was attentive to the
symbolic meaning of the particular
flowers in her bouquets, and perhaps,
as did painters of VANITAS still lifes,
she made reference to the transience of
life, but she seems to have been most in-
terested in the meticulous representa-
tion of her subjects with the most
skilled, perfect artistry that could be
achieved. A close look at *Roses, Con-
volvulus, Poppies and Other Flowers in
an Urn on a Stone Ledge* (c. 1745) re-
veals moths, butterflies, beetles, and
other bugs so that the picture is really
not still at all, but, rather, teeming with
life.

Ryder, Albert Pinkham

1847–1917 • American • painter •
Visionary

*I saw nature springing into life upon
my dead canvas. It was better than
nature, for it was vibrating with the
thrill of new creation. Exultantly I
painted until the sun sank below the
horizon, then I raced around the fields
like a colt let loose, and literally
bellowed for joy.*

Ryder had a strange, haunting, individual style. He is often grouped with another American of the period, BLAKE-LOCK, because both painted unsettling landscapes in eerie light and built them up in thick IMPASTO. Ryder developed an increasingly original technique, applying layer upon layer, constantly reworking a picture and using not only paint but other substances such as grease, candle wax, and BITUMEN as well. The end result was unstable paintings that simply decompose themselves—fall apart—a conservator's nightmare. Ryder's approach was to simplify shapes so that they become geometric forms, and in this he became a tremendous influence on MODERN artists, who regarded him with reverence. His was a struggle to describe the source and depth of his very core of being. "Have you ever seen an inch worm crawl up a leaf or twig, and then clinging to the very end, revolve in the air, feeling for something to reach something? That's like me. I am trying to find something out there beyond the place on which I have a footing," he said. His paintings, most of which are night landscapes or seascapes—he was born in coastal New Bedford, Massachusetts—are mysterious, evocative, and scary (e.g., *Moonlight Marine*, 1880s, and *Toilers of the Sea*, c. 1882), as if haunted by all the sailors who left New Bedford and never returned. The more famous and well off Ryder became, the more eccentric, bedraggled, and reclusive he was, living in poverty and walking the back streets of New York City at night.

S

Saar, Betye
born 1926 • American • mixed media • Pluralist

. . . everywhere there are secrets and everywhere revelations.

Saar, a Californian who raised three children before she returned to school for her teaching credentials, was greatly influenced by an exhibit in Pasadena, in the late 1960s, of CORNELL's boxes. She, too, used mostly found objects and small shadow-box-like constructions to present ideas about African-American life. Humor and pain are combined in *The Liberation of Aunt Jemima* (1972). Roughly 8 by 12 inches, the advertising "Mammy" stereotype of Aunt Jemima is wickedly and wonderfully subverted. The old figure of smiling Jemima with a bandanna on her head turns leering and dangerous, holding shotguns. The 1970s was a decade filled with art often called PLURALIST because it was not characterized by the emergence of a single new style. On the other hand, new political and social consciousness drove much of it. FEMINIST thought and art had a commanding role, and encouraged the examination of exploitation, racism, discrimination, and sexism on many fronts. Saar's Feminist and antiracist images included an exploration of fetishism and voodoo images, mysteries, and rituals, as in the quotation above.

Saarinen, Eero
1910–1961 • Finnish/American • architect • Modern

I think of architecture as the total of man's man-made physical surroundings. The only thing I leave out is nature. You might say it is man-made nature. It is the total of everything we have around us, starting from the largest city plan, including the streets we drive on and its telephone poles and signs, down to the building and house we work and live in and does not end until we consider the chair we sit in and the ash tray we dump our pipe in.

Son and partner of Eliel (see below), Eero was for a time an advocate of the INTERNATIONAL STYLE in architecture, but his interest in sculpture and an almost romantic expressiveness manifested themselves in his later architectural designs. This is apparent in the Trans World Airlines (TWA) Terminal (1956–62) at Kennedy International Airport in New York. The roof of the

building curves like the wings of a bird, and both the interior and exterior appropriately imply the concept of flight. It has, however, been called both beautifully sculptural and a hodgepodge of styles, perhaps because of the inclusion, in the interior, of heavy, GAUDÍ-like curving surfaces.

Saarinen, Eliel
1873–1950 • Finnish • architect • Modern

Indeed, at the time I began to think of architecture it was not considered an art in the part of the world which I knew.

The time to which Saarinen refers in the quotation above is the early 1890s. In searching for new expression, he came to advocate a national ROMANTICISM that manifested itself in a Finnish version of the ARTS AND CRAFTS movement. He persisted in his studies and travels, and became the leading Finnish architect and an inspiration to AALTO, among others. His best-known design in Finland is the railway station at Helsinki (1904–14). Saarinen entered a competition in 1922 to design a skyscraper known as the Chicago Tribune Tower for one of that city's newspapers. While the elegant look of its facade was MEDIEVAL, it was more MODERN in appearance than the forthrightly GOTHIC detailing in the design by Raymond Hood (1881–1934), who won the commission. Saarinen took second place. He moved permanently to the United States in 1923 and became director of the Cranbrook Academy in Bloomfield, Michigan, which he also designed. The school still specializes in all facets of design, including industrial, interior, and furniture. Saarinen's popularity rivaled that of Frank Lloyd WRIGHT. His son, Eero (see above), joined his father's practice in 1937.

Sacchi, Andrea
c. 1599–1661 • Italian • painter • Baroque

. . . a master whose great worth is well known. (Bellori, c. 1625)

BELLORI's appreciation of Sacchi had much to do with Sacchi having taught MARATTA, Bellori's favorite painter. Sacchi was renowned in Rome not only for his painting but also for his "argument" with CORTONA at the Academy of Saint Luke in Rome. The controversy was a theoretical question about whether large paintings with numerous figures—*grandi opere*—were better, as Cortona believed, than those with just a few figures—Sacchi's preference. Sacchi supported the doctrine of UT PICTURA POESIS—using the example from Greek poetic tragedy in which the greatest effect was achieved by a minimum number of actors. While it is not certain that the debate between Sacchi and Cortona actually took place, its topic was one of significant concern. Both artists decorated the BARBERINI palace where Sacchi was employed and housed, initially along with three slaves, a gardener, a dwarf, and an old nurse. But by the end of his stay, Sacchi's improved status elevated him to a rank alongside writers, poets, and secretaries. His ceiling FRESCO *Divine Wisdom*, painted in 1629–31 (in which the Sun, blazing forth from Wisdom's breast, was one of the Barberini family insignias), is in cool

and subtle blues, greens, and grays, a distinct contrast to Cortona's ceiling in the same palace.

sacra conversazione (sacred conversation)

Named well after it had become a convention in its own right, *sacra conversazione* refers to a type of image of the seated Madonna and Child in which she is flanked by saints who sometimes, although not always, seem to be talking with one another. The origin of such a group is uncertain, but an early precedent was the *Madonna and Child Enthroned with Saints* painted by Fra ANGELICO as an ALTARPIECE for the church of the San Marco Monastery in Florence (c. 1440–45). One of the most spectacular examples, by Giovanni BELLINI, was the center panel for his *San Giobbe Altarpiece* (c. 1480). This is a towering monument, more than 15 feet high, painted on wood, with the Madonna enthroned above figures who include Saint Francis and Saint Sebastian. The art historian John Shearman traces several outstanding examples of the *sacra conversazione,* often the center of an altarpiece, and discusses who commissioned them and their original placement in a church or chapel. He demonstrates how, through gesture and glance, spectators on the outside, looking at the work (originally, no doubt, patrons who contracted for the painting), are addressed by figures inside the picture and are thus, in effect, drawn into the Virgin's retinue. He goes so far as to say that in certain instances the dynamic of a scene makes no sense until we, the viewers, are factored in to complete it.

Saenredam, Pieter Jansz.

1597–1665 • Dutch • painter • Baroque

I made this sketched drawing from a big and neat drawing, which I had drawn from life as perfectly as possible on a medium sheet of paper 15½ kermer foot measurement high and about 20 inches of the same measurement wide in the year 1641 on the 15th, 16th, 17th, 18th, 19th and 20th of July working on it assiduously from morning 'till night.

Local SCHOOLS of Dutch painting were usually characterized by a dominant style, and mention of 17th-century Haarlem brings to mind HALS and his followers. However, at least at first glance, nothing could be further from the lively portraits and scenes of everyday life that Haarlem conjures up than paintings by Saenredam. Known primarily for imposing, whitewashed church interiors with scrupulous details and tiny figures, his paintings evoke a luminous serenity within an elaborately constructed PERSPECTIVE. He has been called the "first portraitist of architecture," and in following that analogy we discover that, as in looking at human portraits, a careful, informed consideration is extremely revealing. In the interior of Saint Bavo at Haarlem, painted in 1630 (a church he painted several times; this version is at the Louvre), Saenredam included a tomb with a sculpture of a kneeling bishop, and a plaque behind it. Neither was ever actually in the church, even when it was a Catholic place of worship—Catholicism was forbidden in Haarlem as of 1581. This and other anomalies—for





example, why he painted details, such as chandeliers, that had not yet been installed—may be explained only by conjecture. As part of his process, Saenredam made exactly measured drawings (as he described above) that were sometimes traced onto the canvas after being turned into more precise perspective studies. As his panoramic views encompass more than what a single person could see from one point, his perspectival method is another subject of study. It is known that Saenredam was a hunchback and a cripple, and that he was buried in Saint Bavo, the church whose measure he took so often.

Sage, Kay
1898–1963 • American • painter • Surrealist

I have no comments to make about the arts of today and know nothing of the origins of "Suspension Bridge for the Swallows" except that I painted it. I have no particular reason for painting anything except that I see it in my mind and have a desire to transfer it to canvas.

For the most part self-taught, Sage drew and painted constantly. Her first solo exhibit was in Milan in 1936. She was influenced by de CHIRICO while she lived in Italy during the first half of her life. She then went to Paris and met TANGUY, whom she married in 1940. They lived together in Woodbury, Connecticut. A year before Tanguy's death, a joint retrospective of their work was held at the Wadsworth Atheneum in Hartford, Connecticut. In the SURREALIST vein, her landscapes are vast, empty spaces with inexplicable shadows and strange structures sharply drawn. Both dreamlike and more unreal than any dream, *In the Third Sleep* (1944) is one such painting. Sage wrote poetry throughout her life, and five volumes of her poems were published. The passage quoted above, written in 1959, was in answer to a letter requesting her thoughts on "the arts today."

Saint-Gaudens, Augustus
1848–1907 • American • sculptor • Realist

I have dwelt at considerable length on the likeness of Saint-Gaudens' work to that of an epoch which he has deeply studied and deeply loves, because it seemed to me that in that way only I could show its great technical merit; but it by no means follows that his work is not original. On the contrary, he could not show the spirit of the Renaissance if he were not strongly individual. (Kenyon Cox, 1908)

Saint-Gaudens grew up in New York City, where he was apprenticed to a cameo carver. Later he studied bronze casting at the ÉCOLE DES BEAUX-ARTS in Paris, and then spent several years in Italy. His ability to work at both tiny, delicate, very low RELIEF portraits and enormous freestanding memorials indicates his artistic range. He insisted that his monumental sculptures be more than simply the memorialized figure: He surrounded them with evidence of their moral or spiritual importance, using a pedestal or background wall to carry a pertinent symbol or inscription. The 1884–96 *Robert Gould Shaw Memorial* in Boston, the inscription on which reads ". . . they gave proof that

Americans of African descent possess the pride, devotion and courage of the patriot soldier," is one of his greatest accomplishments. This young, white Civil War officer who led an African-American regiment against insurmountable odds and died at the head of his troops rides his steed with rigid dignity, much as is portrayed the subject of DONATELLO'S EQUESTRIAN statue *Gattamelata*. This is not, however, a freestanding monument, but is more like a gigantic shadow box. The variation from the nearly freestanding Shaw to the shallow-carved Angel of Death against the background wall is a tour de force (see RELIEF). Equally heroic, in its very different way, is a bronze memorial to the wife of his good friend Henry Adams (*The Adams Memorial,* 1886–91), who had committed suicide. The struggle for a means to portray such grief took Saint-Gaudens five years to resolve, but the result is unsentimental: A massive, seated figure, enveloped in a shroud that does not quite cover her face, the figure is a synthesis of unbearable sorrow and eternal rest. A contemporary appreciation of Saint-Gaudens by COX is quoted from above.

Saint Phalle, Niki de
Born 1930 • French/American • sculptor • Feminist

I wanted the outside world to be mine, also. Very early I got the message that MEN HAD POWER AND I WANTED IT./ YES, I WOULD STEAL THEIR FIRE FROM THEM. I would not accept the boundaries that my mother tried to impose on my life because I was a woman.

There is a playful absurdity in much of Saint Phalle's works. The *Nanas*, for example, are large female figures, unshapely but full of movement. They were built up on chicken-wire frames covered with fabric and yarn. One *Nana* of c. 1965 is exceedingly buxom with a small head, and is covered with hearts of different colors and designs. The largest heart shape is in the center of her bosom and is filled with daisies. Saint Phalle was married to TINGUELY, with whom she collaborated on several works, of which the giant *Hon* (1966), a massive reclining woman whose interior was a playground, may be the best known. Saint Phalle's *Tarot Garden* in Tuscany, which she worked on during the 1990s, is a collection of twenty-two enormous, colorful sculptures that are whimsical, strange, and sometimes as ominous as a grinning death's head.

Salle, David
born 1952 • American • painter/mixed media • Neo-Expressionist/appropriation

Everything in this world is simultaneously itself and a representation of the idea of itself. This was in a sense my big art epiphany. . . . The pleasures and challenges of simultaneity continue to be one of the driving forces in my life.

Salle has borrowed from everything: pornographic magazines, sex manuals, comic books, GÉRICAULT, COURBET, and JOHNS. In *Tennyson* (1983), a nude woman seen from behind stretches diagonally across a canvas that is well over 9 feet long. She is painted in ACRYLIC, her sand-colored flesh set

against a sandy beach. The word TEN-NYSON is printed across her body, and in a slash of turquoise blue on the left, a plaster ear is affixed to the canvas. All these images, or signs, simultaneously themselves and representations, as Salle says in the quotation above, are, or may be, references to other art works. For example, Johns used the name Tennyson in one of his paintings, and he used an ear in his painting of a target. The ear also brings to mind the self-mutilation of van GOGH. These associations are just a few that may lead the observer to experience the "pleasures and challenges" of which Salle speaks, although the reaction may be quite the opposite: As many people scoff at as admire his work, and he is among the more controversial artists in America.

Salon

Salon is the French word for a "living room" or "parlor", and by extension fashionable intellectual gatherings. That the term has also come to signify art exhibitions in Paris evolves from the history of the Louvre and its role as a place for showing art. In 1699, members of the Royal Academy (Académie Royale de Peinture et de Sculpture), housed at the Louvre, obtained permission from Louis XIV, who had established his residence at VERSAILLES, to use the Grande Galerie at the Louvre for a public exhibition of its members' work. The exhibit was a great success and beginning in 1725 exhibitions were held at the end of the Grand Galerie, in the Grand Salon—the Salon Carré—from which the term "Salon" as art show derives. Salons were reviewed by well-known writers like DIDEROT in the 18th century and Stendhal (Marie-Henri Beyle, 1783–1842) during the 19th. After the Revolution, Salons were no longer controlled by the Academy, although the jury that selected pictures for exhibition (following ACADEMIC standards) was usually conservative nevertheless. During the 19th century the Salon left the Louvre for a building on the Champs-Élysées. In 1863, acknowledging protests by artists whose work had been turned down by the jury, Napoleon authorized the Salon des Refusés. The Salon des Refusés was mobbed by a public that came largely to deride the art, especially Manet's *Déjeuner sur l'herbe* (1863), but it is seen as a turning point toward the beginning of MODERN ART. Despite dissenters, many artists still submitted to the official Salon, and by the early 1880s there were some 7,000 submissions, of which almost 4,000 were exhibited. In 1881 the Société des Artistes Français took over the running of the Salon from the government. Three years later a group (led by SEURAT and SIGNAC) broke away and founded the Salon des Indépendants, which enabled artists rejected by the official Salon to show their works. Henri ROUSSEAU, whose paintings never would have been seen by the public were it not for the Salon des Indépendants, commemorated it on canvas in 1906: *Liberty Inviting Artists to Take Part in the Twenty-second Exhibition of the Société des Artistes Indépendants*. Other groups continued to break away; in 1890 PUVIS DE CHAVANNES held the Salon du Champs de Mars (named for its location); MATISSE and BONNARD, the SALON D'AUTOMNE in 1903. The history of the French Salon, as of exhi-

bitions everywhere and throughout history (see ARMORY SHOW and DEGENERATE ART), reflects the continual struggle for acknowledgment, authority, and power between the continuously evolving establishment and the persistently challenging avant-garde. (See also EXHIBITION)

Salon d'Automne

The Salon des Indépendants (see above) played a vital role in French art from its foundation in 1884 until the mid-1890s. Then its importance waned, until MATISSE in 1901 and DUFY in 1902 were among the artists showing there. In 1903 the Salon d'Automne was founded by the architect Frantz Jourdain, the critic Ivanhoe Rambosson, and several painters, including ROUAULT and VUILLARD. The concept was to avoid the rigidity of the official, juried Salons and of the jury-free Indépendants, which were often overcrowded with insubstantial efforts. The new venture was sponsored by avant-garde artists who would rotate responsibility for jury duty. Moreover, they would hold exhibitions in the fall—in part because the Indépendants show was in the summer and in part to show painting made outdoors during the preceding summer. Many of those who had shown with the Indépendants supported the Autumn Salon, among them MATISSE, BONNARD, REDON, RENOIR, and CÉZANNE. It was at their 1905 exhibition, when Henri ROUSSEAU, VLAMINCK, and DERAIN joined them, that the FAUVE movement was named.

Salon de la Rose + Croix

In the competition for a spiritual as well as an artistic following, at the end of the 19th century an occult movement called Rosicrucianism was promoted by an extravagant extrovert, Joséphan Péladan, who invented for himself the mysterious honorarium Sâr. Named after a perhaps mythical 15th-century visionary Christian Rosenkreutz, Rosicrucianism had attracted an odd mix of moral and religious reformers and followers over the centuries, including René Descartes. Rosenkreutz was reported to have discovered the secret wisdom of the East on a pilgrimage, and it was claimed that Péladan, on his trip to the Holy Land, rediscovered the authentic tomb of Jesus in the Mosque of Omar. In 1892 Péladan started a SALON, named Rose + Croix based on the mystical brotherhood. The purpose of the Salon de la Rose + Croix was to promote SYMBOLIST art. Among Péladan's goals were to "ruin Realism," reform taste, and create a school of idealist art. HISTORY PAINTING was unacceptable, as were portraits; patriotic, military, and rustic scenes; landscapes or seascapes; and humor, flowers, and so forth. The "Catholic ideal and Mysticism" had highest priority, followed by Legend, Myth, Allegory, and the Dream. These Salons ran for five years, and while the major French Symbolists (e.g., MOREAU and REDON) did not exhibit there, the young ROUAULT, artists connected with GAUGUIN, members of the Belgian group Les XX (see Les VINGT), the Swiss artist HODLER, and the Dutchman Jan Toorop (1858–1928) did.

Salon des Indépendants

See SALON

Salon des Refusés

See SALON

Samaras, Lucas

born 1936 • Greek/American •
sculptor/photographer •
Modern/Assemblage

*I wait until dark before I take out the
camera. Fewer interruptions.
Nostalgia, cuddliness and other warm
feelings of the night envelop my psyche
and chase away logic, anxiety and the
needs of other people. I have the radio
or TV on as an emotionally steady
artificial waterfall. It camouflages
extraneous sounds from other
apartments.*

Born in Greece, Samaras became an
American citizen in 1955. The latent
horror of his early work is manifest in
Photo-Transformation (1973–74), in
which his own face is distorted into a
depraved menace, the epitome of evil.
He explored the concept of repeatedly
reflected images with *Mirrored Room*
(1966). He also uses familiar objects—
containers, books, mirrors, and string
—with objects that provide a sense of
danger: nails, knives, razor blades.
Sometimes these items are painted in
harsh colors.

San Vitale

The plan of the BYZANTINE Church of
San Vitale in Ravenna, commissioned
in 526 and dedicated in 547, is essen-
tially an elaborated octagon with a cen-
tral DOME area encircled by excedra, or
semicircular niches, which are, in turn,
encircled by an ambulatory or aisle. A
MOSAIC in the sanctuary apse (niche)
shows Christ seated on the globe. He is
flanked by Saint Vitalis, the 4th-century
Italian martyr for whom the church is
named, and Saint Ecclesius, the ARIAN
bishop of Ravenna who commissioned

San Vitale (as well as the Church of
Sant' Apollinare in Classe, Ravenna's
port). On an interior wall of San Vitale
a large mosaic (12 feet long) shows the
emperor Justinian in the center of his
retinue, churchmen and soldiers. On
the opposite wall is his wife, Theodora,
and her retinue. With oval faces and
large, staring eyes, all the figures are
forward-facing (FRONTAL), elongated,
and beautifully robed; Justinian and
Theodora are crowned and bejeweled.
These decorations exemplify the shim-
mering beauty of mosaic composition,
and they also have provoked lively dis-
cussion among art historians. Whether
they represent political affirmations of
Justinian's claims to "divine kingship"
as the earthly counterpart of Christ or
show a more self-effacing Justinian,
participating in the ancient pagan tradi-
tion of a processional offering to a god,
remains controversial. In either case, it
seems that Justinian and Theodora did
not attend the dedication ceremonies
for the Church of San Vitale, and may
not, in fact, have ever set foot in
Ravenna.

Sandrart, Joachim von

1606–1688 • German •
writer/painter/printmaker • Baroque

*I went to school in Frankfurt not far
from Uffenbach's house, and often did
him small service; whereupon, if he
was in a good mood, he would show
me these beautiful drawings of
[Matthias Grünewald] . . . which had
been assembled into a book.*

Known for his writing about art rather
than his own works. Sandrart's treatise
*Teutsche Academie (German Academy;
1675–79)* was modeled on precedents

set by VASARI and van MANDER; how-
ever, he had far less of a sense of history
than did Vasari. His text is interesting
mostly for its anecdotal information on
contemporary artists and because it
presents a picture of the taste in Euro-
pean aristocratic circles of the 17th cen-
tury. He does not shy away from being
both personal and judgmental. He re-
ported, for example, that van LAER was
melancholic, and that parents paid
REMBRANDT 100 florins annually to
teach their children. He also wrote that
Rembrandt earned up to 2,500 florins
each year from selling his students'
work; it has been said that Sandrart was
a man who liked to count other people's
money, and that he probably exagger-
ated. Sandrart's appreciation of GRÜNE-
WALD is expressed in the quotation
above, taken from his book, and he is
credited with having named Grünewald
as the painter of the famous *Isenheim
Altarpiece.*

Sangallo, Antonio da, the Younger
See SANGALLO below

Sangallo, Giuliano da
1445–1516 •
architect/engineer/sculptor • Italian
• Renaissance

*I learn from a letter sent by you that
the pope was angry at my departure,
that he is willing to place the money at
my disposal and to carry out what was
agreed upon between us; also that I
am to come back and fear nothing. . . .
Now you write to me on behalf of the
Pope, and in similar manner you will
read this letter to the Pope.*
(Michelangelo, 1506)

The letter Michelangelo wrote to Giu-
liano, quoted from above, concerned
MICHELANGELO's arguments with Pope
Julius II about his work on Julius's
tomb. Giuliano, also employed by the
Pope, was the favorite architect of
Lorenzo (the Magnificent) MEDICI, for
whom he designed the Villa Medici at
Poggio a Caiano in the 1480s. Giuliano
was devoted to the Early Renaissance
style of BRUNELLESCHI, with its symme-
try, simplicity and clarity. An outstand-
ing example of his work is the small
Church of Santa Maria delle Carceri
(1485–1492). It is the first ITALIAN RE-
NAISSANCE church with a true central
plan: a DOME above the square center of
a Greek cross of which the four arms
are each one-half the width of the
square. Giuliano's nephew, Antonio da
Sangallo the younger (1483–1546), was
also an architect in Rome. He was
RAPHAEL's assistant as architect at Saint
Peter's beginning in 1516, and after
Raphael's death he became the church's
chief architect. Upon his own death
Michelangelo succeeded him as arch-
itect of Saint Peter's. Antonio's most re-
nowned work is the prodigious Farnese
Palace in Rome which he began in 1519
and which was also completed by
Michelangelo.

Sansovino, Jacopo (also Tatti)
1486–1570 • Italian • architect •
High Renaissance/Mannerist

*The conceptions which spring from the
heights of your genius have added to
the splendors of the liberal city we
have chosen for our home. . . . Good
has sprung from the evil of the Sack of
Rome, in that in Venice, this place of
God, you carve your sculptures and*

construct your buildings. (Pietro Aretino, 16th century)

Jacopo adopted the name of the sculptor who trained him, Andrea Sansovino. He moved to VENICE after the sack of Rome in 1527 and became the city's chief architect. There had been little building of note in Venice since Saint Mark's Cathedral (begun in 1063), and Jacopo established a new, equally if not more extravagant idiom. As one might expect, his masterpiece, the State Library (begun 1537), is lavishly ornamented with sculpture: life-size statues along the rooftop, decorative garlands above the heavily adorned windows. The arcade at street level was inspired by the COLOSSEUM, and it is said that Sansovino subtly harmonized his building with the Doge's Palace, which stands across the Piazza San Marco. It might also be said that he combined as many rich decorations and conceits as he could reasonably assemble. It is little wonder that art historians have difficulty deciding how to categorize his style.

Santorini
See THERA

Sargent, John Singer
1856–1925 • American • painter • Aesthetic

A knock-down insolence of talent. (Henry James, 1870s)

Born in Florence to wealthy, cultured American parents, Sargent spent his life in Europe as an expatriate; he was 20 years old before he even visited the United States. Probably because he painted the international elite with little

of the reformist's social conscience, he is frequently marginalized as an artist lacking depth. An American art historian, Barbara Novak, has written that his reputation "will perhaps stabilize itself when he is excused for paintings like *The Wyndham Sisters.*" That is an 1899 portrait of three elegant ladies ensconced—seeming even to float—in billows of opulence: silk and satin, brocade, and flowers. It is a very large canvas, more than 9½ feet high and 7 wide, that portrays them in their drawing room, overseen by a full-length portrait of their mother, which is itself flanked by small, oval portrait heads: a family tree in full bloom. Providing an alternate point of view, the British critic FRY wrote, "Since Sir Thomas LAWRENCE's time, no one has been able thus to seize the exact cachet of fashionable life, or to render it in paint with a smartness and piquancy which so exactly correspond to the social atmosphere itself. Such works must have an enduring interest to posterity simply as perfect records of the style and manners of a particular period." (Shortly after Sargent's death, however, Fry wrote a scathing and damaging review of the artist.) A third perspective was expressed in 1994 by Trevor Fairbrother, a Sargent biographer, who endeavored to contemporize appreciation of the artist by casting him in a homoerotic context "prudishly avoided by most scholars." Sargent actually ran afoul of a quite different sort of prudish manners in Paris when he painted a famous society beauty in a deep-cut black dress as *Madame X* (1884). One narrow, jeweled strap had slipped off her shoulder in the original version, but Sargent adjusted that by repainting it after the pic-

ture's scandalous debut. After that, and a subsequent decline of commissions, Sargent moved from Paris to London. When he was selling *Madame X* to the Metropolitan Museum of Art some 30 years later, Sargent wrote, "I suppose it is the best thing I have done." Besides portraits and wonderfully moody scenes of Venice and Algiers, Sargent worked in WATERCOLOR, informal, experimental, and personal pictures that he called "snapshots" and "making the best of an emergency." These guarantee his standing as a watercolorist of the first order. It should be remarked that Sargent named VELÁZQUEZ as a great inspiration.

Sassetta (Stefano di Giovanni)
c. 1392–1450 • Italian • painter • Late Medieval/Early Renaissance

There is but one picture in European art which approaches this panel in its suggestions of an ecstatic harmony with the Spirit of all things. It is Raphael's Transfiguration. *I refer of course to the upper part only.* (Bernard Berenson, 1910)

Only 45 miles south of Florence, artists in SIENA were quite aware of the new rationality of the ITALIAN RENAISSANCE and its devotion to PERSPECTIVE and MODELING. But they and their PATRONS maintained their preference for the old style of pointed ARCHES, gold backgrounds, and extravagant decorative surfaces, on ALTARPIECES especially. Sassetta (an unexplained nickname) was a Sienese artist with a mystical bent that was well expressed in his paintings of Saint Francis for the Borgo San Sepolcro altarpiece (1437–44) on which

BERENSON heaped extravagant praise, an excerpt from which is quoted above. In the picture, the center PANEL of a large altarpiece, Saint Francis levitates above an azure sea, arms extended, eyes heavenward. His halo is inscribed with words that identify him as Patriarch of the Poor. Despite the pursuit of a style that Florentines considered passé, and without being scientific about it, Sassetta actually did produce believable depth of field and credibly weighty forms, although that was not his motivation—he was inspired by religious rapture. In the 20th century, Berenson's effusions were largely responsible for Sassetta's well-deserved popularity. It must be added, however, that Berenson himself owned the panel to which he accorded such superiority, first in an article and later in a book.

Savage, Augusta
1892–1962 • American • sculptor • Realist

I have created nothing really beautiful, really lasting. But if I can inspire one of these youngsters to develop the talent I know they possess, then my monument will be in their work. No one could ask for more than that.

As one of the youngsters she inspired was Jacob LAWRENCE, Savage's wish, expressed in the quotation above, came true. Yet that self-effacing comment contradicts another made to the same person, who arrived at Savage's apartment excited after having heard Marian Anderson sing: "I'm just as important, just as much an artist as Marian Anderson, and you don't act like that after being with me." If she was torn between

pursuing her own art and encouraging that of others, she was also thwarted by prejudice against her as both an African-American and a woman. She was, for example, denied the opportunity to apply for admission to a summer art school for American women because the idea of her traveling with whites was anathema to the judges. She pursued sculpting, receiving some support as well as discouragement. She was skilled at expressing character in her bronze portraits. Much of her work has been lost, but one fine sculpture is *Gamin* (1929), a fond likeness of a street-smart youth who wears his cap at a rakish angle and looks at the viewer with defiant curiosity: bravado combined with innocence and a whiff of anxiety.

Savonarola, Girolamo

1452–1498 • Italian • monk

The devil, through the instrumentality of wicked prelates, has destroyed the temple of God. . . . In the primitive Church, the chalices were of wood, and the prelates of gold. Now-a-days the Church has prelates of wood and chalices of gold.

A Dominican monk and religious reformer, Savonarola preached against the immoral excess he saw in Florence, as well as the rampant corruption in the Church. His impassioned sermons moved crowds of thousands to tears—his followers were known as *piagnoni*, "weepers," and under his influence they built great fires, known as Bonfires of the Vanities, to destroy things like musical instruments, playing cards, fancy clothes, and works of art. Enflamed

themselves by Savonarola's preaching, they turned against the MEDICI family, who were forced to flee the city in 1494. That same year the doom Savonarola had prophesied seemed to come true with the arrival of the armies of the French king Charles VIII and the end of a peace that had reigned for some 40 years. Savonarola himself was tortured, hanged, and burned for sedition and heresy by the Spanish pope Alexander VI in 1498. Inspired by Savonarola's sermons, an apocalyptic fervor and obsession with death gripped Florence. While the mood he embodied and the words he spoke had their effect on a great many artists, BOTTICELLI and MICHELANGELO are the most prominent artists believed to have come under Savonarola's influence.

Schamberg, Morton

1881–1918 • American • sculptor/painter • Dada/Precisionist

God-creation of man in man's image / Machine-creation of man in man's image / God-Machine. (Paul B. Haviland, 1915)

SHEELER and Schamberg were classmates at the Pennsylvania Academy of the Fine Arts (studying under CHASE). They traveled to Paris together in 1906, shared an apartment and studio in Philadelphia, traveled again in 1908 to London, Paris, and Italy, then lived in a Bucks County, Pennsylvania, farmhouse. They worked together, collaborating in a photographic venture. Later they became members of the ARENSBERG CIRCLE. Schamberg was the first American to paint diagrammatic machine parts, but it is his sculpture *God*

(c. 1918) for which he is famous—and infamous. This is a piece of plumbing (a metal trap) set upside down inside a miter box. The historian Abraham A. Davidson believes that the "sculpture" and its title may have been inspired by Paul B. Haviland's writings about machines, especially the equation, or lines, quoted above. The Arensbergs owned Schamberg's *God*.

Schapiro, Meyer
1904–1996 • American • art historian

The humanity of art lies in the artist and not simply in what he represents. It is the painter's constructive activity, his power of impressing a work with feeling and the qualities of thought that give humanity to art.

Schapiro came to this country from Lithuania when he was three, and was introduced to art in evening classes taught by SLOAN at Brooklyn's Hebrew Settlement House. His dissertation was on "The Romanesque Sculpture of Moissac," and his degree was the first Ph.D. in the field of fine arts and archaeology awarded by Columbia University, where he began teaching in 1928 and spent his academic career. The historian David Rosand wrote of him: "In the anonymous art of the Middle Ages Schapiro discovered the artist, the human maker; he intuited the feeling individual responsible for the invention of such expressive form." Schapiro also wrote on the art of every age, as well as *Theory and Philosophy of Art: Style, Artists, and Society* (1994). He was ahead of his generation in his approach to art as a means of understanding its larger social, intellectual, and historical contexts, and also its association with other disciplines, including anthropology, psychology, linguistics, and philosophy.

Schapiro, Miriam
born 1923 • American • constructions • Decorative art

I wanted to explore and express a part of my life which I had always dismissed—my homemaking, my nesting. I wanted to validate the traditional activities of women, to connect myself to the unknown women artists who made quilts, who had done the invisible "women's work" of civilizaiton.

With CHICAGO, Schapiro established the Feminist Art Program, dedicated to training women artists, at the new California Institute of the Arts (CalArts). She celebrated typically female crafts, and a number of her creations were called femmage, a conflation of female and COLLAGE. *Anatomy of a Kimono* (1976) is a 52-foot-long work on canvas with fabric, a monument to female striving and accomplishment, with rich colors and patterns. It also expresses Schapiro's interest in CUBIST allusions that use stripes as geometric divisions. But this great sequence of patterns and forms—which alone covered the walls of a gallery in which it was exhibited—achieved Schapiro's goals as she later described them: "As always since my conversion to Feminism in 1970, I wanted to speak directly to women. I chose the kimono as a ceremonial robe for the new woman. I wanted her to be dressed in the power of her own of-

fice. . . . Later I remembered that men also wore kimonos and so the piece eventually had an androgynous quality. Nice. . . ."

Schiele, Egon
1890–1918 • Austrian • painter/draftsman • Expressionist

At last! At last! At last! At last alleviation of pain. At last paper, pencils, brush, colors for drawing and writing.

Encouraged by KLIMT, who was 28 years his senior, Schiele reacted to the older artist's style: What is elegant and decorative in Klimt is harsh, discordant, and angry in Schiele; Klimt's appreciative eroticism becomes almost malevolent in Schiele. In *The Self Seer II, Death and the Man* (1911), painted with thick, brutal brushstrokes in murky colors, a rigid, staring man, perhaps Schiele's self-portrait, is shadowed and seemingly embraced by a figure of death. The painting is eerily prophetic— Schiele died in the influenza epidemic of 1918. Before that, in April 1912, he was arrested and held, for 24 days, for "immorality" and "seduction of a minor." It was alleged that by careless or willful display of erotic drawings in his studio while sketching child models, Schiele had contributed to their corruption. At first he had no materials, but after a few days of confinement he was given paper and pencil, and that is when he wrote the words quoted above. His skill in drawing was superb, and he specialized in provocative paintings and drawings of women. His series of self-portraits show a man tormented by anxiety and obsessed with sexuality.

Schinkel, Karl Friedrich
1781–1841 • German • architect/painter • Neoclassicist/Gothic revival

Our mind is not free if it is not the master of its imagination; the freedom of the mind is manifest in every victory over self, every resistance to external enticements, every elimination of an obstacle to this goal. Every moment of freedom is blessed.

Schinkel painted with romantic fervor and designed theatrical sets before becoming a successful architect—ultimately, one of the most important architects of the 19th century. He was known as gentle, modest, kind, and consumed by the ethic that is described in the quotation above. New opportunities for building opened in Prussia in 1815 after the final defeat of Napoleon. In 1810 Schinkel had abandoned his short career as an independent architect to work for the state, and in 1830 he became head of the Public Works Department. As Berlin, the capital of Prussia, expanded, Schinkel had much to do with shaping the look of the city. In concert with the intellectual and literary force of German ROMANTICISM, he looked back to German GOTHIC architecture for inspiration. This is evident in the *Kreuzberg Monument* (completed 1821, see WAR MEMORIAL). But he was also an advocate of Greek revival—he is known as a "romantic classicist"—and the CLASSICAL influence in his work is spectacularly evident in the design of the Altes Museum (Old Museum), which has a line of 18 slender Ionic columns along the facade (see COLUMN ORDERS). Originally planned for the

museum's interior but installed outdoors instead (for the pleasure of pedestrians, at the urging of King Friedrich Wilhelm III) is a great granite basin inspired by a porphyry bowl from the Roman emperor Nero's house. Set on a tall base so that its highly polished surface would reflect surrounding architecture and passersby, this attraction was recorded in meticulous detail in a painting, *The Granite Bowl in the Lustgarten, Berlin* (1832), by Johann Erdmann Hummel (1769–1852).

Schlemmer, Oskar
1888–1943 • German • painter/sculptor/designer • Abstract

[Art is] Dionysian in origin, Apollonian in manifestation, symbol of a unity of nature and spirit.

Schlemmer taught at the BAUHAUS from 1920 to 1929. His work was eclectic, combining elements of de CHIRICO's strange PERSPECTIVES with the machine aesthetic of LÉGER. His figures were greatly simplified—he has been compared to GIOTTO—and somewhat robotic. *Figures Resting in Space (Room of Rest)*, 1925, is a painting with all those qualities: The floor is a forward-tilting plane and three figures are stiff, geometric, and ambiguous; the largest figure stands in the foreground, a dark silhouette with its back to us and its legs blocked by the shape of a head. On the far wall is what appears to be a large opening in a thick concrete wall, but there is nothing to see beyond it. Schlemmer designed for the theater, painted public murals, and sculpted. His comment, quoted above, alludes to the ecstatic inspiration, if not inebria-

tion, associated with Dionysus and the rational illumination attributed to Apollo. It also has reference to the dynamic of the Dionysian/Apollonian dichotomy in Friedrich Nietzsche's *The Birth of Tragedy* (1872). Schlemmer's work was exhibited in the Nazi DEGENERATE ART show of 1937.

Schmidt-Rottluff, Karl
See Die BRÜCKE

Schnabel, Julian
born 1951 • American • painter • Neo-Expressionist

All my images are subordinate to the notion of painting. . . . To those who think painting is just about itself, I'm saying the opposite.

The contradictory comments quoted above give pause to anyone endeavoring to understand Schnabel's philosophy of art. The problem is exacerbated by the advertising and promotional assault that accompanied his meteoric rise to fame in 1979. Reeking of opportunism, it was a campaign that caused great dismay among thoughtful artists as well as critics, historians, and dealers. Cutting through all the rhetoric to the work itself shows Schnabel breaking some new ground—or at least crockery. *The Patient and the Doctors* (1978) is composed of broken dishes on painted wooden planes. "I wanted to make something that was exploding as much as I wanted to make something that was cohesive," he explained. His inspiration, he said, was GAUDÍ's use of broken ceramic tile. (The title remains unexplained.) Boisterously experimental, Schnabel used an emblem of Ameri-

can kitsch, painting on black velvet, and made his own "velvet paintings." *Geography Lesson* (1980) is one of four paintings from a series entitled *Huge Wall Symbolizing the Fate's Inaccessibility.* Recognizable elements include a blood red deer, a CLASSICAL column, a globe that could be the moon or the world, and a barren tree that becomes confused with the deer's antlers. Indistinct faces, as if of people in a crowd, surround the boldly painted figures.

Scholasticism

Strictly speaking, scholasticism means "that which is taught in schools." The dominant theological and philosophical worldview of the late MEDIEVAL period, with its origins in France, Scholasticism endeavored to reconcile CLASSICAL philosophy with Christianity, to defend Christian faith with reason. Scholastics believed the Greeks, particularly Aristotle, to be the masters of natural knowledge and the Bible to be the source of all revelation. Saint Thomas Aquinas (1225?–1274) was the leading Scholastic theologian. The expression of Scholasticism in art is seen in the GOTHIC cathedral, a declaration of Medieval intellectual genius in the service of faith.

Schongauer, Martin

c. 1435/50–1491 • German • printmaker • Northern Renaissance

Truly, we must render him undying thanks for leading us to the gate of perfection in art; he worked by the sweat of his brow for this goal.
(Lambert Lombard, in a letter to Vasari, 1565)

Schongauer learned the skill of metal ENGRAVING from a family of goldsmiths. He began to make prints shortly after Gutenberg's invention of movable type led to the printing press. Schongauer's designs were often reproduced for other artists to use as prototypes. He became an extraordinarily sophisticated printmaker, manipulating lines, creating contrasts of open areas with dense or highly patterned ones, and achieving tones, texture, and depth that brought him international fame. A prime example of his skill is *The Temptation of Saint Anthony* (c. 1475), in which the saint is beleaguered by congeries of hairy, spiky devils that seem a cross between the demons of GISLEBERTUS and those of BOSCH. The approaching turn of the century brought angst, and with it apocalyptic fears, which makes this a timely image. DÜRER admired Schongauer and was en route to visit him when Schongauer died. Lambert Lombard (c. 1505–66), himself an accomplished painter admired by VASARI, corresponded with Vasari to provide information about NETHERLANDISH artists. His estimation of Schongauer is quoted above.

school

This term, when combined with the name of a major artist or region, presumes a unifying influence. "School of" may also be used to describe a work of uncertain "authorship" by comparing it with similar but securely assignable works. For example, paintings that are very much like REMBRANDT's may be designated School of Rembrandt. An influential teacher or a WORKSHOP master is implied. The poetic, light-infused

15th-century paintings by the BELLINIS that seem representative of VENICE may be consigned to the Venetian school. The HUDSON RIVER SCHOOL, however, has less to do with the region than with the subjects that were painted. The PONT-AVEN SCHOOL could as well be named the Gauguin-Bernard School, as GAUGUIN and BERNARD were the magnets to the place. The one thing "school" usually does not mean, in this art historical context, is a place with desks and classes.

School of London
See KITAJ

School of Paris
In retreat from Russian Utilitarianism (see CONSTRUCTIVISM), German inflation, cynicism (see NEW OBJECTIVITY), American isolationism and provincialism (see AMERICAN SCENE and REGIONALISM), and other perceived disadvantages, a new wave of foreign artists settled in Paris after World War I. While the School of Paris is sometimes extended to include all MODERNIST painters between the two World Wars, most art historians use the term to refer to a particular group with EXPRESSIONIST tendencies known as *les maudits* (the cursed, or wretched). Many were Jews, plagued by poverty, alienation, and the pervasive anti-Semitism. Best known among painters in the School of Paris are MODIGLIANI, PASCIN, SOUTINE, CHAGALL, and UTRILLO. After World War II another group of painters used the School of Paris title. They were largely disciples of a French teacher, Roger Bissière (1888–1964), and painted in a nonrepresentational style.

Schwitters, Kurt
1887–1948 • German • painter • Dada/Merz

I am a painter and I nail my pictures together.

Schwitters's comment, quoted above, was made by way of introducing himself to the DADA painter Raoul Hausmann. With GROSZ and others, Hausmann was a member of the Berlin Dada group, Club Dada, which denied Schwitters membership. He launched his own Dadaist group in Hanover in 1923, which he called Merz—art historians offer a number of derivations for the word including: (1) from *kommerz* or "commerce," (2) literally "something cast off," like junk, and (3) a nonsense word like Dada itself. Schwitters said, "The word 'Merz' had no meaning when I formed it. Now it has the meaning which I gave it. The meaning of the concept 'Merz' changes with the change in the insight of those who continue to work with it." Schwitters created what he called Merzbilder, which are COLLAGES with discarded stuff—tickets, stamps, receipts, bits of torn papers, price tags—(e.g., *Merz 19, 1920*), and they have a surprising elegance. He also scavenged non-paper junk and made RELIEF constructions, the pictures that, as he said, he "nailed together." When the Nazis drove him from Germany in 1935, Schwitters was constructing a Merzbau, originally an abstract assemblage of rusty tin cans, newspapers, and pieces of broken furniture. He named it *Cathedral of Erotic Misery,* and it contained secret panels that hid other objects or tiny scenes. Later he replaced the junk with abstract forms made of wood. It filled one room of a house and

was growing into another on the second floor when he left for Norway, where he started his second Merzbau. Forced by the German invasion to move again, he built yet another in England. The only one to survive, the third Merzbau is preserved at the University of Newcastle. Schwitters's Merzbau is a forerunner of later trends, especially INSTALLATION art.

Scopas (also Skopas)
active mid-4th century BCE • Greek • sculptor/architect • Late Classical/proto-Hellenistic

There is, by the hand of . . . [Scopas] a colossal seated figure of Ares in the temple . . . besides a nude Aphrodite in the same place which surpasses the famous Aphrodite of Praxiteles and would make any other spot famous. (Pliny the Elder, 1st century CE)

Scopas is known as the artist who showed pathos, or strong emotion, expressions of suffering and despair, to the extent that he established what may be called a Scopadic convention. This anguish is seen especially in the deeply set eyes and furrowed brow on marble heads like those in *Hercules and Telephos* (c. 340 BCE) from the west pediment of the Temple of Athena Alea at Tegea. No specific sculptures can be unequivocally attributed to him, but Scopas is credited with inspiring the style. This interest in emotion, reportedly explored a century earlier in the work of POLYGNOTOS and interrupted by the cool rationalism and idealism of the High CLASSICAL period, forecast the development of emotional excess seen in HELLENISTIC works, like the LAOCOÖN. Scopas also worked on the sculpture for

the MAUSOLEUM OF HALICARNASSUS, and as an architect he designed the temple at Tegea from which the heads, described above, were salvaged.

Scorel, Jan van
1495–1562 • Netherlandish • painter • Northern Renaissance

Soon Scorel departed for Steyer in Carinthia, where his work was in great demand by most of the nobility. He stayed with a baronet, a great lover of pictures, who rewarded him well and wanted him to marry his own daughter. (Carel van Mander, c. 1604)

In his commentary above, van MANDER does not say whether it was Jan van Scorel's artistic talent or his charm that attracted the baronet. However, van Scorel's extensive travels, besides his sojourn with the baronet, are well documented. He left the Netherlands in 1518 and traveled first through Northern and then Southern Europe, and even made a pilgrimage to Jerusalem. As had DÜRER before him, he made fine, if somewhat dramatized, drawings of the sights that interested him, especially in the Alps. He was impressed by Italian art, and in fact served for a time as the administrator in charge of antiquities under a Dutch pope in the Vatican. In a sense he brought the ITALIAN RENAISSANCE home with him, assimilating poses and subject matter, and, for example, in *Mary Magdalen* (c. 1530) dressing the figure in a beautiful Venetian costume. He had a large WORKSHOP that was based on Italian practices. Van Scorel emulated MICHELANGELO's reds, golds, and blues in the *Entry of Christ into Jerusalem* (1527)—the real Jerusalem as he had seen it for himself.

Yet withal those borrowings, there is something relentlessly Northern—intense and serious—about his cast of characters. He had joined the Haarlem Confraternity of Pilgrims to Jerusalem, and painted a group portrait for their chapel in 1528–29. With its subjects seated in double file and shown in three-quarter view, from the waist up, this kind of group portrait is in a tradition that reaches back to GEERTGEN tot Sint Jans and forward to HALS and REMBRANDT, who would more successfully break out of the shooting-gallery effect of heads lined up in a row. Despite the uniform placement and egalitarian treatment van Scorel gives the men, he has discovered and portrayed the individuality of each, resulting in a fascinating parade of faces. Moreover, he sits among them, looking out at us above his inscription, which reads in part, "I am Jan van Scorel, painter and canon of Saint Mary's . . . pray that I might proceed in virtue."

scriptorium

From the Latin *scribere* meaning "to write," a scriptorium is the place where manuscripts are produced. The first monastery as a religious center of scholarship was founded in the early 500s. The curriculum of liberal arts included selected CLASSICAL writings, so to provide such texts, certain monasteries established scriptoria to copy the classics. It is unlikely that the early BENEDICTINE scribes had high esteem for the texts they duplicated, but thanks to their efforts many valuable Latin writings from the ancient world have been preserved. (Many were also preserved by ISLAMIC scholars.) Of course, producing Christian liturgical manuscripts was a major occupation of the scriptoria. In the 16th century, the printing press gained a foothold and scriptoria became all but obsolete. (See also ILLUMINATED MANUSCRIPT and HIBERNO SAXON)

scroll (also rotolus, roll)

A manuscript, usually of papyrus or PARCHMENT, like the Egyptian Book of the Dead and the Hebrew Torah, which must be unrolled to be read. The scroll preceded the CODEX. The word *biblion* originally meant a book in the form of a papyrus roll, and is the root of the word "bible."

Scully, Vincent

born 1920 • American • architectural historian

. . . the relationship of manmade structures to the natural world offers, in my view at least, the richest and most valuable physical and intellectual experience that architecture can show, and it is the one that has been most neglected by Western architectural critics and historians. There are many reasons for this. Foremost among them, perhaps, is the blindness of the contemporary urban world to everything that is not itself, to nature most of all.

Educated at Yale University, Scully also teaches there and at the University of Miami. He has written pioneering studies on American 19th-century domestic architecture in wood—identifying styles known as Shingle and Stick—and on MODERN architects Frank Lloyd WRIGHT and KAHN. From 1955 to 1963,

he studied the relationship between architecture and its environment in Greece, and his best-known book, *The Earth, the Temple, and the Gods* (1962), introduced a new way of thinking about the dynamic between the Greek TEMPLE and its landscape. He found that the individual temple was built to represent the character of the individual god to whom it was dedicated, not only in the subtle specifics of its structure, but also in the lay of the land around it. He sees conscious synergy and drama in the orchestration of a dynamic between the natural and the man-made. For example, Apollo, the rational, civilizing god who subjugated the reigning earth goddess, is worshiped at Delphi in a wild landscape that he dominates, standing firm and secure, triumphant against unruly (mother) nature.

sculpture

From a Latin root meaning "to carve," the term "sculpture" broadens to include three-dimensional objects shaped or constructed by processes other than carving: forming with clay, molding in casts, designing with neon, and using prefabricated materials. Until the 20th century, human and animal figures—in action or in repose, alone or in combination with others—were the predominant subjects of sculpture. With those figures sculptors explored mass, line, texture, light, movement, and especially the interdependence of volume and space. While those interests persist, the redefinition of sculpture during the 20th century has included ABSTRACT art as well as self-destructing objects (see TINGUELY) and EARTH AND SITE works.

scumbling

Probably derived from the word "scum," in reference to the layer of film that rises to the surface of a liquid. In painting, scumbling refers to unblended, "open" brushstrokes of opaque paint that are applied on top of a dried layer of a different color but that allow the lower layer of paint to show through. Scumbling gives a broken, rough, or uneven effect to the brushed-on color. It is a PAINTERLY manner, or style, with the artist's "hand" or touch on the canvas made visible. TITIAN was an early pioneer in the self-expressive technique of scumbling, which he used selectively.

Scuola Metafisica (Metaphysical School)

See CARRÀ and de CHIRICO

seal

Both the object that makes the impression, usually a carved stone, ivory, or metal matrix, and the impression itself, usually on clay or wax, are called seals. Affixing a seal as proof of ownership or of a transaction, as well as a means of securing property before locks were invented, dates back to ancient civilizations. To discourage theft, a seal—like a lump of clay securing a string on a box or a wax seal on a document—might have a "magic" or APOTROPAIC design stamped into it. Seal impressions are made by both cylinders and stamps. The earliest-known seals are from the Neolithic period in Mesopotamia. The idea of using seals spread from Syria to the Aegean. Next to POTTERY, seals are the largest category of archaeological finds from the Aegean Bronze Age.

Many of the well over 5,000 of these Aegean seals, mostly from Crete and carved on ivory, have two or more sides. They often have animal designs, and many are masterpieces of miniature sculpture. Later matrices were flat, engraved stones or gems (perhaps set into rings), or sometimes engraved metals: bronze, silver, or gold. They were used to make impressions on a substance called sealing wax, a mixture of turpentine, beeswax, and PIGMENT, usually vermilion. Seals were used for important papers, such as a Roman deed recording the sale of a slave boy in 166 CE, which is now in the British Museum. During the MEDIEVAL period especially, authenticated document seals often bore portrait heads of sovereigns. During the 11th century, seals were hung from cords and, like coins, had designs on both sides. As duke of Normandy, William the Conqueror used an EQUESTRIAN seal that showed him armed for battle. When he became king of England, he added the image of enthroned ruler on the obverse, setting a trend of combining images of war and peace that was followed by later monarchs. The British seal of a ruler was kept by his or her chancellor, and any document bearing the Great Seal was received with absolute faith. Personal and institutional seals of clergy, knights, squires, colleges, churches, corporations, and every other conceivable organization all bore their identifying emblem, often heraldic and sometimes carrying mottoes. Seals are still official emblems, but their importance and the inventiveness of their design declined after the MEDIEVAL era.

Sebastiano del Piombo (Sebastiano Luciani)

1485/86–1547 • Italian • painter • Renaissance

I have delayed [my work] so long because I do not want Raphael to see my picture until he has finished his.

Sebastiano was working on *The Raising of Lazarus* (1519) when his PATRON, Cardinal Giulio de' MEDICI, commissioned RAPHAEL to paint *Transfiguration* (1517–20). The cardinal was lighting the fire of competition, not so much between those two artists as between MICHELANGELO, Sebastiano's sponsor, and Raphael. The cardinal also knew that Raphael would be less likely to assign his commission to a member of his WORKSHOP if he thought that Michelangelo's protégé was breathing down his neck. That explains the excerpt from a letter written by Sebastiano to Michelangelo quoted above. Sebastiano's Venetian training taught him the importance of landscape as more than background, and when he moved to Rome he showed painters there the dramatic contribution of weather and light to mood (see VENICE). This is evident in *The Raising of Lazarus*. He later conducted important experiments using OIL PAINT on specially prepared walls. Where LEONARDO had failed before him, Sebastiano succeeded. The work, executed in 1516–24, includes an image of the *Flagellation of Christ*, surmounted by his own ecstatic version of the *Transfiguration*, located in the Borgherini Chapel at San Pietro in Montorio, Rome. Christ's body, tied to a column, twists and

strains against his tormentors in a pose based on Michelangelo's *Rebellious Slave* (before 1513). Sebastiano's success with oil allowed darker shading and more muted coloring on walls. When the Medici cardinal became Pope Clement VII, Sebastiano was his painter of choice.

Secession (German **Sezession**)

During the 19th and early 20th centuries, in Germany and Austria especially, groups of artists who withdrew, or seceded, from the prevailing style and system of exhibiting art took the name Secession for their movement. Secession groups were started in Munich in 1892, in Vienna (by KLIMT) in 1897, in Berlin (by Max Liebermann) in 1899. Secession organizations were also formed to promote the aesthetic appreciation of photography: The Linked Ring in London in 1892, renamed the Royal Photographic Society two years later, may have been the first. STIEGLITZ formed the Photo-Secession in New York City in 1902. Other major cities also had Secession groups and movements to sponsor new work and to provide meeting and exhibition space for avant-garde artists.

Second Empire

Covers the period in France when Louis Napoleon (Napoleon III) was in power (president 1848–52, emperor 1852–70). Architecture and the DECORATIVE ARTS were eclectic, ranging from GOTHIC Revival to the Louis XVI style. The fashion for Japanese art began in the 1860s. Styles in painting included REALISM² and IMPRESSIONISM.

Second Style

See MURAL

Segal, George

born 1924 • American • sculptor • New Realist

. . . a summation of gestures and movements, of piling and heaving. It becomes a collection of each individual's ideas about death. Some were relaxed, some were rigid, some were drooped. It's a collection of a series of movements that are all ruminations on death.

Segal makes molds from living models in white plaster. He sets these (usually) unpainted people in lifelike surroundings, INSTALLATIONS. They have a haunting presence that leaves the viewer with a ghostly afterimage. Most of his white statues appear in ordinary places like a soda fountain or subway car (e.g., *Subway,* 1986), shocking the viewer into thinking about the everyday in new contexts. But *Holocaust,* created for San Francisco's Holocaust Memorial, is its own context: a composition of corpses strewn on the ground. Segal's comment quoted above describes the work for which he used his friends as models. One of the figures in the installation is not among the dead but stands looking out, over the sea, in a painfully beautiful setting. "That contrast may in itself speak volumes—about the beauty of the world and the dark underside of human nature," Segal said. There are two versions of *Holocaust:* a model unveiled to the public at the Jewish Museum in New York in 1983 and the outdoor work, unveiled the following

year in California on November 8, the eve of Kristallnacht.

Segers (or Seghers), Hercules
1589/90–1633/38 • Dutch • painter/printmaker • Baroque

"How the artist should behave in the face of adverse fortune" (Samuel van Hoogstraten, 1678)

Despite his brief career, Segers had an enduring impact. There is a visionary quality in both his real and his imaginary landscapes. *Mountain Landscape* (c. 1630–35), for example, which shows the rocky descent to a valley, portrays the melodrama of light and shadow in both the sky and on the ground. Imaginary views make up the bulk of his oeuvre. Segers was admired and collected by REMBRANDT, whose own early landscape paintings Segers inspired; some of Segers's works were even attributed to Rembrandt. Van RUISDAEL also shows Segers's influence. Segers's paintings and even his prints are rare today. He experimented with colored ETCHINGS, using only one plate, but printing on colored paper and retouching the prints with paint. Lawrence Gowing has focused on three aspects of Segers's work that cast it in a MODERNIST light: the concept that the process of making art is, itself, part of the intention of the work; the notion that a work of art is anchored in a larger scheme by being part of a series; and the inclusion and integration into the work of accidents that occur during the creative process. According to legend, Segers was so little appreciated that he had to use the household linens for his paintings and prints. His run of misfortune was entered in van HOOG-STRATEN's book on painting under the chapter heading quoted above. It was Segers's reputedly melancholy disposition, combined with alcoholism and poverty, that, according to contemporary reports, led to his early death.

semiotics/semiosis
Having to do with the study of "signs" (from the Greek *sema*). A sign, whether in language, visual, or other arts, stands (or is "coded") for something besides itself. To the extent that visual images are thought of as "texts," "reading" or interpreting the connection between the sign (e.g., a picture of a cat) and the meaning it conveys (house pet, perhaps, or hunter, or any number of meanings depending on context) involves knowing the code. The term "semiotics" itself gained new meaning during the 20th century. The American philosopher Charles Sanders Peirce (1839–1914) modernized semiotics in using it to name the linguistic field that he founded. Calling it semiology, the study of signs was given its current importance, in literature especially, by the Swiss linguist Ferdinande de Saussure (1857–1913). (For the most part semiotics, semiosis, and semiology are now used interchangeably.) Saussurian semiotics investigates linguistic "signifiers" (what carries meaning) and what is "signified" (the meanings carried), finding meaning by a procedure of substitutions and eliminations: "Cat" denotes something with four paws, whiskers, fur, etc., because it is not "bat" or "dog" or any other alternative. It is important that there is not any logical or necessary link between the signifier

c-a-t and the concept it signifies. On the contrary, that connection is an arbitrary one, dependent on cultural context. Understanding this, it follows that language does not represent reality; rather, it establishes reality. Saussurian theorists believe that underlying structures and the rules that govern them are more important than the ways in which they manifest themselves. In other words, the system through which meaning is determined is more important than a particular meaning (see STRUCTURALISM).

Peircian semiotics relates to the visual arts more directly than does Saussurian. Peirce presumed an audience to interpret meaning and posited a three-part system graphed on a triangle. At the top is the "sign" and at the base angles are "object" and "interpretant." Rather than a system of substitutions and eliminations, for Peirce the sign points to the object, while the interpretant recognizes and translates the implied message. Both Saussure and Peirce are Structuralists who presented scientific systems driven by the belief that observation and analysis lead to truths. Because the semiotic structure or system controlling a work of art exists prior to a particular artist's execution of it, the work will express itself through the artist rather than vice versa. Roland Barthes (1915–1980) elaborated on the semiotic construct to overturn the romantic idea of the artist ("author" of the text) as creative genius. Barthes's essay *The Death of the Author* (1977) describes this idea of the individual circumscribed by the system. (Thus, APPROPRIATION—using something from another medium, another artist, and

any period one might choose—is a strategy that may be linked to Barthes's diminution of authorial integrity.) Subsequently, the semiotic system of Peirce and Saussure was amended by POSTSTRUCTURALIST theorists and critics led by Jacques Derrida (born 1930) and joined by Barthes. Poststructuralism took the significant step of disputing the fixedness and stability of a semiotic structure. Structuralism, Poststructuralism, and DECONSTRUCTION all relate to semiotics, and all are approaches to understanding the meaning of meaning—that is, how knowledge develops and is transmitted.

sepia
From the Latin for a "squidlike fish," sepia is derived from the dark, inky fluid secreted by one of the species, the cuttlefish. This fluid is brownish and is used for pen drawings and WASH (diluted) painting. Brown-tinted photographs are also called sepia.

seriography
See SILK-SCREEN

Serra, Richard
born 1939 • American • sculptor • Process art

The significance of the work is in its effort not in its intentions. And the effort is a state of mind, an activity, an interaction with the world.

As had Robert MORRIS and HESSE, Serra moved from the object-centered art of MINIMALISM to concentrate on the process of the work's creation, as suggested in the quotation above. Most PROCESS ART shows evidence of how it

was made, but Serra took his a step further: He threw molten lead against the wall in the warehouse of the dealer Leo Castelli in a work called *Splashing* (1969), a combination of PERFORMANCE and ACTION PAINTING in which the result—lead cohered to the wall—was removed and destroyed. More controversial was Serra's *Tilted Arc* (1981). Commissioned by the federal government for Foley Square New York, it was a 12-foot-high, 120-foot-long sheet of hot-rolled steel, 2½ inches thick. Placed in the middle of the plaza, it was, by intention, a barrier and interruption of views, ambience, and circulation patterns. Serra's intrusion on public space might be compared to that of CHRISTO, but where Christo was welcome and celebrated, Serra was not. The public felt not only challenged, as it was supposed to be, but also bullied and offended. *Tilted Arc* was ultimately dismantled and removed. For several years Serra worked on 16-foot steel plates bent into elliptical shapes: *Torqued Ellipses* (1997), inspired by BORROMINI's Church of San Carlo alle Quattro Fontane. These are wide bands of steel standing on their edges, somewhat like architecture in that people may enter them (but feel disoriented when they do). They have been oiled and rusted and are colored in shades of orange, brown, silver, and gray. The critic Michael Kimmelman writes, "What comes from this mix of big enclosing forms with bent ones turns out to be shapes oddly impossible to resolve in the mind. . . . To walk around the outside of a sculpture doesn't really tell you what the inside is like, nor vice versa, frustration that sends you back and forth, looking to reconcile inside with out, vainly."

Seurat, Georges

1859–1891 • French • painter • Neo-Impressionist

They see poetry in what I have done. No, I apply my method, and that is all there is to it.

Seurat insisted that his art was a "formula for optical painting" based on repeated, systematic observation of the activity of color and light. It was not the temporary, fugitive effect sought by IMPRESSIONISTs that he was after. Instead, Seurat wished to systematize the techniques Impressionists and other artists used to represent what is seen, and to arrive at a rational, methodical way to capture natural light and color. In short, Seurat was after a permanent truth. He did not need to work outdoors—quickly, by natural light, as Impressionists did—rather, using his quasi-scientific approach, he could work by artificial light, long into the night. The process was one Seurat himself called DIVISIONISM: colors divided, or broken down, into their component parts. The technique is more widely known as POINTILLISM, referring to the application of pigment in minute dots. Instead of blending paint before daubing it on the canvas, Seurat achieved the effects of color modulation by juxtaposing unmixed colors, or hues. To represent water, for example, he applied dots of blues, greens, and whites directly on to the canvas, shading, lightening, and changing the look of the water according to the arrangement of

dots. The mind's eye of the viewer blends the dots and "sees" the wide range and variety of color as unified. How is it, then, that Seurat is so highly regarded as an artist, as Arthur Danto writes, "a chilly geometrist, a chromatic engineer, a scientific placer of bitsy dots . . . as obsessed by the logic of color as Paolo Uccello is legended to have been possessed by, almost drunk on, the logic of linear perspective"? As did UCCELLO's paintings, Seurat's paintings transcend the technique he used to create them. What was said of VELÁZQUEZ's *Las Meninas* (1656) might also be said of Seurat's masterpiece, *Sunday Afternoon on the Island of La Grande Jatte, 1884* (1884–86): It is also a "Theology of Painting." But it is a 19th–20th century theology with different goals and problems: a portrait of an age, rather than of individuals, inhabited by the middle classes, not royalty. And the tradition of painting, the artist's role, concepts of vision and reflection, of illumination, PERSPECTIVE, and COLOR, have been updated to show a world in which machine-made goods are mass produced. Yet while the women wear corsets and bustles, they also mysteriously call to mind sculptures from ancient Mesopotamia and from Egypt. So, too, did Seurat's glimpses of contemporary, popular Parisian entertainment—musicians, the circus, the cancan dancers of *Le Chahut* (1889–90), as well as the geometric, empty stillness of a coastline. Seurat died before he was 32, but he seems to have forecast the major art movements to come, including CUBISM, PRECISIONISM, SURREALISM, and even MINIMALISM.

Seven Wonders of the Ancient World

Perhaps because of their interest in IDEAL prototypes, Greeks of the 3rd and 2nd centuries BCE devised a list of outstanding MONUMENTS: (1) the Three Pyramids at Giza (c. 2500 BCE)—of the seven, only this Wonder still stands; (2) King Nebuchadnezzar's terraced garden on the banks of the Euphrates, built during the 6th century BCE and known as the Hanging Gardens of Babylon—this was already in ruins when the list was made; (3) the 6th-century BCE marble Temple of Artemis at Ephesus; (4) the statue *Zeus at Olympia* (5th century BCE), sculpted by PHEIDIAS; (5) the MAUSOLEUM OF HALICARNASSUS; (6) the 110-foot-high bronze statue of Helios known as the *Colossus of Rhodes* (completed in 282 BCE), said by PLINY the Elder to have been made by Chares of Lindos, a pupil of LYSIPPOS, and to have been destroyed in an earthquake 56 years after it was completed; and (7) the Pharos of Alexandria (290 BCE), a lighthouse more than 450 feet high that marked the entry to the harbor. Five of the Seven Wonders were built by Greeks, although only Olympia was on their mainland—most were in lands conquered by Alexander the Great.

Severini, Gino
1883–1966 • Italian • painter • Futurist

It is in the early years that one recognizes that dualism which is in the depths of each one of us, where another person, unknown to ourselves, tends at the moment of the act of creation to supplant the person we

believed or hoped ourselves to be. My first contact with the art of Seurat, whom I adopted for always as my master, helped me greatly to express myself in accordance with the two simultaneous and often opposed aspirations.

In 1910 Severini signed the FUTURIST painters' manifesto. He brought to Futurism influences he had absorbed while living in Paris for several years: the art and techniques of SEURAT and of CUBISM. Seurat's experiments made a profound impression on Severini, as the comment above makes clear. Ideas about form derived from Cubism, especially that of reconciling different points of view—the dualism of which he also speaks above—were additionally central to his thought. The melding of these stylist approaches is apparent in the painting *Red Cross Train* (1914), in which Severini took up the subjects of war and speed so dear to Futurists. The picture is divided and energized with Futurism's dynamic horizontal lines; the train streaks through a geometrically sliced-up and reassembled Cubist landscape, and, inspired by Seurat, the scene is colored with daubs of Divisionist brushstrokes. Severini also used DIVISIONISM in purely NONOBJECTIVE paintings like *Spherical Expansion of Light* (*Centrifugal*), 1914. This is a composition of geometric shapes made up of dots of brilliant, interacting color, showing the inspiration of DELAUNAY's ORPHISM and the pure color harmonies on which it depends.

Sforza family

This family name may derive from the Italian *forza*, meaning "strong," or from the name of a fortification—the Castella Sforzesco—near the place of their ancestral origin. The Sforza family had control of Milan beginning with Francesco (1401–1466), a military opportunist who secured his power through marriage and became duke of Milan in 1450. FILARETE served in Francesco's court, designing the Ospedale Maggiore (begun 1456, further additions in the 17th and 18th centuries) and responsible for the decoration of the principal tower of the castle. (The tower was destroyed by an explosion in 1521, but was rebuilt according to the supposed plans for the original.) Filarete's *Treatise of Architecture*, written 1461–64, took the form of a dialogue with Francesco, and he named the imaginary city he described Sforzinda. Ludovico Sforza (1452–1508), known as the Moor, perhaps because of his skin tone, was a more dedicated supporter of the arts than was his father. In fact, one of the most famous letters of the ITALIAN RENAISSANCE was written to Ludovico by LEONARDO in 1482. Seeking employment with the duke, Leonardo enumerated his skills, which included plans for bridge design and military prowess of all kinds, making everything from armored cars to cannons, ships, and, in time of peace, architecture. Leonardo proposed to undertake a bronze horse "which shall perpetuate with immortal glory and eternal honor" the name of Ludovico's father. Though Leonardo was hired, and he did actually design a colossal figure of Francesco on horseback for which sketches still exist, the bronze EQUESTRIAN statue was never built (not, at least, until the late 20th century). A clay model of it was finished and stood

in the courtyard of the palace, but the invading armies of the French expelled Ludovico in 1499 and used the statue for target practice. In his letter to Ludovico, Leonardo had barely mentioned his skills as a painter; however, he did many of his most important paintings during the 20 years he spent in Milan, including the *Last Supper* (1495–97/98), which is in the refectory of Santa Maria della Grazie (begun 1492). The design of the church is attributed to BRAMANTE, who is believed to have been working under the influence of Leonardo.

sfumato

From the Italian, means "smoky" and refers to a technique that is epitomized in the paintings of LEONARDO, who invented it. As the word suggests, "sfumato" refers to a blending of color that creates the smoky or foggy effect characteristic of his paintings. It is particularly noticeable in distant views where atmospheric PERSPECTIVE is expressed by a blurred, bluish cast. Like CHIAROSCURO, sfumato manipulates light and dark; however, unlike the strong contrasts that chiaroscuro exploits, sfumato fuses the two. The mood of sfumato is one of harmony rather than drama. Leonardo's *Mona Lisa* (begun c. 1500–03) is a premier example of sfumato, which was used not only for the landscape background but also to dissolve all of the picture's contours, blending and fusing them as if all was seen through a mist. Followers of Leonardo who worked with sfumato were Fra BARTOLOMMEO, ANDREA del Sarto, and CORREGGIO.

Shahn, Ben

1898–1969 • American • painter/photographer • Modern/Social Realist

If I am to be a painter, I must show the world how it looks through my eyes.

Shahn was among those artists who wished to direct attention to injustice in the hope of bringing about reform. His photographs documented the despair of the Great Depression, and he completed 23 paintings inspired by the trial and execution of Nicola Sacco and Bartolommeo Vanzetti. *The Passion of Sacco and Vanzetti* (1931–32), for example, shows the two anarchists, whose executions were the result of whipped-up anti-Communist hysteria, in their coffins. Behind them stand three men, commissioned to investigate the trial, who cleared the way for the death sentence to be carried out. The figures are stilted and exaggerated in sharp, angular forms. The colors are hard and the effect bizarre. This is a powerful denunciation of American "justice."

Sheeler, Charles

1883–1965 • American • painter/photographer • Modern/Precisionist

In these paintings I sought to reduce natural forms to the borderline of abstraction, retaining only those forms which I believed to be indispensable to the design of the picture.

A Philadelphian and a member of the ARENSBERG CIRCLE, Sheeler studied with CHASE and traveled through Europe before he began working as a commercial photographer. His clients

included fashion magazines like *Vogue*, and advertising agencies. He also took pictures for himself, and these often served as models for his paintings; both were in sharp, hard-edged focus, seeming to have been machine cut according to templates, and even mechanically colored with flat paint. The quintessential PRECISIONIST, Sheeler created images that are startling as much for the excruciating exactitude of his detailed representation of, for example, the wheels of a locomotive (*Rolling Power*, 1939), as for the more abridged but just as awesome presence of industrialized form (*American Landscape*, 1930). In 1927 Henry Ford commissioned Sheeler to photograph his new, Model A mass-production facilities at River Rouge, near Detroit. Several paintings evolved from the 32 prints Sheeler made at the factory. Two years later Sheeler took a series of photographs of CHARTRES Cathedral. There is rarely any human presence or movement in his images, except perhaps from smoke or steam. People may be implied by their very absence, but the implication could be that they are obsolete.

Sherman, Cindy
born 1954 • American • photographer • Postmodern

I started feeling uncomfortable about being successful. I wanted to make something that would be difficult for some collector to hang over his couch.

BRYSON has identified Cindy Sherman as one of three "key practitioners of the postmodern," along with the filmmaker David Lynch and the photographer Joel-Peter Witkin. "The structure on which each thinks about the image and

the body is less the sign than the symptom," Bryson explains (see SEMIOTICS), and the characteristic they share is the "affect of dread." Sherman became known for a series of 69 black-and-white "self-portraits" entitled *Film Stills*, which she began c. 1977. Although she dressed herself up, and staged and took the pictures (her camera on a tripod, the shutter released by a 20-foot-long cable), and although they look like stills of a well-known movie star in a popular movie, they are all fictitious enough that they are indefinable either as self- or celebrity portraits. And, as Bryson notes, an inexplicable, anxious fear hovers over all of the situations she creates in her photographs. In *Untitled Film Still #3* (1977) she is tightly cramped in the picture frame, cropped below the waist and across the forehead. She stands by a sink and looks over one shoulder as if taken by surprise. As in each of her works, a NARRATIVE is implied, but must be invented by the viewer. The series was completed in 1980 and Sherman received the discomfiting acclaim she speaks of in the quotation above. She then began a series of photographs using anatomically correct body-part models from a medical catalog. These, in color, are staged in bizarre settings, alluding to macabre but, again, unknown circumstances that one can only, or hardly, imagine.

Shinn, Everett
1876–1953 • American • painter • Realist

. . . his distinct, whimsical humor. He has done some marvelous work. He is full of enthusiastic interest in life, and his works are full of the beauty of his

enthusiasm. (Robert Henri, 1910)

One of the journalist-illustrators who followed HENRI to New York City and became a member of both The EIGHT and the ASHCAN SCHOOL, Shinn was the youngest of the group. Henri's description, quoted above, was written about the Exhibition of Independent Artists in 1910 in which Shinn showed his work. In Philadelphia Shinn had studied with ANSHUTZ, and he also studied in Paris. One of his best-known pictures is a typical Ashcan street scene: a snow-covered city street with a lone ragpicker confronted, in the left middle ground, by a threatening black cat. But unlike most Ashcan pictures, this one is not of New York City, as its title, *Early Morning Paris* (1901), tells us. While starkly realistic, it is also strongly influenced by compositional elements—empty flattened foreground, decentered focus—that made Japanese prints (see UKIYO-E) so important to late-19th-century artists. Shinn was drawn to music halls and the theater, and painted scenes of such entertainment with unusual angles of view reminiscent of MANET and DEGAS. He also painted MURALs for Belasco's Stuyvesant Theater and the Oak Room at the Plaza Hotel.

Sickert, Walter Richard

See LONDON GROUP

Siena

A city in Italy, capital of an independent republic, some 45 miles south of Florence—probably a day's ride during MEDIEVAL times. Siena was in fierce commercial, political, and cultural competition with Florence. Sienese art especially flourished during the first four decades of the 14th century. DUCCIO represented the elegant, refined Sienese style (as the more solid, sculptural figures of GIOTTO characterized Florence). Preceded by Guido da Siena (active c. 1260), Duccio was followed by MARTINI, who carried the grace of Siena with him to AVIGNON, where it fortified the International Style of Late GOTHIC art. One of the LORENZETTI brothers left a panoramic view of Siena in the painting *Good Government in the City* (1338–39). The importance and influence of Siena declined after the bubonic plague of 1348, and the city lost its eminence to Florence during the ITALIAN RENAISSANCE.

Signac, Paul

1863–1935 • French • painter • Neo-Impressionist

By the elimination of all muddy mixtures, by the exclusive use of the optical mixture of pure colors, by a methodical divisionism and a strict observation of the scientific theory of colors, the neoimpressionist insures a maximum of luminosity, of color intensity, and of harmony—a result that has never yet been obtained.

Four years younger than SEURAT, whom he met at the SALON DES INDÉPENDANTS of 1884, Signac worked with Seurat to develop the art and theory of NEO-IMPRESSIONISM in both his own painting and in his manifesto-like book, *From Delacroix to Neo-Impressionism* (1899), from which the quotation above is taken. Signac was convinced that through analyzing the color of an object, the color of the light falling on it, and the color of its reflection, he could scientifically understand and success-

fully manipulate the effect of color in painting. This was an intellectual exercise that fascinated other artists of his time. They compared and measured their own approaches against those of Signac. For example, MATISSE wrote, ". . . Signac is preoccupied by complementary colors and the theoretical knowledge of them will lead him to use a certain tone in a certain place. I, on the other hand, merely try to find a color that will fit my sensation. . . . As a matter of fact, I think that the theory of complementary colors is not absolute. In studying the paintings of artists whose knowledge of colors depends only upon instinct and sensibility and on a consistency of their sensations, it would be possible to define certain laws of color and so repudiate the limitations of the accepted color theory." Signac's paintings were never as inspired as Seurat's, and seem more decorative and formulaic. However, his imaginative portrait of the critic Félix Fénélon, who coined the term "Neo-Impressionism," is fascinating. Dressed as a magician, he stands in profile against a backdrop like a gigantic whirligig with bold patterns on each of its sections. The title is as decorative as the picture: *Against the Enamel of a Background Rhythmic with Beats and Angles, Tones and Colors, Portrait of M. Félix Fénélon in 1890* (1890).

Signorelli, Luca

c. 1450–1523 • Italian • painter • Renaissance

. . . his works were more highly valued than almost any other master's, no matter of what period, because he showed the way to represent nude figures in painting so as to make them appear alive, although with art and difficulty. . . . I do not wonder that Luca's works were always highly praised by Michelangelo, who in his divine Last Judgment in the chapel partly borrowed from Luca such things as angels, demons, the arrangement of the heavens, and other things in which Michelangelo imitated Luca's treatment, as all may see. (Vasari, mid-16th century)

In his major work, FRESCOES at the Orvieto Cathedral, contracted for in 1499 and executed between 1499 and 1503, Signorelli shows that fascination with the body in movement to which VASARI refers in the quotation above. In addition, however, the apocalyptic turn-of-the-century mood in which Signorelli was working finds expression in his *Resurrection of the Dead, Damned Consigned to Hell,* and *Preaching of the Antichrist,* all scenes found in the Orvieto cycle. These have a tangle of devils, demons, sinners—tortured and torturers—falling, floating, and flying in an altogether gruesome melee. MEDIEVAL Last Judgment scenes, such as that of GISLEBERTUS, inevitably come to mind. However, Signorelli's nude, lean, and muscular bodies, contorted by every conceivable kind of physical pain, set a new high-water mark. MICHELANGELO's *Last Judgment* (1536–41) is dignified by comparison. Toward the end of his career, Signorelli returned to his hometown, Cortona, and painted in a more conventional style.

silk-screen (serigraphy)

A method of PRINTING in which the image is created on a porous fabric, orig-

inally silk, today usually cotton or synthetic. That portion of the design to be reproduced is left unblocked on the screen (rather like a stencil). The screen is placed above the surface to be printed on. The paint, or dye, is forced through the screen. Only one color is applied at a time, but several screens may be used for a variety of colors. The silk-screen process, developed during the 20th century, is used both on fabric (especially T-shirts in recent years) and on paper. WARHOL practiced silk-screening extensively.

silverpoint (also metalpoint)

A precursor of the pencil, which overtook silverpoint in the 17th century. The metalpoint—usually silver but sometimes lead, copper, or gold—is used to draw on paper covered with enough of an abrasive coating so that the metal leaves a precise, delicate line. Silverpoint lines cannot be successfully erased. Thus, besides being refined and subtle in nature, silverpoint drawings also require an evolved concept and exacting skill. Over time they oxidize to a light brown. An extraordinarily fine silverpoint self-portrait was drawn by DÜRER in 1484 when he was only 13 years old. LEONARDO is also known for his silverpoint drawings.

simulacrum, simulacra (pl.)

A Latin term derived from PLATO, who used it to differentiate essence from appearance, idea from image. Since the 1960s, in the wake of challenges to what is "real," fueled not only by POSTSTRUCTURALISM but also by the flood of images from all media, the term has taken on new meaning. Reversing the priority given to model over copy, the French philosopher Gilles Deleuze (1925–1995) erases distinctions between them. Contemplation of simulacra was taken in several directions by historians, philosophers, and critics; the effect was to remove the primacy and priority, the sense of inviolability and value given to the "original" work of art. Strategically, this had the same effect as the "death-of-the-author" idea forwarded by Roland Barthes (see SEMIOTICS). Jean Baudrillard (born 1929), also a French philosopher, had far-reaching influence with his essay *The Precession of Simulacra* (1984), in which he reversed the priorities Deleuze had equalized, putting the simulacrum *before* the original. "It is no longer a question of imitation, nor even of parody," he wrote. "It is rather a question of substituting signs of the real for the real itself. . . . Illusion is no longer possible because the real is no longer possible." To Baudrillard, America is the home of simulacra. And his simulacra, having taken over the "real," take on another order of reality in which the original is lost.

singerie

From *singe,* French for "monkey," singerie refers to the use of monkeys in art, usually displaying human characteristics and often dressed in clothing. Monkeys have a long history in art: As early as the Old Kingdom (c. 2700–2150 BCE), they were imported into Egypt from farther south in Africa. Sometimes these monkeys were trained to gather fruit from branches beyond human reach. They are frequently pictured assisting in wine pressing and jumping through the rigging in ships. On the ancient Aegean island of THERA is a brightly colored FRESCO in what is known as the "room of the blue mon-

keys." These large monkeys are leaping, reaching, and bounding on the walls. Since MEDIEVAL times monkeys were shown to parody the behavior of human beings. In the 17th century, monkeys in human costume were incorporated into the elaborate GROTESQUE decor in the court of Louis XIV, and fanciful, lighthearted images of cavorting, dressed-up monkeys became a favorite theme for interior decoration in French ROCOCO. Their decorative popularity declined with the arrival of the NEOCLASSICAL period.

sinopia

A word derived from the Black Sea city of Sinop, known for its red-brown earth, "sinopia" refers both to the color and to drawings made with it. These were usually preliminary drawings applied to the rough plaster of walls to be painted in FRESCO, especially in 14th-century Italy. Sinopia underdrawings were often replaced with CARTOONS by the 15th century.

Siqueiros, David Alfaro

1896–1974 • Mexican • painter • Social Realist

On our side are those who clamor for the disappearance of an old and cruel order; in which you, worker of the field who makes the earth fecund, have your crops taken by the rapaciousness of the landowner and the politician, while you burst with hunger; in which you, worker of the city who run the factories, weave the cloth, and form with your hands all the comforts that give pleasure to the prostitutes and miscreants, while your own flesh is broken with the cold.

Siqueiros's Communist political activities brought some rewards—sponsorship of his studies abroad and mural commissions during the period from 1919 to 1924, for example—but they also resulted in repeated punishments. His role in organizing Mexican workers led to imprisonment and exile; the quotation excerpted above is from the first artists manifesto, written in December 1923, on behalf of El Sindicato—the union of which Siqueiros was elected general secretary. (He fought in the Spanish Civil War during his expulsion from Mexico.) One of the three most important Mexican mural painters (see also RIVERA and OROZCO), like his colleagues Siqueiros received commissions to work in the United States. He painted murals at the New School for Social Research in New York City, where Jackson POLLOCK was among his apprentices. In fact, Siqueiros introduced Pollock and others to his experimental technique not only of using industrial paint, but of splattering it on as well. In Mexico City's Palacio de las Bellas Artes, the country's foremost cultural center, which was scheduled for completion in 1910 but was delayed for 24 years by the Revolution, Siqueiros's *Democracy Freeing Herself*—a nude woman in chains—is in the company of murals by Rivera, Orozco, and TAMAYO.

Sirani, Élisabetta

1638–1665 • Italian • painter • Baroque

I lived in adoration of that merit, which in her was of supreme quality, and of that virtue, which

was far from ordinary, and of that incomparable humility, indescribable modesty, inimitable goodness. (Carlo Cesare Malvasia, 1678)

Count MALVASIA's admiration of the Bolognese artist Élisabetta Sirani was strong enough that he was able to persuade her father, also an artist, to train her, which he had been reluctant to do. She studied the style of RENI and excelled in half-length portraits. *Melpomene, the Muse of Tragedy* (after 1655) is an image of the goddess, seated, with a book in one hand, her tilted head resting on her other. She wears a loosely wound, Turkish-style turban on her head, a conceit that had been used in self-portraits by van EYCK and REMBRANDT, and the mask of tragedy on the table appears to gaze up at the Muse. Sirani's colors are rich and glowing, and she paid particular attention to folds and shadows on various types and textures of fabric. Sirani opened her own studio and was extremely successful, as many anecdotes in Malvasia's writings demonstrate. He describes streams of visitors journeying to Bologna to watch her work. He records that the Crown Prince watched her paint and ordered a Madonna for himself, which she accomplished with great haste in order that he might take it home with him. Her early, sudden death has never been explained—both poisoning and ulcers have been blamed—but the entire city of Bologna mourned her. Sirani was given a magnificent funeral with specially commissioned music and oratory, and, as a final gesture of esteem, she was buried next to Reni.

Sisley, Alfred

1839–1899 • French • painter • Impressionist

Every picture shows a spot with which the artist himself has fallen in love.

Born in France to English parents, Sisley studied at the studio of GLEYRE with MONET, BAZILLE, and RENOIR. He was painting at BARBIZON in 1861, and was a close friend and frequent companion of Renoir. Both men painted at Bazille's studio. Monet was a strong influence and may have persuaded Sisley to devote himself to landscape painting. It is said that Sisley never quite broke out of Monet's orbit, but he worked there as an admirer, not an imitator. The differences between their paintings are best understood by the effects they have on a viewer. Whereas a landscape of Sisley's will transmit that feeling of the artist having fallen in love with at least some part of the scene, as he says in the comment above, a Monet landscape has a more detached and overall effect. Speaking about the sky, Sisley makes an interesting point: "Not only does it give the picture depth through its successive planes (for the sky, like the ground, has its planes), but through its form and through its relations with the whole effect. . . . I emphasize this part of landscape because I would like to make you understand the importance I attach to it." In the painting *Chestnut Trees at La Celle-Saint-Cloud* (1865), although the sky is barely one-eighth of the picture, the sense of depth Sisley bestows on it is as complex as that of the rocks, ground, and trees below.

size

A diluted glue that is used to reduce the absorbency of CANVAS, stiffen PAPER and textiles, or fill in the porous surface of a wood PANEL, all for the purpose of enhancing a GROUND for painting.

Sloan, John

1871–1951 • American • painter • Realist

I'm not a Democrat, I'm of no party. I'm for change—for the operating knife when a party rots in power.

Prominent among urban REALISTs[1], Sloan studied at the Pennsylvania Academy of the Fine Arts with ANSHUTZ, was a close associate of HENRI, exhibited with The EIGHT, and was a member of the ASHCAN SCHOOL, where he was outstanding for both his Socialism and his insistent exposés of the plight of the underclasses. Among his chosen subjects were prostitutes and alcoholics (his wife, a tormented soul, was both). He insisted, however, that his paintings were not political statements, as in the quotation above, and they certainly need no social doctrine to sustain the strength of their composition, the loose, powerfully expressive brushstrokes, and strong color. He was a spectator who roamed the streets or gazed out of his window, and recorded what he saw in both his diaries and his sketches. His paintings are full of emotion and atmosphere. Among the best known is *Hairdresser's Window* (1907), a boisterous, humorous scene in which people on the street look up at a bleached-blond hairdresser in the process of dyeing a client's hair. While anecdotal and an archetype of spectatorship, it is also an example of design and significant concerns, for the building also forms a backdrop for an arrangement of advertising signs, and these play with notions of the printed word and meaning. Although Sloan challenged those who read politics in his paintings, polemics was the purpose of the drawings he did for magazines like *The Masses*. In addition to championing the poor, he was a strong supporter of women's suffrage.

Sluter, Claus

1360–1406 • Netherlandish • sculptor • Late Gothic/International Style

Claus Sluter inhabited a house at Dijon which the duke placed at his disposal; there he lived as a gentleman, but at the same time as a servant of the court. . . . This serfdom of a great art controlled by the will of a princely patron is tragic, but it is at the same time exalted by the heroic efforts of the great sculptor to shake off his shackles. (J. Huizinga, 1919)

Sluter worked in the court of Duke Philip the Bold of Burgundy (see VALOIS), and when the principal supervisor of Philip's main project at Dijon died, Sluter took over as *varlet de chambre*. The duke's project was the grandiose, Carthusian monastery complex that included the Chartreuse (Charterhouse) de Champmol (1385–93). Sluter carved massive, energetic figures for the main portal of this building, including those of Philip and his wife, the Madonna, and two saints. Not only have such formerly attached architectural figures been detached from the structure by Sluter, but also they are the focus of attention rather than an ornament of the building, and they seem to interact with

one another across the spaces that separate them. The best known of Sluter's sculptures was for the interior cloister; it includes a life-size portrayal of Moses, as well as other Old Testament prophets, and is known as the *Well of Moses* (c. 1395–1406). The stone sculpture was originally vividly gilded and painted, but the color is now mostly gone. The eyes and brow of Moses, even his long, knotted beard, radiate fury. Two odd horns growing from the top of his head suggest he might even drive his followers back to Egypt—the text of the scroll in his left hand reads, "The children of Israel do not listen to me." The horns result from Saint Jerome's translation of the Hebrew Bible into Latin—the Vulgate—in the late 4th century. In the passage of Exodus where Moses descends from Mount Sinai, the original text described light emanating from his face. Reluctant to have light radiate from anyone who predated Jesus, Jerome translated "shining" with the word "horned." (Other artists, including MICHELANGELO, also gave Moses horns.) The energy of Sluter's figures, the intensity of their emotions, the deep folds of their DRAPERY, were new and important steps beyond what had been done previously. They were not antithetical, however; the direction of Late GOTHIC sculpture was toward greater expression and individualization, and the dramatic staging of religious mystery plays was also influencing works of art. But the unique dynamic of Sluter's style was recognized, and was soon widely imitated. Considering Sluter in *The Waning of the Middle Ages* (first published in Dutch in 1919, recently retranslated into English and retitled *The Autumn of the Middle Ages*), J. Huizinga writes a fine appreciation of his art; a passage from the book is quoted above.

Smibert, John

1688–1751 • American • painter • Colonial

Thy Fame, O Smibert, shall the Muse rehearse, / And sing her Sister-Art in softer Verse. (Mather Blyes, 1730)

Born in Scotland, trained in Italy, Smibert accepted Dean George Berkeley's invitation to teach drawing at the college Berkeley intended to start in Bermuda. They stopped in America and, as the school was never funded by Parliament, Smibert stayed and opened a studio in Boston. His most renowned picture is a group portrait of Berkeley and his entourage, including the artist himself—*The Bermuda Group (Dean George Berkeley and His Family; 1729)*. It was Smibert's showpiece and led to the first truly successful painting career in America. Before retiring in 1746, Smibert had painted more than 250 portraits and greatly influenced his successors FEKE and COPLEY. The success that met his work is suggested by the lines above taken from a long poem published in the London *Daily Courant* of April 14, 1730.

Smith, David

1906–1965 • American • sculptor • Abstract Expressionist

I do not work with a conscious and specific conviction about a piece of sculpture. It is always open to change and new association. It should be a celebration, one of surprise, not one rehearsed.

For a period of time before World War II, Smith's work took its clues from SURREALISM. This is evident in *Interior* (1937), a sculpture constructed of wrought steel with cast-iron spheres, whose forms flow into one another to create a kind of three-dimensional drawing in air. Later, inspired by photographs of iron sculptures by GONZÁLEZ and PICASSO, Smith—whose ancestors were blacksmiths, as his name suggests—explored the possibilities of welding metal sculpture. "What associations [iron] possesses are those of this century: power, structure, movement, progress, suspension, destruction, brutality," he said. He found materials from discarded parts of army tanks, abandoned tools, and scraps from steel mills. In the early 1960s Smith's *Cubi* series, large geometric forms in stainless steel, usually placed outdoors, sometimes reflect ambient light in a way that challenges a viewer. With this series Smith moved in the direction of MINIMALISM; however, his explorations were ended when he died in an automobile accident. MOTHERWELL, a close friend, mourned his death with these words: "Oh, David, you were as delicate as Vivaldi and as strong as a Mack truck."

Smith, Kiki

born 1954 • American • sculptor • Feminist

The inside and outside are constantly in a shift of what you're letting go and leaving behind—you're breathing in and out and that's becoming you and then being expelled from you. . . . You're something that's constantly changing, and that fluidity is not to be lost.

Smith has concentrated on images of the female body, and she often refers to internal organs, bodily fluids, and isolated limbs. Her wish is to explore human identity and, as in the quotation above, the interactions between inside and outside. *Untitled* of 1986 is a row of 12 empty, identical, narrow-neck bottles, elegant in appearance. On the outside of each bottle is written, in archaic lettering, the name of a human fluid, including blood, tears, urine, and semen. Significant to her work, she briefly studied to be an emergency medical technician. To Smith, the body is irrevocably linked to art, even in work that has no figures in it: Art itself, with its insides and outsides, is like a living body, she believes. An embroidered cloth, for example, is similar to skin; her own skin is covered with tattoos. She says, "I've also tried to make sculptures with tattoos, which comes from looking at African bronzes and Indian art, with all the surface drawings on them." *The Sitter* (1992) is not tattooed. It is a disturbing sculpture of a woman's back. The figure is installed in a corner of a room, facing the wall, and thus immediately confined in space. She sits on her hands with her head bowed, and her back is scored with deep gashes. The physical and emotional distress implicit in this work raises questions about women's roles and suffering. And like a thorn, it pricks the mind to remember a sensuous painting by INGRES of a woman's back (*The Bather of Valpinçon*, 1808), and another of MAN RAY that played on it, *Le Violin d'Ingres*

(1924). Tony SMITH (see below) was her father.

Smith, Tony

1912–1980 • American • sculptor • Minimalist/Conceptual

Why didn't you make it larger so that it would loom over the observer?

I was not making a monument.

Then why didn't you make it smaller so that the observer could see over the top?

I was not making an object.

The questions addressed to Smith, and his answers, in the exchange quoted above, concern a work entitled *Die* (1962). It is a black steel cube, 6 feet square. High MODERN and MINIMALIST in the rigor with which it observes the MIES VAN DER ROHE dictum that "less is more," *Die* is also a post-Minimal, CONCEPTUAL exercise. For one thing, Smith gave the specifications for making it over the telephone and took no part in its actual production. And the ambiguity of its title is a play with language: Does the word "die" refer to the casting process? to dice? to death? This indeterminacy of meaning is thoroughly POSTMODERN. When Smith was four years old, he contracted tuberculosis. The treatment then was isolation, and he lived in a prefabricated house on the family property that is sometimes said to have been the inspiration for his geometric sculptures. He also attended architecture school in Chicago in 1937, a more direct, or at least supporting, source of his preoccupation. Lest the geometric purity of his sculpture be mis-

taken for cold Minimalist objectivity, an exhibition of his drawings, which are capricious rather than systematic, and poetically intuitive rather than mathematically engineered, reveal his sensual and spiritual approach to art. Smith's daughter, Kiki (see above), is a leading contemporary sculptor.

Smithson, Robert

1938–1973 • American • sculptor • Earth and Site

The scale of the Spiral Jetty *tends to fluctuate depending on where the viewer happens to be. Size determines an object, but scale determines art. A crack in the wall if viewed in terms of scale, not size, could be called the Grand Canyon.*

Spiral Jetty (1970), Robert Smithson's best-known work, about which he comments above, was constructed at a remote, abandoned industrial site with the look of a science-fiction wasteland on the Great Salt Lake in Utah. It is a vast spiral, 1,500 feet long and 15 feet wide, made of black basalt, limestone, and earth, that runs from the shore into the lake. Because of its inaccessibility and the fact that it was, before long, undermined by the natural fluctuations of the lake, *Spiral Jetty* could be appreciated only in photographs and, primarily, in the film Smithson made about it. In the film he draws on geography, maps of prehistoric and contemporary sites, the geologic time, mythology, and surveying. Frames of the giant earth-moving machines used to construct *Spiral Jetty* metamorphose into dinosaurs and then robots. The conceptual span of Smithson's references and inspiration

matches the vastness of his creation. Entropy—which has to do with the instability of matter and its propensity for disorderly change—was an important theme, as was his interest in reclaiming, or at least transforming, industrial wastelands. Smithson was killed in a plane crash in 1973 while making an aerial survey of a site in Texas.

Snyders, Frans
1579–1657 • Flemish • painter • Baroque

Original by my hand and the eagle done by Snyders. (Peter Paul Rubens, 1618)

Snyders's father owned an inn in Antwerp that was frequented by artists. When he was just 14, Snyders became a student of Pieter BRUEGEL the Younger. During his career he became a friend and working partner of RUBENS, who described *Prometheus Bound* (c. 1611) as "the flower of my stock," in a letter of April 1618, in which he also credited Snyders for the eagle, as quoted above. This rapacious eagle, with an enormous wingspread, plucks the liver from the tormented Prometheus. Because Snyders's specialty was STILL LIFE painting, there seems to be an attention to detail in the bird that separates it from the looser, more BAROQUE style of Rubens; however, it is generally agreed that the collaboration was a successful one and that Rubens probably composed the overall design of the painting. Snyders revitalized the type of market and kitchen still life with figures developed by AERTSEN, and in about 1610 invented the type of large picture that included "trophies of the hunt": dead game, often a gutted buck surrounded by rabbits and birds, an abundance of luscious fruits, perhaps a couple of hunting dogs, but usually no human figures. His paint was thick, his colors brilliant, his compositions dramatically lighted and monumental. Sometimes they illustrated popular sayings, proverbs, or perhaps one of Aesop's fables—all with an underlying moral message.

Soane, Sir John
1753–1837 • English • architect • Romantic

He was certainly distinguished looking: taller than common; and so thin as to appear taller; his age at this time about seventy-three. He was dressed entirely in black; his waistcoat being of velvet, and he wore knee-breeches with silk stockings. Of course the exception to his black were his cravat, shirt collar, and shirt frill of the period. . . . The Professor unquestionably looked the Professor, and the gentleman. . . . A brown wig carried the elevation of his head to the utmost attainable height; so that, altogether, his physiognomy was suggestive of the picture which is presented on the back of a spoon held vertically. (George Wightwick, 1851)

Wightwick, quoted above, worked for Soane, and after Soane's death wrote the description quoted above in his autobiography. An element of austerity in Soane's architectural designs seems consistent with his physical appearance. The main source of this restraint was CLASSICAL, and it influenced American architects (e.g., LATROBE and JEFFER-

son). Soane's Bank of England building (1788–1808) is an example of the severity of his interpretation of antiquity—the interior surfaces especially, which, beneath a domed roof that has arched windows at its base, are unadorned. Incorporated with the house that he built for himself in Lincoln's Inn Fields in London (1812–13) was a museum with an Egyptian sarcophagus as its centerpiece. The museum building is an intricate design of small, connecting rooms, sometimes one room inside another, sometimes changing levels, with openings appearing overhead and distorting mirrors—all confounding one's sense of stability, order, and boundaries. "This lack of faith in stability and security is utterly un-Grecian and highly romantic," Nikolaus PEVSNER writes. "The Classical Revival . . . is only one facet of the Romantic Movement."

Social Realism

The most inclusive definition of Social Realism links it with 19th-century REALISM[1] and artists, like COURBET, who were moved to protest inequities of class through sympathetic representations of the underprivileged as victims of the well-to-do. (An artist like the 18th-century painter CHARDIN, whose serene pictures of working-class people do not imply injustice, is not a Social Realist.) KOLLWITZ has been called the first of German Social Realists. AMERICAN SCENE and WORKS PROGRESS ADMINISTRATION artists of the 1920s and 1930s, to the extent that they were motivated by social causes, were Social Realists. RIVERA is a Social Realist, but also, considering his political affiliations, is called a SOCIALIST REALIST, as below. Both Social and Socialist Realism are less STYLES than philosophies or principles used in executing a work. But in general they all endeavor to make art that will be widely understood.

Socialist Realism

Painters in the Soviet Union after the Revolution were pressured to adopt a style that would be more understandable and inspirational to the proletariat, and that was, above all, in harmony with the objectives of socialism. This work, glorifying the state's cultural and technological values, is Socialist Realism (as opposed to SOCIAL REALISM). Distinguished among Russian Socialist Realists is the painter, sculptor, mosaicist, and illustrator Aleksandr Deineka (1899–1969). Few of the movement's other artists are internationally recognized, but Socialist Realism reverberated in art like that of the Mexican muralists (e.g., RIVERA). In the United States, where the idea that art should represent the class struggle was less overt, the style of Socialist Realism was unstated but underlay many artistic endeavors during the 1930s, especially in public MURALS.

Société Anonyme Inc.

Organization founded in 1920 by Katherine Dreier (1877–1952), a polemicist for and organizer of early MODERNISM in America; DUCHAMP; and MAN RAY. They raised money to provide exhibition opportunities for the most progressive experiments, and the Société itself bought some of the works. It was, in effect if not officially, the first modern art museum in America, a role soon eclipsed by the Museum of Mod-

ern Art, founded in New York City in 1929. In addition to many American artists, KANDINSKY, SCHWITTERS, MIRÓ, MALEVICH, PICABIA, and KLEE were among the European artists the Société introduced to the American public. Dreier gave the Société's collection to Yale University in 1941 and the group dissolved in 1950.

Society of Independent Artists

An organization of artists that grew out of meetings held during 1916 at the ARENSBERG home in New York City, the society was formed in 1917 with GLACKENS as its first elected president. Other supporters were DUCHAMP, MAN RAY, BELLOWS, Walter Pach, and Katherine Dreier (see SOCIÉTÉ ANONYME). They proclaimed "no jury, no prizes," as had sponsors of the earlier French SALON DES INDÉPENDANTS. Anyone who paid the society annual dues of five dollars and the initiation fee of one dollar could participate. The works were arranged alphabetically, according to the artists' last names. The first exhibition was held April 10, 1917, at the Grand Central Palace in New York City, with a brass band on opening night. With 2,500 works by 1,200 artists from 38 states and several European countries, it was the largest exhibition ever held in the city. There was a wide range of styles, and more than 20,000 people visited the exhibit during its four-week run. Duchamp withdrew, however, when his "ready-made" urinal, *Fountain,* was rejected for exhibition. The society continued to hold exhibitions into the 1940s; however, its importance had dwindled significantly by then.

soft ground etching

See ETCHING

soft sculpture

Works like those by OLDENBURG, Robert MORRIS, HESSE, and RINGGOLD, made of soft material such as canvas, latex, vinyl, or rope, as opposed to sculpture formed of stone, wood, metal, or plaster.

Soutine, Chaim

1893/4–1943 • Russian/French • painter • School of Paris/Expressionist

I still see him approaching Rembrandt's canvases with a kind of respectful fear. He stood for a long time, went into a trance, and pranced about shouting, "it's so beautiful it maddens me!" (Raymond Cogniat, 1953)

Soutine was a friend of MODIGLIANI and also Jewish, but the similarity in the two artists' backgrounds ends there. Soutine was born into an indigent family, the 10th of 11 children. The story is told that at the age of seven he was locked for three days and nights in a damp basement as punishment for stealing pennies to buy colored pencils. His personal torment, nightmares, bad health, and seeming instability are told by his paintings. Soutine's expressive brushstrokes often seem violent, like those of van GOGH, yet without van Gogh's directional control. Where Modigliani stylized faces, exaggerating features without distorting them, Soutine's exaggerations are true distortions: In *Woman in Red* (c. 1922), the strange person in a tawdry red dress

and big blue hat is a parody of a woman. But it is the strangeness of the artist rather than his subjects that his pictures lead a viewer to contemplate. *Side of Beef* (1925) is among Soutine's best-known paintings. It is an adaptation of REMBRANDT's *Slaughtered Ox* (1655), which Soutine might have seen at the Louvre. He was a tireless visitor to that museum, and also made frequent trips to The Hague, where he spent hours looking at Rembrandt's paintings which the quotation above describes. Soutine's *Side of Beef* is accompanied by its own folklore: From day to day, blood was brought to his studio from the butcher's shop to refresh the decaying carcass he used as a model. Neighbors, offended by the smell, called the police. The same red in the dress of *Woman in Red* is now slashes of blood in the hanging carcass, which is set against bright bold blues. The metaphor of human suffering and perhaps the concept of crucifixion is at its rawest here. (For slaughtered ox theme, see TENIERS.)

Spencer, Lilly Martin
1822–1902 • American • painter • Romantic/Genre

Let Men . . . know that with the skill of her hands and the power of her head, she sustains a family. . . . Aye, sustains them a thousandfold, better than she could have done with the needle or the washtub, and gives out to the world besides, the rich treasures which become the rays of sunshine in many a heart and home. (Francis Dana Gage, mid-1850s)

Essentially self-taught, Spencer painted scenes of everyday life as well as sentimental subjects. Most unusual for her time, when she married in 1844 her husband realized that she would be the one to earn the family income, so he took care of the household as well as helping with her business affairs. Spencer's GENRE paintings are important in their representations of the domestic sphere. Though she was more or less forced to paint such pictures, as they were the only ones she, as a woman, was able to sell, she imparted both dignity and individuality to her female subjects and their chores. She ran into trouble, however, when she domesticated a male: *The Young Husband: First Marketing* (1856) received terrible reviews and did not sell. Both her supporters—the writer quoted above, for example—and those who reviled her tended to fall into hyperbole characteristic of the Victorian era.

Spencer, Sir Stanley
1891–1959 • English • painter • Romantic

Love is the essential power in the creation of art. And love is not a talent.

Little known outside of England, and not well celebrated there, Spencer moved into the limelight, literally, in 1996 when a play about his life entitled *Stanley* was produced and a major retrospective exhibition of his work opened. Spencer's neglect is largely due to his rejection of MODERNISM, his insistence on narrative pictures in familiar settings. Distinctly unstylish, commit-

ted to the embodiment of form, color, texture, and tactility, he may best be understood in the emotionally expressive tradition of ROMANTICISM. As he insists in the quotation above, it was love that drove his creativity. "My capacity to draw and paint has got nothing to do with my vision; it's just a meaningless, stupid habit," he also said. That people and objects in his paintings are recognizable, many of them members of his family, friends, and himself, does not make their meanings clear. Nor does it modify their underlying, unsettled, passionate distress. He painted his experiences as a medic in World War I with religious fervor, and later painted disturbing, erotic nudes of women he loved, sometimes including himself in the picture. In *Self-Portrait with Patricia Preece* (1936) Spencer is seen from the back, in the very front of the canvas, cut off at the shoulders. His twisted neck is oddly elongated and looks like nothing so much as that of a plucked chicken. The reclining nude, also pushed to the front of the PICTURE PLANE, occupies most of the canvas. She is cropped at the forehead and at her bent knees, which seem to cradle Spencer's head in a landscape of hilly flesh. "God speaks eloquently through the flesh," Spencer wrote. "That's why he made it."

Spero, Nancy
born 1926 • American • painter • Feminist

It was between eleven o'clock and midnight. For me the result was an anxiety about death, and a rat that found its niche in a piece of bread on the table next to me.

Spero has defied convention throughout her career, working as a FIGURATIVE artist during the 1960s when most American artists were ABSTRACT EXPRESSIONISTs, and ignoring their tendency to overwhelm an audience with the grandiose size of their canvases by using the relatively small medium of paper. The language of discrimination against women interested her, and she used COLLAGE on rice paper in her best-known work, the *Codex Artaud* (1970–71). This is filled with bizarre images—a bent-over, headless body with four breasts, and a head with a thrust-out tongue that turns into a penis. The latter is possibly the most direct interpretation of the idea that language is power, and that those who have power construct language. The "Artaud" of the title was a French SURREALIST writer, Antonin, whose madness freed him from the constrictions of language. The text of *Codex Artaud,* of which a brief excerpt, in translation, is quoted above, is in French. Since the *Artaud* series, Spero has worked on such themes as the torture of women. Some of the accompanying words are quotations from reports of Amnesty International accompanied by excerpts from an ancient Sumerian creation myth. Spero is married to GOLUB.

stained glass
Refers to colored glass, primarily as used in window designs. The color may be either intrinsic to or painted onto the glass surface. Compositions made with pieces of colored glass are held together

by strips of lead, or cames. Although stained glass was known and used previously, during the GOTHIC period architecture became, in effect, a framework for supporting stained-glass windows. Installing these windows in churches was avidly promoted by SUGER, for whom their colored light had spiritual meaning. THEOPHILUS described making stained-glass windows in his treatise *On Diverse Arts* (c. 1100), from building a furnace for firing the glass to plotting the design (and color scheme) on a flat board covered with chalk; from tracing the design onto the glass to cutting the glass; from fixing the lead bands that serve to both outline picture forms and bind the pieces together to assembling the whole and installing the window in an iron frame. Twelfth-century windows on the west facade of CHARTRES survive, as does most of the cathedral's 13th-century stained glass. The glassmaking WORKSHOPS at Chartres were famous. Firing painted details on the glass was part of the process early on, and later became the preferred method of decorating windows. Working with stained glass, rather than painting it, was revitalized during the 19th century. William MORRIS in England and TIFFANY and LA FARGE in America were prominent designers and innovators. The architects SULLIVAN, Frank Lloyd WRIGHT, and HORTA and the artist van DOESBURG also designed elegant, abstract, colored glass windows for a variety of buildings. Notable religious designs were carried out by MATISSE (for a chapel in Vence, France) and by CHAGALL (for a synagogue in Jerusalem).

Stankiewicz, Richard
See JUNK ART

Steen, Jan
1626–1679 • Dutch • painter • Baroque

. . . if this extraordinary man had had the good fortune to have been born in Italy, instead of Holland, had he lived in Rome instead of Leyden, and been blessed with Michael Angelo and Raffaelle for his masters, instead of Brouwer and Van Gowen; the same sagacity and penetration which distinguished so accurately the different characters and expression in his vulgar figures, would, when exerted in the selection and imitation of what was great and elevated in nature, have been equally successful; and he now would have ranged with the great pillars and supporters of our Art. (Sir Joshua Reynolds, 1774)

REYNOLDS's assessment of the everyday domestic pictures Steen painted was the prevailing attitude toward GENRE painting for centuries. Dutch works like Steen's have been awarded more attention and prestige since the 1960s and the writings of E. de Jongh, who saw the moralizing intentions of EMBLEM BOOK sayings hidden in Dutch art. Even in that context Steen stands out. His homes are not the tidy, polished interiors of VERMEER; on the contrary, a "Jan Steen household" to this day alludes to one that is somewhat undisciplined and untidy. Testimony that HALS had influence on Steen is found in two of Steen's interior scenes in which paintings by Hals are shown hanging on the walls. There is also affectionate comedy in his

pictures. *The Lovesick Girl* (early 1660s) illustrates the saying "Love is a sickness that no medicine can cure": A doctor takes the pulse of a young woman who is out of sorts, reacting to a letter she has just read. Lest the point be missed, a small statue of Cupid stands above the doorway, his arrow precisely aimed at the lovelorn girl. That the purpose of such paintings is primarily to put flesh on abstract ideas was challenged in a controversial book by Svetlana Alpers, published in 1983. Alpers gives interpretation a secondary role and argues that Dutch genre scenes, painted in a century during which optical science made great advances, were intended as visually descriptive representations of Dutch life—REALISM[1] for its own sake. Whether one looks at Steen's *Self-Portrait Playing the Lute* (1663–65) as illustrating a proverb or as reflecting what Steen saw when he looked in a mirror, one cannot help but see a man who had a rollicking sense of humor.

Steichen, Edward

1879–1973 • American •
photographer/painter • Pictorialist

Have a look into the faces of the men and the women on these pages. Listen to the story they tell.

With STIEGLITZ, Steichen was a founder of the Photo-Secession group at 291 Fifth Avenue in New York City in 1902. A painter as well as a photographer, Steichen employed special processes to manipulate the printed image—for example, he used a coating of pigmented, light-sensitive substance (gum arabic with WATERCOLOR pig-

ment) that allows manipulation of the printed image during development. This made his pictures look as much if not more like paintings than photographs; even their titles, e.g., *The Pond, Moonrise* (1903), indicate the expressive potential of the scene in painterly and poetic terms of light, line, and color. In 1900 Steichen went to Paris to study. He also acted as liaison between Stieglitz and the French avantgarde, introducing their work to the United States through the 291 Gallery. After World War I Steichen devoted himself to photography, to the extent that he destroyed all of his paintings. He worked in fashion photography and portraiture and after World War II was named head of the photography department at the Museum of Modern Art in New York City. His comment quoted above is taken from the publication, in 1939, of 41 Depression-era photographs.

Stein, Gertrude

1874–1946 • American •
author/collector

And I was and still am satisfied with my portrait of me, it is I, and it is the only reproduction of me which is always I, for me.

Gertrude and brother Leo Stein were wealthy American expatriates living in Paris early in the 20th century. They were among the first to appreciate the FAUVE painters, and bought MATISSE's maligned *Woman with a Hat* at the 1905 exhibition (at which the critic Louis Vauxcelles gave the Fauve movement its name). Leo bought the family's first PICASSO that same year. By 1906

Gertrude had posed some 90 times for the famous portrait of her that Picasso painted and to which she refers in the quotation above. Leo and Gertrude were avid collectors, and from 1905 to the onset of World War I, the Stein apartment was a vital and exciting showplace of avant-garde art and a gathering place for the artistic and literary lights of the era. Matisse and Picasso met there for the first time. Visitors to the Saturday-night "salons" ranged from the poet APOLLINAIRE and the painter LAURENCIN to the idiosyncratic American collector BARNES. Gertrude Stein wrote *Four Saints in Three Acts,* which was scored by Virgil Thomson and had costumes and cellophane sets by STETTHEIMER; was choreographed by Frederick Ashton and directed by John Houseman; and had the first all-black cast in an American opera. In 1934 it premiered at the Wadsworth Atheneum in Hartford, Connecticut, which bragged about having one of the first fully equipped theaters in an American museum.

stele (also stela)

From the Greek term for "standing block," the stele is an upright marker, usually a gravestone. Of special interest to art historians are those from ancient Greece of the Late CLASSICAL period. The tragic plague and loss of the Peloponnesian War probably contributed to the development of the melancholy imagery found in these steles. The *Grave Stele of Hegeso* (c. 400 BCE), a delicately carved image in low RELIEF of a seated woman and her servant examining jewelry, is among the most notable of those steles.

Stella, Frank

born 1936 • American • painter • Post-Painterly Abstraction

My painting is based on the fact that only what can be seen there is there.

Stella entered the art world's consciousness in a 1959 exhibition at the Museum of Modern Art called *Sixteen Americans.* His contemporaries were compelled to recognize his innovative advance in a painting like *The Marriage of Reason and Squalor II* (1959), in which a series of parallel white lines, at equal distances from one another, form the top ends of two rectangles. The bases of the rectangles are somewhere below the bottom of the canvas. As with studying the threads, or skeins, that Jackson POLLOCK wove, following one of Stella's lines to its presumed end is impossible. Where a Pollock skein is lost when it vanishes in the tangle, Stella's line advances and retreats by dint of its own declarative value and then vanishes into infinity, or at least somewhere outside the canvas. In 1960 Stella began to use bright, bold colors, as in his "protractor" series of 1967. These may have been inspired by INTERLACE designs on HIBERNO SAXON manuscripts, which he researched as a student at Princeton University (e.g., *Agbatana I;* 1968). Stella also made canvases that were shaped to complement the geometric subjects he painted—semicircular or triangular, sometimes a series of one or the other. This practice is a parody of the prescription that form should follow function, considering that the function of abstract art is itself. Stella took color into uncharted territory, and on an

enormous canvas his colors may be so strong as to almost defy the viewer's presence in the space it occupies.

Stella, Joseph

1877–1946 • American • painter • Futurist

[It is a] weird metallic apparition under a metallic sky, out of proportion with the winged lightness of its arch . . . massive dark towers dominating the surrounding tumult of surging skyscrapers with their gothic majesty sealed in the purity of their arches . . . the shrine containing all the efforts of the new civilization, America—the eloquent meeting point of all the forces arising in a superb assertion of their powers, an Apotheosis.

The only American artist to come directly under the influence of the Italian FUTURISTS—no doubt because he was born in Italy—immigrated to New York when he was 19 and returned to study in Italy and Paris between 1909 and 1912. He was in Paris when the Futurists had their first exhibition there in February 1912. The year after his return to the United States, Stella painted a brilliant example of Futurism's dynamism in *Battle of Lights, Coney Island* (1913; one of a series). The elements of Coney Island's amusement park are fractured into multitudes of small, geometric, kaleidoscopic forms in strong, pure, bright colors. Slanted "force lines" add to the painting's honky-tonk glitter and energy. Stella painted Futurist interpretations of the Brooklyn Bridge, a subject that fascinated many of his contemporaries. Ex-

cerpts from his commentary on the bridge are quoted above. Stella was among the founders of the SOCIÉTÉ ANONYME INC.

stencil
See PRINTING

Stern, Robert
See POSTMODERNISM

Stettheimer, Florine

1871–1944 • American • painter • "Rococo Subversive"

My attitude is one of Love / is all adoration / for all the fringes / all the color / all tinsel creation / . . . and the sky full of towers / and traffic in the streets / . . . and crystal fixtures / and my pictures . . .

Only in the mid-1990s did Florine Stettheimer's witty, ethereal paintings begin to receive the critical attention they deserve. During her lifetime she had just a single one-person show, and her will specified that her work be destroyed. Fortunately, the will was broken. Many fanciful scenes were peopled with her two sisters, herself, and their friends from the world of arts and letters. She lived in and loved New York, as shown in her poetry quoted above, and she painted a series of four *Cathedral* pictures in honor of the city: *Cathedrals of Broadway* (1929), *Cathedrals of Fifth Avenue* (1931), *Cathedrals of Wall Street* (1939), and *Cathedrals of Art* (1942). Part fantasy, part reality, and all humorous, these are executed in her characteristic light, bright colors and lighthearted style. Her elongated, floating, dimensionless figures are often car-

icatures of the social, political, and art world elite with whom she socialized. The list includes the literary figure Carl van Vechten, the art critic Henry McBride, STIEGLITZ, and DUCHAMP. She also designed the stage set and costumes for *Four Saints in Three Acts,* written by STEIN. Stettheimer fits into no recognizable stylistic category, but the phrase "Rococo Subversive" used by the historian Linda Nochlin, fits nicely.

Stieglitz, Alfred

1864–1946 • American •
photographer • Pictorialist

I am the moment. I am the moment with all of me and anyone is free to be the moment with me. I want nothing from anyone. I have no theory about what the moment should bring. I am not attempting to be in more than one place at a time. I am merely the moment with all of me.

Stieglitz was probably the most significant influence on and motivation for the introduction of MODERN art in America. His art gallery, founded in 1905 and named 291 for its address on Fifth Avenue in New York City, and his publication *Camera Work* both promoted the avant-garde. He not only brought the newest innovations in European art, but also supported Americans in their Modernist ventures. A group known as the Stieglitz Circle included WEBER, DOVE, MARIN, HARTLEY, and O'KEEFFE, whom Stieglitz married and who became his subject in a series of photographs he made over 20 years. The first exhibition of American Modernists was held at 291 in 1909. A pho-

tographer himself, Stieglitz promoted photography as an art rather than for its traditional role of documentation: *The Steerage* is one of his own artful compositions in which people are seen in terms of lines, shapes, and spaces. The movement devoted to this purpose was called Photo-Secession, formed by Stieglitz and STEICHEN in 1902. Among its members were Gertrude Käsebier (1852–1934) and Clarence White (1871–1925). Against institutions and "isms" of all kinds, sometimes Stieglitz was as enigmatic as he was provocative, as is true of his comment quoted above.

Stijl, De (The Style)

Underlying De Stijl, a movement that formed in Amsterdam in 1917, was an effort to impose clarity, certainty, and order on the chaos caused by World War I. While America's reaction to the war was isolationist, politically as well as artistically, one of the European reactions expressed through De Stijl was to search for the spiritual through the rational. (Others—DADA and SURREALISM, for example—were entirely irrational.) Holland had been neutral during the war, but the country was nevertheless beset by a sense of upheaval. Prime movers of De Stijl were the painter van DOESBURG, who launched a periodical called *De Stijl,* and his close ally, until their split in 1924, MONDRIAN. The movement was predicated on teachings of Theosophy, a spiritualism based on Oriental religion. Aware of but rejecting other contemporary styles, van Doesburg and Mondrian insisted on the primacy of the straight line and its expression through right angles and geometric

shapes. Their canvases were painted with the primary colors, red, yellow, and blue, and with neutral black, white, and gray tones. De Stijl experimentation with the straight line encouraged typographical work with geometrical letter shapes and architectural innovations in what came to be the INTERNATIONAL STYLE. Both Mondrian and the American architect Frank Lloyd WRIGHT influenced the building style whose most important De Stijl proponents were H. P. Berlage (1856–1934) and J. P. Oud (1890–1973).

Still, Clyfford E.

1904–1980 • American • painter • Abstract Expressionist

A great free joy surges through me when I work. And as the blues or reds or blacks leap and quiver in their tenuous ambiance or rise in austere thrust to carry their power infinitely beyond the bounds of the limiting field, I move with them and find a resurrection from the moribund oppressions that held me only hours ago.

Still covered his canvases with thick paint, seemingly applied with a trowel. The shapes on his dark backgrounds are indeterminate, but they are not globular or BIOMORPHIC, nor are they recognizable FIGURES, though they are suggestive of forms that individual viewers see differently—e.g., *1946-H (Indian Red and Black); 1946.* The goal he expressed was to turn matter into spirit. He believed in the transformative power of art and thought of himself as something of a shaman.

still life

A branch of painting that, in essence, represents things standing still. The use of the term in English is derived from the Dutch *stilleven*—*leven* originally meant not only "life" but also "model." From PLINY the Elder's account of the rivalry between PARRHASIUS and ZEUXIS, we know that Greek artists painted TROMPE L'OEILS, and we may surmise that they also painted more conventional still lifes. Romans did; called *xenia,* these included the paintings of vegetables, fruits, and dead birds that were fashionable on the walls of domestic interiors in POMPEII. A detail from a Fourth Style wall painting from HERCULANEUM, *Still Life with Peaches* (c. 62–79 CE), shows green peaches arranged on two shelves; with them is a glass jar half-filled with water. The artist painted the view through the glass, through the water and the far side of the jar, to the surface beyond. Whether such images had social or philosophical significance—reference to PLATO's comments on art, or allusions to man's control over nature, for instance—is open to discussion. Elements of still life appeared as marginalia in MEDIEVAL manuscripts. Later, in NORTHERN RENAISSANCE paintings, still life "passages" or details, like the foreground columbine in van der GOES's *Portinari Altarpiece* (c. 1473–78), were, besides their exceptional beauty, symbolically coded to represent ideas like the Holy Ghost. The first autonomous still lifes were approximately concurrent in mid-16th-century Italy and the Netherlands. However, the "Golden Age" of still life painting occurred during the 17th century in the Low Coun-

tries. At the end of the 16th century, when the Reformation reduced the demand for religious paintings and the growing middle class provided a market for other kinds of art, NETHERLANDISH artists became especially accomplished at independent still life pictures. But scholars will argue that apparently secular subjects, like AERTSEN's *Meat Still Life* (1551), make reference to religious topics, just as the humble but superb fruits and vegetables of the Spanish painter COTAN seem sacred. Glorious bouquets in Dutch flower still lifes of the 17th and 18th centuries represent luxury, prestige, and the enormous wealth that was needed to grow such botanical specimens (see RUYSCH). CARAVAGGIO sabotaged that kind of excess when he painted overripe fruit beginning to rot. Moreover, he painted it so that it seems to project from the canvas into the viewer's world (for example *Basket of Fruit*, c. 1600). Still life (*nature morte* in French, "dead life") ranked at the bottom of the French Academy's hierarchy, yet it persisted as an artistic challenge (e.g., CHARDIN). America's first great portrait artist, COPLEY, incorporated a masterful still life of a water glass on a highly polished table in the painting he sent to London for a critique of his skill. Still life also played a central part for artists of IMPRESSIONISM and CUBISM. In American art, O'KEEFFE broke through traditions to hold still life images, from skulls to flowers, in uniquely close, tightly cropped focus, which she also hugely magnified. Still lifes have, in fact, played almost every role possible in art, from incidental to absolutely central. But despite enduring ambition in execution and in metaphysical and metaphorical intention, still life paintings have remained at the bottom of the hierarchy in critical appreciation.

Stokes, Adrian

1902–1972 • English • writer/painter • Aestheticist

Apart from the more or less irrelevant fact that I always want to do it I find I can speak about my own painting only in a negative way.

Stokes praised works of art that deliver their message or meaning to the viewer immediately, without need for or recourse to particular knowledge or ICONOGRAPHY. Because he believed that much of the best art of that kind was made in the 15th century, Stokes devised the term "quattro cento" from the Italian word QUATTROCENTO, or the 1400s. PIERO della Francesca is Stokes's exemplar of the art he admired; he said that Piero's colors and their relationships tell all one needs know of the story. The highly subjective and often passionate AESTHETICISM of Stokes's analysis is found in *The Quattro Cento* (1932) and *The Stones of Rimini* (1934). Stokes himself began to paint in 1936, but while effusive in writing about the artists of the "quattro cento," he was stern regarding the "deficiencies" of his own work, as intimated in the quotation above.

Stoss, Viet

c. 1445/50–1533 • German • sculptor • Late Gothic

Stoss is to be reckoned with as one of the most gifted and individual masters

of Late Gothic sculpture. (James Snyder, 1985)

Stoss was a contemporary of RIEMEN-SCHNEIDER, and like him carved complex painted wood ALTARPIECES with numerous figures, elaborate scenes, and flamboyant decorative work. Stoss's figures were more expressive than Riemenschneider's, and his interpretive approach was also distinctive. For *Death of the Virgin,* the central scene of the *Saint Mary Altarpiece* (1477–79) for a church in Krakow, Poland, he chose to show Mary collapsing to her knees, surrounded by apostles, rather than the typical tableau of Mary dying in bed. Moreover, he used the opportunity to exaggerate her DRAPERY and that of all the apostles, with deep creases, curves, and hard, sharp edges, thus adding more drama than their faces show. (Indeed, if their robes were ironed out, so to speak, it would seem a remarkably less troubling scenario.) The emotion he conveyed results in Stoss's work being labeled "Gothic Baroque." His style seems to mirror the turbulence of his own disposition and fate as much as the scenes he portrayed. "In contrast to the prosperous career of Riemenschneider, that of Stoss was a tragic melodrama of a true individual who made concessions to no popular tastes and was, in his later years, practically an outcast in the artistic community of Nuremberg," writes James Snyder, whose evaluation of Stoss's oeuvre is also quoted above. Stoss's troubles reached a critical point when he was prosecuted for forging a financial document. Though ultimately pardoned by Emperor Maximilian, Stoss never was able to reclaim his earlier prestige.

Strand, Paul

1890–1976 • American • photographer • Pictorialist/Social Documentary

Your photography is a record of your living, for anyone who really sees. You may see and be affected by other people's ways, you may even use them to find your own, but you will have eventually to free yourself of them. That is what Nietzsche meant when he said, "I have just read Schopenhauer, now I have to get rid of him." He knew how insidious other people's ways could be, particularly those which have the forcefulness of profound experience, if you let them get between you and your vision.

Strand studied with Lewis Hine (see RIIS) in New York City and later (1907) was introduced to the STIEGLITZ Circle (Strand had his first exhibition at the 291 Gallery in 1916). He used abstraction in his photographic compositions, examining machinery and other objects, much as PRECISIONIST painters like SHEELER did. He also took tight, close-up photographs of plants that resemble O'KEEFFE's paintings. When he went to New Mexico, Strand took pictures of the same adobe church (*Church, Ranchos de Taos, New Mexico,* 1931) that O'Keeffe painted. Both treated the building abstractly, but were also attentive to its tactile quality and its texture, as well as that of the desert and the sky.

structuralism

Sometime after 1950, structuralism emerged in France. It was an alternative to MARXISM, which focused on economic forces, and to EXISTENTIALISM, which concentrated on the individual's will and self-definition. Structuralism assumes that a system, set of rules, or truths may be discovered by rational means (see SEMIOTICS). With its faith in the human intellect, structuralism is a HUMANISTIC approach. As an approach to ART HISTORY, structuralism is less devoted to revealing the meaning of an individual work of art than to understanding and making explicit the beliefs, practices, and conventions that enable the work to have taken the form and communicated the meaning it does. A structuralist study of visual NARRATIVE, like that carved onto the COLUMN OF TRAJAN, for example, assumes that there is a correct way of "reading" or understanding the story it tells, and the sculptural means of telling it, whether the artist is following an old convention or inventing a new one. POSTSTRUCTURALISM takes exception to this fixing of context, and DECONSTRUCTION demonstrates how understanding is never secure but is always unstable, deferred, subject to change, contingent, and open ended.

Stuart, Gilbert

1755–1828 • American • painter • Federal

On my return to Philadelphia in May 1796 I saw for the first time, in company with my father and uncle, Stuart's portrait. We all agreed that though beautifully painted and touched in a masterly style, as a likeness it was inferior . . . the complexion being too fair and too florid, the forehead too flat, brows too high, eyes too full, nose too broad, about the mouth too much inflated, and the neck too long. Such were the estimates made by artists and others during the lifetime of Washington. This is truth and should be a matter of history. (Rembrandt Peale, 18th century)

For 200 years Americans have seen George Washington with receding hairline and a gray wig that fluffs out over his ears; deep-set, muddy brown, heavy-lidded, expressionless eyes; high forehead and large nose; soft mouth and jowly cheeks. This icon, which appears on everything from the dollar bill to advertisements for cherry pie, is called the Atheneum head because it hung in the Boston Atheneum. It was painted by Gilbert Stuart, first in 1796 and at least 70 times subsequently. Stuart, who kept the original of the Atheneum head tacked up in his studio, became so proficient at painting Washingtons that he could turn out one every two hours; they were called his $100 bills because that is what he charged for them. Charles Willson PEALE and his son, Rembrandt Peale, who is quoted above, both painted Washington from life, as did several others, but their opinion of Stuart's painting was shared. Why, then, did Stuart's image rise to the status of national icon? One theory is that, in rebellion against European aristocracy, Americans wanted their heroes humble and plain. But perhaps it was simply that Stuart's brilliance as a

painter and fame as a portraitist served to elevate this particular work. His style was to brush on paint with fast, easy, and free gestures that captured spirit with spontaneity. He studied in England under WEST and was influenced by the style of REYNOLDS and ROMNEY. But Stuart was irascible, volatile, a man of excess in habits as well as moods. He drank heavily and was always in debt. Indebtedness caused him to move from London, where he was successful, to Ireland, where he both prospered and again fell into debt serious enough to be sent to prison. He fled to America in 1793, declaring that he was returning home to make his fortune by painting George Washington.

Stubbs, George
1724–1806 • English • painter • Romantic

Nature was and always is superior to Art, whether Greek or Roman.

While GAINSBOROUGH and REYNOLDS painted portraits of English aristocracy, Stubbs painted their horses. An authority on anatomy and a superb, self-taught technician, he first made his living painting people. Then, after travel through Italy and avid studies of anatomy that included dissecting horses, he carved a unique and very successful niche; his clients included every nobleman and member of the royal family who owned a horse. Sometimes he also painted the horses' owners, grooms, or coachmen. One of his triumphs is *Hambeltonian, Rubbing Down,* shown at the Royal Academy in 1800. The horse is portrayed just after winning in a spectacular finish an especially grueling race. The owner holds the reins, the young groom a towel, and one cannot but notice how the human figures are diminished in relation to the heroic horse. Elected an associate member of the Royal Academy, Stubbs did not become a full member because he never found time to paint the "presentation picture" that full membership required. As were FLAXMAN and Joseph WRIGHT of Derby, Stubbs was commissioned by Josiah Wedgwood, the innovative and successful pottery manufacturer, to execute designs for production. Another of his clients, the anatomist John Hunter, engaged Stubbs in 1772 to paint a rhinoceros that belonged to a menagerie in London's Strand. A series of paintings that does not fit easily into Stubbs's oeuvre is *Lion Devouring a Horse.* He painted at least 17 known versions of a terrified horse with a lion on its back. According to an often repeated anecdote, Stubbs had seen such an attack while stopping in North Africa on his way home from Italy. This may be a fabrication, but he did study the lion in a private menagerie, and deliberately frightened a horse to capture its expression of startled fear. The image of a lion attacking its prey is ancient, but Stubbs's rendering of this uncontrollable violence presages a theme of the ROMANTIC movement.

study collection
As the term itself implies, this refers to an art collection that serves primarily an educational purpose. The term also implies a collection that is less than first quality, for generally only the largest MUSEUMS can afford MASTERPIECES, and they are not part of colleges and universities. Moreover, because of

space restrictions, large and medium-size museums can keep only a small percentage, the cream of their collection, on permanent display; the rest is in storage. (Scholars may make arrangements to see them, however.) In the 1950s, the Yale University Art Gallery pioneered in publicly exhibiting, rather than concealing, its furniture storage in such a way that it may be used for teaching. Second-quality works are important for educational purposes. The Smith College Museum of Art, in Northampton, Massachusetts, for example (which also owns several masterworks), has DEGAS's uncompleted *The Daughter of Jephthah* (c. 1859–61), a work that reveals much about the artist's painting techniques. Another instructive work in the same collection is COURBET's *The Preparation of the Dead Girl* (c. 1850–55). It formerly was called *The Preparation of the Bride;* the name of this painting was changed after X-RAYS revealed that the original picture was painted over, in order to change the scene to a less morbid subject and, probably, to enhance its economic value after the artist himself had died.

Sturm, Der (*The Assault*)

The name of an avant-garde periodical and gallery founded in Berlin by the poet, critic, musician Herwarth Walden. (Sturm und Drang is the name of a German romantic literary movement of the late 18th century.) Walden showcased the work of German EXPRESSIONISTS—der BLAUE REITER and DIE BRUCKE—as well as Italian FUTURISTS and BRAQUE, DERAIN, VLAMINCK, ENSOR, KLEE, and DELAUNAY. In 1913, the high point of the gallery, a room full of Henri ROUSSEAU's paintings was exhibited in an international show of new and revolutionary art. Between 1910 and 1914, Berlin was a vital city for art and artists, thanks greatly to Walden, but that came to an end with World War I.

style

The word is from the Latin *stilus,* the instrument with which Romans wrote and thus expressed themselves. To the art historian, style is the expression of an individual or group in a culture during a given period of time, and is an essential subject of inquiry. When a new style appears (e.g., AMERICAN IMPRESSIONISM), it may be explained by travel (e.g., see CHASE), migration (see ANIMAL STYLE), trade (see UKIYO-E), or ideology (e.g., the impulse of 15th-century Italians to find inspiration in ancient Rome during the ITALIAN RENAISSANCE). Art historians as early as PLINY the Elder and VASARI discussed style, making judgments with implicit nationalistic, political, or other biases. Methods for the analysis and explanation of style have been the preoccupation of art historians ever since. To the extent that analysis of style (on which the practice of CONNOISSEURSHIP depends) is bound up with the authentication of art for purposes of buying and selling, it has come under attack, especially since the 1970s. But most historians examine style for evidence of deeper meanings. Still, it remains true, as Meyer SCHAPIRO wrote in 1953, "A theory of style adequate to the psychological and historical problems has still to be created. It waits for a deeper knowledge of the principles of form construction and expression and for a unified theory of the processes of social life in which the

practical means of life as well as emotional behavior are comprised."

sub-Antique

The term "sub-Antique" is used to distinguish styles that kept more or less of their own traditional expression despite strong, Greco-Roman influences after conquests by Alexander the Great, and, later, the succession of Roman emperors. Sub-Antique, sometimes called "pseudo-Classical," may be understood as resistant to the CLASSICAL spirit and authority. Regions where this is found include North Africa; the Nile Valley (see FAIYUM); Syria; Parathian and Sasanian Mesopotamia and Persia; inland Asia Minor; and the island of Cyprus. These provincial styles, as the historian Ernst Kitzinger notes, in turn exerted influence in major cities of the Roman Empire.

Sublime, the

In art and literature, during the 18th century, the idea of the Sublime was an antidote to the overriding rationality of the Scientific Revolution and the Age of ENLIGHTENMENT. It was expressed in Edmund Burke's *A Philosophical Inquiry into the Origin of Our Ideas of the Sublime and Beautiful* (1757). This Sublime, seen largely in nature, was a synonym for inexplicable grandeur, awesome power, that which incites terror. Distinctive from the "beautiful," which in theory implied balance and harmony, it was also different from the PICTURESQUE, a slightly later 18th-century concept concerned with irregularity and variety. The Sublime manifested itself in many guises, coming into its own during the ROMANTIC era, when the importance of revealing what was felt took precedence over reporting what was seen. The Sublime could be felt in the wilderness landscapes of COLE, the roiling seas, shipwrecks, and storms of TURNER, the monsters of FUSELI, the melodramas of John MARTIN, and the ravaging beasts sculpted by BARYE. Architects of the Sublime include BOULLÉE and SOANE. Burke's assault on the clarity of rationalism led him to note, "Dark, confused, uncertain images have a greater power on the fancy to form the grander passions than those which are more clear and determinate." The visionary artist BLAKE dedicated his *Book of Job* to Burke, who influenced the selection of verses that Blake illustrated. The value placed on the intuitive and emotional Romanticism was anticipated by the Sublime.

Suger, abbot of Saint-Denis
1081–1151 • French • cleric/patron

When, out of my delight in the beauty of the house of God, the loveliness of the many-colored gems has called me away from external cares, and worthy meditation has induced me to reflect . . . on the diversity of the sacred virtues: then it seems to me that . . . by the grace of God, I can be transported from this inferior to that higher world in an anagogical manner.

Suger, abbot of Saint-Denis, was an exceptionally effective churchman and administrator. Dating back to CAROLINGIAN times, the BENEDICTINE monastery of Saint-Denis, just north of Paris, was an unusually wealthy and politically important abbey. French kings were buried there and it had the relics of Saint Denis, the patron saint of France.

As chief adviser to the king, besides his role as abbot, Suger secured a mutually beneficial alliance between the monarchy and the Church. His rebuilding of Saint-Denis between 1137 and 1144 marks the birth of GOTHIC style. Suger wrote ecstatically and in detail about his entire building enterprise. His radical transformation was to replace the massive, heavy solidity of ROMANESQUE architecture with thin walls, supported on the outside by buttresses, and creating a soaring open interior space filled with colored light shining through STAINED GLASS windows. Suger's new style spread through France and the rest of Europe. CISTERCIAN critics saw ostentation and base materialism in Suger's love of worldly beauty and precious materials, but Suger rationalized the art's anagogical, or mystical, power as a means to transport the individual to a higher, spiritual realm, as the passage quoted above shows.

Sullivan, Louis
1856–1924 • American • architect • Modern

Form ever follows function.

Though Sullivan's name and work are less well known than his famous dictum that form should follow function, quoted above, and though he died in poverty and disrepute, he is among the giants of architectural history. Sullivan is credited with giving shape to the tall building and establishing a theoretical foundation for MODERN architecture in the United States. He insisted that multistory, skyscraper buildings escape the CLASSICAL, Beaux-Arts traditions (despite his having studied at the ÉCOLE DES BEAUX-ARTS) and establish their own language. The nine-story Wainwright Building in Saint Louis, Missouri (1890–91), sets the direction, with an exterior brick facade that reflects its structural frame. While true to their internal forms, his buildings are nevertheless richly ornamented. For Sullivan, ornamentation was more than the complexity and beauty recognized by most, who praised his geometric, floral, and foliate patterns. To him these decorations represented the conviction that "man," the hero—athlete, street-paver, bridge-builder—must surrender his individual will to the supreme will of nature. Sullivan wanted his buildings to remind people of their bond to nature, and to find joy in that attachment. Frank Lloyd WRIGHT was Sullivan's disciple. Though he was fired for moonlighting while working for the firm of Sullivan and Adler (Dankmar Adler, 1844–1900, Sullivan's partner, was concerned more with engineering than with design), Wright and Sullivan were later reconciled, and Wright was among those who remained faithful to the man he called "Master."

Sully, Thomas
1783–1872 • American • painter • Federal

Mr. Sully is, as we believe and sincerely hope, anchored safely in port for life. He has portraits engaged in succession for years to come at liberal prices. His fellow citizens of Philadelphia justly appreciate him as an artist and a man. (William Dunlap, 1834)

Sully was an eminent Philadelphia portrait painter for more than 50 years, as Dunlap, quoted above, wrote in his three-volume history of art in America.

In the beginning he followed in STU-ART's footsteps, but later, after a trip to England and studies under WEST, he acquired a style of his own. He brought idealism and the GRAND MANNER to his pictures, much in the style of Sir Thomas LAWRENCE. On a visit to Scotland in 1817, Sully spent time with Sir Walter Scott and described to him a beautiful young Jew, Rebecca Gratz, to whom he had been introduced in 1807 and whose portrait he would paint three times during the 1830s. There is much evidence that from Sully's description she provided the model for a character, also called Rebecca, in Scott's popular novel *Ivanhoe* (1820).

Superrealism
See PHOTOREALISM

support
Refers to the basic material upon which a work of art is painted—CANVAS, wood, PAPER, plaster, ivory, or another surface. The support is often coated or prepared to receive paint, in which case it is covered by a GROUND, and the ground is the actual surface onto which paint is applied. Thus, in a PANEL painting, the wood panel is the support and GESSO is the ground onto which paint is applied.

Suprematism
Refers to a concept and style arrived at by MALEVICH in 1913 when he "took refuge in the square," thereby unburdening his work of the "object" and devising as pure an ABSTRACT ART as had been painted to date. His manifesto was formulated and the Suprematist movement formed in 1915. After 1920, Abstract art was officially rejected in Russia, but Suprematism (like CONSTRUCTIVISM) gained influence in Germany. In 1927 a publication of the BAUHAUS printed an essay by Malevich in which he wrote, "To the Suprematist the visual phenomena of the objective world are, in themselves, meaningless; the significant thing is feeling, as such, quite apart from the environment in which it is called forth."

Surrealism
In 1922 André Breton led a rebellion against DADA (in which he had earlier participated) on the grounds that it was becoming institutionalized. His group broke up the Dada Congress of Paris in 1922 (the last great Dada exhibition). In 1924 Breton drew up a "Manifesto of Surrealism." Dominated by poets and literary critics, the movement gave central significance to the importance of dreams and the subconscious, and Breton described Surrealism's purpose as to "resolve the previously contradictory conditions of dream and reality into an absolute reality, a surreality." PICABIA, MAN RAY, and ERNST joined Breton. Techniques for exploring the unconscious world that so interested them included automatism: Having emptied the mind of preconceived notions and achieved a passive state, the artist might start to draw or paint. FROTTAGE (rubbing surface texture through paper) was another technique. While automatism was the prompt, once the idea was received, the artist took charge of executing the image with full consciousness. Some artists whom Surrealism tried to claim demurred (e.g., KAHLO and CHAGALL). The first group show of Surrealist artists was in 1925. Exhibitors included ARP, de

CHIRICO, Ernst, KLEE, Man Ray, MIRÓ, and PICASSO. TANGUY, DUCHAMP, Picabia, MAGRITTE, and DALÍ joined later. Besides being a revolutionary movement in art and literature, Surrealism was also political. It maintained a steady Communist line during the 1920s. Artists did not match writers in their propagandistic positions, but Picasso was among those who passed through a Surrealistic phase and became a Communist in protest against Franco's Fascism. With the Nazi invasion of Paris in the spring of 1940, most of the Surrealists, including Ernst, Tanguy, Dalí, MASSON, MATTA, and Breton himself, took refuge in the United States. Their influence on American ABSTRACT EXPRESSIONIST artists was momentous. The most important gathering place for Surrealists in America was GUGGENHEIM's private gallery, called Art of This Century.

Sweerts, Michael
1618–1664 • Flemish • painter • Baroque

[Sweerts] eats no meat, fasts almost every day, sleeps on a hard floor and gives possessions to the poor; each week he takes communion three or four times. (De Chameson, 1661)

Sweerts was one of the BAMBOCCIANTI and among the so-called Birds of a Feather, as the association of NETHERLANDISH artists in Rome was known. He returned home to Brussels and in 1656 received permission to open an academy for life drawing, especially for painters of tapestry CARTOONS. It was not a success, however. He called himself an Eques, or knight, although it is not clear if, or how, he might have ac-

quired the title. About 1660 he became a lay brother and missionary with the Lazarist Fathers, but he seems to have lost his sanity during a trip to the Orient, was dismissed from the mission, and died in India in 1664. He is one of the 17th century's most mysterious painters. In *Visiting the Sick* (from the series the *Seven Acts of Mercy,* c. 1651–52), he infused his humble subjects with stillness, solemnity, and quiet dignity. In his strong contrasting of light and shadow, he seems stylistically akin to the LE NAINS and de LA TOUR.

symbol/symbolic
A symbol signifies something other than itself. Symbols in art are devised by association (e.g., the cross as a symbol for Christ), evocation (the sword as a phallus), or convention (a white lily for purity). Cesare Ripa's *Iconologia* (1593), an alphabetized dictionary of symbols as well as ATTRIBUTEs and personifications, served as a standard reference for artists for more than two centuries (see EMBLEM BOOK). However, some symbols—the fantastic creations in BOSCH's *Garden of Earthly Delights* (c. 1504), for example—fall outside tradition.

Symbolism
From c. 1885 to c. 1900, following and in contrast to REALISM[2] and IMPRESSIONISM, Symbolism was a movement in literature (e.g., Stéphane Mallarmé and Paul Verlaine) as well as the visual arts. In ways an expression of ROMANTICISM, Symbolism was also subjective and emotional rather than objective and detached. The music of Richard Wagner was a source for much inspiration and imagery. Stylistically, Symbol-

ist artists varied widely, but to the extent that one can generalize, there was an inclination to "synthesize" rather than describe what the eye saw, to evoke rather than describe, to suggest ideas by symbols rather than elaborate on them in a reportorial manner. "To conjure up the negated object, with the help of allusive and always indirect words, which constantly efface themselves in a complementary silence . . . comes close to the act of creation," Mallarmé wrote. NEOPLATONIC PHILOSOPHY, the occult, and neo-Catholicism were intellectually fashionable in Symbolist circles. While some explored religious mysticism, even Satanism, and/or the erotic, others were interested in what was deemed "primitive" and exotic. A "Symbolist Manifesto" stated that Symbolism's goals were "to objectify the subjective (the externalization of an idea) instead of subjectifying the objective (nature seen through the eyes of a temperament)." Among artists whose names are connected with Symbolism are MOREAU, PUVIS DE CHAVANNES, GAUGUIN, RYDER, DENIS, REDON, and KLIMT. The NABIS, Rosicrucians of the SALON DE LA ROSE + CROIX, and SYNTHETISM were part of Symbolism.

Synchromism

In the early 1910s two American artists, MACDONALD-WRIGHT and RUSSELL, developed new concepts about using color, hence the combination, from the Greek roots, *syn*, meaning "together," and *chromatic*, meaning "pertaining to color." They were the first American artists to formulate a new aesthetic, complete with manifesto. They called themselves Synchromists and their paintings Synchromies. The catalyst for their ideas was a Canadian artist, Ernest Percyval Tudor-Hart (1873–1954), who promoted a system of color harmonies that established correspondences between tonal sound and color. Their theory offered the idea that color generates meaning and space in addition to form. Synchromism, which declined after about three years, was formulated at the same time as the French movement called ORPHISM, founded by DELAUNAY, and was dismissed as merely an extension of IMPRESSIONISM by the Americans.

Synchronic/Diachronic analysis

Used in connection with SEMIOTICS, these terms concern the notion of movement in time. "Synchrony," from the Greek *syn*, meaning "together," and *chronos*, meaning "time," describes a study or analysis concerned with a particular moment, and thus looks at language, or a work of art, within a limited time, place, and social system. *Dia*, meaning "through," combined with the Greek for time, refers to an analysis that is attentive to evolution and change over time; thus, diachronic studies are historical.

synesthesia

In the visual arts, synesthesia refers to the transfer, or translation, of nonvisual sensations—sound, temperature or movement—to visual representations, not only through color, the most obvious correlation (e.g., red for heat), but also through line and pattern. WHISTLER gave a number of his paintings titles of musical compositions, e.g., *Symphony in White No. II: The Little White Girl* (1864). DOVE experimented

with synesthesia in paintings like *Fog Horns* (1929), and MONDRIAN's *Broadway Boogie-Woogie* (1942–43) provides still another example. MUNCH, KANDINSKY, and BURCHFIELD are others who tried to render sensory experience in visual terms.

Synthetic Cubism
See CUBISM

Synthetism
Word coined by BERNARD and GAUGUIN to describe their effort to distill a deeper meaning from the natural world rather than to represent accurately a mirror image of what they saw.

Tachisme *(L'Art Informel)*

From the French word that means "spot" or "stain," Tachisme is the French version of American ABSTRACT EXPRESSIONISM. Its painters were in the second wave of the SCHOOL OF PARIS, and a spokesman and theorist for the movement was the French critic Michel Tapié (born 1909), whose tract on the subject is entitled *Un Art autre* (1952). In it he writes, "Today, art must stupefy to be art . . . the true creators know that the only way for them to express the inevitability of their message is through the extraordinary—paroxysm, magic, total ecstasy."

Taeuber-Arp, Sophie

1889–1943 • Swiss • painter/designer • Abstraction

. . . the wish to produce beautiful things—when that wish is true and profound—falls together with [one's] striving for perfection.

Working with the most basic forms—circle, square, and rectangle—and few colors, Taeuber-Arp investigated many possible configurations. Much as MONDRIAN experimented with straight lines and right angles, she limited her shapes and colors to simultaneously expand their possibilities. *Composition of Circles and Semicircles* (1935) organizes those two shapes in blue, white, and red on a black background. Her combinations of these entirely abstract, geometric forms may begin to suggest representational shapes—a mouth, a car—as clouds sometimes will do. Besides painting, Taeuber-Arp was a weaver, dancer, marionette maker, and stage, furniture, and house designer, among her multitude of skills. For 13 years she held the post of professor of textile design at Zurich's School of Applied Arts. She appeared in DADA performances and met ARP, whom she married. They lived near Paris and collaborated from 1928 to 1940, when the German occupation of France caused their return to Switzerland. That was followed by her untimely death three years later. She did not sign or date her work until the last two years of her life, and she left behind very few writings. The quotation above is from an article she wrote in 1922.

Takis (Panayiotis Vassilakis)

born 1925 • Greek • sculptor • Nonobjective/Kinetic art

. . . just the first in a series of acts against the stagnant policies of art museums all over the world.

First Takis made experimental sculptures of steel and wire with weights and springs that gave them motion (see KINETIC ART). Then he experimented with

magnetic fields and moving objects, and iron filings within them—for example, *Magnetic Ballets* (1960s). In 1969, however, he attracted more attention than did his work: He and five friends staged a sit-in at the Museum of Modern Art in New York City when the curator of the exhibition entitled *The Machine as Seen at the End of the Mechanical Age* would not replace a 10-year-old work by Takis with a newer one. Takis distributed a handbill referring to this act of defiance and his hope, as stated in the quotation above, that it was just the beginning. In fact, he was a catalyst for a loose coalition of young artists who felt alienated by the "art establishment." They formed the ART WORKERS' COALITION, and among their complaints were the exhibition of works by living artists without their consent and curators' failure to consult with artists about the installation and maintenance of their work.

Talbot, William Henry Fox
See DAGUERRE

Tamayo, Rufino
1899–1991 • Mexican • painter • Figurative abstraction

A lot has been said about my color, but they have not paid any attention to the arrangement of spaces. It's not all color.

Tamayo's parents were Zapotec Indians, and interest in his country's ethnography led to his working, when he was in his early 20s, as director of the now famous National Museum of Anthropology in Mexico City. In a painting like *Animals* (1941), inspired by pre-Columbian ceramics, the traditions of native Mexicans emerge. He used mainly earth colors, which was overly noted by critics, according to his comment quoted above. His simplified figures, often merging with the background, are idiosyncratic and easily recognizable. *Man against the Wall* (1960), for example, combines geometric and BIOMORPHIC or globular masses; the "man" has a circle for a head and abstract shapes for the rest of his body. He is a buff-colored form standing against a muddy, green-brown wall in an environment of muted colors. Tamayo worked in New York during the late 1930s and 1940s, and during the 1950s went to Paris, where he entered into an artistic dialogue with PICASSO and MATISSE. He rejected the political rhetoric of the revolutionary Mexican muralists (see RIVERA and SIQUEIROS). At the mid-20th century, Tamayo was one of the most influential Latin American painters.

Tanguy, Yves
1900–1955 • French/American • painter • Surrealist

We had decided that nothing would be defined / Unless according to the finger resting by chance on the controls of a broken machine. (Paul Éluard, 1932)

On seeing an early de CHIRICO painting in a shop window, Tanguy decided to become a painter, the story goes. He visited André BRETON soon after, became a SURREALIST, and developed expertise in technique and intimacy with the fantastic. He painted an idea of infinite space as eerie desolation inhabited by unrecognizable objects—or creatures. After a 1930 visit to Africa, his paintings incorporated the illumination

of blazing sunlight. Tanguy moved to the United States in 1939 and was married to SAGE. *Multiplication of the Arcs* (1954), his last major painting, was described by the critic James Thrall Soby as "a sort of boneyard of the world." This boneyard is a terrestrial space packed with sharply contoured but unrecognizable forms, neither machines nor objects from nature, all beneath a sky that is almost alive but as soft in its appearance as the rest is hard. All that can be interpreted from his paintings is a sense of foreboding. Among those who appreciated Tanguy was the poet Paul Éluard. The last lines of his poem to Tanguy are quoted above.

Tanner, Henry Ossawa

1859–1937 • American • painter • Realist

Many painters of religious subjects forget that their pictures should be as much works of art as are other paintings with less holy subjects. Whenever such painters assume that because they are treating a more elevated subject than their brother artists they may be excused from giving artistic value to their work or from being careful about a color harmony, for instance, they simply prove that they are less sincere than he who gives the subject his best attention.

The son of a bishop of the African Methodist Episcopal Church, Tanner grew up in Philadelphia, where he studied with EAKINS at the Pennsylvania Academy of Fine Arts. Though encouraged by Eakins, as a black man Tanner faced many roadblocks in America.

Paris was far more accommodating; he loved the city and settled there permanently, enrolling in the ACADÉMIE JULIAN. His best-known work, accepted at the SALON of 1894, is *The Thankful Poor* (1894), a painting that shows his interest in the quality of light, in this instance a holy luminosity, and the quiet piety of good people—an elderly man and a boy seated at table saying grace. In the tradition of MILLET, this is a sentimental dramatization of religious faith among the poor. Though sometimes, as in the instance just mentioned, Tanner painted black people, and he called race a "ghetto of isolation and neglect," race was not his primary artistic concern—religious subjects were his abiding themes, as his comment, quoted above, suggests.

Tanning, Dorothea

born c. 1910 • American • painter • Surrealist

A mon b . . . Max Ernst, le pl . . . du monde, le ra . . . plumes, qui me . . .

Tanning was one of several women who, in the 1930s, became interested in the subconscious, eroticized impulses of SURREALISM. The quotation above is from her painting *To Max Ernst* (c. 1970); the words are inscribed on a partially visible page of an open book. An antique clock on the wall, a bed with high posts, and a strange furry creature are also drawn on the page. (She married ERNST in 1948.) The subject of Tanning's paintings often concerned the sexual fantasies and fears of young girls, who appear in ambiguous spaces and look both seductive and afraid. *Palastra* (1947) is one such painting,

suffused with the sense of a mysterious sexual force sweeping through the air.

Tansey, Mark
born 1949 • American • painter • Postmodern

I love using the word illustration because it's such a bad word in the art world. And I think I'll start using color soon in my work. I'm looking forward to it.

Tansey has been in the forefront of a revival of interest in representational painting since the 1980s. His best-known work is *Triumph of the New York School* (1984). It is a reference to the relocation of the center of artistic activity from Paris to New York after World War II. The protagonists are dressed in army uniforms, a tank is parked nearby, and the fire and smoke of war are in the distance. On scene are recognizable portraits of important artists and critics including PICASSO, MATISSE, and the writer APOLLINAIRE on the French side, Jackson POLLOCK, MOTHERWELL, and the critic GREEN-BERG on the American. Puddles of paint on the ground are said to allude to Pollock's famous "drip" technique, yet the one beneath Greenberg's feet reflects not the man himself but, rather, the pedestal on which he stands. The picture is an ironic reference to France's "surrender" of first place, and an art historical reference to the composition of VELÁZQUEZ's *Surrender at Breda* (1634–35). *Triumph,* in SEPIA tones, is a single-color, or monochromatic, painting, as are most of his works, but his interest in using color, as the comment above suggests, is growing. His paint-

ings are also amusing and steeped in ideas he has absorbed from his reading in POSTSTRUCTURALIST theory. The combination of independence and humor in Tansey's work is also expressed in the comment, quoted above, that he made in 1994.

tapestry
Incorporating the pictorial image into the actual weaving of the fabric, tapestries often served in place of mural painting in MEDIEVAL and in NORTHERN and ITALIAN RENAISSANCE art. In the northern countries, especially, they also helped to allay the chill of winter. Hand-woven from an artist's design, usually in silk and/or wool, tapestry was the most expensive portable work of art. BONDOL's *Angers Apocalypse* (1373–82) is the earliest-surviving suite of GOTHIC tapestries. The important weaving centers of Europe were then in Flanders and France. During 1515–16, RAPHAEL undertook a major project for Pope Leo X, the design of 10 tapestries for the Sistine Chapel. Their CARTOONS, widely distributed as PRINTS, had great influence on later artists. The tapestries were woven in Brussels. Artists had to keep in mind, when planning tapestry designs—as with illustrations for prints—that the finished work would be in reverse.

Tàpies, Antoni
born 1923 • Spanish • painter • Art Informel/Abstract Expressionist

Our senses lose their sharpness in the excess of bustle, garish colors, and noise by which we are always surrounded. We must conquer and learn the most important sense of all:

being able and knowing how to look . . . to concentrate on what we do, having time to meditate, having a minimum of decency and freedom in our lives.

Zen Buddhism was the means Tàpies found to conquer the bustle, garishness, and noise he speaks of above, and he expressed the spiritualism he experienced in his paintings. He was also obsessed with texture and "materiality," as he put it, the "noumenal" or essential spirit of materials. He used somber paint, varnishes, sand, and powdered marble to create the effect of solidity he sought. In *Black Form on Gray Square* (1960), the thick, pasty gray has the texture of ancient walls; a small dark keyhole shape on the bottom suggests alternately a head (surrounded by an inscribed halo), the entry to a dark passage, a lock, and whatever else one might read into so simple and yet evocative a form.

Tarbell, Edmund
See AMERICAN IMPRESSIONISM

Tassi, Agostino
See GENTILESCHI, Artemisia

Tatlin, Vladimir
1885–1953 • Russian • sculptor • Constructivist

Come Tower! / To us / You—here / Are much more needed! / Steel-shining, smoke piercing, / We'll meet you. (Vladimir Mayakovsky, 1923)

Tatlin was inspired by PICASSO's three-dimensional creations such as *Guitar* (1912), and by his statement that the basic problem of constructed sculpture is the assertion of sculptural space rather than sculptural mass. On that basis, Tatlin took the step of translating the Synthetic CUBIST's COLLAGE into nonrepresentational, three-dimensional sculpture. He did this first through a series of RELIEFS composed of wood, metal, and cardboard coated with plaster, GLAZES, and broken glass and suspended by wires. (Only illustrations of these works remain.) Tatlin also expressed the idea that materials should be studied and used according to their internal structural laws, the principles of the "culture of materials," or "truth to materials," a concept of widespread influence. Tatlin's most famous creation was never realized but is known by its model: *Monument to the Third International* (1919–20). It was designed as a landmark architectural structure to span the Neva River in Leningrad. Inspired by the Eiffel Tower—in the poem quoted above, Tatlin's friend Mayakovsky enthusiastically invites that French landmark to Leningrad—Tatlin's tower moves upward as a tilted spiral frame. Its skeleton encloses a conference and meeting room inside a glass cylinder that was meant to rotate 360 degrees once a year. An administrative cone-shaped chamber would rotate once a month; and, on top, a cube-shaped information office was to rotate daily. This tower was to be taller than the Eiffel Tower, about 1,300 feet high and, had it been built, would have been the biggest sculptural form ever constructed by humans. While it is likely that Tatlin's tower, as an international meeting

place, was intended to accomplish what the biblical Tower of Babel did not, it received mostly unfavorable reviews, and did not sufficiently appeal to either Trotsky or Lenin. Moreover, "By the time the Soviet Union had mobilized its construction industry and advanced to greater technological capabilities . . . Social Realism had been declared and . . . the die had been cast," writes the historian Gail Harrison-Roman. Tatlin abandoned his CONSTRUCTIVIST explorations in the early 1920s, when the revolutionary regime discouraged all abstract experiments and supported only practical enterprises that were useful to the country's struggling economy.

Tchelitchew, Pavel
See NEO-ROMANTICISM

Teerlinc, Levina
active 1546, died 1576 • Flemish • painter • Northern Renaissance

king's paintrix . . .

Levina Teerlinc was one of the best-known NORTHERN RENAISSANCE women painters (with van HEMESSEN). Her father (Simon Bening) was also an artist. Teerlinc painted MINIATURE portraits (as her father had done) at the English court where she first worked for Henry VIII—her name appears in court account books with the phrase quoted above—and then for three of his successors, including Queen Elizabeth I. She was the only painter of portrait miniatures between the death of HOLBEIN the Younger in 1543 and the arrival of HILLIARD in 1570. Her annuity was larger than Holbein's had been, and Hilliard's did not equal it for almost 20 years. Teerlinc was influential in establishing the imperial ICONOGRAPHY of the Elizabethan court.

tempera (egg tempera)
Other water-soluble mediums were also used, but tempera usually refers to PIGMENT "tempered" by, or combined with, raw egg (yolk, white, or whole) thinned by water. Used for PANEL painting, tempera dries quickly and is flat (rather than shiny or modulated) and opaque—shading effects were achieved by painting one color over another in fine, parallel lines (hatching) so that the background color showed through. Individual artists varied recipes and ingredients for tempera, and during the 15th and 16th centuries, oil GLAZES were applied over it to achieve a more luminous effect. Finally, OIL PAINTING came to be used alone and tempera became relatively unusual. Andrew WYETH is one of the few recent artists who continue to use tempera.

temple
Structures called temples are known from ancient Egypt and Mesopotamia (e.g. see UR). Solomon's temple, the First Temple in Jerusalem, was built in the 10th century BCE on the site where, by tradition, Isaac was bound. It was destroyed by Nebuchadnezzar II in 586 BCE. Oblong in floor plan, and divided into three equal sections, its precedents are believed to have been in contemporary Canaanite and Phoenician cultures. The Second Temple was begun c. 538 BCE by Jews returning from Babylonian exile. At first it was a modest replication of the earlier building, but in time it expanded, and c. 20 BCE, under

Herod, it was surrounded by a wall. Herod's Temple was ultimately destroyed and pillaged by Romans in 70 CE (see ARCH OF TITUS). Between the First and Second Temples in Jerusalem, a prototype of the Greek temple was being developed. Also rectangular, its floor plan was similarly divided into sections; however, the central space (*cella* or *naos*) fulfilled the building's main purpose of housing a cult statue, rather than the congregation of worshipers served by the Jewish temple. Most pagan Greek ceremonies were outdoors. By the 5th century BCE, the stone, post-and-lintel (trabeated) construction, supported by COLUMNs, had been standardized. The Greek temple's essential form remained immutable even though details changed. For instance, while the number of columns varied, they always followed a given ratio, first 3:1 or 2:1, and later 2:1 + 1, so that the PARTHENON, an example of 2:1 + 1, has 8 columns at each end and 17 along each side. Temple pediments, ornamented with RELIEFS, may have been inspired by MYCENAEAN forms like the *Lion Gate,* in which a non-load-bearing, triangular space was adorned with sculpture. Greek temples were meant to be seen from the outside and thus expressed external space, defining themselves against the landscape and sky. Their columns have been likened to the human form, which was, indeed, the locus of Greek art. Considering the APOTROPAIC or cautionary pedimental RELIEFS—Medusa flanked by lions, and battles between Giants and Amazons or Centaurs, for example—the martial regularity of the columns could suggest metaphorical soldiers. (See also COL-UMN ORDERS) Testimony to the importance, influence, and timelessness of the Greek temple is found in its continual revival throughout the centuries.

Ten, The/Ten American Painters
See AMERICAN IMPRESSIONISM

tenebrism
Derived from the Latin *tenebrae,* for "darkness," tenebrism describes the use of large dark areas in painting, especially by 17th-century followers of CARAVAGGIO, like RIBERA. Ribera worked in Naples when it was under Spanish rule, and his paintings, bought by Spaniards, spread the taste for Caravaggism among artists in Spain. These painters are sometimes called Tenebrists, although they were not an organized group and did not use the term themselves. Whereas tenebrism emphasizes strong shadows, CHIAROSCURO refers to a contrast of dark and light.

Teniers, David, the Younger
1610–1690 • Flemish • painter • Baroque

So I promise you by this letter before a notary and two witnesses assembled that you shall have justice for your portions paid on account . . . I protest to the high amount of the concessions and interests.

Teniers was the son as well as the father of painters of the same name. BROUWER's peasant scenes had a lasting effect on Teniers, though he was never as harsh or as brutal as Brouwer in his interpretations of "low life" (see GENRE).

Teniers also embraced a much wider range of subjects, including "high-life," guard room, religious, and mythical scenes; ARCADIAN landscapes; and even monkey satires (see SINGERIE). He married Anna Bruegel, daughter of Jan BRUEGEL. Hélène Fourment, RUBENS's second wife, was the godmother of their first child. Teniers presents a charming and amusing allusion to family harmony in *The Artist with His Family* (c. 1644), in which he, his wife, and children make music on the terrace while a monkey on a balustrade oversees the scene. Family unity was disturbed, however, when Tenier's children brought suit against him in 1683 for withholding their inheritance after Anna's death. The quotation above is part of Teniers's reaction to their complaint. One of his paintings, also a popular PRINT, was *Butcher's Shop* (1642). A theme that appeared frequently in the 16th and 17th centuries (e.g., AERTSEN, CARACCI, BRUEGEL, and REMBRANDT), slaughtering oxen or pigs was a traditional "Labor of the Month," associated with November. It had added meaning as a reminder of life's transience (see VANITAS and MEMENTO MORI), and further invoked the parable of the Prodigal Son: To celebrate the son's return, the father killed the fatted calf. The symbolism even refers to the crucified Christ because, according to Saint Jerome, "The fatted calf . . . is the Savior Himself, on whose flesh we feed, whose blood we drink daily." Thus, the slaughtered ox refers to the Holy Sacrament. During the 1650s Teniers became court painter to Archduke Leopold Wilhelm and produced 11 pictures for Leopold's art collection.

Tenniel, Sir John

1820–1914 • English • cartoonist/illustrator • Victorian satire

. . . a great artist and a great gentleman. (Arthur James Balfour, 1901)

Best and most widely known as the illustrator of Lewis Carroll's *Alice's Adventures in Wonderland* (1865), Tenniel actually had an extraordinary career as a humorous and satirical artist for *Punch* from 1850 to 1901, during which time he made some 2,000 cartoons and innumerable minor drawings for the magazine, and more for associated publications. In recognition of the good humor and good taste with which he examined British political life, Prime Minister William Gladstone recommended him for knighthood, which was conferred on him in 1893. At a banquet held at his retirement from *Punch*, A. J. Balfour, then leader of the House of Commons, later prime minister (1902–05), made the comment quoted above. Tenniel's drawing skills were as highly praised as his "geniality of satire," and that was all the more remarkable in that he had only one eye; he lost the other in a fencing accident when he was young.

Terbrugghen, Hendrick

1588?–1629 • Dutch • painter • Baroque

Here lies Terbrugghen, surprised and taken unawares by death: / Deprived of the beloved light of life, / Thrust into the dark grave, where flesh becomes dust, / However the fame remains of what he did in his life, / In spite of all envious resentment.

Uncertainty surrounds his early years, but it is believed that Terbrugghen was in Rome for a time, perhaps made two trips, and he was greatly influenced by CARAVAGGIO. The influence deepened throughout his career, and is seen in the contrasts of light and dark (CHIAROSCURO) and in the animation and drama of his works. At the same time, his interpretations were personal. Rethinking *The Calling of Saint Matthew* (1621), which Caravaggio had painted in 1599/1600 (and Terbrugghen himself had also done earlier), he completely changed the emphasis: He has moved the figure of Christ from right to left, put him in shadow, and cropped him so radically that he is only slightly visible; the other figures are more highly lighted and are half-length. Unlike Caravaggio's dark PALETTE, Terbrugghen's colors are pastels—blue, pale yellow, soft white, violet, and red-brown—with a silvery tone. The emphasis is on Christ's pointing finger and on Saint Matthew, who is in a flood of light. Matthew's face and the faces of those who surround him are all highly expressive. Terbrugghen was an important influence on de LA TOUR. The quotation cited above is inscribed on Terbrugghen's tomb.

terra-cotta

From the Italian *cotta* for "cooked" and *terra,* meaning "earth," refers to fired but unglazed clay. Usually red, often used as bricks, terra-cotta was also employed for household items as the "*Frying Pan*" from Syros, Cyclades (c. 2500–2200 BCE), an 11-inch-diameter, elegantly incised object seemingly made for display rather than cooking. Terra-cotta was a favorite material of the ETRUSCANS for architectural ornaments. In 1990, one of the most stunning archaeological finds in history was made in central China when a road-building crew accidentally uncovered tens of thousands of terra-cotta figures from c. 100 BCE. Terra-cotta has long been painted and used decoratively (see ROBBIA and CLODION). Interest in the material is periodically revived, and it was popular as ART DECO cladding—the surface covering or "skin" of a wall. The American architect Louis SULLIVAN found terra-cotta the perfect material for the intricate architectural ornaments he designed in projects like the Henry Babson Residence (1908–09) in Riverside, Illinois. The house itself was destroyed, but a decorative detail inset in its facade is preserved: a molded and modeled terra-cotta panel some 25 by 23 inches, which combines naturalistic foliage and geometric shapes. Delicate in detail, this ornament is colored yellow, green, blue, and purple, and was set into a maroon-brick wall.

Theophanes the Greek
c. 1330–after 1405 • Greek • painter • Late Byzantine

While he delineated and painted all these things no one ever saw him looking at models as some of our painters do who, being filled with doubt, constantly bend over them casting their eyes hither and thither and instead of painting with colors they gaze at the models as often as they need to. He, however, seemed to be painting with his hands, while his feet moved without rest, his tongue conversed with visitors, his mind dwelled on something lofty and wise,

and his rational eyes contemplated that beauty which is rational. (Epifanij the Wise, in a letter written c. 1415)

Most work by Theophanes, who apparently trained in Constantinople, is lost, but he is reported to have been active in Moscow as well as Novgorod, where his major surviving works are the FRESCOES (1378) in the church there, Our Savior of the Transfiguration. One of Theophanes' innovations in his ICONlike figures was to use strong parallel brushstrokes in almost geometric shapes to bring highlights to, for example, the planes of a face. The freedom of his style is alluded to in the letter quoted from above in which Epifanij the Wise, as he was known, lavished praise on the artist he called "a celebrated sage, a most cunning philosopher . . . a famous illuminator of books and an excellent religious painter who painted with his own hand more than forty stone churches." Theophanes was an important influence on RUBLEV.

Theophilus
active c. 1100 • German • monk/metalsmith/author • Romanesque

Theophilus, a humble priest, servant of the servants of God, unworthy of the name and profession of monk, to all who wish to avoid and subdue sloth of mind and wandering of the spirit by useful occupation of the hands and delightful contemplation of new things: the recompense of heavenly reward!

Theophilus is a pseudonym believed to have belonged to Roger of Helmarshausen, one of the finest metalworkers of his day. Two portable metal altars and a bejeweled book cover have been attributed to him. His text, *De diversis artibus (On Diverse Arts),* the preface of which is quoted from above, contains instructions in goldsmithing, BRONZE casting, painting, enameling, and working in STAINED GLASS. Advice is also provided in other related areas. The light he throws on the MEDIEVAL arts and their techniques is invaluable.

Theosophy
See NABIS

Thera (also Santorini)
An island in the Aegean, Thera was prospering during the Bronze Age until it was destroyed by volcanic eruptions that sent steamy plumes of pumice and ash some 17 miles into the stratosphere. The cataclysms reconfigured the island and buried it in ash as deep as 100 feet in some places. A recent dating of the eruption at 1628 BCE seems to discredit a theory that it caused the biblical parting of the Red Sea. Another abandoned theory is that it initiated a tsunami that ended MINOAN civilization on Crete. That Thera may have inspired PLATO's description of lost Atlantis, an ideal city-state, is highly conjectural. It is assumed that early tremors persuaded the population to leave, as no human victims have been found in archaeological excavations. Excavations begun in 1967 at Akrotiri, an urban site preserved by volcanic ash, reveal an advanced civilization with a drainage system beneath paved streets and magnificent wall paintings in buildings. One FRESCO, just 16 inches high but running for 20 feet along three walls, is a maritime NARRATIVE full of lively scenes,

which some scholars believe show the island's pre-destruction coastline. Other paintings show women, plants, animals, birds, and fish (especially dolphins), and associate Thera with the Minoan style. There is also evidence of influence from Egyptian, Cypriot, and Mesopotamian cultures. It is believed that Thera was a trade link connecting with Crete, the Greek mainland, and the ancient Near East.

thermoluminescence dating

Used to date POTTERY, a process that measures the amount of radiation absorbed since the clay was fired. Adapting a thermoluminescence technique used to measure zircon—developed for examining lunar samples brought back to earth—ancient BRONZES are also being dated and redated.

Thiebaud, Wayne
born 1920 • American • painter • New Realist

. . . seeing rows of pies, or a tin of pie with a piece cut out of it and one piece sitting beside it. These little vedute in fragmented circumstances were always poetic to me.

Thiebaud paints food—a lineup of five hot dogs in their rolls, slices of pie, shelves of cake on display in a glass case—usually against an empty, off-white background (e.g., *Pie Counter,* 1963). Though he is sometimes related to POP ART, his pictures are less like commercial art than like a refined, AESTHETIC interpretation of Pop Art and Pop subjects. There is also great irony and humor in his elegant treatment of junk food subjects, or *vedute,* as in the quotation above—Italian for "views,"

like the panoramic landscapes painted by CANALETTO.

Thoré, Theophile (pseudonym W. Bürger)
1807–1869 • French • critic

What a fall from the Greeks of David to the Greeks of M. Gérôme! . . . David represented [them] with an austere conviction; M. Gérôme offers to the young ladies of Paris a doll undressed before disorderly, licentious old satyrs, who smirk as though they had a real naked woman before their eyes for the first time.

Politically left wing. Thoré was exiled after the fall of the French Revolutionary government in 1848. He then lived in London, Switzerland, and Brussels. Using the pen name William Bürger, he produced a two-volume survey of the museums of Holland, and is well known for his single-handed resuscitation of VERMEER with a series of three articles that appeared in the *Gazette des Beaux-Arts* in 1866. Thoré was adamant that contemporary artists reject the routines of the past, as well as AESTHETICISM, in favor of socially conscious, crusading art. He was a friend and champion of COURBET and MILLET. The comment quoted above was his review of the French SALON of 1861.

Thorvaldsen, Bertel
1768/70–1844 • Danish • sculptor • Romantic Classicist

There is a famous bas-relief of Thorvaldsen depicting "Sleep" of which copies or casts are found in all the northern cities. This charming work has not been able to enter

France, for we feel that honor requires us to reject all foreign products.
(Marie-Henri Beyle [Stendhal], 1824)

The mantle of CANOVA descended on Thorvaldsen, a Danish sculptor who studied in Rome. But where Canova had followed the energetic expressiveness of the Greek HELLENISTIC style, Thorvaldsen looked at the still, more severe, CLASSICAL sculpture of the 5th century BCE. In an era of ROMANTICISM, when the artist preferred to be unbounded by the PATRONAGE of church, state, or wealthy individuals, sculptors were less able than painters to cut the bonds of official commissions because of both the cost of their materials and the intrinsic grand scale of major monumental works. (BARYE was something of an exception; however, his bronze animals were usually relatively small.) In 1803, Thorvaldsen broke one of the barriers in the way of independence by making, on his own initiative and at his expense, a full-scale, over-life-size plaster model for a statue of Jason. After putting the model on exhibit, he received a commission to execute it in marble (*Jason with the Golden Fleece*, 1803–28). Ironically, the result of this significant innovation, while liberating, was also to challenge the profession: After the artist invested his time, talent, and energy in the model, special craftsmen carried out the actual finished sculpture. This countermanded the Romantic ideal of the work of art containing the soul of the artist. Thorvaldsen lived from 1797 to 1838 in Rome, where he became the "reigning monarch of sculpture." His studio, filled with original plasters, was *the* place for prominent people to stop, as a painting

by H. D. C. Martens entitled *Pope Leo XII Visiting Thorvaldsen's Studio on Saint Luke's Day, 1826* (1830) makes dramatically clear (Saint LUKE is the patron saint of artists). Stendhal, quoted above, also visited the studio. Thorvaldsen's most famous work, which he was asked to design and whose subject was prescribed, commemorates the Royal Swiss Guards who died trying to protect Louis XVI when the Revolutionary militia stormed the Tuileries in Paris in 1792: *The Lion of Lucerne* (1819–21). This monument, about 30 feet wide, is actually carved into the sheer wall of limestone that rises above a small pond. The dying lion has the appeal of Romantic pathos and Thorvaldsen thought of it as a national monument, honoring, as its inscription says, "The Loyalty and Virtue of the Swiss." He may have been unaware that the opposition saw the lion as a royalist symbol. Regardless, it remains one of the most moving pieces of sculpture in history. As in the case of *Jason,* Thorvaldsen did not execute the carving of the finished sculpture; this was done by Lucas Ahorn (1789–1856).

Tiepolo, Giovanni Battista (also Giambattista)
1696–1770 • Italian • painter • Baroque/Rococo

Painters must try and succeed in large-scale works capable of pleasing the rich and the nobility because it is they who make the fortunes of artists and not the other sort of people, who cannot buy valuable pictures. And so the painter's spirit must always be reaching out for the sublime, the heroic, the perfect.

A Venetian painter of outsize drama, Tiepolo seems to straddle the BAROQUE and ROCOCO, moving from a relatively somber to a much lighter PALETTE. Within his huge theatrical battle scenes and his illusionistic ceiling FRESCOES of heavenly hosts transported on clouds, he had an extraordinary skill at choreographing large numbers of figures, yet his touch was both elegant and energetic in presenting details. He was reputed to be able to paint a picture in less time than it would take another to mix his colors. His frescoes were among the last and most refined of the Italian tradition. But as VENICE had become artistically conservative by the 18th century, when he wished to move beyond the darkness of the Baroque, he usually did so outside of Venice. His frescoes reached a peak in the Kaisersaal Residenz in Würzburg (1751). In one room where he painted both ceiling and wall frescoes, *The Marriage of Frederick Barbarossa and Beatrice of Burgundy* (c. 1751, on the wall) placed an event that had occurred some 500 years earlier in a contemporary setting. Its theatrical illusionism includes carved PUTTI pulling back golden brocade curtains to reveal the marriage ceremony below. Tiepolo's source for much of his work was Cesare Ripa's *Iconologia* (1593), a handbook of symbolic images (see EMBLEM BOOK), and he used the same description ("a beautiful naked woman holds the sun aloft . . .") as BERNINI had 100 years earlier for his *Time Revealing Truth* (1647–52). Tiepolo was working in Spain when he died. A Venetian nobleman wrote, "Letters from Madrid apprise me of the sad loss [of] the famous Venetian painter, the most renowned . . . well known in Europe, and the most honored in his own country . . ."

Tiffany, Louis Comfort

1848–1933 • American • painter/designer • Art Deco/Arts and Crafts

The value attributed to color has been denied by theorists who have started from an untenable assumption that there is a purity, a moral worth attached to the absence of color, in opposition to sensuousness and luxury in a bad sense attached to its presence. This is a convenient theory for a vast majority of artists who are born without the peculiar eyes and senses that distinguish values and respond with sympathy to the vibrations of light.

With the GOTHIC Revival movement of the 19th century came a new interest in STAINED GLASS. Louis Tiffany, son of Charles Louis Tiffany (1812–1902), a highly successful jeweler and silversmith, studied painting in Paris for a year, and on his return home studied MEDIEVAL glassmaking techniques at a glasshouse in Brooklyn. He experimented with new methods of glass manufacturing to produce a wide variety of colors and texture, including "drapery glass," in which the hot glass was pushed and twisted until it moved into rippled folds. The company he formed, eventually named Tiffany Studios, took on widely varied decorative commissions for homes, including the public rooms of the White House in 1883. However, Tiffany remains best known for his stained-glass designs in windows, paneled screens, and lamp shades. *Wisteria Table Lamp* (c. 1900),

in which the bronze lamp stand is wrought to resemble a vine, and for the shade, small glass segments resemble dripping white wisteria blossoms and green leaves, is an example of Tiffany's exquisite artistry. His devotion to color is expressed in the quotation above.

Tinguely, Jean
1925–1991 • Swiss • machine-motion sculptor • New Realist

Always leave a door open; something better may come up.

Tinguely's comment quoted above, and repeated by his former wife, SAINT-PHALLE, aptly describes the contingency-based character of both the man and his sculpture. "Jean was a man who loved contradictions," adds Pontus Hulten, the sculptor's friend and curator of the Jean Tinguely Museum, which opened in Basel in 1996. "There were lots of levels to him. He always kept two or three balls in the air at the same time." Hulten was speaking literally as well as figuratively, for motion was integral to Tinguely's mechanical sculpture. His most famous was *Homage to New York* (1960), a giant motorized assembly of junk that included a weather balloon, 50 bicycle wheels, a piano, and chemicals that caused nasty smells and smoke. *Homage* was to be demonstrated in the Sculpture Garden of the Museum of Modern Art in New York City, but a mistake in connections caused a more unpredictable situation than the artist intended—and a potentially dangerous one, as a loose carriage careened into the crowd while a Klaxon shrieked and smoke and flames billowed forth. Although *Homage* was meant to self-destruct, its life ended prematurely when firemen were called in to douse the demonstration. With KLEIN, Tinguely was a member of a group called New Realists (Nouveau Réalistes) founded in 1960. The "realism" of the title refers to using real materials (the mechanical parts and junk, for example) rather than to any true-to-life philosophy. Tinguely and Saint Phalle collaborated on several works, among them *Hon* (*She*, 1966), a temporary installation at the Moderna Museet in Stockholm. *Hon* was an 82-foot-long woman lying on her back. Visitors entered her body through the vagina and found themselves in a playground/amusement park/shelter with a milk bar installed in a breast.

Tintoretto, Jacopo
1518–1594 • Italian • painter • Mannerist

Given his way, he would have painted every wall in the town . . . he would roll paint on the ceiling above and make pretty pictures below for people to walk on, his brush leaving nothing alone, not the palace fronts on the Grand Canal, not the gondolas, not even (maybe) the gondoliers. (Jean-Paul Sartre, 1964)

Tintoretto's voracious ambition, alluded to above, was matched, according to anecdotes, by a competitiveness so strong that it tainted his reputation. One dubious but much repeated scandal recounts his trickery during the contest to paint a ceiling for the Scuola Grande di San Rocco in VENICE. The story is that competing artists with scale models of their entries arrived at the Scuola building to discover that, during

the night, Tintoretto had managed to secretly install his own full-scale, finished painting overhead. At the bottom of such tales is the artist's prodigious speed of execution, explicit not only in his techniques but also in his style and in the energetic, agitated movement that vibrates across his canvases. The overall somber tone of his paintings was quickly achieved by priming the canvas with flat, dark colors, usually red or brown. He further increased his velocity by painting with a broad brush. Often he created the impression of deep space rising in the distance, as if to make the figures in the foreground hurtle out of the canvas into the viewer's space (e.g., *Discovery of the Body of Saint Mark*, 1562–66). The observer's interaction with Tintoretto's tumultuous paintings is inevitable; *Crucifixion* (c. 1566–67), on one of the walls in the Scuola Grande di San Rocco building, is a 40-foot-long panorama with a vast, agitated crowd surrounding the high Cross. Christ's bent head is at the top of the canvas, and the entire composition seems squeezed by an oppressive force. This sense of agitation and compression is consistent with the MANNERISM of the period, though little else is of Tintoretto's style is. In PALLADIO's church of San Giorgio Maggiore in Venice, Tintoretto's *Last Supper* (1592–94), finished during the last year of his life, is at the summit of his oeuvre. The table races obliquely away from the PICTURE PLANE, appearing to vanish into the dark background. Christ is a relatively distant figure, but is at the center of the canvas, and is singled out by a brilliantly radiant halo. Far more interested in light than in color, Tintoretto illuminates the shadowy room with a flaming oil lamp that hangs from the ceiling and throws light onto vaporous, transparent angels that float in and out of obscurity. Tintoretto engages his audience intellectually as well as emotionally: Counting the apostles present at the table, we note that one is missing, and realize that Judas has left to act out his betrayal. Affirmation of the dogma of transubstantiation is also expressed by the presence of bread, wine, and liturgical vessels.

Tissot, James
1836–1902 • French/English •
painter • Academic realist

. . . this year M. Tissot left the Middle Ages to enter our century. (Théophile Gautier, 1864)

Gautier's barbed remark, quoted above, alludes to the switch Tissot had just made from HISTORY PAINTINGS inspired by RENAISSANCE artists to pictures of fashionable people in modern life. It was the occasion of the SALON of 1864, and one of the two Tissot paintings in the exhibit was *Portrait de Mlle L. L.* (*Young Woman in a Red Jacket;* 1864), which may show some influence of Tissot's friend INGRES. He was also a friend of DEGAS, who painted Tissot's portrait in 1867–68. Because of his involvement in the politics of the Revolutionary Commune of 1871, Tissot moved to London and lived there for about a decade. As did DALOU, Tissot had great success with commissions from the upper class. His flattery, highgloss finish, and tightly painted detail, especially on their elegant clothing, greatly pleased his clients. If Gautier was sardonic, GONCOURT was downright nasty writing about Tissot's stu-

dio: ". . . with a waiting room where, at all times, there is iced champagne at the disposal of visitors, and around the studio, a garden where, all day long, one can see a footman in silk stockings brushing and shining the shrubbery leaves." Tissot returned to Paris after the death of his mistress and model, and began illustrating first the life of Jesus, then scenes from the Hebrew Bible. He made two trips to Palestine and the Near East in an effort to achieve accurate representations. Drawings from his trip were published with great success. The veracity of his paintings became a rich resource for 20th-century filmmakers, including D. W. Griffith and Steven Spielberg.

Titian
c. 1485/90–1576 • Italian • painter • Late Renaissance

They who are compelled to paint by force, without being in the necessary mood, can produce only ungainly works, because this profession requires an unruffled temper.

According to someone who knew him, Titian arrived in VENICE at the age of eight and was soon employed by a mosaicist (see MOSAIC). He went on to work for Gentile and later Giovanni BELLINI. Next he was with GIORGIONE, whose paintings he completed after the master's death—some scholars insist that Titian alone painted *Fête Champêtre*, usually assigned to Giorgione and dated c. 1510. He survived Giorgione by 66 years and outlived not only RAPHAEL and MICHELANGELO, who were born about the same time that he was, but also the younger Mannerists PONTORMO, FIORENTINO, PARMIGIANINO, and BRONZINO (see MANNERISM). Through wise investments Titian gained wealth enough to buy his own palace, yet he also worked for royalty. He was court painter for the emperor Charles V, who made him a count. Visiting the painter in his studio, the story goes, the emperor bent down to pick up a brush that Titian had dropped. Such a break with custom matches Titian's own constant disregard for artistic convention. He defied the symmetry of ITALIAN RENAISSANCE organization by introducing off-center and diagonally constructed compositions. His *Pope Paul III* (1543) is more extraordinary in its emotional drama and psychological insight than in its eccentricity; the pope is presented as a shrewd, tense individual wearing a red velvet cape that is highlighted with gleaming passages of light. Titian's experimentation with color went boldly beyond that of Giorgione: "He used virtually all the pigments available, and he used them in extravagant quantities and inventive combinations," writes Marcia Hall. Titian's color conveys meaning and creates mood and movement. "Flashing" is a word frequently used to describe his brushwork as well as his use of color. Titian's bacchanals vibrate with lustful energy and shimmering color. In *The Rape of Europa* (c. 1560), the buxom Europa is abducted by a great white bull, who is Jupiter in disguise. She is balanced precariously on her back in a suggestive position, and even the sky is aflame with passion. Titian worked in oil paint on canvas in a PAINTERLY manner (though he did not invent that manner, as was previously thought): By leaving brushstrokes of juxtaposed colors unblended, Titian an-

ticipates that the viewer's eye will instinctively blend them. His audience thus becomes an unwitting accomplice of the artist, joining in the visual completion of the painting and thereby contributing to the meaning of the work. Titian's techniques of engagement were new and powerfully effective. Where Giorgione's *Sleeping Venus* (c. 1510) is wistfully sensual and dreamily nostalgic with her eyes closed, Titian's *Venus of Urbino* (c. 1538) is wide awake—she makes eye contact with the presumptively male viewer and invites complicity. What was subdued by Giorgione in the guise of a goddess is made explicit by Titian in the portrayal of a nude, contemporary woman. During his career he painted religious and secular subjects with equal verve, and in his last years subjects of torment and suffering dominated his repertoire. For his own tomb, Titian painted a *Pietà* (c. 1573–76) that included a small, votive picture of his son and himself thanking the Virgin for protecting them against the plague of 1561. They did escape death once, but before Titian finished the painting, both he and his son died, during another epidemic in 1576.

Tobey, Mark

1890–1976 • American • painter • Abstract Expressionist

We have occupied ourselves too much with the outer, the objective, at the expense of the inner world.

Tobey's spiritual search led him to the Baha'i faith, which was founded on a 19th-century movement to foster world peace and harmony. Later he studied Chinese painting and Zen Buddhism in China and Japan. His ABSTRACT EXPRESSIONISM developed in a way that reflected his religious concerns: He used some of the techniques of all-over painting, expressive brushstrokes and poured paint in delicate threads—a refined effect that came to be called his white writing—but where his methods may be similar to those that Jackson POLLOCK used, a comparison of Tobey's *Universal Field* (1949) with one of Pollock's poured paintings is the difference between serenity (Tobey) and turbulence (Pollock).

tonal painting (tone)

Tonal painting strives for overall harmony rather than the juxtaposition or contrast of colors, as is in chromatic painting (where brilliance and distinct hues are stressed; see COLOR). In tonal painting, the outlines of forms soften, sometimes dissolving, and colors are blended and fused for the sake of continuity. LEONARDO's invention of SFUMATO established the concept of tonality to a great degree, and tonal painting became prominent in, and characteristic of, VENICE during the 16th century. In the 17th century, it was used effectively by Dutch LANDSCAPE painters (see van GOYEN). WHISTLER, in the 19th century, worked with tonal relationships.

tondo

Italian for "round," refers to a disk-shaped RELIEF carving, as, for example, MICHELANGELO's unfinished marble *Taddei Madonna* (c. 1500–02), or a round painting, like his *Doni Madonna* (c. 1503). The tondo shape was an innovation that became popular during

the early 15th century and was quickly taken up by both sculptors and painters. It was often associated with marriage during the ITALIAN RENAISSANCE: The *Doni Madonna* was painted to celebrate the wedding of Angelo Doni and Maddalena Strozzi.

Toulouse-Lautrec, Henri de
1864–1901 • French • painter/printmaker • Art Nouveau

What a crush! . . . A hurly-burly of gloved hands carrying pince-nez framed in tortoise-shell or gold. . . . Here are some observations I made among all those elbows.

Toulouse-Lautrec's flattened, outlined figures in bold colors—especially those in posters for the Moulin Rouge and to advertise the famous, provocative dancer Jane Avril, his constant companion—are well known. So is the fact that he was a dwarf who passed his time in Montmartre's seedy underworld of prostitution and alcoholism. He recorded the degradation of that culture with sensitivity: *Rue des Moulins* (1894), with harsh brushstrokes in a cacophony of reds, browns, lavender, and greenish tones, is a vulgar scene of prostitutes standing in line, holding up their skirts as they await their medical examinations. Without being either lascivious or maudlin, the artist has painted this odd scene so that the viewer is left feeling sympathetic rather than offended. Toulouse-Lautrec mixed in the "crush" of the horse races, the theater, cabarets, and brothels, and was, because of his size, in truth "among all those elbows," as he says in the quotation above. He was described by a French singer as "the genius of deformity," and from his vantage point he saw a sordid world and participated in it, destroying himself through dissipation.

Traini, Francesco
active c. 1321–1363 • Italian • painter • Late Medieval

. . . it seems clear that Vasari considered Traini a very good painter . . . good enough to be claimed for Florence, and good enough to have surpassed his supposed master, Andrea di Cione [Orcagna]. Now, whereas modern criticism disagrees with Vasari by holding a relatively lower opinion of Traini's painting. . . . None of these judgments of contemporary criticism seems to me to be sound. (Millard Meiss, 1983)

It is the subject of a series of FRESCOes attributed to Traini of Pisa more than the skill with which he painted them for which Traini's name is known. This series, in Pisa's Campo Santo, includes large panoramic scenes, including the ghoulish *Triumph of Death* (c. 1340): piles of dead bodies and corpses in coffins, ranging from bloated to skeletal, and covered by worms and snakes. In the midst of this is a noble hunting party and a group of elegantly dressed youths apparently oblivious to the approaching figure of the Grim Reaper. It has long been assumed this refers to the Black Death, or bubonic plague, and to BOCCACCIO's *Decameron,* in which a group of nobles escapes to the country to avoid the epidemic. The attribution of these frescoes to Traini is challenged (Buonamico Buffalmacco, who was ac-

tive in the early 14th century, is named as an alternative), and, unfortunately, the paintings were severely damaged by bombing during World War II. Discussion of Traini by the art historian Millard Meiss, whose words are quoted above, reconstructs and reconsiders the artist's oeuvre, accepting some attributions and dismissing others, but ends up with a wish to reveal "a painter with considerably different and very much greater gifts than have been recognized by other students."

Transcendentalism

A philosophy influenced by KANT, who believed that knowledge is intuitive and that objective or rational thought is transcended by insight and revelation. German transcendental mysticism and fantasy was expressed in literature, philosophy, and the art of painters like FRIEDRICH. The Transcendentalist movement began to grow in the United States during the 1830s; the Transcendental Club was organized in Boston in 1836, with Ralph Waldo Emerson (1803–1882) one of its charter members. Emersonian Transcendentalism was a stew that drew largely on Kant for its flavor and on numerous other philosophers for its seasonings, including GOETHE and the mystic Swedenborg. Emerson preached a fusion of God and nature: "All the facts in nature are nouns of the intellect, and make the grammar of the eternal language," he wrote. Landscape art of the HUDSON RIVER SCHOOL is especially associated with his famous statement of 1836: "Standing on the bare ground—my head bathed by the blithe air, and uplifted into infinite space—all mean ego-

tism vanishes. I become a transparent eyeball; I am nothing; I see all, the currents of the Universal Being circulate through me; I am part or parcel of God." This "transparent eyeball" saw the smallest details, from the bark of a tree to the striations of a rock, as evidence of God's handiwork. Organized religion was anathema to them—American Transcendentalists believed that conventional society and religion were oppressive—nature was their church. The influence of Transcendentalism lasted until after the Civil War.

transept

The shorter, horizontal arms of a cruciform plan church.

trecento

"Three hundred," from the Italian, actually refers to the 1300s or, more commonly in English, the 14th century.

triptych

A three-paneled painting or carving, with the two outer PANELS, or wings, hinged so that they may cover the center one. A triptych is the standard format for an ALTARPIECE. BOSCH's *Garden of Delights* (c. 1504) is a triptych.

trompe l'oeil

Translated from the French as "fool or trick the eye," this kind of painting pretends to be the objects it represents. Trompe l'oeil was familiar to the ancient Greeks, according to accounts of the rivalry between PARRHASIUS and ZEUXIS to make easel paintings so believable that they are mistaken for the real thing. Roman interest in deception extended to MOSAICS, like the descrip-

tively titled *Unswept Floor* (2nd century CE), a floor that appears to be littered with scraps of garbage and even a mouse. The difference between trompe l'oeil and STILL LIFE is often one of intention: The former aims to deceive, the latter would rather impress, but sometimes the two are combined. Technically, it is characteristic of trompe l'oeil paintings that the artist's "hand" is invisible—there is no evidence of brushstroke or the human touch. To most effectively fool an audience, these paintings are spatially shallow; that is, the usually flat background presses the objects close to the PICTURE PLANE, and sometimes, to enhance the illusion, an object, or part of it, is painted as if it projects out of that plane into the viewer's space. The Americans HARNETT and PETO are among the most accomplished trompe l'oeil painters of still lifes. Considering their interest in semblance, resemblance, and dissembling, trompe l'oeil paintings are like dessert for recent theorists. Jacques Lacan asks rhetorically, "What is it that attracts and satisfies us in trompe l'oeil?" When we realize what it is, he goes on, "The picture does not compete with appearance, it competes with what Plato designates for us as being the Idea. It is because the picture is the appearance that says it is that which gives the appearance that Plato attacks painting, as if it were an activity competing with his own." Jean Baudrillard, who has written a great deal about that which is not what it seems to be (SIMULACRUM), discusses trompe l'oeil, saying, "Thus trompe l'oeil transcends painting. It is a kind of game with reality which takes on fantastic dimensions and ends up by removing the divisions between painting, sculpture, and architecture."

trope/tropology

A trope is a figure of speech. The "four master tropes" are irony, metaphor, metonymy, and synecdoche (see METONYMY). Other tropes might include parody. Tropology can be a useful critical approach to the study of works of art, considering tropes as part of an artistic rather than a spoken language. As substitution, replacement, and analogy, tropes work by displacement, as when a crown stands in for the ruler.

Trumbull, John

1756–1843 • American • painter • Federal/Romantic

In May, 1777, immediately after my resignation [from the Army], my military accounts were audited and settled at Albany, by the proper accounting officer. . . . In London, 1784, my acquaintance with this gentleman was renewed . . . where he lived in great elegance, a member of Parliament, &c. &c.; and although I was now but a poor student of painting, and he rich, honored, and associated with the great . . . [he] continued to treat me on a footing of equality and I frequently dined at his table with distinguished men.

Despite the above proclamation of humility, Trumbull was born into a wealthy and politically prominent Connecticut family. He went to Harvard and served briefly as an aide-de-camp to General Washington, but resigned from the Army, as noted in the quotation because he was not promoted to gen-

eral. He went to London to study with WEST. Following the example of West's HISTORY PAINTINGS on contemporary themes, Trumbull determined to create a record of the key events of the American Revolution. He worked on these between 1786 and 1789. *Death of General Montgomery in the Attack on Quebec* (1786) is reminiscent of West's *Death of General Wolfe* (1770). But it is smaller, only about 3 feet wide compared to West's 7 feet. Trumbull hoped to have his paintings ENGRAVED and to sell them as PRINTS in America, but the project was not a success. His color is rich and his compositions dynamic. In the 1790s, Trumbull worked in New York City as a portraitist, for he was unable to acquire commissions for his history paintings. However, he painted portraits, like *General George Washington at the Battle of Trenton* (1792), with all the flourish and drama of the GRAND MANNER, though the battle he would have liked to present in the foreground is relegated to the background.

Turner, Joseph Mallard William
1775–1851 • English • painter • Romantic

Innovations so daring and so various could not be introduced without corresponding peril; the difficulties that lay in his way were more than any human intellect could altogether surmount. (John Ruskin, 1873)

A major characteristic of ROMANTICISM was a rebellion against convention and the assertion of individualism, and one sees that in Turner's early painting *Snowstorm: Hannibal and His Army Crossing the Alps* (1812), a large work, almost 8 feet long. Turner created an apocalyptic snowstorm in which SUBLIME, all-powerful nature is seen in the furious circular movement of wind and snow creating an awesome vortex that overwhelms human presence. Only barely and gradually is the scene on the ground understood: a drama of rape, murder, and pillage, Hannibal on his elephant hardly in focus. As the historian Robert Rosenblum writes, ". . . we seem located in a molten caldron of the imagination." Turner here combined his own experience of being in a violent storm on his visit to the Alps with his reading about Hannibal's 218 BCE excursion. He had also seen Jacques-Louis DAVID's extraordinary painting *Napoleon at Saint Bernard* (1800; see EQUESTRIAN), where the name of Hannibal is carved into a rock. It may be, as Rosenblum suggests, that Turner was expressing a British fear of Napoleonic conquest. The affect of this snowstorm, in which forms lose their contour and the world is transformed into veils and movements of color and light, became increasingly characteristic of Turner's painting. If he made an indirect reference to David in *Hannibal,* his painting *Slavers Throwing Overboard the Dead and Dying—Typhoon Coming On* (1840; known as *The Slave Ship*) brings to mind GÉRICAULT's *Raft of the Medusa,* painted some 20 years earlier. As was Géricault's, Turner's picture was founded on a real, scandalous event. In 1783, the captain of a slave ship had thrown sick and dying slaves overboard so that the owner could collect insurance on the claim that they were lost at sea. When Turner painted *The Slave Ship,* the slave trade had long been banned in England, but slavery itself had only recently been abolished in

the colonies. RUSKIN, whose comment about Turner is quoted above, was the artist's great supporter.

Twachtman, John
1853–1902 • American • painter • Impressionist

[Arques-la-Bataille] *is a record of both sight and feeling, with a mood of calm melancholy familiar to this period, and shows Twachtman at his best.* (John Wilmerding, 1976)

Twachtman was a student of DUVE-NECK and studied with him both in Cincinnati and in MUNICH, where the influence of VELÁZQUEZ and HALS was strong, as were dark colors; broad, fluid brushstrokes; and thick paint. These tendencies were moderated when he went on to the ACADÉMIE JULIAN in Paris, and later softened in his dreamy paintings such as *Arques-la-Bataille* (1885), about which the historian Wilmerding writes in the passage above. This river scene treats the landscape as a nearly abstract arrangement of soft grays, greens, and blues. In the foreground, he has painted a clump of weeds that has the elegant simplicity of a Japanese painting. Twachtman's work became increasingly impressionistic during the 1890s. He was a friend of WEIR, and a founding member of The Ten American Painters (see AMERICAN IMPRESSIONISM).

Twombly, Cy
born 1929 • American • painter • Abstract Expressionist

Why would I want more? Why would I want an escalation or something? I have kept my own pace. I think it's a pace the paintings show. I have my pace and a way of living, and I'm not looking for something. I'm not looking for taking on something else.

Twombly made the comment quoted above in September 1994, on the eve of the largest-ever retrospective of his paintings, held at the Museum of Modern Art in New York City. He had been living in Italy since 1957, after studying at BLACK MOUNTAIN COLLEGE. The main challenge of progressive art, he believes, "lies in the complete expression of one's own personality through every faculty available." As adaptations of ABSTRACT EXPRESSIONIST painting that are unique, many of Twombly's early works are like anxiously scribbled ideas, graffiti, on surfaces that are alternately pasty and thin. One, *Untitled* (1960), for example, is oil, crayon, and pencil on canvas, and has very little color. It looks like meaningless jottings, yet the eye cannot resist returning to each individual mark, indecipherable as it is, in an effort to find a hint of meaning, a hidden symbol or resemblance that will allow the mind to gain purchase on the scheme of things. Twombly's later paintings are more like scattered fireworks of bursting colors. They have a beauty that is mysteriously internal.

typology
Of Greek origin (from *typos*, meaning "impression"), typology refers to the Christian practice of looking to the past, predominantly to the Hebrew Scriptures, for types—prefigurations of Christian people and events. Abraham's willingness to sacrifice Isaac, for example, prefigured God's sacrifice of his

son. The emergence of Jonah from the sea monster, as portrayed in the CATACOMBS of Rome, is seen as a parallel, or type, of Christ's resurrection. "Typology differs from allegory in that historical references are never forgotten and give to events a cosmic significance," Marilyn Stokstad writes.

U

Uccello, Paolo
c. 1397–1475 • Italian • painter •
Renaissance

*O! che dolce cosa è questa prospettiva!
[Ah, what a lovely thing perspective is!]*

In the early 1430s, Uccello moved to
Florence from VENICE, where he was
working on MOSAICS, probably for the
Church of San Marco. He was trained
in the International Style (see GOTHIC),
and its fascination with decorative pat-
tern remained with him no matter how
far he progressed in other directions.
His devotion to the study of PERSPEC-
TIVE is expressed in the quotation above
and illustrated by a story about how he
sent his wife to bed alone, preferring to
stay up with his "sweet mistress per-
spective." Reputedly a joker, that seems
to be borne out by his best-known work,
the *Battle of San Romano* (mid-1450s),
actually three brightly colored PANELS
commissioned for a room in the MEDICI
palace. In these compositions his per-
spective mania seems to run riot, for he
uses a network of lances, dead bodies,
and miscellaneous devices to con-
struct—and deconstruct—the idea of a
vanishing point. He clutters the scenes
with stylized horses and men in a mili-
tary engagement that looks more like a
confrontation of windup toys or chess
pieces than of warring troops. It is,
however, a real, historic war that he
was commemorating, and, as one might
imagine considering the Medici connec-
tion, the paintings celebrate a Floren-
tine victory over their Sienese rivals in
1432.

Uffizi (Galleria degli Uffizi)
Commissioned by Cosimo I de' MEDICI
in 1559 and designed by VASARI, this
great Florentine building is four stories
high, borders a long, narrow piazza on
three sides, and is distinguished by the
regularity and repetition of its elements,
such as lines of uniform COLUMNS. It
has been altered over the years, how-
ever, and restored after bomb damage
suffered during World War II, flood
damage in 1966, and terrorist bombing
by the Mafia in 1993. The original pur-
pose of the Uffizi was to house the gov-
ernment (*uffizi* means "offices"); today
it holds the most important collection
of paintings in Italy—in 1743 it was
opened as a public art museum. The
core of the collection is the legacy of
Medici family members, but it is also
strong in many other Italian and non-
Italian areas. A good part of the Uffizi
sculpture collection went to the Bar-
gello Museum during the 19th century,
and during the 20th century numerous
paintings from Florentine churches
were brought in.

Uhde, Wilhelm

1874–1947 • German •
collector/dealer/writer

*[Delaunay] brought me to
[Rousseau's] house and there, on the
easel, I saw this marvelous picture.*

Uhde settled in Paris in 1904. He supported the FAUVE painters and bought work by other avant-garde artists, especially PICASSO. DELAUNAY introduced Uhde to Henri ROUSSEAU, as described in the quotation above; the "marvelous picture" Uhde saw was *The Snake Charmer* (1907), based on a trip to the Indies that Delaunay's mother had described to Rousseau. It was she who commissioned the painting from him. (Uhde was briefly married to Sonia Terk, who later married Delaunay.) Uhde became an early devotee of Rousseau's work, and one of the first and very few to buy it during the artist's lifetime. He organized Rousseau's first exhibition in 1908, but failed to include on the invitation the address of the gallery. In 1911, Uhde published the first book on Rousseau, and later organized subsequent retrospectives of his work. Credited with discovering and promoting interest in self-taught or NAIVE art, Uhde wrote a book, in German, entitled *Five Primitive Masters: Rousseau, Vivin, Bombois, Bauchant, Séraphine* (1947). He also wrote on van GOGH and PICASSO, who painted his portrait in 1910.

Ukiyo-e

Power in Japan had shifted from the emperor into the hands of shoguns (dictators) during that nation's 250 years of isolation preceding the arrival of an American flotilla under the command of Matthew Calbraith Perry and the opening of Japan to the West in 1853. Japanese society was divided into four strata: military, farmers, artisans, and merchants. Whereas landscape painting was patronized and sometimes practiced by the intelligentsia, Ukiyo-e was devoted to representing the tastes and interests of the more plebeian population, especially the urban lower class. They enjoyed scenes of the theater, tea- and bathhouse, brothel and boudoir; the term "Ukiyo-e" refers to images of the "floating" or passing world. Women were most frequently represented. Scorned by the upper classes, Ukiyo-e became not only a popular mode of expression but also a source of historical documentation of changing fashions among the bourgeoisie. Hishikawa Monronubu (c. 1625–1694) is considered the founder of Ukiyo-e. Kitigawa Utamaro (1753–1806) stands out as one of its greatest practitioners; Saido Sharaku, also an 18th-century Ukiyo-e practitioner, painted the Kabuki theater's star female impersonators and was himself an actor in the more upscale No theater. Starting with painting c. 1600, Ukiyo-e expanded into the medium of wood-block prints and then into four-color PRINTING. It became known in Europe and America during the 19th century, especially after Perry's voyage and the flourishing of trade with Japan. Ukiyo-e had tremendous influence on a wide range of artists, from French IMPRESSIONISTS to American REALISTS. Both Ukiyo-e technique (flat, unmodulated paint surfaces, radical cropping, empty foregrounds, and disregard for one-point PERSPEC-

TIVE) and subject matter (the private pleasures of the demimonde) were also adapted in the West. (See also HI-ROSHIGE and HOKUSAI)

Unit One

A short-lived group of British artists and architects including HEPWORTH and Henry MOORE. They held one exhibition in 1933 and published *Unit One: The Modern Movement in English Architecture, Painting and Sculpture* (1934), edited by READ.

Ur

From c. 3000 until 500 BCE (when Greece became prominent), Egypt and Mesopotamia were the loci of civilization, trading with and influencing one another, although each remained culturally distinctive. Mesopotamia started slightly earlier and, in contrast to a more unified Egypt, was characterized by independent city-states. One of these was Ur, in the southern Mesopotamian region called Sumer, on a site now in southeastern Iraq. In the Hebrew Bible it was called Ur of the Chaldees. The brick Ziggurat (c. 2100 BCE), of which only the base remains, was a TEMPLE to their gods; the so-called Standard of Ur (c. 2700 BCE) depicting soldiers and chariots on the shell-inlaid surface of a box, and the inlaid gold, lapis lazuli, and shell decoration on a royal lyre (c. 2600 BCE), including humorous scenes of animals bringing gifts to the gods, are some of the treasures recovered from Ur. Because it was the most outstanding center of the first recorded civilization in which a system of religion, government, and writing arose, Ur has come to express, almost as a code word, the idea of origin.

ut pictura poesis

Latin, meaning "as is painting, so is poetry." The phrase, from the Roman writer Horace's *Ars Poetica* (c. 10 BCE?), placed artist beside poet in the category of liberal arts, rather than alongside the craftsman. The phrase was connected to the idea of MIMESIS in that, according to PLATO, both art and poetry are imitative of nature. It could be interpreted to suggest a dependence of art on literary, or at least poetic precedent. Yet it could also be used as an apologia for nonmimetic practices such as ornamentation with GROTES-QUES, those entirely fanciful decorative designs. In that case, as the historian Keith Moxey writes, *ut pictura poesis* was taken as the justification for artistic license. As a case in point, according to MICHELANGELO: "Horace, the lyric poet . . . in no way blames painters but praises and favors them since he says that poets and painters have license to dare—that is, to dare do what they choose."

Utrecht School

Refers to the work of a group of artists from Utrecht who came under the influence of CARAVAGGIO, primarily by studying his works in the private collections of Rome or by association with Italian CARAVAGGISTI (followers of the master, such as Orazio GENTILESCHI). TERBRUGGHEN, who arrived in Utrecht after spending 10 years in Italy, was the first Dutch painter to work in a Caravaggesque style; van HONTHORST was another.

Utrillo, Maurice
1883–1955 • French • painter •
School of Paris

*My son has been inspired to make
masterpieces by looking at postcards;
others who imagine they are making
masterpieces are really only producing
postcards.* (Suzanne Valadon)

Born out of wedlock to VALADON,
Utrillo became an alcoholic as a child
and was in a sanitarium for alcoholics
by the age of 18. Like his mother, he
was a self-taught artist. He praised her
painting, "her magic colors, her natural
and honest tones," and, as expressed in
the quotation above, she admired his. A
Spanish art critic, Miguel Utrillo, gave
Maurice his surname in an effort to "le-
gitimize" him and help him out. Best
known among Utrillo's works are his
paintings in and around Paris, espe-
cially the streets of Montmartre,
sharply outlined and sophisticated in
composition. He often used "high" or
bright, light colors, but somehow the
emptiness of his streets, flanked by old
one- or two-story buildings, seems un-
friendly, like HOPPER's exposures of
alienation in the modern world. *Street
in Asinèeres* (1913–15) is an example of
a superficially agreeable but somehow
unwelcoming vista.

V

Valadon, Suzanne
1865/67–1938 • French • painter • Post-Impressionist

I paint people to learn to know them.

The daughter of an unmarried domestic worker, Valadon was roaming the streets of Montmartre by the age of six and in her teens posed for PUVIS DE CHAVANNES, TOULOUSE-LAUTREC, and RENOIR. She had no art lessons, but taught herself to draw by watching the artists who painted her. Her talent was recognized and she enjoyed a certain level of critical acclaim from 1921 until her death. Like the men with whom she associated on both a professional and an informal basis, and unlike her female contemporaries MORISOT and CASSATT, Valadon painted numerous female nudes. Breaking the rules of propriety and invading what was then considered male terrain, she defied restrictions women were usually made to feel and observe. She was more in tune with another contemporary woman, MODERSOHN-BECKER: Her nude women are not seductive, nor are her pictures erotically charged. In fact, the woman seated on the edge of her bed in *Nude with Striped Coverlet* (1922) has her eyes cast down to read a book, and is self-contained and demure. In *The Blue Room* (1923), Valadon sabotages the nude ODALISQUE convention of INGRES and MANET—she places a buxom woman with a cigarette in her mouth on a bed, surrounded by patterned fabric, and dressed in what look like wide-striped pajama bottoms and an undershirt. The historian Patricia Mathews thinks that Valadon was painting "the new intellectual woman of the ilk of Gertrude Stein." Valadon also painted many portraits; her models were often friends and family, including her son, UTRILLO. Painting people "to learn to known them," as in the quotation above, was a constant devotion of hers. Valadon's figures are heavily outlined, their faces generally unemotional. There is little directly communicated psychological intensity; complexity in Valadon's work depends on subtle references to scene setting, patterns, color, and circumstance.

Valois dynasty
After the Capetian line of succession to the French throne died out in 1328, it was replaced by the Valois royal house, which ruled until 1589. Three of the four sons of John II the Good (1319–1364; himself the son of the first Valois king, Philip VI) were important PATRONS and sponsors of artists and

purveyors of the courtly International Style of GOTHIC art. Their banquets, pageants, and other entertainments were designed and choreographed by artists and frequently recorded in ILLUMINATED MANUSCRIPTS. Charles V the Wise (1338–1380) inherited his father's throne in 1364. His biography was written by Christine de Pisan, daughter of the court astrologer in Paris. BONDOL was among the artists in Charles's court. John, Duke of Berry (1340–1416), concentrated his efforts on building and refurbishing his many castles and residences and on expanding his library (he acquired PUCELLE's *Belville Breviary* and the *Hours of Jeanne d'Evreux*) and his collections of jewels and curiosities. Numerous painters of MINIATURES were called into service, among them de HESDIN and the LIMBOURG brothers, whose *Très Riches Heures, du Duc de Berry* is one of the most magnificent books in the world. Philip the Bold of Burgundy (1342–1404), youngest of the brothers, was the patron of SLUTER and commissioned the Chartreuse de Champmol, a monastery compound, which the historian PANOFSKY calls "the Saint-Denis of the Burgundian Dynasty." The Burgundian court continued to sponsor art and artists, notably during the reign of Philip the Good (lived 1396–1467), who patronized van EYCK (see also HAPSBURG). John the Good's fourth son, Duke Louis of Anjou (1339–1384), was not as important a patron as were his brothers, but he did commission one of the most significant of the era's works of art, for which he engaged Bondol and Charles's tapestry weaver, Nicolas Bataille: the spectacular *Angers Apocalypse Tapestries* (c. 1375–79).

Vanderlyn, John

1775–1852 • American • painter • Federal/Neoclassicist

The subject may not be chaste enough . . . at least to be displayed in the house of any private individual. . . . But on that account it may attract a great crowd if exhibited publickly.

Vanderlyn was briefly taught by STUART, then went in 1796 to Paris, where he learned the ACADEMIC foundations by painting from casts of ancient statues. He was the first American painter to master the style of French NEOCLASSICISM. *The Death of Jane McCrea* (1804) is his dramatization of an American story told in an epic poem. The grisly scene shows a young woman, an early settler, about to be scalped and murdered by two men of the British-supported Mohawk tribe. It is painted in the operatic GRAND MANNER. An undercurrent of eroticism in that picture emerges full blown in *Ariadne Asleep on the Island of Naxos* (1814), in which Vanderlyn uses the story from Greek mythology—Theseus abandoned Ariadne while she slept—to paint a sensuous nude in a sylvan landscape. It was first shown in the Paris SALON. Vanderlyn anticipated American reaction to this painting in the words above. He returned to America in 1815 and set his great PANORAMA *The Palace of Versailles* (1818–19) in a small rotunda with *Ariadne* in the vestibule. Because Americans found nudes objectionable, the image was clothed in moralistic terms, but the painting's reception was mixed—admired from an intellectual point of view, but disdained by prudes.

He hoped to gain commissions for HIS-TORY PAINTINGS in the Grand Manner, but Americans were still far more interested in portraits, and Vanderlyn was largely disappointed.

vanitas

Describes art in terms of the phrase from Ecclesiastes (Chapter 1), "Vanity of vanities; all is vanity." Designed to encourage viewers to contemplate death, vanitas painting became a popular subset of Dutch STILL LIFE paintings during the 17th century. Their special message is, or at least appears to be, the rejection of the material world, which was exceedingly lavish, as Holland became one of the richest countries in the world. To drive home the message about the transience of life on earth, a skull was often included among a dazzling array of luxurious objects, from gleaming coins, to flowers, to highly polished brasses and porcelain. Ironically, while seeking to discredit the beautiful extravagances of the world, the paintings, themselves expensive commodities, embody them. The paradox of preaching against vanity while artistically celebrating it was not lost on the 17th-century Dutch.

Vasari, Giorgio

1511–1574 • Italian •
writer/painter/architect • Mannerist

The work [on the Sistine Chapel ceiling] was executed in great discomfort as Michelangelo had to stand with his head thrown back, and so injured his eyesight that for several months he could only read and look at designs in that posture. . . . I marvel that Michelangelo supported the discomfort.

Vasari was a successful painter with a very large WORKSHOP that was able to cover many walls in Florence and Rome with FRESCOES. His most significant architectural work was the UFFIZI in Florence. But neither his paintings nor his buildings earned him his reputation as the most influential artist in history. His masterpiece was, rather, his book about art, *Lives of the Most Excellent Painters, Sculptors and Architects,* first published in 1550, then expanded and reissued in 1568. Few art historians argue against the statement that it is the most influential book about the history of art ever written. On the face of it, Vasari's book fulfills the promise of its title, providing brief biographies of painters from CIMABUE to himself, along with some descriptions of their works. The text, which is full of anecdotes like that about MICHELANGELO quoted above, divides the ITALIAN RENAISSANCE into three periods: before 1400 (Proto-Renaissance, Cimabue to Lorenzo di Bicci), the 15th century (Renaissance, JACOPO della Quercia to PERUGINO), and the first half of the 16th (Late Renaissance and MANNERISM, LEONARDO to Michelangelo). His chronological and stylistic categories were adopted over the succeeding centuries, and are still followed in art historical surveys. Yet his text was controversial when it was published, and remains so to this day. Especially galling to opponents was the preferential treatment given to Florentine art, in which he saw a continuous, develop-

mental progression, akin to that from infancy to full adulthood, starting in Florence around 1300 and culminating with Michelangelo. This he emphasized especially by stressing the Florentine skill in *disegno* (meaning "drawing" but expanded to accommodate the idea of form more generally) over color (see also LINE VS. COLOR). Color was a great strength of Venetian artists. Contradictory texts appeared soon after Vasari's, beginning with Ludovico Dolce's *L'Aretino* (1557) on behalf of VENICE. Other partisan regionalist tracts later weighed in, including some from north of the Alps. Vasari's Florentine partiality has been studied, and some explanations are offered: that his work was poorly received in Venice; that his sponsor, the first Grand Duke of Tuscany, Cosimo de' MEDICI, had every reason to support a pro-Florentine/Tuscan bias; not to mention that Vasari's own practice was primarily in Florence and Rome. It was the 19th century before researchers, exploring archival materials, began to discover that Vasari was often wrong on details like dates of birth and death, attribution, and chronology. (He himself corrected some early errors in the second edition of his book.) Twentieth-century scholarship questions the authority of Vasari's entire oeuvre, which, the historian Carl Goldstein proposes, follows a CLASSICAL rhetorical model, the intention of which is to persuade the audience to accept a point of view that the author believes has a high ethical or moral value. Though usually founded on "fact," at least to some extent, such arguments willingly sacrifice truth to a higher goal. Vasari's *Lives* is likened to hagiographies (usually undocumented stories that tell the lives of saints) or to literary fiction, an epic history of the Italian Renaissance in which some artists are heroes (e.g., Michelangelo) and others are villains (e.g., ANDREA del Castagno). Yet other historians challenge Vasari's authorship of the entire work, suggesting that the important prefaces to the three sections that establish the concept of the Renaissance itself as "rebirth," and especially the idea of a developmental progression, were written by Vasari's more scholarly associates. And it is argued that, in fact, Vasari was derelict in conducting the research he should have done, that is, going to look at some of the works of art that he wrote about (like that by ANGUISSOLA and VERONESE). Reevaluation of Vasari's work, and all that has been based on it, inevitably contributes to challenging the entire foundation of Western ART HISTORY, including the interpretation of Classical art, the study of which was, after all, given its current direction during the Renaissance.

vault
A construction in which the top of the arch becomes a ceiling rather than just a passageway. (See ARCH)

Vedder, Elihu
1836–1923 • American • painter • Visionary

I am not a mystic, or very learned in occult matters. I have read much in a desultory manner and have thought much, and so it comes that I take short flights or wade out into the sea of mystery which surrounds us, but soon

getting beyond my depth, return, I must confess with a sense of relief, to the solid ground of common sense; and yet it delights me to tamper and potter in the unknowable. . . . There is another thing—the ease with which I can conjure up visions.

A native New Yorker, Vedder spent most of his life abroad, especially in Italy, where he associated with the MAC-CHIAIOLI, though he also studied in Paris for eight months. He was greatly influenced by works of the ITALIAN RE-NAISSANCE on the one hand, and by exotic stories from the Orient on the other. *The Questioner of the Sphinx* (1863) is an image inspired by the myth of the Great Sphinx of Giza: A proportionally small man crouches in front of the enormous head of the Sphinx, his ear against its lips; a skull rests in the sand nearby. Vedder may have been inspired by HEGEL, who wrote of the Sphinx as ". . . the symbol of the symbolic itself . . . recumbent animal bodies out of which the human body is struggling. . . . The human spirit is trying to force its way forward out of the dumb strength and power of the animal, without coming to a perfect portrayal of its own freedom and animated shape." In Greek mythology, Oedipus avoided death and defeated the Sphinx by answering the riddle it posed. This part of the story was illustrated by INGRES in *Oedipus Explains the Riddle of the Sphinx* (1808). Vedder's visions, which he wrote about in his autobiography, quoted from above (*The Digressions of V. Written for His Own Fun and That of His Friends,* 1910), were also of strange sea serpents and deranged wanderers.

Velázquez, Diego
1599–1660 • Spanish • painter • Baroque

Like a bee, he carefully selected what suited his needs and would benefit posterity. (Antonio Palomino, 1724)

While Spain was at the peak of its political and economic power during the 16th century, artists from Italy and the Netherlands were brought to the Spanish court. The great age of Spanish painting came in the next century, during the reign of Philip IV (1621–65), whose court painter was Velázquez. He worked mainly on portraits of the royal family; included in this category is *Las Meninas* (*The Maids of Honor;* 1656), which another, contemporary painter, GIORDANO, called a "Theology of Painting." The meaning of this phrase is that every significant consideration in the discipline of painting is realized to perfection here: It combines portraiture; it is NARRATIVE; and it treats of tradition of painting, the artist's role, concepts of vision and reflection, illumination, PERSPECTIVE, and COLOR, to mention only some of its concerns. Regarding technique, "it seems as if the hand played no part in its execution, but that it was painted by the will alone," wrote MENGS 100 years later. Very few drawings by Velázquez exist, and it is believed that he painted directly onto the canvas. His broad and fluid brushstroke was to have a profound effect on succeeding artists, as did the natural appearance he gave his subjects, his EQUESTRIAN portraits, and the collection of unconventional people, especially dwarfs, who were kept around for the amusement of the

court. The importance of Velázquez to the BAROQUE period can hardly be exaggerated. The Spanish painter and writer on art Antonio Palomino (1655–1726), who is quoted above, revered Velázquez above all other artists. Velázquez's profound insight into human character is expressed in two portraits that are diametrically opposed in regard to their subjects. He painted his employee, traveling companion, and fellow artist, *Juan de Pareja* (c. 1649–50), in Rome while awaiting, and limbering up for, his call to paint *Pope Innocent X* (c. 1650–51). The first—dark-skinned, dark-eyed, and dressed in brown and green with a wide, lacy white collar—expresses in the portrait a disarming and monumental combination of humility and nobility. The pope, in a shimmering red satin hat and cape over a lacy white vestment, is as hard-edged, tense, and powerful as Pareja is gentle, relaxed, and deferential. The range of Velázquez's influence is similarly diverse: The American painter EAKINS did not undertake painting portraits until after he studied Velázquez in Madrid; the British painter BACON was moved to paint *Study after Velázquez's Pope Innocent X* (1953), which extenuates the original image to a terrifying conclusion. There is a very different sense in which the impact of Velázquez manifested itself during the 20th century. In 1914, to draw attention to the suffragists who were incarcerated in Holloway Prison for their activities in pursuit of the vote for women, Mary Richardson went to the National Gallery in London and severely vandalized Velázquez's *Rokeby Venus* (c. 1651), a naked, reclining woman seen from the back, her

form undulating in curves of exceptional beauty. When she was interviewed by a newspaper some 40 years later, the woman, who was called Mary the Slasher, said, "I didn't like the way men visitors gaped at it all day long."

vellum
See PARCHMENT

Venice
According to legend, Venice was founded on the date of the Annunciation, March 25, in the year 421. This linked the city with the Virgin. Its floating character—surrounded and penetrated by water—in addition to the similarity of names, also associated Venice with Venus, who was born in the water. Located on 117 marshy islets in the Lagoon of Venice, Venice was a major sea power and, with Genoa, able to dominate BYZANTINE trade and to control commerce between East and West, especially luxury goods like spices, gems, perfumes, and fine cloths. Saint Mark's Cathedral (begun 1063) is an example of Byzantine influence on the city's architecture. Venice became an independent republic governed by a constitution, and also the preeminent colonial power, until Spain and Portugal began their expansions. It was also the only Italian city ruled by a merchant aristocracy. The "Myth of Venice"—its stability, its "perfect" constitution, and its impartial justice—was celebrated by PETRARCH in the 14th century and promoted in the mid-15th century. Also by the middle of the 15th century, as seen in a drawing by Jacopo BELLINI (*Flagellation*, c. 1450), artists in Venice were thinking about PERSPECTIVE—Jacopo had been in Florence, where perspective

studies took root. The moist atmosphere in Venice was not conducive to FRESCO, and though earlier artists probably used TEMPERA on linen, around 1470 Venetian painters were using OIL PAINT on wood, which was soon replaced by CANVAS. Oil paint enabled artists, including the BELLINIS, and in the 16th century GIORGIONE, TITIAN, TINTORETTO, and VERONESE, to express the subtle effects and softening of outlines resulting from the heavy, humid Venetian atmosphere seen, for example, in Titian's *Rape of Europa* (1559). The Myth of Venice is woven into Veronese's exultant *Triumph of Venice* (c. 1585), painted for the ceiling of the Hall of the Great Council in the Doge's Palace. Venice is portrayed as the *dea Roma*, goddess of Rome, rising above palatial architecture and an animated crowd in a swirl of clouds. By appropriating the personification of the ancient empire, Venice promoted itself as the "New Rome." For a long time Venetian art took a backseat to that of Florence, due largely to the influential writing of VASARI, who gave Florence and its artists preferential treatment, but that is no longer the case.

Venice Biennale

Started in 1895 as an international exhibition held every two years, the Venice Biennale is "juried"; that is, the selection of what will be shown is adjudicated by a committee, and several rewards are distributed. At its premiere, BURNE-JONES, MOREAU, and ISRAELS were among the 156 artists from 15 countries (excluding Italy, which itself was represented by 129). It was interrupted by World War II, but in 1948 the Biennale became the most important showplace for avant-garde art. Political disputes preempted the 1974 event. The 1997 Biennale was organized by Germano Celant (see ARTE POVERA) and was named *Future Present Past*. Artists from the 1960s through the 1990s were shown, but the event was plagued by administrative problems and, according to the critic Roberta Smith, "weighed down by big-name, over-the-hill talents." Film, video, and "virtual reality" prevailed over painting.

Venturi, Robert

born 1925 • American • architect • Postmodern

Less is a bore.

Venturi is known as the founder of the POSTMODERN in architecture. In his book *Complexity and Contradiction in Architecture* (1966), Venturi discussed the fertility of early building styles in contrast to the sterility of then current trends: To MIES VAN DER ROHE's famous saying "Less is more," Venturi responded, "Less is a bore," as quoted above. He promoted the idea that architects should look to popular culture for inspiration—"Is not Main Street almost alright?" is his famous rhetorical question. *Learning from Las Vegas*, coauthored with Denise Scott Brown (born 1930; his wife and architectural collaborator), was published in 1972. In it he writes, "I like elements which are hybrid rather than 'clear,' distorted rather than 'straightforward,' ambiguous rather than 'articulated.' . . . I am for messy vitality over obvious unity. I include the non sequitur and proclaim the duality. I am for richness of meaning rather than clarity of meaning." Venturi had worked with KAHN and, like

him, admired the examples of ROMAN and RENAISSANCE architecture. He incorporates a mix of styles in his buildings. One of his best known (in collaboration with other architects) is Guild House (1962–66) in Philadelphia, a redbrick public housing project for seniors on a busy thoroughfare. Its main entry facade, in white brick, with its name written in large letters above the door, calls to mind old movie houses and, perhaps, fancy ART DECO apartment buildings, with their entrance canopies and evocative names. The subtleties of this building, the various window shapes, its movement back from the street, and other details reveal themselves, more slowly than the entrance does, as mixing vernacular and historic references in the terms Venturi sets for himself.

Venus de Milo
See APHRODITE OF MELOS

verism
A variant of REALISM[1] and NATURALISM, verism implies verisimilitude, the accurate, factual representation of visual details (distinctions among the three are fluid and not agreed on among art historians). Verism is used especially to characterize ancient Roman portraiture, above all busts that served "for the sake of memory and posterity," as Cicero put it. Such images were often death masks. Called *imagines,* these busts were prominently displayed in homes and at funerals. Roman portraitists vacillated between more or less verism, mediated by idealism and an effort to record the individual's character. In the well-known busts *Hadrian* (c. 120 CE) and *Caracalla* (c. 215 CE), the

artists added remarkable representations of character and emotion to their veristic reporting of physiognomy.

Vermeer, Jan
1632–1675 • Dutch • painter • Baroque

All the figures seem to have been transplanted from ordinary existence into a clear and harmonious setting where words have no sound and thoughts no form. Their actions are steeped in mystery, as those of figures we see in a dream. (J. Huizinga, 1919)

Muted tones, soft light, harmony, balance, and subtlety characterize Vermeer's paintings. They are usually small in size and intimate in subject. They are often of interior scenes, in his own house, containing one, two, or three people occupied with quotidian chores: reading a letter, pouring milk, playing a musical instrument—domestic subjects that sanctify the everyday preoccupations they portray. Two outdoor scenes, *The Little Street* (c. 1658–60) and *View of Delft* (c. 1661), also express the quietude of his interiors, although, as Huizinga went on to say, following the quotation above, "The word 'realism' seems completely out of place here." The hustle and bustle of ordinary life cannot seem to penetrate the extraordinary stillness of Vermeer's interior and exterior scenes. Vermeer spent his life in the old walled city of Delft, and while there is official documentation of certain facts (birth, marriage, death), little is known about his training. His association with other artists also is a mystery, except that he registered as a master painter in the Saint Luke's Guild in 1653 and that he was twice head of

the GUILD after that. (STEEN and de HOOCH were also painters active in Delft during the 1650s.) Before his marriage to Catharina Bolnes in 1653, Vermeer converted to her religion, Catholicism. That seems to explain a few atypical works, like *Saint Praxedis* (1655). His oeuvre seems to have been exceptionally small in number, based both on paintings that are known first-hand, about 36 all told, and on those that have been identified by records. It seems certain that he did not make his living from selling his art; it is likely, rather, that his income came from his father's business, which combined innkeeping and selling pictures. One story is that someone called at his house to buy one of his works and he insisted that he had none to sell, despite a house-ful of paintings. When he died, he left his large family deep in debt. Vermeer's interest in and painting of shadow are as remarkable as his representation of form, and both express his sensitivity to the optical effects of light and color. Ex-perimentation in optics, the science that both explores and expands what the eye sees, flourished in 17th-century Delft. Vermeer is believed to have used a CAM-ERA OBSCURA as an aid in composing his scenes, and was equally fascinated by the other scientific discoveries of his time. He was a friend of a great maker and experimenter with lenses, Anthony van Leeuwenhoek (1632–1723), known for his development of the microscope. Leeuwenhoek was the executor of Vermeer's estate. There would seem to be some poetic justice, then, that when a museum conservator was examining one of Vermeer's paint-ings with a microscope in 1995, he dis-covered that the jewel that had given

the painting the name by which it has long been known—*Girl with a Pearl Earring* (1665–66)—may not be a pearl at all. A fleck of paint had fallen onto the earring to change its shape. Now cleaned, it looks more like a glass or sil-ver ball, on the surface of which light collects and bounces back at the viewer. In other words, the earring itself acts very much like a lens. Thus, the same technology that expanded the age of Vermeer is still able to lead us back to understanding the artist's original in-tention.

Veronese (Paolo Caliari)
1528–1588 • Italian • painter • Late Renaissance

We painters take the same liberties as poets and madmen take.

Painting in VENICE at the same time as TINTORETTO (though originally from Verona), Veronese created work that was as radiant and delightful as Tin-toretto's was dark and troubling. Each painted the *Last Supper,* and these works provide a striking comparison. Tintoretto's, of 1592–94, is a tragic but transcendental moment; Veronese painted a scene of such luxury and inci-dental (even humorous) detail that he was called before the Inquisition in 1573 on account of it. His comment, quoted above, was part of his self-defense for having set the scene as a sumptuous banquet with "buffoons, drunkards, dwarfs, Germans, and simi-lar vulgarities." The result was that he made a few changes, including renam-ing the picture *Feast in the House of Levi* (1573). In general, Veronese's in-tensely colorful compositions recorded the wealth and pageantry of Venetian

life. For the ceiling of the Hall of the Great Council in the Doge's Palace he painted *Triumph of Venice* (1579–82), in which the Republic of Venice is personified as a great queen on her throne being crowned by angels amid illusionistic architecture that climbs into the sky, a bevy of spectators, allegorical figures, and prancing horses seen from behind. As were CORREGGIO's ceilings, this composition was studied avidly by Veronese's BAROQUE successors.

Verrocchio, Andrea del

1435–1488 • Italian •
sculptor/painter • Renaissance

*I am very glad [that Cosimo de'
Medici wants a magnificent altarpiece]
and should be even more glad if I
might paint it myself. . . . And should
this happen, I hope to God I should
produce something wonderful for you,
equal to good masters like Fra Filippo
[Lippi] and Fra Giovanni
[Angelico]. . . . I beg you, so far as it is
possible for a servant to beg his lord,
that it will please you to bestow favor
upon me.*

The letter quoted from above was to Piero, Cosimo de' MEDICI's son, dated April 1, 1438. Verrocchio lost the commission for the ALTARPIECE of San Marco, which was awarded to Fra ANGELICO. Verrocchio (a nickname meaning "true eye") was the master of a large and successful Florentine WORKSHOP in which LEONARDO was a trainee. Verrocchio's *Baptism of Christ* (c. 1475–85) is usually called on to show Leonardo's hand—he painted the head of at least one of the two angels at the left of the picture and possibly some of the landscape. Verrocchio's own work

has some of the intensity seen in CASTAGNO. However, Verrocchio is best known as a sculptor. Where earlier NANNI di Banco and DONATELLO had begun to liberate their sculpted figures from the architectural niches in which they stood, Verrocchio went a step further in the life-size bronze work *Doubting Thomas* (c. 1466–83) at Orsanmichele, Florence: Reaching to touch Christ's wound as proof that he is, indeed, the Lord, Thomas is actually standing on the ledge, outside the niche that encloses the figure of Christ. Verrocchio's specific references to Donatello show just how differently each sculptor used his craft to interpret his subject. Verrocchio's *David* (c. 1475; about 40 years after Donatello's) is clothed rather than nude; while also pensive he is tense, not relaxed, showing tendons and veins—a more specific observation of the body. Verrocchio's figure is keener, aware of his victory, and seems to have been caught in a momentary pause. These two qualities—physical expressiveness and stabilizing a fleeting moment—signify the culmination of 15th-century ITALIAN RENAISSANCE style. They are also apparent in Verrocchio's EQUESTRIAN statue *Bartolomeo Colleoni* (c. 1479–92), though the tension here is in the fierce expression of the face and the torsion in the body of an armed general riding into battle.

Versailles

In 1668 Louis XIV began to build Versailles, then a relatively small compound, into a great palatial complex that included not only a park but also a small city to accommodate, as he believed himself to be, the greatest mon-

arch of the century. Naming himself the Sun King affiliated Louis with the pagan god Apollo. In 1674, the French architect André Félibien wrote, "It must first be pointed out that, since the Sun is the emblem of the King and since the poets confound the Sun and Apollo, there is nothing in this superb residence that is not related to this divinity." From the avenues that radiate from the palace like the sun's rays, to a sculpted Apollo in his chariot pulled by four bronze horses and rising from a pool of water, to small decorative, circular gold interior ornaments, the light of the sun and the light of Louis's reign are represented as synonymous. The palace itself, more than a quarter of a mile in length, was designed by Louis Le Vau (1612–1670) and HARDOUIN-MANSART, and the result is an interpretation of CLASSICAL architecture on an unprecedented, vast scale. The park landscape, designed by André Le Nôtre (1613–1700), is another of the world's great works of art. The interior was incomparably lavish in all the DECORATIVE and FINE ARTS; the work was overseen by the premier art director of the period, LE BRUN.

video

Developments in technology provide artists with new mediums to explore. As photography and film were appropriated by artists, so too have video and computers become appealing mediums. PAIK is one of the pioneers in video art. Artists use video technology in every conceivable way, from manipulating and restaging previously recorded images (e.g., the assassination of John F. Kennedy), to recording their own performances (ANDERSON) or images for INSTALLATIONS. Taking technology that was initially developed for a mass audience, artists have also exploited entertainment/advertising forms, like MTV. As intended, distinctions between "high" and "low," mass and elitist art are purposefully erased. (See also POPULAR CULTURE)

Vienna Secession (Sezession)
See SECESSION

Vigée-Lebrun, Marie-Louise-Élisabeth
1755–1842 • French • painter • Rococo

Happy as I was at the idea of becoming a mother, after nine months of pregnancy, I was not in the least prepared for the birth of my baby. The day my daughter was born, I was still in the studio, trying to work on my Venus Binding the Wings of Cupid *in the intervals between labor pains.*

The cult of love and feminine beauty were intimately bound to ROCOCO aesthetics. Vigée-Lebrun was unlucky in love (she married a man "whose overwhelming passion for extravagant women, combined with a love of gambling, decimated both his fortune and my own," as she wrote in her memoirs), though amply favored in her looks. She painted self-portraits many times, as well as portraits of her children. Her father was her teacher, though he had died by the time she was 13. Successful at portraiture especially, Vigée-Lebrun was appointed court artist to Queen Marie Antoinette and her services were enlisted in the effort to counteract the queen's scandalous reputation as a loose woman. In *Portrait of Marie An-*

toinette with Her Children (1787) the monarch, with an infant on her lap and two children at either side, carries allusions to paintings of the Madonna and Child. There is a Rococo "prettiness" in her pictures, and a freshness that is very much her own. Vigée-Lebrun's income was substantial but squandered, first by her mother's second husband, then by her own husband, a dissolute art dealer who charged high prices for his wife's pictures and pocketed most of her earnings. To increase her income, he suggested she take pupils, which she did, although, as she wrote, it "took me away from my own work and irritated me sharply." One student was Marie-Guillemine BENOIST. Vigée-Lebrun left Paris during the Revolution, as the queen was taken from VERSAILLES under armed guard. She returned to Paris in 1802, but continued to travel as she had done earlier.

Vignola, Giacomo (Jacopo) Barozzi da

1507–1573 • Italian • architect/author • Late Renaissance/Mannerist

Giacomo Barozzi da Vignola codified the rules of classical architecture for the Italian Renaissance . . . (Henry Hope Reed, 1977)

Vignola was the leading Roman architect after MICHELANGELO's death. His most important and influential building is Il Gesù, a church in Rome that was begun in 1568 (completed 1575). Nikolaus PEVSNER writes that "it has probably had a wider influence than any church built in the last 400 years." Vignola's innovations include replacing the usual side aisles with a series of chapels opening off the nave and finding various means to direct attention to the high altar. (The facade of Il Gesù was designed by Giacomo della Porta, a follower of Michelangelo, and the interior was redecorated in BAROQUE style in 1672–83.) Another major contribution of Vignola was the publication in 1562 of *Regola delli cinque ordini d'architettura,* which Reed writes about in the quotation above. The book contained 32 plates based on the five COLUMN ORDERS he found in the remains of ancient Rome. He took the Doric from the Theater of Marcellus and the Corinthian order from the porch of the PANTHEON. He closes with an entablature—horizontal members above the columns: architrave, frieze, cornice—of his own invention. Vastly influential, Vignola's book had numerous Italian editions and was translated into several languages, including Russian.

Villa Boscoreale

Buried and preserved by the eruption of Mount Vesuvius in 79 CE, this villa at Boscoreale, a mile or so north of POMPEII, had walls exquisitely painted with complex and elegant architectural scenes, divided from one another by slim columns, in what is called the Second Style of Roman wall painting (see MURAL). One Boscoreale painting created the illusion of a city street, each building having its own vanishing point, known as herringbone PERSPECTIVE, rather than the one-point perspective devised during the ITALIAN RENAISSANCE. Architectural murals may have imitated backcloths that were used for theatrical stage sets. Some of the Boscoreale murals are at the Metropolitan Museum of Art in New York.

Villa of the Mysteries

This splendid country mansion, just outside POMPEII, was more than 100 years old when it was destroyed by the eruption of Mount Vesuvius in 79 CE. It was underneath nearly 25 feet of volcanic debris when excavations began in 1909; poisonous gases interrupted the work, which was resumed in the 1920s. In 1930 an extraordinary mural was uncovered, dated c. 50 BCE, in the Second Style (see MURAL). This painting gave the villa its name: In a room some 16 by 23 feet are illustrations of rites performed as part of a mystery cult, most likely that of Dionysus/Bacchus (Greek/Roman god of wine), who is painted on the most important but damaged wall, resting his head in the lap of his bride, Ariadne. Scenes, set against a deep red background, are enigmatic and include a young woman, a supposed initiate, about to be lashed by a winged woman brandishing a long whip; a naked woman twirls, perhaps in ecstatic frenzy, and another uncovers a basket containing a phallus; a young boy reads from a papyrus; Silenus (foster father of Bacchus), a satyr, and a faun also populate the walls. The meaning of the scenes is unresolved, but their dramatic impact and religious nature are incontrovertible.

Villard de Honnecourt

active early 13th century • French • master mason • Late Medieval/Gothic

Villard de Honnecourt greets you and begs all who will use the devices found in this book to pray for his soul and remember him.

Villard left behind a notebook, compiled c. 1220–35, with drawings and commentary on a variety of subjects, from buildings—"I have been in many lands but nowhere have I seen a tower like that of Laon"—to lions—"Here is a lion seen from the front. Please remember that he was drawn from life." Although his drawing "from life" is questionable (seeming more anthropomorphic than anatomically correct), and he apparently depended on geometrical forms as much as natural shapes, it is thought that his ideas have had great influence in spreading French ideas throughout Europe.

Vingt, Les (Les XX)

Made up of 20 young Belgian artists, this was an avant-garde group formed in Brussels in 1884. Their purpose—to promote new and original forms of art—was realized by inviting 20 guests, usually foreign artists, to show their works in yearly exhibitions. WHISTLER, MONET, RENOIR, RODIN, REDON, SEURAT, PISSARRO, MORISOT, and CÉZANNE were among the guest artists. They published a journal, *L'Art moderne*. ENSOR was one of the founding members and exhibited with Les XX until the group dissolved in 1893.

Viollet-le-Duc, Eugène-Emmanuel

1814–1879 • French • architectural theorist/restorer • Romantic

. . . among the medieval architects the only scale admitted was man, every part of their structures being composed with reference to the height of the human figure, and hence, necessarily, the unity of the whole. With a point of comparison so familiar, the real

dimensions of their edifices became particularly appreciable.

Working for the French Inspector General of National Monuments and Historical Antiquities in 1834, Viollet-le-Duc acquired a thorough understanding of the construction principles and techniques of GOTHIC architecture. He became an influential writer whose argument on behalf of Gothic design, as in the passage quoted above, contributed to its 19th-century revival, not only in architecture but in the DECORATIVE ARTS and painting, too. Viollet-le-Duc appreciated the structural rationalism of support systems (e.g., the stone rib vault and "flying buttress" of the Gothic cathedral), not the building's religious inspiration. In his books (e.g., *Dictionnaire raisonné de l'architecture française du XIe au XVIe siècle*, 1854–68, and *Entretiens sur l'architecture*, 1863 and 1872), Viollet-le-Duc argued on behalf of using contemporary structural materials, such as iron, for similar support systems. His own designs were not exceptional, but Viollet-le-Duc devoted himself to restoration work and achieved great results with such famous landmarks as Sainte-Chapelle and Nôtre-Dame in Paris. Viollet-le-Duc's English counterpart was PUGIN.

Vitruvius

active late 1st century BCE • Roman • architect/theorist • Ancient

The houses of bankers and farmers of the revenue should be more spacious and imposing [than those of common people] and safe from burglars. . . . For persons of high rank . . . we must provide princely vestibules, lofty halls and very spacious peristyles, plantations and broad avenues finished in a majestic manner.

Vitruvius worked first for Julius Caesar and later for Augustus, to whom he dedicated his treatise *De architectura libri decem,* or *The Ten Books on Architecture* (c. 17 BCE or later), the only complete tract on architecture that survives from the ANCIENT world. As did Augustus, Vitruvius greatly admired GREEK works—he discussed the origins and character of COLUMN ORDERS—and was more conservative than were other ROMAN builders. Part of his intention was to create an intellectual underpinning for architecture, and he promoted education in the liberal arts and mathematics for members of the profession. But Vitruvius was less important during his own time than he would later become. Several manuscript copies of his book were known during the early MEDIEVAL period, but the rediscovery of *On Architecture* (as the treatise is commonly called) during the 15th century catapulted Vitruvius to the forefront of influence during the ITALIAN RENAISSANCE. The obscurity of his writing style led to fanciful interpretations; nevertheless, architects followed his text religiously: ALBERTI was the first to seriously study Vitruvius and based his own *De re aedificaturia* (1452), the first architectural treatise of the Renaissance, on Vitruvian ideas; RAPHAEL requested an Italian translation of *On Architecture* in 1514 and made scale drawings of Roman buildings in order to analyze Vitruvius's concepts; and LEONARDO made the idea of Vitruvian Man famous—the symbol of

ideal proportion expressed by the drawing of a man, arms and legs spread wide, standing inside a circle that is inside a square. The first printed edition of *On Architecture* was published in Rome between 1486 and 1492. Vitruvius's own drawings were lost; the first illustrated edition by Fra Giocondo (a Dominican friar, c. 1433–1515) was published in 1511. PALLADIO illustrated a 1556 publication of *On Architecture;* his own *Four Books of Architecture,* published in Venice in 1570, was based on Vitruvius, but was very much Palladio's own work. Vitruvius's preeminence was lost in the 17th century due to the popularity of Palladio's book, but was revived in the 18th with a new translation.

Vlaminck, Maurice de

1876–1958 • French • painter/writer • Fauve

I knew neither jealousy nor hate, but was possessed by a rage to re-create a new world, the world which my eyes perceived, a world all to myself. I was poor, but I knew that life is beautiful. And I had no other ambition than to discover with the help of new means those deep inner ties that linked me to the very soil.

Vlaminck had a short career as a professional cyclist, then worked as a musician, first in a "gypsy" band and later in a theater orchestra, which allowed him to paint during the day. After three years of military service, he had strong antimilitarist feelings, and, with Zola and others, he rallied to the support of Alfred Dreyfus (see DALOU). Vlaminck befriended DERAIN and the two shared a studio for a time. Derain illustrated Vlaminck's novels. Both young painters were fired with enthusiasm by a 1901 retrospective of van GOGH's paintings, but Vlaminck also felt a great personal, temperamental affinity with van Gogh. He later described the effect of the van Gogh exhibit on him: "I heightened all tones, I transposed into an orchestration of pure colors all the feelings of which I was conscious. I was a barbarian, tender and full of violence. I translated by instinct, without any method, not merely an artistic truth but above all a human one. I crushed and botched the ultramarines and vermilions though they were very expensive and I had to buy them on credit." Vlaminck, with Derain and others, exhibited in the historic 1905 show at the SALON D'AUTOMNE, where they were named FAUVES. His paintings, as his comments suggest, were relatively instinctive, dependent on what he called "candid ignorance"; those of MATISSE and Derain were more carefully and intellectually constructed. He painted numerous landscapes, and *Landscape Near Chatou* (1906), for one example, whips the foreground landscape into something of a frenzy with black dashes defining lines of movement and thick white brushstrokes for clouds. Houses in the distances are small cubes with pitched red roofs.

Vollard, Ambroise

1865–1939 • French • picture dealer/writer

Listen, Monsieur Vollard, painting certainly means more to me than anything else in the world. I think my mind becomes clearer when I am in

*the presence of nature. Unfortunately,
the realization of my sensations is
always a very painful process
with me. I can't seem to express
the intensity which beats upon my
senses.*

Vollard opened his gallery in Paris in 1893, some two years after the death of Theo van Gogh, of GOUPIL's GALLERY, and championed some of the painters van Gogh had supported. Soon Vollard's gallery became the important avant-garde showplace: He gave CÉZANNE his first show 1895, and featured PICASSO (1901) and MATISSE (1904). Vollard was GAUGUIN's dealer, but their relationship was difficult. When people inquired about it, Vollard remained silent even though some accused him of allowing the artist to starve to death. He barely mentioned Gauguin in his autobiography, *Recollections of a Picture Dealer* (1936); however, when their exchange of letters and receipts was examined after Vollard's death, it was found that the dealer had, in fact, both fulfilled his obligations and kept the artist going. Still, his tardiness in payments sometimes made Gauguin's difficult situation worse. As REWALD writes, Gauguin saw Vollard as "a swindler and a thief—in short, as the devil himself." Several artists painted Vollard's portrait, including Cézanne, Picasso, RENOIR, ROUAULT, and BONNARD. Vollard commissioned illustrations of literary classics and, besides his autobiography, wrote on both Cézanne and DEGAS. The quotation above is from Vollard's biographical memoir of Cézanne, published in 1914.

Voragine, Jacobus de

c. 1230–1298 • Italian • monk/author

The passion of eleven thousand virgins was hallowed in this manner. In Britain was a christian [sic] king . . . [whose] daughter shone full of marvellous honesty, wisdom, and beauty, and her fame and renomée was borne all about.

A Dominican friar, born near Genoa, who became archbishop of Genoa, Jacobus wrote the *Golden Legend,* one of the most popular religious works of the MEDIEVAL period. The book is organized according to the Church calendar, beginning with Advent, and tells the stories of the saints, the Virgin, and events related to the Church's feast days. It was the source for numerous works of art throughout the ITALIAN RENAISSANCE—GIOTTO's *Meeting at the Golden Gate* (after 1305); PIERO della Francesca's cycle of decoration for the choir at San Francesco in Arezzo, the *True Cross* legend (c. 1452–57); as well as RAPHAEL's *Marriage of the Virgin* (1504) are examples. NORTHERN RENAISSANCE artists also worked with the *Golden Legend:* BONDOL illustrated a copy of it, and van EYCK very likely had reference to it in painting the *Ghent Altarpiece* (1432). Translated into French during the 14th century, the *Golden Legend* was first translated into English by William Caxton, in 1483, from a French version. The passage quoted above is from the beginning of the legend of "Saint Ursula and the Virgins" in Caxton's translation. The subject was painted by CARPACCIO in the 1490s.

Vorticism

From the word "vortex," a movement in England just before World War I, led by Percy Wyndham LEWIS and his colleagues William Roberts (1895–1980), Henri Gaudier-Brzeska (1891–1915), C. R. W. Nevinson (1889–1946) and others. The photographer Alvin Langdon Coburn (1882–1966) produced abstract images through three mirrors clamped together to form a hollow triangle. These were called Vortographs by Lewis and the poet Ezra Pound. It was Pound who gave the movement its name and, with Lewis, founded its periodical, *Blast*. Vorticism ended with the war.

Vouet, Simon

1590–1649 • French • painter • Baroque

. . . the restorer of painting. (Charles Perrault, 1696–1700)

Among the artists drawn to Rome from all over Europe, Vouet arrived in Italy in 1612 and remained until called home to France by King Louis XIII in 1627. During his stay abroad he was elected president of the Roman Academy of Saint Luke. Vouet's work showed the influence of CARAVAGGIO in deriving mood from light and shadow and the BAROQUE idea of emotional engagement, in religious pictures especially. These tendencies were moderated on his return to Paris, where, in the vein of POUSSIN, he softened his style to a tamer, more CLASSICAL one and made his colors lighter and livelier. Vouet played an important role in cultural restoration, as acknowledged by Perrault in the quotation above, excerpted from his book *Illustrious Men of France During This Century*. Vouet's eminence in French painting was briefly challenged during Poussin's return, but when Poussin left again, Vouet's leadership was reestablished, and his commissions were plentiful. *Presentation in the Temple,* ordered by Richelieu in 1641, with the controlled fervor of its statuesque figures, is a good example of Vouet's approach. He did not really initiate a new style with such paintings, or with the important programs he carried out in wall and illusionistic ceiling decorations, but he trained many succeeding artists, most notably LE BRUN.

Vrubel, Mikhail

1856–1910 • Russian • painter • Symbolist

. . . henceforth the poison of insidious temptation will trouble no more the minds of men. I want to make my peace with Heaven, I want to love and to pray, I want to believe in good; with tears of repentance I will efface the marks of celestial fire from my brow. . . . (Mikhail Lermontov, 1841)

When he was a student helping to restore the FRESCOes in a 12th-century church, Vrubel became devoted to the ethereal BYZANTINE style. He was also influenced by the expressive subjectivity of the French SYMBOLISTs, and by the contemporary exaggerations and asymmetry of ART NOUVEAU. He was a member of the first WORLD OF ART exhibition, and Diaghilev wanted him to execute the designs for his ballet *Firebird;* however, Vrubel was either dying or going mad at the time, according to memoirs of the ballet's composer, Igor

Stravinsky. After illustrating Lermon-tov's poem *The Demon,* Vrubel became obsessed with the devil. In this narrative poem, the demon is an angel who is exiled from heaven. He spreads evil on earth until he falls love with Tamara, to whom the passage quoted from above is dedicated, but in the end he destroys her. *Tamara's Dance* and *The Demon Downcast* (1902) are examples of Vrubel's fascination with the beautiful, androgynous, romanticized demon. Byron was a powerful influence on Lermontov, and that influence extends to Vrubel. Vrubel did have a mental breakdown; he also lost his sight and finally died in an asylum in 1910.

Vuillard, Édouard

1868–1940 • French • painter • Symbolist/Nabi

Then the room of the saints! Vuillard who is triumphant there, expressing the joy and tenderness of things! (Paul Signac, 1899)

A contemporary, close friend, and studio mate of BONNARD, Vuillard was similarly concerned with intimate, everyday scenes. But whereas there is a relaxed, open sense to Bonnard, Vuillard's pictures seem confusing and tense. Interior decor—even the pattern of a dress, rug, or curtain—seems to absorb the human figures present. Such is the case with Vuillard's best-known painting, *Workroom* (1893). In it are his mother, a dressmaker, his sister, and his brother-in-law (also a painter and member of the NABIS). The black and yellow of his mother's dress, the tightly patterned wallpaper, large surfaces of fabrics—dark and light blues, and white—an orange cupboard with dashes of paint on top that may represent a cat, all seem submerged in a sea of dots, dashes, and daubs. It is as if Vuillard wished to paint the confinement of their lives with these patterns. He is not an IMPRESSIONIST, but his short, quick brushstrokes are impressionistic. It is composition and color that sets the mood in his paintings. Even in portraits, like one of the art critic DURET (1912), a supporter of the Impressionists, the interior setting, filled with paintings and folios, swarms about the subject of the painting. The background of Vuillard's painting includes a famous portrait of Duret as a dashing boulevardier painted by WHISTLER 30 years before Vuillard's portrait. Duret is not only a good deal older, but he is also seen by Vuillard with deeper sympathy and sensitivity. Surrounded by his books and papers, with a cat on his knee, he seems lonely and vulnerable, yet self-contained and pensive. It has been said that so great a portrait of an old man had not been painted since REMBRANDT lived some 300 years earlier. The painter SIGNAC, whose description of the artist is quoted above, was an ardent admirer of Vuillard.

wall painting
See MURAL

Walpole, Horace
1717–1797 • English •
writer/architect • Romantic/Neo-
Gothic

*This world is a comedy to those that
think, a tragedy to those that feel.*

Walpole was a novelist and son of the
British prime minister. The renovation
of his "villa," Strawberry Hill (1749–
77), near London, in the earliest stages
of the Romantic period, exemplifies the
contemporary fascination with GOTHIC
style. The roofline of Strawberry Hill
was crenellated to resemble a MEDIEVAL
castle. Turrets, towers, and battlements
were added to the exterior, and the inte-
rior was decorated with shields, lances,
and armorial bearings. In the library,
the bookcases were copied from a tomb
in Westminster Abbey. All these con-
ceits set the stage for chivalric fantasies
and the dark broodings that would be-
come intrinsic to ROMANTICISM.

Wanderers (Peredvizhniki; also Peripatetics and Travelers)
A Russian utopian colony of artists
brought together in 1870 by a wealthy
connoisseur and social idealist, Savva
Mamontov, whose patronage of the
performing arts set a precedent for con-
necting artists with impresarios (see
WORLD OF ART). These artists rebelled
against the Imperial Academy of Arts,
and with humanitarian ideals painted
ordinary people or historic metaphors
to convey their political message. To
popularize and promote their work,
they organized traveling exhibitions,
hence their name. The anti-czarist work
of REPIN, who used scenes from history
as well as contemporary events to raise
social consciousness, is best known
among them.

war memorial
Specifically a monument honoring sol-
diers who died in action, the war
memorial was a Prussian invention of
1793. Glorification of patriotism—in
contrast to EQUESTRIAN monuments,
for example, which extol the heroism of
a particular person—was and remains
the purpose of the war memorial. At
one end of the spectrum is the *Kreuz-
berg Monument* in Berlin (completed
1821). This is an iron tower designed by
the architect SCHINKEL, with niches for
iron sculptures representing specific vic-
tories. At the other end is the Vietnam
Memorial in Washington, D.C. (1981–
83), a highly polished granite wall en-
graved with the names of the fallen, de-
signed by LIN.

Warburg, Aby

1866–1929 • German • art historian

A scholar such as Warburg would not have founded his Library without a burning faith in the potentialities of Kulturwissenschaft [cultural scholarship]. The evolutionist psychology that inspired his faith is no longer ours, but the questions it prompted him to ask still proved fruitful to cultural history. (E. H. Gombrich, 1967)

Opposed to the AESTHETICISM of the late 19th century, Warburg was interested in the exploration of culture through psychology. His vast range extended from the ITALIAN RENAISSANCE to the art of Native Americans. He assembled a formidable collection of books on subjects including economics, costume, and folklore as well as philosophy, psychology, and art. His library in Hamburg was moved to London during the Nazi regime and in 1944 became the nucleus of the library at the Warburg Institute of the University of London. GOMBRICH, whose words are quoted above, wrote *Aby Warburg: An Intellectual Biography* (1970).

Ward, John Quincy Adams

1830–1910 • American • sculptor • Romantic naturalist

. . . an American sculptor will serve himself and his age best by working at home.

The NATURALISM of Ward's work was considered appropriate to American subjects, especially that of his own most renowned bronze sculpture, *Indian Hunter* (1860). A young American Indian, tensely poised, holds his dog with one hand, his bow and arrow in the other, focused intently on his invisible quarry. Small in size ($1^1/_3$ feet high), the work is heroic in intent, and it was in tune with the contemporary search for what was uniquely American. That was the same spirit expressed by Walt Whitman and by paintings of artists of the HUDSON RIVER SCHOOL. One might say that the natural landscape in which this romanticized adventure would have taken place is as implicit in the sculpture as is the unseen quarry.

Warhol, Andy

1925/30?–1987 • American • painter/printmaker/filmmaker • Pop Art

I think everybody should be a machine.

Impresario of the underground culture of the 1960s that reveled in transvestitism, drugs, sadomasochism, pornography, and most other illicit interests, Warhol is widely known for the comment "In the future, everyone will be famous for fifteen minutes." Warhol himself is everlastingly famous for art that defied all standard definitions of "art." Mass production and REPRODUCTION were hallmarks of his work. He called his studio The Factory and insisted on the appropriateness of others producing his work, for which he used mainly photographs, often news photographs, which he printed in multiples by the SILK-SCREEN process. *32 Campbell's Soup Cans* (1961–62) and *White Burning Car III* (1963) show both his range of subject and his narrowness of interest: a familiar, everyday commercial product and an extraordinary but spectacular burning automobile. Both

are APPROPRIATED images, and both are repeated numerous times; the fascination of repetition is its magnetism, perhaps created by our compulsion to find an exception or rogue element. Repetition is also an insinuation of eternity, or infinity, and it has the ability to mesmerize. Warhol was relentlessly detached, cool, and superficial: "If you want to know all about Andy Warhol just look at the surface of my paintings and films and me, and there I am. There is nothing behind it," he said. But the surface he presented was a mirror with a disquieting reflection of contemporary life. Regarding his interest in fame, as a child he kept scrapbooks of film stars, and as an adult he produced images of Elvis Presley, Marilyn Monroe, and Elizabeth Taylor; and he started a magazine, *Interview,* to feature the rich and famous.

wash

The term applies to brush drawings or paintings made with highly diluted ink or PIGMENT, especially WATERCOLOR. (See also ACRYLIC, BISTRE, and SEPIA)

watercolor

Finely ground PIGMENT bound by water-soluble gum arabic or glue is moistened with water before being used. Most watercolors are applied on a paper GROUND, although other surfaces, like GESSO and ivory, have been used. Transparent (aquarelle) watercolor WASH, especially applied on white paper, can be brilliant and subtly modulated, as the color and texture of the paper contribute to the picture. Watercolor is difficult to use because errors cannot be corrected and colors cannot be changed. Opaque watercolor

(GOUACHE) tends to be duller. A few NORTHERN RENAISSANCE artists (e.g., DÜRER and van DYCK) used watercolor with spectacular effect, but for the most part the medium was used for studies of outdoor scenes, not for studio-finished work. During the 19th century, watercolors, as the paintings themselves also are called, acquired more status, but the technique was not taught in art schools. In England it came to be seen as the accomplishment of cultivated individuals; for women it took the place of embroidery. Peasant subjects by MILLET and small landscapes by COROT became popular among collectors. HOMER, LA FARGE, and SARGENT were among the skilled and successful watercolorists of the 19th century; O'KEEFFE was one of the most innovative painters in the medium of the 20th.

Watteau, Antoine
1684–1721 • French • painter • Rococo

From the moment I received [a painting by Rubens] I have not been able to rest quiet, and my eyes do not tire of returning to the stand where I have placed it as upon an altar.

Watteau, born in Flanders, went to Paris at the age of 18. His early work was in interior decorating, for which he painted incidental scenes entwined with garlands, vines, and monkeys (see SINGERIE). One of his patrons was a wealthy textile manufacturer, Jean de Julienne, to whom the letter above was written. In the letter Watteau expresses his admiration for RUBENS, whose work greatly influenced him. Rubens's *The Garden of Love* (1632–34), in which the stages of amorous attraction are

represented, is a painting Watteau knew well, and it seems to have been a source of inspiration. So was the commedia dell'arte, the name given to traveling theater companies, of Italian, mid-16th-century origin, who played before both royalty and commoners throughout Europe and became popular in France. Watteau was also interested in *fêtes galantes,* a ROCOCO period version of the FÊTE CHAMPÊTRE so acclaimed during the late RENAISSANCE. These were excursions designed for love and gallantry in the privileged world of artifice that Watteau observed and painted. Best known is *Pilgrimage to the Island of Cythera* (there are two versions, 1709 and 1717), in which a parade of elegantly costumed aristocrats make their way to a golden barge while PUTTI cavort overhead (as they do in Rubens's *Garden of Love*). Cythera is a Greek island and was the center of the cult of Aphrodite. The shimmer of fabric, feathery trees, and iridescent water are all dreamlike. Imaginary, too, is his other masterpiece, *Gersaint's Shop-sign* (1721), painted for the friend who sold paintings and actually, briefly, used this painting as a sign (it originally had an arched top to fit an area above the shop's front entrance). *Gersaint's Shop-sign* now rivals VELÁZQUEZ's *Las Meninas* (1656), VERMEER's *Allegory of Painting* (c. 1665), and van EYCK's *Arnolfini Double Portrait* (1434) as an interpretative challenge. Watteau's picture appears to be the inside of a shop (though not Gersaint's), its walls covered with paintings. Among the interesting details is a shop hand packing a portrait of Louis XIV into a wooden crate. This may be in reference to the king's death, in 1715, as well as to the name of the shop, *Au Grand Monarque.* Watteau himself died of tuberculosis a few months later. Watteau's friend de Julienne compiled ENGRAVINGS of more than 500 paintings, drawings, and decorations in a tribute known as the *Recueil Julienne* (published 1735). (Also see BOUCHER) It was through this collection that Watteau's work became known and internationally influential.

Weber, Max

1881–1961 • American • painter • Modern

Electrically illumined contours of buildings, rising height upon height against the blackness of the sky now diffused, now interknotted, now interpierced by occasional shafts of colored light. Altogether—a web of colored geometric shapes, characteristic only of the Grand Canyons of New York at night.

Born in Eastern Europe, Weber was brought to the United States when he was 10 and grew up in Brooklyn; at Pratt Institute he studied painting with Arthur Wesley Dow (with whom O'KEEFFE studied at Columbia). Dow's emphasis on structure and design made a lasting impression on Weber. In Paris, Weber studied with MATISSE and absorbed the ideas of all the French MODERNISTS. Back in New York, he became a member of the STIEGLITZ Circle for a time. Somewhat intractable, when some of his pictures were rejected for the ARMORY SHOW, he withdrew them all. Weber experimented with CUBISM and FUTURISM—trapping the energy of movement and city life. This is exemplified in *New York at Night* (1915), which he speaks of in the quotation

above. In his maturity, beginning in the 1920s, Weber began to paint more personal and spiritual themes in a sensitive, representational mode. As the historian Cecil Roth wrote, "His elegiac reconstructions of a vanishing Jewish world, for instance, are humorous in spite of the anxiety and nostalgia they express. Weber's helpless and melancholy female nudes, with their heavily Semitic features, are no odalisques . . . like those of Picasso or Pascin, but fugitives from Lower East Side sweat-shops."

Weems, Carrie Mae
born 1953 • American • photographer • Modernist

Let me say that my primary concern in art, as in politics, is with the status and place of Afro-Americans in our country.

In her major suites of work, series of photographs dating from 1978, Weems tells stories about the life of African-Americans, her driving interest, as she says above. These are often highly personalized, and accompanied in exhibition by audiotapes that recount engaging stories about her family's migration from a Mississippi sharecropper's plantation to Portland, Oregon, where she was born. Her word-image presentations are moving and sensuously beautiful. For a series she did from 1991 to 1992, *Sea Islands Series,* she focused on the Gullah people of the Georgia–South Carolina sea islands. Searching old folklore and customs, she creates an evocative historical chronicle, illustrating it with images of swampy palm tree groves, or perhaps a front yard installed with hubcaps so situated as to ward off evil spirits.

Wegman, William
born 1943 • American • photographer • Postmodern

Language burns out with lies, especially to dogs.

Wegman named his Weimaraner puppy after the photographer MAN RAY and began taking photographs of his pet. His pictures were initially made with a Polaroid and then with a large-format camera. The dog was often costumed in tassels and feathers as *Polynesia,* 1981, or posed in amusing circumstances that mimic, for example, the humans in a PICASSO painting (e.g., Wegman's *Blue Period,* 1981). When Man Ray died in 1982, Wegman worked with a dog named Fay as his model, and then with her offspring. His book entitled *Puppies* was published in 1997. The parody and irony of his photographs, in addition to playing with words in the titles he gives them, adds a POSTMODERN turn to Wegman's work. He also has linked the dogs' bodies to form words, but as for using words of promise to make them perform, he has stopped doing that, as the quotation above explains. Unfailingly humorous and touching in his work, but not saccharine or cute, Wegman raises questions more about human than dog nature.

Weir, Julian Alden
1852–1919 • American • painter • Impressionist

I went across the river the other day to see an exhibition of the work of a new school which call themselves "Impressionists." I never in my life saw more horrible things. . . . They do not observe drawing nor form but give

you an impression of what they call nature. It was worse than the Chamber of Horrors. I was there about a quarter of an hour and left with a headache, but I told the man exactly what I thought. One franc entrée. I was mad for two or three days, not only having paid the money but for the demoralizing effect it must have on many.

The man protesting excessively in a letter home to his parents in New York, quoted from above, became one of the first and leading AMERICAN IMPRESSIONISTS. His initial disdain might be explained in part by the fact that he had studied at the conservative National Academy of Design in New York and then with GÉRÔME in Paris. *The Red Bridge* (1895) shows his switch to Impressionism midway in his career: a painted cast-iron bridge in lush green surroundings. This work demonstrates the momentary sensations of light that preoccupied painters like MONET. During the 1880s, Weir's farm in Connecticut was a gathering place for artists including RYDER and fellow American Impressionists HASSAM and TWACHTMAN, who joined him in painting the surrounding scenery. Weir was one of the founders of the Ten American Painters.

Wesselmann, Tom

born 1931 • American • painter • Pop Art/New Realist

. . . lots of things—bright strong colors, the qualities of materials,

images from art history or advertising—trade on each other. This kind of relationship helps establish a momentum throughout the picture— all the elements are in some way very intense.

Wesselmann first made COLLAGES of found materials, then added three-dimensional objects to the flat surfaces, e.g., a metal advertising sign attached to his canvas. However, his signature paintings are a series called the *Great American Nude*, of the 1960s. These paintings of women, as flat as if they were collages and set against boldly colored and patterned but also flat backgrounds, are anonymous and featureless—except for their lips, nipples, and pubic hair. In effect they erase the women's humanity by reducing them to a sexed commodity. *Great American Nude, No. 57* (1964), against a leopard-skin pattern and a brilliant blue wall, with jonquils and oranges on a table, is yet another variation on the theme of the reclining nude.

West, Benjamin

1738–1820 • American • painter • Neoclassicist/Grand Manner

The event to be commemorated took place on the thirteenth of September 1759, in a region of the world unknown to the Greeks and Romans, and at a period of time when no such nations, nor heroes in their costumes, any longer existed. . . . The same truth that guides the pen of the historian should be given the pencil of the artist.

West was born in Swathmore, Pennsylvania. He began painting portraits, and when he was about 20, he went to Rome to study. After four years he moved to England and became a member of the inner circle of the art establishment there. He received a commission from King George III that led to a long-term friendship between them. West was cofounder, with REYNOLDS, of the Royal Academy of Arts and succeeded Reynolds as its president. He was a magnet, too, for the American painters who flocked to London, prominent among them the PEALES (Charles and Rembrandt), STUART, EARL, TRUMBULL, ALLSTON, SULLY, and MORSE. Though he remained an expatriate, West was probably the most influential American artist, in Europe as well as America, until the mid-20th century. His great innovation and triumph was to revolutionize HISTORY PAINTING by presenting important recent events in the GRAND MANNER style and clothing their subjects in contemporary rather than ancient Greek or Roman costume. *The Death of General Wolfe* (1770) is a melodramatic portrayal of the heroic death of a British commander defeated by the French in the Battle of Quebec. There are allusions to PIETÀs of the RENAISSANCE and BAROQUE composition. When Reynolds tried to convince him to dress his characters in the usual CLASSICAL costumes, West replied with the words quoted above. In *Death on a Pale Horse, or the Opening of the First Five Seals* (1817), the subject is taken from the Book of Revelations, and the scene explodes with apocalyptic fury. The powerful ROMANTICISM of the picture is known by the term *terribilità:* a kind of imagery of the SUBLIME infused with mystical, visionary zeal.

Weston, Edward

1886–1958 • American • photographer • Modern

Only with effort can the camera be forced to lie: basically it is an honest medium: so the photographer is much more likely to approach nature in a spirit of inquiry, of communion, instead of with the saucy swagger of self-dubbed "artists." And contemporary vision, the new life, is based on honest approach to all problems, be they morals or art. False fronts to buildings, false standards in morals, subterfuges and mummery of all kinds, must, will be scrapped.

Fascinated by abstract forms and patterns in nature, Weston photographed landscapes in California, where he lived. His landscapes are, however, entirely unconventional; they concentrate so closely on detail—contrast of textures, light and dark, patterns and shapes—that one can hardly tell that *China Cove, Point Lobos* (1940), for example, is actually a place. One of Weston's best-known pictures is not a place but a vegetable: *Pepper No. 30* (1930) is a tightly focused close-up of a green pepper that looks like nothing so much as a male torso flexing its muscles—or a Weston landscape. Despite his frequent dismissal of the artistry of photography, as expressed in the quotation above, "his demands on photography still contained all the romantic assumptions about the photog-

rapher," as the critic Susan Sontag writes.

Weyden, Rogier van der
c. 1399–1464 • Netherlandish • painter • Northern Renaissance

He improved our art of painting greatly, through his works, by depicting the inner desires and emotions of his subjects whether sorrow, anger, or gladness were exhibited. (Carel van Mander, c. 1604)

The youngest of the Early NETHERLAN-DISH triad, van der Weyden studied with CAMPIN and paid homage to van EYCK. However, his *Deposition* (an AL-TARPIECE also known as the *Escorial Deposition* or *Descent from the Cross*; c. 1435–42), one of the most renowned 15th-century paintings either north or south of the Alps, was unprecedented by his mentors or by any other artist. The scene, with 10 near-life-size figures, is set inside a gold box. It is painted with such skill and contrivance as to look as if the figures were actually sculpted. As the gold paint background echoes the GOTHIC style, so does the S-shape of the figures of Christ and the Virgin—however, van der Weyden's "S" is horizontal—the body of Christ shown as he is taken down from the Cross. Mary, fainting with grief, falls parallel to Christ, the curves of her body mimicking his. There is this kind of doubling throughout the picture: in Christ and Mary's hands, and in the postures of mourners. The emotional content of van der Weyden's paintings is unprecedented, as is the sense of their tangible presence. One explanation may be found in the contemporary taste for private devotion and, more specifi-cally, in the popular doctrine of the compassion and joint suffering of Mary and her son. Van der Weyden settled in Brussels as the official city painter, and also received commissions from private patrons, members both of the Burgun-dian court (see VALOIS) and of the new merchant class. Thus, he straddled, and sometimes shared, the clientele of van Eyck and Campin. For the same Nicolas Rolin whom van Eyck portrayed in *Virgin and Child with Nicolas Rolin* (c. 1435), van der Weyden painted a very large multipaneled altarpiece, meant to rival van Eyck's *Ghent Altarpiece*. The central panel of the *Beaune Last Judgment* (1443–51) is a wrenching parade of sinners, tormented not by demons but—worse still—by their own guilty angst. Van der Weyden also painted portraits of rare subtlety. His faces are ethereal, dignified, contemplative. Whereas van Eyck's faces are less at-tractive than seemingly truthful, van der Weyden smoothed his subjects' blemishes . . . or had better-looking clients. An example is *Portrait of Francesco d'Este* (c. 1460), whose sub-ject is fashionable in dress and refined in feature, gesture, and his somewhat distant expression. Van der Weyden visited Italy in 1450 and made connec-tions with the ESTE court in Ferrara and that of the MEDICIS in Florence.

Whistler, James Abbott McNeill
1834–1903 • American • painter • Aestheticist

Why should not I call my works "symphonies," "arrangements," "harmonies," and "nocturnes"? I

know that many good people think my nomenclature funny and myself "eccentric." Yes, "eccentric" is the adjective they find for me.

Part of Whistler's AESTHETICISM was the conviction that "as music is the poetry of sound, so is painting the poetry of sight." One of his works is named *Nocturne in Black and Gold: The Falling Rocket* (c. 1874) and represents a fireworks display in London over the River Thames. It is similar in approach to TURNER's explorations of light, color, and air. RUSKIN, who was Turner's champion, disparaged Whistler's effort, saying he had "flung a pot of paint in the public's face." Whistler took Ruskin to court for libel and won the case. Regarding his most famous work, popularly known as "Whistler's Mother" (1871), Whistler said, "Take the picture of my mother, exhibited as an *Arrangement in Grey and Black.* Now that is what it is. To me it is interesting as a picture of my mother; but what can or ought the public to care about the identity of the portrait?" Whistler was increasingly interested in arranging and combining tones of paint in patterns on the canvas rather than in creating resemblances to people or places. Born in America, Whistler spent his life abroad. In London he was a friend of ROSSETTI and the PRE-RAPHAELITE BROTHERHOOD.

White, John
active 1575–1593 • English • illustrator • Mannerist

They have groves of trees where they hunt deer, and fields where they sow their corn. In the cornfields they set up a little hut on a scaffold, where a watchman is stationed. He makes a continual noise to keep off birds and beasts. (Thomas Hariot, 1585)

Like LE MOYNE DE MORGUES, whom he knew, White went to the New World to explore and record the sights. He was one of the first artists to show the coast of North America: *Chart of the East Coast from Florida to Chesapeake Bay* (1585) pictures an expanse of water full of huge, spouting whales and relatively small ships, edged by an unprepossessing shoreline. White's pictures portray the layout, the structures, and the life of Native American villages (e.g., *Indian Village of Secoton,* c. 1585) or carefully describe a subject—an example is *A Flamingo* (1585). These illustrations were accompanied by the commentaries of Thomas Hariot, one of which is quoted from above. White's first trip had been a colonizing expedition of about 100 men sent by Sir Walter Raleigh in 1585 to Roanoke Island, off the coast of what is North Carolina today. One of White's WATERCOLORS is of a weed called uppowoc, which, as Hariot commented, "the Spanish call *tobacco.* Its leaves are dried, made into powder, and then smoked by being sucked through clay pipes. . . . The fumes purge superfluous phlegm and gross humors from the body." In 1586 White went back to London aboard a ship commanded by Sir Francis Drake, but the following year he returned to govern Roanoke Colony. However, the colony was abandoned and whatever became of the "Lost Colony" is conjecture. (Some Indians of southeastern

North Carolina believe that the blood of the colonists runs in their veins.)

Whitney, Anne
See HOSMER

Whitney Biennial

The Whitney Museum of American Art in New York City was founded by Gertrude Vanderbilt Whitney in 1930 and opened in 1931. In 1932 she held the first invitational exhibition, and it was an annual event until 1973, when it became biennial. Because artists represented are there by invitation of the curator(s), rather than selected by a jury, the Whitney has frequently been attacked as narrowly reflecting a particular individual's taste, or, the contrary, as having too mixed a menu with too little focus. Although there are many artists whose work has been seen year after year (Paul Cadmus, born 1904, was in 37 invitationals, the last in 1965), each biennial shows some of the most avant-garde art. The 1997 Whitney Biennial made clear that there is wide diversity, an "everything-is-possible" climate in contemporary art. *Bubble Gum Station,* by Charles Long and Stereolab, was a large mound of a substance that looked like bubble gum. Visitors were meant to create something themselves with modeling tools left for that purpose—and for the purpose of suggesting that art is what its audience makes of it, taking RECEPTION THEORY to its logical conclusion. Nineteen ninety-seven was BOURGEOIS's 19th appearance in the Whitney show, and her INSTALLATION was made up of her clothes hung on a rack. In an interview Bourgeois explained, "The piece refers to a period when my mother and father argued about who would put the best clothes on me." One criticism of the exhibit (and of contemporary art generally) is that the works are made for museum exhibition rather than private pleasure. The critic Arthur Danto answers that the same was true during the RENAISSANCE, when works of art were commissioned by power brokers, churchmen, and military leaders to achieve their desired results, whether spiritual, reverential, or deferential.

Whittredge, Worthington
1820–1910 • American • painter • Romantic/Hudson River School

It was impossible for me to shut out from my eyes the works of the great landscape painters I had so recently seen in Europe, while I knew well enough that if I was to succeed I must produce something new and which might claim to be inspired by my home surroundings. I was in despair . . .

A number of American artists met and worked together in Europe. Whittredge, who enrolled in the Düsseldorf Academy, met Eastman JOHNSON, BIERSTADT, and GIFFORD in Germany. Emphasis on detail was stressed as part of DÜSSELDORF training, but that was not necessarily new to American artists, as the historian Barbara Novack points out. Rather, it was compatible with American tradition. Whittredge went on to Rome before he came home to find himself facing the dilemma described in the passage quoted above. He went to the woods and immersed himself in the American landscape: "The forest was a mass of decaying logs and tangled brush wood, no peasants to pick up every vestige of fallen sticks to

burn in their miserable huts, no well-ordered forests, nothing but the primitive woods with their solemn silence reigning everywhere." That was the difference between America and Europe, and acknowledging his debt to DU-RAND, whose landscapes he considered "truly American," that is what Whittridge painted. *The Trout Pool* (c. 1868) is a thickly wooded scene with sunlight filtering through dense, feathery foliage onto a pool of water, serene both in its spiritual TRANSCENDENTALISM and in its celebration of a peaceful moment in the American wilderness.

Wilde, Johannes
1891–1970 • Hungarian/Austrian/British • art historian

As in her politics, Venice on the whole was cautiously progressive in her art. This does not apply to Giovanni Bellini. Indeed, his earliest works known to us must have appeared to his contemporaries as something revolutionary. . . .

Born in Hungary, Wilde was a Communist in his youth. He moved to Austria and became a citizen in 1928. Following Austria's annexation by Germany in 1938, he moved to England, where he was interned by the British government during World War II, but he became a citizen of that country in 1947. Later, at the Courtauld Institute in London, Wilde taught students the skills of interpreting works of art based on visual sources and on written documentation derived from all available sources. He pioneered in using X-RAY technology in the study of art. Wilde was an influence on CLARK and BLUNT. Two collections

of his lectures were published posthumously; the quotation above is excerpted from *Venetian Art from Bellini to Titian* (1974).

Wiligelmo/Wiligelmus
active early 12th century • Italian/German? • sculptor • Romanesque

Among Sculptors your work shines forth, Wiligelmo.

The inscription quoted above is from the Cathedral of Moderna, in Italy, where Wiligelmo is believed to have worked during the first decade of the 12th century. He carved a stone frieze of scenes from Genesis in a style that is intense, compressed, and intricately balanced. His model seems to have been the sculpture of pagan and early Christian sarcophagi and perhaps OTTONIAN ivories. Some portions of the narrative have squarish, front-facing figures like those on the Arch of Constantine (312–315 CE), but others are more animated and expressive.

Wilkie, Sir David
1785–1841 • Scottish • painter • Romantic

How useful, too, it would be [for French artists] to see Wilky's [sic] touching expressions. In a little picture, whose subject is of the simplest, he knows how to turn them to admirable advantage. (Théodore Géricault, 1821)

Wilkie impressed GÉRICAULT while he was in England exhibiting *The Raft of the Medusa* (1819), and Géricault praised Wilkie in the letter home, quoted from above. Géricault found paintings like Wilkie's *Chelsea Pension-*

ers Reading the Gazette of the Battle of Waterloo (1818–22) strong enough to challenge "the silly pride" of self-satisfied French painters who refused to recognize quality outside their own country. *Chelsea Pensioners* was commissioned by the Duke of Wellington himself, and what the picture shows is great levity in the street as the account of Wellington's victory at Waterloo is being read aloud from the newspaper. When the painting was shown at the Royal Academy in 1822, it was so popular that a protective railing had to be installed. And it was very different from the heroic, studied idealism of French art. Wilkie's observation of ordinary people reacting to important news was rooted in 17th-century Dutch GENRE paintings, and in turn Wilkie's pictures worked their way (via PRINTS) into American art of the 19th century. MOUNT, for example, was called "the American Wilkie." Besides its artistic merits, Wilkie's *Chelsea Pensioners* also presents an example of how information regarding contemporary events was disseminated, the importance of the newspaper, and the question of literacy among working classes.

Winckelmann, Johann Joachim
1717–1768 • German • art historian

The history of ancient art which I have undertaken to write is not a mere chronology of epochs, and of the changes which occurred within them. I use the term history in the more extended signification which it has in the Greek language; and it is my intention to attempt a system.

Winckelmann was born in Prussia. His interest in GREEK ART and the CLASSICAL world inspired him to move to Rome and even to convert to Catholicism. Under the patronage of Cardinal AL-BANI, Winckelmann was appointed Superintendent of Antiquities in Rome during the 1760s, and he supervised excavations then beginning in POMPEII and HERCULANEUM. He wrote *The History of Ancient Art,* published 1764, the first authoritative use of the two words—"history" and "art"—in combination. The quotation above is from the preface in which Winckelmann also dedicated the book to his friend MENGS. Though he never went to Greece, Winckelmann became passionately and spiritually devoted to ancient Greek art, effectively shifting the focus away from Rome though unaware that he was generally looking at ROMAN copies of Greek sculpture. He most admired the restrained High Classical period. He wrote, in what has left a famous phrase to art history, "The most prominent general characteristic of the Greek masterpieces is a *noble simplicity and silent grandeur* in pose as well as in expression" [italics added]. Yet Winckelmann was also effusive about the extremely emotional HELLENISTIC sculpture called LAOCOÖN, an apparent dichotomy he resolved with these words: "As the depth of the ocean remains quiet at all times, even though the surface may rage as much as possible, thus the expression of the figures of the Greeks shows a great and composed soul despite all passions. This soul describes itself in the features of the Laocoön—and not only in his features—despite the most violent suffering." Winckelmann himself suffered and died by violence, killed for some gold coins by a man he befriended in Trieste. His murderer, Francesco

Arcangeli, was sentenced to be "broken alive on the wheel, from the head to the feet, until your soul depart from your body." Winckelmann's importance to art scholarship was formidable, prompting dissent (e.g., LESSING) as well as launching, with Mengs, the NEO-CLASSICISM of the 18th–19th century. Equally significant, he prepared, for the first time, an inclusive chronology of ancient art, with stylistic analysis, embracing Egyptian and ETRUSCAN as well as Greek and Roman examples.

Winged Victory
See NIKE OF SAMOTHRACE

Witte, Emanuel de
c. 1617–1691/92 • Dutch • painter • Baroque

. . . in the painting of churches, no one was his equal with regard to orderly architecture, innovative use of light, and well formed figures. (Arnold Houbraken, c. 1718)

De Witte drew on the traditions established by SAENREDAM and others in painting church interiors, and was recognized, as in the comment above, as one of the best painters of his day. After he settled in Amsterdam, in about 1652, he developed his individual style and experimented with PERSPECTIVE in rendering architectural portraits. Looking for new means of representing space, de Witte was responding to contemporary developments in the science of optics and optical devices. Like Saenredam's, the interiors de Witte painted, while inspired by buildings in Amsterdam, were usually not accurate representations of them. Rather, his architectural interiors were adjusted to

suit his interest, and sometimes entirely invented. But even when imaginary, they are persuasive. For unknown reasons de Witte repeatedly included certain types of figures: a gravedigger, a nursing mother, a man in a cape with his back to the viewer. A mood and a feeling of space in his interiors are created by the interplay of shadow and light on architectural forms; this also indicates different times of day—unlike Saenredam's brightly lit churches, in which it always seems to be high noon. De Witte's life was a tormented one. In about 1660 he agreed to exchange everything he painted for room and board and a small stipend, an arrangement that ended up in court. He was always in debt and is thought to have committed suicide.

Wittkower, Rudolf
1901–1971 • German/British/American • art historian

In all fairness, I feel the reader should be warned of what he will not find in this book. Such a first sentence may be psychologically unwise, but it is morally sound.

Thus begins Wittkower's foreword to his survey *Art and Architecture in Italy: 1600–1750* (1958). It is followed by a list of the kinds of material omitted: for example, the struggles sparked by WINCKELMANN between supporters of GREEK and ROMAN ART, and the role of theater, garden, and town design. "My aim is narrower, but perhaps even more ambitious," writes Wittkower. "Instead of saying little about many things, I attempted to say something about a few." Those few are painting, sculp-

ture, and architecture. Wittkower left Germany during the Nazi regime. He went first to London (he became a British citizen in 1934), then in 1956 to New York, where he headed the Department of Fine Arts and Archaeology at Columbia University. His books and articles were mainly about Italian art and architecture in the period of the BAROQUE.

Witz, Konrad
c. 1400/10–1445/46 • German • painter • Northern Renaissance

. . . Conrad Witz was the first to observe . . . the optical law according to which objects immersed in water are visible only as long as the angle of incidence does not exceed the critical limit (ca. 45.5 degrees) beyond which total reflection takes the place of partial refraction. (Erwin Panofsky, 1953)

Witz moved to Basel, a center of religious activity during the early 1430s, and established a WORKSHOP that became well recognized in the city. Little is known about him, and he died after only about a dozen years in Basel. But during that period he produced a body of work that reveals a very original and interesting style. His figures are short and stocky, more bourgeois than noble by far, and they are formed with strong contrasts of dark and light; their physical presence supersedes decorative elements; the interiors are quite stark and have a forward-tilting, disorienting sense of space. This is evident in the *Heilspiegel Altarpiece* (c. 1435–38). On an outside panel of the ALTARPIECE is Synagogia, conventionally a female fig-ure whose eyes are bound but in this case are closed, and who holds tablets with odd script meant to be Hebrew. Paired with Synagogia is a panel with "Ecclesia," symbol of the Church, whose eyes are shown open in the belief that the truth is now unveiled. The interior panels have a more complex program of TYPOLOGY, that is, characters from the Hebrew Scriptures seen as prefiguring those in the New Testament. *The Miraculous Draught of Fishes* (1444) is an unusual work in other ways than those described above. Here Witz presents what is believed to be the first topographical landscape in Northern painting, as well as the astute observation of refraction PANOFSKY alludes to in the quotation above. But while the original story unfolds at the Sea of Galilee, Witz has painted an accurate and highly sophisticated setting of Lake Geneva. Moreover, the cardinal who commissioned the painting had a political message to impart: Just as Peter (the first pope), who floundering in the lake needs help from Christ, so would the pope, it is implied, do well to seek advice from the College of Cardinals.

Wojnarowicz, David
1954–1992 • American • painter/graphic artist • Neo-Expressionist

The person I was just one year ago no longer exists; drifts spinning slowly into the other somewhere way back there. I'm a Xerox of my former self. I can't abstract my own dying any longer.

Wojnarowicz died of AIDS at the age of 38. He had documented his brutal

childhood experiences as a prostitute in New York City, beginning at age nine. The film *Postcards from America* (1994) was drawn from his autobiographical writings, which include a graphic novel that was illustrated by another artist, James Romberger. Wojnarowicz's art, as were his life and his actions, was all angrily seditious. *The Death of American Spirituality* (1987) is a 6-foot 8-inch by 3-foot 8-inch canvas divided into four parts with thick black lines that may be construed as a cross. In each panel is a different, grotesque scene in the colors of fire and blood. A bull ridden by a cowboy is made from newspaper, and out of a circular black void a shark swims toward the cowboy's genitals. A kachina doll, a dark, skull-like face with a snake in its teeth, and a head with no eyes but wearing a crown of thorns are among the other images in this horrific invention. The historian Jonathan Fineberg, who categorizes Wojnarowicz as an American Neo-Expressionist, writes that "[he] developed a confrontational style of working that pushed his art out of the comfort zone. His work concerns the real immediacy of bodily experience and identity filled with unacknowledged violence." That violence spins away in the quotation above, written in the year of his death.

Wölfflin, Heinrich
1864–1945 • Swiss • art historian

Not everything is possible in every period.

Wölfflin brought the "magic lantern," an early version of the slide projector, into the classroom. This enabled him not only to show images during his lectures but also to introduce the methodology of comparisons in the study of art, now standard technique. He wished to make the study of art's history a science by discovering principles (rather like theorems) that could be demonstrated and perhaps even proved. He believed that style in art follows an evolutionary path, as in the comment quoted above. In *Principles of Art History: The Problem of the Development of Style in Later Art* (1915 in German, 1932 in English), Wölfflin discloses five oppositional principles through which he distinguishes between art of the RENAISSANCE and that of the BAROQUE. These are respectively: (1) LINEAR VS. PAINTERLY; (2) plane vs. recession (see PICTURE PLANE); (3) CLOSED FORM (e.g., self-contained) vs. open form; (4) multiplicity (e.g., several independent figures in a composition) vs. unity; (5) absolute vs. relative clarity. His position is that the later period of Baroque art, which he characterizes as "visual," was more advanced, reflecting a higher level of achievement than that of the "tactile" Renaissance. Wölfflin also believed that a zeitgeist, or spirit of the time, in combination with a nationalist identity, served to determine the worldview shared by individuals and groups alike. In many ways he follows in the line of HEGEL. His statement that "It is true, we only see what we look for, but we only look for what we can see" is provocative, especially in regard to his own work. For while he clearly demonstrated stylistic differences between periods based on "what is possible," what he did not look for were the historic or psychological reasons behind such dif-

ferences, or what may have precipitated the cyclical styles he described.

Wood, Grant

1892–1942 • American • painter • Regionalist

Each section [of America] has a personality of its own, in physiography, industry, psychology. Thinking painters and writers who have passed their formative years in these regions will, by care-taking analysis, work out and interpret in their productions these varying personalities.

After studying at the Art Institute of Chicago and making several trips to Europe, Wood returned home to Iowa to paint in, and about the Midwest. There are undercurrents of humor in his signature images of patchwork-quilt rolling hills and forward-facing, sturdy, grim, salt-of-the-earth types. The couple in *American Gothic* (1930), standing, Wood said, like "tintypes from my old family album," are generally assumed to be husband and wife, but are really meant to represent father and daughter—although the models were, in fact, Wood's sister and his dentist. The "Gothic" of the title refers to a pointed-arch window in the house in the background, a standard GOTHIC detail, but the house's vertical, "board-and-batten" siding technique is an entirely American development. Along with BENTON and CURRY, Wood was a RE-GIONALIST whose Americanism was touted; yet it should also be acknowledged that two of his important influences and sources were the Chinese-inspired blue willow-ware dishes of his childhood and 15th-century Flemish paintings of figures with oval heads, stern faces, and meticulous rendering of detail.

woodblock/woodcut

A method of PRINTING in which an image is carved on the surface of a block of wood. The portion to be printed is left in RELIEF, that is, raised above the background of wood that has been carved away. The raised surface is inked and impressed on the material to be printed, much as impressions are made by rubber stamps. A woodcut is made by cutting the image with the grain running parallel to the surface, employing tools that range from a knife blade to special veiners and gouges. Originally used for patterning textiles, woodcut printing on paper was developed during the first decades of the 15th century. Some of the first woodcut prints (also called woodcuts) were sold as souvenirs along pilgrimage routes (see CULT OF SAINTS). Soon woodcuts were being pasted into Bibles, and toward the end of the 15th century they were used for pictorial instruction manuals, such as the *Ars Moriendi (Art of Dying Well),* to help clergy comfort the moribund. In contrast to a woodcut, a wood engraving is made on a surface that is at a right angle to the grain of the wood; that is, it is cut across the grain, using a variety of gravers and burins. Prints from wood engravings were rare in the West until the 18th century. However, Japanese artists perfected the technique for full-color wood-block printing during the 17th century. Their method was to use several blocks, one for each color that was needed. On a blue block, for example, only those elements in the image that should be blue (or a color

that uses some combination of blue) would be carved. The impressions made by these blocks had to be aligned very carefully, a process called registration. Japanese wood-block prints became popular in Europe during the 19th century (see UKIYO-E).

Woodville, Richard Caton
See MOUNT

Works Progress Administration/Federal Art Project
In the midst of the Great Depression, President Franklin Delano Roosevelt authorized the Public Works of Art Project in 1934, commissioning MURALS such as those painted in Mexico by artists like RIVERA. The Works Progress Administration (WPA) began the Federal Art Project, under Holger Cahill, in 1935, broadening the nature of artists' projects beyond murals to easel painting and sculpture. Later, the Farm Security Administration joined in the support of artists by commissioning photographers. The scope of these government-sponsored projects was vast, and gave unemployed artists stipends as well as an important sense of the relevance of their work. About 6,000 artists were employed. Most American artists in what would later become the New York school of ABSTRACT EXPRESSIONISM worked in these programs.

workshop
The place where skilled artisans teach apprentices, who, presumably, will eventually be competent to work on their own. We will probably never know whether the recently discovered Chauvet caves in France, with their spectacular wall drawings more than 30,000 years old, were the first artists' workshops. As city-states developed in Mesopotamia around 3000 BCE, GUILDS with foremen were organized, and their workshops were part of TEMPLE compounds. The famous head of the Egyptian queen NEFERTITI (c. 1355–1335 BCE) was found on the floor in the house of a sculptor who used it as a studio model. Clearly, artists' workshops predate the MEDIEVAL period, when crafts guilds ran them (see MASTERPIECE). In Medieval workshops, 10-year-old boys were apprenticed to a master, and both worked and slept together in the loft of the master's studio—one reason why females were not usually admitted to such organizations, although a widow could become a guild member when she carried on her husband's workshop business. Artists in workshops made their own materials— they belonged to the druggists' guild— and they kept their formulas and methods secret, from the preparation of a wooden PANEL to be painted as an ALTARPIECE to the fineness to which PIGMENT was ground. Decoratively patterned gilt HALOS in paintings were tooled with punches; these were made for a workshop and became as distinctive of that workshop's identity as a signature. During and after the RENAISSANCE (ITALIAN and NORTHERN), artists strove to distinguish themselves as intellectuals rather than craftspeople, and luminaries like RAPHAEL ran their own large workshops. The artist's workshop (*atelier* in French, *bottega* in Italian) sometimes causes problems for the art historian who tries to decide whether a work is by the "hand" of the master or by an anonymous or less esteemed stu-

dent (see SCHOOL and MASTER OF . . .). Occasionally the work of a student whose fame ultimately surpasses that of the teacher is detected, as was the case when one of the two angels in VERROCCHIO's *The Baptism of Christ* (c. 1475–85) was identified as the work of a young LEONARDO da Vinci.

World of Art (*Mir Iskusstva*)

A group of Russian SYMBOLISTS in Saint Petersburg, who gathered around the ballet impresario Serge Diaghilev (1872–1929); the painter BENOIS, who documented the movement in his two-volume memoirs; and the designer BAKST. Their first exhibition, organized by Diaghilev, was in 1897, and the first issue of their magazine, *Mir Iskusstva*, came out in October 1898 (and continued to be published through 1904). The history and folklore of Russia were particularly important to these artists and they made an international reputation as stage designers, especially for the Ballets Russes.

Wren, Sir Christopher

1632–1723 • English • architect • Baroque

Si monumentum requiris, circumspice. [If you would see his monument, look around]. (Inscription in Saint Paul's Cathedral)

Wren was a brilliant young scientist and a professor of astronomy. Sir Isaac Newton thought him one of the best geometricians of the time. Wren even illustrated a medical text on the brain with more elegance and accuracy than had ever been achieved before. In his 30s he began to study architecture, mainly in Paris, where he saw the work of MANSART and Louis Le Vau (1612–70). After the Great Fire of London in 1666, the new skyline of the city showed the influence of Wren, whose majestically domed masterpiece is Saint Paul's Cathedral (1675–1710), a blend of CLASSICAL (e.g., its DOME and paired Corinthian COLUMNS) and BAROQUE style (e.g., the irregular, undulating form of the two towers). Besides rebuilding Saint Paul's, which was intended to rival Saint Peter's in Rome in both style and grandeur, Wren was responsible for 51 other churches in the city, where the ROMAN architectural elements found at Saint Paul's are replaced by original solutions and interiors that are spacious, light, and unified. Wren was also knighted, and was a member of Parliament. Before he died at 91, he wrote that he had "worn out (by God's Mercy) a long life in the Royal Service and having made some figure in the world." He was buried in Saint Paul's where the inscription, quoted above, serves as his epitaph.

Wright, Frank Lloyd

1867–1959 • American • architect • Modern

The principles that build the tree will build the man. That's why I think Nature should be spelled with a capital "N" not because Nature is God but because all that we can learn of God we will learn from the body of God, which we call Nature.

Wright grew up on a farm near Spring Green, Wisconsin, where he eventually built his own home/studio/school. He never finished high school or the University of Wisconsin, but began his professional training in the Madison,

Wisconsin, office of a professor of engineering. In 1887, Wright went to Chicago. In the aftermath of the great fire of 1871 and the feverish rebuilding of the city, Chicago had become the architectural "capital" of the United States. Wright worked as a draftsman under SULLIVAN, the man who gave form to MODERN architecture in America. He left Sullivan's office in 1893 over a disagreement, but the two were reconciled 20 years later, and Wright remained Sullivan's disciple, referring to him as "the Master." Sullivan championed Wright too: About Wright's design for the Imperial Hotel (1916–22) in Tokyo, he wrote that it was a heroic act, "an utterance of man's free spirit, a personal message to every soul that falters, and to every heart that hopes." Wright's reputation grew more rapidly in Europe, especially in Holland and Germany, than in the United States during the early years of the 20th century. He was embraced by the Dutch architect BERLAGE, who particularly admired Wright's fluid treatment of interior space. The Robie House of 1907–09, in the low-to-the-ground Prairie Style that Wright invented, exemplifies his credo that it is space, not mass, that counts. Wright applied his spatial innovations to both private homes and public buildings, and to both large and small commissions. The 1904 Larkin Building in Buffalo, New York, which presented a severe, industrial facade to the outside world, was designed for the workers inside; the interior was restful and harmonious, in Wright's words, with "clean, pure, properly tempered air for them to breathe whatever the season or weather." Illumination from the skylight above the atrium was ample, and the parapets had troughs for plants with trailing vines, bringing the natural world into the office setting. In the rolling hills of his family's farmland in Wisconsin, Wright's design for his own home harmonized with the natural site. Taliesin I (1911) is constructed of native stone and wraps around the top of a hill. Even the complex roofs seem an organic part of the landscape. In 1914, Taliesin was destroyed by fire. Rebuilt, 11 years later Taliesin I was again consumed by fire, and again rebuilt. Wright began to build a second Taliesin in 1938, this time near Phoenix, Arizona, which he called Taliesin West. As with his Wisconsin home, his desert Taliesin integrates and interacts with its environment. The importance of the landscape is expressed in Wright's comment quoted above. In New York City, Wright's controversial design for the Solomon R. Guggenheim Museum (1943–59) spirals on upper Fifth Avenue like a geometric conch shell. In Bear Run, Pennsylvania, the Kaufmann house (Fallingwater, 1936–39) is dramatically cantilevered over a waterfall. The social and architectural critic Lewis Mumford once wrote, "One could not be in the presence of Wright for even half an hour without feeling the inner confidence bred by his genius."

Wright, Patience Lovell

1725–1786 • American • sculptor • Colonial

She untaught, made portraits in wax by a most extraordinary manner, holding the wax under her apron she modeled it into the features of the Person sitting before her! This account we had from Mr. West, with whom she

was very intimate. (Charles Willson Peale, 18th century)

The first American woman sculptor was a renegade who ran away from home when she was 20 years old. Her father was a strict Quaker farmer who made his eight daughters wear wooden shoes and white dresses, stockings, and hats as sign of their purity. To compensate for the lack of color in their clothing, they loved to paint pictures in rich colors they made themselves from the minerals in the earth. Patience developed another skill: She modeled portraits in wax. When they were both widowed, she and one of her sisters went to New York and developed a waxworks show that they took on tour. Patience later moved to London, and even gained entrée into the royal household to make a portrait of the king. She was brash and outspoken about many things, especially the sins of royalty, and she became as notorious for her method of shaping the wax, which PEALE describes in the quotation above, as for the resemblance of her portraits to their models. Visitors to her home discovered that some of her other guests, like the old clergyman reading a paper in the middle of a room, were made of wax. Unfortunately, few of her works survive.

Wright of Derby, Joseph
1734–1797 • English • painter • Romantic

'Tis the most wonderful sight in Nature.

The connection between science and art has taken many forms, but before Joseph Wright of Derby they were usually implicit rather than explicit. For example, paintings that incorporated new discoveries, like PERSPECTIVE in the 15th century, did not show the discovery being demonstrated. Similarly, artists during the 17th century took advantage of the CAMERA OBSCURA, but did not paint the camera obscura itself. During the Age of ENLIGHTENMENT, however, Joseph Wright took an unusual step: He painted scientific experimentation as a dramatic subject in its own right. Wright painted the demonstrators, lecturers, and popularizers of exciting new knowledge in the heroic vein of HISTORY PAINTING. *A Philosopher Giving a Lecture at the Orrery (in which a lamp is put in place of the sun)* (c. 1763–65) is an example. An orrery—named after Charles Boyle, fourth Earl of Orrery, for whom one was made—is a mechanical model of the solar system. In Wright's picture, the lamp standing in for the sun illuminates the people in the audience observing the model as mysteriously as if it were the holy light of God. The analogy is not accidental in a period when human inventions and discoveries were beginning to refashion the world from an agricultural- to an industrial-based economy and science seemed to displace religion. It was a time during which, as the philosopher Richard Rorty writes, "the idea that truth was made rather than found began to take hold of the imagination of Europe." Josiah Wedgwood, whose company pioneered in mass producing POTTERY, and Sir Richard Arkwright, who revolutionized the textile industry, were patrons for works like those of Wright. There is an underlying emotional fervor and a sense of the heroic in Wright's

paintings that ally him with the ROMAN-TIC movement, and in general he is known for images with extraordinary lighting effects: Besides the *Lecture at the Orrery,* he painted forges and smithies, fireworks, and (the ultimate fireworks) the eruption of Mount Vesuvius, which he saw during a trip to Italy that lasted from 1773 to 1775. It was about that eruption that his comment, quoted above, was made. While pictures like these are of great interest to us today, he earned his livelihood by painting portraits.

Wyeth, Andrew
born 1917 • American • painter • Realist

Art to me is seeing. I think you have got to use your eyes as well as your emotion, and one without the other just doesn't work. That's my art.

Wyeth's father, N. C. Wyeth (Newell Convers; 1882–1945), was a top-ranked illustrator who studied with Howard Pyle (1853–1911). Pyle is known as the father of American illustration and was the founder of the Brandywine School of illustration in rural Pennsylvania, the same area where Andrew Wyeth has lived and painted for most of his life. (During the summer he lives and works in Maine.) Wyeth's subjects are local people and scenes, which he records with careful attention to detail. Egg TEMPERA, a difficult medium, is his paint of choice. Wyeth's best-known painting is *Christina's World* (1948). The young woman in the foreground of the picture, crippled by polio, is dragging herself up the hill to the house on the horizon. With its broad empty area of sere grass, meticulous painting, unusual composition, and uncertainty of meaning, this painting has kept its grip on the American consciousness for more than half a century.

X–Z

XP
See CHI RHO

X-radiography/X-ray
This photographic method has been used since the late 1920s to look beneath the surfaces of paintings. Materials that absorb X-rays become visible, including lead-based paint used for "undermodeling," an early stage of a picture. Among the most renowned X-radiography is that done on GIORGIONE's mysterious painting the *Tempest* (c. 1509?). First it revealed that a female figure had been painted, then covered over with the soldier standing at the left; later X-rays showed that her legs were cut off at the knees, suggesting that the canvas of an abandoned project had been trimmed down.

Zeuxis
c. 450–390 BCE • Greek • painter • High Classical

Criticism comes easier than craftsmanship. (Pliny the Elder, 1st century, quoting Zeuxis)

The paintings of Zeuxis are known only by his, and by their, reputation. It was said that to choose a model for his *Helen of Troy*, Zeuxis held a parade of local girls stripped of their clothes. As no individual approached his ideal, he combined the best features of five among them. That was the most famous painting of an artist who was renowned for showing emotion. Zeuxis followed on the heels of APOLLODOROS and, as PLINY the Elder maintained, went one better than his predecessor, to whose method of MODELING he added the touch of highlighting, that is, of showing shaded areas with the impression of reflected light. His drawing skills and the subtlety of his lines brought acclaim; Pliny praised him, saying that he could "reveal what was concealed." Commissioned to decorate the king's palace at Pella, Zeuxis was paid royally, elevating his profession above that of craftsman. Then he gave away his paintings, saying that they could not be sold at a price that matched their value. No Greek easel paintings and almost no Greek wall paintings survive, yet literary references and colorful anecdotes, like accounts of the competition between Zeuxis and his rival PARRHASIUS, infuse their vanished works with life.

Zorach, Marguerite Thompson
1887–1968 • painter • American • Fauve

When the artist meets the public, there are a few vital and perennial questions—I will answer them before they are asked. How long have you been painting? Since the age of three

when I produced a goose that everyone knew was a goose.

Zorach had received the standard ACA-DEMIC training at home in Fresno, California, before she went to Europe in the fall of 1908. During her first day in Paris she went to the SALON D'AUTOMNE and saw an exhibition of FAUVE art that had an immediate impact on her own work. This is apparent in *Man Among the Redwoods* (1912), which she painted the year she returned home and for which she used pure color with a Fauvist freedom from the constraints of reality. Zorach exhibited in the AR-MORY SHOW of 1913 and helped to introduce Fauvism to the United States. She was the only woman whose work was shown in the Forum Exhibition of Modern American Painters in 1916, and the only artist excluded from the catalogue, which contained essays on and reproductions of the work of the 16 other artists in the show. Her husband, William (see below), was also in the exhibition, and the historian Gail Levin speculates, "More than likely [he] had insisted on the inclusion of his wife, for although they worked separately, they appear almost as one—'Wm. and Marguerite Zorach'—in the catalogue's list of artists." Marguerite Zorach made the comment quoted above in 1962 as part of an "artist's statement" for an exhibit of her work. She also said, "There have been periods when I was discovered with much publicity and newspaper articles, and periods when I have been forgotten. . . . I am not interested in style, or a certain way of painting, or a certain range of color or form. I am interested in expression through art."

Zorach, William

1887–1966 • American • sculptor • Abstract

Art Is My Life

Quoted above is the title of Zorach's autobiography, which was published after he died. It begins: "I remember the little village of Euberick in Lithuania where I was born. I remember our house, a low house with a slanting roof built into a bank in a river valley. It was made of logs and bricks and had a long dark hall where big black bears lay in wait for a little boy." He immigrated to the United States when he was four years old, and the family settled near Cleveland, Ohio. After a time spent studying art in Paris, where he met his future wife (see Marguerite above), they relocated to the United States. The couple spent the summer of 1916 at the experimental Provincetown (Massachusetts) Playhouse, contributing their talents as both actors and artists. In 1921 William Zorach drew a charcoal portrait that, with the greatest economy of line and shading, captured the likeness of another member of the Provincetown troupe, the playwright Eugene O'Neill. In about 1922, Zorach turned from painting to sculpture. He carved directly in wood or stone, without working up a rough model or MA-QUETTE beforehand. His sculpture is fluidly structural, not anatomical. A theme to which he frequently returned was that of mother and child; *Devotion* (1946) is a granite representation of a seated mother with a standing child in her arms. The two bodies curve around and dissolve into one another, and their expressions are of sublime contentment.

Zurbarán, Francisco de

1598–1664 • Spanish • painter •
Baroque

Monks of Zurbarán, white-robed
Carthusians who, in the shadows, /
Pass silently over the stones of the
dead, / Whispering Paters and Aves
without end, / What crime do you
expiate with such remorse? (Théophile
Gautier, 1844)

Written when he was visiting Seville,
Gautier's verse describes the haunting
images of Zurbarán's praying and suf-
fering saints. Even his life-size *Saint*
Francis in Ecstasy (late 1630s) goes
against the artistic convention of
portraying Saint Francis in happy com-
munion with the birds: Zurbarán's
kneeling *Francis* is an intense and
wrenching figure. The fervor of the
Counter-Reformation infuses the paint-
ings of Zurbarán, a devout Catholic
who worked for many monastic orders,
including Dominicans, Franciscans,
Carthusians, Carmelites, and both Bare-
foot and Shod Mercedarians. It is for
the last, the Shod Mercedarians, that he
painted *Saint Serapion* in 1628. Be-
lieved to be of Scottish origin, Serapion
took part in the Third Crusade of 1196,
and then, some 26 years later, joined
the Mercedarians. On a mission to res-
cue Christians in Algiers, Serapion was
killed for preaching the Gospel and con-
verting Moslems to Christianity. Zur-
barán's *Saint Serapion* is thought to
have been painted for a monastery in
Seville; it hung in the *sala de profundis,*
where bodies of dead monks were held
before burial. There are conflicting ac-
counts of his martyrdom, and in the one
Zurbarán illustrated Serapion was tied
to a tree, tortured, and then decapi-
tated. He may still be alive, but barely,
as Zurbarán shows him, ropes around
his wrists, eyes closed, his head (still at-
tached) fallen onto one shoulder. The
background is completely dark, in stark
contrast to the creamy white habit that
fills fully three-quarters of the canvas.
Its heavy, rough fabric drapes and falls
from his arms and shoulders in deep,
complexly shadowed folds, each one
magnificently described. The material
itself takes on the importance of doc-
trine. CARAVAGGIO's influence is de-
tected in the dramatic contrast of light
and shadow, but Zurbarán's concentra-
tion is different, and the elimination of
all background and extraneous objects
sets him apart. His heightened material
tactility is also outstanding in his STILL
LIFE paintings, in which objects are
lined up, also against dark back-
grounds, and flooded with raking
light. *Lemons, Oranges, Cup and Rose*
(1633) are independent, self-contained,
and ultimately untouchable objects that
stand for something well beyond every-
thing that meets the eye. "Zurbarán's
whole point is the interpenetration of
what is ordinary and unassuming with
what is exalted and sacred so that . . .
the mundane and the supramundane
change places," BRYSON writes.

BIBLIOGRAPHY

Adams, Laurie Schneider. *The Methodologies of Art: An Introduction.* New York: HarperCollins, 1996.

Age of Caravaggio, The, exhibition catalogue. New York: Metropolitan Museum of Art, 1985.

Alpers, Svetlana. *The Art of Describing: Dutch Art in the Seventeenth Century.* Chicago: University of Chicago Press, 1983.

Anderson, Frank J. *An Illustrated History of the Herbals.* New York: Columbia University Press, 1977.

Arnason, H. H. *History of Modern Art,* 3rd rev. ed. New York: Abrams, 1988.

Baxandall, Michael. *The Limewood Sculptors of Renaissance Germany.* New Haven: Yale University Press, 1980.

———. *Painting and Experience in Fifteenth-Century Italy.* Oxford: Oxford University Press, 1974.

———. *Patterns of Intention: On the Historical Explanation of Pictures.* New Haven: Yale University Press, 1985.

Bazin, Germain. *Baroque and Rococo.* London: Thames and Hudson, 1964.

Bearden, Romare, and Harry Henderson. *A History of African-American Artists.* New York: Pantheon, 1993.

Benesch, O. *The Art of the Renaissance in Northern Europe,* rev. ed. London: Phaidon, 1965.

Berger, John. *Ways of Seeing.* London: BBC and Penguin, 1972.

Biers, William. *The Archaeology of Greece: An Introduction,* rev. ed. Ithaca, N.Y.: Cornell University Press, 1987.

Blair, Sheila S., and Jonathan M. Bloom. *The Art and Architecture of Islam: 1250–1800.* New Haven: Yale University Press, 1994.

Blunt, Anthony. *Art and Architecture in France: 1500–1700,* 4th ed. Pelican History of Art. Harmondsworth, England: Penguin, 1953.

Boardman, John. *Greek Art,* rev. ed. World of Art. New York: Oxford University Press, 1973.

Borsook, Eve, and Fiorella Superbi Gioffredi. *Italian Altarpieces, 1250–1550: Function and Design.* Oxford: Clarendon, 1994.

———. *The Mural Painters of Tuscany: From Cimabue to Andrea del Sarto,* 2nd ed. New York: Oxford University Press, 1986.

Brilliant, Richard. *Pompeii, AD 79.* New York: Clarkson N. Potter, 1979.

———. *Portraiture.* Cambridge, Mass.: Harvard University Press, 1991.

———. *Visual Narratives: Storytelling in Etruscan and Roman Art.* Ithaca, N.Y.: Cornell University Press, 1984.

Broude, Norma. *Impressionism: A Feminist Reading.* New York: Rizzoli, 1991.

Broude, Norma, and Mary Garrard, eds. *The Expanding Discourse: Feminism and Art History.* New York: HarperCollins, 1997.

Broude, Norma, and Mary Garrard. *The Power of Feminist Art: The American Movement of the 1970s, History and Impact.* New York: Abrams, 1994.

Bryson, Norman. *Looking at the Overlooked: Four Essays on Still Life Painting.* London: Reaktion Books, 1990.

Bryson, Norman, ed. *Calligram: Essays in New Art History from France.* Cambridge, England: Cambridge University Press, 1988.

————, ed. *Vision and Painting: The Logic of the Gaze.* New Haven: Yale University Press, 1983.

———— et al., eds. *Visual Theory: Painting and Interpretation.* New York: Cambridge University Press, 1991.

Buitron-Oliver, Diana. *The Greek Miracle,* exhibition catalogue. Washington, D.C.: National Gallery of Art, 1992.

Cahn, Walter. *Masterpieces: Chapters on the History of an Idea.* Princeton, N.J.: Princeton University Press, 1979.

Carpenter, Rhys. *Greek Sculpture: A Critical Review.* Chicago: University of Chicago Press, 1960.

Castriota, David, ed. *Artistic Strategy and the Rhetoric of Power.* Carbondale: Southern Illinois University Press, 1986.

Chadwick, Whitney. *Women, Art, and Society,* rev. ed. New York: Thames and Hudson, 1997.

Champa, Kermit S. *The Rise of Landscape Painting in France: Corot to Monet,* exhibition catalogue. Manchester, N.H.: Currier Gallery, 1991.

Chipp, Herschel B. *Theories of Modern Art: A Source Book by Artists and Critics.* Berkeley: University of California Press, 1968.

Clark, Kenneth. *Landscape into Art,* new ed., New York: Harper & Row, 1976.

————. *The Nude: A Study in Ideal Form.* Garden City, N.Y.: Doubleday, 1956.

Collins, Michael, and Andreas Papadakis. *Post-Modern Design.* New York: Rizzoli, 1989.

Craven, Wayne. *American Art: History and Culture.* Madison, Wis.: Brown & Benchmark, 1994.

Crow, Thomas E. *Painters and Public Life in Eighteenth-Century Paris.* New Haven: Yale University Press, 1985.

Danto, Arthur C. *Embodied Meanings: Critical Essays and Aesthetic Meditations.* New York: Farrar Straus Giroux, 1994.

Davidson, Abraham A. *Early American Modernist Painting: 1910–1935.* New York: Harper & Row, 1981.

Davis, John. *The Landscape of Belief: Encountering the Holy Land in Nineteenth-Century American Art and Culture.* Princeton, N.J.: Princeton University Press, 1996.

De Hamel, Christopher. *A History of Illuminated Manuscripts.* London: Phaidon, 1994.

————. *Medieval Craftsmen: Scribes and Illuminators.* Toronto: University of Toronto Press, 1992.

Eitner, Lorenz. *Neoclassicism and Romanticism, 1750–1850: Sources and Documents,* 2 vols. Englewood Cliffs, N.J.: Prentice-Hall, 1970.

Enggass, R., and J. Brown. *Italy and Spain, 1600–1750: Sources and Documents.* Evanston, Ill.: Northwestern University Press, 1992.

Ettinghausen, Richard, and Oleg Grabar. *The Art and Architecture of Islam: 650–1250.* London: Penguin, 1987.

Fernie, Eric, ed. *Art History and Its Methods: A Critical Anthology.* London: Phaidon, 1995.

Fineberg, Jonathan. *Art Since 1940: Strategies of Being.* New York: Abrams, 1994.

Fleming, John, Hugh Honour, and Nickolaus Pevsner. *The Penguin Dictionary of Architecture,* 4th ed. New York: Penguin, 1991.

Freeberg, S. J. *Painting in Italy, 1500 to 1600,* 3rd ed. Pelican History of Art. New Haven: Yale University Press, 1993.

Freedberg, David. *The Power of Images: Studies in the History and Theory of Response.* Chicago: University of Chicago Press, 1989.

Freedberg, S. J. *Circa 1600: A Revolution of Style in Italian Painting.* Cambridge, Mass.: Harvard University Press, 1983.

———. *Painting in Italy, 1500–1600,* 3rd ed. Pelican History of Art. New Haven: Yale University Press, 1993.

———. *Painting of the High Renaissance in Rome and Florence,* 2 vols. Cambridge, Mass.: Harvard University Press, 1961.

Friedlaender, Walter. *David to Delacroix.* Cambridge, Mass.: Harvard University Press, 1952.

Friedländer, Max J. *Early Netherlandish Painting,* trans. Heinz Norden. Leiden: A. E. Sijthoff, 1976–77.

Friedländer, Max J. *Landscape, Portrait, Still Life: Their Origin and Development.* Glasgow: The University Press of Glasgow, 1949.

Frisch, Teresa Grace. *Gothic Art, 1140–c. 1450: Sources and Documents.* Englewood Cliffs, N.J.: Prentice-Hall, 1971.

Gardner's Art Through the Ages, 10th ed. Tansey, Richard, et al., eds. San Diego: Harcourt Brace, 1995.

Giedion, Siegfried. *Space, Time, and Architecture: The Growth of a New Tradition,* 4th ed. Cambridge, Mass.: Harvard University Press, 1962.

Goldwater, Robert, and Marco Treves. *Artists on Art: From the XIV to the XX Century.* New York: Pantheon, 1945.

Gombrich, E. H. *Art and Illusion: A Study in the Psychology of Pictorial Representation,* 4th ed. New York: Pantheon, 1972.

Greenough, Sarah, et al. *On the Art of Fixing a Shadow: One Hundred and Fifty Years of Photography,* exhibition catalogue. Washington, D.C.: National Gallery of Art, 1989.

Hall, James. *Dictionary of Subjects and Symbols in Art,* rev. ed. New York: Harper & Row, 1979.

Hall, Marcia. *Color and Meaning: Practice and Theory in Renaissance Painting.* Cambridge, England: Cambridge University Press, 1992.

Hanfmann, George M. A. *Roman Art.* New York: Norton, 1975.

Harbison, Craig. *The Mirror of the Artist: Northern Renaissance Art in Its Historical Context.* New York: Abrams, 1995.

Harris, Ann Sutherland, and Linda Nochlin. *Women Artists: 1550–1950.* New York: Knopf, 1977.

Hartt, Frederick. *Italian Renaissance Art,* 4th ed. New York: Abrams, 1993.

Haskell, Francis. *Patrons and Painters: Art and Society in Baroque Italy.* New Haven: Yale University Press, 1980.

Haskell, Francis, and N. Penny. *Taste and the Antique: The Lure of Classical Sculpture, 1500–1900.* New Haven: Yale University Press, 1981.

Hitchcock, Henry-Russell. *Architecture: Nineteenth and Twentieth Centuries.* Harmondsworth, England: Penguin, 1971.

———. *Modern Architecture: Romanticism and Reintegration,* rev. ed. New York: Da Capo Press, 1993.

Holt, Elizabeth Gilmore, ed. *A Documentary History of Art,* 3 vols. New Haven: Yale University Press, 1986.

———, ed. *The Triumph of Art for the Public: The Emerging Role of Exhibitions and Critics.* Garden City, N.Y.: Anchor Books, 1979.

Honour, Hugh. *Neo-Classicism,* rev. ed. London: Penguin, 1977.

———. *Romanticism.* New York: Harper & Row, 1979.

Hood, Sinclair. *The Arts in Prehistoric Greece.* London: Penguin, 1978.

Hooper, Finley. *Greek Realities.* Detroit: Wayne State University Press, 1978.

Hughes, Robert. *American Visions: The Epic History of Art in America.* New York: Knopf, 1997.

———. *Nothing If Not Critical: Selected Essays on Art and Artists.* New York: Knopf, 1990.

———. *The Shock of the New: The Hundred-year History of Modern Art.* New York: Knopf, 1996.

Huizinga, Johan. *The Autumn of the Middle Ages,* trans. Rodney J. Payton and Ulrich Mammitzsch. Chicago: University of Chicago Press, 1997.

Janson, Horst W. *History of Art,* 5th ed., rev. and exp. by Anthony F. Janson. New York: Abrams, 1995.

Jencks, Charles. *Architecture Today,* 2nd ed. London: Academy, 1993.

———. *Post-Modernism: The New Classicism in Art and Architecture.* New York: Rizzoli, 1987.

———. *What Is Post-Modernism?* 3rd rev. ed. London: Academy, 1989.

Johns, Elizabeth. *American Genre Painting: The Politics of Everyday Life.* New Haven: Yale University Press, 1991.

Johnson, Ellen H. *American Artists on Art: From 1940 to 1980.* New York: Harper & Row, 1982.

Jones, Henry Stuart, ed. *Select Passages from Ancient Writers Illustrative of the History of Greek Sculpture.* Chicago, Argonaut, 1966. (Cover title: *Ancient Writers on Greek Sculpture.* Reprint of a work first published in 1895.)

Kitzinger, Ernst. *Early Medieval Art,* rev. ed. Bloomington: Indiana University Press, 1983.

Koerner, Joseph L. *The Moment of Self-Portraiture in German Renaissance Art.* Chicago: University of Chicago Press, 1993.

Kostof, Spiro. *A History of Architecture: Settings and Rituals.* New York: Oxford University Press, 1985.

Krauss, Rosalind E. *The Originality of the Avant-Garde and Other Modernist Myths.* Cambridge, Mass.: MIT Press, 1985.

Krautheimer, Richard. *Early Christian and Byzantine Architecture,* 4th ed. Harmondsworth, England: Penguin, 1986.

Lippard, Lucy. *Pop Art.* New York: Praeger, 1966.

Lucie-Smith, Edward. *Symbolist Art.* New York: Praeger, 1972.

Macdonald, William L. *The Pantheon.* Cambridge, Mass.: Harvard University Press, 1976.

Mâle, Émile. *Religious Art in France, the Late Middle Ages: A Study of Medieval Iconography and Its Sources.* Princeton, N.J.: Princeton University Press, 1986.

Mango, Cyril A., comp. *The Art of the Byzantine Empire, 312–1453: Sources and Documents.* Englewood Cliffs, N.J.: Prentice-Hall, 1972.

Martin, John Rupert. *Baroque.* New York: Harper & Row, 1977.

Martineau, Jane, and Andrew Robison, eds. *The Glory of Venice: Art in the Eighteenth Century,* exhibition catalogue. New Haven: Yale University Press, 1994.

Mathews, Thomas F. *The Clash of Gods: A Reinterpretation of Early Christian Art.* Princeton, N.J.: Princeton University Press, 1993.

McCoubrey, John W. *American Art, 1700–1960: Sources and Documents.* Englewood Cliffs, N.J.: Prentice-Hall, 1965.

Meiss, Millard. *French Painting in the Time of Jean de Berry: The Late Fourteenth Century and the Patronage of the Duke.* New York: Braziller, 1967.

Minor, Vernon Hyde. *Art History's History.* Englewood Cliffs, N.J.: Prentice-Hall, 1994.

Moxey, Keith. *The Practice of Theory: Poststructuralism, Cultural Politics, and Art History.* Ithaca, N.Y.: Cornell University Press, 1994.

National Museum of Women in the Arts, exhibition catalogue. New York: Abrams, 1987.

Nelson, Robert S., and Richard Shiff. *Critical Terms for Art History.* Chicago: University of Chicago Press, 1996.

Nochlin, Linda. *Impressionism and Post-Impressionism 1874–1904: Sources and Documents.* Englewood Cliffs, N.J.: Prentice-Hall, 1966.

———. *Realism.* Harmondsworth, England: Penguin, 1971.

———. *Realism and Tradition in Art 1848–1900: Sources and Documents.* Englewood Cliffs, N.J.: Prentice-Hall, 1966.

———. *Women, Art, and Power, and*

Other Essays. New York: Harper & Row, 1988.

Ozment, Steven. *The Age of Reform, 1250–1550.* New Haven: Yale University Press, 1980.

Pacht, Otto. *Book Illumination in the Middle Ages.* London: Harvey Miller, 1986.

Panofsky, Erwin. *Early Netherlandish Painting: Its Origins and Character,* 2 vols. Cambridge, Mass.: Harvard University Press, 1966.

———. *Meaning in the Visual Arts.* Garden City, N.Y.: Doubleday, 1955.

———. *Studies in Iconology: Humanist Themes in the Art of the Renaissance.* New York: Harper & Row, 1972.

Parker, Roszika, and Griselda Pollock. *Old Mistresses: Women, Art, and Ideology.* New York: Pantheon, 1981.

Pevsner, Nikolaus. *Pioneers of Modern Design: From William Morris to Walter Gropius,* rev. ed. London: Penguin, 1986.

Polcari, Stephen. *Abstract Expressionism and the Modern Experience.* New York: Cambridge University Press, 1991.

Pollitt, J. J. *Art and Experience in Classical Greece.* Cambridge: Cambridge University Press, 1972.

———. *The Art of Rome c. 753 B.C.–337 A.D.: Sources and Documents.* Englewood Cliffs, N.J.: Prentice-Hall, 1966.

Pollock, Griselda. *Vision and Difference: Femininity, Feminism, and the Histories of Art.* New York: Routledge, 1988.

Pope-Hennessey, John. *An Introduction to Italian Sculpture,* 4th ed. London: Phaidon, 1996.

———. *Italian Renaissance Sculpture,* 3rd ed. Oxford: Phaidon, 1986.

Rewald, John. *Post-Impressionism: From Van Gogh to Gauguin.* New York: Museum of Modern Art, 1956.

Roberts, Helene E., ed. *Encyclopedia of Comparative Iconography.* Chicago: Fitzroy Dearborn, 1998.

Rosenberg, Jakob, Seymour Slive, and E. H. ter Kuile. *Dutch Art and Architecture: 1600–1800,* 3rd ed. Harmondsworth, England: Penguin, 1977.

Rosenblum, Robert, and H. W. Janson. *19th-Century Art.* Englewood Cliffs, N.J.: Prentice-Hall, 1984.

Roskill, Mark. *The Interpretation of Pictures.* Amherst, Mass.: University of Massachusetts Press, 1989.

———. *Klee, Kandinsky, and the Thought of Their Time: A Critical Perspective.* Urbana: University of Illinois Press, 1992.

———. *The Languages of Landscape.* University Park: Pennsylvania State University Press, 1997.

———. *Van Gogh, Gauguin, and the Impressionist Circle.* Greenwich, Conn.: New York Graphic Society, 1970.

———. *What Is Art History?* 2nd ed. Amherst, Mass.: University of Massachusetts Press, 1989.

Saarinen, Aline. *The Proud Possessors.* New York: Random House, 1958.

Sandler, Irving. *American Art of the 1960s.* New York: Harper & Row, 1988.

———. *The New York School: The Painters and Sculptors of the Fifties.* New York: Harper & Row, 1978.

Schwartz, Gary. *Rembrandt, His Life, His Paintings.* New York: Viking, 1985.

Scott, Kathleen L. *Later Gothic Manuscripts, 1390–1490,* 2 vols. London: Harvey Miller, 1996.

Scully, Vincent. *The Earth, the Temple, and the Gods: Greek Sacred Architecture,* rev. ed. New Haven: Yale University Press, 1979.

Searing, Helen. *Speaking a New Classicism: American Architecture Now,* exhibition catalogue. Northampton, Mass.: Smith College Museum of Art, 1981.

Searing, Helen, ed. *In Search of Modern Architecture: A Tribute to Henry-Russell Hitchcock.* Cambridge, Mass.: MIT Press, 1982.

Shearman, John. *Mannerism.* Harmondsworth, England: Penguin, 1967.

———. *Only Connect: Art and the Spectator in the Italian Renaissance.* Princeton, N.J.: Princeton University Press, 1992.

Smart, Alastair. *The Renaissance and Mannerism in Italy.* London: Thames and Hudson, 1971.

Snyder, James. *Northern Renaissance Art: Painting, Sculpture, the Graphic Arts, from 1350 to 1575.* New York: Abrams, 1985.

Stebbins, Theodore E., Jr., et al., eds. *A New World: Masterpieces of American Painting, 1760–1910,* exhibition catalogue. Boston: Museum of Fine Arts, 1983.

Stechow, Wolfgang. *Northern Renaissance Art, 1400–1600: Sources and Documents.* Englewood Cliffs, N.J.: Prentice-Hall, 1966.

Stokstad, Marilyn. *Art History.* New York: Abrams, 1995.

———. *Medieval Art.* New York: Harper & Row, 1986.

Sutton, Peter C. *The Age of Rubens.* Boston: Museum of Fine Arts, 1993.

Taylor, Joshua C. *Learning to Look: A Handbook for the Visual Arts,* 2nd ed. Chicago: University of Chicago Press, 1981.

Theophilus. *On Divers Arts: The Treatise of Theophilus,* trans. and notes by John G. Hawthorne and Cyril Stanley Smith. Chicago: University of Chicago Press, 1963.

Tinterow, Gary, and Henri Loyrette. *Origins of Impressionism,* exhibition catalogue. New York: Metropolitan Museum of Art, 1994.

Tufts, Eleanor. *American Women Artists, 1830–1930.* Washington, D.C.: National Museum of Women in the Arts, 1987.

Vasari, Giorgio. *The Lives of the Artists,* trans. Julia Conaway Bondanella and Peter Bondanella. New York: Oxford University Press, 1991.

Vaughn, William. *Romantic Art.* London: Thames and Hudson, 1978.

Weinberg, H. Barbara. *The Lure of Paris: Nineteenth-Century American Painters and Their French Teachers.* New York: Abbeville, 1991.

Weinberg, H. Barbara, et al. *American Impressionism and Realism: The Painting of Modern Life, 1885–1915,* exhibition catalogue. New York: Metropolitan Museum of Art, 1994.

Wheeler, Mortimer. *Roman Art and Architecture.* New York: Thames and Hudson, 1964.

White, John. *Art and Architecture in Italy, 1250–1400,* 3rd. ed. New Haven: Yale University Press, 1993.

Wilmerding, John. *American Art.* Harmondsworth, England: Penguin, 1976.

Wittkower, Rudolf. *Art and Architecture in Italy: 1600–1750,* 5th ed. New Haven: Yale University Press, 1982.

Wolf, Bryan Jay. *Romantic-Revision: Culture and Consciousness in Nineteenth-Century American Painting and Literature.* Chicago: University of Chicago Press, 1986.

Wölfflin, Heinrich. *Principles of Art History: The Problem of the Development of Style in Later Art.* New York: Dover, 1932.

INDEX

Page numbers in *bold italic type* refer to dictionary entries.